2 0 0 0
PHOTO
GRAPHER'S
MARKET

2,000 PLACES TO SELL YOUR PHOTOGRAPHS

EDITED BY
MEGAN LANE

WRITER'S DIGEST BOOKS
CINCINNATI, OHIO

Managing Editor, Annuals Department: Cindy Laufenberg
Supervisory Editor: Barbara Kuroff
Production Editor: Pamala Shields

Writer's Digest Books website: http://www.writersdigest.com

International Standard Serial Number 0147-247X
International Standard Book Number 0-89879-912-0

Attention Booksellers: This is an annual directory of F&W Publications. Return deadline for this edition is December 31, 2000.

contents at a glance

Contents

The Business of Photography

© Spathis and Miller

Page 41

The Markets

The magazines listed here offer hundreds of opportunities for you to see your work in print. These markets include large circulation magazines as well as specialized publications.

Insider Report:

© 1998 Clix Photography

Page 113

© 1990 Wendy Ewald

Page 240

© Deborah Hardee 1999

Page 402

Resources

© Dennis Savage

Page 489

From the Editor

Have you ever heard a word, a word that seemed new and alien to you, looked it up in the dictionary and then, suddenly, began to hear it everywhere? When this happens to me, I often wonder if the word was there all the time, bandied about in casual conversation, but just escaped my notice. I experienced the same feeling, working on *Photographer's Market* this year, about a concept instead of a word.

The concept of "personal vision" first came to my attention at last year's PhotoPlus Expo in New York, during a panel discussion with photographers Chris Rainier and Joyce Tenneson. Rainier was especially adamant that photographers must have a passion for their subjects. He stressed that as the market gets tougher and tougher, a photographer's vision will be what makes his or her work stand out.

I was intrigued by the idea of personal vision and how shooting the work you love might ultimately make you more profitable as a photographer, but most of the articles for the next edition of the book had already been assigned. I asked one writer to focus on the subject, for this edition of *Photographer's Market*. But as other articles came in from contributors, amazingly, it seemed that personal vision played a role in many of them.

"You need to do your visual push-ups," the renowned, New York-based photographer **Jay Maisel** advises in an interview on page 53. "You need to do exercises to keep your body healthy, and you need to do personal work to keep your photography healthy. Actors take classes. So do dancers. But unless they're getting paid to do it, photographers don't practice. It's important to practice."

On page 242, photographer **Wendy Ewald** discusses how she pursued her personal vision without any expectation of publication. "That was very important, because it allowed me to make my own market. All of us have something unique that we can offer, we all see the world in a different way. That's valuable," she says.

Advertising photographer **Deborah Hardee** explains how she uses portfolios of personal work to win prestigious commercial assignments on page 404 and four photography teams discuss how their collaborative vision creates work that transcends the sum of its parts on page 40. "The exchange creates a third entity," explains **Virginia Beahan**, photography partner of **Laura McPhee**. "Neither one of us would have done this work without the other. But that's what creativity is, mixing ingredients together and something new comes out of it."

How can you discover your own personal vision when you're trying to shoot images that you know will sell? For starters, take Jay Maisel's advice and do a few self-assignments. You may find a new direction for your work or develop a new image for your portfolio. And don't forget to find inspiration in the images around you. It's easy to block out all the visual stimuli we receive each day. Try spending a week paying close attention to every image you see.

Go to museums and galleries, flip through coffee-table books, pay attention to print ads, tear out pages from magazines and source books. Start keeping a file of images that inspire you. Ask yourself why you like certain pictures more than others. Is it the color or lack of color? Is it the lighting? Is it the subject matter? Is it the way the image was shot? Looking at other people's work will teach you more about yourself and your own personal vision than you might realize.

Megan Lane

Megan Lane
www.writersdigest.com

"Quick-Start" to Selling Your Photos

If this is your first edition of *Photographer's Market*, you're probably feeling a little overwhelmed by all the information in this book. Before you start flipping through the listings, read the ten steps below to learn how to get the most out of this book and your selling efforts.

1. Be honest with yourself. Are the photographs you make of the same quality as those you see published in magazines and newspapers? If the answer is yes, you may be able to sell your photos.

2. Get someone else to be honest with you. Do you know a professional photographer who would critique your work for you? Other ways to get opinions about your work: join a local camera club or other photo organization, attend a stock seminar led by a professional photographer, attend a regional or national photo conference.

- You'll find a list of photographic organizations on page 563.
- You'll find workshop and seminar listings beginning on page 542.
- Check your local camera store for information about camera and slide clubs in your area.

3. Get Organized. Start making a list of subjects you have photographed and organizing your images in subject groups. Make sure you can quickly find specific images and keep track of any sample images you send out. You can use database software on your home computer to help you keep track of your images. (See page 27 for more information.)

Other Resources:

- *The Photographer's Market Guide to Photo Submission and Portfolio Formats* by Michael Willins, Writer's Digest Books.
- *Sell and ReSell Your Photos* by Rohn Engh, Writer's Digest Books.

4. Consider the format. Are your pictures color snapshots, b&w prints, or color slides? The format of your work will determine, in part, which markets you can approach. Always check the listings in this book for specific format information.

b&w prints—galleries, art fairs, private collectors, literary/art magazines, trade magazines, newspapers, some book publishers.

color prints—newsletters, very small trade or club magazines.

large color prints—galleries, art fairs, private collectors.

color slides (35mm)—most magazines, newspapers, some greeting card and calendar publishers, some book publishers, text book publishers, stock agencies.

color transparencies ($2\frac{1}{4} \times 2\frac{1}{4}$ and 4×5)—magazines, book publishers, calendar publishers, ad agencies, stock agencies.

digital—some newspapers, magazines, stock agencies and ad agencies. All listings that accept digital work are marked with a ▣ symbol.

5. Do you want to sell stock images or accept assignments? A stock image is any photograph you create on your own and then sell to a publisher. An assignment is a photograph created at the request of a specific buyer. Many of the listings in *Photographer's Market* are interested in both stock and assignment work.

- Listings that are only interested in stock photography are marked with a Ⓢ symbol.
- Listings that are only interested in assignment photography are marked with a Ⓐ symbol.

6. Start researching. Generate a list of the publishers that might buy your images—check the newsstand, go to the library, read the listings in this book. Don't forget to look at greeting cards, stationery, calendars and CD covers. Anything you see with a photograph on it from a billboard advertisement to a cereal box is a potential market.

- See page 4 for instructions about how to read the listings in this book.

- If you shoot a specific subject, check the subject index on page 588 to simplify your search.

7. Send for guidelines. Do you know exactly how the publisher you choose wants to be approached? Check the listings in this book first, but if you don't know the format, subject and number of images a publisher wants in a submission you should send a short letter with a self-addressed, stamped envelope (SASE) asking those questions. You could also check the publisher's website or make a quick call to the receptionist to find the answers.

8. Check out the market. Get in the habit of reading industry magazines.

- You'll find a list of useful magazines on page 565.

9. Prepare yourself. Before you send off your first submission make sure you know how to respond when a publisher agrees to "buy" your work.

Pay Rates:

Most magazine and newspapers will tell you what they pay and you can accept or decline. However, you should make yourself familiar with typical pay rates. Don't be afraid to ask other photographers what they charge. Many will be willing to tell you to prevent you from devaluing the market by undercharging. (See page 22 for more information.)

Other resources:

- *Pricing Photography: The Complete Guide to Assignment & Stock Prices*, Allworth Press.
- *FotoQuote*, a software package that is updated each year to list typical stock photo prices, (800)679-0202.

Copyright:

You should always include a copyright notice on any slide or print you send out. While you automatically own the copyright to your work the instant it is created, the notice affords extra protection. The proper format for a copyright notice includes the word or symbol for copyright, the date and your name: © 1998 Megan Lane. To fully protect your copyright and recover damages from infringers you must register your copyright with the Copyright Office in Washington. (See page 29 for more information.)

Rights:

In most cases, you will not actually be selling your photographs, but rather, the rights to publish them. If a publisher wants to buy your images outright, you will lose the right to resell those images in any form or even display them in your portfolio. Most publishers will buy one-time rights and/or first rights. (See page 30 for more information.)

Other Resources:

- *Legal Guide for the Visual Artist* by Tad Crawford, Allworth Press.

Contracts:

Formal contract or not, you should always agree to any terms of sale in writing. This could be as simple as sending a follow-up letter, restating the agreement and asking for confirmation, once you agree to terms over the phone. You should always keep copies of any correspondence in case of a future dispute or misunderstanding. (See page 17 for more information.)

Other Resources:

- *Business and Legal Forms for Photographers* by Tad Crawford, Allworth Press.

10. Prepare your submission. The number one rule when mailing submissions is "follow the directions." Always address letters to specific photo buyers. Always include a SASE of sufficient size and with sufficient postage for your work to be safely returned to you. Never send originals when you are first approaching a potential buyer. Try to include something in your submission that the potential buyer can keep on file such as a tearsheet and your résumé. (See page 16 for more information.)

Other Resources:

- *The Photographer's Market Guide to Photo Submission and Portfolio Formats* by Michael Willins, Writer's Digest Books.

How to Read the Listings in This Book

SYMBOLS

The first thing you'll notice about most of the listings in this book is the group of symbols that appears before the name of each company. Scanning the listings for symbols can help you quickly locate markets that meet certain criteria. (You'll find a quick-reference key to the symbols on the front and back inside covers of the book.) Here's what each symbol stands for:

N The photo buyer is new to this edition of the book.

⊕ This photo buyer is located outside the U.S. and Canada.

✦ This photo buyer is located in Canada.

A This photo buyer uses only images created on assignment.

S This photo buyer uses only stock images.

▣ This photo buyer accepts submissions in digital format.

▨ This photo buyer uses film or other audiovisual media.

PAY SCALE

We asked photo buyers to indicate their general pay scale based on what they typically pay for a single image. Their answers are signified by a series of dollar signs before each listing. Scanning for dollar signs can help you quickly identify which markets pay at the top of the scale, however, not every photo buyer answered this question, so don't mistake a missing dollar sign as an indication of low fees. Also keep in mind that many photo buyers are willing to negotiate.

$ Pays $1-150

$ $ Pays $151-750

$ $ $ Pays $751-1,500

$ $ $ $ Pays more than $1,500

OPENNESS

We also asked photo buyers to indicate their level of openness to freelance photography. Looking for these symbols can help you identify buyers willing to work with newcomers as well as prestigious buyers who only publish top-notch photography.

◻ Encourages beginning or unpublished photographers to submit work for consideration; publishes new photographers. May pay only in copies or have a low pay rate.

◪ Accepts outstanding work from beginning and established photographers; expects a high level of professionalism from all photographers who make contact.

◖ Hard to break into; publishes mostly previously published photographers. May pay at the top of the scale.

◉ Specialized; limited to certain specific subjects or to contributors from a specific region.

∅ Closed to unsolicited submissions.

SUBHEADS

Each listing is broken down into sections to make it easier to locate specific information. In the first section of each listing you'll find mailing addresses, phone numbers, e-mail and website

addresses and the name of the person you should contact. You'll also find general information about photo buyers, from when their business was established to their publishing philosophy. Each listing will include several of the following subheads:

Needs: Here you'll find specific subjects each photo buyer is seeking. You can find an index of these subjects starting on page 588 to help you narrow your search. You'll also find the average number of freelance photos a buyer uses each year to help you gauge your chances of publication.

Audiovisual Needs: If you create images for media such as filmstrips or overhead transparencies or you shoot videotape or motion picture film, look here for photo buyers' specific needs in these areas.

Specs: Look here to learn in what format a buyer wants to receive accepted work. Make sure you can provide your images in that format before you send samples.

Exhibits: This subhead appears only in the gallery section of the book. Like the Needs subhead, you'll find information here about the specific subjects and types of photography a gallery shows.

Making Contact & Terms: When you're ready to make contact with a publisher, look here to find out exactly what they want to see in your submission. You'll also find what the buyer usually pays and what rights they expect in exchange. In the stock section, this subhead is divided into two parts, Payment & Terms and Making Contact, because this information is often lengthy and complicated.

Tips: Look here for advice and information directly from photo buyers in their own words.

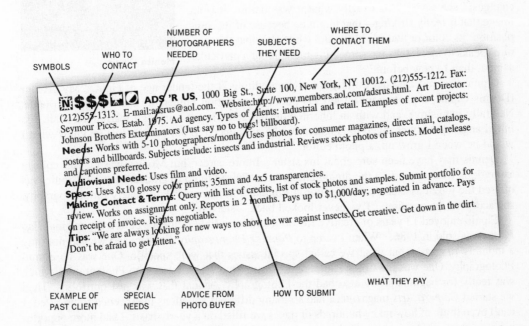

Feature: *Pop Photo's* Picture Editor Champions Photography Into the Next Millennium

BY MEGAN LANE

With her bright smile, cascade of red ringlet hair and infectious enthusiasm, Monica Cipnic is the Fairy Godmother of photography. It is difficult to fathom the number of photographic careers she has aided and celebrated in her 20-plus years as the picture editor of *Popular Photography* magazine, careers that include such successes as Pete Turner and Eric Meola. And in an industry plagued by pessimism about pay rates, turmoil over changing technology and fear of overwhelming competition, Cipnic offers a voice of determination and encouragement.

"What makes a great photograph is not something that changes," she says. "It is exactly what it was before. It is an image that is really striking—that might be because of its composition, its color or that it's black and white. It's that this picture speaks to me. It tells me something more about a particular subject than I knew before."

Monica Cipnic

Cipnic first revealed her affinity for picture editing at the tender age of eight. "My brother (Dennis Cipnic, a photographer) left his photo presentation binders on the living room table. Naturally inquisitive, and with an inherited design gene, in ten minutes I rearranged it all. His initial anger quickly changed to laughter and he announced to our parents that he knew what I would be when I grew up: a photo editor."

Dennis may have been sure about his sister's future career, but Monica wasn't. Her college aspirations were to work in the diplomatic service. Poised to go to graduate school, Cipnic was offered the job of assistant picture editor at *Popular Photography*. Fortunately for photography, she accepted the position. "I've never looked back," she says.

Cipnic enjoyed 13 years of creative freedom and incredible influence before the original *Pop Photo* was sold in 1986. "When I came to *Popular Photography* 20 years ago we had not only a monthly magazine but what we called special issues that were specific. One was on 35mm Photography. One was the Color Photography issue. One was Invitation to Photography, which was really for beginners. We also had the Photography Annual that was just portfolios. Then we started *Camera Arts* magazine. I had so many different situations that needed to be filled. I can't even think of how many hundreds of pages we filled on a yearly basis. I had more opportunities to show photography and photographers' work at different levels of expertise."

After a four-year break from the magazine, during which Cipnic worked at a stock agency, in television and as a freelance picture editor, she returned to a new incarnation of *Pop Photo* in 1990. So what has changed? "Many things," she says. "Less space devoted to picture stories, thinner paper due to costs, budget constraints that affect my travels to see and find new work to publish, lack of sufficient space in my office to view photographers' work, and a long-promised computer that should show up any day now." What hasn't changed? "My desire to

inspire readers and how I go about getting the best photographs from great photographers."

To get the best photographs Cipnic realized she needed to give shooters a forum and encourage them to find her. "I tried when I came back to the magazine to give both the beginner and a more advanced amateur or advanced photography enthusiast some possibilities. I started things like 'Discovery,' which is for someone who is not a well-known, household name kind of person but has a body of photographs they've been working on. It can be black and white, it can be color, it can be technically driven, it can be a theme of some sort, it can be a location, or something like that."

To find the photographers for 'Discovery' and other portfolios she publishes in the magazine, Cipnic looks to promo cards and other mailings as well as portfolio drop-offs. "I'm a visual person," she says. "A phone call or a letter saying 'I have a stock list' means nothing to me." While she doesn't encourage photographers to send original slides or to press her for a decision about samples they've sent, she does like to receive postcards and laser prints to keep on file. "Something may come up. It may not be this week and it may not be next month, but a year from now I might remember somebody who sent me a mailing."

In her first go-round as picture editor, Cipnic was able to set aside three mornings a week to see photographers and review their portfolios. Today, few people in her position have this luxury. "I don't see people on a personal basis anymore because I just don't have the time," she says. "It's hard to make an appointment weeks in advance because I don't know what's going on on an hourly basis in my office." This means portfolios must speak for themselves. "That doesn't mean you have to spend $400 on a presentation case, but it does mean you have to take care and pride in what you present."

Once Cipnic or any picture editor discovers a body of promising work, it's up to the photographer to follow through. "I call certain photographers because they know what I want, they know how to deliver it, they listen to what I say and what I ask for. I think that it's as much in our

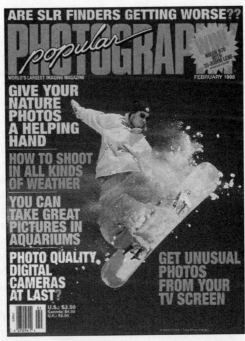

These are just two of the hundreds of *Popular Photography* covers picture editor Monica Cipnic has helped create since she began working for the magazine in 1973.

personal relationships as in our professional relationships. Many of us are so interested in what we're trying to say, that we don't listen to what the person is saying at the other end of the phone. I think it's so important that photographers listen to what is being said, figure out what's being required and deliver the images in a timely manner."

Listening skills are also crucial when calling photo buyers to discuss their needs. While Cipnic will talk to shooters when she has the time, she appreciates considerate photographers who realize she may be busy. "Be perceptive. If you hear in somebody's voice that this is not a good time to talk perhaps you need to contact them in a different way. Maybe you could send a color laser print of some pictures, some ideas and a stock list. Send a postcard they can return with choices like 'yes, I'd like to see samples,' 'no, I'd rather not,' 'would you like to see my book,' 'when can I drop it off,' 'when's a good time to call.' Make it easy. It isn't about a long letter detailing in 2 pages how you spent your 50-year career. It isn't about words if you're a photographer. It's really about the pictures."

It's also about getting the pictures in front of the decision makers: small magazines may not have picture editors; book publishers or greeting card companies may have art directors who buy the photography. In these situations Cipnic advises photographers to be patient and do a lot of research before sending their samples. "However you first approach your potential client has to give the best impression," she says. "That's why you need to be prepared." Find out what the work they publish looks like. If you can't find sample magazines, books or greeting cards, try the Internet, Cipnic advises. And don't forget to investigate how a company likes to receive submissions.

"Sending a thousand cards out to some vague list is a waste of your time and money. You really have to be secure in the knowledge of what you are capable of doing and where your work best fits," Cipnic says. She believes spending time on research will lead to publication. Slowly building your tearsheet collection will help you earn a reputation. "You may not get the big bucks at the beginning," she says, "but if you get steady work at a certain price isn't that better than one big buck thing? Then people see your name consistently and you become the 'expert in the field' or the knowledgeable one or the professional one and I want to work with a professional."

But what does "professional" mean in this industry of rapidly changing technology? For Cipnic, having the latest digital equipment is not necessary to be a pro. "At this moment a lot of the digital technology is only a tool. I think digital cameras right now are in the hands of photographers who work on tight deadlines. When television was invented we thought radio would cease to exist and we know it hasn't. It's just redefined itself. I believe traditional photography—film-based photography—is going to enter a new level. I still want to see one of Ansel's prints on a wall as opposed to it being a screen saver."

To find success in the next millennium, it all comes down to having a personal vision, Cipnic says. "I was thinking about this in terms of creating a personal niche. I think people really have to take a fearless inventory of their strengths and weaknesses and what they're good at." Cipnic advises photographers to go beyond making beautiful pictures we've already seen to putting their personal stamp on every image they create. "Individualize your pictures so when I look at them I'm going to know from the color saturation, the compositional standpoint or the lighting that these are So-and-so's pictures."

And finally, don't get too caught up in trends. Cipnic offers the example of selective focus in still life photography. "Everything now is blurry," she says. "But you know what? Photographers will get over that and they'll go on to something else. So don't transform your whole body of work to copy what's current. If you want to do a couple of pictures like that, fine, but I think you ought to show that you can really focus. You've got to take a fearless inventory of what it is you do well and what it is you want to accomplish."

The Business of Photography
Creating Your Own Destiny

BY SELINA OPPENHEIM

"Creating Your Own Destiny" is the title of a five-step business program that can guide you to the success you deserve. I developed the concept of "Creating Your Own Destiny"(CYOD) over ten years ago. Since then, hundreds of creatives have used the program to develop businesses that meet their own specific goals. Why has the program been embraced so readily? Possibly because it is a tool that all creatives at any stage of development can use to bring about significant changes to their businesses. "But there must be a catch!" you exclaim. There is. The program demands consistent attention and requires you to accept the responsibility for your own success. Undaunted? Read on.

STEP ONE: SETTING YOUR GOALS

CYOD is driven by your individual and specific goals. Every subsequent step of the program starts here. In order to develop a business that is truly yours and meets your needs you must think about and articulate what you want to achieve. Spend time here. Refuse to be discouraged. This is where accepting responsibility for your success begins! In order to help you to begin the process, break your goals into three sections: creative, financial and professional.

1. Creative goals pertain to creative achievements and set the visual direction for your business. Consider the answers to the following questions as the first step toward determining your own creative goals.

- Do I wish to be viewed as a technical facilitator or a creative collaborator?
- Am I clear about my Visual Integrity? (Visual Integrity is your visual fingerprint. The very specific style that you have developed. If you are unclear about yours then make developing or articulating your VI a goal!)
- What processes or techniques do I need to learn and perfect in order to provide clients with the types of images I have chosen to create?
- What percentage of clients will hire me based on my VI (style of shooting)?

2. Financial goals speak to the money-making aspects of your company. Answer these questions to start thinking about your financial goals.

- How much is my yearly overhead? (Make sure to include your salary here.)

Having begun her professional career as a representative for some of Boston's leading photographers, **SELINA OPPENHEIM** *has spent the last 20 years as a consultant to creative professionals, as a nationally acclaimed lecturer and developer of professional workshops. She is president and founder of Port Authority, Inc., a Boston-based creative consulting company. Port Authority can be reached by phone at (617)350-0116 or on the Web at www.1portauthority.com.*

- What type of profit margin am I aiming for? (The Small Business Development Office suggests 30-40 percent for service-based industries.)
- What do I want my sales receipts to be?
- How many days do I want to work during the year?
- Will my income come from assignments only or will I pursue stock sales?
- What type of financial growth am I looking for this year?

3. Professional goals speak to your professional ethics and business policies. Consider the following questions when setting your professional goals.

- How will I price my work? (Consider a project rate that incorporates the usage of the photo in the fee.)
- What business practices will I employ consistently?
- What does superior service look like to me?
- Do I seek to develop many clients and have a high volume business or am I interested in working with fewer clients on longer projects?

Create three separate lists of goals by looking at the answers to your questions. As you finish listing your goals, begin to break them down into objectives you must reach in order to achieve the goals. Example: If your goal is to create a portfolio that clearly expresses your vision to a specific market then your objectives might be:

1. Choose my market direction.
2. View competitive products created for a chosen market (magazines, ads, annual reports etc.).
3. Determine market trends and ascertain how my work applies.
4. Articulate talent direction and create a positioning statement (discussed in step 2 below).
5. Edit current work for positioning statement.
6. List number of new images needed and time line for completion.
7. Create new image ideas.
8. Shoot new images.
9. Choose portfolio format.
10. Edit in final image choices.

A goal will remain elusive until you list the objectives that need to be met in order to reach it. The timing of meeting the objectives is up to you. Once they are listed they become accessible and doable. Once your goals are articulated it is time to develop your Positioning Statement.

STEP 2: CREATING YOUR POSITIONING STATEMENT

A positioning statement is a statement that clearly defines what you do, how you do it and who you seek to market to. It is the message that you will consistently deliver, via your portfolio and all other marketing vehicles. Clients need to quickly gauge your talent and are eager to place you in a specific category. Your job is to provide them with the proper category for placement. An internal tool, the positioning statement is used as an editing tool for all portfolio images and any other visual choices.

Sample positioning statement for photographer Steve Greenberg.

(Steve Greenberg is nationally known for his distinctive digitally rendered illustrations. An award-winning photo illustrator, Greenberg has defined a positioning statement that he constantly refers to when he is interested in adding new work to his book. If a new piece "walks the talk" of his positioning statement, it is added to the portfolio.)

Steve is a photo illustrator working in a digital format whose goal is to create eye-catching visuals that provide the viewer with a new perspective on common objects or ideas. Color, shape and form are the tools Steve utilizes to create images that sell clients' products or

deliver corporate messages. Clients may be graphic designers, art buyers or editorial photo editors from across the country.

When creating your positioning statement consider the following questions:

- What do I shoot and how do I shoot it?
- Do I specialize in a subject category (still life, people, travel)?
- What makes my photography different from others in my area of specialty?
- What tools do I use consistently (light, texture, mood, emotion, color graphics) and in what combination?
- What markets can benefit from my work (advertising, corporate direct, graphic design)?
- What client areas are those markets servicing that would benefit from my work?
- Will I market locally, regionally or nationally?
- Am I a creative collaborator or a technical facilitator?

Once you have clearly spelled out your own positioning statement, pass it by two or three of your fellow photographers or close clients. Ask if they recognize you and determine if you have left out any important considerations. Look at your work and make sure your images speak to your positioning statement and vice versa. Your positioning statement should be three to four sentences and needs to be updated on a yearly basis. As you learn, shoot and develop more skills, you may find your positioning statement changing.

STEP 3: TARGETING AND RESEARCHING MARKETS

You have invested time and energy and are now clear on your goals. Your positioning statement is complete and you now need to determine which markets to pursue. Congratulations! You are building your business rather than allowing your business to build itself.

Targeting your market involves assessing your work, and finding an appropriate fit with clients.

- If you are interested in advertising photography, start looking through magazines. Note publications that have the type of ads you see yourself producing. Determine those companies' messages to consumers.
- If photographing for the editorial side is of interest to you, peruse various periodicals and see which ones fit your style. Determine each magazine's target audience. Is this an audience that could connect with your visual style?
- If you are interested in corporate work, create a list of companies. Call and ask them to send you annual reports and any materials they have produced for interested consumers.

Visual research is an important tool that many creatives overlook. In addition to looking at companies' printed material and ads, look at industry publications. *Communication Arts, Print* and *Graphis* are publications that highlight the work of designers and photographers from around the world. You have an opportunity to see how designers used photography in their recent projects. Each publication produces annuals that are juried competitions of design, photography and advertising and represent some of the most competitive talent around. As you look at the visual materials answer the following questions:

- What is the main message the company, ad or editorial is putting forth?
- Does my photography style fit in?
- Do I have something new to add to the mix?
- Is this a client I care to work with because they have exhibited a level of taste that I share?
- Do they use photography as a main illustration or is it informational?
- Would this client benefit from working with me?
- How would my business benefit from working with them?

As you answer these questions you begin to target your market. Make sure to consider cross markets. For instance, a corporate photographer who shoots people, places and objects for annual reports and capability brochures might also consider editorial business publications as a secondary market. Subject needs are similar and the access and credibility that editorial assignments

provide are helpful when working with corporate and design contacts.

Once you have targeted your markets you need to research the specific decision makers. All too often photographers don't do the front-end research. They spend much time showing work to contacts who do not need the type of photography they provide or find that the contact they just spent an hour with is not the decision maker. Your job is to spend your time and your prospective clients' time wisely.

Research resources

The following resources, which you can use at your public library, will provide you with specific information on the various industries. (See page 565 for additional resources.)

- For corporate, design firms, editorial publications and ad agencies: the *Blue Book of Creative Services*, published by T.F. Lewis, 245 Fifth Ave., New York NY 10016.
- For advertising firms: *The Standard Directory of Advertising Agencies*, published by National Register Publishing, 1121 Chanlon Rd., New Providence NJ 07974.
- For corporate direct: *The Standard Directory of Advertisers*, published by National Register Publishing.
- Use the Web. Many companies, agencies, publications and design studios have Web pages. Surf the Web to find specific and visual information for each contact. This is a new and very powerful tool. It is also convenient and costs little.

Once you have determined the companies you wish to call, create a list of questions that need to be answered. Consider the following as a start:

- Who is the contact hiring photographers (art director, art buyer, graphic designer, photo editor, corporate communications director, marketing director, product manager, ad manager, marcomm director)?
- What accounts (if agency or graphic design firm) does the company handle?
- What is the company's policy on viewing portfolios and meeting with photographers?

In order to answer the questions above, check the listings in this book. If the company you want to approach is not listed here, you will need to call them. At ad agencies, art buyers or creative secretaries will be able to tell you which art director and art buyer is handling a particular account. Receptionists at corporations and magazines can update any listings you have found for contacts at their companies. From here, create a database that contains all of the information you need as you call for appointments.

STEP FOUR: CREATING AN ADVERTISING PROGRAM

It is important to develop an advertising program you can maintain. It is just as important to create a program that has both direct and indirect advertising efforts. Initially your job is to build visual and brand identity. Selling in an overcrowded market, you need to build a program that allows potential clients an opportunity to see your work and to remember you over time. Using direct and indirect ad efforts can help you do that.

Direct advertising efforts are those which seek to "sell the product." Portfolio visits, mailed portfolios and direct mail are considered direct sales tools. They showcase the "product" (your vision) in hopes of making a sale. Indirect advertising efforts build a company's visibility and credibility. Newsletters, endorsement mailers, gallery shows and articles by you or about you all build your company's image. Your job is to create a program you can afford and maintain during your busiest times. Consider the following components when creating your program.

Portfolios

Your portfolio is your strongest selling tool. Make sure your book speaks to the subject area you cover and shows your Visual Integrity. The physical format of your book is important. It should act to highlight the work within, not compete with it. Answer the following questions to make sure your book is as strong as it can be:

- What do I shoot and how do I shoot it (Visual Integrity)?
- Will the subjects in my book attract my audience?
- Do some of my images speak to the messages that my target market seeks to communicate?
- Do all of the images speak to my Visual Integrity?
- Are the images in a sequential order that flows?
- Will I create a tearsheet book or just a gallery section of images?
- Does the physical format of my book express the style of work within?
- Is my presentation easy for clients to use? Easy to send?
- How will I deliver my book?
- Will I be creating multiple books to send to clients?
- How many copies of my portfolio do I need?

Visual mailers

Mailers need to speak to your positioning statement. Sent on a regular basis, once a month or every eight weeks, they act as visual reminders. Buyers will file them away and pull them out if an appropriate job is pending. As contacts expect your portfolio to contain work similar to your mailers, it is important that you construct your mailers carefully. Consider the following questions before designing this tool:

- What's my budget?
- How will I use my mailers? As a follow-up to portfolio visits or as part of an outreach program (mailers are sent alone, not as a follow-up to portfolios)?
- How many mailers will I produce in a year?
- What message do I want my mailers to deliver?
- Will the mailer contain only a visual or is there copy as well?
- Does the visual on the mailer speak the same message as my portfolio?
- What format will my mailer take?
- Do I create a mailer campaign or consider each mailer separately?
- Do I involve an art director or graphic designer?
- How many do I print?
- How will I schedule the timing?

Credibility or endorsement mailer

These mailers do not rely on visual information. The goal is to reassure clients that you have worked well with buyers. Clients consistently look at the same three qualities when assigning work to a new talent: creativity (vision), professionalism and personality.

A credibility mailer is the perfect vehicle to communicate past clients' satisfaction with you. Consider the three important qualities and ask six clients to provide you with quotes. Ask your clients to give you a quote on a specific topic, making sure to choose clients where your past experience matches the quote requested. Take a risk here! While most photographers hesitate to ask, most clients are eager to help. Format your quotes in a style that coordinates with your corporate identity or visual mailers. As you prepare this mailer answer the following questions:

- What qualities do I want clients to address?
- Which clients will I choose?
- Will I edit their quotes? (If so, make sure to read them the edited version before using it.)
- How will the mailer look?
- Do I create it, or will I bring in a graphic designer?
- Will the quote be in my newsletter or on a visual mailer?

The Web

Many photographers think of the Web as a great selling tool. It is currently a great reference tool. Clients tend to cruise the Web and may call to see your portfolio if a job is pending (very

few clients are consistently hiring right off the Web without looking at a portfolio). Photographers can also refer contacts to their sites when they need to quickly view their work.

In the future, as download times shorten and the resolution of images improves, websites will become powerful selling tools. You need to decide what your Web presence will be. Answer the following questions to help you determine what part the Web will play in your advertising program:

- Do I develop my own site or join a Web service? (For a fee, organizations such as ASMP offer members an option to submit images to their site. In addition, there are portfolio sites on the Web that provide space for a fee.)
- Do my clients use the Web in their work or to buy photography?
- What do I expect from the Web? Is it a reference tool or a major component to my program?
- What information do I want to convey? Is it all visual? Will I include client quotes or a client list, bio information, business philosophy?
- Will I arrange my images in subject categories or will the site have the same feel as my portfolio?
- How often will I change the information?

Newsletters

Newsletters are the simplest advertising tool to produce and often the most cost effective. Considered an indirect ad option, newsletters can be designed simply and tastefully as one-page documents. Sent to anyone who has seen a portfolio, newsletters contain studio news, account acquisitions, new equipment, awards won, recent press and staff changes. Information that would be of benefit to the contact, technology changes, and new techniques can be included. Many photographers have used their newsletters to share stories, philosophies and humor. If you are considering a newsletter as an action item, answer the following questions in order to get started:

- What do I want the newsletter to accomplish?
- How often will it be sent?
- Will it include a visual or contain only copy?
- How long will it be?
- What kind of information will I include?
- How will I produce it? Do I use my computer or involve a designer?

Networking

Here is a tool that costs very little. Your time and a small membership fee is generally all that is required. Consider your market. Are you an architectural photographer? A corporate shooter? Or is advertising your field? Find an organization that caters to your clients and join. Actively participate. Sitting side by side and working on committees with potential clients builds relationships quickly. There are many organizations you can join. Organizations to consider include chambers of commerce, Women in Business, art director and creative clubs, the American Institute of Graphic Arts (AIGA) and the Graphic Artists Guild. In addition, there are groups whose members include architects, builders and developers, public relations professionals, and corporate communication and marketing directors.

To find the right group for you, look in the back of *ADWEEK* or other industry trades to determine which groups exist. Use your yellow pages and local newspapers. Ask your clients what organizations they belong to. Attend an initial meeting and determine if it services members from your potential market. If so, join and become actively involved. The goal is to meet your potential clients in a nonselling situation.

While there are other advertising options (sourcebooks, gallery shows, articles, press releases), portfolios (in person and mailed), direct mail (visual and credibility), the Web, newsletters and networking are components that should be in most advertising programs.

Once you have reviewed your budget, available time and ad options, choose a program that

meets your goals and one that can be maintained during your busiest times. Be proactive! Create the program and have it ready to go before your fiscal year begins. When determining what your program will look like, consider the two options below:

Portfolio-based program

This program relies heavily on your book. Researched contacts are called and a portfolio is mailed or an appointment is made. The portfolio is viewed and a response received. A thank-you note is sent two weeks after the book is returned and a visual mailer is sent once a month for the next six months. A second mini book of new images is sent eight to ten months later or brought in person once an appointment is made.

Outreach program

This program relies on reactive measures. Visual mailers sent to a loosely researched database of contacts are the main tool. The mailers are sent monthly for 12 months, incorporate a reply card and are sent to a large number of contacts (1,500 or more).

Most photographers should begin with a portfolio-based program supported by a Web presence either through a portfolio site service or via their own site. Outreach efforts can be layered on top of a portfolio program within one to two years of the initial effort.

STEP 5: REVIEW, COMMIT, SUCCEED

The fifth step of CYOD is huge. It involves reviewing your efforts, committing to your program for three to five years and having a true desire to succeed. Every program needs to be regularly evaluated. Objectives are added as old ones are met. Processes need to be reviewed and new ones added when it is appropriate to do so. You need to construct a review process that will work for your business. Consider answering these questions:

- How often do I need to review my progress? Monthly? Quarterly?
- Which objectives need to be reached by check-in time?
- Have my objectives been met?
- What is working in my plan?
- What is not working?
- What needs to change in order for me to meet my objectives by next review?

All too often, photographers start a program and enthusiastically build it, yet maintain it inconsistently. It is much more productive to create a small plan (fewer contacts and action plans) and follow it consistently than to create a huge effort that cannot be constantly maintained.

Create a program that you can follow during your busiest times not during your slow periods. The success of any goal-oriented program relies heavily on continued effort over an appropriate amount of time. What is an appropriate amount of time to establish a talent? My experience is that it takes five to seven years to build brand and name identity for a new talent on a regional level. You will have clients during this time, however assignments will most likely trickle in and build as the efforts are extended. Marketing efforts are cumulative. They work as building blocks. As a house is not complete when a foundation is laid, a business is not built during the first two foundation years.

This program is about success—your success. You need to know what success looks like to you. What is your goal? Is it having a business you run instead of a business that runs you? Is it working with people you like on assignments that you enjoy? Is it getting paid well for what you love to do? Know what you want this program to accomplish. Be clear on your destiny. Then go out and create it! I have earned a deep respect for one of Goethe's couplets: "Whatever you can do, or dream you can, begin it. Boldness has genius, power and magic in it."

Getting Down to Business

Photography is an art that requires a host of skills, some which can be learned and some which are innate. To make money from your photography, the one skill you can't do without is a knowledge of business. Thankfully, this skill can be learned. What you'll find on the following pages are the basics of running a photography business. We'll cover:

- Submitting Your Work, pg. 16
- Using Essential Business Forms, pg. 17
- Showcasing Your Talent, pg. 20
- Charging for Your Work, pg. 22
- Figuring Small Business Taxes, pg. 25
- Organizing Your Images, pg. 27
- Protecting Your Copyright, pg. 29
- Protecting Your Images on the Internet, pg. 32

For More Information

To learn more about starting a business:

- Take a course at a local college. Many community colleges offer short-term evening and weekend courses on topics like creating a business plan or finding financial assistance to start a small business.
- Contact the Small Business Administration at (800)827-5722 or check out their website at http://www.sba.gov. "The U.S. Small Business Administration was created by Congress in 1953 to help America's entrepreneurs form successful small enterprises. Today, SBA's program offices in every state offer financing, training and advocacy for small firms."
- Contact the Small Business Development Center at (202)205-6766. The SBDC offers free or low-cost advice, seminars and workshops for small business owners.
- Read a book. Try *The Business of Commercial Photography* by Ira Wexler (Amphoto Books) or *The Business of Studio Photography* by Edward R. Lilley (Allworth Press). The business section of your local library will also have many general books about starting a small business.

SUBMITTING YOUR WORK

Editors, art directors and other photo buyers are busy people. Many only spend ten percent of their work time actually choosing photographs for publication. The rest of their time is spent making and returning phone calls, arranging shoots, coordinating production and a host of other unglamorous tasks that make publication possible. They want to discover new talent and you may even have the exact image they are looking for, but if you don't follow a market's submission instructions to the letter, you have little chance of acceptance.

To learn the dos and don'ts of photography submissions, read each market's listing carefully and make sure to send only what they ask for. Don't send prints if they only want slides. Don't send color if the only want black and white. Send for guidelines whenever they are available to get the most complete and up-to-date submission advice. When in doubt follow these ten rules when sending your work to a potential buyer:

1. Don't forget your SASE—Always include a self-addressed stamped envelope whether you want your submission back or not. Make sure your SASE is big enough, has enough packag-

ing and has enough postage to ensure the safe return of your work.

2. Don't over-package—Never make a submission difficult to open and file. Don't tape down all the loose corners. Don't send anything too large to fit in a standard file.

3. Don't send originals—Try not to send things you must have back. **Never** ever send originals unsolicited.

4. Do label everything—Put a label directly on the slide mount or print you are submitting. Include your name, address and phone number, as well as the name or number of the image. Your slides and prints will almost certainly get separated from your letter.

5. Do your research—Always research the places to which you want to sell your work. Request sample issues of magazines, visit galleries, examine ads, look at websites, etc. Make sure your work is appropriate before you send it out. A blind mailing is a waste of postage and a waste of time for both you and the art buyer.

6. Follow directions—Always request submission guidelines. Include a SASE for reply. Follow ALL the directions exactly, even if you think they're silly.

7. Send to a person, not a title—Send submissions to a specific person at a company. When you address a cover letter to Dear Sir or Madam it shows you know nothing about the company you want to buy your work.

8. Include a business letter—Always include a cover letter, no more than one page, that lets the potential buyer know you are familiar with their company, what your photography background is (briefly) and where you've sold work before (if it pertains to what you're trying to do now).

9. Don't forget to follow through—Follow up major submissions with postcard samples several times a year.

10. Have something to leave behind—If you're lucky enough to score a portfolio review, always have a sample of your work to leave with the art director. Make it small enough to fit in a file but big enough not to get lost. Always include your contact information directly on the leave-behind.

USING ESSENTIAL BUSINESS FORMS

Using carefully crafted business forms will not only make you look more professional in the eyes of your clients; it will make bills easier to collect while protecting your copyright. Forms from delivery memos to invoices can be created on a home computer with minimal design skills and printed in duplicate at most quick-print centers. When producing detailed contracts, remember that proper wording is imperative. You want to protect your copyright and, at the same time, be fair to clients. Therefore, it's a good idea to have a lawyer examine your forms before using them.

The following forms are useful when selling stock photography, as well as when shooting on assignment:

Delivery Memo

This document should be mailed to potential clients along with a cover letter when any submission is made. A delivery memo provides an accurate count of the images that are enclosed and it provides rules for usage. The front of the form should include a description of the images or assignment, the kind of media in which the images can be used, the price for such usage and the terms and conditions of paying for that usage. Ask clients to sign and return a copy of this form if they agree to the terms you've spelled out.

Terms & Conditions

This form often appears on the back of the delivery memo, but be aware that conditions on the front of a form have more legal weight than those on the back. Your terms and conditions should outline in detail all aspects of usage for an assignment or stock image. Include copyright information, client liability and a sales agreement. Also be sure to include conditions covering the alteration of your images, transfer of rights and digital storage. The more specific your terms

and conditions are to the individual client, the more legally binding they will be. If you own a computer and can create forms yourself, seriously consider altering your standard contract to suit each assignment or other photography sale.

Invoice

This is the form you want to send more than any of the others, because mailing it means you have made a sale. The invoice should provide clients with your mailing address, an explanation of usage and the amount due. Be sure to include a reasonable due date for payment, usually 30 days. You should also include your business tax identification number or social security number.

Model/Property Releases

Get into the habit of obtaining releases from anyone you photograph. They increase the sales potential for images and can protect you from liability. A model release is a short form, signed by the person(s) in a photo, that allows you to sell the image for commercial purposes. The property release does the same thing for photos of personal property. When photographing children, remember that a parent or guardian must sign before the release is legally binding. In exchange for signed releases some photographers give their subjects copies of the photos, others pay the models. You may choose the system that works best for you but keep in mind that a

PROPERTY RELEASE

In consideration of $_____ and/or _____
_____, receipt of which is acknowledged, I being the legal owner of or having the right to permit the taking and use of photographs of certain property designated as _____, do hereby give _____, his/her assigns, licensees, and legal representatives the irrevocable right to use this image in all forms and media and in all manners, including composite or distorted representations, for advertising, trade, or any other lawful purposes, and I waive any rights to inspect or approve the finished product, including written copy that may be created in connection therewith.

Short description of photographs: _____

Additional information: _____

I am of full age. I have read this release and fully understand its contents.

Please Print:
Name _____
Address _____
City _____ State _____ Zip Code _____

Sample property release

MODEL RELEASE

In consideration of $_____ and/or _____, receipt of which is acknowledged, I, _____, do hereby give _____, his/her assigns, licensees, and legal representatives the irrevocable right to use my image in all forms and media and in all manners, including composite or distorted representations, for advertising, trade, or any other lawful purposes, and I waive any rights to inspect or approve the finished product, including written copy that may be created in connection therewith. The following name may be used in reference to these photographs:

My real name, or _____

Short description of photographs: _____

Additional Information: _____

I am of full age. I have read this release and fully understand its contents.

Please Print:

Name _____

Address _____

City _____ State _____ Zip Code _____

Country _____

Signature _____

Witness _____ Date _____

CONSENT

(If model is under the age of 18) I am the parent or guardian of the minor named above and have the legal authority to execute the above release. I approve the foregoing and waive any rights in the premises.

Please Print:

Name _____

Address _____

City _____ State _____ Zip Code _____

Country _____

Signature _____

Witness _____ Date _____

Sample model release

legally binding contract must involve consideration, the exchange of something of value. Once you obtain a release, keep it in a permanent file.

You do not need a release if the image is being sold editorially. However, some magazine editors are beginning to require such forms in order to protect themselves, especially when an image is used as a photo illustration instead of as a straight documentary shot. You **always** need a release for advertising purposes or for purposes of trade and promotion. In works of art, you only need a release if the subject is recognizable. When traveling in a foreign country it is a good idea to carry releases written in that country's language. To translate releases into a foreign language, check with an embassy or a college language professor.

For More Information

To learn more about forms for photographers try:

- *The Photographer's Market Guide to Photo Submission and Portfolio Formats* by Michael Willins (Writer's Digest Books).
- *Business and Legal Forms for Photographers* by Tad Crawford (Allworth Press).
- *Legal Guide for the Visual Artist* by Tad Crawford (Allworth Press).
- *ASMP Professional Business Practices in Photography* (Allworth Press).
- The American Society of Media Photographers also offers traveling business seminars that cover issues from forms to pricing to collecting unpaid bills. Write them at 14 Washington Rd., Suite 502, Princeton Junction NJ 08550, for a schedule of upcoming business seminars.
- The Volunteer Lawyers for the Arts, 1 E. 53rd St., 6th Floor, New York NY 10022, (212)319-2910. The VLA is a nonprofit organization, based in New York City, dedicated to providing all artists, including photographers, with sound legal advice.

SHOWCASING YOUR TALENT

There are basically three ways to acquaint photo buyers with your work: through the mail, over the Internet or in person. No one way is better or more effective than another. They each serve an individual function and should be used in concert to increase your visibility and, with a little luck, your sales.

Self-promotions

When you are just starting to get your name out there and want to begin generating assignments and stock sales, it's time to design a self-promotion campaign. This is your chance to do your best, most creative work and package it in an unforgettable way to get the attention of busy photo buyers. Self-promotions traditionally are samples printed on card stock and sent through the mail to potential clients. If the image you choose is strong and you carefully target your mailing, a traditional self-promotion can work.

But don't be afraid to go out on a limb here. You want to show just how amazing and creative you are and you want the photo buyer to hang onto your sample for as long as possible. Why not make it impossible to throw away? Instead of a simple postcard, maybe you could send a small, usable notepad with one of your images at the top or a calendar the photo buyer can hang up and use all year. If you target your mailing carefully, this kind of special promotion needn't be expensive.

If you're worried that a single image can't do justice to your unique style, you have two options. One way to get multiple images in front of photo buyers without sending an overwhelming package is to design a campaign of promotions that builds from a single image to a small group of related photos. Make the images tell a story and indicate that there are more to follow.

SAMPLE SELF-PROMOTIONS

This direct mail promotion piece is one of a series of 12 postcards created cooperatively by photographer Robert Hale, design studio Design Mark and printer Multi-Craft Litho. "The benefits of a cooperative piece include the sharing of costs to produce that piece as well as having the piece distributed to a much greater audience," Hale says. "The 12-month postcard series was designed to create greater overall awareness of the business as well as to directly generate new work."

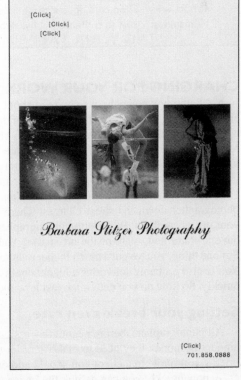

Barbara Stitzer Photography

701.858.0888

"If you're going to make a promotional piece," says photographer Barbara Stitzer, "make it the highest quality you can." Stitzer maintains complete control over all her direct mail promotions. "No one can direct my promotion pieces the way I can," she explains. Her promotion strategy relies on a combination of a strong promo piece and her outgoing personality. Stitzer always carries her cards with her "just in case." She says, "I'm pretty social, and talk to just about anyone, so I find the 'just in case' cards are the ones that bring in about 25 percent of my work."

If you are computer savvy, the other way to showcase a sampling of your work is to point photo buyers to an online portfolio of your best work. Send a single sample that includes your Internet address and ask buyers to take a look.

Portfolio presentations

Once you've actually made contact with potential buyers and piqued their interest they'll want to see a larger selection of your work, your portfolio. Once again, there's more than one way to get this sampling of images in front of buyers. Portfolios can be digital—stored on a disk, CD-ROM or posted on the Internet; they can take the form of a large box or binder and require a special visit and presentation by you; or they can come in a small binder and be sent through the mail. Whichever way or ways you choose to showcase your best work, you should always have more than one portfolio and each should be customized for potential clients.

Keep in mind that your portfolios should contain your best work, dupes only. Never put originals in anything that will be out of your hands for more than a few minutes. Also don't include more than 20 images. If you try to show too many pieces you'll overwhelm the buyer and any image that is less than your best will detract from the impact of your strongest work. Finally, be sure to show only work a buyer is likely to use. It won't do any good to show a shoe manufacturer your shots of farm animals or a clothing company your food pictures.

For More Information

Where to find ideas for great self-promotions:
- *HOW* magazine's self-promotion annual, October issue.
- *The Best Seasonal Promotions* by Poppy Evans (North Light Books).
- *Fresh Ideas in Promotion* by Betsy Newberry (North Light Books).
- Yahoo, www.yahoo.com, follow these links for online portfolios and promotions: Arts and Humanities: Visual Arts: Photography: Photographers.

CHARGING FOR YOUR WORK

No matter how many books you read about what photos are worth and how much you should charge, no one can set your fees for you, and if you let someone try you'll be setting yourself up for financial ruin. Figuring out what to charge for your work is a complex task that will require a lot of time and effort. But the more time you spend finding out how much you need to charge, the more successful you'll be at targeting your work to the right markets and getting the money you need to keep your business, and your life, going.

Keep in mind that what you charge for an image may be completely different from what a photographer down the street charges. There is nothing wrong with this if you've calculated your prices carefully. Perhaps the photographer works in a basement on old equipment and you have a brand new, state-of-the-art studio. You'd better be charging more. Why the disparity? For one thing, you've got a much higher overhead, the continuing costs of running your business. You're also probably delivering a higher quality product and are more able to meet client requests quickly. So how do you determine just how much you need to charge in order make ends meet?

Setting your break-even rate

All photographers, before negotiating assignments, should consider their break-even rate, the amount of money they need to make in order to keep their studios open. To arrive at the actual price you'll quote to a client you should add onto your base rate things like usage, your experience, how quickly you can deliver the image, and what kind of prices the market will bear.

BASE RATE WORKSHEET

(Try to fill in the blanks here. If you're not sure of some of the numbers, estimate by looking at prices in catalogs or at office supply stores. Remember, expenses like film and processing will be charged to your clients.)

Business Expenses:

Rent (office, studio, darkroom)	_____
Gas and electric	_____
Insurance (equipment)	_____
Telephone, fax, internet	_____
Office supplies	_____
Postage	_____
Stationery	_____
Self-promotions/portfolios	_____
Camera and lighting equipment	_____
Office equipment/computers	_____
Staff salaries	_____
Taxes	_____
Professional organization dues	_____
Personal expenses	_____

(Your personal expenses include everything that makes up your standard of living: food, clothing, medical, car and home insurance, gas, repairs and other car expenses, entertainment, retirement savings and investments, etc.)

Before you divide your annual expenses by the 365 days in the year, remember you won't be shooting billable assignments every day. A better way to calculate your base fee is by billable weeks. Assume that at least one day a week is going to be spent conducting office business and marketing your work. This amounts to approximately ten weeks. Add in days for vacation and sick time, perhaps three weeks, and add another week for workshops and seminars. This totals 14 weeks of nonbillable time and 38 billable weeks throughout the year.

Now estimate the number of assignments/sales you expect to complete each week and multiply that number by 38. This will give you a total for your yearly assignments/sales. Finally, divide the total overhead and administrative expenses by the total number of assignments. This will give you an average price per assignment, your break-even or base rate.

As an example, let's say your expenses come to $65,000 per year (this includes $35,000 of personal expenses). If you complete 2 assignments each week for 38 weeks your average price per assignment must be about $855. This is what you should charge to break even on each job. But, don't forget, you want to make money.

Establishing usage fees

Too often, photographers shortchange themselves in negotiations because they do not understand how the images in question will be used. Instead, they allow clients to set prices and prefer to accept lower fees rather than lose sales. Unfortunately, those photographers who shortchange themselves are actually bringing down prices throughout the industry. Clients realize if they

shop around they can find photographers willing to shoot assignments at very low rates.

There are ways to combat low prices, however. First, educate yourself about a client's line of work. This type of professionalism helps during negotiations, because it shows buyers that you are serious about your work. The added knowledge also gives you an advantage when negotiating fees, because photographers are not expected to understand a client's profession.

For example, if most of your clients are in the advertising field, acquire advertising rate cards for magazines so you know what a client pays for ad space. You can also find print ad rates in the *Standard Rate and Data Service* directory at the library. Knowing what a client is willing to pay for ad space and considering the importance of your image to the ad will give you a better idea what the image is really worth to the client.

For editorial assignments, fees may be more difficult to negotiate because most magazines have set page-rates. They may make exceptions, however, if you have experience or if the assignment is particularly difficult or time-consuming. If a magazine's page-rate is still too low to meet your break-even price, consider asking for extra tearsheets and copies of the issue your work appears in. These pieces can be used in your portfolio and as mailers, and the savings they represent in printing costs may make up for the discrepancy between the page-rate and your break-even price.

There are still more ways to negotiate sales. Some clients, such as gift and paper product manufacturers, prefer to pay royalties each time a product is sold. Special markets, such as galleries and stock agencies, typically charge photographers a commission of 20 to 50 percent for displaying or representing their images. In these markets, payment on sales comes from the purchase of prints by gallery patrons, or from fees on the "rental" of photos by clients of stock agencies. Pricing formulas should be developed by looking at your costs and the current price levels in those markets, as well as on the basis of submission fees, commissions and other administrative costs charged to you.

Bidding for jobs

As you build your business you will likely encounter another aspect of pricing and negotiating that can be very difficult. Like it or not, clients often ask photographers to supply bids for jobs. In some cases, the bidding process is merely procedural and the assignment will go to the photographer who can best complete the assignment. In other instances, the photographer who submits the lowest bid will earn the job. When asked to submit a bid, it is imperative to find out which bidding process is being used. Putting together an accurate estimate takes time, and you do not want to waste your efforts if your bid is being sought merely to meet some budget quota.

If you decide to bid on a job it's important to consider your costs carefully. You do not want to bid too much on projects and repeatedly get turned down, but you also don't want to bid too low and forfeit income. When a potential client calls to ask for a bid there are seven dos and don'ts to consider:

1. Always keep a list of questions by the telephone so you can refer to it when bids are requested. The answers to the questions should give you a solid understanding of the project and help you reach a price estimate.
2. Never quote a price during the initial conversation, even if the caller pushes for a "ballpark figure." An on-the-spot estimate can only hurt you in the negotiating process.
3. Immediately find out what the client intends to do with the photos and ask who will own copyrights to the images after they are produced. It is important to note that many clients believe if they hire you for a job they'll own all the rights to the images you create. If they insist on buying all rights, make sure the price they pay is worth the complete loss of the images.
4. If it is an annual project, ask who completed the job last time, then contact that photographer to see what he or she charged.

5. Find out who you are bidding against and contact those people to make sure you received the same information about the job. While agreeing to charge the same price is illegal, sharing information about reaching a price is not.
6. Talk to photographers not bidding on the project and ask them what they would charge.
7. Finally, consider all aspects of the shoot, including preparation time, fees for assistants and stylists, rental equipment and other materials costs. Don't leave anything out.

 ## For More Information

Where to find more information about pricing:
- *Pricing Photography: The Complete Guide to Assignment & Stock Prices* by Michal Heron and David MacTavish (Allworth Press)
- *ASMP Professional Business Practices in Photography* (Allworth Press)
- *fotoQuote*, a software package produced by the CRADOC Corporation, is a customizable, annually updated database of stock photo prices for markets from ad agencies to calendar companies. The software also includes negotiating advice and scripted telephone conversations. Call (800)679-0202 for ordering information.
- Stock Photo Price Calculator, a website that suggests fees for advertising, corporate and editorial stock, http://photographersindex.com/stockprice.htm

FIGURING SMALL BUSINESS TAXES

Whether you make occasional sales from your work or you derive your entire income from your photography skills, it is a good idea to consult with a tax professional. If you are just starting out, an accountant can give you solid advice about organizing your financial records. If you are an established professional, an accountant can double check your system and maybe find a few extra deductions. When consulting with a tax professional, it is best to see someone familiar with the needs and concerns of small business people, particularly photographers. You can also conduct your own tax research by contacting the Internal Revenue Service.

Self-employment tax

As a freelancer it's important to be aware of tax rates on self-employment income. All income you receive over $400 without taxes being taken out by an employer qualifies as self-employment income. Normally, when you are employed by someone else, the employer shares responsibility for the taxes due. However, when you are self-employed you must pay the entire amount yourself.

Freelancers frequently overlook self-employment taxes and fail to set aside a sufficient amount of money. They also tend to forget state and local taxes. If the volume of your photo sales reaches a point where it becomes a substantial percentage of your income, then you are required to pay estimated tax on a quarterly basis. This requires you to project the amount of money you expect to generate in a three-month period. However burdensome this may be in the short run, it works to your advantage in that you plan for and stay current with the various taxes you are required to pay. Read IRS publication #533, Self-Employment Tax and #505, Tax Withholding and Estimated Tax.

Deductions

Many deductions can be claimed by self-employed photographers. It's in your best interest to be aware of them. Examples of 100 percent deductible claims include production costs of résumés, business cards and brochures; photographer's rep commissions; membership dues; costs of purchasing portfolio materials; education/business-related magazines and books; insurance; and legal and professional services.

Additional deductions can be taken if your office or studio is home-based. The catch here is that your work area must be used only on a professional basis; your office can't double as a family room after hours. The IRS also wants to see evidence that you use the work space on a regular basis via established business hours and proof that you've actively marketed your work. If you can satisfy these criteria, then a percentage of mortgage interests, real estate taxes, rent, maintencance costs, utilities and homeowner's insurance, plus office furniture and equipment, can be claimed on your tax form at year's end.

In the past, to qualify for a home-office deduction, the space you worked in had to be "the most important, consequential, or influential location" you used to conduct your business. This meant that if you had a separate studio location for shooting but did scheduling, billing and record keeping in your home office you could not claim a deduction. However, when filing your 1999 taxes, your home office will qualify for a deduction if you "use it exclusively and regularly for administrative or management activities of your trade or business and you have no other fixed location where you conduct substantial administrative or management activities of your trade or business." Read IRS publication #587, Business Use of Your Home, for more details.

If you are working out of your home, keep separate records and bank accounts for personal and business finances, as well as a separate business phone. Since the IRS can audit tax records as far back as seven years, it's vital to keep all paperwork related to your business. This includes invoices, vouchers, expenditures and sales receipts, canceled checks, deposit slips, register tapes and business ledger entries for this period. The burden of proof will be on you if the IRS questions any deductions claimed. To maintain professional status in the eyes of the IRS, you will need to show a profit for three years out of a five-year period.

Sales tax
Sales taxes are complicated and need special consideration. For instance, if you work in more than one state, use models or work with reps in one or more states, or work in one state and store equipment in another, you may be required to pay sales tax in each of the states that apply. In particular, if you work with an out-of-state stock photo agency that has clients over a wide geographic area, you should explore your tax liability with a tax professional.

As with all taxes, sales taxes must be reported and paid on a timely basis to avoid audits and/or penalties. In regard to sales tax, you should:

☑ Always register your business at the tax offices with jurisdiction in your city and state.

☑ Always charge and collect sales tax on the full amount of the invoice, unless an exemption applies.

☑ If an exemption applies because of resale, you must provide a copy of the customer's resale certificate.

☑ If an exemption applies because of other conditions, such as selling one-time reproduction rights or working for a tax-exempt, nonprofit organization, you must also provide documentation.

☑ If an exemption applies because of other conditions, such as selling one-time reproduction rights or working for a tax-exempt, nonprofit organization, you must also provide documentation.

For More Information

To learn more about taxes: Contact the IRS. There are free booklets available that provide specific information, such as allowable deductions and tax rate structure.
- Self-Employment Tax, #533
- Tax Guide for Small Businesses, #334
- Travel, Entertainment and Gift Expenses, #463
- Tax Withholding and Estimated Tax, #505
- Business Expenses, #535
- Accounting Periods and Methods, #538
- Business Use of Your Home, #587
- Guide to Free Tax Services, #910

To order any of these booklets, phone the IRS at (800)829-3676. IRS forms and publications, as well as answers to questions and links to help, are available on the internet at http://www.irs.gov.

ORGANIZING YOUR IMAGES

If a client called you right now and asked to use one of your photos, what are the chances you'd be able to lay your hands on that photo quickly? As a photographer you must be able to do just that if you plan to make money. If you can't, you'll miss out on sales, not only from the immediate projects that come up, but from future sales to clients who know you can meet their deadlines.

The key to locating images is proper organization. Not only do you need a place to store your work; you also must have a filing system in place that allows you to easily retrieve images. Your filing system should simplify the process of quickly locating images and submitting them.

To create a filing system for your images you will need:

☑ labels

☑ plastic protectors (archival quality) for transparencies, negatives and prints

☑ three-ring binders or a filing cabinet

☑ an established coding system for all of your work

☑ a computer with database or labeling software (optional)

Although computers are not essential for labeling images, they certainly simplify the process. Database software not only helps when labeling images; it can assist you in tracking submissions, conducting mailings or completing client correspondence. Plus, if you've ever labeled slides by hand you know that the process is tedious.

Coding and labeling your photos

Developing a coding system is not difficult. At first it may seem overwhelming, especially if you currently house thousands of photos in shoe boxes and have no established coding system. However, once you have the system in place the process becomes routine and relatively simple to maintain.

Start by creating a list of the subjects you shoot. As an example, let's suppose you photograph

wildlife and nature. Make a list of everything you've photographed—birds, flowers mountains, etc. Next, break this list down even further into subcategories. For birds, you may end up with subcategories like waterfowl, raptors or perching birds. Flowers might be separated by seasons in which they flourish, or regions in which they are found. After you've created your list of subjects, assign three-letter codes to each one. And obviously, don't duplicate codes.

Once you establish a coding system for each subject, the next step is to use those codes in conjunction with numbers to identify each image. For example, perhaps you recently photographed a nesting site for a Bald Eagle. Your code might look something like this: 98WBR1-AKO. Translated from left to right this means you took the image in 1998; it's a wildlife photograph of a bird (raptor); and it's the first photo of a raptor catalogued in 1998. The "AK" shows the photo was taken in Alaska and the "O" with a "D" if the image is a duplicate. When you photograph a subject that needs a model release, add "MR" onto the end for further clarification.

Now, you may ask why all this information is necessary. The year shows you how recent the photo is. Clients often prefer images that are current. And it's good to update subjects after a few years. The three-letter subject code is necessary for obvious reasons. When a client needs a specific subject, the three-letter codes make it easy to find the appropriate shot. The number following the three-letter code helps you distinguish one shot from another. The next two letters are state codes that can be extremely useful when submitting work to regional publications. Clients also frequently request shots by region. And the "O" code is important to keep you from submitting original work on speculation to a client.

Along with the file number, each photo should contain your copyright notice which states the year the image was created and gives your name (e.g., © 1999 John Q. Photographer). Also include a brief explanation of the image contents. Remember with captioning software it's easy to write extensive descriptions onto labels. When shooting slides, however, too much information can clutter presentation and may actually be distracting to the viewer. Three or four words should suffice for 35mm. If you want to provide lengthier captions when submitting material, do so on a separate sheet of paper. Be certain to list slide numbers beside each caption. If you shoot with medium or large format cameras, you can either purchase mounts for your images or place the transparencies into plastic sleeves. Labels can be attached to protective sleeves or mounts when work is mailed to potential clients. When submitting prints, place a label on the back of each photo and make sure it contains your copyright notice, image number and a brief description of each image. You should also include your address and telephone number.

One word of cautioni: never submit negatives to potential clients. You risk damaging the negatives, or worse, having them lost. Most buyers can use a print to generate a suitable image. You also can send contact sheets for their review.

Storing your photos

Now that you've properly labeled your work, the next step is to file images so they can be located quickly. First, store them in a cool, dry location. Moisture can produce mold on your film and slide mounts. If your work isn't correctly stored, transparencies can be eaten by moths. To prevent damage, place 35mm slies in archival-quality plastic slide protectors. Each page holds up to 20 slides and can be placed inside a binder for easy storage. The binder system also works for larger transparencies and negatives. Prints also should be kept in plastic pages.

Other storage areas do exist. File cabinets can work well for archiving, but they aren't as portable as binders. I've even heard of one photographer who stores images inside an old refrigerator. His main reason for using a refrigerator is to protect his work in the event of a fire: The insulation content of refrigerators makes them almost as useful as vaults when it comes to photo archiving.

This raises the issue of image protection. Because disasters such as fires or floods can strike at any time, it's wise to store duplicates of your best images in a different location. Safe deposit boxes work well as secondary storage facilities. The last thing you want is for all your work to

be destroyed. Such disasters can ruin your business because most insurance companies will only replace the cost of the film, not the potential value of the images.

Another means of storage is digital archiving. If you are serious about your work, you probably have thousands of images in your files. Digital archiving is a great way to protect your work because CDs and removable media disks (ZIP, JAZ, SyQuest) can store thousands of images in small spaces.

Having images in a digital format can also help you meet client demands. As technology develops, more and more clients are using digital versions of images for things like composition layouts, inhouse newsletter or websites. If you can provide digital images to clients, you might see your sales increase as a result.

One important point to consider if you supply images digitally is that digital images are easy to alter and, therefore, easy to steal. The growth in digital technology makes it important to protect yourself against misuse and theft of your work. If a client plans to make radical changes to your images, stipulate that those alterations must meet your approval.

Also, don't let clients keep digital files of your images. Specify that any digital files of your work should be deleted once your images are published. People change jobs and the next person using a client's computer may find your work and unknowingly think it's fair game for other projects.

Tracking your images

Finally, you need a system of tracking submissions so that you know who has your images and when they were mailed to clients. You want to know who received them, and when the material is due back.

Talk to any professional photographer and you will learn that photo editors, creative directors and art directors habitually hold images for long periods of time. Sometimes this means buyers are deciding which images to use; sometimes buyers are just too busy to return photos. As a photographer, this can be extremely problematic. You don't want to offend potential clients by ordering the return of your images, but you have a business to run.

If you have a computer with database software, you can easily track images by logging in their file codes, jotting down who should have received the material, when it was sent, and when it is due back to you. Sort the file by the dates when the images are due back. If you don't receive your work by the given dates, get on the phone and make some follow-up calls.

When photo editors hold images with no intention of using them, they essentially keep you from submitting those photos to other editors who might buy them. This is one reason that having a sound filing system is so important. By tracking your submissions you can follow up with letters or phone calls to retrieve images from uninterested buyers.

(*"Organizing Your Images" was first printed in* The Photographer's Market Guide to Photo Submission & Portfolio Formats © *1997 by Michael Willins. Published by Writer's Digest Books. Reprinted with permission of Writer's Digest Books.)*

PROTECTING YOUR COPYRIGHT

What makes copyright so important to a photographer? First of all, there's the moral issue. Simply put, stealing someone's work is wrong. By registering your photos with the Copyright Office in Washington DC, you are safeguarding against theft. You're making sure that if someone illegally uses one of your images they can be held accountable. By failing to register your work, it is often more costly to pursue a lawsuit than it is to ignore the fact that the image was stolen.

Which brings us to issue number two—money. You should consider theft of your images to be a loss of income. After all, the person stealing one of your photos used it for a project, their project or someone else's. That's a lost sale for which you will never be paid.

The importance of registration

There is one major misconception about copyright—many photographers don't realize that once you create a photo it becomes yours. You (or your heirs) own the copyright, regardless of whether you register it for the duration of your lifetime plus 70 years.

The fact that an image is automatically copyrighted does not mean that it shouldn't be registered. Quite the contrary. You cannot even file a copyright infringement suit until you've registered your work. Also, without timely registration of your images, you can only recover actual damages—money lost as a result of sales by the infringer plus any profits the infringer earned. For example, recovering $2,000 for an ad sale can be minimal when weighed against the expense of hiring a copyright attorney. Often this deters photographers from filing lawsuits if they haven't registered their work. They know that the attorney's fees will be more than the actual damages recovered, and, therefore, infringers go unpunished.

Registration allows you to recover certain damages to which you otherwise would not be legally entitled. For instance, attorney fees and court costs can be recovered. So too can statutory damages—awards based on how deliberate and harmful the infringement was. Statutory damages can run as high as $100,000. These are the fees that make registration so important.

In order to recover these fees there are rules regarding registration that you must follow. The rules have to do with the timeliness of your registration in relation to the infringement:

- **Unpublished images** must be registered before the infringement takes place.
- **Published images** must be registered within three months of the first date of publication or before the infringement began.

The process of registering your work is simple. Contact the Register of Copyrights, Library of Congress, Washington DC 20559, (202)707-9100, and ask for Form VA (works of visual art). Registration costs $20, but you can register photographs in large quantities for that fee. For bulk registration, your images must be organized under one title, for example, "The works of John Photographer, 1990-1995."

The copyright notice

Another way to protect your copyright is to mark each image with a copyright notice. This informs everyone reviewing your work that you own the copyright. It may seem basic, but in court this can be very important. In a lawsuit, one avenue of defense for an infringer is "innocent infringement"—basically the "I-didn't-know" argument. By placing your copyright notice on your images, you negate this defense for an infringer.

The copyright notice basically consists of three elements: the symbol, the year of first publication and the copyright holder's name. Here's an example of a copyright notice for an image published in 1999—© 1999 John Q. Photographer. Instead of the symbol ©, you can use the word "Copyright" or simply "Copr." However, most foreign countries prefer © as a common designation.

Also consider adding the notation "All rights reserved" after your copyright notice. This phrase is not necessary in the U.S. since all rights are automatically reserved, but it is recommended in other parts of the world.

Know your rights

The digital era is making copyright protection more difficult. Often images are manipulated so much that it becomes nearly impossible to recognize the original version. As this technology grows, more and more clients will want digital versions of your photos. Don't be alarmed, just be careful. Your clients don't want to steal your work. They often need digital versions to conduct color separations or place artwork for printers.

So, when you negotiate the usage of your work, consider adding a phrase to your contract that limits the rights of buyers who want digital versions of your photos. You might want them to guarantee that images will be removed from computer files once the work appears in print.

You might say it's OK to do limited digital manipulation, and then specify what can be done. The important thing is to discuss what the client intends to do and spell it out in writing.

It's essential not only to know your rights under the Copyright Law, but also to make sure that every photo buyer you deal with understands them. The following list of typical image rights should help you in your dealings with clients:

- **One-time rights.** These photos are "leased" on a one-time basis; one fee is paid for one use.
- **First rights.** This is generally the same as purchase of one-time rights, though the photo buyer is paying a bit more for the privilege of being the first to use the image. He may use it only once unless other rights are negotiated.
- **Serial rights.** The photographer has sold the right to use the photo in a periodical. It shouldn't be confused with using the photo in "installments." Most magazines will want to be sure the photo won't be running in a competing publication.
- **Exclusive rights.** Exclusive rights guarantee the buyer's exclusive right to use the photo in his particular market or for a particular product. A greeting card company, for example, may purchase these rights to an image with the stipulation that it not be sold to a competing company for a certain time period. The photographer, however, may retain rights to sell the image to other markets. Conditions should always be in writing to avoid any misunderstandings.
- **Electronic rights.** These rights allow a buyer to place your work on electronic media, such as CD-ROMs or websites. Often these rights are requested with print rights.
- **Promotion rights.** Such rights allow a publisher to use a photo for promotion of a publication in which the photo appeared. The photographer should be paid for promotional use in addition to the rights first sold to reproduce the image. Another form of this—agency promotion rights—is common among stock photo agencies. Likewise, the terms of this need to be negotiated separately.
- **Work for hire.** Under the Copyright Act of 1976, section 101, a "work for hire" is defined as: "(1) a work prepared by an employee within the scope of his or her employment; or (2) a work . . . specially ordered or commissioned for use as a contribution to a collective, as part of a motion picture or audiovisual work or as a supplementary work . . . if the parties expressly agree in a written instrument signed by them that the work shall be considered a work made for hire."
- **All rights.** This involves selling or assigning all rights to a photo for a specified period of time. This differs from work for hire, which always means the photographer permanently surrenders all rights to a photo and any claims to royalties or other future compensation. Terms for all rights—including time period of usage and compensation—should only be negotiated and confirmed in a written agreement with the client.

It is understandable for a client not to want a photo to appear in a competitor's ad. Skillful negotiation usually can result in an agreement between the photographer and the client that says the image(s) will not be sold to a competitor, but could be sold to other industries, possibly offering regional exclusivity for a stated time period.

For More Information

To get more information about protecting your copyright:

- Call the Copyright Office at (202)707-3000 or check outo their website, http://lcweb.loc.gov/copyright, for forms and answers to frequently asked questions.
- The *SPAR Do-It-Yourself Startup Kit* includes sample forms, explanations and checklists of all terms and questions that photographers should ask themselves when negotiating jobs and pricing. (212)779-7464.
- *Legal Guide for the Visual Artist* by Tad Crawford (Allworth Press).

PROTECTING YOUR IMAGES ON THE INTERNET

Boston-based stock photographer Seth Resnick can't say enough about the Internet and how it has impacted his business (www.sethresnick.com). He is also extremely willing to share his experiences with other photographers. Below, Resnick discusses what he has done to protect his images on the Internet.

Has there been an increase in copyright infringement since photographers have begun posting their images on the Internet?

On the professional side of the photo buying market—agencies, corporations, magazines—I think there has been much less infringement as time has progressed. These people are much better educated on copyright and face very stiff penalties if they are caught. In the corporate marketplace, stealing images from the Web is the same as stealing software. There is a uniform zero tolerance policy. If you do it and you're caught, you're out. It's that simple.

The infringements are occurring more from students and the general public. These groups don't know the laws and don't think it is a big deal to take images, or software, for that matter. I am very careful when I design my website code to gear it to certain markets while eliminating others. For example, if you go to AltaVista and search for "stock photography medical," I will come up right near the top. If, however, you search for "stock photos" on the same search engine, I probably won't be found at all. The point is that a professional photo researcher would never do a search for "stock photos." They would always do a search for something like "stock photography medical" or "stock photography environment."

What specific steps do you take to protect the images on your website?

We maintain a legal contract. (All visitors to the site must agree to abide by copyright law before they can enter.) More importantly, we use server-side tracking software to trace all visitors. This is a very sophisticated process, but we are able to tell exactly what images everyone looks at and how much information they download. I also use some very basic processes to protect my images. The most important is to keep the image size small. People assume that the size does not matter and that since images are low resolution at 72 dpi that they are safe. These people could not be more wrong. An image at 72 dpi which is 5×7 when downloaded and saved at 2×3 increases the effective resolution to 300 dpi, which is standard for print. I see so many websites with small images that, when you click them, turn into large images. From my perspective this is a huge risk. I also place all of my images in a graphic frame that looks like a slide mount. In the mount is printed " © Seth Resnick." If you do download one of my images you would have to use Photoshop to cut the image from the mount and resave it. The image is a JPEG to begin with and saving it again is another generational loss. I may take one additional step soon to protect my images through an automated password system that would verify, for example, a working e-mail address before entrance to the site is granted. In addition, I run a CGI script that tracks the names of my images randomly throughout the Web.

What simple steps can photographers take to protect their images on the Internet?

The simple steps are to use some sort of frame, make sure your copyright notice is on every page of your website and, number one, keep the images small.

Is watermarking/encryption software effective?

I don't use this type of software for several key reasons. First none, that I am aware of, are able to pass intact through a firewall (a system used by corporations and web masters to protect websites and file servers from hackers). This process eliminates half the markets on the Web. Second it would not be feasible for me to rescan the thousands of images we have digitized to incorporate new software. I am working with code writers to develop a time-based system, which I view as much more viable. For example, when an image is sold with rights for three

months, the image would corrupt at the end of three months, requiring a key code to reopen the image.

When you do discover an infringement, how do you handle it?

Each case is handled in a different manner. The key is the intention of the infringement. The more severe the infringement, the more severely it is handled. Any large corporate infringement is immediately handled by notifying the company's legal department. Usually this brings about a settlement within 24 hours. If no settlement can be reached, I send it to my copyright attorney with instructions to go for blood. This results in a lawsuit being filed and the two times I have done this a settlement was reached within five days of filing.

Infringement of a lesser level is handled via my own "Copyright Police." Infringers will receive a letter which reads as follows:

> WARNING. YOU HAVE BEEN CAUGHT BY THE COPYRIGHT POLICE. An image, *name of image*, was traced to your URL. All photographs and text appearing in the Seth Resnick Photography site are the exclusive property of Seth Resnick and are protected under United States and international copyright laws. The photographs may not be reproduced, copied, stored or manipulated without the written permission of Seth Resnick. No images are within Public Domain. Use of any image as the basis for another photographic concept or illustration is a violation of copyright. You are hereby notified that *name of image* must be removed from your website within 24 hours of receipt of this letter. If the image is not removed within 24 hours we shall hold you legally responsible for the INTENTIONAL VIOLATION OF COPYRIGHT punishable under Federal statute for up to $100,000.00. In addition, if the image is not removed you will also be charged triple the use fees dating back to the first day of use. Seth Resnick Photography must be notified either by Federal Express, phone or e-mail upon removal of the image to prevent legal prosecution in this matter. Sincerely, The Copyright Police.

How has your use of the Internet impacted your photography business?

When I first set up my site, I had very limited expectations, especially about actually making money on the Internet. Currently, and sequentially, each fiscal quarter surpasses all my estimated numbers by a wide margin. Quite simply, my own business on the Internet is growing at a mind-boggling rate. During the last three years the growth rate of my business specifically due to the Internet has expanded at a rate exceeding 60 percent. In fact, the irony is that due to the Internet, I was so far off in my estimated tax payments that I was penalized by the IRS for making excessive income. I receive stock requests from existing and new clients via phone or e-mail on a daily basis. In addition to my own site, I sell stock through five different stock agencies. During the calendar year of 1998 my own site generated 74 percent more revenue than all of the other agencies combined.

Focus On: Using the Internet to Market Photography

BY MARIA PISCOPO

In every seminar I give, someone asks, "How can I use the Internet to market my work?" This article will just begin to answer that question, and it will explain why creating a website is only a small part of an overall marketing plan. The first thing to keep in mind is that the field of website design is only about six years old. We are all still learning from our mistakes and our success stories. Before you make the leap into web marketing, consider the following five questions and the advice of photographers who've been there.

QUESTION 1: HOW DO I DECIDE IF I AM READY TO BE ON THE INTERNET AT ALL?

Everyone wants to be on the information highway, but just because you can does not mean you should. The first step is to set some goals for a presence on the World Wide Web. Ask yourself if you want to create name recognition or a global presence. Do you want to sell your work as stock? Will you expect clients to contact you for more information? If you don't know why you want to be on the Web, you won't be able to gauge your success there.

Five photographers explain why they chose to be on the Internet:

- Brian Leng (www.e-folio.com/leng) says, "Why not? If your client is looking for someone right that minute and can't wait till tomorrow to get your portfolio, they can look at some images online until your portfolio arrives. It also increases the chances that, if you're not right for the job, you'll hear it before you spend money to send your portfolio by Federal Express."
- Bill Westheimer (www.billwest.com) agrees. "Clients seem to need everything yesterday. The website allows me to send them to my portfolio right now. Also, the Web is becoming an excellent way to research and sell my stock photography."
- Rick Etkin (www.ricketkin.com) says, "First and foremost, my goal is to increase my client base to people that I could not practically reach in any other way. Secondly, I have always tried to be ahead of the majority and set myself at the bleeding edge. The Internet is an interactive information source that can show my work in a new medium. My plan was and is to get the qualified buyers' and clients' attention so they ask for the 'real' portfolio."
- Brian Tremblay (www.tremblayphoto.com) is also trying to reach clients out of town. "I market my work on the Internet to reach clients who are out of my immediate geographic

MARIA PISCOPO *is an art/photo rep and creative services consultant. She started her business as a marketing representative for artists and photographers in 1978. She teaches classes for artists, designers and photographers at colleges including The Art Center College of Design in Pasadena and Brooks Institute of Photography. Her writing has been published in magazines including* HOW, Digital Output, Petersen's PHOTOgraphic, Rangefinder, Step-By-Step, Shutterbug *and* Communication Arts. *Her books include* The Photographer's Guide to Marketing and Self Promotion *(Writer's Digest Books) and* Marketing & Promoting Your Work *(NorthLight Books). She is a member of SPAR.*

area. I want to show them what I am capable of. If they want to see more they can call my toll-free number to call in my book."

- Patrick Jennings (www.jenningsphoto.com) says, "I created an online portfolio to give me the ability to market myself anywhere in the world. It also has been a great tool for art directors to use. Clients can reach my site from their desk or from the comfort of their home 24 hours a day 7 days a week. Also, with the hosting service I have I'm able to track when people are coming to my site and where they are coming from, anywhere in the world."

QUESTION 2: WILL YOUR SITE BE AN ADVERTISEMENT OR A PORTFOLIO?

With a well-designed home page, your site can work both as an advertisement and as a portfolio. The objective of an ad is to make an impression and get a photo client to ask for more information. The objective of a portfolio is to deliver that information. By using a home page with information that loads quickly you have an ad. It should capture the photo buyers' attention and then show where to go next. With thumbnail photos or even a text description, the prospective client can click to his area of interest.

The best sites avoid having long load times for the first (home) page and extensive scrolling down to reach images or information. Also, it is important to have a way to identify the people who visit your site so you can build on that response. Rick Etkin adds, "Most of the reaction

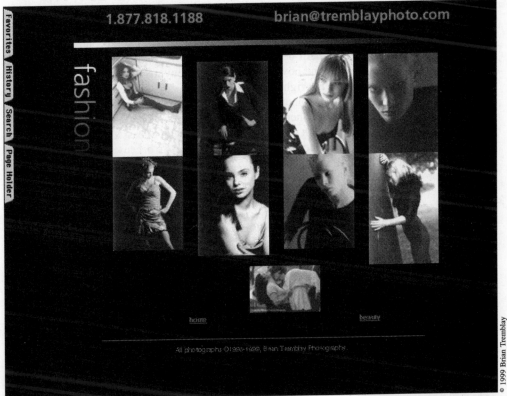

"I market my work on the Internet to reach clients who are out of my immediate geographic area," says photographer Brian Tremblay. "I want to show them what I am capable of. If they want to see more they can call my toll free number to call in my book." To create new images for his website, Tremblay works with local models, shooting test photos they can use in their portfolios.

to the site from clients has been very positive . . . they look at it! The host has tracking software that shows me where people are looking on the site and most of it is in the portfolio, recording multiple searches with each visit. Many clients are passing the URL to coworkers to view the site, so I assume that word of mouth really is important to the site's success. I have made a point to save all of the client's e-mail comments about the site in order to plan and implement suggested changes and improvements.''

QUESTION 3: WHERE SHOULD I BE ON THE INFORMATION HIGHWAY?

One of the biggest challenges when starting an Internet marketing program is to decide whether you want to put your page on a "portfolio" website with other professionals (see Web Resources on page 39) or have a site on your own. You may even decide both are needed.

Existing online sourcebooks or directory sites have the advantage of handling the promotion and getting clients to come to the site. They already have hotlinks to major search engines and are listed in print sourcebooks. Check for ones with the big advantage of a URL that is easy for clients to use and remember. On your own, you have to do all the work to promote your URL and get clients to come and visit. With both, you can build marketing equity when clients get to know your name and your work. As with the traditional marketing tools, success is based on multiple impressions received by the clients.

QUESTION 4: HOW CAN I DESIGN MY SITE AND GET THE PROFESSIONAL HELP I'LL NEED?

Digital technology can give you an advantage or be a black hole of marketing. The very idea of technology does not replace the need for the basics. You must first have a compelling purpose for clients to visit your site. To help define your purpose, first define what you are selling. Second, identify your client base and how they make photo-buying decisions. Third, define the factors that will help them make the right decision—the decision to hire you.

A website is not just a digital version of your promo piece or portfolio. The electronic medium is different from print. As a photographer, you do not need to learn extensive web page programming. Instead, you need to work with a design professional with a least a few years of success in website and page design. Note the use of the word "success" because simply having years of design experience is not sufficient. You need to work with a professional who has happy and satisfied Web clients. To find a qualified designer, start with your local ad club or chapter of AIGA (American Institute of Graphic Arts). Look at awards annuals such as *Communication Arts* magazine (www.commarts.com) for their "best of" list of Web designers. Check out *Target Marketing Magazine*'s (www.targetonline.com) resources directory, which includes graphic designers. What makes a website effective? Use this checklist when working with your design professional. Remember that your website is not art. It is a promotion tool.

☑ What is the call to action that you will use and how will that action be implemented? (It is important to give photo clients options such as an e-mail response, a toll-free number to call or a fax number to request more information. It is also very important to capture information from visitors such as firm names, addresses, phone numbers and e-mail addresses.)

☑ What keywords will you use or purchase when you register your site with the available search engines? (Think carefully before you decide what copy you will supply the search engines to explain your site.)

☑ Make the page easy to use. (Design with easy-to-read fonts and on backgrounds that are not so animated that they interfere with the text. Update the site often and always include the date. Use a home page that allows photo clients to explore without getting lost or sidetracked. Too

many "clicks" to get to their choice takes time and can be frustrating to a visiting client.)

☑ Discuss technical issues with your designer such as site navigation, file size, download time, color depth and palette to name just a few. (As with print promotions, there can be a conflict between "make it pretty" and "make it work." Be careful with designs that slow down the navigation of your site.)

☑ Use the unique factor of the quick speed of electronic response time to test different offers, calls to action and other response mechanisms. (Ask for feedback and be open to learning.)

☑ Find ways to add interesting content to your site. (By using "editorial" side by side with your advertising, you will give your clients a reason to revisit your site. Try a chat room, a survey or a contest—techniques to create interest and interaction. This requires a lot of maintenance but will build reputation, recognition and loyalty to your site.)

☑ Strive to establish a dialogue with your clients. (Respond to their requests quickly and always plan for follow-up. Be personal and personable. You are dealing in a cold, impersonal medium so try to warm things up. When will you next be in contact with them? What happens next?)

☑ Talk with your Web designer about some more advanced tools such as banner advertising, hot links, push technologies, online user groups and Web rings.

QUESTION 5: HOW CAN I ATTRACT CLIENTS TO MY SITE?

Bottom line, how do you get prospective clients to visit your site? First of all, a website will not take the place of a marketing plan (see my *1999 Photographer's Market* article, "Using Professional Marketing Tactics"). Your task is to decide how to use your site as an additional marketing tool. There is too much at stake to wait for clients to stumble across your site, and photo clients will not come looking for you unless you let them know exactly where you are.

Search engines and linking to other sites are excellent ways to promote your site but they are only the beginning of the marketing effort. You will still need traditional marketing tools to promote your site. Howard Davis (www.davis-studios.com) says, "My sourcebook page references the site, and I have a link from the *Black Book* site. I'm still experimenting, but I believe using a sourcebook ad with the site as backup is most effective for me. The ad lends credibility and helps me to stand out from the millions of other photographers out there on the Web. My experience indicates that I need to be in a sourcebook, using the site as a backup to show a body of work as a quick portfolio."

A written marketing plan is the best way to coordinate your print and electronic self-promotion and achieve your marketing goals. A written marketing plan includes specific action items. This plan also includes both the elements of timing and consistency between your print and electronic efforts.

To create your plan, start with a "marketing message," a descriptive statement about the work you are selling. Your message should clearly indicate to photo clients the kind of work you can do for them. Given the great number of photographers to choose from, your message will help clients remember to contact you and not your competition. The next step is to choose the best way or ways of getting your message to potential clients. Your marketing plan could include any combination of advertising, direct mail or public relations to deliver your message.

Advertising

Advertising is a nonpersonal form of marketing designed to reach very large groups of people. It is best used when you want to broadcast your marketing message and have clients call you. With print ads, you will expose thousands of people to your marketing message. With a web

page, the reach is broader in geography and has the potential to reach many more people. To create an effective print/web advertising campaign, your print ads must refer clients to your web page and your web page must refer clients to your print ads. Don't waste any chance to repeat a contact with a potential client.

Direct marketing

Direct marketing by mail is another form of promotion very popular with photographers. Direct mail is becoming more and more sophisticated. It is now necessary to add "selling" copy to your images but don't forget about the visual impression you want to make. A buyer will need to see your logo, company name and any other visual message you want to communicate 6 to 16 times before they recognize who you are and what you do. Again, always include your URL on your mailer and invite clients visiting your web page to join your mailing list.

Rick Etkin has had success using direct mail with his website to promote his business. "There are a series of four 'in your face' type and graphic treatments on postcards that are sent out in three month intervals," he explains. "The cards tie into my new identity and logo for my business ('re') and are based on Web-related words such as re:search, re:view, re:visit, re:act. My direct mail postcards have a measurable effect on traffic and word of mouth seems to have a great deal of impact on getting visits to the site."

Rick Etkin has had success using direct mail *with* his website to promote his business. "There are a series of four 'in your face' type and graphic treatments on postcards that are sent out in three month intervals," he explains. "The cards tie into my new identity and logo for my business ('re') and are based on Web-related words such as re:search, re:view, re:visit, re:act. My direct mail postcards have a measurable effect on traffic and word of mouth seems to have a great deal of impact on getting visits to the site."

Public relations

In your public relations, be sure to list your URL as an additional method of contacting you. Mention it again in the body of the press release copy. When writing project press releases, ask clients to visit your site and see the images from the shoot you just completed. Add quotes from clients and art directors with the images. All clients love to be included in any publicity and will check out your site when their job appears.

The most important thing to remember about any marketing campaign is that your message must be consistent throughout all print and electronic promotions. Be sure to add your URL to everything printed including business cards, letterhead, mailing labels, envelopes, note cards, photo print labels, slide captions and all promo pieces.

WEB RESOURCES

This Resource Section lists online information, portfolio sites, sourcebooks and directories. These are the URLs where a creative professional (photographer, designer, or illustrator) can buy space or get a free listing. This lists concentrates on photography-oriented sites. Some of the sites require membership in an organization to qualify for a listing.

http://www.Asmp.org, American Society of Media Photographers
http://www.sunsite.unc.edu/nppa, National Press Photographers Association
http://www.ppa-world.org, Professional Photographers of America
http://www.Wppi-online.com, Wedding & Portrait Photographers International
http://www.Blackbook.com, creative directory
http://www.AltPick.com, creative directory
http://www.Agpix.com, for the *Blue Book* and the *Green Book*, photo directories
http://www.Showcase.com, creative directories
http://www.Workbook.com, creative directory and sourcebook
http://www.Allworth.com, publisher of *The Photographer's Internet Handbook*
http://www.E-folio.com, portfolio and information site
http://www.Photosource.com, portfolio and directory site
http://www.Photography-guide.com, guide for the fine art photographer
http://www.Photographersindex.com, directory of photographers
http://www.Prophotog.com, directory of photographers
http://www.Photographers.com, directory of photographers
http://www.Atchison.net/PhotoLinks, this site is a directory of sites. It includes professional photographers' listings and portfolios, fine art photography, suppliers and many others.
http://www.Generation.NET/~gjones, this is another directory of sites for listings, associations and other photo resources.

Focus On: Photographic Collaborations

BY TRICIA WADDELL

Artists are often viewed as creative geniuses, toiling alone in their studios. However, the reality is that artists have always had assistants or muses who influenced and propelled their work in new directions, even if these sources of inspiration were never publicly credited. Photographers are no exception, often using talented assistants and stylists to help translate their ephemeral ideas into actual images on paper. But what if two (or more) photographers decided to collaborate as equals, sharing the credit? What if these photographers decided to create as a team, sharing ideas and vision, making themselves open to the influence and opinions of one another, not afraid to take a leap beyond what either could have achieved individually?

As more and more photographers enter the competitive world of image making, photographic collaborations have become a growing trend. Photographer teams not only share a unique vision, they also share the time consuming and costly tasks of managing a photography business. Here are the stories of four such teams, each with an uncommon collaborative style and creative viewpoint. Going way beyond "who pushed the shutter," these teams have discovered methods of working together that are dynamic, challenging and engaging.

SPATHIS & MILLER: TWO HEADS ARE BETTER THAN ONE

Ask food-photography team Dimitri Spathis and Michele Miller to explain the benefits of hiring a photo team and you'll get an assured response. "We sell ourselves as a team because you get two heads working towards one solution," says Spathis. "When people come to our studio and see how we work, they see that everything just clicks. You become family with us because that's what we are." The talented husband and wife team lives one floor above their San Francisco studio, which boasts a full kitchen, prep area, client lounge and workspace. Specializing in food and beverage still-life imagery, their client list includes Chronicle Books, Near East Food Products, Fetzer Vineyards, *Prevention* magazine, *Bon Appetit*, Disneyland Resort Marketing and Crystal Cruise Lines.

Michele Miller and Dimitri Spathis

Spathis and Miller met in 1984 as students at the Brooks Institute of Photography. After graduation, both had assisting jobs with other photographers, but when they decided to venture out on their own they knew that working as a team would be their edge over the competition. "If one person is not as motivated on a particular day as the other, the other one picks up the slack and nothing is lost," Spathis says. "When you work by yourself it's really tough to get motivated every day." Miller agrees completely. "It's really important for me to bounce ideas around with someone and Dimitri is a great person to do that with. On the flipside, if you're doing this alone in your own studio and everything is resting on your shoulders, that's really hard."

After years of working together, Spathis and Miller have developed their own curious method

One of Spathis & Miller's future goals is to do more lifestyle photography incorporating food, like this friendly waitress image. "I think it's important to show a human touch," says Miller. To create shots like this one, Spathis & Miller use a 1,000-square foot studio complete with full kitchen, prep area, client lounge and work space. They also employ a team of stylists, prop shoppers and background artists to help meet client needs.

© Spathis and Miller

of preparing for assignments. They bounce ideas off each other at lightning speed to get their creativity flowing. The curious part is that this creative exchange takes place in their car. "When we get an assignment, it comes to me first," says Miller. "I read it, we take a drive and that's how we have our preproduction meetings. I'm taking notes like mad, Dimitri's driving, and we're talking about how we should approach the assignment even before we talk to the food stylist." The next step is to meet with the prop and food stylists to add their ideas to the creative mix. "By the time we actually photograph, there's been so much preproduction done, the actual shoot happens in half the time," says Miller.

Timing is a key factor in food photography and that's where having two people really makes a difference. "When the food is done, you have to shoot it immediately," says Spathis. "With two of us working together, one can be the middleman between the food stylist and where we are on the set, with the other one behind the camera. Then we constantly look at the overall picture and fine-tune until we both agree." Spathis and Miller admit they each have their strong points when it comes to different assignments. "I'm strong in the editorial end where you can have more creative freedom," says Miller. "Dimitri is strong in the advertising end where you must be very meticulous."

This marketing savvy team also divides up business and self-promotion tasks. Miller takes care of sending postcard promos every six to eight weeks, handwriting messages, a hundred at a time, leaving space for Spathis to sign his name. Spathis lines up the phone calls and divides them based on who made the initial contact with a particular art director. Miller keeps track of outgoing portfolios. In addition they maintain a website at http://www.spathismiller.com.

For Spathis and Miller, living and working together can be intense but they have learned to separate the two. "We live upstairs from the studio, so not only do we work here, we live here and it's constantly 24 hours," says Spathis. "Over the years we've worked it out so after a shoot is finished we move away from it and become like any married couple." In addition, they take time away from each other for their own interests, including shooting personal projects. But ultimately Spathis and Miller enjoy sharing the same creative passions. "We're not just two

people sharing a studio, both going in different directions," says Spathis. "Everything we do is towards one end."

SONJA BULLATY AND ANGELO LOMEO: COLLABORATION OVER COMPETITION

Angelo Lomeo and Sonja Bullaty

She was born in Czechoslovakia and was an assistant to renowned Czech photographer Josef Sudek in Prague. He was born in New York and studied industrial art before turning to photography fulltime. They met shortly after World War II in a building of studios and darkrooms he managed in New York City. She loved apples and maintains he won her heart because he brought her the nicest ones. So began a 50-year partnership in love and photography between Sonja Bullaty and Angelo Lomeo.

Bullaty and Lomeo are best known for their lush photographic essays on the places they love most. They have published several books including *Vermont in All Weathers* (Viking); *Circle of Seasons: Central Park Celebrated* (Amaryllis); and *Provence, Tuscany* and *Venice and the Veneto* (all Abbeville Press). Exhibitions of their work, together and individually, have been staged around the world in museums including the Metropolitan Museum of Art, the International Center of Photography and the Museum of Modern Art in São Paulo, Brazil. Their photographs have appeared in *Life, Time, Orion, Audubon, American Photo, Outdoor Photographer* and other publications.

The secret to Bullaty and Lomeo's successful collaboration is their belief that the final project is more important than their individual egos. Even though they often shoot separately, they combine the best of each other's work for their book projects and share the credit. "Regardless of whose picture it is, the ones that seem to tell the story best are the ones chosen for a book, whether they are mine or Sonja's," says Lomeo. "Sometimes she gets more photos in and sometimes I do." Sonja agrees, "I'm just as happy if something of Angelo's is published as I am if it's mine."

While their books don't tell who clicked the shutter, they do assign individual credit when work is shown in exhibition. "We don't always take dual credit for pictures because the pictures we take are very different," says Lomeo. "We can be standing in the same spot and come out with totally different photos." While on assignment in locations from Venice to Texas, sometimes they go their separate ways to photograph and meet later. Other times they shoot back-to-back. Their books come together as the result of work photographed over many years. Their goal is "to capture the essence of a place," says Bullaty. "It's our persistence and need to understand a place in depth rather than just be superficial observers."

In addition to their editorial work, Bullaty and Lomeo have a long list of commercial clients including American Airlines, Avon, Estee Lauder, Exxon, Kodak, Merrill Lynch, Nikon and Nissan. For stock imagery, they are represented by the Image Bank and also sell their images for use on greeting cards, calendars and postcard books. Despite the high demand for their work, they both admit the business aspect of photography is the part they hate the most. "Most of the business part Sonja does," says Lomeo. Bullaty explains, "It's the weakest part of our cooperation. We both hate it so much! We just muddle through."

While Bullaty and Lomeo have strong individual visions, they believe there is enough competition in the world. "Photography is a solitary search," says Bullaty. "But rather than compete,

© 1995 Sonja Bullaty

© 1995 Angelo Lomeo

These shots are taken from Bullaty & Lomeo's 1998 book, *Venice and the Veneto*. Showing how they can take the same subject, in this case gondolas, and provide different interpretations, Lomeo took the shot showing a fleet of gondolas lined up graphically in a row. Bullaty's image is of gondolas parked along the architectural facades on the Grand Canal. Their combined work, featured in the book, is the result of eight trips to Venice.

we have consciously decided to cooperate and join forces on projects we feel strongly about." As they finish up their latest book for Abbeville, titled *America America*, they admit working together is not always easy. "The best part of collaborating is we can share problems, travel and time together," Lomeo says. "The most challenging part is trying to bring our individual approaches across and not fight too much." However, in the end, this couple wouldn't have it any other way. "Well, let's face it, it's not always easy to work together, especially when you have two strong-willed characters," says Bullaty. "But there is nothing more wonderful than sharing life and one's dedication to work."

CRABTREE PETERSON PHOTOGRAPHY: CREATIVE DEBATE ENSURES SUCCESS

"We absolutely disagree on almost everything," says Christine Crabtree of her six-year photographic collaboration with Peggy Jo Peterson. Creative sparring is the foundation for the success of their Philadelphia-based advertising photography studio, Crabtree Peterson Photography. "Clients get more out of a shoot," says Peterson, "because we're both determined to shoot our own idea." Crabtree adds, "I think our clients have enjoyed our disagreements because we can openly say, 'I'm sorry, I think that idea totally sucks!' and put it in such a way that our clients find it downright entertaining! Peggy and I come in with a real emotional energy and excitement and the clients love it!"

© Crabtree Peterson Photography

This self-promotional piece was created by Crabtree Peterson Photography in an effort to secure more work from pharmaceutical firms. Other future goals for Crabtree and Peterson include signing on with a stock agency, doing more ongoing campaigns and having more shows of their fine art work. This dynamic duo has been fortunate so far to generate more than enough work through word of mouth and referrals without doing any advertising.

The dynamic team connected through an accident of timing. Crabtree had her own photography business, but after an injury put her out of commission for a year, she needed some help around the studio. Peterson was a nurse who pursued photography in her free time. A mutual friend brought the two together. "I used to go into the studio in the evenings and my days off to work with Christine," says Peterson. This part-time arrangement lasted for six or seven months until Peterson had a baby and was on maternity leave. When Crabtree suggested they become full-time equal partners, Peterson quit her nursing position and they've never looked back.

Whether working for clients such as MCI and ADT Home Security or shooting for their portfolio, their work is always credited as a team. "Depending on the project, sometimes we're both behind the camera, and sometimes one person is maneuvering the set and the other one is behind the camera," says Crabtree. While most of their portfolio consists of work shot by one or the other, they consider their work a joint effort. "Both of us feel we are each other's best part of photography because we absolutely feed off one another," says Peterson. When meeting potential clients for the first time, they always go together. "When we're together it's a totally different experience than when it's just one of us," says Crabtree. "Once you meet us, you can't help but want to work with us." Clients must agree because the team admits they get more than enough assignments without advertising.

After years of working together, the influence they've had on each other's work is clear. "We tend to like each other's work a lot more. Before, you could really tell who shot what. Our styles have come a little closer," says Peterson. They describe their photographic style as "airy, simple and feminine." Peterson admits, without Crabtree she never would have considered a career in photography. Crabtree credits Peterson with adding a sense of movement and dimension to her work. "We have become very united and almost don't need to say things aloud," says Crabtree. "We have an unspoken language that comes from working together."

The collaboration between these two strong women has provided both with a once in a lifetime opportunity for creative and personal expression. "I don't know if this experience could ever be repeated," says Peterson. "We have a very unique relationship," adds Crabtree. "I don't have any other relationships in my life where I can be as blunt, direct and emotionally unaffected by stuff, and yet still very affected by her." Crabtree and Peterson also say sharing a similar role as women adds to their successful partnership. "There's an empathy that comes from both being women, both having husbands, both having children and both having the same career. We can really come from the same page," says Crabtree.

While the team believes collaborating is not only more dynamic, but also more fun, they admit people with big egos need not apply. "If you're not willing to let the other person's ideas come in, then you can't work together," says Crabtree. "You have to decide in the beginning how you will work together. Will you work as two individual people under the same roof or will you work as a team? If that goes unspoken or undecided there will be nothing but conflict." Peterson wholeheartedly agrees, "It's like a marriage. It's hit or miss. But if it works, it will blossom."

LAURA McPHEE AND VIRGINIA BEAHAN: A CRITICAL EXCHANGE OF IDEAS

In the introduction to *No Ordinary Land* (Aperture), the first book documenting the collaboration of landscape photographers Laura McPhee and Virginia Beahan, Rebecca Solnit describes their work as a "complex conversation about the ways our lives are intertwined with the spaces and substances of the earth, a conversation that seems to have its origins behind the camera, with two visions and voices rather than one shaping each image." The tangled relationship between humans and landscapes has provided more than enough compelling material for the ten-year "conversation" and collaboration between these two women who share a complex photographic vision.

The team began their friendship in 1977 in a photography class at Princeton when Mc-Phee was a sophomore and Beahan, then a high school English teacher, was auditing a class. After a ten-year friendship, during which both women earned MFA degrees in photography and worked on their own projects, they took a trip to Iceland to photograph its geologically rich landscape with every intention of shooting separately. "We started traveling and we had two 8 × 10 cameras, two 4 × 5 cameras, two 2¼ cameras—we had so much equipment," says McPhee. "Neither of

Laura McPhee and Virginia Beahan

us had photographed landscapes before in any serious way, so we were really starting on something new. As we traveled, we realized we were attracted to similar things so it seemed pointless to set up the 8 × 10 twice, side by side. We decided to try working together. It evolved naturally out of the circumstances."

Their signature panoramic images are all done with an 8x10 Deardorf view camera that makes a negative 60 times larger than a 35mm negative. Reminiscent of 19th century cameras, McPhee and Beahan can both stand under the Deardorf's dark cloth and look through the lens simultaneously. "With the Deardorf we can do everything together," says McPhee. "It's a slow process and that means we are really thinking about how to take the picture. It doesn't matter who clicks the button because we've made a decision about the picture before we take it."

McPhee and Beahan have photographed around the world with a particular focus on volcanic regions such as Iceland, Hawaii, Costa Rica and southern California. "We're interested in volcanic regions because they are so unstable and yet people live there, they live with the instability. In areas of stress like that you can see things. Visually you can see the nature/culture relationship more clearly," says McPhee. The team has also photographed landscapes in Sri Lanka and Italy in addition to the areas where they grew up—New York, New Jersey and Pennsylvania. While Beahan admits that traveling together can sometimes be stressful and demanding, she says their collaboration continues to be a "lively, dynamic and fascinating exchange" of ideas. "I used to joke and say the real interesting piece was not the photography we were making, but the video that wasn't being made of us working together," says Beahan. "We both enjoy our travels, we enjoy adversity to some extent. We share a sense of humor. If we didn't, how could we even do this?"

In addition to their collaborative projects, McPhee and Beahan also have families of their own, college teaching positions at different institutions, and live two and a half hours apart, but somehow they make it work. McPhee lives in Boston, teaches photography at the Massachusetts College of Art and has a three-year-old daughter. Beahan lives in New Hampshire, has taught at Mass Art in addition to Harvard, Wellesley and Columbia, and has a 23-year-old daughter. "We work all the time, but when we travel that's the big work time," says McPhee. "It's hard, but everybody is very supportive of us. We use the phone extensively. We've been doing it for so long, we just have a way of managing it."

McPhee and Beahan believe successful collaboration requires being open to someone else's opinions and learning to articulate ideas you would never have to if you worked alone. It is this exchange and their commitment to the work that have made their collaboration exceed all expectations. "Just be open to what you can learn from someone else," says Beahan. "The exchange creates a third entity. Neither one of us would have done this work without the other. But that's what creativity is, mixing ingredients together and something new comes out of it."

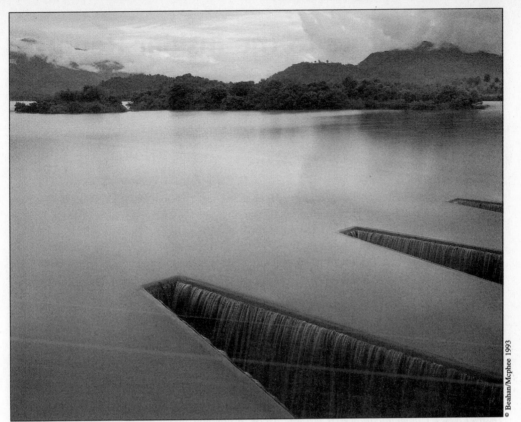

© Beahan/Mcphee 1993

Taken during their 1993 stay in Sri Lanka, Virginia Beahan and Laura McPhee made this amazing shot of sluices at a reservoir that is part of a 2,000-year-old irrigation system. Typically attracted to unstable geological areas, Sri Lanka provided a different dynamic for the pair because it is unstable politically. This offered them an opportunity to look at a wider variety of relationships expressed in nature, including geological, mythical, historical and technological.

Contributors to the Insider Reports

AMANDA HEELE
Amanda Heele is a writer living in Cincinnati. She teaches college composition at Miami University in Oxford, Ohio

MEGAN LANE
Megan Lane is the editor of *Photographer's Market*. She met Deborah Hardee at PhotoPlus in New York last year. Look for her at PhotoPlus 2000. You might end up in *Photographer's Market*.

SARAH MORTON
Sarah Morton is associate editor of *HOW* magazine. She has contributed articles to *Mountain Bike* magazine, *Southeast Ohio* magazine, *Exclusively Yours* magazine and *Guide to Literary Agents*.

ALICE POPE
Alice Pope is editor of *Children's Writer's & Illustrator's Market*. She is the roommate of the editor of this book, but that's not why she got this assignment.

ALLEN RABINOWITZ
Allen Rabinowitz is an Atlanta, Georgia-based writer who has been writing about creative people in a variety of disciplines for more than 20 years. His work has appeared in magazines including *Photo District News*, *Communication Arts*, *Ad Age*, *HOW*, *Folio*, and *Photo Electronic Imaging*.

TRICIA WADDELL
Tricia Waddell is the production editor of *Artist's & Graphic Designer's Market* and *Novel & Short Story Writer's Market*. She is also a fine art photographer.

The Markets

IMPORTANT LISTING INFORMATION

- The majority of markets listed in this book are actively seeking new freelance contributors.
- Some important, well-known companies have declined complete listings and are included within their appropriate section with a brief statement of their policies.
- The photo buyers in this book are contacted every year to verify the information in their listings.
- Photo buyers that for various reasons have not renewed their listings from the 1999 edition are listed, with an explanation for their absence, in the General Index at the back of this book. A photo buyer may not be listed for one of these reasons:
 1. The buyer is not accepting unsolicited submissions.
 2. The buyer did not respond to a request for updated information.
 3. The buyer went out of business.
 4. The business was restructured or sold.
 5. The buyer requested the listing be removed.
 6. We were unable to contact the business because it moved and left no forwarding address.
 7. The buyer was removed because of reader complaints.
- Market listings are based on questionnaires completed by photo buyers. They are published free of charge and are not advertisements. While every measure is taken to ensure that the listing information is as accurate as possible, we cannot guarantee or endorse any listing.
- *Photographer's Market* reserves the right to exclude any listing which does not meet its requirements.
- Although buyers are given the opportunity to update their listing information prior to publication, the photography marketplace changes constantly throughout the year and between editions. Therefore, it is possible that some market information will be out of date by the time you make use of it.

COMPLAINT PROCEDURE

If you feel you have not been treated fairly by a listing in *Photographer's Market*, we advise you to take the following steps:

☑ First try to contact the listing. Sometimes one phone call or a letter can quickly clear up the matter.

☑ Document all your correspondence with the listing. When you write to us with a complaint, provide the details of your submission, the date of your first contact with the listing and the nature of your subsequent correspondence.

☑ We will enter your letter into our files and attempt to contact the listing.

☑ The number and severity of complaints will be considered in our decision about whether to delete the listing from the next edition.

Publications

CONSUMER PUBLICATIONS

Research is the key to selling any kind of photography and if you want your work to appear in a consumer publication you're in luck. Magazines are the easiest market to research because they're available on newsstands and at the library and at your doctor's office and . . . you get the picture. So do your homework. Before you send your query or cover letter and samples, before you drop off your portfolio on the prescribed day, look at a copy of the magazine. The library is an especially helpful place when searching for sample copies because they're free and there will be at least a year's worth of back issues right on the shelf.

Once you've read a few issues and feel confident your work is appropriate for a particular magazine, it's time to hit the keyboard or the typewriter. Most first submissions take the form of a query or cover letter and samples. So what kind of letter do you send? That depends on what kind of work you're selling. If you simply want to let an editor know you are available for assignments or have a list of stock images appropriate for the publication, send a cover letter, a short business letter that introduces you and your work and tells the editor why your photos are right for the magazine. If you have an idea for a photo essay or plan to provide the text and photos for an article, you should send a query letter, a 1- to 1½-page letter explaining your story or essay idea and why you're qualified to shoot it. (You'll find a sample query letter on the next page.)

Both kinds of letters can include a brief list of publication credits and any other relevant information about yourself. Both also should be accompanied by a sample of your work—a tearsheet, a slide or a printed piece, but never an original negative. Be sure your sample photo is of something the magazine might publish. It will be difficult for the editor of a mountain biking magazine to appreciate your skills if you send a sample of your fashion work.

If your letter piques the interest of an editor, he or she may want to see more. If you live near the editorial office you can schedule an appointment to show your portfolio in person. Or you can inquire about the drop-off policy—many magazines have a day or two each week when artists can leave their portfolios for art directors. If you're in Wichita and the magazine is in New York, you'll have to send your portfolio through the mail. Consider using FedEx or UPS; both have tracking services that can locate your book if it gets waylaid on its journey.

To make your search for markets easier, there is a subject index in the back of this book. The index is divided into 55 topics, and markets are listed according to the types of photographs they want to see. Consumer Publications is the largest section in this book so take a look at the Subject Index on page 588 before you tackle it.

◀ This shot of a New York fire escape bathed in slanting rays of light is part of Jay Maisel's "February Light" series. Maisel began the series when the Swiss magazine *Du* requested he create an image that defined the month of February. "I decided to deal with the light in February because every month has different light. I would go back to it year after year. It became a larger exploration of how light changes in different times of the year." Maisel says the "February Light" photos are typical of how personal work themes have evolved for him. (Maisel explains the importance of personal work for all photographers on page 53.)

SAMPLE QUERY LETTER FOR MAGAZINES

January 1, 2000

Megan Lane
1507 Dana Ave.
Cincinnati, OH 45207
(513) 531-2690

Alice Pope
Children's Book Examiner
2410 Ashland Ave.
Cincinnati OH 45206

Dear Ms. Pope:

I've been reading *Children's Book Examiner* for the past several months and have been impressed by both the photography and the writing featured in each issue. Past issues have touched on the subject of children's authors who have left the pressures of the publishing scene for more relaxing careers and I would like to propose a photo essay on the topic.

"Children's Writers: Where Are They Now?" would focus on five former authors who are now working in the fields of horticulture, dog grooming, basket weaving, jogging suit design and social work. Each author would be featured in an environmental portrait and short caption about their new occupation.

I've done similar photo essays for *Rolling Stone* ("Journey: Where Are They Now?") and *Onion World* ("Vidalia: Where Is It Now?"). Enclosed are tearsheets from past assignments that show my photographic skill. You may keep the tearsheets on file, but I've enclosed a SASE for your reply.

I look forward to hearing from you in the near future.

Sincerely,

Megan Lane

You may also include an e-mail address or your website in your contact information.

Make sure to address letter to current photo contact.

Show that you are familiar with the magazine.

Briefly explain your idea.

Enclose copies of relevant work. Never send originals.

Always include a self-addressed, stamped envelope for the magazine's reply.

Personal views: Jay Maisel touts the benefits of self-assignments

Jay Maisel

While many photographers look on personal work as a diversion from their daily tasks, Jay Maisel says there is an important reason to shoot without an assignment. "You need to do your visual push-ups," the renowned, New York-based photographer advises. "You need to do exercises to keep your body healthy, and you need to do personal work to keep your photography healthy. Actors take classes. So do dancers. But unless they're getting paid to do it, photographers don't practice. It's important to practice."

Although he says he can't name an instance where a personal assignment led directly to a paying job, Maisel stresses that work done on his own increases his photographic sensibilities. "If you do your visual push-ups on a regular basis," he explains, "if you're looking all the time, it increases your awareness. If you're serious about what you do, you'll do personal work."

Maisel has been considered one of the world's foremost photographers for over four decades. Whether the assignment is corporate, editorial or advertising, Maisel has brought his eye for composition, flair for graphic design and bold use of color to play to create arresting imagery. The Brooklyn native has won numerous awards and is sought after as a speaker for workshops and classes.

Claiming not to know what might be considered a typical "Jay Maisel photo," he nonetheless has definite opinions about what his personal work should look like. "I'm tired of seeing things I'm well known for," he says. "I'm interested in more esoteric things that other people aren't interested in. I think my personal work varies a great deal from my assignment work, but in some rare instances, it varies not at all."

In today's creative universe, Maisel says art directors require more and more that photographers adhere closely to the layout the creatives have devised. He feels this way of working stifles a photographer's potential for growth. "If you only do the commercial assignments," he explains, "then you're like a leaf drifting in the cross currents of other people's motivations. But, if you do your own work *and* the assignments, it's a nice balance."

Personal work, according to Maisel, helps a photographer identify who he or she really is. "Most commercial assignments won't tell you who you are," he says. "They'll

tell you about the person who sent you out to do it. A great deal of commercial work is repetitive and you're being paid to make a silk purse out of a sow's ear. That doesn't open you up, but instead, defines you in a very narrow frame."

While many young photographers might have their sights set on attaining a position similar to Maisel's, he says they should think about doing work other than paying jobs in order to become better shooters. "If you want to work hard on stuff you're not interested in or not what you're about," he advises, "then go out and make a lot of money. If at the end of that time you've grown, that's wonderful too. But, if at the end of that time you haven't grown, it's time to take a little time out of your money making and shoot for yourself."

Rather than be too locked into a particular style or concept, Maisel says personal work should be liberating and concentrate on the essence of photography. "There's a school of art that talks about painting, not the subject but the act of painting," he explains. "I'm interested in photography that's not necessarily about a building or a tree but is about color or light. The subject matter is wonderful, but it's just a take-off point. Sometimes, I'll go out and do something about light that's marvelous or something that has the most wonderful gesture in the world. Those are the kind of things I'm looking for."

This shot of a flaming fire escape is another image from Maisel's "February Light" series. Maisel believes such personal projects are essential for all photographers. "If you go out and do truly personal work," he says, "it may not be good, but it certainly will help you grow. If you put enough effort into it, however, at some point it will be good. If you do your own personal work, you will inevitably grow. If you don't, you won't. It's as easy as that."

Awareness of the world around him is part of Maisel's approach to personal work. To help capture the world around him, Maisel always carries a camera. Though unsure of why he started the practice, Maisel is certain of the benefits. "It seemed to me," he explains, "that if you went out with a camera all the time, you never had to go out to shoot. It's always there. If you go out with a camera on you, it becomes a part of you."

Maisel says that self-assigned work is not always a conscious occurrence, but rather, evolutionary. "I'll go out shooting," he says, "and I'll notice there's a thing that happens socially at a certain time of the day within a community in New York. That becomes something I'll explore. You go out empty and let the subject fill you."

Unlike other photographers who work for a predetermined time on a specific self-assigned project before dropping it to move on to something else, Maisel describes his shooting style as "picking on the same scab all the time. I don't move on to something else. If I do move on, it doesn't preclude going back to the first thing. Over the years, there have been certain things I like to work on, things I'm never going to stop looking at."

One of the primary subjects for Maisel's lens has been the area around his studio in lower Manhattan. Maisel has worked from a former bank building for 30 years and has documented the changes in the building and neighborhood over that interval. While shooting the view from his building, an idea for another aspect of the project came to Maisel. "I noticed that I was neglecting the inside of the building," he says. "So I started doing pictures of the decorative things I've been gathering."

Another theme that has occupied his attention is "Lunch," an exploration of activities taking place during the noon hour in New York. Maisel has wandered around New York capturing such things as people sunbathing or waiting in line at hot dog stands for their midday meal. On such personal work, Maisel prefers to keep his options open rather than stick to a strict game plan. "My personal assignment is to just go out and shoot," he says. "It doesn't matter what. Sometimes, though, I might decide to go back another time because the light might be better at a different time of the year. Then I'm following a trail I've fallen into."

Maisel also uses these opportunities to try the unexpected. In one instance, a magazine asked Maisel and other noted photographers to do work opposite of what they were known for. In his case, this meant black and white, but instead of meeting expectations on what he would deliver, Maisel sought to do something totally different. "They expected me to go out and shoot things with dramatic lighting and shadows," he says. "But, I went into my collection of things and shot still lifes in black and white. I unconsciously chose objects like gears that had interesting shapes. It's been written that shape is the enemy of color. I picked out all these incredibly complex and beautiful shapes which were stronger images without color."

On another occasion, a Swiss magazine asked Maisel to shoot a project that sparked a long, ongoing self-assignment. He was supposed to shoot a photo that would define the month of February, but he was stumped as to what that might be. "I couldn't find

anything specific to the month that I wanted to do in terms of culture, economics or social things," he explains. "So, I decided to deal with the light in February because every month has different light. I would go back to it year after year. That's become a larger exploration of how light changes in different times of the year." Maisel says the "February" photos are typical of how personal work themes have evolved. The exploration has led to a better understanding of light and about the thought processes in creating imagery.

Although many shooters use their personal work as candidates for stock sales, Maisel doesn't go out with stock in mind. "The only time I do that," he explains, "is if I've found something really applicable and it's a personal challenge. It's happened a few times where I saw something I loved and it's become a big seller. It's become fascinating to me, to then try to do it again."

With a laugh, Maisel says that many of the photos from self assignments "just lay there. A lot of them never see the light of day. Some may get sold in stock, and I put some of them in slide shows to use in lectures." On a few occasions, Maisel's personal work has found it's way into exhibitions. A recent example is a show titled "Light in America" which was displayed at the International Center of Photography in New York.

When judging his personal work, Maisel says he uses the same criteria as a commercial assignment. "It has to stand on its own, whatever you're doing," he explains. "There's no nobility to personal work that's bad, and there's no downside to a commercial job that's good. You have to judge them on their individual merits. You don't judge them on how difficult it was to do or how much fun it was."

He also doesn't seek feedback from others on these photos. "You only get good feedback," Maisel explains, "you never get bad feedback. People may write bad things about you, but they'll never say anything bad to your face. I'll show people work I've done but not to get an opinion. It's more, 'Here's something I've done that I'd love to show to you.'"

According to Maisel, photographers should especially not try to solicit a critique from those in a position to provide future work. "I think photographers make a mistake in showing things to art directors, hoping to get opinions from them," he explains. "What they're doing is putting the art director in the position of a mentor, and mentors don't give you work. Equals give you work. If you have a mentor-student relationship, don't get it muddled by a commercial relationship."

Though photographers may be too tired to go out and shoot personal work after spending long hours looking through a viewfinder for money, Maisel encourages the practice as being an essential ingredient in reaching the top level of the profession. "If you go out and do truly personal work," he declares, "it may not be good, but it certainly will help you grow. If you put enough effort into it, however, at some point it will be good. If you do your own personal work, you will inevitably grow. If you don't, you won't. It's as easy as that."

—Allen Rabinowitz

$ $AAA MICHIGAN LIVING, 2865 Waterloo Dr., Troy MI 48084. (248)816-9265. Fax: (248)816-2251. E-mail: regarbo@aol.com. Editor: Ron Garbinski. Circ. 1.2 million. Estab. 1918. Monthly magazine. Emphasizes auto use, as well as travel in Michigan, US, Canada and foreign countries. Free sample copy and photo guidelines.
Needs: Scenic and travel. "Buys photos without accompanying ms only for stories listed on editorial calendar. Seeks queries about travel in Michigan, US and Canada.
Specs: Uses 35mm, 2¼×2¼ or 4×5 transparencies. For covers in particular, uses 35mm, 4×5 or 8×10 color transparencies. SASE.
Making Contact & Terms: Query with list of stock photo subjects. Send e-mail address to regarbo@aol.com to receive monthly photo needs update from editor. Reports in 6 weeks. Simultaneous submissions and previously published work not accepted. Pays up to $450/color photo depending on quality and size; $450/cover; $55-500/ms. Pays on publication for photos and for mss. Buys one-time rights.

$ $AAA MIDWEST TRAVELER, (formerly *The Midwest Motorist*), Dept. PM, Auto Club of Missouri, 12901 N. Forty Dr., St. Louis MO 63141. (314)523-7350. Fax: (314)523-6982. Managing Editor: Deborah Klein. Circ. 435,000. Bimonthly. Emphasizes travel and driving safety. Readers are "members of the Auto Club of Missouri, ranging in age from 25-65 and older." Free sample copy and photo guidelines with SASE; use large manila envelope.
Needs: Uses 8-10 photos/issue, most supplied by freelancers. "We use four-color photos inside to accompany specific articles. Our magazine covers topics of general interest, historical (of Midwest regional interest), humor (motoring slant), interview, profile, travel, car care and driving tips. Our covers are full color photos mainly corresponding to an article inside. Except for cover shots, we use freelance photos only to accompany specific articles." Captions required. Model release preferred.
Making Contact & Terms: Query with résumé of credits and list of stock photo subjects. Does not keep samples on file. SASE. Reports in 1 month. Simultaneous submissions and previously published work OK. Pays $175-350/cover; $75-200/color photo; $75-350 photo/text package. **Pays on acceptance.** Buys first rights. Credit line given.
Tips: "Send an 8½×11 SASE for sample copies and study the type of covers and inside work we use. Photo needs driven by an editoral calendar/schedule. Write to request a copy and include SASE."

N $ $ $ABARTA MEDIA, (formerly *International Voyager Media*), 11900 Biscayne Blvd., Suite 300, Miami FL 33181-2726. (305)892-6644. Fax: (305)892-1005. E-mail: robinhill@abartapub.com. Photography Director: Mr. Robin Hill. Estab. 1978. Mainly annual and biannual hotel books and cruise magazines. Emphasizes travel. "We have 120 different publications annually." Readers are affluent travelers, ages 35-70. Sample $14-95/book. Photo guidelines free with SASE.
Needs: Uses various numbers of photos/issue; all supplied by freelancers. Needs photos of travel scenics, people enjoying themselves, aerials. Model release preferred; photo captions required (whereabouts, who, what, any pertinent information regarding location of photo).
Making Contact & Terms: Arrange personal interview to show portfolio or submit portfolio for review. Query with résumé of credits. Provide résumé, business card, brochure, flier or tearsheets to be kept on file for possible future assignments. Keeps samples on file. Reports in 1 month. Simultaneous submissions and/or previously published work OK. Payment depends on circulation of publication which varies from 6,000-750,000. Pays $250 minimum/color cover; $75-350/color page; $125 minimum/b&w page. Pays on publication. Buys one-time rights with electronic usage. Credit line given.
Tips: "Our publications emphasize travel with a positive outlook—photos that make a location look attractive, to aid in attracting tourists to an area. Photographers need to show versatility as our assignment work involves still lifes, people, aerials and travel scenics. Good captions are very important. We are looking for photographers with a professional attitude, a willingness to travel at short notice and an interest in travel photography as their foremost specialty. Photographers need to understand that the editorial process is not just dependent on the photo buyer, but is dependent on the budgets that the photo buyer is given for each photo project, which is usually flexible but not always. Persistence and quality work are the main ingredients for success."

$ ACCENT ON LIVING, P.O. Box 700, Bloomington IL 61702. (309)378-2961. Fax: (309)378-4420. E-mail: acntlvng@aol.com. Editor: Betty Garee. Circ. 20,000. Estab. 1955. Quarterly magazine. Emphasizes successful disabled young adults (18 and up) who are getting the most out of life in every way and *how* they are accomplishing this. Readers are physically disabled individuals of all ages, socioeconomic levels and professions. Sample copy $3.50 with 5×7 SAE and 5 first-class stamps. Free photo/writers guidelines; enclose SASE.

Needs: Uses 40-50 photos/issue; 95% supplied by freelancers. Needs photos for Headliners department, "a human interest photo column on disabled individuals who are gainfully employed or doing unusual things." Also uses occasional photo features on disabled persons in specific occupations: art, health, etc. Manuscript required. Photos depict handicapped persons coping with the problems and situations particular to them: how-to, new aids and assistive devices, news, documentary, human interest, photo essay/photo feature, humorous and travel. "All must be tied in with physical disability. We want essentially action shots of disabled individuals doing something interesting/unique or with a new device they have developed—not photos of disabled people shown with a good citizen 'helping' them." Captions preferred.

Specs: Uses glossy prints and color photos, transparencies preferred. Accepts images in digital format for Mac. Send via CD or floppy disk (300dpi). Cover is usually tied in with the main feature inside.

Making Contact & Terms: Query first with ideas, get an OK, and send contact sheet for consideration. Provide letter of inquiry and samples to be kept on file for possible future assignments. SASE. Reports in 3 weeks. Previously published work OK. Pays $150/color cover; pays $10 minimum/color inside; pays $10 minimum/b&w inside. Pays on publication. Credit line given if requested.

Tips: "Concentrate on improving photographic skills. Join a local camera club and go to photo seminars, etc. We find that most articles are helped a great deal with *good* photographs—in fact, good photographs will often mean buying a story and passing up another one with very poor or no photographs at all." Looking for *good* quality photos depicting what article is about. "We almost always work on speculation."

$ $▣ ACROSS THE BOARD MAGAZINE, published by The Conference Board, 845 Third Ave., New York NY 10022-6679. (212)339-0454. Picture Editor: Janice Ackerman. Circ. 30,000. Estab. 1976. General interest business magazine with 10 monthly issues (January/February and July/August are double issues). Readers are senior executives in large corporations.

Needs: Use 10-15 photos/issue some supplied by freelancers. Wide range of needs, including location portraits, industrial, workplace, social topics, environmental topics, government and corporate projects, foreign business (especially east and west Europe and Asia).

Specs: Accepts digital images.

Making Contact and Terms: Query *by mail only* with list of stock photo subjects and clients, and brochure or tearsheets to be kept on file. Cannot return material. "No phone queries please. We pay $125-400 inside, up to $500 for cover or $400/day for assignments. We buy one-time rights, or six-month exclusive rights if we assign the project."

Tips: "Our style is journalistic and we are assigning photographers who are able to deliver high-quality photographs with an inimitable style. We are interested in running full photo features with business topics from the U.S. or worldwide. If you are working on a project, please send non-returnable samples."

⊕ ACTIVE LIFE, Lexicon, 1-5 Clerkenwell Rd., 1st Floor, London, EC1M 5PA United Kingdom. Phone: (44-171)253-5775. Fax: (44-171)253-5676. E-mail: activelex@aol.com. Contact: Helene Hodge. Circ. 300,000. Estab. 1990. Bimonthly consumer magazine.

Needs: Reviews photos with accompanying ms only. Model release required. Photo caption preferred.

Specs: Uses 35mm transparencies.

Making Contact & Terms: Send query letter with samples. Keeps samples on file; include SASE for return of material. Simultaneous submissions and/or previously published work OK. Pays on publication. Rights negotiable. Credit line given.

$ $ ADIRONDACK LIFE, Rt. 9N, P.O. Box 410, Jay NY 12941. (518)946-2191. Art Director: Ann Hough. Circ. 50,000. Estab. 1970. Published 8 times/year. Emphasizes the people and landscape of the Adirondack region. Sample copy $4 with 9×12 SAE and 5 first-class stamps. Photo guidelines free with SASE.

Needs: "We use about 40 photos/issue, most supplied by freelance photographers. All photos must be taken in the Adirondacks and all shots must be identified as to location and photographer."

Specs: Uses b&w prints (preferably 8×10) or color transparencies in any format.

FOR EXPLANATIONS OF THESE SYMBOLS, SEE THE INSIDE FRONT AND BACK COVERS OF THIS BOOK.

Making Contact & Terms: Send one sleeve (20 slides) of samples. SASE. Simultaneous submissions OK. Pays $300/cover; $50-200/color or b&w photo. Pays 30 days after publication. Buys first North American serial rights. Credit line given.

Tips: "Send quality work pertaining specifically to the Adirondacks. In addition to technical proficiency, we look for originality and imagination. We emphasize vistas and scenics. We are using more pictures of people and action."

ADVENTURE CYCLIST, Box 8308, Missoula MT 59807. (406)721-1776. Editor: Dan D'Ambrosio. Circ. 30,000. Estab. 1974. Publication of Adventure Cycling Association. Magazine published 9 times/year. Emphasizes bicycle touring. Sample copy and photographer's guidelines free with 9×12 SAE and 4 first-class stamps.

Needs: Covers. Model release preferred. Captions required.

Making Contact & Terms: Submit portfolio for review. SASE. Reports in 3 weeks. Simultaneous submissions and previously published work OK. Payment negotiable. Pays on publication. Buys one-time rights. Credit line given.

N $ ▣ ◯ AFTER FIVE MAGAZINE, P.O. Box 492905, Redding CA 96049. (800)637-3540. Fax: (530)335-5335. E-mail: editor@after5magazine.com. Publisher: Craig Harrington. Monthly tabloid. Emphasizes news, arts and entertainment. Circ. 32,000. Estab. 1986.

Needs: Uses 8-12 photos/issue; 10% supplied by freelance photographers. Needs photos of scenics of northern California. Also wants regional images of wildlife, rural, adventure, automobiles, entertainment, events, health/fitness, hobbies, humor, performing arts, sports, travel. Model release and captions preferred.

Specs: Accepts images in digital format for Mac, Windows. Send via CD, SyQuest, floppy disk, Jaz, Zip as TIFF files at 150 dpi.

Making Contact & Terms: Provide résumé, business card, brochure, flier or tearsheets to be kept on file for possible assignments. SASE. Reports in 1-2 weeks. Previously published work OK. Pays $60/color or b&w cover; $20/b&w or color inside. Pays on publication. Buys one-time rights. Credit line given.

Tips: "Need photographs of subjects north of Sacramento to Oregon-California border, plus southern Oregon. Query first."

$ AIM MAGAZINE, P.O. Box 1174, Maywood IL 60153. (312)874-6184. Editor: Myron Apilado. Circ. 7,000. Estab. 1974. Quarterly magazine. Magazine dedicated to promoting racial harmony and peace. Readers are high school and college students, as well as those interested in social change. Sample copy for $4 with 9×12 SAE and 6 first-class stamps.

Needs: Uses 10 photos/issue. Needs "ghetto pictures, pictures of people deserving recognition, etc." Needs photos of "integrated schools with high achievement." Model release required.

Specs: Uses b&w prints.

Making Contact & Terms: Send unsolicited photos by mail for consideration. SASE. Reports in 1 month. Simultaneous submissions OK. Pays $25/color cover; $10/b&w cover. **Pays on acceptance.** Buys one-time rights. Credit line given.

Tips: Looks for "positive contributions."

$ S ▣ ◗ ALABAMA LIVING, P.O. Box 244014, Montgomery AL 36124. (334)215-2732. Fax: (334)215-2733. E-mail: area@mindspring.com. Website: http://www.areapower.com. Editor: Darryl Gates. Circ. 330,000. Estab. 1948. Publication of the Alabama Rural Electric Association. Monthly magazine. Emphasizes rural life and rural electrification. Readers are older males and females living in rural areas and small towns. Sample copy free with 9×12 SASE and 4 first-class stamps.

Needs: Uses 6-12 photos/issue; 1-3 supplied by freelancers. Needs photos of nature/wildlife, travel, gardening, rural, agriculture, food/drink, southern region, some scenic and Alabama specific; anything dealing with the electric power industry. Special photos needs include vertical scenic cover shots. Captions preferred; include place and date.

Specs: Accepts images in digital format for Mac. Send via CD or Zip files.

Making Contact & Terms: Query with stock photo list or transparencies ("dupes are fine") in negative sleeves. Keeps samples on file. SASE. Reports in 1 month. Simultaneous submissions OK. Previously published work OK "if previously published out-of-state." Pays $50/color cover; $50/color inside; $60-75/photo/text package. Pays on publication. Buys one-time rights; negotiable. Credit line given.

$ $ ALASKA, 4220 B St., Suite 210, Anchorage AK 99503. (907)561-4772. Fax: (907)561-5669. Editor: Bruce Woods. Photo Editor: Donna Rae Thompson. Circ. 250,000. Estab. 1935. Monthly magazine. Readers are people interested in Alaska. Sample copy $4. Free photo guidelines.

Needs: Buys 500 photos annually, supplied mainly by freelancers. Captions required.

Making Contact & Terms: Send carefully edited, captioned submission of 35mm, 2¼×2¼ or 4×5 transparencies. SASE. Reports in 4 weeks. Pays $50 maximum/b&w photo; $75-500/color photo; $300 maximum/day; $2,000 maximum/complete job; $300 maximum/full page; $500 maximum/cover. Buys one-time rights; negotiable.

Tips: "Each issue of *Alaska* features a 4- to 6-page photo feature. We're looking for themes and photos to show the best of Alaska. We want sharp, artistically composed pictures. Cover photo always relates to stories inside the issue."

$☐ ALIVE NOW MAGAZINE, 1908 Grand Ave., P.O. Box 189, Nashville TN 37202. (615)340-7218. Fax: (615)340-7267. E-mail: alivenow@upperroom.org. Website: http://www.upperroom.org/alive now/. Associate Editor: Eli Fisher. Circ. 70,000. Estab. 1971. Bimonthly magazine published by The Upper Room. "*Alive Now* uses poetry, short prose, photography and contemporary design to present material for personal devotion and reflection. It reflects on a chosen Christian concern in each issue. The readership is composed of primarily college-educated adults." Sample copy free with 6×9 SAE and 4 first-class stamps. Themes list free with SASE; photo guidelines available.

Needs: Uses about 20 b&w prints/issue; 90% supplied by freelancers. Needs b&w photos of babies, children, couples, parents, senior citizens, teens, family, friends, people in positive and negative situations, scenery, environmental, architecture, cities/urban, rural, gardening, religious, celebrations, disappointments, ethnic minority subjects in everyday situations—Native Americans, Hispanics, Asian-Americans and African-Americans. Model release preferred.

Making Contact & Terms: Send 8×10 glossy b&w prints by mail for consideration. Send return postage with photographs. Submit portfolio for review. SASE. Reports in 6 months; "longer to consider photos for more than one issue." Simultaneous and previously published submissions OK. Pays $40/b&w inside; no color photos. Pays on publication. Buys one-time rights. Credit line given.

Tips: Looking for high reproduction, quality photographs. Prefers to see "a variety of photos of people in life situations, presenting positive and negative slants, happy/sad, celebrations/disappointments, etc. Use of racially inclusive photos is preferred. Send photos to keep on file (photocopies are accepted but please send several photographs to show quality)."

Ⓝ $☐ ▣ ALL AMERICAN CHEVYS, Challenge Publications, 7950 Deering Ave., Canoga Park CA 91304-5063. (818)887-0550, ext. 104. Fax: (818)884-1343. E-mail: mail@challengeweb.com. Website: http://www.challengeweb.com. Editor: Dan Kahn. Circ. 100,000. Estab. 1996. Bimonthly consumer magazine. *All American Chevy* is the "1955-1973 Chevrolet authority." Art guidelines available.

Needs: Buys 5-10 photos from freelancers per issue; 20-50 photos per year. Needs photos of automobiles. Reviews photos with or without a ms. Model release required; property release preferred. Photo caption preferred; include make, model, year, owner.

Specs: Uses 35mm transparencies. Accepts images in digital format for Mac. Send via CD as TIFF files.

Making Contact & Terms: Contact through rep or send query letter with slides. Provide self-promotion piece to be kept on file for possible future assignments. Reports in 2 weeks on queries. Payment varies. Pays on publication. Credit line given. Buys one-time rights.

Tips: "Do not be afraid to get creative with angles and lighting. Photographer must be familiar with standard auto-media poses and shots. Submit only color slides."

$◑ ALL-STATER SPORTS, 1373 Grandview Ave., Suite 206, Columbus OH 43212. (614)487-1280. Fax: (614)487-1283. E-mail: sstrong@all-statersports.com. Website: http://www.all-statersports.com. Managing Editor: Stephanie Strong. Circ. 100,000. Estab. 1996. Bimonthly magazine. "Our mission is to inform, inspire and recognize today's high school athlete." Sample copy for $5. Art guidelines free.

Needs: Buys 2 photos from freelancers/issue. Story idea and contact typically provided. Always need photos of outstanding high school athletes in action. Reviews photos with or without ms. Special photo needs include state championship (high school) photos. Model release preferred; property release preferred. News photos do not need model releases. Photo captions required; include who, what, when, where.

Specs: Accepts images in digital format for Mac. Send via CD, floppy disk, Jaz, Zip, e-mail as EPS or JPEG at 300 dpi.

Making Contact & Terms: Send query letter with samples. Editor will contact photographer for possible assignment. Keeps samples on file. Reports in 1-2 months on queries. Previously published work OK. Pays $25-200 for color cover; $10-30 for b&w inside; $10-50 for color inside. Pays on publication. Buys one-time, electronic rights; negotiable. Credit line given.

Tips: "We are a new magazine with a small staff, and we are always looking for good stories with excellent pictures. Let us know of possibilities in your area of the country. Please only send sample work that is sports oriented."

$ $ ☑ AMELIA MAGAZINE, 329 "E" St., Bakersfield CA 93304. (661)323-4064. Fax: (661)323-5326. E-mail: amelia@lightspeed.net. Editor: Frederick A. Raborg, Jr. Circ. 1,750. Quarterly magazine. Emphasizes literary: fiction, non-fiction, poetry, reviews, fine illustrations and photography, etc. "We span all age groups, three genders and all occupations. We are also international in scope. Average reader has college education." Sample copy $9.95 and SASE. Photo guidelines free with SASE.

● Because this is a literary magazine it very seldom uses a lot of photographs. However, the cover shots are outstanding, fine art images.

Needs: Uses 4-6 photos/issue depending on availability; all supplied by freelance photographers. "We look for photos in all areas including male and female nudes and try to match them to appropriate editorial content. We sometimes use photos alone; color photos on cover. We use the best we receive; the photos usually convince us." Subjects include children, couples, multicultural, families, senior citizens, landscapes/scenics, wildlife, architecture, cities/urban, pets, rural, adventure, entertainment, events, health/fitness, hobbies, humor, performing arts, sports, travel, buildings, military, portraits, science, technology, alternative process, avant garde, erotic, fashion/glamour, fine art, historical/vintage, regional. Model release required. Captions preferred.

Specs: Uses b&w or color, 5×7 and up, glossy or matte prints; 35mm or 2¼×2¼ transparencies.

Making Contact & Terms: Send unsolicited photos by mail for consideration. SASE. Reports in 2 weeks. Simultaneous submissions OK. Pays $100/color cover; $50/b&w cover; $10-25/b&w inside; $10-25/color inside (if can be converted to b&w). **Pays on acceptance.** Buys one-time rights or first North American serial rights. "We prefer first North American rights, but one-time is fine." Credit line given.

Tips: In portfolio or samples, looks for "a strong cross-section. We assume that photos submitted are available at time of submission. Do your homework. Examine a copy of the magazine, certainly. Study the 'masters of contemporary' photography, i.e., Adams, Avedon, etc. Experiment. Remember we are looking for photos to be married to editorial copy usually. We allow photographers 40% discount on subscriptions to follow what we do. Requests for discounts must be on letterhead with or without samples."

AMERICA WEST AIRLINES MAGAZINE, 4636 E. Elwood St., Suite 5, Phoenix AZ 85040. (602)997-7200. America West Airlines magazine. Circ. 125,000. Monthly. Emphasizes general interest—including: travel, interviews, business trends, food, etc. Readers are primarily business people and business travelers; substantial vacation travel audience. Photo guidelines free with SASE. Sample copy $3.

Needs: Uses about 20 photos/issue supplied by freelance photographers. "Each issue varies immensely; we primarily look for stock photography of places, people, subjects such as animals, plants, scenics—we assign some location and portrait shots. We publish a series of photo essays with brief, but interesting accompanying text." Model release required. Captions required.

Making Contact & Terms: Provide résumé, business card, brochure, tearsheets or color samples to be kept on file for possible future assignments. Include SASE with portfolio submission but query first. Previously published work OK. Pays $100-225/color inside, depends on size of photo and importance of story. Pays on publication. Buys one-time rights. Credit line given.

Tips: "We judge portfolios on technical quality, consistency, ability to deliver with a certain uniqueness in style or design, versatility and creativity. Photographers we work with most often are those who are both technically and creatively adept and who can take the initiative conceptually by providing new approaches or ideas."

$ $ ▣ AMERICAN ANGLER, The Magazine of Fly Fishing and Fly Tying, Abenaki Publishers, Inc., 160 Benmont Ave., Bennington VT 05201. (802)447-1518. Fax: (802)447-2471. Contact: Art Scheck. Circ. 58,000. Estab. 1978. Bimonthly consumer magazine. "Fly fishing only. More how-to than where-to, but we need shots from all over. More domestic than foreign. More trout, salmon, and steelhead than bass or saltwater." Sample copy for $6 and 9×12 SAE with $2.62 first-class postage or Priority Mail Flate Rate Envelope with $3. Photo guidelines with SAE with 55¢ first-class postage.

Needs: Buys 3-10 photos from freelancers/issue; 18-60 photos/year; most of our photos come from writers of articles. "The spirit, essence and exhilaration of Fly Fishing. Always need good fish-behavioral stuff—spawning, rising, riseforms, etc." Photo captions required.

Specs: Prefers slides, but also uses 4×5 to 8×10 matte to glossy color and b&w prints; must be very sharp and good contrast. Accepts images in digital format, PhotoShop, TIF, minimum 30 dpi; Mac 3½ disk, Zip disk, CO, SyQuest.

Making Contact & Terms: Send query letter with samples, brochure, stock photo list, tearsheets. Provide résumé, business card, self-promotion piece or tearsheets to be kept on file for possible future assignments. Portfolio review by prior arrangement. Query deadline: 6-10 months prior to cover date. Submission deadline: 5 months before cover date. Reports in 4-6 weeks on queries; 3-4 weeks on samples. Simultaneous submission and previously published work OK—"but only for inside 'editorial' use—not for covers, prominent feature openers, etc." Pays $450/color cover; $450/b&w cover; $30-250/b&w inside; $30-250/

color inside. Pays on publication. Buys one-time rights, first rights for covers. Credit line given.

Tips: "We are sick of the same old shots: grip and grin, angler casting, angler with bent rod, fish being released. Sure, we need them, but there's a lot more to fly fishing. Don't send us photos that look exactly like the ones you see in most fishing magazines. Think like a storyteller. Let me know where the photos were taken, at what time of year, and anything else that's pertinent to a fly fisher."

$AMERICAN FITNESS, Dept. PM, 15250 Ventura Blvd., Suite 200, Sherman Oaks CA 91403. (818)905-0040. Editor: Peg Jordan. Circ. 35,000. Estab. 1983. Publication of the Aerobics and Fitness Association of America. Publishes 6 issues/year. Emphasizes exercise, fitness, health, sports nutrition, aerobic sports. Readers are fitness enthusiasts and professionals, 75% college educated, 66% female, majority between 20-45. Sample copy $2.50.

Needs: Uses about 20-40 photos/issue; most supplied by freelancers. Assigns 90% of work. Needs action photography of runners, aerobic classes, swimmers, bicyclists, speedwalkers, in-liners, volleyball players, etc. Also needs food choices, babies, celebrities, children, couples, multicultural, families, parents, teens, senior fitness, people enjoying recreation, beauty, cities/urban, pets, rural, adventure, automobiles, entertainment, events, hobbies, humor, performing arts, sports, travel, medicine, produce shots/still life, science. Interested in alternative process, fashion/glamour, regional, seasonal. Model release required.

Specs: Uses b&w prints; 35mm, 2¼×2¼ transparencies.

Making Contact & Terms: Query with samples or with list of stock photo subjects. SASE. Reports in 2 weeks. Simultaneous submissions and previously published work OK. Pays $10-35/b&w or color photo; $50-100 for text/photo package. Pays 4-6 weeks after publication. Buys first North American serial rights. Credit line given.

Tips: Fitness-oriented outdoor sports are the current trend (i.e. mountain bicycling, hiking, rock climbing). Over-40 sports leagues, youth fitness, family fitness and senior fitness are also hot trends. Wants high-quality, professional photos of people participating in high-energy activities—anything that conveys the essence of a fabulous fitness lifestyle. Also accepts highly stylized studio shots to run as lead artwork for feature stories. "Since we don't have a big art budget, freelancers usually submit spin-off projects from their larger photo assignments."

$ $□ ◐ AMERICAN FORESTS MAGAZINE, Dept. PM, 910 17th St., Suite 600, Washington DC 20006. (202)955-4500, ext 203. Fax: (202)887-1075. E-mail: mrobbins@amfor.org. Website: http://www.americanforests.org. Editor: Michelle Robbins. Circ. 25,000. Estab. 1895. Publication of American Forests. Quarterly. Emphasizes use, enjoyment and management of forests and other natural resources. Readers are "people from all walks of life, from rural to urban settings, whose main common denominator is an abiding love for trees, forests or forestry." Sample copy and free photo guidelines with magazine-sized envelope and 7 first-class stamps.

Needs: Uses about 40 photos/issue, 80% supplied by freelance photographers. Needs woods scenics, wildlife, woods use/management, and urban forestry shots. Also uses babies, celebrities, children, couples, multicultural, families, parents, senior citizens, teens, disasters, environmental, beauty, gardening, adventure, entertainment, events, health/fitness, hobbies, travel, agriculture, science, technology, digital, documentary, historical/vintage, regional, seasonal. Model release preferred. Captions required; include who, what, where, when and why.

Specs: Accepts images in digital format for Mac. Send via CD, floppy disk, Jaz, Zip as TIFF files at 300 dpi.

Making Contact & Terms: Query with résumé of credits. "We regularly review portfolios from photographers to look for potential images for upcoming magazines or to find new photographers to work with." SASE. Reports in 2 months. Pays $400/color cover; $50-75/b&w inside; $75-200/color inside; $250-1,000 for text/photo package. **Pays on acceptance.** Buys one-time rights. Credit line given.

Tips: Seeing trend away from "static woods scenics, toward more people and action shots." In samples wants to see "overall sharpness, unusual conformation, shots that accurately portray the highlights and 'outsideness' of outdoor scenes."

$ ⒮ ■ THE AMERICAN GARDENER, A Publication of the American Horticultural Society, 7931 E. Boulevard Dr., Alexandria VA 22308-1300. (703)768-5700. Fax: (703)768-7533. E-mail: editor@ahs.org. Website: http://www.ahs.org. Managing Editor: Mary Yee. Circ. 26,000. Estab. 1922. Bimonthly magazine. Sample copy $4. Photo guidelines free with SAE and first-class postage.

Needs: Uses 35-50 photos/issue. Needs photos of plants, gardens, landscapes. Reviews photos with or without ms. Photo captions required; include complete botanical names of plants including genus, species and botanical variety or cultivar.

Specs: Prefers color, 35mm slides and 4×5 transparencies. Occasionally uses color prints and digital high-res TIFF files.

Making Contact & Terms: Send query letter with samples, stock photo list. Photographer will be contacted for portfolio review if interested. Does not keep samples on file. Will return unsolicited material with SASE. Pays $200 maximum for color cover; $50-75 for color inside. Pays on publication. Buys one-time rights. Credit line given.

Tips: "Lists of plant species for which photographs are needed are sent out to a selected list of photographers approximately 10 weeks before publication. We currently have about 20 photographers on that list. Most of them have photo libraries representing thousands of species. Before adding photographers to our list, we need to determine both the quality and quantity of their collections. Therefore, we ask all photographers to submit both some samples of their slides (these will be returned immediately if sent with a self-addressed, stamped envelope) and a list indicating the types and number of plants in their collection. After reviewing both, we may decide to add the photographer to our photo call for a trial period of six issues (one year)."

N $☐ ⬤ AMERICAN HOMESTYLE & GARDENING, 375 Lexington Ave., New York NY 10017-5514. (212)499-1532. Fax: (212)499-1536. E-mail: fstjarne@gjusa.com. Photo Editor: Fredrika Stjarne. Circ. 1 million. Estab. 1985 as *Decorating Remodeling*. Consumer magazine published 10 times a year. Magazine emphasizing homes and furnishings, including remodeling, troubleshooting, decorating tips, makeovers. Also focuses on gardens. Sample copies free.

Needs: Needs photos of nature/plants, homes, remodeling, families, architecture, beauty, cities/urban, gardening, interiors/decorating, food/drink, portraits, product shots/still life. Interested in alternative process, documentary, seasonal. Model and property release required. Photo caption preferred.

Specs: Any size color prints; 35mm, 2¼×2¼, 4×5, transparencies. Accepts images in digital format for Mac. Send via Zip as TIFF file at 320 dpi.

Making Contact & Terms: Send query letter with samples. Portfolio may be dropped off "any day of the week to our receiving desk on the 7th floor. Allow one week for us to look over the portfolio. We will call when ready to return." Provide résumé, business card, self-promotion piece or tearsheets to be kept on file for possible future assignments. Keeps samples on file. Reports back only if interested, send nonreturnable samples. Simultaneous submissions and previously published work OK. Pays $300-600 for color cover; $50-300 for color and b&w inside. Pays on publication. Credit line given. Buys one-time rights.

Tips: "Read our magazine—show work that is personal and never try to please. Send promo cards to the photo editor. We often call in books based on a card that looks interesting. Photo editors are busy and excessive phone calls serve to hurt rather than help. Only call to make sure a book was received or if you need a portfolio returned immediately."

$ $ AMERICAN HUNTER, 11250 Waples Mill Rd., Fairfax VA 22030-9400. (703)267-1322. Fax: (703)267-3971. Editor: John Zent. Circ. 1.4 million. Publication of the National Rifle Association. Monthly magazine. Sample copy and photo guidelines free with 9×12 SAE. Free writer's guidelines with SASE.

Needs: Uses wildlife shots and hunting action scenes. Photos purchased with or without accompanying ms. Seeks general hunting stories on North American game. Captions preferred.

Specs: Uses 8×10 glossy b&w prints and 35mm color transparencies. (Uses 35mm transparencies for cover). Vertical format required for cover.

Making Contact & Terms: Send material by mail for consideration. SASE. Reports in 1 month. Pays $25/b&w print; $75-275/transparency; $300/b&w cover; $300/color cover; $200-500 for text/photo package. Pays on publication for photos. Buys one-time rights. Credit line given.

$ $ AMERICAN MOTORCYCLIST, 13515 Yarmouth Dr., Pickerington OH 43147. (614)856-1999. Vice President of Communication: Greg Harrison. Managing Editor: Bill Wood. Circ. 221,000. Publication of the American Motorcyclist Association. Monthly magazine. For "enthusiastic motorcyclists, investing considerable time in road riding or competition sides of the sport. We are interested in people involved in, and events dealing with, all aspects of motorcycling." Sample copy and photo guidelines for $1.50.

Needs: Buys 10-20 photos/issue. Subjects include: travel, technical, sports, humorous, photo essay/feature and celebrity/personality. Captions preferred.

Specs: Uses 5×7 or 8×10 semigloss prints; transparencies.

Making Contact & Terms: Query with samples to be kept on file for possible future assignments. Reports in 3 weeks. SASE. Pays $30-100/photo; $50-100/slide; $250 minimum/cover. Also buys photos in photo/text packages according to same rate; pays $8/column inch minimum for story. Pays on publication. Buys first North American serial rights.

Tips: Uses transparencies for covers. "The cover shot is tied in with the main story or theme of that issue and generally needs to be with accompanying manuscript. Show us experience in motorcycling photography and suggest your ability to meet our editorial needs and complement our philosophy."

$AMERICAN SKATING WORLD, 1816 Brownsville Rd., Pittsburgh PA 15210-3908. (800)245-6280. Fax: (412)885-7617. Managing Editor: H. Kermit Jackson. Circ. 15,000. Estab. 1981. Monthly tabloid. Emphasizes ice skating—figure skating primarily, speed skating secondary. Readers are figure skating participants and fans of all ages. Sample copy $3.25 with 8×12 SAE and 3 first-class stamps. Photo guidelines free with SASE.

Needs: Uses 20-25 photos/issue; 4 supplied by freelancers. Needs performance and candid shots of skaters and "industry heavyweights." Reviews photos with or without manuscript. Model/property release preferred for children and recreational skaters. Captions required; include name, locale, date and move being executed (if relevant).

Making Contact & Terms: Query with résumé of credits. Keeps samples on file. SASE. Report on unsolicited submissions could take 3 months. Simultaneous submissions and/or previously published work OK. Pays $25/color cover; $5/b&w inside. Pays 30 days after publication. Buys one-time rights color; all rights b&w; negotiable.

Tips: "Pay attention to what's new, the newly emerging competitors, the newly developed events. In general, be flexible!" Photographers should capture proper lighting in performances and freeze the action instead of snapping a pose.

$ $AMERICAN SOCIETY FOR THE PREVENTION OF CRUELTY TO ANIMALS (AS-PCA), 424 E. 92nd St., New York NY 10128. (212)876-7700. Fax: (212)410-0087. Website: http://www.aspca.org. Contact: Photo Editor. Estab. 1866. Photos used in quarterly and bi-monthly color magazines, pamphlets, booklets. Publishes *ASPCA Animal Watch Magazine* and *ASPCA Animaland Magazine (for kids 7-12).*

Needs: Photos of animals (domestic and wildlife): farm, domestic, lab, stray and homeless animals, endangered, trapped, injured, fur animals, marine and wildlife, rain forest animals. Model/property release preferred.

Making Contact & Terms: Please send a detailed, alphabetized stock list that can be kept on file for future reference. SASE. Reports when needed. Pays $75/b&w photo (inside use); $75/color photo (inside use); $300/cover. Prefers color. Buys one-time rights; negotiable. Credit line given.

Tips: "We prefer exciting pictures: strong colors, interesting angles, unusual light."

$AMERICAN SURVIVAL GUIDE, % Visionary, L.P., 265 S. Anita Dr., Suite 120, Orange CA 92868-3310. (714)939-9991 ext. 204 or 203. Fax: (714)939-9909. Editor: Jim Benson. Circ. 60,000. Estab. 1980. Monthly magazine. Emphasizes firearms, military gear, emergency preparedness, survival food storage and self-defense products. Average reader is male, mid-40s, all occupations and with conservative views. Sample copy $6. Photo guidelines free with SASE.

Needs: Uses more than 100 photos/issue; 35-45% supplied by freelance photographers and writers. Photos usually purchased with accompanying manuscript. Occasionally buys photos only (e.g., earthquake disaster photos, etc.). Model release required. Captions required.

Making Contact & Terms: Send written query detailing article and photos. Note: Will not accept text without photos or other illustrations. Pays $80/color photo and b&w page rate. Pays on publication. Buys all rights; negotiable. Credit line given.

Tips: Wants to see "professional looking photographs—in focus, correct exposure, good lighting, interesting subject and people in action. Dramatic poses of people helping each other after a disaster, riots or worn torn area. Wilderness survival too. Look at sample copies to get an idea of what we feature. We only accept photos with an accompanying manuscript (floppy disk with WordPerfect or Microsoft Word files). The better the photos, the better chance you have of being published."

N $ ◘ ⬚ ◎ AMERICA'S BARREL RACER, Go Go Communications, Inc., 201 W. Moore, Suite 200, Terrell TX 75160. (972)563-7001. Fax: (972)563-7004. Website: http://www.americasbarrelracer.com. Publisher/Editor: Carroll Brown Arnold. Circ. 5,000. Estab. 1999. Bimonthly equestrian consumer magazine. *America's Barrel Racer* gives global coverage to the entire barrel horse industry. Sample copy for $4.25.

Needs: Buys 2-5 photos from freelancers/issue. Needs photos of barrel racing enthusiasts, owners, trainers, riders and lots of action shots. Reviews photos with or without ms. Model release/property release preferred. Photo captions preferred.

Specs: Uses 35mm, 2¼×2¼, 4×5, 8×10 transparencies. Accepts images in digital format for Windows. Send via floppy disk, Zip or e-mail as TIFF, EPS files.

Making Contact & Terms: Send query letter with samples, brochure, stock photo list, tearsheets. Keeps samples on file. Reports in 2-3 weeks on queries; 2-3 weeks on samples. Pays $5-50 for color cover; $5-25 for b&w and color inside. Pays on publication. Buys one-time rights, electronic rights. Credit line given.

Tips: "You must know our industry. Send samples. Establish a relationship with us."

$ ▣ ◑ ◎ AMERICA'S CUTTER, Go Go Communications, Inc., 201 W. Moore, Suite 200, Terrell TX 75160. (972)563-7001. Fax: (972)563-7004. E-mail: acutterl@airmail.net. Website: http://www.americascutter.com. Publisher/Editor: Carroll Brown Arnold. Circ. 5,000. Estab. 1995. Bimonthly equestrian consumer magazine. *America's Cutter* gives global coverage to the entire cutting horse industry. Sample copy for $4.25.
Needs: Buys 2-5 photos from freelancers/issue. Needs photos of cutting horse enthusiasts, owners, trainers, riders, celebrities and lots of action shots. Reviews photos with or without ms. Model release preferred; property release preferred. Photo captions preferred.
Specs: Uses 35mm, 2¼×2¼, 4×5, 8×10 transparencies. Accepts images in digital format for Windows. Send via floppy disk, Zip, e-mail as TIFF, EPS files.
Making Contact & Terms: Send query letter with samples, brochure, stock photo list, tearsheets. Keeps samples on file. Reports in 2-3 weeks on queries and samples. Pays $5-50 for color cover; $5-25 for b&w and color inside. Pays on publication. Buys one-time rights, electronic rights. Credit line given.
Tips: "You must know our industry. Send samples. Establish a relationship with us."

◎ ANCHOR NEWS, 75 Maritime Dr., Manitowoc WI 54220. (920)684-0218. Fax: (920)684-0219. Editor: Jay Martin. Circ. 1,900. Publication of the Wisconsin Maritime Museum. Quarterly magazine. Emphasizes Great Lakes maritime history. Readers include learned and lay readers interested in Great Lakes history. Sample copy free with 9×12 SAE and $1 postage. Guidelines free with SASE.
Needs: Uses 8-10 photos/issue; infrequently supplied by freelance photographers. Needs historic/nostalgic, personal experience and general interest articles on Great Lakes maritime topics. How-to and technical pieces and model ships and shipbuilding are OK. Special needs include historic photography or photos that show current historic trends of the Great Lakes. Photos of waterfront development, bulk carriers, sailors, recreational boating, etc. Model release required. Captions required.
Making Contact & Terms: Send 4×5 or 8×10 glossy b&w prints by mail for consideration. SASE. Reports in 1 month. Simultaneous submissions and previously published work OK. Pays in copies on publication. Buys first North American serial rights. Credit line given.
Tips: "Besides historic photographs, I see a growing interest in underwater archaeology, especially on the Great Lakes, and underwater exploration—also on the Great Lakes. Sharp, clear photographs are a must. Our publication deals with a wide variety of subjects; however, we take a historical slant with our publication. Therefore photos should be related to a historical topic in some respect. Also, there are current trends in Great Lakes shipping. A query is most helpful. This will let the photographer know exactly what we are looking for and will help save a lot of time and wasted effort."

$ ⊕ Ⓢ ▣ ◑ ANIMAL ACTION/ANIMAL LIFE, RSPCA Photolibrary, RSPCA, Causeway, Horsham, W. Sussex RH12 1HG England. Phone: (1403)223150. Fax: (1403)241048. E-mail: photolibrary @rspca.org.uk. Website: http://www.rspca.org.uk. Photolibrary Manager: Andrew Forsyth. Circ. 70,000. Estab. 1830. Monthly animal welfare campaign magazine. Sample copy free. Art guidelines free.
Needs: Buys 300 photos/year. Needs photos of domestic and wild animals. Reviews photos with or without ms. Special photo needs include African mammals, polar bears and underwater wildlife. Model release preferred for people with domestic animals. Photo caption required; include Latin names (where appropriate).
Specs: Uses 35mm, 2¼×2¼, 4×5, 8×10 transparencies. Accepts images in digital format.
Making Contact & Terms: Send query letter with samples. Art director will contact photographer for portfolio review if interested. Portfolio should include transparencies. Keeps samples on file; include SASE for return of material. Reports in 1 month on queries. Simultaneous submissions and/or previously published work OK. Pays extra for electronic usage of photos. Pays after quarterly sales report. Buys one-time rights; negotiable. Credit line given.
Tips: "Our information pack gives details. We have our own agency to sell and buy photography, so photographers must be willing to allow us to represent their work. Caption clearly and edit more strictly. Quality threshold is ever increasing."

$ $ ANIMALS, 350 S. Huntington Ave., Boston MA 02130. (617)522-7400. Fax: (617)522-4885. Photo Editor: Dietrich Gehring. Publication of the Massachusetts Society for the Prevention of Cruelty to

MARKET CONDITIONS are constantly changing! If you're still using this book and it's 2001 or later, buy the newest edition of *Photographer's Market* at your favorite bookstore or order directly from Writer's Digest Books.

Animals and the American Humane Education Society. Circ. 100,000. Estab. 1868. Bimonthly. Emphasizes animals, both wild and domestic. Readers are people interested in animals, conservation, animal welfare issues, pet care and wildlife. Sample copy $2.95 with 9×12 SASE. Photo guidelines free with SASE.

Needs: Uses about 45 photos/issue; approximately 95% supplied by freelance photographers. "All of our pictures portray animals, usually in their natural settings, however some in specific situations such as pets being treated by veterinarians or wildlife in captive breeding programs." Needs vary according to editorial coverage. Special needs include clear, crisp shots of animals, wild and domestic, both close-up and distance shots with spectacular backgrounds, or in the case of domestic animals, a comfortable home or backyard. Model release required in some cases. Captions preferred; include species, location.

Making Contact & Terms: Query with résumé of credits and list of stock photo subjects. Provide résumé, business card, brochure, flier or tearsheets to be kept on file for possible future assignments. SASE. Reports in 6 weeks. Fees are usually negotiable; pays $50-150/b&w photo; $75-300/color photo; payment depends on size and placement. Pays on publication. Buys one-time rights. Credit line given.

Tips: Photos should be sent to Dietrich Gehring, photo editor. Gehring does first screening. "Offer original ideas combined with extremely high-quality technical ability. Suggest article ideas to accompany your photos, but only propose yourself as author if you are qualified. We have a never-ending need for sharp, high-quality portraits of mixed-breed dogs and cats for both inside and cover use. Keep in mind we seldom use domestic cats outdoors; we often need indoor cat shots."

N $ ◻ ◎ APEX, P.O. Box 1721, Vail CO 81658. (970)476-1495. Website: http://www.apexmag.com. Editor: Tom Winter. Circ. 20,000. Estab. 1996. Quarterly outdoor adventure consumer magazine focusing on skiing, snowboarding, mountaineering, ice and rock climbing, mountain biking, etc. Sample copies and art guidelines available for $3 first-class postage.

Needs: Buys 60 photos from freelancers per issue; thousands of photos per year. Needs photos of adventure, travel, cutting edge sports only. Reviews photos with or without a ms. Photo captions required; include name, address, phone number of photographer on each image plus name, location of subject in image.

Specs: Uses 35mm, 2¼×2¼, 4×5, 8×10 transparencies. "35mm slides are best."

Making Contact & Terms: Send query letter with slides. "We edit submissions upon receipt, return photos we don't want, hold the images we are considering for publication. No previously published work please." Pays $200 for color cover; $100 for full page b&w or color inside. Pays 30-60 days after publication. Credit line given. Buys one-time rights, electronic rights.

Tips: "We get submissions from the best outdoor sports and adventure photographers in the business. Competition is tough, but we like to help new/young photographers break into the biz. Send us your best stuff because you never know who's images may be on the light table next to yours, and you don't want to look bad by comparison. Label all slides with your name, phone number and address as well as subject and location. We won't consider submissions that don't adhere to this rule. Edit tightly! Five great images are better than 20-40 OK images with 5 great ones hidden in your submission."

$ ◻ ◎ APPALACHIAN TRAILWAY NEWS, Box 807, Harpers Ferry WV 25425. (304)535-6331. Fax: (304)535-2667. Editor: Judith Jenner. Circ. 26,000. Estab. 1939. Publication of the Appalachian Trail Conference. Bimonthly. Uses only photos from the Appalachian Trail. Readers are conservationists, hikers. Sample copy $3 (includes postage and guidelines). Guidelines free with SASE.

Needs: Uses about 20-30 b&w and color photos/issue; 4-5 supplied by freelance photographers (plus 13 color slides each year for calendar). Most frequent need is for candids—people/wildlife/trail scenes. Photo information required.

Specs: Uses 5×7 or larger glossy b&w prints, b&w contact sheet; or 35mm transparencies.

Making Contact & Terms: Query with ideas. Duplicate slides preferred over originals (for query). SASE. Reports in 3 weeks. Simultaneous submissions and/or previously published work OK. **Pays on acceptance.** Pays $150/cover; $200 minimum/color slide calendar photo; $10-50/inside. Rights negotiable. Credit line given.

$ $ ◱ ARUBA NIGHTS, (The Island's premiere lifestyle & travel magazine), 1831 René Levesque Blvd. W., Montreal, Quebec H3H 1R4 Canada. (514)931-1987. Fax: (514)931-6273. E-mail: nights@odyssee.net. Office Co-ordinator: Zelly Zuskin. Circ. 225,000. Estab. 1988. Yearly tourist guide of where to eat, sleep, dance etc. in Aruba.

Needs: Buys 30 photos from freelancers/year. Needs travel photos of Aruba—beaches, water, sun, etc. Reviews photos with or without ms. Model release required; property release required for private homes. Photo caption required; include exact location.

Specs: Uses 4×5 matte color and b&w prints; 35mm, 2¼×2¼, 4×5, 8×10 transparencies.

Making Contact & Terms: Send query letter with tearsheets. Art director will contact photographer for portfolio review if interested. Keeps samples on file. Reports back only if interested, send non-returnable

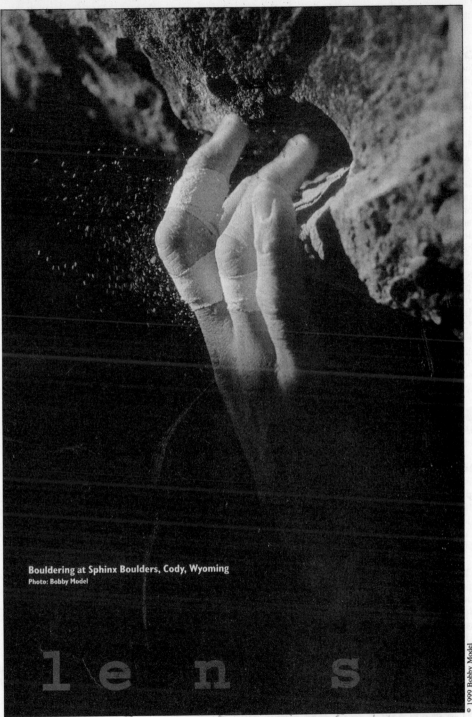

Bouldering at Sphinx Boulders, Cody, Wyoming
Photo: Bobby Model

l e n s

"Interesting light and a decisive moment make great pictures. As a photographer, I look for just that," says Bobby Model of this dramatic climbing shot published in *Apex* magazine. "Bobby Model is an accomplished climber and mountaineer," says editor Tom Winter. "Our best images come from people who are intimately connected to the sports they shoot." Model first made contact with *Apex* by sending them a sample of his work. *Apex* responded with a photo-needs list.

samples. Simultaneous submissions and previously published work OK. Pays $250-400 for color cover; $50 maximum for color inside. **Pays on acceptance**. Buys one-time rights. Credit line given.

$ ASTRONOMY, 21027 Crossroads Circle, Waukesha WI 53187. (414)796-8776. Fax: (414)798-6468. Photo Editor: David J. Eicher. Circ. 175,000. Estab. 1973. Monthly magazine. Emphasizes astronomy, science and hobby. Median reader: 40 years old, 85% male, income approximately $68,000/yr. Sample copy $3. Photo guidelines free with SASE.
Needs: Uses approximately 100 photos/issue; 70% supplied by freelancers. Needs photos of astronomical images. Model/property release preferred. Captions required.
Specs: Uses 8×10 glossy color and b&w photos; 35mm, 2¼×2¼, 4×5, 8×10 transparencies.
Making Contact & Terms: Send unsolicited photos by mail for consideration. Keeps samples on file. SASE. Reports in 1 month. Pays $150/cover; $25 for routine uses. Pays on publication. Credit line given.

$ 🖉 AT-HOME MOTHER, 406 E. Buchanan, Fairfield IA 52556. E-mail: ahmrc@lisco.com. Website: http://www.at-home-mothers.com. Editor-in-Chief: Jeanette Lisefski. Circ. 20,000. Estab. 1997. Quarterly consumer magazine for the support and education of at-home mothers and those who would like to be. Sample copy for $4.
Needs: Buys up to 5 photos from freelancers/issue; up to 20 photos/year. Needs photos of mothers with children—mostly at home (inside) or mothers working in home office with children. Special photo needs include cover shots and interiors to go with editorial spreads. Model release required; property release required.
Specs: Uses 4×5, 8×10 transparencies. Prefer images in digital format for Mac, Windows. Send via CD, floppy disk, Zip, e-mail as BMP, GIF, JPEG files at 300 dpi.
Making Contact & Terms: Send samples that fit needs listed above. Quarterly deadlines: February 1, May 1, August 1, November 1. Keeps samples on file. Reports in 1 month on queries and samples. Simultaneous submissions and previously published work OK. Pays $100-300 for color cover; $5-40 for b&w inside; $10-50 for color inside. Pays on publication. Buys one-time rights. Credit line given.
Tips: "We like colorful work showing happy interaction between mother and child(ren). We need pictures of mother working in a home office with child, also in the picture, playing or interacting with mother. We do not like trendy, 'spikey' or chaotic photos."

$ $ 🖉 ◎ ATLANTA HOMES & LIFESTYLES, 1100 Johnson Ferry Rd. NE, Suite 595, Atlanta GA 30342. (404)252-6670. Fax: (404)252-6673. Editor: Oma Blaise. Circ. 38,000. Estab. 1983. Magazine published 12 times/year. Covers residential design (home and garden); food, wine and entertaining; people, travel and lifestyle subjects. Sample copy $3.95.
Needs: Needs photos of homes (interior/exterior), people, travel, decorating ideas, products, gardens. Model/property release required. Captions preferred.
Specs: Uses 35mm, 2¼×2¼ transparencies.
Making Contact & Terms: Submit portfolio for review. Send unsolicited photos by mail for consideration. Provide résumé, business card, brochure, flier or tearsheets to be kept on file for possible assignments. SASE. Reports in 2 months. Simultaneous submissions and/or previously published work OK. Pays $50-650/job. Pays on publication. Buys one-time rights. Credit line given.

ATLANTA PARENT, 2346 Perimeter Park Dr., Atlanta GA 30341. (770)454-7599. Fax: (770)454-7699. Managing Editor: Peggy Middendorf. Circ. 80,000. Estab. 1983. Monthly magazine. Emphasizes parents, families, children, babies. Readers are parents with children ages 0-18. Sample copy $3.
Needs: Uses 4-8 photos/issue; all supplied by freelancers. Needs photos of babies, children in various activities, parents with kids. Model/property release required. Captions preferred.
Specs: Uses 3×5 or 4×6 b&w prints.
Making Contact & Terms: Query with stock photos or photocopies of photos. Send unsolicited photos by mail for consideration. Keeps samples on file. SASE. Reports in 3 months. Simultaneous and/or previously published work OK. Pays $75/cover; $20/color inside; $20/b&w inside. Pays on publication. Buys one-time rights; negotiable. Credit line given.

🅽 $ $ ATLANTIC CITY MAGAZINE, Dept. PM, Box 2100, Pleasantville NJ 08232. (609)272-7900. Art Director: Michael Lacy. Circ. 50,000. Monthly. Sample copy $2 plus 4 first-class stamps.
Needs: Uses 50 photos/issue; all supplied by freelance photographers. Prefers to see b&w and color portraits in photographic essays. Model release required. Captions required.
Making Contact & Terms: Query with portfolio/samples. Cannot return material. Provide tearsheets to be kept on file for possible future assignments. Payment negotiable; usually $35-50/b&w photo; $50-100/

color; $250-450/day; $175-300 for text/photo package. Pays on publication. Buys one-time rights. Credit line given.

Tips: "We promise only exposure, not great fees. We're looking for imagination, composition, sense of design, creative freedom and trust."

AUDUBON MAGAZINE, 700 Broadway, New York NY 10003. (212)979-3000. Fax: (212)353-0398. Photo Editor: Julia Stires. Bimonthly magazine. Circ. 475,000. Emphasizes wildlife. Sample copy $4. First-class $5.

Needs: Photo essays of nature subjects, especially wildlife, showing animal behavior, unusual portraits with good lighting and artistic composition. Nature photos should be artistic and dramatic, not the calendar or postcard scenic. Uses color covers only; horizontal wraparound format requires subject off-center. Also uses journalistic and human interest photos.

Making Contact & Terms: Important: Query first before sending material; include tearsheets or list previously published credits. SASE. "We are not responsible for unsolicited material."

N⃞ $⃝ AUTO RESTORER, P.O. Box 6050, Mission Viejo CA 92690. (949)855-8822. Fax: (949)855-3045. Editor: Ted Kade. Circ. 75,000. Estab. 1989. Monthly magazine. Emphasizes restoration of collector cars and trucks. Readers are male (98%), professional/technical/managerial, ages 35-55.

Needs: Uses 50 photos/issue; 95% supplied by freelancers. Needs photos of auto restoration projects and restored cars. Reviews photos with accompanying ms only. Model/property release preferred. Captions required; include year, make and model of car; identification of people in photo.

Specs: Prefers transparencies, mostly 35mm, 2¼×2¼.

Making Contact & Terms: Submit inquiry and portfolio for review. Provide résumé, business card, brochure, flier or tearsheets to be kept on file for possible assignments. Does not keep samples on file. SASE. Reports in 1 month. Simultaneous submissions OK. Pays $50/b&w cover; $35/b&w inside. Pays on publication. Buys first North American serial rights; negotiable. Credit line given.

Tips: Looks for "technically proficient or dramatic photos of various automotive subjects, auto portraits, detail shots, action photos, good angles, composition and lighting. We're also looking for photos to illustrate how-to articles such as how-to repair a damaged fender or how-to repair a carburetor."

BABYFACE, The Score Group, 4931 S.W. 75th Ave., Miami FL 33155. (305)662-5959. Fax: (305)662-5952. E-mail: gablel@scoregroup.com. Contact: Lisa Gable. Monthly men's magazine featuring models between ages 18-21. Sample copy for $7. Art guidelines available.

Needs: Model release required as well as copies of 2 forms of I.D. from the model, one of them being a photo I.D.

Specs: Uses 35mm transparencies; kodachrome film or larger format transparencies.

Making Contact & Terms: Portfolio should include color transparencies. "Please do not send individual photos except for test shots." Include SASE for return of material. Reports in 1 month maximum on queries. Pays $1,250-1,800 for color sets of 100-200 transparencies for inside. Pays on publication. Buys first rights in North America with a reprint option, electronic rights and non-exclusive worldwide publishing rights.

$⃝ S⃞ ▣ ⃝ ◎ BACK HOME IN KENTUCKY, P.O. Box 681629, Franklin TN 37068-1629. (615)794-4338. Fax: (615)790-6188. Editor: Nanci Gregg. Circ. 13,000. Estab. 1977. Bimonthly magazine. Emphasizes subjects in the state of Kentucky. Readers are interested in the heritage and future of Kentucky. Sample copy $3.50 with 9×12 SAE and 5 first-class stamps.

Needs: Uses 25 photos/issue; all supplied by freelance photographers, less than 10% on assignment. Needs photos of scenic, specific places, events, people, architecture, beauty, cities, gardening, pets, rural. Reviews photos solo or with accompanying ms. Also seeking vertical cover (color) photos. Special needs include winter, fall, spring and summer in Kentucky; Christmas; the Kentucky Derby sights and sounds; horses— "send us good shots of horses at work and play." Model release required. Captions required.

Specs: Uses color prints and slides. Accepts images in digital format for Mac. Send via CD, floppy disk, Zip 100 disk or 1GB Jaz as TIFF, EPS, JPEG files at 266 dpi (133 line screen or better).

Making Contact & Terms: Send any size color prints or 35mm transparencies by mail for consideration. Reports in 2 weeks. Simultaneous submissions and previously published work OK. Pays $20-50/color photo; $50 maximum/cover; $10-25 for b&w inside; $20-35 for color inside; $15-100/text/photo package. Pays on publication. Usually buys one-time rights; also all rights; negotiable. Credit line given.

Tips: "We look for someone who can capture the flavor of Kentucky—history, events, people, homes, etc. Have a great story to go with the photo—by self or another. Query or send samples of images shot in Kentucky."

■ **BACKPACKER MAGAZINE**, 135 N. Sixth St., Emmaus PA 18098. (610)967-8371. E-mail: dbstauff er@aol.com. Website: http://www.bpbasecamp.com. Photo Editor: Deborah Burnett Stauffer. Magazine published 9 times annually. Readers are male and female, ages 35-45. Photo guidelines free with SASE or via e-mail.

Needs: Uses 40 photos/issue; almost all supplied by freelancers. Needs transparencies of wildlife, scenics, people backpacking, camping. Reviews photos with or without ms. Model/property release required.

Specs: Accepts images in digital format for Mac. Send via online, SyQuest or zip disk.

Making Contact & Terms: Query with résumé of credits, photo list and example of work to be kept on file. SASE. Sometimes considers simultaneous submissions and previously published work. Payment varies. Pays on publication. Rights negotiable. Credit line given.

$ ■ ○ BALLOON LIFE, 2336 47th Ave. SW, Seattle WA 98116-2331. (206)935-3649. Fax: (206)935-3326. E-mail: tom@balloonlife.com. Website: http://www.balloonlife.com. Editor: Tom Hamilton. Circ. 4,000. Estab. 1986. Monthly magazine. Emphasizes sport ballooning. Readers are sport balloon enthusiasts. Sample copy free with 9×12 SAE and 6 first-class stamps. Photo guidelines free with #10 SASE.

Needs: Uses about 15-20 photos/issue; 90% supplied by freelance photographers on assignment. Needs how-to photos for technical articles, scenic for events. Model/property release preferred. Captions preferred.

Specs: "We are now scanning our own color and doing color separations in house. As such we prefer 35mm transparencies above all other photos." Accepts images in digital format for Mac. Send via compact disc, online, floppy disk, SyQuest 44 or Zip disk as TIFF files at 200 dpi.

Making Contact & Terms: Send b&w or color prints; 35mm transparencies by mail for consideration. SASE. Reports in 1 month. Simultaneous submissions and previously published work OK. Pays $50/b&w or color cover; $15/b&w or color inside. Pays on publication. Buys one-time and first North American serial rights. Credit line given.

Tips: "Photographs, generally, should be accompanied by a story. Cover the basics first. Good exposure, sharp focus, color saturation, etc. Then get creative with framing and content. Often we look for one single photograph that tells readers all they need to know about a specific flight or event. We're evolving our coverage of balloon events into more than just 'pretty balloons in the sky.' I'm looking for photographers who can go the next step and capture the people, moments in time, unusual happenings, etc. that make an event unique. Query first with interest in sport, access to people and events, experience shooting balloons or other outdoor special events."

BALLS AND STRIKES SOFTBALL MAGAZINE, (formerly *U.S.A. Softball Magazine*), 2801 NE 50th St., Oklahoma City OK 73111. (405)425-3463. Director of Communications: Brian McCall. Promotion of amateur softball. Photos used in newsletters, newspapers, association magazine.

Needs: Buys 10-12 photos/year; offers 5-6 assignments annually. Subjects include action sports shots. Model release required. Captions required.

Specs: Uses prints or transparencies.

Making Contact & Terms: Contact ASA national office first before doing any work. SASE. Reports in 2 weeks. Pays $50 for previously published photo. Assignment fees negotiable. Buys all rights. Credit line given.

$ BALTIMORE, 1000 Lancaster St., Suite 400, Baltimore MD 21202. (410)752-4200. Fax: (410)625-0280. Art Director: Amanda Laine White. Assistant Art Director: Andrea Prebish. Director of Photography: David Colwell. Circ. 65,000. Estab. 1907. Monthly magazine for Baltimore region. Readers are educated Baltimore denizens, ages 35-60. Sample copy $2.95 with 9×12 SASE.

Needs: Uses 200 photos/issue; 30-50 supplied by freelancers. Needs photos of lifestyle, profile, news, food, etc. Special photo needs include photo essays about Baltimore. Model release required. Captions required; include name, age, neighborhood, reason/circumstances of photo.

Making Contact & Terms: Provide résumé, business card, brochure, flier or tearsheets to be kept on file for possible assignments. SASE. Call for photo essays. Reports in 1 month. Pays $100-350/day. Pays 30 days past invoice. Buys first North American serial rights; negotiable. Credit line given.

$ ○ BAY & DELTA YACHTSMAN, Dept. PM, 155 Glendale Ave. #11, Sparks NV 89431-5751. (775)353-5100. Fax: (775)353-5111. E-mail: customer.service@yachtsforsale.com. Website: http://www.yachtsforsale.com. Publisher: Don Abbott. Circ. 25,000. Estab. 1965. Monthly slick that emphasizes recreational boating for boat owners of northern California. Sample copy $3.

Needs: Buys 5-10 photos/issue. Wants sport photos; power and sail (boating and recreation in northern California); spot news (about boating); travel (of interest to boaters). Seeks mss about power boats and sailboats, boating personalities, locales, piers, harbors, and how-tos in northern California. Photos pur-

chased with or without accompanying ms. Model release required. Captions preferred.

Specs: Uses any size color glossy prints. Uses color slides for cover. Vertical (preferred) or horizontal format.

Making Contact & Terms: "We would love to give a newcomer a chance at a cover." Send material by mail for consideration. SASE. Reports in 1 month. Simultaneous submissions or previously published work OK but must be exclusive in Bay Area (nonduplicated). Pays $5 minimum/b&w photo; $150 minimum/cover photo; $1.50 minimum/inch for ms. Pays on publication. Buys one-time rights. Credit line given.

Tips: Prefers to see action color slides, water scenes. "We do not use photos as stand-alones; they must illustrate a story. The exception is cover photos, which must have a Bay Area application—power, sail or combination; vertical format with uncluttered upper area especially welcome."

$ ⌐ BC OUTDOORS, 780 Beatty St., Suite 300, Vancouver, British Columbia V6B 2M1 Canada. (604)606-4644. Fax: (604)687-1925. Managing Editor: Roegan Lloydd. Editor: Neil Cameron. Circ. 42,000. Estab. 1945. Emphasizes fishing, both fresh water and salt; hunting; RV camping; wildlife and management issues in British Columbia only. Published 8 times/year (January/February, March, April, May, June, July/August, September/October, November/December). Free sample copy with $2 postage (Canadian).

Needs: Uses about 30-35 photos/issue; 99% supplied by freelance photographers. "Fishing (in our territory) is a big need—people in the act of catching or releasing fish. Hunting, canoeing and camping. Family oriented. By far most photos accompany mss. We are always on lookout for good covers—fishing, wildlife, recreational activities, people in the outdoors—vertical and square format, primarily of British Columbia and Yukon. Photos with mss must, of course, illustrate the story. There should, as far as possible, be something happening. Photos generally dominate lead spread of each story. They are used in everything from double-page bleeds to thumbnails. Column needs basically supplied inhouse." Model/property release preferred. Captions or at least full identification required.

Making Contact & Terms: Send by mail for consideration actual 5×7 or 8×10 b&w prints; 35mm, 2¼×2¼, 4×5 or 8×10 color transparencies; color contact sheet. If color negative, send jumbo prints, then negatives only on request. Query with list of stock photo subjects. SASE or IRC. Pays in Canadian currency. Simultaneous submissions not acceptable if competitor. Will consider previously published work. Pays $20-75/b&w photo; $25-200/color photo; and $250/cover. Pays on publication. Buys one-time rights inside; with covers "we retain the right for subsequent promotional use." Credit line given.

Tips: "We see a trend toward more environmental/conservation issues."

[N] $ ▣ ⊘ BEARS MAGAZINE, P.O. Box 88, Tremorton UT 84337. (435)257-0682. Fax: (435)257-4680. Editor and Photo Editor: Brad Garfield. Circ. 20,000. Quarterly magazine. Emphasizes bears and wild bears (grizzly, black, polar bears, etc.) and other top predators. Readers are male and female, ages 5-80. Samples copy $3. Photo guidelines free with SASE.

Needs: Uses 30 photos/issue. Needs photos of bears and other wildlife they interact with; travel, scenics, profiles on bears and how-to articles on where and when to find bears. Reviews photos with accompanying ms only. Model/property release preferred. Captions preferred.

Specs: Uses 35mm, 2¼×2¼, 4×5, 8×10 transparencies. Accepts images in digital format for Mac. Send via Jaz, Zip as TIFF, EPS files at 200 dpi.

Making Contact & Terms: Query with résumé of credits. Keeps samples on file. SASE. Reports in 1 month. Simultaneous submissions and previously published work OK. Pays $100-200/color cover; $25-50/color inside; $25-50/color page rate; $25-50/b&w page rate; $200-400/photo/text package. Pays on publication. Buys one-time rights.

Tips: "Do not send duplicates unless they are sharp. Send only tack-sharp slides with good exposure and composition."

BEAUTY HANDBOOK, 75 Holly Hill Lane, 3rd Floor, Greenwich CT 06830. Fax: (203)869-3971. Creative Director: Blair Howell. Circ. 1.1 million. Quarterly magazine. Emphasizes beauty, health, fitness, hair, cosmetics, nails. Readers are female, ages 25-45, interested in improving appearance. Sample copy free with 9×12 SAE and 7 first-class stamps ($2.24).

● Also publishes *Black Beauty Handbook* and *Health Handbook*.

Needs: Uses 50-60 photos/issue; all supplied by freelancers. Needs photos of studio and natural-setting shots of attractive young women applying makeup, styling hair, etc.—similar in content to *Glamour* and *Mademoiselle*. Model/property release preferred.

Specs: Uses color prints; 35mm, 2¼×2¼, 4×5.

Making Contact & Terms: Send unsolicited photos by mail for consideration. Query with stock photo list. Keeps samples on file. SASE. Reports in 2 weeks. Simultaneous submissions and previously published

work OK. Photographers must be willing to work for tearsheets; moderate pay for completed assignments from publisher. Rights negotiable.

$ ▣ ◯ THE BIBLE ADVOCATE, P.O. Box 33677, Denver CO 80233. (303)452-7973. Fax: (303)452-0657. E-mail: cofgsd@denver.net. Website: http://www.baonline.org. Editor: Calvin Burrell. Associate Editor: Sherri Langton. Circ. 13,500. Estab. 1863. Publication of the Church of God (Seventh Day). Monthly magazine; 10 issues/year. Advocates the Bible and represents the Church of God. Sample copy free with 9×12 SAE and 4 first-class stamps.
Needs: Needs people (children, couples, multicultural, families, parents, teens), churches and some religious shots (Jerusalem, etc.), environmental, landscapes, cities, rural, science, technology, digital, seasonal. Captions preferred, include name, place.
Specs: Accepts images in digital format for Mac. Send via floppy disk, Zip, e-mail as TIFF, JPEG files at 300 dpi.
Making Contact & Terms: Submit portfolio for review. SASE. Reports as needed. Simultaneous submissions and previously published work OK. Pays $25-50 for color cover; $10-35 for color inside. Rights negotiable.
Tips: To break in, "Send samples and we'll review them. We are working several months in advance now. If we like a photographer's work, we schedule it for a particular issue so we don't hold it indefinitely. Be willing to work with low payment. Photos on CD-ROM are preferable."

$ ◎ BIRD TIMES, 7-L Dundas Circle, Greensboro NC 27407-1645. (336)292-4047. Fax: (336)292-4272. Executive Editor: Rita Davis. Bimonthly magazine. Emphasizes pet birds, birds in aviculture, plus some feature coverage of birds in nature. Sample copy $5 and 9×12 SASE. Photo guidelines free with SASE.
Needs: Needs photos of pet birds. Special needs arise with story schedule. Write for photo needs list. Common pet birds are always in demand (cockatiels, parakeets, etc.) Captions required; include common and scientific name of bird; additional description as needed. "Accuracy in labeling is essential."
Specs: Transparencies or slides preferred. Glossy prints acceptable.
Making Contact & Terms: Send unsolicited photos by mail for consideration but include SASE for return. "Please send duplicates. We cannot assume liability for originals." Keeps samples on file. SASE. Reports in 2 months. Pays $150-250/color cover; $25-50/color inside. Pays on publication. Buys all rights; negotiable.
Tips: "We are looking for pet birds primarily, but we frequently look for photos of some of the more exotic breeds, and we look for good composition (indoor or outdoor). Photos must be professional and of publication quality—in focus and with proper contrast. We work regularly with a few excellent freelancers, but are always on the lookout for new contributors. Images we think we might be able to use will be scanned into our CD-ROM file and the originals returned to the photographer."

$ ◪ BIRD WATCHER'S DIGEST, Dept. PM, Box 110, Marietta OH 45750. (740)373-5285. E-mail: editor@birdwatchersdigest.com. Website: http://www.birdwatchersdigest.com. Editor/Photography and Art: Bill Thompson III. Circ. 99,000. Bimonthly. Emphasizes birds and bird watchers. Readers are bird watchers/birders (backyard and field, veterans and novices). Digest size. Sample copy $3.99.
Needs: Uses 25-35 photos/issue; all supplied by freelance photographers. Needs photos of North American species.
Making Contact & Terms: Query with list of stock photo subjects and samples. SASE. Reports in 2 months. Work previously published in other bird publications should not be submitted. Pays $50-up/color inside. Pays on publication. Buys one-time rights. Credit line given.
Tips: "Query with slides to be considered for photograph want-list."

$ 🌐 ▣ ◪ BIRD WATCHING MAGAZINE, EMAP Active Ltd., Apex House, Oundle Rd., Peterborough PEZ 9NP United Kingdom. Phone: (441733) 898 100. Fax: (441733) 315 984. E-mail: dave.cromack@ecm.emap.com. Circ. 21,000. Estab. 1986. Monthly hobby magazine for bird-watchers. Sample copy free for SAE with first-class postage/IRC.
Needs: Needs photos of "birds mainly in action or showing interesting aspects of behavior. Also stunning landscape pictures in birding areas and images of people with binoculars, telescopes, etc." Also considers travel, hobby and gardening shots related to bird watching. Reviews photos with or without ms. Photo caption preferred.
Specs: Uses 35mm, 2¼×2¼ transparencies. Accepts images in digital format for Mac. Send via CD, floppy disk, Zip as TIFF, EPS files at 300 dpi minimum.

Making Contact & Terms: Provide résumé, business card, self-promotion piece or tearsheets to be kept on file for possible future assignments. Keeps samples on file. Returns unsolicited material if SASE enclosed. Reports in 1 month on queries and samples. Simultaneous submissions OK. Pays £70 minimum for color cover; £20 minimum for color inside. Pays on publication. Buys one-time rights.

Tips: "All photos are held on file here in the office once they have been selected. They are returned when used or a request for their return is made. Make sure all slides are well labelled: bird, name, date, place taken, photographer's name and address. Send sample of images to show full range of subject and photographic techniques."

$ ▣ ⊘ BIRDS & BLOOMS, 5400 S. 60th St., Greendale WI 53129. (414)423-0100. Fax: (414)423-8463. Website: http://www.reimanpub.com. Photo Coordinator: Trudi Bellin. Estab. 1994. Bimonthly magazine. Celebrates "the beauty in your own backyard." Readers are male and female 30-50 (majority) who prefer to spend their spare time in their "outdoor living room." Heavy interest in "amateur" gardening, backyard bird-watching and bird feeding. Sample copy $2 with 9 × 12 SASE and 6 first-class stamps.

Needs: Uses 150 photos/issue; 25% supplied by freelancers. Needs photos of backyard flowers, gardens, senior citizens, landscapes/scenics, rural, travel, agriculture and birds. Interested in seasonal, historical/vintage and nostalgia. Special photo needs include vertical materials for cover use, must include humans or "human elements" (i.e., fence, birdhouse, birdbath). Also needs images for two-page spreads focusing on backyard birds or gardening. Model release required for private homes. Photo captions required; include season, location, common and/or scientific names.

Specs: Uses color prints. Prefers color transparencies, all sizes. Accepts images in digital format for Mac. Send via e-mail at 800 dpi.

Making Contact & Terms: Query with résumé of credits. Query with stock photo list. Send unsolicited photos by mail for consideration. Keep samples on file (tearsheets; no dupes). SASE. Reports in 1-3 months for first review. Simultaneous submissions and previously pubilshed work OK. Pays $300/color cover; $150/b&w cover; $300/color inside; $100/b&w inside; $150/color page rate; $100-200/photo/text package. Pays on publication. Buys one-time rights. Credit line given.

Tips: "Technical quality is extremely important; focus must be sharp, no soft focus; colors must be vivid so they 'pop off the page.' Study our magazine thoroughly—we have a continuing need for sharp, colorful images, and those who can supply what we need can expect to be regular contributors. Don't call."

$ $ ⊕ ⊘ BIZARRE, John Brown Publishing, The New Boathouse, 136-142 Bramley Rd., London W10 6SR England. Phone: 171 565 3000. Fax: 171 565 3056. E-mail: miket@johnbrown.co.uk. Website: http://www.bizarremag.com. Picture Editor: Mike Trow. Circ. 95,000. Estab. 1997. Monthly magazine. Sample copy free with SAE and first-class postage or IRC. Art guidelines free with SAE with first-class postage or IRC.

Needs: Needs photos of the bizarre or unusual of any subject. Reviews photos with or without ms. Model release preferred; property release preferred. Photo caption required.

Making Contact & Terms: Send query letter with samples, brochure, stock photo list, tearsheets. Keeps samples on file. Reports in 1 month on queries; 1 month on samples. Simultaneous submissions and/or previously published work OK. All fees negotiable with individual photographers. Pays extra for electronic usage of photos. Pays on publication. Credit line given.

Tips: "Read our magazine. It's unique. When submitting work think about whether your photos really are bizarre and submit some information about the pictures. The image is everything. As long as it is amazing or tells an amazing story the style/format doesn't matter."

⊘ BLIND SPOT PHOTOGRAPHY MAGAZINE, 210 11th Ave., 10th Floor, New York NY 10001. (212)633-1317. Fax: (212)627-9364. E-mail: photo@blindspot.com. Contact: Editors. Circ. 28,000. Estab. 1993. Semi-annual magazine. Emphasizes fine arts and contemporary photography. Readers are creative designers, curators, collectors, photographers, ad firms, publishers, students and media. Sample copy $14. Photo guidelines free with SASE.

● Although this publication does not pay, the image quality inside is superb. It is worth submitting here just to get the tearsheet from an attractive publication.

Needs: Uses 90 photos/issue; all supplied by freelancers. Needs unpublished photos from galleries and museums. Captions required; include titles, dates of artwork.

THE INTERNATIONAL MARKETS INDEX, located in the back of this book, lists markets located outside the U.S. by country.

Specs: Uses up to 16×20 color and b&w prints; 35mm, 2¼×2¼, 4×5, 8×10 transparencies.
Making Contact & Terms: Submit portfolio for review. Limit submission to 25 pieces or fewer. Send SASE with return postage. Deadlines: For May issue—late March; for November issue—late September. Does not keep samples on file. Reports in 3 weeks. Simultaneous submissions OK. No payment available. Acquires one-time and electronic rights.

$ BLUE RIDGE COUNTRY, P.O. Box 21535, Roanoke VA 24018. (540)989-6138. Editor: Kurt Rheinheimer. Circ. 75,000. Estab. 1988. Bimonthly magazine. Emphasizes outdoor scenics of Blue Ridge Mountain region. Photo guidelines free with SASE.
Needs: Uses up to 10-15 photos/issue; all supplied by freelance photographers. Needs photos of travel, scenics and wildlife. Seeking more scenics with people in them. Model release preferred. Captions required.
Specs: Uses 35mm, 2¼×2¼, 4×5 transparencies.
Making Contact & Terms: Query with list of stock photo subjects and samples. SASE. Reports in 2 months. Pays $100/color cover; $25-100/color inside. Pays on publication. Credit line given. Buys one-time rights.

$ $ THE B'NAI B'RITH INTERNATIONAL JEWISH MONTHLY, 1640 Rhode Island Ave. NW, Washington DC 20036. (202)857-6645. Fax: (202)296-1092. E-mail: ijm@bnaibrith.org. Website: http://bnaibrith.org/ijm. Editor: Eric Rozenman. Readership: 200,000. Estab. 1886. Bimonthly magazine. Specializes in social, political, historical, religious, cultural and service articles relating chiefly to the Jewish Community of the US and abroad.
Needs: Buys 200 photos/year, stock and on assignment. Occasionally publishes photo essays.
Making Contact & Terms: Present samples and text (if available). SASE. Reports in 6 weeks. Pays up to $500/color cover; $300/color full-page; $100/b&w page. Pays on publicaiton. Buys first serial rights.
Tips: "Be familiar with our format and offer suggestions or experience relevant to our needs." Looks for "technical expertise, ability to tell a story within the frame."

N $ $ BODYBOARDING MAGAZINE, 950 Calle Amanecer, Suite C, San Clemente CA 92673. (949)492-7873. Fax: (949)498-6485. E-mail: surfing@netcom.com. Photo Editor: Scott Winer. Bimonthly magazine. Emphasizes hardcore bodyboarding action and bodyboarding beach lifestyle photos and personalities. Readers are 15-24 years old, mostly males (96%). Circ. 65,000. Photo guidelines free with SASE.
Needs: Uses roughly 70 photos/issue; 50-70% supplied by freelancers. Needs photos of hardcore bodyboarding action, surf lineups, beach scenics, lifestyles and bodyboarding personalities. Special needs include bodyboarding around the world; foreign bodyboarders in home waves, local beach scenics.
Specs: Uses 35mm and 2¼×2¼ transparencies; b&w contact sheets & negatives.
Making Contact & Terms: Send unsolicited photos by mail for consideration. SASE. Reports in 2 weeks. Pays $20-110/b&w photo; $20-575/color photo; $580/color cover; $40/b&w page rate; $110/color page rate. Pays on publication. Buys one-time rights. Credit line given.
Tips: "We look for clear, sharp, high-action bodyboarding photos preferably on Fuji Velvia 50. We like to see a balance of land and water shots. Be able to shoot in not so perfect conditions. Be persistent and set high standards."

$ $ BONAIRE NIGHTS, (The Island's premiere lifestyle & travel magazine), 1831 René Levesque Blvd. W., Montreal, Quebec H3H 1R4 Canada. (514)931-1987. Fax: (514)931-6273. E-mail: nights@odyssee.net. Office Coordinator: Zelly Zuskin. Circ. 65,000. Estab. 1994. Yearly tourist guide of where to eat, sleep, dance etc. in Bonaire.
Needs: Buys 30 photos from freelancers/year. Needs travel photos of Bonaire with beaches, water, sun, etc. Reviews photos with or without ms. Model release required; property release required for private homes. Photo captions required, include exact location.
Specs: Uses 4×5 matte color and b&w prints; 35mm, 2¼×2¼, 4×5, 8×10 transparencies.
Making Contact & Terms: Send query letter with tearsheets. Art director will contact photographer for portfolio review if interested. Keeps samples on file. Reports back only if interested, send non-returnable samples. Simultaneous submissions and/or previously published work OK. Pays $250-400 for color cover; $50 for color inside. **Pays on acceptance.** Buys one-time rights. Credit line given.

$ $ BOWHUNTER, 6405 Flank Dr., Harrisburg PA 17112. (717)657-9555. Editor: Dwight Schuh. Editorial Director: Richard Cochran. Art Director: Mark Olszewski. Circ. 185,000. Estab. 1971. Published 9 times/year. Emphasizes bow and arrow hunting. Sample copy $2. Writer's guidelines free with SASE.
Needs: Buys 50-75 photos/year. Scenic (showing bowhunting) and wildlife (big and small game of North America). No cute animal shots or poses. "We want informative, entertaining bowhunting adventure, how-to and where-to-go articles." Photos purchased with or without accompanying ms.

Specs: Uses 5×7 or 8×10 glossy b&w and color prints, both vertical and horizontal format; 35mm and 2¼×2¼ transparencies; vertical format preferred for cover.

Making Contact & Terms: Query with samples. SASE. Reports on queries in 2 weeks; on samples in 6 weeks. Pays $50-125/b&w inside; $75-250/color inside; $300/cover, occasionally "more if photo warrants it." **Pays on acceptance.** Buys one-time publication rights. Credit line given.

Tips: "Know bowhunting and/or wildlife and study several copies of our magazine before submitting any material. We're looking for better quality and we're using more color on inside pages. Most purchased photos are of big game animals. Hunting scenes are second. In b&w we look for sharp, realistic light, good contrast. Color must be sharp; early or late light is best. We avoid anything that looks staged; we want natural settings, quality animals. Send only your best, and if at all possible let us hold those we indicate interest in. Very little is taken on assignment; most comes from our files or is part of the manuscript package. If your work is in our files it will probably be used."

$BOWLING MAGAZINE, 5301 S. 76th St., Greendale WI 53129. (414)641-2003. Fax: (414)641-2005. Editor: Bill Vint. Circ. 150,000. Estab. 1934. Publication of the American Bowling Congress. Bimonthly magazine. Emphasizes ten-pin bowling. Readers are males, ages 30-55, in a cross section of occupations. Sample copy free with 9×12 SAE and 5 first-class stamps. Photo guidelines free with SASE.

Needs: Uses 30-40 photos/issue; 5-10 supplied by freelancers. Needs photos of outstanding bowlers or human interest features. Model release preferred. Captions required.

Making Contact & Terms: Provide résumé, business card, brochure, flier or tearsheets to be kept on file for possible assignments. SASE. Reports in 1-2 weeks. Pays $25-50/hour; $100-150/day; $50-150/job; $50-150/color cover; $25-50/color inside; $20-30/b&w inside; $150-300/photo/text package. **Pays on acceptance.** Buys all rights. Credit line given.

$ $BRACKET RACING USA, McMillen Argus, 299 Market St., Saddlebrook NJ 07663. (201)712-9300. Fax: (201)712-9899. Website: http://www.cskpub.com. Drag racing magazine published 8 times/year.

Needs: Buys 70% of photos from freelancers. Needs photos of cars, people racing. Photo captions required.

Specs: Uses color and b&w prints; 35mm transparencies.

Making Contact & Terms: Send query letter with samples. Does not keep samples on file. Pays $75 minimum for b&w cover; $75 minimum for color cover; $400 minimum for b&w inside; $600 for color inside. Pays on publication. Buys all rights. Credit line given.

Tips: "Read our magazine. Give me full captions."

$ ▣ ◎ BRAZZIL, P.O. Box 50536, Los Angeles CA 90050. (323)255-8062. Fax: (323)257-3487. E-mail: brazzil@brazzil.com. Website: http://www.brazzil.com. Editor: Rodney Mello. Assistant Editor: Leda Mello. Circ. 12,000. Estab. 1989. Monthly magazine. Emphasizes Brazilian culture. Readers are male and female, ages 18-80, interested in Brazil. Photo guidelines free; "no SASE needed."

Needs: Uses 1 photo/issue. Special photo needs include close up faces for cover (babies, children, multicultural, senior citizens, teens). Model/property release preferred. Captions preferred; include subject identification.

Specs: Uses 8×10 glossy b&w prints. Accepts images in digital format for Windows (TIFF). Send via online, floppy disk, zip disk.

Making Contact & Terms: Contact by phone. Mail samples. Keeps samples on file. SASE. Reports in 1-2 weeks. Simultaneous submissions and/or previously published work OK. Pays $10-20 for b&w cover. Pays on publication. Buys one-time rights. Credit line given.

◩ ◯ BRIARPATCH, 2138 McIntyre St., Regina, Saskatchewan S4P 2R7 Canada. (306)525-2949. Fax: (306)565-3430. Managing Editor: George Manz. Circ. 2,000. Estab. 1973. Magazine published 10 times per year. Emphasizes Canadian and international politics, labor, environment, women, peace. Readers are left-wing political activists. Sample copy $3.

Needs: Uses 15-30 photos/issue; 15-30 supplied by freelancers. Needs photos of Canadian and international politics, labor, environment, women, peace and personalities. Model/property release preferred. Captions preferred; include name of person(s) in photo, etc.

Specs: Minimum 3×5 color and b&w prints.

Making Contact & Terms: Query with stock photo list. Send unsolicited photos by mail for consideration. Do not send slides! Provide résumé, business card, brochure, flier or tearsheets to be kept on file for possible assignments. Keeps samples on file. SASE. Reports in 1 month. Simultaneous submissions and previously published work OK. "We cannot pay photographers for their work since we do not pay any of our contributors (writers, photo, illustrators). We rely on volunteer submissions. When we publish photos, etc., we send photographer 5 free copies of magazine." Buys one-time rights. Credit line given.

Tips: "We keep photos on file and send free magazines when they are published."

BRIDE AGAIN MAGAZINE, 1240 N. Jefferson, Suite G, Anaheim CA 92807. (714)632-7000. Fax: (714)632-5405. Website: http://www.brideagain.com. Circ. 125,000. Estab. 1998. Quarterly magazine designed specifically for brides getting married for a second (or more) time. The magazine covers issues such as etiquette, remarriage, blending families, unique honeymoon locations and beauty for the older, more mature bride.
Needs: Buys 10-20 photos from freelancers/issue; 40-80 photos/year. Reviews photos with or without ms. Model release required; property release required. Photo caption preferred.
Making Contact & Terms: Send query letter with brochure, stock photo list. Art director will contact photographer for portfolio review of b&w, color prints if interested. Keeps samples on file. Returns unsolicited material if SASE enclosed. Reports in 3 weeks on queries. Simultaneous submissions and/or previously published work OK. Pays on publication. Credit line given.
Tips: "Photos need to relate to a second-time bride: older, mature models, realistic, warm, friendly, welcoming and emotional. We want a photo that makes you connect, such as brides with children and images of families relating."

$ $▣ ◪ BRIDE'S, 140 E. 45th St., New York NY 10017. (212)880-8530. Fax: (212)880-8331. E-mail: phyllis-cox@brides.com. Design Director: Phyllis Richmond Cox. Produced by Conde Nast Publications. Bimonthly magazine. Emphasizes bridal fashions, home furnishings, travel. Readers are mostly female, newly engaged; ages 21-35.
Needs: Needs photos of home furnishings, tabletop, lifestyle, fashion, travel, couples, landscapes/scenics. Model release required.
Specs: Accepts images in digital format for Mac. Send via CD, Zip, e-mail as TIFF, EPS.
Making Contact & Terms: Portfolio may be dropped off Tuesday-Thursday and picked up the following day. Provide résumé, business card, brochure, flier or tearsheets to be kept on file for possible assignments. Keeps samples on file. SASE. Payment negotiable. Pays after job is complete. Buys one-time rights, all rights; negotiable. Credit line given.
Tips: "Send promos or portfolio; do not call."

$ ⑤ ◪ BUGLE MAGAZINE, P.O. Box 8249, Missoula MT 59808-8249. (406)523-4573. Fax: (406)523-4550. E-mail: mia@rmef.org. Website: http://www.rmef.org. Photo Coordinator: Mia McGreevey. Circ. 200,000. Estab. 1984. Publication of the Rocky Mountain Elk Foundation. Bi-monthly magazine. Nonprofit organization that specializes in elk, elk habitat and hunting. Readers are 98% hunters, both male and female; 54% are 35-54; 48% have income over $50,000. Sample copy $5. Photo guidelines free with SASE.
Needs: Uses 50 photos/issue; all supplied by freelancers. Needs photos of landscapes/scenics, wildlife. "*Bugle* editor sends out bi-monthly letter requesting specific images for upcoming issue." Model/property release required. Captions preferred; include name of photographer, location of photo, information on what is taking place.
Making Contact & Terms: Send no more than 20 35mm, 2¼×2¼, 4×5 transparencies by mail for consideration. SASE. Reports in 1-2 weeks. Previously published work OK. Pays $250/cover; $50-175/color inside. Pays on publication. Rights negotiable. Credit line given.
Tips: "We look for high quality, unusual, dramatic and stimulating images of elk and other wildlife. Photos of elk habitat and elk in unique habitat catch our attention, as well as those depicting specific elk behavior. We are also interested in habitat project photos involving trick tanks, elk capture and release, and images showing the effects of human development on elk habitat. Outdoor recreation photos are also welcome. Besides *Bugle* we also use images for billboards, brochures and displays. We work with both amateur and professional photographers."

BUSINESS 99, Success Strategies For Small Business, Group IV Communications, 125 Auburn Court, Suite 100, Thousand Oaks CA 91362. (805)496-6156. Fax: (805)496-5469. E-mail: gosmallbiz@aol.com. Website: http://www.yoursource.com. Photo Editor: Nancy Phillipson. Circ. 175,000. Estab. 1994. Bimonthly magazine. "We provide practical, how-to tips for small business owners." Sample copy for $4 and 9×12 SASE. Art guidelines free with #10 SASE.
Needs: Buys 20 photos from freelancers/issue; 120 photos/year. Needs photos of people in normal, everyday business situations . . . "but no boring shots of someone behind a desk or talking on the phone." Reviews photos with or without ms. Model release required for shots of small business owners, everyday people.
Specs: Uses 35mm 2¼×2¼, 4×5, 8×10 transparencies.
Making Contact & Terms: Send query letter with samples, tearsheets. Provide résumé, business card,

self-promotion piece or tearsheets to be kept on file for possible future assignments. Art director will contact photographer for portfolio review of color tearsheets, slides, transparencies if interested. Keeps samples on file. Reports back only if interested, send non-returnable samples. Pays $600-750 for color cover plus expenses; $400-500 for color inside plus expenses. Pays $100-150 for electronic usage of photos. **Pays on acceptance.** Buys first rights and non-exclusive reprint rights. Credit line given.

Tips: "We want to capture the excitement of running a small business. We do not want typical head shots. People posed on seamless backrounds are not our style. Deliver innovation and solve the shot with craft and creativity. Don't even think of sending film of a person on the phone, at a computer, or shaking hands. When submitting samples of your work give me natural shots of people that fit our simplistic, colorful style. Photos of fruit baskets won't let me determine if you do great work."

$ $ ▣ ◎ CALIFORNIA JOURNAL, Statenet, 2101 K St., Sacramento CA 95816-4920. (916)444-2840. Fax: (916)444-2339. Website: http://www.statenet.com. Art Director: Dagmar Thompson. Circ. 15,000. Estab. 1970. Monthly magazine covering independent analysis of government and politics in California—bi-partisan news reporting. Sample copy free.

Needs: Buys 4-20 photos from freelancers/issue; 300 photos/year. Needs photos of politics, people, environmental issues, human needs, educational issues. Special photo needs include political year in California—campaign candids, political profiles. Photo caption preferred; include photographer credit.

Specs: Uses 17×11 maximum color and b&w prints; 35mm, 2¼×2¼, 4×5 transparencies.

Making Contact & Terms: Send query letter with samples, brochure. Provide résumé, business card, self-promotion piece or tearsheets to be kept on file for possible future assignments. If interested, art director will contact photographer for portfolio review of b&w, color slides, transparencies, Macintosh disks. Keeps samples on file. Reports back only if interested; send non-returnable samples. Simultaneous submissions and/or previously published work OK. Pays $300-600 for color cover; $100-400 for b&w inside. Pays on publication. Buys all rights; negotiable. Credit line given.

Tips: "Interested only in California photography."

▣ $ $▣ CALIFORNIA WILD, (formerly *Pacific Discovery*), California Academy of Sciences, Golden Gate Park, San Francisco CA 94118. (415)750-7116. Fax: (415)221-4853. E-mail: sschneider@cala cademy.org. Art Director: Susan Schneider. Circ. 36,000. Estab. 1948. Quarterly magazine of the California Academy of Sciences. Emphasizes natural history and culture of California, the western US, the Pacific and Pacific Rim countries. Sample copy $1.50 with 9×11 SASE. Photo guidelines free with SASE.

Needs: Uses 40 photos/issue; 90% supplied by freelance photographers and stock photos. Scenics of habitat as well as detailed photos of individual species that convey biological information; wildlife, habitat, ecology, conservation and geology. "Scientific accuracy in identifying species is essential. We do extensive photo searches for every story." Current needs listed in *Guilfoyle Report*, natural history photographers' newsletter published by AG Editions. Model release preferred. "Captions preferred, but captions are generally staff written."

Specs: Uses color prints; 35mm, 2¼×2¼, or 4×5 transparencies; originals preferred. Accepts images in digital format for Mac. Send via Zip, floppy disk as photoshop/TIFF only at 300 dpi minimum.

Making Contact & Terms: Query with list of stock photo subjects, but recommends consulting *Guilfoyle Report* and calling first. SASE. Reports in 6 weeks. Pays $200/color cover photo; $90-200/color inside photo; $50-90 for b&w inside; $100/color page rate; $125 color 1⅓pages; $500-1,000 photo/text packages, but payment varies according to length of text and number of photos. Pays on panel selection. Credit line given. Buys one-time rights.

Tips: "*California Wild* has a reputation for high-quality photo reproduction and favorable layouts, but photographers must be meticulous about identifying what they shoot. Refer to our submission guidelines in *Guilfoyle Report* which publishes all our needs. Include a query letter with photos ℅ Keith Howell, editor. Usually feature articles about places, animals or plants require photos."

$ CALLIOPE, Exploring World History, Cobblestone Publishing, Inc., 30 Grove St., Peterborough NH 03458. (603)924-7209. Fax: (603)924-7380. Managing Editor: Lou Waryncia. Circ. 10,500. Estab. 1990. Magazine published 9 times/year, September-May. Emphasis on non-United States history. Readers are children, ages 8-14. Sample copies $4.95 with 9×12 or larger SAE and 5 first-class stamps. Photo guidelines free with SASE.

Needs: Uses 40-45 photos/issue; 15% supplied by freelancers. Needs contemporary shots of historical locations, buildings, artifacts, historical reenactments and costumes. Reviews photos with or without accompanying ms. Model/property release preferred. Captions preferred.

Specs: Uses b&w or color prints; 35mm transparencies.

Making Contact & Terms: Query with stock photo list. Send unsolicited photos by mail for consideration. Provide résumé, business card, brochure, flier or tearsheets to be kept on file for possible future

assignments. Samples kept on file. SASE. Reports in 1 month. Simultaneous submissions and/or previously published work OK. Pays $15-100/inside; cover (color) photo negotiated. Pays on publication. Buys one-time rights; negotiable. Credit line given.

Tips: "Given our young audience, we like to have pictures which include people, both young and old. Pictures must be dynamic to make history appealing. Submissions must relate to themes in each issue."

$ $ CALYPSO LOG, Box 112, 61 E. Eighth St., New York NY 10003. (212)673-9097. Fax: (212)673-9183. E-mail: cousteauny@aol.com. American Section Editor: Lisa Rao. Circ. 200,000. Publication of The Cousteau Society. Bimonthly. Emphasizes expedition activities of The Cousteau Society; educational/science articles; environmental activities. Readers are members of The Cousteau Society. Sample copy $2 with 9×12 SAE and $1 postage. Photo guidelines free with SASE.

Needs: Uses 10-14 photos/issue; 1-2 supplied by freelancers; 2-3 photos/issue from freelance stock.

Specs: Uses color prints; 35mm and 2¼×2¼ transparencies (duplicates only).

Making Contact & Terms: Query with samples and list of stock photo subjects. SASE. Reports in 5 weeks. Previously published work OK. Pays $75-200/color photo. Pays on publication. Buys one-time rights and "translation rights for our French publication."

Tips: Looks for sharp, clear, good composition and color; unusual animals or views of environmental features. Prefers transparencies over prints. "We look for ecological stories, food chain, prey-predator interaction and impact of people on environment. Please request a copy of our publication to familiarize yourself with our style, content and tone and then send samples that best represent underwater and environmental photography."

$ $ $ ▣ ◐ CAMPUS LIFE, 465 Gundersen Dr., Carol Stream IL 60188. Art Director: Doug Johnson. Circ. 100,000. Estab. 1943. Bimonthly magazine. "*Campus Life* is a magazine for high school and college-age youth. We emphasize balanced living—emotionally, spiritually, physically and mentally." Sample copy $2. Photo guidelines free with SASE.

Needs: Buys 15 photos/issue; 10 supplied by freelancers, most are assigned. Head shots (of teenagers in a variety of moods); humorous, sport and candid shots of teenagers/college students in a variety of settings. "We look for diverse racial teenagers in lifestyle situations, and in many moods and expressions, at work, play, home and school. No travel, how-to, still life, travel scenics, news or product shots. Shoot for a target audience of 17-year-olds." Interested in alternative process, avant garde and fashion/glamour images.

© 1998 Luke Golobitsh, Bonn.

"I look for images that capture an authentic representation of the contemporary teen experience," says Doug Johnson, art director of *Campus Life*. Fortunately, for German photographer Luke Golobitsh, sensitive portraits of teens are one of his specialities. Golobitsh submitted 11 photos of teenagers to the magazine after reading about it in Rohn Engh's *Photoletter*. This is one of two of his images published in the October 1998 issue of the magazine.

Photos purchased with or without accompanying ms. Special needs include "Afro-American males/females in positive shots." Model/property release preferred for controversial stories. Captions preferred.

Specs: Uses 6×9 glossy b&w prints and 35mm or larger transparencies. Accepts images in digital format for Mac. Send via Zip as TIFF, EPS, BMP files at 300 dpi.

Making Contact & Terms: Submit portfolio for review or query with résumé of credits. Provide brochure, tearsheets, résumé, business card or flier to be kept on file for possible assignments. Keeps samples on file. SASE. Simultaneous submissions and previously published work OK if marked as such. Pays $750 minimum for b&w cover; $750-1,500 for color cover; $100-800 for color inside; $100-150/b&w inside. Pays on receipt. Credit line given.

Tips: "Look at a few issues to get a feel for what we choose. Ask for copies of past issues of *Campus Life*. Show work that fits our editorial approach. We choose photos that express the contemporary teen experience. We look for unusual lighting and color. Our guiding philosophy: that readers will see themselves in the pages of our magazine." Looks for "ability to catch teenagers in real-life situations that are well-composed but not posed, technical quality, communication of an overall mood or emotion or action. "

⊠ $✂ ▣ CANADA LUTHERAN, 302-393 Portage Ave., Winnipeg, Manitoba R3B 0H6 Canada. (204)984-9170. Fax: (204)783-7548. Art Director: Darrell Dyck. Editor: Kenn Ward. Circ. 19,000. Estab. 1986. Publication of Evangelical Lutheran Church in Canada. Monthly. Emphasizes faith/religious content; Lutheran denomination. Readers are members of the Evangelical Lutheran Church in Canada. Sample copy for $1.50 with 9×12 SAE and $1 postage (Canadian).

Needs: Uses 4-10 photos/issue; most supplied though article contributors; 1 or 2 supplied by freelancers. Needs photos of people (in worship/work/play etc.).

Specs: Uses 5×7 glossy prints or 35mm transparencies. Accepts images in digital format on CD-ROM or floppy ("call for particulars").

Making Contact & Terms: Send prints or transparencies by mail for consideration. SASE. Pays $15-50/b&w photo; $40-75/color photo. Pays on publication. Buys one-time rights. Credit line given.

Tips: "Give us many photos that show your range. We prefer to keep them on file for at least a year. We have a short-term turnaround and turn to our file on a monthly basis to illustrate articles or cover concepts. Changing technology speeds up the turnaround time considerably when assessing images yet forces publishers to think farther in advance to be able to achieve promised cost savings. U.S. photographers—send via U.S. Mail. We sometimes get wrongly charged duty at the border when shipping via couriers."

$✂ ▣ ⃠ CANADIAN RODEO NEWS, 2116 27th Ave. NE, #223, Calgary, Alberta T2E 7A6 Canada. (403)250-7292. Fax: (403)250-6926. E-mail: rodeonews@iul-ccs.com. Website: http://www.rodeo canada.com. Editor: Vicki Mowat. Circ. 4,285. Estab. 1964. Monthly tabloid. Emphasizes professional rodeo in Canada. Readers are male and female rodeo contestants and fans—all ages. Sample copy and photo guidelines free with 9×12 SASE.

Needs: Uses 15 photos/issue; 5 supplied by freelancers. Needs photos of professional rodeo action or profiles. Captions preferred; include identity of contestant/subject.

Specs: Uses color and b&w prints. Accepts images in digital format for Windows. Send via floppy disk, Zip as TIFF, EPS files at 175 dpi.

Making Contact & Terms: Send unsolicited photos by mail for consideration. Phone to confirm if usable. Keeps samples on file. SASE. Reports in 1 month. Simultaneous submissions and/or previously published work OK. Pays $25/color cover; $15/color inside; $15/b&w inside; $45-75/photo/text package. Pays on publication. Rights negotiable. Credit line given.

Tips: "Photos must be from or pertain to professional rodeo in Canada. Phone to confirm if subject/material is suitable before submitting. *CRN* is very specific in subject."

$ $✂ CANADIAN YACHTING, 395 Matheson Blvd. E., Mississauga, Ontario L4Z 2H2 Canada. (905)890-1846. Fax: (905)890-5769. Editor: Heather Ormerod. Circ. 15,800. Estab. 1976. Bimonthly magazine. Emphasizes sailing (no powerboats). Readers are mostly male, highly educated, high income, well read. Sample copy free with 9×12 SASE.

Needs: Uses 28 photos/issue; all supplied by freelancers. Needs photos of all sailing/sailing related (keelboats, dinghies, racing, cruising, etc.). Model/property release preferred. Captions preferred.

Making Contact & Terms: Submit portfolio for review or query with stock photo list and transparencies. SASE. Reports in 1 month. Simultaneous submissions and previously published work OK. Pays $150-350/color cover; $30-70/color inside; $30-70/b&w inside. Pays on publication. Buys one-time rights.

$ $ CANOE & KAYAK, Dept. PM, P.O. Box 3146, Kirkland WA 98083-3146. (425)827-6363. Fax: (425)827-1893. Art Director: Catherine Black. Circ. 63,000. Estab. 1973. Bimonthly magazine. Emphasizes a variety of paddle sports, as well as how-to material and articles about equipment. For upscale canoe and

kayak enthusiasts at all levels of ability. Also publishes special projects/posters. Free sample copy with 9×12 SASE.

Needs: Uses 30 photos/issue: 90% supplied by freelancers. Canoeing, kayaking, ocean touring, canoe sailing, fishing when compatible to the main activity, canoe camping but no rafting. No photos showing disregard for the environment, be it river or land; no photos showing gasoline-powered, multi hp engines; no photos showing unskilled persons taking extraordinary risks to life, etc. Accompanying mss for "editorial coverage striving for balanced representation of all interests in today's paddling activity. Those interests include paddling adventures (both close to home and far away), camping, fishing, flatwater, whitewater, ocean kayaking, poling, sailing, outdoor photography, how-to projects, instruction and historical perspective. Regular columns feature paddling techniques, conservation topics, safety, interviews, equipment reviews, book/movie reviews, new products and letters from readers." Photos only occasionally purchased without accompanying ms. Model release preferred "when potential for litigation." Property release required. Captions are preferred, unless impractical.

Specs: Uses 5×7 and 8×10 glossy b&w prints; 35mm, 2¼×2¼ and 4×5 transparencies; color transparencies for cover; vertical format preferred.

Making Contact & Terms Interested in reviewing work from newer, lesser-known photographers. Query or send material. "Let me know those areas in which you have particularly strong expertise and/or photofile material. Send best samples only and make sure they relate to the magazine's emphasis and/or focus. (If you don't know what that is, pick up a recent issue first, before sending me unusable material.) We will review dupes for consideration only. Originals required for publication. Also, if you have something in the works or extraordinary photo subject matter of interest to our audience, let me know! It would be helpful to me if those with substantial reserves would supply indexes by subject matter." SASE. Reports in 1 month. Simultaneous submissions and previously published work OK, in noncompeting publications. Pays $300/cover color photo; $150/half to full page color photos; $100/full page or larger b&w photos; $75/quarter to half page color photos; $50/quarter or less color photos; $75/half to full page b&w photos; $50/quarter to half page b&w photos; $25/less than quarter page b&w photos. Pays on publication. Buys one-time rights, first serial rights and exclusive rights. Credit line given.

Tips: "We have a highly specialized subject and readers don't want just any photo of the activity. We're particularly interested in photos showing paddlers' *faces*; the faces of people having a good time. We're after anything that highlights the paddling activity as a lifestyle and the urge to be outdoors." All photos should be "as natural as possible with authentic subjects. We receive a lot of submissions from photographers to whom canoeing and kayaking are quite novel activities. These photos are often clichéd and uninteresting. So consider the quality of your work carefully before submission if you are not familiar with the sport. We are always in search of fresh ways of looking at our sport. All paddlers must be wearing PFDs."

$ $ ▣ ▨ ◎ CAPE COD LIFE INCLUDING MARTHA'S VINEYARD AND NAN-TUCKET, P.O. Box 1385, Pocasset MA 02559-1385. (508)564-4466. Fax: (508)564-4470. E-mail: capelife@capecodlife.com. Website: http://www.capecodlife.com. Publisher: Brian F. Shortsleeve. Circ. 35,000. Estab. 1979. Bimonthly magazine. Emphasizes Cape Cod lifestyle. "Readers are 55% female, 45% male, upper income, second home, vacation homeowners." Sample copy for $3.75. Photo guidelines free with SASE.

Needs: Uses 30 photos/issue; all supplied by freelancers. Needs "photos of Cape and Island scenes, people, places; general interest of this area." Subjects include celebrities, families, environmental, landscapes/scenics, wildlife, architecture, gardening, interiors/decorating, rural, adventure, events, travel, buildings, fine art, historical/vintage, regional, seasonal. Reviews photos with or without a ms. Model release required. Property release preferred. Photo captions required; include location.

Specs: Uses 35mm, 2¼×2¼, 4×5 transparencies. Accepts images in digital format for Mac. Send via zip, floppy disk, e-mail as TIFF files at 300dpi.

Making Contact & Terms: Submit portfolio for review. "Photographers should not drop-by unannounced. We prefer photographers to mail portfolio, then follow-up with a phone call one to two weeks later." Send unsolicited photos by mail for consideration. Keeps samples on file. SASE. Simultaneous submissions and previously published work OK. Pays $225/color cover; $25-175/b&w/color inside, de-

THE SUBJECT INDEX, located at the back of this book, lists publications, book publishers, galleries, greeting card companies, stock agencies, advertising agencies and graphic design firms according to the subject areas they seek.

pending on size. Pays 30 days after publication. Buys one-time rights; reprint rights for *Cape Cod Life* reprints; negotiable. Credit line given.

Tips: "Write for photo guidelines. Mail photos to the attention of our Managing Editor, Nancy E. Berry. Photographers who do not have images of Cape Cod, Martha's Vineyard, Nantucket and the Elizabeth Islands should not submit." Looks for "clear, somewhat graphic slides. Show us scenes we've seen hundreds of times with a different twist and elements of surprise. Photographers should have a familiarity with the magazine and the region first. Prior to submitting, photographers should send a SASE to receive our guidelines. They can then submit works (via mail) and follow-up with a brief phone call. We love to see images by professional-calibre photographers who are new to us and prefer it if the photographer can leave images with us at least 2 months, if possible."

N $ $ CAR CRAFT MAGAZINE, 6420 Wilshire Blvd., Los Angeles CA 90048. (323)782-2320. Fax: (323)782-2263. Editor: David Freiburger. Circ. 375,000. Estab. 1953. Monthly magazine. Emphasizes street machines, muscle cars and modern, high-tech performance cars. Readership is mostly males, ages 18-34.

Needs: Uses 100 photos/issue. Uses freelancers occasionally; all on assignment. Model/property release required. Captions preferred.

Making Contact & Terms: Query with résumé of credits. Provide résumé, business card, brochure, flier or tearsheets to be kept on file for possible assignments. Send 8×10 b&w prints; 35mm and 2¼×2¼ transparencies by mail for consideration. SASE. Reports in 1 month. Pays $35-75/b&w photo; $75-250/ color photo, cover or text; $60 minimum/hour; $250 minimum/day; $500 minimum/job. Payment for b&w varies according to subject and needs. Pays on publication. Buys all rights. Credit line given.

Tips: "We use primarily b&w shots. When we need something special in color or see an interesting color shot, we'll pay more for that. Review a current issue for our style and taste."

$ CAREER FOCUS, 1300 Broadway, Suite 660, Kansas City MO 64111-2412. (816)960-1988. Fax: (816)960-1989. Circ. 250,000. Estab. 1988. Bimonthly magazine. Emphasizes career development. Readers are male and female African-American and Hispanic professionals, ages 21-45. Sample copy free with 9×12 SAE and 4 first-class stamps. Photo guidelines free with SASE.

Needs: Uses approximately 40 photos/issue. Needs technology photos and shots of personalities; career people in computer, science, teaching, finance, engineering, law, law enforcement, government, hi-tech, leisure. Model release preferred. Captions required; include name, date, place, why.

Making Contact & Terms: Query with résumé of credits and list of stock photo subjects. Keeps samples on file. SASE. Reports in 1 month. Pays $10-50/color photo; $5-25/b&w photo. Pays on publication. Credit line given. Buys one-time rights. Simultaneous submissions and previously published work OK.

Tips: "Freelancer must be familiar with our magazine to be able to submit appropriate manuscripts and photos."

$ $ $ CAREERS & COLLEGES MAGAZINE, 989 Avenue of Americas, New York NY 10018. (212)563-4688. Fax: (212)967-2531. E-mail: art@careersandcolleges.com. Website: http://www.careersand colleges.com. Contact: Art Director. Circ. 100,000. Estab. 1980. Quarterly magazine. Emphasizes college and career choices for teens. Readers are high school juniors and seniors, male and female, ages 16-19. Sample copy $2.50 with 9×12 SAE and 5 first-class stamps.

Needs: Uses 4 photos/issue; 80% supplied by freelancers. Needs photos of teen situations, study or career related, some profiles. Model release preferred. Property release required. Captions preferred.

Making Contact & Terms: Send tearsheets and promo cards. Submit portfolio for review; please call for appointment—drop off Monday-Wednesday in morning; can be picked up later in the afternoon. Keeps samples on file. SASE. Reports in 3 weeks. Pays $800-1,000/color cover photo; $350-450/color inside; $600-800/color page rate. **Pays on acceptance.** Buys one-time rights; negotiable. Credit line given.

Tips: "Must work well with teen subjects, hip, fresh style, not too corny. Promo cards or packets work the best, business cards are not needed unless they contain your photography."

$ $ CARIBBEAN TRAVEL AND LIFE MAGAZINE, 330 W. Canton Ave., Winter Park FL 32789. (407)628-4802. Fax: (407)628-7061. Contact: Sue Whitney. Circ. 129,000. Estab. 1985. Published 10 times/year. Emphasizes travel, culture and recreation in islands of Caribbean, Bahamas and Bermuda. Readers are male and female frequent Caribbean travelers, age 32-52. Sample copy $4.95. Photo guidelines free with SASE.

Needs: Uses about 100 photos/issue; 90% supplied by freelance photographers: 10% assignment and 90% freelance stock. "We combine scenics with people shots. Where applicable, we show interiors, food shots, resorts, water sports, cultural events, shopping and wildlife/underwater shots. We want images that show

intimacy between people and place." Captions preferred. "Provide thorough caption information. Don't submit stock that is mediocre."

Specs: Uses 4-color photography.

Making Contact & Terms: Query with list of stock photo subjects. SASE. Reports in 3 weeks. Pays $750/color cover; $350/spread; $250/full page; $150/¾ page; $125/½ page; $75/¼ page. Pays after publication. Buys one-time rights. Does not pay research or holding fees.

Tips: Seeing trend toward "fewer but larger photos with more impact and drama. We are looking for particularly strong images of color and style, beautiful island scenics and people shots—images that are powerful enough to make the reader want to travel to the region; photos that show people doing things in the destinations we cover; originality in approach, composition, subject matter. Good composition, lighting and creative flair. Images that are evocative of a place, creating story mood. Good use of people. Submit stock photography for specific story needs, if good enough can lead to possible assignments. Let us know exactly what coverage you have on a stock list so we can contact you when certain photo needs arise."

$ ▣ CAROLINA QUARTERLY, Greenlaw Hall, CB3520, University of North Carolina, Chapel Hill NC 27599-3520. (919)962-0244. Fax: (919)962-3520. E-mail: cquarter@unc.edu. Website: http://www.unc .edu/student/orgs/cquarter. Editor: Robert West. Circ. 1,100. Estab. 1948. Emphasizes "current poetry, short fiction." Readers are "literary, artistic—primarily, though not exclusively, writers and serious readers." Sample copy $5.

Needs: Sometimes uses 1-8 photos/issue; all supplied by freelance photographers from stock.

Specs: Uses b&w prints. Accepts images in digital format.

Making Contact & Terms: Send b&w prints by mail for consideration. SASE. Reports in 3 months, depending on deadline. Pays $50/job plus 10 contributors copies. Buys one-time rights. Credit line given.

Tips: "Look at a recent issue of the magazine to get a clear idea of its contents and design."

$ Ⓐ ◎ CATHOLIC NEAR EAST MAGAZINE, 1011 First Ave., New York NY 10022-4195. (212)826-1480. Fax: (212)826-8979. Executive Editor: Michael LaCività. Circ. 100,000. Estab. 1974. Bimonthly magazine. A publication of Catholic Near East Welfare Association, a papal agency for humanitarian and pastoral support. *Catholic Near East* informs Americans about the traditions, faiths, cultures and religious communities of Middle East, Northeast Africa, India and Eastern Europe. Sample copy and guidelines available with 6½×9½ SASE.

Needs: 60% of photos supplied by freelancers. Prefers to work with writer/photographer team. Looking for evocative photos of people—not posed—involved in activities; work, play, worship. Liturgical shots also welcomed. Extensive captions required if text is not available.

Making Contact & Terms: Query first. "Please do not send an inventory, rather, send a letter explaining your ideas." Send 6½×9½ SASE. Reports in 3 weeks; acknowledges receipt of material immediately. Simultaneous submissions and previously published work OK, "but neither is preferred. If previously published please tell us when and where." Pays $75-150 for b&w cover; $150-300 for color cover; $50-100 for b&w inside; $75-175 for color inside. Pays on publication. Buys first North American serial rights. Credit line given. "Credits appear on page 3 with masthead and table of contents."

Tips: "Stories should weave current lifestyles with issues and needs. Avoid political subjects, stick with ordinary people. Photo essays are welcomed. Write requesting sample issue and guidelines, then send query. We rarely use stock photos but have used articles and photos submitted by single photojournalist or writer/photographer team."

$ CATS & KITTENS, 7-L Dundas Circle, Greensboro NC 27407. (336)292-4047. Fax: (336)292-4272. Executive Editor: Rita Davis. Bimonthly magazine about cats. "Articles include breed profiles, stories on special cats, cats in art and popular culture." Sample copy for $5 and 9×12 SASE. Photo guidelines free with SASE.

Needs: Photos of various cat breeds, posed and unposed, interacting with other cats and with people. Caption required; include breed name, additional description as needed.

Specs: Transparencies or slides preferred. Glossy prints acceptable.

Making Contact & Terms: Send unsolicited photos by mail for consideration, "but please include SASE if you want them returned. Please send duplicates. We cannot assume liability for unsolicited originals." Reports in 2 months. Pays $150-250/color cover; $25-50/color inside. Pays on publication. Buys all rights, negotiable.

Tips: "We seek good composition (indoor or outdoor). Photos must be professional and of publication quality—good focus and contrast. We work regularly with a few excellent freelancers, but are always seeking new contributors. Images we think we might be able to use will be scanned into our CD-ROM file and the originals returned to the photographer."

$ $ CHARISMA MAGAZINE, 600 Rinehart Rd., Lake Mary FL 32746. (407)333-0600. Design Manager: Mark Poulalion. Circ. 200,000. Monthly magazine. Emphasizes Christians. General readership. Sample copy $2.50.

Needs: Uses approximately 20 photos/issue; ⅓ supplied by freelance photographers. Needs editorial photos—appropriate for each article. Model release required. Captions preferred.

Making Contact & Terms: Send unsolicited photos by mail for consideration. Provide brochure, flier or tearsheets to be kept on file for possible assignments. Send color 35mm, 2¼×2¼, 4×5 or 8×10 transparencies. Cannot return material. Reports ASAP. Pays $500/color cover; $150/b&w inside; $50-150/hour or $400-600/day. Pays on publication. Credit line given. Buys all rights; negotiable. Simultaneous submissions and previously published work OK.

Tips: In portfolio or samples, looking for "good color and composition with great technical ability. To break in, specialize; sell the sizzle rather than the steak!"

$ $ 🄰 🖃 🄲 CHARLOTTE MAGAZINE & CHARLOTTE HOME DESIGN, 127 W. Worthington Ave., Suite 208, Charlotte NC 28203. (704)335-7181. Fax: (704)335-3739. Art Director: Carrie Porter. Circ. 30,000. Estab. 1995. Monthly magazine. Emphasizes Charlotte, North Carolina. Readers are upper-middle class, ages 30 and up. Sample copy $3.95 with 9×12 SASE and 2 first-class stamps.

Needs: Uses 20-30 photos/issue; 15-20 supplied by freelancers. Subject needs include landscapes/scenics, architecture, gardening, interiors/decorating, events, food/drink, travel, still life, documentary, regional. Model release preferred for young children. Captions required; include names.

Specs: Uses 35mm, 2¼×2¼ and 4×5 transparencies. Accepts images in digital format for Mac. Send via Jaz, Zip as EPS files at 300 dpi.

Making Contact & Terms: Submit portfolio for review. Provide résumé, business card, brochure, flier or tearsheets to be kept on file for possible assignments. Keeps samples on file. SASE. Reports in 1-2 weeks. Pays $200-400 for color cover; $600-1,000 for color feature (This is payment for a full feature not per photo). Pays on publication. Buys one-time rights. Credit line given.

Tips: "Look at the publication; get a feel for the style and see if it coincides with your photography style. Call to set up an interview or send sample cards of work."

$ 🖃 CHESS LIFE, 3054 NYS Route 9W, New Windsor NY 12553. (914)562-8350. Fax: (914)561-CHES (2437)/(914)236-4852. E-mail: chesslife_uscf@juno.com. Website: http://www.uschess.org. Editor-in-Chief: Glenn Petersen. Art Director: Jami Anson. Circ. 70,000. Estab. 1939. Publication of the U.S. Chess Federation. Monthly. *Chess Life* covers news of all major national and international tournaments; historical articles, personality profiles, columns of instruction, occasional fiction, humor for the devoted fan of chess. Sample copy and photo guidelines free.

Needs: Uses about 10 photos/issue; 7-8 supplied by freelancers. Needs "news photos from events around the country; shots for personality profiles." Special needs include "Spot Light" section. Model release preferred. Captions preferred.

Specs: Prefers 35mm transparencies for cover shots. Also accepts digital images on broadcast tape, VHS and Beta.

Making Contact & Terms: Query with samples. Provide business card and tearsheets to be kept on file for possible future assignments. SASE. Reports in "2-4 weeks, depending on when the deadline crunch occurs." Simultaneous submissions and previously published work OK. Pays $150-300/b&w or color cover; $25/b&w inside; $35/color inside; $15-30/hour; $150-250/day. Pays on publication. Buys one-time rights; "we occasionally purchase all rights for stock mug shots." Credit line given.

Tips: Using "more color, and more illustrative photography. The photographer's name, address and date of the shoot should appear on the back of all photos. Also, name of person(s) in photograph, and event should be identified." Looks for "clear images, good composition and contrast—with a fresh approach to interest the viewer. Increasing emphasis on strong portraits of chess personalities, especially Americans. Tournament photographs of winning players and key games are in high demand."

🄽 $ $🄲 🖃 CHICKADEE MAGAZINE, 179 John St., Suite 500, Toronto, Ontario M5T 3G5 Canada. (416)340-2700. Fax: (416)340-9769. Website: http://www.owl.on.ca. Researcher: Katherine Murray. Circ. 70,000. Estab. 1979. Published 9 times/year, 1 summer issue. A natural science magazine for children under 8 years. Sample copy for $4.28 with 9×12 SAE and $1.50 money order to cover postage. Photo guidelines free.

● *Chickadee* has received Magazine of the Year, Parents' Choice and The Educational Association of America awards.

Needs: Uses about 3-6 photos/issue; 1-2 supplied by freelance photographers. Needs "crisp, bright, close-up shots of animals in their natural habitat." Model/property release required. Captions required.

Specs: Uses 35mm transparencies; submit digital images on Zip disk or CD scanned at high resolution

(300 dpi) as a TIFF or EPS file (prefer CMYK format, separations included).
Making Contact & Terms: Request photo package before sending photos for review. Reports in 2-3 months. Previously published work OK. Pays $425 Canadian/color cover; $200 Canadian/color page; text/photo package negotiated separately. **Pays on acceptance.** Buys one-time rights. Credit line given.

$ $ CHILDREN'S DIGEST, P.O. Box 567, Indianapolis IN 46206. (317)636-8881 ext. 220. Fax: (317)684-8094. Photo Editor: Penny Rasdall. Circ. 106,000. Estab. 1950. Magazine published 8 times/year. Emphasizes health and fitness. Readers are preteens—kids 10-13. Sample copy $1.25. Photo guidelines free with SASE.
Needs: "We have featured photos of health and fitness, wildlife, children in other countries, adults in different jobs, how-to projects." *Reviews photos with accompanying ms only.* "We would like to include more photo features on nature, wildlife or anything with an environmental slant." Model release preferred.
Specs: Uses 35mm transparencies.
Making Contact & Terms: Send complete manuscript and photos on speculation. SASE. Reports in 10 weeks. Pays $70-275/color cover; $70-155/color inside; $35-70/b&w inside. Pays on publication. Buys one-time rights.

$ ▣ ◯ THE CHRISTIAN CENTURY, 407 S. Dearborn St., Suite 1405, Chicago IL 60605. (312)427-5380. Fax: (312)427-1302. Production Coordinator: Matthew Giunti. Circ. 32,000. Estab. 1884. Weekly journal. Emphasis on religion. Readers are clergy, scholars, laypeople, male and female, ages 40-85. Sample copy $3. Photo guidelines free with SASE.
Needs: Buys 50 photos/year; all supplied by freelancers; 75% comes from stock. People of various races and nationalities; celebrity/personality (primarily political and religious figures in the news); documentary (conflict and controversy, also constructive projects and cooperative endeavors); scenic (occasional use of seasonal scenes and scenes from foreign countries); spot news; and human interest (children, human rights issues, people "in trouble," and people interacting). Reviews photos with or without accompanying ms. For accompanying mss seeks articles dealing with ecclesiastical concerns, social problems, political issues and international affairs. Model/property release preferred. Captions preferred; include name of subject and date.
Specs: Uses 8×10 b&w prints. Accepts digital files on floppy disk in Photoshop or TIFF format (EPS also if it's not too large).
Making Contact & Terms: "Send crisp black-and-white images. We will consider a stack of photos in one submission. Send cover letter with prints. Don't send negatives or color prints." Does not keep samples on file. SASE. Reports in 1 month. Simultaneous submissions and previously published work OK. Pays $50-150/photo (b&w or color). Pays on publication. Buys one-time rights; negotiable. Credit line given.
Tips: Looks for diversity in gender, race, age and religious settings. Photos should reproduce well on newsprint.

$ ⑤ ◎ CHRISTIAN HOME & SCHOOL, 3350 E. Paris Ave. SE, Grand Rapids MI 49512-3054. (616)957-1070, ext. 239. Fax: (616)957-5022. E-mail: rogers@csionline.org. Website: www.gospelcom. net/csi/chs. Senior Editor: Roger Schmurr. Circ. 65,000. Estab. 1922. Publication of Christian Schools International. Published 6 times a year. Emphasizes Christian family and Christian education issues. Readers are parents who support Christian education. Sample copy free with 9×12 SAE and 4 first-class stamps. Photo guidelines free with SASE or along with sample copy.
Needs: Uses 10-15 photos/issue; 7-10 supplied by freelancers. Needs photos of children, family, parents, teens, multicultural, activities, school scenes. Model release preferred.
Specs: Uses color slides and transparencies.
Making Contact & Terms: Query with samples. Query with list of stock photo subjects. SASE. Reports in 3 weeks. Simultaneous submissions and previously published work OK. Pays $125/inside editorial; $250/cover; $75-100/inside spot usage; all color. Pays on publication. Buys one-time rights. Credit line given.
Tips: "Send some samples or publications containing your work. Access our want lists from Visual Support (800-869-5687, X110), Photo Source International (800-223-3860) or Guilfoyle Report (212-929-0959)."

CHRISTIANITY AND THE ARTS, P.O. Box 118088, Chicago IL 60611. (312)642-8606. Fax: (312)266-7719. E-mail: chrnarts@aol.com. Publisher: Marci Whitney-Schenck. Circ. 4,000. Estab. 1994. Nonprofit quarterly magazine. Emphasizes "Christian expression—visual arts, dance, music, literature, film. We reach Protestant, Catholic and Orthodox readers throughout the United States and Canada." Readers are "upscale and well-educated, with an interest in several disciplines, such as music and the visual arts." Sample copy $7.
Needs: "Parting Shot" page is devoted to "arty photos."

Making Contact & Terms: "We occasionally pay a freelance photographer $100/photo. Usually, there is no pay, but the photographer gets exposure."

$ [A] [⌀] THE CHRONICLE OF THE HORSE, P.O. Box 46, Middleburg VA 20118. (540)687-6341. Fax: (540)687-3937. Editor: John Strassburger. Circ. 23,000. Estab. 1937. Weekly magazine. Emphasizes English horse sports. Readers range from young to old. "Average reader is a college-educated female, middle-aged, well-off financially." Sample copy for $2. Photo guidelines free with SASE.

Needs: Uses 10-25 photos/issue; 90% supplied by freelance photographers. Needs photos from competitive events (horse shows, dressage, steeplechase, etc.) to go with news story or to accompany personality profile. "A few stand alone. Must be cute, beautiful or newsworthy. Reproduced in b&w." Prefers purchasing photos with accompanying ms. Captions required with every subject identified.

Specs: Uses b&w and color prints (reproduced b&w).

Making Contact & Terms: Query with idea. SASE. Reports in 3 weeks. Simultaneous submissions and previously published work OK. Pays $15-100/photo/text package. Pays on publication. Buys one-time rights. Prefers first North American rights. Credit line given.

Tips: "We do not want to see portfolio or samples. Contact us first, preferably by letter. Know horse sports."

$ [S] [⌀] CICADA, 329 E St., Bakersfield CA 93304-2031. (661)323-4064. Fax: (661)323-5326. E-mail: amelia@lightspeed.net. Editor: Frederick A. Raborg, Jr. Circ. 600. Estab. 1984. Quarterly literary magazine that publishes Japanese and other Asian and Indian poetry forms and fiction related to the Orient, plus articles and book reviews related to the forms. Sample copy for $4.95. Art guidelines free with SAE and 1 first-class stamp.

Needs: Buys 1-2 photos from freelancers/issue; 4-6 photos/year. Needs photos of anything with an oriental flavor, particularly if somehow arousing a haiku moment. Subjects include babies, children, couples, senior citizens, environmental, landscapes, scenics, wildlife, architecture, beauty, cities/urban, gardening, interiors/decorating, pets, rural, events, humor, performing arts, travel, portraits. "All photos should be Oriental in nature." All types and subjects are considered. Considers b&w only at this time. Reviews photos with or without ms. Model release required in cases of visible faces. Photo captions required only for identification of subject matter.

Specs: Uses 5×7, 8×10 glossy or matte b&w prints only.

Making Contact & Terms: Send query letter with samples. Keeps samples on file. Reports in 2-4 weeks on queries; 1-2 months on samples. Simultaneous submissions and/or previously published work OK if in non-competitive markets. Pays $25 for b&w cover; $10-15 for b&w inside. **Pays on acceptance.** Buys one-time rights.

Tips: "We allow photographers a 40% discount on subscriptions to allow them to follow what we do reasonably. (Regular subscription—$14; price to photographers $8.40.) Submit a strong cross-section of work. Remember to include SASE with sufficient postage and of sufficient size."

$ $ CIRCLE K MAGAZINE, 3636 Woodview Trace, Indianapolis IN 46268. (317)875-8755. Art Director: Dianne Bartley. Circ. 15,000. Published 5 times/year. For community service-oriented college leaders "interested in the concept of voluntary service, societal problems, leadership abilities and college life. They are politically and socially aware and have a wide range of interests."

Needs: Assigns 0-5 photos/issue. Needs general interest photos, "though we rarely use a nonorganization shot without text. Also, the annual convention requires a large number of photos from that area." Prefers ms with photos. Seeks general interest features aimed at the better-than-average college student. "Not specific places, people topics." Captions required, "or include enough information for us to write a caption."

Specs: Uses 8×10 glossy b&w prints or color transparencies. Uses b&w and color covers; vertical format required for cover.

Making Contact & Terms: Works with freelance photographers on assignment only basis. Provide calling card, letter of inquiry, résumé and samples to be kept on file for possible future assignments. Send query with résumé of credits. SASE. Reports in 3 weeks. Previously published work OK if necessary to text. Pays $225-350 maximum for text/photo package, or on a per-photo basis—$25 minimum/b&w print and $100 minimum/cover. **Pays on acceptance.** Credit line given.

[N] $ CITY LIMITS, New York's Urban Affairs Magazine, 120 Wall St, 20th Floor, New York NY 10005. (212)479-3344. Fax: (212)344-6457. E-mail: citlim@aol.com. Website: http://www.citylimits.org. Associate Editor: Kemba Johnson. Circ. 5,000. Estab. 1976. "*City Limits* is an urban policy monthly offering intense journalistic coverage of New York City's low-income and working-class neighborhoods." Sample copies free for 8×11 SAE with $1.50 first-class postage. Art guidelines available for SASE.

Needs: Buys 20 photos from freelancers per issue; 200 photos per year. Needs assigned portraits, photo-journalism, action, ambush regarding stories about people in low income neighborhoods, government or social service sector. Reviews photos with or without a ms. Special photo needs: lots of b&w photo essays about urban issues. Model release required for children.

Specs: Uses 5×7 and larger b&w prints.

Making Contact & Terms: Send query letter with samples. Provide résumé, business card, self-promotion piece or tearsheets to be kept on file for possible future assignments. Art director will contact photographer for portfolio review if interested. Portfolio should include b&w prints and tearsheets. Keeps samples on file; cannot return material. Reports back only if interested, send nonreturnable samples. Simultaneous submissions and previously published work OK. Pays $50-75 for b&w cover; $20-50 for b&w inside. Pays on publication. Credit line given. Buys one-time rights.

Tips: "We need good photojournalists who can capture the emotion of a scene. We offer huge play for great photos."

$ 🌐 🖥 ◑ CLASSIC CD MAGAZINE, Future Publishing, 30 Monmouth St., Bath, Avon BA1 2BW Great Britain. (44)1225 442244. Fax: (44)1225 732285. E-mail: david.eachus@futurenet.co.uk. Art Editor: David Eachus. Circ. 36,000. Estab. 1990. Monthly consumer magazine. "Classic CD is the complete guide to classical music with articles and reviews of the top releases exclusively illustrated by extracts on our cover disc." Sample copy available.

Needs: Needs photos of composers, musicians, celebrities, landscapes/scenics, architecture, religious, entertainment, events, performing arts, travel, fine art, historical/vintage. Reviews photos with or without a ms. Photo captions preferred.

Specs: Accepts images in digital format for Mac. Send via floppy disk, Zip, e-mail, ISDN as TIFF, EPS, PICT, JPEG files at 72-250 dpi.

Making Contact & Terms: Send query letter with tearsheets. Provide résumé, business card, self-promotion piece or tearsheets to be kept on file for possible future assignments. To show portfolio, photographer should follow-up with call and/or letter after initial query. Art director will contact photographer for portfolio review if interested. Portfolio should include b&w and color prints, slides, thumbnails, tearsheets, transparencies. Keeps samples on file. Reports back only if interested, send non-returnable samples. Simultaneous submissions and/or previously published work OK. Pays È150 for ½ day; È250 for full day. Pays 30 days after publication. Buys one-time rights. Credit line given.

Tips: "Read our magazine. Do not submit too much."

$ $ 🌐 Ⓐ 🖥 ◑ ◎ THE CLASSIC MOTORCYCLE, Mortons Motorcycle Media, Ltd., Newspaper House, Horncastle, Lincs LN9 6JR United Kingdom. Phone: (441507)524004. Fax: (441507)525002. E-mail: tcm@classicmotorcycle.co.uk. Circ. 30,000. Monthly consumer magazine covering classic motorcycles 1900-1970 including European machines as well as those manufactured in the UK.

Needs: Needs photos of classic motorcycles. Reviews photos with or without ms. Photo captions preferred.

Specs: Uses 35mm, 2¼×2¼ transparencies; Fuji Provia film. Accepts images in digital format for Mac, Windows. Send via SyQuest, floppy disk, Jaz as EPS files.

Making Contact & Terms: Provide résumé, business card, self-promotion piece or tearsheets to be kept on file for possible future assignments. To show portfolio, photographer should follow-up with call. Portfolio should include transparencies. Keeps samples on file. Reports in 2 weeks. Pays £150/day for a photo shoot plus film and expenses. Pays on publication. Buys first rights. Credit line given.

Tips: "Action photography is difficult—we are always impressed with good action photography."

$ 🌐 🖥 ◯ ◎ CLASSICS, Security Publications Ltd., Berwick House, 8/10 Knoll Rise, Orpington, Kent BR6 0PS United Kingdom. Phone: (01689)887200. Fax: (01689)838844. E-mail: classics@splgroup.demon.co.uk. Editor: Andrew Noakes. Estab. 1997. Published monthly on the first Wednesday of every month. "The essential, practical magazine for classic car owners, filled with authoritative technical advice on maintenance and restoration, plus stories of reader's own cars and a unique guide to 2,000 specialists in every issue." Sample copy free for 9×12 SAE. Art guidelines free.

Needs: Buys 70 photos from freelancers/issue; 1,000 photos/year. Needs photos of classic cars—1970s and earlier, mostly English/European. Also uses celebrities, still life, historical/vintage. Reviews photos with or without ms. Special photo needs include restoration picture sequences and "we are looking for overseas correspondants." Photo captions required; include make/model of vehicle, names of people and any technical details.

Specs: "Freelance submissions can be in any format if quality is good." Accepts images in digital format for Mac. Send via CD, Zip as TIFF, EPS files at 300 dpi.

Making Contact & Terms: Send query letter with samples, stock photo list, tearsheets. Art director will contact photographer for portfolio review if interested. Keeps samples on file. Simultaneous submissions

and/or previously published work OK. Pays $10-50 for b&w and color inside. Pays 30 days after publication. Buys one-time rights and all rights on some occasions; negotiable.

Tips: "Read the magazine to see what we use—then supply us with more of the same. Weed out the unsharp, the badly exposed and the poorly cropped. They are always unusable."

$ $ ◫ ⊘ CLEVELAND MAGAZINE, City Magazines Inc., 1422 Euclid Ave., #730, Cleveland OH 44115. (216)771-2833. Fax: (216)781-6318. E-mail: information@clevelandmagazine.com. Website: http://www.clevelandmagazine.com. Design Director: Gary Sluzewski. Circ. 50,000. Estab. 1972. Monthly consumer magazine. General interest to upscale audience.

Needs: Buys 50 photos from freelancers/issue; 600 photos/year. Needs photos of people (celebrities, couples, multicultural, families, parents, senior citizens), architecture, interiors, environmental, beauty, urban, education, gardening, entertainment, events, food/drink, health/fitness, humor, performing arts, sports, buildings, business, computers, industry, medicine, political, portraits, still life, technology, digital, documentary, regional. Reviews photos with or without ms. Model release required for portraits; property release required for individual homes. Photo caption required; include names, date, location, event, phone.

Specs: Uses color and b&w prints; 35mm, 2¼ × 2¼, 4 × 5, 8 × 10 transparencies. Accepts images in digital format. Accepts images in digital format for Mac. Send via CD, Jaz, Zip, e-mail as TIFF files at 300 dpi.

Making Contact & Terms: Provide business card, self-promotion piece or tearsheets to be kept on file for possible future assignments. To show portfolio, photographer should follow-up with call. Portfolio should include "only your best, favorite work." Keeps samples on file. Reports back only if interested, send non-returnable samples. Simultaneous submissions and/or previously published work OK. Pays $300-600 for color cover; $100-300 for b&w inside; $100-600 for color inside. **Pays on acceptance.** Buys one-time publication, electronic and promotional rights. Credit line given.

Tips: "Ninety percent of our work is people. Send sample. Follow up with phone call. Make appointment for portfolio review. Arrange the work you want to show me ahead of time and be professional, instead of telling me you just threw this together."

$ ◫ ⊘ COBBLESTONE: AMERICAN HISTORY FOR KIDS, Cobblestone Publishing Company, 30 Grove St., Suite C, Peterborough NH 03458. (603)924-7209. Fax: (603)924-7380. Website: http://www.cobblestonepub.com. Editor: Meg Chorlian. Circ. 35,000. Estab. 1980. Publishes 9 issues/year, September-May. Emphasizes American history; each issue covers a specific theme. Readers are children 8-14, parents, teachers. Sample copy for $4.95 and 9 × 12 SAE with 5 first-class stamps. Photo guidelines free with SASE.

Needs: Uses about 40 photos/issue; 5-10 supplied by freelance photographers. "We need photographs related to our specific themes (each issue is theme-related) and urge photographers to request our themes list." Model release required. Captions preferred.

Specs: Uses 8 × 10 glossy prints or 35mm, 2¼ × 2¼ transparencies. Accepts images in digital format for Mac or Windows.

Making Contact & Terms: Query with samples or list of stock photo subjects. SASE. Send via SyQuest or Zip disk. "Photos must pertain to themes, and reporting dates depend on how far ahead of the issue the photographer submits photos. We work on issues 6 months ahead of publication." Simultaneous submissions and previously published work OK. Pays $200-300 for color cover; $15-50 for b&w inside; $15-100 for color inside (payment depends on size of photo). Pays on publication. Buys one-time rights. Credit line given.

Tips: "Most photos are of historical subjects, but contemporary color images of, for example, a Civil War battlefield, are great to balance with historical images. However, the amount varies with each monthly theme. Please review our theme list and submit related images."

◫ ⊘ COLLAGES & BRICOLAGES, P.O. Box 360, Shippenville PA 16254. Fax: (814)226-5799. E-mail: cb@penn.com. Editor: Marie-José Fortis. Art Editor: Michael Kressley. Estab. 1986. Annual magazine. Emphasizes literary works, avant-garde, poetry, fiction, plays and nonfiction. Readers are writers and the general public in the US and abroad. Sample copy $10.

Needs: Uses 5-10 photos/issue; all supplied by freelancers. Needs photos that make a social statement, surrealist photos and photo collages. Reviews photos (August-March) with or without a ms. Photo captions preferred; include title of photo and short biography of artist/photographer.

 SPECIAL COMMENTS within listings by the editor of *Photographer's Market* are set off by a bullet.

Specs: "Photos should be no larger than 8½×11 with at least a 1" border." Send matte b&w prints. Accepts images in digital format for Windows.

Making Contact & Terms: Send unsolicited photos by mail for consideration. SASE. Reports in 3 months. Pays in copies.

Tips: "*C&B* is primarily meant for writers. It will include photos if: a) they accompany or illustrate a story, a poem, an essay or a focus *C&B* might have at the moment; b) they constitute the cover of a particular issue; or c) they make a statement (political, social, spiritual). Submit material to Michael Kresslery, art director. This material should include photos (8½×11; 1" border); a short bio, and a SASE. Material without a SASE will not be considered."

Ⓝ $ $ $ COLLEGE PREVIEW, 3100 Broadway, Suite 660, Kansas City MO 64111-2413. (816)960-1988. Fax: (816)960-1989. Editor: Neoshia Michelle Paige. Circ. 600,000. Bimonthly magazine. Emphasizes college and college-bound African-American and Hispanic students. Readers are African-American, Hispanic, ages 16-24. Sample copy free with 9×12 SAE and 4 first-class stamps.

Needs: Uses 30 photos/issue. Needs photos of students in class, at work, in interesting careers, on-campus. Special photo needs include computers, military, law and law enforcement, business, aerospace and aviation, health care. Model/property release required. Captions required; include name, age, location, subject.

Making Contact & Terms: Query with résumé of credits. Query with ideas and SASE. Reports in 1 month, "usually less." Simultaneous submissions and/or previously published work OK. Pays $10-50/color photo; $5-25/b&w inside. Pays on publication. Buys first North American serial rights.

$ ▢ ◎ COMPANY: A MAGAZINE OF THE AMERICAN JESUITS, Dept. PM, 3441 N. Ashland Ave., Chicago IL 60657. (773)281-1534. Fax: (773)281-2667. E-mail: editor@companysj.com. Website: http://www.companysj.com. Editor: Martin McHugh. Circ. 128,000. Estab. 1983. Published by the Jesuits (Society of Jesus). Quarterly magazine. Emphasizes people; "a human interest magazine about people helping people." Sample copy free with 9×12 SAE and 4 first-class stamps. Photo guidelines free with SASE.

Needs: All photos supplied by freelancers. Needs photo-stories of Jesuit and allied ministries and projects, only photos related to Jesuit works. Photos purchased with or without accompanying ms. Captions required.

Specs: Accepts images in digital format for Mac or Windows. Send via floppy or Zip disk, SyQuest or Online at 220-300 dpi.

Making Contact & Terms: Query with samples. Provide résumé, business card, brochure, flier or tear-sheets to be kept on file for possible future assignments. SASE. Reports in 1 month. Pays $300/color cover; $100-400/job. Pays on publication. Buys one-time rights; negotiable. Credit line given.

Tips: "Avoid large-group, 'smile-at-camera' photos. We are interested in people photographs that tell a story in a sensitive way—the eye-catching look that something is happening."

$ ◎ COMPLETE WOMAN, 875 N. Michigan Ave., Suite 3434, Chicago IL 60611-1901. (312)266-8680. Art Director: Gail Mitchell. Estab. 1980. Bimonthly magazine. General interest magazine for women. Readers are "females, 21-40, from all walks of life."

Needs: Uses 50-60 photos/issue; 300 photos/year. Needs high-contrast shots of attractive women, how-to beauty shots, celebrities, couples, health/fitness, beauty, business concepts. Interested in fashion/glamour. Model release required.

Specs: Uses color or b&w transparencies (slide and large format).

Making Contact & Terms: Query with list of stock photo subjects and samples. Portfolio may be dropped off and picked up by appointment only. Provide résumé, business card, brochure, flier or tearsheets to be kept on file for possible assignments. Send b&w, color prints and transparencies. Each print/transparency should have its own protective sleeve. Do not write or make heavy pen impressions on back of prints. Identification marks will show through affecting reproduction. SASE. Reports in 1 month. Simultaneous and previously published work OK. Pays $75-150/b&w or color inside. Pays on publication. Buys one-time rights. Credit line given.

Tips: "We use photography that is beautiful and flattering, with good contrast and professional lighting. Models should be attractive, 18-28, and sexy. We're always looking for nice couple shots."

Ⓝ $ $ $ ▢ COMPUTER CURRENTS, 1250 Ninth St., Berkeley CA 94710. (510)527-0333. Fax: (510)527-4106. E-mail: scullison@compcurr.com. Production Director: Sherry Scllison. Circ. 600,000. Estab. 1983. Magazine: biweekly in Bay Area; monthly in Los Angeles, New York City, Chicago, Boston, Atlanta and Texas. Emphasizes business and personal computing (PCs and Macs). Readers are PC and Mac users with 4-5 years experience; mostly male, 25-55. Sample copy for 10½×12½ SAE and $3 postage. Photo guidelines free with SASE.

Needs: Uses 1 cover photo/issue; all supplied by freelancers. Needs illustriave photos representing a given concept. Reviews photos purchased with accompanying ms only. Model/property release required.
Specs: Uses 2¼×2¼, 4×5 transparencies. Accepts images in digital format. Send via SyQuest, Zip in TIFF Photoshop, Illustrator files.
Making Contact & Terms: Send unsolicited photos by mail for consideration. Provide résumé, business card, brochure, flier or tearsheets to be kept on file for possible future assignments. Keeps samples on file. SASE. Reports in 1 month. Simultaneous submissions and previously published work OK. Pays $800-1,000/color cover. **Pays on acceptance.** Buys first North American serial, electronic and nonexclusive rights. Credit line given.
Tips: "Photographers wishing to work with us should have Photoshop and QuarkXPress awareness or experience."

[N] $ CONFRONTATION: A LITERARY JOURNAL, English Dept., C.W. Post of L.I.U., Brookville NY 11548. (516)299-2391. Fax: (516)299-2735. E-mail: mtucker@liu.edu. Editor: Martin Tucker. Circ. 2,000. Estab. 1968. Semiannual magazine. Emphasizes literature. Readers are college-educated lay people interested in literature. Sample copy $3.
Needs: Reviews photos with or without a manuscript. Captions preferred.
Making Contact & Terms: Query with résumé of credits and stock photo list. Reports in 1 month. Simultaneous submissions OK. Pays $25-100/b&w; $50-100/color cover; $20-40/b&w page rate; $100-300/job. Pays on publication. Buys first North American serial rights; negotiable. Credit line given.

$ ▣ ◯ COUNTRY, 5925 Country Lane, Greendale WI 53129. (414)423-0100. Fax: (414)423-8463. Website: http://www.reimanpub.com. Photo Coordinator: Trudi Bellin. Estab. 1987. Bimonthly magazine. "For those who live in or long for the country." Readers are rural-oriented, male and female. "*Country* is supported entirely by subscriptions and accepts no outside advertising." Sample copy $2. Photo guidelines free with SASE.
Needs: Uses 150 photos/issue; 20% supplied by freelancers. Needs photos of country scenics, rural people, gardening, animals, senior citizens, rural, travel, agriculture. Interested in seasonal, historical/vintage and nostalgia. Model/property release required. Captions preferred; include season, location.
Specs: Uses all sizes of color transparencies. Accepts images in digital format for Mac. Send via e-mail at 800 dpi.
Making Contact & Terms: Query with list of stock photo subjects. Send unsolicited photos by mail for consideration. Tearsheets kept on file but not dupes. SASE. Reports within 3 months. Previously published work OK. Pays $300/color cover; $150/b&w cover; $300/color inside; $100/b&w inside; $150/color page (full-page bleed). Pays on publication. Buys one-time rights. Credit line given.
Tips: "Technical quality is extremely important: focus must be sharp, no soft focus; colors must be vivid so they 'pop off the page.' Study our magazine thoroughly—we have a continuing need for sharp, colorful images, and those who can supply what we need can expect to be regular contributors. Don't call."

[N] $ ▣ THE COVENANT COMPANION, 5101 N. Francisco Ave., Chicago IL 60625. (773)784-3000. Fax: (773)784-4366. E-mail: covcom@compuserve.com. Website: http://www.covchurch.org. Editor: Donald L. Meyer. Managing Editor: Jane K. Swanson-Nystrom. Art Director: David Westerfield. Circ. 20,000. Monthly denominational magazine of the Evangelical Covenant Church. Emphasizes "issues that impact the church worldwide and locally, and issues that Christians face daily."
Needs: Mood shots of home life, church life, church buildings, nature, commerce and industry and people. Also uses fine art, scenes, city life, etc.
Specs: Uses 5×7 and 8×10 glossy prints; color slides for cover only. Also accepts digital images in TIFF files. Send via CD or floppy disk.
Making Contact & Terms: "We need to keep a rotating file of photos for consideration." SASE. Simultaneous submissions OK. Pays $25/b&w photo; $50-75/color cover. Pays within 2 months of publication. Buys one-time rights. Credit line given.
Tips: "Give us photos that illustrate life situations and moods. We use b&w photos which reflect a mood or an aspect of society—wealthy/poor, strong/weak, happiness/sadness, conflict/peace. These photos or illustrations can be of nature, people, buildings, designs and so on. Give us a file from which we can draw."

$ ▣ ◯ CRC PRODUCT SERVICES, 2850 Kalamazoo Ave SE, Grand Rapids MI 49560. (616)246-0780. Fax: (616)246-0834. E-mail: heetderd@crcna.org. Website: http://www.crcna.org/cr/crop/croparte.htm. Art Acquisition: Dean Heetderks. Publishes numerous magazines with various formats. Emphasizes living the Christian life. Readers are Christians ages 35-85. Photo guidelines available at our website.
Needs: Uses 6-8 photos/issue; all supplied by freelancers. Needs photos of people, holidays and concept.

Reviews photos purchased with or without a ms. Special photo needs include real people doing real activities: couples, families. Model/property release required. Captions preferred.

Specs: Uses any color or b&w prints; 35mm, 2¼×2¼, 4×5, 8×10 transparencies. Accepts images in digital format.

Making Contact & Terms: Provide résumé, business card, brochure, flier or tearsheets to be kept on file for possible assignments. Keeps samples on file. Cannot return material. Simultaneous submissions and/or previously published work OK. Pays $300-600/color cover; $200-400/b&w cover; $200-300/color inside; $200-300/b&w inside. **Pays on acceptance.** Buys one-time and electronic rights.

$ $◻ CRUISING WORLD MAGAZINE, 5 John Clark Rd., Newport RI 02840. (401)847-1588. Fax: (401)848-5048. Art Director: William Roche. Circ. 156,000. Estab. 1974. Emphasizes sailboat maintenance, sailing instruction and personal experience. For people interested in cruising under sail. Sample copy free for 9×12 SAE.

Needs: Buys 25 photos/year. Needs "shots of cruising sailboats and their crews anywhere in the world. Shots of ideal cruising scenes. No identifiable racing shots, please." Also wants exotic images of cruising sailboats, people enjoying sailing, tropical images, different perspectives of sailing, good composition, bright colors. For covers, photos "must be of a cruising sailboat with strong human interest, and can be located anywhere in the world." Prefers vertical format. Allow space at top of photo for insertion of logo. Model release preferred. Property release required. Captions required; include location, body of water, make and model of boat.

Specs: Uses 35mm color transparencies for cover; 35mm b&w slides for inside only with ms.

Making Contact & Terms: "Submit original 35mm slides. *No* duplicates. Most of our editorial is supplied by author. We look for good color balance, very sharp focus, the ability to capture sailing, good composition and action. Always looking for *cover shots*." Reports in 2 months. Pays $50-300/color inside; $500/color cover. Pays on publication. Buys all rights, but may reassign to photographer after publication; first North American serial rights; or one-time rights. Credit line given.

$ $▧ CURAÇAO NIGHTS, (The Island's premiere lifestyle & travel magazine), 1831 René Levesque Blvd. W., Montreal, Quebec H3H 1R4 Canada. (514)931-1987. Fax: (514)931-6273. E-mail: nights@odyssee.net. Office Coordinator: Zelly Zuskin. Circ. 155,000. Estab. 1991. Yearly tourist guide of where to eat, sleep, dance etc. in Curaçao.

Needs: Buys 30 photos/year. Needs travel photos of Curaçao—beaches, water, sun etc. Reviews photos with or without ms. Model release required; property release required for private homes. Photo caption required; include exact location.

Specs: Uses 4×5 matte color, b&w prints; 35mm, 2¼×2¼, 4×5, 8×10 transparencies.

Making Contact & Terms: Send query letter with tearsheets. Art director will contact photographer for portfolio review if interested. Keeps samples on file. Reports back only if interested; send non-returnable samples. Simultaneous submissions and/or previously published work OK. Pays $250-400 for color cover; $50 maximum for color inside. **Pays on acceptance.** Buys one-time rights. Credit line given.

$▣ CURIO, P.O. Box 522, Bronxville NY 10708-0522. (914)961-8649. E-mail: qenm20b@prodigy.com. Publisher: M. Teresa Lawrence. Circ. 50,000. Estab. 1996. Quarterly consumer magazine. "*Curio* is a quarterly publication that features lively coverage and analysis of arts, politics, health, entertainment and lifestyle issues. The magazine, as a whole, is best described as a salon; a place where people come to exchange ideas." Sample copy for $6. Art guidelines for SASE. "Specific guidelines apply for specific sections in the magazine. Artists are strongly suggested to query with SASE first."

Needs: Buys 50-200 photos/year. Specifically interested in photo-essays. Reviews photos with or without a ms. Model release is required. Photo captions required.

Specs: Accepts images in digital format for Mac on Quark. Send via Zip disk, floppy disk or JAZZ.

Making Contact & Terms: Provide résumé, business card, self-promotion piece or tearsheets to be kept on file for possible future assignments or "send complete 6-page photo layout for review and/or acceptance (color copies of layouts are fine for initial review)." Art director will contact photographer for portfolio review if interested. Portfolio should include b&w and/or color prints, tearsheets, transparencies. Keeps samples on file. Reports in 2 months on queries if interested, send non-returnable samples. Simultaneous submissions and previously published work OK. Pays $140 max for individual photos; $250-500 per photo shoot; $300 flat fee for 6-page photo essay; $50 extra is paid for electronic usage. Pays on publication. Buys first rights, electronic rights. Provides summer and winter photography internships.

Tips: "I want to see variety, passion and edgy attitude in the work."

$▣ ⬚◻ DAKOTA OUTDOORS, P.O. Box 669, Pierre SD 57501. (605)224-7301. Fax: (605)224-9210. E-mail: dakdoor@aol.com. Website: http://www.capjournal.com/dakoutdoors. Managing

Editor: Rachel Engbrecht. Circ. 8,000. Estab. 1978. Monthly magazine. Emphasizes hunting and fishing in the Dakotas. Readers are sportsmen interested in hunting and fishing, ages 35-45. Sample copy free for 9×12 SAE and 3 first-class stamps. Photo guidelines free with SASE.

Needs: Uses 15-20 photos/issue; 8-10 supplied by freelancers. Needs photos of hunting and fishing. Reviews photos with or without ms. Special photo needs include: scenic shots of sportsmen. Model/property release required. Captions preferred.

Specs: Uses 3×5 b&w prints; 35mm b&w transparencies. Accepts images in digital format for Mac. Send via Zip disk as EPS files.

Making Contact & Terms: Query with samples. Keeps samples on file. SASE. Reports in 3 weeks. Pays $20-75/b&w cover; $10-50/b&w inside; payment negotiable. Pays on publication. Usually buys one-time rights; negotiable. Credit line given.

Tips: "We want good quality outdoor shots, good lighting, identifiable faces, etc.—photos shot in the Dakotas. Use some imagination and make your photo help tell a story. Photos with accompanying story are accepted."

$DANCING USA, 10600 University Ave. NW, Minneapolis MN 55448-6166. (612)757-4414. Fax: (612)757-6605. Editor: Patti P. Johnson. Circ. 20,000. Estab. 1982. Bimonthly magazine. Emphasizes romance of ballroom, Latin and swing dance and big bands, techniques, personal relationships, dance music reviews. Readers are male and female, all backgrounds, with ballroom dancing and band interest, age over 45. Sample copy free with 9×12 SAE and 4 first-class stamps.

Needs: Uses 25 photos/issue; 1-3 supplied by freelancers. Prefer action dancing/band photos. Non-dance competitive clothing, showing romance and/or fun of dancing. Model/property release preferred. Captions preferred; include who, what, when, where, how if applicable.

Specs: Uses 4×5 matte color or b&w prints.

Making Contact & Terms: Send unsolicited photos by mail for consideration. Keeps samples on file. SASE. Reports in 1 month. Simultaneous submissions and previously published work OK. Pays $50-100/color cover; $20/color inside; $10/b&w inside; $10-50/photo/text package. Pays on publication. Buys one-time rights. Credit line given.

$ ⑤ ▣ ◯ DAS FENSTER, 1060 Gaines School Rd., B-3, Athens GA 30605. (706)548-4382. Fax: (706)548-8856. Owner/Business Manager: Alex Mazeika. Circ. 18,000. Estab. 1904. Monthly magazine. Emphasizes general topics written in the German language. Readers are German, ages 35 years plus. Sample copy free with SASE.

Needs: Uses 25 photos/issue; 20-25 supplied by freelancers. Needs photos of German scenics, wildlife and travel. Captions preferred.

Specs: Uses 4×5 glossy b&w prints. Accepts images in digital format for Mac. Send via floppy disk or zip disk as TIFF at 266 dpi.

Making Contact & Terms: Send unsolicited photos by mail for consideration. Keeps samples on file. SASE. Reports in 3 weeks. Previously published work OK. Pays $40/b&w page rate. Pays on publication. Buys one-time rights; negotiable. Credit line given.

$ $ DECORATIVE ARTIST'S WORKBOOK, F&W Publications, 1507 Dana Ave., Cincinnati OH 45207. (513)531-2690. Fax: (513)531-2902. E-mail: dawedit@fwpubs.com. Editor: Anne Hevener. Circ. 86,000. Estab. 1987. Bimonthly magazine. "How-to magazine for decorative painters. Includes step-by-step projects for a variety of skill levels." Sample copy for $3. "This magazine uses mostly local photographers who can shoot on location in Cincinnati."

Needs: Buys 3-6 photos/year. Specific location shots of home interiors.

Specs: Uses 2¼×2¼, 4×5 transparencies.

Making Contact & Terms: Provide résumé, business card, self-promotion piece or tearsheets to be kept on file for possible future assignments. Art director will contact photographer for portfolio review if interested. Does not keep samples on file; include SASE for return of material. Pays $250-350/color inside. Credit line given. Buys first rights.

$ $ DEER AND DEER HUNTING, 700 E. State St., Iola WI 54990. (715)445-2214. Editor: Pat Durkin. Distribution 200,000. Estab. 1977. 9 issues/year. Emphasizes white-tailed deer and deer hunting. Readers are "a cross-section of American deer hunters—bow, gun, camera." Sample copy and photo guidelines free with 9×12 SAE with 7 first-class stamps.

Needs: Uses about 25 photos/issue; 20 supplied by freelance photographers. Needs photos of deer in natural settings. Model release and captions preferred.

Making Contact & Terms: Query with résumé of credits and samples. "If we judge your photos as being usable, we like to hold them in our file. It is best to send us duplicates because we may hold the

photo for a lengthy period. Most people send originals—send SASE if you want them returned." Reports in 2 weeks. Simultaneous submissions and previously published work OK. Pays $500/color cover; $50/b&w inside; $75-250/color inside. Pays within 10 days of publication. Buys one-time rights. Credit line given.

Tips: Prefers to see "adequate selection of b&w 8×10 glossy prints and 35mm color transparencies, action shots of whitetail deer only as opposed to portraits. We also need photos of deer hunters in action. We are currently using almost all color—very little b&w. Submit a limited number of quality photos rather than a multitude of marginal photos. Have your name on all entries. Cover shots must have room for masthead."

N $ $ DEFENDERS, 1101 14th St. NW, Suite 1400, Washington DC 20005. (202)682-9400. Fax: (202)682-1331. Editor: James G. Deane. Circ. 210,000. Membership publication of Defenders of Wildlife. Quarterly magazine. Emphasizes wildlife and wildlife habitat. Sample copy free with 9×12½ SAE and 6 first-class stamps. Photo guidelines free with SASE.

Needs: Uses 35 or more photos/issue; "many" from freelancers. Captions required.

Making Contact & Terms: Query with list of stock photo subjects. In portfolio or samples, wants to see "wildlife group action and behavioral shots in preference to static portraits. High technical quality." SASE. Reports ASAP. Pays $75-450/color photo. Pays on publication. Buys one-time rights. Credit line given.

Tips: "*Defenders* focuses heavily on endangered species and destruction of their habitats, wildlife refuges and wildlife management issues, primarily North American, but also some foreign. Images must be sharp. Think twice before submitting anything but low speed (preferably Kodachrome) transparencies."

$ $ ◩ DETECTIVE FILES GROUP, Globe Publishing, 1350 Sherbrooke St. W., Montreal, Quebec H3G 2T4 Canada. (514)849-7733. Fax: (514)849-7730. Editor-in-Chief: Dominick Merle. Circ. 150,000. Bimonthly consumer magazines of factual detective articles for a general audience. Sample copy free for SAE with IRCs. Art guidelines available.

Needs: Buys 50-80 cover shots. Needs photos of models in crime scenes. Reviews photos with or without ms. Model release required.

Specs: Uses 2¼×2¼ transparencies.

Making Contact & Terms: Send query letter with samples. Reports in 2 weeks on queries; 6 weeks on samples. Pays $200 minimum for color cover. **Pays on acceptance.** Buys all rights. Credit line not given.

N $ ⊕ ▣ ◪ DIGITAL PHOTOFX, Emap Active, Apex House, Oundle Rd., Peterborough PE2 9NP England. (44)1733 898100. Fax: (44)1733 894472. E-mail: dpfx@ecm.emap.com. Circ. 20,000. Estab. 1998. Bimonthly consumer magazine. "The practical guide to creative digital imaging for anyone with a camera who wants to use a computer to enhance pictures or computer users who want to learn photo manipulation techniques."

Needs: Needs photos of any subject providing it has been digitally manipulated. Reviews photos with or without a ms. Model and property release preferred. Photo caption preferred.

Specs: Uses up to 8×10, glossy, color, b&w prints; 35mm, 2¼×2¼ transparencies. Accepts images in digital format for Mac and Windows. Send via CD, floppy disk, Zip, e-mail, ISDN 0044 1733 551117 as TIFF, JPEG files at 300 dpi.

Making Contact & Terms: Send query letter with résumé, slides, prints, photocopies, tearsheets or transparencies. Provide SAE for eventual return. Reports within 1 month on queries. Pays £50-150 for color cover; £10-50 for color inside. Pays on publication. Credit line given. Buys first rights.

Tips: "Read magazine—check type of images we use and send a sample of images you think would be suitable. The broader your style the better for general acceptance, while individual styles appeal to our portfolio section. Supply a contact sheet or thumbnail of all the images supplied in electronic form to make it easier for us to make a quick decision on the work."

$ $ DIRT RAG, AKA Productions, 3483 Saxonburg Rd., Pittsburgh PA 15238. (412)767-9910. Fax: (412)767-9920. E-mail: artdirector@dirtragmag.com. Website: http://www.dirtragmag.com. Art Director: Tom Mitchell. Circ. 32,000. Estab. 1989. Published every 6 weeks from February-November. "Mountain bike lifestyle magazine. Focus is the sport of mountain biking, but we do also cover music, beer, movies and books." Sample copies and art guidelines are available with SAE and first-class postage.

Needs: Buys 6 photos from freelancers/issue; 42 photos/year. Needs photos of mountain biking. Reviews photos with or without ms. Special photo needs include 4-color cover shots. Model release required. Photo caption preferred.

Making Contact & Terms: "Send in what you have and we'll take a look." Keeps samples on file; include SASE for return of material. Reports back only if interested. Simultaneous submissions and/or

previously published work OK. Pays $350 minimum for color cover; $25-100 for b&w or color inside. Pays on publication. Buys one-time rights. Credit line given.

Tips: "Check out our magazine. It's different. We try and have a certain style. A little off center. Leave space for the logo in upper left corner on cover shots. We stay away from rad, extreme stuff."

N **$** **$** **DIRT RIDER**, 6420 Wilshire Blvd., Los Angeles CA 90048-5515. (323)782-2390. Fax: (323)782-2372. Editor: Ken Faught. Moto Editor: Scott Hoffman. Circ. 185,000. Estab. 1982. Monthly magazine. Covers off-road motorcycles, specializing in product tests, race coverage and rider interviews. Readers are predominantly male blue-collar/white-collar, between the ages of 20-35 who are active in motorcycling. Sample copy $3.50.

Needs: Uses 125 photos/issue; 40 supplied by freelancers. "We need everything: technical photos, race coverage and personality profiles. Most subject matter is assigned. Any photo aside from race coverage or interview needs a release." Captions preferred.

Making Contact & Terms: Phone Ken Faught. Keeps samples on file. Cannot return material. Reports in 2 weeks. Simultaneous submissions OK. Pays $200/color cover; $200/b&w cover; $50/color inside; $25/b&w inside; $50/color page rate; $25/b&w page rate. Pays on publication. Credit line given.

Tips: "Familiarize yourself with *Dirt Rider* before submitting photos for review or making initial contact. Pay strict attention to deadlines."

$ **$** **DIVERSION MAGAZINE**, 1790 Broadway, 6th Floor, New York NY 10019. (212)969-7542. Fax: (212)969-7557. E-mail: creutzphoto@yahoo.com. Photo Editor: Christina Creutz. Circ. 176,000. Monthly magazine. Emphasizes travel. Readers are doctors/physicians. Sample copy free with SASE.

Needs: Uses varying number of photos/issue; all supplied by freelancers. Needs a variety of subjects, "mostly worldwide travel, hotels, resorts, cruises, restaurants and people." Also considers landscapes/ scenics, wildlife, architecture, gardening, adventure, automobiles, events, food/drink, hobbies, performing arts, sports, still life. Captions preferred; include precise locations.

Making Contact & Terms: Query with list of stock photo subjects. Keeps samples on file. SASE. Reports in 3 weeks. Simultaneous submissions and/or previously published work OK. Pays $350-700 for color cover; $135-200 for color inside; $200-250/day. Pays on publication. Buys one-time rights. Credit line given.

Tips: "Send updated stock list and photo samples regularly. Call to schedule appointment, then drop-off portfolio."

N **$** **A** **DODGE CITY JOURNAL**, Motherloaf Productions, P.O. Box 420375, San Francisco CA 94142. (415)273-5156. E-mail: dodgecityj@aol.com. Editors/Publishers: Stephanie Ray and Andrew Wagner. Circ. 5,000. Estab. 1995. Quarterly consumer magazine featuring urban documentary. Sample copies available for $3.50 and SAE with first-class postage.

Needs: Buys 30 photos from freelancers per issue; 100 photos per year. Needs photos of architecture, cities/urban, documentary. Reviews photos with or without a ms. Model and property release preferred. Photo caption preferred.

Specs: Uses 3×5, matte, b&w prints; 2¼×2¼ transparencies. Accepts images in digital format for Mac. Send via CD, Zip as TIFF files at 300 dpi.

Making Contact & Terms: Send query letter with résumé, prints, photocopies, tearsheets. Provide résumé, business card, self-promotion piece to be kept on file for possible future assignments. Reports in 2 months on queries. Reports back only if interested, send nonreturnable samples. Pays on publication. Credit line given. Buys one-time rights.

Tips: "Definitely read magazine for concept. Photographers must be willing to travel. We are less inclined to publish work that was not contracted specifically by us. There are, of course, exceptions. When contacting us, photographer should explain why they are interested in working for dodge."

$ **DOG & KENNEL**, 7-L Dundas Circle, Greensboro NC 27407. (336)292-4047. Fax: (336)292-4272. Executive Editor: Rita Davis. Bimonthly magazine about dogs. "Articles include breed profiles, stories about special dogs, dogs in art and popular culture, etc." Sample copy for $5 and 9×12 SASE. Photo guidelines free with SASE.

Needs: Photos of dogs, posed, candid and interacting with other dogs and people. Captions required,

include the breed name and additional descriptions as needed.

Specs: Transparencies or slides preferred. Glossy prints acceptable.

Making Contact & Terms: Send unsolicited photos by mail for consideration, "but please include SASE if you want them returned. Please send duplicates. We cannot assume liability for unsolicited originals." Reports in 2 months. Pays $150-250/color cover; $25-50/color inside. Pays on publication. Buys all rights, negotiable.

Tips: "We seek good composition (indoor or outdoor). Photos must be professional and of publication quality—good focus and contrast. We work regularly with a few excellent freelancers, but are always seeking new contributors. Images we think we might be able to use will be scanned into our CD-ROM file and the originals returned to the photographer."

N $ $⊘ DOG FANCY, P.O. Box 6050, Mission Viejo CA 92690. Website: http://www.dogfancy.c om. Editor: Betty Liddick. Circ. 270,000. Estab. 1970. Monthly. Readers are "men and women of all ages interested in all phases of dog ownership." Sample copy $5.50; photo guidelines available with SASE.

Needs: Uses 20-30 photos/issue, 100% supplied from freelance stock. Specific breed featured in each issue. Prefers "photographs that show the various physical and mental attributes of the breed. Include both environmental and portrait-type photographs. Dogs must be well groomed and, if purebred, good examples of their breed. By good example, we mean a dog that has achieved some recognition on the show circuit and is owned by a serious breeder or exhibitor. We also have a major need for good-quality, interesting photographs of any breed or mixed breed in any and all canine situations (dogs with veterinarians; dogs eating, drinking, playing, swimming, etc.) for use with feature articles." Model release required. Captions preferred (include dog's name and breed and owner's name and address).

Making Contact & Terms: Send by mail for consideration actual 35mm or 2¼×2¼ color transparencies. Address submission to "Photo Editors." Present a professional package: 35mm slides in sleeves, labeled, numbered or otherwise identified; a run sheet listing dog's name, titles (if any) and owner's name; and a return envelope of the appropriate size with the correct amount of postage. Reports in 6 weeks. Pays $200 for color cover; $50-75 for color inside; $200 for 4-color centerspreads. Buys first North American print rights and non-exclusive rights to use in electronic media. Credit line given.

Tips: "Nothing but sharp, high contrast shots. Send SASE for list of photography needs. We're looking more and more for good quality photo/text packages that present an interesting subject both editorially and visually. Bad writing can be fixed, but we can't do a thing with bad photos. Subjects should be in interesting poses or settings with good lighting, good backgrounds and foregrounds, etc. We are very concerned with sharpness and reproducibility; the best shot in the world won't work if it's fuzzy, and it's amazing how many are. Submit a variety of subjects—there's always a chance we'll find something special we like." Send a professional package of sharp, well-lit, 35mm or 2¼×2¼ color transparencies to our editorial offices: *Dog Fancy* magazine, photo department, 3 Burroughs, Irvine CA 92618.

N DOLL READER, Primedia, 6405 Flank Dr., Harrisburg PA 17112. (717)540-6656. Fax: (717)540-6169. Editor: Deborah Thompson. Estab. 1972. Magazine published 9 times/year. Emphasizes doll collecting. Photo guidelines free with SASE.

Needs: Buys 100-250 photos/year; 50 photos/year supplied by freelancers. "We need photos of specific dolls to accompany our articles." Model/property release required. Captions required; include name of object, height, medium, edition size, costume and accessory description; name, address, telephone number of artist or manufacturer; price.

Specs: Uses 3½×5 glossy color prints; 35mm, 2¼×2¼, 4×5 transparencies. Transparencies are preferred.

Making Contact & Terms: Query with stock list and samples. Provide résumé, business card, brochure, flier or tearsheets to be kept on file for possible assignments. Submit portfolio for review. Keeps samples on file. SASE. Reports in 1 month. Simultaneous submissions OK. Payment negotiable. "If photos are accepted, we pay on receipt of invoice." Buys one-time rights. Credit line given.

$ $ THE DOLPHIN LOG, Box 112, 61 E. Eighth St., New York NY 10003. (212)673-9097. Fax: (212)673-9183. E-mail: cousteauny@aol.com. Editor: Lisa Rao. Circ. 80,000. Estab. 1981. Publication of The Cousteau Society, Inc., a nonprofit organization. Bimonthly magazine. Emphasizes "ocean and water-related subject matter for children ages 8 to 12." Sample copy $2.50 with 9×12 SAE and 3 first-class stamps. Photo guidelines free with SASE.

Needs: Uses about 20 photos/issue; 2-6 supplied by freelancers; 10% stock. Needs "selections of images of individual creatures or subjects, such as architects and builders of the sea, how sea animals eat, the smallest and largest things in the sea, the different forms of tails in sea animals, resemblances of sea creatures to other things. Also excellent potential for cover shots or images which elicit curiosity, humor or interest." No aquarium shots. Model release required if person is recognizable. Captions preferred,

include when, where and, if possible, scientifically accurate identification of animal.

Making Contact & Terms: Query with samples or list of stock photos. Send 35mm, 4×5 transparencies or b&w contact sheets by mail for consideration. Send duplicates only. SASE. Reports in 1 month. Simultaneous and previously published submissions OK. Pays $50-200/color photo. Pays on publication. Buys one-time rights and worldwide translation rights. Credit line given.

Tips: Prefers to see "rich color, sharp focus and interesting action of water-related subjects" in samples. "No assignments are made. A large amount is staff-shot. However, we use a fair amount of freelance photography, usually pulled from our files, approximately 45-50%. Stock photos purchased only when an author's sources are insufficient or we have need for a shot not in file. These are most often hard-to-find creatures of the sea." To break in, "send a good submission of dupes in keeping with our magazine's tone/content; be flexible in allowing us to hold slides for consideration."

$ DOUBLETAKE MAGAZINE. (This magazine is in the process of moving to Boston.) (919)660-3669. Fax: (919)660-3668. E-mail: dtmag@aol.com. Website: http://www.duke.edu/doubletake/. Assistant Photo Editor: Rebecca Cheatham. Circ. 65,000. Estab. 1995. Quarterly magazine covering all writing (fiction, nonfiction and poetry) and photography, mostly documentary. General interest, 18 and over. Sample copy for $12. Photo guidelines free with SASE.

Needs: Uses photos on approximately half of the pages (50+ pages/issue); 95% supplied by freelancers. Needs completed photo essays. "We also accept works in progress. We are interested in work that is in the broad photo-journalistic/humanistic tradition." Model release preferred for children. Captions preferred.

Making Contact & Terms: Send SASE for guidelines. "We prefer to review 35mm copy slides, no more than 40. We have an ongoing review process. We do not keep samples from every photographer." SASE. Reports in up to 10 weeks usually (varies). Simultaneous submissions OK. Pays $250/full published page; $125/half page; etc. Minimum is $75. **Pays on acceptance.** Buys first North American serial rights. Credit line given.

$ ⊕ DRIVING MAGAZINE, Safety House, Beddington Farm Rd., Croydon CR0 4XZ United Kingdom. Phone: (44)181 665 5151. Fax: (44)181 665 5565. E-mail: driving@atlas.co.uk. Estab. 1979. Monthly magazine.

Needs: Buys 6 photos from freelancers/issue. Needs photos with "road safety themes—serious accidents but . . . humorous pix of traffic signs etc." Reviews photos with or without ms. Property release preferred. Photo caption preferred.

Specs: Uses color prints.

Making Contact & Terms: Provide résumé, business card, self-promotion piece or tearsheets to be kept on file for possible future assignments. Keeps samples on file; cannot return material. Simultaneous submissions OK. Pays £10 minimum for color inside. Pays on publication. Buys one-time rights.

Tips: "Put your name and address on back of all submitted material."

$ $ DUCKS UNLIMITED, One Waterfowl Way, Memphis TN 38120. (901)758-3825. Managing Editor: Doug Barnes. Circ. 580,000. Estab. 1937. Association publication of Ducks Unlimited, a nonprofit organization. Bimonthly magazine. Emphasizes waterfowl hunting and conservation. Readers are professional males, ages 40-50. Sample copy $3. Guidelines free with SASE.

Needs: Uses approximately 140 photos/issue; 60% supplied by freelance photographers. Needs images of wild ducks and geese, waterfowling and scenic wetlands. Special photo needs include dynamic shots of waterfowl interacting in natural habitat.

Making Contact & Terms: Send only top quality portfolio of not more than 40 35mm or larger transparencies for consideration. SASE. Reports in 1 month. Previously published work OK, if noted. Pays $100 for images less than half page; $125/half page; $150/full page; $225/2-page spread; $400/cover. **Pays on acceptance.** Buys one-time rights plus permission to reprint in our Mexican and Canadian publications. Credit line given.

$ $ ◉ E MAGAZINE, 28 Knight St., Norwalk CT 06851. (203)854-5559. Fax: (203)866-0602. E-mail: trembert@emagazine.com. Photo Editor: Tracey Rembert. Circ. 50,000. Estab. 1990. Nonprofit consumer magazine. Emphasizes environmental issues. Readers are environmental activists; people concerned about the environment. Sample copy for 9×12 SAE and $5. Photo guidelines free with SASE.

Needs: Uses 42 photos/issue; 55% supplied by freelancers. Needs photos of threatened landscapes, environmental leaders, people and the environment, pollution, transportation, energy, wildlife and activism. Photo captions required: location, identities of people in photograph, date, action in photograph.

Making Contact & Terms: Query with résumé of credits and list of stock photo subjects. Keeps printed samples on file. Reports in 6 weeks. Simultaneous submissions and previously published work OK. Pays

up to $125/¼ page; up to $150/½ page; up to $175/full page; up to $300/cover. Pays several weeks after publication. Buys print and web version rights. Credit line given.

Tips: Wants to see "straightforward, journalistic images. Abstract or art photography or landscape photography is not used." In addition, "please do not send manuscripts with photographs. These can be addressed as queries to the managing editor."

N $ $ $ $ EASYRIDERS MAGAZINE, Dept. PM, P.O. Box 3000, Agoura Hills CA 91376-3000. (818)889-8740. Fax: (818)889-1252. Editorial Director: Keith R. Ball. Estab. 1971. Monthly. Emphasizes "motorcycles (Harley-Davidsons in particular), motorcycle women, bikers having fun." Readers are "adult men who own, or desire to own, custom motorcycles—the individualist—a rugged guy who enjoys riding a custom motorcycle and all the good times derived from it." Free sample copy. Photo guidelines free with SASE.

Needs: Uses about 60 photos/issue; "the majority" supplied by freelance photographers; 70% assigned. Needs photos of "motorcycle riding (rugged chopper riders), motorcycle women, good times had by bikers, etc." Model release required. Also interested in technical articles relating to Harley-Davidsons.

Making Contact & Terms: Send b&w prints, color prints, 35mm transparencies by mail for consideration. SASE. Call for appointment for portfolio review. Reports in 3 months. Pays $30-100/b&w photo; $40-250/color photo; $30-2,500/complete package. Other terms for bike features with models to satisfaction of editors. Pays 30 days after publication. Buys all rights. Credit line given. All material must be exclusive.

Tips: Trend is toward "more action photos, bikes being photographed by photographers on bikes to create a feeling of motion." In samples, wants photos "clear, in-focus, eye-catching and showing some emotion. Read magazine before making submissions. Be critical of your own work. Check for sharpness. Also, label photos/slides clearly with name and address."

$ $ THE ELKS MAGAZINE, 425 W. Diversey Pkwy., Chicago IL 60614-6196. (773)528-4500. E-mail: elksmag@elks.org. Website: http://www.elksmag.com. Associate Editor: Peter Milne. Circ. 1.2 million. Estab. 1922. Monthly magazine whose mission is to provide news of Elks to all 1.2 million members. "In addition, we have general interest articles. Themes: Americana; history; wholesome, family info; sports; industries; adventure. We do not cover religion, politics, controversial issues." Sample copy free.

Needs: Buys 1 photo from freelancers/issue; 7 photos/year. Needs photos of nature—for covers only. Reviews photos with or without ms. Photo caption required; include facts only: Location of photo.

Specs: Uses 35mm, 2¼ × 2¼, 4 × 5, 8 × 10 transparencies.

Making Contact & Terms: Send query letter with samples, brochure. Does not keep samples on file. Reports in 6-8 weeks on queries. Simultaneous submissions OK. Pays $450-500 for color cover. **Pays on acceptance.** Buys one-time rights. Credit line given.

Tips: "Just send your slides of nature (landscape or rural scenes, woodland animals). We will review them as soon as possible and return those we don't purchase. Artistry and technical excellence are as important as subject matter."

$ S ⊘ ENERGY TIMES, 548 Broad Hollow Rd., Melville NY 11747. (516)777-7773. Fax: (516)755-1064. Art Director: Ed Canavan. Circ. 600,000. Estab. 1992. Published 10 times/year. Emphasizes health food industry. Readers are 72% female, 28% male, average age 42.3, interested in supplements and alternative health care, exercise 3.2 times per week. Sample copy $1.25.

Needs: Uses 25 photos/issue; 5 supplied by freelancers. Needs photos of herbs, natural lifestyle, food. Model/property release required. Captions preferred.

Making Contact & Terms: Provide résumé, business card, brochure, flier or tearsheets to be kept on file for possible assignments. Keeps samples on file. SASE. Reports in 2 weeks. Previously published work OK. Pays $275/color cover; $85/color inside; "inside rates negotiable based on size." Pays on publication. Rights negotiable.

Tips: "Photos must clearly illustrate the editorial context. Photos showing personal energy are highly regarded. Sharp, high-contrast photos are the best to work with. Bright but non-tacky colors will add vibrance to a publication. When shooting people, the emotion captured in the subject's expression is often as important as the composition."

$ $ ▣ ENTREPRENEUR, Dept. PM, 2392 Morse Ave., Irvine CA 92614. (949)261-2325. E-mail: rricardo@entrepreneurmag.com. Website: http://www.entrepreneurmag.com. Photo Editor: Rachelle Ricardo. Publisher: Lee Jones. Editor: Rieva Lesonsky. Design Director: Richard R. Olson. Circ. 435,000. Estab. 1977. Monthly. Emphasizes business. Readers are existing and aspiring small business owners.

Needs: Uses about 30 photos/issue; many supplied by freelance photographers; 60% on assignment; 40% from stock. Needs "people at work: home office, business situations. I want to see colorful shots in all formats and styles." Model/property release preferred. Captions required; include names of subjects.

Specs: Accepts images in digital format for Mac. Send via compact, Zip or floppy disk, SyQuest or online (300 dpi).

Making Contact & Terms: Arrange a personal interview to show portfolio or query with samples or list of stock photo subjects. Provide résumé, business card, brochure, flier or tearsheets to be kept on file for possible future assignments; "follow-up for response." Pays $75-200/b&w photo; $250-350/color photo; $125-225/color stock. Pays "depending on photo shoot, per hour or per day. We pay $350 per day plus up to $250 for expenses for assignments." Pays on publication. Buys one-time rights; negotiable. Credit line given.

Tips: "I am looking for photographers who use the environment creatively; I do not like blank walls for backgrounds. Lighting is also important. I prefer medium format for most shoots. I think photographers are going back to the basics—a good clean shot, different angles and bright colors. I am extremely tired of a lot of motion-blurred effect with gelled lighting. I prefer examples of your work—promo cards and tearsheets along with business cards and résumés. Portfolios are always welcome."

N $ $ S ▣ ◎ ENVIRONMENT, Dept. PM, 1319 18th St. NW, Washington DC 20036. (202)296-6267. Fax: (202)296-5149. Editor: Barbara T. Richman. Editorial Assistant: Catherine Feeny. Circ. 7,500. Estab. 1958. Magazine published 10 times/year. Covers science and science policy from a national, international and global perspective. "We cover a wide range of environmental topics—acid rain, tropical deforestation, nuclear winter, hazardous waste disposal, energy topics and environmental legislation." Readers include libraries, colleges and universities and professionals in the field of environmental science and policy. Sample copy $8.

Needs: Uses 15 photos/issue; varying number supplied by freelance photographers; 90% comes from stock. "Our needs vary greatly from issue to issue—but we are always looking for good photos showing human impact on the environment worldwide—industrial sites, cities, alternative energy sources, pesticide use, disasters, third world growth, hazardous wastes, sustainable agriculture and pollution. Interesting and unusual landscapes, wildlife, science and technology are also needed." Model release required. Captions required, include location and subject.

Specs: Accepts images in digital format for Mac. Send via Zip, e-mail as TIFF, JPEG files at 300 dpi.

Making Contact & Terms: Query with list of stock photo subjects. Provide business card, brochure, flier or tearsheets to be kept on file for possible future assignments. Simultaneous submissions and previously published work OK. Pays $50-300/b&w photo; $50-500/color photo; $250-400/color cover. Pays on publication. Buys one-time rights. Credit line given.

Tips: "We are looking for international subject matter—especially environmental conditions in developing countries. Provide us with a stock list, and if you are going someplace specific to shoot photos let us know. Look for requests in photo reports like *Guilfoyle* to see if you have what we are looking for at the moment."

$ ⊕ ▣ EOS MAGAZINE, Robert Scott Associates, The Old Barn, Ball Lane, Tackley, Kidlington, Oxfordshire OX5 3AG United Kingdom. Phone: (+44)(0)1869 331741. Fax: (+44)(0)1869 331641. E-mail: robert.scott@eos-magazine.com. Website: http://www.eos-magazine.com. Publisher: Robert Scott. Circ. 18,400. Estab. 1993. Quarterly consumer magazine for all users of Canon EOS cameras. Art guidelines free.

Needs: Buys 100 photos from freelancers/issue; 400 photos/year. Needs photos showing use of or techniques possible with EOS cameras and accessories. Reviews photos with or without ms. Model release preferred. Photo caption required; include technical details of photo equipment and techniques used.

Specs: Uses 8×10 glossy color and b&w prints; 35mm transparencies. Accepts images in digital format.

Making Contact & Terms: Send query letter with samples. Keeps samples on file; include SASE for return of material. Reports in 1 week on queries; 2 weeks on samples. Simultaneous submissions and/or previously published work OK. Pays $75 for color cover; $15-45 for b&w or color inside. Pays extra for electronic usage of photos. Pays on publication. Buys one-time rights. Credit line given.

Tips: "Request our 'Notes for Contributors' leaflet."

N $ ✦ EVENT, Douglas College, Box 2503, New Westminster, British Columbia V3L 5B2 Canada. (604)527-5293. Fax: (604)527-5095. Editor: Calvin Wharton. Visuals Editor: Chris Dixon. Circ. 1,000. Magazine published every 4 months. Emphasizes literature (short stories, reviews, poetry). Sample copy $5.

Needs: Buys 3 photos/year intended for cover art. Documentary, fine art, human interest, nature, special effects/experimental, still life and travel. Wants any "nonapplied" photography, or photography not intended for conventional commercial purposes. Needs excellent quality. Must be a series. "No unoriginal, commonplace or hackneyed work."

Specs: Uses 8×10 color or b&w prints. Any smooth finish OK. Vertical format preferred for cover.

Making Contact & Terms: Send material by mail for consideration. SAE and IRC or Canadian stamps.

Simultaneous submissions OK. Pays $100 on publication. Buys one-time rights. Credit line given.
Tips: "We prefer work that appears as a sequence: thematically, chronologically, stylistically. Individual items will only be selected for publication if such a sequence can be developed. Photos should preferably be composed for vertical, small format (6×9)."

$FACES: The Magazine About People, Cobblestone Publishing Inc., 30 Grove St., Peterborough NH 03458. (603)924-7209. Fax: (603)924-7380. Editor: Elizabeth Crooker. Circ. 13,500. Estab. 1984. 9 issues/year, September-May. Emphasizes cultural anthropology for young people ages 8-14. Sample copy $4.95 with 8×11 SASE and 5 first-class stamps. Photo guidelines free with SASE.
Needs: Uses about 30-35 photos/issue; about 75% supplied by freelancers. "Photos (color) for text must relate to themes; cover photos (color) should also relate to themes." Send SASE for themes. Photos purchased with or without accompanying ms. Model release preferred. Captions preferred.
Making Contact & Terms: Query with stock photo list and/or samples. SASE. Reports in 1 month. Simultaneous submissions and previously published work OK. Pays $25-100/inside use; cover (color) photos negotiated. Pays on publication. Buys one-time rights. Credit line given.
Tips: "Photographers should request our theme list. Most of the photographs we use are of people from other cultures. We look for an ability to capture people in action—at work or play. We primarily need photos showing people, young and old, taking part in ceremonies, rituals, customs and with artifacts and architecture particular to a given culture. Appropriate scenics and animal pictures are also needed. All submissions must relate to a specific future theme."

$☉ FAMILY MOTOR COACHING, 8291 Clough Pike, Cincinnati OH 45244. (513)474-3622. Fax: (513)388-5286. E-mail: magazine@fmca.com. Website: http://www.fmca.com. Editor: Robbin Gould. Circ. 125,000. Estab. 1963. Publication of Family Motor Coach Association. Monthly. Emphasizes motor homes. Readers are members of national association of motor home owners. Sample copy $2.50. Writer's/photographer's guidelines free with SASE.
Needs: Uses about 50-60 photos/issue; 45-50 supplied by freelance photographers. Each issue includes varied subject matter—primarily needs travel with scenic shots, couples, families, senior citizens, hobbies and how-to material. Photos purchased with accompanying ms only. Model release preferred. Captions required.
Specs: Accepts images in digital format for Mac. Send via floppy disk SyQuest, Zip, JAZ as EPS, TIFF files at 300 dpi.
Making Contact & Terms: Query with résumé of credits. Submit samples, contact sheets, résumé. SASE. Reports in 3 months. Pays $100 for color cover; $25-100 for b&w and color inside. $125-500/text/ photo package. **Pays on acceptance.** Prefers first North American rights, but will consider one-time rights on photos *only*. Credit line given if requested.

$▣ FAMILY PUBLISHING GROUP, INC., 141 Halstead Ave., Mamaroneck NY 10543. (914)381-7474. Fax: (914)381-7672. E-mail: editor@familygroup.com. Senior Editor: Betsy F. Woolf. Circ. 155,000. Estab. 1986. Monthly magazine. Emphasizes parenting. Readers are women, ages 25-50. Sample copy $3.50 with 8½×11 SASE.
 ● This publisher produces *New York Family, Westchester Family, Connecticut Family, Baby Guide* and *Can't Live Without It.*
Needs: Uses 10 photos/issue; 3-5 supplied by freelancers. Needs photos of children, families. Model release required. Photographers need to identify subjects on occasion, but rarely need captions.
Specs: Uses 5×7 matte or glossy color and b&w prints. Accepts images in digital format for Mac on floppy disk.
Making Contact & Terms: Query with stock photo list. Provide résumé, business card, brochure, flier or tearsheets to be kept on file for possible assignments. Reporting time varies. Pays $40-60/color inside; $25-40/b&w inside. Pays on publication. Buys one-time rights with exclusivity for 2 years within readership area; negotiable. Credit line given.

$▨ ▣ FARM & COUNTRY, 1 Yonge St., Suite 1504, Toronto, Ontario M5E 1E5 Canada. (416)364-5324. Fax: (416)364-5857. E-mail: agpub@inforamp.net. Website: http://www.agpub.on.ca. Editor: Richard Charteris. Circ. 45,000. Estab. 1935. Magazine published 24 times/year. Emphasizes agriculture. Readers are farmers, ages 20-70. Sample copy free with SASE. Photo guidelines available.
Needs: Uses 50 photos/issue; 5 supplied by freelancers. Needs photos of farm livestock, farmers farming, farm activities. *No rural scenes.* Special photo needs include food processing, shoppers, rural development, trade, politics. Captions preferred; include subject name, location, description of activity, date.
Specs: Uses 2¼×2¼ transparencies. Also accepts images in digital format for Mac. Send via e-mail, floppy disk, SyQuest (266 dpi).

Making Contact & Terms: Submit portfolio for review. Query with résumé of credits, stock photo list. Send unsolicited photos by mail for consideration. Provide résumé, business card, brochure, flier or tearsheets to be kept on file for possible assignments. Keeps samples on file. SASE. Reports in 1 month. Previously published work OK. Pays $30-50/b&w photo; $50-100/color photo; $20-40/hour; $150-350/ job. Pays on publication. Buys all rights; negotiable.

Tips: Looking for "action, color, imaginative angles, vertical. Be able to offer wide range of color—on disk, if possible."

$ ▣ ◎ FARM & RANCH LIVING, 5400 S. 60th St., Greendale WI 53129. (414)423-0100. Fax: (414)423-8463. Website: http://www.reimanpub.com. Associate Editor: Trudi Bellin. Estab. 1978. Bi-monthly magazine. "Concentrates on farming and ranching as a way of life." Readers are full-time farmers and ranchers. Sample copy $2. Photo guidelines free with SASE.

Needs: Uses about 130 photos/issue; about 25% from freelance stock; 45% assigned. Needs agricultural, country folks, senior citizens, couples, families, landscapes/scenics, gardening, rural, travel, agriculture and scenic photos. "If model or property releases are in question, don't send the photos." Captions should include season, location.

Specs: Uses color transparencies, all sizes. Accepts images in digital format for Mac. Send via e-mail at 800 dpi.

Making Contact & Terms: Query with samples or list of stock photo subjects. SASE. "We only want to see one season at a time; we work one season in advance." Reports within 3 months. Previously published work OK. Pays $300/color cover; $150/b&w cover; $300/color inside; $100/b&w inside; $150/color page (full-page bleed). Pays on publication. Buys one-time rights.

Tips: "Technical quality is extremely important. Colors must be vivid so they pop off the page. Study our magazines thoroughly. We have a continuing need for sharp, colorful images. Those who supply what we need can expect to be regular contributors. Don't call."

$ ⒮ ◯ FELLOWSHIP, Box 271, Nyack NY 10960. (914)358-4601. Fax: (914)358-4924. Editor. Richard Deats. Circ. 8,500. Estab. 1935. Publication of the Fellowship of Reconciliation. Publishes 32-page b&w magazine 6 times/year. Emphasizes peace-making, social justice, nonviolent social change. Readers are people interested in peace, justice, nonviolence and spirituality. Sample copy for $1.35 and 8½×11 SAE.

Needs: Uses 8-10 photos/issue; 90% supplied by freelancers. Needs stock photos of people, civil disobedience, demonstrations—Middle East, Latin America, Caribbean, prisons, anti-nuclear, children, farm crisis, gay/lesbian, the former Soviet Union. Also natural beauty, scenic, disasters, environment, wildlife, religious, humor, fine art; b&w only. Captions required.

Making Contact & Terms: Provide résumé, business card, brochure, flier or tearsheets to be kept on file for possible future assignments. "Call on specs." SASE. Reports in 3 weeks. Simultaneous submissions and/or previously published work OK. Pays $30/b&w cover; $15/b&w inside. Pays on publication. Buys one-time rights. Credit line given.

Tips: "You must want to make a contribution to peace movements. Money is simply token."

🌐 ▣ THE FIELD, Room 2115, Kings Reach Tower, Strattford St., London SEI 9LS United Kingdom. (44171)261-6237. Fax: (44171)261-5358. Website: http://www.thefield.co.uk. Art Editor: Rebecca Hawtrey. Circ. 31,000. Estab. 1853. Monthly consumer magazine. "Oldest country magazine in England; full color/gloss." Sample copy free. Art guidelines free.

Needs: Needs landscapes/scenics, wildlife, gardening, sports, travel, agriculture, portraits, fine art, seasonal. Reviews photos with or without a ms. Model release required; property release preferred. Photo captions required; include full name of either animal, person or location and date.

Specs: Accepts images in digital format. Send via CD as TIFF, EPS, PICT files.

Making Contact & Terms: Send query letter with samples. Provide résumé, business card, self-promotion piece or tearsheets to be kept on file for possible future assignments. To show portfolio, photographer should follow-up with call. Keeps samples on file. Reports back only if interested, send non-returnable samples. Simultaneous submissions OK. Pays day rate on publication. Buys first rights. Credit line given.

Tips: "Read our magazine. Any submission needs to be appropriate. Query with color copies of work. No originals."

Ⓝ FIGURINES & COLLECTIBLES, Scott Adv. and Publishing, 30595 Eight Mile, Livonia MI 48152. (248)477-6650. Fax: (248)477-6795. Managing Editor: Ruth Keessen. Estab. 1994. Bimonthly magazine. Emphasizes figurine collecting.

Needs: Photos of figurines. Model/property release required. Captions required; include name of object,

© 1998 Nancy Dundatscheck

Nancy Dundatscheck's winter coastal scene reflects the "spiritual style" of her work and of *Fellowship* magazine. Dundatscheck worked for the magazine as a freelance editor and was asked to submit a selection of her photos to be kept on file. Art director Sally Savage contacted the photographer for permission to use this image on the magazine's January/February 1998 cover. Dundatscheck says she is grateful to Savage for her faith in her work.

height, medium, edition size and accessory description, name, address, telephone number of artist or manufacturer; price.

Specs: Uses 3½×5 glossy color prints; 35mm, 2¼×2¼, 4×5 transparencies. Transparencies are preferred.

Making Contact & Terms: Query with stock photo list and samples. Provide résumé, business card, brochure, flier or tearsheets to be kept on file for possible assignments. Submit portfolio for review. Keeps samples on file. SASE. Reports in 1 month. Simultaneous submissions OK. Payment negotiable. "If photos are accepted, we pay on receipt of invoice." Buys all rights. Credit line given.

$ [S] [◎] FINESCALE MODELER, 21027 Crossroads Circle, P.O. Box 1612, Waukesha WI 53187-1612. (414)796-8776. Fax: (414)796-1383. E-mail: editor@finescale.com. Website: http://www.finescale.com. Editor: Terry Thompson. Circ. 80,000. Published 10 times/year. Emphasizes "how-to-do-it information for hobbyists who build nonoperating scale models." Readers are "adult and juvenile hobbyists who build nonoperating model aircraft, ships, tanks and military vehicles, cars and figures." Sample copy $3.95. Photo guidelines free with SASE.

Needs: Uses more than 50 photos/issue; "anticipates using" 10 supplied by freelance photographers. Needs "in-progress how-to photos illustrating a specific modeling technique; photos of full-size aircraft, cars, trucks, tanks and ships." Model release required. Captions required.

Making Contact & Terms: Provide résumé, business card, brochure, flier or tearsheets to be kept on file for possible future assignments. "Phone calls are OK." Reports in 2 months. "Will sometimes accept previously published work if copyright is clear." Pays $25 minimum/color cover; $8 minimum inside; $40/page; $50-500 for text/photo package. **Pays for photos on publication, for text/photo package on acceptance.** Buys all rights. Credit line given.

Tips: Looking for "sharp contrast prints or slides of model aircraft, ships, cars, trucks, tanks, figures, and science-fiction subjects. In addition to photographic talent, must have comprehensive knowledge of objects photographed and provide complete caption material. Freelance photographers should provide a catalog stating subject, date, place, format, conditions of sale and desired credit line before attempting to sell us photos. We're most likely to purchase color photos of outstanding models of all types for our regular feature, 'Showcase.' "

$ FIRST HAND LTD., P.O. Box 1314, Teaneck NJ 07666. (201)836-9177. Fax: (201)836-5055. E-mail: firsthand3@aol.com. Editor: Bob Harris. Circ. 60,000. Estab. 1980. Monthly digest. Emphasizes gay erotica and stories and letters from readers. Readers are male, gay, wide range of ages. Sample copy $5. Photo guidelines free with SASE.
Needs: Uses 1 photo/issue; all supplied by freelancers. Needs erotic male photographs for covers. "No full-frontal nudity. We especially need photos with an athletic theme." Model release required. "We need proof of age with all model releases, preferably a copy of a driver's license." Captions preferred; include model's name.
Specs: Uses 35mm transparencies.
Making Contact & Terms: Send unsolicited photos by mail for consideration. Does not keep samples on file. Reports in 1 month. Previously published work OK. Pays $150/color cover. Pays on publication. Buys all rights; negotiable. Credit line given.

N $ FIRST OPPORTUNITY, 3100 Broadway, Suite 660, Kansas City MO 64111. (816)960-1988. Fax: (816)960-1989. Editor: Neoshia Michelle Paige. Circ. 500,000. Semi-annual magazine. Emphasizes advanced vocational/technical education opportunities, career prospects. Readers are African-American, Hispanic, ages 16-22. Sample copy free with 9×12 SAE and 4 first-class stamps.
Needs: Uses 30 photos/issue. Needs photos of students in class, at work, in vocational/technical training, in health field, in computer field, in technology, in engineering, general interest. Model/property release required. Captions required; include name, age, location, action.
Making Contact & Terms: Query with résumé of credits. Query with ideas and SASE. Reports in 1 month, "usually less." Simultaneous submissions and/or previously published work OK. Pays $10-50/color photo; $5-25/b&w inside. Pays on publication. Buys first North American serial rights.

$ ▢ ◯ ◎ FLOWER AND GARDEN MAGAZINE, 4645 Belleview, Kansas City MO 64112. (816)531-5730. Fax: (816)531-3873. Editorial Assistant: Amy Engelhardt. Senior Editor: Angela Hughes. Estab. 1957. "We publish 6 times a year and require several months of lead time." Emphasizes home gardening. Readers are male and female homeowners with a median age of 47. Sample copy $5. Photo guidelines free with SASE.
Needs: Uses 25-50 photos/issue; 75% supplied by freelancers. "We purchase a variety of subjects relating to home lawn and garden activities. Specific horticultural subjects must be accurately identified." Model/property release preferred. Captions preferred; please provide exact name of plant (botanical), variety name and common name.
Specs: Accepts images in digital format for Mac. Send via CD as TIFF, EPS files at 300 dpi.
Making Contact & Terms: To make initial contact, "do not send great numbers of photographs, but rather a good selection of 1 or 2 specific subjects. We do not want photographers to call. We return photos by certified mail—other means of return must be specified and paid for by the individual submitting them. It is not our policy to pay holding fees for photographs." Pays $75/¼ page (smaller $60); $125/½ page; $175/full page; $300/cover. Prefers color. Pays on publication. Buys one-time and non-exclusive reprint rights.
Tips: Wants to see "clear shots with crisp focus. Also, appealing subject matter—good lighting, technical accuracy, depictions of plants in a home garden setting rather than individual close-ups. Let us know what you've got, we'll contact you when we need it. We see more and more freelance photographers trying to have their work published. In other words, supply is greater than demand. Therefore, a photographer who has too many conditions and provisions will probably not work for us."

FLY FISHERMAN, Primedia Enthusiast Publications, 6405 Flank Dr., Harrisburg PA 17112. (717)657-9555. Editor and Publisher: John Randolph. Managing Editor: Philip Hanyok. Circ. 150,000. Published 6 times/year. Emphasizes all types of fly fishing for readers who are "100% male, 83% college educated, 98% married. Average household income is $81,800 and 49% are managers or professionals; 68% keep their copies for future reference and spend 35 days a year fishing." Sample copy $3.95 with 9×12 SAE and 4 first-class stamps. Photo/writer guidelines for SASE.
Needs: Uses about 45 photos/issue, 80% of which are supplied by freelance photographers. Needs shots of "fly fishing and all related areas—scenics, fish, insects, how-to." Captions required.
Making Contact & Terms: Send 35mm, 2¼×2¼, 4×5 or 8×10 color transparencies by mail for

THE GEOGRAPHIC INDEX, located in the back of this book, lists markets by the state in which they are located.

consideration. SASE. Reports in 6 weeks. Payment negotiable. Pays on publication. Buys one-time rights. Credit line given.

\$ \$Ⓢ◐◎ FLY ROD & REEL: THE MAGAZINE OF AMERICAN FLY-FISHING, Dept. PM, P.O. Box 370, Camden ME 04843. (207)594-9544. Fax: (207)594-5144. E-mail: jbutler@flyrodreel.com. Editor-in-Chief: Jim Butler. Magazine published bimonthly. Emphasizes fly-fishing. Readers are primarily fly fishermen ages 30-60. Circ. 62,500. Estab. 1979. Free sample copy with SASE. Photo guidelines free with SASE.
Needs: Uses 25-30 photos/issue; 15-20 supplied by freelancers. Needs "photos of fish, scenics (preferrably with anglers in shot), equipment." Photo captions preferred; include location, name of model (if applicable).
Specs: Uses glossy b&w, color prints; 35mm, 2¼×2¼, 4×5 transparencies.
Making Contact & Terms: Query with list of stock photo subjects. Send unsolicited photos by mail for consideration. Provide résumé, business card, brochure, flier or tearsheets to be kept on file for possible assignments. Keeps samples on file. SASE. Reports in 1 month. Pays $500-650/color cover photo; $75-200/color inside; $75/b&w inside. Pays on publication. Buys one-time rights. Credit line given.
Tips: "Photos should avoid appearance of being too 'staged.' We look for bright color (especially on covers), and unusual, visually appealing settings. Trout and salmon are preferred for covers. Also looking for saltwater fly-fishing subjects. Ask for guidelines, then send 20 to 40 shots showing breadth of work."

🌐 ◐ ◎ FLY-FISHING & FLY-TYING, Rolling River Publications Ltd., 3 Aberfeldy Rd., Kenmore, Perthshire PH15 2HF United Kingdom. Phone: +44 1887 830526. Fax: +44 1887 830526. Website: http://www.flyfishing-and-flytying.co.uk. Administrator: Hazel Pirie. Estab. 1990. Bimonthly magazine about fly fishing on rivers and lakes.
Needs: Buys 10 photos from freelancers/issue; 80 photos/year. Needs photos of fly-fishers in picturesque settings. Reviews photos with or without ms. Photo caption required; include location, time of year.
Specs: Uses color prints; 35mm transparencies.
Making Contact & Terms: Send query letter with samples and SAE. Portfolio should include color, slides. Keeps samples on file; include SASE for return of material. Pays on publication. Buys first rights.

Ⓝ \$ \$ FOOD & WINE, Dept. PM, 1120 Avenue of the Americas, New York NY 10036. (212)382-5600. Photo Editor: Patti Wilson. Monthly. Emphasizes food and wine. Readers are an "upscale audience who cook, entertain, dine out and travel stylishly." Circ. 850,000. Estab. 1978.
Needs: Uses about 25-30 photos/issue; freelance photography on assignment basis 85%, 15% freelance stock. "We look for editorial reportage specialists who do restaurants, food on location and travel photography." Model release and captions required.
Making Contact & Terms: Drop-off portfolio on Wednesdays. Call for pickup. Submit fliers, tearsheets, etc. to be kept on file for possible future assignments and stock usage. Pays $450/color page; $100-450 color photo. **Pays on acceptance.** Buys one-time world rights. Credit line given.

FOR SENIORS ONLY, 339 N. Main St., New City NY 10956. (914)638-0333. Fax: (914)634-9423. Art Director: David Miller. Circ. 350,000. Estab. 1970. Biannual publication. Emphasizes career and college guidance—with features on travel, computers, etc. Readers are male and female, ages 16-19. Sample copy free with 6½×9½ SAE and 8 first-class stamps.
Needs: Uses various number of photos/issue; 50% supplied by freelancers. Needs photos of travel, college-oriented shots and youths. Reviews photos with or without ms. Model/property release required.
Specs: Uses 5½×8½ color prints; 35mm, 8×10 transparencies.
Making Contact & Terms: Send unsolicited photos by mail for consideration. SASE. Reports when needed. Simultaneous submissions and/or previously published work OK. Payment negotiable. Pays on publication. Buys one-time rights; negotiable. Credit line given.

Ⓝ \$ \$ FORTUNE, Dept. PM, Rockefeller Center, Time-Life Bldg., 1271 Avenue of the Americas, New York NY 10020. (212)522-3803. Managing Editor: John Huey. Picture Editor: Michele F. McNally. Emphasizes analysis of news in the business world for management personnel.
Making Contact & Terms: Picture Editor reviews photographers' portfolios on an overnight drop-off basis. Photos purchased on assignment only. Day rate on assignment (against space rate): $400; page rate for space: $400; minimum for b&w or color usage: $150. Pays extra for electronic rights.

\$ \$🌐 Ⓢ◐◎ FRANCE MAGAZINE, Normandy House, 311 High St., Cheltenham, Gloucestershire GL50 3HU England. Phone: (44)1242 259853. Fax: (44)1242 259869. E-mail: francemag@btinternet.com. Website: http://www.francemag.com. Picture Researcher: Alison Hughes. Circ. 61,000. Estab.

1990. Quarterly magazine about France. Readers are male and female, ages over 45; people who holiday in France. Sample copy $9.

Needs: Uses 250 photos/issue; 200 supplied by freelancers. Needs photos of France and French subjects: people, places, customs, curiosities, produce, towns, cities, countryside. Captions required; include location and as much information as is practical.

Specs: Uses 35mm, 2¼×2¼ transparencies. Accepts images via e-mail.

Making Contact & Terms: Interested in receiving work on spec: themed sets very welcome. Send unsolicited photos by mail for consideration. Keeps samples on file. SASE. Reports in 1 month. Previously published work OK. Pays £100/color cover; £50/color full page; £25/¼ page and under. Pays quarterly following publication. Buys one-time rights. Credit line given.

$ ▣ ◙ FRANCE TODAY, France Press, 1051 Divisadero St., San Francisco CA 94115. Fax: (415)921-0213. E-mail: fpress@francepress.com. Website: http://www.francepress.com. Editor: Cara Ballard. Circ. 25,000. Estab. 1982. Bimonthly magazine geared towards an English speaking audience interested in French culture and travel. Sample copy for SAE with 4 first-class stamps.

Needs: Needs original and unique photos of France and French related themes (French celebrities, travel, adventure). Reviews photos with or without ms. Model release preferred. Photo caption preferred.

Specs: Uses color, b&w prints; 35mm, 2¼×2¼, 4×5, 8×10 color transparencies. Accepts images in digital format for Windows. Send as JPEG files.

Making Contact & Terms: Send query letter with samples. To show portfolio, photographer should follow-up with call. Portfolio can include photos in any format. Keeps samples on file; include SASE for return of material. Reports in 2 months on queries. Simultaneous submissions and/or previously published work OK. Pays $100-200 for color cover; $25-50 for b&w and color inside. Pays on publication. Buys all rights; negotiable.

$ FUR-FISH-GAME, A.R. Harding Publishing, 2878 E. Main St., Columbus OH 43212. Editor: Mitch Cox. Monthly outdoor magazine emphasizing hunting, trapping, fishing and camping.

Needs: Buys 4 photos from freelancers/issue; 50 photos/year. Needs photos of fresh water fish, wildlife and wilderness and rural scenes. Reviews photos with or without ms. Photo caption required; include subject.

Specs: Uses color, b&w prints; 35mm transparencies.

Making Contact & Terms: Send query letter "and nothing more." Does not keep samples on file; include SASE for return of material. Reports in 2-4 weeks on queries. Simultaneous submissions and/or previously published work OK. Pays $25 minimum for b&w and color inside. Pays on publication. Buys one-time rights. Credit line given.

$ $ $ ⊕ ⑤ ◙ GALAXY PUBLICATIONS LTD., P.O. Box 312, Witham, Essex CM8 3SZ United Kingdom. Phone: (441376) 534544. Fax: (441376) 534546. E-mail: drider@fiesta.org. Website: http://www.fiesta.org. Picture Editor: Andy Morgan. 4 monthly magazines: *Fiesta, Knave, Ravers, Teazer*. Sample copy free. Art guidelines free.

Needs: Buys 100 photos from freelancers/issue; 2,000 photos/year. Needs photos of nude female models, glamour. Reviews photos with or without ms. Model release required; property release required. Photo caption required; include photographers name and address and reference number.

Specs: Uses 35mm, 2¼×2¼ transparencies.

Making Contact & Terms: Photographers can send samples or full sets of 100 transparencies or more. Art director will contact photographer for portfolio review if interested. Portfolio should include slides. Does not keep samples on file; include SASE for return of material. Reports in 2 weeks on queries. Previously published work OK. Pays £600 maximum for color inside. Pays on publication. Buys first UK rights. Credit line not given.

Tips: "Read our magazine, look at what is being accepted. Sets have to be technically good, colourful, interesting, have a good selection of poses. Those photographers who supply sets with cover poses will have an advantage over others. Supply contact name and address, reference number, model release. Supply slides mounted in glass-less mounts and sleeved. Editors are looking for young girl sets—trendy-trashy or plush sets."

$ $ GAME & FISH PUBLICATIONS, 2250 Newmarket Pkwy., Suite 110, Marietta GA 30067. (404)953-9222. Fax: (404)933-9510. Photo Editor: Michael Skinner. Editorial Director: Ken Dunwoody. Combined circ. 525,000. Estab. 1975. Publishes 31 different monthly outdoors magazines: *Alabama Game & Fish, Arkansas Sportsman, California Game & Fish, Florida Game & Fish, Georgia Sportsman, Great Plains Game & Fish, Illinois Game & Fish, Indiana Game & Fish, Iowa Game & Fish, Kentucky Game & Fish, Louisiana Game & Fish, Michigan Sportsman, Mid-Atlantic Game & Fish, Minnesota Sportsman,*

Mississippi Game & Fish, Missouri Game & Fish, New England Game & Fish, New York Game & Fish, North Carolina Game & Fish, Ohio Game & Fish, Oklahoma Game & Fish, Pennsylvania Game & Fish, Rocky Mountain Game & Fish, South Carolina Game & Fish, Tennessee Sportsman, Texas Sportsman, Virginia Game & Fish, Washington-Oregon Game & Fish, West Virginia Game & Fish, Wisconsin Sportsman, and *North American Whitetail.* All magazines (except *Whitetail*) are for experienced fishermen and hunters and provide information about where, when and how to enjoy the best hunting and fishing in their particular state or region, as well as articles about game and fish management, conservation and environmental issues. Sample copy $2.50 with 10×12 SAE. Photo guidelines free with SASE.

Needs: 50% of photos supplied by freelance photographers; 5% assigned. Needs photos of live game animals/birds in natural environment and hunting scenes; also underwater game fish photos and fishing scenes. Model release preferred. Captions required; include species identification and location. Number slides/prints. In captions, identify species and location.

Making Contact & Terms: Send 8×10 glossy b&w prints or 35mm transparencies (preferably Fujichrome, Ekta, Kodachrome) with SASE for consideration. Reports in 1 month. Simultaneous submissions not accepted. Pays $250/color cover; $75/color inside; $25/b&w inside. Pays 75 days prior to publication. Tearsheet provided. Buys one-time rights. Credit line given.

Tips: "Study the photos that we are publishing before sending submission. We'll return photos we don't expect to use and hold remainder in-house so they're available for monthly photo selections. Please do not send dupes. Photos will be returned upon publication or at photographer's request."

$ $ $ ▣ ◎ GAMES MAGAZINE, Kappa Publishing Group, Inc., 7002 W. Butler Pike, Ambler PA 19002. (215)643-6385. Fax: (215)628-3571. E-mail: gamespub@itw.com. Art Director: Carl Doney. Circ. 182,000. Estab. 1977. Bimonthly consumer magazine. Unique collection of puzzles, brain teasers, Eyeball Benders, games of logic and mystery etc. Also reporting on events of interest to puzzle and game people. Art guidelines free for SASE.

Needs: Buys 30-200 photos/year. Reviews photos with or without ms but only with an idea for a puzzle. Model release preferred; property release preferred. Photo caption required; include everything that relates to the puzzle.

Specs: Uses 35mm, 2¼×2¼, 4×5 transparencies. Accepts images in digital format for Mac or Windows. Send via CD, SyQuest, floppy disk, Zip, e-mail as TIFF, EPS, PICT, BMP, JPEG files at 300 dpi. "We work on the Macintosh platform."

Making Contact & Terms: Send query letter with samples. "We are interested only in photos with puzzle or quiz ideas." Art director will contact photographer for portfolio review if interested. Portfolio should include photos with puzzle ideas. Keeps samples on file. Reports back only if interested, send nonreturnable samples. Simultaneous submissions and/or previously published work OK. Pays $1,000-2,000 for color cover; $50-1,500 for b&w inside; $50-2,000 for color inside. Pays extra for electronic usage of photos. Supplemental use pays from 10% to 50% of initial fee, depending on use. Pays on publication. Buys one-time rights, sometimes more. Credit line given.

Tips: "Read the magazine. We have a very narrow niche market. Submit photos only with idea for use as a puzzle or eyeball bender etc."

$ $ ▣ GENERAL LEARNING COMMUNICATIONS, 900 Skokie Blvd., Northbrook IL 60062. (847)205-3093. Fax: (847)564-8197. E-mail: gwilson@glcomm.com. Supervisor/Photography: Gina Wilson. Estab. 1969. Publishes four monthly school magazines running September through May. *Current Health I* is for children aged 9-13. *Current Health II, Writing!, Career World* are for high school teens.

Needs: Color photos of children aged 11-13 for *Current Health,* all other publications for teens aged 14-18, geared to our topic themes for inside use and cover; 35mm or larger transparencies only. Model release preferred. Captions preferred.

Specs: Accepts images in digital format for Mac. Send via CD, Zip disk or online at 300 dpi.

Making Contact & Terms: "Send business card and tearsheets and fax or e-mail any info about yourself. Photographers can contact me monthly to find out what my current needs are." Simultaneous submissions and previously published work OK. Pays $100/inside; $400/cover. Pays on publication. Payment negotiable for electronic usage. Buys one-time rights. Credit line given.

Tips: "We are looking for contemporary photos of children and teens, including minoritites. Do not send outdated or posed photos. Please adhere to age requirements. If the kids are not the right age they will not be used."

Ⓝ GENRE, 7080 Hollywood Blvd., Suite 1104, Hollywood CA 90028. (213)896-9778. Publisher: Richard Settles. Editor: Ron Kraft. Circ. 45,000. Estab. 1990. Monthly. Emphasizes gay life. Readers are gay men, ages 24-35. Sample copy $5.

Needs: Uses 40 photos/issue. Needs photos of fashion, celebrities, scenics. Model/property release re-

quired. Captions preferred.

Making Contact & Terms: Provide résumé, business card, brochure, flier or tearsheets to be kept on file for possible assignments. Cannot return material. Reports only if interested. Pays on publication. Buys all rights; negotiable. Credit line given.

$ $◨ GENT, 14411 Commerce Way, Suite 420, Miami Lakes FL 33016. (305)362-5580. Fax: (305)362-3120. E-mail: gent@dugent.com. Website: http://www.dugent.com. Editor: Jack Lisa. Circ. 150,000. Monthly magazine. Showcases "slim and stacked" D-cup nude models. Sample copy $7 (postpaid). Photo guidelines free with SASE.

Needs: Buys in sets, not by individual photos. "Nude models must be extremely large breasted (minimum 38" bust line). Sequence of photos should start with woman clothed, then stripped to brassiere and then on to completely nude. Bikini sequences also recommended." Model release and photocopy or photograph of picture ID required.

Specs: Uses transparencies. Prefer Kodachrome or large format.

Making Contact & Terms: Send material by mail for consideration. Include SASE. Reports in 4-6 weeks. Previously published work OK. Pays $1,200-2,500/set (first rights); $600-1,200 (second rights); $300/cover; $250-500 for text and photo package. Pays on publication. Buys one-time rights or second serial (reprint) rights and electronic rights for website.

Tips: "Include SASE with submission."

$◨ ○ GERMAN LIFE MAGAZINE, Zeitgeist Publishing, Inc., 226 N. Adams St., Rockville MD 20850. (301)294-9081. Fax: (301)294-7821. E-mail: editor@germanlife.com. Website: http://www.germanl ife.com. Editor: Heidi L. Whitesell. Circ. 40,000. Estab. 1994. Bimonthly magazine focusing on history, culture, and travel relating to German-speaking Europe. Also devoted to covering the German influence on the shaping of North America. Sample copy for $4.95 and 9 × 12 SAE with $1.47 postage. Art guidelines free for 9½ × 4¼ SAE with 1 first-class stamp.

Needs: Buys up to 8 photos from freelancers/issue; up to 50 photos/year. Needs photos relating to German-speaking Europe and German-American topics. Subjects include landscapes/scenics, architecture, cities, gardening, interiors, decorating, rural, travel, culture, political, documentary, fine art, historical/vintage, regional, seasonal. Reviews photos with or without ms. Special photo needs include summer festivals, Oktoberfests, wine festivals, Christmas, winter activities. Model release required; property release required. Photo caption required. Include correct name of place/location; correct names and/or titles of person(s); correct date of event shown.

Specs: Uses 5 × 7 minimum glossy color and b&w prints; 35mm, 2¼ × 2¼, 4 × 5, 8 × 10 transparencies. Accepts images in digital format for Windows. Send via Zip, e-mail as JPEG files at 266 dpi.

Making Contact & Terms: Send query letter with samples (no more than 25), stock photo list. Provide résumé, business card, self-promotion piece or tearsheets to be kept on file for possible future assignments. Reports in 1 month on queries. Simultaneous submissions and/or previously published work OK. Pays $250 minimum for color cover; $40-60 for b&w inside; $50-75 for color inside. Pays on publication. Buys one-time rights. Credit line given.

Tips: "Read our magazine. We especially look for off-the-beaten track insights/shots regarding Germany, Switzerland and Austria. Include complete caption information. Send advance query showing experience specifically regarding German-speaking Europe or German-American topics."

Ⓝ $ $◨ ○ GIG MAGAZINE, Miller Freeman PSN Inc., 460 Park Ave. S., 9th Floor, New York NY 10016. (212)378-0400. Fax: (212)378-2160. E-mail: gershuny@psn.com. Managing Editor: Diane Gershuny. Circ. 80,000. Estab. 1996. Monthly consumer magazine for professional bands and musicians who make money making music. Sample copies available.

Needs: Needs photos of entertainment, performing arts, live bands, behind the scenes at concerts (prefers images of lesser-known bands). Photo captions preferred.

Specs: Uses color prints; 35mm, 2¼ × 2¼ transparencies. Accepts images in digital format for Mac. Send via CD, floppy disk, Zip, e-mail as JPEG files at 300 dpi.

Making Contact & Terms: Send query letter with slides, prints, tearsheets, stock list. Portfolio may be dropped off Monday through Saturday. Keep samples on file. Simultaneous submissions OK. Pays $200 minimum for b&w cover; $25-200 for b&w inside. Pays on publication. Credit line given.

Tips: "Read our magazine. Put contact names (both band and photographer) on slides, tranparencies and prints."

$◨ ◨ ◎ GIRLFRIENDS MAGAZINE, HAF Enterprises, 3415 Cesar Chavez, Suite 101, San Francisco CA 94110. (415)648-9464. Fax: (415)648-4705. E-mail: staff@gfriends.com. Website: http:// www.gfriends.com. Contact: Editorial Dept. Circ. 75,000. Estab. 1994. Monthly, glossy, national magazine

focused on culture, politics, and entertainment from a lesbian perspective. Sample copy for $4.95 and 9×12 SAE with $1.50 first-class postage. Art guidelines free.

Needs: Needs photos of travel, celebrities, stock photos of lesbians/the community. Reviews photos with or without ms. Model release required; property release preferred. Photo caption preferred; include name of models, contact information.

Specs: Uses 8×10 glossy color prints; 35mm, 2¼×2¼ transparencies. Accepts images in digital format by prior arrangement.

Making Contact & Terms: Send query letter with samples. Provide résumé, business card, self-promotion piece or tearsheets to be kept on file for possible future assignments. Art director will contact photographer for portfolio review if interested. Portfolio should include color. Keeps samples on file; include SASE for return of material. Reports in 6-8 weeks on queries; 6-8 weeks on samples. Simultaneous submissions OK. Payment for cover arranged individually. Pays $30-200 for color inside. Pays on publication. Buys one-time rights. Credit line given.

Tips: "Read our magazine to see what type of photos we use. We're looking to increase our stock photography library of women. We like colorful, catchy photos, beautifully composed, with models who are diverse in age, size and ethnicity."

$ $ ▣ GO BOATING MAGAZINE, Duncan McIntosh Co., 17782 Cowan, Suite C, Irvine CA 92614. (949)660-6150. Fax: (949)660-6172. Website: http://www.goboatingmag.com. Managing Editor: Eston Ellis. Circ. 100,000. Estab. 1997. Bimonthly consumer magazine geared to active families that own power boats from 14-25 feet in length. Contains articles on cruising and fishing destinations, new boats and marine electronics, safety, navigation, seamanship, maintenance how-tos, consumer guides to boating services, marine news and product buyer guides. Sample copy for $5. Art guidelines free with SASE.

Needs: Buys 25 photos from freelancers/issue. Needs photos of cruising destinations, boating events, seamanship, boat repair procedures and various marine products. "We are always in search of photos depicting families having fun in small power boats (14 to 28 feet)." Reviews photos with or without ms. Model release required. Photo caption preferred; include place, date, identify people and any special circumstances.

Specs: Uses color transparencies; 35mm, 2¼×2¼. Accepts images in digital format for Mac. Send via CD, SyQuest or Zip disk.

Making Contact & Terms: Send query letter with stock photo list and provide résumé, business card, self-promotion piece or tearsheets to be kept on file for possible future assignments. Art director will contact photographer for portfolio review if interested. Reports in 1-2 months on queries. Simultaneous submissions and/or previously published work OK. Pays $250 maximum for color cover; $35 maximum for b&w inside; $50-200 for color inside. Pays on publication. Buys first North American, second rights and reprint rights for one year via print and electronic media. Credit line given.

Tips: "When submitting work, label each slide with your name, address, daytime phone number and Social Security Number on a photo delivery memo. Submit photos with SASE. All photos will be returned within 60 days."

$ $ GOLF ILLUSTRATED, P.O. Box 5300, Jenks OK 74037-5300 or 5300 Cityplex Tower, 2448 E. 81st St., Tulsa OK 74137-4207. (918)491-6100. Fax: (918)491-9424. Executive Editor: Mark Chesnut. Circ. 250,000. Estab. 1914. Magazine published 6 times/year. Emphasizes golf. Readers are mostly male, ages 40-60. Sample copy $2.95. Photo guidlines free with SASE.

Needs: Uses 40-60 photos/issue; 90% supplied by freelancers. Needs photos of various golf courses, golf travel, other golf-related shots. Model/property release preferred. Captions required; include who, what, when and where.

Specs: Uses 35mm, 2¼×2¼ transparencies.

Making Contact & Terms: Query with résumé of credits. Provide résumé, business card, brochure, flier or tearsheets to be kept on file for possible assignments. Keeps samples on file. SASE. Reports in 3 weeks. Previously published work OK. Pays $400-600/color cover; $100-300/color inside. Pays on publication. Buys one-time rights. Credit line given.

$ $ ▣ ▱ GOLF TIPS, 12121 Wilshire Blvd., #1200, Los Angeles CA 90025. (310)820-1500. Fax: (310)826-5008. Art Director: Warren Keating. Circ. 300,000. Estab. 1986. Magazine published 9 times/year. Readers are hardcore golf enthusiasts. Sample copy free with SASE.

Needs: Uses 60 photos/issue; 40 supplied by freelancers. Needs photos of golf instruction (usually pre-arranged, on-course); equipment, health/fitness, travel. Interested in alternative process, digital, documentary, fashion/glamour. Photos purchased with accompanying ms only. Model/property release preferred. Captions required.

Specs: Uses prints; 35mm, 2¼×2¼, 4×5, 8×10 transparencies. Accepts images in digital format for

Mac. Send via Zip disk as TIFF files at 300 dpi.

Making Contact & Terms: Query with résumé of credits. Submit portfolio for review. Cannot return material. Reports in 1 month. Pays $500-1,000 for b&w or color cover; $100-300 for b&w inside; $150-450 for color inside. Pays on publication. Buys one-time rights; negotiable.

GOLF TRAVELER, 2575 Vista del Mar Dr., Ventura CA 93001. (805)667-4100. Fax: (805)667-4217. Website: http://www.golfcard.com. Editor: Valerie Law. Bimonthly magazine. Emphasizes golf; senior golfers. Readers are "avid golfers who have played an average of 24 years." Circ. 130,000. Estab. 1976. Sample copy $2.50 and SASE.

Needs: Uses 10-20 photos/issue; all supplied by freelancers. Needs photos of "affiliated golf courses associated with Golf Card;" personality photos of PGA Tour golfers; general interest golf photos. Model release required for cover images. Photo captions preferred that include who and where.

Making Contact & Terms: Send stock list. Does not keep samples on file. SASE. Reports in 1 month. Previously published work OK. Pays $475/color cover; $150/color inside. **Pays on acceptance.** Buys one-time rights. Credit line given.

Tips: Looks for "good color-saturated images."

GOSPEL HERALD, 4904 King St., Beamsville, Ontario L0R 1B6 Canada. (905)563-7503. Fax: (905)563-7503. E-mail: EPerry9953@aol.com. Webpage: http://www.geocities.com/~centralc ofc/gh.html. Co-editor: Wayne Turner. Managing Editor: Eugene Perry. Circ. 1,370. Estab. 1936. Consumer publication. Monthly magazine. Emphasizes Christianity. Readers are primarily members of the Churches of Christ. Sample copy free with SASE.

Needs: Uses 2-3 photos/issue. Needs scenics, children, families, parents, wildlife, seasonal, especially those relating to readership—moral, religious and nature themes.

Specs: Uses b&w, any size and any format. Accepts images in digital format for Windows. Send via CD, floppy disk, e-mail.

Making Contact & Terms: Send unsolicited photos by mail for consideration. Payment not given, but photographer receives credit line.

Tips: "We have never paid for photos. Because of the purpose of our magazine, both photos and stories are accepted on a volunteer basis."

GRIT MAGAZINE, 1503 SW 42nd St., Topeka KS 66609. (800)678-5779. Fax: (913)274-4305. Fax: (785)274-4305. E-mail: grit@cjnetworks.com. Website: http://www.grit.com. Contact: Editor. Circ. 400,000. Estab. 1882. Biweekly magazine. Emphasizes "family-oriented material which is helpful, inspiring or uplifting. Readership is national." Sample copy $4.

Needs: Buys "hundreds" of photos/year; 90% from freelancers. Needs on a regular basis "photos of all subjects, provided they have up-beat themes that are so good they surprise us. Need *short*, unusual stories—heartwarming, nostalgic, inspirational, off-beat, humorous—or human interest with b&w or color photos. Be certain pictures are well composed, properly exposed and pin sharp. No cheesecake. No pictures that cannot be shown to any member of the family. No pictures that are out of focus or over-or under-exposed. No ribbon-cutting, check-passing or hand-shaking pictures. We use 35mm and up." Subjects include hobbies, children, couples, multicultural, families, parents, senior citizens, environmental, landscapes, scenics, wildlife, beauty, gardening, pets, religious, rural, health/fitness, hobbies, humor, travel, agriculture, historical/vintage. Photos purchased with accompanying ms. Model release required. Captions required. "Single b&w photo or color slide, that stands alone must be accompanied by 50-100 words of meaningful caption information."

Specs: Prefers color slides/professional quality. Accepts images in digital format for Mac. Send via SyQuest or Zip disk.

Making Contact & Terms: Study magazine. Send material by mail for consideration. SASE. Reports in 6 months. Pays $150-550 for color cover; $35-75 for b&w inside; $35-100 for color inside. Uses much more color than b&w. Pays on publication. Rights negotiable.

FOR EXPLANATIONS OF THESE SYMBOLS,
SEE THE INSIDE FRONT AND BACK COVERS OF THIS BOOK.

Tips: "We need major-holiday subjects: Easter, Fourth of July, Christmas or New Year. Remember that *Grit* publishes on newsprint and therefore requires sharp, bright, contrasting colors for best reproduction. Avoid sending shots of people whose faces are in shadows; no soft focus. Need photos of small town, rural life; outdoor scenes with people; gardens; back roads and country life shots. Send samples/actual slides for review. Most purchases are for covers—full frame—so images must be clear, color slides—originals— to reproduce. All of our covers have people in them."

N $ $ ▣ ◑ GUEST INFORMANT, 21200 Erwin St., Woodland Hills CA 91367. (818)716-7484. Fax: (818)716-7583. Contact: Photo Editor. Quarterly and annual city guide books. Emphasizes city-specific photos for use in guide books distributed in upscale hotel rooms in approximately 30 U.S. cities.
Needs: "We review people-oriented, city-specific stock photography that is innovative and on the cutting edge." Needs photos of celebrities, couples, multicultural, families, landscapes/scenics, wildlife, architecture, cities/urban, adventure, events, food/drink, health/fitness, performing arts, sports, travel. Interested in fashion/glamour, fine art, historical/vintage, regional, seasonal. Other subjects: lifestyle, regional food, cultural color. Captions required; include city, location, event, etc.
Specs: Uses transparencies. Accepts images in digital format for Mac. Send via compact disc.
Making Contact & Terms: Provide promo, business card and list of cities covered. Send transparencies with a delivery memo stating the number and format of transparencies you are sending. All transparencies must be clearly marked with photographer's name and caption information. They should be submitted in slide pages with similar images grouped together. To submit portfolio for review "call first." Pays $250-300 for b&w cover; $250-400 for color cover; $100-200 for b&w inside; $100-200 for color inside. 50% reuse rate. Pays on publication, which is about 60 days from initial submission. Credit line given. Offers internships for photographers. Contact Senior Photo Editor: Susan Warmbo.
Tips: Contact photo editor at (800)275-5885 for guidelines and submission schedule before sending your work.

$ $ GUIDE, Review & Herald Publishing Association, 55 W. Oak Ridge Dr., Hagerstown MD 21740-7390. (301)791-7000. Fax: (301)790-9734. E-mail: guide@rhpa.org. Website: http://www.guidemagazine.o

United States Capitol

© 1999 James Lemass

James Lemass has been working with the publishers of *Guest Informant* for over six years. He first contacted the company when he was just starting out. "This is a landmark travel image for the Washington, D.C. area," says photo editor Heidi Wrage. "It's an interesting shot. The perspective through the branches added a nice frame to the building." Lemass was paid $125 for one-time, 1/4-page use. Though he prefers not to license his images for such low fees, *Guest Informant* frequently reuses images, paying 50 percent of the initial fee.

rg. Editor: Tim Lale. Circ. 33,000. Estab. 1953. Weekly 32-page Christian story magazine given out in churches to 10- to 14-year-olds. Each issue contains 3-4 true or based-on-truth stories by, about, or of interest to fifth to eighth graders, and 1-3 Bible-based puzzles. Most stories are adventure, humor, nature, or personal growth situations; all must have a clear spiritual point. Published by Seventh-day Adventists, but stories are accepted from Christian writers of other denominations.

Making Contact & Terms: Send query letter with samples, brochure, stock photo list tearsheets. Art director will contact photographer for portfolio review if interested. Portfolio should include b&w and/or color, prints, tearsheets or slides. Keeps samples on file. Reports back only if interested, send non-returnable samples. Pays $200 maximum for b&w cover; $200 maximum for b&w inside. **Pays on acceptance**. Buys one-time rights. Credit line given.

Tips: "We need fast workers with quick turnaround."

$ $ ◨ GUIDEPOSTS, Dept. PM, 16 E. 34th St., 21st Floor, New York NY 10016. (212)251-8124. Fax: (212)684-0679. Website: http://www.guideposts.org. Photo Editor: Candice Smilow. Circ. 4 million. Estab. 1945. Monthly magazine. Emphasizes tested methods for developing courage, strength and positive attitudes through faith in God. Free sample copy and photo guidelines with 6×9 SAE and 3 first-class stamps.

Needs: Uses 85% assignment, 15% stock (variable). "Photos are mostly of an editorial reportage nature or stock photos, i.e., scenic landscape, agriculture, people, animals, sports." Also uses children, multicultural, families, parents, senior citizens, disasters, wildlife, architecture, cities, events, performing arts, travel, business, medicine, portraits, still life, science, technology, fine art, historical/vintage, seasonal. "We work four months in advance. It's helpful to send stock pertaining to upcoming seasons/holidays. No lovers, suggestive situations or violence." Model release preferred.

Specs: Uses 35mm transparencies; vertical format required for cover, usually shot on assignment.

Making Contact & Terms: Send photos or arrange a personal interview. SASE. Reports in 1 month. Simultaneous submissions OK. Pays by job or on a per-photo basis; pays $150-400/color inside; $800 and up/color cover; $400-600/day; negotiable. **Pays on acceptance.** Buys one-time rights. Credit line given.

Tips: "I'm looking for photographs that show people in their environment. I like warm, saturated color for portraits and scenics. We're trying to appear more contemporary. We want to stimulate a younger audience and yet maintain a homey feel. For stock—scenics; graphic images with intense color. *Guideposts* is an 'inspirational' magazine. NO violence, nudity, sex. No more than 60 images at a time. Write first and ask for a photo guidelines/sample issue; this will give you a better idea of what we're looking for. I will review transparencies on a light box. I am interested in the experience as well as the photograph. I am also interested in the photographer's sensibilities—Do you love the city? Mountain climbing? Farm life? We also publish *Angels on Earth*."

GUNGAMES MAGAZINE, P.O. Box 516, Moreno Valley CA 92556. (909)485-7986. Fax: (909)485-6628. E-mail: ggamesed@aol.com. Editor: Roni Toldanes. Circ. 125,000. Estab. 1995. Bimonthly magazine. Emphasizes shooting sports—"the fun side of guns." Readers are male and female gun owners, ages 18-90. Sample copy $3.95 plus S&H or SASE.

Needs: Uses many photos/issue; most supplied by freelancers. Needs photos of personalities, shooting sports and modern guns and equipment. "No self-defense topics; avoid hunting photos. Just shooting tournaments." Captions required.

Specs: Uses color prints; 35mm transparencies.

Making Contact & Terms: Send unsolicited photos by mail for consideration. Does not keep samples on file. Cannot return material. Reports in 1 month. Payment negotiable. Pays on publication. Buys one-time rights; negotiable. Credit line given.

$ $ HADASSAH MAGAZINE, 50 W. 58th St., New York NY 10019. (212)688-0558. Fax: (212)446-9521. Editorial Assistant: Leah Finkelshteyn. Circ. 300,000. Publication of the Hadassah Women's Zionist Organization of America. Monthly magazine. Emphasizes Jewish life, Israel. Readers are 85% females who travel and are interested in Jewish affairs, average age 59. Photo guidelines free with SASE.

Needs: Uses 10 photos/issue; most supplied by freelancers. Needs photos of travel and Israel. Captions preferred, include where, when, who and credit line.

Making Contact & Terms: Submit portfolio for review. Send unsolicited photos by mail for consideration. Keeps samples on file. SASE. Reports in 1 month. Pays $400/color cover; $100-125/¼ page color inside; $75-100/¼ page b&w inside. Pays on publication. Buys one-time rights. Credit line given.

Tips: "We're looking for kids of all ethnic/racial make up. Cute, upbeat kids are a plus. We also need photos of families and travel photos, especially of places of Jewish interest."

N **$** **$** ▣ ⬤ **HARPER'S MAGAZINE**, Harper's Magazine Foundation, 666 Broadway, 11th Floor, New York NY 10012. (212)614-6500. Fax: (212)228-5889. E-mail: angela@harpers.org. Website: http://www.harpers.org. Art Director: Angela Riechers. Circ. 250,000. Estab. 1850. Monthly literary magazine. "The nation's oldest continually-published magazine providing fiction, satire, political criticism, social criticism, essays."

Needs: Buys 8-10 photos from freelancers per issue; 120 photos per year. Interested in alternative process, avant garde, digital, documentary, fine art, historical/vintage. Model and property release preferred.

Specs: Uses any format. Accepts images in digital format for Mac. Send via CD, SyQuest, floppy disk, Zip, e-mail as TIFF, EPS, JPEG files at 300 dpi.

Making Contact & Terms: Send query letter with résumé, slides, prints, photocopies, tearsheets, transparencies. Portfolio may be dropped off last Thursday of the month. Provide self-promotion piece to be kept on file for possible future assignments. Reports in 1 week on queries; 1 week on portfolios. Pays $800-1,200 for color cover; $200-500 for color inside; $200-400 for b&w inside. Pays on publication. Credit line given. Buys one-time rights; negotiable.

Tips: "*Harper's* is geared more toward fine art photos or artist's portfolios than to 'traditional' photo usages. For instance, we never do fashion, food, travel (unless it's for political commentary), lifestyles or

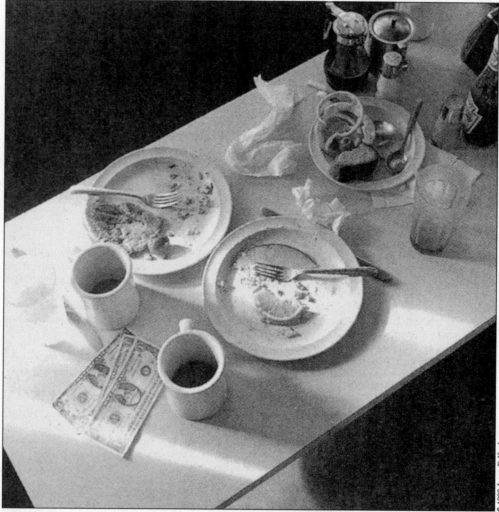

© 1998 Jason Fulford

"All of my income goes back into my work in the form of new equipment, supplies, food, road trips and buying time to think," says photographer Jason Fulford. This image is part of a series Fulford shot to illustrate a story about living on minimum wage for *Harper's* magazine. Fulford got the assignment by sending samples of his work to the magazine.

celebrity profiles. A good understanding of the magazine is crucial for photo submissions. We consider all styles and like experimental or non-traditional work. Understand the needs of this publication—and don't confuse us with *Harper's Bazaar*!"

🌐 **HEALTH & BEAUTY MAGAZINE**, 10 Woodford, Brewery Rd., Blackrock, Dublin, Ireland. Phone: (01)2954095. Mobile: 087-531566. Fax: (01)01-2954095. Advertising Manager: David Briggs. Circ. 11,0 00. Estab. 1985. Bimonthly magazine. Emphasizes all body matters. Readers are male and female, ages 17-50 (all keen on body matters). Sample copy free with A4 SASE.
Needs: Uses approximately 100 photos/issue; 50% supplied by freelancers. Needs photos related to health, hair, fashion, beauty, food, drinks. Reviews photos with or without ms. Model/property release preferred. Captions preferred; include photo description.
Specs: Uses any size glossy color and b&w prints; 35mm, 2¼×2¼, 4×5, 8×10 transparencies; prints preferred.
Making Contact & Terms: Send unsolicited photos by mail for consideration. Provide résumé, business card, brochure, flier or tearsheets to be kept on file for possible assignments. Keeps samples on file. SASE. Reports in 1 month. Simultaneous submissions and/or previously published work OK. Payment negotiable. Buys all rights; negotiable. Credit line given.
Tips: Looks for "male and female models of good body shape, shot in interesting locations with interesting body and facial features. Continue on a regular basis to submit good material for review."

💲 **HIGHLIGHTS FOR CHILDREN**, Dept. PM, 803 Church St., Honesdale PA 18431. (570)253-1080. Photo Editor: Sharon Umnik Circ. nearly 3 million. Monthly magazine. For children, ages 2-12. Free sample copy.
● *Highlights* is currently expanding photographic needs.
Needs: Buys 100 or more photos annually. "We will consider outstanding photo essays on subjects of high interest to children." Photos purchased with accompanying ms. Wants no single photos without captions or accompanying ms.
Specs: Prefers transparencies.
Making Contact & Terms: Send photo essays for consideration. SASE. Reports in 7 weeks. Pays $30 minimum/b&w photo; $55 minimum/color photo. Pays $100 minimum for ms. Buys all rights.
Tips: "Tell a story which is exciting to children. We also need mystery photos, puzzles that use photography/collage, special effects, anything unusual that will visually and mentally challenge children."

💲 💲 🖥 ⬛ 📷 **HIGHWAYS, The Official Publication of The Good Sam Club**, Affinity Group Inc., 2575 Vista Del Mar Dr., Ventura CA 93001-3920. (805)667-4100. Fax: (805)667-4454. E-mail: goodsam@tl.com. Website: http://www.goodsamclub.com/highways. Editor: Ron Epstein. Circ. 925,000. Estab. 1966. Consumer magazine published 11 times/year. "We go exclusively to recreation vehicle owners so our stories and photos include traveling in an RV or the RV industry including motorhomes, trailers, pop-ups, tents, etc." Sample copies free for 8½×11 SAE. Art guidelines free.
Needs: Buys 2 photos from freelancers/issue; 25 photos/year. Needs photos of recreational vehicles in various travel destinations, couples and senior citizens. Reviews photos with accompanying ms only. Model release preferred; property release preferred. Photo captions required. "The obvious is fine."
Specs: Uses 35mm, 2¼×2¼ transparencies. Accepts images in digital format for Mac. Send via CD, Jaz, Zip as EPS, JPEG files at 300 dpi.
Making Contact & Terms: Send query letter with samples, stock photo list. Art director will contact photographer for portfolio review if interested. Portfolio should include color tearsheets. Unsolicited material returned by SASE. Reports in 6 weeks on queries; 1 months on samples. Simultaneous submissions, previously published work OK. Pays $350-500/color cover; $50-150/b&w inside; $75-275/color inside. Pays on publication. Buys one-time rights. Credit line given.
Tips: "We mostly buy packages—manuscript and photos—from freelancers, so we rely on freelance photographers primarily for cover photos. (All covers are vertical.) If you shoot RVs with colorful scenery, there's a good chance we can do business sometime. Our travel features touch on all parts of the United States and Canada. Photographers who shoot RVs are scarce, so this is good chance to get into the market. Know who reads the magazine. We go to RV owners, not car enthusiasts. If you've never shot a picture of an RV, then don't send us anything."

💲 💲 🖥 ⬛ **HISTORIC TRAVELER, The Guide to Great Historic Destinations**, Primedia Enthusiast Publications, 6405 Flank Dr., Harrisburg PA 17112. (717)540-6703. Fax: (717)657-9552. E-mail: jeffk@cowles.com. Website: http://www.cowles.com. Design Director: Jeff King. Circ. 130,000. Estab. 1994. Bimonthly travel magazine emphasizing historic destinations, primarily in North America. Includes 1 international destination/issue. Sample copy for $5. Art guidelines available for SASE.

Needs: Buys 70 photos from freelancers/issue; 420 photos/year. Needs photos of travel, historical/vintage, architecture. *Historic Traveler* is 75% recent coverage and 25% archive shots. Reviews photos with or without ms. Model release preferred; property release preferred. Photo caption required.

Specs: Uses 35mm, 2¼×2¼, 4×5, 8×10 transparencies. Accepts images in digital format for Mac. Send as TIFF files.

Making Contact & Terms: Send query letter with stock photo list. Art director will contact photographer for portfolio review if interested. Portfolio should include color tearsheets or slides. Include SASE for return of material. "Prefer not to receive unsolicited samples (slides)." Reports in 1 month on queries; 1 month on samples. Simultaneous submissions and/or previously published work OK. Pays $600-900 for b&w or color cover; $125-275 for b&w or color inside. Pays $25 for web use on http://www.thehistorynet.com. Pays on publication. Buys one-time rights. Credit line given.

Tips: "We like to mix solid shots with detail shots—artifacts of history. Edit your submission to only the best and most appropriate shots."

$HOCKEY ILLUSTRATED, 233 Park Ave. S., New York NY 10003. (212)780-3500. Fax: (212)780-3555. Editor: Stephen Ciacciarelli. Circ. 50,000. Published 4 times/year, in season. Emphasizes hockey superstars. Readers are hockey fans. Sample copy $3.50 with 9×12 SASE.

Needs: Uses about 60 photos/issue; all supplied by freelance photographers. Needs color slides of top hockey players in action. Captions preferred.

Making Contact & Terms: Query with action color slides. SASE. Pays $150/color cover; $75/color inside. **Pays on acceptance.** Buys one-time rights. Credit line given.

N $ $◻ HOLIDAY INN EXPRESS NAVIGATOR, Pace Communications, 1301 Carolina St., Greensboro NC 27401. (336)378-6065, Fax: (336)378-8278. E-mail: vbnavat@aol.com. Photo Researcher: Veronda Bryk. Circ. 315,000. Estab. 1998. Bimonthly consumer magazine. "A fun magazine for people who stay at Holiday Inn Express."

Needs: Buys 50 photos from freelancers per issue; 300 photos per year. Needs photos of celebrities, landscapes/scenics, wildlife, architecture, beauty, cities/urban, gardening, interiors/decorating, adventure, automobiles, entertainment, events, food/drink, health/fitness, hobbies, humor, performing arts, sports, travel. Interested in fine art, historical/vintage.

Specs: Uses any size, glossy, matte, color and/or b&w prints; 35mm, 2¼×2¼, 4×5, 8×10 transparencies preferred.

Making Contact & Terms: Send query letter with résumé, photocopies, stock list, samples. Provide résumé, business card, self-promotion piece to be kept on file for possible future assignments. Reports back only if interested, send nonreturnable samples. Simultaneous submissions and previously published work OK. Pays $150-500 for b&w inside; $150-600 for color inside. Pays on publication. Credit line given. Buys one-time rights.

Tips: "We need eye-catching images. We rarely use photo-journalistic images. Allow for a lenient holding period."

$◻ ◯ HOME EDUCATION MAGAZINE, P.O. Box 1083, Tonasket WA 98855. (509)486-1351. E-mail: hem-editor@home-ed-magazine.com. Website: http://www.home-ed-magazine.com. Managing Editor: Helen Hegener. (509)486-1351. Circ. 8,900. Estab. 1983. Bimonthly magazine. Emphasizes homeschooling. Readership includes parents, educators, researchers, media, etc.—anyone interested in home schooling. Sample copy for $4.50. Photo guidelines free with SASE.

Needs: Number of photos used/issue varies based on availability; 50% supplied by freelance photographers. Needs photos of parents, children, teens, families. Special photo needs include homeschool personalities and leaders. Model/property releases preferred. Captions preferred.

Specs: Uses 35mm transparencies. Prefers b&w prints in normal print size (3×5). "Enlargements not necessary for inside only—we need enlargements for cover submissions." Accepts images in digital format for Mac. Send via CD, Zip disk (266 dpi).

Making Contact & Terms: Send unsolicited b&w prints by mail for consideration. SASE. Reports in 1 month. Pays $50/color cover; $10/b&w inside; $50-150/photo/text package. **Pays on acceptance.** Buys first North American serial rights; negotiable. Credit line given.

Tips: In photographer's samples, wants to see "sharp clear photos of children doing things alone, in groups or with parents. Know what we're about! We get too many submissions that are simply irrelevant to our publication."

$◻ ◰ ◎ HORIZONS MAGAZINE, P.O. Box 2639, Bismarck ND 58502. (701)222-0929. Fax: (701)222-1611. E-mail: lyle_halvorson@gnda.com. Website: http://www.ndhorizons.com. Editor: Lyle Halvorson. Estab. 1971. Quality regional magazine. Photos used in magazines, audiovisual and calendars.

After reading about *Horse Illustrated* in the *1986 Photographer's Market* and writing for their guidelines, Shawn Hamilton began sending them her equestrian images. "*Horse Illustrated* first published my work in the summer of 1986 and this gave me the confidence to pursue other publications. My photos now appear monthly in *Horse Illustrated* as well as other equestrian publications and calendars. I have recently completed a children's book on horse breeds for a Canadian publishing company and am headed for my third Olympics as an official equestrian photographer."

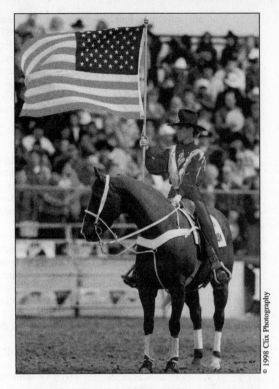

© 1998 Clix Photography

Needs: Buys 50 photos/year; offers 25 assignments/year. Needs scenics of North Dakota events, places and people. Also needs wildlife, cities/urban, rural, adventure, entertainment, events, hobbies, performing arts, travel, agriculture, industry. Interested in historical/vintage, regional, seasonal. Model/property release preferred. Captions preferred.
Specs: Uses 8×10 glossy b&w prints; 35mm, 2¼×2¼, 4×5 transparencies. Accepts images in digital format for Mac. Send via CD, Zip as TIFF, EPS files.
Making Contact & Terms: Query with samples and stock photo list. Does not keep samples on file. SASE. Reports in 2 weeks. Pays $50-100 for color cover; $10-25 for b&w inside; $25-100 for color inside. Pays on usage. Buys one-time rights; negotiable. Credit line given.
Tips: "Know North Dakota events, places. Have strong quality of composition and light." Send list of subject matter by e-mail.

N $ $ HORSE ILLUSTRATED, Dept. PM, P.O. Box 6050, Mission Viejo CA 92690. (714)855-8822. Fax: (714)855-3045. Editor: Moira C. Harris. Readers are "primarily adult horsewomen between 18-40 who ride and show mostly for pleasure and who are very concerned about the well being of their horses." Circ. 180,000. Sample copy $4.50; photo guidelines free with SASE.
Needs: Uses 20-30 photos/issue, all supplied by freelance photographers; 50% from assignment and 50% from freelance stock. Specific breed featured every issue. Prefers "photos that show various physical and mental aspects of horses. Include environmental, action and portrait-type photos. Prefer people to be shown only in action shots (riding, grooming, treating, etc.). We like all riders—especially those jumping—to be wearing protective headgear."
Specs: "We generally use color transparencies and have them converted to b&w if needed." Also uses 35mm and 2¼×2¼ color transparencies.
Making Contact & Terms: Send by mail for consideration. Reports in 2 months. Pays $25/b&w photo; $60-200/color photo and $100-350 per text/photo package. Buys one-time rights. Credit line given.
Tips: "Nothing but sharp, high-contrast shots. Looks for clear, sharp color shots of horse care and training. Healthy horses, safe riding and care atmosphere is the current trend in our publication. Send SASE for a list of photography needs and for photo guidelines and submit work."

$ $ HORTICULTURE MAGAZINE, 98 N. Washington St., Boston MA 02114. (617)742-5600. Fax: (617)367-6364. E-mail: t.schwinder@primediasi.com. Photo Editor: Tina Schwinder. Circ. 350,000. Estab.

1904. Monthly magazine. Emphasizes gardening. Readers are all ages. Sample copy $4.50 with 9×12 SAE with $3 postage. Photo guidelines free with SASE.
Needs: Uses 25-30 photos/issue; 100% supplied by freelance photographers. Needs photos of gardening, individual plants. Model release preferred. Captions required.
Making Contact & Terms: Arrange a personal interview to show portfolio. Query with samples. Send 35mm color transparencies by mail for consideration. Submit portfolio for review. Provide résumé, business card, brochure, flier or tearsheets to be kept on file for possible future assignments. SASE. Reports in 1 month. Simultaneous submissions OK. Pays $500/color cover; $50-250/color page. Pays on publication.-Buys one-time rights. Credit line given.
Tips: Wants to see gardening images only.

$ HOST COMMUNICATIONS, INC., 904 N. Broadway, Lexington KY 40505. (606)226-4510. Fax: (606)226-4575. Production Manager: Joe Miller. Estab. 1971. Weekly magazine. Emphasizes collegiate athletics. Includes football, basketball and Texas football sections and NCAA Basketball Championship Guide. Readers are predominantly male, ages 18-49. Sample copy free with 9×12 SAE and $2.90 postage.
Needs: Uses 30 photos/issue; 25 supplied by freelancers. Needs action photography. Model release preferred; photo captions preferred.
Specs: Uses color prints; 35mm transparencies.
Making Contact & Terms: Submit portfolio for review. Send unsolicited photos by mail for consideration. Provide résumé, business card, brochure, flier or tearsheets to be kept on file for possible future assignments. Deadlines vary depending on publication. SASE. Pays $50-100/color cover; $50-100/color inside; $25-100/color page. Pays on publication. Buys one-time rights. Credit line given.
Tips: Looks for crispness, clarity of photography, action captured in photography.

N ■ HUES, A Woman's Guide to Power & Attitude, New Moon Publishing, P.O. Box 3620, Duluth MN 55803-3620. (218)728-5507. Fax: (218)728-0314. E-mail: ophira@hues.net. Website: http://www.hues.net. Editor-in-Chief: Ophira Edut. Circ. 10,000. Estab. 1995. Bimonthly consumer magazine. "A hip, down to earth magazine for women of all cultures, sizes and lifestyles." Sample copies available for $5.50. Art guidelines available for #10 SAE with first-class postage.
Needs: Buys 30 photos from freelancers per issue; 200 photos per year. Needs photos of women in their 20s, especially women of color. Reviews photos with or without a ms. Model release required.
Specs: Uses any size prints. Accepts images in digital format (Photoshop files).
Making Contact & Terms: Send query letter with samples. Provide résumé, business card, self-promotion piece or tearsheets to be kept on file for possible future assignments. Art director will contact photographer for portfolio review if interested. Keeps samples on file; cannot return material. Reports in 4-6 weeks on queries and samples. Reports back only if interested, send nonreturnable samples. Simultaneous submissions and previously published work OK. Payment negotiable. Pays on publication. Credit line given. Buys all rights.
Tips: "Check out the magazine—the emphasis of *Hues* is in depicting the flavor of 'real women'—models can look hip, but also approachable. The content and missions of *Hues* is to take a direct stance against overly glamorized images which are damaging to young women's self-esteem. Photos capturing confidence, attitude, personality and intelligence—presented in hip, edgy compositions—are best."

N $ ⑤ ⊘ I LOVE CATS, 450 Seventh Ave., Suite 1701, New York NY 10123. (212)888-1855. Fax: (212)838-8420. E-mail: yankee@dancom.com. Website: http://www.iluvcats.com. Editor: Lisa M. Allmendinger. Circ. 200,000. Bimonthly magazine. Emphasizes cats. Readers are male and female ages 10-100. Sample copy $4. Photo guidelines free with SASE.
Needs: Uses 30-40 photos/issue; all supplied by freelancers. Needs color shots of cats in any environment. "Pay attention to details. Don't let props overplay cat." Model/property release preferred for children. Caption preferred.
Specs: Uses any size, any finish, color and b&w prints; 35mm transparencies.
Making Contact & Terms: Send unsolicited photos by mail for consideration. Provide résumé, business card, brochure, flier or tearsheets to be kept on file for possible assignments. SASE. Reports in 2 months. Pays $450/color cover; $25-50/color inside; $25/b&w inside; $100-200/photo/text package. Pays on publication. Buys all rights but, photos are returned after use. Credit line given.
Tips: Wants to see "crisp, clear photos with cats as the focus. Big eyes on cats looking straight at the viewer for the cover. Inside photos can be from the side with more props, more soft, creative settings. Don't send cats in dangerous situations. Keep the family perspective in mind. Always include a SASE with enough postage. Don't bug an editor, as editors are very busy. Keep the theme, intent and purpose of the publication in mind when submitting material. Be patient and submit material that is appropriate. Get a copy of the magazine."

IMMERSED MAGAZINE, The International Technical Diving Magazine, FDR Station, P.O. Box 7934, New York NY 10150. Phone/fax: (201)792-1331. E-mail: immersed@njscuba.com. Website: http://www.immersed.com. Editor/Publisher: Robert J. Sterner. Circ. 20,000. Estab. 1996. Quarterly consumer magazine that covers the cutting edge of scuba diving with articles that emphasize training, safety, science and history. Art guidelines free.

Needs: Buys 3 photos from freelancers/issue; 12 photos/year. Needs underwater photos taken under extreme conditions: gear, shipwrecks, animals and plantlife. Reviews photos with or without ms. "Manuscript gives photos an edge in use. Special photo needs include medical treatments involving divers and moderate to deep ocean depths." Model release preferred for photos with identifiable faces. Property release preferred. Photo caption required.

Specs: Uses 35mm transparencies. Accepts images in digital format.

Making Contact & Terms: Send query letter with stock photo list. Provide résumé, business card, self-promotion piece or tearsheets to be kept on file for possible future assignments. Art director will contact photographer for portfolio review if interested. Keeps samples on file. Reports back only if interested, send non-returnable samples. Simultaneous submissions OK. Payment negotiated individually. Pays on publication. Buys all rights; negotiable. Credit line given.

Tips: "We're read by scuba divers who aggressively pursue their sport wherever there is water, warm or cold. The more challenging the conditions, the better. Query first before submitting work. We're theme oriented, so the stories and art needed to illustrate them tend to fall into subjects like medical treatments, gear design or archaeology."

IN MAGAZINE, (formerly *Insider Magazine*), 4124 Oakton St., Skokie IL 60076-3267. (847)673-3703. Fax: (847)329-6358. E-mail: insidermag.com. Website: http://www.incard.com. Publisher: Mark Jansen. Editor-in-Chief: Dave Serritella. Circ. 1 million. Estab. 1984. Bimonthly magazine. Emphasizes general interest focusing on male and female readers, ages 18-29. Sample copy $1.95.

Needs: Uses 100 photos/issue. Reviews photos purchased with accompanying ms only. Model release required. Captions required.

Specs: Uses 8×10 color prints; 35mm, 4×5 transparencies.

Making Contact & Terms: Query with résumé of credits and stock photo list. Provide résumé, business card, brochure, flier or tearsheets to be kept on file for possible assignments. Keeps samples on file. SASE. Reports in 1 month.

$ $ INDEPENDENT BUSINESS, America's Small Business Magazine, Group IV Communications, 125 Auburn Court, Suite 100, Thousand Oaks CA 91362. (805)496-6156. Fax: (805)496-5469. E-mail: gosmallbiz@aol.com. Website: http://www.yoursource.com. Circ. 600,000. Estab. 1989. *IB* is a bimonthly national business magazine for and about small business in America. "Our readership consists of well-established small business owners who've been in business an average of 19 years. We appeal to these people by providing images of down-to-earth people who are proud of their business and their independence." Sample copy for $4 and 9×12 SASE. Art guidelines free with #10 SASE.

Needs: Buys 6 photos from freelancers/issue; 50 photos/year. Needs photos of people in natural business situations. Reviews photos with or without ms. Model release required for all subjects.

Specs: Uses 35mm, 2¼×2¼, 4×5, 8×10 transparencies.

Making Contact & Terms: Provide résumé, business card, self-promotion piece or tearsheets to be kept on file for possible future assignments. Art director will contact photographer for portfolio review if intereted. Portfolio should include color prints, tearsheets, slides, transparencies or thumbnails. Keeps samples on file. Reports back only if interested, send non-returnable samples. Pays $650-750 and expenses for color cover; $400-500 and expenses for color inside. Pays extra for electronic usage of photos; $100-150/use. **Pays on acceptance.** Buys first rights, non-exclusive reprint rights. Credit line given.

Tips: "No visionary shots gazing over the sea or a city skyline. The article will deliver the inspiration. We want you to deliver innovation and solve the shot with craft and creativity. Don't even think of sending film of an owner talking on the phone, working at a computer or shaking hands."

$ $ INSIDE TRIATHLON, 1830 N. 55th St., Boulder CO 80301-2700. (303)440-0601. Fax: (303)443-9919. Photo Editor: Nate Cox. Paid Circ. 30,000. The journal of triathlons. Sample copy free with 9×12 SAE and 4 first-class stamps.

Needs: Looking for action and feature shots that show the emotion of triathlons, not just finish-line photos with the winner's arms in the air. Photos purchased with or without accompanying ms. Uses news, features, profiles. Captions and identification of subjects required.

Specs: Uses negatives and transparencies.

Making Contact & Terms: Send samples of work or tearsheets with assignment proposal. Query first

on ms. SASE. Reports in 3 weeks. Pays $24-72/b&w inside; $48-300/color inside; $225/color cover. Pays on publication. Buys one-time rights. Credit line given.

Tips: "Photos must be timely."

$ $ ☑ INSIGHT MAGAZINE, Review & Herald Publishing Assoc., 55 W. Oak Ridge Dr., Hagerstown MD 21740-7390. (301)791-7000. Fax: (301)790-9734. E-mail: insight@rhpa.org. Designer: Doug Bendall. Circ. 20,000. Estab. 1970. *INSIGHT* is a weekly Seventh-day Adventist teen magazine. "We print teens' true stories about God's involvement in their lives. All stories, if illustrated by a photo, must uphold moral and church organization standards while capturing a hip, teen style." Sample copy free.

Needs: "Query with photo samples so we can evaluate style." Model/property release required. Photo caption preferred; include who, what, where, when.

Making Contact & Terms: Send query letter with samples. Provide résumé, business card, self-promotion piece or tearsheets to be kept on file for possible future assignments. Reports back only if interested; send non-returnable samples. Simultaneous submissions and/or previously published work OK. Pays $150-300 for b&w cover; $200-400 for color cover; $150-300 for b&w inside; $200-400 for color inside. **Pays on acceptance.** Buys first rights. Credit line given.

⊞ INTERNATIONAL RESEARCH & EDUCATION (IRE), 21098 IRE Control Center, Eagan MN 55121-0098. (612)888-9635. Fax: (612)888-9124. IP Director: George Franklin, Jr. IRE conducts in-depth research probes, surveys and studies to improve the decision support process. Company conducts market research, taste testing, brand image/usage studies, premium testing and design and development of product/service marketing campaigns. Photos used in brochures, newsletters, posters, audiovisual presentations, annual reports, catalogs, press releases and as support material for specific project/survey/reports.

Needs: Buys 75-110 photos/year; offers 50-60 assignments/year. "Subjects and topics cover a vast spectrum of possibilities and needs." Model release required.

Audiovisual Needs: Uses freelance filmmakers to produce promotional pieces for 16mm or videotape.

Specs: Uses prints (15% b&w, 85% color), transparencies and negatives.

Making Contact & Terms: Provide résumé, business card, brochure, flier or tearsheets to be kept on file for possible future assignments. "Materials sent are put on optic disk for options to pursue by project managers responsible for a program or job." Works on assignment only. Cannot return material. Reports when a job is available. Payment negotiable; pays on a bid, per job basis. Buys all rights. Credit line given.

Tips: "We look for creativity, innovation and ability to relate to the given job and carry out the mission accordingly."

Ⓝ $ $ ▣ ☑ INTERNATIONAL WILDLIFE, Photo Submissions, IW Publications, 8925 Leesburg Pike, Vienna VA 22184. Website: http://www.nwf.org. Photo Editor: John Nuhn. Circ. 275,000. Estab. 1970. Bimonthly magazine. Emphasizes world's wildlife, nature, environment, conservation. Readers are people who enjoy viewing high-quality wildlife and nature images, and who are interested in knowing more about the natural world and man's interrelationship with animals and environment on all parts of the globe. Sample copy $3 from National Wildlife Federation Membership Services (same address). Send separate SASE for free photo guidelines to Photo Guidelines, International Wildlife Publications (same address).

● This photo editor looks for the ability to go one step farther to make a common shot unique and creative.

Needs: Uses about 45 photos/issue; all supplied by freelance photographers; 10% on assignment, 90% from stock. Needs photos of world's wildlife, wild plants, nature-related how-to, conservation practices, conservation-minded people (tribal and individual). Special needs include single photos for various uses (primarily wildlife but also plants, scenics); story ideas (with photos) from Europe, former Soviet republics, Pacific, China. Model release preferred. Captions required.

Specs: Accepts images in digital format.

Making Contact & Terms: "Study the magazine, and ask for and follow photo guidelines before submitting. No unsolicited submissions from photographers whose work has not been previously published or considered for use in our magazine. Instead, send nonreturnable samples (tearsheets or photocopies) to 'Photo Queries'." If nonreturnable samples are acceptable, send 35mm or larger transparencies (magazine is 100% color) for consideration. SASE. Reports in 1 month. Previously published work OK. Pays $1,000/color cover; $300-750/inside; negotiable/photo text package. **Pays on acceptance.** Buys one-time rights with limited magazine promotion rights. Credit line given.

Tips: "While *Interntional Wildlife* does not encourage submissions, the annual photo contest in our companion magazine, *National Wildlife*, is an excellent way to introduce your photography. The contest is open to professional and amateur photographers alike. **Rules are updated each year** and printed along with the winning photos in the December/January issue. Rules are also available on the website."

$ $⊘ THE IOWAN MAGAZINE, 504 E. Locust St., Des Moines IA 50309. (515)282-8220. Fax: (515)282-0125. E-mail: iowan@iowan.com. Website: http://www.iowan.com. Editor: Jay P. Wagner. Circ. 25,000. Estab. 1952. Quarterly magazine. Emphasizes "Iowa—its people, places, events, nature and history." Readers are over 30, college-educated, middle to upper income. Sample copy $4.50 with 9×12 SAE and 8 first-class stamps. Photo guidelines free with SASE.
Needs: Uses about 80 photos/issue; 50% by freelance photographers on assignment and 50% freelance stock. Needs "Iowa scenics—all seasons." Also needs environmental, landscape/scenics, wildlife, architecture, rural, entertainment, events, performing arts, travel. Interested in historical/vintage, regional, seasonal. Model/property releases preferred. Captions required.
Specs: Uses 35mm, 2¼×2¼, 4×5 color transparencies. Accepts images in digital format for Mac. Send via Zip as EPS files at 300 dpi.
Making Contact & Terms: Send color 35mm, 2¼×2¼ or 4×5 transparencies by mail for consideration. SASE. Reports in 1 month. Pays $25-50/b&w photo; $50-200/color photo; $200-500/day. Pays on publication. Buys one-time rights; negotiable. Credit line given.

$ $▣ ⊘ ISLANDS AND AQUA MAGAZINES, Island Publishing, 6309 Carpinteria Ave., Carpinteria CA 93013. (805)745-7126. Fax: (805)745-7102. E-mail: lwilliams@islandsmag.com. Website: http://www.islandsmag.com and http://www:aquamag.com. Photo Researcher: Liza Williams. Circ. 250,000 (*Islands*), 125,000 (*Aqua*). Bimonthly magazines. "*Islands* is a travel magazine and *AQUA* is a water sports/scuba magazine."
Needs: Buys 25 photos from freelancers/issue; 300 photos/year. Needs photos of travel, water sports. Reviews photos with or without ms. Model/property release preferred. Photo captions required; include name, phone, address, subject information.
Specs: Uses color 35mm, 2¼×2¼, 4×5, 8×10 transparencies. Accepts images in digital format for Mac. Send via CD or online as TIFF.
Making Contact & Terms: Send query letter with tearsheets. Provide résumé, business card, self-promotion piece or tearsheets to be kept on file for possible future assignments. To show portfolio, photographer should follow-up with call. Portfolio should include b&w and/or color prints, slides, tearsheets, transparencies. Keeps samples on file. Unsolicited material returned by SASE. Simultaneous submissions OK. Pays $250-600/color cover; $75-350/color inside. Pays 30 days after publication. Buys one-time rights. Credit line given.

$ $▣ ⊘ ITALIAN AMERICA, 219 E St., NE, Washington DC 20002. (202)547-8115. Fax: (202)546-8168. E-mail: iaedit@aol.com. Website: http://www.osia.org. Circ. 65,000. Estab. 1996. Quarterly. "*Italian America* is the official publication of the Order Sons of Italy in America, the nation's oldest and largest organization of American men and women of Italian heritage. *Italian America* strives to provide timely information about OSIA, while reporting on individuals, institutions, issues and events of current or historical significance in the Italian-American community." Sample copy free. Art guidelines free.
Needs: Buys 5-10 photos from freelancers/issue; 25 photos/year. Needs photos of travel, history, personalities; anything Italian or Italian American. Reviews photos with or without ms. Special photo needs include travel in Italy. Model release preferred. Photo caption required.
Specs: Prefers 35mm, 4×5, 8×10 transparencies. Accepts images in digital format for Mac, Windows. Send via CD, floppy disk, Zip, e-mail as TIFF, EPS, JPEG files at 300 dpi.
Making Contact & Terms: Send query letter with tearsheets. Provide résumé, business card, self-promotion piece or tearsheets to be kept on file for possible future assignments. Art director will contact photographer for portfolio review if interested. Portfolio should include color tearsheets. Keeps samples on file. Reports back only if interested, send non-returnable samples. Simultaneous submissions OK. Pays $250-500 for color cover; $50-250 for color inside. Pays on publication. Buys one-time rights. Credit line given.
Tips: "Send inquiries, ideas, actual work to: Brenda Dalessandro, Editor, 51 Alderman Dr., Morgantown,

MARKET CONDITIONS are constantly changing! If you're still using this book and it's 2001 or later, buy the newest edition of *Photographer's Market* at your favorite bookstore or order directly from Writer's Digest Books.

WV 26505."

$ $◫ ITE JOURNAL, 525 School St. SW, #410, Washington DC 20024. (202)554-8050. Fax: (202)863-5486. Website: http://www.ite.org. Director of Communications and Marketing: Shannon Gore Peters. Production Editor: Linda S. Streaker. Circ. 14,000. Estab. 1930. Publication of Institute of Transportation Engineers. Monthly journal. Emphasizes surface transportation, including streets, highways and transit. Readers are transportation engineers and professionals.
Needs: One photo used for cover illustration per issue. Needs "shots of streets, highways, traffic, transit systems." Also considers landscapes, cities, rural, automobiles, travel, industry, technology, historical/vintage. Model release required. Captions preferred, include location, name or number of road or highway and details.
Making Contact & Terms: Query with list of stock photo subjects. Send 35mm or 2¼×2¼ transparencies by mail for consideration. Provide résumé, business card, brochure, flier or tearsheets to be kept on file for possible assignments. "Send originals; no dupes please." Simultaneous submissions and/or previously published work OK. Pays $250/color cover; $50/b&w cover. Pays on publication. Buys multiple-use rights. Credit line given.
Tips: "Send a package to me in the mail; package should include samples in the form of slides and/or transparencies."

Ⓝ $JAZZTIMES, 8737 Colesville Rd., 5th Floor, Silver Spring MD 20910. (301)588-4114. Fax: (301)588-2009. Editor: Mike Joyce. Circ. 100,000. Estab. 1969. Monthly glossy magazine (10 times/year). Emphasizes jazz. Readers are jazz fans, record consumers and people in the music industry, ages 15-75.
Needs: Uses about 50 photos/issue; 30 supplied by freelance photographers. Needs performance shots, portrait shots of jazz musicians. Model release required. Captions preferred.
Making Contact & Terms: Send 5×7 b&w prints by mail for consideration. "If possible, we keep photos on file till we can use them." SASE. Reports in 2 weeks. Simultaneous submissions and previously published work OK. Pays $50/color; $15-20/b&w inside. Negotiates fees for cover photo. Pays on publication. Buys one-time or reprint rights; negotiable. Credit line given.
Tips: "Send whatever photos you can spare. Name and address should be on back."

$ $▣ ◎ JEWISH ACTION, The Magazine of the Orthodox Union, 333 Seventh Ave., New York NY 10001-5004. (212)613-8146. Fax: (212)564-9058. Editor: Ms. Friedland. Circ. 20,000. Estab. 1986. Quarterly magazine with adult Orthodox Jewish readership. Sample copy for $5 and 8½×11 SAE.
Needs: Buys 6 photos/year. Needs photos of Jewish lifestyle, landscapes and travel photos of Israel and occasional photo essays of Jewish life. Reviews photos with or without ms. Model release preferred; property release preferred. Photo caption required; include description of activity where taken, when.
Specs: Uses color and/or b&w prints. Accepts images in digital format for Mac. Send CD, Jaz, Zip as TIFF, GIF, JPEG files.
Making Contact & Terms: Send query letter with samples, brochure or stock photo list. Keeps samples on file. Reports in 2 months on queries; 2 months on samples. Simultaneous submissions OK. Pays $250 maximum for b&w cover; $400 maximum for color cover; $100 maximum for b&w inside; $150 maximum for color inside. Pays within 6 weeks of publication. Buys one-time rights. Credit line given.
Tips: "Be aware that models must be clothed in keeping with Orthodox laws of modesty. Make sure to include identifying details. Don't send work depicting religion in general. We are specifically Othodox Jewish."

$ $▣ JOURNAL OF ASIAN MARTIAL ARTS, Via Media Publishing Co., 821 W. 24th St., Erie PA 16502-2523. (814)455-9517. Fax: (877)526-5262. E-mail: info@goviamedia.com. Website: http://www.goviamedia.com. Editor-in-Chief: Michael DeMarco. Circ. 10,000. Estab. 1992. "An indexed, notch bound quarterly magazine exemplifying the highest standards in writing and graphics available on the subject. Comprehensive, mature, and eye-catching. Covers all historical and cultural aspects of Asian martial arts." Sample copy for $10. Art guidelines for SAE with 1 first-class stamp.
Needs: Buys 120 photos from freelancers/issue; 580 photos/year. Needs photos of action shots; technical sequences of martial arts; photos that capture the philosophy and aesthetics of Asian martial traditions. Model release preferred for photos taken of subjects not in public demonstration; property release preferred. Photo caption preferred. Include short description, photographer's name, year taken.
Specs: Uses color and b&w prints; 35mm, 2¼×2¼, 4×5, 8×10 transparencies. Accepts images in digital format.
Making Contact & Terms: Send query letter with samples, stock photo list. Provide résumé, business card, self-promotion piece or tearsheets to be kept on file for possible future assignments. Art director will contact photographer for portfolio review if interested. Keeps samples on file; include SASE for return of

material. Reports in 2 months on queries; 2 months on samples. Previously published work OK. Pays $100-500 for color cover; $10-100 for b&w inside. Buys first rights and reprint rights. Credit line given.
Tips: "Read the journal. We are unlike any other martial arts magazine and would like photography to compliment the text portion, which is sophisticated with the flavor of traditional Asian aesthetics. When submitting work, be well organized and include a SASE."

$ $JUNIOR SCHOLASTIC, 555 Broadway, New York NY 10012. (212)343-6295. Fax: (212)343-6333. Website: http://www.juniorscholastic.com. Editor: Lee Baier. Senior Photo Researcher: Diana Gongora Circ. 589,000. Biweekly educational school magazine. Emphasizes middle school social studies (grades 6-8): world and national news, US and world history, geography, how people live around the world. Sample copy $1.75 with 9×12 SAE.
Needs: Uses 20 photos/issue. Needs photos of young people ages 11-14; non-travel photos of life in other countries; US news events. Reviews photos with accompanying ms only. Model release required. Captions required.
Making Contact & Terms: Arrange a personal interview to show portfolio. "Please do not send samples—only stock list or photocopies of photos." Reports in 1 month. Simultaneous submissions OK. Pays $200/color cover; $75/b&w inside; $150/color inside. **Pays on acceptance.** Buys one-time rights. Credit line given.
Tips: Prefers to see young teenagers; in US and foreign countries, especially "personal interviews with teenagers worldwide with photos."

N A ⬛ KALLIOPE, A Journal of Women's Literature & Art, 3939 Roosevelt Blvd., Jacksonville FL 32205. Website: http://www.fccj.org/kalliops/kalliope.htm. Contact: Art Editor. Circ. 1,500. Estab. 1978. Journal published 3 times/year. Emphasizes art by women. Readers are interested in women's issues. Sample copy $7. Photo guidelines free with SASE.
Needs: Uses 18 photos/issue; all supplied by freelancers. Needs art and fine art that will reproduce well in b&w. Needs photos of nature, people, fine art by excellent sculptors and painters, and shots that reveal lab applications. Model release required. Photo captions preferred. Artwork should be titled.
Specs: Uses 5×7 b&w prints.
Making Contact & Terms: Send unsolicited photos by mail for consideration. SASE. Reports in 1 month. Pays contributor 3 free issues or 1-year free subscription. Buys one-time rights. Credit line given.
Tips: "Send excellent quality photos with an artist's statement (50 words) and résumé."

$ ⬛ KANSAS, 700 SW Harrison, Suite 1300, Topeka KS 66603. (785)296-3479. Fax: (785)296-6988. Editor: Andrea Glenn. Circ. 50,000. Estab. 1945. Quarterly magazine. Emphasizes Kansas travel, scenery, arts, recreation and people. Photos are purchased with or without accompanying ms or on assignment. Free sample copy and photo guidelines.
Needs: Buys 60-80 photos/year; 75% from freelance assignment, 25% from freelance stock. Animal, human interest, nature, seasonal, rural, photo essay/photo feature, scenic, sport, travel and wildlife, all from Kansas. No b&w, nudes, still life or fashion photos. Model/property release preferred. Captions (with subject and specific location of photograph identified) required.
Specs: Uses 35mm, 2¼×2¼ or 4×5 transparencies.
Making Contact & Terms: Send material by mail for consideration. Transparencies must be identified by location and photographer's name on the mount. Photos are returned after use. Previously published work OK. Pays $50 minimum/color inside; $150 minimum/color cover. **Pays on acceptance.** Buys one-time rights. Credit line given.
Tips: Kansas-oriented material only. Prefers Kansas photographers. "Follow guidelines, submission dates specifically. Shoot a lot of seasonal scenics."

$ ⬛ KASHRUS MAGAZINE—The Guide for the Kosher Consumer, P.O. Box 204, Parkville Station, Brooklyn NY 11204. (718)336-8544. Website: http://www.kosherinfo.com. Editor: Rabbi Yosef Wikler. Circ. 10,000. Bimonthly. Emphasizes kosher food and food technology, travel, catering, weddings, remodeling, humor. Readers are kosher food consumers, vegetarians and food producers. Sample copy $2.
Needs: Uses 3-5 photos/issue; all supplied by freelance photographers. Needs photos of travel, food, food technology, children, environmental, landscapes, interiors, Jewish, rural, food/drink, humor, travel, product shots, technology, regional, seasonal, seasonal nature photos and Jewish holidays. Model release preferred. Captions preferred.
Specs: Uses 2¼×2¼, 3½×3½ or 7½×7½ matte b&w prints.
Making Contact & Terms: Send unsolicited photos by mail for consideration. Provide business card, brochure, flier or tearsheets to be kept on file for possible future assignments. SASE. Reports in 1 week. Simultaneous submissions and previously published work OK. Pays $40-75/b&w cover; $50-100 for color

cover; $25-50/b&w inside; $75-200/job; $50-200/text/photo package. Pays part on acceptance; part on publication. Buys one-time rights, first North American serial rights, all rights; negotiable.

$ $◫ ◑ KEYNOTER, 3636 Woodview Trace, Indianapolis IN 46268. (317)875-8755. Fax: (317)879-0204. Art Director: Jim Patterson. Circ. 190,000. Publication of the Key Club International. Monthly magazine through school year (7 issues). Emphasizes teenagers, above average students and members of Key Club International. Readers are teenagers, ages 14-18, male and female, high GPA, college-bound, leaders. Sample copy free with 9 × 12 SAE and 3 first-class stamps. Photo guidelines free with SASE.

Needs: Uses varying number of photos/issue; varying percentage supplied by freelancers. Needs vary with subject of the feature article. Reviews photos purchased with accompanying ms only.

Specs: Accepts images in digital format. Send via compact disc, floppy disk or SyQuest.

Making Contact & Terms: Query with résumé of credits. Pays $700/color cover; $500/b&w cover; $400/color inside; $100/b&w inside. **Pays on acceptance.** Buys first North American serial rights and first international serial rights. Credit line given.

◨ KIPLINGER'S PERSONAL FINANCE MAGAZINE, 1729 H St. NW, Washington DC 20006. (202)887-6492. Fax: (202)331-1206. Photography Editor: Wendy Tefenbacher. Circ. 1.2 million. Estab. 1935. Monthly magazine. Emphasizes personal finance.

Needs: Uses 15 photos/issue; 90% supplied by freelancers. Needs "creative business portraits and photo illustration dealing with personal finance issues (i.e. investing, retirement, real estate) and fine art documentary work. Model release required. Property release preferred. Captions required.

Making Contact & Terms: Arrange personal interview to show portfolio. Provide business card, brochure, flier or tearsheets to be kept on file for possible assignments. Keeps samples on file. SASE. Reports in 2 weeks. Pays $1,200/color and b&w cover; $350-1,200/day against space rate per page. **Pays on acceptance.** Buys one-time rights. Credit line given.

$◎ KITE LINES, P.O. Box 466, Randallstown MD 21133-0466. (410)922-1212. Fax: (410)922-4262. E-mail: kitelines@compuserve.com. Publisher-Editor: Valerie Govig. Circ. 13,000. Estab. 1977. Quarterly. Emphasizes kites and kite flying exclusively. Readers are international adult kiters. Sample copy $5. Photo guidelines free with SASE.

Needs: Uses about 45-65 photos/issue; "up to about 50% are unassigned or over-the-transom—but nearly all are from *kiter*-photographers." Needs photos of "unusual kites in action (no dimestore plastic kites), preferably with people in the scene (not easy with kites). Needs to relate closely to *information* (article or long caption)." Special needs include major kite festivals; important kites and kiters. Captions required. "Identify kites, kitemakers and kitefliers as well as location and date."

Making Contact & Terms: Query with samples or send 2-3 b&w 8 × 10 uncropped prints or 35mm or larger transparencies (dupes OK) by mail for consideration. Provide relevant background information, i.e., knowledge of kites or kite happenings. SASE. Reports in "2 weeks to 2 months (varies with work load, but any obviously unsuitable stuff is returned quickly—in 2 weeks." Previously published work considered. Pays $0-30/inside; $0-50/cover; special jobs on assignment negotiable; generally on basis of film expenses paid only. "We provide extra copies to contributors. Our limitations arise from our small size. However, *Kite Lines* is a quality showcase for good work." Pays within 30 days after publication. Buys one-time rights; usually buys first world serial rights.

Tips: In portfolio or samples wants to see "ability to select important, *noncommercial* kites. Just take a great kite picture, and be patient with our tiny staff. Considers good selection of subject matter; good composition—angles, light, background and sharpness. But we don't want to look at 'portfolios'—just *kite* pictures, please."

$ $ $◫ ◑ KIWANIS MAGAZINE, 3636 Woodview Trace, Indianapolis IN 46268. (317)875-8755. Fax: (317)879-0204. E-mail: jpatterson@kiwanis.org. Website: http://www.kiwanis.org. Managing Editor: Chuck Jonak. Art Director: Jim Patterson. Circ. 285,000. Estab. 1915. Published 10 times/year. Emphasizes organizational news, plus major features of interest to business and professional men and women involved in community service. Free sample copy and writer's guidelines with SAE and 5 first-class stamps.

Needs: Needs photos of babies, children, multicultural, families, parents, senior citizens, teens, landscapes/scenics, education, business, computers, medicine, science, technology, fine art, regional. Uses photos with or without ms.

Specs: Uses 5 × 7 or 8 × 10 glossy b&w prints; accepts 35mm but prefers 2¼ × 2¼ and 4 × 5 transparencies. Accepts images in digital format for Windows. Send via CD, floppy disk, SyQuest, Zip as TIFF, BMP.

Making Contact & Terms: Send résumé of stock photos. Provide brochure, business card and flier to

be kept on file for future assignments. Assigns 95% of work. Pays $800-1,000 for b&w or color cover; $25-800 for b&w or color inside. Buys one-time rights.

Tips: "We can offer the photographer a lot of freedom to work *and* worldwide exposure. And perhaps an award or two if the work is good. We are now using more conceptual photos. We also use studio set-up shots for most assignments. When we assign work, we want to know if a photographer can follow a concept into finished photo without on-site direction." In portfolio or samples, wants to see "studio work with flash and natural light."

$ [A] ☐ LACROSSE MAGAZINE, 113 W. University Pkwy., Baltimore MD 21210. (410)235-6882. Fax: (410)366-6735. E-mail: mbouchard@lacrosse.org. Editor: Marc Bouchard. Circ. 15,000. Estab. 1978. Publication of The Lacrosse Foundation. Monthly magazine during lacrosse season (March, April, May, June); bimonth off-season (July/August, September/October, November/December, January/February). Emphasizes sport of lacrosse. Readers are male and female lacrosse enthusiasts of all ages. Sample copy free with general information pack.

Needs: Uses 30-40 photos/issue; 50-75% supplied by freelancers. Needs lacrosse action shots. Captions required; include rosters with numbers for identification.

Specs: Uses 4×6 glossy color and b&w prints.

Making Contact & Terms: Send unsolicited photos by mail for consideration. Provide résumé, business card, brochure, flier or tearsheets to be kept on file for possible assignments. Keeps samples on file. SASE. Reports in 3 weeks. Simultaneous submissions and/or previously published work OK. Pays $100/color cover; $50/color inside; $50/b&w inside. Pays on publication. Buys one-time rights. Credit line given.

[N] $ $ LADIES HOME JOURNAL, Dept. PM, 125 Park Ave., New York NY 10017. (212)557-6600. Fax: (212)351-3650. Contact: Photo Editor. Monthly magazine. Features women's issues. Readership consists of women with children and working women in 30s age group. Circ. 6 million.

Needs: Uses 90 photos per issue; 100% supplied by freelancers. Needs photos of children, celebrities and women's lifestyles/situations. Reviews photos only without ms. Model release and captions preferred. No photo guidelines available.

Making Contact & Terms: Provide résumé, business card, brochure, flier or tearsheet to be kept on file for possible assignment. "Do not send slides or original work; send only promo cards or disks." Reports in 3 weeks. Pays $200/b&w inside; $200/color page rate. **Pays on acceptance.** Buys one-time rights. Credit line given.

$ ☐ LAKE SUPERIOR MAGAZINE, Lake Superior Port Cities, Inc., P.O. Box 16417, Duluth MN 55816-0417. (218)722-5002. Fax: (218)722-4096. E-mail: edit@lakesuperior.com. Website: http://www.lakesuperior.com. Editor: Paul L. Hayden. Circ. 20,000. Estab. 1979. Bimonthly magazine. "Beautiful picture magazine about Lake Superior." Readers are ages 35-55, male and female, highly educated, upper-middle and upper-management level through working. Sample copy $3.95 with 9×12 SAE and 5 first-class stamps. Photo guidelines free with SASE.

Needs: Uses 30 photos/issue; 70% supplied by freelance photographers. Also buys photos for calendars and books. Needs photos of scenic, travel, wildlife, personalities, underwater, all photos Lake Superior-related. Photo captions preferred.

Specs: Uses b&w prints; 35mm, 2¼×2¼, 4×5 transparencies.

Making Contact & Terms: Send unsolicited photos by mail for consideration. Provide résumé, business card, brochure, flier or tearsheets to be kept on file for possible assignments. SASE. Reports in 3 weeks. Simultaneous submissions OK. Pays $125/color cover; $40/color inside; $20/b&w inside. Pays on publication. Buys first North American serial rights; reserves second rights for future use. Credit line given.

Tips: "Be aware of the focus of our publication—Lake Superior. Photo features concern only that. Features with text can be related. We are known for our fine color photography and reproduction. It has to be 'tops.' We try to use images large, therefore detail quality and resolution must be good. We look for unique outlook on subject, not just snapshots. Must communicate emotionally."

$ LAKELAND BOATING MAGAZINE, 500 Davis St., Suite 100, Evanston IL 60201. (847)869-5400. Editor: Randall W. Hess. Circ. 45,000. Estab. 1945. Monthly magazine. Emphasizes powerboating in the Great Lakes. Readers are affluent professionals, predominantly men over 35. Sample copy $6 with 9×12 SAE and 10 first-class stamps.

Needs: Needs shots of particular Great Lakes ports and waterfront communities. Model release preferred. Captions preferred.

Making Contact & Terms: Query with list of stock photo subjects. Provide résumé, business card, brochure, flier or tearsheets to be kept on file for possible assignments. SASE. Pays $20-100/b&w photo; $25-100/color photo. **Pays on acceptance.** Buys one-time rights. Credit line given.

⊠ $ $ ▣ ◯ LATINA MAGAZINE, 1500 Broadway, Suite 600, New York NY 10036. (212)642-0600. Fax: (212)997-2553. E-mail: latinamag@aol.com. Photo Editor: Laura Encinas. Circ. 300,000. Estab. 1996. Monthly since 1998. Emphasizes lifestyle. Readers are female hispanic, ages 25-40.

Needs: Needs photos of babies, celebrities, children, couples, multicultural, families, parents, senior citizens, teens, architecture, beauty, cities/urban, education, religious, rural, adventure, entertainment, food/drink, health/fitness, humor, performing arts, sports, travel, political, portraits, still life, fashion/glamour. Model release required for celebrities. Captions required; include photographer's name.

Specs: Accepts images in digital format for Mac. Send via online, floppy disk, Zip disk (300 dpi).

Making Contact & Terms: Submit portfolio for review. Drop off portfolios at mailroom of *Essence* magazine, 1500 Broadway, 6th Floor, New York NY 10036. Provide résumé, business card, brochure, flier or tearsheets to be kept on file for possible assignments. "Only send your portfolio." Keeps samples on file. Cannot return material. Reports in 1-2 weeks. Pays $100-250/b&w inside; $250/color page rate. Pays on publication. Buys one-time and all rights; negotiable. Credit line given.

⊠ $ $ ⑤ ▣ ◿ LAUNCH WAKEBOARD MAGAZINE, e-x Inc., 1030 Calle Sambra, A-2, San Clemente CA 92673. (949)361-7715. Fax: (949)361-7716. E-mail: launchwake@aol.com. Website: http://www.e-xtreme.com. Editor: Jeff Barten. Monthly consumer sport-oriented wakeboarding publication. Sample copies available.

Needs: Buys 100 photos from freelancers per issue; 1,000 photos/year. Model and property release preferred.

Specs: Uses 2¼×2¼ transparencies. Accepts images in digital format for Mac. Send via Zip.

Making Contact & Terms: Send query letter with slides. Does not keep samples on file; include SASE for return of material. Pays $250 minimum for color cover; $125 minimum for b&w inside. Pays on publication. Credit line given. Buys one-time rights.

Tips: "Be readily available for assignment. Keep a current stock with us no more than 6 months old. Send a letter talking about other avenues of contributions that are not reflected in initial submission."

$ $ $ $◿ LEG SEX, The SCORE Group, 4931 S.W. 75th Ave., Miami FL 33155. (305)662-5959. Fax: (305)662-5952. E-mail: foxs@scoregroup.com. Contact: Sue Fox. Monthly men's magazine featuring photo sets of models with a strong emphasis on the legs and feet. Sample copy for $7. Art guidelines available.

Needs: Model release required; as well as copies of two forms of I.D. from the model, one of them being a photo I.D.

Specs: Uses color prints; 35mm transparencies; Kodachrome film or larger format transparencies.

Making Contact & Terms: Query with samples. "Please do not send individual photos except for test shots." Portfolio should include color transparencies. Include SASE for return of material. Reports in 1 month maximum on queries. Pays $1,250-1,800 for color sets of 100-200 transparencies. Pays on publication. Buys first rights in North America with a reprint option, electronic rights and non-exclusive worldwide publishing rights.

⊠ $ ⚑ ⑤ ▣ ◿ LEISURE WORLD, 1253 Ouellette Ave., Windsor, Ontario N8X 1J3 Canada. E-mail: doug@ompc.com. Website: http://www.ompc.com. Editor-in-Chief: Doug O'Neil. Circ. 321,214. Estab. 1988. Bimonthly magazine. Emphasizes travel and leisure. Readers are members of the Canadian Automobile Association, 50% male, 50% female, middle to upper middle class. Sample copy $2.

Needs: Uses 20-25 photos/issue; 25-30% supplied by freelance photographers. "*Leisure World* is looking for travel and destination features that not only serve as accurate accounts of real-life experiences, but are also dramatic narratives, peopled by compelling characters. Nonfiction short stories brought home by writers who have gone beyond the ordinary verities of descriptive travel writing to provide an intimate glimpse of another culture." Model release preferred. Captions required.

Specs: Uses 35mm, 2¼×2¼, 4×5, or 8×10 transparencies. Accepts images in digital format for Windows. Send via CD, SyQuest, Zip, Jaz, e-mail as TIFF files at 300 dpi (minimum).

Making Contact & Terms: Send unsolicited photos by mail for consideration. Provide business card, brochure, flier or tearsheets to be kept on file for possible assignments. SASE. Reports in 2 weeks. Pays $100/color cover; $50/color inside; or $150-300/photo/text package. Pays on publication. Buys one-time rights. Credit line given.

Tips: "We expect that the technical considerations are all perfect—frames, focus, exposure, etc. Beyond that we look for a photograph that can convey a mood or tell a story by itself. We would like to see 50% landscape, 50% portrait format in 35mm photographs. We encourage talented and creative photographers who are trying to establish themselves."

$ ▣ ◑ LIBIDO: THE JOURNAL OF SEX AND SENSIBILITY, 5318 N. Paulina St., Chicago IL 60640. (773)275-0842. Fax: (773)275-0752. E-mail: rune@mcs.com. Photo Editor: Marianna Beck. Circ. 10,000. Estab. 1988. Quarterly journal. Emphasizes erotic photography. Subscribers are 60% male, 40% female, generally over 30, college educated professionals. Sample copy $8. Photo guidelines free with SASE.
Needs: Uses 30-35 photos/issue; 30 supplied by freelancers. Needs erotic photos (need not be nude, but usually it helps); nude figure-studies and couples. Reviews photos with or without ms. Model release required. "Besides dated releases, all photos taken after July 5, 1995 must comply with federal record keeping requirements."
Specs: Uses 4×5, 5×7, 8×10 matte or glossy b&w prints and slides. Accepts images in digital format for Mac. Send via online, floppy disk as TIFF files.
Making Contact & Terms: Send unsolicited photos, contact sheets and portfolios by mail for consideration. Keeps samples on file. Reports in 1 month. Previously published work OK. Pays $75/b&w cover; $20-50/b&w inside. Pays on publication. Credit line given.
Tips: "Fit your work to the style and tone of the publication. We're print driven; photos must support stories and poems."

$ Ⓐ ◑ THE LION, 300 22nd St., Oak Brook IL 60523-8842. (630)571-5466. Fax: (630)571-8890. E-mail: lionpr@worldnet.att.net. Website: http://www.lionsclubs.org. Editor: Robert Kleinfelder. Circ. 600,000. Estab. 1918. For members of the Lions Club and their families. Monthly magazine. Emphasizes Lions Club service projects. Free sample copy and guidelines available.
Needs: Uses 50-60 photos/issue. Needs photos of Lions Club service or fundraising projects. "All photos must be as candid as possible, showing an activity in progress. Please, no award presentations, meetings, speeches, etc. Generally photos purchased with ms (300-1,500 words) and used as a photo story. We seldom purchase photos separately." Model release preferred for young or disabled children. Captions required.
Specs: 5×7, 8×10 glossy b&w and color prints; 35mm transparencies.
Making Contact & Terms: Works with freelancers on assignment only. Provide résumé to be kept on file for possible future assignments. Query first with résumé of credits or story idea. SASE. Reports in 2 weeks. Pays $10-25/photo; $200-600/text/photo package. **Pays on acceptance.** Buys all rights; negotiable.

$ ▣ ◑ THE LIVING CHURCH, 816 E. Juneau Ave., P.O. Box 514036, Milwaukee WI 53203. (414)276-5420. Fax: (414)276-7483. Managing Editor: John Schuessler. Circ. 9,000. Estab. 1878. Weekly magazine. Emphasizes news of interest to members of the Episcopal Church. Readers are clergy and lay members of the Episcopal Church, predominantly ages 35-70. Sample copies available.
Needs: Uses 8-10 photos/issue. Needs photos to illustrate news articles. Need stock photos—churches, scenic, people in various settings. Captions preferred.
Specs: Uses 5×7 or larger glossy b&w prints. Accepts images in digital format. Send as TIFF files at 300 dpi.
Making Contact & Terms: Send unsolicited photos by mail for consideration. SASE. Reports in 1 month. Pays $25-50/b&w cover; $10-25/b&w inside. Pays on publication. Credit line given.

$ $◑ LOG HOME LIVING, 4200 T Lafayette Center Dr., Chantilly VA 20151. Website: http://www.loghomeliving.com. Editor: Janice Brewster. Circ. 120,000. Estab. 1989. Monthly magazine. Emphasizes buying and living in log homes. Sample copy $4/issue. Photo guidelines free with SASE.
Needs: Uses over 100 photos/issue; 10 supplied by freelancers. Needs photos of homes—living room, dining room, kitchen, bedroom, bathroom, exterior, portrait of owners, design/decor—tile sunrooms, furniture, fireplaces, lighting, porch and deck, doors. Model release preferred. Caption required.
Making Contact & Terms: Send unsolicited photos by mail for consideration. Keeps samples on file. SASE. Reports back only if interested. Previously published work OK. Pays $600 minimum/color cover; $75-800/color inside; $100/color page rate; $500-1,000/photo/text package. **Pays on acceptance.** Buys first North American serial rights; negotiable. Credit line given.
Tips: "Send photos of log homes, both interiors and exteriors."

$ ▣ LOTTERY & CASINO NEWS, 321 New Albany Rd., Moorestown NJ 08057. (609)778-8900. Fax: (609)273-6350. E-mail: regalpub@lottery-casino-news.com. Editor-in-chief: Samuel W. Valenza, Jr..

THE INTERNATIONAL MARKETS INDEX, located in the back of this book, lists markets located outside the U.S. by country.

Circ. 200,000. Estab. 1981. Bi-monthly tabloid. Covers gaming industry news: lottery, casinos, riverboat casinos, Indian casinos, with an emphasis on winners in all aspects of gaming; Casino show reviews. Will accept photos with or without ms. Captions required.

Needs: Uses 15-20 photos/issue; 1-2 supplied by freelancers. Needs photos of people buying lottery tickets, lottery winners, lottery and gaming activities. Reviews photos with or without ms. Captions required.

Specs: Accepts images in digital format for Windows. Send via floppy or Zip disk or online.

Making Contact & Terms: Provide résumé, business card, brochure, flier or tearsheets to be kept on file for possible assignments. "Call with ideas." Keeps samples on file. SASE. Reports in 3 weeks. Pays $20-60/color cover; $20/b&w inside; rates vary. Pays 2 months after publication. Simultaneous submissions and/or previously published work OK. Buys one-time rights, first North American serial rights, all rights; negotiable.

Tips: "Photos should be clear, timely and interesting, with a lot of contrast."

LOUIE, 234 Berkeley St., Boston MA 02116. (617)262-6100. Fax: (617)262-4549. Website: http://www.louis-boston.com. Contact: Maria Fei. Circ. 75,000. Twice a year consumer magazine. "Cutting edge catalog concept (no prices!)/magazine geared towards affluent, well educated, professionals who appreciate the finer things." Sample copy free.

Needs: Reviews photos with accompanying ms only depending on issue. Photo caption preferred.

Specs: Uses 4×5 prints.

Making Contact & Terms: Send query letter with samples, brochure, stock photo list, tearsheets. Provide résumé, business card, self-promotion piece or tearsheets to be kept on file for possible future assignments. Portfolio should include b&w and/or color, prints or tearsheets. Reports back only if interested, send non-returnable samples. Payment varies. Buys negotiated rights. Credit line sometimes given depending upon circumstances.

N $ $ ▣ ⊘ THE LUTHERAN, 8765 W. Higgins Rd., Chicago IL 60631. (773)380-2540. Fax: (773)380-2751. E-mail: mwatson@elca.org. Website: http://www.thelutheran.org. Art Director: Michael Watson. Publication of Evangelical Lutheran Church in America. Circ. 650,000. Estab. 1988. Monthly magazine. Sample copy 75¢ with 9×12 SASE.

Needs: Assigns 35-40 photos/issue; 10-15 supplied by freelancers. Needs current news, mood shots. Subjects include babies, children, couples, multicultural, families, parents, senior citizens, teens, disasters, landscapes/scenics, cities/urban, education, religious, portraits, digital, fine art, seasonal. "We usually assign work with exception of 'Reflections' section." Model release required. Captions preferred.

Specs: Accepts images in digital format for Mac. Send via CD, floppy disk, SyQuest, Zip as TIFF files at 300 dpi.

Making Contact & Terms: Query with list of stock photo subjects. Provide résumé, brochure, flier or tearsheets to be kept on file for possible future assignments. SASE. Reports in 3 weeks. Pays $300-500 for color cover; $175-300 for color inside; $250/half day; $500 for full day. Pays on publication. Buys one-time rights. Credit line given.

Tips: Trend toward "more dramatic lighting. Careful composition." In portfolio or samples, wants to see "candid shots of people active in church life, preferably Lutheran. Churches-only photos have little chance of publication. Submit sharp well-composed photos with borders for cropping. Send samples (printed or dupes) no originals, that we can keep on file. If we like your style we will call you when we have a job in your area."

$ LUTHERAN FORUM, P.O. Box 327, Delhi NY 13753. (607)746-7511. Editor: Ronald Bagnall. Circ. 3,500. Quarterly. Emphasizes "Lutheran concerns, both within the church and in relation to the wider society, for the leadership of Lutheran churches in North America."

Needs: Uses cover photo occasionally. "While subject matter varies, we are generally looking for photos that include people, and that have a symbolic dimension. We use *few* purely 'scenic' photos. Photos of religious activities, such as worship, are often useful, but should not be 'cliches'—types of photos that are seen again and again." Captions "may be helpful."

Making Contact & Terms: Query with list of stock photo subjects. SASE. Reports in 2 months. Simultaneous submissions or previously published work OK. Pays $15-25/b&w photo. Pays on publication. Buys one-time rights. Credit line given.

$ $ ▣ ▣ MACLEAN'S MAGAZINE, 777 Bay St., Toronto, Ontario M5G 2C8 Canada. (416)596-5379. Fax: (416)596-7730. E-mail: pbregg@macleans.ca. Photo Editor: Peter Bregg. Circ. 500,000. Estab. 1905. Weekly magazine. Emphasizes news/editorial. Readers are a general audience. Sample copy $3 with 9×12 SASE.

Needs: Uses 50 photos/issue. Needs a variety of photos similar to *Time* and *Newsweek*. Captions required;

include who, what, where, when, why.

Specs: Uses color prints; transparencies; 266 dpi, 6×8 average digital formats.

Making Contact & Terms: Send business card. Cannot return unsolicited material. Dupes preferred. Reports in 3 weeks. Simultaneous submissions and previously published work OK. Pays $350/day; $600/ color cover; $200/color inside; $50 extra for electronic usage. Pays on publication. Buys one-time and electronic rights. Credit line given.

THE MAGAZINE ANTIQUES, 575 Broadway, New York NY 10012. (212)941-2800. Fax: (212)941-2819. Editor: Allison E. Ledes. Circ. 63,969. Estab. 1922. Monthly magazine. Emphasizes art, antiques, architecture. Readers are male and female collectors, curators, academics, interior designers, ages 40-70. Sample copy $10.50.

Needs: Uses 60-120 photos/issue; 40% supplied by freelancers. Needs photos of interiors, architectural exteriors, objects. Reviews photos with or without ms.

Specs: Uses 8×10 glossy prints; 4×5 transparencies.

Making Contact & Terms: Submit portfolio for review; phone ahead to arrange dropoff. Does not keep samples on file. SASE. Reports in 2 weeks. Previously published work OK. Payment negotiable. Pays on publication. Buys one-time rights; negotiable. Credit line given.

$ $▣ MARLIN MAGAZINE, P.O. Box 2456, Winter Park FL 32790. (407)628-4802. Fax: (407)628-7061. E-mail: marlin@worldzine.com. Editor: David Ritchie. Circ. 40,000 (paid). Estab. 1981. Bimonthly magazine. Emphasizes offshore big game fishing for billfish, tuna and other large pelagics. Readers are 94% male, 75% married, average age 43, very affluent businessmen. Free sample copy with 8×10 SASE. Photo guidelines free with SASE.

Needs: Uses 40-50 photos/issue; 98% supplied by freelancers. Needs photos of fish/action shots, scenics and how-to. Special photo needs include big game fishing action and scenics (marinas, landmarks etc.). Model release preferred. Captions preferred.

Specs: Uses 35mm transparencies. Also accepts high resolution images for Mac on CD or Zip.

Making Contact & Terms: Send unsolicited photos by mail for consideration. SASE. Reports in 1 month. Simultaneous submissions OK, with notification. Pays $750/color cover; $50-300/color inside; $35-150/b&w inside. Pays on publication. Buys first North American rights.

Tips: "Send in sample material with SASE. No phone call necessary."

$▣ MARTIAL ARTS TRAINING, P.O. Box 918, Santa Clarita CA 91380-9018. (805)257-4066. Fax: (805)257-3028. E-mail: rainbow@rsabbs.com. Editor: Douglas Jeffrey. Circ. 40,000. Bimonthly. Emphasizes martial arts training. Readers are martial artists of all skill levels. Sample copy free. Photo guidelines free with SASE.

Needs: Uses about 100 photos/issue; 90 supplied by freelance photographers. Needs "photos that pertain to fitness/conditioning drills for martial artists. Photos purchased with accompanying ms only. Model release required. Captions required.

Specs: Uses prints and transparencies. Accepts images in digital format for Mac.

Making Contact & Terms: Send 5×7 or 8×10 color prints; 35mm transparencies; contact sheet or negatives by mail for consideration. SASE. Reports in 1 month. Pays $50-150 for photo/text package. Pays on publication. Buys all rights. Credit line given.

Tips: Photos "must be razor-sharp, color. No black & white. Technique shots should be against neutral background. Concentrate on training-related articles and photos."

MATURE OUTLOOK, Meredith Corp., 1716 Locust St., Des Moines IA 50309-3023. (515)284-2647. Fax: (515)284-2064. E-mail: bshearer@mdp.com. Circ. 700,000. Bimonthly magazine. General interest (food, travel, health, recreation) for mature audience (55+).

Needs: Buys 50 photos from freelancers/issue; 300 photos/year. Needs photos of hobbies, locations and recreation with seniors. Reviews photos with or without a ms. Model release required; property release preferred. Photo captions required; include who and what.

Specs: Uses 35mm transparencies.

Making Contact & Terms: Art director will contact photographer for portfolio review if interested. Portfolio should include b&w and/or color prints, slides, tearsheets, transparencies. Keeps samples on file. Reports back only if interested, send non-returnable samples. Simultaneous submissions OK. Pays extra for electronic usage of photos. Pays on publication. Buys one-time rights. Credit line given.

Tips: "I like 'natural' looking people doing 'natural' looking things. Include business card with home location."

$ $ ◉ ◯ MAYFAIR MAGAZINE, Paul Raymond Publications, 2 Archer St., London W1V 8JJ England. Phone: (0171)292 8000. Fax: (0171)734 5030. E-mail: mayfair@pr-org.co.uk. Editor: Steve Shields. Estab. 1966. Monthly consumer magazine. Adult glamor.

Needs: Buys many photos from freelancers. "Extreme sports, humor, thrills and spills!" Subjects include celebrities, couples, disasters, environmental, landscapes, wildlife, cities, adventure, automobiles, entertainment, events, food/drink, health/fitness, hobbies, humor, performing arts, sports, travel, science, technology, digital, erotic, fashion/glamour, regional. Reviews photos with or without a ms. "We're always looking for mad, bad, dangerous and/or crazy images! Any female featured must be over 18 years."

Making Contact & Terms: Send query letter with samples. Does not keep samples on file; include SASE for return of material. Reports back only if interested, send non-returnable samples. Simultaneous submissions and/or previously published work OK. Pays $400-1,000 for color cover; $100 minimum for color inside. Pays week before publication.

Tips: "Send in your work by all means, but don't be 'pushy' or keep calling—we'll let you know. Think carefully before going to all the trouble—you wouldn't believe how many inappropriate images we receive. Maddening!!! Include cover letter and phone number."

◯ MEDIPHORS, P.O. Box 327, Bloomsburg PA 17815. E-mail: mediphor@ptd.net. Website: http://www.mediphors.org. Editor: Eugene D. Radice, MD. Circ. 900. Estab. 1993. Semiannual magazine. Emphasizes literary/art in medicine and health. Readers are male and female adults in the medical fields and literature. Sample copy $6. Photo guidelines free with SASE.

Needs: Uses 5-7 photos/issue; all supplied by freelancers. Needs artistic photos related to medicine and health. Also photos to accompany poetry, essay, and short stories. Releases usually not needed—artistic work. Photographers encouraged to submit titles for their artwork.

Specs: Uses minimum 3×4 any finish b&w prints.

Making Contact & Terms: Send unsolicited photos by mail for consideration. Keeps samples on file. SASE. Reports in 1 month. Pays on publication 2 copies of magazines. Buys first North American serial rights. Credit line given.

Tips: Looking for "b&w artistic photos related to medicine & health. Our goal is to give new artists an opportunity to publish their work. Prefer photos where people CANNOT be specifically identified. Examples: Drawings on the wall of a Mexican Clinic, an abandoned nursing home, an old doctor's house, architecture of an old hospital."

$ MENNONITE PUBLISHING HOUSE, 616 Walnut Ave., Scottdale PA 15683. (724)887-8500. Fax: (724)887-3111. Photo Secretary: Debbie Cameron. Publishes *Story Friends* (ages 4-9), *On The Line* (ages 10-14), *Christian Living*, *The Mennonite*, *Purpose* (adults).

Needs: Buys 10-20 photos/year. Needs photos of children engaged in all kinds of legitimate childhood activities (at school, at play, with parents, in church and Sunday School, at work, with hobbies, relating to peers and significant elders, interacting with the world); photos of youth in all aspects of their lives (school, work, recreation, sports, family, dating, peers); adults in a variety of settings (family life, church, work, and recreation); abstract and scenic photos. Model release preferred.

Making Contact & Terms: Send 8½×11 b&w photos by mail for consideration. Provide résumé, business card, brochure, flier or tearsheets to be kept on file for possible assignments. SASE. Reports in 1 month. Simultaneous submissions and/or previously published work OK. Pays $30-70/b&w photo. Buys one-time rights. Credit line given.

$ $ MICHIGAN NATURAL RESOURCES MAGAZINE, 30600 Telegraph Rd., Suite 1255, Bingham Farms MI 48025-4531. (248)642-9580. Fax: (248)642-5290. Editor: Vicki Robb. Creative Director: Katie Trombley. Circ. 55,000. Estab. 1931. Bimonthly. Emphasizes natural resources in the Great Lakes region. Readers are "appreciators of the out-of-doors; 15% readership is out of state." Sample copy $4. Photo guidelines free with SASE.

Needs: Uses about 40 photos/issue; 25% from assignment and 75% from freelance stock. Needs photos of Michigan wildlife, Michigan flora, how-to, travel in Michigan, outdoor recreation. Captions preferred.

Making Contact & Terms: Query with samples or list of stock photo subjects. Send original 35mm color transparencies by mail for consideration. SAE. Reports in 1 month. Pays $50-250/color page; $500/job; $800 maximum for photo/text package. Pays on publication. Buys one-time rights. Credit line given.

Tips: Prefers "Kodachrome 64 or 25 or Fuji 50 or 100, 35mm, *razor-sharp in focus!* Send about 20 slides with a list of stock photo topics. Be sure slides are sharp, labeled clearly with subject and photographer's name and address. Send them in plastic slide filing sheets. Looks for unusual outdoor photos. Flora, fauna of Michigan and Great Lakes region. Strongly recommend that photographer look at past issues of the magazine to become familiar with the quality of the photography and the overall content. We'd like our photographers to approach the subject from an editorial point of view. Every article has a beginning, middle

and end. We're looking for the photographer who can submit a complete package that does the same thing."

$ ▣ ▱ ◎ MICHIGAN OUT-OF-DOORS, P.O. Box 30235, Lansing MI 48909. (517)371-1041. Fax: (517)371-1505. Editor: Dennis C. Knickerbocker. Circ. 120,000. Estab. 1947. Monthly magazine. For people interested in "outdoor recreation, especially hunting and fishing; conservation; environmental affairs." Sample copy $2.50; free editorial guidelines.
Needs: Use 6-12 freelance photos/issue. Animal, nature, scenic, sport (hunting, fishing and other forms of noncompetitive recreation), and wildlife. Materials must have a Michigan slant. Captions preferred.
Making Contact & Terms: Send any size glossy b&w prints; 35mm or 2¼×2¼ color transparencies. SASE. Reports in 1 month. Previously published work OK "if so indicated." Pays $20 minimum/b&w photo; $175/cover photo; $40/inside color. Buys first North American serial rights. Credit line given.
Tips: Submit seasonal material 6 months in advance. Wants to see "new approaches to subject matter."

MODE MAGAZINE, 22 E. 49th St., 6th Floor, New York NY 10017. (212)843-4038. (212)843-4096. E-mail: modemag@aol.com. Art Coordinator: Stephanie Meadows. Published 10 times/year. Circ. 550,000. Emphasizes beauty and fashion for women sizes 12 and up. Readers are females of all occupations, ages 18-55.
Needs: Uses 75-100 photos/issue; 25 supplied by freelancers. Needs photos of fashion spreads, still lifes, personalities. Model/property release required. Captions preferred; include where photo was taken if on location, name of clothing/accessories and stores where they can be purchased.
Specs: Uses 35mm, 2¼×2¼, 4×5, 8×10 transparencies. "No negatives."
Making Contact & Terms: Contact through rep. Provide resume, business card, brochure, flier or tearsheets to be kept on file for possible assignments. Keeps samples on file. SASE. Reports in 1-2 weeks. Payment negotiable. **Pays on acceptance.** Buys one-time rights. Credit line given.
Tips: "Be innovative, creative and have a fresh outlook—uniqueness stands out."

Ⓝ $ $ MODERN DRUMMER MAGAZINE, 12 Old Bridge Rd., Cedar Grove NJ 07009. (201)239-4140. Fax: (201)239-7139. Editor: Ron Spagnardi. Photo Editor: Scott Bienstock. Circ. 100,000. Magazine published 12 times/year. For drummers at all levels of ability: students, semiprofessionals and professionals. Sample copy $4.95.
Needs: Buys 100-150 photos annually. Needs celebrity/personality, product shots, action photos of professional drummers and photos dealing with "all aspects of the art and the instrument."
Making Contact & Terms: Submit freelance photos with letter. Send for consideration b&w contact sheet, b&w negatives, 5×7 or 8×10 glossy b&w prints, 35mm, 2¼×2¼, 8×10 color transparencies. SASE. Previously published work OK. Pays $200/cover; $30-150/color inside; $15-75/b&w inside. Pays on publication. Buys one-time international usage rights per country. Credit line given.

$ $ MODERN MATURITY, 601 E. St., NW, Washington DC 20049. (202)434-2277. Photo Editor: M.J. Wadolny. Circ. 20 million. Bimonthly. Readers are age 50 and older. Sample copy free with 9×12 SASE. Guidelines free with SASE.
Needs: Uses about 50 photos/issue; 45 supplied by freelancers; 75% from assignment and 25% from stock.
Making Contact & Terms: Arrange a personal interview to show portfolio. SASE. Pays $50-200/b&w photo; $150-1,000/color photo; $350/day. **Pays on acceptance.** Buys one-time and first North American serial rights. Credit line given.
Tips: Portfolio review: Prefers to see clean, crisp images on a variety of subjects of interest. "Present yourself and your work in a professional manner. Be familiar with *Modern Maturity*. Wants to see creativity and ingenuity in images."

$ MOPAR MUSCLE MAGAZINE, 3816 Industry Blvd., Lakeland FL 33811. (941)644-0449. Fax: (941)648-1187. Website: http://www.d-p-g.com. Editor: Jerry Pitt. Circ. 100,000. Estab. 1988. Monthly magazine. Emphasizes Chrysler products—Dodge, Plymouth, Chrysler (old and new). Readers are Chrysler product enthusiasts of all ages. Guidelines free with SASE.
Needs: Uses approximately 120 photos/issue; 50% supplied by freelancers. Needs photos of automotive personalities, automobile features, technical how-tos. Reviews photos with or without ms. Model release required. Property release required of automobile owners. Captions required; include all facts relating to the automotive subject.
Specs: Uses 35mm, 2¼×2¼, 4×5 color transparencies.
Making Contact & Terms: Send unsolicited photos by mail for consideration. Keeps samples on file. Reports in 3 weeks. Pays $50 minimum. Pays on publication. Buys all rights; negotiable. Credit line given.

$ $ $ ▣ MOTHER EARTH NEWS, Sussex Publishers, 49 E. 21st St., 11th Floor, New York NY 10010. (212)260-3214. Fax: (212)260-7445. Photo Editor: Katrin Bodyikoglu. Estab. 1992. Bimonthly magazine. Readers are male and female, highly educated, active professionals. Photo guidelines free with SASE.

● Sussex also publishes *Psychology Today* listed in this section.

Needs: Uses 19-25 photos/issue; all supplied by freelancers. Needs photos of environmental issues and farmlands, animals, countryside living, crafts/tools, portraits of people on their land and in gardens, etc. Model/property release preferred.

Specs: Accepts images in digital format for Mac.

Making Contact & Terms: Submit portfolio for review. Send promo card with photo. Call before you drop off portfolio. Keeps samples on file. Cannot return material. Reports back only if interested. For assignments, pays $1,000/cover plus expenses; $300-500/inside photo plus expenses; for stock, pays $100/ ¼ page; $300/full page.

$ ◎ MOUNTAIN LIVING, Wiesner Publishing, 7009 S. Potomac St., Englewood CO 80112. (303)397-7600. Fax: (303)397-7619. E-mail: rawlings@winc.usa.com. Website: http://www.mtnliving.c om. Editor: Irene Rawlings. Circ. 35,000. Estab. 1994. Bimonthly magazine. Emphasizes shelter, lifestyle.

Needs: Uses 50-75 photos/issue; all supplied by freelancers. Needs photos of home interiors, architecture, gardening. Reviews photos purchased with accompanying ms only. Model/property release required. Captions preferred.

Specs: Uses 35mm, 2¼×2¼ transparencies.

Making Contact & Terms: Submit portfolio for review. Query with stock photo list. Provide resume, business card, brochure, flier or tearsheets to be kept on file for possible assignments. Keeps samples on file. SASE. Reports in 6 weeks. Previously published work OK. Pays $500-600/day. **Pays on acceptance**. Buys one-time and first North American serial rights; negotiable. Credit line given.

$ MULTINATIONAL MONITOR, P.O. Box 19405, Washington DC 20036. (202)387-8030. Fax: (202)234-5176. E-mail: monitor@essential.org. Website: http://www.essential.org/monitor. Editor: Robert Weissman. Circ. 6,000. Estab. 1978. Monthly magazine. "We are a political-economic magazine covering operations of multinational corporations." Emphasizes multinational corporate activity. Readers are in business, academia and many are activists. Sample copy free with 9×12 SAE.

Needs: Uses 12 photos/issue; number of photos supplied by freelancers varies. "We need photos of industry, people, cities, technology, agriculture and many other business-related subjects." Captions required, include location, your name and description of subject matter.

Making Contact & Terms: Query with list of stock photo subjects. SASE. Reports in 3 weeks. Pays $0-35/color and b&w photos and transparencies. Pays on publication. Buys one-time rights. Credit line given.

$ ▦ Ⓓ MUSCLEMAG INTERNATIONAL, 6465 Airport Rd., Mississauga, Ontario L4V 1E4 Canada. (905)678-7311. Fax: (905)678-9236. Editor: Johnny Fitness. Circ. 300,000. Estab. 1974. Monthly magazine. Emphasizes male and female physical development and fitness. Sample copy $6.

Needs: Buys 3,000 photos/year; 50% assigned; 50% stock. Needs celebrity/personality, fashion/beauty, glamour, swimsuit, how-to, human interest, humorous, special effects/experimental and spot news. "We require action exercise photos of bodybuilders and fitness enthusiasts training with sweat and strain." Wants on a regular basis "different" pics of top names, bodybuilders or film stars famous for their physique (i.e., Schwarzenegger, The Hulk, etc.). No photos of mediocre bodybuilders. "They have to be among the top 100 in the world or top film stars exercising." Photos purchased with accompanying ms. Captions preferred.

Specs: Uses 8×10 glossy b&w prints, 35mm, 2¼×2¼ or 4×5 transparencies; uses vertical format preferred for cover.

Making Contact & Terms: Send material by mail for consideration; send $3 for return postage. Query with contact sheet. Reports in 1 month. Pays $85-100/hour; $500-700/day and $1,000-3,000/complete package. Pays $20-50/b&w photo; $25-500/color photo; $500/cover photo; $85-300/accompanying ms. **Pays on acceptance.** Buys all rights. Credit line given.

Tips: "We would like to see photographers take up the challenge of making exercise photos look like exercise motion." In samples wants to see "sharp, color balanced, attractive subjects, no grain, artistic eye. Someone who can glamorize bodybuilding on film." To break in, "get serious: read, ask questions, learn, experiment and try, try again. Keep trying for improvement—don't kid yourself that you are a good photographer when you don't even understand half the attachments on your camera. Immerse yourself in photography. Study the best; study how they use light, props, backgrounds, best angles to photograph.

Current biggest demand is for swimsuit-type photos of fitness men and women (splashing in waves, playing/posing in sand, etc.) Shots must be sexually attractive."

$ $ S ▣ ◻ MUZZLE BLASTS, P.O. Box 67, Friendship IN 47021. (812)667-5131. Fax: (812)667-5137. E-mail: mblastmag@seidata.com. Website: nmlra@nmlra.org. Art Director: Terri Trowbridge. Circ. 25,000. Estab. 1939. Publication of the National Muzzle Loading Rifle Association. Monthly magazine emphasizing muzzleloading. Sample copy free. Photo guidelines free with SASE.
Needs: Interested in North American wildlife, muzzleloading hunting, primitive camping. "Ours is a specialized association magazine. We buy some big-game wildlife photos but are more interested in photos featuring muzzleloaders, hunting, powder horns and accoutrements." Model/property release required. Captions preferred.
Specs: Accepts images in digital format for Windows. Send via CD, Zip as TIFF, EPS files.
Making Contact & Terms: Query with stock photo list. Keeps samples on file. SASE. Reports in 1-2 weeks. Simultaneous submissions OK. Pays $300/color cover; $25-50/b&w inside. Pays on publication. Buys one-time rights. Credit line given.

$ ◱ NA'AMAT WOMAN, 200 Madison Ave., New York NY 10016-4001. (212)725-8010. Fax: (212)447-5187. Editor: Judith A. Sokoloff. Circ. 20,000. Estab. 1926. Published 4 times/year. Organization magazine focusing on issues of concern to contemporary Jewish families. Sample copy free for SAE with $1.21 first-class postage.
Needs: Buys 5-10 photos from freelancers/issue; 50 photos/year. Needs photos of Jewish themes, Israel, women and children. Reviews photos with or without a ms. Photo captions preferred.
Specs: Uses color, b&w prints.
Making Contact & Terms: Provide résumé, business card, self-promotion piece or tearsheets to be kept on file for possible future assignments. Art director will contact photographer for portfolio review if interested. Keeps samples on file; include SASE for return of material. Reports in 6 weeks on queries; 6 weeks on samples. Pays $150 maximum for b&w cover; $35-50 for b&w inside. Pays on publication. Buys one-time, first rights. Credit line given.

$ $ A ▣ ◱ NAKED MAGAZINE, Serengeti Publishing Corp., 7985 Santa Monica Blvd., Suite 109-232, W. Hollywood CA 90046. (800)796-2533. President: Robert Steele. Circ. 20,000. Estab. 1994. Monthly gay male special interest magazine. Sample copy free. Art guidelines free.
Needs: Buys 6 photos from freelancers/issue. Needs photos of naked events. Interested in alternative process and erotic. Reviews photos with accompanying ms. Model release required; property release required. Photo captions required.
Specs: Uses 2¼ × 2¼ transparencies. Accepts images in digital format for Mac.
Making Contact & Terms: Send query letter with samples. Art director will contact photographer for portfolio review if interested. Keeps samples on file. Reports in 1 month only if interested, send nonreturnable samples. Simultaneous submissions and/or previously published work OK. Payment varies. Pays on publication. Buys all rights; negotiable. Credit line given.

$ $ ▣ ◱ ◎ NATIONAL GARDENING, Dept. PM, 180 Flynn Ave., Burlington VT 05401. (802)863-1308. Fax: (802)863-5962. E-mail: nga@garden.org. Website: http://www.garden.org. Editor: Michael MacCaskey. Managing Editor: Shila Patel. Circ. 195,000. Estab. 1979. Publication of the National Gardening Association. Bimonthly. Covers fruits, vegetables, herbs and ornamentals. Readers are home and community gardeners. Sample copy $3.50. Photo guidelines free with SASE.
Needs: Uses about 50-60 photos/issue; 80% supplied by freelancers. "Most of our photographers are also gardeners or have an avid interest in gardening or gardening research." Ongoing needs include: "people gardening; special techniques; how-to; specific varieties (please label); garden pests and diseases; soils; unusual (or impressive) gardens in different parts of the country. We sometimes need someone to photograph a garden or gardener in various parts of the country for a specific story." Also considers landscapes/scenics, food/drink.
Specs: Accepts images in digital format for Mac. Send via Zip disk or online as EPS, JPEG files at 300 dpi.

THE SUBJECT INDEX, located at the back of this book, lists publications, book publishers, galleries, greeting card companies, stock agencies, advertising agencies and graphic design firms according to the subject areas they seek.

Making Contact & Terms: "We send out a photo request list for each issue." Query with samples or list of stock photo subjects. SASE. Reports in 2 months. Pays $450/color cover; and $50-200/color inside. Also negotiates day rate against number of photos used. Pays on publication. Buys first North American serial rights and electronic rights for NGA website use. Credit line given.

Tips: "We need top-quality work. Most photos used are color. We look for general qualities like sharp focus, good color balance, good sense of lighting and composition. Also interesting viewpoint, one that makes the photos more than just a record (getting down to ground level in the garden, for instance, instead of shooting everything from a standing position). Look at the magazine carefully and at the photos used. When we publish a story on growing broccoli, we love to have photos of people planting or harvesting broccoli, in addition to lush close ups. We like to show process, step-by-step, and, of course, inspire people. Request Photographer's Guidelines and send portfolio (with SASE) for consideration."

N $ $ S ⦸ ◎ NATIONAL PARKS MAGAZINE, 1776 Massachusetts Ave. NW, Washington DC 20036. (202)223-6722. E-mail: hpmag@npca.org. Website: http://www.npca.org. Editor-in-Chief: Linda M. Rancourt. Circ. 400,000. Estab. 1919. Bimonthly magazine. Emphasizes the preservation of national parks and wildlife. Sample copy $3. Photo guidelines free with SASE.

Needs: Photos of wildlife and people in national parks, scenics, national monuments, national recreation areas, national seashores, threats to park resources and wildlife.

Specs: Uses 4×5 or 35mm transparencies.

Making Contact & Terms: Send stock list with example of work if possible. Do not send unsolicited photos or mss. SASE. Reports in 1 month. Pays $125-275/color inside; $500 full-bleed color covers. Pays on publication. Buys one-time rights.

Tips: "Photographers should be specific about national park system areas they have covered. We are a specialized publication and are not interested in extensive lists on topics we do not cover. *National Parks* photos follow editorial content. Photographers should find out our needs and arrange permission to submit photos. Submit tearsheets, examples of work done with a list of photos from U.S. national parks."

N $ $ ▣ ☻ NATIONAL WILDLIFE, Photo Submissions, NW Publications, 8925 Leesburg Pike, Vienna VA 22184. Website: http://www.nwf.org. Photo Editor: John Nuhn. Circ. 650,000. Estab. 1962. Bimonthly magazine. Emphasizes wildlife, nature, environment and conservation. Readers are people who enjoy viewing high-quality wildlife and nature images from around the world, and who are interested in knowing more about the natural world and man's interrelationship with animals and environment. Sample copy $3; send to National Wildlife Federation Membership Services (same address). Send separate SASE only for free photo guidelines, to Photo Guidelines, National Wildlife Publications (same address).

Needs: Uses about 45 photos/issue; all supplied by freelance photographers; 90% stock, 10% assigned. Photo needs include worldwide photos of wildlife, wild plants, nature-related how-to, conservation practices. Subject needs include single photos for various uses (primarily wildlife but also plants, scenics). Captions required.

Specs: Accepts images in digital format for Mac. "While we accept digital format for photos we specifically request, we do not accept them for unsolicited submissions."

Making Contact & Terms: "Study the magazine, and ask for and follow photo guidelines before submitting. No unsolicited submissions from photographers whose work has not been previously published or considered for use in our magazine. Instead, send nonreturnable samples (tearsheets or photocopies) to Photo Queries (same address). If nonreturnable samples are acceptable, send 35mm or larger transparencies (magazine is 100% color) for consideration." SASE. Reports in 1 month. Previously published work OK. Pays $1,000/cover; $300-750/inside; text/photo package negotiable. **Pays on acceptance.** Buys one-time rights with limited magazine promotion rights. Credit line given.

Tips: "While *National Wildlife* does not encourage unsolicited submissions, the annual photo contest is an excellent way to introduce your photography. The contest is open to professional and amateur photographers alike. Rules are updated each year and printed along with the winning photos in the December/January issue. Rules are also available on the website."

$ ▣ ⦸ NATIVE PEOPLES MAGAZINE, 5333 N. Seventh St., Suite C-224, Phoenix AZ 85014. (602)252-2236. Fax: (602)265-3113. E-mail: editorial@nativepeoples.com. Website: http://www.nativepeoples.com. Editor: Bar Winton. Circ. 94,000. Estab. 1987. Quarterly magazine. Dedicated to the sensitive protrayal of the arts and lifeways of the Native peoples of the Americas. Readers are primarily upper-demographic members of affiliated museums (i.e. National Museum of the American Indian/Smithsonian). Photo and writers guidelines free with SASE.

Needs: Uses 50-60 photos/edition; 100% supplied by freelancers. Needs Native American lifeways photos (babies, celebrities, children, couples, multicultural, families, parents, senior citizens, teens). Model/property release preferred. Captions preferred; include names, location and circumstances.

Specs: Uses transparencies, all formats. Accepts images in digital format for Mac. Send via CD, floppy disk, Zip.

Making Contact & Terms: Submit portfolio for review. Send unsolicited photos by mail for consideration. SASE. Reports in 1 month. Pays $250/color or b&w cover; $45-150 color or b&w inside. Pays on publication. Buys one-time rights.

Tips: "Send samples or if in the area, arrange a visit with the editors."

NATURAL LIVING TODAY, 175 Varick St., New York NY 10014. (212)924-1762. Fax: (212)989-9987. Editor-in-Chief: Alexis Tannenbaum. Circ. 150,000. Estab. 1996. Bimonthly magazine. Emphasizes natural living for women, (ex: natural beauty, alternative healing, vegetarianism, organic and macrobiotic eating). Readers are women aged 18-40, from various occupations (students, executives).

Needs: Uses 60-70 photos/issue; 70% supplied by freelancers. Needs photos of celebrities, cosmetics, models and food. Model release required.

Making Contact & Terms: Query with résumé of credits. Usually wants to work with photographers on assignment. However, stock of celebrities is needed. "Send nothing unsolicited." Payment negotiable. Pays on publication. Rights negotiable. Credit line given.

N $ ▣ ◯ NATURALLY NUDE RECREATION & TRAVEL MAGAZINE, Events Unlimited, P.O. Box 317, Newfoundland NJ 07435-0317. (973)697-3552. Fax: (973)697-8313. E-mail: naturally@nac.net. Website: http://www.internaturally.com. Director of Operations: Cheryl Hanenberg. Circ. 35,000. Estab. 1981. Quarterly publication which focuses on "family nude, recreation and travel." Sample copies available for $9. Art guidelines available for $4 \times 9\frac{1}{2}$ SAE with 33¢ first-class postage.

Needs: Needs photos of hobbies, travel. Reviews photos with accompanying ms only. Model and property release required.

Specs: Uses glossy, matte, color, b&w prints; 35mm, $2\frac{1}{4} \times 2\frac{1}{4}$ transparencies. Accepts images in digital format. Send via floppy disk, Jaz, Zip as JPEG files.

Making Contact & Terms: Send query letter with slides, prints. Keeps samples on file. Reports back only if interested, send nonreturnable samples. Simultaneous submissions and previously published work OK. Pays $140-200 for color cover; $25-70 for color inside. Pays on publication. Buys one-time rights.

Tips: "We encourage photography at all clothes-free events by courteous and considerate photographers."

$ $ ▣ ◭ NATURE CONSERVANCY MAGAZINE, 4245 N. Fairfax Dr., Suite 100, Arlington VA 22203. Fax: (703)841-9692. E-mail: cgelb@tnc.org. Website: http://www.tnc.org. Photo Editor: Connie Gelb. Circ. 900,000. Estab. 1951. Publication of The Nature Conservancy. Bimonthly. Emphasizes "nature, rare and endangered flora and fauna, ecosystems in North and South America, the Caribbean, Indonesia, Micronesia and South Pacific and compatible development." Readers are the membership of The Nature Conservancy. Sample copy free with 9×12 SAE and 5 first-class stamps. Write for guidelines. Articles reflect work of the Nature Conservancy and its partner organizations.

Needs: Uses about 20-25 photos/issue; 70% from freelance stock. Needs photos of babies, children, couples, multicultural, families, parents, senior citizens, teens, landscapes/scenics, wildlife, rural, adventure. The Nature Conservancy welcomes permission to make duplicates of slides submitted to the magazine for use in slide shows and online use. Captions required; include location and names (common and Latin) of flora and fauna. Proper credit should appear on slides.

Specs: Uses color transparencies. Accepts images in digital format for Windows. Send via CD, floppy disk, Zip as JPEG files at 72 dpi.

Making Contact & Terms: Many photographers contribute the use of their slides. Pays $400/color cover; $300/color back cover; $150-350/color inside; $250/b&w inside; negotiable day rate. Will occasionally pay extra for photos of rare/endangered species. Pay from $35-200 for unlimited Web use for 1 year. Pays on publication. Buys one-time rights; starting to consider all rights for public relations and online purposes; negotiable. Credit line given.

Tips: Seeing more large-format photography and more interesting uses of motion and mixing available light with flash and b&w. "Photographers must familiarize themselves with our organization. We only run articles reflecting our work (in the U.S.) or that of our partner organizations in Latin America and Asia/Pacific. Will purchase images of Conservancy and partner preserves on spec. Membership in the Nature Conservancy is only $25/year. The magazine and the state newsletter will keep photographers up to date on what the Conservancy is doing in your state. Many of the preserves are open to the public. We look for rare and endangered species, wetlands and flyways, indigenous/traditional people of Latin America, South Pacific and the Caribbean. Start at the local level. Find out where the Conservancy works, how we work and who our partners are."

$ NATURE PHOTOGRAPHER, P.O. Box 2019, Quincy MA 02269. (617)847-0095. Fax: (617)847-0952. E-mail: mjsquincy@pipeline.com. Co-Editors-in-Chief/Photo Editors: Helen Longest-Slaughter Saccone and Evamarie Mathaeg. Circ. 26,000. Estab. 1990. Bimonthly, 4-color, high-quality magazine. Emphasizes "conservation-oriented, low-impact nature photography" with strong how-to focus. Readers are male and female nature photographers of all ages. Sample copies free with 10×13 SAE with 6 first-class stamps.
Needs: Uses 25-35 photos/issue; 90% supplied by freelancers. Needs nature shots of "all types—abstracts, animal/wildlife shots, flowers, plants, scenics, environmental images, etc." Shots must be in natural settings; no set-ups, zoo or captive animal shots accepted. Reviews photos with or without ms twice a year, May (for fall/winter issues) and November (for spring/summer). Captions required; include description of subject, location, type of equipment, how photographed. "This information published with photos."
Making Contact & Terms: Prefers to see 35mm, 2¼×2¼ and 4×5 transparencies. Does not keep samples on file. SASE. Reports within 4 months, according to deadline. Simultaneous submissions and previously published work OK. Pays $100/color cover; $25-40/color inside; $20/b&w inside; $75-150/photo/text package. Pays on publication. Buys one-time rights. Credit line given.
Tips: Recommends working with "the best lens you can afford and slow speed slide film." Suggests editing with a 4× or 8× lupe (magnifier) on a light board to check for sharpness, color saturation, etc. Color prints are not normally used for publication in magazine.

$ ◻ ◎ NATURIST LIFE INTERNATIONAL, P.O. Box 300-F, Troy VT 05868-0300. (802)744-6565. E-mail: jcc@naturistlife.com. Website: www.naturistlife.com. Editor-in-chief: Jim C. Cunningham. Circ. 2,000. Estab. 1987. Quarterly magazine. Emphasizes nudism. Readers are male and female nudists, age 30-80. Sample copy $5. Photo guidelines free with SASE.
● *Naturist Life* holds yearly Vermont Naturist Photo Safaris organized to shoot nudes in nature.
Needs: Uses approximately 45 photos/issue; 80% supplied by freelancers. Needs photos depicting family-oriented, nudist/naturist work, recreational activity and travel. Reviews photos with or without ms. Model release required for recognizable nude subjects. Captions preferred.
Specs: Uses 8×10 glossy color and b&w prints; 35mm, 2¼×2¼, 4×5, 8×10 (preferred) transparencies.
Making Contact & Terms: Query with résumé of credits. Send unsolicited photos by mail for consideration. Provide résumé, business card, brochure, flier or tearsheets to be kept on file for possible assignments. SASE. Reports in 2 weeks. Pays $50 color cover; others, $10-25. Pays on publication. "Prefer to own all rights but sometimes agree to one-time publication rights." Credit line given.
Tips: "The ideal *NLI* photo shows ordinary-looking people of all ages doing everyday activities, in the joy of nudism."

$ NAUGHTY NEIGHBORS, 4931 SW 75th Ave., Miami FL 33155. (305)662-5959. Fax: (305)662-5952. E-mail: gablel@scoregroup.com Assistant Editor: Lisa Gable. Circ. 250,000. Estab. 1995. Published 13 times/year. Emphasizes "nude glamor with a voyeuristic focus—amateurs and the swinging scene." Readers are male, 18 and over. Sample copy $7. Photo guidelines free with SASE.
Needs: Uses approximately 200 photos/issue; all supplied by freelancers. Needs photos of nude females; "amateurs, not professional models." Model release required, as well as two forms of I.D. from model (one must be a picture I.D.).
Specs: Uses 4×6 or 8×10 glossy color prints; 35mm transparancies or larger format. Kodachrome film.
Making Contact & Terms: Send unsolicited photos by mail for consideration. "Please do not send individual photos, except for test shots." Keeps samples on file. SASE. Reports in 1 month. Simultaneous submissions OK. Pays $150-900 for color sets of around 40 transparancies or high quality prints. Pays on publication. Buys firstrights in North America with reprint option, electronic rights and non-exclusive worldwide publishing rights.
Tips: "Study samples of the magazine for insights into what we are looking for. We recommend using on-camera flash or one umbrella to enhance 'amateur' feeling of the photography."

NEW CHOICES LIVING EVEN BETTER AFTER 50, Readers Digest Rd., Pleasantville NY 10570. Photo Editor: Regina Flanagan. Circ. 600,000. 10 issues a year (double issues—July/Aug., Dec./Jan.). Emphasizes people over 50, retired or planning to retire. Readers are 50 plus years old, male and female, interested in retirement living.
Needs: Uses 30-40 photos/issue; 50% supplied by freelancers; 50% supplied by stock. Needs photos related to health and fitness, money and finances, family values, travel and entertainment. Reviews photos with or without ms. "No unsolicited photos please!" Model release required; property release preferred. Captions required.
Making Contact & Terms: Provide résumé, business card, brochure, flier or tearsheets to be kept on file for possible assignments. Reports in 1 month. Pays $200/¼ color page rate. **Pays on acceptance** and assignment within 30 days. Buys one-time rights; negotiable. Credit line given.

Tips: "*New Choices* targets a very select market—seniors, people aged fifty and over. Our assignments are very specific concepts and the key to a successful assignment is communication. I rarely send a photographer more than 300 miles for an assignment because our budget just doesn't allow for it, so I end up calling photgraphers in the location of my subjects, which vary with each article. Communication is very important between the photo editor and the photographer."

[N] $ $ NEW MEXICO MAGAZINE, Dept. PM, 495 Old Santa Fe Trail, Santa Fe NM 87503. (505)827-7447. Fax: (505)827-6496. Art Director: John Vaughan. Circ. 123,000. Monthly magazine. For affluent people age 35-65 interested in the Southwest or who have lived in or visited New Mexico. Sample copy $3.95 with 9×12 SAE and 3 first-class stamps. Photo guidelines free with SASE.
Needs: Uses about 60 photos/issue; 90% supplied by freelancers. Needs New Mexico photos only—landscapes, people, events, architecture, etc. "Most work is done on assignment in relation to a story, but we welcome photo essay suggestions from photographers." Cover photos usually relate to the main feature in the magazine. Model release preferred. Captions required; include who, what, where.
Specs: Uses transparencies.
Making Contact & Terms: Submit portfolio to John Vaughan; SASE. Pays $450/day; $300/color cover; $300/b&w cover; $60-100/color inside; $60-100/b&w inside. Pays on publication. Buys one-time rights. Credit line given.
Tips: Prefers transparencies submitted in plastic pocketed sheets. Interested in different viewpoints, styles not necessarily obligated to straight scenic. "All material must be taken in New Mexico. Representative work suggested. If photographers have a preference about what they want to do or where they're going, we would like to see that in their work. Transparencies or dupes are best for review and handling purposes."

$ [A] ▣ NEW MOON:®, The Magazine for Girls and Their Dreams, P.O. Box 3620, Duluth MN 55803-3620. (218)728-5507. Fax: (218)728-0314. E-mail: girl@newmoon.org. Website: http://www.n ewmoon.org. Girls Editorial Board: %Bridget Grosser or Deb Mylin. Circ. 22,000. Estab. 1993. Bimonthly magazine. Emphasizes girls, ages 8-14; *New Moon* is edited by girls for girls. Readers are girls, ages 8-14. Sample copy $6.50.
Needs: Uses 15-25 photos/issue; 5 supplied by freelancers. Needs photos for specific stories. Subjects include children, multicultural, teens, wildlife, pets, hobbies. Model/property release required. Captions required; include names, location, ages of kids.
Specs: Uses 4×6 glossy color, b&w prints; 35mm transparencies. Accepts images in digital format for Mac. Send via CD, floppy disk, Zip as TIFF, EPS files at 300 dpi.
Making Contact & Terms: Submit portfolio for review. Call for details. Keeps samples on file. SASE. Reports in 6 months. Simultaneous submissions and previously published work OK. Pays $25-50/b&w inside. Pays on publication. Buys one-time rights. Credit line given.
Tips: "Read and get to know style of magazine first! Work with an author on an article for submission or submit samples relevant to magazine's themes (6 per year)."

NEW YORK SPORTSCENE, 990 Motor Pkwy., Central Islip NY 11722. (516)435-8890. Fax: (516)435-8925. Editor-in-Chief: Jerry Beech. Managing Editor: Eric Justic. Circ. 42,000. Estab. 1995. Monthly magazine. Emphasizes professional and major college sports in New York. Readers are 95% male; median age: 30; 85% are college educated. Sample copy $3.
Needs: Uses 30 photos/issue; all supplied by freelancers. Needs photos of sports action, fans/crowd reaction.
Specs: Uses color prints; 35mm transparencies.
Making Contact & Terms: Send unsolicited photos by mail for consideration. Keeps samples on file. SASE. Reports in 3 weeks. Payment negotiable. Pays 30 days after publication.
Tips: "Slides should capture an important moment or event and tell a story. There are numerous sports photographers out there—your work must stand out to be noticed."

$ ▢ NEW YORK STATE CONSERVATIONIST MAGAZINE, Editorial Office, NYSDEC, 50 Wolf Rd., Albany NY 12233-4502. (518)457-5547. Fax: (518)457-0858. Contact: Photo Editor. Circ. 100,000. Estab. 1946. Bimonthly nonprofit, New York State government publication. Emphasizes natural history, environmental, and outdoor interests pertinent to New York State. Sample copy $3.50. Photo guidelines free with SASE.
Needs: Uses 40 photos/issue; 80% supplied by freelance photographers. Needs wildlife shots, people in the environment, outdoor recreation, forest and land management, fisheries and fisheries management, environmental subjects. Also needs landscapes/scenics, cities, travel, historical/vintage, regional, seasonal. Model release preferred. Captions required.
Making Contact & Terms: Send 35mm, 2¼×2¼, 4×5 or 8×10 transparencies by mail for consider-

ation or submit portfolio for review. Provide résumé, business card, brochure, flier or tearsheets to be kept on file for possible future assignments. Reports in 3 weeks. Simultaneous submissions and previously published work OK. Pays $15/b&w or color photo. Pays on publication. Buys one-time rights.

Tips: Looks for "artistic interpretation of nature and the environment, unusual ways of picturing environmental subjects (even pollution, oil spills, trash, air pollution, etc.); wildlife and fishing subjects at all seasons. Try for unique composition, lighting. Technical excellence a must."

$ ⬮ NORTH AMERICAN WHITETAIL MAGAZINE, P.O. Box 741, Marietta GA 30061. (770)953-9222. Fax: (770)933-9510. Photo Editor: Gordon Whittington. Circ. 151,000. Estab. 1982. Published 8 times/year (July-February) by Game & Fish Publications, Inc. Emphasizes trophy whitetail deer hunting. Sample copy $3. Photo guidelines free with SASE.

Needs: Uses 20 photos/issue; 40% supplied by freelancers. Needs photos of large, live whitetail deer, hunter posing with or approaching downed trophy deer, or hunter posing with mounted head. Also use photos of deer habitat and sign. Model release preferred. Captions preferred; include where scene was photographed and when.

Specs: Uses 8×10 b&w prints; 35mm transparencies.

Making Contact & Terms: Query with résumé of credits and list of stock photo subjects. Will return unsolicited material in 1 month if accompanied by SASE. Simultaneous submissions not accepted. Pays $250/color cover; $75/inside color; $25/b&w photo. Tearsheets provided. Pays 75 days prior to publication. Buys one-time rights. Credit line given.

Tips: "In samples we look for extremely sharp, well-composed photos of whitetailed deer in natural settings. We also use photos depicting deer hunting scenes. Please study the photos we are using before making submission. We'll return photos we don't expect to use and hold the remainder. Please do not send dupes. Use an 8× loupe to ensure sharpness of images and put name and identifying number on all slides and prints. Photos returned at time of publication or at photographer's request."

N $ ⬚ ⬮ NORTH & SOUTH, The Magazine of Civil War Conflict, 33756 Black Mountain Rd., Tollhouse CA 93667. Phone/fax: (209)855-8637. E-mail: kpoulter@aol.com. Website: http://www.northandsouthmagazine.com. Publisher: Keith Poulter. Circ. 15,000. Estab. 1997. Consumer magazine published 7 times a year. *North & South* provides a "fresh and accurate history of the Civil War." Sample copies available for $4.95.

Needs: Needs photos of Civil War sites. Reviews photos with or without a ms. Photo captions required.

Specs: Uses glossy, color prints. Accepts images in digital format for Mac. Send as TIFF files.

Making Contact & Terms: Send query letter with résumé. Does not keep samples on file; include SASE for return of material. Reports back only if interested, send nonreturnable samples. Pays $20-50 for color inside. Pays on publication. Credit line given. Buys one-time rights.

N $ $ NORTHWOODS PUBLICATIONS INC., Division of Peterson Publishing, P.O. Box 6349, Harrisburg PA 17112-0349. (717)541-1877. Publishes *Pennsylvania Sportsman*, *New York Sportsman*, *Michigan Hunting & Fishing*. Editorial Director: J. Scott Rupp. Circ. 120,000. Estab. 1977. Published 8 times/year. Emphasizes outdoor hunting and fishing. Readers are of all ages and backgrounds. Photo guidelines free with SASE.

Needs: Uses 40-70 photos/issue; 30% supplied by freelancers. Needs photos of wildlife. Special photo needs include deer, turkey, bear, trout, bass, pike, walleye and panfish. Captions preferred.

Specs: Uses 35mm transparencies.

Making Contact & Terms: Query with stock photo list. Keeps samples on file. SASE. Pays $175/color cover; $25-125/color inside; $25-150/b&w inside. Pays on publication. Buys first North American serial rights. Credit line given.

Tips: "Look at the magazine to become familiar with needs."

N $ NOR'WESTING, P.O. Box 70608, Seattle WA 98107. (206)783-8939. Fax: (206)783-9011. Editor: Joe Pyke. Monthly magazine. Emphasis on cruising destinations in the Pacific Northwest. Readers are male and female boat owners ages 25-65 centered around family activities. Sample copy free with 9×12 SAE with $1.50 in postage. Photo guidelines available.

Needs: Uses 20 photos/issue; 75% supplied by freelancers. Interested in scenic Northwest destination shots, boating, slice-of-life nautical views. Model release preferred for anyone under age 18. Captions required; include location, type of boat, name of owner, crew (if available).

Specs: Uses 3×5 glossy b&w prints for editorial; 35mm transparencies for cover.

Making Contact & Terms: Interested in seeing work from fresh photographers with an "eye." "We're looking for active outdoor photographers in the Pacific Northwest who can capture the spirit of boating." Send unsolicited photos by mail for consideration. Provide résumé, business card, brochure, flier or tear-

sheets to be kept on file for possible assignments. Keeps samples on file. SASE. Reports in 2 months. Simultaneous submissions and/or previously published work OK. Pays $100-250/color cover; $25-50/b&w inside. Pays within 60 days after publication. "Everything is negotiable."
Tips: "No posed shots; capture the moment."

$ $ NUGGET, 14411 Commerce Way, Suite 420, Miami Lakes FL 33016. (305)362-5580. Editor-in-Chief: Christopher James. Circ. 100,000. Magazine published 13 times a year. Emphasizes sex and fetishism for men and women of all ages. Sample copy $5 postpaid; photo guidelines free with SASE.
Needs: Uses 200 photos/issue. Interested only in nude sets—single woman, female/female or male/female. All photo sequences should have a fetish theme (sadomasochism, leather, bondage, transvestism, transsexuals, lingerie, golden showers, infantilism, wrestling—female/female or male/female—women fighting women or women fighting men, amputee models, etc.). Also seeks accompanying mss on sex, fetishism and sex-oriented products. Model release required.
Specs: Uses 35mm transparencies, prefers Kodachrome or large format; vertical format required for cover.
Making Contact & Terms: Submit material for consideration. Buys in sets, not by individual photos. No Polaroids or amateur photography. SASE. Reports in 2 weeks. Previously published work OK. Pays $250 minimum/b&w set; $400-1,200/color set; $200/cover; $250-350/ms. Pays on publication. Buys one-time rights or second serial (reprint) rights. Credit line given.

$ ODYSSEY, Adventures in Science, Cobblestone Publishing, Inc., 30 Grove St., Peterborough NH 03458. (603)924-7209. Fax: (603)924-7380. E-mail: edody@aol.com. Senior Editor: Elizabeth Lindstrom. Circ. 29,000. Estab. 1979. Monthly magazine, September-May. Emphasis on science and technology. Readers are children, ages 10-16. Sample copy $4.50 with 9×12 or larger SAE and 5 first-class stamps. Photo guidelines free with SASE.
Needs: Uses 30-35 photos/issue. Needs photos of children, science and technology. Reviews photos with or without ms. Model/property release required. Captions preferred.
Specs: Uses color prints or transparencies. Accepts images in digital format for Mac.
Making Contact & Terms: Query with stock photo list. Send unsolicited photos by mail for consideration. Provide résumé, business card, brochure, flier or tearsheets to be kept on file for possible future assignments. SASE. Reports in 1 month. Payment negotiable for color cover and other photos; $25-100/inside color use. Pays on publication. Buys one-time and all rights; negotiable. Credit line given.
Tips: "We like photos that include kids in reader-age range and plenty of action. Each issue is devoted to a single theme. Photos should relate to those themes. It is best to request theme list."

$ $ OFF DUTY MAGAZINE, 3505 Cadillac Ave., Suite 0-105, Costa Mesa CA 92626. Fax: (714)549-4222. E-mail: odutyedit@aol.com. Managing Editor: Tom Graves. Circ. 507,000. Estab. 1970. Published 6 times/year. Emphasizes the military community. Readers are military members and their spouses, ages 20-45. Sample copy free with 9×12 SASE and 6 first-class stamps.
Needs: Uses 25 photos/issue; 5 supplied by freelancers. "We're looking solely for freelancers to handle occasional assignments around the U.S." Model/property release preferred. Captions required.
Specs: Accepts digital files in TIFF, EPS, or JPEG 300 dpi or higher preferably on Mac-formatted disk; Zip disk, SyQuest 135 OK.
Making Contact & Terms: Provide résumé, business card, brochure, flier or tearsheets to be kept on file for possible assignments. Pays $300/color cover; up to $75-200/color inside. **Pays on acceptance**. Buys one-time rights. Credit line given.
Tips: "I don't want to receive unsolicited photos for consideration, just résumés and brochure/samples for filing. Send good samples and you have a good shot at an assignment if something comes up in your area."

$ $ OFFSHORE, 220 Reservoir St., Suite 9, Needham MA 02494. (781)449-6204, ext. 21. Fax: (781)449-9702. Editor: Betsy Frawley Hagerty. E-mail: offeditor@aol.com. Monthly magazine. Emphasizes boating in the Northeast region, from Maine to New Jersey. Sample copy free with 9×12 SASE.
Needs: Uses 25-30 photos/issue; 25-30 supplied by freelancers. Needs photos of recreational boats and boating activities. Boats covered are mostly 20-50 feet, mostly power, but some sail, too. Especially looking for inside back page photos of a whimsical, humorous, or poignant nature, or that say "Goodbye" (all nautically themed)—New Jersey to Maine. Captions required; include location.
Specs: Cover photos should be vertical format and have strong graphics and/or color. Accepts images in digital format for Mac. Send via online, floppy disk, SyQuest.
Making Contact & Terms: Please call before sending photos. Simlultaneous submissions and/or previously published work OK. Pays $300/color cover; $50-200 for color inside. Pays on publication. Buys one-time rights. Credit line given.

$ $ ▣ OHIO MAGAZINE, 62 E. Broad St., Columbus OH 43215. (614)461-5083. Website: http://www.ohiomagazine.com. Art Director: Brooke Wenstrup. Estab. 1979. Magazine published 10 times/year. Emphasizes features throughout Ohio for an educated, urban and urbane readership. Sample copy $4 postpaid.

Needs: Travel, photo essay/photo feature, b&w scenics, personality, sports and spot news. Photojournalism and concept-oriented studio photography. Model/property releases preferred. Captions required.

Specs: Uses 8×10 b&w glossy prints; contact sheet requested. Also uses 35mm, 2¼×2¼ or 4×5 transparencies; square format preferred for covers. Accepts images in digital format for Mac via Zip disk.

Making Contact & Terms: Query with samples or arrange a personal interview to show portfolio. SASE. Reports in 1 month. Pays $100-1,000/job; $30-250/color photo; $350/assignment. Pays within 90 days after acceptance. Buys one-time rights; negotiable. Credit line given.

Tips: "Please look at magazine before submitting to get an idea of what type of photographs we use. Send sheets of slides and/or prints with return postage and they will be reviewed. Dupes for our files are always appreciated—and reviewed on a regular basis. We are leaning more toward well-done documentary photography and less toward studio photography. Trends in our use of editorial photography include scenics, single photos that can support an essay, photo essays on cities/towns, more use of 180° shots. In reviewing a photographer's portfolio or samples we look for humor, insight, multi-level photos, quirkiness, thoughtfulness; stock photos of Ohio; ability to work with subjects (i.e., an obvious indication that the photographer was able to make subject relax and forget the camera—even difficult subjects); ability to work with givens, bad natural light, etc.; creativity on the spot—as we can't always tell what a situation will be on location."

$ ▣ ◑ OKLAHOMA TODAY, P.O. Box 53384, Oklahoma City OK 73152. (405)521-2496. Fax: (405)522-4588. E-mail: mccune@oklahomatoday.com. Website: http://www.oklahomatoday.com. Editor-in-Chief: Louisa McCune. Photo Editor: Aimee Downs. Circ. 45,000. Estab. 1956. Bimonthly magazine. "We cover all aspects of Oklahoma, from history to people profiles, but we emphasize travel." Readers are "Oklahomans, whether they live in-state or are exiles; studies show them to be above average in education and income." Sample copy $4.95. Photo guidelines free with SASE.

Needs: Uses about 50 photos/issue; 90-95% supplied by freelancers. Needs photos of "Oklahoma subjects only; the greatest number are used to illustrate a specific story on a person, place or thing in the state. We are also interested in stock scenics of the state." Other areas of focus are adventure—sport/travel, reenactment, historical and cultural activities. Model release required. Captions required.

Specs: Uses 8×10 glossy b&w prints; 35mm, 2¼×2¼, 4×5, 8×10 transparencies. No color prints. Also accepts images in digital format for Mac. Send via Zip, e-mail.

Making Contact & Terms: Query with samples. Send portfolio or sample to the photo editor. SASE. Reports in 2 months. Simultaneous submissions and/or previously published work OK (on occasion). Pays $25-150/b&w photo; $50-250/color photo; $125-1,000/job. Pays on publication. Buys one-time rights with a six-month from publication exclusive, plus right to reproduce photo in promotions for magazine without additional payment with credit line.

Tips: To break in, "read the magazine. Subjects are normally activities or scenics (mostly the latter). I would like good composition and very good lighting. I look for photographs that evoke a sense of place, look extraordinary and say something only a good photographer could say about the image. Look at what Ansel Adams and Eliot Porter did and what Muench and others are producing and send me that kind of quality. We want the best photographs available and we give them the space and play such quality warrants."

◑ ◎ ONBOARD MEDIA, 960 Alton Rd., Miami Beach FL 33139. (305)673-0400. Fax: (305)674-9396. E-mail: bryan@onboard.com. Production Coordinator: Bryan Batty. Circ. 792,184. Estab. 1992. Annual magazine. Emphasizes travel in the Caribbean, Europe, Mexican Riviera, Bahamas, Alaska, Bermuda, Las Vegas. The publication reaches cruise vacationers or 3-1-night Caribbean, Bahamas, Mexican Riviera, Alaska and European itineraries. Sample copy free with 11×14 SASE. Photo guidelines free with SASE.

Needs: All photos supplied by freelancers. Needs photos of scenics, nature, prominent landmarks based in Caribbean, Mexican Riviera, Bahamas and Alaska. Model/property release preferred. Captions required; include where the photo was taken and explain the subject matter.

Specs: Uses 35mm, 2¼×2¼, 4×5, 8×10 transparencies.

Making Contact & Terms: Query with stock photo list. Provide résumé, business card, brochure, flier

CONTACT THE EDITOR of *Photographer's Market* by e-mail at photomarket@fwpubs.com with your questions and comments.

or tearsheets to be kept on file for possible assignments. Keeps samples on file. SASE. Reports in 3 weeks. Previously published work OK. Rates negotiable per project. Pays on publication.

$ THE OTHER SIDE, 300 W. Apsley St., Philadelphia PA 19144. (804)979-2516. Art Director: Ellen Osborn. Circ. 17,000. Estab. 1965. Bimonthly magazine. Emphasizes social justice issues from a Christian perspective. Sample copy $4.
• This publication is an Associated Church Press and Evangelical Press Association award winner.
Needs: Buys 6 photos/issue; 95-100% from stock, 0-5% on assignment. Documentary, human interest and photo essay/photo feature. Model/property release preferred. Captions preferred.
Specs: Uses 8×10 glossy b&w prints; or color transparencies.
Making Contact & Terms: Send samples of work to be photocopied for our files and/or photos. Materials will be returned on request. SASE. Simultaneous submissions and previously published work OK. Pays $40/b&w photo; $50-75/cover. Buys one-time rights. Credit line given.
Tips: In reviewing photographs/samples, looks for "sensitivity to subject, creativity, and good quality darkroom work."

$ ☒ OUR FAMILY, P.O. Box 249, Battleford, Saskatchewan, S0M 0E0 Canada. Fax: (306)937-7644. E-mail: ourfamily@marianpress.sk.ca. Editor: Marie Louise Ternier-Gommers. Circ. 8,000. Estab. 1949. Monthly magazine. Emphasizes Christian faith as a part of daily living for Roman Catholic families. "1999 is our 50th anniversary of continuous publication." Sample copy $3 with 9×12 SAE and $1.50 Canadian postage. Free photo and writer's guidelines with SAE and 55¢ Canadian postage.
Needs: Buys 5 photos/issue; cover by assignment, contents all freelance. Needs head shot (to convey mood); human interest ("people engaged in the various experiences of living"); humorous ("anything that strikes a responsive chord in the viewer"); photo essay/photo feature (human/religious themes); and special effects/experimental (dramatic—to help convey a specific mood). "We are always in need of the following: family (aspects of family life); couples (husband and wife interacting and interrelating or involved in various activities); teenagers (in all aspects of their lives and especially in a school situation); babies and children; any age person involved in service to others; individuals in various moods (depicting the whole gamut of human emotions); religious symbolism; and humor. We especially want people photos, but we do not want the posed photos that make people appear 'plastic,' snobbish or elite. In all photos, the simple, common touch is preferred. We are especially in search of humorous photos (human and animal subjects). Stick to the naturally comic, whether it's subtle or obvious." Photos are purchased with or without accompanying ms. Model release required if editorial topic might embarrass subject. Captions required when photos accompany ms.
Specs: Uses 8×10 glossy b&w prints; transparencies or 8×10 glossy color prints are used on inside pages but are converted to b&w.
Making Contact & Terms: Send material by mail for consideration or query with samples after consulting photo spec sheet. Provide letter of inquiry, samples and tearsheets to be kept on file for possible future assignments. SAE and IRC. (Personal check or money order OK instead or IRC.) Reports in 1 month. Simultaneous submissions or previously published work OK. Pays $35/b&w photo; 7-10¢/word for original mss; 5¢/word for nonoriginal mss. **Pays on acceptance.** Buys one-time rights and simultaneous rights. Credit line given.
Tips: "Send us a sample (20-50 photos) of your work after reviewing our Photo Spec Sheet. Looks for "photos that center around family life—but in the broad sense — i.e., our elderly parents, teenagers, young adults, family activities. Our covers (full color) are a specific assignment. We do not use freelance submissions for our cover."

Ⓝ $ $ ▣ Ⓒ OUR STATE MAGAZINE: Down Home in North Carolina, Mann Media, P.O. Box 4552, Greensboro NC 27404. (336)286-0600. Fax: (336)286-0100. E-mail: mannmedia2@aol.com. Art Director: Jennifer Swafford. Circ. 45,000. Estab. 1933. Monthly consumer magazine of travel, history, culture of North Carolina. Art guidelines available for SASE.
Needs: Buys 45 photos from freelancers per issue; 420 photos per year. Needs photos of landscapes/ scenics, wildlife, cities/urban, gardening, rural, adventure, events. North Carolina subjects only. Interested in historical/vintage, regional, seasonal. Model release required; property release preferred. Photo captions required; include location.
Specs: Uses 35mm, 2¼×2¼ transparencies. Accepts images in digital format for Mac. Send via CD, floppy disk, Jaz, Zip as TIFF files at 300 dpi.
Making Contact & Terms: Send query letter with résumé, stock list. Does not keep samples on file; cannot return sample material. Reports back only if interested, send nonreturnable samples. Pays $250-600 for color cover; $75-300 for color inside. Pays on publication. Credit line given. Buys one-time rights.
Tips: "Include a comprehensive Photo Delivery Receipt."

■ **OUT MAGAZINE**, 110 Greene St., Suite 600, New York NY 10012. (212)334-9119. Fax: (212)334-9227. E-mail: outmag@aol.com. Creative Director: Dan Lori. Photo Editor: Ayanna Quint. Circ. 150,000. Estab. 1992. Monthly magazine. Emphasizes gay and lesbian lifestyle. Readers are gay men and lesbians of all ages and their friends.

Needs: Uses over 100 photos/issue; more than half supplied by freelancers. Needs portraits, photojournalism and fashion photos. Reviews photos with or without ms. Model release required. Captions required.

Making Contact & Terms: Submit portfolio every Wednesday for review. Also accepts digital images on Zip disk and images via the Internet. Accepts "visual dispatch" and party photos from around the country; return postage required. Unsolicited material is not returned. Simultaneous submissions and/or previously published work OK. Payment negotiated directly with photographer. Pays on publication. Buys all rights; negotiable. Credit line given.

Tips: "Don't ask to see layout. Don't call every five minutes. Turn over large portion of film."

$ ■ ◯ **OUTBURN, Subversive and Post Alternative Music**, P.O. Box 3187, Thousand Oaks CA 91359. (805)493-5861. Fax: (805)493-5609. E-mail: outburn@outburn.com Website: http://www.outburn.com. Art Director: Rodney. Circ. 5,000. Estab. 1996. Three times/year consumer magazine. "*Outburn* is a music magazine featuring industrial, gothic, ethereal, electronic, rock and experimental genres. We feature in depth interviews with exclusive photos of musicians, as well as fine art and fashion photography." Sample copy for $5.50.

Needs: Needs photos of bands (celebrities, entertainment, events) and artistic photos (alternative process, avant garde, digital, erotic, fashion/glamour, fine art). Reviews photos with or without ms.

Specs: Uses any size color b&w prints. Accepts images in digital format for Mac. Send via CD, floppy disk, Zip as TIFF, EPS files at 300 dpi.

Making Contact & Terms: Send query letter with samples. Provide résumé, business card, self-promotion piece or tearsheets to be kept on file for possible future assignemtns. Art director will contact photographer for portfolio review if interested. Portfolio should include b&w and/or color, prints. Keeps samples on file; include SASE for return of material. Reports back only if interested, send non-returnable samples. In addition to any payment, "we print your bio, contact information and self-portrait." Credit line given.

Tips: "We look for work that is confrontational, unusual and personal."

$ $ [S] ■ ◿ **OUTDOOR AMERICA**, 707 Conservation Lane, Gaithersburg MD 20878-2983. (301)548-0150. Fax: (301)548-0146. E-mail: jay@iwla.org. Website: http://www.iwla.org. Editor: Zachary Hoskins. Art Director: Jay Clark. Circ. 45,000. Estab. 1922. Published quarterly. Emphasizes natural resource conservation and activities for outdoor enthusiasts, including hunters, anglers, hikers and campers. Readers are members of the Izaak Walton League of America and all members of Congress. Sample copy $2.50 with 9×12 envelope. Guidelines free with SASE.

Needs: Needs vertical wildlife or shots of anglers or hunters for cover. Buys pictures to accompany articles on conservation and outdoor recreation for inside. Model release preferred. Captions required; include date taken, model info, location and species.

Specs: Uses 35mm and 2¼×2¼ slides. Accepts images in digital format for Windows. Send via CD, Zip, e-mail as TIFF, EPS, PICT files at 300 dpi.

Making Contact & Terms: Query with résumé of photo credits. Send stock photo list. Tearsheets and non-returnable samples only. Not responsible for return of unsolicited material. SASE. Simultaneous and/or previously published work OK. Pays $350/color cover; $150-200/inside. Pays on publication. Buys one-time rights. Credit line given.

Tips: "*Outdoor America* seeks vertical photos of wildlife (particular game species); outdoor recreation subjects (fishing, hunting, camping or boating) and occasional scenics (especially of the Chesapeake Bay and Upper Mississippi river). We also like the unusual shot—new perspectives on familiar objects or subjects. We do not assign work. Approximately one half of the magazine's photos are from freelance sources."

$ ☖ ◿ **OUTDOOR CANADA**, 340 Ferrier St., Suite 210, Markham, Ontario L3R 2Z5 Canada. (905)475-8440. Fax: (905)475-9560. E-mail: oceditorial@outdoorcanadamagazine.com. Editor: James Little. Circ. 95,000. Estab. 1972. Magazine published 8 times a year. Free writers' and photographers' guidelines "with SASE or SAE and IRC only."

Needs: Buys 200-300 photos annually. Needs photos of wildlife, people fishing, hunting, ice-fishing, action shots. Captions required including identification of fish, bird or animal.

Specs: For cover allow undetailed space along left side of photo for cover lines.

Making Contact & Terms: Send a selection of color photocopies, or transparencies with return postage for consideration. SAE and IRC for American contributors, SASE for Canadians must be sent for return

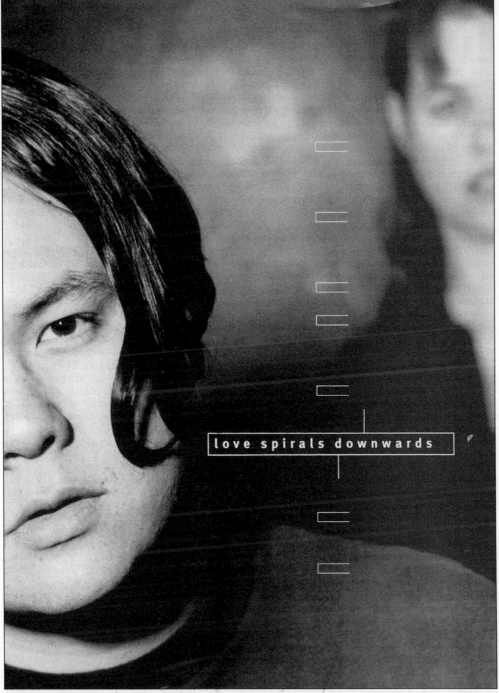

love spirals downwards

"This piece is good advertising for my photography and leads to more business for me," says Betty Cobb. "*Outburn* gives me creative freedom to explore nontraditional portraiture in a public forum." This image of the band Love Spirals Downwards reflects the personalities of the musicians, says art director rodent EK, who licensed one-time rights for the image.

of materials. Reports in 1 month. Pays $400/cover photo; $75-250/inside color photo depending on size used. Pays on publication. Buys one-time rights.

N $ ▣ ◯ OUTPOST MAGAZINE, The Traveller's Journal, Outpost Incorporated, 490 Adelaide St. W., #303, Toronto, Ontario M5V 7T2 Canada. (416)703-5394. Fax: (416)504-3628. E-mail: info@outpostmagazine.com. Website: http://www.outpostmagazine.com. Editor-in-Chief: Kisha Ferguson. Quarterly consumer travel magazine. Sample copies available for $5. Art guidelines available for SASE.
Needs: Needs photos of multicultural, environmental, landscapes/scenics, wildlife, architecture, cities/urban, rural, adventure, events, food/drink, travel, medicine. Interested in documentary, regional, seasonal. Reviews photos with or without a ms. Photo captions preferred; include location, description of scene, year.
Specs: Uses glossy or matte, color and b&w prints; 35mm, 2¼×2¼ transparencies. Accepts images in digital format for Mac, Windows. Send via CD, floppy disk, Zip, e-mail as TIFF, JPEG files at 100 dpi.
Making Contact & Terms: Send query letter with résumé, slides, prints, photocopies, tearsheets, transparencies. Portfolio may be dropped off Monday-Saturday. Does not keep samples on file; include SASE for return of material. Reports in 2 months on queries; 1 month on portfolios. Simultaneous submissions and previously published work OK. Pays 30-60 days after publication. Credit line given. Buys one-time rights, electronic rights.

$ OVER THE BACK FENCE, 5311 Meadow Lane Ct., Suite 3, Elyria OH 44035. (440)934-1812. Fax: (440)934-1816. E-mail: kbsagent@centuryinter.net. Creative Editor: Rocky Alten. Estab. 1994. Quarterly magazine. "This is a regional magazine serving Northern and Southern Ohio. We are looking for photos of interesting people, events, and history of our area." Sample copy $4. Photo guidelines free with SASE.
Needs: Uses 50 photos/issue; 80% supplied by freelance assignment; 20% by freelance stock. Needs photos of scenics, attractions, food (specific to each issue), historical locations in our region (call for specific counties). Model release required for identifiable people. Captions preferred; include locations, description, names, date of photo (year); and if previously published, where and when.
Making Contact & Terms: Provide résumé, business card, brochure, flier or tearsheets to be kept on file for possible assignments. Query with stock photo list and résumé of credits. SASE. Reports in 3 months. Simultaneous submissions and previously published work OK "but must identify photos used in other publications." Pays $100/color cover; $100/b&w cover; $25-100/color inside; $25-100/b&w inside. "We pay mileage fees to photographers on assignments. Request our photographer's rates and guidelines for specifics." Pays on publication. Buys one-time rights. Credit line given except in the case of ads, where it may or may not appear.
Tips: "We are looking for sharp, colorful images and prefer using color transparencies over color prints when possible. Nostalgic and historical photos are usually in black & white."

N $ $ ⬙ S ▣ ◉ OWL MAGAZINE, 179 John St., Suite 500, Toronto, Ontario M5T 3G5 Canada. (416)340-2700. Fax: (416)340-9769. E-mail: katherine@owl.on.ca. Website: http://www.owl.on.ca. Researcher: Katherine Murray. Circ. 80,000. Estab. 1976. Published 9 times/year; 1 summer issue. A science and nature magazine for children ages 8-13. Sample copy $4.28 and 9×12 SAE. Photo guidelines with SAE.
Needs: Uses approximately 15 photos/issue; 50% supplied by freelancers. Needs photos of animals/wildlife, science, technology, scientists working in the field (i.e. with animals), babies, children, families, parents, environmental, landscapes, pets, adventure, hobbies, humor, sports. Interested in avant garde, digital, regional and seasonal images. Model/property release preferred. Captions required.
Specs: Uses 35mm transparencies. Also accepts digital files scanned on to Zip disk or CD at high resolution (300 dpi) as a TIFF or EPS file (prefers CMYK format, separations included).
Making Contact & Terms: Request photo package before sending photos for review. "We prefer promotional brochures but will accept up to 20 slides for review if accompanied by payment for return courier/mail. We accept no responsibility for unsolicited material." Keeps samples on file. Include SAE and IRCs. Reports in 2-3 months. Previously published work OK. Pays $450 Canadian/color cover; $150 Canadian/color inside; $250 Canadian/color page rate; $125-500 US/color photo. **Pays on acceptance.** Buys one-time rights. Credit line given.
Tips: "Photos should be sharply focused with good lighting showing animals in their natural environment. It is important that you present your work as professionally as possible. Become familiar with the magazine—study back issues."

N $ $ $ ◉ ▣ THE OXFORD AMERICAN MAGAZINE, The Southern Magazine of Good Writing, 1000 Jackson Ave., Suite 201, Oxford MS 38655. (601)236-1836. Fax: (601)236-3141. E-mail: oxam@watervalley.net. Photography Editorial Assistant: Grayson Splane. Circ. 50,000. Estab.

1992. Bimonthly literary magazine specializing in Southern writers, artists, photographers and subject matter. Sample copies for $5.

Needs: Needs photos of celebrities, environmental, landscapes/scenics, religious, rural, performing arts, portraits, still life. Interested in avant garde, documentary, fine art, historical/vintage, regional. Reviews photos with or without ms. Model and property release preferred. Photo captions required; include titles, date, place.

Specs: Uses 8×10 matte, color or b&w prints; 35mm, 2¼×2¼, 4×5 or 8×10 transparencies. Accepts images in digital format for Mac. Send via Jaz.

Making Contact & Terms: Send query letter with slides, prints, photocopies, tearsheets, transparencies, stock list. Provide business card, self-promotion piece to be kept on file for possible future assignments. Reports back only if interested. Simultaneous submissions OK. Pays $500-1,000/b&w or color cover; $125-1,500/b&w or color inside. Pays on publication. Credit line given. Buys one-time rights.

Tips: "Be familiar with our previously published photographers' work. Do not send big portfolios unless you plan to pay for shipping."

$ $ **OXYGEN,** Muscle Mag International Corp. (USA), 6465 Airport Rd., Mississauga, Ontario L4V 1E4 Canada. Phone/fax: (905)678-7311. Editor-in-Chief: Robert Kennedy. Circ. 250,000. Estab. 1997. Bimonthly magazine. Emphasizes exercise and nutrition for women. Readers are women, ages 16-35. Sample copy $5.

Needs: Uses 300 photos/issue; 80% supplied by freelancers. Needs photos of women in weight training and exercising aerobically. Model release preferred. Captions preferred; include names of subjects.

Specs: Uses 35mm, 2¼×2¼ transparencies.

Making Contact & Terms: Send unsolicited photos by mail for consideration. Does not keep samples on file. SASE. Reports in 3 weeks. Pays $100-200/hour; $400-600/day; $400-1,000/job; $500-600/color cover; $35-50/color or b&w inside. **Pays on acceptance.** Buys all rights. Credit line given.

Tips: "We are looking for attractive, fit women working out on step machines, joggers, rowers, walkers, or women running for fitness, jumping, climbing. Professional pictures only please."

N $ **PACIFIC UNION RECORDER,** Box 5005, Westlake Village CA 91359. (805)497-9457. Fax: (805)495-2644. E-mail: 74617.614@compuserve.com. Editor: C. Elwyn Platner. Circ. 58,500. Estab. 1901. Monthly company publication of Pacific Union Conference of Seventh-day Adventist. Emphasizes religion. Readers are primarily age 18-90 church members. Sample copy free with 8½×11 SAE and 3 first-class stamps. Photo guidelines free with SASE.

Needs: Uses photos for cover only; 40% supplied by freelance photographers. Needs photos of animal/wildlife shots, travel, scenics, couples, multicultural, families, parents, senior citizens, teens; limited to subjects within Nevada, Utah, Arizona, California and Hawaii. Model release required. Captions required.

Making Contact & Terms: Send 35mm, 2¼×2¼, 4×5, 8×10 vertical transparencies by mail for consideration in September only. Limit of 10 transparencies or less/year per photographer. SASE. Reports in 1-2 months after contest. Pays $75/color cover photo. Pays on publication. Buys first one-time rights. Credit line given.

Tips: "Avoid the trite, Yosemite Falls, Half Dome, etc." Holds annual contest October 1 each year; submit entries in September only.

N $ **PACIFIC YACHTING MAGAZINE,** 780 Beatty St., Suite 300, Vancouver, British Columbia V6B 2MI Canada. (604)606-4644. Fax: (604)687-1925. E-mail: op@mindlink.bc.ca. Editor: Duart Snow. Circ. 25,000. Estab. 1968. Monthly magazine. Emphasizes boating on West Coast. Readers are male, ages 35-60, boaters, power and sail. Sample copy free with 8½×11 SAE with IRC.

Needs: Uses 125 photos/issue; 125 supplied by freelancers. Needs photos of landscapes/scenics, adventure, sports, historical/vintage, regional, seasonal. Reviews photos with accompanying ms only.

Making Contact & Terms: Keeps samples on file. Simultaneous submissions and/or previously published work OK. Payment negotiable. Buys one-time rights. Credit line given.

$ **PADDLER MAGAZINE,** P.O. Box 5450, Steamboat Springs CO 80477. (970)879-1450. Fax: (970)870-1404. E-mail: editor@aca-paddler.org. Website: http://www.aca-paddler.org/paddler. Editor: Eugene Buchanan. Circ. 85,000. Estab. 1990. Bimonthly magazine. Emphasizes kayaking, rafting, canoeing and sea kayaking. Sample copy $3.50. Photo guidelines free with SASE.

Needs: Uses 30-50 photos/issue; 90% supplied by freelancers. Needs photos of scenics and action. Model/property release preferred. Captions preferred; include location.

Specs: Uses 35mm transparencies. Accepts images in digital format on compact disc, Zip disk or floppy.

Making Contact & Terms: Query with stock photo list. Send unsolicited photos by mail for consideration. Keeps samples on file. SASE. Reports in 2 months. Pays $25-200/color photo; $200-300/color cover;

$50/inset color cover; $75/color full page inside. Pays on publication. Buys first North American serial rights; negotiable. Credit line given.

Tips: "Send dupes and let us keep them on file."

N $⊕ ▢ ⊘ THE PEAK, Magazines Incorporated, 15-B Temple St., Singapore 058562. Phone: (65) 3231119. Fax: (65) 3237776/9. E-mail: mag_inc@pacific.net.sg. Managing Editor: Kannan Chandran. Circ. 40,000. Estab. 1984. Monthly "lifestyle magazine on various topics—travel, business, fashion, cars, music, profiles etc.—reaching the top 2% income earners in Singapore, Malaysia and Indonesia."

Needs: Buys approximately 1,000 photos per year. Needs photos of celebrities, multicultural, families, landscapes/scenics, wildlife, architecture, beauty, rural, adventure, automobiles, entertainment, events, food/drink, health/fitness, hobbies, humor, sports, travel, buildings, business concepts, computers, medicine, portraits, product shots/still life, science, technology. Interested in avant garde, digital, fashion/glamour, fine art, historical/vintage, regional, seasonal. "Magazines Incorporated has a stable of magazines. We have 8 titles currently, including magazines for: Singapore Airlines, Hong Kong Bank and Standard Chartered Bank. We have titles on food and property as well, and our pool is growing. We also publish Marie Claire (Singapore edition)." Reviews photos with accompanying ms only. Photo caption required; include value-added captions.

Specs: Uses 35mm transparencies. Accepts images in digital format for Mac. Send via e-mail as TIFF files.

Making Contact & Terms: Send query letter with photocopies. Does not keep samples on file. Reports back only if interested; send nonreturnable samples. Previously published work OK. Pays $200 (Singapore) for color cover; $50 (Singapore) maximum for color inside. Pays 6 weeks after publication. Credit line given. Buys electronic rights; negotiable.

Tips: "Be reliable and innovative. Give good, clear captions. Ensure no duplicates are offered."

$ $PENNSYLVANIA ANGLER & BOATER, P.O. Box 67000, Harrisburg PA 17106-7000. (717)657-4518. Fax: (717)657-4549. E-mail: amichaels@fish.state.pa.us. Website: http://www.fish.state.pa.us. Editor: Art Michaels. Bimonthly. "*Pennsylvania Angler & Boater* is the Keystone State's official fishing and boating magazine, published by the Pennsylvania Fish and Boat Commission." Readers are "anglers and boaters in Pennsylvania." Sample copy and photo guidelines free with 9 × 12 SAE and 9 oz. postage.

Needs: Uses about 50 photos/issue; 80% supplied by freelancers. Needs "action fishing and boating shots." Model release preferred. Captions required.

Making Contact & Terms: Query with résumé of credits. Send 35mm or larger transparencies by mail for consideration. SASE. Reports in 2 weeks. Pays up to $400/color cover; $25 up/color inside; $50-300 for text/photo package. **Pays on acceptance.** Credit line given.

PENNSYLVANIA GAME NEWS, 2001 Elmerton Ave., Harrisburg PA 17110-9797. (717)787-3745. Editor: Bob Mitchell. Circ. 150,000. Monthly magazine. Published by the Pennsylvania Game Commission. For people interested in hunting, wildlife management and conservation in Pennsylvania. Free sample copy with 9 × 12 SASE. Free editorial guidelines.

Needs: Considers photos of "any outdoor subject (Pennsylvania locale), except fishing and boating." Photos purchased with accompanying ms.

Making Contact & Terms: Send 8 × 10 glossy b&w prints. SASE. Reports in 2 months. Pays $5-20/ photo. **Pays on acceptance.** Buys all rights, but may reassign after publication.

$PENNSYLVANIAN MAGAZINE, Dept. PM, 2941 N. Front St., Harrisburg PA 17110. (717)236-9526. Fax: (717)236-8164. Editor: T. Michael Mullen. Circ. 7,000. Estab. 1962. Monthly magazine of Pennsylvania State Association of Boroughs (and other local governments). Emphasizes local government in Pennsylvania. Readers are officials in municipalities in Pennsylvania. Sample copy free with 9 × 12 SAE and 5 first-class stamps.

Needs: Number of photos/issue varies with inside copy. Needs "color photos of scenics (Pennsylvania), local government activities, Pennsylvania landmarks, ecology—for cover photos only; authors of articles supply their own photos." Special photo needs include photos of street and road maintenance work; wetlands scenic. Model release preferred. Captions preferred that include identification of place and/or subject.

Specs: Uses color prints and 35mm transparencies.

Making Contact & Terms: Query with résumé of credits and list of stock photo subjects. Send unsolicited photos by mail for consideration. Provide résumé, business card, brochure, flier or tearsheets to be kept on file for possible assignments. Does not keep samples on file. SASE. Reports in 1 month. Pays $25-30/ color cover. Pays on publication. Buys one-time rights.

Tips: "We're looking for a variety of scenic shots of Pennsylvania which can be used for front covers of the magazine, especially special issues such as engineering, winter road maintenance or park and recreation. Photographs submitted for cover consideration should be vertical shots; horizontal shots receive minimal consideration."

$ ▣ ◨ ◎ PENTECOSTAL EVANGEL, 1445 Boonville, Springfield MO 65802. (417)862-2781. Fax: (417)862-0416. E-mail: pevangel@ao.org. Website: http://www.ag.org/evangel. Editor: Hal Donaldson. Managing Editor: Ken Horn. Circ. 250,000. Official voice of the Assemblies of God, a conservative Pentecostal denomination. Weekly magazine. Emphasizes denomination's activities and inspirational articles for membership. Free sample copy and photographer's/writer's guidelines.
 • *Pentecostal Evangel* uses a number of images taken from the Internet and CD-ROMs.
Needs: Uses 25 photos/issue; 5 supplied by freelance photographers. Human interest (very few children and animals). Also needs seasonal and religious shots. "We are interested in photos that can be used to illustrate articles or concepts developed in articles. We are not interested in merely pretty pictures (flowers and sunsets) or in technically unusual effects or photos. We use a lot of people and mood shots." Model release preferred. Captions preferred.
Specs: Uses 8×10 b&w and color prints; 35mm or larger transparencies; color 2¼×2¼ to 4×5 transparencies for cover; vertical format preferred. Also accepts digital images for Mac in TIFF files (300 dpi).
Making Contact & Terms: Send material by mail for consideration. SASE. Reports in 6-8 weeks. Simultaneous submissions and previously published work OK if indicated. Pays $30-50/b&w photo; $50-200/color photo; $100-500/job. **Pays on acceptance.** Buys one-time rights; simultaneous rights; or second serial (reprint) rights. Credit line given.
Tips: "Send seasonal material six months to a year in advance—especially color."

$ ▣ ◨ PERSIMMON HILL, 1700 NE 63rd, Oklahoma City OK 73111. (405)478-6404. Fax: (405)478-4714. E-mail: nchf@aol.com. Website: www.cowboyhalloffame.org. Editor: M. J. Van Deventer. Circ. 15,000. Estab. 1970. Publication of the National Cowboy Hall of Fame museum. Quarterly magazine. Emphasizes the West, both historical and contemporary views. Has diverse international audience with an interest in preservation of the West. Sample copy $9 with 9×12 SAE and 10 first-class stamps. Writers and photography guidelines free with SASE.
 • This magazine has received Outstanding Publication honors from the Oklahoma Museums Association, the International Association of Business Communicators and Ad Club.
Needs: Uses 70 photos/issue; 95% supplied by freelancers; 90% of photos in each issue come from assigned work. "Photos must pertain to specific articles unless it is a photo essay on the West." Western subjects include celebrities, multicultural, families, senior citizens, landscapes, wildlife, rural, adventure, events, travel, portraits, fine art, historical/vintage, regional, seasonal. Model release required for children's photos. Photo captions required including location, names of people, action. Proper credit is required if photos are of an historical nature.
Specs: Accepts images in digital format for Mac. Send via SyQuest.
Making Contact & Terms: Submit portfolio for review. SASE. Reports in 6 weeks. Pays $100-400/color cover; $50-100/color inside; $50-75/b&w inside; $200/photo/text package; $40-60/hour; $250-500/day; $300-750/job. Buys first North American serial rights. Credit line given.
Tips: "Make certain your photographs are high quality and have a story to tell. We are using more contemporary portraits of things that are currently happening in the West and using fewer historical photographs. Work must be high quality, original, innovative. Photographers can best present their work in a portfolio format and should keep in mind that we like to feature photo essays on the West in each issue. Study the magazine to understand its purpose. Show only the work that would be beneficial to us or pertain to the traditional Western subjects we cover."

$ ⊕ Ⓐ ◨ PET REPTILE, Freestyle Publications Ltd., Alexander House, Ling Rd., Tower Park, Poole, Dorset BH12 4NZ United Kingdom. Phone: (441202)735090. Fax: (441202)733969. E-mail: gjames@freepubs.co.uk. Website: http://www.freepubs.co.uk. Editor: Gethin James. Estab. 1997. Monthly magazine aimed at anyone with an interest in keeping reptiles, amphibians or invertebrates. Sample copy free.
Needs: Buys 50 photos from freelancers/issue; 600 photos/year. Needs photos of all reptiles, amphibians, invertebrates. Reviews photos with or without ms. Special photo needs include good quality cover shots. Photo captions required.
Making Contact & Terms: Send query letter with samples. Art director will contact photographer for portfolio review if interested. Portfolio should include b&w and/or color, prints, tearsheets, slides, transparencies or thumbnails. Include SASE for return of material. Previously published work OK. Pays £50-75 for color cover; £10-50 for b&w inside; £10-50 for color inside. Pays on publication. Rights negotiated.

Tips: "Variety is important. Unusual angles are preferrable." Please send query letter with samples. Art director will contact photographer for samples if interested. Portfolio should include b&w and/or color, prints, tearsheets, slides, transparencies or thumbnails. Include SASE for return of material."

$ $ Ⓐ ◑ PETERSEN'S PHOTOGRAPHIC, 6420 Wilshire Blvd., Los Angeles CA 90048-5515. (323)782-2200. Fax: (323)782-2465. Editor: Ron Leach. Circ. 200,000. Estab. 1972. Monthly magazine. Emphasizes photography. Sample copies available on newsstands. Photo guidelines free with SASE.
Needs: All queries, outlines and mss must be accompanied by a selection of images that would illustrate the article. Possible subjects include babies, couples, families, parents, landscapes/scenics, wildlife, architecture, cities/urban, pets, adventure, sports, travel, fashion/glamour, fine art, seasonal.
Making Contact & Terms: Submit portfolio for review. Send unmounted glossy color or b&w prints no larger than 8×10; 35mm, 2¼×2¼, 4×5, 8×10 transparencies preferred. All queries and mss must be accompanied by sample photos for the article. SASE. Reports in 2 months. Previously published photos OK. Pays $200-400 for color cover; $50-150 for b&w or color inside. Pays on publication. Buys one-time rights. Credit line given.
Tips: "Typically we only purchase photos as part of an editorial manuscript/photo package. We need images that are visually exciting and technically flawless. The articles mostly cover the theme 'We Show You How.' Send great photographs with an explanation of how to create them. Submissions must be by mail."

$ $ Ⓢ PHI DELTA KAPPA, Eighth & Union Sts., P.O. Box 789, Bloomington IN 47402. Website: http://www.pdkintl.org/kappan.htm. Design Director: Carol Bucheri. Estab. 1915. Produces *Phi Delta Kappan* magazine and supporting materials. Photos used in magazine, fliers and subscription cards.
Needs: Buys 5 photos/year. Education-related subjects: innovative school programs, education leaders at state and federal levels, social conditions as they affect education. Reviews stock photos. Model release required. Photo captions required; include who, what, when, where.
Specs: Uses 8×10 b&w prints.
Making Contact & Terms: Query with list of education-related stock photo subjects before sending samples. Provide photocopies, brochure or flier to be kept on file for possible future assignments. SASE. Reports in 3 weeks. Pays $20-100/b&w photo; $30-400/color photo; $30-500/job. Buys one-time rights. Credit line and tearsheets given.
Tips: "Don't send photos that you wouldn't want to hang in a gallery. Just because you do a photo for publications does not mean you should lower your standards. Spots should be touched up (not with a ball point pen), the print should be good and carefully done, subject matter should be in focus. Send me photocopies of your b&w prints that we can look at. We don't convert slides and rarely use color."

$ $ ⬚ Ⓐ ▣ ◑ PHOTO LIFE, Apex Publications, One Dundas St. W., Suite 2500, P.O. Box 84, Toronto, Ontario M5G 1Z3 Canada. (800)905-7468. Fax: (800)664-2739. Editor: Susie Ketens. Circ. 73,500. Magazine published 6 times/year. Readers are advanced amateur and professional photographers. Sample copy or photo guidelines free with SASE.
Needs: Uses 70 photos/issue; 100% supplied by freelance photographers. Needs landscape/wildlife shots, travel, scenics, b&w images and so on. Priority is given to Canadian photographers.
Specs: Accepts images in digital format for Mac. Send via SyQuest, CD or Zip disk (300 dpi).
Making Contact & Terms: Query with résumé of credits. SASE. Reports in 1 month. Pays $75-100/ color photo; $400 maximum/complete job; $700 maximum/photo/text package. **Pays on acceptance**. Buys first North American serial rights and one-time rights.
Tips: "Looking for good writers to cover any subject of interest to the advanced photographer. Fine art photos should be striking, innovative. General stock, outdoor and travel photos should be presented with a strong technical theme."

$ $ ⊕ ▣ ◑ PHOTO TECHNIQUE, IPC Magazines, Kings Reach Tower, Stamford St., London United Kingdom SE1 9LS. Phone: 44171-261 6627. Fax: 44171-261 5404. E-mail: phototechnique@cpc.co .uk. Website: http://www.cpc.co.uk. Editor: Alisa McWhinnie. Circ. 39,000. Estab. 1993. Monthly consumer magazine for amateur and professional photographers with emphasis on improving techniques. Sample copy available.

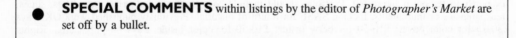

● **SPECIAL COMMENTS** within listings by the editor of *Photographer's Market* are set off by a bullet.

Needs: Needs photos of everything—especially outdoor, portraits and action. Also considers celebrities, landscapes/scenics, wildlife, adventure, humor, sports, travel, still life, alternative process, digital, documentary, fashion/glamour, seasonal. Reviews photos with or without ms. Special photo needs include high impact shots with interesting technique/anecdote behind them. Photo captions preferred; include type of camera, lens, film, exposure, filters, tripod used.
Specs: Uses 8×10 maximum color/b&w prints or transparencies. Accepts images in digital format for Mac. Send via CD, floppy disk, Jaz as TIFF files at 300 dpi.
Making Contact & Terms: Send query letter with samples. Portfolios may be dropped off every Wednesday. Keeps samples on file 6 months maximum. Pays £200-300 for cover; £50-300 for inside. Pays on publication. Buys one-time rights, first rights. Credit line given.
Tips: "Read our magazine. Phone with ideas or email. Send SAE. Don't sent previously published work which has been in UK photo magazines. Please don't send 1970-80s glamour. Submit a selection of 20 images which reflect a cross section of your work. Include a letter with details of your specialities."

$ ⬛ PHOTO TECHNIQUES, Preston Publications, 6600 W. Touhy Ave., Niles IL 60714. (847)647-2900. Fax: (847)647-1155. Editor: Michael C. Johnston. Circ. 37,000. Estab. 1979. Bimonthly traditional photography magazine for advanced workers—most own their own darkrooms. Sample copy for $5 or free with 9×12 SASE. Art guidelines for SAE.
Needs: Publishes expert technical articles about photography. Especially needs "On Assignment" and lighting articles. Reviews photos with or without ms. Photo captions required; include technical data.
Specs: Uses any and all formats—prefer 8×10 prints.
Making Contact & Terms: Send article or portfolio for review. Portfolio should include b&w and/or color, prints, slides or transparencies. Keeps samples on file; include SASE for return of material. "Prefer that work not have been previously published in any competing photography magazine; small, scholarly, or local publication OK." Pays $300 and up for color cover; $100-225 per page. Pays on publication. Buys one-time rights. Credit line given.
Tips: "We need people to be familiar with our magazine before submitting/querying; however, we receive surprisingly few portfolios and are interested in seeing more. We are most interested in non-big-name photographers. Include return postage/packaging. Also, we much prefer complete finished submissions; when people ask 'would you be interested . . . ?' Often the answer is simply, 'we don't know! Let us see it.' We are very interested in having freelance writers submit work they've written about local or lesser-known working photographers, along with pictures. Often the photographers will not take the time to create a viable magazine piece. Even with minimal written material, having a writer manage the submission can be very helpful."

⬛ ⬛ PHOTORESOURCE MAGAZINE, 1411 S. Alamo, Suite A, Las Cruces NM 88001. (505)532-6114. E-mail: info@photoresource.com. Website: www.photoresource.com. Editor: William Johnson. Circ. 150,000-250,000. Estab. 1994. Semi-monthly magazine. Readers are male and female, ages 18-55. Photo/writers guidelines available only on website.
Needs: Uses 2-6 photos/issue; all supplied by freelancers. All subjects considered. Model/property release required. Photo captions required.
Specs: Accepts images in digital format for Windows. Send via e-mail as JPEG files at 72-150 dpi.
Making Contact & Terms: Can send 3 photos via E-mail to artdept@photoresource.com for consideration. Does not keep samples on file. Reports in 1 week. Simultaneous submissions OK. Payment negotiable. Pays on publication. Buys one-time rights. Credit line given.

Ⓝ $ 🌐 ⬛ PILOT MAGAZINE, The Clock House, 28 Old Town, Clapham, London SW4 0LB United Kingdom. (44)171 498 2506. Fax: (44)171 498 6920. E-mail: pilotmagazine@compuserve.com. Website: http://www.hiway.co.uk/pilot. Editor: James Gilbert. Circ. 29,358. Estab. 1968. Monthly consumer magazine. Art guidelines available.
Needs: Needs photos of aviation. Reviews photos with or without a ms. Photo captions required.
Specs: Uses glossy, color prints; 35mm, $2\frac{1}{4} \times 2\frac{1}{4}$, 4×5, 8×10 transparencies. Accepts images in digital format for Mac. Send as JPEG files.
Making Contact & Terms: Does not keep samples on file; include SASE for return of material. Previously published work OK. Pays £26 for color inside. Pays on publication. Credit line given. Buys one-time rights.
Tips: "Read our magazine. Label all photos with name and address. Supply generous captions."

$ PLAYBOY, 680 North Lake Shore Dr., Chicago IL 60611. (312)751-8000. Fax: (312)587-9046. Photography Director: Gary Cole. Circ. 3.15 million, US Edition; 5 million worldwide. Estab. 1954. Monthly

magazine. Readers are 75% male and 25% female, ages 18-70; come from all economic, ethnic and regional backgrounds.
> ● This is a premiere market that demands photographic excellence. *Playboy* does not use freelance photographers per se, but if you send images they like they may use your work and/or pay a finder's fee.

Needs: Uses 50 photos/issue. Needs photos of glamour, fashion, merchandise, travel, food and personalities. Model release required. Models must be at least 18 years old.

Specs: Uses color 35mm, 2¼×2¼, 4×5, 8×10 transparencies.

Making Contact & Terms: Contact through rep. Submit portfolio for review. Query with résumé of credits. Provide résumé, business card, brochure, flier or tearsheets to be kept on file for possible assignments. Reports in 1-2 weeks. Pays $300 and up/job. **Pays on acceptance**. Buys all rights.

Tips: Lighting and attention to detail is most important when photographing women, especially the ability to use strobes indoors. Refer to magazine for style and quality guidelines.

PLAYBOY'S NEWSSTAND SPECIALS, 680 N. Lakeshore Dr., Chicago IL 60611. (312)751-8000. Fax: (312)751-2818. E-mail: newstand@playboy.com. Circ. 300,000. Estab. 1984. Monthly magazine for male sophisticate. Art guidelines available.

Needs: Needs photos of beautiful women. Model/property release required. Photo captions required.

Specs: Uses 35mm, 2¼×2¼ tranparencies; Kodachrome film.

Making Contact & Terms: Send query letter with samples. Does not keep samples on file. Buys one-time rights or all rights. Credit line given.

N̄ $ $PLAYERS MAGAZINE, 8060 Melrose Ave., Los Angeles CA 90046. (323)653-8060. Fax: (323)655-9452. E-mail: psi@loop.com. Photo Editor: Tim Connelly. Editor-in-Chief: David Jamison. Monthly magazine. Emphasizes black adults. Readers are black men over 18. Sample copy free with SASE. Photo guidelines free with SASE.

Needs: Number of photos/issue varies; all supplied by freelancers. Needs photos of various editorial shots and female pictorials. Reviews photos purchased with accompanying ms only. Model release required for pictorial sets. Property release preferred for pictorial sets. Captions required.

Making Contact & Terms: Submit portfolio for review. Send 35mm, 2¼×2¼×2¼ transparencies. Keeps samples on file. SASE. Reports in 1-2 weeks. Simultaneous submissions and/or previously published work OK. Pays $200-250/color cover; $100-150/color inside. Pays on publication. Buys first North American serial and all rights; negotiable. Credit line given.

Tips: "We're interested in innovative, creative, cutting-edge work and we're not afraid to experiment."

N̄ $ A □ ◎ PN/PARAPLEGIA NEWS, 2111 E. Highland Ave., Suite 180, Phoenix AZ 85016-4702. (602)224-0500. Fax: (602)224-0507. E-mail: pvapub@aol.com. Website: http://www.pva.org/pn. Director of Art & Production: Susan Robbins. Circ. 27,000. Estab. 1946. Monthly magazine. Emphasizes all aspects of living for people with spinal-cord injuries or diseases. Readers are primarily well-educated males, 40-55, who use wheelchairs for mobility. Sample copy free with 9×12 SASE and 7 first-class stamps.

Needs: Uses 30-50 photos/issue; 10% supplied by freelancers. Articles/photos must deal with accessibility or some aspect of wheelchair living. "We do not accept photos that do not accompany manuscript." Model/property release preferred. Captions required; include who, what, when, where.

Specs: Accepts images in digital format for Mac. Send via CD, SyQuest, floppy disk, Zip, e-mail as TIFF, EPS, GIF, JPEG files at 300 dpi.

Making Contact & Terms: Provide résumé, business card, brochure, flier or tearsheets to be kept on file for possible assignments. "OK to call regarding possible assignments in your locale." Keeps samples on file. SASE. Reports in 1 month. Simultaneous submissions and previously published work OK. Pays $25-200/color cover; $10-25/color inside; $10-25/b&w inside; $50-200/photo/text package; other forms of payment negotiable. Pays on publication. Buys one-time, all rights; negotiable. Credit line given.

Tips: "Feature a person in a wheelchair in photos whenever possible. Person should preferably be involved in some activity."

$ $POETS & WRITERS MAGAZINE, 72 Spring St., New York NY 10012. (212)226-3586. Fax: (212)226-3963. E-mail: jim@pw.org. Website: http://www.pw.org. Circ. 60,000. Estab. 1987. Bimonthly literary trade magazine. "Designed for poets, fiction writers and creative nonfiction writers. We supply our readers with information about the publishing industry, conferences and workshop opportunities, grants and awards available to writers, as well as interviews with contemporary authors."

Needs: Buys 2 photos from freelancers/issue. Needs photos of contemporary writers: poets, fiction writers, writers of creative nonfiction. Photo captions required.

Specs: Uses b&w prints.

Making Contact & Terms: Provide résumé, business card, self-promotion piece or tearsheets to be kept on file for possible future assignments. Art director will contact photographer for portfolio review if interested. Pays $500 maximum for b&w cover; $150 maximum for b&w inside. Pays on publication. Credit line given.

Tips: "We seek black and white photographs to accompany articles and profiles. We'd be pleased to have photographers' lists of author photos."

$ ◎ POLO PLAYERS EDITION MAGAZINE, 3500 Fairlane Farms Rd., #9, Wellington FL 33414. (561)793-9524. Fax: (561)793-9576. Editor: Gwen Rizzo. Circ. 7,000. Estab. 1975. Monthly magazine. Emphasizes the sport of polo and its lifestyle. Readers are primarily male; average age is 40. 90% of readers are at professional/managerial levels, including CEO's and presidents. Sample copy free with 10×13 SASE. Photo guidelines free with SASE.

Needs: Uses 50 photos/issue; 70% supplied by freelance photographers; 20% of this by assignment. Needs photos of polo action, portraits, travel, party/social and scenics. Most polo action is assigned, but freelance needs range from dynamic action photos to spectator fashion to social events. Photographers may write and obtain an editorial calendar for the year, listing planned features/photo needs. Captions preferred, where necessary include subjects and names.

Making Contact & Terms: Query with list of stock photo subjects. Provide résumé, business card, brochure, flier or tearsheets to be kept on file for possible assignments. SASE. Reports in 2 weeks. Simultaneous submissions and previously published work OK "in some instances." Pays $25-150/b&w photo, $30-300/color photo, $150/half day, $300/full day, $200-500/complete package. Pays on publication. Buys one-time or all rights; negotiable. Credit line given.

Tips: Wants to see tight focus on subject matter and ability to capture drama of polo. "In assigning action photography, we look for close-ups that show the dramatic interaction of two or more players rather than a single player. On the sidelines, we encourage photographers to capture emotions of game, pony picket lines, etc." Sees trend toward "more use of quality b&w images." To break in, "send samples of work, preferably polo action photography."

$ ◘ PONTOON & DECK BOAT, Harris Publishing, 520 Park Ave., Idaho Falls ID 83402. (208)524-7000. Fax: (208)522-5241. E-mail: steve@houseboating.net. Website: http://www.pontoon.net. Editor: Steve Smede. Circ. 82,000. Estab. 1995. Bimonthly consumer magazine geared towards the pontoon and deck boating lifestyle. "Our audience is composed of people who utilize these boats for varied family activities and fishing. Sample copies available. Call for guidelines.

Needs: Buys 2-6 photos/issue photos from freelancers; 14-20 photos/year. Needs photos of family activities, travel, vessel layouts and components. Reviews photos with or without ms. Special photo needs include: family activities and remodeling, scenics with pontoon or deck boat. Property release and captions preferred.

Making Contact & Terms: Send query letter with samples. To show portfolio, photographer should follow-up with call. Portfolio should include color slides and transparencies. Keeps samples on file. Reports in 1-2 months on queries. Simultaneous submissions OK. Pays on publication. Buys one-time rights. Credit line sometimes given depending on nature of use.

Tips: "We're saturated with 'brochure' photography. Show us something daring you won't find in a brochure or advertisement. This is a family publication and should illustrate how families utilize pontoon and deck boats."

$ $ ▣ POP CULTURE, Turquoise Productions, 3932 Wilshire Blvd., #212, Los Angeles CA 90010. (213)383-1091. Fax: (213)383-1093. E-mail: popcultmag@aol.com. Website: http://www.pop-culture.com. Creative/Editorial Director: Sean Perkin. Circ. 100,000. Estab. 1993. *Pop Culture* is a bimonthly general interest international publication that chronicles the events and ideas that shape culture. Each issue explores the numerous aspects of life, people and events worldwide that define the times in which we live.

Needs: Buys 50-100 photos from freelancers/issue; 350-600 photos/year. Needs photos of popular culture. Reviews photos with or without ms. Model release required; property release preferred. Photo captions preferred.

Specs: Uses 8×10 color/b&w prints; 35mm, 2¼×2¼, 4×5, 8×10 transparencies. Accepts images in digital format.

Making Contact & Terms: Send query letter with samples, tearsheets. Provide résumé, business card, self-promotion piece or tearsheets to be kept on file for possible future assignments. Art director will contact photographer for portfolio review if interested. Portfolio should include work representative of photographers talent. Reports back only if interested, send non-returnable samples. Previously published work OK. Pays $25-500 for b&w inside; $25-500 for color inside. Pays on publication. Credit line given.

Tips: "Photographer's should be aware of the trend in multi-platform publishing—print, video, internet, promotional."

$ $ POPULAR ELECTRONICS, 500 Bi-County Blvd., Farmingdale NY 11735. (516)293-3000. Fax: (516)293-3115. Editor: Konstantinos Karagiannis. Circ. 58,207. Estab. 1989. Monthly magazine. Emphasizes hobby electronics. Readers are hobbyists in electronics, amateur radio, CB, audio, TV, etc.— "Mostly male, ages 13-59." Sample copy free with 9 × 12 SAE and 90¢ postage.
Needs: Uses about 20 photos/issue; 20% supplied by freelance photographers. Photos purchased with accompanying ms only. Special needs include regional photo stories on electronics. Model/property release required. Captions preferred.
Making Contact & Terms: Send complete ms and photo package with SASE. Reports in 2 weeks. Simultaneous submissions and previously published work OK. Pays $200-350 for text/photo package. **Pays on acceptance.** Buys all rights; negotiable. Credit line given.

$ $ POPULAR PHOTOGRAPHY, 1633 Broadway, New York NY 10019. (212)767-6578. Fax: (212)767-5629. Send to: Your Best Shot/Hard Knocks. Circ. 450,000. Estab. 1937. Monthly magazine. Readers are male and female photographers, amateurs to professionals of all ages. Photo guidelines free with SASE.
Needs: Uses many photos/issue; many supplied by freelancers, mostly professionals. Uses amateur and professional photos for monthly contest feature, Your Best Shot, and Hard Knocks. Needs scenics, nature, portraits.
Making Contact & Terms: Send unsolicited photos by mail for consideration. Send prints size 8 × 12 and under, color and b&w; any size transparencies. Does not keep samples on file. SASE. Reports in 3 months. Pays prize money for contest: $300 (first), $200 (second), $100 (third) and honorable mention. **Pays on acceptance.** Buys one-time rights. Credit line given.

N $ $ $ POPULAR SCIENCE MAGAZINE, Times Mirror Magazines, Two Park Ave., 9th FloorNew York NY 10016. (212)779-5345. Fax: (212)481-8062. E-mail: carnett@popsci.com. Website: http://www.popsci.com. Picture Editor: John B. Carnett. Circ. 1.55 million. Estab. 1872. World's largest monthly science and technology magazine.
Needs: Buys 4 photos from freelancers per issue; 48 photos per year. Needs photos of disasters, environmental, landscapes/scenics, adventure, automobiles, hobbies, travel, agriculture, buildings, computers, industry, medicine, military, portraits, product shots/still life, science, technology. Interested in alternative process, digital, documentary. Reviews photos with or without ms. Photo captions preferred.
Specs: Uses 8 × 10, glossy prints; 35mm, 2¼ × 2¼, 4 × 5, 8 × 10 transparencies. Accepts images in digital format for Mac. Send via Zip as TIFF, EPS, JPEG files at 300 dpi.
Making Contact & Terms: Send query letter with tearsheets. Provide self-promotion piece to be kept on file for possible future assignments. Reports back only if interested, send nonreturnable samples. Simultaneous submissions OK. Pays $1,000-1,300 for b&w or color cover; $150-1,200 for b&w or color inside. Day rate is $650 plus expenses. **Pays on acceptance.** Credit line given. Buys one-time rights.
Tips: "Understand our style; read the magazine on a regular basis." Submissions should be "neat and clean."

$ PRESBYTERIAN RECORD, 50 Wynford Dr., Toronto, Ontario M3C 1J7 Canada. (416)441-1111. Fax: (416)441-2825. E-mail: pcrecord@presbyterian.ca. Website: http://www.presbycan.ca/record. Editor: Rev. John Congram. Circ. 55,000. Estab. 1875. Monthly magazine. Emphasizes subjects related to The Presbyterian Church in Canada, ecumenical themes and theological perspectives for church-oriented family audience. Photos purchased with or without accompanying ms. Free sample copy and photo guidelines with 9 × 12 SAE and $1 Canadian postage minimum or International Reply Coupons.
Needs: Religious themes related to features published. No formal poses, food, nude studies, alcoholic beverages, church buildings, empty churches or sports. Captions preferred.
Specs: Uses 8 × 10, 4 × 5 glossy b&w or color prints and 35mm and 2¼ × 2¼ color transparencies. Usually uses 35mm color transparency for cover or ideally, 8 × 10 transparency. Vertical format used on cover.
Making Contact & Terms: Send photos. SAE, IRCs for return of work. Reports in 1 month. Simultaneous submissions and/or previously published work OK. Pays $15-35/b&w print; $60 minimum/cover; $30-60 for text/photo package. Pays on publication. Buys one-time rights; negotiable. Credit line given.
Tips: "Unusual photographs related to subject needs are welcome."

N PREVENTION MAGAZINE, 33 E. Minor St., Emmaus PA 18098. (215)967-5171. Art Director: Ken Palumbo. Circ. 3 million. Monthly magazine. Emphasizes health. Readers are mostly female, 35-50, upscale.

Needs: Uses 20-25 photos/issue; 75% on assignment, 25% from stock, but seeing trend toward "more assignment work than usual." Photo needs very specific to editorial, health, beauty, food. Model release required.

Making Contact & Terms: Provide résumé, business card, brochure, flier or tearsheets to be kept on file for possible future assignments; tearsheets and/or dupes very important. Cannot return unsolicited material. Reports in 1 month. Pays per assignment. Buys one-time rights. Credit line given.

Tips: Prefers to see ability to do one thing very well. "Good lighting technique is a must." Wants to see "something different, taking an unusual twist to an ordinary subject."

PRIMAVERA, Box 37-7547, Chicago IL 60637. (773)324-5920. Co-Editor: Ruth Young. Annual magazine. "We publish original fiction, poetry, drawings, paintings and photographs that deal with women's experiences." Sample copy $5. Photo guidelines free with SASE.

Needs: Uses 2-12 photos/issue; all supplied by freelancers.

Specs: Uses b&w prints.

Making Contact & Terms: Send unsolicited photos or photocopies by mail for consideration. SASE. Reports in 1 month. Pays on publication 2 copies of volume in which art appears. Buys one-time rights. Credit line given.

$ PRIME TIME SPORTS & FITNESS, Dept. PM, P.O. Box 6097, Evanston IL 60204. Fax: (847)864-1206. E-mail: rallyden@prodigy.net. Editor: Dennis Dorner. Magazine publishes 8 times/year. Emphasizes sports, recreation and fitness; baseball/softball, weight lifting and bodybuilding, etc. Readers are professional males (50%) and females (50%), 19-45. Photo guidelines on request.

Needs: Uses about 70 photos/issue; 60 supplied by freelancers. Needs photos concerning women's fitness and fashion, swimwear and aerobic routines. Special photo needs include women's workout and swimwear photos. Upcoming short-term needs: summer swimwear, women's aerobic wear, portraits of women in sports. "Don't send any photos that would be termed photobank access." Model/property release required. Captions preferred; include names, the situation and locations.

Specs: Accepts images in digital format for Windows via compact disc.

Making Contact & Terms: Send unsolicited photos by mail for consideration. Submit portfolio for review. "Contact us by fax, phone or mail and we will set appointment." SASE. Reports in 2 months. Simultaneous submissions and previously published work OK. Pays $200/color and b&w cover; $20/color and b&w inside; $20/color page rate; $50/b&w page rate; $30-60/hour. Time of payment negotiable. Buys all rights; negotiable. Credit line given. Offers internships for photographers during the summer. Contact Editor.

Tips: Wants to see "tight shots of personalities, people, sports in action, but only tight close-ups." There are a "plethora of amateur photographers who have trouble providing quality action or fashion shots and yet call themselves professionals. Photographers can best present themselves by letting me see their work in our related fields (both published and unpublished) by sending us samples. Do not drop by or phone, it will not help."

$ ▣ ◯ PRIME TIMES, Members Magazine of NARCUP, Inc., 634 W. Main St., Suite 207, Madison WI 53703-2662. (608)257-4640. Fax: (608)257-4670. E-mail: grotepub@mailbag.com. Art Director: Gary Cox. Circ. 80,000. Estab. 1979. Bimonthly publication sent to members of National Association for Retired Credit Union People (NARCUP, Inc.) containing financial and consumer related information. Magazine contains information related or directed to the over 50 age group. Sample copy for $3.75 and 9×12 SAE with 4 first-class stamps.

Needs: Buys 10-15 photos from freelancers/issue; 50-60 photos/year. Needs photos of national and international travel and seniors in daily activities alone and with families. Reviews photos with or without ms. Model release required for senior citizens in activities. Photo captions preferred.

Specs: Uses 35mm, 2¼×2¼, 4×5 transparencies. Accepts images in digital format. Mac platform— Photoshop 3.0, TIFFs.

Making Contact & Terms: Send query letter with samples, stock photo list. Provide résumé, business card, self-promotion piece of tearsheets to be kept on file for possible future assignments. Art director will contact photographer for portfolio review if interested. Portfolio should include slides or transparencies. Include SASE for return of material. Reports in 1-2 months on queries. Previously published work OK. Reports back only if interested, send non-returnable samples. Pays on publication. Buys one-time rights. Credit line given.

Tips: "We need great color and 'in focus' images! Send business card for my rolodex file."

Ⓝ $ $ $ PRINCETON ALUMNI WEEKLY, 194 Nassau St., Princeton NJ 08542. (609)258-4722. E-mail: wszola@princeton.ed. Editor-in-Chief: J.I. Merritt. Art Director: Stacy Wszola. Circ. 58,000. Bi-

weekly. Emphasizes Princeton University and higher education. Readers are alumni, faculty, students, staff and friends of Princeton University. Sample copy $1.50 with 9 × 12 SAE and 2 first-class stamps.

Needs: Uses about 15 photos/issue (not including class notes section); 10 supplied by freelance photographers. Needs b&w photos of "people, campus scenes; subjects vary greatly with content of each issue. Show us photos of Princeton." Captions required.

Making Contact & Terms: Arrange a personal interview to show portfolio. Provide brochure to be kept on file for possible future assignments. SASE. Reports in 1 month. Simultaneous submissions and previously published work OK. Pays $60-100/hour; $300-1,000/day; $50-450/color photo; $40-300/b&w photo. Pays on publication. Buys one-time rights.

$ $ THE PROGRESSIVE, 409 E. Main St., Madison WI 53703. Art Director: Patrick JB Flynn. Circ. 40,000. Estab. 1909. Monthly political magazine. "Grassroots publication from a left perspective, interested in foreign and domestic issues of peace and social justice." Free sample copy and photo guidelines upon request.

Needs: Uses 12 or more b&w photos/issue; generally supplied by freelance photographers. Looking for images documenting the human condition and the social/political environments of contemporary society. Special photo needs include "Third World countries, labor activities, environmental issues and political movements." Captions (name, place, date) and credit information required.

Making Contact & Terms: Query with photocopies and stock photo list to be kept on file for possible future assignments. Art director will contact photographer for portfolio review if interested. SASE. Reports once every month. Simultaneous submissions and previously published work OK. Pays $300/color and b&w cover photo; $50-150/b&w inside photo. Pays on publication. Buys one-time rights. Credit line given. All material returned.

Tips: "Interested in the aesthetics of imaging, photo essays and images that stand alone as visual statements."

$ $ PSYCHOLOGY TODAY, Sussex Publishers, 49 E. 21st St., 11th Floor, New York NY 10010. (212)260-3214, ext. 117. Fax: (212)260-7445. Photo Editor: Katrin Bodyikoglu. Estab. 1992. Bimonthly magazine. Readers are male and female, highly educated, active professionals. Photo guidelines free with SASE.

● Sussex also publishes *Mother Earth News* listed in this section.

Needs: Uses 19-25 photos/issue; supplied by freelancers and stock agencies. Needs photos of humor, photo montage, symbolic, environmental, portraits, conceptual. Model/property release preferred.

Making Contact & Terms: Submit portfolio for review. Send promo card and stock list. Also accepts Mac files but prefers photographic images. Keeps samples on file. Cannot return material. Reports back only if interested. Payment for assignments negotiable; for stock, pays $100/¼ page; $300/full page.

$ ▣ Q SAN FRANCISCO MAGAZINE, 584 Castro St., Suite 521, San Francisco CA 94114. (415)764-0324. Fax: (415)626-5744. E-mail: qsf1@aol.com. Website: http://www.qsanfrancisco.com. Editor: Robert Adams. Circ. 47,000. Estab. 1995. Bimonthly magazine. Emphasizes city, entertainment, travel. Readers are 75% gay male, 20% lesbian, 5% straight males and females. Sample copy free with 9 × 12 SAE and $1.93 postage.

Needs: Uses 20 photos/issue; 10 supplied by freelancers. Needs photos of travel, personalities. Model release required. Property release preferred. Captions required; include name, place, date.

Specs: Accepts images in digital format for Mac. Send via Zip disk or floppy disk at size 100%, resolution 300 dpi.

Making Contact & Terms: Provide resume, business card, brochure, flier or tearsheets to be kept on file for possible assignments. Arrange personal interview to show portfolio. Reports in 6-8 weeks. Pays $50-200/job; $100-200/color or b&w cover; $50-150/color inside; $50-100/b&w inside; $50-150/color or b&w page. Pays on publication. Rights negotiable. Credit line given.

$ RACQUETBALL MAGAZINE, 1685 W. Uintah, Colorado Springs CO 80904-2921. (719)635-5396. Fax: (719)635-0685. E-mail: rbzine@webaccess.net. Website: http://www.racqmag.com. Production Manager: Kevin Vicroy. Circ. 45,000. Estab. 1990. Publication of the United States Racquetball Association. Bimonthly magazine. Emphasizes racquetball. Sample copy $4. Photo guidelines available.

THE GEOGRAPHIC INDEX, located in the back of this book, lists markets by the state in which they are located.

Needs: Uses 20-40 photos/issue; 20-40% supplied by freelancers. Needs photos of action racquetball. Model/property release preferred. Captions required.

Making Contact & Terms: Provide résumé, business card, brochure, flier or tearsheets to be kept on file for possible assignments. Keeps samples on file. SASE. Reports in 1 month. Previously published work OK. Pays $200/color cover; $25-75/color inside; $3-5/b&w inside. Pays on publication. Buys all rights; negotiable. Credit line given.

$ $ RADIANCE, The Magazine for Large Women, P.O. Box 30246, Oakland CA 94604. Phone/fax: (510)482-0680. Website: http://www.radiancemagazine.com. Publisher/Editor: Alice Ansfield. Circ. 15,000. Estab. 1984. Quarterly magazine. "We're a positive/self-esteem magazine for women all sizes of large. We have diverse readership, 90% women, ages 25-70 from all ethnic groups, lifestyles and interests. We focus on body acceptance. We encourage and support women in living proud, full, active lives, now, with self-love and self-respect." Sample copy $3.50. Writer's guidelines free with SASE. Photo guidelines not available.

Needs: Uses 20 photos/issue; all supplied by freelance photographers. Needs portraits, cover shots, fashion photos. Model release preferred. Captions preferred.

Making Contact & Terms: Send unsolicited photos by mail for consideration. Provide résumé, business card, brochure, flier or tearsheets to be kept on file for possible assignments. SASE. Reports in 4 months. Simultaneous submissions OK. Pays $50-200/color cover; $15-25/b&w inside; $8-20/hour; $400/day. Pays on publication. Buys one-time rights. Credit line given.

Tips: In photographer's portfolio or samples wants to see "clear, crisp photos, creativity, setting, etc." Recommends freelancers "get to know the magazine. Work with the publisher (or photo editor) and get to know her requirements. Try to help the magazine with its goals."

⬤ RAG MAG, Box 12, Goodhue MN 55027. (651)923-4590. Editor: Beverly Voldseth. Circ. 300. Estab. 1982. Magazine. Emphasizes poetry and fiction, but is open to good writing in any genre. Sample copy $6 with 6¼×9¼ SAE and 4 first-class stamps.

Needs: Uses 3-4 photos/issue; all supplied by freelancers. Needs photos that work well in a literary magazine; faces, bodies, stones, trees, water, multicultural, architecture, fine art, etc. Reviews photos without a manuscript. Uses photos on covers.

Specs: Prefers 6×9 vertical shots.

Making Contact & Terms: Send up to 6 unsolicited photocopies of photos by mail for consideration; include name on back of copies with brief bio. Always supply your name and address and add an image title or number on each photo for easy reference. Do not send originals. Does not keep samples on file. SASE. Reports in 2 weeks-2 months. Simultaneous submissions and previously published work OK. Pays in copies. Pays on publication. Buys one-time rights.

Tips: "I do not want anything abusive, sadistic or violent."

$ RAILNEWS MAGAZINE, P.O. Box 379, Waukesha WI 53187. (414)542-4900. Fax: (414)542-7595. E-mail: pentrex@execpc.com. Editor: John Gruber. Circ. 28,000. Estab. 1968. Monthly magazine. Emphasizes modern railroading. Readers are mostly male, well-educated, ages 25-60. Photo guidelines free with SASE.

Needs: Uses 15-20 photos/issue; all supplied by freelancers. Needs photos of all aspects of contemporary railroading—freight, passengers, commuters. Reviews photos with or without ms. Model/property release preferred for any recognizable person in the photo. Captions required; include name of train, direction of travel, date, location.

Making Contact & Terms: Send unsolicited photos by mail for consideration. Send 5×7 glossy b&w prints; 35mm, 2¼×2¼ transparencies. Does not keep samples on file. SASE. Reports in 1-6 months. Pays $100/color cover; $15-75/color and b&w inside. Pays on publication. Credit line given. Buys one-time rights.

Tips: "Railnews covers all aspects of railroading today—hobby, operational, industry, breaking news. We feel this magazine is a good way for unknown photographers to see their work in print and get their name before the public."

$ $ $ ▢ ◪ ◎ RANGER RICK AND YOUR BIG BACKYARD, 8925 Leesburg Pike, Vienna VA 22184-0001. (703)790-4525. Fax: (703)790-4035. E-mail: carr@nwf.org. Website: http://www.nwf.org/rrick. Photo Editor: Page Carr. Monthly educational magazines published by the National Wildlife Federation. *Ranger Rick* for children age 7 and up. Circ. 610,000. Estab. 1967. *Your Big Backyard* for children age 3-6. Circ. 450,000.

Needs: Both magazines publish only the highest possible quality photographs. Needs photos of wild animals of every kind and other subjects related to natural sciences and the environment, with an emphasis

on their appeal to children. Subjects are varied and can include anything that is visually exciting, humorous, unusual, or of scientific interest to kids. Also publishes photo stories about real kids involved with conservation, their environment, the outdoors, science, and wildlife, ethnic diversity preferred. *Ranger Rick* uses 90% stock, assigns 10%. *Your Big Backyard* needs the same kind of material, but in a simpler more direct style to appeal to very young children (e.g. portraits of baby animals); uses 100% stock.

Specs: Accepts images in digital format for Mac. Send via CD, SyQuest, Zip as TIFF, JPEG files.

Making Contact & Terms: Send SASE for guidelines, non-returnable printed samples or website addresses are also welcome. Pays $600-1,000 for color cover; $200-750 for color inside. *Ranger Rick* space rates: $300 (quarter page) to $1,000 (cover); *Your Big Backyard*: $200-600. Pays 3 months before publication.

Tips: "Production standards are extremely high for both magazines, and photography is by leading professionals. Fresh, creative approaches and unusual subjects are always welcome, but technical quality must be exceptional. Production lead time is long and originals may be held for months. Accurate scientific identification of wildlife is appreciated. Get organized, request guidelines, send samples we can keep (e.g. color photcopies/laser prints). Better yet, show your work on a website."

$ S ▣ ◻ REAL PEOPLE, 450 Fashion Ave., Suite 1701, New York NY 10123-1799. (212)244-2351. Fax: (212)244-2367. Editor: Alex Polner. Circ. 100,000. Estab. 1988. Bimonthly magazine. Emphasizes celebrities. Readers are women 35 and up. Sample copy $4 with 6×9 SAE.

Needs: Uses 30-40 photo/issue; 10% supplied by freelancers. Needs celebrity photos. Reviews photos with accompanying ms. Model release preferred where applicable. Photo captions preferred.

Specs: Accepts images in digital format for Mac. Send via compact disc, floppy disk, SyQuest, Zip disk as EPS, TIFF, JPEG files (high).

Making Contact & Terms: Query with résumé of credits and/or list of stock photo subjects. Provide résumé, business card, brochure, flier or tearsheets to be kept on file for possible assignments. Send samples or tearsheets, perhaps even an idea for a photo essay as it relates to entertainment field. SASE. Reports only when interested. Pays $100-200/day. Pays on publication. Buys one-time rights. Credit line given.

N $ ▣ ◿ RECREATIONAL HAIR NEWS, 138 West, Burke VT 05871. E-mail: bfitzgerald@uppercuts.com. Editor: Bob Fitzgerald. Circ. 2,000. Monthly newsletter. Emphasizes "unusual, radical, bizarre hairstyles and fashions, such as a shaved head for women, waist-length hair or extreme transformations from very long to very short." Sample copy $3. Photo guidelines free with SASE.

Needs: Celebrity/personality, documentary, fashion/beauty, glamour, head shots, nudes, photo essay/photo feature, spot news, travel, fine art, special effects/experimental, avant garde, documentary, erotic, glamour, historical/vintage, how-to and human interest "directly related to hairstyles and innovative fashions. We are also looking for old photos showing hairstyles of earlier decades—the older the better. If it's not related to hairstyles in the broadest sense, we're not interested." Model release preferred. Captions preferred.

Specs: Uses 5×7, 8×10 color and b&w prints; 35mm transparencies; and "accompanying manuscripts that are interviews/profiles of individuals with radical or unusual haircuts." Vertical format preferred. Accepts images in digital format for Windows. Send via floppy disk, e-mail as GIF, JPEG files.

Making Contact & Terms: Send material by mail for consideration. Include samples of work and description of experience. SASE. Reports in 3 weeks. Simultaneous submissions and previously published work OK. Pays: $10-100/b&w or color photo; $50 minimum/job; $50 minimum/manuscript. Buys one-time and all rights. Credit line given.

Tips: "The difficulty in our publication is finding the subject matter, which is unusual and fairly rare. Anyone who can overcome that hurdle has an excellent chance of selling to us."

N $ $ $ RECREATIONAL ICE SKATING, 17120 N. Dallas Pkwy., Suite 140, Dallas TX 75248. (972)735-8800. Fax: (972)735-8815. E-mail: isi@skateisi.com. Publications Coordinator: Erin McCabe. Estab. 1976. A publication of Ice Skating Institute. Quarterly magazine. Emphasizes figure skating, hockey and speedskating—recreational aspects of these sports. Readers are male and female skating enthusiasts—all professions; ages 6-80. Sample copy free with 9×12 SASE and 3 first-class stamps.

Needs: Uses 50 photos/issue; 68% supplied by freelancers. Needs photos of travel (ISIA event venues); art with stories—skating, hockey. Model/property release required for skaters, bystanders, organization property (i.e. Disney World, etc.) and any photo not directly associated with story content. Captions preferred; include name(s) of person/people locations, ages of people—where they are from, skate, etc.

Making Contact & Terms: Query with stock photo list. Provide résumé, business card, brochure, flier or tearsheets to be kept on file for possible assignments. Keeps samples on file. Deadlines: July 1, October 1, January 1, April 1. SASE. Reports in 1 month. Previously published work OK. Pays $25-50/hour; $100-200/day; $100-1,000/job; pays $10-35/color cover; $10-15/b&w inside; $15-35/color page rate; $10-35/photo/text package. Pays on publication. Buys one-time rights and all rights; negotiable. Credit line given.

Tips: "Show an ability to produce lean action photos within indoor rinks that have poor lighting conditions."

REFORM JUDAISM, 633 Third Ave., 6th Floor, New York NY 10017-6778. (212)650-4240. Managing Editor: Joy Weinberg. Circ. 305,000. Estab. 1972. Publication of the Union of American Hebrew Congregations. Quarterly magazine. Emphasizes Reform Judaism. Readers are members of Reform congregations in North America. Sample copy $3.50.
Needs: Uses 35 photos/issue; 10% supplied by freelancers. Needs photos relating to Jewish life or Jewish issues, Israel, politics. Captions required.
Making Contact & Terms: Provide résumé, business card, brochure, flier or tearsheets to be kept on file for possible assignments. Reports in 1 month. Simultaneous submissions and/or previously published work OK. Pays on publication. Buys one-time rights; first North American serial rights. Credit line given.
Tips: Wants to see "excellent photography: artistic, creative, evocative pictures that involve the reader."

$ ■ ◘ REMINISCE, 5400 S. 60th St., Greendale WI 53129. (414)423-0100. Fax: (414)423-8463. Website: http://www.reimanpub.com. Photo Coordinator: Trudi Bellin. Estab. 1990. Bimonthly magazine. "For people who love reliving the good times." Readers are male and female, interested in nostalgia, ages 55 and over. "*Reminisce* is supported entirely by subscriptions and accepts no outside advertising." Sample copy $2. Photo guidelines free with SASE.
Needs: Uses 125 photos/issue; 25% supplied by freelancers. Needs photos with people interest—"we need high-quality color shots of memorabilia, as well as good quality b&w vintage photography. Also needs photos of senior citizens, landscapes/scenics, gardening, rural, travel, agriculture." Model/property release required. Captions preferred; season, location.
Specs: Uses color and b&w transparencies, all sizes and vintage color or b&w prints.
Making Contact & Terms: Query with list of stock photo subjects. Send unsolicited photos by mail for consideration. Submit seasonally. Tearsheets filed but not dupes. SASE. Reports within 3 months. Previously published work OK. Pays $100/color cover; $100/b&w cover; $75-150/color inside; $150/color page (full page bleed); $50-100/b&w photo. Pays on publication. Buys one-time rights. Credit line given.
Tips: "We are continually in need of authentic color taken in the '40s, '50s and '60s and b&w stock photos. Technical quality is extremely important; focus must be sharp, no soft focus; we can work with faded color on vintage photos. Study our magazine thoroughly—we have a continuing need for vintage color and b&w images, and those who can supply what we need can expect to be regular contributors. Don't call."

$ $ RIFLE & SHOTGUN SPORT SHOOTING, 5300 CityPlex Tower, 2448 E. 81st St., Tulsa OK 74137-4207. (918)491-6100. Fax: (918)491-9424. Executive Editor: Mark Chesnut. Circ. 115,000. Estab. 1994. Published 4 times/year. Emphasizes shooting sports, including hunting. Readers are primarily male over 35. Sample copy $2.50. Photo guidelines free with SASE.
Needs: Uses 40-50 photos/issue; all supplied by freelancers. Needs photos of various action shots of shooting sports. Special photo needs include skeet, trap, sporting clays, rifle shooting and hunting shots for inside use. Model/property release preferred. Captions preferred.
Specs: Uses 35mm, 2¼×2¼ transparencies.
Making Contact & Terms: Send unsolicited photos by mail for consideration. Keeps samples on file. SASE. Reports in 3 weeks. Pays $400-600/color cover; $75-200/color inside; $300-450/photo/text package. **Pays on acceptance.** Buys first North American serial rights. Credit line given.

$ THE ROANOKER, P.O. Box 21535, Roanoke VA 24018. (540)989-6138. Fax: (540)989-7603. Editor: Kurt Rheinheimer. Circ. 14,000. Estab. 1974. Bimonthly. Emphasizes Roanoke and western Virginia. Readers are upper income, educated people interested in their community. Sample copy $3.
Needs: Uses about 40 photos/issue; most are supplied on assignment by freelance photographers. Needs "travel and scenic photos in western Virginia; color photo essays on life in western Virginia." Model/property releases preferred. Captions required.
Making Contact & Terms: Send any size glossy b&w or color prints and transparencies (preferred) by mail for consideration. SASE. Reports in 1 month. Simultaneous submissions and previously published work OK. Pays $15-25/b&w photo; $20-35/color photo; $100/day. Pays on publication. Rights purchased vary; negotiable. Credit line given.

$ $ ◘ ROCK & ICE, P.O. Box 3595, Boulder CO 80307. (303)499-8410. E-mail: photo@rockandice. com. Website: http://www.rockandice.com. Photo Editor: Galen Nathanson. Circ. 50,000. Estab. 1984. Bimonthly magazine. Emphasizes rock and ice climbing and mountaineering. Readers are predominantly professional, ages 10-90. Sample copy for $6.50. Photo guidelines free with SASE.

● Photos in this publication usually are outstanding action shots. Make sure your work meets the magazine's standards. Do not limit yourself to climbing shots from the U.S.

Needs: Uses 90 photos/issue; all supplied by freelance photographers; 20% on assignment, 80% from stock. Needs photos of climbing action, personalities and scenics. Buys photos with or without ms. Captions required.

Specs: Uses b&w prints; 35mm, 2¼×2¼ and 4×5 transparencies.

Making Contact & Terms: Query with list of stock photo subjects. Send unsolicited photos by mail for consideration. SASE. Previously published work OK. Pays $600/cover; $50-350/color and b&w inside; $25/Website image. Pays on publication. Buys one-time rights and first North American serial rights. Credit line given.

Tips: "Samples must show some aspect of technical rock climbing, ice climbing, mountain climbing or indoor climbing, scenics of places to climb or images of people who climb or who are indigenous to the climbing area. Climbing is one of North America's fastest growing sports."

ROCKFORD REVIEW, P.O. Box 858, Rockford IL 61105. Editor: David Ross. Association publication of Rockford Writers' Guild. Triquarterly magazine. Circ. 750. Estab. 1982. Emphasizes poetry and prose of all types. Readers are of all stages and ages who share an interest in quality writing and art. Sample copy $5.

● This publication is literary in nature and publishes very few photographs. However, the photos on the cover tend to be experimental (e.g. solarized images, photograms, etc.).

Needs: Uses 1-5 photos/issue; all supplied by freelancers. Needs photos of scenics and personalities. Model/property release preferred. Captions preferred; include when and where of the photos and biography.

Specs: Uses 8×10 or 5×7 glossy b&w prints.

Making Contact & Terms: Send unsolicited photos by mail for consideration. Does not keep samples on file. SASE. Reports in 6 weeks. Simultaneous submissions OK. Pays in one copy of magazine, but work is eligible for *Review*'s $25 Editor's Choice prize. Pays on publication. Buys first North American serial rights. Credit line given.

Tips: "Experimental work with a literary magazine in mind will be carefully considered. Avoid the 'news' approach."

ROLLING STONE, Dept. PM, 1290 Avenue of the Americas, New York NY 10104. (212)484-1616. Photo Editor: Racheal Knepfer. Emphasizes all forms of entertainment (music, movies, politics, news events).

Making Contact & Terms: "All our photographers are freelance." Provide brochure, calling card, flier, samples and tearsheet to be kept on file for future assignments. Needs famous personalities and rock groups in b&w and color. No editorial repertoire. SASE. Reports immediately.

Tips: "Drop off portfolio at mail room any Wednesday between 10 am and 3 pm. Pick up Thursday between 11 am and 3 pm. Leave a card with sample of work to keep on file so we'll have it to remember."

THE ROTARIAN, 1560 Sherman Ave., Evanston IL 60201. (847)866-3000. Fax: (847)866-9732. E-mail: 75457.3577@compuserve.com. Website: http://www.rotary.org. Editor-in-Chief: Willmon L. White. Editor: Charles W. Pratt. Circ. 514,565. Estab. 1911. Monthly organization magazine for Rotarian business and professional men and women and their families. "Dedicated to business and professional ethics, community life and international understanding and goodwill." Free sample copy and photo guidelines with SASE.

Needs: Buys 5 photos from freelancers per issue; 60 photos per year. "Our greatest needs are for the identifying face or landscape, one that says unmistakably, 'This is Japan, or Minnesota, or Brazil, or France or Sierra Leone,' or any of the other states, countries and geographic regions this magazine reaches and we need lively shots of people." Property release and captions preferred.

Specs: Uses b&w and color; 35mm, 2¼×2¼, 4×5.

Making Contact & Terms: Query with résumé of credits, stock photo list, or send photos for consideration. Art director will contact photographer for portfolio review if interested. Portfolio should include color slides, tearsheets and transparencies. Keeps samples on file. SASE. Reports in 3 weeks. Simultaneous submissions and previously published work OK. **Pays on acceptance.** Payment negotiable. Buys one-time rights; occasionally all rights; negotiable. Credit line given.

Tips: "We prefer vertical shots in most cases. The key words for the freelance photographer to keep in mind are *internationality* and *variety*. Study the magazine. Read the kinds of articles we publish. Think how your photographs could illustrate such articles in a dramatic, story-telling way. Key submissions to general interest, art-of-living material."

$ [A] ◯ RUGBY MAGAZINE, 2350 Broadway, New York NY 10024. (212)787-1160. Fax: (212)595-0934. E-mail: rugbymag@aol.com. Publisher: Ed Hagerty. Circ. 10,000. Estab. 1975. Monthly tabloid. Emphasizes rugby matches. Readers are male and female, wealthy, well-educated, ages 23-60. Sample copy $4 with $1.25 postage.

Needs: Uses 20 photos/issue mostly supplied by freelancers. Needs rugby action shots. Reviews photos purchased with accompanying ms only.

Specs: Uses 3×5 color and b&w prints; 2¼×2¼ transparencies.

Making Contact & Terms: Send unsolicited photos by mail for consideration. Provide résumé, business card, brochure, flier or tearsheets to be kept on file for possible assignments. Keeps samples on file. SASE. Reports in 1-2 weeks. Simultaneous submissions and previously published work OK. "We only pay when we assign a photographer. Rates are very low, but our magazine is a good place to get some exposure." Pays on publication. Buys one-time rights. Credit line given.

■ RUNNER'S WORLD, 135 N. Sixth St., Emmaus PA 18098. (610)967-8917. Fax: (610)967-7725. E-mail: lreap1@rodalepress.com. Executive Editor: Amby Burfoot. Photo Editor: Liz Reap. Circ. 455,000. Monthly magazine. Emphasizes running. Readers are median aged: 37, 65% male, median income $40,000, college-educated. Photo guidelines free with SASE.

Needs: Uses 100 photos/issue; 25% freelance, 75% assigned; features are generally assigned. Needs photos of action, features, photojournalism. Model release and captions preferred.

Specs: Accepts images in digital format for Mac.

Making Contact & Terms: Query with samples. Contact photo editor before sending portfolio or submissions. Simultaneous submissions and previously published work OK. Pays as follows: color—$350/full page, $250/half page, $210/quarter page, $600/full page spread. Cover shots are assigned. Pays on publication. Credit line given.

Tips: "Become familiar with the publication and send photos in on spec. Also send samples that can be kept in our source file. Show full range of expertise; lighting abilities—quality of light—whether strobe sensitivity for people—portraits, sports, etc.. Both action and studio work if applicable, should be shown." Current trend is non-traditional treatment of sports coverage and portraits. Call prior to submitting work. Be familiar with running, as well as the magazine."

$ ■ RURAL HERITAGE, 281 Dean Ridge Lane, Gainesboro TN 38562-5039. (931)268-0655. E-mail: editor@ruralheritage.com. Website: http://www.ruralheritage.com. Editor: Gail Damerow. Circ. 4,000. Estab. 1976. Bimonthly magazine in support of modern day farming and logging with draft animals (horses, mules, oxen). Sample copy $6 ($6.50 outside the U.S.).

Needs: "Most of the photos we purchase illustrate stories or poems. Exceptions are front cover, where we use draft animals in harness."

Specs: "For covers we prefer color horizontal shots, 5×7 glossy (color or 35mm slide). Interior is b&w. Accepts images in digital format for Mac (TIFF, EPS). Send via compact disc, floppy disk, Zip (1200 line art, 300 half tones). "Do not submit photo files via e-mail please."

Making Contact & Terms: Query with samples. "Please include SASE for the return of your material, and put your name and address on the back of each piece." Pays $10/photo to illustrate a story or poem; $15/photo for captioned humor; $75/front cover. Also provides 2 copies of issue in which work appears. Pays on publication.

Tips: "Animals usually look better from the side than from the front. We like to see all the animal's body parts, including hooves, ears and tail. For animals in harness, we want to see the entire implement or vehicle. We prefer action shots (plowing, harvesting hay, etc.). Look for good contrast that will print well in black and white (for interior shots); watch out for shadows across animals and people. Please include the name of any human handlers involved, the farm, the town (or county), state, and the animal's names (if any) and breeds."

$ ■ RUSSIAN LIFE MAGAZINE, 89 Main St., #2, Montpelier VT 05602. (802)223-4955. (802)223-6105. E-mail: ruslife@rispubs.com. Executive Editor: Mikhail Ivanov. Estab. 1956. Bimonthly magazine.

Needs: Uses 25-35 photos/issue. Offers 10-15 freelance assignments annually. Needs photojournalism related to Russian culture, art and history. Model/property release preferred.

Making Contact & Terms: Works with local freelancers only. Query with samples. Send 35mm, 2¼×2¼, 4×5, 8×10 transparencies; 35mm film; Kodak CD digital format. SASE "or material not returned." Reports in 1 month. Pays $25-100 (color photo with accompanying story), depending on placement in magazine. Pays on publication. Buys one-time and electronic rights. Credit line given.

[N] $ $ [A] SACRAMENTO MAGAZINE, Dept. PM, 4471 D St., Sacramento CA 95819. (916)452-6200. Fax: (916)452-6061. Editor: Krista Hendricks Minard. Managing Editor: Darlena Belushin. Art

Director: Debbie Hurst. Circ. 20,000. Monthly magazine. Emphasizes culture, food, outdoor recreation, home and garden and personalities for middle to upper middle class, urban-oriented Sacramento residents with emphasis on women.

Needs: Uses about 40-50 photos/issue; most supplied by freelance photographers. "Photographers are selected on the basis of experience and portfolio strength. No work assigned on speculation or before a portfolio showing. Photographers are used on an assignment only basis. Stock photos used only occasionally. Most assignments are to area photographers and handled by phone. Photographers with studios, mobile lighting and other equipment have an advantage in gaining assignments. Darkroom equipment desirable but not necessary." Needs news photos, essay, avant-garde, still life, landscape, architecture, human interest and sports. All photography must pertain to Sacramento and environs. Captions required.

Making Contact & Terms: Arrange a personal interview to show portfolio. Also query with résumé of photo credits. Will consider simultaneous submissions and previously published work, providing they are not in the northern California area. Pays $100-500/assignment. **Pays on acceptance.** Buys one-time rights. Credit line given.

SAILING, Dept. PM, 125 E. Main St., Box 249, Port Washington WI 53074. (414)284-3494. Fax: (414)284-7764. Editor: Gregory Jones. Circ. 50,000. Monthly magazine. Emphasizes sailing. Our subtitle is "the beauty of sail." Readers are experienced sailors, both racing, cruising and daysailing on all types of boats: dinghies, large and small mono and multihulls. Sample copy free with 11×15 SAE and 9 first-class stamps. Photo guidelines free with SASE.

Needs: "We are a large-format journal, with a strong emphasis on top-notch photography backed by creative, insightful writing. Roughly 50% of each issue is devoted to photographs, plus an annual photography issue. Needs photos of sailing, both long shots and on-deck. We encourage creativity; send me a sailing photograph I have not seen before."

Specs: Uses 35mm and up transparencies with captions (boat and people IDs, location, conditions, etc.). Always looking for topnotch verticals for cover and intro pictures.

Making Contact & Terms: Query with samples/portfolios. Send submissions by mail; e-mail samples or portfolios will not be considered. SASE. Reports in 1 month. Tell us of simultaneous submissions; previously published work OK "if not with other sailing publications who compete with us." Pays $50 for "postage stamps," and up from there. Pays 30 days after publication.

Tips: "You must be a sailor to get the type of work we need. Look at the magazine; read guidelines first. Exciting, clear, sharp, action-filled or evocative photos will be well-displayed in our large-format magazine. Will work with photographers to develop their career and skills; always interested in new photographers. Writer/photographers especially sought. If we need to specify transparencies, only then you might not be for us."

SAILING WORLD, 5 John Clarke Rd., Newport RI 02840. (401)845-5134. Fax: (401)848-5048. Photo Editor: Trixie Bobrovniczky. Assistant Art Director: Mike Boardman. Circ. 62,000. Estab. 1962. Monthly magazine. Emphasizes sailboat racing and performance cruising for sailors, upper income. Readers are males 35-45, females 25-35 who are interested in sailing. Sample copy $5. Photo guidelines free with SASE.

Needs: "We will send an updated photo letter listing our needs on request." Freelance photography in a given issue: 20% assignment and 80% freelance stock. Covers most sailing races.

Specs: Uses 35mm and 2¼×2¼ transparencies for covers. Vertical and square (slightly horizontal) formats.

Making Contact & Terms: Reports in 1 month. Pays $500 for cover; regular color $50-300 (varies with use). Pays on publication. Buys first N.A. serial rights. Credit line given.

Tips: "We look for photos that are unusual in composition, lighting and/or color that feature performance sailing at its most exciting. We would like to emphasize speed, skill, fun and action. Photos must be of high quality. We prefer Fuji Velvia or Kodachrome 64 film. We have a format that allows us to feature work of exceptional quality. A knowledge of sailing and experience with on-the-water photography is really a requirement. Please call with specific questions or interests. We cover current events and generally only use photos taken in the past 30-60 days."

$ $⊠ ST. MAARTEN NIGHTS, (The Island's premiere lifestyle & travel magazine), 1831 René Levesque Blvd. W., Montreal, Quebec H3H IR4 Canada. (514)931-1987. Fax: (514)931-6273. E-mail: nights@odyssee.net. Office Coordinator: Zelly Zuskin. Circ. 225,000. Estab. 1983. Yearly tourist magazine guide of where to eat, sleep, dance etc. in St. Maarten.

Needs: Buys 30 photos/year. Needs travel photos of St. Maarten, such as beaches, water, sun etc. Reviews photos with or without ms. Model release required; property release required for private homes. Photo captions required; include exact location.

Specs: Uses 4×5 matte color and b&w prints; 35mm, 2¼×2¼, 4×5, 8×10 transparencies.
Making Contact & Terms: Send query letter with tearsheets. Art director will contact photographer for portfolio review if interested. Keeps samples on file. Reports back only if interested, send non-returnable samples. Simultaneous submissions and/or previously published work OK. Pays $250-400 for color cover; $50 maximum for color inside. **Pays on acceptance.** Buys one-time rights. Credit line given.

$ $⬜◐ SALT WATER SPORTSMAN, 263 Summer St., Boston MA 02210. (617)790-5400. Fax: (617)790-5455. E-mail: editor@saltwatersportsman.com. Website: http://www.saltwatersportsman.c om. Editor: Barry Gibson. Circ. 150,000. Estab. 1939. Monthly magazine. Emphasizes all phases of salt water sport fishing for the avid beginner-to-professional salt water angler. "Number-one monthly marine sport fishing magazine in the US." Sample copy free with 9×12 SAE and 7 first-class stamps. Free photo and writer's guidelines.
Needs: Buys photos (including covers) without ms; 20-30 photos/issue with ms. Needs salt water fishing photos. "Think scenery, mood, fishing action, storytelling close-ups of anglers in action. Make it come alive—and don't bother us with the obviously posed 'dead fish and stupid fisherman' back at the dock. Wants, on a regular basis, cover shots (verticals depicting salt water fishing action)." For accompanying ms needs fact/feature articles dealing with marine sportfishing in the US, Canada, Caribbean, Central and South America. Emphasis on how-to.
Specs: Uses 35mm or 2¼×2¼ transparencies; cover transparency vertical format required. Accepts images in digital format for Mac. Send via Syquest.
Making Contact & Terms: Send material by mail for consideration or query with samples. Provide résumé and tearsheets to be kept on file for possible future assignments. Holds slides for 1 year and will pay as used. SASE. Reports in 1 month. Pay included in total purchase price with ms, or pays $50-400/ color photo; $1,000 maximum/cover; $250-up/text-photo package. **Pays on acceptance.**
Tips: "Prefers to see a selection of fishing action and mood; must be sport fishing oriented. Read the magazine! Example: no horizontal cover slides with suggestions it can be cropped, etc. Don't send Ektach-rome. We're using more 'outside' photography—that is, photos not submitted with ms package. Take lots of verticals and experiment with lighting. Most shots we get are too dark."

$◐◎ SANDLAPPER MAGAZINE, P.O. Box 1108, Lexington SC 29071. (803)359-9941. Fax: (803)359-0629. Managing Editor: Dan Harmon. Estab. 1989. Quarterly magazine. Emphasizes South Carolina topics.
Needs: Uses about 5 photographers/issue. Needs photos of South Carolina subjects. Model release preferred. Captions required; include places and people.
Specs: Uses 8×10 color and b&w prints; 35mm, 2¼×2¼, 4×5, 8×10 transparencies.
Making Contact & Terms: Query with samples. Keeps samples on file. SASE. Reports in 1 month. Pays $25-100/color inside; $25-75/b&w inside. Pays on publication. Buys first rights plus right to reprint. Credit line given.
Tips: Looking for any South Carolina topic—scenics, people, action, mood, etc.

$ $⬜ SCHOLASTIC MAGAZINES, 555 Broadway, New York NY 10012. (212)343-6172. Fax: (212)343-6185. Director of Photography: Susan Vermazen. Estab. 1920. Publication of magazine varies from weekly to monthly. "We publish 22 titles per year on topics from current events, science, math, fine art, literature and social studies. Interested in featuring high-quality well-composed images of students of all ages and all ethnic backgrounds." Sample copy free with 9×12 SAE with 3 first-class stamps.
Needs: Uses 15 photos/issue. Needs photos of various subjects depending upon educational topics planned for academic year. Model release preferred. Captions required. Images must be interesting, bright and lively!
Specs: Accepts digital images for Mac (compact disc, online, SyQuest).
Making Contact & Terms: Query with résumé, business card, brochure, flier or tearsheets to be kept on file for possible assignments. Material cannot be returned. Previously published work OK. Pays $400/

FOR EXPLANATIONS OF THESE SYMBOLS,
SEE THE INSIDE FRONT AND BACK COVERS OF THIS BOOK.

color cover; $100/b&w inside (¼ page); $125/color inside (¼ page). Pays 25% additional for electronic usage. Pays on publication. Buys one-time rights.

SCHOOL MATES, 3054 NYS Rt. 9W, New Windsor NY 12553. (914)562-8350, ext. 152. Fax: (914)236-4852. E-mail: schoolmate-uscf@juno.com. Website: http://www.uschess.org. Publication Director: Jay Hastings. Publication of the US Chess Federation. Bimonthly magazine. Emphasizes chess. Readers are male/female, ages 7-15. Sample copy free with 9×12 SAE and 2 first-class stamps.
Needs: Buys 5-30 photos/issue; most supplied by freelancers. Needs photos of children playing chess. Photo captions preferred; IDs on photos required.
Specs: Uses color or b&w prints. Accepts images in digital format for Windows. Send via compact disc, Zip disk or floppy disk at 600 dpi.
Making Contact & Terms: Send xerox samples of kids and chess. Provide résumé, business card, brochure, flier or tearsheets to be kept on file for possible future assignments. Keeps samples on file. SASE. Reports in 1 month. Pays $15 minimum for b&w or color inside photo. Pays $100-150/color cover. Pays on publication. Rights negotiable. Credit line given.

$ 🔘 ◎ **SCORE**, 4931 SW 75th Ave., Miami FL 33155. (305)662-5959. Fax: (305)662-5952. E-mail: score@scoregroup.com. Website: http://www.scoreland.com. Editor: Michael T. Uwate. Circ. 225,000. Estab. 1992. Published 13 times a year. Emphasizes large-busted models. Readers are males between 18-50 years of age.
Needs: Uses 150 photos/issue; 100% supplied by freelancers. Model release required; photo identification (such as a driver's license) is also required and/or copy of model's birth certificate.
Specs: Uses 35mm transparencies.
Making Contact & Terms: Query with stock photo list. Send unsolicited photos by mail for consideration. Photo submissions should consist of a minimum of 100 transparencies of one model. SASE. Reports in 3 weeks. Pays $150/color page rate; photo sets of individual models—$1,250-1,800. Pays on publication. Buys one-time rights; negotiable. Credit line given (if requested).
Tips: "Study samples of our publication. We place a premium on—and pay a premium for—new discoveries and exclusives."

$ $ 🔲 ◐ **SCORE, Canada's Golf Magazine**, 287 MacPherson Ave., Toronto, Ontario M4V 1A4 Canada. (416)928-2909. Fax: (416)928-1357. Editor: Bob Weeks. Circ. 160,000. Estab. 1980. Magazine published 6 times/year. Emphasizes golf. "The foundation of the magazine is Canadian golf and golfers." Readers are affluent, well-educated, 80% male, 20% female. Sample copy $2 (Canadian). Photo guidelines free with SAE with IRC.
Needs: Uses between 30 and 40 photos/issue; approximately 95% supplied by freelance photographers. Needs "professional-quality, golf-oriented color and b&w material on prominent Canadian male and female pro golfers on the US PGA and LPGA tours, as well as the European and other international circuits, scenics, travel, close-ups and full-figure." Model releases (if necessary) required. Captions required.
Specs: Uses 8×10 or 5×7 glossy b&w prints and 35mm or 2¼×2¼ transparencies.
Making Contact & Terms: Query with samples and with list of stock photo subjects. Provide résumé, business card, brochure, flier or tearsheets to be kept on file for possible future assignments. SASE with IRC. Reports in 3 weeks. Simultaneous submissions OK. Pays $75-100/color cover; $30/b&w inside; $50/ color inside; $40-65/hour; $320-520/day; and $80-2,000/job. **Pays on acceptance.** Buys all rights. Credit line given.
Tips: "When approaching *Score* with visual material, it is best to illustrate photographic versatility with a variety of lenses, exposures, subjects and light conditions. Golf is not a high-speed sport, but invariably presents a spectrum of location puzzles: rapidly changing light conditions, weather, positioning, etc. Capabilities should be demonstrated in query photos. Scenic material follows the same rule. Specific golf hole shots are certainly encouraged for travel features, but wide-angle shots are just as important, to 'place' the golf hole or course, especially if it is located close to notable landmarks or particularly stunning scenery. Approaching *Score* is best done with a clear, concise presentation. A picture is absolutely worth a thousand words, and knowing your market and your particular strengths will prevent a mutual waste of time and effort. Sample copies of the magazine are available and any photographer seeking to work with *Score* is encouraged to investigate it prior to querying."

SCOUTING MAGAZINE, Boy Scouts of America Magazine Division, 1325 W. Walnut Hill Lane, Irving TX 75038. (972)580-2358. Fax: (972)580-2079. Contact: Photo Editor. Circ. 1 million. Published 6 times a year. Magazine for adults within the Scouting movement.
 • Boy Scouts of America Magazine Division also publishes *Boys' Life* magazine.
Needs: Assigns 90% of photos; uses 10% from stock. Needs photos dealing with success and/or personal

interest of leaders in Scouting. Captions required.

Making Contact & Terms: Send written query with ideas. SASE. Pays $400 base editorial day rate against placement fees. **Pays on acceptance.** Buys one-time rights.

Tips: Study the magazine carefully.

N $ $ S ▣ ◯ ◎ SEA, The Magazine of Western Boating, 17782 Cowan, Suite C, Irvine CA 92614. (949)660-6150. Fax: (949)660-6172. E-mail: seamgzn2.earthlink.net. Website: http://www.sea mag.com. Senior Editor: Eston Ellis. Art Director: Jeffrey Fleming. Circ. 60,000. Monthly magazine. Emphasizes "recreational boating in 13 western states (including some coverage of Mexico and British Columbia) for owners of recreational power boats." Sample copy and photo guidelines free with 10×13 SAE.

Needs: Uses about 50-75 photos/issue; most supplied by freelance photographers; 10% assignment; 70% requested from freelancers existing photo files or submitted unsolicited. Needs "people enjoying boating activity (families, parents, senior citizens) and scenic shots (travel, regional); shots which include parts or all of a boat are preferred." Special needs include "vertical-format shots involving power boats for cover consideration." Photos should have West Coast angle. Model release required. Captions required.

Specs: Accepts images in digital format for Mac. Send via CD, SyQuest, floppy disk, Zip, e-mail as TIFF, EPS, JPEG files at 266 dpi.

Making Contact & Terms: Query with samples. SASE. Reports in 1 month. Pays $250/color cover; inside photo rate varies according to size published. Range is from $35 for b&w and $50-200 for color. Pays on publication. Buys one-time North American rights. Credit line given.

Tips: "We are looking for sharp color transparencies with good composition showing pleasure boats in action, and people having fun aboard boats in a West Coast location. We also use studio shots of marine products and do personality profiles. Black & white also accepted, for a limited number of stories. Color preferred. Send samples of work with a query letter and a résumé or clips of previously published photos. No phone calls please; *Sea* does not pay for shipping; will hold photos up to six weeks."

N $ ⊕ ▣ ◯ SEA BREEZES, Mannin Media Group, 28-30 Spring Valley Industrial Estate, Braddan, Isle of Mann 1M2 2QS. Phone: (1624)626018. Fax: (1624)661655. E-mail: manninmedia@enterprise. net. Website: http://www.enterprise.net/manninmedia. Captain: A.C. Douglas. Circ. 14,500. Estab. 1919. Monthly publication devoted to shipping enthusiasts and historians. Sample copies available.

Needs: Needs shipping related photos only. Reviews photos with accompanying ms only. Model release preferred; property release required. Photo caption required; include all specific details and correct information—the magazine deals only in factual interest.

Specs: Uses color prints; 35mm, 2¼×2¼, 4×5, 8×10 transparencies. Accepts images in digital format for Mac. Send via CD, SyQuest, Jaz, Zip as TIFF, EPS, PICT, JPEG, ISDN files at 300 dpi.

Making Contact & Terms: Send query letter with photocopies, stock list. Portfolio may be dropped off Monday-Friday. Does not keep samples on file; cannot return material. Reports in 3 weeks on queries; 3 months on portfolios. Pays £20-50 for color cover; £8-10 for b&w inside; £10-50 for color inside. Pays on publication. Credit line given. Buys all rights.

Tips: "Remember, the readers of *Sea Breezes* are enthusiasts to the limit. They know almost everything technical about ships and shipping and the photos must reflect this. Use portrait images as well as landscape."

$ S ◑ ◎ SEA KAYAKER, P.O. Box 17170, Seattle WA 98107. (206)789-1326. Fax: (206)781-1141. E-mail: mail@seakayakermag.com. Website: http://www.seakayakermag.com. Editor: Christopher Cunningham. Circ. 25,000. Estab. 1984. Bimonthly magazine. Emphasizes sea kayaking—kayak cruising on coastal and inland waterways. Sample copy $5.75. Photo guidelines free with SASE.

Needs: Uses 50 photos/issue; 85% supplied by freelancers. Needs photos of sea kayaking locations, coastal camping and paddling techniques. Reviews photos with or without ms. Always looking for cover images (some to be translated into paintings, etc.). Model/property release preferred. Captions preferred.

Specs: Uses 5×7 color and b&w prints; 35mm transparencies.

Making Contact & Terms: Submit portfolio for review. Send unsolicited photos by mail for consideration. Keeps samples on file. SASE. Reports in 1 month. Pays $400/color cover; $25-100/color inside; $15-75/b&w inside. Pays on publication. Buys one-time rights; first North American serial rights. Credit line given.

Tips: Subjects "must relate to sea kayaking and cruising locations. Send dupe slides."

$ $ SECURE RETIREMENT, 10 G St NE, Washington DC 20002. (202)216-0420. Fax: (202)216-0451. E-mail: secure_retirement@ncpssm.org. Editor: Denise Fremeau. Circ. 2 million. Estab. 1992. Publication of the National Committee to Preserve Social Security and Medicare. Magazine published 6 times

yearly. Emphasizes aging and senior citizen issues. Readers are male and female retirees/non-retirees, ages 50-80. Sample copy free with 9×12 SASE.

Needs: Uses 20-25 photos/issue; all supplied by freelancers. Needs photos of generic, healthy lifestyle seniors, intergenerational families. Model release required. Captions preferred.

Making Contact & Terms: Arrange personal interview to show portfolio. Provide résumé, business card, brochure, flier or tearsheets to be kept on file for possible assignments. Do not send unsolicited 35mm or 4×5 slides; color or b&w prints OK. SASE. Simultaneous submissions and/or previously published work OK. Pays $100-500/day; $100-500/color and b&w inside. Pays on publication. Credit line given.

Tips: "We are interested in hiring freelancers to cover events for us across the nation (approximately 3-7 events/month)."

$ SEEK, Standard Publishing, 8121 Hamilton Ave., Cincinnati OH 45231-2396. (513)931-4050, ext. 365. Fax: (513)931-0904. Website: http://www.standardpub.com. Editor: Eileen Wilmoth. Circ. 45,000. Estab. 1970. Weekly consumer magazine. "Colorful, illustrated weekly take-home or pass-along paper designed to appeal to modern adults/older teens. Its use ranges from the classroom of the Sunday morning Bible class to group discussion and light inspirational reading for individuals and the family."

Needs: Buys 1-2 photos from freelancers/issue; 50-75 photos/year. Reviews photos with or without a ms. Model release required; property release required for private homes.

Specs: Uses color and b&w prints.

Making Contact & Terms: Send query letter with samples. Does not keep samples on file. Reports back only if interested, send non-returnable samples. Simultaneous submissions and previously published work OK. Pays $60/b&w cover; $50/b&w inside. **Pays on acceptance.** Buys one-time rights. Credit line given.

$ ⊕ SELECT MAGAZINE, Emap Metro, Emap Place, Mappin House, 4 Winsley St., 1st Floor, W1N 7AR England. Fax: (0181)312 8250. Circ. 110,000. Estab. 1992. Monthly magazine emphasizing music and lifestyle.

Needs: Needs photos of themes and personalities. Special photo needs include gossip. Photo captions required.

Specs: Uses color prints.

Making Contact & Terms: Send query letter with samples, brochure. Portfolios may be dropped off every Thursday. Portfolio should include color prints, tearsheets. Reports back only if interested, send non-returnable samples. Will return material with SASE. Simultaneous submissions OK. Pays £125/half day; £250/full day. Pays on publication.

Tips: "Read the magazine, know my name and understand our style of photography. Always shoot in color and understand the gutter has got to go somewhere."

$ SENTIMENTAL SOJOURN, 11702 Webercrest, Houston TX 77048. (713)733-0338. Editor: Charlie Mainze. Circ. 1,000. Estab. 1993. Annual magazine. Sample copy $12.50.

Needs: Uses photos on almost every page. Needs sensual images evocative of the sentimental, usually including at least one human being, suitable for matching with sentimental poetry. "Delicate, refined, romantic, nostalgic, emotional idealism—can be erotic, but must be suitable for a general readership." Model/property release required for any model.

Specs: Uses color and b&w prints; 35mm, 2¼×2¼, 4×5 transparencies.

Making Contact & Terms: Send unsolicited photos by mail for consideration. Provide résumé, business card, brochure, flier or tearsheets to be kept on file for possible assignments. Keeps samples on file. SASE, but generally keep for a few years. Reports when need for work arises, could be 2 years. Previously published work OK. Pays $50-200/color cover; $50-200/b&w cover; $10-100/color inside; $10-100/b&w inside; also pays a percentage of page if less than full page. Buys one-time rights, first North American serial rights. Credit line given.

Tips: "Symbols of the dead and dying had better be incomparably delicate. Send a celebration of emotions."

$ $ ▣ ◗ ◎ SHOWBOATS INTERNATIONAL, 1600 SE 17th St., Suite 200, Ft. Lauderdale FL 33316. (954)525-8626. Fax: (954)525-7954. E-mail: showboats@aol.com. Executive Editor: Marilyn Mower. Circ. 60,000. Estab. 1981. Bimonthly magazine with annual charter issue. Emphasizes exclusively large yachts (100 feet or over). Readers are mostly male, 40 plus years of age, incomes above $1 million, international. Sample copy $6.

• This publication has received 20 Florida Magazine Association Awards plus two Ozzies since 1989.

Needs: Uses 90-150 photos/issue; 80-90% supplied by freelancers. Needs photos of very large yachts and

exotic destinations. "Almost all shots are commissioned by us." Model/property releases required. Color photography only. Captions preferred.

Specs: Accepts images in digital format for Mac. Send via compact disc, SyQuest, Zip disk (high resolution).

Making Contact & Terms: Arrange personal interview to show portfolio. Submit portfolio for review. Query with résumé of credits, business card, brochure, flier or tearsheets to be kept on file for possible assignments. Does not keep samples on file. SASE. Reports in 3 weeks. Previously published work OK, however, exclusivity is important. Pays $500/color cover; $100-375/color page rate; $550-850/day. Pays on publication. Buys first serial rights, all rights; negotiable. Credit line given.

Tips: Looking for excellent control of lighting; extreme depth of focus; well-saturated transparencies. Prefer to work with photographers who can supply both exteriors and beautiful, architectural quality interiors. "Don't send pictures that need any excuses. The larger the format, the better. Send samples. Exotic location shots should include yachts."

SKATING, 20 First St., Colorado Springs CO 80906-3697. (719)635-5200. Fax: (719)635-9548. E-mail: lfawcett@usfsa.org. Editor: Laura Fawcett. Circ. 45,000. Estab. 1923. Publication of The United States Figure Skating Association. Magazine published 10 times/year. Emphasizes competitive figure skating. Readers are primarily active skaters coaches and officials and girls who spend up to 15 hours a week skating. Sample copy $3.

Needs: Uses 25 photos/issue; 90% supplied by freelancers. Needs sports action shots of national and world-class figure skaters; also casual, off-ice shots of skating personalities. Model/property release required. Captions preferred; include who, what, when where.

Specs: Uses 3½×5, 4×6, 5×7 glossy color prints; 35mm transparencies. Accepts images in digital format for Mac.

Making Contact & Terms: Send unsolicited photos by mail for consideration. Keeps samples on file. Cannot return material. Reports in 2 weeks. Pays $50/color cover photo; $35/color inside photo; $15/b&w inside photo. Pays on publication. Buys one-time rights; negotiable. Credit line given.

Tips: "We look for a mix of full-body action shots of skaters in dramatic skating poses and tight, close-up or detail shots that reveal the intensity of being a competitor. Shooting in ice arenas can be tricky. Flash units are prohibited during skating competitions, therefore, photographers need fast, zoom lenses that will provide the proper exposure, as well as stop the action."

$ ⧉ SKI CANADA, 117 Indian Rd., Toronto, Ontario M6R 2V5 Canada. (416)538-2293. Fax: (416)538-2475. E-mail: mac@skicanadamag.com. Editor: Iain MacMillan. Monthly magazine published 6 times/year, September through February. Readership is 65% male, ages 25-44, with high income. Circ. 55,000. Sample copy free with SASE.

Needs: Uses 40 photos/issue; 100% supplied by freelance photographers. Needs photos of skiing—travel (within Canada and abroad), competition, equipment, instruction, news and trends. Model release not required; photo captions preferred.

Specs: Uses color 35mm transparencies.

Making Contact & Terms: Send unsolicited photos by mail for consideration. Provide résumé, business card, brochure, flier or tearsheets to be kept on file for possible assignments. SASE. Reports in 1 month. Simultaneous submissions OK. Pays $100/photo/page; cover $350; rates are for b&w or color. Pays within 30 days of publication. Credit line given.

Tips: "Please request in writing (or by fax) an editorial lineup available in late fall for the following year's publishing schedule. Areas covered: travel, equipment, instruction, competition, fashion and general skiing stories and news."

SKIPPING STONES: A Multicultural Children's Magazine, P.O. Box 3939, Eugene OR 97403. (541)342-4956. E-mail: skipping@efn.org. Website: http://www.nonviolence.org/skipping. Managing Editor: Arun N. Toké. Circ. 3,000. Estab. 1988. Nonprofit, noncommercial magazine published 5 times/year. Emphasizes multicultural and ecological issues. Readers are youth ages 8-16, their parents and teachers, schools and libraries. Sample copy $6 (including postage). Photo guidelines free with SASE.

● Winner of 1997 NAME Award.

Needs: Uses 25-40 photos/issue; most supplied by freelancers. Needs photos of animals, wildlife, children 8-16, cultural celebrations, international, travel, school/home life in other countries or cultures. Model release preferred. Captions preferred; include site, year, names of people in photo.

Specs: Uses 4×6, 5×7 glossy color or b&w prints.

Making Contact & Terms: Send unsolicited photos by mail for consideration. Keeps samples on file. SASE. Reports in 4 months. Simultaneous submission OK. Pays contributor's copy; "we're a labor of love." For photo essays; "we provide 5 copies to contributors. Additional copies at a 25% discount.

Sometimes, a small honorarium for photography." Buys one-time and first North American serial rights; negotiable. Credit line given.

Tips: "We publish b&w inside; color on cover. Should you send color photos, choose the ones with good contrast which can translate well into b&w photos. We are seeking meaningful, humanistic and realistic photographs."

$ SKYDIVING, 1725 N. Lexington Ave., DeLand FL 32724. (904)736-4793. Fax: (904)736-9786. E-mail: edit@skydivingmagazine.com. Editor: Sue Clifton. Circ. 14,200. Estab. 1979. Monthly magazine. Readers are "sport parachutists worldwide, dealers and equipment manufacturers." Sample copy $3. Photo guidelines for SASE.

Needs: Uses 50 photos/issue; 5 supplied by freelancers. Selects photos from wire service, photographers who are skydivers and freelancers. Interested in anything related to skydiving—news or any dramatic illustration of an aspect of parachuting. Model release preferred. Captions preferred; include who, what, why, when, how.

Making Contact & Terms: Send actual 5×7 or larger b&w or color photos or 35mm or 2¼×2¼ transparencies by mail for consideration. Keeps samples on file. SASE. Reports in 1 month. Pays $50-100/color cover; $25-50/color inside; $15-50/b&w inside. Pays on publication. Buys one-time rights. Credit line given.

$ [S] [■] [◯] SOARING, Box E, Hobbs NM 88241-7504. (505)392-1177. Fax: (505)392-8154. E-mail: 74521.116@compuserve.com. Website: http://www.ssa.org. Art Director: Jon McKinley. Circ. 16,010. Estab. 1937. Monthly magazine. Emphasizes the sport of soaring in sailplanes and motorgliders. Readership consists of professional males and females, ages 14 and up. Sample copy and photo guidelines free with SASE.

Needs: Uses 25 or more photos/issue; 95% supplied by freelancers. Needs photos of sailplane gliders in terms of hobbies, sports, travel. "We need a good supply of sailplane transparencies for our yearly calendar." Model release preferred. Captions required.

Specs: Uses b&w prints, any size and format. Also uses transparencies, any format. Accepts images in digital format for Mac. Send hi res images only via CD or Zip as TIFF, EPS, PIC, BMP, GIF, JPEG files at 300 dpi.

Making Contact & Terms: Send unsolicited photos by mail for consideration. SASE. "We hold freelance work for a period of usually six months, then it is returned. If we have to keep work longer, we notify the photographer. The photographer is always updated on the status of his or her material." Simultaneous submissions OK. Pays $50/color cover. Pays $50-100 for calendar photos. Pays on publication. Buys one-time rights. Credit line given.

Tips: "Exciting air-to-air photos, creative angles and techniques are encouraged. We pay only for the front cover of our magazine and photos used in our calendars. We are a perfect market for photographers who have sailplane photos of excellent quality. Send work dealing with sailplanes only and label all material. A simple note, picture and address will get things rolling."

$ SOARING SPIRIT, P.O. Box 38, Malibu CA 90265. Editor: Dick Sutphen. Art Director: Jason D. McKean. Circ. 120,000. Estab. 1976. Quarterly magazine. Emphasizes metaphysical, psychic development, reincarnation, self-help with tapes. Everyone receiving the magazine has attended a Sutphen Seminar or purchased Valley of the Sun Publishing books or tapes from a line of over 300 titles: video and audio tapes, subliminal/hypnosis/meditation/New Age music/seminars on tape, etc. Sample copy free with 9×12 SAE and 5 first-class stamps.

Needs: "We purchase about 10 photos per year for the magazine and also for cassette album covers, videos and CDs. We are especially interested in surrealistic photography which would be used as covers, to illustrate stories and for New Age music cassettes. Even seminar ads often use photos that we purchase from freelancers." Model release required.

Making Contact & Terms: Send b&w and color prints; 35mm transparencies by mail for consideration. SASE. Reports in 2 weeks. Simultaneous submissions and previously published work OK. Pays $100/color photo; $50/b&w photo. Pays on publication. Buys one-time rights; negotiable. Credit line given if desired.

[N] $ $ $ $ SOLDIER OF FORTUNE MAGAZINE, 5735 Arapahoe Ave., Boulder CO 80303. (303)449-3750, ext. 309. E-mail: tomr@sofmag.com. Website: http://www.sofmag.com. Managing Editor: Dwight Swift. Deputy Editor: Tom Reisinger. Monthly magazine. Emphasizes adventure, combat, military units and events. Readers are mostly male—interested in adventure and military related subjects. Circ. 175,000. Estab. 1975. Sample copy $5.

Needs: Uses about 60 photos/issue; 33% on assignment, 33% from stock. Needs photos of combat—

under fire, or military units, military—war related. "We always need front-line combat photography." Not interested in studio or still life shots. Model/property release preferred. Captions required; "include as much tech information as possible."

Making Contact & Terms: Contact Tom Reisinger by phone with queries; send 8×10 glossy b&w, color prints, 35mm transparencies, b&w contact sheets by mail for consideration. SASE. Reports in 3 weeks. Pays $50-150/b&w photo; $50-500/color cover; $150-2,000/complete job. Will negotiate a space-rate payment schedule for photos alone. Pays on publication. Buys one-time rights. Credit line given.

Tips: "Combat action photography gets first consideration for full-page and cover layouts. Photo spreads on military units from around the world also get a serious look, but stay away from 'man with gun' shots. *Give us horizontals and verticals!* The horizontal-shot syndrome handcuffs our art director. *Get close!* Otherwise, use telephoto. Too many photographers send us long distance shots that just don't work for our audience. *Give us action!* People sitting, or staring into the lens, mean nothing. *Consider using black & white* along with color. It gives us options in regard to layout; often, black & white better expresses the combat/military dynamic."

$ SPARE TIME MAGAZINE, 5810 W. Oklahoma Ave., Milwaukee WI 53219. (414)543-8110. Fax: (414)543-9767. Editor: Peter Abbott. Circ. 301,500. Estab. 1955. Published 11 times yearly (monthly except July). Emphasizes income-making opportunities. Readers are income opportunity seekers with small capitalization. People who want to learn new techniques to earn extra income. Sample copy $2.50.

Needs: Uses one photo/issue. Needs photos that display money-making opportunities. Model/property release required.

Specs: Uses color or b&w prints; 2¼×2¼ transparencies.

Making Contact & Terms: Send unsolicited photos by mail for consideration. Keeps samples on file. Contacts photographer if photo accepted. Simultaneous submissions and previously published work OK. Pays $15-50/color or b&w photo. Pays on publication. Buys one-time rights, all rights; negotiable.

$ ▣ ◯ SPFX: SPECIAL EFFECTS MAGAZINE, 70 W. Columbia Ave., Palisades Park NJ 87650-1004. (201)945-1112. Fax: (201)945-2662. E-mail: spfxted@aol.com. Editor: Ted A. Bohus. Circ. 6,000-10,000. Estab. 1978. Biannual film magazine emphasizing science fiction, fantasy and horror films past, present and future. Includes feature articles, interviews and rare photos. Sample copy for $5. Art guidelines free.

Needs: Needs film stills and film personalities. Reviews photos with or without ms. Special photo needs include rare film photos. Model/property release preferred. Photo captions preferred.

Specs: Uses any size prints. Accepts images in digital format for Macintosh. Send via floppy disk, Jaz, Zip, e-mail as TIFF, EPS files at 300 dpi.

Making Contact & Terms: Send query letter with samples. Provide résumé, business card, self-promotion piece or tearsheets to be kept on file for possible future assignments. To show portfolio, photographer should follow-up with letter after initial query. Art director will contact photographer for portfolio review if interested. Pays $150-200 for color cover; $10-50 for b&w and color inside. Portfolio should include b&w and/or color, prints, tearsheets, slides, transparencies or thumbnails. Keeps samples on file. Reports back only if interested, send nonreturnable samples. Previously published work OK. Payment varies. Pays on publication. Credit line given.

Ⓝ $ $ $▣ ◪ SPIRIT, American Airlines Publishing, 4333 Amon Carter Blvd., MD 5598, Ft. Worth TX 76155. (817)967-1818. Fax: (817)967-1571. E-mail: dianne_gibson@amrcorp.com. Circ. 300,000 print order; 1.6 million readership. Monthly inflight consumer magazine. Sample copies available for $3 and 8½×11 SAE. Art guidelines available for SASE.

Needs: Buys 35 photos from freelancers per issue; 500 photos per year. Needs photos of celebrities, landscapes/scenics, adventure, entertainment, food/drink, performing arts, sports, travel, portraits. Interested in alternative process, documentary. Reviews photos with or without a ms. Model and property release preferred. Photo caption required; include names, accurate, descriptive information.

Specs: Uses 8×10, matte b&w prints; 35mm, 2¼×2¼, 4×5 transparencies. Accepts images in digital format for Mac. Send via CD, SyQuest, Zip as TIFF, EPS files at 304 dpi.

Making Contact & Terms: Send query letter with slides. Provide self-promotion piece to be kept on file for possible future assignments. Reports back only if interested, send nonreturnable samples. "Cover story assignments pay up to $3,500—includes photos inside; $250-800 stock rates; feature assignments up to $2,500; flat fee basis—we pay no expenses." Pays on publication. Credit line given. Buys one-time rights.

Tips: "Reading the magazine is helpful for story types and styles; we look for work that follows the story well—or, when required, tells the story in a single image. Photographer needs to create a great sense of composition. Work quickly, and be willing to handle coordinating shoot from start to finish. Go beyond

the call of duty with enthusiasm. Target markets appropriately! Match your work to that done by the potential client."

N $ $ ⊡ ⊘ SPORT FISHING, 330 W. Canton, Winter Park FL 32789. (407)628-5662. Fax: (407)628-7061. E-mail: sportfish@worldzine.com. Editor-in-Chief: Doug Olander. Circ. 150,000 (paid). Estab. 1986. Publishes 9 issues/year. Emphasizes saltwater sport fishing. Readers are upscale boat owners and affluent fishermen. Sample copy $2.50 with 9×12 SAE and 6 first-class stamps. Photo guidelines free with SASE or via e-mail.
Needs: Uses 50 photos/issue; 75% supplied by freelance photographers. Needs photos of salt water fish and fishing—especially good action shots. "We are working more from stock—good opportunities for extra sales on any given assignment." Model release preferred; releases needed for subjects (under "unusual" circumstances) in photo.
Specs: Uses 35mm, 2¼×2¼ and 4×5 transparencies. "Kodachrome 64 and Fuji 100 are preferred." Accepts images in digital format. E-mail for information on submitting.
Making Contact & Terms: Query with samples. Send unsolicited photos by mail for consideration. Provide résumé, business card, brochure, flier or tearsheets to be kept on file for possible future assignments. Reports in 3 weeks. Pays $20-100/b&w page; $50-300/color page; $1,000/cover; $50-200/b&w or color photo. Buys one-time rights unless otherwise agreed upon.
Tips: "Tack-sharp focus critical; avoid 'kill' shots of big game fish, sharks; avoid bloody fish in/at the boat. The best guideline is the magazine itself. Know your market. Get used to shooting on, in or under water. Most of our needs are found there. If you have first-rate photos and questions: e-mail."

$ $ ⊡ ⊘ SPORT MAGAZINE, 110 Fifth Ave., 4th Floor, New York NY 10011. (212)866-3600. Fax: (212)229-4838. Website: http://www.petersenco.com. Photo Director: Grace How. Monthly magazine. Emphasizes sports, both professional and collegiate. Readers are ages 9-99, male and female. Circ. 1 million.
Needs: Uses 90 photos/issue. Needs photos of dynamic sports action (i.e., strobed basketball, hockey, football, baseball). Also considers sports celebrities, adventure, entertainment, events, health/fitness, travel, portraits, historical/vintage. "We are always looking to work with motivated professionals and up and coming photographers who are passionate about photography and people."
Specs: Uses color transparencies and color prints. Accepts images in digital format for Mac. Send via floppy disk, Zip as TIFF, JPEG files.
Making Contact & Terms: Query with résumé of credits or stock photo subjects. "Portfolio may be dropped off every Friday with 4th floor receptionist. Include contact information and samples. Pick up on following Thursday. No unsolicited work accepted." Pays $700/color cover; $100/color inside; $400/day. Pays on publication. Buys one-time rights. Credit line given.
Tips: In portfolio or samples looking for "tight, sharp, action—hockey and basketball must be strobed, color transparencies preferred, well-lighted portraits or feature style and candid shots of athletes. No prints. Assignments are being given to those who continue to excel and are creative. Send letter and résumé dealing with work experience with samples of published work or samples as slide dupes that can be kept on file. Don't call!!"

N $ $ SPORTSCAR, 1371 E. Warner, Suite E, Tustin CA 92680. (714)259-8240. Editor: Richard James. Circ. 50,000. Estab. 1944. Publication of the Sports Car Club of America. Monthly magazine. Emphasizes sports car racing and competition activities. Sample copy $2.95.
Needs: Uses 75-100 photos/issue; 75% from assignment and 25% from freelance stock. Needs action photos from competitive events, personality portraits and technical photos.
Making Contact & Terms: Query with résumé of credits or send 5×7 color or b&w glossy/borders prints or 35mm or 2¼×2¼ transparencies by mail for consideration. Provide résumé, business card, brochure, flier or tearsheets to be kept on file for possible assignments. SASE. Reports in 1 month. Simultaneous submissions OK. Pays $25/color inside; $10/b&w inside; $250/color cover. Negotiates all other rates. Pays on publication. Buys first North American serial rights. Credit line given.
Tips: To break in with this or any magazine, "always send only the absolute best work; try to accommodate the specific needs of your clients. Have a relevant subject, strong action, crystal sharp focus, proper contrast

MARKET CONDITIONS are constantly changing! If you're still using this book and it's 2001 or later, buy the newest edition of *Photographer's Market* at your favorite bookstore or order directly from Writer's Digest Books.

and exposure. We need good candid personality photos of key competitors and officials."

$ ▣ ◐ SPOTLIGHT MAGAZINE, 126 Library Lane, Mamaroneck NY 10543. (914)381-4740, ext. 20. Fax: (914)381-4641. Publisher: Susan Meadow. Contact: Kathee Casey Pennucci. Circ. 75,000. Monthly magazine. Readers are largely upscale, about 60% female. Sample copy $2.50.
Needs: Uses 30-35 photos/issue; 10-15 supplied by freelancers. Model release required. Captions required.
Specs: Accepts images in digital format for Mac. Send via compact disc, floppy disk, SyQuest, Zip disk as TIFF (high resolution).
Making Contact & Terms: Query with résumé of credits. Keeps samples on file. SASE. Reports in 1 month. Pays $40-125/photo. Pays on publication. Buys all rights "but flexible on reuse." Credit line given.

$ SPSM&H, Shakespeare, Petrarch, Sidney, Milton & Hopkins, Amelia, 329 E St., Bakersfield CA 93304-2031. (661)323-4064. E-mail: amelia@lightspeed.net. Editor: Frederick A. Raborg, Jr. Circ. 600. Estab. 1985. Quarterly literary magazine. "Publishes sonnets, sonnet sequences and crowns, fiction of a Gothic/romantic nature, articles about the sonnet and book reviews of sonnet volumes." Sample copy $4.95. Art guidelines for SAE with 1 first-class stamp.
Needs: Buys 1-2 photos/issue; 4-6 photos/year. "Anything slightly out of the ordinary with romantic concept. Some Gothic. Black & white only, preferably photos which can be used as wrap-around cover." Reviews photos with or without a manuscript. "Surprise us!" Model release required for any portrait or body shots when face is recognizable. Photo captions required for content identification.
Specs: Uses 5×7 or 8×10 glossy or matte b&w prints.
Making Contact & Terms: Send query letter with samples. Keeps samples on file. Reports in 2 weeks on queries; 2-8 weeks on close samples. Simultaneous submissions and previously published work in non-competitive markets OK. Pays $25/b&w cover; $10-20/b&w inside. **Pays on acceptance.** Buys one-time rights. Credit line given.
Tips: "We allow photographers a 40% discount on subscriptions to follow what we do. Request for discount must be on letterhead with or without samples. Enclose SASE of appropriate size."

STAR, 660 White Plains Rd., Tarrytown NY 10591. (914)332-5000. Editor: Phillip Bunton. Photo Director: Alistair Duncan. Circ. 2.8 million. Weekly. Emphasizes news, human interest and celebrity stories. Sample copy and photo guidelines free with SASE.
Needs: Uses 100-125 photos/issue; 75% supplied by freelancers. Reviews photos with or without accompanying ms. Model release preferred. Captions required.
Making Contact & Terms: Query with samples and with list of stock photo subjects. Send 8×10 b&w prints; 35mm, $2\frac{1}{4} \times 2\frac{1}{4}$ transparencies by mail for consideration. SASE. Reports in 2 weeks. Simultaneous submissions and previously published work OK. Payment negotiable. Pays on publication. Credit line sometimes given.

$ ▣ ◐ THE STATE: Down Home in North Carolina, P.O. Box 4552, Greensboro NC 27408-7017. (910)286-0600 or (800)948-1409. Fax: (910)286-0100. E-mail: mannmedia2@aol.com. Editor: Mary Ellis. Circ. 45,500. Estab. 1933. Monthly magazine. Regional publication, privately owned, emphasizing travel, history, nostalgia, folklore, humor, all subjects regional to North Carolina for residents of, and others interested in, North Carolina. Sample copy $3. "Send for our photography guidelines."
Needs: Freelance photography used; 5% assignment and 5% stock. Photos on travel, history and human interest in North Carolina. Captions required.
Specs: Prefers color transparencies. Uses 5×7 and 8×10 glossy color and b&w prints. Accepts images in digital format for Mac (TIFF). Send via CD, SyQuest, Zip, Jaz or floppy disk (300-500 dpi).
Making Contact & Terms: Send material by mail for consideration. SASE. Pays $25/b&w inside; $75-500/cover; $125-500/complete job. Pays on publication. Credit line given.
Tips: Looks for "North Carolina material; solid cutline information."

$ $ STOCK CAR RACING MAGAZINE, 65 Parker St., #2, Newburyport MA 01950. (978)463-3787. Fax: (978)463-3250. Editor: Dick Berggren. Circ. 400,000. Estab. 1966. Monthly magazine. Emphasizes all forms of stock car competition. Read by fans, owners and drivers of race cars and those with racing businesses. Photo guidelines free with SASE.
Needs: Buys 50-70 photos/issue. Documentary, head shot, photo essay/photo feature, product shot, personality, crash pictures, special effects/experimental, technical and sport. No photos unrelated to stock car racing. Photos purchased with or without accompany ms and on assignment. Model release required unless subject is a racer who has signed a release at the track. Captions required.
Specs: Uses 8×10 glossy b&w prints; 35mm or $2\frac{1}{4} \times 2\frac{1}{4}$ transparencies. Kodachrome 64 or Fuji 100 preferred.

Making Contact & Terms: Send material by mail for consideration. Pays $20/b&w inside; $35-250/color inside; $250/cover. Pays on publication. Buys one-time rights. Credit line given.

Tips: "Send the pictures. We will buy anything that relates to racing if it's interesting, if we have the first shot at it, and it's well printed and exposed. Eighty percent of our rejections are for technical reasons—poorly focused, badly printed, too much dust, picture cracked, etc. We get far fewer cover submissions than we would like. We look for full-bleed cover verticals where we can drop type into the picture and position our logo."

$ ◨ STRAIGHT, 8121 Hamilton Ave., Cincinnati OH 45231. (513)931-4050. Fax: (513)931-0950. Editor: Heather E. Wallace. Circ. 35,000. Estab. 1950. Weekly. Readers are ages 13-19, mostly Christian; a conservative audience. Sample copy free with SASE and 2 first-class stamps. Photo guidelines free with SASE.

Needs: Uses about 4 photos/issue; all supplied by freelance photographers. Needs color photos of teenagers involved in various activities such as sports, study, church, part-time jobs, school activities, classroom situations. Outside nature shots, groups of teens having good times together are also needed. "Try to avoid the sullen, apathetic look—vital, fresh, thoughtful, outgoing teens are what we need. Any photographer who submits a set of quality color transparencies for our consideration, whose subjects are teens in various activities and poses, has a good chance of selling to us. This is a difficult age group to photograph without looking stilted or unnatural. We want to purport a clean, healthy, happy look. No smoking, drinking or immodest clothing. We especially need masculine-looking guys and minority subjects." Model release required.

Making Contact & Terms: Send color transparencies by mail for consideration. Enclose sufficient packing and postage for return of photos. Reports in 6 weeks. Simultaneous submissions and previously published work OK. Pays $125 minimum for color cover; $75 minimum for color inside. **Pays on acceptance.** Buys one-time rights. Credit line given.

Tips: "Our publication is almost square in shape. Therefore, 5×7 or 8×10 prints that are cropped closely will not fit our proportions. Any photo should have enough 'margin' around the subject that it may be cropped square. This is a simple point, but absolutely necessary. Look for active, contemporary teenagers with light backgrounds for photos. For our publication, keep up with what teens are interested in. Subjects should include teens in school, church, sports and other activities. Although our rates may be lower than the average, we try to purchase several photos from the same photographer to help absorb mailing costs. Review our publication and get a feel for our subjects. We purchase photos four times a year. It is best for a photographer to call and get specific information about our needs as well as dates when photos will be purchased."

$ THE STRAIN, 1307 Diablo Dr., Crosby TX 77532-3004. (713)738-4887. For articles contact: Alicia Adler; for columns, Charlie Mainze. Circ. 1,000. Estab. 1987. Monthly magazine. Emphasizes interactive arts and 'The Arts'. Readers are mostly artists and performers. Sample copy $5 with 9×12 SAE and 7 first-class stamps. Photo guidelines free with SASE.

Needs: Uses 5-100 photos/issue; 95% supplied by freelance photographers. Needs photos of scenics, personalities, portraits. Model release required. Captions preferred.

Making Contact & Terms: Send any format b&w and color prints or transparencies by mail for consideration. SASE. The longer it is held, the more likely it will be published. Reports in 1 year. Simultaneous submissions and previously published work OK. Pays $50/color cover; $100/b&w cover; $5 minimum/color inside; $5 minimum/b&w inside; $5/b&w page rate; $50-500/photo/text package. Pays on publication. Buys one-time rights or first North American serial rights. Credit line given.

$ $ ◩ SUB-TERRAIN MAGAZINE, 204-A, 175 E. Broadway, Vancouver, British Columbia V5T 1W2 Canada. (604)876-8710. Fax: (604)879-2667 (for queries only). E-mail: subter@pinc.com. Website: http://www.anvilpress.com. Managing Editor: Brian Kaufman. Estab. 1988. Quarterly b&w literary magazine.

Needs: Uses "many" unsolicited photos. Needs "artistic" photos. Captions preferred.

Specs: Uses color or b&w prints.

Making Contact & Terms: Submit portfolio for review. Send unsolicited photos by mail for consideration. Keeps samples on file "sometimes." Reports in 2-4 months. Simultaneous submissions OK. Pays $50-300/photo (solicited material only). Also pays in contributor's copies. Pays on publication. Buys one-time rights. Credit line given.

$ ⑤ ◨ THE SUN, 107 N. Roberson St., Chapel Hill NC 27516. (919)942-5282. Fax: (919)932-3101. E-mail: thesun@thesunmagazine.org. Website: http://www.thesunmagazine.org. Art Director: Julie Burke. Circ. 40,000. Estab. 1974. Monthly literary magazine featuring personal essays, interviews, poems, short

stories, photos and photo essays. Sample copy $5. Art guidelines free with SASE.
Needs: Buys 10-30 photos/issue; 200-300 photos/year. Model and property release preferred.
Specs: Uses 4×5 to 11×17 glossy, matte, b&w prints.
Making Contact & Terms: Send query letter with prints. Portfolio may be dropped off Monday-Friday. Does not keep samples on file; include SASE for return of material. Reports in 4-6 weeks on queries and portfolios. Simultaneous submissions and previously published work OK. Pays $250 for b&w cover; $50-150 for b&w inside. Pays on publication. Credit line given. Buys one-time rights.
Tips: "We're looking for artful and sensitive photographs that aren't overly sentimental. We use many photographs of people—though generally not portrait style. We're open to unusual work. Read the magazine to get a sense of what we're about. Send the best possible prints of your work. Send return postage and secure return packaging."

⊠ $ SUPER FORD, 3816 Industry Blvd., Lakeland FL 33811. (941)644-0449. Senior Editor: Steve Turner. Circ. 65,000. Estab. 1977. Monthly magazine. Emphasizes high-performance Ford automobiles. Readers are males, ages 18-40, all occupations. Sample copy free with 11×14 SASE and 8 first-class stamps.
Needs: Uses 75 photos/issue; 30-40 supplied by freelancers. Needs photos of high performance Fords. Model/property release preferred. Captions required.
Specs: Uses 5×7 glossy color or b&w prints; 35mm, 2¼×2¼ transparencies.
Making Contact & Terms: Send unsolicited photos by mail for consideration. Provide résumé, business card, brochure, flier or tearsheets to be kept on file for possible assignments. Does not keep samples on file. SASE. Reports in 1 month, "can be longer." Pays $200/day; $65/color inside; $45/b&w inside. Pays on publication. Buys one-time rights; negotiable. Credit line given.
Tips: "Do not park/pose cars on grass."

⊠ ▣ ⌀ SURFACE MAGAZINE, American Avant Garde, 7 Isadora Duncan Ln., San Francisco CA 94102. (415)929-5100. Fax: (415)929-5103. E-mail: surfacemag@surfacemag.com. Circ. 96,000. Estab. 1994. Bimonthly consumer magazine.
Needs: Uses 200 photos from freelancers per issue. Needs photos of celebrities, environmental, landscapes/scenics, architecture, beauty, cities/urban, gardening, interiors/decorating, adventure, automobiles, entertainment, events, food/drink, humor, performing arts, travel, buildings, computers, product shots/still life, science, technology, alternative process, avant garde, documentary, erotic, fashion/glamour, fine art, regional, seasonal.
Specs: Uses 11×17, glossy, matte prints; 35mm, 2¼×2¼, 4×5, 8×10 transparencies. Accepts images in digital format for Mac. Send via Zip as TIFF files.
Making Contact & Terms: Contact through rep or send query letter with prints, photocopies, tearsheets. Provide self-promotion piece to be kept on file for possible future assignments. Reports back only if interested, send nonreturnable samples. Simultaneous submissions OK. Credit line given.
Tips:

⊠ $ SURFING MAGAZINE, P.O. Box 3010, San Clemente CA 92672. (714)492-7873. Photo Editor: Larry Moore. Monthly magazine. Circ. 180,000. Emphasizes "surfing and bodyboarding action and related aspects of beach lifestyle. Travel to new surfing areas covered as well. Average age of readers is 17 with 95% being male. Nearly all drawn to publication due to high quality, action packed photographs." Free photo guidelines with SASE. Sample copy free with legal size SAE and 9 first-class stamps.
Needs: Uses about 180 photos/issue; 45% supplied by freelance photographers. Needs "in-tight, front-lit surfing action photos, as well as travel-related scenics. Beach lifestyle photos always in demand."
Specs: Uses 35mm, 2¼×2¼ transparencies; b&w contact sheet and negatives.
Making Contact & Terms: Send samples by mail for consideration. SASE. Reports in 1 month. Pays $750/color cover photo; $30-275/color inside; $20-100/b&w inside; $600/color poster photo. Pays on publication. Buys one-time rights. Credit line given.
Tips: Prefers to see "well-exposed, sharp images showing both the ability to capture peak action, as well as beach scenes depicting the surfing and bodyboarding lifestyle. Color, lighting, composition and proper film usage are important. Ask for our photo guidelines prior to making any film/camera/lens choices."

⊠ $ $⌀ SWANK, 210 Route 4 East, Paramus NJ 07652. (201)843-4004. Fax: (201)843-8636. Circ. 350,000. Estab. 1954. Published 13 times a year magazine. Emphasizes adult entertainment. Readers are mostly male of all backgrounds, ages 22 to 55. Sample copy $6.95. Photo guidelines free with SASE.
Needs: Needs photos of new models for explicit, all nude photo shoots. Reviews photos with or without a ms. Model/property release required.
Specs: Uses color prints, 35mm transparencies.

Making Contact & Terms: Send unsolicited photos by mail for consideration. SASE. Reports in 2 weeks. Average pay for one set $1,800. Rates vary. Pays on publication. Buys all rights.

Tips: "We mostly work with established erotic photographers, but always looking for new talent. Make sure there are enough photos submitted for us to have a good idea of your ability."

$ [S] [▪] Ⓓ TAMPA REVIEW, The University of Tampa, 19F, Tampa FL 33606-1490. E-mail: utpress @alpha.utampa.edu. Editor: Richard B. Mathews. Circ. 750. Estab. 1988. Semiannual literary magazine. Emphasizes literature and art. Readers are intelligent, college level. Sample copy $5. Photo guidelines free with SASE.

Needs: Uses 6 photos/issue; 100% supplied by freelancers. Needs photos of artistic, museum-quality images and landscapes/scenics. Interested in alternative process, avant garde, digital, fine art, regional. Photographer must hold rights, or release. "We have our own release form if needed." Photo captions required.

Specs: Uses b&w, color prints suitable for vertical 6×8 or 6×9 reproduction. Accepts images in digital format for Mac. Send via floppy disk, Zip as TIFF files at 400 dpi.

Making Contact & Terms: Provide résumé, business card, brochure, flier or tearsheets to be kept on file for possible assignments. SASE. Reports in 3 months. Pays $10/image, offers 1 free copy of the review and a 40% discount on additional copies. Pays on publication. Buys first North American serial rights. Credit line given.

Tips: "We are looking for artistic photography, not for illustration, but to generally enhance our magazine. We will consider paintings, prints, drawings, photographs, or other media suitable for printed reproduction. Submissions should be made in February and March for publication the following year."

$ [▪] TENNIS WEEK, 341 Madison Ave., New York NY 10017. (212)808-4750. Fax: (212)983-6302. E-Mail: tennisweek@tennisweek.com. Website: http://www.tennisweek.com. Publisher: Eugene L. Scott. Managing Editors: Heather Holland and Kim Kodl. Circ. 80,000. Biweekly. Readers are "tennis fanatics." Sample copy $4 current issue, $5 back issue.

Needs: Uses about 16 photos/issue. Needs photos of "off-court color, beach scenes with pros, social scenes with players, etc." Emphasizes originality. Subject identification required.

Specs: Uses b&w and color prints. Accepts images in digital format for Mac in EPS-CYMK format. Send via CD, SyQuest, e-mail, Zip, or floppy disk at 270 LPI, 133.

Making Contact & Terms: Send actual 8×10 or 5×7 b&w photos by mail for consideration. Send portfolio via mail or CD-Rom. SASE. Reports in 2 weeks. Pays $50/b&w photo; $150/color cover. Pays on publication. Rights purchased on a work-for-hire basis. Credit line given.

[N] $ TEXAS FISH & GAME, 7600 W. Tidwell, Suite 708, Houston TX 77040. (713)690-3474. Fax: (713)690-4339. Editor: Larry Bozka. Circ. 100,000. Estab. 1983. Magazine published 10 times/year; November/December and June/July are double issues. Features all types of hunting and fishing. Must be Texas only. Photo guidelines free with SASE.

Needs: Uses 20-30 photos/issue; 80% supplied by freelance photographers. Needs photos of fish: action, close up of fish found in Texas; hunting: Texas hunting and game of Texas. Model release preferred. Captions required.

Making Contact & Terms: Query with list of stock photo subjects. SASE. Reports in 1 month. Pays $200-300/color cover and $50-100/color or b&w inside. Pays on publication. Buys one-time rights. Credit line given.

Tips: "Query first. Ask for guidelines. For that 'great' shot, prices will go up. Send best shots and only subjects the publication you're trying to sell uses."

[N] TEXAS MONTHLY, P.O. Box 1569, Austin TX 78767. (512)320-6900. Art Director: D.J. Stout. Assistant Art Director: Kathy Marcus. *Texas Monthly* is edited for the urban Texas audience and covers the state's politics, sports, business, culture and changing lifestyles. It contains lengthy feature articles, reviews and interviews and presents critical analysis of popular books, movies and plays.

Making Contact & Terms: Send samples or tearsheets. No preference on printed material—b&w or color. Call for information on sending portfolios. Reports back only if interested. Keeps samples on file. SASE. Uses about 50 photos/issue.

THIN AIR MAGAZINE, P.O. Box 23549, Flagstaff AZ 86002. (520)523-6743. Fax: (520)523-7074. Website: http://www.nau.edu/~english/thinair/. Circ. 500. Estab. 1995. Biannual magazine. Emphasizes arts and literature—poetry, fiction and essays. Readers are collegiate, academic, writerly adult males and females interested in arts and literature. Sample copy $4.00.

Needs: Uses 2-4 photos/issue; all supplied by freelancers. Needs scenic/wildlife shots and b&w photos

that portray a statement or tell a story. Looking for b&w cover shots. Model/property release preferred for nudes. Captions preferred; include name of photographer, date of photo.

Specs: Uses 8 × 10 b&w prints.

Making Contact & Terms: Send unsolicited photos by mail for consideration. Photos accepted August-May only. Keeps samples on file. SASE. Reports in 3 months. Simultaneous submissions and previously published work OK. Pays with 2 contributor's copies. Buys one-time rights. Credit line given.

$ $⬛◎ TIGER BEAT, TV Movie Screen, Primedia Corp., 233 Park Ave. S, New York NY 10003. (212)780-3500. Fax: (212)780-3555. E-mail: tigerbmail@aol.com. Website: http://www.tigerbeat.com. Editor: Louise Barile. Circ. 250,000. Estab. 1965. *Tiger Beat* is a monthly entertainment magazine for teenage girls interested in young celebrities in movies, music and on TV.

Needs: Buys 30 photos from freelancers/issue; 300 photos/year. Needs photos of young celebrities, fashion/glamour. Reviews photos with or without ms. Model/property release preferred. Photo captions preferred.

Making Contact & Terms: Send query letter with samples. Art director will contact photographer for portfolio review if interested. Does not keep samples on file. Reports in 1 month. Simultaneous submissions and/or previously published work OK. Pays $50 minimum for b&w cover; $50-200 color cover; $35-75 for b&w inside; $50-300 for color inside. Pays on publication. Credit line not given.

Tips: "We are looking for clear, crisp photos of celebrities looking as attractive as possible. Please look at a current issue for the personalities we cover."

$ TIKKUN, 26 Fell St., San Francisco CA 94102. (415)575-1200. Fax: (415)575-1434. E-mail: magazine@tikkun.org. Website: http://www.tikkun.org. Contact: David Van Ness or Jo Ellen Green-Kaiser. Circ. 20,000. Estab. 1986. Bimonthly journal. Publication is a political, social and cultural Jewish critique. Readers are 75% Jewish, white, middle-class, literary people ages 30-60.

Needs: Uses 15 photos/issue; 30% supplied by freelancers. Needs political, social commentary; Middle Eastern; US photos. Reviews photos with or without ms.

Specs: Uses b&w prints. Accepts images in digital format for Mac (Photoshop EPS). Send via Zip disk.

Making Contact & Terms: Send b&w prints or good photocopies. Keeps samples on file. SASE. Reporting time varies. "Turnaround is 4 months, unless artist specifies other." Simultaneous submissions and/or previously published work OK. Pays $50/b&w inside. Pays on publication. Buys all rights; negotiable. Credit line given.

Tips: "Send samples. Look at our magazine and suggest how your photos can enhance our articles and subject material."

TODAY'S MODEL, 37-26 76th St., Jackson Heights NY 11372. (718)651-8523. Fax: (718)651-8863. Publisher: Sumit Arya. Circ. 100,000. Estab. 1993. Monthly magazine. Emphasizes modeling and performing arts. Readers are male and female ages 13-28, parents of kids 1-12.

Needs: Uses various number photos/issue. Needs photos of fashion—studio/on location/runway; celebrity models, performers, beauty and hair—how-to; photojournalism—modeling, performing arts. Reviews photos with or without ms. Needs models of all ages. Model/property release required. Captions preferred; include name and experience (résumé if possible).

Making Contact & Terms: Provide résumé, sample photos, promo cards, business card, brochure, flier or tearsheets to be kept on file for possible future assignments. "Please do not request photo guidelines." Keeps samples on file. Reports only when interested. Considers simultaneous submissions and/or previously published work. Payment negotiable. Pays on publication. Buys all rights; negotiable.

TODAY'S PHOTOGRAPHER INTERNATIONAL, P.O. Box 777, Lewisville NC 27023. Fax: (336)945-3711. Photography Editor: Vonda H. Blackburn. Circ. 131,000. Estab. 1986. Bimonthly magazine. Emphasizes making money with photography. Readers are 90% male photographers. For sample copy, send 9 × 12 SASE. Photo guidelines free with SASE.

Needs: Uses 40 photos/issue; all supplied by freelance photographers. Model release required. Photo captions preferred.

Making Contact & Terms: Send 35mm, 2¼ × 2¼, 4 × 5, 8 × 10 b&w and color prints or transparencies by mail for consideration. SASE. Reports at end of the quarter. Simultaneous submissions and previously published work OK. Payment negotiable. Buys one-time rights, per contract. Credit line given.

Tips: Wants to see "consistently fine-quality photographs and good captions or other associated information. Present a portfolio which is easy to evaluate—keep it simple and informative. Be aware of deadlines. Submit early."

$ ▣ ◯ TOUCH, P.O. Box 7259, Grand Rapids MI 49510. (616)241-5616. Fax: (616)241-5558. E-mail: gemsgccs@iserv.net. Managing Editor: Carol Smith. Circ. 15,500. Estab. 1970. Publication of Gems. Monthly. Emphasizes "girls 9-14 in action. The magazine is a Christian girls' publication geared to the needs and activities of girls in the above age group." Readers are "Christian girls ages 9-14; multiracial." Sample copy and photo guidelines for $1 with 9×12 SASE. "Also available is a theme update listing all the themes of the magazine for one year."
Needs: Uses about 5-6 photos/issue. Needs "photos suitable for illustrating stories and articles: photos of girls aged 9-14 from multicultural backgrounds involved in sports, Christian service and other activities young girls would be participating in." Model/property release preferred.
Specs: Uses 5×7 glossy color prints. Accepts images in digital format for Mac. Send via compact or Zip disk, SyQuest or online as TIFF files.
Making Contact & Terms: Send 5×7 glossy color prints by mail for consideration. SASE. Reports in 2 months. Simultaneous submissions OK. Pays $20-40/photo; $50/cover. Pays on publication. Buys one-time rights. Credit line given.
Tips: "Make the photos simple. We prefer to get a spec sheet or CDs rather than photos and we'd really like to hold photos sent to us on speculation until publication. We select those we might use and send others back. Freelancers should write for our annual theme update and try to get photos to fit the theme of each issue." Recommends that photographers "be concerned about current trends in fashions and hair styles and that all girls don't belong to 'families.' " To break in, "a freelancer can present a selection of his/her photography of girls, we'll review it and contact him/her on its usability."

$ ▣ ◒ ◎ TRACK & FIELD NEWS, 2570 El Camino Real, Suite 606, Mountain View CA 94040. (650)948-8417. Fax: (650)948-9445. E-mail: edit@trackandfieldnews.com. Website: http://www.trackandfieldnews.com. Associate Editor (Features/Photography): Jon Hendershott. Circ. 35,000. Estab. 1948. Monthly magazine. Emphasizes national and world-class track and field competition and participants at those levels for athletes, coaches, administrators and fans. Sample copy free with 9×12 SASE. Free photo guidelines.
Needs: Buys 10-15 photos/issue; 75% of freelance photos on assignment, 25% from stock. Wants on a regular basis, photos of national-class athletes, men and women, preferably in action. "We are always looking for quality pictures of track and field action, as well as offbeat and different feature photos. We always prefer to hear from a photographer before he/she covers a specific meet. We also welcome shots from road and cross-country races for both men and women. Any photos may eventually be used to illustrate news stories in *T&FN*, feature stories in *T&FN* or may be used in our other publications (books, technical journals, etc.). Any such editorial use will be paid for, regardless of whether material is used directly in *T&FN*. About all we don't want to see are pictures taken with someone's Instamatic or Polaroid. No shots of someone's child or grandparent running. Professional work only." Captions required; include subject name, meet date/name.
Specs: Prefers 8×10 glossy b&w prints; 35mm transparencies, although color prints are acceptable. Accepts images in digital format for Mac (limited use). Send via compact disc, online, floppy disk, Zip disk.
Making Contact & Terms: Query with samples or send material by mail for consideration. SASE. Reports in 7-10 days. Pays $25/b&w inside; $60/color inside ($100/interior color, full page); $175/color cover. Payment is made bimonthly. Buys one-time rights. Credit line given.
Tips: "No photographer is going to get rich via *T&FN*. We can offer a credit line, nominal payment and in some cases, credentials to major track and field meets to enable on-the-field shooting. Also, we can offer the chance for competent photographers to shoot major competitions and competitors up close, as well as being the most highly regarded publication in the track world as a forum to display a photographer's talents."

$ ▣ ◒ TRAILER BOATS MAGAZINE, Poole Publications Inc., 20700 Belshaw Ave., Carson CA 90746. (310)537-6322. Fax: (310)537-8735. E-mail: tbmeditors@aol.com. Editor: Jim Hendricks. Circ.

THE INTERNATIONAL MARKETS INDEX, located in the back of this book, lists markets located outside the U.S. by country.

90,000. Estab. 1971. Monthly magazine. "We are the only magazine devoted exclusively to trailerable boats and related activities" for owners and prospective owners. Sample copy $1.25. Free writer's guidelines.

Needs: Uses 15 photos/issue with ms. 95-100% of freelance photography comes from assignment; 0-5% from stock. Scenic (with ms), how-to, humorous, travel (with ms). For accompanying ms, need articles related to trailer boat activities. Photos purchased with or without accompanying ms. "Photos must relate to trailer boat activities. No long list of stock photos or subject matter not related to editorial content." Captions preferred; include location of travel pictures.

Specs: Uses transparencies. Accepts images in digital format for Mac. Send as EPS, TIFF, PIC at 300 dpi.

Making Contact & Terms: Query or send photos or contact sheet by mail for consideration. SASE. Reports in 1 month. Pays per text/photo package or on a per-photo basis. Pays $25-200/color photo; $150-400/cover; additional for mss. **Pays on acceptance.** Buys one-time and all rights; negotiable. Credit line given.

Tips: "Shoot with imagination and a variety of angles. Don't be afraid to 'set-up' a photo that looks natural. Think in terms of complete feature stories; photos and mss. It is rare any more that we publish freelance photos without accompanying manuscripts."

N $ ⑤ ◻ TRANSITIONS ABROAD, 18 Hulst Rd., P.O. Box 1300, Amherst MA 01004. Fax: (413)256-0373. E-mail: trabroad@aol.com. Website: http://www.transitionsabroad.com. Editor: Clay Hubbs. Circ. 20,000. Estab. 1977. Bimonthly magazine. Emphasizes educational and special interest travel abroad. Readers are people interested in cultural travel and learning, living, or working abroad, all ages, both sexes. Sample copy $6.25. Photo guidelines free with SASE.

Needs: Uses 10 photos/issue; all supplied by freelancers. Needs photos in international settings of people of other countries. Each issue has an area focus: January/February—Asia and the Pacific Rim; March/April—Europe and the former Soviet Union; May/June—The Americas and Africa (South of the Sahara); November/December—The Mediterranean Basin and the Near East. Captions preferred.

Specs: Prefers b&w; sometimes uses transparencies.

Making Contact & Terms: Send unsolicited 8 × 10 b&w prints by mail for consideration. SASE. Reports in 6 weeks. Simultaneous submissions and previously published work OK. Pays $35-50/inside; $150/b&w cover. Pays on publication. Buys one-time rights. Credit line given.

Tips: In freelance photographer's samples, wants to see "mostly people in action shots—people of other countries; close-ups preferred for cover. We use very few landscapes or abstract shots. Send black & white prints or color slides by mail."

$ $ $ TRAVEL & LEISURE, 1120 Avenue of the Americas, New York NY 10036. (212)382-5600. Photo Editor: Jim Frankle. Design Director: Pamela Berry. Circ. 1.2 million. Monthly magazine. Emphasizes travel destinations, resorts, dining and entertainment.

Needs: Nature, still life, scenic, sport and travel. Does not accept unsolicited photos. Model release required. Captions required.

Specs: Uses 8 × 10 semigloss b&w prints; 35mm, 2¼ × 2¼, 4 × 5 and 8 × 10 transparencies, vertical format required for cover.

Making Contact & Terms: Query with samples. SASE. Previously published work OK. Pays $200-500/b&w inside; $200-500/color inside; $1,000/cover or negotiated. Sometimes pays $450-1,200/day; $1,200 minimum/complete package. Pays on publication. Buys first world serial rights, plus promotional use. Credit line given.

Tips: Seeing trend toward "more editorial/journalistic images that are interpretive representations of a destination."

$ ⊕ TRAVELLER, 45-49 Brompton Road, London SW3 1DE Great Britain. Phone: (0171)581-0500. Fax: (0171)581-1357. Editor: Jonathan Lorie. Circ. 35,000. Quarterly. Readers are predominantly male, professional, age 35 and older. Sample copy £2.50.

Needs: Uses 30 photos/issue; all supplied by freelancers. Needs photos of travel, wildlife. Reviews photos with or without ms. Captions preferred.

Making Contact & Terms: Send 35mm transparencies. Does not keep samples on file. SASE. Reports in 1 month. Pays £50/color cover; £25/color inside. Pays on publication. Buys one-time rights.

Tips: Looks for "original, quirky shots with impact, which tell a story."

⊕ TRIUMPH WORLD, CH Publications, P.O. Box 75, Tadworth, Surrey KT20 7XF England. Phone: 01895 623612. Fax: 01895 623613. Editor: Tony Beadle. Estab. 1995. Top quality bimonthy magazine for enthusiasts and owners of Triumph cars.

Needs: Buys 60 photos from freelancers/issue. Needs photos of Triumph cars. Reviews photos with or

without ms. Photo captions preferred.

Specs: Uses color and b&w prints; 35mm, 2¼×2¼, 4×5 transparencies.

Making Contact & Terms: Send query letter with samples, tearsheets. Pays 6 weeks after publication. Buys first rights. Credit line given.

Tips: "Be creative—we do not want cars parked on grass or public car parks with white lines coming out from underneath. Make use of great 'American' locations available. Provide full information about where and when subject was photographed."

$ $ ◑ ◎ TROUT: The Voice of America's Trout and Salmon Anglers, 1500 Wilson Blvd., Suite 310, Arlington VA 22209-2404. Fax: (703)284-9400. Website: http://www.tu.org. Editor: Christine Arena. Circ. 98,000. Estab. 1959. Quarterly magazine. Emphasizes conservation, protection, and restoration of North America's trout and salmon species and the streams and rivers they inhabit. Readers are conservation-minded anglers, primarily male, with an average age of 50. Sample copy free with 9×12 SAE and 4 first-class stamps. Photo guidelines free with SASE.

Needs: Uses 25-50 photos/issue; 80% supplied by freelancers. Needs photos of trout and salmon, trout and salmon angling, conservation issues, and river/watershed scenics, as well as authentic examples of environmental degradation (ex. forest logging, eroded streams, livestock grazing, acid rain/air pollution, hydroelectric dams, hard-rock mining and mining pollution, etc.). Special photo needs include endangered species of trout and salmon especially native desert trout species. Pacific and Atlantic salmon. Model/property release required. Captions preferred; include species of fish; if angling shot: location (river/stream, state, name of park or wilderness area). U.S.A. only.

Making Contact & Terms: Query with résumé of credits. Does not keep samples on file. Send non-returnable samples. SASE. Reports in 2 months. Simultaneous submissions OK. Pays $500/color cover; $75-350/color inside; $75-350/b&w inside. Pays on publication. Buys first North American serial rights; negotiable. Credit line given.

Tips: "If the fish in the photo could not be returned to the water alive with a reasonable expectation it would survive, we will not run the photo. The exception is when the photo is explicitly intended to represent 'what not to do.' Our emphasis is on fly fishing; however, we need photos of spin casting on occasion. Send non-returnable samples."

$ $ TURKEY & TURKEY HUNTING, Krause Publications, 700 E. State St., Iola WI 54990-0001. (715)445-2214. Fax: (715)445-4087. E-mail: lovettb@krause.com. Circ. 50,000. Estab. 1983. Magazine published 6 times a year. Provides features and news about wild turkeys and turkey hunting. Sample copies free. Art guidelines free.

Needs: Buys 150 photos/year. Needs action photos of wild turkeys and hunter interaction scenes. Reviews photos with or without ms.

Specs: Uses 35mm transparencies.

Making Contact & Terms: Send query letter with samples. Include SASE for return of material. Reports in 3 months on queries. Pays $300 minimum for color cover; $75 minimum for b&w inside; $260 minimum for color inside. Pays on publication. Buys one-time rights. Credit line given.

$ $ TURKEY CALL, P.O. Box 530, Edgefield SC 29824. Parcel services: 770 Augusta Rd. (803)637-3106. Fax: (803)637-0034. Publisher: National Wild Turkey Federation, Inc. (nonprofit). Editor: Jay Langston. Circ. 160,000. Estab. 1973. Bimonthly magazine. For members of the National Wild Turkey Federation—people interested in conserving the American wild turkey. Sample copy $3 with 9×12 SASE. Contributor guidelines free with SASE.

Needs: Buys at least 50 photos/year. Needs photos of "wild turkeys, wild turkey hunting, wild turkey management techniques (planting food, trapping for relocation, releasing), wild turkey habitat." Captions required.

Specs: Uses 8×10 glossy b&w prints; color transparencies, any format; prefers originals, 35mm accepted.

Making Contact & Terms: Send copyrighted photos to editor for consideration. SASE. Reports in 6 weeks. Pays $35 minimum/b&w photo; maximum $200/inside color; $400/cover. **Pays on acceptance.** Buys one-time rights. Credit line given.

Tips: Wants no "poorly posed or restaged shots, mounted turkeys representing live birds, domestic turkeys representing wild birds or typical hunter-with-dead-bird shots. Photos of dead turkeys in a tasteful hunt setting are considered. Keep the acceptance agreement/liability language to a minimum. It scares off editors and art directors." Sees a trend developing regarding serious amateurs who are successfully competing with pros. "Newer equipment is partly the reason. In good light and steady hands, full auto is producing good results. I still encourage tripods, however, at every opportunity."

TV GUIDE, News America Publications, Inc., Four Radnor Corporate Center, Radnor PA 19088. (610)293-8500. Fax: (610)293-6216. *TV Guide* watches television with an eye for how TV programming affects and reflects society. It looks at the shows, the stars and covers the medium's impact on news, sports, politics, literature, the arts, science, and social issues through reports, profiles, features and commentaries. This magazine uses staff members to shoot photos.

N $ ▣ ◨ ◎ TWISTGRIP, Motorcycle Magazine, High Speed Productions, 1303 Underwood Ave., San Francisco CA 94124-3308. (415)822-3083. Fax: (415)822-8359. E-mail: editor@twistgrip.com. Website: http://www.twistgrip.com. Photo Editor: Nick Cedar. Circ. 70,000. Estab. 1997. "*TWISTGRIP* is a quarterly motorcycle magazine which emphasizes the people and places which make motorcycling interesting and exciting. *TWISTGRIP* is aimed at the enthusiast who wants to read about riders and riding and less about the machinery and market place. *TWISTGRIP* covers all areas of motorcycling and all brands of bikes." Art guidelines available.
Needs: Buys 10-30 photos from freelancers per issue. The "shots" feature in every issue requires photos of interesting or unusual images of motorcycling and/or motorcyclists. Reviews photos with or without a ms. Model release and property release preferred. Photo caption required; include basic who, what, when, where and any further information relevant to the photo.
Specs: Uses 5×7 and 8×10 b&w prints; 35mm, 2¼×2¼, 4×5 transparencies. Accepts images in digital format for Mac. Send via CD, Zip, e-mail as TIFF, EPS files at 260 dpi.
Making Contact & Terms: Send query letter with slides, tearsheets. Does not keep samples on file; include SASE for return of material. Reports in 2 weeks on queries and portfolios. Simultaneous submissions OK. Will not consider work previously published in other motorcycle magazines. Pays $200 minimum for color cover; $25-100 for b&w inside; $25-100 for color inside. Credit line given. Buys one-time rights; negotiable.
Tips: "Read at least two issues. *TWISTGRIP* is a magazine for enthusiasts and fans of motorcycling. Our articles and photos are different from anything else on the U.S. market. Contributors need to see what's been used in the past. Give as much information as possible for captions. Don't send color print film, unless absolutely necessary."

N $ ▣ U. THE NATIONAL COLLEGE MAGAZINE, 1800 Century Park E., Suite 820, Los Angeles CA 90067. (310)551-1381. Fax: (310)551-1659. E-mail: editor@umagazine.com. Website: http://www.umagazine.com. Editor: Frances Huffman. Circ. 1.5 million. Estab. 1987. Monthly magazine. Emphasizes college. Readers are college students at 275 schools nationwide. Sample copy free for 9×12 SAE with 3 first-class stamps.
Needs: Uses 15 photos/issue; all supplied by student freelancers. Needs color feature shots of students, college life and student-related shots. Model release preferred. Captions required that include name of subject, school.
Specs: Uses any size color prints; 35mm, 2¼×2¼, 4×5, 8×10, but prefers color slides. Also uses photo illustrations, collages, etc. Accepts digital images on disk (Mac) or via e-mail, Illustrator or Photoshop. Files should be 220 dpi minimum TIFF or EPS format, CMYK color. Must include all fonts if any used.
Making Contact & Terms: Send unsolicited photos by mail for consideration. Provide résumé or tearsheets to be kept on file for possible assignments. "Send samples and we will commission shots as needed." Keeps sample on file. Reports in 3 weeks. Simultaneous submissions and previously published work OK. Pays $100/color cover photo; $25/color inside photo. Pays on publication. Buys all rights. Credit line given.
Tips: "We look for photographers who can creatively capture the essence of life on campus. Also, we need light, bright photos since we print on newspaper. We are looking for photographers who are college students."

N ▣ UNO MAS MAGAZINE, P.O. Box 1832, Silver Spring MD 20915. Fax: (301)770-3250. E-mail: unomasmag@aol.com. Website: http://www.unomas.com. Editor: Jim Saah. Circ. 3,500. Estab. 1990. Quarterly magazine. Emphasizes pop culture: Music, film, literture, fine art drawings and photography. Readers are male and female, ages 25-40. Sample copy $3. Photo guidelines free with SASE.
Needs: Uses 15-30 photos/issue; half supplied by freelancers. "We publish a wide array of photography: Fine art, documentary, photojournalism, portraiture etc. So the guidelines are wide open. We only ask that you submit b&w images no larger than 11×14." Model/property release preferred. Captions required; include names, place and dates.
Specs: Uses 11×14 or smaller b&w prints; 35mm transparencies; digital format (high-resolution scans on disk). "We will never digitally alter any photo submitted without the photographer's consent."
Making Contact & Terms: Query with résumé of credits. Send unsolicited photos by mail for consideration. Provide résumé, business card, brochure, flier or tearsheets to be kept on file for possible assignments.

Simultaneous submissions and/or previously published work OK. *Uno Mas* is an arts magazine. We pay with issues of the finished magazine; 2 issues to each contributor, more for artists trying to get their work published." Pays on publication. Credit line given. "We also publish photographs on our website. Please state if you rather not have your photographs appear on the web when you submit. Otherwise we may consider publishing them on our website."

$ $◻ US AIRWAYS ATTACHÉ, Pace Communications, 1301 Carolina St., Greensboro NC 27401. (336)378-6065. Fax: (336)378-8278. E-mail: vbnavat@aol.com. Photo Researcher: Veronda Bryk. Circ. 40,000. Estab. 1997. Monthly consumer magazine. "*Attaché* offers 'The Best of the World' to frequent travelers, mainly those in business. Highly visual stories always include a superlative of some sort." Sample copies available for $7.50.

Needs: Buys 50 photos from freelancers per issue; 600 photos per year. Needs photos of celebrities, environment, landscapes/scenics, wildlife, architecture, cities/urban, interiors/decorating, rural, automobiles, entertainment, events, food/drink, hobbies, humor, sports, travel, portraits, product shots/still life, fine art, historical/vintage.

Specs: Uses any size, glossy, matte, color, b&w prints; 35mm, 2¼×¼, 4×5, 8×10 transparencies preferred.

Making Contact & Terms: Send query letter with résumé, tearsheets, stock list, samples. Provide résumé, business card, self-promotion piece to be kept on file for possible future assignments. Reports back only if interested, send nonreturnable samples. Simultaneous submissions and previously published work OK. Pays $700 minimum for b&w cover or color cover; $150-600 for b&w inside; $150-700 for color inside. Credit line given. Buys one-time rights; negotiable.

Tips: "We strive for a beautiful magazine and need images that are sharp and bold. Remember the motto of the publication is 'The Best of the World' and that includes the images we buy."

$◎ V.F.W. MAGAZINE, 406 W. 34th St., Kansas City MO 64111. (816)756-3390. Fax: (816)968-1169. Editor: Richard Kolb. Art Director: Robert Widener. Circ. 2.2 million. Monthly magazine, except July. For members of the Veterans of Foreign Wars (V.F.W.)—men and women who served overseas and their families. Sample copy free with SAE and 2 first-class stamps.

Needs: Photos illustrating features on current defense and foreign policy events, veterans issues and accounts of "military actions of consequence." Photos purchased with or without accompanying ms. Present model release on acceptance of photo. Captions required.

Specs: Uses mostly color prints and transparencies but will consider b&w.

Making Contact & Terms: Query with samples. SASE. Reports in 1 month. Pays $25-50/b&w photo; $35-250/color photo. **Pays on acceptance.** Buys one-time and all rights; negotiable.

Tips: "Go through an issue or two at the local library (if not a member) to get the flavor of the magazine." When reviewing samples "we look for familiarity with the military and ability to capture its action and people. We encourage military photographers to send us their best work while they're still in the service. Though they can't be paid for official military photos, at least they're getting published by-lines, which is important when they get out and start looking for jobs."

VANITY FAIR, Condé Nast Building, 350 Madison Ave., New York NY 10017. (212)880-8800. Photography Director: Susan White. Monthly magazine.

Needs: 50% of photos supplied by freelancers. Needs portraits. Model/property release required for everyone. Captions required for photographer, styles, hair, makeup, etc.

Making Contact & Terms: Contact through rep or submit portfolio for review. Provide résumé, business card, brochure, flier or tearsheets to be kept on file for possible assignments. Reports in 1-2 weeks. Payment negotiable. Pays on publication.

Tips: "We solicit material after a portfolio drop. So, really we don't want unsolicited material."

$◻ VERMONT LIFE, 6 Baldwin St., Montpelier VT 05602. Editor: Tom Slayton. Circ. 85,000. Estab. 1946. Quarterly magazine. Emphasizes life in Vermont: its people, traditions, way of life, farming, industry and the physical beauty of the landscape for "Vermonters, ex-Vermonters and would-be Vermonters." Sample copy $5 with 9×12 SAE. Free photo guidelines.

Needs: Buys 30 photos/issue; 90-95% supplied by freelance photographers, 5-10% from stock. Wants on a regular basis scenic views of Vermont, seasonal (winter, spring, summer, autumn), submitted 6 months prior to the actual season, animal, documentary, human interest, humorous, nature, landscapes, beauty, gardening, sports, photo essay/photo feature, still life, travel and wildlife. "We are using fewer, larger photos and are especially interested in good shots of wildlife, Vermont scenics." No photos in poor taste, nature close-ups, cliches or photos of places other than Vermont. Model/property releases preferred. Captions required.

Specs: Uses 35mm or 2¼×2¼ color transparencies.

Making Contact & Terms: Query first. SASE. Reports in 3 weeks. Simultaneous submissions OK. Pays $500 minimum for color cover; $50-150 for b&w inside; $50-150 for color inside; $400-800 job. Pays on publication. Buys one-time rights; negotiable. Credit line given.

Tips: "We look for clarity of focus; use of low-grain, true film (Kodachrome or Fujichrome are best); unusual composition or subject."

$ $⬛ VERMONT MAGAZINE, 20½ Main St., Middlebury VT 05753. (802)388-8480. Fax: (802)388-8485. E-mail: vtmag@sover.net. Photo Editor: Cronin Sleeper. Circ. 50,000. Estab. 1989. Bimonthly magazine. Emphasizes all facets of Vermont and nature, politics, business, sports, restaurants, real estate, people, crafts, art, architecture, etc. Readers are people interested in Vermont, including residents, tourists and summer home owners. Sample copy $3.50 with 9×12 SAE and 5 first-class stamps. Photo guidelines free with SASE.

Needs: Uses 30-40 photos/issue; 75% supplied by freelance photographers. Needs animal/wildlife shots, travel, Vermont scenics, how-to, portraits, products and architecture. Special photo needs include Vermont activities such as skiing, ice skating, biking, hiking, etc. Model release preferred. Captions required.

Making Contact & Terms: Query with résumé of credits and samples of work. Send 8×10 b&w prints or 35mm or larger transparencies by mail for consideration. Submit portfolio for review. Provide tearsheets to be kept on file for possible assignments. SASE. Reports in 2 months. Previously published work OK, depending on "how it was previously published." Pays $450/color cover; $200/color page rate; $75-200/color or b&w inside; $300/day. Pays on publication. Buys one-time rights and first North American serial rights; negotiable. Credit line given.

Tips: In portfolio or samples, wants to see tearsheets of published work and at least 40 35mm transparencies. Explain your areas of expertise. Looking for creative solutions to illustrate regional activities, profiles and lifestyles. "We would like to see more illustrative photography/fine art photography where it applies to the articles and departments we produce."

VIBE, 215 Lexington Ave., New York NY 10016. (212)448-7300. Fax: (212)448-7400. Circ. 600,000. Estab. 1993. Monthly magazine. Sample copy free. Art guidelines free.

Needs: Buys 5-10 photos from freelancers/issue; 100 photos/year. Needs photos of hip hop artists (candid or formal) and multicultural paparazzi images. Reviews photos with or without a ms. Special photo needs include excellent documentary work on socio-political, multicultural, and unusual original themes. Model release preferred. Photo captions required; include location, dates, names of subjects, motivation of photographer for exploring subject.

Specs: Uses color and b&w prints; 35mm, 2¼×2¼, 4×5, 8×10 transparencies. Accepts images in digital format.

Making Contact & Terms: Send query letter with samples, tearsheets. Provide résumé, business card, self-promotion piece or tearsheets to be kept on file for possible future assignments. Portfolio may be dropped off every Wednesday. Portfolio should include b&w and/or color, prints or tearsheets. "Disc fine but not ideal." Keeps samples on file; cannot return material. Simultaneous submissions OK. **Pays on acceptance.** Buys one-time rights, electronic rights; negotiable. Credit line given.

Tips: "Read our magazine. We're always looking for well-crafted, authentic, stylish, compassionate photography in all genres but especially portraiture, fashion, documentary, digital, still life, and any hybrid combination of these directions. Submit commercial and successful personal work. Examine a year's worth of *Vibe* before submitting. Don't judge us by one issue!! Aspire beyond trends to a level of excellence!"

VIDEOMAKER MAGAZINE, P.O. Box 4591, Chico CA 95927. (916)891-8410. Fax: (916)891-8443. E-mail: editor@videomaker.com. Website: http://www.videomaker.com. Editor: Stephen Muratore. Art Director: Sam Piper. Circ. 150,000. Estab. 1986. Monthly magazine. Emphasizes video production from hobbyist to low-end professional level. Readers are mostly male, ages 25-40. Sample copy free with 9×12 SAE.

Needs: Uses 50-60 photos/issue; 10-15% supplied by freelancers. Subjects include tools and techniques of consumer video production, videomakers in action. Reviews photos with or without ms. Model/property release required. Captions required.

Making Contact & Terms: Send unsolicited photos by mail for consideration; any size or format, color or b&w. SASE. Reports in 1 month. Simultaneous submissions and previously published work OK. Payment negotiable. Pays on publication. Rights negotiable. Credit line given.

$ ⬛ ▣ ⬛ ◉ VIPER MAGAZINE, The Quarterly Magazine for Dodge Viper Enthusiasts, J.R. Thompson Company, 31690 W. 12 Mile Rd., Farmington Hills MI 48334. (248)553-4566. Fax: (248)553-2138. E-mail: jrt@jrthompson.com. Editor-in-Chief: Mark Gianotta. Circ. 15,000. Estab. 1992.

Quarterly magazine published by and for the enthusiasts of the Dodge Viper sports car. Sample copy for $6. Art guidelines free.

Needs: Buys 3-10 photos from freelancers/issue; 12-40 photos/year. Needs photos of "All Viper, only Viper—unless the shot includes another car suffering indignity at the Viper's hands." Reviews photos with or without a ms. "Can always use fresh pro outlooks on racing or pro/amateur series." Model release required; property release preferred for anything not shot in the public domain or in a "news" context. Photo captions required; include names and what's happening.

Specs: 35mm slides preferred. Uses any size color prints; 2¼×2¼, 4×5, 8×10 transparencies. Accepts images in digital format for Mac.

Making Contact & Terms: Send query letter with samples, brochure, stock photo list or tearsheets. Provide résumé, business card, self-promotion piece or tearsheets to be kept on file for possible future assignments. Keeps samples on file; include SASE for return of material. Reports in 3-4 weeks on queries; 2-3 weeks on samples. Simultaneous submissions and/or previously published work OK. Payment varies. **Pays on acceptance.** Buys all rights; negotiable. Credit line given.

Tips: "Know what we want—we don't have time to train anyone. That said, unpublished pro-grade work will probably find a good home here. Send first-class work—not outtakes, have patience; and don't waste our time—or yours. Would like to see less 'buff-book—standard' art and more of a 'fashion' edge."

$ VIRGINIA WILDLIFE, P.O. Box 11104, Richmond VA 23230. (804)367-1000. Editor: Lee Walker. Art Director: Emily Pels. Circ. 55,000. Monthly magazine. Emphasizes Virginia wildlife, as well as outdoor features in general, fishing, hunting and conservation for sportsmen and conservationists. Free sample copy and photo/writer's guidelines.

Needs: Buys 350 photos/year; about 95% purchased from freelancers. Photos purchased with accompanying ms. Needs good action shots relating to animals (wildlife indigenous to Virginia), action hunting and fishing shots, photo essay/photo feature, scenic, human interest outdoors, nature, outdoor recreation (especially boating) and wildlife. Photos must relate to Virginia. Accompanying mss: features on wildlife; Virginia travel; first-person outdoors stories. Pays 15¢/printed word. Model release preferred for children. Property release preferred for private property. Captions required; identify species and locations.

Making Contact & Terms: Send 35mm and 2¼×2¼ or larger transparencies. Vertical format required for cover. SASE. Reports (letter of acknowledgment) within 30 days; acceptance or rejection within 45 days of acknowledgement. Pays $30-50/color inside; $125/cover; $75/back cover. Pays on publication. Buys one-time rights. Credit line given.

Tips: "We don't have time to talk with every photographer who submits work to us, since we do have a system for processing submissions by mail. Our art director will not see anyone without an appointment. In portfolio or samples, wants to see a good eye for color and composition and both vertical and horizontal formats. We are seeing higher quality photography from many of our photographers. It is a very competitive field. Show only your best work. Name and address must be on each slide. Plant and wildlife species should also be identified on slide mount. We look for outdoor shots (must relate to Virginia); close-ups of wildlife."

$ $ ▣ ◗ VISTA, 999 Ponce de Leon Blvd., Suite 600, Coral Gables FL 33134. (305)442-2462. Fax: (305)443-7650. E-mail: vistamag@shadow.net. Website: http://www.vistamagazine.com. Editor: Peter Ekstein. Circ. 1.2 million. Estab. 1985. Monthly newspaper insert. Emphasizes Hispanic life in the US. Readers are Hispanic-Americans of all ages. Sample copy available.

Needs: Uses 10-50 photos/issue; all supplied by freelancers. Needs photos mostly of personalities with story only (celebrities, multicultural, families, events). No "stand-alone" photos. Reviews photos with accompanying ms only. Special photo needs include events in the Hispanic American communities. Model/property release preferred. Captions required.

Specs: Accepts images in digital format for Mac. Send via CD, e-mail, floppy disk, SyQuest, Zip, Jaz (1GB) as TIFF, EPS files at 300 dpi.

Making Contact & Terms: Provide résumé, business card, brochure, flier or tearsheets to be kept on file for possible assignments. Keeps samples on file. SASE. Reports in 3 weeks. Previously published work OK. Pays $300/color cover; $150/color inside; $75/b&w inside; day assignments are negotiated. Pays 25% extra for Web usage. Pays on publication. Buys one-time rights. Credit line given.

THE SUBJECT INDEX, located at the back of this book, lists publications, book publishers, galleries, greeting card companies, stock agencies, advertising agencies and graphic design firms according to the subject areas they seek.

Tips: "Build a file of personalities and events. Hispanics are America's fastest-growing minority."

N $ ⊠ VITALITY MAGAZINE, Toronto's Monthly Wellness Journal, 356 Dupont St., Toronto, Ontario M5R 1V9 Canada. (416)964-0528. Circ. 44,000. Estab. 1989. Toronto's monthly wellness journal highlights natural foods, nutrition, herbal medicine, personal growth, consumer issues, environment, vegetarian food. Sample copies available for $2 (cash only).
Needs: Buys 4-5 photos from freelancers per issue. Needs photos of herbs (closeups), healthy, active people, flowers. Photo captions preferred; include name of herb or flower.
Making Contact & Terms: Send query letter with samples, stock photo list. Keeps samples on file. Reports in 1-2 months on samples. Simultaneous submissions and previously published work OK. Pays $150 maximum (Canadian) cover; $75 maximum (Canadian) for inside. Pays on publication. Credit line given. Buys one-time rights.
Tips: "We like good photos of herbs, flowers, landscapes, vegetarian food that will work in color or black & white (i.e. if you send us a color photo, we may need to scan it into black & white for our purposes.)"

$ VOICE OF SOUTH MARION, P.O. Box 700, Belleview FL 34421. (904)245-3161. E-mail: vosn@a ol.com. Editor: Jim Waldron. Circ. 1,800. Estab. 1969. Weekly tabloid. Readers are male and female, ages 12-65, working in agriculture and various small town jobs. Sample copy $1.
Needs: Uses 15-20 photos/issue; 2 supplied by freelance photographers. Features pictures that can stand alone with a cutline. Captions required.
Making Contact & Terms: Send b&w or color prints by mail for consideration. SASE. Reports in 2 weeks. Pays $10/b&w cover; $5/b&w inside. Pays on publication. Buys one-time rights. Credit line given.

$ ⊠ ▣ ◪ THE WAR CRY, The Salvation Army, 615 Slaters Lane, Alexandria VA 22313. (703)684-5500. Fax: (703)684-5539. E-mail: warcry@usn.salvationarmy.org. Website: http://www.publications.salva tionarmyusa.org. Editor-in-Chief: Lt. Colonel Marlene Chase. Circ. 300,000. Publication of The Salvation Army. Biweekly. Emphasizes the inspirational. Readers are general public and membership. Sample copy free with SASE.
Needs: Uses about 6 photos/issue. Needs "inspirational, scenic, general photos and photos of people that match our themes (write for theme list)."
Specs: Uses color prints and slides. Accepts images in digital format for Mac. Send via CD, SyQuest, floppy disk, Jaz as TIFF, EPS files.
Making Contact & Terms: Send color prints or color slides by mail for consideration. SASE. Reports in 2 weeks. Simultaneous submissions and previously published work OK. Pays up to $200/color cover; $50 maximum for b&w inside; $75 maximum for color inside; payment varies for text/photo package. **Pays on acceptance.** Buys one-time rights. Credit line given "if requested."
Tips: "Write for themes; send a brochure and/or samples. Get a copy of our publication first. We use clear shots, and are trying to merge out of 'posed' stock photography."

$ $ ▣ ◪ WASHINGTONIAN, 1828 L St. NW, Suite 200, Washington DC 20036. (202)296-3600. Fax: (202)785-1822. Website: http://www.washingtonian.com. Photo Editor: Jay Sumner. Monthly city/regional magazine emphasizing Washington metro area. Readers are 40-50, 54% female, 46% male and middle to upper middle professionals. Circ. 160,000. Estab. 1965.
Needs: Uses 75-150 photos/issue; 100% supplied by freelance photographers. Needs photos for illustration, portraits, reportage, tabletop of products, food, restaurants, nightlife, house and garden, fashion, celebrities, landscapes, sports, politics and local and regional travel. Model release preferred; captions required.
Specs: Accepts images in digital format for Mac. Send via SyQuest, Zip, e-mail as TIFF, JPEG files.
Making Contact & Terms: Submit portfolio for review. Provide résumé, business card, brochure, flier or tearsheets to be kept on file for possible assignments. Pays $1,000 for b&w or color cover; $175-500 for b&w or color inside. Buys one-time rights ("on exclusive shoots we share resale"). Credit line given.
Tips: "Read the magazine you want to work for. Show work that relates to its needs. Offer photo-story ideas. Send samples occasionally of new work. We are always happy to look at portfolios. Just call first to make sure I'm in that day."

$ ⒶⒸ THE WATER SKIER, 799 Overlook Dr., Winter Haven FL 33884. (941)324-4341. Fax: (941)325-8259. E-mail: usawaterski@usawaterski.org. Website: http://usawaterski.org. Editor: Greg Nixon. Circ. 30,000. Estab. 1950. Publication of USA Water Ski. Magazine published 9 times a year. Emphasizes water skiing. Readers are male and female professionals ages 20-45. Sample copy $2.50. Photo guidelines available.
Needs: Uses 25-35 photos/issue. 1-5 supplied by freelancers. Needs photos of sports action. Model/

property release required. Captions required.

Making Contact & Terms: Call first. Pays $25-50/b&w photo; $50-150/color photo. Pays on publication. Buys all rights. Credit line given.

$ $ ▣ ◯ WATERCRAFT WORLD, 6420 Sycamore Lane, Maple Grove MN 55369. (612)476-2200. Fax: (612)476-8065. E-mail: editor@watercraftworld.com. Website: http://www.ehlertpowersports.-com. Managing Editor: Matt Gruhn. Circ. 40,000. Estab. 1987. Published 9 times/year. Emphasizes personal watercraft (jet skis). Readers are 95% male, average age 35, boaters, outdoor enthusiasts. Sample copy $3.

Needs: Uses 30-50 photos/issue; 25% supplied by freelancers. Needs photos of jet ski travel, action, technology, race coverage. Model/property release required. Captions preferred.

Specs: Accepts images in digital format for Mac via Jaz, Zip, e-mail as TIFF, EPS, GIF, JPEG files at 300 dpi.

Making Contact & Terms: Query with résumé of credits. Provide résumé, business card, brochure, flier or tearsheets to be kept on file for possible future assignments. "Call with ideas." SASE. Reports in 1 month. Pays $250 maximum for b&w cover; $25-200 for b&w inside; $50-250 for color inside. Pays on publication. Rights negotiable. Credit line given.

Tips: "Call to discuss project. We take and use many travel photos from all over the United States (very little foreign). We also cover many regional events (i.e. charity rides, races)."

$ ◪ WATERWAY GUIDE, 6151 Powers Ferry Rd. NW, Atlanta GA 30339. (770)618-0313. Fax: (770)618-0349. Editor: Judith Powers. Circ. 50,000. Estab. 1947. Cruising guides with 3 annual regional editions. Emphasizes recreational boating. Readers are men and women ages 25-65, management or professional, with average income $95,000 a year. Sample copy $36.95 and $3 shipping. Photo guidelines free with SASE.

Needs: Uses 10-15 photos/issue; all supplied by freelance photographers. Needs photos of boats, Intracoastal Waterway, bridges, landmarks, famous sights and scenic waterfronts. Expects to use more coastal shots from Maine to the Bahamas; also, Hudson River, Lake Champlain and Gulf of Mexico. Model release required. Captions required.

Specs: Uses color prints or 35mm transparencies.

Making Contact & Terms: Send unsolicited photos by mail for consideration. SASE. Reports in 4 months. Pays $600/color cover; $50/color inside. Pays on publication. Credit line given. Must sign contract for copyright purposes.

$ $ $ WESTERN HORSEMAN, P.O. Box 7980, Colorado Springs CO 80933. (719)633-5524. Editor: Pat Close. Monthly magazine. Circ. 230,000. Estab. 1936. Readers are active participants in western horse activities, including pleasure riders, ranchers, breeders and riding club members. Model/property release preferred. Captions required; include name of subject, date, location.

Needs: Articles and photos must have a strong horse angle, slanted towards the western rider—rodeos, shows, ranching, stable plans, training. "We do not buy single photographs/slides; they must be accompanied by an article. The exception: We buy 35mm color slides for our annual cowboy calendar. Slides must depict ranch cowboys/cowgirls at work."

Specs: "For color, we prefer 35mm slides. For b&w, either 5×7 or 8×10 glossies. We can sometimes use color prints if they are of excellent quality."

Making Contact & Terms: Submit material by mail for consideration. Pays $30/b&w photo; $50-75/color photo; $400-800 maximum for articles. For the calendar, pays $125-225/slide. "We buy mss and photos as a package." Payment for 1,500 words with b&w photos ranges from $100-600. Buys one-time rights; negotiable.

Tips: "In all prints, photos and slides, subjects must be dressed appropriately. Baseball caps, T-shirts, tank tops, shorts, tennis shoes, bare feet, etc., are unacceptable."

$ $ ▣ ◪ WESTERN OUTDOORS, 3197-E Airport Loop, Costa Mesa CA 92626. (714)546-4370. E-mail: woutdoors@aol.com. Editor: Jack Brown. Circ. 100,000. Estab. 1961. Magazine published 9 times/year. Emphasizes fishing and boating for Far West states. Sample copy free. Editorial and photo guidelines free with SASE.

Needs: Uses 80-85 photos/issue; 70% supplied by freelancers; 80% comes from assignments, 25% from stock. Needs photos of fishing in California, Oregon, Washington, Baja. "We are moving toward 100% four-color books, meaning we are buying only color photography. A special subject need will be photos of boat-related fishing, particularly small and trailerable boats and trout fishing cover photos." Most photos purchased with accompanying ms. Model/property release preferred for women and men in brief attire. Captions required.

Specs: Uses 35mm transparencies. Accepts images in digital format for Mac.

Making Contact & Terms: Query or send photos for consideration. SASE. Reports in 3 weeks. Pays $50-150/color inside; $300-400/color cover; $400-600 for text/photo package. **Pays on acceptance**. Buys one-time rights for photos only; first North American serial rights for articles; electronic rights are negotiable.

Tips: "Submissions should be of interest to Western fishermen, and should include a 1,120-1,500 word ms; a Trip Facts Box (where to stay, costs, special information); photos; captions; and a map of the area. Emphasis is on fishing and hunting how-to, somewhere-to-go. Submit seasonal material 6 months in advance. Query only; no unsolicited mss. Make your photos tell the story and don't depend on captions to explain what is pictured. Avoid 'photographic cliches' such as 'dead fish with man.' Get action shots, live fish. In fishing, we seek individual action or underwater shots. For cover photos, use vertical format composed with action entering picture from right; leave enough left-hand margin for cover blurbs, space at top of frame for magazine logo. Add human element to scenics to lend scale. Get to know the magazine and its editors. Ask for the year's editorial schedule (available through advertising department) and offer cover photos to match the theme of an issue. In samples, looks for color saturation, pleasing use of color components; originality, creativity; attractiveness of human subjects, as well as fish; above all—sharp, sharp, sharp focus! Send duplicated transparencies as samples, but be prepared to provide originals."

N $ ☐ WHAP! MAGAZINE, Retro Systems, P.O. Box 69491, Los Angeles CA 90069. (323)782-9427. Fax: (323)653-6805. Website: http://www.whapmag.com. Editor: Keri Pentauk. Circ. 20,000. Estab. 1995. Quarterly consumer magazine. "*Whap!* advocates that women take charge of their relationships and train their men to obey them." Sample copies available for $7.95. Art guidelines available for SASE.

Needs: Needs photos of couples. Interested in alternative process, avant garde, erotic, fashion/glamour, fine art, historical/vintage. Reviews photos with or without a ms. Model release required.

Specs: Uses 35mm transparencies.

Making Contact & Terms: Send query letter with slides, prints, photocopies. Does not keep samples on file; include SASE for return of material. Reports in 3 months on queries. Simultaneous submissions and previously published work OK. Pays $100-350 for b&w cover or color cover; $25-100 for b&w inside; $25-100 for color inside. Pays on publication. Credit line given. Buys one-time rights, electronic rights; negotiable.

Tips: "We need fun photos of women disciplining their men. We prefer 1940s and 50s styles and fashion, and no female nudity, gothic s&m, or explicit erotica, please. Please take a look at our unique publication before submitting to us. Either purchase a copy for $7.95, look us up online or find a copy at your local Tower Records or Borders Books."

$ $ ☐ WHERE MAGAZINE, 475 Park Ave. S., Suite 2100, New York NY 10016. (212)725-8100. Fax: (212)725-3412. Website: http://www.wheremag.com. Editor-in-Chief: Lois Anzelowitz-Tanner. Circ. 119,000. Estab. 1936. Monthly. Emphasizes points of interest, shopping, restaurants, theater, museums, etc. in New York City (specifically Manhattan). Readers are visitors to New York staying in the city's leading hotels. Sample copy available in hotels.

Needs: Buys cover photos only. Covers showing New York scenes: celebrities, landscapes/scenics, wildlife, interiors/decorating, entertainment, events, food/drink, travel. Interested in fashion/glamour, seasonal. Other subjects: restaurants, shops, people, moody. Vertical compositions preferred. Model release preferred. Captions preferred.

Making Contact & Terms: Arrange a personal interview to show portfolio. Does not return unsolicited material. Simultaneous submissions and previously published work OK. Pays $300-500/color photo. Pays on publication. Rights purchased vary. Credit line given.

N ☐ ■ WHISKEY ISLAND MAGAZINE, Cleveland State University, Department of English, Cleveland OH 44115. (216)687-2056. Fax: (216)687-6943. E-mail: whiskeyisland@popmail.csuohio.edu. Website: http://www.csuohio.edu/whiskey_island/. Contact: Editor. Circ. 1,000. Estab. 1967. Biannual literary magazine publishing thoughtful, socially conscious, conversation-provoking work. Sample copies for $5. Art guidelines available for SASE.

Needs: Buys 10 photos/issue; 20 photos/year. Needs photos of children, multicultural, teens, disasters, environmental, landscapes/scenics, wildlife, cities/urban, pets, religious, rural, political, science, technology. Interested in alternative process, avant garde, digital, documentary, fine art, seasonal. Looking for work "with spirit and originality. Encourages images with a highly personal/intimate quality. Surreal and abstract are welcome." Reviews photos with or without ms. Model and property release preferred. Photo captions required; include title of work, photographer's name, address, phone number, e-mail, etc.

Specs: Uses b&w prints. Accepts images in digital format for Windows. Send via Zip, e-mail as TIFF files at 300 dpi.

Making Contact & Terms: Send query letter with slides or photocopies. Does not keep samples on file;

include SASE for return of material. Reports in 3 months. Pays 2 copies and a year subscription. Credit line not given.

Tips: "Label all material clearly. Include as much contact information as possible."

WIESNER INC., 7009 S. Potomac, Englewood CO 80112. (303)397-7600 Fax: (303)397-7619. E-mail: rawlings@winc.usa.com. Website: http://www.mtnlivingmag.com. Art Director: Loneta Showell. Consumer magazines. Publishes the following magazines: *Atlanta Homes & Lifestyles*; *Colorado Homes & Lifestyles Magazine*; *Seattle Homes and Lifestyles*; *St. Louis Homes & Lifestyles*; *Mountain Living*; and *Colorado Business*.

Needs: Needs photos of homes, architecture, art, sports and travel.

Making Contact & Terms: Send query letter with samples. Provide résumé, business card, self-promotion piece or tearsheets to be kept on file for possible future assignments. Does not keep samples on file. Reports in 6 weeks on queries. Reports back only if interested, send non-returnable samples. Simultaneous submissions and/or previously published work OK. **Pays on acceptance.**

$ $WINDSURFING, 330 W. Canton Ave., Winter Park FL 32789. (407)628-4802. Fax: (407)628-7061. Editor: Tom James. Managing Editor: Jason Upright. Circ. 75,000. Monthly magazine published 8 times/year. Emphasizes board-sailing. Readers are all ages and all income groups. Sample copy free with SASE. Photo guidelines free with SASE.

Needs: Uses 80 photos/issue; 60% supplied by freelance photographers. Needs photos of boardsailing, flat water, recreational travel destinations to sail. Model/property release preferred. Captions required; include who, what, where, when, why.

Specs: Uses 35mm, $2\frac{1}{4} \times 2\frac{1}{4}$ and 4×5 transparencies. Kodachrome and slow Fuji preferred.

Making Contact & Terms: Query with samples. Send unsolicited photos by mail for consideration. Provide résumé, business card, brochure, flier or tearsheets to be kept on file for possible future assignments. SASE. Reports in 3 weeks. Previously published work OK. Pays $450/color cover; $40-150/color inside. Pays on publication. Buys one-time print rights and all Internet rights. Credit line given.

Tips: Prefers to see razor sharp, colorful images. The best guideline is the magazine itself. "Get used to shooting on, in or under water. Most of our needs are found there."

■ WINE & SPIRITS, 2 West 32nd, Suite 601, New York NY 10001. (212)695-4660, ext. 12. Fax: (212)695-2920. E-mail: winespir@aol.com. Art Director: Michael St. George. Circ. 70,000. Estab. 1985. Bimonthly magazine. Emphasizes wine. Readers are male, ages 39-60, married, parents, children, $70,000 plus income, wine consumers. Sample copy $2.95; September and November special issues $6.50.

Needs: Uses 0-30 photos/issue; all supplied by freelancers. Needs photos of food, wine, travel, people. Captions preferred; include date, location.

Specs: Accepts images in digital format for Mac. Send via SyQuest, Zip disk (266 dpi).

Making Contact & Terms: Submit portfolio for review. Provide résumé, business card, brochure, flier or tearsheets to be kept on file for possible assignments. Reports in 1-2 weeks, if interested. Simultaneous submissions OK. Pays $200-1,000/job. Pays on publication. Buys one-time rights. Credit line given.

N $⟳ WITH, The Magazine for Radical Christian Youth, P.O. Box 347, Newton KS 67114. (316)283-5100. Fax: (316)283-0454. E-mail: deliag@gcmc.org. Editor: Carol Duerksen. Circ. 6,200. Estab. 1968. Magazine published eight times a year. Emphasizes "Christian values in lifestyle, vocational decision making, conflict resolution for US and Canadian high school students." Sample copy free with 9×12 SAE and 4 first-class stamps. Photo and writer's guidelines free with SASE.

Needs: Buys 70 photos/year; 8-10 photos/issue. Buys 80% of freelance photography from assignment; 20% from stock. Documentary (related to concerns of high school youth "interacting with each other, with family and in school environment; intergenerational"); head shot; photo essay/photo feature; scenic; human interest; humorous. Particularly interested in action shots of teens, especially of ethnic minorities. We use some mood shots and a few nature photos. Prefers candids over posed model photos. Few religious shots, e.g., crosses, steeples, etc. Photos purchased with or without accompanying ms and on assignment. For accompanying mss wants issues involving youth—school, peers, family, hobbies, sports, community involvement, sex, dating, drugs, self-identity, values, religion, etc. Model release preferred.

Specs: Uses 8×10 glossy b&w prints.

Making Contact & Terms: Send material by mail for consideration. SASE. Reports in 2 months. Simultaneous submissions and previously published work OK. Pays $40/b&w inside; $50/b&w cover; 5¢/word for text/photo packages, or on a per-photo basis. **Pays on acceptance.** Buys one-time rights. Credit line given.

Tips: "Candid shots of youth doing ordinary daily activities and mood shots are what we generally use. Photos dealing with social problems are also often needed. Needs to relate to teenagers—either include

them in photos or subjects they relate to; using a lot of 'nontraditional' roles, also more ethnic and cultural diversity. Use models who are average-looking, not obvious model-types. Teenagers have enough self-esteem problems without seeing 'perfect' teens in photos."

WOMAN'S DAY SPECIAL INTEREST PUBLICATIONS, Hachette Filipacchi Magazines, 1633 Broadway, New York NY 10019. (212)767-6794. Fax: (212)767-5612. Associate Art Director: Peter Hedrington. Circ. 150,000. Estab. 1970. "*Woman's Day Special Interest Publications* are high-end one subject consumer magazines. 41 issues are produced annually with subjects ranging from food, health, home decorating and remodeling, crafts and Christmas Ideas."
Needs: Buys 50 photos from freelancers/issue; 2,000 photos/year. Needs photos of food, crafts, interiors, kids, gardening, remodeling projects, health, Christmas and holidays. Reviews photos with or without a ms. Model/property release preferred. Photo captions preferred.
Specs: Uses 35mm, 2¼×2¼, 4×5 transparencies.
Making Contact & Terms: Send query letter with samples, tearsheets. Provide résumé, business card, self-promotion piece or tearsheets to be kept on file for possible future assignments. Art director will contact photographer for portfolio review if interested. Portfolio should include tearsheets or transparencies. Keeps samples on file; cannot return material. Reports back only if interested, send non-returnable samples. Simultaneous submissions and/or previously published work OK. Payment negotiable. **Pays on acceptance.** Buys one-time rights. Credit line given.
Tips: "All materials should be tasteful and upscale. Always include card to keep on file and sample that can also be kept. Trends include the use of natural light and simple but sophisticated proping."

$WOODENBOAT MAGAZINE, P.O. Box 78, Brooklin ME 04616. (207)359-4651. Fax: (207)359-8920. Editor: Matthew P. Murphy. Circ. 105,000. Estab. 1974. Bimonthly magazine. Emphasizes wooden boats. Sample copy $4.95. Photo guidelines free with SASE.
Needs: Uses 100-125 photos/issue; 95% supplied by freelancers. Needs photos of wooden boats: in use, under construction, maintenance, how-to. Captions required; include identifying information, name and address of photographer on each image.
Making Contact & Terms: Query with stock photo list. Keeps samples on file. SASE. Reports in 1 month. Simultaneous submissions and/or previously published work OK with notification. Pays $350/day; $350/color cover; $25-125/color inside; $15-75/b&w page rate. Pays on publication. Buys first North American serial rights. Credit line given.

$ $▣ WOODMEN, 1700 Farnam St., Omaha NE 68102. (402)342-1890. Fax: (402)271-7269. E-mail: service@woodmen.com. Website: http://www.woodmen.com. Editor: Scott J. Darling. Assistant Editor: Billie Jo Foust. Circ. 500,000. Estab. 1890. Official publication for Woodmen of the World/Omaha Woodmen Life Insurance Society. Bimonthly magazine. Emphasizes American family life. Free sample copy and photographer guidelines.
Needs: Buys 15-20 photos/year. Needs photos of the following themes: historic, family, insurance, photo essay/photo feature, scenic, human interest, humorous; nature, still life, travel, health and wildlife. Model release required. Captions preferred.
Specs: Uses 8×10 glossy b&w prints on occasion; 35mm, 2¼×2¼ and 4×5 transparencies; 4×5 transparencies for cover, vertical format preferred. SASE. Accepts images in digital format for Mac. Send high res scan via Zip or compact disk.
Making Contact & Terms: Send material by mail for consideration. Reports in 1 month. Previously published work OK. Pays $250 minimum/color inside; $500-600/cover. **Pays on acceptance.** Buys one-time rights. Credit line given on request.
Tips: "Submit good, sharp pictures that will reproduce well."

$WRESTLING WORLD, Sterling/MacFadden, 233 Park Ave. S., New York NY 10003. (212)780-3500. Fax: (212)780-3555. Editor: Stephen Ciacciarelli. Circ. 50,000. Monthly magazine. Emphasizes professional wrestling superstars. Readers are wrestling fans. Sample copy $3.50 with 9×12 SAE and 3 first-class stamps.
Needs: Uses about 60 photos/issue; all supplied by freelance photographers. Needs photos of wrestling superstars, action and posed, color slides and b&w prints.
Making Contact & Terms: Query with representative samples, preferably action. SASE. Reports ASAP. Pays $150/color cover; $75/color inside; $50-125/text/photo package. **Pays on acceptance.** Buys one-time rights. Credit line given on color photos.

N̄ $ $YANKEE MAGAZINE, Main St., Dublin NH 03444. (603)563-8111. Fax: (603)563-8252. Picture Editor: Ann Card. Circ. 700,000. Estab. 1935. Monthly magazine. Emphasizes general interest

within New England. Readers are of all ages and backgrounds, majority are actually outside of New England. Sample copy $1.95. Photo guidelines free with SASE.

Needs: Uses 50 photos/issue; 70% supplied by freelancers (on assignment). Needs environmental portraits, travel, food, still lifes, photojournalistic essays. "Always looking for outstanding photo packages shot in New England." Model/property release preferred. Captions required; include name, locale, pertinent details.

Making Contact & Terms: Submit portfolio for review. Keeps samples on file. SASE. Reports in 1 month. Simultaneous submissions and previously published work OK. Pays $300/day; $100-400/color inside; $100-400/b&w inside; $200/color page rate; $200/b&w page rate. Buys one-time rights; negotiable. Credit line given.

Tips: "Submit only top-notch work. I don't need to see development from student to pro. Show me you can work with light to create exciting images."

$⬛◯◎ YOGA JOURNAL, 2054 University Ave., Suite 600, Berkeley, CA 94704. (510)841-9200. Fax: (510)644-3101. E-mail: jonathan@yogajournal.com. Website: http://www.yogajournal.com. Art Director: Jonathan Wieder. Circ. 108,000. Estab. 1975. Bimonthly magazine. Emphasizes yoga, holistic health, bodywork and massage, meditation, and Eastern spirituality. Readers are female, college educated, median income, $74,000, and median age, 47. Sample copy $5.

Needs: Uses 20-30 photos/issue; 1-5 supplied by freelancers. Needs photos of travel, editorial by assignment. Special photo needs include botanicals, foreign landscapes. Model release preferred. Captions preferred; include name of person, location.

Specs: Uses 35mm, 2¼×2¼, 4×5, 8×10 transparencies. Accepts images in digital format for Mac. Send via CD or Zip as TIFF, EPS files at 300 dpi.

Making Contact & Terms: "Do not send unsolicited original art." Provide samples or tearsheets for files. Keeps samples on file. Reports in 1 month only if requested. Pays $100 maximum for b&w inside; $200 maximum for color inside. **Pays on acceptance**. Buys one-time rights.

Tips: Seeking electronic files or printed samples sent by mail.

Ⓝ $◻ YOU! MAGAZINE, 29963 Mulholland Highway, Agoura Hills CA 91301. (818)991-1813. Fax: (818)991-2024. E-mail: youmag@earthlinc.net. Website: http://www.youmagazine.com. Managing Editor: Katie Mac. Circ. 100,000. Estab. 1987. Monthly tabloid. Emphasizes teen social and moral issues from a Christian/Catholic perspective. Readers are male and female, 13-21. Sample copy $2. Photo guidelines available.

Needs: Uses 50 photos/issue; 20-30 supplied by freelancers. Needs photos of teens in every situation imaginable, close ups, goofy shots, outrageous or funky shots, artsy shots. Also needs celebrities, couples, multicultural, religious, adventure, sports, fashion/glamour. Model release preferred for close-ups.

Specs: Uses any size color or b&w matte or glossy prints; 35mm, 2¼×2¼, 4×5 transparencies. Accepts images in digital format for Windows. Send via Zip.

Making Contact & Terms: Send unsolicited photos by mail for consideration. Keeps samples on file. SASE. Reports in 1 month. Simultaneous submissions and/or previously published work OK. Pays $25-500/color cover; $25-100/color inside; $10-100/b&w inside. Pays on publication. Rights negotiable. Credit line given.

Tips: "We're looking for upbeat, hip, teen-oriented, up close, clear people shots, and action shots. Look at our magazine; give us a call."

Ⓝ $◻◎ YOUNG ROMANTIC, P.O. Box 1264, Huntington WV 25714. Contact: Photography Editor. Circ. 4,000. Estab. 1998. Quarterly. Interested in "anything designed to entertain multicultural and historical romance writers and readers." Sample copies and art guidelines available for SASE (use 2 33¢ stamps).

Needs: Buys 4 photos from freelancers per issue; 16 photos per year. Needs photos of children, couples, multicultural, families, teens, landscapes/scenics, wildlife, alternative process, avant garde, documentary, fine art, historical/vintage, regional, seasonal. "Multicultural and historical romance are the focus of *Young Romantic*. Photographers should consider this fact when sending their work to our publication." Reviews photos with or without a ms. Model and property release preferred. Photo captions preferred.

Making Contact & Terms: Send query letter with résumé, slides, prints, transparencies, stock list or portfolio may be dropped off. Provide résumé, self-promotion piece to be kept on file for possible future assignments. Reports in 1 month on queries. Simultaneous or previously published work OK. Pays $15-150. **Pays on acceptance**. Credit line given. Buys one-time rights, first rights; negotiable.

$⬛◻ YOUR HEALTH, 5401 NW Broken Sound Blvd., Boca Raton FL 33487. (561)989-1176. Fax: (561)241-5689. E-mail: yhealth@aol.com. Website: http://www.yourhealthmag.com. Editor: Susan

Gregg. Photo Editor: Judy Browne. Circ. 40,000. Estab. 1963. Published 8 times a year. Emphasizes healthy lifestyles: aerobics, sports, eating, celebrity fitness plans, plus medical advances and the latest technology. Readers are consumer audience; males and females 20-70. Sample copy free with 9×12 SASE. Call for photo guidelines.

Needs: Uses 40-45 photos/issue; all supplied by freelance photographers. Needs photos depicting lifestyles (babies, children, couples, multicultural, families, parents, senior citizens, teens), nutrition and diet, sports (runners, tennis, hiking, swimming, etc.), food, celebrities, travel, arthritis, back pain, headache, etc. Also any photos illustrating exciting technological or scientific breakthroughs. Model release required.

Specs: Accepts images in digital format for Mac.

Making Contact & Terms: Provide résumé, business card, brochure, flier or tearsheets to be kept on file for possible future assignments, and call to query interest on a specific subject. SASE. Reports in 2 weeks. Simultaneous submissions and previously published work OK. Pay depends on photo size and color. Pays $400 maximum for color cover; $50 maximum for b&w inside; $75 for color inside; $75-150/photo/text package. Pays on publication. Buys one-time rights.

Tips: "Pictures and subjects should be interesting; bright and consumer-health oriented. We are using both magazine-type mood photos, and hard medical pictures. We are looking for different, interesting, unusual ways of illustrating the typical fitness, health nutrition story; e.g. an interesting concept for fatigue, insomnia, vitamins. Send prints or dupes to keep on file. Our first inclination is to use what's on hand."

$ ▣ YOUTH RUNNER MAGAZINE, P.O. Box 1156, Lake Oswego OR 97035. (503)236-2524. Fax: (503)620-3800. E:mail: dank@youthrunner.com. Website: http://www.youthrunner.com. Editor: Dan Kesterson. Circ. 100,000. Estab. 1996. Quarterly magazine and website. Emphasizes track and cross country and road racing for young athletes, 8-18. Sample copy free with 9×12 SASE and 5 first-class stamps. Photo guidelines free with SASE.

Needs: Uses 30-50 photos/issue. Needs action shots from track and cross country meets and indoor meets. Model release preferred. Property release required. Captions preferred.

Specs: Uses color transparencies, b&w prints. Accepts images in digital format.

Making Contact & Terms: Send unsolicited photos by mail for consideration. Provide résumé, business card, brochure, flier or tearsheets to be kept on file for possible assignments. Call. SASE. Reports in 1 month. Simultaneous submissions OK. Payment $25 minimum. Buys all and electronic rights. Credit line given.

$ YOUTH UPDATE, St. Anthony Messenger Press, 1615 Republic St., Cincinnati OH 45210. (513)241-5615. Fax: (513)241-0399. Art Director/Youth Update: June Pfaff Daley. Circ. 27,000. Estab. 1982. Company publication. Monthly 4-page, 3-color newsletter. Emphasizes topics for teenagers (13-19) that deal with issues and practices of the Catholic faith but also show teens' spiritual dimension in every aspect of life. Readers are male and female teenagers in junior high and high school. Sample copy free with SASE.

Needs: Uses 2 photos/issue; 2 supplied by freelancers. Needs photos of teenagers in a variety of situations. Model/property release preferred. Captions preferred.

Specs: Uses b&w prints.

Making Contact & Terms: Query with stock photo list. Send unsolicited photos by mail for consideration. Provide résumé, business card, brochure, flier or tearsheets to be kept on file for possible future assignments. Keeps samples on file. SASE. Reports in 1 month. Simultaneous submissions and/or previously published work OK. Pays $75-90/hour; $200-300/job; $50/b&w cover; $50/b&w inside. Buys one-time rights. Pays on publication.

NEWSPAPERS & NEWSLETTERS

When working with newspapers always remember that time is of the essence. Newspapers have various deadlines for each section that is produced. An interesting feature or news photo has a better chance of getting in the next edition if the subject is timely and has local appeal. Most of the markets in this section are interested in regional coverage. Find publications near you and contact editors to get an understanding of their deadline schedules.

Also, ask editors if they prefer certain types of film or if they want color slides or black and white prints. Many smaller newspapers do not have the capability to run color images, so black and white prints are preferred. However, color slides can be converted to black and white. Editors who have the option of running color or black and white photos often prefer color film because of its versatility.

Although most newspapers rely on staff photographers, some hire freelancers as stringers for

certain stories. Act professionally and build an editor's confidence in you by supplying innovative images. For example, don't get caught in the trap of shooting "grip-and-grin" photos when a corporation executive is handing over a check to a nonprofit organization. Turn the scene into an interesting portrait. Capture some spontaneous interaction between the recipient and the donor. By planning ahead you can be creative.

When you receive assignments, think about the image before you snap your first photo. If you are scheduled to meet someone at a specific location, arrive early and scout around. Find a proper setting or locate some props to use in the shoot. Do whatever you can to show the editor that you are willing to make that extra effort.

Always try to retain resale rights to shots of major news events. High news value means high resale value, and strong news photos can be resold repeatedly. If you have an image with national appeal, search for larger markets, possibly through the wire services. You also may find buyers among national news magazines, such as *Time* or *Newsweek*.

While most newspapers offer low payment for images, they are willing to negotiate if the image will have a major impact. Front page artwork often sells newspapers, so don't underestimate the worth of your images.

$ 🖂 ALBERTA SWEETGRASS, Aboriginal Multi Media Society of Alberta, 15001 112 Ave., Edmonton, Alberta T5M 2V6 Canada. (403)455-2945. Fax: (403)455-7639. E-mail: edsweet@ammsa.com. Website: http://www.ammsa.com. Editor: Marie Rourke. Circ. 8,000. Estab. 1983. Monthly newspaper with emphasis on Aboriginal issues in Alberta i.e. native arts, crafts, sports, community events, powwows and news issues. Sample copy free. Art guidelines free.
Needs: Needs any human interest photos depicting Aboriginal lifestyles or events. Special photo needs include cultural photos of Aboriginal special events, powwows, round dances, or Aboriginal dignitaries for picture library file. Photo captions required; include name, age, place, date and Aboriginal background (what first nation or reserve they are from).
Specs: Uses color prints and 35mm transparencies.
Making Contact & Terms: Provide résumé, business card, self-promotion piece or tearsheets to be kept on file for possible future assignments. "Photographers should also telephone us." SASE. Reports in 1 month on queries. Previously published work OK. Pays $50 maximum/color cover; $15 maximum/b&w inside; $15 maximum/color inside. Pays on publication. Buys all rights. Credit line given.
Tips: "We want photos that focus on events that are taking place away from a main event, i.e., people getting ready for a powwow as well as the powwow itself. Cute kids are always good. When submitting your work, get it in on time with time to spare. Include all information for the cutline and make sure names are correct."

Ⓝ $ Ⓐ ▣ ◑ ◎ AMERICAN METAL MARKET, Cahners Business Information, 350 Hudson St., New York NY 10014. (212)519-7200. Fax: (212)519-7520. Website: http://www.amm.com. Editor-in-chief: Gloria LaRue. Contact: Joe Innace, managing editor. Circ. 11,500. Estab. 1882. Daily newspaper. Emphasizes metals production and trade. Readers are top level management (CEOs, chairmen, and presidents) in metals and metals-related industries. Sample copies free with 10×13 SASE.
Needs: 90% of photos supplied by freelancers. Needs photos of press conferences, executive interviews, industry action shots and industry receptions. Photo captions required.
Specs: Accepts images in digital format for Windows. Send as TIFF files.
Making Contact & Terms: Provide résumé, business card, brochure, flier or tearsheets to be kept on file for possible assignments. Cannot return material. Simultaneous submissions OK. Payment negotiable. Buys all rights; negotiable. Credit line given.
Tips: "We tend to avoid photographers who are unwilling to release all rights. We produce a daily newspaper and maintain a complete photo file. We cover events worldwide and often need to hire freelance photographers. Best bet is to supply business card, phone number and any samples for us to keep on file. Keep in mind action photos are difficult to come by. Much of the metals industry is automated and it has become a challenge to find good 'people' shots."

$ $ 🖾 AMERICAN SPORTS NETWORK, Box 6100, Rosemead CA 91770. (626)292-2222. Website: http://www.fitnessamerica.com or http://www.musclemania.com. President: Louis Zwick. Associate Producer: Ron Harris. Circ. 873,931. Publishes 4 newspapers covering "general collegiate, amateur and professional sports, i.e., football, baseball, basketball, wrestling, boxing, powerlifting and bodybuilding, fitness, health contests, etc."

Needs: Uses about 10-85 photos/issue in various publications; 90% supplied by freelancers. Needs "sport action, hard-hitting contact, emotion-filled photos. Publishes special bodybuilder annual calendar, collegiate and professional football pre-season and post-season editions." Model release and captions preferred.
Audiovisual Needs: Uses film and video.
Making Contact & Terms: Send 8×10 glossy b&w prints, 4×5 transparencies, video demo reel or film work by mail for consideration. Provide résumé, business card, brochure, flier or tearsheets to be kept on file for possible future assignments. SASE. Reports in 1 week. Simultaneous submissions and previously published work OK. Pays $1,400/color cover; $400/inside b&w; negotiates rates by the job and hour. Pays on publication. Buys first North American serial rights.

ARIZONA BUSINESS GAZETTE, Box 194, Phoenix AZ 85001. (602)444-7300. Fax: (602)444-7363. Editor: Lucy Scott. Circ. 8,000. Estab. 1880. Weekly newspaper.
Needs: 25% of photos come from assignments. Specializes in real estate and law. Model release preferred. Captions required; include name, title and photo description.
Making Contact & Terms: Provide résumé, business card, brochure, flier or tearsheets to be kept on file for possible assignments. Cannot return unsolicited material. Reports when possible. Does not consider simultaneous submissions or previously published work. Pays $90/shoot. Pays on publication. Buys one-time rights.
Tips: "Photographers should live in Arizona and have some newspaper experience."

 ASBO INTERNATIONAL, 11401 N. Shore Dr., Reston VA 20190. (703)478-0405. Fax: (703)478-0205. Publications Coordinator: Katherine Jones. Estab. 1924. Professional association. Photos used in newspapers, magazines, press releases and catalogs.
Needs: Buys 12 photos/year; offers 12 assignments/year. School or business-related photos. Reviews stock photos.
Specs: Uses 5×7 glossy b&w prints; 2¼×2¼ and 4×5 transparencies.
Making Contact & Terms: Query with samples. Works with local freelancers only. Keeps samples on file. SASE. Reports in 3 weeks. Payment negotiable. Pays on acceptance depending upon usage. Buys one-time or all rights; negotiable.

$ BIG APPLE PARENT, Family Communications, Inc. 9 E. 38th St., 4th Floor, New York NY 10016. (212)889-6400. E-mail: parentspaper@mindspring.com. Managing Editor: Helen Freedman. Circ. 62,000. Estab. 1985. Monthly newspaper. Sample copy free.
Needs: Buys 1-2 photos from freelancers/issue; 15 photos/year. Needs photos of kids and family themes. Reviews photos with or without a ms. Model release required.
Specs: Uses color, b&w prints; 35mm transparencies.
Making Contact & Terms: "We need photocopies of available photos to keep on file." Keeps samples on file; include SASE for return of material. Reports in 1 week on samples. Simultaneous submissions and previously published work OK. Pays $30/b&w inside maximum. Pays at the end of month following publication. Buys one-time New York City rights.
Tips: "All kid and family themes are possible for us—from infant through teen. We are always looking for photos to illustrate our articles. Candid shots are best. We don't use portraiture. Our approach is journalistic. Send us photocopies of your photos that we can keep on file. Make sure your name, address and phone number is on every copy as we catalog according to theme. If your photo fits a particular story, we'll call you."

$ S CAPPER'S, 1503 SW 42nd St., Topeka KS 66609-1265. (800)678-5779, ext. 4346. Fax: (800)274-4305. Editor: Ann Crahan. Circ. 240,000. Estab. 1879. Biweekly tabloid. Emphasizes human-interest subjects. Readers are "mostly Midwesterners in small towns and on rural routes." Sample copy $1.95.
Needs: Uses about 20-25 photos/issue, 1-3 supplied by freelance photographers. "We make no photo assignments. We select freelance photos with specific issues in mind." Needs "35mm color slides or larger

transparencies of human-interest activities, nature (scenic), etc., in bright primary colors. We often use photos tied to the season, a holiday or an upcoming event of general interest." Captions necessary.

Making Contact & Terms: "Send for guidelines and a sample copy (SAE, 85¢ postage). Study the types of photos in the publication, then send a sheet of 10-20 samples with caption material for our consideration. Although we do most of our business by mail, a phone number is helpful in case we need more caption information. Phone calls to try to sell us on your photos don't really help." Reporting time varies. Pays $10-15/b&w photo; $10-40/color photo; only cover photos receive maximum payment. Pays on publication. Buys one-time rights. Credit line given.

Tips: "Generally, we're looking for photos of everyday people doing everyday activities. If the photographer can present this in a pleasing manner, these are the photos we're most likely to use. Seasonal shots are appropriate for *Capper's*, but they should be natural, not posed. We steer clear of dark, mood shots; they don't reproduce well on newsprint. Most of our readers are small town or rural Midwesterners, so we're looking for photos with which they can identify. Although our format is tabloid, we don't use celebrity shots and won't devote an area much larger than 5×6 to one photo."

$ [S] ○ CATHOLIC HEALTH WORLD, 4455 Woodson Rd., St. Louis MO 63134. (314)427-2500. Fax: (314)427-0029. Editor: Sandy Gilfillan. Circ. 11,500. Estab. 1985. Publication of Catholic Health Association. Semimonthly newspaper emphasizing health care—primary subjects deal with our member facilities. Readers are hospital and long-term care facility administrators, health system CEO's, spiritual caregivers, public relations staff people. Sample copy free with 9×12 SASE.

Needs: Uses 4-15 photos/issue; 1-2 supplied by freelancers. Any photos that would help illustrate health concerns (i.e., care of the poor, pregnant teens, elderly). Model release required.

Specs: Uses 5×7 or 8×10 b&w and color glossy prints.

Making Contact & Terms: Send unsolicited photos by mail for consideration. SASE. Reports in 2 weeks. Simultaneous submissions OK. Pays $40-60/photo. Pays on publication. Buys one-time rights for print and web publication. Credit line given.

[N] $ [⊕] [S] [■] ○ CHRISTIAN HERALD, Christian Media Centre, 96 Dominion Rd., Worthing, West Sussex BN1W 8JP England. Phone: (44)1903-821082. Fax: (44)1903-821081. E-mail: news@christia nherald.org.uk. Website: http://www.christianherald.org.uk. Circ. 18,806. Estab. 1800. Weekly. "Evangelical Christian newspaper." Sample copies with first-class postage.

Needs: Needs photos of celebrities, children, couples, families, parents, senior citizens, teens, religious, health/fitness, travel. Reviews photos with or without a ms. Model and property release required. Photo caption required.

Specs: Uses color or b&w prints; 35mm transparencies. Accepts images in digital format for Windows as JPEG files.

Making Contact & Terms: Send query letter with prints. Keeps samples on file. Reports in 1 month on queries. Pays £5-20 depending on size used. Pays on publication. Credit line given. Buys one-time rights.

Tips: "Read our magazine. Include (on each photo) details of subject, name and address of photographer. Also include return postage."

[N] $ [⊕] [◎] THE CHURCH OF ENGLAND NEWSPAPER, 10 Little College St., London SW1P 3SM United Kingdom. Phone: (44)171 878 1545. Fax: (44)171 976 0783. E-mail: colin.blakely@parlicom. com. News Editor: Andrew Carey. Circ. 12,000. Estab. 1828. Weekly religious newspaper. Sample copies available.

Needs: Buys 2-3 photos from freelancers per issue; 100 photos per year. Needs political photos. Reviews photos with or without a ms. Photo caption required.

Specs: Uses glossy, color prints; 35mm transparencies.

Making Contact & Terms: Does not keep samples on file; include SASE for return of material. Reports in 1 month on queries. Reports back only if interested, send nonreturnable samples. Pays on publication. Credit line given. Buys one-right rights.

[♡] COMPIX PHOTO AGENCY, 3621 NE Miami Court, Miami FL 33137. (305)576-0102. Fax: (305)576-0064. President: Alan J. Oxley. Estab. 1986. News/feature syndicate. Has 1 million photos. Clients include: mostly magazines and newspapers.

Needs: Wants news photos and news/feature picture stories, human interest, celebrities and stunts. Photo captions required; include basic journalistic info.

Specs: Uses 35mm, 2¼×2¼, 4×5, 8×10 transparencies.

Making Contact & Terms: "Send us some tearsheets. Don't write asking for guidelines." Pays 50% commission.

Tips: "This is an agency for the true picture journalist, not the ordinary photographer. We are an interna-

tional news service which supplies material to major magazines and newspapers in 30 countries. We shoot hard news, feature stories, celebrities, royalty, stunts, animals and things bizarre. We offer guidance, ideas and assignments but work *only* with experienced, aggressive photojournalists who have good technical skills and can generate at least some of their own material."

THE FRONT STRIKER BULLETIN, P.O. Box 18481, Asheville NC 28814. (828)254-4487. Fax: (828)254-1066. E-mail: bill@matchcovers.com. Website: http://www.matchcovers.com. Owner: Bill Retskin. Circ. 600. Estab. 1986. Publication of The American Matchcover Collecting Club. Quarterly newsletter. Emphasizes matchcover collecting. Readers are male, blue collar workers, average age 55 years. Sample copy $4.00
Needs: Uses 2-3 photos/issue. Needs table top photos of older match covers or related subjects. Reviews photos with accompanying ms only.
Specs: Uses 5×7 matte b&w prints.
Making Contact & Terms: Send unsolicited photos by mail for consideration. Keeps samples on file. SASE. Reports in 1 month. Payment negotiable. Pays on publication. Buys one-time rights; negotiable. Credit line given.

$ $☑ GLOBE, Dept. PM, 5401 NW Broken Sound Blvd., Boca Raton FL 33487. Photo Editor: Ron Haines. Circ. 2 million. Weekly tabloid. "For everyone in the family. *Globe* readers are the same people you meet on the street, and in supermarket lines—average, hard-working Americans."
Needs: Celebrity photos only!!!
Making Contact & Terms: Send transparencies or prints for consideration. Color preferred. SASE. Reports in 1 week. Pays $75/b&w photo (negotiable); $125/color photo (negotiable); day and package rates negotiable. Buys first serial rights. Pays on publication unless otherwise arranged.
Tips: "Do **NOT** write for photo guidelines. Study the publication instead."

$ Ⓐ ☑ GRAND RAPIDS BUSINESS JOURNAL, 549 Ottawa NW, Grand Rapids MI 49503. (616)459-4545. Fax: (616)459-4800. Editor: Carole Valade. Circ. 6,000. Estab. 1983. Weekly tabloid. Emphasizes West Michigan business community. Sample copy $1.
Needs: Uses 10 photos/issue; 100% supplied by freelancers. Needs photos of local community, manufacturing, world trade, stock market, etc. Model/property release required. Captions required.
Making Contact & Terms: Query with résumé of credits. Query with stock photo list. SASE. Reports in 1 month. Simultaneous submissions and previously published work OK. Pays $25-35/b&w cover; $35/color inside; $25/b&w inside. Pays on publication. Buys one-time rights and first North American serial rights; negotiable. Credit line given.

$ INSIDE TEXAS RUNNING, Dept. PM, 9514 Bristlebrook, Houston TX 77083. (281)498-3208. Fax: (281)879-9980. E-mail: insidetx@aol.com. Website: http://www.runningnetwork.com/texasrunning. Publisher/Editor: Joanne Schmidt. Circ. 10,000. Estab. 1977. Tabloid published 10 times/year. Readers are Texas runners and joggers of all abilities. Sample copy for 9 first-class stamps.
Needs: Uses about 16 photos/issue; 10 supplied by freelancers; 80% percent of freelance photography in issue comes from assignment from freelance stock. Needs photos of "races, especially outside of Houston area; scenic places to run; how-to (accompanying articles by coaches); also triathlon and road races." Special needs include "top race coverage; running camps (summer); variety of Texas running terrain." Captions preferred.
Making Contact & Terms: Send glossy b&w or color prints by mail for consideration. SASE. Reports in 1 month. Simultaneous submissions outside Texas and previously published work OK. Pays $10-25/b&w or color inside; $10-50/color cover. Pays on publication. Buys one-time rights; negotiable. Credit line given.
Tips: Prefers to see "human interest, contrast and good composition" in photos. Must use color prints for covers. "Look for the unusual. Race photos tend to look the same." Wants "clear photos with people near front; too often photographers are too far away when they shoot and subjects are a dot on the landscape." Wants to see road races in Texas outside of Houston area.

INTERNATIONAL PUBLISHING MANAGEMENT ASSOCIATION, 1205 W. College St., Liberty MO 64068-3733. (816)781-1111. Fax: (816)781-2790. E-mail: ipmainfo@ipma.org. Website: http://www.ipma.org. Membership association for corporate publishing professionals. Photos used in brochures and newsletters.
Needs: Buys 5-10 photos/year. Subject needs: equipment photos, issues (i.e., soy ink, outsourcing), people. Reviews stock photos. Captions preferred (location).
Specs: Uses 5×7 b&w prints.

Making Contact & Terms: Query with stock photo list. Provide résumé, business card, brochure, flier or tearsheets to be kept on file for possible future assignments. Keeps samples on file. SASE. Reports in 3 weeks. Payment negotiable. Pays on usage.Buys one-time rights. Credit line given.

INTERNATIONAL RESEARCH & EDUCATION (IRE), 21098 IRE Control Center, Eagan MN 55121-0098. (612)888-9635. Fax: (612)888-9124. IP Director: George Franklin, Jr. IRE conducts in-depth research probes, surveys, and studies to improve the decision support process. Company conducts market research, taste testing, brand image/usage studies, premium testing, and design and development of product/service marketing campaigns. Photos used in brochures, newsletters, posters, audiovisual presentations, annual reports, catalogs, press releases and as support material for specific project/survey/reports.
Needs: Buys 75-110 photos/year; offers 50-60 assignments/year. "Subjects and topics cover a vast spectrum of possibilities and needs." Model release required.
Audiovisual Needs: Uses freelance filmmakers to produce promotional pieces for 16mm or videotape or CD's.
Making Contact & Terms: Provide résumé, business card, brochure, flier or tearsheets to be kept on file for possible future assignments. "Materials sent are put on optic disk for options to pursue by project managers responsible for a program or job." Works on assignment only. Uses prints (15% b&w, 85% color), transparencies and negatives. Cannot return material. Reports when a job is available. Payment negotiable; pays on a big, per job basis. Credit line given. Buys all rights.
Tips: "We look for creativity, innovation and ability to relate to the given job and carry out the mission accordingly."

KEYSTONE PRESS AGENCY, INC., 202 E. 42nd St., New York NY 10017. (212)924-8123. E-mail: balpert@worldnet.att.net. Managing Editor: Brian F. Alpert. Types of clients: book publishers, magazines and major newspapers.
Needs: Uses photos for slide sets. Subjects include: photojournalism. Reviews stock photos/footage. Captions required.
Specs: Uses 8×10 glossy b&w and color prints; 35mm and 2¼×2¼ transparencies.
Making Contact & Terms: Cannot return material. Reports upon sale. Payment is 50% of sale per photo. Credit line given.

$ THE LAWYERS WEEKLY, 75 Clegg Rd., Markham, Ontario L6G 1A1 Canada. (905)479-2665. Fax: (905)479-3758. E-mail: tlw@butterworths.ca. Website: http://www.butterworths.ca/tlw.htm. Editorial Assistant: Mirella Pulera. Circ. 6,300. Estab. 1983. Weekly newspaper. Emphasizes law. Readers are male and female lawyers and judges, ages 25-75. Sample copy $8. Photo guidelines free with SASE.
Needs: Uses 12-20 photos/issue; 5 supplied by freelancers. Needs head shot photos of lawyers and judges mentioned in story.
Specs: Accepts images in digital format (JPEG, TIFF).
Making Contact & Terms: Provide résumé, business card, brochure, flier or tearsheets to be kept on file for possible assignments. Deadlines: 1-2 day turnaround time. Does not keep samples on file. SASE. Reports only when interested. **Pays on acceptance.** Credit line not given.
Tips: "We need photographers across Canada to shoot lawyers and judges on an as-needed basis. Send a résumé and we will keep your name on file. Mostly black & white work."

N $ THE LEADER, 4818 Turney Rd., Garfield Heights OH 44125. (216)883-0300. Fax: (216)883-0301. Editor: Troy Cefaratti. Circ. 3,000. Estab. 1946. Weekly newspaper. Local newspaper serving Garfield Heights, Brooklyn Heights, Cuyahoga Heights, Valley View and surrounding communities in Ohio. Samples copies available for $1 and SAE with $1 first-class postage.
Needs: "Needs photos of local interest to our readers. Basically anything that happens in the cities we cover." Subjects include photos of babies, celebrities, children, couples, multicultural, families, parents, senior citizens, teens, disasters, landscapes/scenics, education, religious, entertainment, events, performing arts, sports, military, political, portraits, regional, seasonal. Reviews photos with or without a ms. Model release preferred. Photo caption required; identify all people and what they are doing. Include date and location of event.
Specs: Uses at least 4×6, glossy, matte, color and b&w. "We can accept color prints, but we publish in black and white." Accepts images in digital format for Windows. Send via CD, floppy disk, Zip as TIFF, JPEG files at 300 dpi.
Making Contact & Terms: Send query letter with résumé, prints. Portfolio may be dropped off every Monday through Friday. Provide résumé. Reports in 1 month on queries; 1 week on portfolios. Pays $30

maximum for b&w cover; $20 maximum for b&w inside. Pays on publication. Credit line given. Buys all rights; negotiable.

Tips: "We need local photographers who can cover assignments on short notice and deliver quality photographs with complete and accurate photo captions."

$ A ▣ ◐ THE LOG NEWSPAPERS, 2924 Emerson, Suite 200, San Diego CA 92106. (619)226-6140. Fax: (619)226-1037. E-mail: log1edit@aol.com. Website: http://www.thelog.com. Editor: Robb Marshall. Circ. 65,000. Estab. 1971. Biweekly newspaper. Emphasizes recreational boating.

Needs: Uses 20-25 photos/issue; 75% supplied by freelancers. Needs photos of marine-related, historic sailing vessels, sailing/boating in general. Model/property release preferred for up-close people, private yachts. Captions required; include location, name and type of boat, owner's name, race description if applicable.

Specs: Uses 4×6 or 8×10 glossy color or b&w prints; 35mm transparencies; digital format on TIFF or EPS files.

Making Contact & Terms: Provide résumé, business card, brochure, flier or tearsheets to be kept on file for possible assignments. Keeps samples on file. SASE. Reports in 1 month. Simultaneous submissions and/or previously published work OK. Pays $75/color cover; $25/b&w inside. Pays on publication. Buys all rights; negotiable. Credit line given.

$ MILL CREEK VIEW, 16212 Bothell-Everett Hwy., Suite F-313, Mill Creek WA 98012-1219. (425)357-0549. Fax: (425)357-1639. Publisher: F.J. Fillbrook. Newspaper.

Needs: Photos for news articles and features. Captions required.

Specs: Uses 4×6 matte b&w prints.

Making Contact & Terms: Submit portfolio for review. Send unsolicited photos by mail for consideration. Provide résumé, business card, brochure, flier or tearsheets to be kept on file for possible assignment. Keeps samples on file. SASE. Reports in 1 month. Pays $10-25/b&w photo. Pays on publication. Credit line given.

$ MISSISSIPPI PUBLISHERS, INC., 201 S. Congress St., Jackson MS 39205. (601)961-7073. Photo Editor: J.D. Schwan. Circ. 115,000. Daily newspaper. Emphasizes photojournalism: news, sports, features, fashion, food and portraits. Readers are in a very broad age range of 18-70 years; male and female. Sample copy for 11×14 SAE and 54¢.

Needs: Uses 10-15 photos/issue; 1-5 supplied by freelance photographers. Needs news, sports, features, portraits, fashion and food photos. Special photo needs include food and fashion. Model release and captions required.

Specs: Uses 8×10 matte b&w and color prints; 35mm, 2¼×2¼ transparencies.

Making Contact & Terms: Provide résumé, business card, brochure, flier or tearsheets to be kept on file for possible assignments. SASE. Reports 1 week. Pays $50-100/color cover; $25-50/b&w cover; $25/b&w inside; $20-50/hour; $150-400/day. Pays on publication. Buys one-time or all rights; negotiable. Credit line given.

$ MODEL NEWS, 244 Madison Ave., Suite 393, New York NY 10016-2817. (212)969-8715. Publisher: John King. Circ. 288,000. Estab. 1975. Monthly newspaper. Emphasizes celebrities and talented models, beauty and fashion. Readers are male and female, ages 15-80. Sample copy $2.00 with 8×10 SAE and 1 first-class stamp. Photo guidelines $2.00.

Needs: Uses 1-2 photos/issue; 1-2 supplied by freelancers. Reviews photos with accompanying ms only. Special photo needs include new celebrities, famous faces, VIP's, old and young, events and entertainment. Model release preferred. Captions preferred.

Specs: Uses 8×10 b&w prints.

Making Contact & Terms: Contact through rep or arrange personal interview to show portfolio. Submit portfolio for review. Provide résumé, business card, brochure, flier or tearsheets to be kept on file for possible future assignments. Keeps samples on file. SASE. Reports in 3 weeks. Considers simultaneous submissions. Pays $50-60/b&w or color inside. Pays on publication. Buys all rights. Credit line given.

$ MOM GUESS WHAT NEWSPAPER, 1725 L St., Sacramento CA 95814. (916)441-6397. Fax: (916)441-6422. E-mail: info@mgwnews.com. Website: http://www.mgwnews.com. Editor: Linda Birner. Circ. 21,000. Estab. 1978. Weekly tabloid. Gay/lesbian newspaper that emphasizes political, entertainment, etc. Readers are gay and straight people. Sample copy $1. Photo guidelines free with SASE.

Needs: Uses about 8-10 photos/issue; all supplied by freelancers, 80% from assignment and 20% from stock. Model release required. Captions required. Accepts images in digital format for Mac and Windows in Photoshop 4. Send via Zip disk.

Making Contact & Terms: Arrange a personal interview to show portfolio. Send 8 × 10 glossy color or b&w prints by mail for consideration. SASE. Previously published work OK. Pays $5-100/photo; $50-75/hour; $100-250/day; $5-200 per photo/text package. Pays on publication. Buys one-time rights; negotiable. Credit line given.

Tips: Prefers to see gay/lesbian related stories, human rights, civil rights and some artsy photos in portfolio; *no* nudes or sexually explicit photos. "When approaching us, give us a phone call first and tell us what you have or if you have a story idea." Uses photographers as interns (contact editor).

$ $ $ A 🖉 NATIONAL NEWS BUREAU, P.O. Box 43039, Philadelphia PA 19129. (215)849-9016. Editor: Andy Edelman. Circ. 300 publications. Weekly syndication packet that emphasizes entertainment. Readers are leisure/entertainment-oriented, 17-55 years old.

Needs: "Always looking for new female models for our syndicated fashion/beauty columns." Also needs celebrities, beauty, entertainment, performing arts, avant garde, erotic. Uses about 20 photos/issue; 15 supplied by freelance photographers. Captions required.

Making Contact & Terms: Arrange a personal interview to show portfolio or send via UPS. "We pay both ways." Query with samples. Send 8 × 10 b&w prints, b&w contact sheet by mail for consideration. SASE. Reports in 1 week. Pays $50-1,000 for b&w inside; $200-1,500 for color inside. Pays on publication. Buys all rights. Credit line given.

Tips: "Send one or two 8 × 10s or color slides and we'll respond. We're presently setting up European distributors for new faces—new bodies of hot female photos."

$ $ NEW YORK TIMES MAGAZINE, 229 W. 43rd St., New York NY 10036. (212)556-7434. Photo Editor: Kathy Ryan. Weekly. Circ. 1.8 million.

Needs: The number of freelance photos varies. Model release and photo captions required.

Making Contact & Terms: Drop off portfolio for review. "Please Fed Ex mailed-in portfolios." SASE. Reports in 1 week. Pays $345/full page; $230/quarter page; $260/half page; $400/job (day rates); $750/color cover. **Pays on acceptance.** Buys one-time rights. Credit line given.

N $ PITTSBURGH CITY PAPER, 911 Penn Ave., 6th Floor, Pittsburgh PA 15222. (412)560-2489. Fax: (412)281-1962. E-mail: info@pghcitypaper.com. Website: http://www.pghcitypaper.com. Editor: Andy Newman. Art Director: Kevin Shepherd. Circ. 80,000. Estab. 1991. Weekly tabloid. Emphasizes Pittsburgh arts, news, entertainment. Readers are active, educated young adults, ages 29-54, with disposable incomes. Sample copy free with 12 × 15 SASE.

Needs: Uses 6-10 photos, all supplied by freelancers. Model/property release preferred. Captions preferred. Generally supplies film and processing. "We can write actual captions, but we need all the pertinent facts."

Making Contact & Terms: Arrange personal interview to show portfolio. Query with résumé of credits. Provide résumé, business card, brochure, flier or tearsheets to be kept on file for possible assignments. Does not keep samples on file. SASE. Reports in 2 weeks. Previously published work OK. Pays $25-125/job. Pays on publication. Credit line given.

Tips: Provide "something beyond the sort of shots typically seen in daily newspapers. Consider the long-term value of exposing your work through publication. In negotiating prices, be honest about your costs, while remembering there are others competing for the assignment. Be reliable and allow time for possible re-shooting to end up with the best pic possible."

$ $ S 🖵 ◯ PLAY THE ODDS, Raley Management Inc., 11614 Ashwood, Little Rock AR 72211. Phone/fax: (501)228-5237. E-mail: playtheodds@worldnet.att.net. Website: http://home.att.net/~playtheodds/index.html. Art Director: Jennifer Fox. Estab. 1997. Monthly newsletter that covers all areas of the gaming industry including casino news, new games, entertainment, etc. Sample copy for $2.50. Art guidelines free.

Needs: Buys 2 photos from freelancers/issue; 24 photos/year. Needs photos of casinos, entertainers and casino properties. Also needs celebrities, entertainment, events, food/drink, travel, fashion/glamour. Reviews photos with or without ms. Special photo needs include photos of "casinos located outside of major gaming areas and cover girls in sexy showgirl outfits." Model release required. Photo captions preferred.

Specs: Uses 35mm, 4 × 5 transparencies. Accepts images in digital format for Windows. Send via floppy disk.

CONTACT THE EDITOR of *Photographer's Market* by e-mail at photomarket@fwpubs.com with your questions and comments.

Making Contact & Terms: Send query letter with samples. Art director will contact photographer for portfolio review if interested. Portfolio should include b&w and/or color, prints. Keeps samples on file; include SASE for return of material. Reports in 1 month. Simultaneous submissions and previously published work OK. Pays $200-500/b&w cover; $50-150/b&w inside. Pays on acceptance. Buys one-time rights. Credit line given.

Tips: "Check out a copy of our newsletter to see if we are a market you are interested in. Write a cover letter and introduce yourself, don't just send in photos with a SASE."

$ 🅰 ▣ ⬧ ◎ PRORODEO SPORTS NEWS, 101 Pro Rodeo Dr., Colorado Springs CO 80919. (719)593-8840. Fax: (719)548-4889. Editor: Paul Asay. Circ. 40,000. Publication of Professional Rodeo Cowboys Association. Biweekly newspaper, weekly during summer (12 weeks). Emphasizes professional rodeo. Sample copy free with 8×10 SAE and 4 first-class stamps. Photo guidelines free with SASE.

• *Prorodeo* scans about 95% of their photos, so *high quality* prints are very helpful.

Needs: Uses about 25-50 photos/issue; all supplied by freelancers. Needs action rodeo photos. Also uses behind-the-scenes photos, cowboys preparing to ride, talking behind the chutes—something other than action. Model/property release preferred. Captions required, including contestant name, rodeo and name of animal.

Specs: Uses 5×7, 8×10 glossy b&w and color prints. Also accepts images in digital format, contact for information.

Making Contact & Terms: Send 5×7, 8×10 glossy b&w and color prints by mail for consideration. SASE. Pays $85/color cover; $35/color inside; $15/b&w inside. Other payment negotiable. Pays on publication. Buys one-time rights. Credit line given.

Tips: In portfolio or samples, wants to see "the ability to capture a cowboy's character outside the competition arena, as well as inside. In reviewing samples we look for clean, sharp reproduction—no grain. Photographer should respond quickly to photo requests. I see more PRCA sponsor-related photos being printed."

$ SHOW BIZ NEWS, 244 Madison Ave., 393, New York NY 10016-2817. (212)969-8715. Publisher: John King. Circ. 310,000. Estab. 1975. Monthly newspaper. Emphasizes model and talent agencies coast to coast. Readers are male and female, ages 15-80. Sample copy $2.00 with 8×10 SAE and 1 first-class stamp. Photo guidelines $2.00.

Needs: Uses 1-2 photos/issue; 1-2 supplied by freelancers. Reviews photos with accompanying ms only. Needs photos of new celebrities, famous faces, VIP's, old and young, entertainment, political, fashion/glamour. Model release preferred. Captions preferred.

Specs: Uses 8×10 b&w prints.

Making Contact & Terms: Contact through rep, arrange personal interview to show portfolio, submit portfolio for review or send unsolicited photos by mail for consideration. Keeps samples on file. SASE. Reports in 3 weeks. Considers simultaneous submissions. Pays $50-60/b&w, color inside. Pays on publication. Buys all rights. Gives credit line.

$ $ $ ▣ ⬧ SINGER MEDIA CORP., INC., Seaview Business Park, 1030 Calle Cordillera, Unit #106, San Clemente CA 92673. (949)498-7227. Fax: (949)498-2162. E-mail: singer@deltanet.com. Worldwide media licensing. Estab. 1940. Newspaper syndicate (magazine, journal, books, newspaper, newsletter, tabloid). Emphasis on foreign syndication.

Needs: Needs photos of celebrities, movies, TV, rock/pop music pictures, top models, posters. Will use dupes or photocopies, cannot guarantee returns. Usually requires releases on interview photos. Photo captions required and accompanying text desired.

Specs: Uses 35mm, 2¼×2¼, 4×5. Color preferred. Accepts images in digital format for Windows (JPEG or GIF).

Making Contact & Terms: Query with list of stock photo subjects or tearsheets of previously published work. Reports in 6 weeks. Previously published work preferred. Pays $25-1,000/b&w photo; $50-1,000/color photo. Pays 50/50% of all syndication sales. Pays after collection. Negotiates one-time, foreign rights. Credit line given.

Tips: "Worldwide, mass market, text essential. Trend is toward international interest. Survey the market for ideas."

$ ⬧ SLO-PITCH NEWS, VARSITY SPORTS COMMUNICATIONS, 13540 Lake City Way NE, Suite 3, Seattle WA 98125. (206)367-2420. Fax: (206)367-2636. Editor: Dick Stephens. Circ. 15,800. Estab. 1985. Publication of United States Slo-Pitch Softball Association (USSSA). Tabloid published 8 times/year. Emphasizes slo-pitch softball. Readers are men and women, ages 13-70. Sample copy for 10×14 SASE and $2. Photo guidelines free with SASE.

Needs: Uses 10-30 photos/issue; 90% supplied by freelancers. Needs photos of celebrities, children, multicultural, families, parents, teens, stills and action softball shots. Special photo needs include products, tournaments, general, etc. Model/property release preferred for athletes. Captions required.
Specs: Uses color and b&w prints.
Making Contact & Terms: Send unsolicited photos by mail for consideration. Provide résumé, business card, brochure, flier or tearsheets to be kept on file for possible assignments. Deadlines: 1st of every month. Keeps samples on file. Cannot return material. Reports in 1 month. Simultaneous submissions and previously published work OK. Pays $10-30/b&w cover; $10-30/color inside; $10-25/b&w inside; $10-25/color page rate; $10-25/b&w page rate. Pays on publication. Rights negotiable. Credit line given.
Tips: Looking for good sports action and current stock of subjects. "Keep sending us recent work and call periodically to check in."

$ SOUTHERN MOTORACING, P.O. Box 500, Winston-Salem NC 27102. (336)723-5227. Fax: (336)722-3757. Associate Editor: Greer Smith. Editor/Publisher: Hank Schoolfield. Circ. 15,000. Biweekly tabloid. Emphasizes autoracing. Readers are fans of auto racing.
Needs: Uses about 10-15 photos/issue; some supplied by freelance photographers. Needs "news photos on the subject of Southeastern auto racing." Captions required.
Making Contact & Terms: Query with samples; send 5×7 or larger matte or glossy b&w prints; b&w negatives by mail for consideration. SASE. Reports in 1 month. Simultaneous submissions OK. Pays $25-50/b&w cover; $5-50/b&w inside; $50-100/page. Pays on publication. Buys first North American serial rights. Credit line given.
Tips: "We're looking primarily for *news* pictures and staff produces many of them—with about 25% coming from freelancers through long-standing relationships. However, we're receptive to good photos from new sources and we do use some of those. Good quality professional pictures only, please!"

$ 🖻 🖉 SUN, 5401 NW Broken Sound Blvd., Boca Raton FL 33487. (561)989-1070. Fax: (561)998-0798. Photo Editor: Bella Center. Weekly tabloid. Readers are housewives, college students, middle Americans. Sample copy free with extra large SAE and $1.70 postage.
Needs: Uses about 60 photos/issue; 50% supplied by freelance photographers. Wants varied subjects: prophesies and predictions, amazing sightings (i.e., Jesus, Elvis, angels), stunts, unusual pets, health remedies, offbeat medical, human interest, inventions, spectacular sports action; offbeat pix and stories; and

© 1998 Julius Vitali

"We love to receive photos that can act as stand-alone, quirky, funny or unusual images or photos that are interesting enough to generate story ideas," says *Sun* editor Bella Center. Julius Vitali's computer-generated photo of the face of God was just such an image. Vitali has been using computers in his photography since 1980. The model for this image is also Vitali's girlfriend. "Now we know that God is a woman," he jokes.

celebrity photos. "Also—we are always in need of interesting, offbeat, humorous stand-alone pix." Model release preferred. Captions preferred.

Specs: Uses 8×10 b&w prints, 35mm transparencies. Accepts digital images via Mac to Mac W Z modem, ISDN, Leaf Desk, SyQuest, floppy disk.

Making Contact & Terms: Query with stock photo list and samples. Reports in 2 weeks. Simultaneous submissions and previously published work OK. Pays $150-250/day; $150-250/job; $75/b&w cover; $125-200/color cover; $50-125/b&w inside; $125-200/color inside. Pays on publication. Buys one-time rights.

Tips: "We are specifically looking for the unusual, offbeat, freakish true stories and photos. *Nothing* is too far out for consideration. We would suggest you send for a sample copy and take it from there."

$ $ ☑ ▣ ⊘ **TORONTO SUN PUBLISHING,** 333 King St., Toronto, Ontario M5A 3X5 Canada. (416)947-2399. Fax: (416)947-3580. Director of Photography: Hugh Wesley. Circ. 300,000. Estab. 1971. Daily newspaper. Emphasizes sports, news and entertainment. Readers are 60% male, 40% female, ages 25-60. Sample copy free with SASE.

Needs: Uses 30-50 photos/issue; 20% supplied by freelancers. Needs photos of Toronto personalities making news out of town. Also disasters, beauty, sports, erotic, fashion/glamour. Reviews photos with or without ms. Captions preferred.

Specs: Accepts images in digital format for Mac. Send via CD, Zip, e-mail.

Making Contact & Terms: Arrange personal interview to show portfolio. Send any size color prints; 35mm transparencies; press link digital format. Deadline: 11 p.m. daily. Does not keep samples on file. Reports in 1-2 weeks. Simultaneous submissions and previously published work OK. Pays $125-500 for color cover; $50-500 for b&w inside. Pays on publication. Buys one-time and other negotiated rights. Credit line given.

Tips: "The squeeky wheel gets the grease when it delivers the goods. Don't try to oversell a questionable photo. Return calls promptly."

$ $ **VELONEWS,** 1830 N. 55th St., Boulder CO 80301-2700. (303)440-0601. Fax: (303)443-9919. Photo Editor: Nate Cox. Paid circ. 55,000. The journal of competitive cycling. Covers road racing, mountain biking and recreational riding. Sample copy free with 9×12 SAE and 4 first-class stamps.

Needs: Bicycle racing (road, mountain and track). Looking for action and feature shots that show the emotion of cycling, not just finish-line photos with the winner's arms in the air. No bicycle touring. Photos purchased with or without accompanying ms. Uses news, features, profiles. Captions and identification of subjects required.

Specs: Uses negatives and transparencies.

Making Contact & Terms: Send samples of work or tearsheets with assignment proposal. Query first on ms. SASE. Reports in 3 weeks. Pays $24-72/b&w inside; $48-300/color inside; $225/color cover. Pays on publication. Buys one-time rights. Credit line given.

Tips: "Photos must be timely."

$ ▣ **WATERTOWN PUBLIC OPINION,** Box 10, Watertown SD 57201. (605)886-6903. Fax: (605)886-4280. Editor: Gordon Garnos. Circ. 17,500. Estab. 1887. Daily newspaper. Emphasizes general news of this area, state, national and international news. Sample copy 50¢.

Needs: Uses up to 8 photos/issue. Reviews photos with or without ms. Model release required. Captions required.

Specs: Uses b&w or color prints. Accepts images in digital format for Mac. Send via compact disc.

Making Contact & Terms: Send unsolicited photos by mail for consideration. Does not keep samples on file. SASE. Reports in 1-2 weeks. Simultaneous submissions OK. Pays $5-25/b&w or color cover; $5-25/b&w or color inside; $5-25/color page rate. Pays on publication. Buys one-time rights; negotiable. Credit line given.

WESTART, Box 6868, Auburn CA 95604. (530)885-0969. Editor-in-Chief: Martha Garcia. Circ. 4,000. Emphasizes art for practicing artists, artists/craftsmen, students of art and art patrons, collectors and teachers. Free sample copy and photo guidelines.

Needs: Uses 20 photos/issue, 10 supplied by freelancers. "We will publish photos if they are in a current exhibition, where the public may view the exhibition. The photos must be black & white. We treat them as an art medium. Therefore, we purchase freelance articles accompanied by photos." Wants mss on exhibitions and artists in the Western states. Captions required.

Making Contact & Terms: Send 5×7 or 8×10 b&w prints by mail for consideration. SASE. Reports in 2 weeks. Simultaneous and previously published submissions OK. Payment is included with total purchase price of ms. Pays $25 on publication. Buys one-time rights.

TRADE PUBLICATIONS

Most trade publications are directed toward the business community in an effort to keep readers abreast of the ever-changing trends and events in their specific professions. For photographers, shooting for these professions can be financially rewarding and can serve as a stepping stone toward acquiring future jobs.

As often happens with this category, the number of trade publications produced increases or decreases as professions develop or deteriorate. In recent years, for example, magazines involving computers have flourished as the technology continues to grow.

Trade publication readers are usually very knowledgeable about their businesses or professions. The editors and photo editors, too, are often experts in their particular fields. So, with both the readers and the publications' staffs, you are dealing with a much more discriminating audience. To be taken seriously, your photos must not be merely technically good pictures, but also should communicate a solid understanding of the subject and reveal greater insights.

In particular, photographers who can communicate their knowledge in both verbal and visual form will often find their work more in demand. If you have such expertise, you may wish to query about submitting a photo/text package that highlights a unique aspect of working in that particular profession or that deals with a current issue of interest to that field.

Many photos purchased by these publications come from stock—both from freelance inventories and from stock photo agencies. Generally, these publications are more conservative with their freelance budgets and use stock as an economical alternative. For this reason, listings in this section will often advise sending a stock list as an initial method of contact. Some of the more established publications with larger circulations and advertising bases will sometimes offer assignments as they become familiar with a particular photographer's work. For the most part, though, stock remains the primary means of breaking in and doing business with this market.

$ 🖳 ⟁ AAP NEWS, 141 Northwest Pt. Blvd., Elk Grove Village IL 60007. (847)981-6755. Fax: (847)228-5097. E-mail: mhayes@aap.org. Website: http://www.aap.org. Art Director/Production Coordinator: Michael Hayes. Estab. 1985. Publication of American Academy of Pediatrics. Monthly tabloid newspaper.
Needs: Uses 60 photos/year. 12 freelance assignments offered/year. Needs photos of babies, families, teens, children, pediatricians, health care providers—news magazine style. Model/property release required as needed. Captions required; include names, dates, location and explanation of situations.
Specs: Accepts images in digital format for Mac. Send via CD, SyQuest, floppy disk, Jaz, Zip as TIFF, EPS, JPEG files at 300 dpi.
Making Contact & Terms: Provide résumé, business card, tearsheets to be kept on file (for 1 year) for possible assignments. Cannot return material. Simultaneous submissions and previously published work OK. Pays $75/hour; $75-125/one-time use of photo. Pays on publication. Buys one-time or all rights; negotiable.
Tips: "We want great photos of 'real' children in 'real-life' situations, and the more diverse the better."

$ $🖳 ⟁ ◎ ABA BANKING JOURNAL, 345 Hudson St., New York NY 10014. (212)620-7256. Fax: (212)633-1165. E-mail: wendyababj@aol.com. Website: http://www.banking.com. Art Director: Wendy Williams. Circ. 30,000. Estab. 1909. Monthly magazine. Emphasizes "how to manage a bank better. Bankers read it to find out how to keep up with changes in regulations, lending practices, investments, technology, marketing and what other bankers are doing to increase community standing."
Needs: Buys 12-24 photos/year; freelance photography is 50% assigned, 50% from stock. Personality, and occasionally photos of unusual bank displays or equipment. "We need candid photos of various bankers who are subjects of articles." Photos purchased with accompanying ms or on assignment.
Specs: For color: uses 35mm transparencies and 2¼ × 2¼ transparencies. For cover: uses color transparencies. Accepts images in digital format for Mac. Send via Jaz, Zip, e-mail.
Making Contact & Terms: Query with samples. Call to drop off portfolio. Call and set up appointment for portfolio review. SASE. Reports in 1 month. Pays $200-500/photo. **Pays on acceptance**. Buys one-time rights. Credit line given.
Tips: "Most of our subjects are not comfortable being photographed."

$ $ Ⓐ ⊘ ACCOUNTING TODAY, 11 Penn Plaza, New York NY 10001. (212)631-1596. Fax: (212)564-9896. Contact: Managing Editor. Circ. 35,000. Estab. 1987. Biweekly tabloid. Emphasizes finance. Readers are CPAs in public practice.

Needs: Uses 2-3 photos/issue; all supplied by freelancers. "We assign news subjects, as needed." Captions required.

Making Contact & Terms: Provide résumé, business card, brochure, flier or tearsheets to be kept on file for possible assignments. Keeps samples on file. Cannot return material. Pays $250/shoot. **Pays on acceptance.** Buys all rights; negotiable. Credit line given.

Ⓝ $ $ $⊠ ◎ ADVANCED MANUFACTURING, Clifford/Elliott Ltd., 209-3228 S. Senre Rd., Burlington, Ontario L7N 3H8 Canada. (905)634-2100. E-mail: tp@industrialsourcebook.com. Website: http://www.advancedmanufacturing.com. Managing Editor: Paul Challen. Circ. 14,000. Estab. 1998. Quarterly trade magazine providing a window on the world of advanced manufacturing. Sample copies available for SAE with first-class postage.

Needs: Buys 6 photos from freelancers per issue. Subjects include industry, science and technology. Reviews photos with or without a ms. Model release required. Photo caption preferred.

Specs: Uses 5×7, color prints; 4×5 transparencies. "We prefer that you send transparencies." Accepts images in digital format for Mac. Send via SyQuest, Jaz, Zip as TIFF files.

Making Contact & Terms: Send query letter with résumé, stock list. Provide self-promotion piece to be kept on file for possible future assignments. Reports back only if interested. Simultaneous submissions and previously published work OK. Pays $200-1,000 for color cover; $150-1,000 for color inside. Pays 30-45 days after invoice date. Credit line given. Buys one-time rights, electronic rights; negotiable.

Tips: "Read our magazine. Put yourself in your clients' shoes. Meet their needs and you will excel. Understand your audience and the editors' needs. Meed deadlines, be reasonable and professional."

Ⓝ $ $ Ⓢ ▣ ⊘ ◎ AFTERMARKET BUSINESS, Advanstar Communications, 7500 Old Oak Blvd., Cleveland OH 44130. (440)891-2604. Fax: (440)891-2675. E-mail: mwillins@advanstar.com. Website: http://www.aftermarketbusiness.com. Managing Editor: Mike Willins. Circ. 40,439. Estab. 1936. Monthly trade magazine. "*Aftermarket Business* is a monthly tabloid-sized magazine, written for corporate executives and key decision-makers responsible for buying automotive products (parts, accessories, chemicals) and other services sold at retail to consumers and professional installers. It's the oldest continuously published business magazine covering the retail automotive aftermarket today and is the only publication dedicated to the specialized needs of this industry." Sample copies available. Call (888)527-7008 for rates.

Needs: Buys 1-2 photos from freelancers per issue; 12-15 photos per year. Needs photos of automobiles, product shots/still life. "Review our editorial calendar to see what articles are being written. We use lots of conceptual material." Model release and property release preferred.

Specs: Uses 35mm, 2¼×2¼ transparencies. Accepts images in digital format for Mac. Send via CD, SyQuest, floppy disk, Jaz, Zip, e-mail as TIFF, JPEG files at 300 dpi.

Making Contact & Terms: Send query letter with slides, transparencies, stock list. Provide business card, self-promotion piece to be kept on file for possible future assignments. Reports back only if interested, send nonreturnable samples. Pays $300-500 for color cover; $100-200 for color inside. Pays on publication. Credit line given. Buys one-time rights.

Tips: "We have special issues on an annual basis. Looking through sample copies will show you a lot about what we need. Show us a variety of stock and lots of it. Send only dupes."

$ $⊘ AIR CARGO WORLD, Journal of Commerce, 1230 National Press Bldg., Washington DC 20045. (202)661-3387. Fax: (202)783-2550. Editor: Paul Page. Circ. 23,000. Estab. 1942. Monthly trade magazine aimed at businesses in the air cargo industry or customers of air cargo companies. Sample copy for SAE with first-class postage.

Needs: Buys 1 photo/issue; 12 photos/year. Needs photos of air cargo operations. Reviews photos with or without ms.

Making Contact & Terms: Send query letter with samples. Keeps samples on file. Reports back only if interested, send non-returnable samples. Simultaneous submissions OK. Pays $500/color cover. Pays on publication. Buys one-time rights.

MARKET CONDITIONS are constantly changing! If you're still using this book and it's 2001 or later, buy the newest edition of *Photographer's Market* at your favorite bookstore or order directly from Writer's Digest Books.

Tips: "Looking for graphically interesting, dynamic approach to a topic that generally produces hackneyed results."

$ ⑤ ▣ ◻ ◎ AIR LINE PILOT, 535 Herndon Pkwy., Box 1169, Herndon VA 22070. (703)481-4460. Fax: (703)689-4370. E-mail: 73714.41@compuserve.com. Website: http://www.alpa.org. Editor-in-Chief: Gary DiNunno. Circ. 72,000. Estab. 1933. Publication of Air Line Pilots Association. 10 issues/year. Emphasizes news and feature stories for commercial airline pilots. Photo guidelines for SASE. Guidelines available on website.

Needs: Uses 12-15 photos/issue; 25% comes from freelance stock. Needs dramatic 35mm transparencies, prints or high resolution IBM compatible images on disk or CD of commercial aircraft, pilots and co-pilots performing work-related activities in or near their aircraft. "Pilots must be ALPA members in good standing. Our editorial staff can verify status." Special needs include dramatic images technically and aesthetically suitable for full-page magazine covers. Especially needs vertical composition scenes. Model release required. Captions required; include aircraft type, airline, location of photo/scene, description of action, date, identification of people and which airline they work for.

Specs: Accepts images in digital format for Windows. Send via compact disc, SyQuest, zip disk or online.

Making Contact & Terms: Query with samples. Send unsolicited photos by mail for consideration. "Currently use two outside vendors for assignment photography. Most freelance work is on speculative basis only." SASE. Simultaneous submissions and previously published work OK. Pays $25-100/b&w photo; $50-350/color photo. **Pays on acceptance.** Buys all rights.

Tips: In photographer's samples, wants to see "strong composition, poster-like quality and high technical quality. Photos compete with text for space so they need to be very interesting to be published. Be sure to provide brief but accurate caption information and send in only professional quality work. For our publication, cover shots do not need to tie in with current articles. This means that the greatest opportunity for publication exists on our cover. Check website for criteria and requirements. Send samples of slides to be returned upon review. Make appointment to show portfolio."

$ $▣ ◎ AMERICAN AGRICULTURIST, 2389 N. Triphammer Rd., Ithaca NY 14850. (607)257-8670. Fax: (607)257-8238. Circ. 21,000. Estab. 1842. Monthly. Emphasizes agriculture in New York. Photo guidelines free with SASE.

Needs: Occasionally photos supplied by freelance photographers; 90% on assignment, 25% from stock. Needs photos of farm equipment, general farm scenes, animals. Geographic location: only New York. Reviews photos with or without accompanying ms. Model release required. Captions preferred.

Specs: Uses 35mm transparencies. Accepts images in digital format for Windows. Send via floppy disk as TIFF files.

Making Contact & Terms: Query with samples and list of stock photo subjects. SASE. Reports in 3 months. Pays $200/color cover and $75-150/inside color photo. **Pays on acceptance.** Buys one-time rights. Credit line given.

Tips: "We need shots of modern farm equipment with the newer safety features. Also looking for shots of women actively involved in farming and shots of farm activity. We also use scenics. We send out our editorial calendar with our photo needs yearly."

$ $▣ AMERICAN BANKER, Dept. PM, 1 State St. Plaza, New York NY 10004. (212)803-8313. Fax: (212)843-9600. Photo Editor: Karen Barr. Art Director: Debbie Romaner. Circ. 20,000. Estab. 1835. Daily tabloid. Emphasizes banking industry. Readers are male and female, senior executives in finance, ages 35-59.

● This publication scans its photos on computer.

Needs: "We are a daily newspaper and we assign a lot of pictures throughout the country. We mostly assign environmental portraits with an editorial, magazine style to them." Also uses buildings.

Specs: Accepts images in digital format for Mac. Send via e-mail as JPEG files at 200 dpi.

Making Contact & Terms: Portfolio may be dropped off by appointment only. Provide résumé, business card, brochure, flier or tearsheets to be kept on file for possible assignments. Keeps samples on file. SASE. Pays creative fee of $300. Credit line given.

Tips: "We look for photos that offer a creative insight to corporate portraiture and technically proficient photographers who can work well with stuffy businessmen in a limited amount of time—30 minutes or less is the norm. Photographers should send promo cards that indicate their style and ability to work with executives. Portfolio should include 5-10 samples either slides or prints, with well-presented tearsheets of published work. Portfolio reviews by appointment only. Samples are kept on file for future reference."

$ ◎ AMERICAN BEE JOURNAL, Dept. PM, 51 S. Second St., Hamilton IL 62341. (217)847-3324. Fax: (217)847-3660. Editor: Joe M. Graham. Circ. 13,000. Estab. 1861. Monthly trade magazine. Empha-

sizes beekeeping for hobby and professional beekeepers. Sample copy free with SASE.
Needs: Uses about 25 photos/issue; 1-2 supplied by freelance photographers. Needs photos of beekeeping and related topics, beehive products, honey and cooking with honey. Special needs include color photos of seasonal beekeeping scenes. Model release preferred. Captions preferred.
Making Contact & Terms: Query with samples. Send 5×7 or 8½×11 b&w and color prints by mail for consideration. SASE. Reports in 2 weeks. Pays $75/color cover; $10/b&w inside. Pays on publication. Buys all rights. Credit line given.

AMERICAN BREWER MAGAZINE, Box 510, Hayward CA 94543-0510. (510)538-9500. President: Bill Owens. Circ. 15,000. Estab. 1986. Quarterly magazine. Emphasizes micro-brewing and brewpubs. Readers are males ages 25-35. Sample copy $5.
Needs: Uses 5 photos/issue; 5 supplied by freelancers. Reviews photos with accompanying ms only. Captions required.
Making Contact & Terms: Contact by phone. Reports in 2 weeks. Simultaneous submissions OK. Payment negotiable per job. **Pays on acceptance.** Buys one-time rights; negotiable. Credit line given.

$ AMERICAN CHAMBER OF COMMERCE EXECUTIVES, 4232 King St., Alexandria VA 22302. (703)998-0072. Fax: (703)931-5624. Vice President of Marketing: Marlies Mulckhuyse. Circ. 5,000. Monthly trade newsletter. Emphasizes chambers of commerce. Readers are chamber professionals (male and female) interested in developing chambers and securing their professional place. Free sample copy.
Needs: Uses 1-15 photos/issue; 0-10 supplied by freelancers. Special photo needs include coverage of our annual conference in October 1999 in Detroit, Michigan. Model release required. Captions preferred.
Making Contact & Terms: Query with stock photo list. Provide résumé, business card, brochure, flier or tearsheets to be kept on file for possible future assignments. Send 4×6 matte b&w prints. Keeps samples on file. SASE. Reports in 1-2 weeks. Pays $10-50/hour. **Pays on acceptance** Buys all rights.

$ AMERICAN CRAFT, 72 Spring St., New York NY 10012. (212)274-0630. Fax: (212)274-0650. Editor/Publisher: Lois Moran. Managing Editor: Pat Dandignac. Circ. 45,000. Estab. 1941. Bimonthly magazine of the American Craft Council. Emphasizes contemporary creative work in clay, fiber, metal, glass, wood, etc. and discusses the technology, materials and ideas of the artists who do the work. Free sample copy with 9×12 SAE and $2.50.
Needs: Visual art. Shots of crafts: clay, metal, fiber, etc. Captions required.
Specs: Uses 8×10 glossy b&w prints; 4×5 transparencies and 35mm film; 4×5 color transparencies for cover, vertical format preferred.
Making Contact & Terms: Arrange a personal interview to show portfolio. SASE. Reports in 1 month. Previously published work OK. Pays according to size of reproduction; $40 minimum/b&w and color photos; $175-500/cover photos. Pays on publication. Buys one-time rights.

$ AMERICAN FARRIERS JOURNAL, P.O. Box 624, Brookfield WI 53008-0624. (414)782-4480. Fax: (414)782-1252. Editor: Frank Lessiter. Circ. 8,500 (paid). Estab. 1974. Magazine published 7 times/year. Emphasizes horseshoeing and horse health for professional horseshoers. Sample copy free with SASE.
Needs: Looking for horseshoeing photos, documentary, how-to (of new procedures in shoeing), photo/essay feature, product shot and spot news. Photos purchased with or without accompanying ms. Captions required.
Specs: Uses 4-color transparencies for covers. Vertical format. Artistic shots.
Making Contact & Terms: Query with printed samples. SASE. Pays $25-50/b&w photo; $30-100/color photo; up to $150/cover photo. Pays on publication. Credit line given.

$ [S] [Ø] AMERICAN FIRE JOURNAL, Dept. PM, 9072 Artesia Blvd., Suite 7, Bellflower CA 90706. (562)866-1664. Fax: (562)867-6434. Editor: Carol Carlsen Brooks. Circ. 6,000. Estab. 1952. Monthly magazine. Emphasizes fire protection and prevention. Sample copy $3.50 with 10×12 SAE and 6 first-class stamps. Free photo and writer's guidelines.
Needs: Buys 5 or more photos/issue; 90% supplied by freelancers. Documentary (emergency incidents, showing fire personnel at work); how-to (new techniques for fire service); and spot news (fire personnel at work). Captions required. Seeks short ms describing emergency incident and how it was handled by the agencies involved.
Specs: Uses b&w semigloss prints; for cover uses 35mm color transparencies; covers must be verticals.
Making Contact & Terms: Query with samples. Provide résumé, business card or letter of inquiry. SASE. Reports in 1 month. Pays $10-25/b&w inside, negotiable; $25-100/color inside; $100/cover; $1.50-2/inch for ms.
Tips: "Don't be shy! Submit your work. I'm always looking for contributing photographers (especially if

they are from outside the Los Angeles area). I'm looking for good shots of fire scene activity with captions. The action should have a clean composition with little smoke and prominent fire and show good firefighting techniques, i.e., firefighters in full turnouts, etc. It helps if photographers know something about firefighting so as to capture important aspects of fire scene. We like photos that illustrate the drama of firefighting—large flames, equipment and apparatus, fellow firefighters, people in motion. Write suggested captions. Give us as many shots as possible to choose from. Most of our photographers are firefighters or 'fire buffs.' "

N $ ▣ ◯ ◎ AMERICAN POWER BOAT ASSOCIATION, 17640 E. Nine Mile Rd., Box 377, Eastpointe MI 48021-0377. (810)773-9700. Fax: (810)773-6490. E-mail: propmag@aol.com. Website: http://www.apba-boatracing.com. Publications Editor: Tana Moore. Estab. 1903. Sanctioning body for US power boat racing; monthly magazine. Majority of assignments made on annual basis. Photos used in monthly magazine, brochures, audiovisual presentations, press releases, programs and website.
Needs: Power boat racing—action and candid. Captions required.
Specs: Uses 5×7 and up, b&w prints and 35mm slides for cover. Accepts images in digital format for Mac. Send via CD, SyQuest, floppy disk, Zip, e-mail as TIFF, EPS, PICT, JPEG files at 300 dpi.
Making Contact & Terms: Initial personal contact preferred. "Suggests initial contact by phone possibly to be followed by evaluating samples." Provide résumé, business card, brochure, flier or tearsheets to be kept on file for possible future assignments. SASE. Reports in 2 weeks when needed. Payment varies. Standard is $25/cover; $15/b&w inside. Buys one-time rights; negotiable. Photo usage must be invoiced by photographer within the month incurred. Credit line given.
Tips: Prefers to see selection of shots of power boats in action or pit shots, candids, etc., (all identified). Must show ability to produce clear b&w action shots of racing events. "Send a few samples with introduction letter, especially if related to boat racing."

$ ▣ ◢ ◎ ANIMAL SHELTERING, Humane Society of the US, 2100 L St. NW, Washington DC 20037. (202)452-1100. Fax: (301)258-3081. E-mail: asm@ix.netcom.com. Editor: Scott Kirkwood. Circ. 5,000. Estab. 1978. Bimonthly magazine. Emphasizes animal protection. Readers are animal control and shelter workers, men and women, all ages. Sample copy free.
Needs: Uses 25 photos/issue; 75% supplied by freelance photographers. Needs photos of domestic animals interacting with humane workers; animals in shelters; animal care and obedience; humane society work and functions. "We do not pay for manuscripts." Model release required for cover photos only. Captions preferred.
Specs: Accepts images in digital format for Mac, Windows. Send via floppy disk as TIFF, EPS, JPEg files.
Making Contact & Terms: Provide résumé, business card, brochure, flier or tearsheets to be kept on file for possible assignments. SASE. Reports in 4 weeks. Pays $75/b&w cover; $50/b&w inside. "We accept color, but magazine prints in b&w." **Pays on acceptance.** Buys one-time rights. Credit line given.
Tips: "We almost always need good photos of people working with animals in an animal shelter, in the field or in the home. We do not use photos of individual dogs, cats and other companion animals as much as we use photos of people working to protect, rescue or care for dogs, cats and other companion animals."

$ ◢ APPALOOSA JOURNAL, P.O. Box 8403, Moscow ID 83843. (208)882-5578. Fax: (208)882-8150. E-mail: journal@appaloosa.com. Website: http://www.appaloosa.com. Editor: Robin Hirzel. Circ. 23,000. Estab. 1946. Association publication of Appaloosa Horse Club. Monthly magazine. Emphasizes Appaloosa horses. Readers are Appaloosa owners, breeders and trainers, child through adult. Sample copy $5. Photo guidelines free with SASE.
Needs: Uses 30 photos/issue; 10% supplied by freelance photographers. Needs photos (color and b&w) to accompany features and articles. Special photo needs include photographs of Appaloosas (high quality horses) in winter scenes. Model release required. Captions required.
Making Contact & Terms: Send unsolicited 4×6 b&w and color prints or 35mm and 2¼×2¼ transparencies by mail for consideration. Reports in 3 weeks. Previously published work OK. Pays $100-300/color cover; $25-50/color inside; $25-50/b&w inside. **Pays on acceptance.** Buys first North American serial rights. Credit line given.
Tips: In photographer's samples, wants to see "high-quality color photos of world class, characteristic Appaloosa horses with people in appropriate outdoor environment. We often need a freelancer to illustrate a manuscript we have purchased. We need specific photos and usually very quickly."

N ARMY RESERVE MAGAZINE, 1421 Jefferson Davis Hwy., Suite 12300, Arlington VA 22202-3259. (703)601-0854. Fax: (703)601-0836. Circ. 450,000. Estab. 1954. Publication for U.S. Army Reserve. Quarterly magazine. Emphasizes training and employment of Army Reservists. Readers are ages 17-60,

60% male, 40% female, all occupations. No particular focus on civilian employment. Sample copy free. Write for guidelines.

• *Army Reserve Magazine* won the NAGC International "Blue Pencil" award for outstanding governmental magazine.

Needs: Uses 35-45 photos/issue; 85% supplied by freelancers. Needs photos related to the mission or function of the U.S. Army Reserve. "We're looking for well-written feature stories accompanied by high-quality photos." Model release preferred (if of a civilian or non-affiliated person). Captions required.

Specs: Uses 5×7 color prints; 35mm or 2¼×2¼ transparencies.

Making Contact & Terms: "Call the editor to discuss your idea." Reports in 1 month. Simultaneous submissions and previously published work OK. "No pay for material; credit only since we are a government publication." Unable to purchase rights, but consider as "one-time usage."

Tips: "High quality color transparencies and prints of Army Reserve-related training or community activities are in demand."

N $ S ▣ ○ ◎ ASIAN ENTERPRISE, Asian Business Ventures, Inc., P.O. Box 2135, Walnut CA 91788-2135. (909)860-3316. Fax: (909)865-4915. E-mail: asianent@yahoo.com. Publisher: Gelly Borromio. Circ. 33,000. Estab. 1993. Monthly trade magazine. "Largest Asian American small business focus magazine in U.S." Sample copies available with first-class postage.

Needs: Buys 3-5 photos from freelancers per issue. Needs photos of multicultural, environmental, travel, business concepts, industry, political, technology. Interested in digital, documentary. Reviews photos with or without a ms. Model and property release required.

Specs: Uses 4×6, matte, b&w prints. Accepts images in digital format for Windows. Send via Zip as TIFF files.

Making Contact & Terms: Send query letter with prints. Provide self-promotion piece to be kept on file for possible future assignments. Reports back only if interested, send nonreturnable samples. Simultaneous submissions OK. Pays $50-200 for color cover; $25-100 for b&w inside. Pays on publication. Credit line given. Buys one-time rights.

N $ $ ATHLETIC BUSINESS, % Athletic Business Publications Inc., 4130 Lien Rd., Madison WI 53704. (608)249-0186. Fax: (608)249-1153. Art Directors: Kay Lum and Jennifer Molander. Monthly magazine. Emphasizes athletics, fitness and recreation. "Readers are athletic, park and recreational directors and club managers, ages 30-65." Circ. 40,000. Estab. 1977. Sample copy $5.

Needs: Uses 4 or 5 photos/issue; 50% supplied by freelancers. Needs photos of sporting shots, athletic equipment, recreational parks and club interiors. Model and/or property release and photo captions preferred.

Making Contact & Terms: Send unsolicited color prints or 35mm or 4×5 transparencies by mail for consideration. Does not keep samples on file. SASE. Reports in 1-2 weeks. Simultaneous submissions and previously published work OK but should be explained. Pays $350/color cover; negotiable; $150/color inside; $250/color page rate. Pays on publication. Buys all rights; negotiable. Credit line given.

Tips: Wants to see ability with subject, high quality and reasonable price. To break in, "shoot a quality and creative shot from more than one angle."

$ ▣ ATLANTIC PUBLICATION GROUP INC., 2430 Mall Dr., Suite 160, Charleston SC 29406. (843)747-0025. Fax: (843)744-0816. E-mail: info@atlanticpublicationgrp.com. Website: http://atlanticpublicationgrp.com. Editorial Services Manager: Shannon Clark. Circ. 6,500. Estab. 1985. Publications for Chambers of Commerce and Visitor Products from Hawaii to the East Coast. Quarterly magazines. Emphasizes business. Readers are male and female business people who are members of chambers of commerce, ages 30-60.

Needs: Uses 10 photos/issue; all supplied by freelancers. Needs photos of business scenes, manufacturing, real estate, lifestyle. Model/property release required. Captions preferred.

Specs: Accepts images in digital format for Mac. Send via SyQuest or Zip disk.

Making Contact & Terms: Provide résumé, business card, brochure, flier or tearsheets to be kept on file for possible assignment. Query with stock photo list. Unsolicited material will not be returned. Keeps samples on file. SASE. Reports in 1 month. Simultaneous submissions and previously published work OK. Pays $100-400/color cover; $100-250/b&w cover; $50-100/color inside; $50/b&w inside. **Pays on acceptance.** Buys one-time rights; negotiable. Credit line given.

N $ AUTO TRIM & RESTYLING NEWS, 6255 Barfield Rd., Suite 200, Atlanta GA 30328-4300. (404)252-8831. Fax: (404)252-4436. Editor: Dave Doucette. Circ. 8,503. Estab. 1951. Publication of National Association of Auto Trim and Restyling Shops. Monthly. Emphasizes automobile restyling and

restoration. Readers include owners and managers of shops specializing in restyling, customizing, graphics, upholstery, trim, restoration, detailing, glass repairs, and others.

Needs: Uses about 15-20 photos/issue; 10-15 supplied by freelance photographers, all on assignment. Needs "how-to, step-by-step photos; restyling showcase photos of unusual and superior completed work." Special needs include "restyling ideas for new cars in the aftermarket area; soft goods and chrome add-ons to update Detroit." Also needs feature and cover-experienced photographers. Captions required.

Making Contact & Terms: Interested in receiving work from photographers with a minimum of 3 years professional experience. Provide résumé, business card, brochure, flier or tearsheets to be kept on file for possible future assignments. Photographer should be in touch with a cooperative shop locally. SASE. Reports in 2-3 weeks. Pays $35/b&w photo; up to $700/color cover. Assignment fees negotiable. Pays on publication. Buys all rights. Credit line given if desired.

Tips: "In samples we look for experience in shop photography, ability to photograph technical subject matter within automotive and marine industries."

$ $ AUTOMATED BUILDER, 1445 Donlon St. #16, Ventura CA 93003. (805)642-9735. Fax: (805)642-8820. E-mail: abmag@autbldrmag.com. Website: http://www.autbldrmag.com. Editor and Publisher: Don Carlson. Circ. 26,000. Estab. 1964. Monthly. Emphasizes home and apartment construction. Readers are "factory and site builders and dealers of all types of homes, apartments and commercial buildings." Sample copy free with SASE.

Needs: Uses about 40 photos/issue; 10-20% supplied by freelance photographers. Needs in-plant and job site construction photos and photos of completed homes and apartments. Photos purchased with accompanying ms only. Captions required.

Making Contact & Terms: "Call to discuss story and photo ideas." Send 3×5 color prints; 35mm or 2¼×2¼ transparencies by mail for consideration. Will consider dramatic, preferably vertical cover photos. SASE. Reports in 2 weeks. Pays $300/text/photo package; $150/cover. Buys first time reproduction rights. Credit line given "if desired."

Tips: "Study sample copy. Query editor by phone on story ideas related to industrialized housing industry."

$ $ ▣ ▱ ◎ AVIONICS MAGAZINE, 1201 Seven Locks Rd., Potomac MD 20854. (301)340-7788, ext. 2007. Fax: (301)762-4196. Editor-in-Chief: David Jensen. Associate Editor: Kimberly Shepherd. Circ. 24,000. Estab. 1978. Monthly magazine. Emphasizes aviation electronics. Readers are avionics engineers, technicians, executives. Sample copy free with 9×12 SASE.

Needs: Uses 15-20 photos/issue; 10% supplied by freelancers. Needs photos of travel, business concepts, industry, technology, aviation. Interested in alternative process, avant garde, digital. Reviews photos with or without ms. Captions required.

Specs: Uses 8½×11 glossy color prints; 35mm, 2¼×2¼, 4×5, 8×10 transparencies. Accepts images in digital format for Mac. Send via CD, Zip, e-mail (high resolution only).

Making Contact & Terms: Send unsolicited photos by mail for consideration. Provide résumé, business card, brochure, flier or tearsheets to be kept on file for possible assignments. Keeps samples on file. SASE. Simultaneous submissions OK. Reports in 1-2 months. Pays $200-500/color cover. **Pays on acceptance.** Rights negotiable. Credit line given.

BARTENDER MAGAZINE, P.O. Box 158, Liberty Corner NJ 07938. (908)766-6006. Fax: (908)766-6607. E-mail: barmag@aol.com. Website: www.bartender.com. Art Director: Erica DeWitte. Circ. 150,000. Estab. 1979. Quarterly magazine. *Bartender Magazine* serves full-service drinking establishments (full-service means able to serve liquor, beer and wine). "We serve single locations including individual restaurants, hotels, motels, bars, taverns, lounges and all other full-service on-premises licensees." Sample copy $2.50.

Needs: Number of photos/issue varies. Number supplied by freelancers varies. Needs photos of liquor-related topics, drinks, bars/bartenders. Reviews photos with or without ms. Model/property release required. Captions preferred.

Making Contact & Terms: Provide résumé, business card, brochure, flier or tearsheets to be kept on file for possible assignments. SASE. Previously published work OK. Payment negotiable. Pays on publication. Buys all rights; negotiable. Credit line given.

$ $ BEVERAGE & FOOD DYNAMICS, Dept. PM, 1180 Avenue of the Americas, 11th Floor, New York NY 10036. (212)827-4700. Fax: (212)827-4720. Editor: Richard Brandes. Art Director: Paul Viola. Circ. 67,000. Magazine published nine times/year. Emphasizes distilled spirits, wine and beer and all varieties of non-alcoholic beverages (soft drinks, bottled water, juices, etc.), as well as gourmet and specialty foods. Readers are national—retailers (liquor stores, supermarkets, etc.), wholesalers, distillers, vintners, brewers, ad agencies and media.

Needs: Uses 30-50 photos/issue; 5 supplied by freelance photographers and photo house (stock). Needs photos of retailers, product shots, concept shots and profiles. Special needs include good retail environments; interesting store settings; special effect photos. Model release required. Captions required.

Making Contact & Terms: Query with samples and list of stock photo subjects. Send non-returnable samples, slides, tearsheets, etc. with a business card. "An idea of your fee schedule helps, as well as knowing if you travel on a steady basis to certain locations." SASE. Reports in 2 weeks. Simultaneous submissions OK. Pays $550-750/color cover; $450-950/job. Pays on publication. Buys one-time rights or all rights on commissioned photos. Credit line given.

Tips: "We're looking for good location photographers who can style their own photo shoots or have staff stylists. It also helps if they are resourceful with props. A good photographer with basic photographs is always needed. We don't manipulate other artists work, whether its an illustration or a photograph. If a special effect is needed, we hire a photographer who manipulates photographs."

BUILDINGS: The Facilities Construction and Management Magazine, 615 5th St., SE, P.O. Box 1888, Cedar Rapids IA 52406. (319)364-6167. Fax: (319)364-4278. Editor: Linda Monroe. Circ. 56,600. Estab. 1906. Monthly magazine. Emphasizes commercial real estate. Readers are building owners and facilities managers. Sample copy $8.

Needs: Uses 50 photos/issue; 10% supplied by freelancers. Needs photos of concept, building interiors and exteriors, company personnel and products. Model/property release preferred. Captions preferred.

Making Contact & Terms: Provide résumé, business card, brochure, flier or tearsheets to be kept on file for possible assignments. Send 3×5, 8×10, b&w or color prints; 35mm, 2¼×2¼, 4×5 transparencies upon request only. SASE. Reports as needed. Simultaneous submissions OK. Payment is negotiable. Pays on publication. Rights negotiable. Credit line given.

$ ▣ ◎ BUSINESS NH MAGAZINE, 404 Chestnut St., #201, Manchester NH 03101. (603)626-6354. Fax: (603)626-6359. E-mail: bnhmag@aol.com. Art Director: Nikki Bonenfant. Circ. 13,000. Estab. 1984. Monthly magazine. Emphasizes business. Readers are male and female—top management, average age 45. Sample copy free with 9×12 SAE and 5 first-class stamps.

Needs: Uses 3-6 photos/issue. Needs photos of people, high-tech, software, locations, business concepts, industry, product shots/still life, regional. Model/property release preferred. Captions required; include names, locations, contact phone number.

Specs: Accepts images in digital format for Mac (TIFF). Send via compact disc, floppy disk, Zip disk (300 PPI, ISOLPI).

Making Contact & Terms: Arrange personal interview to show portfolio. Provide résumé, business card, brochure, flier or tearsheets to be kept on file for possible assignments. Keeps samples on file. SASE. Reports in 3 weeks. Pays $300-500/color cover; $50-100/color inside; $50-75/b&w inside. Pays on publication. Buys one-time rights. Credit line given. Offers internships for photographers. Contact Art Director: Nikki Bonenfant.

Tips: Looks for "people in environment shots, interesting lighting, lots of creative interpretations, a definite personal style. If you're just starting out and want excellent statewide exposure to the leading executives in New Hampshire, you should talk to us. Send letter and samples, then arrange for a portfolio showing."

Ⓝ $ $▣ ◪ ◎ CHEF, The Food Magazine for Professionals, Talcott Communications Corp., 20 N. Wacker Dr., #1865, Chicago IL 60606. (312)849-2220. Fax: (312)849-2174. E-mail: chefmag@aol.com. Website: http://www.talcott.com. Editor-in-Chief: Brent T. Frei. Circ. 50,000. Estab. 1956. Trade magazine. "We are a food magazine for chefs. Our focus is to help chefs enhance the bottom lines of their businesses through food preparation, presentation and marketing the menu."

Needs: Buys 5-10 photos from freelancers per issue; 60-90 photos per year. Needs photos of food/drink. Other specific photo needs: chefs, establishments. Reviews photos with or without a ms. Model and property release preferred. Photo caption preferred.

Specs: Uses 8×10, glossy, color; 35mm, 2¼×2¼, 4×5, 8×10 transparencies. Accepts images in digital format for Mac. Send via CD, Jaz, Zip as EPS files at 600 dpi.

Making Contact & Terms: Send query letter with résumé, photocopies, tearsheets, stock list. Provide résumé, business card, self-promotion piece to be kept on file for possible future assignments. Reports in 1 month on queries; 3 months on portfolios. Previously published work OK. Pays $250-850 for color cover; $100-400 for color inside. Pays on publication. Buys one-time rights (prefers one-time rights to include electronic). Credit line given.

Ⓝ $▣ THE CHRISTIAN MINISTRY, 407 S. Dearborn St., Chicago IL 60605-1150. (312)427-5380. Fax: (312)427-1302. Managing Editor: Victoria A. Rebeck. Circ. 7,000. Estab. 1969. Bimonthly magazine. Emphasizes religion—parish clergy. Readers are 30-65 years old, 80% male, 20% female, parish

clergy and well-educated. Sample copy free with 9×12 SAE and 4 first-class stamps. Photo guidelines free with SASE.

Needs: Uses 2 photos/issue; all supplied by freelancers. Needs photos of clergy (especially female clergy), church gatherings, school classrooms and church symbols. Future photo needs include social gatherings and leaders working with groups. Candids should appear natural. Model release preferred. Captions preferred.

Making Contact & Terms: Send 8×10 b&w prints by mail for consideration. Also accepts digital images. SASE. Reports in 3 weeks. Will consider simultaneous submissions. Pays $75/color cover; $35/color inside. On solicited photography, pays $75/photo plus expenses and processing. Pays on publication. Buys one-time rights. Credit line given.

Tips: "We're looking for up-to-date photos of clergy, engaged in preaching, teaching, meeting with congregants, working in social activities. We need photos of women, African-American and Hispanic clergy. Images should be high in contrast and sharply focused."

$ CIVITAN MAGAZINE, P.O. Box 130744, Birmingham AL 35213-0744. (205)591-8910. Fax: (205)592-6307. E-mail: civitan@civitan.org. Website: http://www.civitan.org/civitan. Editor: Dorothy Wellborn. Circ. 36,000. Estab. 1920. Publication of Civitan International. Bimonthly magazine. Emphasizes work with mental retardation/developmental disabilities. Readers are men and women, college age to retirement and usually managers or owners of businesses. Sample copy free with 9×12 SASE and 2 first-class stamps. Photo guidelines not available.

Needs: Uses 8-10 photos/issue; 50% supplied by freelancers. Always looking for good cover shots (travel, scenic and how-to). Model release preferred. Captions preferred.

Making Contact & Terms: Send unsolicited 2¼×2¼ or 4×5 transparencies or b&w prints by mail for consideration. Provide résumé, business card, brochure, flier or tearsheets to be kept on file for possible assignments. Reports in 1 month. Simultaneous submissions and previously published work OK. Pays $50/color cover; $10 b&w inside. **Pays on acceptance.** Buys one-time rights.

$ CLASSICAL SINGER, (formerly *The New York Opera Newsletter*), P.O. Box 278, Maplewood NJ 07040. (973)378-9549. Fax: (973)378-2372. E-mail: ebrunson@classicalsinger.com. Editor: C.J. Williamson. Circ. 4,000. Estab. 1988. Monthly trade journal for classical singers, about classical singers and by classical singers. Sample copy free.

Needs: "We've been using headshots but would like to move to many more types of photographs of classical singers, their life and their work." Needs photos of singers as people not icons, young singers at a lesson, singers coming to a performance, audience—looking for photos with personality, emotion, pathos. Reviews photos with or without ms. Call for calendar and ideas. Photo caption preferred include; where, when, who.

Specs: Uses b&w prints.

Making Contact & Terms: Send query letter with samples. Send e-mail. Portfolio may be dropped off any time. Portfolio should include b&w prints. Keeps samples on file; will return material with SASE. Reports in 1 month on queries. Simultaneous submissions and/or previously published work OK. Pays $50/b&w cover maximum; $10-35/b&w inside. Pays on publication. Buys one-time rights. Photo may be used in a reprint of an article on paper or website. Credit line given.

Tips: "We would like to use photos to go with a story—but also photos which reveal the exultation and devastation of a singer's life and career, their ordinary life portrayed with sensitivity. We need singers of all levels from college to retired, performing and touching people from nursing homes to the Metropolitan Opera. Could use competition winners/losers, singers with nerves before a performance, exhaustion after. Our publication is expanding rapidly. We want to make insightful photographs a big part of that expansion."

$ $ CLAVIER, Dept. PM, 200 Northfield Rd., Northfield IL 60093. (847)446-5000. Fax: (847)446-6263. Editor: Judy Nelson. Circ. 20,000. Estab. 1962. Magazine published 10 times/year. Readers are piano and organ teachers. Sample copy $2.

Needs: Human interest photos of keyboard instrument students and teachers. Special needs include synthesizer photos and children performing.

Specs: Uses glossy b&w prints. For cover: Kodachrome, glossy color prints or 35mm transparencies. Vertical format preferred.

Making Contact & Terms: Send material by mail for consideration. SASE. Reports in 1 month. Pays

THE INTERNATIONAL MARKETS INDEX, located in the back of this book, lists markets located outside the U.S. by country.

$225/color cover; $10-25/b&w inside. Pays on publication. Buys all rights. Credit line given.

Tips: "We look for sharply focused photographs that show action and for clear color that is bright and true. We need photographs of children and teachers involved in learning music at the piano. We prefer shots that show them deeply involved in their work rather than posed shots. Very little is taken on specific assignment except for the cover. Authors usually include article photographs with their manuscripts. We purchase only one or two items from stock each year."

$🞉 CLEANING & MAINTENANCE MANAGEMENT MAGAZINE, 13 Century Hill Dr., Latham NY 12110. (518)783-1281. Fax: (518)783-1386. E-mail: dominic@facility~maintenance.com. Website: http://www.cmmonline.com. Managing Editor: Dominic Tom. Circ. 40,000. Estab. 1963. Monthly. Emphasizes management of cleaning/custodial/housekeeping operations for commercial buildings, schools, hospitals, shopping malls, airports, etc. Readers are middle- to upper-level managers of in-house cleaning/custodial departments, and managers/owners of contract cleaning companies. Sample copy free (limited) with SASE.

Needs: Uses 10-15 photos/issue. Needs photos of cleaning personnel working on carpets, hardwood floors, tile, windows, restrooms, large buildings, etc. Model release preferred. Captions required.

Making Contact & Terms: Provide résumé, business card, brochure, flier or tearsheets to be kept on file for possible assignments. "Query with specific ideas for photos related to our field." SASE. Reports in 1-2 weeks. Simultaneous submissions and previously published work OK. Pays $25/b&w inside. Rights negotiable. Credit line given.

Tips: "Query first and shoot what the publication needs."

$▣ CLIMATE BUSINESS MAGAZINE, P.O. Box 13067, Pensacola FL 32591. (904)433-1166. Fax: (904)435-9174. E-mail: burchellpub@gulf.net. Website: http://www.burchellpublishing.com. Publisher: Elizabeth A. Burchell. Circ. 15,000. Estab. 1990. Bimonthly magazine. Emphasizes business. Readers are executives, ages 35-54, with average annual income of $80,000. Sample copy $4.75.

Needs: Uses 50 photos/issue; 20 supplied by freelancers. Needs photos of Florida topics: technology, government, ecology, global trade, finance, travel, regional and life shots. Model/property release required. Captions preferred.

Specs: Uses 5×7 b&w or color prints; 35mm, 2¼×2¼ transparencies. Accepts images in digital format for Mac (TIFF and EPS). Send at 300 dpi via compact, floppy or Zip disk, SyQuest or online.

Making Contact & Terms: Send unsolicited photos by mail for consideration. Provide résumé, business card, brochure, flier or tearsheets to be kept on file for possible assignments. Keeps samples on file. SASE. Reports in 3 weeks. Pays $75/color cover; $25/color inside; $25/b&w inside; $75/color page. Pays on publication. Buys one-time rights.

Tips: "Don't overprice yourself and keep submitting work."

ℕ COMMERCIAL BUILDING, 615 Fifth St. SE, P.O. Box 1888, Cedar Rapids IA 52406. (319)364-6167. Fax: (319)364-4278. Editor: Linda Monroe. Art Director: Elisa Geneser. Circ. 75,000, Estab. 1999. Bimonthly magazine emphasizing commercial real estate. Readers are commercial contractors, specialty contractors, architects and engineers. Sample copy $5.

Needs: Uses 50 photos/issue; 10% supplied by freelancers. Needs photos of business concepts, building interiors and exteriors, company personnel and products. Model/property release preferred. Captions preferred.

Specs: Uses 3×5, 8×10, b&w or color prints; 35 mm, 2¼×2¼, 4×5 transparencies.

Making Contact & Terms: Provide résumé, business card, brochure, flier or tearsheets to be kept on file for possible assignments. SASE. Reports as needed. Simultaneous submissions OK. Payment is negotiable. Pays on publication. Credit line given. Rights negotiable.

CONSTRUCTION BULLETIN, 9443 Science Center Dr., New Hope MN 55428. (612)537-7730. Fax: (612)537-1363. Editor: G.R. Rekela. Circ. 5,000. Estab. 1893. Weekly magazine. Emphasizes construction in Minnesota, North Dakota and South Dakota *only*. Readers are male and female executives, ages 23-65. Sample copy $3.75.

Needs: Uses 25 photos/issue; 1 supplied by freelancers. Needs photos of construction equipment in use on Minnesota, North Dakota, South Dakota job sites. Reviews photos purchased with accompanying ms only. Captions required; include who, what, where, when.

Making Contact & Terms: Send 8×10 matte color prints by mail for consideration. Keeps samples on file. SASE. Reports in 1 month. Previously published work OK. Payment negotiable. Pays on publication. Buys one-time rights. Credit line given.

Tips: "Be observant, keep camera at hand when approaching construction sites in Minnesota, North Dakota and South Dakota."

CONSTRUCTION EQUIPMENT GUIDE, 470 Maryland Dr., Ft. Washington PA 19034. (215)885-2900 or (800)523-2200. Fax: (215)885-2910. E-mail: cegglen@aol.com. Editor: Beth Baker. Circ. 80,000. Estab. 1957. Biweekly trade newspaper. Emphasizes construction equipment industry, including projects ongoing throughout the country. Readers are male and female of all ages. Many are construction executives, contractors, dealers and manufacturers. Free sample copy.

Needs: Uses 75 photo/issue; 20 supplied by freelancers. Needs photos of construction job sites and special event coverage illustrating new equipment applications and interesting projects. Call to inquire about special photo needs for coming year. Model/property release preferred. Captions required for subject identification.

Making Contact & Terms: Send any size matte or glossy b&w prints by mail for consideration. Provide résumé, business card, brochure, flier or tearsheets to be kept on file for possible future assignments. Keeps samples on file. SASE. Reports in 3 weeks. Payment negotiable. Pays on publication. Buys all rights; negotiable. Credit line given.

N $ $ A Ø ◎ CORPORATE LEGAL TIMES, 3 E. Huron St., Chicago IL 60611. (312)654-3500. Fax: (312)654-3525. E-mail: jking@cltmag.com. Website: http://www.corporatelegaltimes.com. Managing Editor: Jennifer King. Circ. 45,000. Estab. 1991. Monthly business magazine for lawyers. Sample copies available for $17.

Needs: Buys 5 photos from freelancers per issue; 60 photos per year. Needs portraits. Reviews photos with or without a ms. Model release preferred. Photo caption required; include name of subject.

Specs: Uses 5×8, glossy, b&w prints; 35mm transparencies.

Making Contact & Terms: Send query letter with tearsheets. Provide business card. Reports back only if interested, send nonreturnable samples. Pays $150 minimum for color cover; $100 minimum for b&w inside; $150 minimum for color inside. Pays publication. Credit line given. Buys all rights; negotiable.

$ CORRECTIONS TECHNOLOGY & MANAGEMENT, Hendon Publishing, Inc., 1000 Skokie Blvd., Suite 500, Wilmette IL 60091. (847)256-8555. Fax: (847)256-8574. E-mail: timburke@flash.net. Editor-in-Chief: Tim Burke. Circ. 21,000. Estab. 1997. Trade journal published 6 times/yr. "CTM brings a fresh, lively, independent view of what's hot in the corrections market to busy correctional facility managers and officers. CTM delivers useful information in an eye-catching format." For sample copy, send 9×12 SASE with $1.71 first-class postage.

Needs: Buys 5-10 photos from freelancers/issue. Needs photos of correctional professionals doing their job. Reviews photos with or without ms. Special photo needs include technology in corrections industry and facility design. Model release required for inmates; property release required. Photo caption required; include description of actions, correct spelling of locations, facilities, names of people in photos.

Specs: Uses color prints.

Making Contact & Terms: Provide résumé, business card, self-promotion piece or tearsheets to be kept on file for possible future assignments. Call editor. Art director will contact photographer for portfolio review if interested. Keeps samples on file; include SASE for return of material. Reports in 2-4 weeks. Pays $300 for cover; $25 for inside. Pays within 30 days. Credit line given.

Tips: "Read CTM to get a feel. Then go get the shot nobody else can get! That's the one we want. Think of our reader, a professional in the field of corrections, who has seen a lot of things. The photos must be able to grab that reader's attention. Make your work the best it can be. Don't send it to us unless it's thrilling."

$ $ THE CRAFTS REPORT, 300 Water St., Wilmington DE 19801. (302)656-2209. Fax: (302)656-4894. Art Director: Mike Ricci. Circ. 30,000. Estab. 1975. Monthly. Emphasizes business issues of concern to professional craftspeople. Readers are professional working craftspeople, retailers and promoters. Sample copy $5.

Needs: Uses 15-25 photos/issue; 0-10 supplied by freelancers. Needs photos of professionally-made crafts, craftspeople at work, studio spaces, craft schools—also photos tied to issue's theme. Model/property release required; shots of artists and their work. Captions required; include artist, location.

Making Contact & Terms: Query with résumé of credits. Provide résumé, business card, brochure, flier or tearsheets to be kept on file for possible assignments. SASE. Simultaneous submissions and previously published work OK. Pays $250-400/color cover; $25-50/inside; assignments negotiated. Pays on publication. Buys one-time and first North American serial rights; negotiable. Credit line given.

Tips: "Shots of craft items must be professional-quality images. For all images be creative—experiment. Color, black & white and alternative processes considered."

$ A ▣ ◻ CRANBERRIES, Dept. PM, P.O. Box 190, Rochester MA 02770. (508)763-8080. Fax: (508)763-4141. E-mail: cranberries@mediaone.net. Publisher/Editor: Carolyn Gilmore. Circ. 1,200. Monthly, but December/January is a combined issue. Emphasizes cranberry growing, processing, marketing

and research. Readers are "primarily cranberry growers but includes anybody associated with the field." Sample copy free.

Needs: Uses about 10 photos/issue; half supplied by freelancers. Needs "portraits of growers, harvesting, manufacturing—anything associated with cranberries." Captions required.

Specs: Uses prints. Accepts images in digital format for Windows (TIFF). Send via compact disc, floppy disk.

Making Contact & Terms: Send 4×5 or 8×10 b&w or color glossy prints by mail for consideration; "simply query about prospective jobs." SASE. Simultaneous submissions and previously published work OK. Pays $25-60/b&w cover; $15-30/b&w inside; $35-100 for text/photo package. Pays on publication. Buys one-time rights. Credit line given.

Tips: "Learn about the field."

$ $ DAIRY TODAY, Farm Journal Publishing, Inc., Centre Square West, 1500 Market St., Philadelphia PA 19102-2181. (215)557-8900. Fax: (215)568-3989. Website: http://www.farmjournal.com. Art Director: Alfred Casciato. Circ. 111,000. Monthly magazine. Emphasizes American agriculture. Readers are active farmers, ranchers or agribusiness people. Sample copy and photo guidelines free with SASE.

● This company also publishes *Farm Journal*, *Beef Today*, *Hogs Today* and *Top Producer* and *Global Agribusiness*.

Needs: Uses 10-20 photos/issue; 50% supplied by freelancers. "We use studio-type portraiture (environmental portraits), technical, details, scenics." Model release preferred. Captions required.

Making Contact & Terms: Arrange a personal interview to show portfolio. Query with résumé of credits along with business card, brochure, flier or tearsheets to be kept on file for possible assignments. "Portfolios may be submitted via CD-ROM or floppy disk." SASE. Reports in 2 weeks. Simultaneous submissions OK. Pays $75-400/color photo; $200-400/day. Pays extra for electronic usage of images. "We pay a cover bonus." **Pays on acceptance.** Buys one-time rights. Credit line given, except in advertorials.

Tips: In portfolio or samples, likes to "see about 40 slides showing photographer's use of lighting and ability to work with people. Know your intended market. Familiarize yourself with the magazine and keep abreast of how photos are used in the general magazine field."

$ 📰 🔘 DANCE TEACHER, Lifestyle Ventures, 250 W. 57th St., Suite 420, New York NY 10107. (212)265-8890. Fax: (212)265-8908. E-mail: dancenow@aol.com. Website: http://www.dance-teacher.com. Editor: Susie Eley. Circ. 8,000. Estab. 1979. Magazine published 10 times per year. Emphasizes dance, business, health and education. Readers are dance instructors and other related professionals, ages 15-90. Sample copy free with 9×12 SASE. Guidelines free with SASE.

Needs: Uses 20 photos/issue; all supplied by freelancers. Needs photos of action shots (teaching, etc.). Reviews photos with accompanying ms only. Model/property release preferred. Model releases required for minors and celebrities. Captions preferred; include date and location.

Specs: Accepts digital images for Windows on SyQuest, Zip disk, floppy or online; call art director for requirements.

Making Contact & Terms: Provide résumé, business card, brochure, flier or tearsheets to be kept on file for possible assignments. Keeps samples on file. SASE. Pays $50 minimum/color cover; $20-150/color inside; $20-125/b&w inside. Pays on publication. Buys one-time rights plus publicity rights; negotiable. Credit line given.

Ⓝ $ $📰 DEALMAKERS, TKO, P.O. Box 2630, Mercerville NJ 08690. (609)587-6200. Fax: (609)587-3511. E-mail: ted@dealmakers.net. Website: http://www.property.com Publisher: Ann O'Neal. Circ. 6,500. Estab. 1998. Weekly trade magazine. Sample copies free.

Needs: Buys 5 photos per year. Needs photos of celebrities, buildings. Interested in alternative process, digital, regional. Reviews photos with or without a ms. Model release required; property release required.

Specs: Accepts images in digital format for Windows. Send via CD, e-mail.

Making Contact & Terms: Send query letter with stock list. Portfolio may be dropped off Monday-Friday. Provide self-promotion piece to be kept on file for possible future assignments. Reports in 2 weeks on queries. Simultaneous submissions OK. Pays on publication. Credit line given. Buys one-time.

$ Ⓢ 🔘 DECA DIMENSIONS, 1908 Association Dr., Reston VA 20191. (703)860-5000. Fax: (703)860-4013. E-mail: carol_lund@DECA.org. Website: http://www.DECA.org. Managing Editor: Carol Lurd. Circ. 160,000. Estab. 1947. Quarterly association magazine. Membership magazine for ages 16-20 enrolled in marketing education and interested in marketing, management, entrepreneurship, leadership and personal development. Sample copy free.

Needs: Needs photos of young people at work, in school, or doing community service. Also uses photos of teens, multicultural, business concepts. Reviews photos with or without ms. Special photo needs include

young people in work situations. Model release preferred. Photo caption preferred stating type of activity.
Specs: Uses 3×5 glossy color prints; 35mm transparencies. Accepts images in digital format for Mac. Send via CD, SyQuest, floppy disk, Zip as TIFF, EPS, GIF, JPEG.
Making Contact & Terms: Send query letter with stock photo list, tearsheets. Provide résumé, business card, self-promotion piece or tearsheets to be kept on file for possible future assignments. Art director will contact photographer for portfolio review if interested. Portfolio should include b&w and/or color, prints, tearsheets or thumbnails. Keeps samples on file; include SASE for return of material. Reports back only if interested. Simultaneous submissions and/or previously published work OK. Pays $150/color cover maximum; $35/b&w inside maximum; $60/color inside maximum. **Pays on acceptance.** Buys one-time rights. Credit line given.
Tips: "I like color and action with an ethnic mix and gender mix."

DM NEWS, 100 Avenue of the Americas, New York NY 10013. (212)925-7300. Fax: (212)925-8754. E-mail: editor@dmnews.com. Executive Editor: Tad Clarke. Circ. 37,000. Estab. 1979. Company publication for Mill Hollow Corporation. Weekly newspaper. Emphasizes direct marketing. Readers are male and female professionals ages 25-55. Sample copy $2.
Needs: Uses 20 photos/issue; 3-5 supplied by freelancers. Needs photos of news head shots, product shots. Reviews photos purchased with accompanying ms only. Captions required.
Making Contact & Terms: Provide résumé, business card, brochure, flier or tearsheets to be kept on file for possible assignments. SASE. Reports in 1-2 weeks. Payment negotiable. **Pays on acceptance.** Buys one-time rights.
Tips: "News and business background are a prerequisite."

$ ▣ EDUCATIONAL LEADERSHIP MAGAZINE, 1250 N. Pitt St., Alexandria VA 22314. (703)549-9110, ext. 430. Fax: (703)299-8637. E-mail: judiconnelly@ascd@ccmail.ascd.org. Designer: Judi Connelly. Circ. 175,000. Publication of the Association for Supervision and Curriculum Development. Magazine; 8 issues/year. Emphasizes schools and children, especially grade school and high school levels, classroom activities. Readers are teachers and educators worldwide.
Needs: Uses 30-40 photos/issue; all supplied by freelancers. Needs photos of children and education. Model release required. Property release preferred. Captions preferred.
Specs: Uses all size glossy b&w prints; 35mm, 2¼×2¼, 4×5 transparencies. Accepts images in digital format for Photoshop. Send via compact disc, floppy disk, SyQuest.
Making Contact & Terms: Provide résumé, business card, brochure, flier or tearsheets to be kept on file for possible future assignments. Keeps samples on file. Cannot return material. Reports in 3 weeks. Simultaneous submissions and previously published work OK. Pays $75/b&w photo; $125/color photo; $400/day minimum. Pays on publication. Buys one-time rights.

$ $ ◪ ELECTRIC PERSPECTIVES, 701 Pennsylvania Ave. NW, Washington DC 20004. (202)508-5714. Fax: (202)508-5759. E-mail: eblume@eei.org. Associate Editor: Eric Blume. Circ. 20,000. Estab. 1976. Publication of Edison Electric Institute. Bimonthly magazine. Emphasizes issues and subjects related to investor-owned electric utilities. Sample copy available on request.
Needs: Uses 20-25 photos/issue; 60% supplied by freelancers. Needs photos relating to the business and operational life of electric utilities—from customer service to engineering, from executive to blue collar. Model release required. Captions preferred.
Specs: Uses 8×10 glossy color prints; 35mm, 2¼×2¼, 4×5 transparencies.
Making Contact & Terms: Query with stock photo list or send unsolicited photos by mail for consideration. Provide résumé, business card, brochure, flier or tearsheets to be kept on file for possible assignments. Keeps samples on file. SASE. Reports in 1 month. Pays $200-400/color cover; $100-300/color inside; $200-350/color page rate; $750-1,500/photo/text package. Pays on publication. Buys one-time rights; negotiable (for reprints).
Tips: "We're interested in annual-report quality transparencies in particular. Quality and creativity is often more important than subject."

$ Ⓐ ELECTRICAL APPARATUS, Barks Publications, Inc., 400 N. Michigan Ave., Chicago IL 60611-4198. (312)321-9440. Associate Publisher: Elsie Dickson. Circ. 17,000. Monthly magazine. Emphasizes industrial electrical machinery maintenance and repair for the electrical aftermarket. Readers are "persons engaged in the application, maintenance and servicing of industrial and commercial electrical and electronic equipment." Sample copy $4.
Needs: "Assigned materials only. We welcome innovative industrial photography, but most of our material is staff-prepared." Photos purchased with accompanying ms or on assignment. Model release required "when requested." Captions preferred.

Making Contact & Terms: Query with résumé of credits. Contact sheet or contact sheet with negatives OK. SASE. Reports in 3 weeks. Pays $25-100/b&w or color. Pays on publication. Buys all rights, but exceptions are occasionally made. Credit line given.

$ $ ▣ ◪ ERGONOMICS IN DESIGN, Human Factors and Ergonomics Society, P.O. Box 1369, Santa Monica CA 90406-1369. (310)394-1811. Fax: (310)394-2410. E-mail: hfes@compuserve.com. Website: http://hfes.org. Managing Editor: Lois Smith. Circ. 5,400. Estab. 1993. Quarterly magazine. Emphasizes how ergonomics research is applied to tools, equipment and systems people use. Readers are BA/MA/PhDs in psychology, engineering and related fields. Sample copy $10.
Needs: Needs photos of technology areas such as medicine, transportation, consumer products. Model/property release preferred. Captions preferred.
Specs: Accepts digital images; inquire before submitting.
Making Contact & Terms: Query with stock photo list. Keeps samples on file. SASE. Reports in 2 weeks. Simultaneous submissions and previously published work OK. Pays on publication. Buys one-time rights. Credit line given.
Tips: Wants to see high-quality color work for strong (sometimes subtle) cover that can also be modified in b&w for lead feature opener inside book.

$ EUROPE, 2300 M St. NW, 3rd Floor, Washington DC 20037. (202)862-9557. Editor-in-Chief: Robert J. Guttman. Managing Editor: Peter Gwin. Circ. 30,000. Magazine published 10 times a year. Covers the Europe Union with "in-depth news articles on topics such as economics, trade, US-EU relations, industry, development and East-West relations." Readers are "business people, professionals, academics, government officials." Free sample copy.
Needs: Uses about 20-30 photos/issue, most of which are supplied by stock houses and freelance photographers. Needs photos of "current news coverage and sectors, such as economics, trade, small business, people, transport, politics, industry, agriculture, fishing, some culture, some travel. No traditional costumes. Each issue we have an overview article on one of the 15 countries in the European Union. For this we need a broad spectrum of photos, particularly color, in all sectors. If photographers query and let us know what they have on hand, we might ask them to submit a selection for a particular story. For example, if they have slides or b&ws on a certain European country, and if we run a story on that country, we might ask them to submit slides on particular topics, such as industry, transport or small business." Model release preferred. Captions preferred; identification necessary.
Making Contact & Terms: Query with list of stock photo subjects. Initially, a list of countries/topics covered will be sufficient. SASE. Reports in 1 month. Simultaneous submissions and previously published work OK. Pays $75-150/b&w inside; $100 minimum/color inside; $400/cover; per job negotiable. Pays on publication. Buys one-time rights. Credit line given.
Tips: "For certain articles, especially the Member States' Reports, we are now using more freelance material than previously. We need good photo and color quality but not touristy or stereotypical. We want to show modern Europe growing and changing. Feature business or industry if possible."

Ⓝ $ $ FARM CHEMICALS, Dept. PM, 37733 Euclid Ave., Willoughby OH 44094. (216)942-2000. Fax: (216)942-0662. Editorial Director: Charlotte Sine. Executive Editor: Jim Sulecki. Circ. 32,000. Estab. 1894. Monthly magazine. Emphasizes application and marketing of fertilizers and protective chemicals for crops for those in the farm chemical industry. Free sample copy and photo guidelines with 9×12 SASE.
Needs: Buys 6-7 photos/year; 5-30% supplied by freelancers. Photos of agricultural chemical and fertilizer application scenes (of commercial—not farmer—applicators). Model release preferred. Captions required.
Specs: Uses 8×10 glossy b&w and color prints or transparencies.
Making Contact & Terms: Query first with résumé of credits. SASE. Reports in 3 weeks. Simultaneous submissions and previously published work OK. Pays $25-50/b&w photo; $50-125/color photo. **Pays on acceptance.** Buys one-time rights.

$ $ ◎ FARM JOURNAL, CORP., Centre Square West, 1500 Market St., Philadelphia PA 19102-2181. (215)557-8959. Fax: (215)568-3989. Editor: Sonja Hillgren. Art Director: Alfred Casciato. Circ. 600,000. Estab. 1877. Monthly magazine. Emphasizes the business of agriculture: "Good farmers want to know what their peers are doing and how to make money marketing their products." Free sample copy upon request.
● This company also publishes *Top Producer*, *Global Agribusiness*, *Beef Today* and *Dairy Today*. *Farm Journal* has received the Best Use of Photos/Design from the American Agricultural Editors' Association (AAEA).
Needs: Freelancers supply 60% of the photos. Photos having to do with the basics of raising, harvesting

and marketing of all the farm commodities. People-oriented shots are encouraged. Also uses human interest and interview photos. All photos must relate to agriculture. Photos purchased with or without accompanying ms. Model release required. Captions required.

Specs: Uses glossy or semigloss color or b&w prints; 35mm or 2¼×2¼ transparencies, all sizes for covers.

Making Contact & Terms: Arrange a personal interview or send photos by mail. Provide calling card and samples to be kept on file for possible future assignments. SASE. Reports in 1 month. Simultaneous submissions OK. Pays by assignment or photo. Pays $200-400/job. Cover bonus. **Pays on acceptance.** Buys one-time rights; negotiable. Credit line given.

Tips: "Be original and take time to see with the camera. Be selective. Look at use of light—available or strobed—and use of color. I look for an easy rapport between photographer and subject. Take as many different angles of subject as possible. Use fill where needed."

$ ⊕ §⃞ ☉ FARMERS WEEKLY, Reed Business Information Ltd., Quadrant House, The Quadrant, Sutton, Surrey SM2 5AS England. Phone: (0181)652 4914. Fax: (0181)652 4005. E-mail: farmers.pictures @rbi.co.uk. Website: http://www.fwi.co.uk. Picture Library Manager: Barry Dixon. Circ. 100,000. Estab. 1934. Weekly trade journal aimed at UK agricultural industry.

Needs: Needs photos of agriculture, environment, landscapes. Reviews photos with or without ms. Photo captions required; include full agricultural technical information.

Specs: Uses 35mm, 2¼×2¼ transparencies.

Making Contact & Terms: Photographers should contact us by phone to show portfolio. Portfolio should include slides, tearsheets. Does not keep samples on file; include SASE for return of material. Payment varies. Pays on publication. Will negotiate with a photographer unwilling to sell all rights.

Tips: "Read our magazine. Ring first before submitting work."

N⃞ $ §⃞ ◎ FASHION ACCESSORIES, S.C.M. Publications, Inc., 65 W. Main St., Bergenfield NJ 07621-1696. (201)384-3336. Fax: (201)384-6776. Circ. 9,500. Estab. 1948. Monthly trade magazine covering all aspects of fashion jewelry. Sample copies available for $3.

Needs: Interested in fashion/glamour.

Specs: Uses 5×7, glossy, color, b&w prints; any size transparencies.

Making Contact & Terms: Send query letter. Provide self-promotion to be kept on file for possible future assignments. Reports back only if interested, send nonreturnable samples. Pays on publication. Credit line given. Buys one-time rights.

Tips:

$ $ ☉ FIRE CHIEF, 35 E. Wacker, Suite 700, Chicago IL 60601. (312)726-7277. Fax: (312)726-0241. E-mail: firechfmag@ichiefs.org. Website: http://www.loczlgov.com. Editor: Scott Baltic. Circ. 50,000. Estab. 1956. Monthly magazine. Emphasizes fire department management and operations. Readers are overwhelmingly fire officers and predominantly chiefs of departments. Free sample copy. Photo guidelines free with SASE.

Needs: Uses 1 photo/issue; all supplied by freelancers. Needs photos of a fire chief in action at an emergency scene. "Contact us for a copy of our current editorial calendar." Model/property release preferred. Captions required; include names, dates, brief description of incident.

Making Contact & Terms: Send any glossy color prints; 35mm, 2¼×2¼ transparencies by mail for consideration. Keeps samples on file. SASE. Reports in 1 month. Pays $300/color cover; $25-50/color inside. Pays on publication. Buys first serial rights; negotiable.

Tips: "We want a photo that captures a chief officer in command at a fire or other incident, that speaks to the emotions (the burden of command, stress, concern for others). Most of our cover photographers take dozens of fire photos every month. These are the people who keep radio scanners on in the background most of the day. Timing is everything."

$ $⃞ ☉ ◎ FIRE ENGINEERING, Park 80 West Plaza 2, 7th Floor, Saddle Brook NJ 07663. (201)845-0800. Fax: (201)845-6275. E-mail: dianef@pennwell.com. Editor: Bill Manning. Estab. 1877. Training magazine for firefighters. Photo guidelines free with SASE.

Needs: Uses 400 photos/year. Needs action photos of disasters, firefighting, EMS, public safety, fire investigation and prevention, rescue. Captions required; include date, what is happening, location and fire department contact.

Specs: Uses prints; 35mm transparencies. "We accept scans of photos as long as it is a high-resolution version."

Making Contact & Terms: Send unsolicited photos by mail for consideration. SASE. Reports in up to

3 months. Pays $35-150/color inside; $300/color cover. Pays on publication. Rights negotiable. Credit line given.

Tips: "Firefighters must be doing something. Our focus is on training and learning lessons from photos."

N $ S ▣ ◑ FIREHOUSE MAGAZINE, 445 Broad Hollow Rd., Suite 21, Melville NY 11747. (516)845-2700. Fax: (516)845-7109. Website: http://www.firehouse.com. Editor-in-Chief: Harvey Eisner. Circ. 110,000. Estab. 1973. Monthly. Emphasizes "firefighting—notable fires, techniques, dramatic fires and rescues, etc." Readers are "paid and volunteer firefighters, EMTs." Sample copy $3 with 9 × 12 SASE and approximately 6 first-class stamps. Photo guidelines free with SASE.

Needs: Uses about 30 photos/issue; 20 supplied by freelance photographers. Needs photos of fires, terrorism, firefighter training, natural disasters, highway incidents, hazardous materials, dramatic rescues. Model release preferred.

Specs: Accepts images in digital format for Mac. Send via CD, floppy disk, Zip, e-mail as TIFF, EPS, JPEG files at 300 dpi.

Making Contact & Terms: Send 3 × 5, 5 × 7, 8 × 10 matte or glossy b&w or color prints; 35mm transparencies by mail for consideration. "Photos must not be more than 30 days old." Include SASE. "Photos cannot be returned without SASE." Reports ASAP. Pays $200/color cover; $20/b&w; $20/color. Pays on publication. Credit line given. Buys one-time rights.

Tips: "Mostly we are looking for action-packed photos—the more fire, the better the shot. Show firefighters in full gear, do not show spectators. Fire safety is a big concern. Much of our photo work is freelance. Try to be in the right place at the right time as the fire occurs. *Firehouse* encourages submissions of high-quality action photos which relate to the firefighting/EMS field. Please understand that while we encourage first-time photographers, a minimum waiting period of 3-6 months is not unusual. Although we are capable of receiving photos over the Internet, please be advised that there are color variations. Include captions. Photographers must include an SASE, and we cannot guarantee the return of unsolicited photos. Mark name and address on the back of each photo."

$ $ A ▣ ▨ ◑ FLORAL MANAGEMENT MAGAZINE, 1601 Duke St., Alexandria VA 22314. (703)836-8700. Fax: (800)208-0078. E-mail: kpenn@safnow.org. Editor and Publisher: Kate Penn. Estab. 1894. National trade association magazine representing growers, wholesalers and retailers of flowers and plants. Photos used in magazine and promotional materials.

Needs: Offers 15-20 assignments/year. Needs photos of floral business owners, employees on location and retail environmental portraits. Reviews stock photos. Model release required. Captions preferred.

Audiovisual Needs: Uses slides (with graphics) for convention slide shows.

Specs: Uses b&w prints, or transparencies. Accepts images in digital format for Mac. Send via CD, Zip as TIFF files.

Making Contact & Terms: Query with samples. Provide résumé, business card, brochure, flier or tearsheets to be kept on file for possible future assignments. SASE. Reports in 1 week. Pays $150-600/color cover shot; $75-150/hour; $125-250/job; $75-500/color inside. Buys one-time rights. Credit line given.

Tips: "We shoot a lot of tightly composed, dramatic shots of people so we look for these skills. We also welcome input from the photographer on the concept of the shot. Our readers, as business owners, like to see photos of other business owners. Therefore, people photography, on location, is particularly popular." Photographers should approach magazine "Via letter of introduction and sample. We'll keep name in file and use if we have a shoot near photographer's location."

N $ ◻ ◎ FLORIDA UNDERWRITER, Dept. PM, 9887 Fourth St. N., Suite 230, St. Petersburg FL 33702. (727)576-1101. Editor: James E. Seymour. Circ. 10,000. Estab. 1984. Monthly magazine. Emphasizes insurance. Readers are insurance professionals in Florida. Sample copy free with 9 × 12 SASE.

Needs: Uses 10-12 photos/issue; 1-2 supplied by freelancers; 80% assignment and 20% freelance stock. Needs photos of insurance people, subjects, meetings and legislators. Captions preferred.

Making Contact & Terms: Query first with list of stock photo subjects. Send prints, 35mm, 2¼ × 2¼, 4 × 5, 8 × 10 transparencies by mail for consideration. Provide résumé, business card, brochure, flier or tearsheets to be kept on file for possible assignments. SASE. Reports in 3 weeks. Simultaneous submissions and previously published work OK (admission of same required). Pays $50-150/b&w cover; $15-35/b&w inside; $5-20/color page rate. Pays on publication. Buys all rights; negotiable. Credit line given.

 SPECIAL COMMENTS within listings by the editor of *Photographer's Market* are set off by a bullet.

Tips: "Like the insurance industry we cover, we are cutting costs. We are using fewer freelance photos (almost none at present)."

$FOOD DISTRIBUTION MAGAZINE, 1580 NW Boca Raton Blvd., #6, Boca Raton FL 33432. (561)447-0810. Fax: (561)368-9125. Editor: Susan Friedman. Circ. 35,000. Estab. 1959. Monthly magazine. Emphasizes gourmet and specialty foods. Readers are male and female food-industry executives, ages 30-60. Sample copy $5.
Needs: Uses 10 photos/issue; 3 supplied by freelancers. Needs photos of food: prepared food shots, products on store shelves. Reviews photos with accompanying ms only. Model release required for models only. Captions preferred; include photographer's name, subject.
Making Contact & Terms: Send any size color prints or slides and 4×5 transparencies by mail for consideration. SASE. Reports in 1-2 weeks. Simultaneous submissions OK. Pays $100 minimum/color cover; $50 minimum/color inside. Pays on publication. Buys all rights. Credit line given.

$ⓈⒷⓄ FOREST LANDOWNER, P.O. Box 95385, Atlanta GA 30347. (404)325-2954. Fax: (404)325-2955. E-mail: snewton100@aol.com. Managing Editor: Steve Newton. Circ. 10,000. Estab. 1950. Publication of Forest Landowners Association. Bimonthly magazine. Emphasizes forest management and forest policy issues for private forest landowners. Readers are forest landowners and forest industry consultants; 94% male between the ages of 46 and 55. Sample copy $3 (magazine), $25 (manual).
Needs: Uses 15-25 photos/issue; 3-4 supplied by freelancers. Needs photos of unique or interesting southern forests. Other subjects: environmental, regional, wildlife,landscapes. Model/property release preferred. Captions preferred.
Specs: Accepts images in digital format for Windows. Send via compact disc, Zip disk or e-mail as TIFF files at 300 dpi.
Making Contact & Terms: Send Zip disk, color prints, negatives or transparencies by mail for consideration. Query with stock photo list. Keeps samples on file. SASE. Reports in 3 weeks. Simultaneous submissions and previously published work OK. Pays $100-200/ color cover; $30-50/inside b&w; $30-50/inside color. Pays on publication. Buys one-time and all rights; negotiable. Credit line given.
Tips: "We most often use photos of timber management, seedlings, aerial shots of forests, and unique southern forest landscapes."

Ⓝ $ⒷⓄ FUNWORLD, IAAPA, 1448 Duke St., Alexandria VA 22314. Fax: (703)836-4801. E-mail: mmoran@iaapa.org. Website: iaapa.org. Circ. 9,000. Estab. 1984. Monthly trade magazine. Emphasizes amusement parks, entertainment venues, zoos, museums, waterparks, entertainment centers. Sample copies available.
Needs: Buys 15 photos per year. Needs photos of entertainment, food/drink. Interested in regional photos. Other specific needs: amusement park elements and people. Reviews photos with or without a ms. Model release and property release required. Photo caption required.
Specs: Uses 35mm transparencies. Accepts images in digital format for Mac. Send via CD, Zip as TIFF files at 300 dpi.
Making Contact & Terms: Send query letter with résumé, prints. Provide résumé, self-promotion piece to be kept on file for possible future assignments. Reports in 2-4 weeks on queries; 1 month on portfolios. Pays $250-600 for color cover; $50-200 for color inside. **Pays on acceptance**. Credit line given. Buys one-time, first rights; negotiable.
Tips: "We are always looking for fresh perspectives, angles and ideas."

Ⓝ $GOVERNMENT TECHNOLOGY, 9719 Lincoln Village, #500, Sacramento CA 95827. (916)363-5000. Fax: (916)363-5197. Creative Director: Michelle MacDonnell. Circ. 65,000. Estab. 1988. Monthly tabloid. Emphasizes technology in state and local government—no federal. Readers are male and female state and local government executives. Sample copy free with tabloid-sized SAE and 10 first-class stamps.
Needs: Uses 20-30 photos/issue; 1-5 supplied by freelancers. Needs photos of action or aesthetic—technology in use in state and local government, e.g., fire department, city hall, etc. Model/property release required; model and government agency. Captions preferred; who, what and where.
Specs: Uses 35mm, 2¼×2¼, 4×5, 8×10 transparencies.
Making Contact & Terms: Send unsolicited photos by mail for consideration. Cannot return materials. Reports back when used. Simultaneous submissions and previously published work OK. Pays $300-500/ color cover; $25-200/color inside; $50-100/b&w inside. Pays on publication. Buys all rights; negotiable. Credit line given.
Tips: Looking for "before and after shots. Photo sequences that tell the story. Get copies of our magazine. Tell me your location if you are willing to do assignments on spec."

N $ ▣ **GRAIN JOURNAL**, Dept. PM, 3065 Pershing Court, Decatur IL 62526. (217)877-9660. Fax: (217)877-6647. E-mail: ed@grainnet.com. Website: www.grainnet.com. Editor: Ed Zdrojewski. Circ. 11,303. Bimonthly. Emphasizes grain industry. Readers are "elevator managers primarily as well as suppliers and others in the industry." Sample copy free with 10×12 SAE and 3 first-class stamps.
Needs: Uses about 1-2 photos/issue. "We need photos concerning industry practices and activities. We look for clear, high-quality images without a lot of extraneous material." Captions preferred.
Specs: Accepts images in digital format. Send via online, floppy disk, Zip disk.
Making Contact & Terms: Query with samples and list of stock photo subjects. SASE. Reports in 1 week. Pays $100/color cover; $30/b&w inside. Pays on publication. Buys all rights; negotiable. Credit line given.

N $ **THE GREYHOUND REVIEW**, P.O. Box 543, Abilene KS 67410. (785)263-4660. Contact: Gary Guccione or Tim Horan. Circ. 4,000. Publication of the National Greyhound Association. Monthly. Emphasizes Greyhound racing and breeding. Readers are Greyhound owners and breeders. Sample copy with SAE and 11 first-class stamps.
Needs: Uses about 5 photos/issue; 1 supplied by freelance photographers. Needs "anything pertinent to the Greyhound that would be of interest to greyhound owners." Captions required.
Making Contact & Terms: Query first. After response, send b&w or color prints and contact sheets by mail for consideration. Submit portfolio for review. Provide résumé, business card, brochure, flier or tearsheets to be kept on file for possible future assignments. Can return unsolicited material if requested. Reports within 1 month. Simultaneous submissions and previously published work OK. Pays $85/color cover; $25-100/color inside. **Pays on acceptance.** Buys one-time and North American rights. Credit line given.
Tips: "We look for human-interest or action photos involving Greyhounds. No muzzles, please, unless the greyhound is actually racing. When submitting photos for our cover, make sure there's plenty of cropping space on all margins around your photo's subject; full bleeds on our cover are preferred."

$ ▣ **THE GROWING EDGE**, 341 SW Second St., P.O. Box 1027, Corvallis OR 97333. (541)757-2511. Fax: (541)757-0028. E-mail: aknutson@peak.org. Website: http://www.growingedge.com. Editor: Amy Knutson. Circ. 20,000. Estab. 1989. Published bimonthly. Emphasizes "new and innovative techniques in gardening indoors, outdoors and in the greenhouse—hydroponics, artificial lighting, greenhouse operations/control, water conservation, new and unusual plant varieties." Readers are serious amateurs to small commercial growers.
Needs: Uses about 40 photos per issue; most supplied with articles by freelancers. Occasional assignment work (5%); 80% from freelance stock. Needs photos of gardening, environment, landscapes, technology. Model release required. Captions required; include plant types, equipment used.
Specs: Prefers 35mm slides. Accepts b&w or color prints; transparencies (any size); b&w or color negatives with contact sheets. Accepts images in digital format for Mac.
Making Contact & Terms: Send query with samples. SASE. Reports in 6 weeks or will notify and keep material on file for future use. Pays $175/cover; $25-50/b&w inside; $25-175/color inside; $300-800/text/ photo package. Pays on publication. Buys first world and one-time anthology rights; negotiable. Credit line given.
Tips: "Most photographs are used to illustrate processes and equipment described in text. Some photographs of specimen plants purchased. Many photos are of indoor plants under artificial lighting. The ability to deal with tricky lighting situations is important." Expects more assignment work in the future, especially for covers. Need cover photos.

N $ ▣ ◐ ◎ **HARVARD DESIGN MAGAZINE**, Harvard University GSD, 48 Quincy St., Cambridge MA 02138. (617)495-7814. Fax: (617)496-3391. E-mail: hdm@gsd.harvard.edu. Website: http://www.harvard.edu/hdm. Business/Circulation Coordinator: Jeffrey Gonyeau. Circ. 16,000. Estab. 1997. Trade magazine published 3 times/year. "The *Harvard Design Magazine* contains thoughtful essays, discussions, book reviews, visual material, and interviews on major design and educational issues, practitioners, and projects of interest to architects, landscape architects, urban planners, and urban designers, both in academia and professional practice, plus some interested 'lay people.'" Sample copies available for $10. Art guidelines available.
Needs: Buys 12 photos from freelancers per issue; 36 photos per year. Needs photos of landscape/scenics, architecture, cities/urban, buildings, product shots/still life, technology, documentary, fine art, historical/ vintage. Reviews photos with accompanying ms only. Model release required; property release preferred. Photo caption required; include title, photographer, date.
Specs: Uses 8×10, glossy, b&w prints; 35mm, 8×10 transparencies. Accepts images in digital format for Mac. Send via Zip, e-mail at 300 dpi.

Making Contact & Terms: Send query letter with résumé, tearsheets. Does not keep samples on file; include SASE for return of material. Reports in 2 weeks on queries; 2 weeks on portfolios. Previously published work OK. Pays $100-500 for color cover. $50-150 for b&w inside; $50-150 for color inside. Pays on publication. Credit line given. Buys one-time rights.

Tips: "Look at the magazine, particularly the portfolio sections, for the type of photos we publish. We don't want just 'pretty pictures,' something that exudes a deeper meaning. Contact us by phone/fax/e-mail before sending anything. Because our issues are 'themed' as much as a year in advance we would need to discuss this with any photographer at the outset."

N **$ $□ ◎ HEALTH PRODUCTS BUSINESS**, Cygnus Publishing, 2 University Plaza, Suite 204, Hackensack NJ 07601. (201)487-7800. Fax: (201)487-1061. E-mail: hfbiz@idt.net. Website: http:// www.healthproductsbusiness.com. Editor: Gina Geslewitz. Circ. 16,000. Estab. 1955. Monthly trade magazine for health products industry. Sample copies available.

Needs: Buys 1 photo from freelancers per issue; 12 photos per year. Needs photos of food/drink, health/ fitness. Other specific photo needs: herbs, vitamins, fitness. Model release required. Photo caption required.

Specs: Uses any size, color prints; all size transparencies. Accepts images in digital format for Mac. Send via SyQuest, floppy disk Zip as TIFF, EPS files at 90 dpi.

Making Contact & Terms: Send query letter with photocopies, tearsheets. Provide self-promotion piece to be kept on file for possible future assignments. Previously published work OK. Pays $175-400 for color cover; payement negotiable color inside. Pays on publication. Credit line given. Buys all rights.

N **$ $□ HEARTH AND HOME**, Dept. PM, P.O. Box 2008, Laconia NH 03247. (603)528-4285. Fax: (603)524-0643. Editor: Richard Wright. Design Director: Denise Tardif. Circ. 18,500. Monthly magazine. Emphasizes new and industry trends for specialty retailers and manufacturers of solid fuel and gas appliances, barbecue grills, hearth accessories and casual furnishings. Sample copy $5.

Needs: Uses about 30 photos/issue; 10% supplied by freelance photographers. Needs "shots of energy and patio furnishings stores (preferably a combination store), retail displays, wood heat installations, fireplaces, wood stoves and lawn and garden shots (installation as well as final design), gas grill, gas fireplaces, gas installation indoor/outdoor. Assignments available for interviews, conferences and out-of-state stories." Model release required; captions preferred.

Specs: Uses color glossy prints, transparencies. Also accepts digital images with color proof in Photoshop, CMYK and SyQuest.

Making Contact & Terms: Contact before submitting material. SASE. Reports in 2 weeks. Simultaneous and photocopied submissions OK. Pays $50-300/color photo, $250-750/job. Pays within 60 days. Buys various rights. Credit line given.

Tips: "Call first and ask what we need. We're *always* on the lookout for material."

$ $🔧 □ ◐ HEATING, PLUMBING & AIR CONDITIONING (HPAC), 1370 Don Mills Rd., Suite 300, Don Mills, Ontario M3B 3N7 Canada. (416)759-2500. Fax: (416)759-6979. Publisher: Bruce Meacock. Circ. 17,000. Estab. 1927. Bimonthly magazine plus annual buyers guide. Emphasizes heating, plumbing, air conditioning, refrigeration. Readers are predominantly male, mechanical contractors ages 30-60. Sample copy $4.

Needs: Uses 10-15 photos/issue; 2-4 supplied by freelancers. Needs photos of mechanical contractors at work, product shots. Model/property release preferred. Captions preferred.

Specs: Uses 4×6, glossy/semi-matte color b&w prints; 35mm transparencies. Also accepts digital images.

Making Contact & Terms: Send unsolicited photos by mail for consideration. Cannot return material. Reports in 1 month. Simultaneous submissions and/or previously published work OK. Payment negotiable. Pays on publication. Buys one-time rights; negotiable. Credit line given.

$○ ◎ HOME LIGHTING & ACCESSORIES, 1011 Clifton Ave., Clifton NJ 07013. (973)779-1600. Fax: (973)779-3242. Editor-in-Chief: Linda Longo. Circ. 12,000. Estab. 1923. Monthly magazine. Emphasizes outdoor and interior lighting. Readers are small business owners, specifically lighting showrooms and furniture stores. Sample copy $6.

Needs: Uses 50 photos/issue; 10 supplied by freelancers. Needs photos of lighting applications that are unusual—either landscape for residential or some commercial and retail stores. Reviews photos with accompanying ms only. Model/property release preferred. Captions required (location and relevant names of people or store).

Specs: Uses 5×7, 8×10 color prints; 4×5 transparencies.

Making Contact & Terms: Query with résumé of credits. Send unsolicited photos by mail for consideration. Provide résumé, business card, brochure, flier or tearsheets to be kept on file for possible future assignments. Keeps samples on file. SASE. Reports in 1 month. Simultaneous submissions and/or pre-

viously published work OK. Pays $90/color cover; $5-10/color inside. Pays on publication. Buys one-time rights. Credit line given.

$ ▣ THE HORSE, 1736 Alexandria Dr., Lexington KY 40504. (606)278-2361. Fax: (606)276-4450. E-mail: sappleyard@thehorse.com. Website: http://www.thehorse.com. Editorial Assistant: Susan Appleyard. Circ. 24,900. Estab. March 1995 (name changed from *Modern Horse Breeding* to *The Horse*). Monthly magazine. Emphasizes equine health. Readers are equine veterinarians and top-level horse owners, trainers and barn managers. Sample copy free with SASE. Photo guidelines free with SASE.

Needs: Uses 30 photos/issue; 10-20 supplied by freelancers. Needs generic horse shots, horse health such as farrier and veterinarian shots. "We use all breeds and all disciplines." Model/property relese preferred. Captions preferred.

Specs: Uses color and b&w prints; 35mm, 2¼×2¼, 4×5, 8×10 transparencies. Accepts images in digital format for Mac. Send via compact disc, online, floppy disk, SyQuest, Zip disk, Jazz as TIFF, JPEG (300 dpi 6×4).

Making Contact & Terms: Send unsolicited photos by mail for consideration. Keeps samples on file. Reports in 1-2 weeks. Previously published work OK. Pays $150/color cover; $150/b&w cover; $25-75/color inside; $25-75/b&w inside. Pays on publication. Buys one-time rights.

$ IB (INDEPENDENT BUSINESS): AMERICA'S SMALL BUSINESS MAGAZINE, Group IV Communications, 125 Auburn Court, Suite 100, Thousand Oaks CA 91362. (805)496-6156. Fax: (805)496-5469. E-mail: gosmallbiz@aol.com. Website: http://www.yoursource.com. Editor: Daniel Kehrer. Editorial Director: Don Phillipson. Photo Editor: Nancy Phillipson. Circ. 600,000. Estab. 1990. Bimonthly magazine. Emphasizes small business. All readers are small business owners throughout the US. Sample copy $4. Photo guidelines free with SASE.

Needs: Uses 25-35 photos/issue; all supplied by freelancers. Needs photos of "people who are small business owners. All pictures are by assignment; no spec photos." Special photo needs include dynamic, unusual photos of offbeat businesses and their owners. Model/property release required. Captions required; include correct spelling on name, title, business name, location.

Making Contact & Terms: Query with résumé of credits and samples. Provide résumé, business card, brochure, flier or tearsheets to be kept on file for possible assignments. Unsolicited original art will not be returned. Pays $350/color inside plus expenses. Pays $400-500 per complete job plus expenses. Pays $100-150 per electronic use of images. **Pays on acceptance.** Buys first and nonexclusive reprint rights. Credit line given.

Tips: "We want colorful, striking photos of small business owners that go well above-and-beyond the usual business magazine. Capture the essence of the business owner's native habitat."

$ $ ▣ ◎ IEEE SPECTRUM, 3 Park Ave., 17th Floor, New York NY 10016. (212)419-7568. Fax: (212)419-7570. Website: http://www.spectrum.ieee.org. Art Director: Mark Montgomery. Circ. 330,000. Publication of Institute of Electrical and Electronics Engineers, Inc. (IEEE). Monthly magazine. Emphasizes electrical and electronics field and high technology. Readers are male/female; educated; age range: 24-60.

Need: Uses 3-6 photos/issue; 3 provided by freelancers. Needs photos of environment, business concepts, computers, industry, medicine, military, portraits, product shots/still life, science, technology. Interested in alternative process, avant garde, digital, documentary. Model/property release required. Captions preferred.

Specs: Accepts images in digital format for Mac. Send via CD, Zip as TIFF, JPEG files at 300 dpi.

Making Contact & Terms: Arrange personal interview to show portfolio. Provide résumé, business card, brochure, flier or tearsheets to be kept on file for possible assignments. Previously published work OK. Pays $1,500-2,000/color cover; $200-400/color inside. **Pays on acceptance.** Buys one-time rights. Credit line given.

Tips: Wants photographers who are consistent, have an ability to shoot color and b&w, display a unique vision and are receptive to their subjects. "Send mailer with printed samples. Call at the end of the month only. We are too busy to look at portfolios or talk from the 5th of the month through the 17th of the month."

INDOOR COMFORT NEWS, 454 W. Broadway, Glendale CA 91204. (818)551-1555. Fax: (818)551-1115. Managing Editor: Chris Callard. Circ. 20,000. Estab. 1955. Publication of Institute of Heating and Air Conditioning Industries. Monthly magazine. Emphasizes news, features, updates, special sections on CFC's, Indoor Air Quality, Legal. Readers are predominantly male—25-65, HVAC/R/SM contractors, wholesalers, manufacturers and distributors. Sample copy free with 10×13 SAE and 10 first-class stamps.

Needs: Interested in photos with stories of topical projects, retrofits, or renovations that are of interest to

the heating, venting, and air conditioning industry. Property release required. Captions required; include what it is, where and what is unique about it.

Specs: Uses 3×5 glossy color and b&w prints.

Making Contact & Terms: Send unsolicited photos by mail for consideration. Provide résumé, business card, brochure, flier or tearsheets to be kept on file for possible assignments. Keeps samples on file. SASE. Reports in 1-2 weeks. Payment negotiable. Credit line given.

Tips: Looks for West Coast material—projects and activities with quality photos of interest to the HVAC industry. "Familiarize yourself with the magazine and industry before submitting photos."

$ $ [A] 🔾 INSIDE AUTOMOTIVES, 21700 Northwestern Hwy., Suite 565, Southfield MI 48075. (248)557-2430. Fax: (248)557-2431. E-mail: scottw@ancarpub.com. Managing Editor: Scott Worden. Circ. 11,200. Estab. 1994. Monthly magazine. Emphasizes automotive interiors. Readers are engineers, designers, management OEMS and material and components suppliers. Sample copy $4. Photo guidelines free with SASE.

Needs: Uses 20 photos/issue; 10% supplied by freelancers. Needs photos of technology related to articles and cover photos. Model/property release preferred for technical information. Captions required; include who and what is in photos.

Specs: Uses 3×5, 5×7 color and b&w photos; 35mm transparencies.

Making Contact & Terms: Provide résumé, business card, brochure, flier or tearsheets to be kept on file for possible future assignments. Contact editor by letter or fax. Keeps samples on file. SASE. Simultaneous submissions OK. Payment negotiable. Pays on publication. Buys one-time rights. Credit line given.

[N] $ ▣ 🔾 INTERNATIONAL PHOTO COLLEGE, 3773 Willow Pass Rd., Concord CA 94519-1001. Phone/fax: (925)691-6833. E-mail: admin@photocollege.com. Website: http://www.photocollege.com. Director: Bob Shepherd. Academic Administrator: Mee Cho. Estab. 1996. Distance learning institution offering an Associate in Arts degree in Professional Photo Editing. Brochures free upon request. Photo guidelines free with SASE.

Needs: Uses 40-50 photos per year. IPC's Photo Editing Course is revised on a yearly basis with new photos; photos supplied by both talented amateur and professional photographers. About 40% supplied by amateurs. Needs all kinds of photos, but photos must meet criteria listed under Tips, below. All photographic images must include universal themes. Model/property release required for identifiable private property and portraits.

Specs: Accepts images in digital format for Windows. Send via CD, Zip, e-mail as GIF, JPEG files at 600 dpi.

Making Contact & Terms: Query with résumé of credits. Query with sample 3×5 to 8×10 glossy prints. Provide return envelope and sufficient postage if photos are to be returned. "Because of misunderstandings by some photo contributors, we must make clear that although we will take every precaution to protect your photographic images from being lost or damaged, we cannot guarantee their safe return. All photos mailed to International Photo College are unsolicited submissions. Therefore, only send copies of originals." Photo samples are normally kept on file for future reference. Reports in 6 weeks. Simultaneous submissions and previously published work OK. Pays $50/b&w photo; $100/color photo; up to $300 for photo assignment. **Pays on acceptance.** Rights negotiable. Credit line given and portrait of photographer published.

Tips: "We are an educational institution that publishes a professional photo editing course; therefore, only photos that exhibit universal themes will be given serious consideration. Universal themes are represented by images that are meaningful to people everywhere. We look for five basic characteristics by which we select photographic images: sharp exposures (unless the image was intended as a soft-focus shot), impact, easily identifiable theme or subject, emphasis of the theme or subject and simplicity."

$ $▣ JEMS COMMUNICATIONS, 1947 Camino Vida Roble, Suite 200, Carlsbad CA 92008. (760)431-9797. Fax: (760)431-9567. E-mail: jems.editor@mosby.com. Managing Editor: Lisa Dionne. Circ. 45,000. Estab. 1980. Monthly magazine. Emphasizes emergency medical services by out-of-hospital providers. Readers are EMTS and paramedics. Sample copy available. Photo guidelines free with SASE.

Needs: Uses 35-40 photos/month; 15-20 supplied by freelancers. Needs photos of paramedics and EMTs on actual calls following proper procedures with focus on caregivers, not patients. Model/property release required for EMS providers, patients and family members. Captions preferred; include city, state, incident and response organizations identified.

Specs: Uses 8×10 glossy color and b&w prints; 35mm 2¼×2¼, 4×5, 8×10 transparencies. Accepts photos in digital format for Mac (Photoshop).

Making Contact & Terms: Query with letter requesting rates and guidelines. Keeps samples on file. Cannot return material. Reports in 3 weeks. Pays $200+/color cover; $25-300/color inside; $25-100/b&w

inside; pays extra for electronic usage of photos. Buys one-time rights. Credit line given.

Tips: "Study samples before submitting. We want the photos to focus on caregivers, not patients. We want providers following protocols in a variety of settings."

$ $🖵 JOURNAL OF PROPERTY MANAGEMENT, 430 N. Michigan Ave., 7th Floor, Chicago IL 60611. (312)329-6059. Fax: (312)661-0217. Website: http://www.irem.org. Associate Editor: Laura Otto. Executive Editor: Mariwyn Evans. Estab. 1934. Bimonthly magazine. Emphasizes real estate management. Readers are mid- and upper-level managers of investment real estate. Sample copy free with SASE.

Needs: Uses 6 photos/issue; 50% supplied by freelancers. Needs photos of buildings (apartments, condos, offices, shopping centers, industrial), building operations and office interaction. Model/property release preferred.

Specs: Accepts images in digital format for Windows. Send via compact disc, floppy disk, SyQuest, Zip disk as TIFF, EPS.

Making Contact & Terms: Pays $200/color photo.

JOURNAL OF PSYCHOACTIVE DRUGS, Dept. PM, 612 Clayton St., San Francisco CA 94117. (415)565-1904. Fax: (415)864-6162. Editor: Richard B. Seymour. Circ. 1,400. Estab. 1967. Quarterly. Emphasizes "psychoactive substances (both legal and illegal)." Readers are "professionals (primarily health) in the drug abuse treatment field."

Needs: Uses 1 photo/issue; supplied by freelancers. Needs "full-color abstract, surreal, avant garde or computer graphics."

Making Contact & Terms: Query and send 4×6 color prints or 35mm slides by mail for consideration. SASE. Reports in 2 weeks. Simultaneous submissions and previously published work OK. Pays $50/color cover. Pays on publication. Buys one-time rights. Credit line given.

$ $🖵 ◑ JUDICATURE, 180 N. Michigan, Suite 600, Chicago IL 60601-7401. (312)558-6900, ext. 119. Fax: (312)558-9175. E-mail: drichert@ajs.org. Website: http://www.ajs.org. Editor: David Richert. Circ. 11,000. Estab. 1917. Publication of the American Judicature Society. Bimonthly. Emphasizes courts, administration of justice. Readers are judges, lawyers, professors, citizens interested in improving the administration of justice. Sample copy free with 9×12 SAE and 6 first-class stamps.

Needs: Uses 2-3 photos/issue; 1-2 supplied by freelancers. Needs photos relating to courts, the law. "Actual or posed courtroom shots are always needed." Interested in fine art and historical photos. Model/property releases preferred. Captions preferred.

Specs: Uses b&w and color prints. Accepts images in digital format for Mac. Send via CD, Zip, e-mail as JPEG files at 600 dpi.

Making Contact & Terms: Send 5×7 glossy b&w prints or slides by mail for consideration. Provide résumé, business card, brochure, flier or tearsheets to be kept on file for possible future assignments. SASE. Reports in 2 weeks. Simultaneous submissions and previously published work OK. Pays $250/b&w cover; $350/color cover; $125-300/color inside; $125-250/b&w inside. Pays on publication. Buys one-time rights. Credit line given.

🅽 KITCHEN & BATH BUSINESS, One Penn Plaza, 10th Floor, New York NY 10119. (212)615-2993. Fax: (212)279-3963. E-mail: dschultz@mfi.com. Art Director: Dan Schultz. Circ. 52,000. Estab. 1955. Monthly magazine. Emphasizes kitchen and bath design, sales and products. Readers are male and female kitchen and bath dealers, designers, builders, architects, manufacturers, distributors and home center personnel. Sample copy free with 9×12 SASE.

Needs: Uses 40-50 photos/issue; 4-8 supplied by freelancers. Needs kitchen and bath installation shots and project shots of never-before-published kitchen and baths. Reviews photos with accompanying ms only. Captions preferred; include relevant information about the kitchen or bath—remodel or new construction, designer's name and phone number.

Making Contact & Terms: Send any size color and b&w prints by mail for consideration. Keeps samples on file. Reports in 3 weeks. Simultaneous submissions OK. Payment negotiable. Pays on publication. Buys one-time rights.

THE SUBJECT INDEX, located at the back of this book, lists publications, book publishers, galleries, greeting card companies, stock agencies, advertising agencies and graphic design firms according to the subject areas they seek.

LACMA PHYSICIAN, P.O. Box 513465, Los Angeles CA 90051-1465. (213)630-1123. Fax: (213)630-1152. E-mail: lpmag@lacmanet.org. Website: www.lacmanet.org. Managing Editor: Barbara L. Feiner. Circ. 11,000. Estab. 1875. Monthly. Emphasizes Los Angeles County Medical Association news and medical issues. Readers are physicians and members of LACMA.
Needs: Uses about 1-12 photos/issue; from both freelance and staff assignments. Needs photographers who can conceptualize and work with editor to illustrate cover stories and other articles. Model release required.
Making Contact & Terms: Send promo piece. Pay varies based on photo use. Pays on publication with submission of invoice. Buys one-time rights or first North American serial rights "depending on what is agreed upon; we buy nonexclusive rights to use work on our website." Credit line given.
Tips: "We want photographers who can get an extraordinary photo that captures the subject matter."

$☑ LAW & ORDER MAGAZINE, Hendon Publishing, 1000 Skokie Blvd., Suite 500, Wilmette IL 60091. (847)256-8555. Fax: (847)256-8574. Editorial Director: Bruce Cameron. Circ. 35,000. Estab. 1953. Monthly magazine published for police department administrative personnel. The articles are designed with management of the department in mind and are how-to in nature. Sample copy free. Art guidelines free.
Needs: Buys 10 photos from freelancers/issue; 120 photos/year. Needs photos of police, crime, technology, weapons, vehicles. Reviews photos with or without ms. Special photo needs include police using technology—laptop computers etc. Model release required for any police department personnel. Property release required. Photo caption required; include name and department of subject, identify products used.
Specs: Uses color prints; 35mm, 4×5 transparencies.
Making Contact & Terms: Send query letter with stock photo list. Art director will contact photographer for portfolio review if interested. Portfolio should include color, prints, slides, transparencies. Keeps samples on file; include SASE for return of material. Reports in 3 weeks on queries; 2 weeks on samples. Simultaneous submissions OK. Pays $200-350/color cover; $25/color inside. Pays on publication. Buys all rights; negotiable. Credit line given.
Tips: "Read the magazine. Get a feel for what we cover. We like work that is dramatic and creative. Police are moving quickly into the high tech arena. We are interested in photos of that. Police officers during training activities are also desirable."

N $☐ ◎ LETTER ARTS REVIEW, 1624 24th Ave. SW, Norman OK 73072. (405)364-8914. Fax: (405)364-8914. E-mail: mail@letterarts.com. Website: http://www.letterarts.com. Publisher: Karyn L. Gilman. Estab. 1982. Quarterly trade magazine. "A very directed audience of lettering artists and calligraphers comprise our readership." Sample copies for SAE with first-class postage. Art guidelines available.
Needs: Photos must be of lettering, instruments of lettering or other articles related to lettering. Reviews photos with or without a ms. Photo caption required; include title, artist, media, size, year.
Specs: Uses glossy, b&w prints; 35mm, 2¼×2¼, 4×5, 8×10 transparencies. Accepts images in digital format for Mac. Send via Zip as TIFF files.
Making Contact & Terms: Send query letter with photocopies. Does not keep samples on file; include SASE for return of material. Reports in 1 month on queries. Simultaneous submissions and previously published work OK. All rates are negotiable. Pays on publication. Credit line given. Buys one-time rights.
Tips: "Read our magazine—look at what we do. Send a good sample with explanatory cover letter."

$ LLAMAS MAGAZINE, P.O.Box 250, Jackson CA 95642. (209)295-7800. Fax: (209)295-7878. E-mail: claypres@volcano.com. Circ. 5,500. Estab. 1979. Publication of The International Camelid Journal. Magazine published 5 times a year. Emphasizes llamas, alpacas, vicunas, guanacos and camels. Readers are llama and alpaca owners and ranchers. Sample copy $5.75. Photo and editorial guidelines free with SASE.
Needs: Uses 30-50 photos/issue; all supplied by freelancers. Wants to see "any kind of photo with llamas, alpacas, camels in it. Always need good verticals for the cover. Always need good action shots." Model release required. Captions required.
Making Contact & Terms: Send unsolicited b&w or color 35mm prints or 35mm transparencies by mail for consideration. Provide résumé, business card, brochure, flier or tearsheets to be kept on file for possible assignments. SASE. Reports in 2 weeks. Simultaneous submissions and previously published work OK. Pays $5-25/b&w; $25-300/color. Pays on publication. Buys one-time rights. Credit line given.
Tips: "You must have a good understanding of llamas and alpacas to submit photos to us. It's a very specialized market. Our rates are modest, but our publication is a very slick 4-color magazine and it's a terrific vehicle for getting your work into circulation. We are willing to give photographers a lot of free tearsheets for their portfolios to help publicize their work."

MARKETERS FORUM, 383 E. Main St., Centerport NY 11721. (516)754-5000. Fax: (516)754-0630. Publisher: Martin Stevens. Circ. 70,000. Estab. 1981. Monthly magazine. Readers are entrepreneurs and retail store owners. Sample copy $5.

Needs: Uses 3-6 photos/issue; all supplied by freelancers. "We publish trade magazines for retail variety goods stores and flea market vendors. Items include: jewelry, cosmetics, novelties, toys, etc. (five-and-dime-type goods). We are interested in creative and abstract impressions—not straight-on product shots. Humor a plus." Model/property release required.

Specs: Uses color prints; 35mm, 4×5 transparencies.

Making Contact & Terms: Send unsolicited photos by mail for consideration. Does not keep samples on file. SASE. Reports in 2 weeks. Simultaneous submissions and/or previously published work OK. Pays $100/color cover; $50/color inside. **Pays on acceptance.** Buys one-time rights.

$ $⬛ MARKETING & TECHNOLOGY GROUP, 1415 N. Dayton, Chicago IL 60622. (312)266-3311. Fax: (312)266-3363. Corporate Design Director: Queenie Burns. Circ. 18,000. Estab. 1993. Publishes 3 magazines: *Carnetec*, *Meat Marketing & Technology*, and *Poultry Marketing & Technology*. Emphasizes meat and poultry processing. Readers are predominantly male, ages 35-65, generally conservative. Sample copy $4.

Needs: Uses 15-30 photos/issue; 1-3 supplied by freelancers. Needs photos of food, processing plant tours, product shots, illustrative/conceptual. Model/property release preferred. Captions preferred.

Making Contact & Terms: Provide résumé, business card, brochure, flier or tearsheets to be kept on file for possible assignments. Submit portfolio for review. Keeps samples on file. Reports in 1 month. Simultaneous submissions and previously published work OK. Payment negotiable. Pays on publication. Buys all rights; negotiable. Credit line given.

Tips: "Work quickly and meet deadlines. Follow directions when given; and when none are given be creative while using your best judgment."

Ⓝ $ $⬛ ▢ MGI PUBLICATIONS, 301 Oxford Valley Rd., Suite 804, Yardley PA 19067. (215)321-9662, ext. 39. Fax: (215)321-5122. Art Director: Sherilyn Kulesh. Circ. 100,000. Monthly trade magazine covering commercial real estate.

Needs: Buys 10 photos from freelancers/issue; 300-400 photos/year. Needs photos of landscapes/scenics, architecture, interiors/decorating, entertainment, buildings, business concepts, portraits, digital. Reviews photos with or without ms. Photo captions preferred.

Specs: Uses 8×10 glossy color prints; 4×5 transparencies. Accepts images in digital format for Mac. Send via Jaz as JPEG file at 300 dpi.

Making Contact & Terms: Send query letter with résumé, tearsheets. Provide self-promotion piece to be kept on file for possible future assignments. Pays on publication. Credit line give. Buys all rights.

Tips: Looks for "reliable service with outstanding quality and turnaround."

$⬛ MODERN BAKING, 2700 River Rd., Suite 102, Des Plaines IL 60018. (847)299-4430. Fax: (847)296-1968. Editor: Ed Lee. Circ. 27,000. Estab. 1987. Monthly. Emphasizes on-premise baking, in supermarkets, food service establishments and retail bakeries. Readers are owners, managers and operators. Sample copy for 9×12 SASE with 10 first-class stamps.

Needs: Uses 30 photos/issue; 1-2 supplied by freelancers. Needs photos of on-location photography in above-described facilities. Model/property release preferred. Captions required; include company name, location, contact name and telephone number.

Making Contact & Terms: Provide résumé, business card, brochure, flier or tearsheets to be kept on file for possible future assignments. SASE. Reports in 2 weeks. Pays $50 minimum; negotiable. **Pays on acceptance.** Buys all rights; negotiable. Credit line given.

Tips: Prefers to see "photos that would indicate person's ability to handle on-location, industrial photography."

$ $Ⓢ ⬛ MORTGAGE ORIGINATOR MAGAZINE, 1360 Sunset Cliffs Blvd., San Diego CA 92107. (619)223-9989. Fax: (619)223-9943. E-mail: mtgemom@aol.com Publisher: Chris Salazar. Circ. 16,000. Estab. 1991. Monthly magazine. Emphasizes mortgage banking. Readers are sales staff. Sample copy $8.95.

Needs: Uses 8 photos/issue. Needs photos of business.

Specs: Uses color prints; 35mm transparencies.

Making Contact & Terms: Query with stock photo list. Send unsolicited photos by mail for consideration. Keeps samples on file. Simultaneous submissions and previously published work OK. Payment negotiable. Pays on publication. Buys exclusive industry rights. Credit line given.

$ A ■ MOUNTAIN PILOT, 7009 S. Potomac St., Englewood CO 80112-4029. (303)397-7600. Fax: (303)397-7619.E-mail: ehuber@winc.usa.com. Website: http://www.mountainpilot.com. Editor: Ed Huber. Quarterly national newsletter on mountain aviation. Circ. 6,000. Estab. 1985. Published by Wisner Publishing Inc. Emphasizes mountain aviation—flying, safety, education, experiences, survival, weather, location destinations. Readers are mid-life male, affluent, mobile. Sample copy free with SASE.
Needs: Uses assignment photos. Model release and photo captions required.
Specs: Accepts digital format for Mac (TIFF or EPS). Send via floppy disk, SyQuest, Zip disk (300 live screen 150 for output).
Making Contact & Terms: Provide résumé, business card, brochure, flier or tearsheets to be kept on file for possible assignments: contact by phone. SASE. Reports in 1 month. Simultaneous submissions and previously published work OK. Pays negotiable text package. Pays 30 days after publication. Buys all rights; negotiable. Credit line given.
Tips: Looks for "unusual destination pictures, mountain aviation oriented." Trend is "imaginative." Make shot pertinent to an active pilot readership. Query first. Don't send originals—color copies acceptable. Copy machine reprints OK for evaluation.

$ S ■ 🖋 ◎ MUSHING MAGAZINE, P.O. Box 149, Ester AK 99725. (907)479-0454. Fax: (907)479-3137. E-mail: editor@mushing.com. Website: http://www.mushing.com. Publisher: Todd Hoener. Circ. 6,000. Estab. 1987. Bimonthly magazine. Readers are dog drivers, mushing enthusiasts, dog lovers, outdoor specialists, innovators and sled dog history lovers. Sample copy $5 in US. Photo guidelines free with SASE.
Needs: Uses 20 photos/issue; most supplied by freelancers. Needs action photos: all-season and wilderness; also still and close-up photos: specific focus (sledding, carting, dog care, equipment, etc). Special photo needs include skijoring, feeding, caring for dogs, summer carting or packing, 1-3 dog-sledding and kids mushing. Model release preferred. Captions preferred.
Specs: Accepts images in digital format for Mac. Send via CD, floppy disk, Zip, e-mail. Must be accompanied by hard copy.
Making Contact & Terms: Send unsolicited photos by mail for consideration. Reports in 6 months. Pays $150 maximum/color cover; $50 maximum/color inside; $20-35/b&w inside. Pays $10 extra for one year of electronic user rights on the web. Pays on publication. Buys first serial rights and second reprint rights. Credit line given.
Tips: Wants to see work that shows "the total mushing adventure/lifestyle from environment to dog house." To break in, one's work must show "simplicity, balance and harmony. Strive for unique, provocative shots that lure readers and publishers. Send 10-40 images for review. Allow for 2-6 months' review time for at least a screened selection of these."

$ ■ 🖋 NAILPRO, 7628 Densmore Ave., Van Nuys CA 91406-2042. (818)782-7328. Fax: (818)782-7450. E-mail: nailpro@aol.com. Website: http://www.nailpro.com. Executive Editor: Kathy Kirkland. Circ. 60,000. Estab. 1989. Published by Creative Age Publications. Monthly magazine. Emphasizes topics for professional manicurists and nail salon owners. Readers are females of all ages. Sample copy $2 with 9×12 SASE.
Needs: Uses 10-12 photos/issue; all supplied by freelancers. Needs photos of beautiful nails illustrating all kinds of nail extensions and enhancements; photographs showing process of creating and decorating nails, both natural and artificial. Also needs salon interiors, health/fitness, fashion/glamour. Model release required. Captions required; identify people and process if applicable.
Specs: Accepts images in digital format for Mac. Send via Zip, e-mail as TIFF, EPS files at 300 dpi or better.
Making Contact & Terms: "Art directors are rarely available, but photographers can leave materials and pick up later (or leave nonreturnable samples)." Send color prints; 35mm, 2¼×2¼, 4×5. Keeps samples on file. SASE. Reports in 1 month. Previously published work OK. Pays $500/color cover; $50-250/color inside, **Pays on acceptance**. Buys one-time rights. Credit line given.
Tips: "Talk to the person in charge of choosing art about photo needs for the next issue and try to satisfy that immediate need; that often leads to assignments. Submit samples and portfolios with letter stating specialties or strong points."

N $ ■ ◎ NAILS MAGAZINE, Bobit Publishing, 21061 S. Western Ave., Torrance CA 90501. (310)533-2400. Fax: (310)533-2504. E-mail: nailsmag@bobit.com. Website: http://www.nailsmag.com. Managing Editor: Debbie Rosenkrantz. Circ. 60,000. Estab. 1982. Monthly trade publication for nail technicians and beauty salon owners. Sample copies available.
Needs: Buys up to 10 photos from freelancers per issue. Needs photos of celebrities, buildings, historical/

vintage. Other specific photo needs: salon interiors, product shots, celebrity nail photos. Reviews photos with or without a ms. Model release required. Photo caption preferred.

Specs: Uses 35mm transparencies. Accepts images in digital format for Mac. Send via CD, SyQuest, Zip as TIFF, EPS files at 266 dpi.

Making Contact & Terms: Send query letter with résumé, slides, prints. Keep samples on file. Reports in 1 month on queries. **Pays on acceptance.** Credit line sometimes given if it's requested. Buys all rights.

$ $THE NATIONAL NOTARY, 9350 DeSoto Ave., Box 2402, Chatsworth CA 91313-2402. (818)739-4000. Editor: Charles N. Faerber. Circ. 154,000. Bimonthly. Emphasizes "Notaries Public and notarization—goal is to impart knowledge, understanding and unity among notaries nationwide and internationally." Readers are employed primarily in the following areas: law, government, finance and real estate. Sample copy $5.

Needs: Uses about 20-25 photos/issue; 10 supplied by non-staff photographers. "Photo subject depends on accompanying story/theme; some product shots used." Unsolicited photos purchased with accompanying ms only. Model release required.

Making Contact & Terms: Query with samples. Provide business card, tearsheets, résumé or samples to be kept on file for possible future assignments. Prefers to see prints as samples. Cannot return material. Reports in 6 weeks. Previously published work OK. Pays $25-300 depending on job. Pays on publication. Buys all rights. Credit line given "with editor's approval of quality."

Tips: "Since photography is often the art of a story, the photographer must understand the story to be able to produce the most useful photographs."

$ $NATION'S BUSINESS, U.S. Chamber of Commerce, 1615 H St. NW, Washington DC 20062. (202)463-5447. Photo Editor: Laurence L. Levin. Assistant Photo Editor: Frances Borchardt. Circ. 865,000. Monthly. Emphasizes business, how to run your business better, especially small business. Readers are managers, upper management and business owners. Sample copy free with 9×12 SASE.

Needs: Uses about 40-50 photos/issue; 60% supplied by freelancers. Needs portrait-personality photos, business-related pictures relating to the story. Model release preferred. Captions required.

Making Contact & Terms: Arrange a personal interview to show portfolio or submit portfolio for review. SASE. Reports in 3 weeks. Pays $200/b&w or color inside; $175-300/day. Pays on publication. Buys one-time rights. Credit line given.

Tips: In reviewing a portfolio, "we look for the photographer's ability to light, taking a static situation and turning it into a spontaneous, eye-catching and informative picture."

$ NAVAL HISTORY, US Naval Institute, 291 Wood Rd., Annapolis MD 21402. (410)268-6110. Fax: (410)269-7940. Website: http://www.USNI.org. Contact: Photo Editor. Circ. 50,000. Estab. 1873. Bimonthly association publication. Emphasizes Navy, Marine Corps, Coast Guard. Readers are age 18 and older, male and female, naval officers, enlisted, retirees, civilians. Sample copy free with 9×12 SASE. Photo guidelines free with SASE.

Needs: Uses 50 photos/issue; 40% supplied by freelancers. Needs photos of foreign and US Naval, Coast Guard and Marine Corps vessels, personnel and aircraft. Captions required.

Specs: Uses 8×10 glossy or matte, b&w or color prints; transparencies. Accepts images in digital format for Mac. Send via compact disc, Zip disk, floppy disk or online as JPEG at 300 dpi.

Making Contact & Terms: Send unsolicited photos by mail for consideration. SASE. Reports in 1 month. Simultaneous submissions and previously published work OK. Pays $200/color or b&w cover; $25/color inside; $25/b&w page rate; $250-500/photo/text package. Pays on publication. Buys one-time rights. Credit line given.

N $ $ NEW HOLLAND NEWS, New Holland North America, Inc., P.O. Box 1895, 500 Diller Ave., New Holland PA 17557-0903. (717)393-3821 (editor). Website: http://www.newholland.com/na. Editor: Gary Martin. Full-color magazine to inform and entertain successful farmers and ranchers published 8 times/year. Sample copies available for 9×12 SAE with first-class postage.

Needs: Buys 10 photos from freelancers per issue; 80 photos per year. Needs photos of families, rural, agriculture. Other specific photo needs: For covers, North American agriculture at its scenic best—no equipment. Reviews photos with or without a ms. Model and property release preferred. Photo caption required; include where, what crop, animal, etc., who, why—as necessary.

Specs: Uses glossy, matte, color, b&w prints; 35mm, 2¼×2¼, 4×5 transparencies.

Making Contact & Terms: Send query letter with slides, prints, transparencies. Provide business card, self-promotion piece to be kept on file for possible future assignments. Reports in 2 weeks on queries; 2 weeks on portfolios. Previously published work OK. Pays $300-500 for color cover; $150-300 for color inside. **Pays on acceptance.** Credit line given. Buys one-time rights, first rights.

Tips: "Demonstrate a genuine appreciation for agriculture in your work. Don't be afraid to get dirty. Include meaningful captions."

N $ ⊕ ○ ◎ THE NEW IMPACT JOURNAL, Anser House, Courtyard Offices, 3 High St., Marlow Bucks SL7 1AX England. (+44)01628 481581. Fax: (+44)01628 475570. E-mail: nuimpact93@a ol.com. Website: http://www.newimpact.com. Circ. 10,000. Estab. 1993. Bimonthly magazine. A publication for "minority professionals and businesses, especially equal opportunity employers. A forum for sharing ideas and best practice in diversity management and professional achievement between the mainstream and minority groups."
Needs: Buys 3 photos from freelancers per issue. Needs photos of multicultural, business concepts, portraits, documentary. Reviews photos with accompanying ms only.
Specs: Uses any prints.
Making Contact & Terms: Send query letter with photocopies. Provide self-promotion piece to be kept on file for possible future assignments. Reports back only if interested, send nonreturnable samples. Simultaneous submissions OK. Payment negotiable (between £20-30). Pays on publication. Credit line given. Buys one-time rights.
Tips: "Inquire first. Photographs are only required with articles which are related."

NEW METHODS, P.O. Box 22605, San Francisco CA 94122-0605. (415)379-9065. Art Director: Ronald S. Lippert, AHT. Circ. 5,600. Estab. 1981. Monthly. Emphasizes veterinary personnel, animals. Readers are veterinary professionals and interested consumers. Sample copy $3.20 (20% discount on 12 or more). Photo guidelines free with SASE.
Needs: Uses 12 photos/issue; 2 supplied by freelance photographers. Assigns 95% of photos. Needs animal, wildlife and technical photos. Most work is b&w. Model/property releases preferred. Captions preferred.
Making Contact & Terms: Arrange a personal interview to show portfolio. Query with résumé of credits, samples or list of stock photo subjects. Provide résumé, business card, brochure, flier or tearsheets. SASE. Reports in 2 months. Simultaneous submissions and previously published work OK. Payment is rare, negotiable; will barter. Credit line given.
Tips: Ask for photo needs before submitting work. Prefers to see "technical photos (human working with animal(s) or animal photos (*not cute*)" in a portfolio or samples. On occasion, needs photographer for shooting new products and local area conventions.

$ ▣ 911 MAGAZINE, P.O. Box 11788, Santa Ana CA 92711. (714)544-7776. E-mail: editor@9-1-1magazine.com. Editor: Randall Larson. Circ. 13,000. Estab. 1988. Bimonthly magazine. Emphasizes public safety communications—police, fire, paramedic, dispatch, etc. Readers are ages 20-65. Sample copy free with 9×12 SASE and 7 first-class stamps. Photo guidelines free with SASE.
Needs: Uses up to 25 photos/issue; 75% supplied by freelance photographers; 20% comes from assignment, 5% from stock. "From the Field" department photos are needed of incidents involving public safety communications showing proper techniques and attire. Subjects include rescue, traffic, communications, training, stress, media relations, crime prevention, etc. Model release preferred. Captions preferred; if possible include incident location by city and state, agencies involved, duration, dollar cost, fatalities and injuries.
Specs: Uses 35mm, 2¼×2¼, 4×5, 8×10 glossy contacts, b&w or color prints; 35mm, 2¼×2¼, 4×5, 8×10 transparencies. Accepts images in digital format for Mac or Windows.
Making Contact & Terms: Query with list of stock photo subjects. Send unsolicited photos by mail for consideration. Provide résumé, business card, brochure, flier or tearsheets to be kept on file for possible assignments. SASE. Reports in 3 weeks. Pays $100-300/color cover; $50-75/color inside; $20-50/b&w inside. Pays on publication. Buys one-time rights. Credit line given.
Tips: "We need photos for unillustrated cover stories and features appearing in each issue. Calendar available. Assignments possible."

$ $ Ⓐ ▣ NORTHEAST EXPORT, 404 Chestnut St., 201, Manchester NH 03101. (603)626-6354. Fax: (603)626-6359. Art Director: Margaret Miller. Circ. 12,000. Estab. 1997. Semimonthly magazine. Emphasizes international trade by Northeast companies. Readers are male and female—top management, average age 45. Sample copy free with 9×12 SASE and 5 first-class stamps.
Needs: Uses 3-6 photos/issue. Needs photos of exporting, shipping and receiving, cargo, international trade zones, high-tech and manufacturing. Model/property release preferred. Captions required; include names, locations, contact phone number.
Specs: Accepts images in digitial format for Mac. Send via compact disc, floppy disk, zip disk as TIFF at 300 dpi, 150 lpi.

Making Contact & Terms: Arrange personal interview to show portfolio. Provide résumé, business card, brochure, flier or tearsheets to be kep on file for possible assignments. Keeps samples on file. SASE. Reports in 3 weeks. Pays $300-500/color cover; $50-100/color inside; $50-75/b&w inside. Pays on publication. Buys one-time rights. Credit line given.

Tips: Looks for "people in environment shots, interesting lighting, lots of creative interpretations, a definite personal style. We are a publishing company that has a reputation for quality, award-winning publications."

$ $OCULAR SURGERY NEWS, Dept. PM, 6900 Grove Rd., Thorofare NJ 08086. (609)848-1000. Fax: (609)853-5991. E-mail: lgaymon@slackinc.com. Associate Editor: Lee Gaymon. Circ. 18,000. Bi-weekly newspaper. Emphasizes ophthalmology, medical and eye care. Readers are ophthalmologists in the US. Sample copy free with 9×12 SAE and 10 first-class stamps.

Needs: Uses 30 photos/issue; less than 10% supplied by freelancers. Needs photos for business section on a monthly basis. Topics like managed care, money management, computers and technology, patient satisfaction, etc.

Making Contact & Terms: Query with list of stock photo subjects. Provide résumé, business card, brochure, flier or tearsheets to be kept on file for possible assignments. SASE. Reports in 2 weeks. Pays $300/color cover; $150/color inside; $150-250/day. Pays on publication. Buys one-time rights. Credit line given.

$OHIO TAVERN NEWS, 329 S. Front St., Columbus OH 43215. (614)224-4835. Fax: (614)224-8649. Editor: Chris Bailey. Circ. 4,000. Estab. 1939. Tabloid newspaper. Emphasizes beverage alcohol/hospitality industries in Ohio. Readers are liquor permit holders: restaurants, bars, distillers, vintners, wholesalers. Sample copy free for 9×12 SASE.

Needs: Uses 1-4 photos/issue. Needs photos of people, places, products covering the beverage alcohol/hospitality industries in Ohio. Captions required; include who, what, where, when and why.

Specs: Uses up to 8×10 glossy b&w prints.

Making Contact & Terms: Send unsolicited photos by mail for consideration. Keeps samples on file. SASE. Reports in 1 month. Simultaneous submissions OK. Pays $15/photo. Pays on publication. Buys one-time rights; negotiable. Credit line given.

$ 🄰 ▣ ◎ PACIFIC BUILDER & ENGINEER, Vernon Publications Inc., 12437 NE 173rd Place, Woodinville WA 98072. (425)486-8553. Fax: (425)488-0946. E-mail: carlmolesworth@cmdg.com. Editor: Carl Molesworth. Circ. 14,500. Estab. 1902. Biweekly magazine. Emphasizes non-residential construction in the Northwest and Alaska. Readers are construction contractors. Sample copy $7.

Needs: Uses 8 photos/issue; 4 supplied by freelancers. Needs photos of ongoing construction projects to accompany assigned feature articles. Reviews photos purchased with accompanying ms only. Photo captions preferred; include name of project, general contractor, important subcontractors, model/make of construction equipment, what is unusual/innovative about project.

Specs: Accepts images in digital format for PC (Quark, Photoshop, FreeHand). Send via floppy disk, SyQuest, Zip disk (133 line screen ERP 2438 dots/inch).

Making Contact & Terms: Query with résumé of credits. Does not keep samples on file. SASE. Reports in 1 month. Pays $125 minimum/color cover; $15-50/b&w inside. Pays on publication. Buys first North American serial rights.

Tips: "All freelance photos must be coordinated with assigned feature stories."

$◎ PACIFIC FISHING, 1515 NW 51st, Seattle WA 98107. (206)789-5333. Fax: (206)784-5545. Editor: Brad Warren. Art Director: Barbara Bosh. Circ. 9,100. Estab. 1979. Monthly magazine. Emphasizes commercial fishing on West Coast—California to Alaska. Readers are 80% owners of fishing operations, primarily male, ages 25-55; 20% processors, marketers and suppliers. Sample copy free with 11×14 SAE and 8 first-class stamps. Photo guidelines free with SASE.

Needs: Uses 15 photos/issue; 10 supplied by freelancers. Needs photos of *all* aspects of commercial fisheries on West Coast of US, Canada and Pacific islands. Special needs include "high-quality, active photos and slides of fishing boats and fishermen working their gear, dockside shots and the processing of seafood." Model/property release preferred. Captions required; include names and locations.

Making Contact & Terms: Query with résumé of credits, sample photos and list of stock photo subjects.

THE GEOGRAPHIC INDEX, located in the back of this book, lists markets by the state in which they are located.

Keeps samples on file. SASE. Reports in 2-6 weeks. Previously published work OK "if not previously published in a competing trade journal." Pays $200/color cover; $50-100/color inside; $25-50/b&w inside. Pays on publication. Buys one-time rights, first North American serial rights. Credit line given.
Tips: Wants to see "clear, close-up and active photos, especially on board fishing vessels."

PAPER AGE, 51 Mill St., Suite 5, Hanover MA 02339-1650. (781)829-4581. Fax: (781)829-4503. Editor: John F. O'Brien Jr.. Circ. 35,000. Estab. 1884. Monthly tabloid. Emphasizes paper industry—news, pulp and paper mills, technical reports on paper making and equipment. Readers are employees in the paper industry. Sample copy free.
Needs: Uses 25-30 photos/issue; very few supplied by freelancers. Needs photos of paper mills—inside/outside; aerial; forests (environmentally appealing shots); paper recycling facilities. Property release preferred (inside shots of paper mill equipment). Photo captions required; include date, location, description of shot.
Making Contact & Terms: Send any size glossy prints by mail for consideration. Keeps samples on file. SASE. Reports in 1-2 weeks. Payment negotiable. Pays on publication. Buys all rights; negotiable. Credit line given.

$ THE PARKING PROFESSIONAL, 701 Kenmore, Suite 200, Fredericksburg VA 22401. (540)371-7535. Fax: (540)371-8022. Editor: Lucia Cobo. Circ. 10,000. Estab. 1984. Publication of the International Parking Institute. Monthly magazine. Emphasizes parking: public, private, institutional, etc. Readers are male and female public parking managers, ages 30-60. Free sample copy.
Needs: Uses 12 photos/issue; 4-5 supplied by freelancers. Model release required. Captions preferred, include location, purpose, type of operation.
Specs: Uses 5×7, 8×10 color or b&w prints; 35mm, 2¼×2¼, 4×5, 8×10 transparencies.
Making Contact & Terms: Contact through rep. Arrange personal interview to show portfolio for review. Query with résumé of credits. Provide résumé, business card, brochure, flier or tearsheets to be kept on file for possible assignments. Keeps samples on file. SASE. Reports in 1-2 weeks. Previously published work OK. Pays $100-300/color cover; $25-100/color inside; $25-100/b&w inside; $100-500/photo/text package. Pays on publication. Buys one-time, all rights; negotiable. Credit line given.

$ $ PEDIATRIC ANNALS, 6900 Grove Rd., Thorofare NJ 08086. (609)848-1000. E-mail: pedann@slackinc.com. Website: http://www.slackinc.com/ped.htm. Editor: Shirley Strunk. Circ. 40,000. Monthly journal. Readers are practicing pediatricians. Sample copy free with SASE.
Needs: Uses 1 cover photo/issue. Needs photos of "children in medical settings, some with adults." Written release required. Captions preferred.
Making Contact & Terms: Query with samples. Provide résumé, business card, brochure, flier or tearsheets to be kept on file for possible future assignments. Simultaneous submissions and previously published work OK. Pays $300-600/color cover. Pays on publication. Buys one-time North American rights including any and all subsidiary forms of publication, such as electronic media and promotional pieces. Credit line given.

■ PEI, Photo Electronic Imaging, 229 Peachtree St., NE, Suite 2200, International Tower, Atlanta GA 30303. Fax: (404)614-6406. E-mail: info@peimag.com. Website: http://www.peimag.com. Circ. 45,000. Monthly magazine covering digital imaging techniques and processes. Audience includes professional imaging specialists, desktop publishers, graphic artists and related fields. Readership seeks in-depth articles on current technology, step-by-step tutorials and artist profiles. Sample copies available for $4.
Needs: Buys technical manuscripts with accompanying photos, 15-20/issue. Model release preferred. Caption preferred. Include how the images were created, platform, software, file size, etc.
Specs: Uses glossy color and b&w prints and 35 mm, 2¼×2¼, 4×5, 8×10 transparencies. Accepts images in digital format. Send via CD, floppy disk, JAZ or ZIP cartridges as TIFF or Photoshop files.
Making Contact & Terms: Send query letter with samples, brochure, tearsheets. To show portfolio, photographer should follow up with call. Keeps samples on file. Reports back only if interested; send nonreturnable samples. Previously published work OK. Pays on publication. Buys first rights. Credit line given.
Tips: "We are looking for digital artists with dynamic imagery to feature in the magazine."

$ $⊕ ▣ ⊘ PEOPLE MANAGEMENT, Personnel Publications Ltd., 17 Britton St., London EC1M 5TP England. Phone: 0171 880 6200. Fax: 0171 336 7635. E-mail: mark@ppltd.co.uk. Website: http://www.peoplemanagement.co.uk. Circ. 80,000. Trade journal for professionals in personnel, training and development.
Needs: Needs photos of buildings, industry, medicine, portraits. Interested in alternative process, documen-

tary. Reviews photos with or without ms. Model release preferred. Photo captions preferred.
Specs: Accepts images in digital format for Mac. Send via CD, Jaz, Zip, e-mail, ISDN as TIFF, EPS, JPEG files at 300 dpi.
Making Contact & Terms: Send query letter with samples. To show portfolio, photographer should follow-up with call. Portfolio should include b&w prints, slides, transparencies. Keeps samples on file; include SASE for return of material. Reports back only if interested, send non-returnable samples. Pays £500-650 for cover; £400-650/inside. Pays on publication. Rights negotiable.

$ PET BUSINESS, 7-L Dundas Circle, Greensboro NC 27407. (910)292-4047. Fax: (910)292-4272. Executive Editor: Rita Davis. Circ. 19,000. Estab. 1974. Monthly news magazine for pet industry professionals. Sample copy $3. Guidelines free with SASE.
Needs: Photos of well-groomed pet animals (preferably purebred) of any age in a variety of situations. Identify subjects. Animals: dogs, cats, fish, birds, reptiles, amphibians, small animals (hamsters, rabbits, gerbils, mice, etc.) Also, can sometimes use shots of petshop interiors—but must be careful not to be product-specific. Good scenes would include personnel interacting with customers or caring for shop animals. Model/property release preferred. Captions preferred; include essential details regarding animal species.
Making Contact & Terms: Submit photos for consideration. Reports within 3 months with SASE. Pays $20/color print or transparency for inside use; $100 for cover use. Pays on publication. Buys all rights; negotiable. Credit line given.
Tips: Wants uncluttered background. Portrait-style always welcome. Close-ups best. News/action shots if timely. "Make sure your prints have good composition, and are technically correct, in focus and with proper contrast. Avoid dark pets on dark backgrounds! Send only 'pet' animal, not zoo or wildlife, photos."

$ ▣ ◐ PET PRODUCT NEWS MAGAZINE, P.O. Box 6050, Mission Viejo CA 92690. (949)855-8822. Fax: (949)855-3045. E-mail: ppn@fancypubs.com. Website: http://www.petproductnews.com. Contact: Mary K. McHale. Monthly tabloid. Emphasizes pets and the pet retail business. Readers are pet store owners and managers. Sample copy $5.50. Photo guidelines free with SASE.
Needs: Uses 25-50 photos/issue; 75-100% supplied by freelancers. Needs photos of people interacting with pets, retailers interacting with customers and pets, pets doing "pet" things, pet stores and vets examining pets. Also needs wildlife, events, buildings, industry, portraits, product shots/still life. Interested in regional, seasonal photos. Reviews photos with or without ms. Model/property release preferred. Enclose a shipment description with each set of photos detailing the type of animal, name of pet store, name of well-known subjects and any procedures being performed on an animal that are not self-explanatory.
Specs: Accepts images in ditital format for Mac. Send via floppy disk, e-mail as TIFF, EPS, JPEG files.
Making Contact & Terms: "We cannot assume responsibility for submitted material, but care is taken with all work. Freelancers must include a self-addressed, stamped envelope for returned work." Send sharp 35mm color slides or prints by mail for consideration. SASE. Reports in 2 months. Previously published work OK. "Photo prices vary, typically ranging from $45-65/photo." Pays on publication. Buys one-time rights. Credit line given; name and identification of subject must appear on each slide or photo.
Tips: Looks for "appropriate subjects, clarity and framing, sensitivity to the subject. No avant garde or special effects. We need clear, straight-forward photography. Definitely no 'staged' photos; keep it natural. Read the magazine before submission. We are a trade publication and need business-like, but not boring, photos that will add to our subjects."

$ $ Ⓐ ▣ ◐ PHOTO TECHNIQUES, Dept. PM, Preston Publications, 6600 W. Touhy, P.O. Box 48312, Niles IL 60714. (847)647-2900. Fax: (847)647-1155. E-mail: michaeljohnston@ameritech.net. Website: http://www.phototechmag.com. Publisher: Tinsley S. Preston, III. Editor: Mike Johnston. Circ. 35,000. Estab. 1979. Bimonthly magazine. Covers darkroom techniques, creative camera use, photochemistry and photographic experimentation/innovation, plus general user-oriented photography articles aimed at advanced amateurs and professionals. Sample copy $4.50. Photography and article submission guidelines free with SASE.
Needs: "The best way to publish photographs in *Photo Techniques* is to write an article on photo or darkroom techniques and illustrate the article. The exceptions are: cover photographs—we are looking for striking poster-like images that will make good newsstand covers; and the Portfolio feature—photographs of an artistic nature. Most freelance photography comes from what is currently in a photographer's stock." Needs multicultural, landscapes, architecture, beauty, cities/urban, rural, adventure, travel, portraits. Interested in alternative process, digital, documentary, fine art, historical/vintage. Model/property release preferred. Captions required if photo is used.
Specs: Send dupe slides first. All print submissions should be 8×10. Accepts images in digital format for Mac, Windows. Send via CD, floppy disk, Zip, e-mail as TIFF, EPS files at 300 dpi.

Making Contact & Terms: "Undolicited material will not be returned unless accompanied by SASE. Not responsible for incidental loss/damage; submissions of duplicates recommended. We do not want to receive more than 10 or 20 slides in any one submission. We ask for submissions on speculative basis only. Except for portfolios, we publish few single photos that are not accompanied by some type of text." Pays $300/covers; $100/page and up for text/photo package; negotiable. Pays on publication only. Buys one-time rights. Credit line given.

Tips: "We are looking for exceptional photographs with strong, graphically startling images. No run-of-the-mill postcard shots please. We are the most technical general-interest photographic publication on the market today. Authors are encouraged to substantiate their conclusions with experimental data. Submit samples, article ideas, etc. It's easier to get photos published with an article."

$ $ PLASTICS NEWS, 1725 Merriman Rd., Akron OH 44313. (330)836-9180. Fax: (330)836-2322. Managing Editor: Don Loepp. Circ. 60,000. Estab. 1989. Weekly tabloid. Emphasizes plastics industry business news. Readers are male and female executives of companies that manufacture a broad range of plastics products; suppliers and customers of the plastics processing industry. Sample copy $1.95.

Needs: Uses 10-20 photos/issue; 1-3 supplied by freelancers. Needs photos of technology related to use and manufacturing of plastic products. Model/property release preferred. Captions required.

Making Contact & Terms: Send unsolicited photos by mail for consideration. Provide résumé, business card, brochure, flier or tearsheets to be kept on file for possible assignments. Query with stock photo list. Keeps samples on file. SASE. Reports in 2 weeks. Simultaneous submissions and previously published work OK. Pays $125-175/color cover; $125-175/color inside; $100-150/b&w inside. Pays on publication. Buys one-time and all rights. Credit line given.

$ POLICE AND SECURITY NEWS, DAYS Communications, Inc., 15 W. Thatcher Rd., Quakertown PA 18951-2503. (215)538-1240. Fax: (215)538-1208. E-mail: p&sn@netcarrier.com. Associate Publisher: Al Menear. Circ. 21,982. Estab. 1984. Bimonthly trade journal. "*Police and Security News* is edited for middle and upper management and top administration. Editorial content is a combination of articles and columns ranging from the latest in technology, innovative managerial concepts, training and industry news in the areas of both public law enforcement and private security." Sample copy free with 9½×10 SAE and $2.17 first-class postage.

Needs: Buys 2 photos from freelancers/issue; 12 photos/year. Needs photos of law enforcement and security related. Reviews photos with or without a ms. Captions preferred.

Specs: Uses color and b&w prints.

Making Contact & Terms: Provide résumé, business card, self-promotion piece or tearsheets to be kept on file for possible future assignments. Art director will contact photographer for portfolio review if interested. Portfolio should include b&w, color, prints or tearsheets. Keeps samples on file; include SASE for return of material. Reports back only if interested, send non-returnable samples. Simultaneous submissions and previously published work OK. Pays $60/b&w inside. Pays on publication. Buys one-time rights; negotiable. Credit line not given.

$ ▣ ◑ POLICE MAGAZINE, 21061 South Western Ave., Torrance CA 90501. (310)533-2400. Fax: (310)533-2504. E-mail: police@bobit.com. Website: policemag.com. Executive Editor: Dennis Hall. Estab. 1976. Monthly. Emphasizes law enforcement. Readers are various members of the law enforcement community, especially police officers. Sample copy $2 with 9×12 SAE and 6 first-class stamps. Photo guidelines free with SASE.

Needs: Uses in-house photos and freelance submissions. Needs law enforcement related photos. Special needs include photos relating to daily police work, crime prevention, international law enforcement, police technology and humor. Model release required. Property release preferred. Captions preferred.

Specs: Prefers color photos. Accepts digital images for Mac, Windows. Send via Zip.

Making Contact & Terms: Arrange a personal interview to show portfolio. Send b&w prints, 35mm transparencies, b&w contact sheet or color negatives by mail for consideration. SASE. Simultaneous submissions OK. Payscale available in photographer's guidelines. Pays 250 maximum for color cover; $35 maximum for b&w inside; $35 for color inside. Pays on publication. Buys all rights.

Tips: "Send for our editorial calendar and submit photos based on our projected needs. If we like your work, we'll consider you for future assignments. A photographer we use must grasp the conceptual and the action shots."

$ ◖ POLICE TIMES/CHIEF OF POLICE, 3801 Biscayne Blvd., Miami FL 33137. (305)573-0070. Fax: (305)573-9819. E-mail: policeinfo@aphf.org. Website: http://www.aphf.org. Executive Editor: Jim Gordon. Circ. 50,000. Quarterly (*Police Times*) and bimonthly (*Chief of Police*). Trade magazine. Readers are law enforcement officers at all levels. *Police Times* is the official journal of the American Federation

of Police and concerned citizens. Sample copy $2.50. Photo guidelines free with SASE.

Needs: Buys 60-90 photos/year. Photos of police officers in action, civilian volunteers working with the police and group shots of police department personnel. Wants no photos that promote other associations. Police-oriented cartoons also accepted on spec. Model release preferred. Captions preferred.

Making Contact & Terms: Send glossy b&w and color prints for consideration. SASE. Reports in 3 weeks. Simultaneous submissions and previously published work OK. Pays $5 for b&w; $25 for color. **Pays on acceptance.** Buys all rights, but may reassign to photographer after publication; includes internet publication rights. Credit line given if requested; editor's option.

Tips: "We are open to new and unknowns in small communities where police are not given publicity."

$ POWERLINE MAGAZINE, 1650 S. Dixie Hwy., 5th Floor, Boca Raton FL 33432. (561)750-5575. Fax: (561)395-8557. E-mail: e-mail@egsa.org. Website: http://www.egsa.org. Editor: James McMullen. Photos used in trade magazine of Electrical Generating Systems Association and PR releases, brochures, newsletters, newspapers and annual reports.

Needs: Buys 40-60 photos/year; gives 2 or 3 assignments/year. "Need cover photos, events, award presentations, groups at social and educational functions." Model release required. Property release preferred. Captions preferred; include identification of individuals only.

Specs: Uses 5×7 glossy b&w and color prints; b&w and color contact sheets; b&w and color negatives.

Making Contact & Terms: Provide résumé, business card, brochure, flier or tearsheets to be kept on file for possible future assignments. Solicits photos by assignment only. SASE. Reports as soon as selection of photographs is made. Payment negotiable. Buys all rights; negotiable.

Tips: "Basically a freelance photographer working with us should use a photojournalistic approach, and have the ability to capture personality and a sense of action in fairly static situations. With those photographers who are equipped, we often arrange for them to shoot couples, etc., at certain functions on spec, in lieu of a per-day or per-job fee."

$ THE PREACHER'S MAGAZINE, E. 10814 Broadway, Spokane WA 99206. (509)226-3464. Fax: (509)926-8740. Editor: Cindy Osso. Circ. 18,000. Estab. 1925. Quarterly professional journal for ministers. Emphasizes the pastoral ministry. Readers are pastors of large to small churches in 5 denominations; most pastors are male. No sample copy available. No photo guidelines.

Needs: Uses 1 photo/issue; all supplied by freelancers. Large variety needed for cover, depends on theme of issue. Model release preferred.

Making Contact & Terms: Send 35mm b&w/color prints by mail for consideration. Reports ASAP. Simultaneous submissions and previously published work OK. Pays $25/b&w inside; $75/color cover. **Pays on acceptance.** Buys one-time rights. Credit line given.

Tips: In photographer's samples wants to see "a variety of subjects for the front cover of our magazine. We rarely use photos within the magazine itself."

$ PRINCIPAL MAGAZINE, 1615 Duke St., Alexandria VA 22314-3483. (703)684-3345. Website: http://www.haesp.org. Editor: Lee Greene. Circ. 30,000. Estab. 1921. Publication of the National Association of Elementary School Principals. Bimonthly (5 issues per year). Emphasizes public education—kindergarten to 8th grade. Readers are mostly principals of elementary and middle schools. Sample copy free with SASE.

Needs: Uses 10-15 b&w photos/issue; mostly supplied by freelancers. Needs photos of school scenes (classrooms, playgrounds, etc.), teaching situations, school principals at work, computer use and technology and science activities. The magazine sometimes has theme issues, such as back to school, technology and early childhood education. *No posed groups.* Close-ups preferred. Reviews photos and returns any that don't meet its needs in SASE; holds those that will be considered for future publication indefinitely. Model release preferred.

Making Contact & Terms: Query with samples and list of stock photo subjects. Send b&w prints, photocopies, b&w contact sheet by mail for consideration. SASE. "We hold submitted photos indefinitely for possible stock use, so send dupes or photocopies." Reports in 1-2 months. Pays $50/b&w photo. Pays on publication. Buys one-time rights; negotiable. Credit line given.

$ ▣ ◨ PROCEEDINGS, (formerly *US Naval Institute Proceedings*), U.S. Naval Institute, 291 Wood Rd., Annapolis MD 21402. (410)268-6110. Website: http://www.USNI.org. Contact: Photo Editor. Circ. 90,000. Monthly magazine. Emphasizes matters of current interest in naval, maritime and military affairs—including strategy, tactics, personnel, shipbuilding and equipment. Readers are officers in the Navy, Marine Corps and Coast Guard; also for enlisted personnel of the sea services, members of other military services in this country and abroad and civilians with an interest in naval and maritime affairs. Free sample copy.

Needs: Buys 15 photos/issue. Needs photos of Navy, Coast Guard and merchant ships of all nations;

military aircraft; personnel of the Navy, Marine Corps and Coast Guard; and maritime environment and situations. No poor quality photos. Captions required.

Specs: Uses 8×10 glossy, color and b&w prints or transparencies. Accepts images in digital format for Mac. Send via compact disc, Zip disk, floppy disk or online as JPEG files at 300 dpi.

Making Contact & Terms: Query first with résumé of credits. SASE. Reports in 1 month on pictorial feature queries; 6-8 weeks on other materials. Pays $10 for official military photos submitted with articles; $250-500 for naval/maritime pictorial features; $200/color cover; $50 for article openers; $25/inside editorial. Pays on publication. Buys one-time rights.

Tips: "These features consist of copy, photos and photo captions. The package should be complete, and there should be a query first. In the case of the $25 shots, we like to maintain files on hand so they can be used with articles as the occasion requires. Annual photo contest—write for details."

$ $ [A] [□] [◎] PRODUCE MERCHANDISING, a Vance Publishing Corp. magazine, Three Pine Ridge Plaza, 10901 W. 84th Terrace, Lenexa KS 66214. (913)438-8700. Fax: (913)438-0691. E-mail: producemerchandising@compuserv.com. Website: http://www.producemerchandising.com. Managing Editor: Janice L. McCall. Circ. 12,000. Estab. 1988. Monthly magazine. Emphasizes the fresh produce industry. Readers are male and female executives who oversee produce operations in US and Canadian supermarkets. Sample copy available.

Needs: Uses 30 photos/issue; 2-5 supplied by freelancers. Needs in-store shots, either environmental portraits for cover photos or display pictures. Captions preferred; include subject's name, job title and company title—all verified and correctly spelled.

Specs: Accepts images in digital format for Windows. Send via CD, SyQuest.

Making Contact & Terms: Provide résumé, business card, brochure, flier or tearsheets to be kept on file for possible future assignments. Keeps samples on file. Reporting time "depends on when we will be in a specific photographer's area and have a need." Pays $500-600/color cover transparencies; $25-50/ color photo; $50-100/color roll inside. **Pays on acceptance.** Buys all rights. Credit line given.

Tips: "We seek photographers who serve as our on-site 'art director,' to ensure art sketches come to life. Supermarket lighting (fluorescent) offers a technical challenge we can't avoid. The 'greening' effect must be diffused/eliminated."

$ [A] [□] [◎] PROFESSIONAL PHOTOGRAPHER/STORYTELLERS, 229 Peachtree St. NW, Suite 2200, International Tower, Atlanta GA 30303. (404)522-8600. Fax: (404)614-6406. E-mail: ppaeditor @aol.com. Editorial Director: Kimberly Brady. Art Director: Debbie Todd. Circ. 28,000. Estab. 1907. Monthly. Emphasizes professional photography in the fields of portrait, wedding, commercial/advertising, stock, sports, outdoor, corporate and industrial. Readers include professional photographers and photographic services and educators. Approximately half the circulation is Professional Photographers of America members. Sample copy $5 postpaid. Photo guidelines free with SASE.

 ● PPA members submit material unpaid to promote their photo businesses and obtain recognition. Images sent to *Professional Photographer* should be technically perfect and photographers should include information about how the photo was produced.

Needs: Uses 25-30 photos/issue; all supplied by freelancers. "We only accept material as illustration that relates directly to photographic articles showing professional studio, location, commercial and portrait techniques. A majority are supplied by Professional Photographers of America members." Reviews photos with accompanying ms only. "We always need commercial/advertising and industrial success stories. How to sell your photography to major accounts, unusual professional photo assignments. Also, photographer and studio application stories about the profitable use of electronic still imaging for customers and clients." Model release preferred. Captions required.

Specs: Uses 8×10 glossy unmounted b&w or color prints; 35mm, $2\frac{1}{4} \times 2\frac{1}{4}$, 4×5 and 8×10 transparencies. Accepts images in digital format for Mac. Send via compact disc, online, floppy disk, SyQuest, Zip disk, jaz.

Making Contact & Terms: Query with résumé of credits. "We prefer a story query, or complete ms if writer feels subject fits our magazine. Photos will be part of ms package." SASE. Reports in 2 months. Credit line given.

$ $ [□] [◎] PROGRESSIVE RENTALS, 9015 Mountain Ridge Dr., Suite 220, Austin TX 78759. (512)794-0095. Fax: (512)794-0097. E-mail: nferguson@apro-rto.com. Art Director: Neil Ferguson. Circ. 5,000. Estab. 1983. Published by the Association of Progressive Rental Organizations. Bimonthly magazine. Emphasizes the rental-purchase industry. Readers are owners and managers of rental-purchase stores in North America, Canada, Great Britain and Australia. Sample copy free with 9×12 SASE and $1.50 postage.

Needs: Uses 1-2 photos/issue; all supplied by freelancers. Needs "strongly conceptual, cutting edge photos

that relate to editorial articles on business/management issues." Model/property release preferred.

Specs: Uses glossy color and b&w prints; 2¼×2¼, 4×5 transparencies; digital format (high resolution, proper size, flattened image, saved in proper format, etc.).

Making Contact & Terms: Provide brochure, flier or tearsheets to be kept on file for possible assignments. Keeps samples on file. SASE. Reports in 1 month "if we're interested." Simultaneous submissions and previously published work OK. Pays $200-450/job; $350-450/color cover; $200-450/color inside; $200-350/b&w inside. Pays on publication. Buys one-time and electronic rights. Credit line given.

Tips: "Always ask for a copy of the publication you are interested in working with. Understand the industry and the specific editorial needs of the publication, i.e., don't send beautiful still life photography to a trade association publication."

PUBLIC WORKS MAGAZINE, 200 S. Broad St., Ridgewood NJ 07450. (201)445-5800. Fax: (201)445-5170. E-mail: jkircher@pwmag.com. Contact: James Kircher. Circ. 67,000. Monthly magazine. Emphasizes the planning, design, construction, inspection, operation and maintenance of public works facilities (bridges, water systems, landfills, etc.) Readers are civil engineers, consulting engineers and private contractors doing municipal work. Sample copy free upon request.

Needs: Uses dozens of photos/issue. "Most photos are supplied by authors or with company press releases." Captions required.

Making Contact & Terms: Provide résumé, business card, brochure, flier or tearsheets to be kept on file for possible assignments. SASE. Reports in 2 weeks. Payment negotiated with editor. Buys one-time rights. Credit line given "if requested."

Tips: "Nearly all of the photos used are submitted by the authors of articles (who are generally very knowledgeable in their field). They may occasionally use freelancers. Cover photos are done by staff and freelance photographers." To break in, "learn how to take good clear photos of public works projects that show good detail without clutter. Prepare a brochure and pass around to small and mid-size cities, towns and civil type consulting firms; larger (organizations) will probably have staff photographers."

$ $⊘ PURCHASING MAGAZINE, 275 Washington St., Newton MA 02158. (617)964-3030. Fax: (617)558-4705. Art Director: Michael Roach. Circ. 93,000. Estab. 1915. Bimonthly. Readers are management and purchasing professionals.

Needs: Uses 0-10 photos/issue, most on assignment. Needs corporate photos and people shots. Model/property release preferred. Captions required.

Making Contact & Terms: Arrange a personal interview to show portfolio. Provide résumé, business card, brochure, flier or tearsheets to be kept on file for possible future assignments. Cannot return material. Simultaneous submissions and previously published work OK. Pays $300-500/b&w; $300-500/color; $50-100/hour; $400-800/day; $200-500/photo/text package. **Pays on acceptance.** Buys all rights for all media including electronic media. Credit line given.

Tips: In photographer's portfolio looks for informal business portrait, corporate atmosphere.

$ $▣ ⊘ QSR, The Magazine of Quick Service Restaurant Success, 4905 Pine Cone Dr., Suite 2, Durham NC 27707. (919)489-1916. Fax: (919)489-4767. E-mail: tory@journalistic.com. Website: http://www.jayi.com. Art Director: Tory Bartelt. Estab. 1997. Bimonthly trade magazine directed toward the business aspects of quick-service restaurants (fast food). "Our readership is primarily management level and above, usually franchisers and franchisees. Our goal is to cover the quick-service restaurant industry objectively, offering our readers the latest news and information pertinent to their business." Sample copies and art guidelines available for free.

Needs: Buys 1-5 photos from freelancers/issue; 15-20 photos/year. Needs corporate identity portraits, images associated with fast food, general images for feature illustration. Interested in alternative process, documentary, regional. Reviews photos with or without ms. Model and property release preferred.

Specs: Uses 8×10 color prints and 2¼×2¼, 4×5, 8×10 transparencies. Accepts images in digital format for Mac. Send via CD, Zip as TIFF, EPS files at 300 dpi.

Making Contact & Terms: Send query letter with samples, brochure, stock photo list, tearsheets. Art director will contact photographer for portfolio review if interested. Portfolio should include slides and digital sample files. Keeps samples on file. Reports back only if interested, send non-returnable samples. Simultaneous submissions and previously published work OK. Pays $250-500 for color cover; $250-500 for color inside. Pays on publication. Buys all rights, negotiable.

Tips: "Willingness to work with subject and magazine deadlines essential. Willingness to follow artistic guidelines necessary but should be able to rely on one's own eye should need arise. Our covers always feature quick-service restaurant executives with some sort of name recognition (i.e. a location shot with signage in the background, use of product props which display company logo)."

$ ▱ ◎ QUICK FROZEN FOODS INTERNATIONAL, 2125 Center Ave., Suite 305, Fort Lee NJ 07024-5898. (201)592-7007. Fax: (201)592-7171. Editor/Publisher: John M. Saulnier. Circ. 13,000. Quarterly magazine. Emphasizes retailing, marketing, processing, packaging and distribution of frozen foods around the world. Readers are international executives involved in the frozen food industry: manufacturers, distributors, retailers, brokers, importers/exporters, warehousemen, etc. Review copy $12.

Needs: Buys 20-30 photos/year. Uses photos of agriculture, buildings, business concepts, technology, plant exterior shots, step-by-step in-plant processing shots, photos of retail store frozen food cases, head shots of industry executives, product shots, etc. Captions required.

Specs: Uses 5×7 glossy b&w and color prints.

Making Contact & Terms: Query first with résumé of credits. SASE. Reports in 1 month. Payment negotiable. Pays on publication. Buys all rights but may reassign to photographer after publication.

Tips: A file of photographers' names is maintained; if an assignment comes up in an area close to a particular photographer, she/he may be contacted. "When submitting your name, inform us if you are capable of writing a story, if needed."

$ ◎ READING TODAY, International Reading Association, 800 Barksdale Rd., P.O. Box 8139, Newark DE 19714-8139. (302)731-1600, ext. 250. Fax: (302)731-1057. E-mail: jmicklos@reading.org. Website: http://www.reading.org. Editor: John Micklos, Jr. Circ. 90,000. Estab. 1983. Publication of the International Reading Association. Bimonthly newspaper. Emphasizes reading education. Readers are educators who belong to the International Reading Association. Sample copy available. Photo guidelines free with SASE.

Needs: Uses 20 photos/issue; 3 supplied by freelancers. Needs classroom shots and photos of people of all ages reading in various settings. Reviews photos with or without ms. Model/property release preferred. Captions preferred; include names (if appropriate) and context of photo.

Specs: Uses 3½×5 or larger color and b&w (preferred) prints.

Making Contact & Terms: Query with résumé of credits and stock photo list. Send unsolicited photos by mail for consideration. SASE. Reports in 1 month. Simultaneous submissions and previously published work OK. Pays $45/b&w inside; $75/color inside. **Pays on acceptance.** Buys one-time rights. Credit line given.

$ RECOMMEND WORLDWIDE, 5979 NW 151st St., Suite 120, Miami Lake FL 33014. (305)828-0123. Art Director: Janet Rosemellia. Photo Editor: Greg Oates. Circ. 65,000. Estab. 1985. Monthly. Emphasizes travel. Readers are travel agents, meeting planners, hoteliers, ad agencies. Sample copy free with 8½×11 SAE and 10 first-class stamps.

Needs: Uses about 40 photos/issue; 50% supplied by freelance photographers. "Our publication divides the world up into seven regions. Every month we use travel destination-oriented photos of animals, cities, resorts and cruise lines. Features all types of travel photography from all over the world." Model/property release required. Captions preferred; identification required on every slide.

Making Contact & Terms: "We prefer a résumé, stock list and sample card or tearsheets with photo review later." SASE. Simultaneous submissions and previously published work OK. Pays $150/color cover; up to 20 square inches: $25; 21-35 square inches $35; 36-80 square inches $50; over 80 square inches $75; supplement cover: $75; front cover less than 80 square inches $50. Pays 30 days upon publication. Buys one-time rights. Credit line given.

Tips: Prefers to see "35mm, quality transparencies, travel-oriented. Photos must have high color saturation and evoke a sense of local impact."

$ ▱ REFEREE, P.O. Box 161, Franksville WI 53126. (414)632-8855. Fax: (414)632-5460. E-mail: jstern@referee.com. Photo Editor: Jeff Stern. Circ. 35,000. Estab. 1976. Monthly magazine. Readers are mostly male, ages 30-50. Sample copy free with 9×12 SAE and 5 first-class stamps. Photo guidelines free with SASE.

Needs: Uses up to 50 photos/issue; 75% supplied by freelancers. Needs action officiating shots—all sports. Photo needs are ongoing. Captions required.

Specs: Accepts images in digital format for Mac (TIFF). Send via SyQuest, optical 128m (266).

Making Contact & Terms: Send unsolicited photos by mail for consideration. Any format is accepted. Reports in 2 weeks. Simultaneous submissions and previously published work OK. Pays $100/color cover; $75/b&w cover; $35/color inside; $20/b&w inside. Pays on publication. Rights purchased negotiable. Credit line given.

Tips: Prefers photos which bring out the uniqueness of being a sports official. Need photos primarily of officials at or above the high-school level in baseball, football, basketball, soccer and softball in action. Other sports acceptable, but used less frequently. "When at sporting events, take a few shots with the officials in mind, even though you may be on assignment for another reason. Don't be afraid to give it a

try. We're receptive, always looking for new freelance contributors. We are constantly looking for pictures of officials/umpires. Our needs in this area have increased."

$ $ [A] ▣ ◎ REGISTERED REPRESENTATIVE, 18818 Teller Ave., Suite 280, Irvine CA 92612. Art Director: Chuck LaBresh. Circ. 90,000. Estab. 1976. Monthly magazine. Emphasizes stock brokerage industry. Magazine is "requested and read by 90% of the nation's stock brokers."
Needs: Uses about 8 photos/issue; 5 supplied by freelancers. Needs environmental portraits of financial and brokerage personalities, and conceptual shots of financial ideas, all by assignment only. Model/property release is photographer's responsibility. Captions required.
Specs: Prefers 100 ISO film or better. Accepts images in digital format for Mac. Send via ZIP or Jaz disk as TIFF at 300 dpi.
Making Contact & Terms: Provide brochure, flier or tearsheets to be kept on file for possible future assignments. Cannot return material. Simultaneous submissions and previously published work OK. Pays $300-600/b&w or color cover; $200-300/b&w or color inside. Pays 30 days after publication. Buys one-time rights. Credit line given. Publisher requires signed rights agreement.
Tips: "I usually give photographers free reign in styling, lighting, camera lenses, and such. I want something unusual but not strange. I assume the photographer is the person on the scene who can best make visual decisions."

▣ RELAY MAGAZINE, P.O. Box 10114, Tallahassee FL 32302-2114. (850)224-3314. Editor: Stephanie Wolanski. Circ. 1,800. Estab. 1957. Association publication of Florida Municipal Electric. Monthly magazine. Emphasizes municipally owned electric utilities. Readers are city officials, legislators, public power officials and employees.
Needs: Uses various amounts of photos/issue; various number supplied by freelancers. Needs b&w photos of electric utilities in Florida (hurricane/storm damage to lines, utility workers, etc.). Special photo needs include hurricane/storm photos. Model/property release preferred. Captions required.
Specs: Uses 3×5, 4×6, 5×7 or 8×10 b&w prints. Also accepts digital images.
Making Contact & Terms: Query with letter, description of photo or photocopy. Keeps samples on file. SASE. Simultaneous submissions and/or previously published work OK. Payment negotiable. Rates negotiable. Pays on use. Buys one-time rights, repeated use (stock); negotiable. Credit line given.
Tips: "Must relate to our industry. Clarity and contrast important. Query first if possible. Always looking for good black & white hurricane, lightning-storm and Florida power plant shots."

$ ▣ ◯ RESOURCE RECYCLING, P.O. Box 10540, Portland OR 97296-0540. (503)227-1319. Fax: (503)227-6135. E-mail: resrecycle@aol.com. Editor: Jerry Powell. Circ. 16,000. Estab. 1982. Monthly. Emphasizes "the recycling of post-consumer waste materials (paper, metals, glass, plastics etc.) and composting." Readers are "recycling company managers, local government officials, waste haulers and environmental group executives." Sample copy free with 11 first-class stamps plus 9×12 SAE.
Needs: Uses about 5-15 photos/issue; 1 supplied by freelancers. Needs "photos of recycling facilities, curbside recycling collection, secondary materials (bundles of newspapers, soft drink containers, compost), etc." Also needs environmental, landscapes, agriculture, computers, industry, science, technology. Interested in digital, documentary, regional, seasonal. Model release preferred. Captions required.
Specs: Accepts images in digital format for Mac. Accepts images in digital format for Mac. Send via CD, SyQuest, Zip, e-mail as TIFF, EPS, JPEG files at 300 dpi.
Making Contact & Terms: Send glossy color prints and contact sheet. SASE. Reports in 1 month. Simultaneous submissions OK. Pays $100 maximum for color cover. Pays on publication. Buys first North American serial rights. Credit line given.
Tips: "Because *Resource Recycling* is a trade journal for the recycling and composting industry, we are looking only for photos that relate to recycling and composting issues. Send samples as slides, color photocopies or contact sheets, and we will review."

$ $ ▣ ◗ RESTAURANT HOSPITALITY, 1100 Superior Ave., Cleveland OH 44114. (216)931-9942. Fax: (216)696-0836. E-mail: croberto@penton.com. Editor-in-Chief: Michael Sanson. Art Director: Christopher Roberto. Circ. 123,000. Estab. 1919. Monthly. Emphasizes "hands-on restaurant management ideas and strategies." Readers are "restaurant owners, chefs, food service chain executives."
● *Restaurant Hospitality* won the Ozzie Award for best design (circulation over 50,000) in 1993 and 1994 and the *Folio* Editorial Excellence Award for best written/edited magazine in food service, 1994, 1995, 1996, 1997 and 1998.
Needs: Uses about 30 photos/issue; 50% supplied by freelancers. Needs "people with food, restaurant and food service interiors and occasional food photos." Special needs include "subject-related photos; query first." Model release preferred. Captions preferred.

Specs: Accepts images in digital format for Mac. Send via online or disk.

Making Contact & Terms: Send samples or list of stock photo subjects if available. Provide résumé, business card, brochure, flier or tearsheets to be kept on file for possible future assignments. Previously published work OK "if exclusive to foodservice press." Pays $350/half day; $150-450/job includes normal expenses. **Pays on acceptance.** Buys one-time rights plus reprint rights in all media. Credit line given.

Tips: "Let us know you exist. We can't assign a story if we don't know you. Send samples along with introductory letter to Art Director Christopher Roberto."

N $ THE RETIRED OFFICER MAGAZINE, 201 N. Washington St., Alexandria VA 22314. (800)245-8762. Fax: (703)838-8179. Contact: Photo Editor. Circ. 400,000. Estab. 1945. Monthly. Publication represents the interests of retired military officers from the seven uniformed services: recent military history (particularly Vietnam and Korea), travel, health, second-career job opportunities, military family lifestyle and current military/political affairs. Readers are officers or warrant officers from the Army, Navy, Air Force, Marine Corps, Coast Guard, Public Health Service and NOAA. Free sample copy and photo guidelines with 9×12 SASE.

Needs: Uses about 24 photos/issue; 8 (the cover and some inside shots) usually supplied by freelancers. "We're always looking for good color slides of active duty military people and healthy, active mature adults with a young 50s look—our readers are 55-65."

Specs: Uses original 35mm, 2¼×2¼ or 4×5 transparencies.

Making Contact & Terms: Query with list of stock photo subjects. Provide résumé, brochure, flier to be kept on file. "Do *not* send original photos unless requested to do so." Pays $300/color cover; $20/b&w inside; $50-125 transparencies for inside use (in color); $50-150/quarter-page; complimentary copies. Other payment negotiable. "Photo rates vary with size and position." Pays on publication. Buys one-time rights. Credit line given.

Tips: "A photographer who can also write and submit a complete package of story and photos is valuable to us. Much of our photography is supplied by our authors as part of their manuscript package. We periodically select a cover photo from these submissions—our covers relate to a particular feature in each issue." In samples, wants to see "good color saturation, well-focused, excellent composition."

RISTORANTE MAGAZINE, P.O. Box 73, Liberty Corner NJ 07938. (908)766-6006. Fax: (908)766-6607. Art Director: Erica Lynn DeWitte. Circ. 50,000. Estab. 1994. Quarterly magazine for the Italian connoisseur and Italian restaurants with liquor licenses.

Needs: Number of photos/issue varies. Number supplied by freelancers varies. "Think Italian!" Reviews photos with or without ms. Model/property release required. Captions preferred.

Making Contact & Terms: Provide résumé, business card, brochure, flier or tearsheets to be kept on file for possible assignments. SASE. Previously published work OK. Payment negotiable. Pays on publication. Buys all rights; negotiable. Credit line given.

N $ THE SCHOOL ADMINISTRATOR, 1801 N. Moore St., Arlington VA 22209. (703)875-0753. Fax: (703)528-2146. E-mail: lgriffin@aasa.org. Website: http://www.aesa.org. Managing Editor: Liz Griffin. Circ. 16,500. Publication of American Association of School Administrators. Monthly magazine. Emphasizes K-12 education. Readers are school administrators including superintendents and principals, ages 50-60, largely male though this is changing. Sample copy $7.

Needs: Uses 8-10 photos/issue. Needs classroom photos, photos of school principals and superintendents and school board members interacting with parents and students. Model/property release preferred for physically handicapped students. Captions required; include name of school, city, state, grade level of students and general description of classroom activity.

Specs: Uses 5×7, 8×10 matte or glossy color b&w prints; 35mm, 2¼×2¼, 4×5, 8×10 transparencies.

Making Contact & Terms: Provide résumé, business card, brochure, flier or tearsheets to be kept on file for possible assignments. Send photocopy of b&w prints by mail for consideration. Photocopy of prints should include contact information including fax number. "Send a SASE for our editorial calendar. In cover letter include mention of other clients. Familiarize yourself with topical nature and format of magazine before submitting prints." Work assigned is 3-4 months prior to publication date. Keeps samples on file. SASE. Reports in 3 weeks. Simultaneous submissions and previously published work OK. Pays $200-300/color cover. $10-75/color and b&w inside. Buys one-time rights. Credit line given.

Tips: "Prefer photos with interesting, animated faces and hand gestures. Always looking for the unusual human connection where the photographer's presence has not made subjects stilted. Also, check out our editorial calendar on our website."

$ ▣ ◑ ◎ SCIENCE AND CHILDREN, 1840 Wilson Blvd., Arlington VA 22201-3000. E-mail: s&c@nsta.org. Website: http:www.nsta.org/pubs/sc. Associate Editor: Katherine Roberts. Circ. 24,000.

Publication of the National Science Teachers Association. Monthly (September to May) journal. Emphasizes teaching science to elementary school children. Readers are male and female elementary science teachers and other education professionals.

Needs: Uses 10 photos/issue; 1-2 supplied by freelancers. Needs photos that include children, teens and families doing science in all settings, especially in the classroom and at science fairs. Model/property release required. Captions required.

Specs: Accepts images in digital format for Windows. Send via CD, Jaz, Zip as TIFF files at 300 dpi.

Making Contact & Terms: Send stock lists and photocopies of color prints. Unsolicited material will not be returned. Pays $200-250/color cover; $60-150/color inside. Pays on publication. Credit line given.

Tips: "We look for candid shots that are sharp in focus and show the excitement of science discovery. We also want photographs that reflect the fact that science is accessible to people of every race, gender, economic background and ability."

$ ▣ SCIENCE SCOPE, 1840 Wilson Blvd., Arlington VA 22201. (703)243-7100. Fax: (703)243-7177. E-mail: sciencescope@nsta.org. Website: http://www.nsta.org/pubs/scope. Assistant Editor: Vicki Moll. Publication of the National Science Teachers Association. Journal published 8 times/year during the school year. Emphasizes activity-oriented ideas—ideas that teachers can take directly from articles. Readers are mostly middle school science teachers. Single copy $6.25. Photo guidelines free with SASE.

Needs: Uses cover shots, about half supplied by freelancers. Needs photos of mostly classroom shots with students participating in an activity. "In some cases, say for interdisciplinary studies articles, we'll need a specialized photo." Need for photo captions "depends on the type of photo."

Specs: Accepts images in digital format for Windows. Send via SyQuest, Zip disk or online.

Making Contact & Terms: Arrange personal interview to show portfolio. Query with stock photo list. Provide résumé, business card, brochure, flier or tearsheets to be kept on file for possible assignments. Keeps samples on file. SASE. Considers previously published work; "prefer not to, although in some cases there are exceptions." Pays $200 for cover photos and $50 for small b&w photos. Pays on publication. Sometimes pays kill fee. Buys one-time rights; negotiable. Credit line given.

Tips: "We look for clear, crisp photos of middle level students working in the classroom. Shots should be candid with students genuinely interested in their activity. (The activity is chosen to accompany manuscript.) Please send photocopies of sample shots along with listing of preferred subjects and/or listing of stock photo topics."

$ $ ▣ SCRAP, 1325 G St. NW, Suite 1000, Washington DC 20005. (202)737-1770. Fax: (202)626-0900. E-mail: kentkiser@scrap.org. Website: http://www.scrap.org. Editor: Kent Kiser. Circ. 7,000. Estab. 1988. Publication of the Institute of Scrap Recycling Industries. Bimonthly magazine. Covers scrap recycling for owners and managers of recycling operations worldwide. Sample copy $7.50.

Needs: Uses approximately 100 photos/issue; 15% supplied by freelancers. Needs operation shots of companies being profiled and studio concept shots. Model release required. Captions required.

Specs: Accepts images in digital format for Windows. Send via online, floppy disk or SyQuest (270 dpi).

Making Contact & Terms: Arrange personal interview to show portfolio. Query with list of stock photo subjects. Provide résumé, business card, brochure, flier or tearsheets to be kept on file for possible assignment. Reports in 1 month. Previously published work OK. Pays $600-1,000/day. Pays on publication. Rights negotiable. Credit line given.

Tips: Photographers must possess "ability to photograph people in corporate atmosphere, as well as industrial operations; ability to work well with executives, as well as laborers. We are always looking for good color photographers to accompany our staff writers on visits to companies being profiled. We try to keep travel costs to a minimum by hiring photographers located in the general vicinity of the profiled company. Other photography (primarily studio work) is usually assigned through freelance art director."

$ SECURITY DEALER, Dept. PM, 445 Broad Hollow Rd., Suite 21, Melville NY 11747. (516)845-2700. Fax: (516)845-7109. Associate Publisher/Editor: Susan Brady. Circ. 28,000. Estab. 1967. Monthly magazine. Emphasizes security subjects. Readers are business owners who install alarm, security, CCTV, home automation and access control systems. Sample copy free with SASE.

Needs: Uses 2-5 photos/issue; none at present supplied by freelance photographers. Needs photos of security-application-equipment. Model release preferred. Captions required.

Making Contact & Terms: Send b&w and color prints by mail for consideration. SASE. Reports "immediately." Simultaneous submissions and/or previously published work OK. Pays $25-50/b&w; $400/color cover; $50-100/inside color. Pays 30 days after publication. Buys one-time rights in security trade industry. Credit line given.

Tips: "Do not send originals, dupes only, and only after discussion with editor."

N $ A ▣ ⊘ SHOOTER'S RAG—THE PRACTICAL PHOTOGRAPHIC GAZETTE, 6100 Pine Cone Lane, Austell GA 30168. (770)745-4170. E-mail: havelin@mindspring.com. Website: http://www.mindspring.com/~havelin Editor: Michael Havelin. Circ. 2,000. Estab. 1992. "Printed intermittently." Emphasizes photographic techniques, practical how-tos and electronic imaging. Readers are male and female professionals, semi-professionals and serious amateurs. Sample copy $3 with 10×13 SAE and 90¢ postage. Photo guidelines free with SASE.

Needs: Uses 3-10 photos/issue; 50-75% supplied by freelancers. "Single photos are not needed. Query for text with photographs." Special photo needs include humorous b&w cover shots with photographic theme, Band-Aid and detailed description of how the shot was done with accompanying set-up shots. Model/property release preferred. Captions required.

Specs: Accepts images in digital format for Windows (PCX, TIFF, GIF, JPG). Send via compact disc, online, floppy disk, Zip disk. Electronic submissions preferred via website or e-mail attachments. Do not send unsolicited submissions.

Making Contact & Terms: Query with résumé of credits, ideas for text/photo packages. Do not send portfolios. Does not keep samples on file. Reports in 1-3 months. Simultaneous submissions and/or previously published work OK. Payment in copies only. Interested in one-time rights; negotiable. Credit line given.

Tips: "Writers who shoot and photographers who write well should query. Develop your writing skills as well as your photography. Don't wait for the world to discover you. Announce your presence."

SIGNCRAFT MAGAZINE, P.O. Box 60031, Fort Myers FL 33906. (941)939-4644. Editor: Tom McIltrot. Circ. 20,000. Estab. 1980. Bimonthly magazine. Readers are sign makers and sign shop personnel. Sample copy $5. Photo guidelines free with SASE.

Needs: Uses over 100 photos/issue; few at present supplied by freelancers. Uses photos of well-designed, effective signs. Captions preferred.

Making Contact & Terms: Query and send b&w or color prints; 35mm, 2¼×2¼ transparencies; b&w, color contact sheet by mail for consideration. SASE. Reports in 1 month. Previously published work possibly OK. Payment negotiable. Pays on publication. Buys first North American serial rights. Credit line given.

Tips: "If you have some background or past experience with sign making, you may be able to provide photos for us."

$ SOCIAL POLICY, 25 W. 43rd St., Room 620, New York NY 10036. (212)642-2929. Fax: (212)642-1956. Managing Editor: Audrey Gartner. Circ. 3,500. Estab. 1970. Quarterly. Emphasizes "social policy issues—how government and societal actions affect people's lives." Readers are academics, policymakers, lay readers. Sample copy $2.50.

Needs: Uses about 9 photos/issue; all supplied by freelance photographers. Needs photos of social consciousness and sensitivity. Model release preferred.

Making Contact & Terms: Arrange a personal interview to show portfolio. Query with samples. Provide résumé, business card, brochure, flier or tearsheets to be kept on file for possible future assignments. Reports in 2 weeks. Simultaneous submissions and previously published work OK. Pays $100/b&w cover; $40/b&w inside. Pays on publication. Buys one-time rights. Credit line given.

Tips: "Be familiar with social issues. We're always looking for relevant photos."

$ ▣ ⊘ ◎ SONGWRITER'S MONTHLY, "The Stories Behind Today's Songs", 332 Eastwood Ave., Feasterville PA 19053-4514. (215)953-0952 or (800)574-2986. Fax: (215)953-0952. E-mail: alfoster@aol.com. Website: http://www.geocities.com/TimesSquare/1917. Editor: Allen Foster. Circ. 2,500. Estab. 1992. Monthly trade publication for songwriters and individuals interested or involved in music or the music business. Call to request sample copies. For art guidelines send SAE with 1 first-class stamp.

Needs: Buys 1 photo from freelancers/issue; 12 photos/year. Need great live shots of known or unknown musicians performing and photos of music events or conferences. Model release preferred; property release preferred. Photo caption preferred; include who, where, when and if applicable, what song is being performed.

Specs: Uses b&w prints. Accepts images in digital format for Mac. Send via floppy disk, Zip, e-mail as JPEG files at 200 dpi (at least).

Making Contact & Terms: Send query letter with tearsheets. "Contact us with your interests." Does not keep samples on file; include SASE for return of material. Reports in 2-3 weeks. Simultaneous submissions and/or previously published work OK. Pays $15-20/b&w cover; $10-15/b&w inside. **Pays on acceptance.** Buys one-time rights. Credit line given if requested.

Tips: "We want images with good contrast that capture the artist's emotion. Query (by mail or e-mail) first."

$ ⑤ ▣ ◯ ◎ SOUTHERN LUMBERMAN, 128 Holiday Court, Suite 116, P.O. Box 681629, Franklin TN 37068-1629. (615)791-1961. Fax: (615)790-6188. Managing Editor: Nanci Gregg. Circ. 13,500. Estab. 1881. Monthly. Emphasizes forest products industry—sawmills, pallet operations, logging trades. Readers are predominantly owners/operators of midsized sawmill operations nationwide. Sample copy $3.50 with 9×12 SAE and 5 first-class stamps. Photo guidelines free with SASE.

Needs: Uses about 3-4 photos/issue; 25% supplied by freelancers. "We need color prints or slides of 'general interest' in the lumber industry. We need photographers from across the country to do an inexpensive color shoot in conjunction with a phone interview. We need 'human interest' shots from a sawmill scene—just basic 'folks' shots—a worker sharing lunch with the company dog, sawdust flying as a new piece of equipment is started; face masks as a mill tries to meet OSHA standards, etc." Looking for photo/text packages. Model release required. Captions required.

Specs: Uses 5×7 or 8×10 glossy color prints; 35mm, 4×5 transparencies. Accepts images in digital format for Mac. Send via CD, Jaz, Zip as TIFF, EPS, JPEG files at 266 dpi.

Making Contact & Terms: Query with samples. SASE. Reports in 6 weeks. Pays minimum $30-58 for color cover; $20-40 for color inside; $100-150/photo/text package. Pays on publication. Buys first North American serial rights. Credit line given.

Tips: Prefers color close-ups in sawmill, pallet, logging scenes. "Try to provide what the editor wants—call and make sure you know what that is, if you're not sure. Don't send things that the editor hasn't asked for. We're all looking for someone who has the imagination/creativity to provide what we need. I'm not interested in 'works of art'—I want and need color feature photos capturing essence of employees working at sawmills nationwide. I've never had someone submit anything close to what I state we need—try that. *Read* the description, shoot the pictures, send a contact sheet or a couple 4×6s."

Ⓝ $ ⑤ ◎ SPECIALTY TRAVEL INDEX, Alpine Hansen Publishing, 305 San Anselmo Ave., Suite 313, San Anselmo CA 94960. (415)459-4900. Fax: (415)459-4974. E-mail: spectrav@ix.netcom.com. Website: specialtytravel.com. Managing Editor: Susan Kostrzewa. Circ. 46,000. Estab. 1982. Biannual trade magazine. Directory of special interest travel geared toward travel agents. Sample copies available for $3.

Needs: Needs photos of children, couples, multicultural, adventure, health/fitness, travel. "We're mainly looking for cover shots (2/year). We're most interested in photos that include 'tourists' and locals interacting." Reviews photos with or without a ms. Photo caption preferred.

Specs: Uses 35mm transparencies.

Making Contact & Terms: Send query letter with résumé, slides, stock list. Does not keep samples on file; include SASE for return of material. Reports in 6 months on portfolios; 2 weeks on queries. Simultaneous submissions and previously published work OK. Pays $200 maximum for color cover. **Pays on acceptance.** Credit line given.

Tips: "We like a combination of scenery and active people. Read our magazine and refer to previous covers for a sense of what we need."

Ⓝ $ Ⓐ ▣ ◎ STAINED GLASS, Quarterly for Stained Glass Association of America, 6 SW Second St., #7, Lee-s Summit MO 64063-2352. (800)438-9581. Fax: (816)524-9405. E-mail: sgmagaz @kcnet.com. Website: http://www.stainedglass.org. Business Manager: Katei Gross. Circ. 8,000. Estab. 1906. Quarterly trade magazine. "*Stained Glass* is the premier magazine for architectural stained glass. The magazine is considered a historical property and is archived in libraries around the world. Though our principal readership is the large studio owner, it also includes architects, interior designers, artists and hobbyists." Art guidelines available.

Needs: Buys up to 5 photos from freelancers per issue; up to 10 photos per year. Needs photos of architectural stained glass and art glass using architectural techniques. Reviews photos with or without a ms. Property release required. Photo caption required.

Specs: Uses 35mm, 2¼×2¼, 4×5, 8×10 transparencies. Accepts images in digital format for Mac. Send via CD, SyQuest, Jaz, Zip, e-mail as TIFF, EPS files at 300 dpi.

Making Contact & Terms: Send query letter with slides, transparencies. Does not keep samples on file; include SASE for return of material. Reports in 3 months on queries and portfolios. Reports back only if

MARKET CONDITIONS are constantly changing! If you're still using this book and it's 2001 or later, buy the newest edition of *Photographer's Market* at your favorite bookstore or order directly from Writer's Digest Books.

interested. Simultaneous submissions and previously published work OK (only if submission is not in stained glass field). Credit line given. Buys one-time rights.

Tips: "The magazine will only accept top quality photography. Photographing stained glass in an architectural setting can be very difficult. We do not need 'artsy' photos but photos that show the true color and size of the window. GET GUIDELINES FIRST. Our photo guidelines are very specific on what film should be used and how captions should be written."

[A] ⊚ STEP-BY-STEP GRAPHICS, 6000 N. Forest Park Dr., Peoria IL 61614-3592. (309)688-2300. Fax: (309)688-8515. Managing Editor: Emily Potts. Circ. 45,000. Estab. 1985. Bimonthly. How-to magazine for traditional and electronic graphics. Readers are graphic designers, illustrators, art directors, studio owners, photographers. Sample copy $7.50.

Needs: Uses 130 photos/issue; all supplied by freelancers. Needs how-to ("usually tight") shots taken in artists' workplaces. Assignment only. Model release required. Captions required.

Making Contact & Terms: Query with samples. Provide résumé, business card, brochure, flier or tearsheets to be kept on file for possible future assignments. SASE. Reports in 1 month. Pays by the job on a case-by-case basis. **Pays on acceptance.** Buys one-time rights or first North American serial rights. Credit line given.

Tips: In photographer's samples looks for "color and lighting accuracy particularly for interiors." Most shots are tight and most show the subject's hands. Recommend letter of inquiry plus samples.

$ $SUCCESSFUL MEETINGS, 355 Park Ave. S., New York NY 10010. (212)592-6401. Fax: (212)592-6409. Art Director: Don Salkaln. Circ. 75,000. Estab. 1955. Monthly. Emphasizes business group travel for all sorts of meetings. Readers are business and association executives who plan meetings, exhibits, conventions and incentive travel. Sample copy $10.

Needs: Special needs include *good*, high-quality corporate portraits, conceptual, out-of-state shoots (occasionally).

Making Contact & Terms: Arrange a personal interview to show portfolio. Query with résumé of credits and list of stock photo subjects. SASE. Reports in 2 weeks. Simultaneous submissions and previously published work OK "only if you let us know." Pays $500-750/color cover; $50-150/b&w inside; $75-200/color inside; $150-250/b&w page; $200-300/color page; $200-600/text/photo package; $50-100/hour; $175-350/½ day. **Pays on acceptance.** Buys one-time rights. Credit line given.

$ $⊘ TECHNIQUES, 1410 King St., Alexandria VA 22314. (703)683-3111. Fax: (703)683-7424. E-mail: acte@acteonline.org. Website: http://www.acteonline.org. Circ. 42,000. Estab. 1926. Monthly magazine for Association for Career and Technical Education. Emphasizes education for work and on-the-job training. Readers are teachers and administrators in high schools and colleges. Sample copy free with 10×13 SASE.

• This publication has begun to use computer manipulated images.

Needs: Uses 8-10 photos/issue, 1-2 supplied by freelancers. Needs "students in classroom and job training settings; teachers; students in work situations." Model release preferred for children. Captions preferred; include location, explanation of situation.

Specs: Uses 5×7 color prints and 35mm transparencies.

Making Contact & Terms: Query with list of stock photo subjects. Send unsolicited photos by mail for consideration. Provide résumé, business card, brochure, flier or tearsheets to be kept on file for possible assignments. Keeps samples on file. SASE. Reports as needed. Simultaneous submissions and previously published work OK. Pays $400 up/color cover; $50 up/color inside; $30 up/b&w inside; $500-1,000/job. Pays on publication. Buys one-time rights; sometimes buys all rights; negotiable. Credit line given.

$⊚ THOROUGHBRED TIMES, P.O. Box 8237, Lexington KY 40533. (606)260-9800. Editor: Mark Simon. Circ. 24,000. Estab. 1985. Weekly tabloid magazine. Emphasizes thoroughbred breeding and racing. Readers are wide demographic range of industry professionals. No photo guidelines.

Needs: Uses 18-20 photos/issue; 40-60% supplied by freelancers. "Looks for photos only from desired trade (thoroughbred breeding and racing)." Needs photos of specific subject features (personality, farm or business). Model release preferred. Captions preferred.

Making Contact & Terms: Provide résumé, business card, brochure, flier or tearsheets to be kept on file for possible assignments. SASE. Reports in 1 month. Previously published work OK. Pays $25/b&w cover or inside; $50/color; $150/day. Pays on publication. Buys one-time rights. Credit line given.

[N] $TOBACCO INTERNATIONAL, 130 W. 42 St., Suite 1050, New York NY 10036. (212)391-2060. Fax: (212)827-0945. Editor: Tom Sosnowski. Circ. 5,000. Estab. 1886. Monthly international busi-

ness magazine. Emphasizes cigarettes, tobacco products, tobacco machinery, supplies and services. Readers are executives, ages 35-60. Sample copy free with SASE.

Needs: Uses 20 photos/issue. "Prefer photos of people smoking, processing or growing tobacco products from all around the world, but any interesting news-worthy photos relevant to subject matter is considered." Model and/or property release preferred.

Making Contact & Terms: Query with photocopies, transparencies, slides or prints. Does not keep samples on file. Reports in 3 weeks. Simultaneous submissions OK (not if competing journal). Pays $50/color photo. Pays on publication. Credit line may be given.

$TOPS NEWS, % TOPS Club, Inc., Box 07360, Milwaukee WI 53207. Editor: Kathleen Davis. Estab. 1948. TOPS is a nonprofit, self-help, weight-control organization. Photos used in membership magazine.

Needs: "Subject matter to be illustrated varies greatly." Reviews stock photos.

Specs: Uses any size transparency or print.

Making Contact & Terms: Query with stock photo list. Provide résumé, business card, brochure, flier or tearsheets to be kept on file for possible future assignments. SASE. Reports in 1 month. Pays $75-135/color photo. Buys one-time rights.

Tips: "Send a brief, well-composed letter along with a few selected samples with a SASE."

[N] $ $TRAFFIC SAFETY, 1121 Spring Lake Dr., Itasca IL 60143. (800)621-7615. Fax: (630)775-2285. Acting Publisher: John H. Kennedy. Editor: John Jackson. Circ. 17,000. Publication of National Safety Council. Bimonthly. Emphasizes highway and traffic safety, incident prevention. Readers are professionals in highway-related fields, including law-enforcement officials, traffic engineers, fleet managers, state officials, driver improvement instructors, trucking executives, licensing officials, community groups, university safety centers.

• *Traffic Safety* uses computer manipulation for cover shots.

Needs: Uses about 10 photos/issue; most supplied by freelancers. Needs photos of road scenes, vehicles, driving; specific needs vary.

Making Contact & Terms: Query with four-color and/or b&w prints. SASE. Reports in 2 weeks. Pays $100-1,000/cover. **Pays on acceptance.** Credit line given.

[N] $[S] [🖥] [◎] TREE CARE INDUSTRY, National Arborist Association, P.O. Box 1094, Amherst NH 03031-1094. (603)673-3311. Fax: (603)672-2613. E-mail: naa@natlarb.com. Website: http://www.natl arb.com. Editor: Mark Garvin. Circ. 28,500. Estab. 1990. Monthly trade magazine for arborists, landscapers and golf course superintendents interested in professional tree care practices. Sample copies available for $5.

Needs: Buys 3-6 photos per year. Needs photos of landscapes/scenics, gardening, environment. Reviews photos with or without a ms.

Specs: Uses color prints; 35mm transparencies. Accepts images in digital format for Windows. Send via Zip, Jaz or e-mail as TIFF files at 300 dpi.

Making Contact & Terms: Send query letter with stock list. Does not keep samples on file; include SASE for return of material. Reports back only if interested, send nonreturnable samples. Pays $100 maximum for color cover; $100 minimum for color inside. Pays on publication. Credit line given. Buys one-time rights.

Tips: Query by e-mail.

$TRUCK ACCESSORY NEWS, 6255 Barfield Rd., Suite 200, Atlanta GA 30328. (404)252-8831. Fax: (404) 252-4436. Editor: Alfreda Vaughn. Circ. 10,000. Estab. 1994. Monthly magazine. Emphasizes retail truck accessories. Readers are male and female executives. Sample copy available.

Needs: Uses 75 photos/issue; 5-10 supplied by freelancers. Needs photos of trucks and truck accessory retailers. Model/property release required. Captions required.

Specs: Uses 5×7, 8×10 color prints; 2¼×2¼, 4×5, 8×10 transparencies.

Making Contact & Terms: Provide résumé, business card, brochure, flier or tearsheets to be kept on file for possible assignments. Keeps samples on file. SASE. Reports in 3 weeks. Pays $350-450/half day. Pays on publication. Buys all rights; negotiable. Credit line given.

[N] $ $UNITED AUTO WORKERS (UAW), 8000 E. Jefferson Ave., Detroit MI 48214. (313)926-5291. Fax: (313)331-1520. E-mail: uawsolidarity@compuserv.com. Editor: Dick Olson. Trade union representing 800,000 workers in auto, aerospace, agricultural-implement industries, government and other areas. Publishes *Solidarity* magazine. Photos used for brochures, newsletters, posters, magazines and calendars.

• The publications of this organization have won International Labor Communications Association journalism excellence contest and several photography awards.

Needs: Buys 85 freelance photos/year and offers 12-18 freelance assignments/year. Needs photos of workers at their place of work and social issues for magazine story illustrations. Reviews stock photos. Model releases preferred. Captions preferred.

Specs: Uses 8 × 10 prints.

Making Contact & Terms: Arrange a personal interview to show portfolio. In portfolio, prefers to see b&w and color workplace shots. Query with samples and send material by mail for consideration. Prefers to see published photos as samples. Provide résumé and tearsheets to be kept on file for possible future assignments. Notifies photographer if future assignments can be expected. SASE. Reports in 2 weeks. Pays $75-175/b&w or color; $275/half-day; $525/day. Buys one-time rights and all rights; negotiable. Credit line given.

$UTILITY AND TELEPHONE FLEETS, P.O. Box 183, Cary IL 60013. (847)639-2200. Fax: (847)639-9542. Editor: Sam Phillips. Circ. 18,000. Estab. 1987. Magazine published 8 times a year. Emphasizes equipment and vehicle management and maintenance. Readers are fleet managers, maintenance supervisors, generally 35 and older in age and primarily male. Sample copy free with SASE. No photo guidelines.

Needs: Uses 35-40 photos/issue; 20% usually supplied by a freelance writer with an article. Needs photos of vehicles and construction equipment. Special photo needs include alternate fuel vehicles and eye-grabbing colorful shots of utility vehicles in action as well as utility construction equipment. Model release preferred. Captions required; include person's name, company and action taking place.

Making Contact & Terms: Provide résumé, business card, brochure, flier or tearsheets to be kept on file for possible assignments. SASE. Reports in 2 weeks. Pays $50/color cover; $10/b&w inside; $50-200/photo/text package ($50/published page). Pays on publication. Buys one-time rights; negotiable. Credit line given.

Tips: "Looking for shots focused on our market with workers interacting with vehicles, equipment and machinery at the job site."

$▣ WATER WELL JOURNAL, 601 Dempsey Rd., Westerville OH 43081. (614)882-8179. Fax: (614)898-7786. E-mail: jross@ngwa.org. Website: http://www.ngwa.org. Senior Editor: Jill Ross. Circ. 32,000. Estab. 1947. Monthly. Emphasizes construction of water wells, development of ground water resources and ground water cleanup. Readers are water well drilling contractors, manufacturers, suppliers and ground water scientists. Sample copy $21 (US); $36 (foreign).

Needs: Uses 1-3 freelance photos/issue plus cover photos. Needs photos of installations and how-to illustrations. Model release preferred. Captions required.

Specs: Accepts images in digital format for Mac. Send via CD, floppy disk, Zip as TIFF files.

Making Contact & Terms: Contact with résumé of credits; inquire about rates. "We'll contact." Pays $10-50/hour; $200/color cover; $50/b&w inside; "flat rate for assignment." Pays on publication. Buys all rights. Credit line given "if requested."

Tips: "E-mail inquiries (or write); we'll reply if interested. Unsolicited materials will not be returned."

N: THE WHOLESALER, 1838 Techny Court, Northbrook IL 60062. (847)564-1127. Fax: (847)564-1264. E-mail: editor@thewholesaler.com. Editor: John Schweizer. Circ. 29,600. Estab. 1946. Monthly news tabloid. Emphasizes wholesaling, distribution in the plumbing, heating, air conditioning, piping (inc. valves), fire protection industry. Readers are owners and managers of wholesale distribution businesses, also manufacturer representatives. Sample copy free with 11 × 15½ SAE and 5 first-class stamps.

Needs: Uses 1-5 photos/issue; 3 supplied by freelancers. Interested in field and action shots in the warehouse, on the loading dock, at the job site. Property release preferred. Captions preferred. "Just give us the facts."

Making Contact & Terms: Query with stock photo list. Send any size glossy print, color and b&w by mail for consideration. SASE. Reports in 2 weeks. Simultaneous and/or previously published work OK. Pays on publication. Buys one-time rights.

$▣ WINES & VINES, 1800 Lincoln Ave., San Rafael CA 94901. (415)453-9700. Fax: (415)453-2517. E-mail: geninfo@winesandvines.com. Contact: Dottie Kubota-Cordery. Circ. 5,000. Estab. 1919. Monthly magazine. Emphasizes winemaking in the US for everyone concerned with the wine industry, including winemakers, wine merchants, suppliers, consumers, etc.

Needs: Wants color cover subjects on a regular basis.

Specs: Accepts images in digital format for Mac or Windows (Adobe, Aldus, Quark). Send via compact disc, SyQuest, Zip disk (150-200).

Making Contact & Terms: Query or send material by mail for consideration. Will call if interested in reviewing photographer's portfolio. Provide business card to be kept on file for possible future assignments.

SASE. Reports in 3 months. Previously published work OK. Pays $50/b&w print; $100-300/color cover. Pays on publication. Buys one-time rights. Credit line given.

$ $ A ▣ ⃠ ◎ WIRELESS REVIEW, 9800 Metcalf, Overland Park KS 66212-2215. (913)967-7258. Fax: (913)967-1905. E-mail: cheri_jones@intertec.com. Website: http://www.wirelessreview.com. Art Director: Cheri Jones. Published twice a month. Emphasizes cellular industry. Readers are male and female executives.

Needs: Uses 15 photos/issue; 3 supplied by freelancers, usually the cover photo. Needs executive portraits, photo/illustration. Assignments are given out based on subjects area.

Specs: Accepts images in digital format for Windows. Send via CD, Zip as EPS files at 300 dpi.

Making Contact & Terms: Provide business card, brochure or tearsheets to be kept on file for possible assignments. Keeps samples on file. SASE. Simultaneous submissions OK. Pays $300-700/job; $700/color cover and one inside; $400/color inside. Buys one-time rights. Credit line given.

Tips: "Must be professional on the phone. If you are going to be taking a photo of a CEO, I need to make sure you are professional. I need someone who can take a blah environment and make it spectacular through the use of color and composition."

N $ WISCONSIN ARCHITECT, 321 S. Hamilton St., Madison WI 53703. (608)257-8477. Managing Editor: Brenda Taylor. Circ. 3,700. Estab. 1931. Publication of American Institute of Architects Wisconsin. Bimonthly magazine. Emphasizes architecture. Readers are design/construction professionals.

Needs: Uses approximately 35 photos/issue. "Photos are almost exclusively supplied by architects who are submitting projects for publication. Of these, approximately 65% are professional photographers hired by the architect."

Making Contact & Terms: "Contact us through architects." Keeps samples on file. SASE. Reports in 1-2 weeks when interested. Simultaneous submissions and/or previously published work OK. Pays $50-100/color cover when photo is specifically requested. Pays on publication. Rights negotiable. Credit line given.

$ WOMAN ENGINEER, Equal Opportunity Publications, Inc., 1160 E. Jericho Turnpike, Suite 200, Huntington NY 11743. (516)421-9478. Fax: (516)421-0359. Editor: Anne Kelly. Circ. 16,000. Estab. 1979. Published three times a year. Emphasizes career guidance for women engineers at the college and professional levels. Readers are college-age and professional women in engineering. Sample copy free with 9×12 SAE and 6 first-class stamps.

Needs: Uses at least one photo per issue (cover); planning to use freelance work for covers and possibly editorial; most of the photos are submitted by freelance writers with their articles. Model release preferred. Captions required.

Making Contact & Terms: Query with list of stock photo subjects or call to discuss our needs. SASE. Reports in 6 weeks. Simultaneous submissions OK. Pays $25/color cover photo; $15/b&w photo; $15/color photo. Pays on publication. Buys one-time rights. Credit line given.

Tips: "We are looking for strong, sharply focused photos or slides of women engineers. The photo should show a woman engineer at work, but the background should be uncluttered. The photo subject should be dressed and groomed in a professional manner. Cover photo should represent a professional woman engineer at work and convey a positive and professional image. Read our magazine, and find actual women engineers to photograph. We're not against using cover models, but we prefer cover subjects to be women engineers working in the field."

$ WORLD FENCE NEWS, Dept. PM, 6101 W. Courtyard Dr., Bldg. 3, Suite 115, Austin TX 78730. (800)231-0275. Fax: (512)349-2567. Managing Editor: Rick Henderson. Circ. 13,000. Estab. 1983. Monthly tabloid. Emphasizes fencing contractors and installers. Readers are mostly male fence company owners and employees, ages 30-60. Sample copy free with 10×12 SASE.

Needs: Uses 35 photos/issue; 20 supplied by freelancers. Needs photos of scenics, silhouettes, sunsets which include all types of fencing. Also, needs installation shots of fences of all types. "Cover images are a major area of need." Model/property release preferred mostly for people shots. Captions required; include location, date.

Making Contact & Terms: "If you have suitable subjects, call and describe." SASE. Reports in 3 weeks. Previously published work OK. Pays $100/color cover; $25/b&w inside. **Pays on acceptance.** Buys one-time rights. Credit line given.

⊕ WORLD FISHING, For a Global View of the Fishing Industry, Nexus Media Ltd., Nexus House, Azalea Dr., Swanley, Kent BR8 8HY United Kingdom. Phone: 44(1322)660070. Fax:

JUNE 15, 1998

From the Publishers of Cellular Business & WirelessWorld

WIRELESS REVIEW

INTELLIGENCE FOR COMPETITIVE PROVIDERS™

The Chong Legacy

Hierarchical Cell Structures

Risk Management

An INTERTEC/PRIMEDIA Publication

© 1998 Sharon Beals

"I, like most of my peers, am always trying to evolve technically and aesthetically," says photographer Sharon Beals. "Most magazine art directors expect you to bring your own sensibility to the shoot. I love editorial work because of this challenge." This portrait is one of a pair of Beals's images licensed by *Wireless Review* for their June 15, 1998 issue. Art director Cheri Jones discovered Beals's work in the *Corporate Showcase of Photography*. Beals was paid $800 for one-time rights for the cover image and one inside photo.

44(1322)666408. E-mail: Mark.Say@nexusmedia.co.uk. Circ. 5,800. Monthly glossy trade journal with commercial fisheries focus.

Needs: Photos of fishing vessels, especially at sea; processing at sea scenes; ports. Reviews photos with or without ms. Photo captions required.

Making Contact & Terms: Previously published work OK. Pays on publication. Buys one-time rights.

Tips: "Keep focus on fishing industry. We will take stock photos. We are unable to commission photos."

$YALE ROBBINS, INC., 31 E. 28th St., 12th Floor, New York NY 10016. (212)683-5700. Fax: (212)545-0764. Managing Editor: Peg Rivard. Circ. 10,500. Estab. 1983. Annual magazine and photo directory. Emphasizes commercial real estate (office buildings). Readers are real estate professionals—brokers, developers, potential tenants, etc. Sample copy free to interested photographers.

Needs: Uses 150-1,000 photos/issue. Needs photos of buildings. Property release required.

Specs: Uses 35mm transparencies.

Making Contact & Terms: Provide résumé, business card, brochure, flier or tearsheets to be kept on file for possible future assignments. Keeps samples on file. SASE. Reports in 1 month. Simultaneous submissions and previously published work OK. Pays $15-20/color slide; payment for color covers varies. Pays on publication. Buys all rights; negotiable. Credit line given.

THE INTERNATIONAL MARKETS INDEX, located in the back of this book, lists markets located outside the U.S. by country.

Book Publishers

PHOTO ILLUSTRATIONS

There are diverse needs for photography in the book publishing industry. Publishers need photos for the obvious covers, jackets, text illustration and promotional materials, but now may also need them for use on CD-ROMs and even websites. Generally, though, publishers either buy individual or groups of photos for text illustration, or they publish entire books of photography.

Those in need of text illustration use photos for cover art and interiors of textbooks, travel books and nonfiction books. For illustration, photographs may be purchased from a stock agency or from a photographer's stock or the publisher may make assignments. Publishers usually pay for photography used in book illustration or on covers on a per-image or per-project basis. Some pay photographers on hourly or day rates, if on an assignment basis. No matter how payment is made, however, the competitive publishing market requires freelancers to remain flexible.

To approach book publishers for illustration jobs, send a cover letter and photographs or slides and a stock photo list with prices, if available. If you have published work, tearsheets are very helpful in showing publishers how your work translates to the printed page.

PHOTO BOOKS

Publishers who produce photography books usually publish themed books featuring the work of one or several photographers. It is not always necessary to be well-known to publish your photographs as a book. What you do need, however, is a unique perspective, a saleable idea and quality work.

For entire books, publishers may pay in one lump sum or with an advance plus royalties (a percentage of the book sales). When approaching a publisher for your own book of photographs, query first with a brief letter describing the project and samples. If the publisher is interested in seeing the complete proposal, photographers can send additional information in one of two ways depending on the complexity of the project.

Prints placed in sequence in a protective box, along with an outline, will do for easy-to-describe, straight-forward book projects. For more complex projects, you may want to create a book dummy. A dummy is basically a book model with photographs and print arranged as they will appear in finished book form. Book dummies show exactly how a book will look including the sequence, size, format and layout of photographs and accompanying text. The quality of the dummy is important, but keep in mind the expense can be prohibitive.

To find the right publisher for your work first check the Subject Index on page 588 to help narrow your search, then read the appropriate listings carefully. Send for catalogs and guidelines for those publishers that interest you. You may find guidelines on publishers' websites as well. Also, become familiar with your local bookstore. By examining the books already published, you can find those publishers who produce your type of work. Check for both large and small publishers. While smaller firms may not have as much money to spend, they are often more willing to take risks, especially on the work of new photographers.

◀ Award-winning documentary photographer Wendy Ewald's image of two sisters, "Hansa and her sister combing their hair," is one of many compelling images featured in her book *I Dreamed I Had a Girl in My Pocket: The Story of an Indian Village* (Doubletake Books/W.W. Norton). Photographed during her seven months living and teaching in the village of Vichya in Gujarat, India, this image exemplifies Ewald's commitment to showing the world through the eyes of its children. (Ewald discusses her unique method of helping children create photographic images and her struggles to find publishers for her work on page 242.)

insider report

Collaborative vision: Wendy Ewald captures the world through children's eyes

Wendy Ewald

Ask award-winning documentary photographer and educator Wendy Ewald about the importance of trusting your own personal vision, and she'll tell you there's no sense in doing something that somebody else can do. "I never started out with expectations that I was going to do a book or that I was going to have a market. That was very important because it allowed me to make my own market. All of us have something unique that we can offer, we all see the world in a different way. That's valuable."

Ewald's own personal vision is an ongoing discussion of the nature of childhood and the intersecting issues of class, race, culture and identity. When she's not at Duke University where she is a Senior Research Associate at the Center for Documentary Studies and the Project Director of the Literacy Through Photography Program, she is working collaboratively with children in communities around the world. For two decades she has been giving children cameras and film and encouraging them to use their personal vision to document their lives, dreams, fears, sense of self and community.

The editor and photographer of five books, Ewald incorporates photographs of and by her subjects with insightful interviews. As a photographer, educator and social artist, Ewald's unique approach has gained her numerous awards and international recognition. However, she admits that starting out she had to struggle to have her style of working respected or even understood. "When I started out in 1969, it was practically unheard of. And for a long time it wasn't considered relevant or valid or photography. It took me five years to get my first book published because nobody considered it part of how they saw the world, whether it was the photography world, the oral history world, or the sociology world. It didn't fall into anybody's camp."

Ewald's first three books were published by small publishers and evolved out of her experience as an artist-in-residence from 1976-1980 in Appalachia for the Kentucky Arts Commission. While *Appalachia: A Self-Portrait* (Appalshop, 1979) and *Appalachian Women: Three Generations* (Appalshop, 1981) focused on community residents of all ages, Ewald's unique collaboration with children was first celebrated in her

third book, *Portraits and Dreams: Photographs and Stories by Children of the Appalachians* (Writers and Readers Publications, Inc., 1985). Named one of the ten best art books of the year by the American Library Association, *Portraits and Dreams* broke new ground, but Ewald still struggled to get her work published.

Her next book, *Magic Eyes: Scenes from an Andean Girlhood* (Bay Press, 1992), combined photographs by Ewald and the children of Raquira, Colombia, with stories told to Ewald by two local women. Ewald wanted to do a book that was equal parts photographs and text. "I wasn't interested in doing the same thing I had done before," she says. "Because *Magic Eyes* was a different kind of collaboration, people didn't

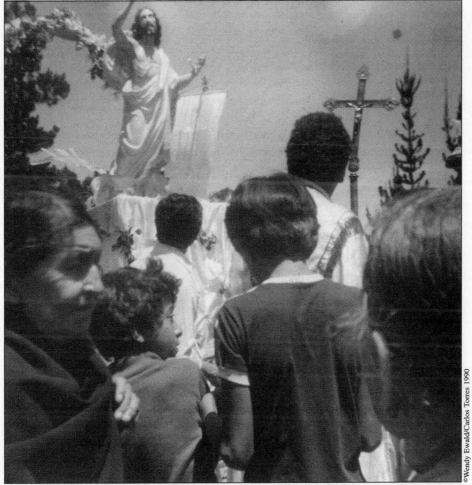

©Wendy Ewald/Carlos Torres 1990

This image of Colombian children from Wendy Ewald's book *Magic Eyes: Scenes from an Andean Girlhood*, provides a glimpse into the magically rich folk culture of the Colombian Andes. *Magic Eyes* combined photographs taken by Ewald and her students with stories told by two local women, Maria Vasquez and her daughter Alicia. The "magic eyes" belong to Alicia, who recounts her story of the evil eye, which she associates with the camera lens.

know whether it was a storybook or a photography book. It didn't take five years to publish, but maybe it took two years." Ewald admits that publishing photography books is a difficult enterprise. "I went to a lot of publishers and it was interesting because I got to learn about the book world that way." She has worked with four different publishers for each of her books and book packagers for her early books, which were completely designed before a publisher accepted them.

Ewald's most recent book, *I Dreamed I Had a Girl in My Pocket: The Story of an Indian Village* (Doubletake Books/W.W. Norton, 1996), combines stories and photographs of and by the children of Vichya, India. The book was published by Doubletake Books, the publishing arm of the Center for Documentary Studies where Ewald teaches, in conjunction with Norton to make it financially viable. During her 7 months living in Vichya, she helped children across caste lines, ages 10-14, photograph their own lives and dreams and then juxtaposed their images and hers with moving and sometimes disturbing testimonies by the children.

Often putting herself in a completely foreign environment, Ewald struggles to adjust and learn from everything new around her with each project. "The work for me is very difficult for the first half or three quarters of the time. I have a lot of self doubts and don't know if I can see what's going on. It's part of my process because I have to suspend anything that I knew about before, to start seeing the way people there are seeing. But it's very uncomfortable. By the last quarter, I'm absolutely euphoric because I see how things fit together, and I'm very close with people. It's wonderful, but then I have to leave. It's very difficult for me to go back to the states."

A true collaborator, Ewald credits each individual child on photographs and always partners with an organization in the host city of her projects. She also makes a point of giving money from exhibition and book sales back to the communities she has worked in. In addition to her projects in Appalachia, India and Colombia, she has also worked with children in South Africa, the Netherlands, Mexico and cities across the U.S. Understandably, Ewald spends a lot of time looking for funding for her projects. She has received National Endowment for the Arts grants, a Fulbright Fellowship and a MacArthur Fellowship, among others. Ewald typically looks for fellowship and exchange grants or educational grants that fund her to do a project as an educational model and teach it to other people who want to replicate it.

Ewald is currently at work on a retrospective exhibition, and a book documenting her work from 1969 to the present that Scalo will publish in 2000. She is also writing a book that explains her method of working and teaching. Ewald constantly challenges herself to fulfill her own creative vision and goals of being a social artist. "I look at what's useful in what I do, not just for the work but how I can share it with other people. I find at this point, if I can figure out something that's really crucial to me, some interesting work comes out of it."

—*Tricia Waddell*

$ AAIMS PUBLISHERS, 11000 Wilshire Blvd., P.O. Box 241777, Los Angeles CA 90024-9577. (213)968-1195. Fax: (323)931-7217. E-mail: aaims1@earthlink.net. Personnel Manager: Samuel P. Elliott. Estab. 1969. Publishes adult trade, "how-to," description and travel, sports, adventure, fiction and poetry. Photos used for text illustration, promotional materials and book covers. Examples of recently published titles: *Family Reunions: How To Plan Yours*; *A Message From Elvis*; and *U.S. Marines Force Recon: A Black Hero's Story*.
Needs: Offers 4 or 5 freelance assignments annually. Shots of sports figures and events. Reviews stock photos. Model/property release required.
Specs: Uses 3×5 glossy b&w/prints.
Making Contact & Terms: Arrange personal interview to show portfolio or query with samples. SASE. Reports in 3 weeks. Pays $10-50/b&w photo; $50/hour. Buys all rights; negotiable. Credit line may be given. Offers internships for photographers. Contact Assistant Director: Olatunde Master.

AGRITECH PUBLISHING GROUP INC., 95 Court St., Unit A, Exeter NH 03833-2621. (603)773-9823. President and Publisher: Robert P. Griset. Vice President of Sales: Andi Taylor. Estab. 1988. Publishes and distributes adult trade, juvenile, textbooks. Subject matter includes horses, pets, farm animals/management, gardening, Western art/Americana and agribusiness. 60% of books related to horses. Photos used for text illustration, promotional materials, book covers and dust jackets.
Needs: Number of purchases and assignments varies. Reviews stock photos. Model/property release required. Captions preferred.
Making Contact & Terms: Submit portfolio for review. Query with samples. Provide résumé, business card, brochure, flier, duplicates or tearsheets to be kept on file for possible future assignments. Keeps samples on file. SASE. Payment negotiable. Pays on publication. Buys book rights and all rights. Credit line sometimes given depending upon subject and/or photo.
Tips: "Limit queries to what we are looking for and need."

N ALFRED PUBLISHING CO., INC., P.O. Box 10003, Van Nuys CA 91410-0003. Art Director: Ted Engelbart. Estab. 1922. Examples of recent uses: educational music book covers (4×5); Enhanced CD ad campaign (2¼×2¼) and brochures for sales promotions (35mm and 2¼×2¼).
Needs: Photos of musical instruments. Reviews stock photos of musical instruments. Model/property release required for people and music halls.
Specs: Uses 35mm, 2¼×2¼, 4×5 transparencies.
Making Contact & Terms: Provide résumé, self-promotion piece or tearsheets to be kept on file for possible future assignments. Works on assignment only. Does not report back, keeps on file. Payment negotiable. Buys all rights (unless stock); negotiable.
Tips: "Send requested profile. Do not call. Provide any price or release requirements." Looks for "graphic or mood presentation of musical instruments and musicians; general interest such as Americana, landscapes and churches."

$ $ ALLYN AND BACON PUBLISHERS, 160 Gould St., Needham MA 02494. Fax: (781)455-1294. Photography Director: Susan Duane. Textbook publisher (college). Photos used in textbook covers and interiors.
Needs: Offers 4 assignments plus 80 stock projects/year. Multi-ethnic photos in education, health and fitness, people with disabilities, business, social sciences and good abstracts. Reviews stock photos. Model/property release required.
Specs: Uses b&w prints, any format; all transparencies.
Making Contact & Terms: Provide self-promotion piece or tearsheets to be kept on file for possible future assignments. "Do not call or send stock lists." Keeps samples on file. Cannot return samples. Reports back in "24 hours to 4 months." Pays $50-225/photo; negotiable/day or complete job. Pays on usage. Buys one-time rights; negotiable. Credit line given. Offers internships for photographers January-June. Contact Photography Director: Susan Duane.
Tips: "Send tearsheets and promotion pieces. Need bright, strong, clean abstracts and unstaged, nicely lit people photos."

$ $ AMERICAN BAR ASSOCIATION PRESS, 750 N. Lake Shore Dr., Chicago IL 60611. (312)988-6054. Fax: (312)988-6035. Photo Service Coordinator: Russell Glidden. "The ABA Press publishes 10 magazines, each addressing various aspects of the law. Readers are members of the sections of the American Bar Association." Photos used for text illustration, promotional materials, book covers. Examples of published titles: *Business Law Today*, portrait shot of subject of story; *Criminal Justice*, photo for story on crack. Photo guidelines free with SASE.
Needs: Buys 3-5 photos/issue. Rarely gives freelance assignments. "We are looking for serious photos

that illustrate various aspects of the law, including courtroom scenes and still life law concepts. Photos of various social issues are also needed, e.g., crime, AIDS, homelessness, families, etc. Photos should be technically correct. Photos should show emotion and creativity. Try not to send any gavels or Scales of Justice. We have plenty of those." Reviews stock photos. Model/property release preferred; "required for sensitive subjects." Photo captions preferred.

Specs: Uses 5×7, 8×10 b&w prints; 35mm, 2¼×2¼, 4×5, 8×10 transparencies.

Making Contact & Terms: Query with stock photo list or send unsolicited photos by mail. Provide résumé, business card, brochure, flier or tearsheets with SASE to be kept on file for possible future assignments. Keeps samples on file. Reports in 4-6 weeks. Simultaneous submissions and/or previously published works OK. Pays $150-450/b&w; $500-700/color. Assignment fees will be negotiated. When photos are given final approval, photographers will be notified to send an invoice. Buys one-time rights; negotiable. "We reserve the right to republish if publication is used on the Internet." Credit line given.

Tips: "Be patient, present only what is relevant."

$ $ ◑ **AMERICAN BIBLE SOCIETY**, 1865 Broadway, New York NY 10023. Fax: (212)408-1305. Assistant Director/Product Development: Christina Murphy. Estab. 1816. Publishes Bibles, New Testaments, illustrated Scripture booklets, leaflets and wide range of products on religious and spiritual topics. Photos used for covers, text illustration, promotional materials, calendar and tray cards. Examples of published titles: *Pocket Scripture Calendar Cards; Year of the CEV New Testament for Youth*; and *Run Toward the Goal*, booklet for youth.

Needs: Buys approx. 10-25 photos annually; offers at least 10 freelance assignments annually. Needs nature/scenic photos, people (multicultural), religious activities, international locations (particularly Israel, Jerusalem, Bethlehem, etc.). Reviews stock photos. Model release required. Property release preferred. Releases needed for portraits and churches. Captions preferred; include location and names of identifiable persons.

Specs: Uses any size glossy color and b&w prints; 35mm, 2¼×2¼, 4×5, 8×10 transparencies.

Making Contact & Terms: Query with samples. Provide résumé, business card, brochure, flier or tearsheets to be kept on file for possible future assignments. Keeps samples on file. Reports within 2-3 months. Simultaneous submissions and/or previously published work OK. Pays $100-500/color photo; $50-200/b&w photo. **Pays on receipt of invoice.** Buys one-time and all rights; negotiable. Credit line sometimes given depending on nature of publication.

Tips: Looks for "special sensitivity to religious and spiritual subjects and locations; uplifting nature settings; contemporary, multicultural people shots are especially desired."

◪ ▣ **AMERICAN COLLEGE OF PHYSICIAN EXECUTIVES**, 4890 W. Kennedy Blvd., Suite 200, Tampa FL 33609-2575. (813)287-2000. Fax: (813)287-8993. E-mail: ssasenick@acp.org. Editor: Susan Sasenick. Estab. 1979. Publishes adult trade for physician executives. Photos used for text illustration. Example of recently published title: *Physician Executivie Journal*.

Needs: Buys 10 photos annually. Looking for photos of abstracts and still lifes. Reviews stock photos.

Spec: Accepts all formats, including prints, transparencies, film and videotape and digital. Keeps samples on file.

Making Contact & Terms: Query with samples and stock photo list. Provide résumé, business card, brochure, flier or tearsheets to be kept on file for possible future assignments. SASE. Reports in 1 month. Simultaneous submissions and previously published work OK. Payment negotiable. Pays on publication, receipt of invoice. Buys one-time rights and electronic rights; negotiable. Credit line given.

$ $ ▣ ◑ ◎ **AMERICAN PLANNING ASSOCIATION**, 122 S. Michigan, Suite 1600, Chicago IL 60603. (312)431-9100. Fax: (312)431-9985. Art Director: Richard Sessions. Publishes planning and related subjects. Photos used for text illustration, promotional materials, book covers, dust jackets. Examples of recently published titles; *Planning* (text illustrations, book cover), *PAS Reports* (text illustrations, book cover). Photo guidelines and sample for $1 postage. Do not send cash.

FOR EXPLANATIONS OF THESE SYMBOLS,
SEE THE INSIDE FRONT AND BACK COVERS OF THIS BOOK.

Needs: Buys 100 photos annually; offers 8-10 freelance assignments annually. Needs planning related photos. Caption information required; include what's in the photo and credit information.

Specs: Uses 8×10 glossy color or b&w prints. Accepts images in digital format for Mac. Send via CD, SyQuest, floppy disk, Zip, e-mail as TIFF, EPS, JPEG files at 350 dpi minimum.

Making Contact & Terms: Provide résumé, business card, brochure, flier or tearsheets to be kept on file for possible future assignments. Do not send original work—slides, prints, whatever—with the expectation of it being returned. Pays $300-400 maximum for color and $50-100 for b&w. Keeps samples on file. SASE. Reports in 1-2 weeks. Simultaneous submissions and previously published work OK. Pays $80-100 for existing stock photos. **Pays on receipt of invoice.** Buys one-time and electronic rights (CD-ROM and online). Credit line given.

Tips: "Send a sample I can keep."

AMERICAN SCHOOL HEALTH ASSOCIATION, P.O. Box 708, Kent OH 44240. (330)678-1601. Fax: (330)678-4526. Managing Editor: Thomas M. Reed. Estab. 1927. Publishes professional journals. Photos used for book covers.

Needs: Looking for photos of school-age children. Model/property release required. Captions preferred; include photographer's full name and address.

Specs: Uses 35mm transparencies.

Making Contact & Terms: Query with samples. Does not keep samples on file. SASE. Reports as soon as possible. Simultaneous submissions and previously published work OK. Payment negotiable. Pays on publication. Buys one-time rights. Credit line given.

$ AMHERST MEDIA INC., P.O. Box 586, Amherst NY 14226. (716)874-4450. Fax: (716)874-4508. Publisher: Craig Alesse. Estab. 1979. Publishes how-to photography. Photos used for text illustration and book covers. Examples of published titles: *The Freelance Photographer's Handbook*; *Wedding Photographer's Handbook* (illustration); and *Lighting for Imaging* (illustration).

Needs: Buys 100 photos annually; offers 12 freelance assignments annually. Model release required. Property release preferred. Captions preferred.

Specs: Uses 5×7 prints; 35mm transparencies.

Making Contact & Terms: Query with résumé of credits. Does not keep samples on file. SASE. Reports in 1 month. Simultaneous submissions OK. Pays $30-100/color photo; $30-100/b&w photo. Pays on publication. Rights negotiable. Credit line sometimes given depending on photographer.

$ ▨ ☐ ANVIL PRESS, 204-A 175 E. Broadway, Vancouver, British Columbia V5T 1W2 Canada. (604)876-8710. Fax: (604)879-2667. E-mail: subter@pinc.com. Website: http://www.anvilpress.com. Managing Editor: Brian Kaufman. Estab. 1988. Publishes trade paperback originals and reprints. Subjects include contemporary literature. Photos used for book covers. Examples of recently published titles: *Where Words Like Monarchs* (book cover) and *Salvage King, Ya!* (book cover).

Needs: Buys 20 freelance photos annually.

Marketing Contact & Terms: Send query letter with samples. To show portfolio, photographer should follow-up with call. Keeps samples on file. Reports in 6 months on queries; 2 months on samples. Send non-returnable samples. Considers simultaneous subimssions. Pays $150 maximum for b&w/color cover. Pays $10-30 for inside photos.

$ $ ▣ ☑ APPALACHIAN MOUNTAIN CLUB BOOKS, 5 Joy St., Boston MA 02108. (617)523-0636. Fax: (617)523-0722. Website: http://www.outdoors.org. Production Manager: Elisabeth L. Brady. Estab. 1876. Publishes hardcover originals, trade paperback originals and reprints. Subjects include nature, outdoor, recreation, paddlesports, hiking/backpacking, skiing. Photos used for text illustrations, book covers. Examples of recently published titles: *River Rescue, 3rd ed.* (cover); *Exploring the Hidden Charles* (cover); *Appalachia* (cover).

Needs: Buys 10-15 freelance photos annually. Looking for photos of paddlesports, skiing and outdoor recreation. Model/property release required. Photo caption preferred; include where photo was taken, description of subject, author's name and phone number.

Specs: Uses 3×5 glossy color and b&w prints; 35mm, $2\frac{1}{4} \times 2\frac{1}{4}$ transparencies.

Marketing Contact & Terms: Send query letter with brochure, stock photo list or tearsheets. Art director will contact photographer for portfolio review if interested. Portfolio should include b&w or color, prints, tearsheets. Works with local freelancers on assignment only. Keeps samples on file; include SASE for return of material. Reports back only if interested, send non-returnable samples. Considers previously published work. Pays by the project, $200-450 for color cover; $50 for b&w inside. **Pays on acceptance.** Buys first North American serial rights. Credit line given.

$ $ ⬛ ⬛ ▢ ◗ ARNOLD PUBLISHING LTD., 11016-127 St., Edmonton, Alberta T5M 0T2 Canada. (780)454-7477. Fax: (780)454-7463. E-mail: info@arnold.ca. Website: http://www.arnold.cq. Contact: Production Coordinator. Publishes social studies textbooks and related materials. Photos used for text illustration and CD-ROM. Examples of recently published titles: *China* (text illustrations, promotional materials, book cover, dust jacket); *Marooned Island Geography* (educational CD-ROM).

Needs: Buys hundreds of photos annually. Looking for photos of history of Canada, world geography, geography of Canada. Also needs multicultural religious, adventure, travel, agriculture, political, disasters, environmental, landscapes/scenics, wildlife. Reviews stock photos. Model/property release required. Captions preferred; include description of photo and setting.

Specs: Accepts images in digital format for Mac. Send via CD, e-mail as JPEG files at 300 dpi.

Making Contact & Terms: Query with stock photo list. Provide résumé, prices, business card, brochure, flier or tearsheets to be kept on file for possible future assignments.

Tips: "Send information package via mail."

$ $ ART DIRECTION BOOK CO., INC., 456 Glenbrook Rd., Stamford CT 06906. (203)353-1441 or (203)353-1355. Fax: (203)353-1371. Contact: Art Director. Estab. 1939. Publishes only books of advertising art, design, photography. Photos used for dust jackets.

Needs: Buys 10 photos annually. Needs photos for advertising.

Making Contact & Terms: Submit portfolio for review. Works on assignment only. SASE. Reports in 1 month. Pays $200 minimum/b&w photo; $500 minimum/color photo. Buys one-time and all rights. Credit line given.

$ $ ◗ ◎ ASSOCIATION OF BREWERS, INC., 736 Pearl St., Boulder CO 80302. (303)447-0816. Fax: (303)447-2825. Website: http://www.beertown.org. Art Director: Stephanie Johnson. Estab. 1978. Publishes beer how-to, cooking with beer, adult trade, hobby, brewing and beer-related books. Photos used for text illustration, promotional materials, books, magazines. Examples of published magazines: *Zymurgy* (front cover and inside), *The New Brewer* (front cover and inside) and *The New Brewer International* (front cover and inside). Examples of published book titles: *Great American Beer Cook Book* (front/back covers and inside); *Scotch Ale* (cover front/back).

Needs: Buys 15-30 photos annually; offers 10-12 freelance assignments annually. Needs photos of food/drink, beer, hobbies, agriculture, industry, product shots/still life, science, technology. Reviews stock photos. Model/property release preferred.

Specs: Uses color and b&w prints, 35mm transparencies.

Making Contact & Terms: Query with nonreturnable samples. Provide résumé, business card, brochure, flier or tearsheets to be kept on file for possible future assignments. Keeps samples on file. SASE. Simultaneous submissions and previously published works OK. Payment negotiable; all jobs done on a quote basis. Pays 30 days after receipt of invoice. Preferably buys one-time usage rights, but negotiable.

Tips: "Send samples for us to keep in our files which depict whatever your specialty is plus some samples of beer-related objects, equipment, events, people, etc."

$ $ ▢ AUGSBURG FORTRESS, PUBLISHERS, P.O. Box 1209, Minneapolis MN 55440. (612)330-3300. Fax: (612)330-3455. Contact: Photo Secretary. Publishes Protestant/Lutheran books (mostly adult trade), religious education materials, audiovisual resources and periodicals. Photos used for text illustration, book covers, periodical covers and church bulletins. Guidelines free with SASE.

Needs: Buys 1,000 color photos and 250 b&w photos annually. No assignments. People of all ages, variety of races, activities, moods and unposed. "Always looking for church scenarios—baptism, communion, choirs, acolites, ministers, Sunday school, etc." In color, wants to see nature, seasonal, church year and mood. Model release required.

Specs: Uses 8 × 10 glossy or semigloss b&w prints, 35mm, 2¼ × 2¼ color transparencies. Accepts images in digital format for Mac. Send via CD, Zip as EPS or TIFF files at 300 dpi.

Making Contact & Terms: Write for guidelines, then submit on a regular basis. We are interested in stock photos. Provide tearsheets or low res. digital files to be kept on file for possible future assignments. SASE. Reports in 6-8 weeks. Simultaneous submissions and previously published work OK. Pays $55-165/b&w photo; $93-328/color photo. Buys one-time rights. Credit line nearly always given.

AUTONOMEDIA, P.O. Box 568, Brooklyn NY 11211. Phone/fax: (718)963-2603. E-mail: jim@autono media.org. Website: http://www.autonomedia.org. Editor: Jim Fleming. Estab. 1974. Publishes books on radical culture and politics. Photos used for text illustration and book covers. Examples of recently published titles: *TAZ* (cover illustration); *Cracking the Movement* (cover illustration); and *Zapatistas* (cover and photo essay).

Needs: The number of photos bought annually varies, as does the number of assignments offered. Model/

property release preferred. Captions preferred.

Making Contact & Terms: Query with samples. Works on assignment only. Does not keep samples on file. SASE. Reports in 1 month. Payment negotiable. Pays on publication. Buys one-time and electronic rights.

N $ $ BEACON PRESS, 25 Beacon St., Boston MA 02108. (617)742-2110. Fax: (617)742-2290. Creative Director: Sara Eisenman. Estab. 1854. Publishes adult nonfiction trade and scholarly books; African-American, Jewish, Asian, Native American, gay and lesbian studies; anthropology; philosophy; women's studies; environment/nature. Photos used for book covers and dust jackets. Examples of published titles: *Straight Talk about Death for Teenagers* (½-page cover photo, commissioned); *The Glory and the Power* (full-bleed cover photo, stock); and *Finding Home* (full-bleed cover photo, stock).

Needs: Buys 5-6 photos annually; offers 1-2 freelance assignments annually. "We look for photos for specific books, not any general subject or style." Model/property release required. Captions preferred.

Specs: Uses 8×10 glossy b&w prints; 35mm, 2¼×2¼ transparencies.

Making Contact & Terms: Provide résumé, business card, brochure, flier or tearsheets to be kept on file for possible future assignments. Keeps samples on file. SASE. Reports in 1 month. Previously published work OK. Pays $500-750/color photo; $150-250/b&w photo. **Pays on receipt of invoice.** Buys English-language rights for all (paperback and hardcover) editions; negotiable. Credit line given.

Tips: "I only contact photographers if their area of expertise is appropriate for particular titles for which I need a photo. I do not 'review' portfolios because I'm looking for specific images for specific books. Be willing to negotiate. We are a nonprofit organization, so our fees are not standard for the photo industry."

N $ $ S ▯ ♥ BEDFORD/ST. MARTIN'S, 75 Arlington St., Boston MA 02116. (617)426-7440. Fax: (617)426-8582. Art Director: Donna Lee Dennison. Estab. 1981. Publishes college textbooks (English, communications, political science, philosophy, religion, music and history). Photos used for text illustration, promotional materials and book covers. Examples of recently published titles: *Subjects/Strategies, Eighth Edition* (stock photo cover); *Film: An Introduction* (six stock photos used on cover); *Our Times: Readings for Recent Periodicals, 5th Edition* (commissioned cover photo).

Needs: Buys 12 photos annually; offers 2 freelance assignments annually. "We use photographs editorially, tied to the subject matter of the book (generally historic period pieces)." Also wants artistic, abstract, conceptual photos; nature or city; people—America or other cultures, multiracial often preferred, rural, entertainment, performing arts, science, technology, environmental, landscapes/scenics. Interested in alternative process, avant garde, digital, fine art, historical/vintage. Also uses product shots for promotional material. Reviews stock photos. Model/property release required.

Specs: Uses 8×10 b&w and color prints; 35mm, 2¼×2¼, 4×5 transparencies. Accepts images in digital format for Mac. Send via CD, Jaz, Zip as TIFF, EPS files.

Making Contact & Terms: Query with samples and list of stock photo subjects. Provide résumé, business card, brochure, flier or tearsheets to be kept on file for possible future assignments. Prefers artwork, such as promo cards, that doesn't need to be returned. Works with local freelancers only for product shots. SASE. Reports in 3 weeks. Simultaneous submissions and/or previously published work OK. Pays $50-500/color photo; $50-500/b&w photo; $250-1,000/job; $500-1,800/day. Buys one-time rights and all rights in every media; depends on project; negotiable. Credit line always included for covers, never on promo."

Tips: "We want artistic, abstract, conceptual photos, computer-manipulated works, collages, etc. that are nonviolent and nonsexist. We like Web portfolios; we keep postcards, sample sheets on file if we like the style and/or subject matter."

$ $ BEHRMAN HOUSE INC., 235 Watchung Ave., West Orange NJ 07052. (973)669-0447. Fax: (973)669-9769. Attn: Editorial Dept. Estab. 1921. Publishes Judaica textbooks. Photos used for text illustration, promotional materials and book covers.

Needs: Interested in stock photos of Jewish content, particularly holidays, with children. Model/property release required.

Making Contact & Terms: Query with résumé of credits and samples. Provide résumé, business card, brochure, flier or tearsheets to be kept on file for possible future assignments. Interested in stock photos. SASE. Reports in 3 weeks. Pays $50-500/color photo; $20-250/b&w photo. Buys one-time rights; negotiable. Credit line given.

Tips: Company trend is increasing use of photography.

▯ BENTLEY AUTOMOTIVE PUBLISHERS, 1734 Massachusetts Ave., Cambridge MA 02138. (617)547-4170. Fax: (617)876-9235. E-mail: hr@rb.com. President: Michael Bentley. Estab. 1950. Publishes professional, technical, consumer how-to books. Photos used for text illustration, promotional materials, book covers, dust jackets. Examples of published titles: *Race Car Aerodynamics* (cover); *Chevy By*

the Numbers (cover and interior photos); and *Going Faster: The Skip Barber Racing School Textbook of Race Driving* (cover).
Needs: Buys 70-100 photos annually; offers 5-10 freelance assignments annually. Looking for motorsport, automotive technical and engineering photos. Reviews stock photos. Model/property release required. Captions required; include date and subject matter.
Specs: Uses 8×10 transparencies. Accepts images in digital format.
Making Contact & Terms: Query with samples. Provide résumé, business card, brochure, flier or tearsheets to be kept on file for possible future assignments. Keeps samples on file; cannot return material. Works on assignment only. SASE. Reports in 4-6 weeks. Simultaneous submissions and previously published work OK. Payment negotiable. Buys electronic and one-time rights. Credit line given.

BLACKBIRCH PRESS, INC., 260 Amity Rd., Woodbridge CT 06525. (203)387-7525. Fax: (203)389-1596. Contact: Sonja Glassman. Estab. 1979. Publishes juvenile nonfiction. Photos used for text illustration, promotional materials, book covers. Example of published titles: *Nature Close-Up: Earthworms*.
Needs: Buys 300 photos annually. Interested in set up shots of kids, studio product/catalog photos and location shots. Reviews stock photos of nature, animals and geography. Model release required. Property release preferred. Captions required.
Specs: Uses 35mm, 2¼×2¼, 4×5 transparencies.
Making Contact & Terms: Query with résumé of credits and samples. Query with stock photo list. Works on assignment only. Keeps samples on file. Cannot return material. Simultaneous submissions and previously published work OK. Pay negotiable. Pays on acceptance or publication. Buys one-time, book, all rights; negotiable. Credit line given.
Tips: "We're looking for photos of people, various cultures and nature."

$⬛ BONUS BOOKS, INC., 160 E. Illinois St., Chicago IL 60611. (312)467-0580. Fax: (312)467-9271. E-mail: bb@bonus-books.com. Website: http://www.bonus-books.com. Managing Editor: Benjamin Strong. Estab.1980. Publishes adult trade: sports, consumer, self-help, how-to and biography. Photos used for text illustration and book covers. Examples of recently published titles: *Agassi and Ecstasy*, *MJ Unauthorized*, *Shock Marketing*.
Needs: Buys 1 freelance photo annually; gives 1 assignment annually. Model release required. Property release preferred with identification of location and objects or people. Captions required.
Specs: Uses 8×10 matte b&w prints and 35mm transparencies. Accepts images in digital format for Windows. Send via SyQuest, Zip disk or floppy as JPEG files at 600 dpi.
Making Contact & Terms: Query with résumé of credits and samples. Provide résumé, business card, brochure, flier or tearsheets to be kept on file for possible future assignments. Solicits photos by assignment only. Does not return unsolicited material. Reports in 1 month. Pays in contributor's copies and $150 maximum for color transparency. Buys one-time rights. Credit line given if requested.
Tips: "Don't call. Send written query. In reviewing a portfolio, we look for composition, detail, high quality prints, well-lit studio work. We are not interested in nature photography or greeting-card type photography."

▞ BOSTON MILLS PRESS, 132 Main St., Erin, Ontario N0B 1T0 Canada. (519)833-2407. Fax: (519)833-2195. Publisher: John Denison. Estab. 1974. Publishes coffee table books, local guide books. Photos used for text illustration, book covers and dust jackets. Examples of recently published titles: *Union Pacific: Salt Lake Route*; *Gift of Wings*; and *Superior: Journey on an Inland Sea*.
Needs: "We're looking for book length ideas *not* stock. We pay a royalty on books sold plus advance."
Specs: Uses 35mm transparencies.
Making Contact & Terms: Query with résumé of credits. Does not keep samples on file. SAE/IRC. Reports in 3 weeks. Simultaneous submissions OK. Payment negotiated with contract. Credit line given.

$◨ ⬛ BRISTOL FASHION PUBLICATIONS, P.O. Box 20, Enola PA 17025-0020. Fax: (800)543-9030. Publisher: John P. Kaufman. Estab. 1993. Publishes marine, how-to and boat repair books. Photos used for front and back covers and text illustration. Examples of recently published titles: *Racing the Ice to Cape Horn (back book cover)*.
Needs: Buys 10-50 photos annually. Looking for b&w photos of hands using tools for boat repair (before and after cosmetic repairs). Reviews stock photos. Model/property release preferred for identifiable people and boats. "If the job being photographed needs an explanation, we cannot use the photo. When we review photos it should be obvious what job is being done. Subject needs change rapidly with each new title."
Specs: Uses 3½×5 to 5×7 glossy color (cover) and b&w (inside) prints; 35mm, 2¼×2¼, 4×5 transparencies; color and b&w scanned images in TIFF, JPEG and BMP. Prefers JPEG. Submit via floppy disk, Zip disk or CD, (300 dpi or better).

Making Contact & Terms: No calls. Query with nonreturnable samples. Provide résumé, business card, brochure, flier or tearsheets to be kept on file for possible future assignments. Will keep samples on file. Reports in 2 weeks. Simultaneous submissions and/or previously published work OK. Pays $75-150/color photo; $25-75/b&w photo; will assign specific shots and pay stock amounts for photos used. Pays on publication. Buys book rights. Credit line given.

Tips: "We are more apt to use a scanned image supplied by the photographer. We make copies of the photos we may use and note the photographers name and phone number on the copy. If we want an image for a book, we will call and ask for a new disk or photos to be sent within seven days. We scan all photos for our books. Mail new submissions each month if possible. Our editors use more photos because the disk or photo is in their hands. Good contrast and sharp images are recommended, but neither help if we do not have the image to use. We would use more interior photos to replace line drawings but we cannot acquire them easily."

$ $ [S] [◎] THE BUREAU FOR AT-RISK YOUTH, 135 Dupont St., P.O. Box 760, Plainview NY 11803-0760. (516)349-5520, ext. 210. Fax: (516)349-5521. E-mail: sallyg@at-risk.com. Editor-in-Chief: Sally Germain. Estab. 1990. Publishes educational materials for teachers, mental health professionals, social service agencies on children's issues such as building self-esteem, substance abuse prevention, parenting information, etc. Photos used for text illustration, promotional materials, posters, catalogs. Examples of recently published titles: "Teen Talk Pamphlet" series (text illustrations and book cover). Began publishing books that use photos in 1994.

Needs: Occasionally uses photos for posters of children and adults in family and motivational situations. Needs multicultural, families, parents, teens. Model release required.

Specs: Uses $2\frac{1}{4} \times 2\frac{1}{4}$ transparencies.

Making Contact & Terms: Send unsolicited photos by mail for consideration. Provide résumé, business card, brochure, flier or tearsheets to be kept on file for possible future assignments. "Please call if you have questions." Keeps samples on file. SASE. Reports in 3-6 months. Simultaneous submissions and/or previously published work OK. Payment negotiable; "Fees have not yet been established." Will pay on a per project basis. Pays on publication or receipt of invoice. Rights purchased depend on project; negotiable. Credit line sometimes given, depending upon project.

Tips: "Call first to see if we are looking for anything in particular."

$ [S] [▣] [◪] CAPSTONE PRESS, 151 Good Counsel Dr., Mankato MN 56001. (507)388-6650. Fax: (507)625-4662. E-mail: danger@capstone-press.com or schoof@capstone-press.com. Contact: Photo Researcher. Estab. 1991. Publishes juvenile nonfiction and educational books; subjects include animals, ethnic groups, vehicles, sports and scenics. Photos used for text illustration, promotional materials and book covers. Examples of recently published titles: *The Golden Retriever*; *Monster Trucks*; and *Rock Climbing* (covers and interior illustrations). Photo "wish lists" for projects are available on request.

Needs: Buys 1,000-2,000 photos annually. "Our subject matter varies (usually 100 or more different subjects/year); no artsy stuff." Model/property release preferred. Captions are preferred; "basic description; if people of color, state ethnic group; if scenic, state location."

Specs: Uses various sizes color prints and b&w prints (if historical); 35mm, $2\frac{1}{4} \times 2\frac{1}{4}$, 4×5 transparencies; accepts digital format.

Making Contact & Terms: Query with stock photo list. Provide résumé, business card, brochure, flier or tearsheets to be kept on file for possible future assignments. Keeps samples on file. Reports in 6 months. Simultaneous submissions and previously published work OK. Pays $50/interior photo; $150/cover photo. **Pays on receipt of invoice.** Buys one-time rights; North American rights negotiable. Credit line given.

Tips: "Be flexible. Book publishing usually takes at least six months. Capstone does not pay holding fees. Be prompt. The first photos in are considered for covers first."

CELO VALLEY BOOKS, 346 Seven Mile Ridge Rd., Burnsville NC 28714. Production Manager: D. Donovan. Estab. 1987. Publishes all types of books. Photos used for text illustration, book covers and dust jackets. Examples of published titles: *Foulkeways: A History* (text illustraton and color insert); *Tomorrow's Mission* (historical photos); *River Bends and Meanders* (cover and text photos).

Specs: Uses various sizes b&w prints.

Making Contact & Terms: Provide résumé, business card, brochure, flier or tearsheets to be kept on file for possible future assignments. Keeps samples on file. Reports only as needed. Simultaneous submissions OK. Payment negotiable. Buys one-time rights and book rights. Credit line given.

Tips: "Send listing of what you have. We will contact you if we have a need."

[N] $ [▨] CENTER PRESS, Box 16473, Encino CA 91416-6473. (818)754-4410. Art Director: Richelle Bixler. Estab. 1980. Publishes mostly little/literary, some calendars, and a joint venture European "*Esquire-*

type" magazine. Photos used for text illustration, promotional, magazine, posters and calendars. Example of recently published title: *La Lectrice* (cultural/literary magazine distributed in Europe for liberal men and women).

Needs: Buys hundreds of photos annually. Looking for female erotica and art photos. Model/property release required prior to payment and use. Captions required; editors create this from a questionnaire the photographer supplies.

Specs: Uses 5×7, 8×10 glossy color and b&w prints; 35mm, 2¼×2¼, 4×5, 8×10 transparencies; VHS videotape.

Making Contact & Terms: Query with samples. Keeps samples on file if requested and résumé included. SASE; doesn't return photos without adequate postage. Reporting time depends on workload. Simultaneous submissions and previously published work OK. Pays $10-100/color photo; $10-50/b&w photo. Pays on publication. Buys one-time, book and all rights; negotiable. Credit line given.

Tips: "The photos we use are primarily female nudes, art-type and erotic. We'd like to see more photos of women by women and even self-portraits."

$ $▣ ◎ CENTERSTREAM PUBLICATION, P.O. Box 17878, Anaheim CA 92807. Phone/fax: (714)779-9390. E-mail: censtrm@aol.com. Owner: Ron Middlebrook. Estab. 1982. Publishes music history (guitar—drum), music instruction (all instruments), adult trade, juvenile, textbooks. Photos used for text illustration, book covers. Examples of published titles: *Dobro Techniques*, *History of Leedy Drums*, *History of National Guitars*; *Blues Dobro* (book cover), *Jazz Guitar Christmas* (book cover).

Needs: Reviews stock photos of music. Model release preferred. Captions preferred.

Specs: Uses color and b&w prints; 35mm, 2¼×2¼, 4×5 transparencies. Accepts images in digital format for Mac. Send via Zip as TIFF files.

Making Contact & Terms: Query with samples and stock photo list. Send unsolicited photos by mail for consideration. Provide résumé, business card, brochure, flier or tearsheets to be kept on file for possible future assignments. Works on assignment only. Keeps samples on file. Reports in 1 month. Simultaneous submissions and/or previously published work OK. Payment negotiable. **Pays on receipt of invoice.** Buys all rights. Credit line given.

Ⓝ ▣ ◎ CHARLESBRIDGE PUBLISHING, Talewinds, 85 Main St., Watertown MA 02472. (617)926-0329, ext. 141. Fax: (617)926-5720. E-mail: ampusey@charlesbridge.com. Website: http://www.charlesbridge.com. Estab. 1978. Publishes hardcover originals, trade paperback originals, CD-ROMs. Subjects include natural science, astronomy, physical science. Photos used for book covers. Art guidelines available.

Needs: Buys 4-5 freelance photos annually. Needs photos of children, multicultural, environmental, landscapes/scenics, wildlife, science. Photo caption preferred; include subject matter.

Specs: Accepts images in digital format for Mac. Send via CD, Zip as EPS files at 350 dpi.

Making Contact & Terms: Send query letter with résumé and photocopies. Provide résumé, self-promotion piece to be kept on file for possible future assignments. Reports in 2 weeks on queries; 1 month on portfolios. Reports back only if interested; send nonreturnable samples. Simultaneous submissions and previously pubished work OK. Pays on publication. Credit line given. Buys one-time, first and all rights.

Tips: "We only use photos for specific projects, mainly to illustrate our science book."

Ⓝ $◑ CHATHAM PRESS, Box A, Old Greenwich CT 06870. (203)531-7755. Fax: (718)359-8568. Editor: Roger Corbin. Estab. 1971. Publishes New England and ocean-related topics. Photos used for text illustration, book covers, art and wall framing.

Needs: Buys 25 photos annually; offers 5 freelance assignments annually, preferably New England and ocean-related topics. Also needs photos of architecture, beauty, cities/urban, education, gardening, rural, landscapes/scenics, adventure, automobiles, entertainment, events, food/drink, health/fitness, performing arts, travel, buildings, portraits, science, technology. Interested in avant garde, erotic, fashion/glamour, fine art, historical/vintage. Model release preferred; photo captions required.

Specs: Uses b&w prints.

Making Contact & Terms: Query with samples. SASE. Reports in 1 month. Payment negotiable. Buys all rights. Credit line given.

THE SUBJECT INDEX, located at the back of this book, lists publications, book publishers, galleries, greeting card companies, stock agencies, advertising agencies and graphic design firms according to the subject areas they seek.

Tips: To break in with this firm, "produce superb b&w photos. There must be an Ansel Adams-type of appeal—which is instantaneous to the viewer!"

$ CLEANING CONSULTANT SERVICES, P.O. Box 1273, Seattle WA 98111. (206)682-9748. Fax: (206)622-6876. E-mail: wgriffin@cleaningconsultants.com. Website: http://www.cleaningconsultants.com. Publisher: William R. Griffin. "We publish books on cleaning, maintenance and self-employment. Examples are related to janitorial, housekeeping, maid services, window washing, carpet cleaning, etc. We also publish a monthly magazine for self-employed cleaners. For a sample issue of *Cleaning Business* send $3/ SASE." Photos are used for text illustration, promotional materials, book covers and all uses related to production and marketing of books. Photo guidelines free with SASE.
Needs: Buys 20-50 freelance photos annually; offers 5-15 freelance assignments annually. Need photos of people doing cleaning work. "We are always looking for unique cleaning-related photos." Reviews stock photos. Model release preferred. Captions preferred.
Specs: Uses 5×7 and 8×10 glossy b&w and color prints.
Making Contact & Terms: Query with résumé of credits, samples, list of stock photo subjects or send unsolicited photos by mail for consideration. Provide résumé, business card, brochure, flier or tearsheets to be kept on file for possible future assignments. SASE. Reports in 3 weeks. Simultaneous submissions and previously published work OK. Pays $5-50/b&w photo; $5/color photo; $10-30/hour; $40-250/job; negotiable depending on specific project. Buys all rights; depends on need and project; rights negotiable. Credit lines generally given.
Tips: "We are especially interested in color photos of people doing cleaning work in other countries, for use on the covers of our monthly magazine, *Cleaning Business*. Be willing to work at reasonable rates. Selling two or three photos does not qualify you to earn top-of-the-line rates. We expect to use more photos but they must be specific to our market, which is quite select. Don't send stock sample sheets. Send photos that fit our specific needs. Call if you need more information or would like specific guidance."

$ CLEIS PRESS, Box 14684, San Francisco CA 94114. (415)575-4700. Fax: (415)575-4705. E-mail: fdcleis@aol.com. Art Director: Frédérique Delacoste. Estab. 1979. Publishes fiction, nonfiction, trade and lesbian/gay erotica. Photos used for book covers. Examples of recently published titles: *Best Lesbian Erotica 1999*, *Best Gay Erotica 1999*, *The Woman Who Knew Too Much* (mystery).
Needs: Buys 20 photos annually. Reviews stock photos.
Specs: Uses color and b&w prints; 35mm transparencies.
Making Contact & Terms: Provide résumé, business card, brochure, flier or tearsheets to be kept on file for possible future assignments. Works with local freelancers on assignment only. Keeps samples on file. SASE. Reports in 3 weeks. Pays $150/photo for all uses in conjunction with book. **Pays on acceptance**. Buys book rights; negotiable. Credit line given.

$ $ ▣ ◪ COFFEE HOUSE PRESS, 27 N. Fourth St., Suite 400, Minneapolis MN 55401. (612)338-0125. Fax: (612)338-4004. E-mail: http://www.kelly@coffeehousepress.org. Website: http://www.coffeehousepress.org. Art Director: Kelly Kofron. Publishes hardcover originals, trade paperback reprints and originals, letterpress. Subjects include literary fiction and poetry. Photos used for text illustration, book covers, dust jackets. *Our Sometime Sister* (cover art); *Glass Houses* (cover art); *Paul Metcalf, Collected Works, Vol. 2* (text illustration) *The Cockfighters* (dust jacket). Photo guidelines sheet free with SASE.
Needs: Buys 5-15 freelance photos annually. Interested in reviewing stock photos, unique, artistic and historical images. Also needs photos of architecture, landscape/scenics, gardening, multicultural, product shots/still life. Interested in alternative process, avant garde, documentary, regional, seasonal, portraits (specific). Model release preferred; property release preferred. Photo captions required; include name and date (optional title).
Specs: Uses matte, color and b&w prints; 35mm, 4×5, 8×10 transparencies. Accepts images in digital format for Mac. Send via Jaz, Zip as TIFF files at 100 dpi, compression okay.
Making Contact & Terms: Provide business card, self-promotion piece or tearsheets to be kept on file for possible future assignment. Art director will contact photographer for portfolio review if interested. Portfolio should include b&w and color prints. Keeps samples on file. SASE. Reports back only if interested, send non-returnable samples. Simultaneous submissions and previously published work OK. Pays $250-400 for b&w or color cover. Pays on publication. Buys one-time rights. Credit line given.
Tips: "Send samples once a year."

$ $ ◪ COMPASS AMERICAN GUIDES, 5332 College Ave., Suite 201, Oakland CA 94618. (510)547-7233. Fax: (510)547-2145. Creative Director: Christopher C. Burt. Estab. 1990. Publishes travel guide series for every state in the U.S. and 15 major cities. Photos used for text illustration and book covers. Examples of recently published titles: *Compass American Guide to Coastal California, Compass*

American Guide to North Carolina, and *Compass American Guide to Underwater Wonders of the National Parks, Florida* (text illustrations, book cover).

Needs: Buys 1,000-1,500 photos annually; offers 8-10 freelance assignments annually. Needs photos of celebrities, multicultural, landscapes/scenics, wildlife, architecture, cities/urban, interiors/decorating, rural, adventure, events, food/drink, travel. Interested in historical/vintage. Reviews stock photos (depends on project). Captions required.

Specs: Uses 35mm, 2¼×2¼, 4×5, 8×10 transparencies.

Making Contact & Terms: Provide résumé, business card, brochure, flier or tearsheets to be kept on file for possible future assignments. "Do not phone; fax OK." Works on assignment only. Keeps samples on file. Cannot return unsolicited material. Reports in "one week to five years." Simultaneous submissions and previously published work OK. Pays $250-500 for color cover. Pays $50-150 for color inside. Pays by the project, $1,500-15,000 for inside shots (100-200 images). Pays $5,000/job. **Pays ⅓ advance, ⅓ acceptance, ⅓ publication.** Buys one-time and book rights. Photographer owns copyright to images.

Tips: "Our company works only with photographers native to or currently residing in the state or city in which we are publishing the guide. We like creative approaches that capture the spirit of the place being covered. We need a mix of landscapes, portraits, things and places."

$ CONSERVATORY OF AMERICAN LETTERS, P.O. Box 298, Thomaston ME 04861. (207)354-0998. Fax: (207)354-8953. E-mail: cal@americanletter.org. Website: http://www.americanletter.org. President: Robert Olmsted. Estab. 1986. Publishes "all types of books except porn and evangelical." Photos used for promotional materials, book covers and dust jackets. Examples of recently published titles: *Dan River Stories* and *Dan River Anthology* (cover); *After the Light* (covers).

Needs: Buys 2-3 photos annually. Model release required if people are identifiable. Photo captions preferred.

Specs: Uses 3×5 to 8×10 b&w glossy prints, also 5×7 or 6×9 color prints, vertical format.

Making Contact & Terms: Query with samples. SASE. Reports in 1 week. Pays $5-50/b&w photo; $20-200/color photo; per job payment negotiable. Buys one-time and all rights; negotiable. Credit line given.

Tips: "We are a small market. We need *few* photos, but can never find them when we do need them."

■ THE CONSULTANT PRESS LTD., 163 Amsterdam Ave., 201, New York NY 10023. (212)838-8640. Fax: (212)873-7065. Website: http://www.consultantpress.com. Estab. 1980. Publishes how-to, art and photography business. Photos used for book covers. Examples of recently published titles: *Art of Displaying Art* (cover); *Publishing Your Art as Cards, Posters and Calendars* (cover/art); and *Art of Creating Collectors* (text).

Needs: Buys 20 photos annually (usually from author of text). Model release required.

Specs: Uses 35mm, 2¼×2¼ transparencies; digital format.

Making Contact & Terms: Query with samples. Provide résumé, business card, brochure, flier or tearsheets to be kept on file for possible future assignments. Does not keep samples on file. SASE. Reports in 1-2 weeks. Payment factored into royalty payment for book. Pays on publication. Buys book rights. Credit line given.

Tips: "Visit web site to see types and descriptions of books"

▣ CORNERSTONE PRODUCTIONS INC., 1754 Austin Dr., Decatur GA 30032. (770)621-2514. President/CEO: Ricardo A. Scott J.D. Estab. 1985. Publishes adult trade, juvenile and textbooks. Photos used for text illustration, promotional materials and book covers. Examples of published titles: *A Reggae Education* (illustrative); and *Allied Health Risk-Management* (illustrative).

Needs: Buys 10-20 photos annually; offers 50% freelance assignments annually. Photos should show life in all its human and varied forms—reality! Reviews stock photos of life, nature, medicine, science, the arts. Model/property release required. Captions required.

Specs: Uses 5×7, 10×12 glossy color and b&w prints; 4×5, 8×10 transparencies; VHS videotape. Keeps samples on file. SASE.

Making Contact & Terms: Submit portfolio for review. Send unsolicited photos by mail for consideration. Reports in 1 month. Simultaneous submissions and previously published work OK. Payment negotiable. Pays on publication. Buys all rights; negotiable. Credit line sometimes given depending upon the particular projects and arrangements are done on an individual basis.

Tips: "The human aspect and utility value is of prime importance. Ask 'how can this benefit the lives of others?' Let your work be a reflection of yourself. Let it be of some positive value and purpose towards making this world a better place."

N $⊡ ⬚ ◎ THE COUNTRYMAN PRESS, Imprints: Backcountry Publications. W.W. Norton & Co., Inc., P.O. Box 748, Mt. Tom Bldg., Woodstock VT 05091. (802)457-4826. Fax: (802)457-1678. E-mail: countrymanpress@wwnorton.com. Website: http://www.countrymanpress.com. Contact: Production Manager. Estab. 1973. Publishes hardcover originals, trade paperback original and reprints. Subjects include travel, nature, hiking, biking, paddling, cooking and fishing. Examples of recently published titles: *New Hampshire: An Explorer's Guide* (text illustrations, book cover); *50 Hikes in the Adirondacks* (text illustrations, book cover). Catalog available for 7½ × 10½ SASE.

Needs: Buys 25 freelance photos annually. Varies depending on need. Needs photos of environmental, landscapes/scenics, wildlife, architecture, gardening, rural, sports, travel. Interested in historical/vintage, regional, seasonal. Model/property release preferred. Photo caption preferred; include location, state, season.

Specs: Uses 4 × 6, glossy, matte, color, b&w prints; 35mm, 2¼ × 2¼, 4 × 5, 8 × 10 transparencies. Accepts images in digital format for Mac. Send via CD, floppy disk, Zip as TIFF files at 300 dpi.

Making Contact & Terms: Send query letter with résumé, slides, tearsheets, stock list. Provide résumé, business card, self-promotion piece to be kept on file for possible future assignments. Reports in 2 months on queries; 2 months on portfolios. Reports back only if interested. Simultaneous submissions and previously pubished work OK. Pays $100-500 for color cover; $10-25 for b&w inside. Pays on publication. Credit line given. Buys all rights for life of edition (normally 2-7 years); negotiable.

Tips: "Our catalog demonstrates the range of our titles and shows our emphasis on travel and the outdoors. Crisp focus, good lighting, and strong contrast are goals worth striving for in each shot. We prefer images which invite rather than challenge the viewer, yet also look for eye-catching content and composition."

$ CRABTREE PUBLISHING COMPANY, 350 Fifth Ave., Suite 3308, New York NY 10118. (800)387-7650. Fax: (800)355-7166. Photo Researcher: Hannelore Sotzek. Estab. 1978. Publishes juvenile nonfiction, library and trade—natural science, history, geography (including cultural geography), 18th and 19th-century North America. Photos used for text illustration, book covers. Examples of recently published titles: *Vietnam: the Land* (text illustration, cover); *Spanish Missions* (text illustration); *How a Plant Grows* (text illustration, cover); and "What is a Bird?" (text illustration, cover).

● When reviewing a portfolio, this publisher looks for bright, intense color and clarity.

Needs: Buys 400-600 photos annually. Wants photos of children, cultural events around the world, animals (exotic and domestic) and historical reenactments. Model/property release required for children, photos of artwork, etc. Captions preferred; include place, name of subject, date photographed, animal behavior.

Specs: Uses color prints; 35mm, 2¼ × 2¼, 4 × 5, 8 × 10 transparencies.

Making Contact & Terms: Unsolicited photos will be considered but not returned without SASE. Provide résumé, business card, brochure, flier or tearsheets to be kept on file for possible future assignments. Keeps samples on file. Reports in 1-2 weeks. Simultaneous submissions and/or previously published works OK. Pays $40-75/color photo. Pays on publication. Buys non-exclusive rights. Credit line given.

Tips: "Since books are for younger readers, lively photos of children and animals are always excellent." Portfolio should be "diverse and encompass several subjects rather than just one or two; depth of coverage of subject should be intense so that any publishing company could, conceivably, use all or many of a photographer's photos in a book on a particular subject."

N $⬚ S ⬚ THE CREATIVE COMPANY, Imprint: Creative Education. 123 S. Broad St., Mankato MN 56001. (507)388-6273. Fax: (507)388-1364. E-mail: creativeco@aol.com. Contact: Photo Editor. Estab. 1933. Publishes hardcover originals, textbooks. Subjects include animals, nature, geography, history, sports (professional and college), science, technology and biographies. Photos used for text illustrations, book covers. Examples of recently published titles: *Let's Investigate* series (text illustrations, book cover); *Ovations (biography)* series (text illustration, book cover). Catalog available for 9 × 12 SAE with $2 first-class postage. Subject list available for #10 SAE with first-class postage.

Needs: Buys 2,250 freelance photos annually. Needs photos of celebrities, disasters, environmental, landscapes/scenics, wildlife, architecture, cities/urban, gardening, pets, rural, adventure, entertainment, events, health/fitness, hobbies, performing arts, sports, travel, agriculture, buildings, industry, science, technology. Interested in fine art, historical/vintage, regional, seasonal. Other specific photo needs: NFL, NHL, NBA, WNBA, Major League Baseball. Photo caption required; include photographer or agent's name.

Specs: Uses any size, glossy, matte, color, b&w prints; 35mm, 2¼ × 2¼, 4 × 5 transparencies. Accepts images in digital format for Mac. Send via CD, floppy disk, Zip as JPEG files. Requires low-resolution for placement; hi-resolution for usage (must be two separate files).

Making Contact & Terms: Send query letter with photocopies, tearsheets, stock list. Provide self-promotion piece to be kept on file for possible future assignments. Reports in 1 month on queries. Simultaneous submissions and previously pubished work OK. Pays $100-150 for b&w and color cover; $50-150 for b&w and color inside; by the project, $2,000-3,000 for inside and cover shots. Projects with photos

and text are considered as well. Pays on publication. Credit line given. Buys one-time rights and foreign publication rights as requested; pricing is one-third original.

Tips: "We have a set of policies that will be sent in response to queries. We're always looking for project proposals and photographer/writers. We're seldom in a big rush—overnight shipping is a waste of money. Unless we say overnight, don't do it."

N $ 回 ◪ CREATIVE EDITIONS, The Creative Company, 123 S. Broad St., Mankato MN 56001. (507)388-6273. Fax: (507)388-1364. E-mail: creativeco@aol.com. Managing Editor: Melissa Gish. Estab. 1989. Publishes hardcover originals. Subjects include photo essays, travel, biography, nature, ecology, animals. Photos used for text illustrations, book covers, dust jackets. Examples of recently published titles: *Chased By The Light*, by Jim Brandenburg (text illustrations, book cover, dust jacket); *Poe* (text illustrations, book cover, dust jacket). Catalog available.

Needs: Buys 200-500 freelance photos annually. Needs photos of celebrities, landscapes/scenics, wildlife, travel. Interested in fine art, historical/vintage. Other specific photo needs: unusual corners of the world. Photo caption required; include photographer and agency name.

Specs: Uses any size, glossy, matte, color, b&w prints; 35mm, 2¼×2¼, 4×5, 8×10 transparencies. Accepts images in digital format for Mac. Send via CD, floppy disk, Zip as JPEG files at 72 dpi minimum. High-res upon request only.

Making Contact & Terms: Send query letter with publication credits and project proposal, prints, photocopies, tearsheets of previous publications, stock list for proposed project. Provide self-promotion piece to be kept on file for possible future assignments. Reports in 3 weeks on queries. Simultaneous submissions and previously pubished work OK. Pays by the project, $2,000-4,000 for inside and cover shots. Advance to be negotiated. Credit line given. Buys world rights for the book; photos remain property of photographer.

Tips: "We would like to see proposals for books about rarely seen places or people, wildlife and nature; projects which reveal secrets about our world. Explain how you'd like to see the project's goal achieved through your photography. What do you want your art to say from the pages of a book?"

CREATIVE WITH WORDS PUBLICATIONS, P.O. Box 223226, Carmel CA 93922. (831)655-8627. Fax: (831)655-8627. Website: http://members.tripod.com/~CreativeWithWords. Editor: Brigitta Geltrich. Estab. 1975. Publishes poetry and prose anthologies according to set themes. Uses b&w photos for text illustration and book covers. Examples of recently published titles: humor; sports and hobbies; and sky, space, heaven. Ask for photo guidelines with SASE.

Needs: Looking for theme-related b&w photos. Model/property release preferred.

Specs: Uses any size b&w photos.

Making Contact & Terms: Request theme list, then query with photos. "We will reduce to fit the page." Does not keep samples on file. SASE. Reports in 2-3 weeks after deadline if submitted for a specific theme. Payment negotiable. Pays on publication. Buys one-time rights. Credit line given.

$ A ◎ CROSS CULTURAL PUBLICATIONS, INC., P.O. Box 506, Notre Dame IN 46556. (219)272-0889. Fax: (219)273-5973. E-mail: crosscult@aol.com. Website: http://www.crossculturalpub@aol.com. General Editor: Cy Pullapilly. Estab. 1980. Publishes nonfiction, multicultural books. Photos used for book covers and dust jackets. Examples of recently published titles: *Paper Airplanes in the Himalayas*, *An Agenda for Sustainability*, and *The Cloud and the Lights* (all covers).

Needs: Buys very few photos annually; offers very few freelance assignments annually. Model release preferred. Captions preferred.

Making Contact & Terms: Provide résumé, business card, brochure, flier or tearsheets to be kept on file for possible future assignments. Works on assignment only. Does not keep samples on file. Cannot return material. Reports in 3 weeks. Simultaneous submissions and previously published work OK. Payment negotiable; varies depending on individual agreements. **Pays on acceptance.** Credit line given.

$ $ S 回 ◪ ◎ CROSSING PRESS, P.O. Box 1048, Freedom CA 95019. (831)722-0711. Fax: (831)722-2749. E-mail: knarita@crossingpress.com. Website: http://www.crossingpress.com. Publisher: Elaine Gill. Art Director: Karen Narita. Estab. 1971. Publishes adult trade, cooking, natural health, and New Age books. Photos used for text illustration, book covers. Examples of recently published titles: *Recurring Dreams*, *Nature's Aphrodisiacs*, and *Biscotti, Bars, and Brownies* (all covers).

Needs: Buys 70-100 photos annually. Looking for photos of nature images, dream images, food, people, abstract/conceptual imagery. Also wants photos of babies, children, couples, multicultural, families, parents, senior citizens, environmental, landscapes/scenics, wildlife, architecture, beauty, cities/urban, education, pets, rural, adventure, health/fitness, buildings, business concepts, medicine, product shots/still life. Interested in alternative process, avant garde, documentary, fine art.

Specs: Uses color and b&w slides, prints, promo materials. Accepts images in digital format for Mac. Send via CD, Zip, e-mail or floppy disk as TIFF, EPS, JEPG files.

Making Contact & Terms: Query with samples. Provide brochure, flier or tearsheets to be kept on file for possible future assignments. SASE. Simultaneous submissions and previously published works OK. Payment $100-250 for b&w cover, $200-500 for color cover. Pays $20-100 for b&w inside. Pays on publication. Buys one-time and book rights; negotiable. Credit line given.

Tips: Looking for "photos of evocative images, prepared food, nature shots, conceptual/imaginary images. Send samples that can be retained in our files of freelancers."

[N] [] CRUMB ELBOW PUBLISHING, P.O. Box 294, Rhododendron OR 97049. Publisher: Michael P. Jones. Estab. 1979. Publishes juvenile, educational, environmental, nature, historical, multicultural, travel and guidebooks. Photos used for text illustration, promotional materials, book covers, dust jackets and educational videos. "We are just beginning to use photos in books and videos." Examples of recently published titles: *Where the Silence Creeps* (text illustrations); *Cascade Crossing: Mount Hood's Infamous Oregon Trail* (text illustration). Photo guidelines free with SASE.

Needs: Looking for nature, wildlife, historical, environmental, folklife, historical reenactments, ethnicity and natural landscapes. Also wants photos of babies, celebrities, children, couples, multicultural, parents, senior citizens, teens, architecture, beauty, cities/urban, education, gardening, interiors/decorating, pets, religious, rural, adventure, automobiles, entertainment, events, food/drink, health/fitness, hobbies, humor, performing arts, sports, travel, agriculture, buildings, business concepts, computers, industry, medicine, military, political, portraits, product shots/still life, science, technology. Interested in alternative process, avant garde, digital, documentary, erotic, fashion/glamour, fine art, historical/vintage, regional, seasonal. Model/property release preferred for individuals posing for photos. Captions preferred.

Specs: Uses 3×5, 5×7, 8×10 color or b&w prints; 35mm transparencies; videotape.

Making Contact & Terms: Submit portfolio for review. Query with résumé of credits and samples. Send stock photo list. Provide résumé, business card, brochure, flier or tearsheets to be kept on file for possible future assignments. Works on assignment only. Keeps samples on file. SASE. Reports in 1 month depending on work load. Simultaneous submissions OK. Pays in contributor's copies. Pays on publication. Buys one-time rights. Credit line given. Offers internships for photographers year round. Contact Publisher: Michael P. Jones.

Tips: "Publishers are still looking for black & white photos due to high production costs for color work. Don't let opportunities slip by you. Use two cameras—one for black & white and one for color. Multimedia is the coming thing and more opportunities for freelancers will result. Slide work is perfect for still photography in videos, for which the need is growing. Create with your camera. Capture the spirit of your subject matter by bonding with it. Then and only then will you catch the 'eye' of everyone."

$ $ $ $ [A] [] CUSTOM & LIMITED EDITIONS, 41 Sutter St. #1634, San Francisco CA 94104. Phone/fax: (415)337-0177. E-mail: customltd@aol.com. Publisher: Ron Fouts. Estab. 1987. Specializes in museum-quality monographs.

Needs: "We are interested in artists/photographers whose work warrants a monograph or book-length production. We do issue a few limited edition portfolios each year. The photographers we choose to work with have a definite and clearly articulated purpose or use of a museum-quality product."

Making Contact & Terms: "Send at least three examples of your photography, a statement of your purpose in photography, a short biography and résumé and a list of galleries, publications and collections representing your work. All of our work is custom and payments are negotiated in each case."

Tips: "Be able to articulate the purpose, or reason, for the work, subject matter, focus, etc. Be able to demonstrate commitment in the work."

DIAL BOOKS FOR YOUNG READERS, 375 Hudson St., New York NY 10014. (212)414-3415. Fax: (212)414-3394. Senior Editor: Toby Sherry. Publishes children's trade books. Photos used for text illustration, book covers. Examples of published titles: *How Many* (photos used to teach children how to count); *Jack Creek Cowboy*; *It's Raining Laughter* (text illustrations, dust jacket).

Making Contact & Terms: Photos are only purchased with accompanying book ideas. Works on assignment only. Does not keep samples on file. Payment negotiable. Credit line given.

DOCKERY HOUSE PUBLISHING INC., 1720 Regal Row, Suite 112, Dallas TX 75235. (214)630-4300. Fax: (214)638-4049. Art Director: Janet Todd. Photos used for text illustration, promotional material, book covers, magazines. Example of recently published title: *Celebration of America* (scenery of travel spots).

Needs: Looking for food, scenery, people. Needs vary. Reviews stock photos. Model release preferred.

Specs: Uses all sizes and finishes of color, b&w prints; 35mm, $2\frac{1}{4} \times 2\frac{1}{4}$, 4×5 transparencies.

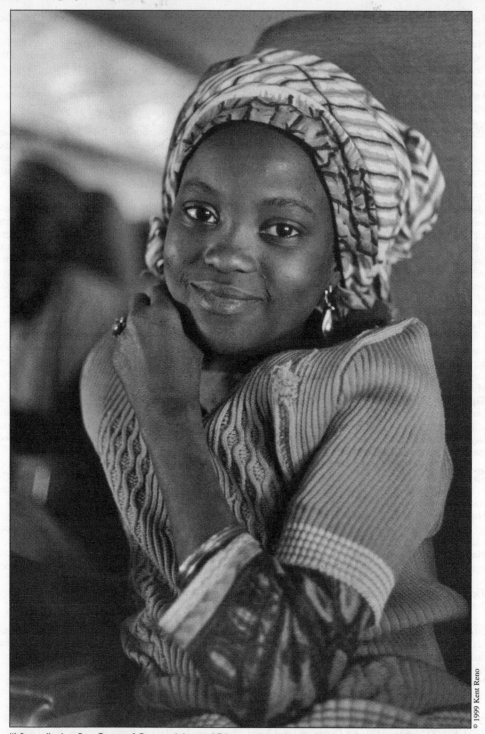

© 1999 Kent Reno

"I first talked to Ron Fouts, of Custom & Limited Editions, about doing a book while at an ASMP meeting. Ron was on a panel of publishers talking about books," says photographer Kent Reno. Fouts went on to publish a monograph of Reno's work titled *Ground Time*. This image, from the monograph, was taken while Reno was a pilot. "We were taking Moslem pilgrims from Africa to Mecca," Reno says.

Making Contact & Terms: Query with samples. Provide résumé, business card, brochure, flier or tear-sheets to be kept on file for possible future assignments. Works on assignment only. Keeps samples on file. Cannot return material. Payment negotiable. Pays net 30 days. Buys all rights; negotiable. Credit line sometimes given depending upon type of book.

$ ◨ DUMMIES TRADE PRESS/IDG BOOKS, 645 N. Michigan Ave., Suite 800, Chicago IL 60611. E-mail: mfkelly@idgbooks.com. Website: http://www.idgbooks.com. Editorial Coordinator: Maureen Kelly. Estab. 1992. Publishes trade paperback originals. Subjects include: performing arts, animals/pets, gardening, home decorating and remodeling, sports and fitness, health and medical, travel. Photos used for text illustration, promotional materials, book covers. Examples of recently published titles: *Annuals for Dummies, Grilling for Dummies, Decks & Patios for Dummies*. Photo guidelines sheet available.

Needs: Buys 700 freelance photos/year. Looking for action sports photos, sports star portraits, travel photos. Interested in reviewing stock photos of performing arts, animals/pets, gardening, sports, home decorating. Model release required; property release required.

Making Contact & Terms: Provide résumé, business card, self-promotion piece or tearsheets to be kept on file for possible future assignments. Works with freelancers on assignment only. Keeps samples on file. Reports back only if interested, send non-returnable samples. Simultaneous submissions OK. Pays by the project, $75-175 for color inside. Pays on publication. Buys one-time world rights. Credit line given on copyright page.

Tips: "Please query by mail, e-mail, not by phone."

$ $ Ⓐ EASTERN PRESS, INC., P.O. Box 881, Bloomington IN 47402. (812)339-3985. Publisher: Don Lee. Estab. 1981. Publishes university-related Asian subjects: language, linguistics, literature, history, archaeology; Teaching English as Second Language (TESL); Teaching Korean as Second Language (TKSL); Teaching Japanese as Second Language (TJSL); Chinese, Arabic. Photos used for text illustration. Examples of recently published titles: *An Annotated Bibliography on South Asia* and *An Annotated Prehistoric Bibliography on South Asia*.

Needs: Depends on situation; looking for higher academic. Captions for photos related to East Asia/Asian higher academic.

Specs: Uses 6×9 book b&w prints.

Making Contact & Terms: Provide résumé, business card, brochure, flier or tearsheets to be kept on file for possible future assignments. Keeps samples on file. Reports in 1 month (sometimes 1-2 weeks). Payment negotiable. **Pays on acceptance**. Rights negotiable. Credit line sometimes given.

Tips: Looking for "East Asian/Arabic textbook-related photos. However, it depends on type of book to be published. Send us a résumé and about two samples. We keep them on file. Photos on, for example, drama, literature or archaeology (Asian) will be good, also TESL."

$ ◫ ◨ ECW PRESS, 2120 Queen St. E., Toronto, Ontario M4E 1E2 Canada. (416)694-3348. Fax: (416)698-9906. E-mail: ecw@sympatico.ca. Website: http://www.ecw.ca/press. Publisher: Jack David. Estab. 1974. Publishes hardcover original, trade paperback original. Subjects include biography, sports, travel, fiction, poetry. Photos used for text illustrations, book covers, dust jackets. Examples of recently published titles: *Melissa Etheridge* (text illustration); *Gillian Anderson* (text illustration); *Godzilla* (text illustration).

Needs: Buys hundreds of freelance photos annually. Looking for color, b&w, fan/backstage, paparazzi, action, original, rarely used. Interested in reviewing stock photos. Property release required for entertainment or star shots. Photo captions required; include identification of all people.

Making Contact & Terms: Send query letter. Provide e-mail. To show portfolio, photographer should follow-up with letter after initial query. Does not keep samples on file; include SASE for return of material. Reports in 3 weeks. Pays by the project, $250-600/color cover; $50-125/color inside. Pays on publication. Buys one-time book rights (all markets). Credit line given.

Tips: "We have many projects on the go. Query for projects needing illustrations."

◨ ENTRY PUBLISHING, INC., 27 W. 96th St., New York NY 10025. (212)662-9703. Fax: (212)622-0549. President: Lynne Glasner. Estab. 1981. Publishes education/textbooks, secondary market. Photos used for text illustrations.

Needs: Number of freelance photos bought and freelance assignments given vary. Often looks for shots of young teens in school settings. Reviews stock photos. Model release required. Captions preferred.

Specs: Uses b&w prints. Accepts images in digital format for Windows.

Making Contact & Terms: Query with list of stock photo subjects. Provide résumé, business card, brochure, flier or tearsheets to be kept on file for possible future assignments. SASE. Reports in 3 weeks.

Simultaneous submissions and previously published work OK. Payment depends on job requirements. Buys one-time rights; negotiable. Credit line given if requested.

Tips: "Have a wide range of subject areas for review and use. Stock photos are most accessible and can be available quickly during the production of a book."

$ $⊠ FIFTH HOUSE PUBLISHERS, #9, 6125-11th St. SE, Calgary, Alberta T2H 2L6 Canada. (403)571-5230. Fax: (403)571-5235. E-mail: 5thhouse@cadvision.com. Managing Editor: Charlene Dobmeier. Estab. 1982. Publishes calendars, history, biography, Western Canadiana. Photos used for text illustration, book covers, dust jackets and calendars. Examples of recently published titles: *The Canadian Weather Trivia Calendar, Wild Birds Across the Prairies* and *Once Upon a Tomb: Stories from Canadian Graveyards*.
Needs: Buys 15-20 photos annually. Looking for photos of Canadian weather. Model/property release preferred. Captions required; include location and identification.
Making Contact & Terms: Query with samples and stock photo list. Keeps samples on file. SASE. Reports in 3 weeks. Pays $300 (Canadian)/calendar image. Pays on publication. Buys one-time rights. Credit line given.

$ $FINE EDGE PRODUCTIONS, 13589 Clayton Lane, Anacortes WA 98221. (360)299-8500. Fax: (360)299-0535. E-mail: mail@fineedge.com. Website: http://www.fineedge.com. Contact: Don Douglass. Estab. 1986. Publishes outdoor guide and how-to books; custom topographic maps—mostly mountain biking and sailing. Publishes 6 new titles/year. Photos used for text illustration, promotional materials, book covers. Examples of recently published titles: *Mountain Biking the Eastern Sierra's Best 100 Trails*; *Exploring the North Coast of British Columbia*; *Exploring the San Juan & Gulf Islands*. "Call to discuss" photo guidelines.
Needs: Buys 200 photos annually; offers 1-2 freelance assignments annually. Looking for area-specific mountain biking (trail usage), Northwest cruising photos. Model release required. Captions preferred with place and activity.
Specs: Uses 3×5, 4×6 glossy b&w prints; color for covers.
Making Contact & Terms: Query with samples. SASE. Reports in 1-2 months. Simultaneous submissions and/or previously published works OK. Pays $150-500/color photo; $10-50/b&w photo. Pays on publication. Rights purchased vary. Credit line given.
Tips: Looking for "photos which show activity in realistic (not artsy) fashion—want to show sizzle in sport. Increasing—now going from disc directly to film at printer."

[N] ⊠ FISHER HOUSE PUBLISHERS, 10907 34 A Ave., Edmonton, Alberta T6J 2T9 Canada. (403)988-0321. Fax: (403)468-2058. E-mail: fisher@livingbetter.org. Website: http://www.livingbetter.org/fisher/house/publishers.htm. Editor: John R. Fisher. Estab. 1991. Publishes textbooks, biographies, histories, government/politics, how-to. Photos used for text illustration, book covers, dust jackets and artwork in poetry books. Example of recently published titles: *Reflections at Christmas* (cover photography).
Needs: Looking for photos of nature and human interest. Model release preferred. Captions preferred.
Specs: Uses color and b&w prints. SASE.
Making Contact & Terms: Query with samples and stock photo list. Reports in 1 month. Simultaneous submissions and previously published work OK. Rights negotiable. Credit line given.
Tips: "We prefer to work with beginning photographers who are building a portfolio."

$ [S] ▣ ◎ FIVE CORNERS PUBLICATIONS, 5052 Rt. 100, Plymouth VT 05056. (802)672-3868. Fax: (802)672-3296. E-mail: editor@fivecorners.com. Website: http://www.fivecorners.com. Editor: Donald Kroitzsh. Estab. 1990. Publishes adult trade (such as coffee table photo books), a travel newsletter and how-to books about travel. Photos used for text illustration. Examples of published titles: *American Photographers at the Turn of the Century: People & Our World*; *American Photographers at the Turn of the Century: Nature & Landscape; and The Curiosity Book* (text illustration using 35mm b&w prints).
Needs: Buys 20 photos annually. Interested in complementary photos to articles, showing technical matter and travel scenes. Model release preferred. Captions required.
Specs: Uses color and b&w prints; 35mm, 2¼×2¼, 4×5, 8×10 transparencies. Accepts images in digital format for Windows. Send via compact disc, online, floppy disk, or Zip disk as TIFF, GIF, JPEG files.

● **SPECIAL COMMENTS** within listings by the editor of *Photographer's Market* are set off by a bullet.

Making Contact & Terms: Query with résumé of credits. Works with freelancers only. SASE. Reports in 1-2 weeks. Simultaneous submissions and/or previously published work OK. Pays $25/color photo; $25/ b&w photo. Pays on publication. Buys one-time rights. Credit line given.

N M O FOCAL PRESS, Butterworth Heinemann, 225 Wildwood Ave., Woburn MA 01801-2041. (781)904-2500. Fax: (781)904-2640. E-mail: lavernlavery@bhusa.com. Website: http://www.focalpress.c om. Editor: Lavern Lavery. Estab. 1938. Publishes hardcover originals, trade paperback originals, mass market paperback originals, textbooks, CD-ROMs.
Needs: "We publish professional reference titles, practical guides and student textbooks in all areas of media and communications technology including photography and imaging. We are always looking for new proposals for book ideas." Buys all rights; negotiable.
Making Contact & Terms: Simultaneous submissions and previously pubished work OK.

$ ▣ MICHAEL FRIEDMAN PUBLISHING GROUP, INC., 15 W. 26th St., New York NY 10010. (212)685-6610. Fax: (212)685-0102. E-mail: photo@metrobooks.com. Website: http://www.metrobooks.c om. Photography Director: Christopher Bain. Estab. 1977. Publishes adult trade: interior design; travel; gardening; transportation; sports; food and entertaining; stage and screen; history; and culture. Photos used for text illustration, promotional materials, book covers and dust jackets.
Needs: Buys 12,000 freelance photos annually; offers 10-15 freelance assignments annually. Reviews stock photos. Captions preferred.
Specs: Uses 35mm, 120 and 4×5 transparencies. Accepts images in digital format for Mac and Windows. Send via CD or Zip disk.
Making Contact & Terms: Query with specific list of stock photo subjects. Pays $75-100/color stock photo; $350-600/day. Payment upon publication of book for stock photos; within 30-45 days for assignment. Simultaneous submissions and previously published work OK. For terms, see website. Buys rights for all editions. Credit line always given.

$ $ GOLDEN WEST PUBLISHERS, 4113 N. Longview, Phoeix AZ 85014. (602)265-4392. Fax: (602)279-6901. Contact: Hal Mitchell. Estab. 1972. Publishes trade paperback originals. Subjects primarily include regional cookbooks and general interest. Photos used for book covers. Examples of recently published titles: *Low Fat Mexican Recipes (cover); Winning Recipes* (cover).
Needs: Buys 10-20 freelance photos annually. Looking for photos of food and geographic interest. Interested in reviewing stock photos of fresh and prepared foods. Photo caption preferred.
Specs: Uses color prints; 35mm, 2¼×2¼, 4×5, 8×10 transparencies.
Marketing Contact & Terms: Send query letter with samples, brochure, stock photo list. Art director will contact photographer for portfolio review if interested. Portfolio should include color, prints, tearsheets, slides, transparencies. Keeps samples on file; include SASE for return of material. Reports back only if interested, send non-returnable samples. Simultaneous submissions and/or previously published work OK. Pays by the project, $200-375 for color cover. **Pays on acceptance.** Buys one-time and all rights; negotiable. Credit line given.
Tips: "We produce affordable cookbooks and we need to purchase affordable photos. Send samples that pertain to our needs."

$ $ ▣ M GRAPHIC ARTS CENTER PUBLISHING COMPANY, P.O. Box 10306, Portland OR 97296-0306. (503)226-2402. Fax: (503)223-1410. Photo Editor: Diana Eilers. Publishes adult trade photo essay books and state, regional recreational calendars. Examples of published titles: *Plateau Light; California; Oregon Golf*; and *Washington II*.
Needs: Offers 5-10 freelance assignments annually. Needs photos of landscape, nature, people, historic, architecture and destiny attractions.
Specs: Uses 35mm, 2¼×2¼ and 4×5 transparencies. Accepts images in digital format for Mac. Send via JAZZ, Zip or CD.
Making Contact & Terms: Query with samples. Pays by royalty—amount varies based on project; advances against royalty are given. Pays $2,200-4,000/calendar fees. Buys book rights. Credit line given.
Tips: "Photographers must be previously published and have a minimum of five years fulltime professional experience to be considered. Call first to present your book or calendar proposal before you send in a submission. Topics proposed must have strong market potential."

GREAT QUOTATIONS PUBLISHING CO., 1967 Quincy Court, Glendale Heights IL 60139. (630)582-2800. Fax: (630)582-2813. Contact: Cheryl Henderson. Estab. 1985. Publishes gift books.
Needs: Buys 10-20 photos annually; offers 10 freelance assignments annually. Looking for inspirational or humorous. Reviews stock photos of inspirational, humor, family. Model/property release preferred.

Specs: Uses color and b&w prints; 35mm, 2¼×2¼, 4×5 transparencies.

Making Contact & Terms: Provide résumé, business card, brochure, flier or tearsheets to be kept on file for possible future assignments. Works on assignment only. Keeps samples on file. SASE. "We prefer to maintain a file of photographers and contact them when appropriate assignments are available." Simultaneous submissions and previously published work OK. Payment negotiable. Pays on publication. "We will work with artist on rights to reach terms all agree on."

Tips: "We intend to introduce 30 new books per year. Depending on the subject and book format, we may use photographers or incorporate a photo image in a book cover design. Unfortunately, we decide on new product quickly and need to go to our artist files to coordinate artwork with subject matter. Therefore, more material and variety of subjects on hand is most helpful to us."

$ $ ⑤ ▣ ◪ GROLIER, INC., 6 Park Lawn Dr., Bethel CT 06801. (203)797-3500. Fax: (203)797-3344. Director of Photo Research: Cindy Joyce. Estab. 1829. Publishes encyclopedias and yearbooks. Examples of published titles: *The New Book of Knowledge*; and *Encyclopedia Americana*, and corresponding annuals. Photo use is text illustration and/or online.

Needs: Buys 5,000 stock photos/year. Interested in unposed photos of the subject in its natural habitat that are current and clear. Model/property release preferred for any photos used in medical articles, education articles, etc. Captions mandatory; include dates, specific locations and natural history subjects should carry Latin identifications.

Specs: Uses 8×10 glossy b&w/color prints; 35mm, 4×5, 8×10 (reproduction quality dupes preferred) transparencies. Accepts images in digital format for Mac, Windows. Send via photo CD as JPEG files at 300 dpi, unless online, then at 72 dpi.

Making Contact & Terms: Query with list of stock photo subjects. Cannot return unsolicited material. Pays $65-100/b&w photo; $125-200/color photo. Very infrequently freelance photography is negotiated by the job. Buys one-time and foreign language rights; negotiable. Credit line given either under photo or on illustration credit page.

Tips: "Send subject lists and small selection of samples. Printed samples *only* please. In reviewing samples, we consider the quality of the photographs, range of subjects and editorial approach. Keep in touch but don't overdo it."

$ $ $ ▣ ◎ GRYPHON HOUSE, P.O. Box 207, Beltsville MD 20704. (301)595-9500. Fax: (301)595-0051. E-mail: rosanna@ghbooks.com. Editor-in-Chief: Kathy Charner. Estab. 1970. Publishes educational resource materials for teachers and parents of young children. Examples of recently published titles: *Global Art*; and *125 Brain Games for Babies*.

Needs: Looking for b&w and color photos of young children, (birth-6 years.) Reviews stock photos. Model release required.

Specs: Uses 5×7 glossy color (cover only) and b&w prints. Accepts images in digital format for Mac. Send via CD as SyQuest or Zip.

Making Contact & Terms: Query with samples and stock photo list. Keeps samples on file. Simultaneous submissions OK. Payment negotiable. **Pays on receipt of invoice.** Buys book rights. Credit line given.

$ ✥ GUERNICA EDITIONS, INC., P.O. Box 117, Station P, Toronto, Ontario M5S 2S6 Canada. (416)657-8885. Editor: Antonio D'Alfonso. Estab. 1978. Publishes adult trade (literary). Photos used for book covers. Examples of recently published titles: *French Poets of Today* (cover); *Viameria* (cover); *Variable Star* (cover); *Phrases and Passages for a Salutary Song* (cover).

Needs: Buys various number of photos annually; "often" assigns work. Needs life events, including characters; houses. Photo captions required.

Specs: Uses color and/or b&w prints.

Making Contact & Terms: Query with samples. Sometimes keeps samples on file. Cannot return material. Reports in 1-2 weeks. Pays $100-150 for cover. Pays on publication. Buys book rights. "Photo rights go to photographers. All we need is the right to reproduce the work." Credit line given.

HANCOCK HOUSE PUBLISHERS, 1431 Harrison Ave., Blaine WA 98231-0959. (800)938-1114. Fax: (800)983-2262. President: David Hancock. Estab. 1968. Publishes trade books. Photos used for text illustration, promotions, book covers. Examples of recently published titles: *Antarctic Splendor*, by Frank S. Todd (over 250 color images); *Pheasants of the World* (350 color photos). Photos used for text illustration.

Needs: Birds/nature. Model release and photo captions preferred. Reviews stock photos.

Making Contact & Terms: Query with samples. SASE. Reports in 1 month. Simultaneous submissions and previously published work OK. Payment negotiable. Buys non-exclusive rights. Credit line given.

◀ ◎ **HARMONY HOUSE PUBLISHERS**, P.O. Box 90, Prospect KY 40059 or 1008 Kent Rd., Goshen KY 40026. (502)228-4446. Fax: (502)228-2010. Owner: William Strode. Estab. 1984. Publishes photographic books on specific subjects. Photos used for text illustration, promotion materials, book covers and dust jackets. Examples of published titles: *The Crystal Coast-North Carolina's Treasure By The Sea* (text illustrations, promotional material, book cover, dust jacket); *Bearcats-The Story of Basketball at the University of Cincinnati.*

Needs: Number of freelance photos purchased varies. Assigns 30 shoots each year. Captions required.

Specs: Uses 35mm, 2¼×2¼, 4×5 or 8×10 transparencies.

Making Contact & Terms: Query with résumé of credits along with business card, brochure, flier or tearsheets to be kept on file for possible future assignments. Send samples or stock photo list. Submit portfolio for review. Works on assignment mostly. Simultaneous submissions and previously published work OK. Payment negotiable. Buys one-time and book rights. Credit line given.

Tips: To break in, "send in book ideas to William Strode, with a good tray of slides to show work."

▣ **HERALD PRESS**, 616 Walnut Ave., Scottdale PA 15683. (724)887-8500. Fax: (724)887-3111. E-mail: jim@mph.org. Website: http://www.mph.org. Contact: James Butti. Estab. 1908. Photos used for book covers and dust jackets. Examples of published titles: *Lord, Teach Us to Pray*; *Starting Over*; and *Amish Cooking* (all cover shots).

Needs: Buys 5 photos annually; offers 10 freelance assignments annually. Subject matter varies. Reviews stock photos of people and other subjects. Model/property release required. Captions preferred (identification information).

Specs: Uses varied sizes of glossy color and/or b&w prints; 35mm transparencies. Accepts images in digital format for Windows in TIFF, EPS, WMT files. Send via Zip, floppy disk or online.

Making Contact & Terms: Query with samples. Provide résumé, business card, brochure, flier or tearsheets to be kept on file for possible future assignments. Works on assignment only or select from file of samples. Keeps samples on file. SASE. Reports in 1 month. Simultaneous submissions and previously published work OK. Payment negotiable. **Pays on acceptance.** Buys book rights; negotiable. Credit line given.

Tips: "We put your résumé and samples on file. It is best to send 5×7 or 8×10 samples for us to circulate through departments."

N $ S ▣ HILLER PUBLISHING, Hiller Industries, 631 #400 W., Salt Lake City UT 84103. (801)521-2411. Fax: (801)521-2420. Estab. 1922. Publishes textbooks. Photos used for text illustrations, promotional materials, book covers, dust jackets.

Needs: Needs photos of babies, children, couples, families, parents, beauty, gardening, religious, hobbies. Interested in fine art, historical/vintage, regional, seasonal.

Specs: Accepts images in digital format for Mac. Send via CD.

Making Contact & Terms: Send query letter with prints, photocopies. Does not keep samples on file; include SASE for return of material. Reports back only if interested. **Pays on acceptance.** Buys all rights.

$ HIPPOCRENE BOOKS INC., 171 Madison Ave., New York NY 10016. (212)685-4371. Fax: (212)779-9338. E-mail: hippocre@ix.netcom.com. Website: http://www.netcom.com/~hippocre. Managing Editor: Carol Chitnis. Estab. 1970. Publishes hardcover originals and reprints, trade paperback originals and reprints, foreign language dictionaries. Subjects include foreign language dictionaries and study guides, international ethnic cookbooks, travel, bilingual international love poetry, Polish interest, Russian interest, Judaica. Photos used for book covers, dust jackets. Examples of recently published titles: 1998 Spring Catalog (on cover); 1997 Fall Catalog (cover-inside, front and back).

Needs: Buys 3 freelance photos annually. Looking for ethnic food, travel destinations/sites. Interested in reviewing stock photos of ethnic/international food. Photo captions preferred.

Making Contact & Terms: Send query letter with samples, brochure, stock photo list, tearsheets. Reports back only if interested; send non-returnable samples. Considers simultaneous submissions and previously published work. Pays by the project, $50-200 for color cover. Buys all rights. Credit line given.

Tips: "We only use color photographs on covers. We want colorful, eye-catching work."

$ $ ▣ HOLLOW EARTH PUBLISHING, P.O. Box 1355, Boston MA 02205-1355. Phone/fax: (603)433-8735. E-mail: hep2@aol.com. President/Publisher: Helian Yvette Grimes. Publishes adult trade, mythology, computers (Macintosh), science fiction and fantasy. Photos used for text illustration, promotional materials, book covers, dust jackets and magazines. Examples of published titles: *Complete Guide to B&B's and Country Inns (USA)*, *Complete Guide to B&B's and Country Inns (worldwide)*, and *Software Guide for the Macintosh Power Book*. E-mail us for photo guidelines.

Needs: Buys 150-300 photos annually. Needs photos of bed & breakfasts, country inns, Macintosh Powerbook and computer peripherals. Reviews stock photos. Model/property release required. Captions required; include what it is, where and when.

Specs: Uses 5×7, 8½×11 glossy or matte color and b&w prints; 35mm, 2¼×2¼, 4×5 transparencies. Also accepts images on disk in EPS, TIFF, or Adobe Photoshop formats.

Making Contact & Terms: E-mail queries only. No unsolicited photographs. Works with local freelancers on assignment only. Keeps samples on file. SASE. Reports in 1 month. No simultaneous submissions. Pays $50-600/color photo; $50-600/b&w photo. **Pays on acceptance.** Buys all rights "but photographer can use photographs for other projects after contacting us." Rights negotiable. Credit line given.

Tips: Wants to see portfolios with strong content, impact, graphic design. "Be unique and quick in fulfilling assignments, and pleasant to work with."

N **$ $ HOLT, RINEHART AND WINSTON**, 1120 Capital of Texas Hwy. S., Austin TX 78746. (512)314-6500. Fax: (512)314-6590. Manager of Photo Research: Tim Taylor. Estab. 1866. "The Photo Research Department of the HRW School Division in Austin obtains photographs for textbooks in subject areas taught in secondary schools." Photos are used for text illustration, promotional materials and book covers. Examples of published titles: *Elements of Writing*, *Science Plus*, *People and Nations*, *World Literature*, *Biology Today* and *Modern Chemistry*.

Needs: Buys 3,500 photos annually. Photos to illustrate mathematics, the sciences—life, earth and physical—chemistry, history, foreign languages, art, English, literature, speech and health. Reviews stock photos. Model/property releases preferred. Photo captions required; include scientific explanation, location and/or other detailed information.

Specs: Uses any size glossy b&w prints and color transparencies.

Making Contact & Terms: Send a letter and printed flier with a sample of work and a list of subjects in stock. Do not call! Cannot return unsolicited material. Reports as needed. Pays $125-180/b&w photo; $150-225/color photo; $75-125/hour and $700-1,000/day. Buys one-time rights. Credit line given.

Tips: "We use a wide variety of photos, from portraits to studio shots to scenics. We like to see slides displayed in sheets. We especially like photographers who have specialties . . . limit themselves to one or two subjects." Looks for "natural looking, uncluttered photographs labeled with exact descriptions, technically correct and including no evidence of liquor, drugs, cigarettes or brand names." Photography should be specialized with photographer showing competence in 1 or more areas.

$ $ HOME PLANNERS, Wholly owned by Hanley-Wood, Inc., 3275 W. Ina Road, Suite 110, Tucson, AZ 85741. (520)297-8200. Fax: (520)297-6219. Art Director: Cindy J. Coatsworth Lewis. Estab. 1946. Publishes material on home building and planning and landscape design. Photos used for text illustration, promotional materials and book covers. Examples of recently published titles: *European Dream Homes*; *Craftsman Collection*; and *Colonial Houses*. In all 3, photos used for cover and text illustrations.

Needs: Buys 25 freelance photos annually; offers 10 freelance assignments annually. Wants homes/houses—"but for the most part, it must be a specified house built with one of our plans." Property release required.

Specs: Uses 4×5 transparencies.

Making Contact & Terms: Provide résumé, business card, brochure, flier or tearsheets to be kept on file for possible assignments. Works on assignment only. SASE. Reports in 1 month. Simultaneous submissions and previously published work OK. Pays $25-100/color photo; $500-750/day; maximum $500/4-color cover shots. Buys all rights. Credit line given.

Tips: Looks for "ability to shoot architectural settings and convey a mood. Looking for well-thought out, professional project proposals."

$ $ HOMESTEAD PUBLISHING, Box 193, Moose WY 83012. Editor: Carl Schreier. Publishes 20-30 titles per year in adult trade, natural history, guidebooks, fiction, Western American, art and fiction. Photos used for text illustration, promotional, book covers and dust jackets. Examples of published titles: *Yellowstone: Selected Photographs*; *Field Guide to Yellowstone's Geysers; Hot Springs and Fumaroles*; *Field Guide to Wildflowers of the Rocky Mountains*; *Rocky Mountain Wildlife*; and *Grand Teton Explorers Guide*.

Needs: Buys 600-700 photos annually; offers 6-8 freelance assignments annually. Wants natural history. Reviews stock photos. Model release preferred. Photo captions required; accuracy and the highest quality very important.

Specs: Uses 8×10 glossy b&w prints; 35mm, 2¼×2¼, 4×5 and 6×7 transparencies.

Making Contact & Terms: Query with samples. Provide résumé, brochure, flier or tearsheets to be kept on file for possible future assignments. SASE. Reports in 4-6 weeks. Simultaneous submissions and

previously published work OK. Pays $70-300/color photo, $50-300/b&w photo. Buys one-time and all rights; negotiable. Credit line given.

Tips: In freelancer's samples, wants to see "top quality—must contain the basics of composition, clarity, sharpness, be in focus, low grain etc. Looking for well-thought out, professional project proposals."

$ ▢ ◎ HOWELL PRESS, INC., 1713-2D Allied Lane, Charlottesville VA 22903. Fax: (804)971-7204. E-mail: howellpress@aol.com. Website: http://www.howellpress.com. President: Ross A. Howell, Jr. Estab. 1986. Publishes illustrated books. Examples of recently published titles: *Sprint Car Racing*; *Virginia's Past Today*; *Before Centuries: USAFE Fighters 1948-1959* (photos used for illustration, jackets and promotions for all books).

Needs: Aviation, military history, gardening, maritime history, motor sports, cookbooks, transportation, regional (Mid-Atlantic and Southeastern US) only. Model/property release preferred. Captions required; clearly identify subjects.

Specs: Uses b&w and color prints; transparencies.

Making Contact & Terms: Photographer's guidelines available; send query. Keeps samples on file. SASE. Reports in 1 month. Simultaneous submissions and previously published work OK. Payment negotiable. Buys one-time rights.

Tips: "We work individually with photographers on book-length projects. Photographers who wish to be considered for assignments, or who have proposals for book projects, should submit a written query." When submitting work, please "provide a brief outline of project, including cost predictions and target market for project. Be specific in terms of numbers and marketing suggestions."

$ ▨ ▢ I.G. PUBLICATIONS LTD., 1311 Howe St., Suite 601, Vancouver, British Columbia V6Z 2P3 Canada. (604)691-1749. Fax: (604)691-1748. Editor: Jane Lightle. Estab. 1977. Publishes visitor magazines of local interest which include areas/cities of Vancouver, Victoria, Banff/Lake Louise and Calgary. Photos used for text illustration, book covers and on websites. Examples of published titles: *International Guide, Banff/Lake Louise Official Visitor Guide* and *Visitor's Choice*, text illustration and covers. Photo guidelines free with SASE.

Needs: Looking for photos of attractions, mountains, lakes, views, lifestyle, architecture, festivals, people, sports and recreation, specific to each area as mentioned above. Model release required. Property release is preferred. Captions required "detailed but brief."

Specs: Uses color and b&w prints, 35mm transparencies. Accepts images in digital format.

Making Contact & Terms: Query with samples. Works with Canadian photographers. Keeps digital images on file. SASE. Reports in 3 weeks. Previously published works OK. Pays $65/color photo for unlimited use of photos purchased. Pays in 30-60 days. Credit line given.

Tips: "Please submit photos that are relative to our needs only. Photos should be specific, clear, artistic, colorful."

$ $▢ INNER TRADITIONS INTERNATIONAL, 1 Park St., Rochester VT 05767. (802)767-3174. Fax: (802)767-3726. E-mail: peric@gotoit.com. Website: http://www.InnerTraditions.com. Art Director: Peri Champine. Estab. 1975. Publishes adult trade: New Age, health, self-help, esoteric philosophy. Photos used for text illustration and book covers. Examples of recently published titles: *Great Book of Hemp* (cover, interior); *Birth Without Violence* (cover); and *Aroma Therapy: Scent and Psyche* (cover); *Gesundheit* (text illustrations, book cover).

Needs: Buys 10-50 photos annually; offers 10-50 freelance assignments annually. Needs photos of babies, children, multicultural, landscapes/scenics, pets, religious, food/drink, portraits, product shots/still life. Intrested in fine art, historical/vintage. Reviews stock photos. Model/property release required. Captions preferred.

Specs: Uses 35mm, 4×5 transparencies. Accepts images in digital format for Mac. Send via CD, Jaz, Zip, e-mail as TIFF, EPS, JPEG files at 300 dpi.

Making Contact & Terms: Provide résumé, business card, brochure, flier or tearsheets to be kept on file for possible future assignments. Works with freelancers on assignment only. Keeps samples on file. SASE. Reports in 1 month. Simultaneous submissions OK. Pays $200-500 for color cover. Pays on publication. Buys book rights; negotiable. Credit line given.

$ $ $▢ ▢ JOSSEYBASS PUBLISHERS, 350 Sansome St., 5th Floor, San Francisco CA 94104. (415)433-1740. Fax: (415)433-4611. Website: http://www.jbp.com. Art Director: Paula Goldstein. Estab. 1968. Publishes hardcover originals; trade paperback originals and trade paperback reprints; CD-ROMs; Training Packages. Subjects include business, people in everyday settings, kids in educational settings, nature scenes, abstracts and religious images. Photos used for book covers, dust jackets. Examples of

recently published titles: *Leading Without Power (full cover image, nature scene); Daughters of Thunder* (image of face on cover); *All Kids are Our Kids* (image of children).
Needs: Buys 50 freelance photos annually. Looking for photos of people of varied races in normal settings, not posed; abstracts; still lifes; nature scenes; and education related shots of kids. Interested in reviewing stock photos. Model release required; property release preferred. Photo caption preferred.
Specs: Uses color, b&w prints; 35mm transparencies. Accepts images in digital format.
Marketing Contact & Terms: Send query letter with samples. Provide résumé, business card, self-promotion piece or tearsheets to be kept on file for possible future assignments. Art director will contact photographer for portfolio review if interested. Keeps samples on file. Reports back only if interested; send non-returnable samples. Payment varies by project. Pays extra for electronic usage of photos. Pays on publication. Buys one-time worldwide rights but prefers all rights. Credit line given.

$ $☑ JUDICATURE, 180 N. Michigan Ave., Suite 600, Chicago IL 60601. (312)558-6900 ext 119. Fax: (312)558-9175. E-mail: drichert@ajs.org.. Editor: David Richert. Estab. 1917. Publishes legal journal, court and legal books. Photos are used for text illustration and cover of bimonthly journal.
Needs: Buys 10-12 photos annually; rarely offers freelance assignments. Looking for photos relating to courts, the law. Reviews stock photos. Model/property release preferred. Captions preferred.
Specs: Uses 5×7 color and b&w prints; 35mm transparencies.
Making Contact & Terms: Query with samples. Works on assignment only. Keeps samples on file. SASE. Reports in 1-2 weeks. Simultaneous and/or previously published work OK. Pays $150-200/color photo; $150-200/b&w photo; cover use $200-300. **Pays on receipt of invoice.** Buys one-time rights. Credit line given.

🅽 $ $▣ ◎ KALI PRESS, P.O. Box 2169, Pagosa Springs CO 81147-2169. (970)264-5200. Fax: (970)264-5202. E-mail: info@kalipress.com. Website: http://www.kalipress.com. Director: Cynthia Brunetti Olsen. Estab. 1989. Publishes trade paperback originals. Subjects include health. Photos used for text illustrations. Examples of recently published titles: *Don't Drink the Water* (text illustrations); *Essiac: Nature Herbal Cancer Remedy* (book cover).
Needs: Buys environmental, pets, health/fitness.
Specs: Uses 4×6 glossy, matte, color, b&w prints; 4×5 transparencies. Accepts images in digital format for Mac. Send via CD as TIFF files at 1,200 dpi.
Making Contact & Terms: Send query letter with résumé, prints. Does not keep samples on file; include SASE for return of material. Reports in 1 month on queries; 2 months on portfolios. Simultaneous submissions and previously pubished work OK. Pays $50-200 for b&w inside; $100-300 for color inside. Pays by the project. Pays on publication. Buys all rights; negotiable.

🅽 $ $🆂 ☑ ◎ LANGENSCHEIDT PUBLISHERS, INC., Imprints: Insight Guides, APA Publications, 46-35 54th Rd., Maspeth NY 11378. (718)784-0055. Fax: (718)784-0640. E-mail: spohja@langenscheidt.com. Estab. 1969. Publishes trade paperback originals. Subjects include travel. Photos used for text illustrations, book covers. Examples of recently published titles: *Insight GT London* (book cover); *Pocket Guide Costa Rica* (text illustration). Catalog available.
Needs: Buys hundreds of freelance photos annually. Needs photos of travel. Model/property release required.
Making Contact & Terms: Send query letter with résumé, photocopies. Does not keep samples on file; cannot return material. Reports back only if interested, send nonreturnable samples. Simultaneous submissions OK. Pays on publication. Credit line given. Buys one-time rights.
Tips: "We look for spectacular color photographs relating to travel. See our catalog for examples."

$ LAYLA PRODUCTION INC., 340 E. 74, New York NY 10021. (212)879-6984. Fax: (212)879-6399. Manager: Lori Stein. Estab. 1980. Publishes adult trade and how-to gardening. Photos used for text illustration and book covers. Example of recently published title: *American Garden Guides*, 12 volumes (commission or stock, over 4,000 editorial photos).
Needs: Buys over 150 photos annually; offers 6 freelance assignments annually. Uses gardening photos. Buys all rights.
Making Contact & Terms: Provide résumé, business card, brochure, flier or tearsheets to be kept on file

CONTACT THE EDITOR of *Photographer's Market* by e-mail at **photomarket@fwpubs.com with your questions and comments.**

for possible future assignments. Prefers no unsolicited material. SASE. Reports in 1 month. Simultaneous submissions and previously published work OK. Pays $25-200/color photo; $10-100/b&w photo; $30-75/hour; $250-400/day. Other methods of pay depends on job, budget and quality needed.

Tips: "We're usually looking for a very specific subject. We *do* keep all résumés/brochures received on file—but our needs are small, and we don't often use unsolicited material. We will be working on gardening books through 1999."

$ [S] [□] [◑] LERNER PUBLICATIONS COMPANY, 241 First Ave. N., Minneapolis MN 55401. (612)332-3344 or (800)328-4929. Fax: (612)332-7615. E-mail: betho@lernerbooks.com. Website: www.lernerbooks.com. Senior Photo Researcher: Beth Osthoff. Estab. 1959. Publishes educational books for young people covering a wide range of subjects, including animals, biography, history, geography and sports. Photos used for text illustration, promotional materials, book covers. Examples of recently published titles: *Get Around in the City* (text illustrations and cover); *Sea Horses* (text illustrations and cover); and *Stinky and Stringy: Stem and Bulb Vegetables* (text illustrations).

Needs: Buys over 1,000 photos annually; rarely offers assignments. Model/property release preferred when photos are of social issues (i.e., the homeless). Captions required; include who, where, what and when.

Specs: Uses any size glossy color and b&w prints; 35mm, 2¼×2¼, 4×5 transparencies. Accepts images in digital format for Mac, Windows. Send via CD, floppy disk, e-mail as TIFF, JPEG files.

Making Contact & Terms: Query with detailed stock photo list by fax, e-mail or mail. Provide flier or tearsheets to be kept on file. "No calls, please." Cannot return material. Reports only when interested. Previously published works OK. Pays $50-125/color photo; $35-75/b&w photo; negotiable. **Pays on receipt of invoice.** Buys one-time rights. Credit line given.

Tips: Prefers crisp, clear images that can be used editorially. "Send in as detailed a stock list as you can, and be willing to negotiate use fees."

LIFETIME BOOKS, 2131 Hollywood Blvd., Hollywood FL 33020. (954)925-5242. Fax: (954)925-5244. Senior Editor: Callie Rucker. Estab. 1943. Publishes nonfiction business, health, cookbooks, self-help, how-to and psychology. Photos are used for text illustration, book covers and dust jackets.

Needs: Reviews stock photos. Model release required. Captions preferred.

Specs: Uses color prints.

Making Contact & Terms: Query with samples and stock photo list. Keeps samples on file. SASE. Simultaneous submissions and/or previously published work OK. Payment negotiable. **Pays on acceptance.** Buys nonexclusive, multiple-use rights; negotiable. Credit line given.

[N] LITTLE, BROWN & CO., 1271 Avenue of the Americas, New York NY 10020. (212)522-1793. Fax: (212)467-4502. Art Department Coordinator: Scott Richards. Publishes adult trade. Photos used for book covers and dust jackets.

Needs: Reviews stock photos. Model release required.

Making Contact & Terms: Provide tearsheets to be kept on file for possible future assignments. "Samples should be nonreturnable." SASE. Reporting time varies. Payment negotiable. Buys one-time rights. Credit line given.

$ [□] [◑] [◎] LITURGY TRAINING PUBLICATIONS, 1800 N. Hermitage, Chicago IL 60622. (773)486-8970. Fax: (773)486-7094. Contact: Design Manager. Estab. 1964. Publishes materials that assist parishes, institutions and households in the preparation, celebration and expression of liturgy in Christian life. Photos used for text illustration, book covers. Examples of published titles: *Infant Baptism, a Parish Celebration* (text illustration); *The Postures of the Assembly During the Eucharistic Prayer* (cover); and *Teaching Christian Children about Judaism* (text illustration).

Needs: Buys 30 photos annually; offers 5 freelance assignments annually. Needs photos of processions, assemblies with candles in church, African-American worship, sacramental/ritual moments. Interested in fine art. Reviews stock photos. Model/property release preferred. Captions preferred.

Specs: Uses 5×7 glossy b&w prints; 35mm transparencies. Keeps samples on file. Accepts images in digital format for Mac. Send via CD, SyQuest, floppy disk, Jaz, Zip, e-mail (any).

Making Contact & Terms: Arrange personal interview to show portfolio or submit portfolio for review. Query with résumé of credits, samples and stock photo list. Provide résumé, business card, brochure, flier or tearsheets to be kept on file for possible future assignments. SASE. Reports in 1-2 weeks. Simultaneous submissions; previously published work. Pays $50-225/color photo; $25-200/b&w photo. Pays on publication. Buys one-time rights; negotiable. Credit line given.

Tips: "Please realize that we are looking for very specific things—people of mixed age, race, socio-economic background; shots in focus; post-Vatican II liturgical style; candid photos; photos that are not

dated. We are not looking for generic religious photography. We're trying to use more photos, and will if we can get good ones at reasonable rates."

$ $▣ ⊘ LLEWELLYN PUBLICATIONS, P.O. Box 64383, St. Paul MN 55164. Website: http://www.llewellyn.com. Art Director: Lynne Menturweck. Publishes consumer books (mostly adult trade paperback) with astrology, wiccan, occult, self-help, health and New Age subjects geared toward an educated audience. Uses photos for book covers. Examples of recently published titles: *Life Is A Stretch* (text illustrations, book cover); *Earth Magic, Earth Divination* (book cover).
Needs: Buys 10-20 freelance photos annually. Also needs science/fantasy, sacred sites, gods and goddesses (statues, etc.), nature, high-tech, special effects, couples, multicultural, landscapes/scenics, gardening, pets, religious, health/fitness, sports. Interested in digital, erotic, fine art, historical/vintage. Reviews stock photos. Model release preferred.
Specs: Prefers 35mm or 4×5 transparencies. Accepts images in digital format for Mac. Send via CD, SyQuest, Jaz, Zip, e-mail as TIFF, EPS files at 300 dpi.
Making Contact & Terms: Query with samples. Provide slides, brochure, flier or tearsheets to be kept on file for possible future assignments. SASE. Reports in 5 weeks. Pays by the project, $200-600 for cover shots; $30-100 for b&w and for color inside. Pays on publication. Buys all rights. Credit line given.
Tips: "Send materials that can be kept on file."

$ $▣ ⊘ LONELY PLANET PUBLICATIONS, 150 Linden St., Oakland CA 94607-2538. Fax: (510)893-8572. E-mail: joshs@lonelyplanet.com. Website: http://www.lonelyplanet.com. Photo Editor: Josh Schefers. Estab. 1971. Publishes trade paperback originals and reprints. Subjects include travel. Photos used for text illustrations, promotional materials, book covers. Examples of recently published titles: *USA Guide* (text illustrations, book cover); *Rocky Mountains* (text illustrations, book cover). Contact for photo guidelines.
Needs: Buys 500-1,000 freelance photos annually. Looking for "off the beaten track" travel imagery; no monuments. Also wants children, couples, multicultural, families, parents, senior citizens, teens, environmental, landscapes/scenics, wildlife, cities/urban, rural, adventure, travel. Interested in historical/vintage, regional, seasonal. Interested in reviewing stock photos. Model release required for photos of individuals for book covers. Photo captions required.
Specs: Uses 35mm, 2¼×2¼, 4×5 transparencies. Accepts images in digital format for Mac. Send via CD, floppy disk, Jaz, Zip, e-mail as TIFF, EPS, GIF, JPEG files at 150 dpi.
Marketing Contact & Terms: "Portfolios can be dropped off must be dupes. No meetings with CP employees are guaranteed." Send query letter with samples, stock photo list, tearsheets. Provide résumé, business card, self-promotion piece or tearsheets to be kept on file for possible future assignments. Art director will contact photographer for portfolio review if interested. Portfolio should include slides. Does not keep samples on file; include SASE for return of material. Reports in 3-4 weeks on queries; 3-4 weeks on samples. Reports back only if interested, send non-returnable samples. Simultaneous submissions and/or previously published work OK. Pays by the project, $500-1,500 for color cover; $200-500 for color inside. Pays on publication. Buys one-time rights. Credit line given.
Tips: "When choosing freelancers I like to see a good selection of printed samples first. We're looking for travel images that convey the spirit of a place through off-beat views, details and people photos. Not so interested in staged photos or clichéd, classic shots (i.e. Eiffel Tower, etc.). Phone, e-mail, send stocklist to see if our photo needs match up with the stock of the photographers. Amateurs and professionals are encouraged to send stocklist and photo samples (non-returnable) to Production Department."

$ ◎ LOOMPANICS UNLIMITED, P.O. Box 1197, Port Townsend WA 98368. (360)385-2230. Fax: (360)385-7785. E-mail: loompanics@olympus.net Website: http://wwwloompanics.com. Chief Editor: Vanessa McGrady. Estab. 1975. Publishes how-to and nonfiction for adult trade. Photos used for book covers. Examples of published titles: *Free Space!* (color photos on cover and interior); *Secrets of a Superhacker* (photo collage on cover); and *Stoned Free* (interior photos used as line-drawing guide).
Needs: Buys 2-3 photos annually; offers 1-2 freelance assignments annually. "We're always interested in photography documenting crime and criminals." Reviews stock photos. Model/property release preferred. Captions preferred.
Specs: Uses b&w prints.
Making Contact & Terms: Query with samples and stock photo list. Provide tearsheets to be kept on file for possible future assignments. Samples kept on file. SASE. Reports in 1 month. Simultaneous submissions and previously published work OK. Pays $10-250 for cover photo; $5-20 interior photo. Buys all rights. Credit lines given.
Tips: "We look for clear, high contrast b&w shots that *clearly* illustrate a caption or product. Find out as much as you can about what we are publishing and tailor your pitch accordingly. Send a query letter and

samples. If you want your work returned, you must send adequate postage. We will contact those whom we are interested in."

$ $S O LUCENT BOOKS, P.O. Box 289011, San Diego CA 92128. (619)485-7424. Fax: (619)485-8019. E-mail: traceye@greenhaven.com. Website: http://www.lucentbooks.com. Production Coordinator: Tracey Engel. Estab. 1987. Publishes juvenile nonfiction—social issues, biographies and histories. Photos used for text illustration and book covers. Examples of recently published titles: *The Death Penalty* (text illustration), *Teen Smoking* (text illustration).

Needs: Buys hundreds of photos annually, including many historical and biographical images, as well as controversial topics such as euthanasia. Needs celebrities, teens, disasters, environmental, wildlife, education. Interested in documentary, historical/vintage. Reviews stock photos. Model/property release required; photo captions required.

Specs: Uses 5×7, $8\frac{1}{2} \times 11$ b&w prints. Accepts images in digital format for Mac. Send via CD, SyQuest, Zip, e-mail at 266 dpi.

Making Contact & Terms: Submit portfolio for review. Query with résumé of credits and samples. Provide résumé, business card, brochure, flier or tearsheets to be kept on file for possible future assignments. Keeps samples on file. SASE. Reports in 1 month. Simultaneous submissions and previously published work OK. Pays $100-300 for color cover; $50-100 for b&w inside. Credit lines given on request.

$ $ ⬚ S ▢ ▨ ◎ LYNX IMAGES INC., 104 Scollard St., Toronto, Ontario M5R 1G2 Canada. (416)925-8422. Fax: (416)925-8352. E-mail: photo@lynximages.com. Website: http://www.lynximages.com. Contact: Russell Floren. Estab. 1988. Publishes travel, history. Photos used for text illustration, promotional materials, book covers and dust jackets. Examples of recently published titles: *Alone In The Night* (cover, promotional materials); *North Channel* (cover and promotional materials); *Superior: Under the Shadow of the Gods* (cover, promotional materials); and *Northern Lights: The Lighthouses of Canada* (cover, promotional material).

Needs: Buys 10-20 photos annually; offers 10 freelance assignments annually. Looking for photos of mood, style to fit book. Reviews stock photos of the Great Lakes and other travel images. Also needs disasters, environmental, landscapes/scenics, rural, adventure. Interested in documentary, historical/vintage, regional. Model release preferred for people. Property release required for ships. Captions required, include date, location and site.

Specs: Uses 16mm film and Betacame SP videotape. Accepts images in digital format for Mac. Send via CD, Zip, e-mail as EPS files at 230 dpi.

Making Contact & Terms: Query with samples. Works with local freelancers only. Keeps samples on file. Reports in 1 month. Simultaneous submissions OK. Pays a negotiated flat fee for work. **Pays on receipt of invoice.** Credit line sometimes given depending upon work. Buys all rights.

Tips: "Familiarize yourself with our current publishings and if you have work which is in the same vein, call/e-mail/fax or write us to find out about future projects and possibility of submitting work."

◎ MAGE PUBLISHERS, 1032 29th St. NW, Washington DC 20007. (202)342-1642. Fax: (202)342-9269. E-mail: info@mage.com. Website: http://www.mage.com. Editor: Tony Ross. Estab. 1987. Publishes hardcover original and reprint, trade paperback original and reprint. Subjects include books on Persian art, cooking, culture, history. Photos used for text illustrations, book covers, dust jackets.

Needs: Buys 5 freelance photos annually. Only looking for photos taken in Iran. Photo captions preferred; include location, date.

Making Contact & Terms: Send query letter. Art director will contact photographer for portfolio review if interested. Portfolio should include b&w and color prints, slides, transparencies. Reports in 2 months only if interested; send non-returnable samples. Simultaneous submissions OK. **Pays half on acceptance and half at publication.** Buys all rights. Credit line given.

Tips: "We are only interested in photos taken in Iran. Query first."

N $ ⬚ A ▢ ◎ MEKLER & DEAHL, PUBLISHERS, 237 Prospect St. S., Hamilton, Ontario L8M 2Z6 Canada. (905)312-1779. Fax: (905)312-8285. E-mail: meklerdeahl@globalserve.net. Editor-in-Chief: Gilda L. Mekler. Estab. 1994. Publishes trade paperback originals. Photos used for text illustrations, book covers.

Needs: Buys very few freelance photos annually; depends on projects. Needs photos of business concepts, computers. Photo caption preferred.

Specs: Uses matte, b&w. Accepts images in digital format for Mac. Send via SyQuest, floppy disk, e-mail as TIFF files.

Making Contact & Terms: Send query letter with résumé. Provide résumé, business card. Reports in 2

months on queries. Usually works with local freelancers. Pays on publication. Credit line given. Buys one-time rights; negotiable.

N $⊘ MILKWEED EDITIONS, 430 First Ave. N., Suite 400, Minneapolis MN 55401-1743. (612)332-3192. Fax: (612)332-6248. Website: http://www.milkweed.org. Estab. 1980. Publishes hardcover originals and trade paperback originals. Subjects include literary fiction, nonfiction, poetry, children's fiction. Photos used for book covers and dust jackets. Examples of recently published titles: *Arousal* (dust jacket); *Verse & Universe* (book cover). Catalog available for $1.50. Art guidelines available with first-class postage.

Needs: Buys 1-3 freelance photos annually. Needs photos of environment, landscapes/scenics.

Specs: Uses any size, glossy, matte, color, b&w prints; 2¼×2¼, 4×5 transparencies.

Making Contact & Terms: Send query letter with résumé, slides, prints. Provide résumé, business card, self-promotion piece to be kept on file for possible future assignments. Reports back only if interested; send nonreturnable samples. Simultaneous submissions OK. Credit line given. Buys one-time rights.

$ $ S ▣ ⊘ MOON PUBLICATIONS, INC., P.O. Box 3040, Chico CA 95927-3040. (530)345-5473. Fax: (530)345-6751. E-mail: dhurst@moon.com. Photo Buyer: Dave Hurst. Estab. 1973. Publishes travel material. Photos used for text illustration, promotional materials and book covers. Examples of recently published titles: *Indonesia Handbook*, 6th Edition; *Nepal Handbook*, (3rd Edition) and *South Pacific Handbook* (7th Edition). All photos used for cover and text illustration. Photo guidelines free with SASE.

Needs: Buys 25-30 photos annually. Looking for people and activities typical of area being covered, landscape or nature. Reviews stock photos. Photo captions preferred; include location, description of subject matter.

Specs: Uses 35mm, 2¼×2¼, 4×5, 8×10 transparencies. Accepts images in digital format for Mac. Send via CD, Zip disk or floppy disk as TIFF and EPS files.

Making Contact & Terms: Query with stock photo list. Provide brochure, flier or tearsheets to be kept on file for possible future assignments. Keeps samples on file. SASE. Previously published work OK. Pays $400/cover photo. Pays on publication. Buys book rights; negotiable. Credit line given.

Tips: Wants "sharp focus, visually interesting (even unusual) compositions portraying typical activities, styles of dress and/or personalities of indigenous people of area covered in handbook. Unusual land or seascapes. Don't send snapshots of your family vacation. Try to look at your work objectively and imagine whether the photograph you are submitting deserves consideration for the cover of a book that will be seen worldwide. We continue to refine our selection of photographs that are visually fascinating, unusual."

MOTORBOOKS INTERNATIONAL, 729 Prospect Ave., Osceola WI 54020. (715)294-3345. Fax: (715)294-4448. Estab. 1965. Publishes trade and specialist and how-to, automotive, aviation and military. Photos used for text illustration, book covers and dust jackets. Examples of recently published titles: *The American Drive-In*, *Fire Trucks in Action* and *Corvette: America's Sports Car* (photos used for text illustration and covers).

Needs: Anything to do with transportation including tractors, cycles or airplanes. Model release preferred.

Making Contact & Terms: "Present a résumé and cover letter first, and we'll follow up with a request to see samples." Unsolicited submissions of original work are discouraged. Works on assignment typically as part of a book project. SASE. Reports in 6 weeks. Simultaneous submissions and previously published work OK. Payment negotiable. Rights negotiable. Credit line given.

▣ JOHN MUIR PUBLICATIONS, P.O. Box 613, Santa Fe NM 87504. Production Manager: Janet Cochran. Estab. 1969. Publishes adult travel books. Photos used for text illustration and book covers. Examples of recently published titles: *Travel Smart* series, *City Smart Guidebook* series, *Adventures in Nature* series and Rick Steves' European Travel Guides.

Needs: Travel photos (sights, hotels, restaurants, scenics) of US and Canadian cities and regions. Also, general travel coverage of Central American and European countries. Model release preferred.

Specs: Accepts images in digital format for Mac for preview only. Submit via Zip disk or diskette.

Making Contact & Terms: Query with samples, stock photo list, résumé and/or letter of interest. No disks or samples will be returned. Payment negotiable. Rights negotiable. Terms vary from project to project.

$ MUSIC SALES CORP., 257 Park Ave. S., New York NY 10010. (212)254-2100. E-mail: dan_earley @musicsales.com. Contact: Daniel Earley. Publishes instructional music books, song collections and books on music. Recent titles include: *Bob Dylan: Time Out of Mind*; *Paul Simon: Songs from the Capeman*; and *AC/DC Bonfire*. Photos used for cover and/or interiors.

Needs: Buys 200 photos annually. Present model release on acceptance of photo. Captions required.
Specs: Uses 8×10 glossy prints; 35mm, 2×2 or 5×7 transparencies.
Making Contact & Terms: Query first with résumé of credits. Provide business card, brochure, flier or tearsheet to be kept on file for possible future assignments. SASE. Reports in 2 months. Simultaneous submissions and previously published work OK. Pays $50-75/b&w photo, $250-750/color photo.
Tips: In samples, wants to see "the ability to capture the artist in motion with a sharp eye for framing the shot well. Portraits must reveal what makes the artist unique. We need rock, jazz, classical—on stage and impromptu shots. Please send us an inventory list of available stock photos of musicians. We rarely send photographers on assignment and buy mostly from material on hand." Send "business card and tearsheets or prints stamped 'proof' across them. Due to the nature of record releases and concert events, we never know exactly when we may need a photo. We keep photos on permanent file for possible future use."

$ $ NASW PRESS, National Association of Social Workers, 750 First St., NE, Suite 700, Washington DC 20002-4241. (202)408-8600. Fax: (202)336-8312. Website: http://www.naswpress.org. Contact: Will Schroeder. Estab. 1955. Publishes textbooks, CD-ROMs, journals. Subjects include social work, health, education. Photos used for journal covers. Examples of recently published titles: *Social Work*, *Health & Social Work*, *Social Work in Education*.
Needs: Buys 10 freelance photos annually. Wants photos about social work, healthcare, education, poverty and multicultural issues. Model release required. Photo caption preferred.
Specs: Uses color prints.
Marketing Contact & Terms: Send query letter with samples. To show portfolio, photographer should follow-up with call. Art director will contact photographer for portfolio review if interested. Keeps samples on file. Reports back only if interested; send non-returnable samples. Considers simultaneous submissions and previously published work. Pays by the project, $250 maximum for color cover. Pays on publication. Buys one-time, all, electronic rights; negotiable. Credit line given.

$ NEW LEAF PRESS, INC., Box 726, Green Forest AR 72638. (870)438-5288. Art Director: Janell Robertson. Publishes adult trade, fiction of religious nature, gifts, devotions and general trade. Photos used for book covers and dust jackets. Example of published title: *Moments for Friends*.
Needs: Buys 10 freelance photos annually. Landscapes, dramatic outdoor scenes, "anything that could have an inspirational theme." Reviews stock photos. Model release required. Captions preferred.
Specs: Uses 35mm slides and transparencies.
Making Contact & Terms: Query with copies of samples and list of stock photo subjects. "Not responsible for submitted slides and photos from queries. Please send copies, no originals unless requested." Does not assign work. SASE. Reports in 4-6 weeks. Simultaneous submissions and previously published work OK. Pays $100-175/color photo and $50-100/b&w photo. Buys one-time and book rights. Credit line given.
Tips: In order to contribute to the company, send color copies of "quality, crisp photos." Trend in book publishing is toward much greater use of photography.

N $ S NICHOLAS-HAYS INC., P.O. Box 2039, York Beach ME 03910-2039. (207)363-4393, ext. 12. Fax: (207)363-5799. E-mail: nicolashays@weiserbooks.com. Publisher: Betty Lundsted. Estab. 1976. Publishes trade paperback originals, trade paperback reprints. Subjects include Eastern philosophy, Jungian psychology. Photos used for book covers. Examples of recently published titles: *Modern Mysticism* (book cover). Catalog available for first-class postage.
Needs: Buys 1 freelance photo annually. Needs photos of landscapes/scenics.
Specs: Uses color prints; 35mm, $2\frac{1}{4} \times 2\frac{1}{4}$, 4×5 transparencies. Accepts images in digital format for Mac.
Making Contact & Terms: Send query letter with photocopies, tearsheets. Provide self-promotion piece to be kept on file for possible future assignments. Reports back only if interested; send nonreturnable samples. Simultaneous submissions and previously pubished work OK. Pays $100-200 for color cover.
Pays on acceptance. Credit line given. Buys one-time rights.
Tips: "We are a small company and do not use many photos. We keep landscapes/seascapes on hand—images need to inspirational."

NORTHLAND PUBLISHING, P.O. Box 1389, Flagstaff AZ 86002. (520)774-5251. Fax: (520)774-0592. E-mail: design@northlandpub.com. Art Director: Jennifer Schaber. Estab. 1966. Southwest themes—native American, cowboy, hispanic culture—all in trade, juvenile, cookbooks, fiction. Photos used for text illustration, promotional materials, book covers and dust jackets. Examples of recently published titles: *Mountains and Mesas* (cover/interior); *Healthy Southwest Cooking* (interior); and *Writing Down the River* (interior).
Needs: Buys 10-50 photos annually; offers 6-8 freelance assignments annually. Looking for photos with

creative interesting angles—"try not to use computer-aided material." Reviews stock photos of natural history. Model/property release required. Captions preferred.

Specs: Uses 2¼×2¼, 4×5 transparencies.

Making Contact & Terms: Query with samples. Works on assignment only. Keeps samples on file. SASE. Previously published work OK. Payment negotiable. Pays within 30 days of invoice. Buys one-time and all rights. Credit line given.

Tips: "Often we look for specific images but frequently publish a new book with an idea from a photographer."

$ ⑤ ▣ ⊘ W.W. NORTON AND COMPANY, 500 Fifth Ave., New York NY 10110. (212)354-5500. Fax: (212)869-0856. Website: http://www.wwnorton.com. Trade and College Department Photo Editors: Ruth Mandel and Neil Hoos. Estab. 1923. Photos used for text illustration, book covers and dust jackets. Examples of recently published titles: *Shaping a Nation*; and *We the People*.

Needs: Variable. Photo captions preferred.

Specs: Accepts images in digital format for Mac. Send via CD, SyQuest, Online, Zip disk or floppy disk at 300 dpi for reproduction and archival work.

Making Contact & Terms: Send stock photo list. Do not enclose SASE. Simultaneous submissions and previously published work OK. Reports as needed. Payment negotiable. Buys one-time rights; negotiable. Credit line given.

Tips: "Competitive pricing and minimal charges for electronic rights are a must."

$ $ ▣ ⊘ NTC/CONTEMPORARY PUBLISHING GROUP, Tribune Co., 4255 W. Touhy Ave, Lincolnwood IL 60646-1975. (847)679-5500. Fax: (847)679-6388. Art Director: Kim Bartko. Estab. 1961. Publishes hardcover originals, trade paperback originals and reprints; textbooks. Subjects include business, language instruction, parenting, cooking, travel, crafts, quilting, exercise, self-help, sports and entertainment. Photos used for text illustration, book covers, dust jackets. Examples of recently published titles: *Feng Shui in the Garden* (cover); *And Then Fuzzy Told Seve* (cover); *Ultimate Snowboarding* (cover and interior).

Needs: Buys 75 freelance photos annually. Looking for photos of families, sports and travel. Interested in reviewing stock photos of families (multicultural), sports and travel. Model release preferred for people on the cover; property release required. Photo caption preferred, include copyright owner and location.

Specs: Uses 35mm, 2¼×2¼, 4×5 transparencies. Accepts images in digital format via e-mail or disk.

Marketing Contact & Terms: Send query letter with brochure, stock photo list, tearsheets. "Do not send original photos." Provide résumé, business card and tearsheets to be kept on file for possible future assignments. Art director will contact photographer for portfolio review if interested. Portfolio should include prints, tearsheets, slides, transparencies. Reports back only if interested, send non-returnable samples. Previously published work OK. Payment negotiable by project. **Pays on acceptance.** Buys all rights; negotiable. Credit line given.

Tips: "Study the categories we specialize in. We prefer color and recent shots. Send brief stock list (not more than 1 page)."

$ ▢ THE OLIVER PRESS, Charlotte Square, 5707 W. 36th St., Minneapolis MN 55416-2510. (612)926-8981. Fax: (612)926-8965. E-mail: teresa@oliverpress.com. Editor: Teresa Faden. Estab. 1991. Publishes history books and collective biographies for the school and library market. Photos used for text illustration, promotional materials and book covers. Examples of published titles: *Women of the U.S. Congress* (9 freelance photos in the book, 1 on the back cover); *Women Who Reformed Politics* (7 freelance photos in the book); and *Amazing Archaeologists and Their Finds* (8 freelance photos in the book, 3 on the front cover).

Needs: Photographs of people in the public eye: politicians, business people, activists, etc. Also wants photos of agriculture, buildings, computers, environmental, industry medicine, military, portraits, science, technology. Reviews stock photos. Captions required; include the name of the person photographed, the year, and the place/event at which the picture was taken.

Specs: Uses 8×10 glossy b&w prints.

Making Contact & Terms: Query with stock photo list. Keeps samples on file. SASE. Reports in 1 month. Simultaneous submissions and previously published work OK. Pays $35-50/b&w photo. Pays on

THE GEOGRAPHIC INDEX, located in the back of this book, lists markets by the state in which they are located.

publication.Buys book rights, including the right to use photos in publicity materials; negotiable. Credit line given.

Tips: "We are primarily interested in photographs of public officials, or people in other fields (science, business, law, etc.) who have received national attention. We are not interested in photographs of entertaine rs. Do not send unsolicited photos. Instead, send us a list of the major subjects you have photographed in the past."

$ [S] [□] [] [◎] C. OLSON & CO., P.O. Box 100-PM, Santa Cruz CA 95063-0100. (831)459-9700. E-mail: bittersweet@jps.net. Editor: C. L. Olson. Estab. 1977. Examples of published titles: *World Health; Carbon Dioxide & the Weather* (cover).

Needs: Uses 2 photos/year—b&w or color; all supplied by freelance photographers. Photos of fruit and nut trees (in blossom or with fruit) in public access locations like parks, schools, churches, streets, businesses. "You should be able to see the fruit up close with civilization in the background." Also needs photos of people under stress from loud noise, photos relating to male circumcision, photos showing people (children and/or adults) wounded in war. Model/property release required for posed people and private property. Captions preferred.

Specs: Accepts images in digital format for Mac. Send via CD, Macintosh Zip 100 cartridge, floppy disk or Online.

Making Contact & Terms: Query with samples. SASE, plus #10 window envelope. Reports in 2 weeks. Simultaneous submissions and previously published work OK. Payment negotiable. **Pays on acceptance** or publication. Buys all rights. Credit line given on request.

Tips: Open to both amateur and professional photographers. "To ensure that we buy your work, be open to payment based on a royalty for each copy of a book we sell."

$ [A] [] OUR SUNDAY VISITOR, INC., 200 Noll Plaza, Huntington IN 46750. (219)356-8400. Fax: (219)356-8472. Managing Editor: Richard G. Beemer. Estab. 1912. Publishes religious (Catholic) periodicals, books and religious educational materials. Photos used for text illustration, promotional materials, book covers and dust jackets. Examples of recently published titles: *St. Leonard's Way of the Cross* (b&w on cover); *Catholic Traditions in the Garden* (color on cover); and *The Inner Life of Thérèse Lisieux* (color on cover).

Needs: Buys 15-20 photos annually; offers 25-30 freelance assignments annually. Interested in family settings, "anything related to Catholic Church." Reviews stock photos. Model/property release required. Captions preferred.

Specs: Uses 8×10 glossy, color and/or b&w prints; 35mm transparencies.

Making Contact & Terms: Query with samples. Works with freelancers on assignment only. Keeps samples on file. SASE. Reports in 1 month. Payment negotiable. Pays on acceptance, receipt of invoice. Buys one-time rights. Credit line given.

OUTDOOR EMPIRE PUBLISHING, INC., Box C-19000, Seattle WA 98109. (206)624-3845. Fax: (206)695-8512. Art Director: Patrick McGann. Publishes how-to, outdoor recreation and large-sized paperbacks. Photos used for text illustration, promotional materials, book covers and newspapers.

Needs: Buys 6 photos annually; offers 2 freelance assignments annually. Wildlife, hunting, fishing, boating, outdoor recreation. Model release preferred. Captions preferred.

Specs: Uses 8×10 glossy b&w and color prints; 35mm, 2¼×2¼ and 4×5 transparencies.

Making Contact & Terms: Query with samples or send unsolicited photos by mail for consideration. Provide résumé, business card, brochure, flier or tearsheets to be kept on file for possible future assignments. Works on assignment only. SASE. Reports in 3 weeks. Simultaneous submissions OK. Payment "depends on situation/publication." Buys all rights. Credit line given.

Tips: Prefers to see slides or contact sheets as samples. "Be persistent; submit good quality work. Since we publish how-to books, clear informative photos that tell a story are very important."

$ [A] [] RICHARD C. OWEN PUBLISHERS, INC., P.O. Box 585, Katonah NY 10536. (914)232-3903. Fax: (914)232-3977. Editor (Children's Books): Janice Boland. Editor (Professional Books): Amy Haggblom. Publishes picture/storybook fiction and nonfiction for 5- to 7-year-olds; author autobiographies for 7- to 10-year-olds; professional books for educators. Photos used for text illustration, promotional materials and book covers of professional books. Examples of recently published titles: *Meet the Author*; *Books for Young Learners* (children's); *Best Friends.*

Needs: Number of photos bought annually varies; offers 3-10 freelance assignments annually. Needs unposed people shots and nature photos that suggest storyline. "For children's books, must be child-appealing with rich, bright colors and scenes, no distortions or special effects. For professional books, similar, but often of classroom scenes, including teachers. Nothing posed, should look natural and realistic."

Reviews stock photos of children involved with books and classroom activities, age ranging from kindergarten to sixth grade, "not posed or set up, not portrait type photos. Realistic!" Also wants photos of families, pets, wildlife, environmental, multicultural, automobiles, sports. (All must be of interest to children 5-9 yrs.) Model release required for children and adults. Children (under the age of 21) must have signature of legal guardian. Property release preferred. Captions required. Include "any information we would need for acknowledgements, including if special permission was needed to use a location."

Specs: "For materials that are to be used, we need 35mm mounted transparencies. We usually use full-color photos."

Making Contact & Terms: Submit portfolio by mail for review. Provide résumé, business card, brochure, flier, or tearsheets to be kept on file for possible future assignments. Include a cover letter with name, address, and daytime phone number, and indicate *Photographer's Market* as a source for correspondence. Works with freelancers on assignment only. "For samples, we like to see any size color prints (or color copies)." Keeps samples on file "if appropriate to our needs." Reports in 1 month. Simultaneous submissions OK. Pays flat fee of $100-150/photo or $500 for project. . "Each job has its own payment rate and arrangements." **Pays on acceptance.** For children's books, publisher retains ownership, possession and world rights, and applies to first and all subsequent editions of a particular title and to all promotional materials. "After a project, (children's books) photos can be used by photographer for portfolio." Credit line given sometimes, depending on the project. "Photographers' credits appear in children's books, and in professional books, but not in promotional materials for books or our company."

Tips: Wants to see "real people in natural, real life situations. No distortion or special effects. Bright, clear images with jewel tones and rich colors. Keep in mind what would appeal to children. Be familiar with what the publishing company has already done. Listen to the needs of the company. Send tearsheets, color photocopies with a mailer. No slides please."

$ $ ⑤ ▣ ⬤ PELICAN PUBLISHING CO., P.O. Box 3110, Gretna LA 70054. (504)368-1175. Fax: (504)368-1195. Production Manager: Tracey Clements. Publishes adult trade, juvenile, textbooks, how-to, cooking, fiction, travel, science and art books. Photos used for book covers. Examples of published titles: *Maverick, Hawaii* (cover), *Maverick Berlin*, *Coffee Book* and *Maverick Guide to Hawaii* (book cover).

Needs: Buys 8 photos annually; offers 3 freelance assignments annually. Wants to see travel (international) shots of locations and people and cooking photos of food. Reviews stock photos of travel subjects. Model/property release required. Captions required.

Specs: Uses 8×10 glossy color prints; 35mm, 4×5 transparencies. Accepts images in digital format for Windows. Send via CD as TIFF files.

Making Contact & Terms: Query with stock photo list. Provide résumé, business card, brochure, flier or tearsheets to be kept on file for possible future assignments. Keeps samples on file. SASE. Reports as needed. Pays $100-500/color photo; negotiable with option for books as payment. **Pays on acceptance.** Buys one-time and book rights; negotiable. Credit line given.

Ⓝ $ $⬤ PETER PAUPER PRESS, 202 Mamaroneck Ave., Suite 400, White Plains NY 10601. (914)681-0144. Fax: (914)681-0389. E-mail: pauperp@aol.com. Creative Director: Sol Skolnick. Estab. 1928. Publishes hardcover originals, photo albums, guided journals. "We publish small-format, illustrated, color gift books." Photos used for text illustrations, book covers, dust jackets. Examples of recently published titles: *Amazing Grace: The Song* (text illustration, dust jacket).

Needs: Buys 8-20 freelance photos annually. Looking for images primarily focused on a single theme or relationship, e.g. friendship, sisters, teachers, graduation, weddings, Christmas, Hanukkah, Kwanzaa, Mother's Day, etc. Also wants photos of landscapes/scenics, gardening, pets. Interested in reviewing stock photos. Model/property release required. Photo caption preferred, include name and place of subject.

Specs: Uses 35mm, 2¼×2¼, 4×5 transparencies.

Marketing Contact & Terms: Send query letter with samples, brochure, tearsheets. Provide résumé, business card, self-promotion piece or tearsheets to be kept on file for possible future assignments. Portfolios may be sent anytime with prior request. Portfolio should include color prints, slides, transparencies. Does not keep samples on file; returns unsolicited material by SASE. Reports in 1 month. Pays $350-1,000 for color cover; by the project, $50-1,000 for color photos; $50-150 for color inside. **Pays on acceptance.** Buys one-time rights; negotiable. Credit line given.

$⬜ PHOTOGRAPHER'S MARKET, 1507 Dana Ave., Cincinnati OH 45207. (513)531-2690, ext. 226. Fax: (513)531-7107. E-mail: photomarket@fwpubs.com. Photo guidelines free with SASE.

Needs: Publishes 30-35 photos per year. Uses general subject matter. Photos must be work sold to listings in *Photographer's Market*. Photos are used to illustrate to readers the various types of images being sold to photo buyers listed in the book. "We receive many photos for our Publications section. Your chances

of getting published are better if you can supply images for sections other than Publications." Look through this book for examples.

Specs: Uses color and b&w (b&w preferred) prints, any size and format; 5×7 or 8×10 preferred. Also uses tearsheets and transparencies, all sizes, color and b&w.

Making Contact & Terms: Submit photos for inside text usage in fall and winter to ensure sufficient time to review them by deadline (beginning of February). Be sure to include SASE for return of material. All photos are judged according to subject uniqueness in a given edition, as well as technical quality and composition within the market section in the book. Photos are held and reviewed at close of deadline. Simultaneous submissions OK. Work must be previously published. Pays $75 plus complimentary copy of book. Pays when book goes to printer (June). Book forwarded in September upon arrival from printer. Buys second reprint and promotional rights. Credit line given.

Tips: "Send photos with brief cover letter describing the background of the sale. If sending more than one photo, make sure that photos are clearly identified. Slides should be enclosed in plastic slide sleeves and prints should be reinforced with cardboard. Cannot return material if SASE is not included. Tearsheets will be considered disposable unless SASE is provided and return is requested. Because photos are printed in black and white on newsprint stock, some photos, especially color shots, may not reproduce well. Photos should have strong contrast and not too much fine detail that will fill in when photo is reduced to fit our small page format."

$ THE PHOTOGRAPHIC ARTS CENTER, 163 Amsterdam Ave., 201, New York NY 10023. (212)838-8640. Fax: (212)873-7065. Website: http://www.consultantpress.com. Publisher: Robert S. Persky. Estab. 1980. Publishes books on photography and art, emphasizing the business aspects of being a photographer, artist and/or dealer. Photos used for book covers. Examples of recently published titles: *Publishing Your Art as Cards, Posters & Calendars* (cover illustration); *The Photographer's Complete Guide to Getting & Having an Exhibition*; and *Creating Successful Advertising* (text illustration).

Needs: Business of photography and art. Model release required. "Majority of images provided by authors of our books."

Specs: Uses 5×7 glossy b&w or color prints; 35mm transparencies.

Making Contact & Terms: Query with samples and text. SASE. Reports in 3 weeks. Pays $25-100/ b&w and color photos. Buys one time rights. Credit line given.

Tips: Sees trend in book publishing toward "books advising photographers how to maximize use of their images by finding business niches such as gallery sales, stock and cards and posters." In freelancer's submissions, looks for "manuscript or detailed outline of manuscript with submission. Visit our website to see titles and descriptions of books we publish."

$ 🖳 ◎ PLAYERS PRESS INC., P.O. Box 1132, Studio City CA 91614. Vice President: David Cole. Estab. 1965. Publishes entertainment books including theater, film and television. Photos used for text illustration, promotional materials, book covers and dust jackets. Examples of recently published titles: *Essential Film List* (text illustrations); and *Mens Costume 17th and 18th Century* (text illustrations).

Needs: Buys 50-1,000 photos annually. Needs photos of entertainers, actors, directors, theaters, productions, actors in period costumes, scenic designs and clowns. Reviews stock photos. Model release required for actors, directors, productions/personalities. Photo captions preferred for names of principals and project/ production.

Specs: Uses 8×10 glossy or matte b&w prints; 5×7 glossy color prints; 35mm, 2¼×2¼ transparencies. Accepts images in digital format for Mac via CD or floppy disk.

Making Contact & Terms: Query with list of stock photo subjects. Send unsolicited photos by mail for consideration. SASE. Reports in 3 weeks. Simultaneous submissions and previously published work OK. Pays $100 for color/b&w photo. Buys all rights; negotiable in "rare cases." Credit line sometimes given, depending on book.

Tips: Wants to see "photos relevant to the entertainment industry. Do not telephone; submit only what we ask for."

$ 🔄 Ⓢ 🖳 ⊘ POLESTAR BOOK PUBLISHERS, P.O. Box 5238, Station B, Victoria, British Columbia V8R 6N4 Canada. (250)361-9718. Fax: (250)361-9738. E-mail: polestar@direct.ca. Publisher: Michelle Benjamin. Estab. 1981. Publishes sports, fiction, poetry, junior/YA fiction. Photos are used for book covers and dust jackets. Examples of recently published titles: *Cadillac Kind* (covers); *Long Shot* (text, illustration); and *Celebrating Excellence* (text and cover).

Needs: Buys 50 photos annually. Reviews stock photos of sports and general. Model/property release preferred.

Specs: Uses color and b&w prints; 35mm, 2¼×2¼ transparencies; accepts digital format.

Making Contact & Terms: Provide résumé, business card, brochure, flier or tearsheets to be kept on

file for possible future assignments. Keeps samples on file. SAE and IRC. Simultaneous submissions and/
or previously published work OK. Pays $20-300/color photo; $20-100/b&w photo. Pays on publication.
Buys book rights; negotiable. Credit line given.

PRAKKEN PUBLICATIONS, INC., 3970 Varsity Dr., P.O. Box 8623, Ann Arbor MI 48107. (734)975-
2800. Fax: (734)975-2787. Production & Design Manager: Sharon K. Miller. Estab. 1934. Publishes *The
Education Digest* (magazine), *Tech Directions* (magazine for technology and vocational/technical educa-
tors), text and reference books for technology and vocational/technical education and general education
reference. Photos used for text illustration, promotional materials, book covers, magazine covers and text.
Examples of titles: *Managing the Occupational Education Laboratory* (text and marketing); and *Tech
Directions* (covers and marketing). No photo guidelines available.
Needs: Education "in action" and especially technology and vocational-technical education. Photo cap-
tions necessary; scene location, activity.
Specs: Uses any size image and all media.
Making Contact & Terms: Query with samples. Send unsolicited photos by mail for consideration.
Keeps sample on file. SASE. Payment negotiable. Methods of payment to be arranged. Rights negotiable.
Credit line given.
Tips: Wants to see "high-quality action shots in tech/voc-ed classrooms" when reviewing portfolios. Send
inquiry with relevant samples to be kept on file. "We buy very few freelance photographs but would be
delighted to see something relevant."

$ ⬤ **PROSTAR PUBLICATIONS INC.**, 3 Church Circle, Suite 109, Annapolis MD 21401. Phone/
fax: (800)481-6277. Editor: Peter L. Griffes. Estab. 1989. Publishes how-to, nonfiction. Photos used for
book covers. Examples of published titles: *Pacific Boating Almanac* (aerial shots of marinas); and *Pacific
Northwest Edition*. Photo guidelines free with SASE.
Needs: Buys less than 100 photos annually; offers very few freelance assignments annually. Reviews
stock photos of nautical (sport). Model/property release required. Captions required.
Specs: Uses color and b&w prints.
Making Contact & Terms: Query with stock photo list. Does not keep samples on file. SASE. Reports
in 1 month. Simultaneous submissions and previously published work OK. Pays $10-50/color or b&w
photo. Pays on publication. Buys book rights; negotiable. Credit line given.

THE QUARASAN GROUP, INC., 214 W. Huron, Chicago IL 60610-3616. (312)787-0750. Fax:
(312)787-7154. E-mail: quarasan@aol.com. Photography Coordinator: Amy Cismoski. A complete book
publishing service and design firm. Offers design of interiors and covers to complete editorial and produc-
tion stages, art and photo procurement. Photos used in brochures, books and other print products.
Needs: Buys 1,000-5,000 photos/year; offers 75-100 assignments/year. "Most products we produce are
educational in nature. The subject matter can vary. For textbook work, male-female/ethnic/handicapped/
minorities balances must be maintained in the photos we select to ensure an accurate representation."
Reviews stock photos and CD-ROMs. Model release required. Captions required.
Specs: Prefers 8×10 b&w glossy prints; 35mm, 2¼×2¼, 4×5, or 8×10 transparencies, or b&w contact
sheets.
Making Contact & Terms: Query with stock photo list or nonreturnable samples (photocopies OK).
Provide résumé, business card, brochure, flier or tearsheets to be kept on file for possible future assignments.
Cannot return material. "We contact once work/project requires photos." Payment based on final use size.
Pays on a per photo basis or day rate. Usually buys all rights or sometimes North American rights. Credit
line given but may not always appear on page.
Tips: "Learn the industry. Analyze the products on the market to understand *why* those photos were
chosen. Clients still prefer work-for-hire, but this is changing. We are always looking for experienced
photo researchers and top-notch photographers local to the Chicago area."

$ 📷 ▣ ◎ **REIDMORE BOOKS INC.**, 18228 102 St., Edmonton, Alberta T5S 1S7 Canada.
(780)444-0912. Fax: (780)444-0933. E-mail: reidmore@compusmart.ab.ca. Website: http://www.reidmore.
com. Editorial Director: Leah-Ann Lymer. Estab. 1979. Publishes social studies textbooks for K-12. Photos
used for text illustration, and book covers. Examples of recently published titles: *All About Canadian
Animals; Japan: Its People and Culture,* 2nd edition; and *Finding Your Voice*. Photo guidelines available.
Needs: Buys 500 photos annually; offers 1-3 freelance assignments annually. Looking for Canadian photos
of children, multicultural, families, senior citizens, environmental, landscapes/scenics, wildlife, cities/ur-
ban, education, rural, adventure, events, food/drink, hobbies, performing arts, sports, agriculture, industry,
political, product shots/still life, technology. Interested in documentary, historical/vintage, regional and
famous Canadians. "Photo depends on the project; however, images should contain unposed action."

Reviews stock photos. Model release required; property release preferred. Captions required; "include scene description, place name and photographer's control number."

Specs: Uses color prints and 35mm transparencies. Accepts images in digital format for Mac. Send via CD, Jaz, Zip, e-mail as TIFF, EPS files at 300 dpi.

Making Contact & Terms: Query with résumé of credits. Query with samples. Query with stock photo list. Provide résumé, business card, brochure, flier or tearsheets to be kept on file for possible future assignments. Art director will contact photographer for portfolio review if interested. Portfolio should include color prints and slides. Keeps samples of tearsheets, etc. on file. Cannot return material. Reports in 1 month. Simultaneous submissions and previously published work OK. Pays $75-150 for color cover; $50-75 for b&w inside; $75-100 for color inside. Payment for electronic usage is negotiable. Pays on publication. Buys one-time and book rights; negotiable. Credit line given.

Tips: "I look for unposed images which show lots of action. Please be patient when you submit images for a project. The editorial process can take a long time, and it is in your favor if your images are at hand when last minute changes are made."

$ [S] [■] [✎] REIMAN PUBLICATIONS L.L.C., 5400 S. 60th St., Greendale WI 53129. (414)423-0100. Fax: (414)423-8463. Photo Coordinator: Trudi Bellin. Estab. 1965. Publishes adult trade—cooking, people-interest, nostalgia, country themes. Examples of recently published titles: *Motorin' Along!* (covers, text illustration); *Life in the Slow Lane* (covers, text illustration); and *Tough Times, Strong Women* (covers, text illustration).

Needs: Buys "hundreds" of photos/annually. Looking for vintage color photos; nostalgic b&w photos, seasonal and colorful, sharp-focus agricultural, scenic, people and backyard beauty photos. Reviews stock photos of nostalgia, senior citizens, travel, agriculture, rural, scenics, birds, flowers and flower gardens. Model/property release required for children and private homes. Photo captions preferred; include season, location, era (when appropriate).

Specs: Uses color transparencies, any size. Accepts images in digital format for Mac. Send via e-mail at 800 dpi.

Making Contact & Terms: Query with résumé of credits and stock photo list. Send unsolicited photos by mail for consideration. Keeps samples on file ("tearsheets; no duplicates"). SASE. Reports in 3 months for first review. Simultaneous submissions and previously published work OK. Pays $75-300/color photo; $25-100/b&w photo. Pays on publication. Buys one-time rights. Credit line given.

Tips: "Our nostalgic books need authentic color taken in the '40s, '50s, and '60s and b&w stock photos. All projects require technical quality: focus must be sharp, no soft focus; colors must be vivid so they 'pop off the page.' "

[N] $ $ [S] [■] [◐] [◎] RODALE PRESS, 400 S. Tenth St., Emmaus PA 18098-0099. (610)967-8948. Fax: (610)967-8961. E-mail: jgalluc1@rodalepress.com. Website: http://www.rodalepress.com. Photo Editor: James A. Gallucci. Estab. 1938. Publishes hardcover originals, trade paperback originals, trade paperback reprints. Subjects include how-to, cooking, men/women health, gardening. Photos used for text illustration, promotional materials, book covers, dust jackets. Examples of recently published titles: *Perenial All-Stars* (text illustrations, promotional materials, book cover, dust jacket); *French Culinary Institute* (text illustrations, promotional materials, book cover, dust jacket). Art guidelines available.

Needs: Needs photos of gardening, pets, religious, health/fitness. Interested in digital, fine art, historical/ vintage. Model and property release required. Photo caption required.

Specs: Uses 35mm, 2¼×2¼, 4×5 transparencies. Accepts images in digital format for Mac. Send via CD, Zip as PICT, JPEG files at 300 dpi.

Making Contact & Terms: Send query letter with slides, tearsheets. Provide self-promotion piece to be kept on file for possible future assignments. Reports back in 2 months only if interested; send nonreturnable samples. Simultaneous submissions and previously pubished work OK. Pays for cover and inside; by the project, $500-750 day rate plus expenses. Pays on publication. Credit line given. Buys one-time and promotional rights, if not provided; negotiable.

Tips: "Research client publications and submit specifically to those needs."

[N] $ $ $[■] [✎] THE ROSEN PUBLISHING GROUP, INC., 29 E. 21st St., New York NY 10010. (212)777-3017. Fax: (212)777-0277. E-mail: rosenprod@erols.com. Photo Manager: Christine Innamorato. Estab. 1950. Publishes juvenile and young adult nonfiction books. Photos used for text illustrations and book covers. Examples of recently published titles: *Body Blues: Weight and Depression*; *Let's Talk About Feeling Nervous*; and *Everything You Need to Know About Sports Injuries*.

Neeeds: Buys 2,000 photos annually; offers 80-100 freelance assignments annually. Needs photos of celebrities, children, couples, multicultural, families, parents, teens, disasters, environmental, wildlife, edu-

cation, religious, health/fitness, sports, science. Interested in documentary, historical/vintage. Reviews stock photos. Model release required for subjects in photo. Captions preferred.

Specs: Buys 5×7, 8×10 color and b&w prints; 35mm, 2¼×2¼ transparencies; 35mm or medium format film. Accepts images in digital format for Mac. Send via CD, Jaz, Zip as EPS files at 300 dpi.

Making Contact & Terms: Arrange personal interview to show portfolio. Query with résumé of credits. Provide résumé, business card, brochure, flier or tearsheets to be kept on file for possible future assignments. Works with freelancers on assignment only. Keeps samples on file. SASE. Reports in 1-2 weeks. Simultaneous submissions and previously published work OK. Pays $500-1,200/job. **Pays on acceptance**. Buys all rights; negotiable. Credit line given.

N $ ▣ ◐ ◎ RUTLEDGE HILL PRESS, 211 Seventh Ave. N., Nashville TN 37219. (615)244-2700. Fax: (615)244-2978. Website: rutledgehillpress.com. Executive Editor: Mike Towle. Estab. 1985. Publishes hardcover originals and reprints, trade paperback originals and reprints. Subjects include Civil War, sports, cookbooks, trivia books, regionalized travel and country music biographies. Photos used for text illustrations, book covers. Examples of recently published titles: *Traveling the Trace* (text illustrations, promotional materials, book cover, dust jacket); *Hogan* (text illustrations, promotional materials, book cover, dust jacket). Catalog available with 8½×11 SASE.

Needs: Buys 1,000 freelance photos annually. Needs photos of celebrities, food/drink, sports, travel. Interested in regional. Other specific photo needs are specific to whatever books are being published at any given time. Model/property release required. Photo caption required; include who, what, where, when.

Specs: Uses 5×7 or 8×10, glossy, color, b&w. Accepts images in digital format. Send via SyQuest, Zip as TIFF files at 300 dpi.

Making Contact & Terms: Send query letter with résumé, photocopies, tearsheets, stock list. Reports in 2 months. Simultaneous submissions and previously published work OK. Pays $50-250 for b&w cover; $100-400 for color cover; $25-100 for b&w inside; $25-125 for color inside. "Expect volume discounts, too." Pays 30 days net of final acceptance. Credit line given. Buys all rights; negotiable.

Tips: "It isn't often that we go to independent photographers, but such photographers need to understand the idiosyncrasies of book publishing and meeting those needs with a willingness to go bottom line on prices. Send dupes only—if you send originals and something happens to them, don't blame us. Look at our catalog. Tape captions to the photos and allow us a lot of time to hold onto the prints or slides."

$ SILVER MOON PRESS, 160 Fifth Ave., Suite 622, New York NY 10010. (212)242-6499. Fax: (212)242-6799. Editor: David Katz. Estab. 1991. Publishes juvenile fiction and general nonfiction. Photos used for text illustration, book covers, dust jackets. Examples of published titles: *Police Lab* (interiors); *Drums at Saratoga* (interiors); *A World of Holidays* (interiors).

Needs: Buys 5-10 photos annually; offers 1 freelance assignment annually. Looking for general-children, subject-specific photos and American historical fiction photos. Reviews general stock photos. Captions preferred.

Making Contact & Terms: No samples. Provide résumé, business card, brochure, flier or tearsheets to be kept on file for possible future assignments. Keeps samples on file. SASE. Reports in 1 month. Simultaneous submissions and/or previously published works OK. Pays $25-100/b&w photo. Pays on publication. Buys all rights; negotiable. Credit line given.

$ $ ▣ ◐ SKYLIGHT TRAINING AND PUBLISHING INC., Simon & Schuster, 2626 S. Clearbrook Dr., Arlington Heights IL 60005. (847)290-7455. Fax: (847)290-6609. E-mail: info@iriskylight.com. Website: http://www.iriskylight.com. Production Supervisor: Bob Crump. Estab. 1976. Publishes trade paperback originals, textbooks. Examples of recently published titles: *Teaching Emotional Intelligence* (book cover); *Brain Compatible Mathematics* (book cover).

Needs: Buys photos of children, parents, teens, education.

Specs: Accepts images in digital format for Mac. Send via CD, Zip, e-mail as TIFF, EPS files at 300 dpi.

Making Contact & Terms: Buys one-time rights. Pays $100-700 for color cover.

Tips: "Follow directions and when submitting work show all the blocks of a shot. Call first. Send sample upon request."

N $ ⑤ ▣ ◐ SMART APPLE MEDIA, 123 S. Broad St., Mankato MN 56001. (507)388-6273. Fax: (507)388-1364. Contact: Photo Editor. Estab. 1994. Publishes hardcover originals and textbooks. Subjects include science, nature, technology, hobbies, geography, animals, space, climate/weather, ecology. Photos used for text illustrations and book covers. Examples of recently published titles: *Bugbooks series* (text illustrations, book cover). Catalog available. Art guidelines available.

Needs: Buys 2,000 freelance photos annually. Needs photos of disasters, environmental, landscape/scenics, wildlife, architecture, cities/urban, education, pets, rural, adventure, automobiles, entertainment, events,

food/drink, health/fitness, hobbies, performing arts, sports, travel, agriculture, buildings, computers, industry, medicine, military, science, technology. Interested in documentary, fine art, historical/vintage, regional. Photo caption required; include name of photographer or agency.

Specs: Uses any size, glossy, matte, color, b&w prints; 35mm, 2¼×2¼, 4×5 transparencies. Accepts images in digital format for Mac. Send via CD, floppy disk, Zip as JPEG files; low resolution for placement submissions, high resolution upon request only.

Making Contact & Terms: Send query letter with photocopies, tearsheets, stock list. Provide self-promotion piece to be kept on file for possible future assignments. Reports in 1 month on queries. Simultaneous submissions and previously pubished work OK. Pays $100-150 for b&w and color cover; $50-150 for b&w and color inside; by the project, $2,000-3,000 for inside and cover shots. Pays on publication. Credit line given. Buys one-time rights, foreign reprints one-third of original fee.

Tips: "We like to see a lot of variety. Often our books are very specific; so many options for a particular subject is best. Be sure the slides are captioned clearly."

$ $ [S] [◻] THE SPEECH BIN INC., 1965 25th Ave., Vero Beach FL 32960. (561)770-0007. Fax: (561)770-0006. Senior Editor: Jan J. Binney. Estab. 1984. Publishes textbooks and instructional materials for speech-language pathologists, occupational and physical therapists, audiologists and special educators. Photos used for book covers, instructional materials and catalogs. Example of published title: *Talking Time* (cover); also catalogs. Catalogs available for $1.60 first-class postage and 9×12 SASE.

Needs: Scenics are currently most needed photos. Also needs events and travel. Model release required.

Specs: Uses any size prints. Accepts images in digital format for Windows as TIFF files at a high resolution.

Making Contact & Terms: Send query letter with photocopies, tearsheets, transparencies, stock list. Does not keep samples on file; include SASE for return of material. SASE. Reports in 1-2 months. Previously published work OK. Payment on publication. Buys one time rights. Credit line given.

Tips: "When presenting your work, select brightly colored eye-catching photos. We like unusual and very colorful seasonal scenics."

$ $ [◻] [◐] SPINSTERS INK, 3241 Columbus Ave. S., Minneapolis MN 55407-2030. (612)827-6177. Fax: (612)827-4417. E-mail: liz@spinsters-ink.com. Website: http://www.spinsters-ink.com. Production Manager: Liz Tufte. Estab. 1978. Publishes feminist books by women. Photos used for book covers. Example of recently published titles: *Closed in Silence* (cover); *A Woman Determined* (cover); and *Deadline for Murder*. Photo guidelines free on request.

Needs: Buys 1 photo annually; offers 6 freelance assignments annually. Wants positive images of women in all their diversity. "We work with photos of women by women." Also needs multicultural, landscapes/scenics. Interested in digital, fine art. Model release required. Captions preferred.

Specs: Uses 5×7, 8×10 color or b&w prints; 4×5 transparencies; Macintosh disk; 100mb Zip disk; photo CD.

Making Contact & Terms: Query with samples. Works with freelancers on assignment only. Keeps samples on file. SASE. Reports in 4-6 weeks. Simultaneous submissions OK. Pays $150-250/job. **Pays on acceptance.** Buys book rights; negotiable. Credit line given.

Tips: "Spinsters Ink books are produced electronically, so we prefer to receive a print as well as a digital image when we accept a job. Please ask for guidelines before sending art."

$ [S] [◐] [◎] STAR PUBLISHING COMPANY, 940 Emmett Ave., Belmont CA 94002. (650)591-3505. Fax: (650)591-3898. E-mail: hoffman@starpublishing.com. Website: http://www.starpublishing.com. Managing Editor: Stuart Hoffman. Estab. 1978. Publishes textbooks, regional history, professional reference books. Photos used for text illustrations, promotional materials and book covers. Examples of recently published titles: *Applied Food Microbiology* and *Medical Mycology*.

Needs: Biological illustrations, photomicrographs, business, industry and commerce. Also wants photos of medicine and environmental. Reviews stock photos. Model release required. Captions required.

Specs: Uses 5×7 minimum b&w and color prints; 35mm transparencies.

**FOR EXPLANATIONS OF THESE SYMBOLS,
SEE THE INSIDE FRONT AND BACK COVERS OF THIS BOOK.**

Making Contact & Terms: Query with samples and list of stock photo subjects. Provide résumé, business card, brochure, flier or tearsheets to be kept on file for possible future assignments. SASE. Reports within 90 days when a response is appropriate. Previously published submissions OK. Payment negotiable "depending on publication, placement and exclusivity." Buys one-time rights; negotiable. Credit line given.
Tips: Wants to see photos that are technically (according to book's subject) correct, showing photographic excellence.

$ $◨ STRANG COMMUNICATIONS COMPANY, 600 Rinehart Rd., Lake Mary FL 32746. (407)333-0600. Fax: (407)333-7100. E-mail: markp@strang.mhs.compuserve.com. Design Assistant: Brittney Tate. Estab. 1975. Publishes religious magazines and books for Sunday School and general readership. Photos used for text illustration, promotional materials, book covers and dust jackets. Examples of recently published titles: *Charisma Magazine*; *New Man Magazine*; *Ministries Today Magazine*; and *Vida Cristiana* (all editorial, cover). Photo guidelines free with SASE.
Needs: Buys 75-100 photos annually; offers 75-100 freelance assignments annually. Needs photos of people, environmental portraits, situations. Reviews stock photos. Model/property release preferred for all subjects. Captions preferred; include who, what, when, where.
Specs: Uses 8×10 prints; 35mm, 2¼×2¼, 4×5 transparencies. Accepts photographs in digital format for Mac (PhotoShop). Send via compact disc, online, floppy disk, SyQuest or Zip disk.
Making Contact & Terms: Arrange personal interview to show portfolio or call and arrange to send portfolio. Query with samples. Provide résumé, business card, brochure, flier or tearsheets to be kept on file for possible future assignments. Works with freelancers on assignment only. Keeps samples on file. SASE. Simultaneous submissions and previously published work OK. Pays $5-75/b&w photo; $50-550/color photo; negotiable with each photographer. Pays on publication and receipt of invoice. Buys one-time, first-time, book, electronic and all rights; negotiable. Credit line given. Offers internships for photographers. Contact Design Manager: Mark Poulalion.

$ $✄ ⃞ THISTLEDOWN PRESS LTD., 633 Main St., Saskatoon, Saskatchewan S7H 0J8 Canada. (306)244-1722. Fax: (306)244-1762. Director of Production: A.M. Forrie. Publishes adult/young adult fiction and poetry. Photos used for text illustration, promotional materials, book covers.
Needs: Looking for realistic color or b&w photos.
Making Contact & Terms: Query with samples. Include SAE and IRCs. "Project oriented—rates negotiable."

$ TRAKKER MAPS INC., 12027 SW 117th Ct., Miami FL 33186. (305)255-4485. Fax: (305)232-5257. Production Manager: Oscar Darias. Estab. 1980. Publishes street atlases and folding maps. Photos used for covers of folding maps and atlas books. Examples of recently published titles: *Florida Folding Map* (cover illustration).
Needs: Buys 3 photos annually. Looking for photos that illustrate the lifestyle/atmosphere of a city or region (beach, swamp, skyline, etc.). Reviews stock photos of Florida cities.
Specs: Uses color prints; 35mm, 2¼×2¼ transparencies.
Making Contact & Terms: Provide résumé, business card, brochure, flier or tearsheets to be kept on file for possible future assignments. Keeps samples on file. SASE. Reports in 1 month. Simultaneous submissions and previously published work OK. Pays $50-200/color photo. **Pays on receipt of invoice**. Buys all rights. Credit line sometimes given depending upon request of photographer.
Tips: "We want to see "clarity at 4×4½" (always vertical) and 6×8" (always horizontal); colors that complement our red-and-yellow cover style; subjects that give a sense of place for Florida's beautiful cities; scenes that draw customers to them and make them want to visit those cities and, naturally, buy one of our maps or atlases to help them navigate. Have patience. We buy few freelance photos but we do buy them. Let your photos do your talking; don't hassle us. *Listen* to what we ask for. We want eye-grabbing shots that *say* the name of the city. For example, a photo of a polo match on the cover of the West Palm Beach folding map says 'West Palm Beach" better than a photo of palm trees or flamingos."

◧ ⃝ ◎ TRUTH CONSCIOUSNESS/DESERT ASHRAM, 3403 W. Sweetwater Dr., Tucson AZ 85745-9301. Editors: Marianne Martin, Sita Stuhlmiller. Estab. 1974. Publishes books and a periodical, *Light of Consciousness, A Journal of Spiritual Awakening* (text illustrations).
Needs: Buys/assigns about 45 photos annually. "Wants universal spiritual, all traditions that in some way illustrate or evoke upliftment, reverence, devotion or other spiritual qualities." Art used relates to or supports a particular article. Also wants: babies, celebrities, children, couples, multicultural, families, parents, senior citizens, teens, beauty, gardening, religious, rural landscapes/scenics, wildlife. Interested in fine art. Model release preferred. Captions preferred.
Specs: Accepts images in digital format for Mac in Photoshop. Send via CD, SyQuest, Zip disk or floppy

disk at 300 dpi, 150 linescreen.

Making Contact & Terms: Send b&w and color slides, cards, prints. Include SASE for return of work. Payment negotiable; prefers gratis. Credit line given; also, artist's name/address/phone (if wished) printed in separate section in magazine.

TUTTLE PUBLISHING, Imprint of Periplus Editions, 153 Milk St., 5th Floor, Boston MA 02109. Fax: (617)951-4045. Estab. 1953 in Japan; 1991 in US. Publishes hardcover originals and reprints; trade paperback originals and reprints. Subjects include cooking, martial arts, alternative health, Eastern religion and philosophy, spirituality. Photos used for text illustrations, promotional materials, book covers, dust jackets. Examples of recently published titles: *Food of Jamaica* (text illustration); *Food of Santa Fe* (text illustration); *An Accidental Office Lady* (cover).

Needs: Buys 50 freelance photos annually. Model release preferred; property release preferred. Photo caption required, include location, description and some additional information-color.

Specs: Uses 35mm, 2¼×2¼, 4×5, 8×10 transparencies.

Making Contact & Terms: Provide résumé, business card, self-promotion piece or tearsheets to be kept on file for possible future assignments. "No calls please." Art director will contact photographer for portfolio review if interested. Portfolio should include color tearsheets. Keeps samples on file. Reports back only if interested, send non-returnable samples. Simultaneous submissions and previously published work OK. Payment varies. Buys one-time rights, all rights.

Tips: "For our regional cookbooks we look for exciting photos that reveal insider familiarity with the place. We are always looking for new interpretations of 'East meets West.'"

2M COMMUNICATIONS LTD., 121 W. 27 St., New York NY 10001. (212)741-1509. Fax: (212)691-4460. President: Madeleine Morel. Estab. 1982. Publishes adult trade biographies. Photos used for text illustration. Examples of previously published titles: *Lauryn Hill, Shania Twain* and *Backstreet Boys;* all for text illustration.

Needs: Buys approximately 200 photos annually. Candids and publicity. Reviews stock photos. Model release required. Captions preferred.

Specs: Uses b&w prints; 35mm transparencies.

Making Contact & Terms: Query with stock photo list. Reports in 1 month. Simultaneous submissions OK. Payment negotiable. Buys one-time, book and world English language rights. Credit line given.

$ $ ▣ ULYSSES PRESS, P.O. Box 3440, Berkeley CA 94703. (510)601-8301. Fax: (510)601-8307. Publisher: Leslie Henriques. Estab. 1983. Publishes trade paperbacks, including travel guidebooks and health books. Photos used for book covers. Examples of previously published titles: *Hidden Hawaii* (cover photos on front and back); *New Key to Costa Rica* (color signature); and *Hidden Southwest* (cover photos).

Needs: Buys hundreds of photos annually. Wants scenic photographs of destinations covered in guidebooks and covers for health books. Some use of portraits for back cover. Model release required. Property release preferred.

Specs: Uses 35mm, 2¼×2¼ transparencies. Accepts images in digital format for Windows. Send via compact disc or Zip disk.

Making Contact & Terms: Query with stock photo list. Provide résumé, business card, brochure, flier or tearsheets to be kept on file for possible future assignments. Does not keep samples on file. Cannot return material. Reports as needed. Simultaneous submissions and previously published work OK. Payment depends on placement and size of photo: $150-350 non-agency color photo. Pays on publication. Buys one-time rights. Credit line given.

$ ▣ U.S. NAVAL INSTITUTE PRESS, 291 Wood Rd., Annapolis MD 21402. (410)268-6110. Fax: (410)269-7940. Contact: Photo Editor. Estab. 1873. Publishes naval and maritime subjects, novels. Photos used for text illustration, promotional materials, book covers and dust jackets. Examples of published titles: *The Hunt for Red October* (book cover); *The U.S.N.I. Guide to Combat Fleet* (70% photos); and *A Year at the U.S. Naval Academy* (tabletop picture book). Photo guidelines free with SASE.

Needs: Buys 240 photos annually; offers 12 freelance assignments annually. "We need dynamic cover-type images that are graphic and illustrative." Reviews stock photos. Model release preferred. Captions required.

Specs: Uses 8×10 glossy color and b&w prints; 35mm, 2¼×2¼, 4×5, 8×10 transparencies. Accepts imges in digital format.

Making Contact & Terms: Query with résumé of credits. Keeps samples on file. SASE. Reports in 1 month. Simultaneous submissions and previously published work OK. Pays $25-200/color and b&w photos. Pays on publication or receipt of invoice. Buys one-time rights; negotiable. Credit line given.

Tips: "Be familiar with publications *Proceedings* and *Naval History* published by U.S. Naval Institute."

◎ **VERNON PUBLICATIONS LLC**, 12437 NE 173rd Place, Woodinville WA 98072. Fax: (425)488-0946. Editorial Director: Wendy McLeod. Estab. 1960. Publishes relocation guides and directories. Photos used for text illustrations, promotional materials and book covers. Examples of published titles: *Greater Seattle Info Guide* (annual guide). Photo guidelines free with SASE, specify which publication you want guidelines for.
 • This publisher likes to see high-resolution, digital images.
Needs: Uses 100-200 photos annually. Needs photos of the Seattle and Puget Sound area only, including King, Snohomish, Pierce, Thurston, Mason and Lewis counties. Model release required. Property release preferred. Captions required; include place, time, subject, and any background information.
Specs: Uses color prints; 35mm, 2¼ × 2¼ transparencies.
Making Contact & Terms: Don't send originals." Include SASE for return. Reporting time varies. Simultaneous submissions and previously published work OK; however, it depends on where the images were previously published. Does not pay. Credit line given.

$ ▣ ◑ **VICTORY PRODUCTIONS**, 581 Pleasant St., Paxton MA 01612. (508)755-0051. Fax: (508)755-0025. E-mail: victory@victoryprd.com. Website: http://www.VictoryPrd.com. Contact: S. Littlewood. Publishes children's books. Examples of recently published titles: *Ecos del Pasado* (text illustrations); and *Enciclopedia Puertorriqueña (text illustrations)*.
Needs: Children and animals. "We do a lot of production for educational companies." Model/property release required.
Specs: Accepts images in digital format for Mac. Send via compact disc, Online, floppy disk, SyQuest or Zip disk.
Making Contact & Terms: Provide résumé, business card, brochure, flier or tearsheets to be kept on file for possible future assignments. Works on assignment only. Keeps samples on file. Reports in 1-2 weeks. Payment negotiable; varies by project. Rights negotiable. Credit line usually given, depending upon project.

VINTAGE BOOKS, Random House, 23-1 201 E. 50th St., New York NY 10022. (212)572-4973. Fax: (212)940-7676. E-mail: mslocum@randomhouse.com. Art Director: John Gall. Publishes trade paperback reprint; fiction. Photos used for book covers. Examples of recently published titles: *Selected Stories*, by Alice Munro (cover); *The Fight*, by Norman Mailer (cover); *Bad Boy*, by Thompson (cover).
Needs: Buys 100 freelance photos annually. Model/property release required. Photo captions preferred.
Making Contact & Terms: Send query letter with samples, stock photo list. Portfolios may be dropped off every Wednesday. Keeps samples on file. Reports back only if interested; send non-returnable samples. Pays by the project, per use negotiation. Pays on publication. Buys one-time and first North American serial rights. Credit line given.
Tips: "Show what you love. Include samples with name, address and phone number."

$ ▣ ◑ ◎ **VOYAGEUR PRESS**, 123 N. Second St., Stillwater MN 55082. Fax: (651)430-2211. E-mail: tberger@voyageurpress.com. Website: http://www.voyageurpress.com. Acquisitions Editor: Todd R. Berger. Estab. 1972. Publishes adult trade books, hardcover originals and hardcover reprints. Subjects include travel, wildlife, Americana, collectibles, dogs, cats, farms, hunting, fishing and cooking. Photos used for text illustrations, book covers, dust jackets, calendars. Examples of recently published titles: *This Old Farm* (text illustrations, book cover, dust jacket); *Love of German Shepherds (text illustrations, book cover, dust jacket)*. Photo guidelines free with SASE.
Needs: Buys 700 photos annually. Primarily wildlife, specific dog breeds and large game animals. Also wants environmental, landscapes/scenics, architecture, cities/urban, rural, automobiles, sports, travel, farm equipment, agricultural, buildings. Interested in documentary, fine art, historical/vintage, regional, seasonal. Artistic angle is crucial—books often emphasize high-quality photos. Model release required. Captions preferred; include location, species, interesting nuggets, depending on situation.
Specs: Uses 35mm, 2¼ × 2¼, 4 × 5, some 8 × 10 transparencies. Accepts images in digital format for Windows. Send via CD, Zip, e-mail as TIFF, BMP, GIF, JPEG files.
Making Contact & Terms: Query with résumé of credits, samples, brochure, detailed stock list or tearsheets to be kept on file for possible future assignments. Keeps samples on file. Cannot return material. Reports back only if interested; send nonreturnable samples. Considers simultaneous submissions. Payment negotiable. Pays on publication. Buys all rights; negotiable. Credit line given.
Tips: "We are often looking for specific material, (crocodile in the Florida Keys; farm scenics in the Southwest; wolf research in Yellowstone) so subject matter is important. But outstanding color and angles, interesting patterns and perspectives, are strongly preferred whenever possible. If you have the capability and stock to put together an entire book, your chances with us are much better. Though we use some freelance material, we publish many more single-photographer works. Include detailed captioning info on

the mounts. Request guidelines. We accept nonreturnable samples and must receive a stocklist."

N **$ $ $** **WARNER BOOKS**, 1271 Avenue of the Americas, 9th Floor, New York NY 10020. (212)522-2842. Vice President & Creative Director/Warner Books: Jackie Merri Meyer. Publishes "everything but text books." Photos used for book covers and dust jackets.

Needs: Buys approximately 100 freelance photos annually; offers approximately 30 assignments annually. Needs photos of landscapes, people, food still life, women and couples. Reviews stock photos. Model release required. Captions preferred.

Specs: Uses color prints/transparencies; also some b&w and hand-tinting.

Making Contact & Terms: Send brochure, flier or tearsheets to be kept on file for possible future assignments. Cannot return unsolicited material. Simultaneous submissions and previously published work OK. Pays $800 and up/color photo; $1,200 and up/job. Buys one-time rights. Credit line given.

Tips: "Printed and published work (color copies are OK, too) are very helpful. Do not call, we do not remember names—we remember samples. Be persistent."

$ **WAVELAND PRESS, INC.**, P.O. Box 400, Prospect Heights IL 60070. (847)634-0081. Fax: (847)634-9501. E-mail: info@waveland.com. Photo Editor: Jan Weissman. Estab. 1975. Publishes college textbooks. Photos used for text illustrations and book covers. Examples of published titles: *Our Global Environment*, Fourth Edition (inside text); *Africa & Africans*, Fifth Edition (chapter openers and cover); and *Intercultural Communication* (text illustrations).

Needs: Number of photos purchased varies depending on type of project and subject matter. Subject matter should relate to college disciplines: criminal justice, anthropology, speech/communication, sociology, archaeology, etc. Needs photos of multicultural, environmental, cities/urban, education, religious, rural, agriculture, political. Interested in fine art, historical/vintage. Model/property release required. Captions preferred.

Specs: Uses 5×7, 8×10 glossy b&w prints. Accepts images in digital format for Windows. Send via CD, Zip, e-mail.

Making Contact & Terms: Query with stock photo list. Provide résumé, business card, brochure, flier or tearsheets to be kept on file for possible future assignments. SASE. Reports in 2-4 weeks. Simultaneous submissions and previously published work OK. Pays $25-100/color or b&w inside; $50-200/cover. Pays on publication. Buys one-time and book rights. Credit line given.

Tips: "Mail stock photo list and price list."

$ **WEIGL EDUCATIONAL PUBLISHERS LIMITED**, 1902 11th St. SE, Calgary, Alberta T2G 3G2 Canada. (403)233-7747. Fax: (403)233-7769. E-mail: calgary@weigl.com. Website: http://www.weigl.com. Attention: Editorial Department. Estab. 1979. Publishes textbooks, library and multimedia resources: social studies, biography, life skills, environment/science studies, multicultural, language arts and geography. Photos used for text illustrations and book covers. Example of published titles: *Early Canada Revised* (cover and inside); *The Untamed World Series* (cover and inside); *Science and Work* (cover and inside); and *Living Science* (cover and inside).

Needs: Buys 200-300 photos annually. Social issues and events, politics, education, technology, people gatherings, multicultural, environment, science, agriculture, life skills, landscape, wildlife, biography and people doing daily activities. Reviews stock photos. Model/property release required. Captions required.

Specs: Uses 5×7, 3×5, 4×6, 8×10 color/b&w prints; 35mm, $2\frac{1}{4} \times 2\frac{1}{4}$ transparencies. Accepts images in digital format for Mac. Send via Cd, Zip, e-mail as TIFF files at 600 dpi.

Making Contact & Terms: Query with samples and stock photo list. Provide tearsheets to be kept on file for possible future assignments. Tearsheets or samples that don't have to be returned are best. Keeps samples on file. SASE. "We generally get in touch when we actually need photos." Simultaneous submissions and previously published work OK. Payment is negotiable. Buys one-time, book and all rights; negotiable. Credit line given (photo credits as appendix).

Tips: Needs "clear, well-framed shots that don't look posed. Action, expression, multicultural representation are important, but above all, education value is sought. People must know what they are looking at. Please keep notes on what is taking place, where and when. As an educational publisher, our books use specific examples as well as general illustrations."

$ **SAMUEL WEISER INC.**, P.O. Box 612, York Beach ME 03910-0612. Fax: (207)363-5799. E-mail: email@weiserbooks.com. Website: http://www.weiserbooks.com. Vice President: B. Lundsted. Estab. 1956. Publishes hardcover originals, hardcover reprints, trade paperback originals and trade reprints on esoterica, Eastern philosophy, astrology, psychology, mysticism, tarot, Kabbalah, magic, Wicca, tai chi, martial arts, alternative health and mystery traditions. Photos used for book covers. Examples

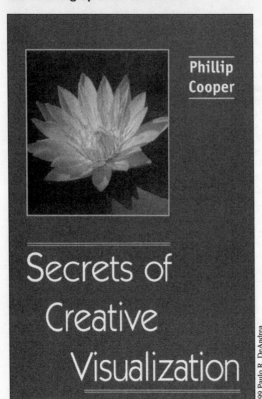

Phillip
Cooper

Secrets of
Creative
Visualization

© 1999 Paulo R. DeAndrea

"It is a simple illustration that crossed our desk at the right time," says Samuel Weiser vice president B. Lundsted of Paulo DeAndrea's flower photograph. The image was chosen for the cover of *Secrets of Creative Visualization*, a self-help book that teaches readers to use mind power techniques to change their lives. Samuel Weiser often uses simple images like lotus flowers on the covers of their books.

of published titles: *Modern Mysticism*, by Michael Gellert (Nicolas Hays imprint); *Foundations of Personality*, by Hamaker-Zondag. Photo guidelines and catalog available.

Needs: Buys 2-5 photos annually. Needs photos of flowers, abstracts (such as sky, paths, roads, sunsets), landscapes/scenics and inspirational or religious themes. Reviews stock photos.

Specs: Uses color prints. Accepts images in digital format for Mac. Send via CD, SyQuest, floppy disk, Jaz, Zip, e-mail as TIFF, EPS, PICT, BMP, GIF, JPEG files.

Making Contact & Terms: Query with photocopies and tearsheets. Send unsolicited photos by mail for consideration. Provide résumé, business card, brochure, flier or tearsheets and self-promotion piece to be kept on file for possible future assignments. "We'll take color snapshots to keep on file, or color copies." Keeps samples on file. SASE. Reports in 2 months. Reports back only if interested; send nonreturnable samples. Simultaneous submissions and previously published work OK. Pays $100-200 for color cover. Pays on **acceptance**. Credit line given. Buys one-time rights. "We pay once for life of book because we do small runs." Credit line given.

Tips: "We don't pay much and we don't ask a lot. We have to keep material on file or we won't use it. Color photocopies, cheap Kodak prints, something that shows us an image that we assume is pristine on a slide and we can call you or fax you for it. We do credit line on back cover, and on copyright page of book, in order to help artist/photographer get publicity. We like to keep inexpensive proofs because we may see a nice photo and not have anything to use it on now. We search our files for covers, usually on tight deadline. Sometimes, we lose good photographers who don't update addresses. We don't want to see goblins and Halloween costumes. Lotus flowers, great roses, a path in the woods—inspirational shots are great."

$ WISCONSIN TRAILS BOOKS, P.O. Box 5650, Madison WI 53705. (608)231-2444. Photo Editor: Kathy Campbell. Estab. 1960. Publishes adult nonfiction, guide books and photo essays. Photos used for text illustration and book covers. Examples of titles: *Ah Wisconsin* (all photographs) and *Best Wisconsin Bike Trips* (cover and ⅓ inside-photos). Photo guidelines free on request with SASE.

Needs: Buys many photos and gives large number of freelance assignments annually. Wisconsin nature

and historic scenes and activities. Captions preferred, include location information.
Specs: Uses 5×7 or 8×10 b&w prints and any size transparencies.
Making Contact & Terms: Query with samples or stock photo list. Provide résumé to be kept on file for possible assignments. SASE. Reports in 1 month. Simultaneous submissions and previously published work OK. Pays $25-100/b&w photo; $50-200/color photo. Buys one-time rights. Credit line given.
Tips: "See our products and know the types of photos we use."

$ $ $ $ ■ ◑ WORD PUBLISHING, P.O. Box 141000, Nashville TN 37214. Executive Art Director: Tom Williams. Estab. 1951. Publishes Christian books. Photos used for book covers, publicity, brochures, posters and product advertising. Examples of recently published titles: *Just Like Jesus*, by Max Lucado; *Angels*, by Billy Graham; and *Power, Money, and Sex*, by Deion Sanders. Photos used for covers. "We do not provide want lists or photographer's guidelines."
Needs: Needs photos of people, studio shots and special effects. Model release required; property release preferred.
Specs: Accepts images in digital format for Mac. Send via CD, Zip, e-mail as TIFF EPS, JPEG files.
Making Contact & Terms: Provide brochure, flier or tearsheets to be kept on file for possible future assignments. "Please don't call." SASE. Reports in 1 month. Assignment photo prices determined by the job. Pays $350-1,500 for stock. Rights negotiable. Credit line given.
Tips: In portfolio or samples, looking for strikingly lighted shots, good composition, clarity of subject. Something unique and unpredictable. "We use the same kinds of photos as the secular market. I don't need crosses, church windows, steeples, or wheat waving in the sunset. Don't send just a letter. Give me something to look at, not to read about." Opportunity is quite limited: "We have hundreds of photographers on file, and we use about 5% of them."

$ ◪ ◎ WUERZ PUBLISHING LTD., 895 McMillan Ave., Winnipeg, Manitoba R3M 0T2 Canada. (204)956-0308. Fax: (204)956-5053. Director: Steve Wuerz. Estab. 1989. Publishes university-level science textbooks, especially in environmental sciences (chemistry, physics and biology). Photos used for text illustrations, book covers to accompany textbooks in diskettes or CD-ROM materials. Examples of published titles: *Mathematical Biology*; *Energy Physics & the Environment*; and *Environmental Chemistry* (all cover and text illustrations). Photo guidelines free with SASE.
Needs: Buys more than 100 photos annually; offers 4 assignments with research combined. Reviews stock photos. Model/property release "as appropriate." Captions required; include location, scale, genus/species.
Making Contact & Terms: Query with résumé of credits, samples and stock photo list. Provide résumé, business card, brochure, flier or tearsheets to be kept on file for possible future assignments. Works on assignment only. SAE and IRCs. Reports usually in 1 month. Simultaneous submissions and previously published work OK. Payment negotiable. Buys book rights. Credit line given.
Tips: "In all cases, the scientific principle or the instrument being displayed must be clearly shown in the photo. In the past we have used photos of smog in Los Angeles and Denver, tree frogs from Amazonia, wind turbines from California, a plasma reactor at Harwell United Kingdom, fireworks over London, and about 50 different viruses. Summarize your capabilities. Summarize your collection of 'stock' photos, preferably with quantities. Outline your 'knowledge level,' or how your collection is organized, so that searches will yield answers in reasonable time."

$ $ ■ ◑ ZOLAND BOOKS, 384 Huron Ave., Cambridge MA 02138. Website: http://www.zoland books.com. Design Director: Lori K. Pease. Publishes adult trade, some juvenile, mostly fiction, some photography, poetry. Photos used for book covers and dust jackets. Examples of recently published titles: *The Long Run of Myles Mayberry,* by Alfred Alcorn (book cover, dust jacket); *Reinventing a Continent*, by André Brink (book cover, dust jacket). Photo guidelines and catalog free with 5×8 SASE.
Needs: Buys 3-5 photos annually; offers 3-5 freelance assignments annually. Subject matter varies greatly with each book.
Specs: Use 4×5 glossy, b&w prints; $2\frac{1}{4} \times 2\frac{1}{4}$, 4×5 transparencies. Accepts images in digital format for Mac. Send via CD.
Making Contact & Terms: Query with samples. Provide résumé, business card, brochure, flier or tearsheets to be kept on file for possible future assignments. Mostly works with freelancers. Keeps samples on file. SASE. Reports in 1-2 months. Simultaneous submissions and previously published work OK. Payment negotiable. **Pays on acceptance**. Rights vary with project; negotiable. Credit line given.

Greeting Cards, Gifts & Products

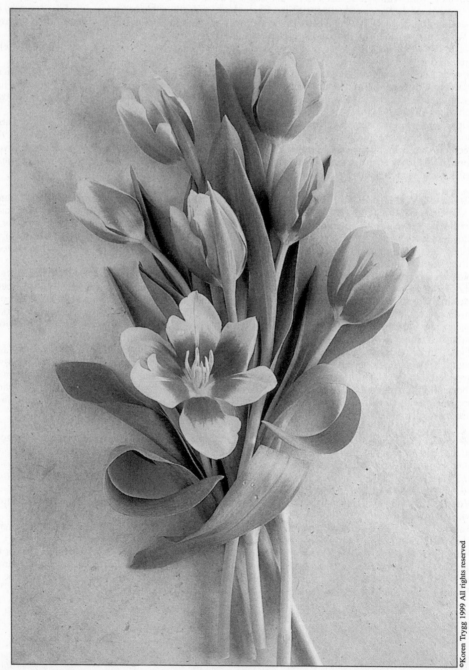

GREETING CARDS AND BEYOND

The greeting card industry takes in close to $7.5 billion a year—80 percent through giants American Greetings, Gibson Greetings and Hallmark Cards. Naturally, the "big three" are difficult companies to break into, but there is plenty of room for photo sales to smaller companies.

There are more than 1,800 greeting card companies in the United States, many of which produce low-priced cards that fill a niche in the market, focusing on anything from the cute to the risqué to seasonal topics. A number of listings in this section produce items like calendars, mugs and posters, as well as greeting cards.

Before approaching greeting card, poster or calendar companies, it's important to research the industry to see what's being bought and sold. Start by checking out card, gift and specialty stores that carry greeting cards and posters. Pay attention to the selections of calendars, especially the large seasonal displays during December. Studying what you see on store shelves will give you an idea of what types of photos are marketable.

There is also a new greeting card industry publication available. Edgell Publications recently started *Greetings etc.* for marketers, publishers, designers and retailers of greeting cards. The magazine offers industry news, and information on trends, new products and trade shows. Look for the magazine at your library or call (973)895-3300, ext. 234 to subscribe.

APPROACHING THE MARKET

After your initial research, query companies you are interested in working with and send a stock photo list. You can help narrow your search by consulting the Subject Index on page 588. Check the index for companies interested in the topics you shoot.

Since these companies receive large volumes of submissions, they often appreciate knowing what is available rather than actually receiving samples. This kind of query can lead to future sales even if your stock inventory doesn't meet their immediate needs. Buyers know they can request additional submissions as their needs change. Some listings in this section advise sending quality samples along with your query while others specifically request only a list. As you plan your queries, follow the instructions to establish a good rapport with companies from the start.

Some larger companies have staff photographers for routine assignments, but also look for freelance images. Usually, this is in the form of stock, and images are especially desirable if they are of unusual subject matter or remote scenic areas for which assignments—even to staff shooters—would be too costly. Freelancers are usually offered assignments once they have established track records and demonstrated a flair for certain techniques, subject matter or locations. Smaller companies are more receptive to working with freelancers, though they are less likely to assign work because of smaller budgets for photography.

The pay in this market can be quite lucrative if you provide the right image at the right time for a client in need of it, or if you develop a working relationship with one or a few of the better paying markets. You should be aware, though, that one reason for higher rates of payment in this market is that these companies may want to buy all rights to images. But with changes in the copyright law, many companies are more willing to negotiate sales which specify all rights for limited time periods or exclusive product rights rather than complete surrender of copyright.

◄ "I look for the beauty in life and try to capture it in my photographs," says Koren Trygg. She submitted this delicate tulip image to Recycled Paper Greetings for review and they purchased greeting cards rights for the image in exchange for a royalty percentage. "Recycled Paper Greetings has used my photography for the past 12 years on a freelance basis," explains Trygg.

$ACME GRAPHICS, INC., Box 1348, Cedar Rapids IA 52406. (319)364-0233. Fax: (319)363-6437. President: Stan Richardson. Estab. 1913. Specializes in printed merchandise for funeral directors.
Needs: Religious, nature. Reviews stock photos.
Specs: Uses 35mm transparencies; color contact sheets; color negatives.
Making Contact & Terms: Query with samples. SASE. Reports in 2 weeks. Pays $50/b&w photo; $50/color photo. Also, pays according to price set by photographer. **Pays on acceptance.** Buys all rights.

$ $⬛ ⬤ADVANCED GRAPHICS, P.O. Box 8517, 2101 Martin Way, Pittsburg CA 94565. (925)432-2262. Fax: (925)432-9259. E-mail: adv2101@aol.com. Website: http://www.cardboardpeople.com. Photo Editor: Steve Henderson. Estab. 1985. Specializes in life-size standups and cardboard displays, decorations and party supplies.
Needs: Buys 20 images annually; number supplied by freelancers varies. Interested in celebrities (movie and TV stars, entertainers), babies, children, couples, multicultural, families, parents, senior citizens, teens, wildlife, seasonal. Reviews stock photos.
Specs: Uses 4×5, 8×10 transparencies. Accepts images in digital format. Send via CD floppy disk, Jaz, Zip, e-mail.
Making Contact & Terms: Query with stock photo list. Keeps samples on file. SASE. Reports in 1 month. Pays $400 maximum per image; royalties of 7-10%. Simultaneous submissions and/or previously published work OK. **Pays on acceptance.** Buys exclusive product rights; negotiable. Credit line given.
Tips: "We specialize in publishing life-size standups which are cardboard displays of celebrities. Any pictures we use must show the entire person, head to toe. We must also obtain a license for each image that we use from the celebrity pictured or from that celebrity's estate. The image should be vertical and not too wide."

⬤ALFRESCO PUBLICATIONS, P.O. Box 14191, Tulsa OK 74159. President: Jim Bonner. Estab. 1989. Specializes in posters, framing prints and print sets. Photo guidelines $1 with SASE.
Needs: Buys 300-400 images annually; all supplied by freelancers. Interested in glamour, semi-nude, nude. Model release required.
Specs: Uses color prints.
Making Contact & Terms: Send for guidelines. Does not keep samples on file. SASE. Reports in 1 week. Simultaneous submissions and/or previously published work OK. **Pays on acceptance.** Buys all rights; negotiable. Credit line sometimes given depending upon usage.
Tips: "We like working with beginners using amateur models, so we don't have to teach them how to avoid the professional posed look. If you are looking for your first sale, we want to see your work."

◩ART IN MOTION, 2000 Hartley Ave., Coquitlam, British Columbia V3K 6W5 Canada. (604)525-3900. Fax: (604)525-6166. Submissions Director: Jackie White. Specializes in greeting cards, postcards, posters, framing prints and wall decor.
Needs: "We are publishers of fine art reproductions, so we have not been involved in the use of photographs until now. We are not looking for ordinary photographs. Decorative subjects with alternative techniques, like polaroid transfers or hand coloring a plus. Looking for creativity only."
Making Contact & Terms: Submit portfolio for review. Does not keep samples on file. Reports in 1-2 weeks. Simultaneous submissions OK. Payment negotiable. Pays on usage. Buys all rights; negotiable. Credit line given.

$ $⒜ ⬛ ⬤ART RESOURCE INTERNATIONAL LTD./BON ART, Fields Lane, Brewster NY 10509. (914)277-8888. Fax: (914)277-8602. E-mail: sales@fineartpublishers.com. Website: http://www.fineartpublishers.com. Vice President: Robin Bonnist. Estab. 1980. Specializes in posters and open edition fine art prints.
Needs: Buys 50 images/year. Interested in landscapes, scenics, wildlife, architecture, cities/urban, gardening, interiors/decorating, rural, adventure, health/fitness, extreme sports, fine art. Model release required. Captions preferred.
Specs: Uses 35mm, 4×5 and 8×10 transparencies. Accepts images in digital format for Windows. Send via CD, floppy disk, Zip, e-mail as TIFF, JPEG files at 72 dpi.
Making Contact & Terms: Send unsolicited photos by mail for consideration. Works on assignment only. SASE. Reports in 1 month. Simultaneous submissions and previously published work OK. Pays advance against royalties—specific dollar amount is subjective to project. Pays on publication. Buys all rights; exclusive reproduction rights. Credit line given if required.

Tips: "Send us new and exciting material; subject matter with universal appeal. Submit color copies, slides, transparencies, actual photos of your work, and if we feel the subject matter is relevant to the projects we are currently working on, we'll contact you."

ASHTON-DRAKE GALLERIES, 9200 N. Maryland Ave., Niles IL 60714. (847)581-8107. Fax: (847)966-3026. Senior Manager Artist Relations and Recruitment: Andrea Ship. Estab. 1985. Specializes in collectible dolls and ornaments.

Needs: Interested in children, babies and fashion. Model release required.

Specs: Uses color prints; 8×10 transparencies.

Making Contact & Terms: Submit portfolio for review. Works with freelancers on assignment only. Keeps samples on file. Reports in 1 month or more. Pays flat fee for job. **Pays on acceptance.** Buys all rights.

$ $ ▨ ◑ ◎ **AVANTI PRESS INC.**, 134 Spring St., Suite 602, New York NY 10012. Fax: (212)941-8008. Attention: Art Submissions. Estab. 1980. Specializes in photographic greeting cards, note cards and related products. Photo guidelines free with SASE.

Needs: Buys approximately 250 images annually; all supplied by freelancers. Offers assignments annually. For Avanti line, interested in humorous, narrative, colorful, simple, to the point: babies, children (4 years old and younger with universal appeal), animals (in humorous situations). 4U line uses personal, artistic, expressive, friendly, intimate and whimsical imagery of children, couples, animated still lifes and exceptional florals to illustrate general celebrations, romance, love, friendship and specific events (birth, wedding, support, holidays). Has specific deadlines for seasonal material. Does NOT want travel, sunsets, landscapes, nudes, high-tech. Reviews stock photos. Model/property release required.

Specs: Will work with all mediums and formats. Accepts images in digital format for Mac. Send via CD, Jaz, Zip as TIFF, JPEG files.

Making Contact & Terms: Request guidelines for submission with SASE or visit website. Arrange personal interview to show portfolio or query with stock photo list. DO NOT submit original material. Pays on license. Buys 5-year worldwide, exclusive card rights. Credit line given.

Tips: "Know our card lines. Stretch the boundaries of creativity."

Ⓝ $ $ Ⓢ ▨ ◐ **BARTON-COTTON, INC.**, % 10099 S.E. White Pelican Way, Jupiter FL 33469. (561)743-4700. Fax: (561)743-4704. Art Acquisitions Manager: Carol White. Estab. 1928. Specializes in calendars, greeting cards, stationery. Art guidelines available.

Needs: Buys 80 images annually; 40 are supplied by freelancers. Needs photos of environment, landscapes/scenics, wildlife, pets, religious. Interested in seasonal images. Submit seasonal material 6 months in advance. Photo captions are required.

Specs: Uses 35mm 4×5 transparencies. Accepts images in digital format. Send via CD, Zip.

Making Contact & Terms: Send query letter with résumé, slides, tearsheets, stock list. Provide résumé, business card to be kept on file for possible future assignments. Reports in 1 month on queries. Send nonreturnable samples. Previously published work OK. Pays by the project, $150-500/image. **Pays on acceptance.** Credit line given. Buys one-time or all rights; negotiable.

$ $ $ BEPUZZLED, 22 E. Newberry Rd., Bloomfield CT 06002. (800)874-6556. Fax: (860)769-5799. Creative Service Manager: Sue Tyska. Estab. 1986. Specializes in mystery, puzzles and games.

Needs: Buys 10-20 images annually; 10% supplied by freelancers. Offers 50-70 assignments annually. Interested in humorous and seasonal. Submit seasonal material 3 months in advance. Reviews stock photos. Model/property release required.

Specs: Uses 2¼×2¼, 4×5, 8×10 transparencies.

Making Contact & Terms: Arrange personal interview to show portfolio. Provide résumé, business card, self-promotion piece or tearsheets to be kept on file for possible future assignments. Works with local freelancers only. Keeps samples on file. SASE. Cannot return material. Call to follow up. Simultaneous

submissions OK. Pays $1,000-1,500/job. Pays on usage. Buys all rights, exclusive product rights and world-wide rights. Credit line sometimes given.

Tips: "We use very little digital photography. We prefer local photographers (but have used stock or other photos). We have two cycles a year for development of new products—timing is everything."

$ $ $ [S] [■] [◎] BILLIARD LIBRARY COMPANY, 1570 Seabright Ave., Long Beach CA 90813. (562)437-5413. Fax: (562)436-8817. E-mail: info@billiardlibrary.com. Website: http://www.billiardlibrary.com. Production Manager: Darian Baskin. Estab. 1973. Specializes in calendars, giftwrap, greeting cards, mugs, ornaments, posters, T-shirts.

Needs: Buys 3-7 images annually; all supplied by freelancers. "We specialize in leisure sports, specifically billiards, but also bowling and darts." Model/property release preferred.

Specs: Uses any size color and b&w prints; 35mm, 2¼×2¼, 4×5, 8×10 transparencies. Accepts images in digital format for Mac, Windows. Send via CD, Jaz, Zip as TIFF, EPS, GIF, JPEG files.

Making Contact & Terms: Query with samples. Keeps samples on file. Reports in 1 month. Simultaneous submissions and/or previously published work OK. Pays royalty of 7.5-10% on images based on prints sold. Pays on usage. Credit line given.

Tips: "First, be sure the subject matter is either billiards, bowling or darts. Then, simply send a sample with some artist background information. We'll contact you if the submission fits our needs."

$ $ [S] [■] [◢] [◎] BLUE SKY PUBLISHING, P.O. Box 19974, Boulder CO 80308-2974. (303)530-4654. Fax: (303)530-4627. Estab. 1989. Specializes in greeting cards, calendars, stationary, address books, journals and note pads.

Needs: Buys 12-24 images annually; all supplied by freelancers. Interested in Rocky Mountain winter landscapes, dramatic winter scenes featuring wildlife in mountain settings, winter scenes from the Southwest, unique and creative Christmas still life images, and scenes that express the warmth and romance of the holidays. Submit seasonal material 1 year in advance. Reviews stock photos. Model/property release preferred.

Specs: Uses 35mm, 4×5 (preferred) transparencies. Accepts images in digital format for Mac.

Making Contact & Terms: Submit 24-48 of your best images for review. Provide résumé, business card, self-promotion piece or tearsheets to be kept on file for possible future assignments. Keeps samples on file. SASE. "We try to respond within one month—sometimes runs two months." Simultaneous submissions and/or previously published work OK. Pays $150 advance against royalties; 3-5% royalties. **Pays on acceptance**. Buys exclusive product rights for 5 years; negotiable. Credit line given.

Tips: "We choose photographs with expressive use of color and composition, and strong emotional impact."

[■] BRISTOL GIFT CO. INC., P.O. Box 425, Washingtonville NY 10992. (914)496-2821. Fax: (914)496-2859. E-mail: bristolg@frontiernet.net. President: Matthew Ropiecki. Estab. 1988. Specializes in framing prints and wall decor.

Needs: Interested in religious, nature, still life. Submit seasonal material 6 months in advance. Reviews stock photos. Model/property release preferred.

Specs: Uses 4×5, 8×10 color prints; 4×5 transparencies. Accepts images in digital format for Windows. Send via compact disc or floppy disk.

Making Contact & Terms: Query with samples. Keeps samples on file. SASE. Reports in 1 month. Previously published work OK. Payment negotiable; depends on agreement. Buys exclusive product rights.

[N] $ $ BURGOYNE INC., 2030 E. Byberry Rd., Philadelphia PA 19116. (215)677-8000. Fax: (215)677-6081. Contact: Creative Director. Estab. 1907. Specializes in greeting cards.

Needs: Buys numerous photos annually; all are supplied by freelancers. Interested in holiday themes—especially humorous Christmas (i.e. with kids, animals, etc.). Does not want anything other than winter and/or Christmas season.

Specs: Uses 4×5 transparencies.

Making Contact & Terms: Query with samples. Provide résumé, business card, self-promotion piece or tearsheets to be kept on file for possible future assignments. Keeps samples on file. SASE. Reports in 1-2 months. Pays $300 minimum/color photo. **Pays on acceptance.** Buys exclusive product rights. Credit line sometimes given depending upon layout of card and upon request.

[■] [◢] CARDMAKERS, High Bridge Rd., P.O. Box 236, Lyme NH 03768. (603)795-4422. Fax: (603)795-4222. Owner: Peter D. Diebold. Estab. 1978. Specializes in greeting cards.

● This company expects photo cards to be a growing portion of their business.

Needs: Buys stock and assigns work. Needs nautical scenes which make appropriate Christmas and

everyday card illustrations. Also needs adventure, automobiles, entertainment, health/fitness, hobbies, humor, sports, travel. Interested in alternative process, avant garde, digital, historical/vintage, seasonal. Model/property release preferred.

Specs: Uses color prints; 35mm, 4×5, 8×10 transparencies. Accepts images in digital format for Windows.

Making Contact & Terms: Provide self-promotion piece to be kept on file for possible future assignments. Keeps samples on file. SASE. Reports in 3 weeks. Simultaneous submissions and previously published work OK. Pays by the project, $100 minimum per image. **Pays on acceptance.** Buys exclusive product rights and all rights; negotiable. Credit line negotiable.

Tips: "We are seeking photos primarily for our nautical Christmas and everyday card line but would also be interested in any which might have potential for business to business Christmas greeting cards. Emphasis is on humorous situations. A combination of humor and nautical scenes is best. Please do not load us up with tons of stuff. We have recently acquired/published designs using photos and are active in the market presently. The best time to approach us is during the first nine months of the year (when we can spend more time reviewing submissions)."

N 🖼 🖉 CASCADE GEOGRAPHIC SOCIETY, P.O. Box 294, Rhododendron OR 97049. Curator: Michael P. Jones. Estab. 1979. "Our photographs are for exhibits, educational materials, fliers, posters, etc., including historical artifact catalogs. We are a nonprofit organization." Photo guidelines free with SASE.

Needs: Buys 200 photos annually; offers 20 freelance assignments annually. Needs American history, wildlife, old buildings, Civil War, Revolutionary War, Indian Wars, Oregon Trail, pioneer history, living history, historical re-enactment, nature and environmental. Also interested in celebrities, children, couples, multicultural, families, parents, senior citizens, disasters, environmental, architecture, cities, education, gardening, pets, rural, adventure, automobiles, entertainment, events, health/fitness, hobbies, humor, performing arts, sports, travel, agriculture, buildings, industry, military, political, portraits, still life, science, technology, alternative process, avant garde, documentary, fashion, glamour, fine art, regional, seasonal. Examples of recent uses: "Enola Hill" (American Indian sacred site); "Oregon Trail" (educational exhibit); wild mushroom exhibit (species and habitat). Model release preferred. Captions preferred.

Specs: Uses 5×7, 8×10 b&w or color prints; 35mm, 2¼×2¼, 4×5, 8×10 transparencies; videotape.

Making Contact & Terms: Query with résumé of credits. Send unsolicited photos by mail for consideration. Submit portfolio for review. Provide résumé, business card, brochure, flier or tearsheets to be kept on file for possible future assignments. Works on assignment only. Keeps samples on file. SASE. Reports in 3 weeks. Simultaneous submissions and previously published work OK. Offers copies of published images in place of payment. Buys one-time rights. Credit line given. Offers internships for photographers year-round.

Tips: "We want photos that bond people to the earth and history. Send us enough samples so that we can really understand you and your work. Think of nature and think of history. Capture these subjects with your lens and we'll be interested in your photography. Be patient. More and more doors are being opened for photographers due to multimedia. We are moving in that direction."

$ $ S 🖉 CEDCO PUBLISHING CO., 100 Pelican Way., San Rafael CA 94901. Website: http://www.cedco.com. Contact: Photo Dept. Estab. 1980. Specializes in calendars and picture books. Photo guidelines free with SASE or refer to website under "art submission guidelines."

Needs: Buys 1,500 images/year; 1,000 supplied by freelancers. Wildlife: whales, dolphins, Australian wildlife. Travel/scenic: Ireland, Israel, islands. Sports: Adventure sports, surfing. Misc: pigs, golf courses, Buddhas, men in swimsuits on the beach, footprints in sand, flowers, crystals and minerals, inspirational, sailing. New ideas welcome. Model/property release required. Captions required.

Specs: Uses 35mm, 2¼×2¼, 4×5, 8×10 transparencies.

Making Contact & Terms: Query with non-returnable samples and a list of stock photo subjects. "Do not send any returnable material unless requested." Keeps samples on file. Reports as needed. Simultaneous submissions and previously published work OK. Pays by the project, $100-250. Pays the December prior to the year the calendar is dated (i.e., if calendar is 2000, photographers are paid in December 1999). Buys one-time rights. Credit line given.

Tips: No phone calls.

$ 🖾 CENTRIC CORPORATION, 6712 Melrose Ave., Los Angeles CA 90038. (213)936-2100. Fax: (213)936-2101. E-mail: centric@juno.com. President: Sammy Okdot. Estab. 1986. Specializes in gift products: T-shirts, clocks, watches, pens, mugs and frames.

Needs: Interested in humor, nature and thought-provoking images. Submit seasonal material 5 months in advance. Reviews stock photos.

Specs: Uses 8½ × 11 color and b&w prints; 35mm transparencies.
Making Contact & Terms: Submit portfolio for review or query with résumé of credits. Provide résumé, business card, self-promotion piece or tearsheets to be kept on file for possible future assignments. Works with local freelancers only. Keeps samples on file. SASE. Reports in 1-2 weeks. Pays by the job; negotiable. **Pays on acceptance.** Rights negotiable.

N $ S ■ ◯ CITY MERCHANDISE INC., P.O. Box 320081, 68 34th St., Brooklyn NY 11232. (718)832-2931. Fax: (718)832-2939. E-mail: citymdse@aol.com. Website: http://www.citymerchandise.com. Contact: Heather Bowe. Estab. 1986. Specializes in bookmarks, calendars, CD-ROMS, gifts, greeting cards, mugs.
Needs: Buys 100 images annually; all supplied by freelancers. Needs New York and New Jersey scenes and photos of babies, landscapes/scenics, food/drink, travel. Model and property release preferred. Photo captions preferred.
Specs: Uses 35mm, 2¼ × 2¼, 4 × 5, 8 × 10. Accepts images in digital format for Mac.
Making Contact & Terms: Send query letter with slides, transparencies. Portfolio may be dropped off every Friday. Keeps samples on file. Reports in 6 weeks on queries. Simultaneous submissions and previously published work OK. Pays on publication. Buys all rights; negotiable.

$ ■ ◎ COMSTOCK CARDS, 600 S. Rock Blvd., Suite 15, Reno NV 89502. (702)856-9400. Fax: (702)856-9406. E-mail: comstock@intercomm.com. Website: http://www.comstockcards.com. Contact: Cindy Thomas or Patti Wolf. Estab. 1986. Specializes in greeting cards, invitations, notepads, games and gift wrap. Photo guidelines free with SASE.
Needs: Buys/assigns 30-40 photos/year; all supplied by freelancers. Want wild, outrageous and shocking adult humor; seductive hot men or women images. "No male frontal nudity. We like suggestive images, not 'in your face' images." Definitely does not want to see traditional, sweet, cute, animals or scenics. "If it's appropriate to show your mother, we don't want it!" Submit seasonal material 10 months in advance. Model/property release required. Photo captions preferred with cutline.
Specs: Uses 5 × 7 color prints, 35mm, 2¼ × 2¼ color transparencies. Accepts images in digital format.
Making Contact & Terms: Query with samples and tearsheets. SASE. Reports in 1-2 months. Pays $50-150/color photo. Pays on publication. Buys all rights; negotiable. Credit line given if requested.
Tips: "Submit with SASE if you want material returned."

$ $ S ■ ◯ CONCORD LITHO GROUP, 92 Old Turnpike Rd., Concord NH 03301. (603)225-3328. Fax: (603)225-6120. Website: http://www.concordlitho.com. Vice President/Creative Services: Lester Zaiontz. Estab. 1958. Specializes in bookmarks, greeting cards, calendars, postcards, posters, framing prints, stationery and gift wrap. Photo guidelines free with SASE.
Needs: Buys 150 images annually; 60% are supplied by freelancers. Does not offer assignments. Interested in nature, seasonal, domestic animals, dogs and cats, religious, inspirational, florals and scenics. Also considers children, multicultural, families, parents, senior citizens, teens, gardening, rural, business concepts, fine art, regional. Submit seasonal material minimum 6-8 months in advance. Does not want nudes, comedy or humorous—nothing wild or contemporary. Model/property release required for historical/nostalgia, homes and gardens, dogs and cats. Captions preferred; include accurate information pertaining to image (location, dates, species, etc.).
Specs: Uses 8 × 10 satin color prints; 35mm, 2¼ × 2¼, 4 × 5, 8 × 10 transparencies. Accepts images in digital format for Mac. Send via CD, Jaz, Zip as TIFF, EPS, JPEG files.
Making Contact & Terms: Submit samples/dupes for review along with stock photo list. Keeps samples/dupes on file. SASE. Reporting time may be as long as 6 months. Simultaneous submissions and/or previously published work OK. Pays by the project, $150-800. Pays on usage. Buys one-time rights. Credit line sometimes given depending upon client and/or product.

■ CREATIVE ARTS BOOK COMPANY, 833 Bancroft Way, Berkeley CA 94710. (570)848-4777. Fax: (570)848-4844. Website: http://www.creativeartsbooks.com. Editor: G. Samsa. Estab. 1968. Specializes in calendars, books.
Needs: Buys 150 images annually; 100% are supplied by freelancers. Interested in everything but religious. Submit seasonal material 9-12 months in advance. Reviews stock photos. Model/property release preferred. Photo caption preferred.
Specs: Uses any size color or b&w prints; 35mm, 4 × 5 transparencies. Accepts images in digital format.
Making Contact & Terms: Send query letter with samples, brochure, stock photo list, tearsheets. Provide résumé, business card, self-promotion piece or tearsheets to be kept on file for possible future assignments. To show portfolio, photographer should follow-up with letter after initial query. Portfolio should include b&w and/or color, prints, tearsheets, slides or thumbnails. Does not keep samples on file. SASE. Reports

in 2 months on queries; 1 month on samples. Payment varies by project. Pays on publication. Buys one-time rights; negotiable. Credit line given.

N $ $□ ⊘ CURRENT, INC., Taylor Corporation, 1005 E. Woodmen Rd., Colorado Springs CO 80920. (719)594-4100. Fax: (719)531-2564. Freelance Manager: Dana Grignano. Estab. 1940. Specializes in bookmarks, calendars, decorations, games, gifts, giftwrap, greeting cards, limited edition plates, mugs, ornaments, stationery. Art guidelines for SASE.
Needs: Buys at least 50 images annually; all are supplied by freelancers. Needs photos of babies, children, landscapes/scenics, wildlife, gardening, rural, adventure, humor, travel. Interested in fine art, regional, seasonal. Submit seasonal material 16 months in advance. Model release required.
Specs: Uses 35mm, 2¼×2¼, 4×5, 8×10 transparencies. Accepts images in digital format for Mac. Send via CD, SyQuest.
Making Contact & Terms: Send query letter with photocopies, tearsheets, transparencies. Keeps samples on file. Reports back only if interested, send nonreturnable samples. Considers previously published work. Pays $500 maximum per image. **Pays on acceptance**, receipt of invoice. Credit line sometimes given depending upon product type. Buys one-time rights, all rights; negotiable.
Tips: "Request and review catalog prior to sending work to see what we look for." Also uses photographers for advertising and catalogs.

$ A □ ⊘ DALOIA DESIGN, P.O. Box 140268, Howard Beach NY 11414. (718)835-7641. E-mail: daloiades@aol.com. Owner/Creative Director: Peter Daloia. Estab. 1983. Specializes in bookmarks, gifts, giftwrap, stationery, k-rings, frames, magnets, mirrors, doorhangers, etc.
Needs: Uses freelancers for humorous, abstract, odd shots, backgrounds, collage, montage, patterns, scenics, nature, textures. Reviews stock photos in all categories. Model/property release required.
Specs: Uses 8×10, 5×7, 4×6 color and b&w prints; 35mm slides. Accepts images in digital format. Send via CD, floppy disk, e-mail as BMP, JPEG files.
Making Contact & Terms: Query with samples. Provide résumé, business card, samples to be kept on file for possible future assignments. Works with freelancers on assignment only. Keeps samples on file. Cannot return material. Reports only when interested. Pays "prevailing rates or royalties." Pays upon usage. Buys one-time rights and exclusive product rights. Credit line sometimes given depending on use.
Tips: "Show everything, even what you don't think is good. Send several print samples/contact sheets so we can see style, quality, creativity, subjects, etc."

□ DESIGN DESIGN, INC., P.O. Box 2266, Grand Rapids MI 49501. (616)774-2448. Fax: (616)774-4020. Creative Director: Tom Vituj. Estab. 1986. Specializes in greeting cards.
Needs: Licenses stock images from freelancers and assigns work. Specializes in humorous topics. Submit seasonal material 1 year in advance. Model/property release required.
Specs: Accepts images in digital format for Mac. Send via SyQuest or Zip disk.
Making Contact & Terms: Submit portfolio for review. Provide résumé, business card, self-promotion piece or tearsheets to be kept on file for possible future assignments. Do not send original work. SASE. Pays royalties, negotiable. Pays upon sales. Credit line given.

N $○ □ DESIGNER GREETINGS, P.O. Box 140729, Staten Island NY 10314. (718)981-7700. Fax: (718)981-0151. Contact: Art Department. Estab. 1978. Specializes in greeting cards. Art guidelines available.
Needs: Buys 100 images annually; all are supplied by freelancers. Needs photos of babies, children, environmental, landscapes/scenics, wildlife, beauty, pets, humor. Interested in alternative process, avant garde, digital, fine art, historical/vintage, regional, seasonal. Submit seasonal material 6 months in advance. Model/property release preferred.
Specs: Uses 35mm, 2¼×2¼, 4×5 transparencies. Accepts images in digital format for Mac. Send via SyQuest, Jaz, Zip as TIFF, EPS files.
Making Contact & Terms: Send query letter with slides, prints, photocopies, tearsheets, transparencies, stock list. Reports only if interested in 1 month. Simultaneous submissions and previously published work OK. Pays by the project; $75-150/image. **Pays on acceptance.** Buys greeting card rights.

□ DODO GRAPHICS INC., P.O. Box 585, Plattsburgh NY 12901. (518)561-7294. Fax: (518)561-6720. President: Frank How. Estab. 1979. Specializes in posters and framing prints.
Needs: Buys 50-100 images annually; 100% supplied by freelancers. Offers 25-50 assignments annually. Needs all subjects. Submit seasonal material 3 months in advance. Reviews stock photos. Model/property release preferred. Captions preferred.
Specs: Uses color and b&w prints; 35mm, 4×5 transparencies.

Making Contact & Terms: Submit portfolio for review. Query with samples and stock photo list. Works on assignment only. Keeps samples on file. SASE. Reports in 1 month. Simultaneous submissions OK. Payment negotiable. **Pays on acceptance.** Buys all rights; negotiable. Credit line given.

$ ⑤ ▣ ◪ DYNAMIC GRAPHICS, 6000 Forest Park Dr., Peoria IL 61614. (309)687-0236. Fax: (309)688-8828. E-mail: henvick@dgusa.com. Website: http://www.dgusa.com. Photo Editor: Jenna Henvick. Estab. 1964. Specializes in CD-ROMs, clip-art. Guidelines sheet free with SASE.

Needs: Buys 275+ images annually; 50% are supplied by freelancers. Interested in holiday and seasonal, retail and model-released people photos. Submit seasonal material 6 months in advance. Not interested in copyrighted material (logos, etc.). Subjects include babies, children, couples, multicultural, families, parents, senior citizens, teens, landscapes/scenics, wildlife, education, gardening, religious holidays, adventure, events, health/fitness, travel, business concepts, medicine, avant garde, fashion/glamour. Only want tasteful, conservative photos. Reviews stock photos of holiday, seasonal, model interaction. Model/property release required for all identifiable people and places.

Specs: Uses 8×10 color b&w prints; 35mm, 2¼×2¼ transparencies. Accepts images in digital format: Accepts images in digital format for Mac. Send via CD, Jaz, Zip as TIFF, EPS, JPEG files at 300 dpi.

Making Contact & Terms: Send query letter with samples. Art director will contact photographer for portfolio review if interested. Portfolio should include b&w and/or color, prints, slides, transparencies. Does not keep samples on file; include SASE for return of material. Reports in 2 weeks on queries; 6-8 weeks on samples. Pays by the project, $100 minimum; $150 maximum for color (depends on quality and need); $60-85 for b&w. Pays on receipt of invoice. Buys one-time rights. Credit line not given.

Tips: "We use photos also as illustration reference, and in several aspects of our company besides clip-art, including advertising and marketing promos. Send in a submission or request for guidelines via mail or e-mail."

$ $ ⑤ ◪ ELEGANT GREETING, 2330 Westwood Blvd., Suite 205, Los Angeles CA 90064. (310)446-4929. Fax: (310)446-4819. Owner: Sheldon Steier. Estab. 1991. Specializes in greeting cards, calendars, postcards, posters, framing prints, stationery, mugs and T-shirts.

Needs: Wants all types of subject matter. Currently looking for humorous, seasonal, girl friends, spiritual, babies, children, couples, architecture, beauty, cities/urban, gardening, pets, adventure, automobiles. Interested in avant garde, fashion/glamour, fine art, historical/vintage.

Specs: Accepts images in digital format for Windows.

Making Contact & Terms: Submit portfolio for review. Works with local freelancers only. SASE Reports in 1-2 weeks. Payment negotiable. Credit line given.

Tips: "Basically, my company provides sales and marketing services for a wide variety of publishers of cards and boxed stationery and gift items. If I see something I like, I submit it to a manufacturer."

Ⓝ $ $ ⑤ ◪ KRISTIN ELLIOTT, INC., 6 Opportunity Way, Newburyport MA 01950. (978)526-7126. Fax: (978)465-6522. Creative Director: Barbara Elliott. Estab. 1946. Specializes in greeting cards, stationery.

Needs: Buys 20 images annually; all are supplied by freelancers. Needs photos of animals and wildlife. Also interested in environmental, landscapes/scenics, beauty, cities/urban, interiors/decorating, pets, rural, performing arts, travel, fine art, regional, seasonal. Submit seasonal material by August 1.

Specs: Uses 3½×5 glossy, color prints.

Making Contact & Terms: Send query letter with prints, photocopies, tearsheets. Provide self-promotion piece to be kept on file. Reports in 3 weeks on queries. Payment negotiable. Pays on distribution.

Tips: Looking for "full-color, upbeat subjects."

$ FLASHCARDS, INC., 1211A NE Eighth Ave., Fort Lauderdale FL 33304. (954)467-1141. Photo Researcher: Micklos Huggins. Estab. 1980. Specializes in postcards, greeting cards, notecards and posters.

Needs: Buys 500 images/year. Humorous, human interest, animals in humorous situations, nostalgic looks, Christmas material, valentines, children in interesting and humorous situations. No traditional postcard material; no florals or scenic. "If the photo needs explaining, it's probably not for us." Submit seasonal material 8 months in advance. Reviews stock photos. Model release required.

Specs: Uses any size color or b&w prints, transparencies and color or b&w contact sheets.

Making Contact & Terms: Query with samples. Provide résumé, business card, brochure, flier or tearsheets to be kept on file for possible future assignments. SASE. Reports in 5 weeks. Simultaneous and previously published submissions OK. Pays $100 for exclusive product rights. Pays on publication. Buys exclusive product rights. Credit line given.

⑤ ▣ ◑ **FOTOFOLIO, INC.**, 561 Broadway, New York NY 10012. (212)226-0923. Fax: (212)226-0072. E-mail: fotofolio@aol.com. Website: http://www.fotofolio.com. Contact: Editorial Department. Estab. 1976. Specializes in greeting cards, postcards, postcard books, books, posters, T-shirts and notecards. The Fotofolio line of over 5,000 images comprises the complete history of photography and includes the work of virtually every major photographer, from past masters such as Walker Evans, Berenice Abbott, Brassai, Philippe Halsman and Paul Strand to contemporary artists including William Wegman, Richard Avedon, Andres Serrano, Cindy Sherman, Herb Ritts and Sandy Skoglund. Photo guidelines free with SASE.
Needs: Specializes in humorous, seasonal material. Submit seasonal material 9 months in advance. Reviews stock photos. Captions required; include name, date and title.
Specs: Uses up to 11 × 14 color and b&w prints; 35mm, 2¼ × 2¼, 4 × 5, 8 × 10 transparencies. Accepts images in digital format.
Make Contact & Terms: Send for guidelines. Does not keep samples on file. SASE. Reports in 1 month. Simultaneous submissions and/or previously published work OK. Pays royalties. Pays on usage. Buys exclusive product rights (only for that item—eg., postcard rights). Credit line given.

▣ **FRONT LINE ART PUBLISHING**, 9808 Waples St., San Diego CA 92121. (800)321-2053 or (619)552-0944. Fax: (619)552-0534. Vice President Creative Director: Benita Sanserino. Specializes in posters and prints.
Needs: Buys 350 images annually; 100% are supplied by freelancers. Interested in "dramatic," sports, landscaping, animals, contemporary, b&w, hand tint and decorative. Reviews stock photos of sports and scenic. Model release is required. Photo captions are preferred.
Specs: Uses color and b&w prints; 35mm, 2¼ × 2¼, 4 × 5, 8 × 10 transparencies. Accepts images in digital format.
Making Contact & Terms: Send query letter with samples, brochure, stock photo list, tearsheets. Art director will contact photographer for portfolio review if interested. Portfolio should include b&w and color, prints, tearsheets, slides, transparencies or thumbnails. Include SASE for return of unsolicited material. Reports in 1 month on queries. Pays on publication. Rights negotiable. Credit line given.

GALLANT GREETINGS CORP., P.O. Box 308, Franklin Park IL 60131. (847)671-6500. Fax: (847)671-7500. Vice President-Sales & Marketing: Chris Allen. Estab. 1966. Specializes in greeting cards.
Needs: Produces material for Christmas, Easter, Mother's Day, Father's Day, graduation, Halloween, Thanksgiving, Valentine's Day, birthday, and most other card-giving occasions.
Making Contact & Terms: Contact Brandywine Art at phone: (415)435-6533. Does not keep samples on file. Cannot return material. Reports back only if interested.

$ $ ◪ ◎ **RAYMOND L. GREENBERG ART PUBLISHING**, P.O. Box 239, Circleville NY 10919-0239. (914)469-6699. (914)469-5955. Owner: Ray Greenberg. Estab. 1995. Publisher of posters and art prints. Guidelines sheet free with SASE.
Needs: Buys 100 images annually; all are supplied by freelancers. Interested in inspirational, juvenile, ethnic, floral still life, romantic, babies, children, couples, gardening, religious, automobiles, humor, erotic, fine art, seasonal. Seasonal material should be submitted 7 months in advance. Reviews stock photos. Model release preferred. Photo captions preferred.
Specs: Uses 35mm, 2¼ × 2¼, 4 × 5, 8 × 10 transparencies.
Making Contact & Terms: Send query letter with samples, brochure, stock photo list, tearsheets. Provide résumé, business card, self-promotion piece or tearsheets to be kept on file for possible future assignments. Art director will contact photographer for portfolio review if interested. Keeps samples on file. Reports in 3 weeks on queries; 6 weeks on samples. Pays by the project, $50-200 per image or pays advance of $50-100 plus royalties of 5-8%. **Pays on acceptance.** Buys all rights, negotiable. Credit line sometimes given depending on photographer's needs.
Tips: "Be patient in awaiting answers on acceptance of submissions."

$ ⑤ ▣ ◎ **HIGH RANGE GRAPHICS**, P.O. Box 346, Victor ID 83455. (208)787-2277. Fax: (208)287-2276. E-mail: tshirts@mail.pdt.net. Art Director: J.L. Stuessi. Estab. 1989. Specializes in screen printed T-shirts.

THE GEOGRAPHIC INDEX, located in the back of this book, lists markets by the state in which they are located.

Needs: Buys 5-10 images annually; all supplied by freelancers. May offer one assignment annually. Interested in snowboarding, mountain biking, skiing (speed or Big Air), whitewater rafting. Submit seasonal material 6 months in advance. Reviews stock photos. Captions preferred, "just so we can identify the image in conversation."

Specs: Uses 8×10 maximum color prints; 35mm transparencies. Accepts images in digital format for Mac. Send via Zip as TIFF, EPS files at 300 dpi.

Making Contact & Terms: Query with samples. Keeps samples on file. SASE. "We reply if interested." Simultaneous submissions and/or previously published work OK. Pays $75/color photo; flat fee (plus one T-shirt). Pays on usage. Buys exclusive product rights for screen printed garments only.

Tips: "We often graphically alter the image (i.e., posterize) and incorporate it as part of a design. Know the T-shirt market. Dynamite images on paper simply don't always work on garments. Action images need to be tack-sharp with good contrast and zero background competition."

[S] [■] [◑] IMAGE CONNECTION AMERICA, INC., 456 Penn St., Yeadon PA 19050. (610)626-7770. Fax: (610)626-2778. E-mail: imageco@earthlink.net. President: Michael Markowicz. Estab. 1988. Specializes in postcards, posters, bookmarks, calendars, giftwrap, greeting cards.

Needs: Wants contemporary photos of babies, celebrities, children, families, pets, entertainment, humor, portraits. Interested in alternative process, avant garde, digital, documentary, erotic, fashion/glamour, fine art, historical/vintage. Model release required. Captions preferred.

Specs: Uses 8×10 b&w prints and 35mm transparencies. Accepts images in digital format for Mac. Send via floppy disk, Zip as TIFF, EPS, PICT files.

Making Contact & Terms: Query with samples. Send unsolicited photos by mail for consideration. SASE. Payment negotiable. Pays quarterly or monthly on sales. Buys exclusive product rights; negotiable. Credit line given.

IMPACT, 4961 Windplay Dr., El Dorado Hills CA 95762. (916)939-9333. Fax: (916)939-9334. Estab. 1975. Specializes in calendars, bookmarks, magnets, postcard packets, postcards, posters and books for the tourist industry. Photo guidelines and fee schedule free with SASE.

● This company sells to specific tourist destinations; their products are not sold nationally. They need material that will be sold for at least a 5 year period.

Needs: Buys stock and assigns work. Buys 3,000 photos/year. Offers 10-15 assignments/year. Wildlife, scenics, US travel destinations, national parks, theme parks and animals. Submit seasonal material 4-5 months in advance. Model/property release required. Captions preferred.

Specs: Uses 35mm, 2¼×2¼, 4×5, 8×10 transparencies.

Making Contact & Terms: Query with samples. Query with stock photo list. Provide business card, self-promotion piece or tearsheets to be kept on file for possible future assignments. Keeps samples on file. SASE. Reports in 1 month. Simultaneous submissions and previously published work OK. Request fee schedule; rates vary by size. Pays on usage. Buys one-time and nonexclusive product rights. Credit line and printed samples of work given.

$ $[■] [◑] INSPIRATIONART & SCRIPTURE, P.O. Box 5550, Cedar Rapids IA 52406. (319)365-4350. Fax: (319)861-2103. E-mail: charles@inspirationart.com. Website: http://www.inspirationart.com. Contact: Charles Edwards. Estab. 1996. Specializes in Christian posters (all contain scripture and are geared toward teens and young adults). Photo guidelines free with SASE.

Needs: Buys 10-15 images annually; all supplied by freelancers. Will consider babies, celebrities, children, couples, multicultural, families, parents, senior citizens, teens, cities, gardening, pets, rural, adventure, events, food/drink, health/fitness, hobbies, humor, performing arts, sports, political, portraits, science, technology, alternative process, avant garde, digital, documentary, fashion/glamour, fine art, historical/vintage, regional, seasonal. "All images must be able to work with scripture." Submit seasonal material 6 months in advance. Reviews stock photos. Model/property release required.

Specs: Uses 35mm, 2¼×2¼, 4×5, 8×10 transparencies. Prefers 2¼×2¼ or 4×5 but can work with 35mm. ("We go up to 24×36.) Accepts images in digital format for Mac, Windows. Send via CD, SyQuest, floppy disk, Jaz, Zip, e-mail as TIFF, EPS, JPEG.

Making Contact & Terms: Query with samples. Request catalog for $3. Works with local freelancers on assignment only. Keeps samples on file. SASE. Reports in 3-4 months. Art acknowledgement is sent upon receipt. Pays by the project, $25-1,000/image; royalties of 10%. Pays on usage. Buys exclusive rights to use as a poster only. Credit line given.

Tips: "Photographers interested in having their work published by InspirationArt & Scripture should consider obtaining a catalog of the type of work we do prior to sending submissions. Also remember that we review art monthly; please allow 90 days for returns."

"My first contact with Impact was through the *1993 Photographer's Market*," says B.J. Nelson. "I sent for their photo guidelines and fee schedule and after a few submissions, started receiving their want lists regularly." This image of a mother polar bear protecting her cubs from an approaching male bear was licensed for $650, for use on a postcard, poster, bookmark, key chain, magnet and screen saver. "I spent a week in the Canadian Arctic photographing these magnificent bears and feel so lucky to have witnessed a small part of their lifestyles," Nelson says.

N ▣ $ INTERCONTINENTAL GREETINGS, 176 Madison Ave., New York NY 10016. (212)683-5830. Fax: (212)779-8564. Art Director: Nancy Hoffman. Estab. 1967. Reps artists in 50 countries, with clients specializing in greeting cards, calendars, postcards, posters, art prints, stationery, gift wrap, giftware, food tins and playing cards. Photo guidelines free with SASE.
Needs: Acquires 20-50 photos and digital images/year. Graphics, sports, occasions (i.e. Christmas, baby, birthday, wedding), "soft-touch" romantic themes, studio photography. No nature, landscape. Accepts seasonal material any time. Model release preferred.
Specs: Uses Adobe Photoshop files on disk, 2¼×2¼, 4×5 and 8×10 transparencies.
Making Contact & Terms: Query with samples. Send unsolicited photos/color copies by mail with SASE. Provide résumé, business card, brochure, flier or tearsheets to be kept on file for possible future assignments. Upon request, submit portfolio for review. Simultaneous submissions and previously published work OK. Pays 20% royalties on sales. Pays on publication. Buys one-time rights and exclusive product rights. No credit line given.
Tips: In photographer's portfolio samples, wants to see "a neat presentation, perhaps thematic in arrangement." The trend is toward "modern, graphic studio photography."

$ $ $ ⑤ ◯ JII SALES PROMOTION ASSOCIATES, INC., 545 Walnut St., Coshocton OH 43812. (740)622-4422. Photo Editor: Walt Andrews. Estab. 1940. Specializes in advertising calendars. Photo guidelines free with SASE.
Needs: Buys 200 photos/year. Interested in traditional scenics, mood/inspirational scenics, human interest, special interest (contemporary homes in summer and winter, sailboats, hot air balloons), animals, plants. Reviews stock photos. Model release required. Captions with location information only required.
Specs: Uses 2¼×2¼, 4×5, 8×10 transparencies.
Making Contact & Terms: Query with SASE. Send unsolicited photos by mail for consideration in late September. Reports in 2 weeks. Pays by the project, $400-1,000 per image. **Pays on acceptance.** Buys all time advertising and calendar rights, some special 1 year rights.
Tips: "Our calendar selections are nearly all horizontal compositions."

$ $ JILLSON & ROBERTS GIFT WRAPPINGS, 5 Watson Ave., Irvine CA 92618. (949)859-8781. Fax: (949)859-0257. Art Director: Joshua J. Neufeld. Estab. 1974. Specializes in gift wrap, totes, printed tissues, accessories. Photo guidelines free with SASE.

Needs: Needs vary. Specializes in everyday and holiday products. Submit seasonal material 3-6 months in advance.

Making Contact & Terms: Submit portfolio for review or query with samples. Provide résumé, business card, self-promotion piece or tearsheets to be kept on file for possible future assignments. Reports in 3 weeks. Pays average flat fee of $250; or royalties.

N: ARTHUR A. KAPLAN CO., INC., 460 W. 34th St., New York NY 10001. (212)947-8989. Art Director: Colleen Buchweitz. Assistant Art Director: Christine Pratti. Estab. 1956. Specializes in posters, wall decor and fine prints and posters for framing.

Needs: Flowers, scenics, animals, still life, Oriental motif, musical instruments, Americana, hand-colored and *unique* imagery. Reviews stock photos. Model release required.

Specs: Uses any size color prints; 35mm, 2¼×2¼, 4×5 and 8×10 transparencies.

Making Contact & Terms: Send unsolicited photos or transparencies by mail for consideration. Reports in 2-3 weeks. Simultaneous submissions OK. Royalty 5-10% on sales. Offers advances. Pays on publication. Buys exclusive product rights.

Tips: "Our needs constantly change, so we need diversity of imagery. We are especially interested in images with international appeal."

N ⊕ S □ ⊘ KAT KARDS, 10 Pamment St., North Fremantle 6159 Australia. Phone: (618)9335-2028. Fax: (618)9430-7768. E-mail: katkards@katkards.com.au. Contact: Art Director. Estab. 1988. Specializes in bookmarks, giftwrap, greeting cards, stationery.

Needs: Needs photos of landscape/scenics, wildlife, pets, rural, food/drink. Submit seasonal material 1 year in advance. Model and property release preferred. Photo captions are preferred.

Specs: Accepts images in digital format for Mac. Send via CD, SyQuest (88mb), floppy disk, e-mail as TIFF, EPS, JPEG files at 300 dpi.

Making Contact & Terms: Send query letter with slides, prints, photocopies. Keeps samples on file. Reports in 6 weeks on queries; 6 weeks on portfolios. Simultaneous submissions OK. Pays on receipt of invoice.

Tips: "Provide innovative images in impeccable presentation."

◤ □ KEENE KARDS INC., #17-1950 Government St., Victoria, British Columbia V8T 4N8 Canada. (250)361-4449. Fax: (250)361-4479. Art Director: Paul Keene. Estab. 1987. Specializes in calendars, greeting cards, stationery, T-shirts.

Needs: Buys 200 images annually; 100 are supplied by freelancers. Interested in nature, humorous nature, humorous situations with children, risqué photos (humorous). Submit seasonal material 9 months in advance. Model/property release preferred. Photo caption preferred.

Specs: Uses b&w prints and 4×5 transparencies. Accepts images in digital format.

Making Contact & Terms: Send query letter with samples. Art director will contact photographer for portfolio review if interested. Portfolio should include "anything relevant, which will be discussed before appointment." Works with local freelancers only. Keeps samples on file. Reports in 2 weeks on queries; 1 month on samples. Pays royalties only. Paid quarterly. Rights negotiated for greeting cards. Credit line given.

A KOGLE CARDS, INC., 1498 S. Lipan St., Denver CO 80223. (303)698-9007. Fax: (303)698-9242. Send submissions Attn: Art Director. Estab. 1982. Specializes in greeting cards and postcards for all business occasions. Photo guidelines sheet free with SASE.

Needs: Buys about 250 photos/year. Interested in Thanksgiving, Christmas and other holidays, also humorous. Submit seasonal material 9 months in advance. Reviews stock photos. Model release required.

Specs: Uses 35mm, 2¼×2¼, 4×5 transparencies. Sizes: Postcards, 4¼×6; Greeting Cards, 5×7. "When artwork is finished, be sure it is in proportion to the sizes listed. Allow ¼" bleed when bleed is used." Will work with color only.

Making Contact & Terms: Query with samples and tearsheets. "Do not send originals." Send slides or color photocopies with SASE. Provide résumé, business card, self-promotion piece or tearsheets to be kept on file for possible future assignments. Art director will contact photographer for portfolio review if interested. Portfolio should include prints, slides, tearsheets. Works with freelancers on assignment only. SASE. Reports in 1 month. Payment negotiable. **Pays on acceptance**. Rights negotiable. Credit line not given.

[S] [○] LESLIE LEVY FINE ART PUBLISHING, INC., 1505 N. Hayden Rd., Suite J10, Scottsdale AZ 85257. (602)945-8491. Fax: (602)945-8104. E-mail: leslevy@ix.netcom.com. Website: http://www.lesl ielevy.com. Director: Leslie Levy. Estab. 1976. Publishes posters.
- Laura Levy is a licensing agent.

Needs: Interested in landscape, city scenes, celebrities, wildlife, figurative, Southwest, children—b&w, color or handtinted photography. Reviews stock photos and slides. Model/property release required. Include location, date, subject matter or special information.

Specs: Uses 16×20, 22×28, 18×24, 24×30, 24×36 color and b&w prints; 4×5 transparencies.

Making Contact & Terms: Submit photos or slides for review. Send SASE. Do not call. Reports in 4-6 weeks. Simultaneous submissions and previously published work OK. Pays royalties quarterly based upon sales. Buys exclusive product rights.

$ $ $ $ [S] [○] BRUCE McGAW GRAPHICS, INC., 389 W. Nyack Rd., West Nyack NY 10994. (914)353-8600. Fax: (914)353-8907. Director of Purchasing/Acquisitons: Martin Lawlor. Estab. 1979. Specializes in posters, framing prints, wall decor.

Needs: 150-200 images in a variety of media are licensed annually; 10-15% in photography. Interested in b&w: still life, floral, figurative, landscape. Color: landscape, still life, floral. Also considers celebrities, environmental, wildlife, architecture, rural, fine art, historical/vintage. Does not want images that are too esoteric or too commercial. Model/property release required for figures, personalities, images including logos or copyrighted symbols. Captions required; include artist's name, title of image, year taken.

Specs: Uses color and b&w prints; 35mm, 2¼×2¼, 4×5, 8×10 transparencies.

Making Contact & Terms: Submit portfolio for review. "Review is typically 1-2 weeks on portfolio dropoffs. Be certain to leave phone number for pick up." Provide résumé, business card, self-promotion piece or tearsheets to be kept on file for possible future assignments. Include SASE for return of materials. Do not send originals! SASE. Reports in 1 month. Simultaneous submissions and/or previously published work OK. Pays royalties on sales. Pays quarterly following first sale and production expenses. Buys exclusive product rights for all wall decor. Credit line given.

Tips: "Work must be accessible without being too commercial. Our posters/prints are sold to a mass audience worldwide who are buying art prints. Images that relate a story typically do well for us. The photographer should have some sort of unique style or look that separates him from the commercial market."

$ $ [○] [◎] MODERN ART, 276 Fifth Ave., Suite 205, New York NY 10001. (212)779-0700. Fax: (212)779-1807. Director of Product Development: Mary Mizerany. Specializes in posters, wall decor, open edition fine art prints.

Needs: Interested in nature, seasonal landscapes, seascapes, European scenes, floral still life, abstracts, wildlife, cities, gardening, sports, fine art. Reviews stock photos. Model/property release required.

Specs: Uses 16×20 and larger color and b&w prints; 35mm, 2¼×2¼, 4×5, 8×10 transparencies.

Making Contact & Terms: Submit portfolio for review. Keeps samples on file "if the artist will let us." SASE. Reports in 3 weeks. Simultaneous submissions OK. Pays advance of $100-300 plus royalties of 10%. Pays on usage. Buys one-time, all and exclusive product rights. Credit line given.

Tips: "Submit 35mm slides for our review with SASE. We respond back to artist within 1 month."

[■] [○] NEW YORK GRAPHIC SOCIETY PUBLISHING GROUP, P.O. Box 1469, Greenwich CT 06836-1469. (203)661-2400. Fax: (203)661-2480. Estab. 1925. Publish fine art reproductions, prints and posters.

Needs: Buys 150 images annually; 125 supplied by freelancers. "Looking for variety of images."

Specs: Uses 4×5 transparencies. Accepts images in digital format for Mac. Send via Jaz, Zip, e-mail. "We don't review initial submissions in digital format."

Making Contact & Terms: Query with samples. Does not keep samples on file. SASE. Reports in 1 month. Payment negotiable. Pays on usage. Buys exclusive product rights. Credit line given.

Tips: "Submission sent with cover letter, samples of work (prints, brochures, transparencies) are best. Images must be color correct with SASE."

[N] $ [S] [■] [◎] ANDREW NOCH & ASSOCIATES, 4949 Galaxy Pkwy., Suite K, Cleveland OH 44128. (216)591-1999. Fax: (216)292-4824. Director of Licensing: Gail Nanowsky. Estab. 1990. Specializes in greeting cards.

Needs: Buys 15 images annually; 15 are supplied by freelancers. Needs photos of celebrities, sports action. Also needs contemporary, unique photos for use in humorous greeting cards. Submit seasonal material 4 months in advance. Photo captions preferred.

Specs: Accepts images in digital format for Mac, Windows. Send via floppy disk, Zip.

Making Contact & Terms: Contact through rep. Provide self-promotion piece to be kept on file for possible future assignments. Reports back only if interested. Simultaneous submissions OK. Pays by the project, $100-200/image. Pays on publication or receipt of invoice. Credit line not given. Buys one-time rights.

NORS GRAPHICS, HC 33, Box 180, Arrowsic ME 04530. (207)442-0159. Fax: (207)442-8904. E-mail: bridge@cybertours.com. Publisher: Alexander Bridge. Estab. 1982. Specializes in posters and stationery products.
Needs: Buys 6 images annually; 50% supplied by freelancers. Offers 2 assignments annually. Interested in rowing/crew and sailing. Submit seasonal material 6-12 months in advance. Does not want only rowing photos. Reviews stock photos of sports. Model release required. Photo captions preferred.
Specs: Uses 4×5 transparencies.
Making Contact & Terms: Query with samples. Keeps samples on file. SASE. Reports in 3 weeks. Payment negotiable. Pays on usage. Buys all rights. Credit line given.

$ ▣ Ⓞ NOVA MEDIA INC., 1724 N. State St., Big Rapids MI 49307-9073. (616)796-4637. E-mail: trund@nov.com. Website: http://www.nov.com. President: Thomas J. Rundquist. Estab. 1981. Specializes in CD-ROMs,CDs/tapes, games, limited edition plates, posters, school supplies, T-shirts. Photo guidelines free with SASE.
Needs: Buys 100 images annually; most supplied by freelancers. Offers 20 assignments annually. Interested in art fantasy photos. Considers celebrities, multicultural, families, teens, landscapes/scenics, beauty, education, religious, rural, entertainment, health/fitness, computers, military, political, portraits, documentary, erotic, fashion/glamour, fine art, historical/vintage. Submit seasonal material 2 months in advance. Reviews stock photos. Model release required. Photo captions preferred.
Specs: Uses color and b&w prints. Accepts images in digital format for Windows. Send via CD, floppy disk as JPEG files.
Making Contact & Terms: Query with samples. SASE. Reports in 1 month. Simultaneous submissions and/or previously published work OK. Payment negotiable. Pays extra for electronic usage of photos. Pays on usage. Buys electronic rights; negotiable. Credit line given.
Tips: "The most effective way to contact us is by e-mail or regular mail."

$ ▣ PORTERFIELD'S FINE ART IN LIMITED EDITIONS, 5 Mountain Rd., Concord NH 03301. (800)660-8345. Fax: (603)228-1888. E-mail: ljklass@mediaone.net. Website: http://www.porterfields.com. President: Lance J. Klass. Estab. 1994. Specializes primarily in limited-edition collectibles. Photo guidelines free with SASE.
Needs: Buys 12-15 images annually. Interested only in photos of children ages 1½-4, with 1 or 2 children in each photo. Submit seasonal material as soon as available. "We are seeking excellent color photographs of early childhood to be used as photo references and conceptual materials by one of America's leading portraitists, whose paintings will then be used as the basis for collectible products, principally collector plates and related material. We are seeking high-quality photographs, whether prints, slides or digital images, which show the wonder and joy, and occasionally even the sad moments, of real children in real-life settings. No posed images, no man-made toys, no looking 'at the camera,' but only photos which provide the viewer with a window into a special, perhaps magical moment of early childhood. Each image should be of one or two children engaged in some purposeful activity which is reminiscent of our own childhood or of the years when our own children or grandchildren were small, or which depicts a typical, lovely, charming or emotional activity or event in the life of a small child." Reviews stock photos. Model release required for children.
Specs: Uses color prints; transparencies; digital images: TIFF or JPEG.
Making Contact & Terms: Query with samples. Keeps samples on file. SASE required. Reports in 1-2 weeks. Simultaneous submissions and previously published work OK. "We pay $150 or more for single-use rights, but will negotiate. No foreign submissions accepted, other than Canadian. We'll work one on one with photographers." **Pays on acceptance.** Buys single-use rights. "Porterfield's seeks the exclusive right to use a particular photo only to create derivative works, such as paintings, from which further derivative works such as collector plates may be made and sold. We have no desire to and never will reproduce a licensed photograph in its original form for any commercial use, thereby leaving the photographer free to continue to market the photo in its current form for direct reproduction in any medium other than derivative works." Credit line not given.

$ Ⓢ ▣ Ⓞ PORTFOLIO GRAPHICS, INC., 4060 S. 500 West, Salt Lake City UT 84123. (801)266-4844. Fax: (801)263-1076. E-mail: info@portfoliographics.com. Website: http://www.portfoliogr

aphics.com. Creative Director: Kent Barton. Estab. 1986. Specializes in greeting cards and posters. Photo guidelines free with SASE.

Needs: Buys 100 images annually; nearly all supplied by freelancers. Interested in photos with a fine art/decorative look; all subjects considered. Want "artistic, unique, fresh looks" for cards, "anything goes." For posters, "keep in mind that we need decorative art that can be framed and hung on the wall." Submit seasonal material on an ongoing basis. Reviews stock photos. Photo captions preferred.

Specs: Uses prints, 4×5 transparencies. Accepts images in digital format for Mac. Send via CD, floppy disk, Jaz, Zip as TIFF, EPS, JPEG files.

Making Contact & Terms: Send slides, transparencies, tearsheets with SASE. Works with local freelancers only. Art director will contact photographer for portfolio review if interested. Does not keep samples on file. SASE. Reports in 2 weeks on queries, 1 month on samples. Pays 5-10% royalty on sales. Quarterly royalties paid per pieces sold. Buys exclusive product rights license per piece. Credit line given.

Tips: "Mail in slides or transparencies (12-30) with SASE."

N $ $ ▣ ⬤ POSTER PORTERS, P.O. Box 9241, Seattle WA 98109-9241. (206)286-0818. Fax: (206)286-0820. E-mail: marksimard@posterporters.com. Estab. 1981. Specializes in gifts, mugs, posters, stationery, t-shirts.

Needs: Buys 30 images annually; 10 are supplied by freelancers. Interested in landscapes, nature, cities/urban, rural, fine art, historical/vintage, regional. Seasonal material should be submitted 3 months in advance. Not interested in nudes, people.

Specs: Accepts images in digital format for Windows. Send via e-mail as JPEG files.

Making Contact & Terms: Send query letter with samples, tearsheets. Art director will contact photographer for portfolio review if interested. Portfolio should include color, tearsheets, thumbnails. Keeps samples on file. Reports back only if interested, send non-returnable samples. Pays by the project, $500-700 per image; royalties of 5-7%. Buys one-time rights; negotiable.

$ $ $ $ A ▣ ⬤ THE PRESS CHAPEAU, P.O. Box 4591, Baltimore MD 21212. Director: Elspeth Lightfoot. Estab. 1976. Specializes in fine art originals for corporate facilities, museums and private collectors. Photo guidelines free with SASE.

● Press Chapeau maintains an image bank of 40,000 images.

Needs: Buys 400 images annually; 10% supplied by freelancers. Offers 10-20 commissions annually. Subjects include architecture, cities/urban, interiors/decorating, buildings, portraits, still life, alternative process, documentary, fine art, historical/vintage. Model/property release required. Captions required.

Specs: Uses 8×10, 24×30 matte b&w prints; 35mm, 2¼×2¼, 8×10 transparencies. Accepts images in digital format for Windows. Send via floppy disk, Jaz as GIF, JPEG files.

Making Contact & Terms: Query with samples, business card, self-promotion piece or tearsheets to be kept on file for possible future assignments. "No artist's statements please." Keeps samples on file. SASE. Reports in 1-2 weeks. Photographer determines rate. **Pays on acceptance.** Credit line given.

Tips: "Your work is more important than background, résumé or philosophy. We judge solely on the basis of the image before us."

$ $ S ⬤ RECYCLED PAPER GREETINGS, INC., Art Dept., 3636 N. Broadway, Chicago IL 60613. (773)348-6410. Art Manager: Cindy Elsman. Specializes in greeting cards.

Needs: Buys 30-50 photos/year. "Primarily humorous photos for greeting cards. Photos must have wit and a definite point of view. Unlikely subjects and offbeat themes have the best chance, but will consider all types." Subjects include: babies, children, landscapes/scenics, wildlife, beauty, pets, humor. Interested in alternative process, fine art, historical/vintage, seasonal. Model release required.

Specs: Uses 4×5 b&w and color prints; b&w or color contact sheets. Please do not submit slides or original photos.

Making Contact & Terms: Send for artists' guidelines. SASE. Reports in 1 month. Simultaneous submissions OK. Pays $250/b&w or color photo. **Pays on acceptance.** Buys card rights. Credit line given.

Tips: Prefers to see "up to ten samples of photographer's best work. Cards are printed 5×7 format. Please include messages. The key word for submissions is wit."

$ S ▣ ⬤ REIMAN PUBLICATIONS, L.L.C., 5400 S. 60th St., Greendale WI 53129. (414)423-0100. Fax: (414)423-8463. Photo Coordinator: Trudi Bellin. Estab. 1965. Specializes in calendars and occasionally posters and cards.

Needs: Buys more than 275 images annually; all supplied by freelancers. Interested in humorous cow, pig and chicken photos as well as scenic country images including barns and churches, senior citizens, landscapes/scenics, gardening, rural, travel, agriculture. Also need backyard and flower gardens, butterflies, wild birds, song birds, humming birds, North American scenics by season, spring and winter shots from

southern half of USA. Unsolicited calendar work must arrive between September 1-15. Does not want smoking, drinking, nudity. Reviews stock photos. Model/property release required for children, private homes. Captions required; include season, location; birds and flowers must include common and/or scientific names.

Specs: Uses color transparencies, all sizes.

Making Contact & Terms: Query with cover letter and résumé of credits. Query with stock photo list and ID each image. Photo guidelines free with SASE. Tearsheets are kept on file but not dupes. Reports in 3 months for first review. Simultaneous submissions and previously published work OK. Pays $300/color photo. Pays on publication. Buys one-time rights. Credit line given.

Tips: "Tack-sharp focus is a must if we are to consider photo for enlargement. Horizontal format is preferred. The subject of the calendar theme must be central to the photo composition. All projects look for technical quality. Focus has to be sharp—no soft focus and colors must be vivid so they 'pop off the page.'"

$ $ ▣ ◑ ◎ RENAISSANCE GREETING CARDS, INC., P.O. Box 845, Springvale ME 04083-0845. Photo Editor: Wendy Crowell. Estab. 1977. Specializes in greeting cards. Photo guidelines free with SASE. Send submissions: ATTN: Product Development Assistant.

● Renaissance is doing more manipulation of images and adding of special effects.

Needs: Buys/assigns 50-100 photos/year. "We're interested in photographs that are artsy, quirky, nostalgic, dramatic, innovative and humorous. Very limited publication of nature/wildlife photos at this time. Special treatment such as hand-tinted b&w images are also of interest. Send holiday submissions at least 5 months before." No animals in clothing, risqué or religious. Limit slides/images to less than 50 per submission. Do not send originals on submission. Reviews stock photos. Model release preferred. Captions required; include location and name of subject.

Specs: Uses b&w 35mm, 2¼×2¼, 4×5 transparencies. Accepts images in digital format for Mac. Send via CD, floppy disk, Jaz, Zip as TIFF, EPS files (as small as possible).

Making Contact & Terms: Query with b&w, color contact sheets or color copies. SASE. Cannot return originals without postage supplied. Reports in 2 months. Rates negotiable. Pays $175-350 flat fee/color or b&w photo, or $150 advance against royalties. Buys all rights or exclusive product rights; negotiable. Credit line given.

Tips: "We strongly suggest starting with a review of our guidelines."

RIGHTS INTERNATIONAL GROUP, 463 First St., Suite 3C, Hoboken NJ 07030. (201)963-3123. Fax: (201)420-0679. President: Robert Hazaga. Estab. 1996. Rights International Group is a licensing agency specializing in representing photographers and artists to manufacturers for licensing purposes. Manufacturers include greeting cards, calendars, posters and gift wrap companies.

Needs: Interested in all subjects. Submit seasonal material 9 months in advance. Reviews stock photos. Model/property release required.

Specs: Uses prints, slides, transparencies.

Making Contact & Terms: Submit portfolio for review. Keeps samples on file. SASE. Reports in 1-2 weeks. Simultaneous submissions and/or previously published work OK. Payment negotiable. Pays on license deal. Buys exclusive product rights. Credit line given.

◰ ⒮ ▣ ROBINSON GREETING CARD CO., 2351 Des Carrières, Montreal, Quebec H2G 1X6 Canada. (514)279-6387. Fax: (514)279-9325. Art Director: Robert Lavoie. Specializes in greeting cards.

Needs: Reviews stock photos of flowers.

Specs: Uses 4×5 transparencies. Accepts images in digital format.

Making Contact & Terms: Send query letter with stock photo list. Art director will contact photographer for portfolio review if interested. Portfolio should include prints. Keeps samples on file; include SASE for return of material. Buys rights for Canada and US.

$ $ ROCKSHOTS, INC., 632 Broadway, 8th Floor, New York NY 10012. Fax: (212)353-8756. Art Director: Bob Vesce. Estab. 1978. Specializes in greeting cards.

Needs: Buys 20-50 photos/year. Sexy (including male and female nudes and semi-nudes), outrageous,

MARKET CONDITIONS are constantly changing! If you're still using this book and it's 2001 or later, buy the newest edition of *Photographer's Market* at your favorite bookstore or order directly from Writer's Digest Books.

satirical, ironic, humorous photos. "One of our specialties is super-size female models, 500 to 650 lbs. Another is our male and female nude and semi-nude fantasy cards." Submit seasonal material at least 6 months in advance. Model release required.

Specs: Uses color prints; 35mm, 2¼×2¼ and 4×5 slides.

Making Contact & Terms: Send SASE requesting photo guidelines. Provide flier and tearsheets to be kept on file for possible future assignments. "Do not send originals!" SASE. Reports in 8-10 weeks. Simultaneous submissions and previously published work OK. Pays $125-300/color photo; other payment negotiable. **Pays on acceptance.** Rights negotiable.

Tips: Prefers to see "greeting card themes, especially birthday, Christmas, Valentine's Day. Remember, male and female nudes and semi-nudes are fantasies. Models should definitely be better built than average folk. Also, have fun with nudity, take it out of the normal boundaries. It's much easier to write a gag line for an image that has a theme and/or props. We like to look at life with a very zany slant, not holding back because of society's imposed standards. We are always interested in adding freelance photography because it broadens the look of the line and showcases different points of view. We shoot extensively inhouse."

$ 🌐 Ⓢ ◯ SANGHAUI ENTERPRISES LTD., D-24, M.I.D.C., Satpur., Nasik 422 007 India. Phone: 253-350181. Fax: 253-351381. E-mail: seplnsk@usnl.com. Managing Director: H.L. Sanghaui. Estab. 1974. Specializes in greeting cards, calendars and stationery.

Needs: Buys approx. 50 photos/year. Landscapes, gardening, children, wildlife, nudes. No graphic illustrations. Submit seasonal material anytime throughout the year. Reviews stock photos.

Specs: Send any size color prints.

Making Contact & Terms: Query with samples. Reports in 1 month. Previously published work OK. Pays $25/color photo. Pays on publication. Credit line given.

Tips: In photographer's samples, "quality of photo is important; would prefer nonreturnable copies. No originals please. Send us duplicate photos, not more than 10 for selection."

▨ SCAN VIDEO ENTERTAINMENT, P.O. Box 183, Willernie MN 55090-0183. (651)426-8492. Fax: (651)426-2022. President: Mats Ludwig. Estab. 1981. Distributors of Scandinavian video films, books, calendars, cards.

Needs: Buys 100 photos; 5-10 films/year. Wants any subject related to the Scandinavian countries. Examples of recent uses: travel videos, feature films and Scandinavian fairy tales, all VHS. Reviews stock photos. Model/property release required.

Audiovisual Needs: Uses videotape for marketing and distribution to retail and video stores. Subjects include everything Scandinavian: travel, history, feature, children's material, old fashion, art, nature etc.

Specs: Uses color prints; 35mm transparencies; film and videotape.

Making Contact & Terms: Query with stock photo list. Does not keep samples. Will return materials if requested. SASE. Replies only if interested. Pays royalties on sales. Buys all rights; negotiable. Credit line not given.

Tips: Wants professionally made and edited films with English subtitles or narrated in English. Seeks work which reflects an appreciation of Scandinavian life, traditions and history.

Ⓝ $ $ Ⓐ ◎ SOLE SOURCE, INC., 63820 Clausen Dr., Bend OR 97701. (800)285-1657. Fax: (541)389-0642. E-mail: corp@sole-source.com. Website: http://www.sole-source.com. Art Director: Starr Hume. Specializes in greeting cards.

Needs: Pets, trucking and construction.

Making Contact & Terms: Send query letter with résumé. Does not keep samples on file; include SASE for return of material. Reports back only if interested. Pays by the project. Pays on receipt of invoice.

Tips: "We use limited photography for our catalogs."

$ $ Ⓢ ▣ ◭ SPARROW & JACOBS, K&W Enterprises, 2870 Janitell Rd., Colorado Springs CO 80906. (719)579-9011. Fax: (719)579-9007. Art Director: Peter A. Schmidt. Estab. 1986. Specializes in bookmarks, calendars, greeting cards, stationery, post cards.

Needs: Buys 28 images annually; 18 are supplied by freelancers. The number of freelance images could grow depending on year. Interested in houses, doors, windows, flowers, animals, nature shots, seasonal, humorous animals. Submit seasonal material 1 year in advance. Not interested in babies, people (unless in a nature scene), foreign, eastern sites. Property release preferred.

Specs: Accepts images in digital format that are scanable for output to at least 4.25″×6″ at 300 dpi resolution.

Making Contact & Terms: Send query letter with samples, brochure, stock photo list, tearsheets. Provide résumé, business card, self-promotion piece to be kept on file for possible future assignments. Art director will contact photographer for portfolio review if interested. Portfolio should include color, tearsheets,

slides, transparencies. Keeps samples on file; include SASE for return of material. Pays by the project, $250-350 for color. Pays on receipt of invoice. Buys all rights; negotiable.

N ○ SUNRISE PUBLICATIONS, INC., P.O. Box 4699, Bloomington IN 47402. (812)336-9900. Fax: (812)336-8712. Administrative Assistant for Artistic Resources: Amy Kellams. Estab. 1974. Specializes in greeting cards, posters, stationery. Photo guidelines free with SASE.
Needs: Buys approximately 30 images/year supplied by freelancers. Interested in interaction between people/children/animals evoking a mood/feeling, nature, endangered species (color or b&w photography). Does not want to see sexually suggestive or industry/business photos. Reviews stock photos. Model release required. Property release preferred.
Specs: Uses 35mm; 4×5 transparencies.
Making Contact & Terms: Submit portfolio for review. Works on assignment only. Keeps samples on file. Reports in 3 months. Simultaneous submissions and previously published work OK. Payment negotiable. **Pays on acceptance.** Buys exclusive product rights; negotiable. Credit line given.
Tips: "Look for Sunrise cards in stores; familiarize yourself with quality and designs before making a submission."

$ ▣ ◎ SYRACUSE CULTURAL WORKERS, Box 6367, Syracuse NY 13217. (315)474-1132. Fax: (315)475-1277. E-mail: scw@syrculturalworkers.org. Website: http://www.syrculturalworkers.org. Research/Development Director: Dik Cool. Art Director: Karen Kerney. Specializes in posters, greeting cards, calendars and t-shirts.
Needs: Buys 15-25 freelance photos/year. Images of social content, reflecting a consciousness of diversity, multiculturalism, community building, social justice, environment, liberation, etc. Also uses photos of teens, education, gardening, performing arts. Interested in alternative process, documentary, historical/vintage. Model release preferred. Captions preferred.
Specs: Uses any size b&w; 35mm, 2¼×2¼, 4×5 or 8×10 color transparencies. Accepts images in digital format for Mac. Send via Zip as TIFF, EPS files.
Making Contact & Terms: Send unsolicited photos by mail for consideration. SASE. Reports in 2-4 months. Pays $75-100/b&w or color photo plus free copies of item. Pays by the project, $100-400. Pays royalties of 6%. Buys one-time rights. Credit line given.
Tips: "We are interested in photos that reflect a consciousness of peace and social justice, that portray the experience of people of color, the disabled, elderly, gay/lesbian—must be progressive, feminist, non-sexist. Look at our catalog (available for $1)—understand our philosophy and politics. Send only what is appropriate and socially relevant. We are looking for positive, upbeat and visionary work."

$ ⚎ Ⓢ ◨ TELDON CALENDARS, A Division of Teldon International Inc., 3500 Viking Way, Richmond, British Columbia, V6V 1N6 Canada. (604)272-0556. Fax: (604)272-9774. E-mail: move@rogers.wave.ca. Photo Editor: Monika Vent. Estab. 1968. Publishes high quality scenic and generic advertising calendars. Photos used for one time use in calendars. Photo guidelines free with SAE (9×11) and IRCs or stamps only for return postage.
Needs: Buys over 1,000 images annually, 70% are supplied by freelancers. Looking for travel (world), wildlife (North America), classic automobiles, golf, scenic North America photos and much more. Reviews stock photos. Model/property release required for residential houses, people. Photo captions required that include complete detailed description of destination, i.e., Robson Square, Vancouver, British Columbia, Canada. "Month picture taken also required as we are 'seasonal driven.'"
Specs: Uses 35mm, 2¼×2¼, 4×5, 6×7, 8×10 horizontal only transparencies. "We are making duplicates of what we think is possible material and return the originals within a given time frame. Originals are recalled once final selection has been made."
Making Contact & Terms: Query. No submissions accepted unless guidelines have been received and reviewed. Works with freelancers and stock agencies. SAE. Reports in 1 month, depending on work load. Simultaneous submissions and/or previously published works OK. Pays $100 for one-time use. Pays in September of publication year. Credit line and complementary calendar copies given.
Tips: Horizontal transparencies only, dramatic and colorful nature/scenic/wildlife shots. City shots to be no older than 1 year. For scenic and nature pictures avoid "man made" objects, even though an old barn captured in the right moment can be quite beautiful. "Examine our catalogs and fliers carefully and you will see what we are looking for. Capture the beauty of nature and wildlife as long as it's still around—and that's the trend."

$ $ Ⓢ ◨ TIDE-MARK PRESS, Box 280311, East Hartford CT 06128-0311. (860)289-0363. Fax: (860)289-3654. E-mail: tidemark@tiac.net. Contact Sidelines Editor: Carol Berto. Estab. 1979. Specializes

in calendars, coffee table books and women's adventure travel (trade books). Photo guidelines free with SASE.

Needs: Buys 700 images annually; 600 are supplied by freelancers. Needs complete calendar concepts which are unique, but also have identifiable markets; groups of photos which could work as an entire calendar; ideas and approach must be visually appealing and innovative but also have a definable audience. No general nature or varied subjects without a single theme. Interested in arts and architecture, birds, animals, gardens, hobby, inspiration, nature, nautical, landscapes, rural, food/drink, humor, performing arts, sports, regional, transport and travel. Submit seasonal material 18 months in advance. Reviews stock photos. Model release preferred. Captions required.

Specs: Uses 35mm, 2¼×2¼, 4×5 and 8×10 transparencies.

Making Contact & Terms: "Contact us to offer specific topic suggestion which reflect specific strengths of your stock." Send query letter with stock photo list. Editor will contact photographer for portfolio review if interested. SASE. Reports in 1 month. Pays $150-250/color photo; royalties on net sales if entire calendar supplied. Pays on publication or per agreement. Buys one-time rights. Credit line given.

Tips: "We tend to be a niche publisher and we rely on niche photographers to supply our needs. Ask for a copy of our guidelines and a copy of our catalog so that you will be familiar with our product. Then send a query letter of specific concepts for a calendar. The same goes for a book proposal."

$ $UNIQUE GREETINGS, INC., P.O. Box 5783, Manchester NH 03108. Estab. 1988. Specializes in calendars, decorations, gifts, greeting cards. Guidelines sheet free with SASE.

Needs: Buys 12 images annually; 10 are supplied by freelancers. Interested in humorous images. Submit seasonal material 6 months in advance. Reviews stock photos of foliage, animals and b&w images. Model release required. Photo captions are required.

Specs: Uses 4×6 prints.

Making Contact & Terms: Send query letter with samples and SASE. To show portfolio, photographer should follow-up with letter after initial query. Art director will contact photographer for portfolio review if interested. Portfolio should include b&w and/or color. Works with local freelancers only. Include SASE for return of material. Reports back only if interested, send non-returnable samples. Pays by the project, $250-500 for color. Pays on publication. Buys one-time rights. Credit line not given.

Tips: "We also use photos for brochures."

$ $▣ ◉ VAGABOND CREATIONS, INC., 2560 Lance Dr., Dayton OH 45409. (937)298-1124. E-mail: vagabond@siscom.net. Website: http://www.vagabondcreations.com. President: George F. Stanley, Jr. Specializes in greeting cards.

Needs: Buys 3 photos/year. Interested in general Christmas scenes (non-religious). Submit seasonal material 9 months in advance. Reviews stock photos.

Specs: Uses 35mm transparencies. Accepts images in digital format for Windows.

Making Contact & Terms: Query with stock photo list. SASE. Reports in 1 week. Pays by the project, $200-250 per image. **Pays on acceptance.** Buys all rights. Simultaneous submissions OK.

Ⓝ $Ⓢ ◯ ◎ WARM GREETINGS, 15414 N. Seventh St., #8-172, Phoenix AZ 85022. Phone/fax: (602)439-2001. E-mail: warmgreet@aol.com. Website: http://www.warmgreetings.com. Contact: Jean Cosgriff. Estab. 1978. Specializes in greeting cards.

Needs: Buys 30-40 images annually; all are supplied by freelancers. "We are primarily a Southwest greeting card company specializing in Christmas/holiday cards. We are interested in any Southwest image, especially southwest Christmas. We also need any other Christmas images, images of golf, Indian culture, or business photos suitable for greeting cards." Also considers photos of babies, children, landscapes/scenics, wildlife, adventure, events, business concepts. Interested in fine art, regional, seasonal. Submit seasonal material 8-12 months in advance. Model and property release preferred. Photo captions preferred.

Specs: Uses 35mm, 2¼×2¼, 4×5 transparencies.

Making Contact & Terms: Send query letter with photocopies, tearsheets, stock list. Does not keep samples on file; cannot return material. Reports back only if interested; send nonreturnable samples. Simultaneous submissions and previously published work OK. Pays on publication. Buys one-time rights.

Tips: "No phone calls or in-person visits. Send non-returnable samples please."

$▣ ◉ WISCONSIN TRAILS, Box 5650, Madison WI 53705. (608)231-2444. Fax: (608)231-1557. E-mail: kjc@wistrails.com. Art Director: Kathie Campbell. Estab. 1960. Specializes in calendars (horizontal and vertical) portraying seasonal scenics, some books and activities from Wisconsin.

Needs: Buys 35 photos/issue. Needs photos of nature, landscapes, wildlife and Wisconsin activities. Makes selections in January for calendars, 6 months ahead for issues. Captions required.

Specs: Uses 35mm, 2¼×2¼ and 4×5 transparencies. Accepts images in digital format for Mac (Photo-

shop). Send via CD, floppy disk, SyQuest, Zip, Jaz as TIFF, EPS files at 300-1,250 dpi.

Making Contact & Terms: Submit material by mail for consideration or submit portfolio. Reports in 1 month. Simultaneous submissions OK "if we are informed, and if there's not a competitive market among them." Previously published work OK. Pays $50-100/b&w photo; $50-200/color photo. Buys one-time rights.

Tips: "Be sure to inform us how you want materials returned and include proper postage. Calendar scenes must be horizontal to fit 8½ × 11 format, but we also want vertical formats for engagement calendars. See our magazine and books and be aware of our type of photography. Submit only Wisconsin scenes. Call for an appointment."

$ $ $ ▣ ⬚ ◎ ZOLAN FINE ARTS, LLC., Dept. PM, P.O. Box 656, Hershey PA 17033-2173. (717)534-2446. Fax: (717)534-1095. E-mail: donaldz798@aol.com. Website: http://www.zolan.com. President/Art Director: Jennifer Zolan. Commercial and fine art business. Photos used for artist reference in oil paintings.

Needs: Buys 16-24 photos/year; assignments vary on need. Interested in candid, heart-warming, and endearing photos of children with high emotional appeal between the ages of 2-4 capturing the golden moments of early childhood. "Currently we are looking for the following subject matter: children in country scenes, children kissing, at the beach, children with pets, etc. Also, very interested in photographs of Hispanic, Asian, and African-American children between the ages two to four in endearing moments." Reviews stock photos. Model release preferred.

Specs: Uses any size color or b&w prints; 35mm, 2¼ × 2¼, 4 × 5, 8 × 10 transparencies. Accepts images in digital format for Mac. Send via e-mail, floppy disk, CD, Zip as TIFF, EPS, PICT, JPEG files.

Making Contact & Terms: Write and send for photo guidelines by mail, fax or America Online. Does not keep samples on file. SASE. Queries on guidelines 3-4 weeks; photo returns or acceptances up to 60 days. Pays $200-500/b&w or color photo; pays up to $1,000 to buy exclusive rights for artist reference. **Pays on acceptance.** Buys exclusive rights only for use as artist reference; negotiable.

Tips: "Photos should have high emotional appeal and tell a story. Children should be involved with activity or play. Photos should look candid and capture a child's natural mannerisms. Write for free photo guidelines before submitting your work. We are happy to work with amateur and professional photographers. We are always looking for human interest types of photographs on early childhood, ages two to four. Photos should evoke pleasant and happy memories of early childhood. Photographers can write, e-mail or fax for guidelines before submitting their work. No submissions without receiving the guidelines."

Stock Photo Agencies

© Tony Freeman/PhotoEdit

STOCK FACTS

If you are unfamiliar with how stock agencies work, the concept is easy to understand. Stock agencies house large files of images for contracted photographers and market the photos to potential buyers. In exchange for selling the images agencies typically extract a 50 percent commission from each sale. The photographer receives the other 50 percent.

In recent years the stock industry has witnessed enormous growth, with agencies popping up worldwide. Many of these agencies, large and small, are listed in this section. However, as more and more agencies compete for sales there has been a trend toward partnerships among some small to mid-size agencies. In order to match the file content and financial strength of larger stock agencies, small agencies have begun to combine efforts when putting out catalogs and other promotional materials. In doing so they've pooled their financial resources to produce top-notch catalogs, both print and CD-ROM.

Other agencies have been acquired by larger agencies and essentially turned into subsidiaries. Often these subsidiaries are strategically located to cover different portions of the world. Typically, smaller agencies are bought if they have images that fill a need for the parent company. For example, a small agency might specialize in animal photographs and be purchased by a larger agency that needs those images but doesn't want to search for individual wildlife photographers.

The stock industry is extremely competitive and if you intend to sell stock through an agency you must know how they work. Below is a checklist that can help you land a contract with an agency:

☑ Build a solid base of quality images before contacting any agency. If you send an agency a package of 50-100 images, they are going to want more if they're interested. You must have enough quality images in your files to withstand the initial review and get a contract.

☑ Be prepared to supply new images on a regular basis. Most contracts stipulate that photographers must send additional submissions periodically—perhaps quarterly, monthly, or annually. Unless you are committed to shooting regularly, or unless you have amassed a gigantic collection of images, don't pursue a stock agency.

☑ Make sure all of your work is properly cataloged and identified with a file number. Start this process early so that you're prepared when agencies ask for this information. They'll need to know what is contained in each photograph so that the images can be properly referenced in catalogs and on CD-ROMs and websites.

☑ Research those agencies that might be interested in your work. Often smaller agencies are more receptive to newcomers because they need to build their image files. When larger agencies seek new photographers, they usually want to see specific subjects in which photographers specialize.

◀ "Hispanic adult daughter hugs her senior mom from behind" reads the caption on the slide mount of this image. PhotoEdit stumbled upon its niche in 1989 when Leslye Borden traveled to New York City armed with some slides. "I picked quite a few (unconsciously) of Asian and Hispanic people and children," she says. "And they just went crazy for them in New York. They said, 'You have the right Hispanics.'" What they meant was that in New York City most of the Hispanic population is Puerto Rican, but 60% of the Hispanic people in the world look like the individuals in the slides Borden had shown them. (Leslye Borden explains the important role of multicultural images in education and her stock agency's role in providing such images to text book publishers on page 311.)

If you specialize in a certain subject area, be sure to check out our Subject Index on page 588, listing companies according to the types of images they need.

☑ Conduct reference checks on any agencies you plan to approach to make sure they conduct business in a professional manner. Talk to current clients and other contracted photographers to see if they are happy with the agency. Remember you are interviewing them, too. Also, some stock agencies are run by photographers who market their own work through their own agencies. If you are interested in working with such an agency, be certain that your work will be given fair marketing treatment.

☑ Once you've selected a stock agency, write a brief cover letter explaining that you are searching for an agency and that you would like to send some images for review. Wait to hear back from the agency before you send samples. Then only send duplicates for review so that important work won't get lost or damaged. And always include a SASE.

☑ Finally, don't expect sales to roll in the minute a contract is signed. It usually takes a few years before initial sales are made. Most agency sales come from catalogs and often it takes a while for new images to get printed in a catalog.

SIGNING AN AGREEMENT

When reviewing stock agency contracts there are several points to consider. First, it's common practice among many agencies to charge photographers fees, such as catalog insertion rates or image duping. Don't be alarmed and think the agency is trying to cheat you when you see these clauses. Besides, it might be possible to reduce or eliminate these fees through negotiation.

Another important item in most contracts deals with exclusive rights to market your images. Some agencies require exclusivity to sales of images they are marketing for you. In other words, you can't market the same images they have on file. This prevents photographers from undercutting agencies on sales. Such clauses are fair to both sides as long as you can continue marketing images that are not in the agency's files.

An agency also may restrict your rights to sign with another stock house. Usually such clauses are merely designed to keep you from signing with a competitor. Be certain your contract allows you to work with other agencies. This may mean limiting the area of distribution for each agency. For example, one agency may get to sell your work in the United States, while the other gets Europe. Or it could mean that one agency sells only to commercial clients, while the other handles editorial work.

Finally, be certain you understand the term limitations of your contract. Some agreements renew automatically with each submission of images. Others renew automatically after a period of time unless you terminate your contract in writing. This might be a problem if you and your agency are at odds for any reason. So, be certain you understand the contractual language before signing anything.

STOCK TRENDS REPORT

Stock use by graphic design firms, ad agencies, corporations and publishers is up to 86 percent, according the 11th annual stock survey by *Graphic Design USA* magazine. More importantly, two-thirds of those stock users reported using stock imagery more than six times during the year. What does this mean for you as a photographer? Stock is here to stay and you should consider getting in on the action.

One thing to keep in mind when looking for a stock agent is how they plan to market your work. The *Graphic Design USA* survey showed that 87 percent of respondents had used tradi-

tional stock agencies, finding images through agency searches or catalogs. But 64 percent reported they had used royalty-free CDs to find images and 47 percent said they had used the Internet. A combination of marketing methods seems the best way to attract buyers and most large stock agencies are moving in that direction, offering catalogs, CDs and websites.

But don't discount small, specialized agencies. Even if they don't have the marketing muscle of big companies, they do know their clients well and often offer personalized service and deep image files that can't be matched by more general agencies. If you specialize in regional or scientific imagery you may want to consider a specialized agency.

Unfortunately, the struggles in the stock industry over royalty free versus rights controlled imagery and unfavorable fee splits between agencies and photographers are following us into the next millenium. Before you sign any agency contract, make sure you can live with the conditions, including 40/60 fee splits favoring the agency.

If you find the terms of traditional agencies unacceptable there are alternatives available. Many photographers are turning to the Internet as a way to sell their stock images without an agent. Boston-based photographer Seth Resnick is one of a handful of shooters who are doing very well selling their own stock. Check out his website at www.sethresnick.com. Your other option is to join with other photographers sharing space on the Web. Check out PhotoSource International at www.photosource.com and MIRA at www.mira.com.

One of the best ways to get into stock is to sell outtakes from assignments. The use of stock images in advertising, design and editorial work has risen in the last five years. As the quality of stock images continues to improve, even more creatives will embrace it as an inexpensive and effective means of incorporating art into their designs. Retaining the rights to your assignment work will provide income even when you are no longer able to work as a photographer. At last year's PhotoPlus Expo in New York, ASMP Executive Director Richard Weisgrau advised all photographers to look at outtakes from editorial assignments as their retirement funds and to plan to sell these images over the Internet.

Where to Learn More About the Stock Industry

There are numerous resources available for photographers who want to learn about the stock industry. Here are a few of the best.

- **PhotoSource International, (800)223-3860**, website: http://www.photosource.com. Owned by author/photographer Rohn Engh, this company produces several newsletters that can be extremely useful for stock photographers. A few of these include *PhotoStock-Notes*, *PhotoMarket*, *PhotoLetter* and *PhotoBulletin*.
- *Selling Stock*, **(301)251-0720**, website: http://www.pickphoto.com. This newsletter is published by one of the photo industry's leading insiders, Jim Pickerell. He gives plenty of behind-the-scenes information about agencies and is a huge advocate for stock photographers.
- **The Picture Agency Council of America, (800)457-7222**, website: http://www.pacaoffice.org. Anyone researching an American agency should check to see if the agency is a member of this organization. PACA members are required to practice certain standards of professionalism in order to maintain membership.
- **British Association of Picture Libraries and Agencies, (44171)713-1780**, website: http://www.bapla.org.uk. This is PACA's counterpart in the United Kingdom and is a quick way to examine the track record of many foreign agencies.

insider report

Balancing books: stock agency provides multicultural images

Pick up a typical stock photography cata-log and you'll see people doing all types of activities. But what you won't usually see is all types of people participating in these activities. Instead, the majority of images feature middle-class white adults and children. Long Beach, California-based PhotoEdit's mission is to fill this multicultural gap in the stock photo in-dustry. With 90% of its business coming from textbook publishers, PhotoEdit strives to offer images with which stu-

Leslye Borden and Liz Ely

dents from a variety of ethnic backgrounds can identify, helping publishers achieve a racial representation that closely matches the ethnic make-up of their readerships.

PhotoEdit began as a freelance photo-research team, pooling the resources of partners Leslye Borden and Liz Ely who met while they both worked as photo re-searchers for Atlantic Richfield Corp. in the early 1980s. The two women initially worked out of a bedroom in Borden's Tarzana, California, home. The company got its first break in June 1987 when photographer Alan Oddie retired to France, leaving his collection of 30,000 slides for Borden and Ely to manage. They began marketing these images, turning away from researching and locating photos for others. Then PhotoEdit stumbled upon its niche in 1989 when Borden traveled to New York City armed with some slides. "I picked quite a few (unconsciously) of Asian and Hispanic people and children," Borden says. "And they just went crazy for them in New York. They said, 'You have the right Hispanics.'" What they meant was that in New York City most of the Hispanic population is Puerto Rican, but 60% of the Hispanic people in the world look like the individuals in the slides Borden had shown them. "Instantly, we knew what our niche in the market was," Borden says. PhotoEdit grew to 8 employees and, in 1995, Borden and the company moved to separate Long Beach locations, eliminating Ely's 76-mile daily commute to Tarzana.

Today, Borden and Ely continue to market the late Oddie's images. But those images now make up a small portion of the 600,000 photographs in PhotoEdit's collec-tion. The company has grown to 18 staff members who help represent the work of 60 freelance photographers. Despite the size of its collection, PhotoEdit is dedicated to hiring college-educated individuals who personally choose images from the database

to send to clients, rather than relying soley on keyword searches to select photos. Borden and Ely are equally as selective in choosing photographers, stressing that they only want to work with "shooting" photographers. "They can't be someone who's just going to send us five boxes of slides and say, 'That's it, I'm on to something else now,'" Borden says. "We never say no to a client. If a client asks for something and we don't have it in our files, we quickly get someone to do it. Because of this, it's important that the photographers are energetic, eager to work and have models available, have lights and equipment and can hustle." It also means that photographers who work with PhotoEdit need to have access to an ethnically diverse group of people who are willing to model for stock photos.

Textbook publishers count up the total number of people in each book and make sure the ethnic make-up matches that of its audience—usually an agreed-upon nationwide standard. PhotoEdit makes assignments to its photographers based on these percentages. Therefore, it's important that photographers demonstrate to PhotoEdit that they are sensitive to and interested in working with minority people, including gays and lesbians. "It's very hard if you're a white photographer who has always shot white people and lived in a white community to go out there and start getting black families," Borden explains. PhotoEdit has some ethnic diversity among its photographers but would like to work with more minority photographers.

© David Young Wolff/PhotoEdit

"Educational psychologists know that a child learns best if he can identify with things in a book," Leslye Borden says. "So it's very important, we feel, for every child to be able to open a textbook and see someone who looks like him." Therefore, it's important that photographers demonstrate to PhotoEdit that they are sensitive to and interested in working with minority people. PhotoEdit has some ethnic diversity among its photographers but would like to work with more minority photographers.

To be successful with PhotoEdit, photographers also must have financial resources as it's often at least a year before they're paid after shooting a photo for the agency. This long lag time is due to the nature of the textbook industry's production schedules. Also, the photographers are responsible for covering the expenses for each shoot. In exchange, they retain the rights to their photographs and receive 50% of the payment for each image PhotoEdit sells. The company sells most photos for $150-200. Occasionally, the client covers shooting or model costs, money that PhotoEdit passes directly to the photographer.

Borden stresses that the company's values have nothing to do with affirmative action but, instead, good educational principles. Borden, who has been committed to education and diversity since she was a high school exchange student to the Netherlands, believes PhotoEdit provides an important service. "Educational psychologists know that a child learns best if he can identify with things in a book," she says. "So it's very important, we feel, for every child to be able to open a textbook and see someone who looks like him." Borden believes it is important for photographers who work with PhotoEdit to share this belief.

Photographers benefit from the personal attention and encouragement PhotoEdit can give since the company works with only 60 photographers—a small number by stock-photo industry standards. "I think you just have a much better opportunity in an agency with a small number of photographers and dynamic, energetic leaders like Liz and me who can motivate them to shoot things that really sell," Borden says. "There's a lot of personal encouragement, and we work with the photographers closely." PhotoEdit photographers also cash in on the company's repeat business. Textbook publishers revise their books every two to five years, often using the same images for which the agency is paid a second or third time. Borden and Ely request that photographers keep this in mind and try to shoot "timeless" photographs. "We encourage everyone to be careful about allowing dates to appear, hairstyles and clothing," Borden says. She points to Oddie's collection, explaining that they still sell many of his images because of their timeless quality.

With an annual revenue of $1.5 million, PhotoEdit has carved a name for itself in the stock photo industry. The company's success is largely due to its unique place in the market and the values its employees and photographers embrace. Borden also feels strongly that stock photographers have advantages far outweighing those of assignment photographers. She believes the strongest benefit for PhotoEdit's photographers is that they retain the rights to their images.

Although an assignment photographer may be paid more up front, Borden feels stock photographers are richer in the end. "If a person is accustomed to being an assignment photographer, joining our agency and working the way we do is very hard to understand because there's nobody to pay for all of these expenses," she says. "But what you get back from it is so much more if you can wait. It's such an investment in your own self. It's like buying stock."

—*Sarah Morton*

■ **AAA IMAGE MAKERS**, 337 W. Pender St., Suite 301, Vancouver, British Columbia V6B 1T3 Canada. (604)688-3001. Owner: Reimut Lieder. Art Director: Neonila Lilova. Estab. 1981. Stock photo agency. Has 250,000 photos. Clients include: advertising agencies, public relations firms, audiovisual firms, businesses, book/encyclopedia publishers, magazine and textbook publishers, postcard publishers, calendar companies and greeting card companies.

Needs: Model-released lifestyles, high-tech, medical, families, industry, computer-related subjects, active middle age and seniors, food, mixed ethnic groups, students, education, occupations, health and fitness, extreme and team sports, and office/business scenes. "We provide our photographers with a current needs list on a regular basis."

Specs: Uses 8×10 glossy or pearl b&w prints; 35mm, 2¼×2¼, 4×5 and 8×10 transparencies.

Payment & Terms: Pays 50% commission on color and b&w. Average price per image (to clients): $400-800/b&w and color. Enforces minimum prices. Offers volume discount to customers; terms specified in photographer's contract. Discount sales terms not negotiable. Works on contract basis only. Offers limited regional exclusivity, guaranteed subject exclusivity. Charges 50% duping fee, 50% catalog insertion fee. Statements issued quarterly. Payment made quarterly. Photographers allowed to review account records. Rights negotiated by client needs. Does not inform photographer or allow him to negotiate when client requests all rights. Model releases required. "All work must be marked 'MR' or 'NMR' for model release or no model release. Photo captions required.

Making Contact: Interested in receiving work from established, especially commercial, photographers. Arrange personal interview to show portfolio or submit portfolio for review. Query with résumé of credits. Query with samples. Send SAE (IRCs) with letter of inquiry, résumé, business card, flier, tearsheets or samples. Expects minimum initial submission of 200 images. Reports in 2-3 weeks. Photo guideline sheet free with SAE (IRC). Market tips sheet distributed quarterly to all photographers on contract; free with SAE (IRCs).

Tips: "As we do not have submission minimums, be sure to edit your work ruthlessly. We expect quality work to be submitted on a regular basis. Research your subject completely and shoot shoot shoot!!"

图 ACCENT ALASKA/KEN GRAHAM AGENCY, P.O. Box 272, Girdwood AK 99587. (907)783-2796. Fax: (907)783-3247. E-mail: info@accentalaska.com. Website: http://www.accentalaska.com. Owner: Ken Graham. Estab. 1979. Stock agency. Has 270,000 photos in files. Clients include: advertising agencies, public relations firms, audiovisual firms, businesses, book publishers, magazine publishers, newspapers, calendar companies, greeting card companies, postcard publishers, CD-ROM encyclopedias.

Needs: Wants photos of children, couples, multicultural, families, parents, senior citizens, teens, cities/urban, gardening, pets, religious, rural, adventure, automobiles, entertainment, events, health/fitness, hobbies, humor, performing arts, sports, travel, agriculture, buildings, business concepts, computers, industry, medicine, military, political, portraits, product shots/still life, science, technology. Interested in regional, seasonal images of Alaska, Northwest and Hawaii.

Specs: Uses 35mm, 2¼×2¼, 4×5, 8×10 transparencies.

Payment & Terms: Pays 50% for color photos. Average price per image (to clients): $150 minimum for color photos. Negotiates fees below standard minimum prices. Sometimes we accept less for large (quantity) rights. Works with photographers on contract basis only. Offers nonexclusive contract. Contracts renew automatically with additional submissions. Statements issued monthly. Payment made monthly. Photographers allowed to review account records in cases of discrepancies only.

Making Contact: Send query letter with stock list. Does not keep samples on file; include SASE for return of material. Expects minimum initial submission of 60 images. Reports in 1 month. Photo guidelines sheet free with SASE. Market tips sheet available.

Tips: "Realize we specialize in Alaska and the Northwest although we do accept images from Hawaii, Pacific, Antarctica and Europe. The bulk of our sales are Alaska-related. We are always interested in seeing submissions of sharp, colorful, and professional quality images with model-released people when applicable."

⊕ ■ ACE PHOTO AGENCY, Satellite House, 2 Salisbury Rd., Wimbledon, London SW19 4EZ United Kingdom. Phone: (181)944-9944. Fax: (181)944-9940. E-mail: info@acestock.com. Website: http://www.acestock.com. Chief Editor: John Panton. Stock photo agency. Has approximately 300,000 photos. Clients include: ad agencies, audiovisual firms, businesses, book/encyclopedia publishers, magazine publishers, postcard companies, calendar companies, greeting card companies, design companies and direct mail companies.

Needs: Needs photos of babies, children, couples, multicultural, families, parents, senior citizens, teens, environmental, landscapes/scenics, wildlife, pets, adventure, automobiles, food/drink, health/fitness, hobbies, humor, sports, travel, business concepts, computers, industry, medicine, portraits, product shots/still

life, science, technology. Interested in alternative process, avant garde, digital, documentary, fashion/glamour, seasonal.

Specs: Uses 35mm, $2\frac{1}{4} \times 2\frac{1}{4}$, 4×5 and 8×10 transparencies. Accepts images in digital format for Mac. Send via compact disc, SyQuest, Jazz, Zip or e-mail as JPEG files.

Payment & Terms: Pays 50% commission on color photos, 30% overseas sales. General price range: $135-1,800. Works on contract basis only; offers limited regional exclusivity contracts. Contracts renew automatically for 2 years with each submission. Charges catalog insertion fee, $100 deducted from first sale. Statements issued quarterly. Payment made quarterly. Photographers permitted to review sales records with 1 month written notice. Offers one-time rights, first rights or mostly non-exclusive rights. Informs photographers when client requests to buy all rights, but agency negotiates for photographer. Model/property release required for people and buildings. Photo captions required; include place, date and function.

Making Contact: Arrange a personal interview to show portfolio. Query with samples. SASE (IRCs). Reports in 2 weeks. Photo guidelines free with SASE. Distributes tips sheet twice yearly to "Ace photographers under contract."

Tips: Prefers to see "total range of subjects in collection. Must be commercial work, not personal favorites. Must show command of color, composition and general rules of stock photography. All people must be mid-Atlantic to sell in UK. Must be sharp and also original. No dupes. Be professional and patient. We are now fully digital. Scanning and image manipulation is all done inhouse. We market CD-ROM stock to existing clients. Photographers are welcome to send CD, SyQuest, cartridge or diskette for speculative submissions. Please provide data for Mac only."

ADVENTURE PHOTO & FILM, 24 E. Main St., Ventura CA 93001. (805)643-7751. Fax: (805)643-4423. Estab. E-mail: apf@west.net. Estab. 1987. Stock agency. Member of Picture Agency Council of America (PACA). Has 250,000 images. Clients include: advertising agencies, public relations firms, businesses, publishers, calendar and greeting card companies.

Needs: Adventure Photo & Film offers its clients 4 principal types of images: adventure sports (sailing, windsurfing, rock climbing, skiing, mountaineering, mountain biking, etc.), adventure travel worldwide, nature/landscapes and wildlife.

Specs: Uses 35mm, $2\frac{1}{4} \times 2\frac{1}{4}$ and 4×5 transparencies, b&w prints, footage.

Payment & Terms: Pays 50% commission. Works on contract basis only. Offers image exclusive contract. Statements issued monthly. Payment made monthly. Photographers allowed to review sales figures. Offers one-time rights; occasionally negotiates exclusive and unlimited use rights. "We notify photographers and work to settle on acceptable fee when client requests all rights." Model and property release required. Captions required, include description of subjects, locations and persons.

Making Contact: Write to photo editor for copy of submission guidelines. SASE. Reports in 1 month. Photo guidelines free with SASE.

Tips: Wants to see artist's portfolio/samples of "well-exposed, repro-quality transparencies of unique outdoor adventure sports, travel and wilderness photography. We love to see images that illustrate metaphors commonly used in advertising business (risk taking, teamwork, etc.)." To break-in, "We request inquiring artists send AP&F 40-60 images that best represent their work. After we sign an artist, we pass ideas along regularly about the type of imagery our clients are requesting. We direct our artists to always take note on the kinds of images our clients are using by looking at current media."

AFLO FOTO AGENCY, Sun Bldg., 8th Floor, 5-13-12 Ginza Chuoku, Tokyo Japan 104-0061. Phone: (81)(0)3-3546-0900. Fax: (81)(0)3-3546-0258. E-mail: info@aflo.com Website: http://www.aflo.com Contact: Ken Soga. Estab. 1980. Stock agency, picture library and news/feature syndicate. Member of the Picture Agency Council of America. (PACA). Has 1 million photos in files. We have other offices in Tokyo and one in Osaka. Photographers should contact Ken Soga. Clients include: advertising agencies, businesses, public relations firms, book publishers, magazine publishers.

Needs: Wants photos of babies, celebrities, children, couples, multicultural, families, parents, senior citizens, teens, disasters, environmental, landscapes/scenics, wildlife, architecture, beauty, cities/urban, education, gardening, interiors/decorating, pets, religious, rural, adventure, automobiles, entertainment, events, food/drink, health/fitness, hobbies, humor, performing arts, sports, travel, agriculture, buildings, business concepts, computers, industry, medicine, military, political, portraits, product shots/still life, science, technology. Interested in alternative process, avant garde, digital, documentary, erotic, fashion/glamour, fine art, historical/vintage, regional, seasonal.

Specs: Uses 35mm. $2\frac{1}{4} \times 2\frac{1}{4}$, 4×5, 8×10 transparencies. Accepts images in digital format for Mac. Send via e-mail.

Payment & Terms: Pays 50% commission for b&w photos; 50% for color photos; 50% for film; 50% for videotape. Average price per image (to clients): $195 minimum for b&w photos; $250 minimum for

color photos; $250 minimum for film; $250 minimum for videotape. Offers volume discounts to customers; terms specified in photographers' contracts. Photographers can choose not to sell images on discount terms. Works with photographers with or without a contract; negotiable. Contract type varies. Contracts renew automatically with additional submissions; for 3 years. Statements issued quarterly. Payment made quarterly. Photographers allowed to review account records. Model release preferred; property release preferred. Photo captions required.

Making Contact: Send query letter with transparencies, stock list. Provide self-promotion piece to be kept on file. Expects minimum initial submission of 100 images with quarterly submissions of at least 25 images. Reports in 2 weeks on samples. Photo guidelines sheet free for SASE. Catalog negotiable.

Tips: "We wish everyone luck when submitting work."

N ⊕ ▣ AGE FOTOSTOCK, Aplicaciones de la Imagen Sl, Buenaventura Munoz 16, Barcelona Spain. Phone: (3493)3002552. E-mail: age@agefotostock.com. Website: http://www.agefotostock.com. Photographer Liaison: Ruth Persselin. Estab. 1973. Stock agency. Has 2 million photos in files. There are branch offices in Madrid, Bilbao, and a subsidiary company in New York City, Age Fotostock America Inc. Photographers should contact the Barcelona office. Clients include: advertising agencies, businesses, newspapers, postcard publishers, public relations firms, book publishers, calendar companies, audiovisual firms, magazine publishers, greeting card companies.

Needs: "We are a general stock agency and are constantly producing new catalogs, and feeding images into our duping program. Therefore we constantly require new photos from all categories.

Specs: Uses all prints and film. Accepts images in digital format for Mac and Windows. Send via CD as TIFF, EPS, PICT, BMP, GIF, JPEG files at 72 dpi.

Payment & Terms: Pays 50% commission for b&w photos; 50% for color photos; 50% for film. Terms specified in photographers' contract. Works with photographers on contract basis only. Offers image exclusivity worldwide. Statements issued monthly. Payment made monthly. Photographers allowed to review account records. Model release required; property release required. Photo captions required.

Making Contact: Send query letter with résumé, slides, prints, transparencies. Expects minimum initial submission of 100 images with regular submissions. Photo guidelines sheet, catalog, market tips sheet free with SASE.

N ⊕ ▣ AGENCEE D'ILLUSTRATION PHOTOGRAPHIQUE EDIMEDIA, Rue Beaubourg, Suite 58, Paris France 75003. Phone: 07.44.54.5757. Fax: 07.48.87.79.75. E-mail: info@edimedia.fr. Website: http://www.edimedia.fr. Estab. 1980. Stock agency, picture library. Has 450,000 photos in files. Clients include: advertising agencies, businesses, newspapers, postcard publishers, public relations firms, book publishers, calendar companies, audiovisual firms, magazine publishers, greeting card companies.

Needs: Wants photos of babies, celebrities, children, couples, multicultural, families, parents, senior citizens, teens, disasters, environmental, wildlife, architecture, cities/urban, education, gardening, interiors/decorating, pets, religious, rural, automobiles, entertainment, events, food/drink, health/fitness, sports, travel, and historical photos of agriculture, buildings, industry, medicine, military, political, portraits, science, technology. Interested in historic, erotic, fashion/glamour, fine art, regional.

Specs: Uses b&w prints; 35mm, 2¼×2¼, 4×5, 8×10. Accepts images in digital format for Mac and Windows. Send via e-mail as PICT, JPEG files.

Payment & Terms: Pays $600 minimum-$700 maximum for b&w photos; $750 minimum-$7,000 maximum for color photos. Offers volume discounts to customers; terms specified in photographers' contract. Photographers can choose not to sell images on discount terms. Works with photographers on contract basis only. Offers nonexclusive contract. Statements issued every 3 months. Photographers allowed to review account records. Offers agency promotion rights. Photo captions required/preferred.

Making Contact: Send query letter with résumé, stock list.

AGSTOCKUSA, 25315 Arriba Del Mundo Dr., Carmel CA 93923. (831)624-8600. Fax: (831)626-3260. E-mail: agstockusa@aol.com. Website: http://www.agstockusa.com. Owner: Ed Young. Estab. 1996. Stock photo agency. Has 100,000 photos. Clients include: advertising agencies, graphic design firms, businesses, public relations firms, book/encyclopedia publishers, calendar companies, magazine publishers and greeting card companies.

Needs: Photos should cover all aspects of agriculture worldwide—agricultural scenes; fruits, vegetables and grains in various growth stages, studio work, aerials, harvesting, processing, irrigation, insects, weeds, farm life, agricultural equipment, livestock, plant damage and plant disease.

Specs: Uses 35mm, 2¼×2¼, 4×5, 6×7 and 6×17 transparencies.

Payment & Terms: Pays 50% on color photos. Enforces minimum price of $200. Offers volume discounts to customers; inquire about specific terms. Photographers can choose not to sell images on discount terms. Works on contract basis only. Offers nonexclusive contracts. Contracts renew automatically with additional

submissions for two years. Charges 50% catalog insertion fee; 50% for production costs for direct mail and CD-ROM advertising. Statements issued monthly. Payment made monthly. Photographers allowed to review account records. Offers unlimited use and buyouts if photographer agrees to sale. Informs photographer when client requests all rights; final decision made by agency. Model/property release preferred. Captions required; include location of photo and all technical information (what, why, how, etc.).
Making Contact: Submit portfolio for review. Call first. Keeps samples on file. SASE. Expects minimum initial submission of 100 images. Reports in 3 weeks. Photo guidelines free with SASE. Agency newsletter distributed yearly to contributors under contract.
Tips: "Build up a good file (quantity and quality) of photos before approaching any agency. A portfolio of images is currently displayed on our website. We plan to issue a CD-ROM disk by April, 1999."

N ⊕ ◼ AKEHURST BUREAU ITD., 345 Portobello Rd., London W10 5SA United Kingdom. Phone: (0181)969 0453. Fax: (0181)960 0085. Contact: Nicky Akehurst. Estab. 1994. Stock agency. Has 10,000 photos in files. We have access to over 200 fine art photographers' output and numerous private collections of images dating back to last century. Clients include: advertising agencies, newspapers, postcard publishers, book publishers, calendar companies, magazine publishers, greeting card companies.
Needs: Wants photos of landscapes, still life. Interested in alternative process, avant garde, digital, erotic, fashion/glamour, fine art, creative and unusual stock images with style.
Specs: Uses 8×10, matte, color and/or b&w prints; 35mm, 2¼×2¼, 4×5, 8×10 transparencies. Accepts images in digital format for Windows. Send via CD at 72 dpi for viewing only.
Payment & Terms: Pays 50-75% commission for b&w photos. Price to clients varies according to usage of image. Enforces minimum prices as recommended by Bapla. Offers volume discounts to customers. Photographers can choose not to sell images on discount terms. Works with photographers with or without contract; negotiable. Offers guaranteed subject exclusivity (within files). Contracts renew automatically for new work. Be prepared to give one year trial period, then continue on for 3 year period. Statements issued quarterly. Payment made quarterly. Photographers allowed to review account records in cases of discrepancies only. Offers one-time rights. Informs photographers and allows them to negotiate when client requests all rights. Model release required; property release required. Photo captions required; include reference codes.
Making Contact: Send query letter with slides, prints, photocopies, tearsheets, transparencies by appointment only. Keeps samples on file if "we feel the work suitable for our client base. If not, we do not keep samples on file." Include SASE for return of material. Expects minimum initial submission of 50 images with quarterly submissions of at least 50 images. Reports in 2 weeks on samples; 1 week on portfolios.
Tips: "The Akehurst Bureau is in the unique position to access contemporary fine art photography from well known to little known 'art Photographers', with work from photographers who ordinarily may not place their work with stock libraries. The images are diverse and reflect the personal style and creativity of the photographer, not just a theme or subject. We want diverse images which reflect the personal style and creativity of the photographer, not just a theme or subject. We are interested in subjects such as glamour, rock music, personalities and theater."

◼ ALASKA STOCK IMAGES, 2505 Fairbanks St., Anchorage AK 99503. (907)276-1343. Fax: (907)258-7848. E-mail: photoinfo@alaskastock.com. Website: http://www.Alaskastock.com. Owner: Jeff Schultz. Stock photo agency. Member of the Picture Agency Council of America (PACA). Has 200,000 transparencies. Clients include: advertising agencies, businesses, newspapers, postcard publishers, book/encyclopedia publishers and calendar companies.
Needs: Outdoor adventure, wildlife, recreation, environmental, landscapes, travel—images which were or could have been shot in Alaska. Interested in alternative process, digital, historical/vintage, regional, seasonal.
Specs: Uses 35mm, 2¼×2¼, 4×5, 6×17 panoramic transparencies. Accepts images in digital format for Mac, Windows. Send via e-mail as TIFF, JPEG files.
Payment & Terms: Pays 50% commission on color photos, b&w, film and video; minimum use fee $125. Charges 100% duping fee. Charges 50% for catalog insertion. Offers volume discounts to customers; inquire about specific terms. Photographers can choose not to sell images on discount terms. Works on contract basis only. Offers nonexclusive contract; exclusive contract for images in promotions. Contracts renew automatically with additional submissions; nonexclusive for 3 years. Charges variable catalog insertion fee. Statements issued monthly. Payment made monthly. Photographers allowed to review account records. Offers negotiable rights. Informs photographer and negotiates rights for photographer when client requests all rights. Model/property release preferred for any people and recognizable personal objects (boats, homes, etc.). Captions required; include who, what, when, where.
Making Contact: Query with samples. Samples not kept on file. SASE. Expects minimum initial submission of 200 images with periodic submission of 100-200 images 1-4 times/year. Reports in 3 weeks. Photo

guidelines free on request. Market tips sheet distributed 2 times/year to those with contracts.
Tips: "Send e-mail samples—all images should be in one file, not a separate image per file."

🌐 J. CATLING ALLEN PHOTO LIBRARY, St. Giles House, Little Torrington, Devon EX38 8PS
England. Phone: (01805)622497. Estab. 1965. Picture library. Has 90,000 photos in files. Clients include:
book publishers, magazine publishers, calendar companies, greeting card companies, postcard publishers.
Needs: Specializes in Bible lands including archaeological sites, religions of Christianity, Islam and Juda-
ism; medieval abbeys, priories, cathedrals, churches; historic, rural and scenic Britain.
Payment/Terms: Average price per image (to clients): depends on size of reproductions and rights
required. Offers volume discounts to customers.

N 🌐 ▢ ALLPIX PHOTO AGENCY, 4 Bitzaron St., Tel Aviv Israel 67220. Phone: (972)-3-
5623267. E-mail: gilhadny@internet-zahav.net. Director: Gil Hadani. Estab. 1995. Stock agency. Has
60,000 photos in files. Clients include: advertising agencies, public relations firms, businesses, book pub-
lishers, magazine publishers, newspapers.
Needs: Wants photos of babies, celebrities, children, couples, multicultural, families, parents, senior citi-
zens, teens, disasters, environmental, landscapes/scenics, wildlife, architecture, beauty, cities/urban, educa-
tion, gardening, interiors/decorating, pets, religious, adventure, automobiles, entertainment, events, food/
drink, health/fitness, hobbies, humor, performing arts, sports, travel, agriculture, buildings, business con-
cepts, computers, industry, medicine, military, political, portraits, product shots/still life, science, technol-
ogy. Interested in alternataive process, avant garde, digital, documentary, erotic, fashion/glamour, fine art,
historical/vintage, regional, seasonal.
Specs: Uses 5×7, glossy, color and/or b&w prints; 35mm, 2¼×2¼, 4×5, 8×10 transparencies. No
originals. Only high quality dupes. Accepts images in digital format for Windows. Send via e-mail as JPEG
files at 72 dpi. "Not more than 40K!! 10 samples max."
Payment & Terms: Pays 50% commission. Average price per image (to clients): $50-5,000 for color
photos. Enforces strict minimum prices. Offers volume discounts to customers. Discount sales terms not
negotiable. Works with photographers on contract basis only. Offers exclusive Israel, nonexclusive world-
wide. Contracts renew automatically with additional submissions; for 4 years. Statements issued quarterly.
Payment made quarterly. Offers agency promotion rights. Informs photogaphers and allows them to negoti-
ate when a client requests all rights. Model release preferred; property release preferred. Photo captions
required.
Making Contact: E-mail query letter with résumé and stock list. Does not keep samples on file; cannot
return material. Expects minimum initial submission of 50 images. Reports back only if interested, send
non-returnable samples.
Tips: "We need high-quality images of celebrities, sports and general stock. Be very creative; amaze the
viewer."

N 🌐 ▢ ALPHASTOCK, Greenheys Centre, Pencroft Way, Manchester M15 6JJ England.
(44)(0)161 226 8000. Fax: (44)(0)161 226 2022. E-mail: pictures@alphastock.co.uk. Website: http://www.a
lphastock.co.uk. Estab. 1978. Picture library. Has 150,000 photos in files. Clients include: advertising
agencies, businesses, book publishers, magazine publishers.
Needs: Wants photos of babies, children, couples, families, senior citizens, teens, environmental, interiors/
decorating, health/fitness, sports, travel, business concepts, computers, industry, science, technology. Inter-
ested in regional, seasonal.
Specs: Uses 35mm, 2¼×2¼, 4×5, 8×10. Accepts images in digital format for Mac, Windows. Send
via CD, Zip, e-mail as TIFF files at various dpi.
Payment & Terms: Buys photos outright. Pays 50% commission for b&w photos; 50% for color photos.
Average price per image (to clients): $80 minimum for b&w photos; $80 minimum for color photos. Offers
volume discounts to customers. Discount sales terms not negotiable. Works with photographers on contract
basis only. Contracts renew automatically with additional submissions. Payment made quarterly. Photogra-
phers allowed to review account records in cases of discrepancies only. Offers one-time rights. Informs
photographers and allows them to negotiate when client requests all rights. Model release preferred; prop-
erty release preferred. Photo captions preferred; include facts only.
Making Contact: Portfolio with slides, transparencies may be dropped off Monday-Saturday. Does not
keep samples on file; include SASE for return of material. Expects minimum initial submission of 30
images. Reports in 1 month on samples. Photo guidelines free with SASE.
Tips: "See guidelines on our website."

N 🌐 AMERICAN PHOTO LIBRARY, Plans, Ltd., YS Bldg. 6F 2-3-4 Kyobashi Chuo-ku, Tokyo
Japan 104-0031. Phone: (81)3-3245-1030. Fax: (81)3-3245-1613. E-mail: yoshida@plans-jp.com. Website:

http://www.plans-jp.com. President: Takashi Yoshida. Estab. 1982. Stock agency. Has 250,000 photos in files. Has offices in Sapporo, Yokohama, Nagano, Kanazawa, Nagoya, Osaka, Hiroshima and Fukuoka. Clients include: advertising agencies, newspapers, book publishers, magazine publishers.

Needs: Wants photos of babies, celebrities, children, couples, multicultural, families, parents, senior citizens, teens, disasters, environmental, landscapes/scenics, wildlife, architecture, beauty, cities/urban, education, gardening, interiors/decorating, pets, religious, rural, adventure, automobiles, entertainment, events, food/drink, health/fitness, hobbies, humor, performing arts, sports, travel, agriculture, buildings, business concepts, computers, industry, medicine, military, political, portraits, product shots/still life, science, technology. Interested in alternative process, avant garde, digital, documentary, erotic, fashion/glamour, fine art, historical/vintage, regional, seasonal, Japanese Ukiyoe prints.

Specs: Uses 35mm, $2\frac{1}{4} \times 2\frac{1}{4}$, 4×5 transparencies.

Payment & Terms: Pays 50% commission for b&w photos; 50% for color photos. Average price per image (to clients): $70 minimum-$1,000 maximum for b&w photos or color photos. Negotiates fees below standard minimum prices. Offers volume discounts to customers. Discount sales terms not negotiable. Works with photographers with or without contract; negotiable. Offers nonexclusive contract. Contracts renew automatically with additional submissions. Statements issued monthly. Payment made monthly. Photographers allowed to review account records. Offers one-time rights, electronic media rights, agency promotion rights. Model release preferred. Photo captions required; include year, states, cities.

Making Contact: Send query letter with résumé, slides, stock list. Does not keep samples on file; cannot return material. Reports back only if interested, send non-returnable samples. Catalog available.

Tips: "We do need all kinds of photographs of the United States."

🌐 **THE ANCIENT ART & ARCHITECTURE COLLECTION**, 410-420 Rayners Lane, Suite 7, Pinner, Middlesex, London HA5 5DY England. Phone: (181)429-3131. Fax: (181)429-4646. E-mail: library @aaacollection.co.uk. Contact: Michelle Jones. Picture library. Has 250,000 photos. Clients include: advertising agencies, book/encyclopedia publishers, magazine publishers and newspapers.

Needs: Ancient and medieval buildings, sculptures, objects, artifacts, religious, travel. Interested in fine art, historical/vintage.

Specs: Uses 35mm, $2\frac{1}{4} \times 2\frac{1}{4}$ or 4×5 transparencies.

Payment & Terms: Pays 50% commission for color photos. Works with photographers on contract basis only. Offers nonexclusive contracts. Contracts renew automatically with additional submissions. Statements issued quarterly. Payment made quarterly. Photographers allowed to review account records. Offers one-time rights. Fully detailed captions required.

Making Contact: Query with samples and list of stock photo subjects. SASE. Reports in 2 weeks.

Tips: "Material must be suitable for our specialist requirements. We cover historical and archeological periods from 25,000 BC to the 19th century AD, worldwide. All civilizations, cultures, religions, objects and artifacts as well as art are includable. Pictures with tourists, cars, TV aerials, and other modern intrusions not accepted. Send us a submission of color transparencies by mail together with a list of other material that may be suitable for us."

🌐 **ANDES PRESS AGENCY**, 26 Padbury Ct., London E2 7EH England. Phone: (0171)613-5417 Fax: (0171)739-3159. E-mail: photos@andespress.demon.co.uk. Website: http://andespress.demon.co.uk. Contact: Val Baker. Picture library and news/feature syndicate. Has 300,000 photos. Clients include: magazine publishers, advertising agencies, businesses, book publishers, non-governmental charities and newspapers.

Needs: "We have a large section of travel photographs on social, political and economic aspects of Latin America, Africa, Asia, Europe and Britain, specializing in contemporary world religions."

Specs: Uses 8×10 glossy b&w prints; 35mm and $2\frac{1}{4} \times 2\frac{1}{4}$; b&w contact sheets and negatives.

Payment & Terms: Pays 50% commission for b&w and color photos. General price range (to clients): £80-200/b&w photo; £80-300/color photo. Negotiates fees below stated minimums occasionally to local papers. Works on contract basis only. Offers nonexclusive contract. Contracts renew with additional submissions. Statements issued bimonthly. Payment made bimonthly. Photographers allowed to review account records in cases of discrepancies only. Offers one-time rights. "We never sell all rights; photographer has to negotiate if interested." Model/property release preferred. Captions required.

Making Contact: Query with samples. Send stock photo list. SASE. Reports in 3 weeks. Photo guidelines free with SASE.

Tips: "We want to see that the photographer has mastered one subject in depth. Also, we have a market for photo features as well as stock photos. When submitting work, send a small selection of no more than 100 color transparencies."

⊕ ▣ ◪ **(APL) ARGUS PHOTOLAND, LTD.**, Room 3901 Windsor House, 311 Gloucester Rd., Hong Kong. Phone: (852)2890-6970. Fax: (852)2881-6979. E-mail: argus@argusphoto.com.hk. Website: http://www.argusphoto.com.hk. Director: Joan Li. Estab. 1992. Stock photo agency. Has 160,000 photos; has 4 offices in mainland China which includes Beijing, Shanghai, Guangzhou and Shenzhen. Clients include: advertising agencies, graphic houses, public relations firms, book/encyclopedia publishers, magazine publishers, postcard publishers, calendar companies, greeting card companies, mural printing companies and trading firms/manufacturers.

Needs: "We cover general subject matters with urgent needs of people images (baby, children, woman, couple, family and man, etc.) in all situations; business and finance; industry; science & technology; living facilities; flower arrangement/bonsai; waterfall/streamlet; securities; interior (including office/hotel lobby, shopping mall, museum, opera, library); cityscape and landscape; and highlight of Southeast Asian countries and sport images." Other subjects include: multicultural, families, parents, teens, disasters, environmental, wildlife, beauty, education, pets, adventure, automobiles, entertainment, events, food/drink, health/fitness, hobbies, humor, performing arts, travel, agriculture, computers, medicine, military, political, portraits, product shots/still life, fashion/glamour, fine art, seasonal.

Specs: 120mm film and 4×5 transparencies. Accepts images in digital format. Send via CD, e-mail as TIFF, JPEG files at 300 dpi or higher.

Payment & Terms: Buys photos outright. Pays $5,500-12,000 for color photos. Average price per image (to clients): $250-9,000 for color photos. Pays 50% commission for color photos. Offers volume discounts to customers. Works on contract basis only. Offers regional exclusivity. Contracts renew automatically with additional submissions. Statements issued quarterly. Payment made quarterly. Photographers allowed to review account records. Offers one-time rights, agency promotion rights. Informs photographer and allows them to negotiate when client requests all rights. Model/property releases a must. Photo captions required: include name of event(s), name of building(s), location and geographical area.

Making Contact: Submit portfolio for review. Expects minimum initial submission of 200 pieces with submission of at least 300 images quarterly. Reports in 2 weeks.

◪ ⊕ ▣ **A+E**, 9 Hochgernstr., Stein 83371 Germany. Phone: (49)8621-61833. Fax: (49)8621-63875. E-mail: apluse@aol.com. Website: http://members.aol.com/AplusE. Directress: Elizabeth Pauli. Estab. 1987. Picture library. Has 25,000 photos. Clients include newspapers, postcard publishers, book publishers, calendar companies, magazine publishers.

Needs: Needs photos of environmental, landscapes/scenics, wildlife, pets, adventure, sports, travel.

Specs: Uses 8×10 glossy, color and b&w prints; 35mm, 2¼×2¼, 4×5 transparencies. Accepts images in digital format for Windows. Send via CD as JPEG file at 100 dpi for referencing purposes only.

Payment/Terms: Pays 50% commission. Average price of image (to clients): $15-100/b&w; $75-1000/color. Offers volume discounts to customers. Works with photographers on contract basis only. Offers nonexclusive contacts. Subject exclusivity may be negotiated. Statements issued annually. Payment made annually. Photographers allowed to review account records in cases of discrepancies only. Offers one-time rights. Model/property release required. Photo captions preferred; include country, date, name of person, town, landmark, etc.

Making Contact: Send query letter with transparencies, stock list. Include SASE for return of material in Europe. Cannot return material outside Europe. Expect minimum initial submission of 100 images with annual submissions of at least 100 images. Reports in 1 month in Europe. Reports back only if interested outside of Europe.

Tips: "Judge your work critically. Only technically perfect photos—sharp focus, high colors, creative views—are likely to attract any photo editor's attention."

APPALIGHT, Griffith Run Rd., Clay Rt. Box 89-C, Spencer WV 25276. Phone/fax: (304)927-2978. Website: http://www.photosource.com/psb/psb_5785.html. Director: Chuck Wyrostok. Estab. 1988. Stock photo agency. Has over 30,000 photos. Clients include advertising agencies, public relations firms, businesses, book/encyclopedia publishers, magazine publishers, calendar companies, greeting card companies and graphic designers.

● This agency also markets images through the Photo Source Bank.

Needs: General subject matter with emphasis on the people, natural history, culture, commerce, flora, fauna, and travel destinations of the Appalachian Mountain region and Eastern Shore of the United States. Also wants babies, children, couples, multicultural, families, parents, senior citizens, teens, environmental, landscapes, wildlife, gardening, pets, religious, rural, adventure, humor, travel, agriculture, political. Interested in alternative process, avant garde, documentary, historical/vintage, regional, seasonal.

Specs: Uses 8×10, glossy b&w prints; 35mm, 2¼×2¼, 4×5 transparencies.

Payment & Terms: Pays 50% commission for b&w and color photos. Average price per image (to clients): $50 minimum for b&w and color photos. Works on contract basis only. Contracts renew automatically for 2-year period with additional submissions. Charges 100% duping rate. Statements issued quarterly. Payment made quarterly. Photographers allowed to review account records during regular business hours or by appointment. Offers one-time rights, electronic media rights. Model release required. Captions required.

Making Contact: Expects minimum initial submission of 300-500 images with periodic submissions of 200-300 several times/year. Reports in 1 month. Photo guidelines free with SASE. Market tips sheet distributed "periodically" to contracted photographers.

Tips: "We look for a solid blend of topnotch technical quality, style, content and impact. Images that portray metaphors applying to ideas, moods, business endeavors, risk-taking, teamwork and winning are especially desirable." Send for free submission guidelines with SASE.

N **ARCAID**, The Factory, 2 Acre Rd., Kingston Upon Thames, Surrey United Kingdom KT2 6EF. Phone: (+44)181 546-4352. Fax: (+44)181 541-5230. E-mail: arcaid@arcaid.co.uk. Website: http://www.arcaid.co.uk. Contact: Lynne Bryant. Estab. 1985. Picture library. Has 150,000 photos in files. Clients include: advertising agencies, public relations firms, book publishers, magazine publishers, newspapers, design articles. Member of BAPLAC (British Association of Picture Libraries and Agencies).

Needs: Wants photos of architecture, cities/urban, interiors/decorating.

Specs: Uses 35mm, 2¼×2¼, 4×5 transparencies with perspective control.

Payment & Terms: Pays 40/50% commission for color photos. Average price per image (to clients): $100 minimum for color photos. Offers volume discounts to customers. Discount sales terms not negotiable. Works with photographers on contract basis only. Offers nonexclusive contract, guaranteed subject exclusivity (within files). Contracts renew automatically with additional submissions. Charges first year 40% of sales, second year 50% administrative costs included. Statements issued quarterly. Payment made quarterly. Photographers allowed to review account records in cases of discrepancies only. Model release preferred. Photo captions required for specific buildings, architect or designer, location and building type.

Making Contact: Send query letter with photocopies, tearsheets, stock list. Does not keep samples on file; cannot return material. Expects minimum initial submission of 50-100 images. Photo guidelines sheet available. See our website.

Tips: "Learn something about the library you are submitting to. Realize things take time, see the relationship as a long term investment. The more information we are given the more saleable the image could be."

N **ARCHIPRESS**, 16 Rue de la Pierre Levee, Paris France 75011. Phone: (33)01433851 81. Fax: (33)0143550144. Contact: Heline Claudie. Estab. 1988. Picture library. Has 70,000 photos in files. Clients include: advertising agencies, public relations firms, audiovisual firms, book publishers, magazine publishers, newspapers

Needs: Environmental, landscapes/scenics, architecture, cities/urban, gardening, buildings, portraits. Interested in documentary, fine art, historical/vintage, regional.

Specs: Uses 35mm, 4×5 transparencies.

Payment & Terms: Pays 50% commission for b&w photos; 50% for color photos. Average price per image (to clients): $100 minimum-$7,000 maximum for b&w photos or color photos. Enforces strict minimum prices. Photographers can choose not to sell images on discount terms. Works with photographers on contract basis only. Offers guaranteed subject exclusivity (within files). Statements issued quarterly. Payment made quarterly. Photographers allowed to review account records. Offers one-time rights, electronic media rights. Informs photographers and allows them to negotiate when client requests all rights. Photo captions required. Include photographer's credits.

Making Contact: Send query letter with résumé, photocopies, stock list. Portfolio may be dropped off once a month by appointment. Keeps samples on file. Provide self-promotion piece to be kept on file. Expects minimum initial submission of 20 images.

Tips: "Call first. Plan to present a series of 10 to 20 4×5 transparencies of a building with an architectural

interest or on a theme concerning urbanism (no slides). We also publish photography books."

■ ▲ ARCHIVE PHOTOS, 530 W. 25th St., New York NY 10001. (800)536-8442. Fax: (212)675-0379. Website: http://www.archivephotos.com. Vice President of Sales: John McQuaid. Estab. 1991. Stock photo agency. Member of the Picture Agency Council of America (PACA). Has 20 million photos; 14,000 hours of film. Has 8 branch offices. Clients include: advertising agencies, public relations firms, audiovisual firms, businesses, book/encyclopedia publishers, magazine publishers, newspapers, postcard publishers, calendar companies, greeting card companies, multimedia publishers.
Needs: All types of historical and new photos.
Specs: Uses 8×10 color and b&w prints; all sizes of transparencies, digital transmissions, film and videotape.
Payment & Terms: Pays 60% commission on b&w and color photos; 50% commission on film and videotape. Average price per image (to clients): $125-5,000/b&w; $125-5,000/color; $25-200/sec of film. Enforces minimum prices. Offers volume discounts to customers; inquire about specific terms. Discount sales terms not negotiable. Works with or without contract. Offers nonexclusive contract. Contracts renew automatically with additional submissions. Statements issued monthly. Payment for photos made monthly within 15 days; payment for footage made quarterly within 30 days. Photographers allowed to review account records. Offers one-time rights, electronic media rights, agency promotion rights. Does not inform photographers or allow them to negotiate when client requests all rights. Captions required.
Making Contact: Query with résumé of credits and samples. Does not keep samples on file. SASE. Expects minimum initial submission of 100 images. Reports in 3 weeks.

▣ ⊕ ART DIRECTORS & TRIP PHOTO LIBRARY, 57 Burdon Lane, Cheam, Surrey 5M2 7BY England. (44-181)642-3593. Fax: (44-181)395-7230. E-mail: images@tripphoto.demon.co.uk. Website: http://www.tripphoto.demon.con.uk. Estab. 1992. Stock agency. Has 1 million photos in files. Clients include: advertising agencies, businesses, newspapers, postcard publishers, public relations firms, book publishers, calendar companies, magazine publishers, greeting card companies.
Needs: Wants photos of babies, children, couples, multicultural, families, parents, senior citizens, teens, disasters, environmental, landscapes/scenics, wildlife, beauty, cities/urban, education, interiors/decorating, pets, religious, rural, adventure, automobiles, entertainment, events, food/drink, health/fitness, hobbies, humor, performing arts, sports, travel, agriculture, buildings, business concepts, computers, industry, medicine, military, political, portraits, product shots/still life, science, technology. Interested in avant garde, documentary, regional, seasonal.
Specs: Uses 35mm, 2¼×2¼, 4×5, 8×10 transparencies.
Payment & Terms: Pays 50% commission for b&w photos; 50% for color photos. Average price per image (to clients): $65-500 for b&w photos or color photos. Enforces strict minimum prices. Offers volume discounts to customers. Discount sales terms not negotiable. Works with photographers on contract basis only. Offers nonexclusive contract. Statements issued qurarely; payment made quarterly. Photographers allowed to review account records in cases of discrepancies only. Offers one-time rights, electronic media rights. Model and property release preferred. Photo captions required; include as much relevant information as is possible.
Making Contact: Contact through rep or send query letter with slides, transparencies. Does not keep samples on file; include SASE for return of material. Expects minimum initial submission of 50 images with periodic submissions of at least 50 images. Reports in 6 weeks on queries. Photo guidelines sheet free with SASE.
Tips: "Fully caption material and submit in chronological order."

ART RESOURCE, 65 Bleecker St., 9th Floor, New York NY 10012. (212)505-8700. Fax: (212)420-9286. E-mail: requests@artres.com. Website: http://www.artres.com. Permissions Director: Joanne Greenbaum. Estab. 1970. Stock photo agency specializing in fine arts. Member of the Picture Agency Council of America (PACA). Has access to 3 million photos. Clients include: advertising agencies, public relations firms, audiovisual firms, businesses, book/encyclopedia publishers, magazine publishers, newspapers, postcard publishers, calendar companies, greeting card companies and all other publishing and scholarly businesses.
Needs: Painting, sculpture, architecture *only*.
Specs: Uses 8×10 b&w prints; 35mm, 4×5, 8×10 transparencies.
Payment & Terms: Charges 50% commission. Average price per image (to client): $75-500/b&w photo; $185-10,000/color photo. Negotiates fees below standard minimum prices. Offers volume discounts to customers; terms specified in photographer's contract. Discount sales terms not negotiable. Offers exclusive only or nonexclusive rights. Contracts renew automatically with additional submissions. Statements issued quarterly. Payment made quarterly. Photographers allowed to review account records. Offers one-time

rights, electronic media rights, agency promotion and other negotiated rights. Photo captions required.
Making Contact: Query with stock photo list. "Only fine art!"
Tips: "We only represent European fine art archives and museums in U.S and Europe but occasionally represent a photographer with a specialty in certain art."

ARTWERKS STOCK PHOTOGRAPHY, Artworks Design, 2915 Estrella Brillante NW, Albuquerque NM 87120. (505)836-1206. Fax: (505)836-1206. E-mail: photojournalistjerry@juno.com. Owner: Jerry Sinkover. Estab. 1984. News/feature syndicate. Has 100 million photos in files. Clients include: advertising agencies, public relations firms, businesses, book publishers, magazine publishers, calendar companies, postcard publishers.
Needs: American Indians, ski action, ballooning, British Isles, Europe, Southwest scenery, environmental, landscapes/scenics, wildlife, cities/urban, adventure, entertainment, events, food/drink, health/fitness, hobbies, sports, travel, agriculture, buildings, business concepts, computers, industry, military, product shots/still life, science, technology. Interested in avant garde, documentary, fine art, historical/vintage, regional, seasonal.
Specs: Uses 8×10, glossy, color and b&w prints; 35mm, 2¼×2¼, 4×5 transparencies.
Payment/Terms: Charges 40% commission. Average price per image (to clients): $100-400 for b&w; $100-1,500 for color. Negotiates fees below stated minimums depending on number of photos being used. Offers volume discounts to customers. Terms not specified in photographers' contracts. Discount sales terms not negotiable. Works with or without a contract, negotiable. Offers nonexclusive contract. Charges 100% duping fee. Statements issued quarterly. Payments made quarterly. Offers one-time rights. Does not inform photographers or allow them to negotiate when a client requests all rights. Model release preferred; property release preferred. Photo captions preferred.
Making Contact: Send query letter with brochure, stock photo list, tearsheets. Provide résumé, business card. Portfolios may be dropped off every Monday. To show portfolio, photographer should follow-up with call. Agency will contact photographer for portfolio review if interested. Portfolio should include slides, tearsheets, transparencies. Works with freelancers on assignment only. Does not keep samples on file; include SASE for return of material. Expects minimum initial submission of 20 images. Reports in 2 weeks. Reports back only if interested, send non-returnable samples. Catalog free with SASE. Market tip sheet not available.

N ⊕ ▣ ASAP ISRAEL STOCK PHOTO AGENCY INTERNATIONAL, 10 Hafetz Hayim, Tel Aviv 67441 Israel. Phone: (972)3-6912966. Fax: (972)3-6912968. E-mail: asap@actcom.co.il. Website: http://www.ASAP.co.il. Managing Director: Israel Talby. Estab. 1991. Stock agency. Has 150,000 photos. Clients include: advertising agencies, businesses, newspapers, postcard publishers, public relations firms, book publishers, calendar companies, multimedia companies, audiovisual firms, magazine publishers, greeting card companies.
Needs: "We cover all aspects of life in Israel and have a special Holy Land collection." Looking for Israeli photos of environmental, landscapes/scenics, wildlife, architecture, education, religious, events, performing arts, travel, agriculture, buildings, computers, industry, medicine, military, political, portraits, science, technology, documentary.
Specs: Uses 35mm, 2¼×2¼, 4×5 transparencies. Accepts images in digital format for Windows. Send via floppy disk, Zip, e-mail as JPEG file.
Payment/Terms: Pays 50% commission. Average price per image (to clients): $80-3,500. Enforces strict minimum prices. Offers volume discounts to customers. Photographers can choose not to sell images on discount terms. Works with photographers on contract basis only. Offers limited regional exclusivity. Statements issued quarterly. Payments made quarterly. Photographers allowed to review account records. Offers one-time, electronic media and agency promotion rights. Model/property release preferred. Photo captions required.
Making Contact: Send query letter with slides, transparencies. Does not keep samples on file. Include SAE or IRC for return of material. Expects minimum initial submission of 100 images. Reports in 2 weeks. Catalog available for $12 postage paid.
Tips: "We cover all aspects of Israel and Holy Land life. We are constantly looking for fresh and better material and we'll carefully view every submission. Please edit carefully. Select your best. Never send 'seconds.' Shoot sharp and go for the most saturated colors. A great photograph will almost always sell. Keep sending submissions on a regular basis and regular royalties will flow in your direction."

N ⊕ ▣ ASIA PACIFIC PHOTOGRAPHIC LIBRARY PTY. LTD., Suite 12, Level 4, 46-56 Holt St., Surry Hills, Sydney N.S.W 2010 Australia. Phone: (61)2 9319-3373. Fax: (61)2 9310-5785. E-mail: asiapacific@bigpond.com. Website: http://www.asiapacificphotolib.com.au. Office Manager: Maria Ianelli. Estab. 1995. Stock agency, picture library. Has 86,000 photos in files. Clients include: advertising agencies,

businesses, newspapers, postcard publishers, public relations firms, book publishers, calendar companies, audiovisual firms, magazine publishers, greeting card companies.

Needs: Wants photos of babies, children, couples, multicultural, families, parents, senior citizens, teens, disasters, environmental, landscapes/scenics, wildlife, architecture, beauty, cities/urban, education, gardening, interiors/decorating, pets, rural, adventure, automobiles, entertainment, events, food/drink, health/ fitness, hobbies, humor, performing arts, sports, travel, agriculture, buildings, business concepts, computers, industry, medicine, military, political, portraits, science, technology. Interested in alternative process, avant garde, fashion/glamour, fine art.

Specs: Uses 8×10, glossy, b&w prints; 35mm, 2¼×2¼, 4×5 transparencies. Accepts images in digital format for Mac, Windows. Send via CD, Zip as TIFF files at up to 1,950 and not less than 600 dpi.

Payment & Terms: Pays 50% commission for b&w photos; 50% for color photos. Enforces strict minimum prices. Offers volume discounts to customers. Discount sales terms not negotiable. Works with photographers on contract basis only. Offers limited regional exclusivity. Statements issued quarterly. Photographers allowed to review account records in cases of discrepancies only. Offers one-time rights, electronic media rights. Informs photographers and allows them to negotiate when client requests all rights. Model release required; property release preferred. Photo captions preferred.

Making Contact: Contact via e-mail or send query letter with slides. Does not keep samples on file; include SASE for return of material. Expects minimum initial submission of 300 images with quarterly submissions of at least 100 images. Reports in 3 weeks/months on samples. Photo guidelines sheet free with SASE. Market tips sheet available every 6 months to all interested photographers.

Tips: "Asia Pacific Photographic Library is a specialized photo agency representing the cultures, lifestyles and environments of this region. We promote images that are distinct in style which will appeal to enlightened clientele. Therefore to us photographic style is actually more important than technical correctness. We welcome introductions over the Internet. Your sample images should be medium resolution JPEG. Choose images which are representative of your style."

AURORA & QUANTA PRODUCTIONS, 188 State St., Suite 300, Portland ME 04101. (207)828-8787. Fax: (207)828-5524. E-mail: info@auroraquanta.com. Website: http://www.auroraquanta.c om. C.O.O.: Robert S. Mellis. Estab. 1993. Stock agency, news/feature syndicate. Member of the Picture Agency Council of America (PACA). Has 500,000 photos in files. Clients include: advertising agencies, businesses, book publishers, magazine publishers, newspapers, calendar companies, postcard publishers.

Needs: Wants photos of babies, celebrities, children, couples, multicultural, senior citizens, cities/urban, education, gardening, rural, adventure, hobbies, sports, travel, agriculture, business concepts, computers, industry, medicine, military, political, portraits, science, technology. Interested in alternative process, avant garde, digital, documentary, regional, seasonal.

Specs: Uses 35mm transparencies. Accepts images in digital format for Mac. Send via CD as PICT.

Payment & Terms: Pays 50% commission for film. Average price per image (to clients): $200 minimum-$30,000 maximum for film. Offers volume discounts to customers. Photographers can choose not to sell images on discount terms. Works with photographers with or without a contract; negotiable. Statements issued quarterly. Payment made quarterly. Photographers allowed to review account records. Offers one-time rights, electronic media rights. Model release preferred. Photo captions required.

Making Contact: Send query letter. Does not keep samples on file; include SASE for return of material. Reports in 1 month on samples, 1 month on portfolios.

Tips: E-mail after viewing our website. List area of photo expertise/interest.

AUSTRALIAN PICTURE LIBRARY, 2 Northcote St., St. Leonards NSW 2065 Australia, Phone: (02)9438-3011. Fax: (02)4939-6527. E-mail: pictures@apl.aust.com. General Manager: Chris Boydell. Estab. 1979. Stock photo agency and news/feature syndicate. Has over 1 million photos. Clients include: advertising agencies, public relations firms, audiovisual firms, businesses, book/encyclopedia publishers, magazine publishers, newspapers, postcard publishers, calendar companies and greeting card companies.

Needs: Photos of Australia—sports, people, industry, personalities.

Specs: Uses 8×10 b&w prints; 35mm, 2¼×2¼ and 6×7cm transparencies.

Payment & Terms: Pays 50% commission. Offers volume discounts to customers. Works on contract basis only; offers exclusive contracts. Statements issued quarterly. Payment made quarterly. Offers one-time rights. Informs photographer and allows them to negotiate when client requests all rights. Model/ property release required. Captions required.

Making Contact: Submit portfolio for review. Expects minimum initial submission of 400 images with minimum yearly submissions of at least 1,000 images. Images can be digitally transmitted using modem and ISDN. Reports in 1 month. Photo guidelines free with SASE. Catalog available. Market tips sheet distributed quarterly to agency photographers.

Tips: Looks for formats larger than 35mm in travel, landscapes and scenics with excellent quality. "There must be a need within the library that doesn't conflict with existing photographers too greatly."

■ ⊕ **AUSTRAL-INTERNATIONAL PHOTOGRAPHIC LIBRARY P/L**, 1 Chandos Level 5, St. Leonards NSW Australia 2065. Phone: (02)94398222. Fax: (02)99065258. E-mail: australphoto@compuserve.com. Website: http://www.australphoto.com.au. Contact: Nicki Robertson. Estab. 1944. Stock photo agency, picture library, news/feature syndicate. Has 2 million photos in files. Clients include: advertising agencies, public relations firms, audiovisual firms, businesses, book publishers, magazine publishers, newspapers, calendar companies, greeting card companies, postcard publishers.
Needs: Interested in all categories of stock photography.
Specs: Uses $2\frac{1}{4} \times 2\frac{1}{4}$ transparencies. Accepts images in digital format for Mac, Windows. Send via CD, Jaz, Zip, e-mail as TIFF, EPS, PICT, BMP, GIF, JPEG files at 600 dpi.
Payment/Terms: Pays 50% commission on b&w and color photos and film. Average price per image (to clients): $350 minimum for b&w photos; $350 minimum for color photos. Enforces strict minimum prices. Offers volume discounts to customers. Discount sales terms not negotiable. Works with photographers with or without a contract, negotiable. Offers nonexclusive contract. Contracts renew automatically with additional submissions. Statements issued monthly; payments made monthly. Photographers allowed to review account records in cases of discrepencies only. Offers one-time rights, electronic media rights, agency promotion rights. Does not inform photographers to negotiate when a clients requests all rights. Model/property release required. Photos captions required.
Making Contact: Send query letter with samples. Portfolios may be dropped off every Friday. Portfolios should include transparencies. Does not keep samples on file.

Ⓝ ⊕ ▢ **ERIC BACH PRODUCTION**, Parent Company of Superbild Bildarchiv, Superbild GmbH, Incolor AG Foto Stock International S.L., Incolor Fotostock International, Britstock-1FA, Bussardsrass 2, 82024 Taufkirchen Germany. Phone: (49-89)614-4340. Fax: (49-89)614-43410. E-mail: 100776.442@compuserve.com. Stock agency. Member of the Picture Agency Council of America (PACA) and Cepic. Clients include: advertising agencies, newspapers, postcard publishers, public relations firms, book publishers, calendar companies, magazine publishers, greeting card companies.
Needs: Wants photos of people, technical, lifestyle, food, animals, computer graphics, cities, nature, architecture.
Specs: Uses 4.5×6cm and larger; 35mm for animals, sports, people. Accepts images in digital format. Send via CD as JPEG files.
Payment & Terms: Pays 50% for color photos. Average price per image (to clients): $100-5,000 for color photos. Works with photographers on exclusive contract only. Contracts renew automatically with additional submissions for 1 year. Statements issued quarterly. Payment made quarterly. Photographers allowed to review account records in cases of discrepancies only. Model release required; property release required.

Ⓝ ⊕ **BARNABY'S PICTURE LIBRARY**, Barnaby House, 19 Rathbone St., London W1P 1AF England. Phone: (0171)636-6128. Fax: (0171)637-4317. Contact: Mrs. Mary Buckland. Stock photo agency and picture library. Has 4 million photos. Clients include: ad agencies, public relations firms, audiovisual firms, businesses, book/encyclopedia publishers, magazine publishers, newspapers, film production companies, BBC, all TV companies, record companies, etc.
Specs: Uses 8×10 b&w prints; 35mm, $2\frac{1}{4} \times 2\frac{1}{4}$, 4×5 and 8×10 transparencies.
Payment & Terms: Pays 50% commission on b&w and color photos. Works on contract basis only. Offers nonexclusive contracts. "Barnaby's does not mind photographers having other agents as long as there are not conflicting rights." Statements issued semi-annually. Payment made semi-annually. "Very detailed statements of sales for photographers are given to them biannually and tearsheets kept." Offers one-time rights. "The photographer must trust and rely on his agent to negotiate best price!" Model release required. Captions required.
Making Contact: Arrange a personal interview to show portfolio. Send unsolicited photos by mail for consideration. Submit portfolio for review. SASE. "Your initial submission of material must be large enough for us to select a minimum of 200 pictures in color or b&w and they must be your copyright." Reports in 3 weeks. Photo guidelines free with SASE. Tips sheet distributed quarterly to anyone for SASE.
Tips: "Please ask for 'photographer's information pack' which (we hope) tells it all!"

Ⓝ ⊕ **BAVARIA BILDAGENTUR GmbH & CO. UG**, Postfach 1160, 8035 Gauting, West Germany. Phone: (089)893390. Fax: (089)89339-156. E-mail: service@bavaria-bildagentur.de. Website: http://www.bavaria-bildagentur.de. Director: Christian Artmann. Stock photo agency and picture library. Has 800,000 photos. Clients include: ad agencies, public relations firms, audiovisual firms, businesses, book/encyclope-

dia publishers, magazine publishers, newspapers, postcard companies, calendar companies and greeting card companies.

● This agency's last catalog, The European Creative Stockbook III, appears on CD-ROM. The company was purchased in 1996 by London-based Visual Communications Group.

Needs: All subjects.

Specs: Uses 35mm, 2¼×2¼, 4×5 and 8×10 transparencies.

Payment & Terms: Pays 50% commission on color photos. Works on contract basis only. Charges catalog insertion fee. Statements issued monthly. Payment made monthly. Photographers allowed to review account records. Offers one-time rights and first rights. Model/property release required. Captions required.

Making Contact: Query with samples. Send unsolicited photos by mail for consideration. Submit portfolio for review. SASE. Reports in 2 weeks. Photo guidelines sheet for SASE. Bavaria Bildagentur GmbH & Co. UG does not take any liability for lost or damaged images during the contact phase with photographers.

▨ ⊕ ▣ ▨ BENELUX PRESS B.V., Zwantelaan 24, Voorburg 2271-BR Holland. Phone: (31)70-3871072. Fax: (31)70-3870355. E-mail: info@beneluxpress.com. Website: http://www.beneluxpress.com. Contact: Marina Peters. Estab. 1975. Stock agency. International affiliate of the Picture Agency Council of America. Has 500,000 photos. Clients include: advertising agencies, businesses, newspapers, postcard publishers, public relations firms, book publishers, calendar companies, audiovisual firms, magazine publishers, greeting card companies, travel industry.

Needs: Looking for photos of babies, children, couples, multicultural, families, parents, senior citizens, teens, disaster, environmental, landscapes/scenics, wildlife, beauty, cities/urban, education, gardening, interiors/decorating, pets, religious, rural, adventure, food/drink, health/fitness, hobbies, humor, performing arts, sports, travel, agriculture, business concepts, computers, industry, medicine, science, technology. Interested in avant garde, digital, historical/vintage, seasonal.

Specs: Uses A4 glossy, color and b&w prints; 35mm, 2¼×2¼, 4×5 prints; U-matic, VHS video. Accepts images in digital format for Windows. Send via CD, floppy disk, e-mail as JPEG file.

Payment/Terms: Pays 50% commission. Average price per image (to clients): $125 minimum. Enforces strict minimum prices. Offers volume discounts to customers. Discount sales terms not negotiable. Offers exclusive contracts only. Charges $12.50 per image for reproducing b&w prints as slides; $250 per image for catalog insertion. Statements issued monthly. Payments made monthly. Photographers allowed to review account records in cases of discrepancies only. Model/property release required. Photo captions required; include as much information as possible.

Making Contact: Send query letter with slides, prints, tearsheets, stock list. Expects minimum initial submission of 100 images; quarterly submissions of at least 50 images. Reports in about 2 months on samples. Photo subject sheet available.

Tips: "Send us only material you think is saleable in our country. Give us as much information on the subject as possible."

ROBERT J. BENNETT, INC., 310 Edgewood St., Bridgeville DE 19933. (302)337-3347. Fax: (302)337-3444. President: Robert Bennett. Estab. 1947. Stock photo agency.

Needs: General subject matter.

Specs: Uses 8×10 glossy b&w prints; 35mm, 2¼×2¼ and 4×5 transparencies.

Payment & Terms: Pays 50% commission US; 40-60% foreign. Pays $5-50/hour; $40-400/day. Pays on publication. Works on contract basis only. Offers limited regional exclusivity. Charges filing fees and duping fees. Statements issued monthly. Payment made monthly. Photographers allowed to review account records to verify sales figures. Buys one-time, electronic media and agency promotion rights. Informs photographer and allows them to negotiate when client requests all rights. Model/property release required. Captions required.

Making Contact: Query with résumé of credits. Query with stock photo list. Provide résumé, business card, brochure or tearsheets to be kept on file for possible future assignments. Works on assignment only. Keeps samples on file. Reports in 1 month.

BRUCE BENNETT STUDIOS, 329 W. John St., Hicksville NY 11801. (516)681-2850. Fax: (516)681-2866. E-mail: bwinkler@bbshockey.com. Website: http://www.bbshockey.com and http://www.longislandny.com. Studio Director: Brian Winkler. Estab. 1973. Stock photo agency. Has 4 million photos. Clients include: ad agencies, book/encyclopedia publishers, magazine publishers and newspapers.

Needs: Ice hockey and hockey-related, especially images shot before 1975.

Specs: Uses b&w photos and 35mm transparencies.

Payment & Terms: Buys photos outright; pays $3-30/color photo. Average price per image (to clients): $25-50/b&w photo; $50-150/color photo. Negotiates fees below stated minimum prices. Offers volume discounts to customers; terms specified in photographer's contract. Discount sales terms are negotiable.

Works with or without contract. Offers nonexclusive contracts. Statements issued monthly. Payment made monthly. Offers one-time, electronic media or agency promotion rights. Does not inform photographer or allow him to negotiate when client requests all rights.

Making Contact: Query with samples. Works on assignment only. Samples not kept on file. SASE. Expects minimum initial submission of 10 images. Reports in 3 weeks.

Tips: "We have set up a subscribers-only Internet site service where clients can download photos they need."

N ▪ **THE BERGMAN COLLECTION**, Division of Project Masters, Inc., P.O. Box AG, Princeton NJ 08542-0872. (609)921-0749. Fax: (609)921-6216. E-mail: savants@worldnet.att.net. Vice President: Victoria B. Bergman. Estab. 1980 (Collection established in the 1930s.) Stock agency. Has 20,000 photos. Clients include: advertising agencies, book publishers, audiovisual firms, magazine publishers.

Needs: "Specializes in medical, technical and scientific stock images of high quality and accuracy."

Specs: Uses color and b&w prints; 35mm, 2¼×2¼ transparencies. Accepts images in digital format for Windows. Send via CD, floppy disk, Zip, e-mail as TIFF, BMP, JPEG files.

Payment/Terms: Pays on commission basis. Works with photographers on contract basis only. Offers one-time rights. Model/property release required. Photo captions required; must be medically, technically, scientifically accurate.

Making Contact: "Do not send unsolicited images. Call, write, fax or e-mail to be added to our database of photographers able to supply, on an as-needed basis, specialized images not already in the collection. Include a description of the field of medicine, technology and science in which you have images. We contact photographers when a specific need arises."

Tips: "Our needs are for very specific images that usually will have been taken by specialists in the field as part of their own research or professional practice. A good number of the images placed by The Bergman Collection have come from photographers in our database."

N 🌐 ▪ **BIG PICTURES UK**, 50-54 Clerkenwell Rd., London EC1M 5PS England. (44)171 250 3555. Fax: (44)171 250 0033. E-mail: info@bigpictures.co.uk. Website: http://www.bigpictures.co.uk. General Manager: Greg Allen. Estab. 1992. Stock agency, picture library, news/feature syndicate. Member of Picture Agency Council of America (PACA), (NY office). Has 2 million photos in files. Big USA—New York Contact: Stephanie Young. Big Australia—Sydney Contact: Melissa Kelly. Clients include: advertising agencies, newspapers, postcard publishers, public relations firms, book publishers, calendar companies, production companies i.e. TV and cinema, magazine publishers.

Needs: Wants photos of celebrities, disasters, wildlife, beauty, cities/urban, entertainment, events, food/drink, health/fitness, hobbies, humor, performing arts, political, portraits. Interested in erotica, fashion/glamour.

Specs: Uses any size, glossy, matte, color prints; 35mm transparencies. Accepts images in digital format for Mac.

Payment & Terms: Pays on commission basis. Average price per image (to clients): £50-300 maximum for color photos. Offers volume discounts to customers. Offers exclusive contract only; limited regional exclusivity; nonexclusive contract; guaranteed subject exclusivity. Statements issued monthly. Records are not kept in house. Offers one-time rights. Model release required; property release required. Photo captions required.

Making Contact: Send query letter with résumé, photocopies, tearsheets, stock list. Provide résumé, business card, self-promotion piece to be kept on file. Reports back only if interested; send non-returnable samples.

Tips: "Make sure we have as much information about material as possible. When? where? who? how? etc. submitted in suitable packaging so we can receive it safely."

D. DONNE BRYANT STOCK PHOTOGRAPHY (DDB STOCK), P.O. Box 80155, Baton Rouge LA 70898. (225)763-6235. Fax: (225)763-6894. E-mail: dougbryant@aol.com. Website: http://www.ddb.-simplenet.com. President: Douglas D. Bryant. Stock photo agency. Estab. 1970. Member of American Society of Picture Professionals. Currently represents 110 professional photographers. Has 500,000 photos. Clients include: ad agencies, audiovisual firms, book/encyclopedia publishers, magazine publishers, CD-ROM publishers and a large number of foreign publishers.

Needs: Specializes in picture coverage of Latin America with emphasis on Mexico, Central America, South America, the Caribbean Basin and the Southern USA. Eighty percent of picture rentals are for editorial usage. Important subjects include agriculture, anthropology/archeology, art, commerce and industry, crafts, education, festivals and ritual, geography, history, indigenous people and culture, museums, parks, political figures, religion, scenics, sports and recreation, subsistence, tourism, transportation, travel and urban centers.

Specs: Accepts 35mm, 2¼×2¼, 4×5 and 8×10 transparencies.

Payment & Terms: Pays 50% commission; 30% on foreign sales through foreign agents. Payment rates: $50-2,000 for b&w and $50-10,000 for color. Average price per image (to clients): $100-400 b&w and $170-3,400 for color. Offers volume discount to customers; terms specified in photographers contract but are not negotiable. Works with or without a signed contract, negotiable. Offers nonexclusive contracts. Three year initial contract minumum after which all slides can be demanded for return by photographer. Statements issued monthly. Payment made monthly. Does not allow photographers to review account records to verify sales figures. "We are a small agency and do not have staff to oversee audits." Offers one-time, electronic media, world and all language rights. Offers $1,500 per image for all rights. Model/property release preferred, especially for ad set-up shots. Captions required; include location and brief description. "We have a geographic focus and need specific location info on captions."

Making Contact: Interested in receiving work from professional photographers who regularly visit Latin America. Query with brochure, tearsheets and list of stock photo subjects. Expects minimum initial submission of 300 images with yearly submissions of at least 500 images. Reports in 3 weeks. Photo guidelines free with SASE and on Website. Tips sheet distributed every 3 months to agency photographers and on website.

Tips: "Speak Spanish and spend one to six months shooting in Latin America every year. Follow our needs list closely. Shoot Fuji transparency film and cover the broadest range of subjects and countries. We have an active duping service where we provide European and Asian agencies with images they market in film and on CD. The Internet provides a great delivery mechanism for marketing stock photos and we have digitized and put up hundreds on our site. Edit carefully. Eliminate any images with focus framing or exposure problems. Be an active professional before sending imges to DDB Stock. The market is far too competitive for average pictures and amateur photographers."

CALIFORNIA VIEWS/MR. PAT HATHAWAY HISTORICAL COLLECTION, 469 Pacific St., Monterey CA 93940-2702. (831)373-3811. E-mail: hathaway@caviews.com. Website: http://www.caviews.com. Photo Archivist: Mr. Pat Hathaway. Estab: 1928. Picture library; historical collection. Has 75,000 b&w images, 10,000 35mm color. Clients include: advertising agencies, public relations firms, audiovisual firms, book/encyclopedia publishers, magazine publishers, museums, postcard companies, calendar companies, television companies, interior decorators, film companies.

Needs: Historical photos of California from 1860-1999, including disasters, landscapes/scenics, automobiles, travel, military and portraits.

Payment & Terms: Payment negotiable. Offers volume discounts to customers.

Making Contact: "We accept donations of photographic material in order to maintain our position as one of California's largest archives. Please do not send unsolicited images." Does not keep samples on file; cannot return material. Reports in 3 months.

CAMERA PRESS LTD., 21 Queen Elizabeth Street, London SE1 2PD England. Phone: (0171)378-1300. Fax: (0171)278-5126. Modem: (0171)378 9064. ISDN: (Planet) (0171)378 6078 or (0171)378 9141. Operations Director: Roger Eldridge. Picture library, news/feature syndicate. Clients include: advertising agencies, public relations firms, audiovisual firms, book/encyclopedia publishers, magazine publishers, newspapers, postcard companies, calendar companies, greeting card companies and TV stations. Clients principally press but also advertising, publishers, etc.

● Camera Press has a fully operational electronic picture desk to receive/send digital images via modem/ISDN lines.

Needs: Celebrities, world personalities (e.g. politics, sports, entertainment, arts, etc.), features, news/documentary, scientific, human interest, humor, women's features, stock.

Specs: Uses prints; 35mm, 2¼×2¼ and 4×5 transparencies; b&w contact sheets and negatives.

Payment & Terms: Pays 50% commission for color or b&w photos. "Top rates in every country." Contracts renewable every year. Statements issued every 2 months. Payment made every 2 months. Photographers allowed to review account records. Offers one-time rights. Informs photographers and permits them to negotiate when a client requests to buy all rights. Model release preferred. Captions required.

Making Contact: SASE.

Tips: "Camera Press celebrated 50 years in the pictures business in 1997. We represent some of the top names in the photographic world but also welcome emerging talents and gifted newcomers. We seek lively, colorful features which tell a story and individual portraits of world personalities, both established and up-and-coming. We specialize in world-wide syndication of news stories, human interest, features, show business personalities 'at home' and general portraits of celebrities. Good accompanying text and/or interviews are an advantage; accurate captions are essential. Remember there is a big world-wide demand for premieres, openings and US celebrity-based events. Other needs include: scientific development and novelties; beauty, fashion, interiors, food and women's interests; humorous pictures featuring the weird, the

wacky and the wonderful. Camera Press is also developing a top-quality stock image service (model release essential). In general, remember that subjects which seem old-hat and clichéd in America may have considerable appeal overseas. Try to look at the US with an outsider's eye."

CAMERIQUE INC. INTERNATIONAL, Main office: Dept. PM, 1701 Skippack Pike, P.O. Box 175, Blue Bell PA 19422. (610)272-4000. Fax: (610)272-7651. Representatives in Boston, Los Angeles, Chicago, New York City, Montreal, Sarasota, Florida and Tokyo. Photo Director: Christopher C. Johnson. Estab. 1973. Has 1 million photos. Clients include: advertising agencies, public relations firms, audiovisual firms, businesses, book/encyclopedia publishers, magazine publishers, newspapers, postcard companies, calendar companies, greeting card companies.

Needs: "Only professional freelancers need submit—does not use entries from amateur photographers." Needs general stock photos, all categories. Emphasizes people activities all seasons. Always need large format color scenics from all over the world. No fashion shots. All people shots, including celebrities, must have releases.

Specs: Uses 35mm, 2¼×2¼, 4×5 transparencies; b&w contact sheets; b&w negatives; "35mm accepted if of unusual interest or outstanding quality."

Payment & Terms: Sometimes buys photos outright; pays $10-25/photo. Also pays 50-60% commission on b&w/color after sub-agent commissions. General price range (for clients): $300-500. Works on contract basis only. Offers nonexclusive contracts. Contracts are valid "indefinitely until canceled in writing." Charges 50% of cost of catalog insertion fee; for advertising, CD and online services. Statements issued monthly. Payment made monthly; within 10 days of end of month. Photographers allowed to review account records. Offers one-time rights, electronic media and multi-rights. Informs photographer and allows them to negotiate when client requests all rights. Model/property release required for people, houses, pets. Captions required; include "date, place, technical detail and any descriptive information that would help to market photos."

Making Contact: Query with list of stock photo subjects. Send unsolicited photos by mail for consideration. "Send letter first, we'll send our questionnaire and spec sheet." SASE. Reports in 2 weeks. "You must include correct return postage for your material to be returned." Tips sheet distributed periodically to established contributors.

Tips: Prefers to see "well-selected, edited color on a variety of subjects. Well-composed, well-lighted shots, featuring contemporary styles and clothes. Be creative, selective, professional and loyal. Communicate openly and often."

CAPITAL PICTURES, 49-51 Central St., London EC1V 8AB England. Phone: (+44)171-253-1122. Fax: (+44)171-253-1414. E-mail: post@capitalpictures.demon.co.uk. Picture library. Has 500,000 photos in files. Clients include: advertising agencies, book publishers, magazine publishers, newspapers.

Needs: Specialize in high quality photographs of famous people (politics, royalty, music, fashion, film and television).

Specs: Uses 35mm, 2¼×2¼ transparencies. Accepts images in digital format for Mac. Send via CD, e-mail as JPEG.

Payment/Terms: Pays 50% commission on b&w and color photos and film, videotape. "We have our own price guide but will negotiate competitive fees for large quantity usage or supply agreements." Offers volume discounts to customers. Discount sales terms negotiable. Works with photographers with or without a contract; negotiable, whatever is most appropriate. No charges—only 50% commission on sales. Statements issued monthly; payment made monthly. Photographers allowed to review account records. Offers any rights they wish to purchase. Informs photographer and allows them to negotiate when client requests all rights "if we think it is appropriate." Photo captions preferred; include date, place, event, name of subject(s).

Making Contact: Send query letter with samples. Agency will contact photographer for portfolio review if interested. Portfolio should include color transparencies. Keeps samples on file. Expects minimum initial submission of 24 images with monthly submissions of at least 24 images. Reports in 1 month on queries. Market tips sheet not available.

CATHOLIC NEWS SERVICE, 3211 Fourth St. NE, Washington DC 20017-1100. (202)541-3251. Fax: (202)541-3255. E-mail: cnspix@aol.com. Photos/Graphics Manager: Nancy Wiechec. Photos/Graphics Researcher: Bob Roller. Wire service transmitting news, features and photos to Catholic newspapers and stock to Catholic publications.

Needs: News or feature material related to the Catholic Church or Catholics; head shots of Catholic newsmakers; close-up shots of news events, religious activities. Also interested in photos aimed toward a general family audience and photos depicting modern lifestyles, e.g., family life, human interest, teens, poverty, active senior citizens, families in conflict, unusual ministries, seasonal and humor.

Specs: Uses 8×10 color glossy prints/slides. Accepts images in digital format for Mac or Windows (JPEG high quality, 8×10 inches, 170 ppi). Send via compact disc, online, floppy disk, Zip disk (8×10 inch @ 170 ppi).

Payment & Terms: Pays $50/photo; $75-200/job. Charges 50% on stock sales. Payments made monthly. Offers one-time rights. Informs photographer and allows them to negotiate when clients request all rights. Model/property release preferred. Captions preferred; include who, what, when, where, why.

Making Contact: Send material by mail for consideration. SASE.

Tips: Submit 10-20 good quality prints covering a variety of subjects. Some prints should have relevance to a religious audience. "Knowledge of Catholic religion and issues is helpful. Read a Diocesan newspaper for ideas of the kind of photos used. Photos should be up-to-date and appeal to a general family audience. No flowers, no scenics, no animals. As we use more than 1,000 photos a year, chances for frequent sales are good. Send only your best photos."

CEPHAS PICTURE LIBRARY, Hurst House, 157 Walton Rd., E. Molesey, Surrey KTB 0DX United Kingdom. Phone: (0181)979-8647. Fax: (0181)224-8095. E-mail: mickrock@cephas.co.uk. Website: http://www.cephas.co.uk. Director: Mick Rock. Picture library. Has 120,000 photos. Clients include: ad agencies, public relations firms, businesses, book/encyclopedia publishers, magazine publishers, postcard companies and calendar companies.

Needs: "Wine industry, food and drink, whiskey, rum and tobacco."

Specs: Prefers 2¼×2¼ transparencies, 35mm accepted.

Payment & Terms: Pays 50% commission for color photos. General price range: £50-500 (English currency). Works on contract basis only. Offers global representation. Contracts renew automatically after 3 years. Photographers allowed to review account records. Statements issued quarterly with payments. Offers one-time rights. Informs photographers when a client requests to buy all rights. Model release preferred. Captions required.

Making Contact: Send best 40 photos by mail for consideration. SASE. Reports in 1 week. Photo guidelines for SASE.

Tips: Looks for "transparencies in white card mounts with informative captions and names on front of mounts. Only top-quality, eye-catching transparencies required."

CHARLTON PHOTOS, INC., 11518 N. Port Washington Rd., Mequon WI 53092. (414)241-8634. Fax: (414)241-4612. E-mail: charlton@execpc.com. Website: http://www.charltonphotos.com. Director of Research: Karen Kirsch. Estab. 1981. Stock photo agency. Has 475,000 photos; 200 hours film. Clients include: ad agencies, public relations firms, audiovisual firms, businesses, book/encyclopedia publishers, magazine publishers, newspapers and calendar companies.

Needs: "We handle photos of agriculture and pets."

Specs: Color photos; 35mm, 2¼×2¼, 4×5 transparencies only.

Payment & Terms: Pays 50% commission on color photos. Average price per image (to clients): $500-650/color photo. Offers volume discounts to customers; terms specified in photographer's contract. Works on contract basis only. Prefers exclusive contract, but negotiable based on subject matter submitted. Contracts renew automatically with additional submissons for 2 years minimum. Charges duping fee, 50% catalog insertion fee and materials fee. Statements issued monthly. Payment made monthly. Photographers allowed to review account records which relate to their work. Offers one-time rights. Informs photographer and allows them to negotiate when client requests all rights. Model/property release required for identifiable people and places. Captions required; include who, what, when, where.

Making Contact: Query by phone before sending any material. SASE. No minimum number of images expected in initial submission. Reports in 1-2 weeks. Photo guidelines free with SASE. Market tips sheet distributed quarterly to contract freelance photographers; free wtih SASE.

Tips: "Provide our agency with images we request by shooting a self-directed assignment each month. Visit our website."

CHINASTOCK, 2506 Country Village, Ann Arbor MI 48103-6500. (734)996-1440. Fax: (734)996-1481 or (800)315-4462. Director: Dennis Cox. Estab. 1993. Stock photo agency. Has 50,000 photos. Has branch office in Beijing and Shanghai, China. Clients include: advertising agencies, public relations firms, book/encyclopedia publishers, magazine publishers, newspapers, calendar companies.

Needs: Only handles photos of China (including Hong Kong and Taiwan) including tourism, business, historical, cultural relics, etc. Needs hard-to-locate photos of all but tourism and exceptional images of tourism subjects.

Specs: Uses 35mm, 2¼×2¼ transparencies.

Payment & Terms: Pays 50% commission on color photos. Occasionally negotiates fees below standard minimum prices. "Prices are based on usage and take into consideration budget of client." Offers volume

discounts to customers. Photographers can choose not to sell images on discount terms. Works with or without a signed contract. "Will negotiate contract to fit photographer's and agency's mutual needs." Photographers are paid quarterly. Photographers allowed to review account records. Offers one-time rights and electronic media rights. Informs photographer and allows them to negotiate when client requests all rights. Model/property release preferred. Captions required; include where image was shot and what is taking place.

Making Contact: Query with stock photo list. "Let me know if you have unusual material." Keeps samples on file. SASE. Agency is willing to accept 1 great photo and has no minimum submission requirements. Reports in 1-2 weeks. Market tips sheet available upon request.

Tips: Agency "represents mostly veteran Chinese photographers and some special coverage by Americans. We're not interested in usual photos of major tourist sites. We have most of those covered. We need more photos of festivals, modern family life, joint ventures, and all aspects of Hong Kong and Taiwan."

■ BRUCE COLEMAN PHOTO LIBRARY, 117 E. 24th St., New York NY 10010. (212)979-6252. Fax: (212)979-5468. E-mail: info@bciusa.com. Website: http://www.bciusa.com. Photo Director: Norman Owen Tomalin. Estab. 1970. Stock photo agency. Has 1,250,000 photos. Clients include: advertising agencies, public relations firms, audiovisual firms, businesses, book/encyclopedia publishers, magazine publishers, newspapers, postcard publishers, calendar companies, greeting card companies, zoos (installations), TV.

Needs: Wants photos of babies, celebrities, children, couples, multicultural, families, parents, senior citizens, teens, disasters, environmental, landscapes, wildlife, architecture, cities/urban, pets, rural, adventure, hobbies, sports, travel, agricultural, buildings, business concepts, industry, portraits, product shots/still life, science, technology, digital.

Specs: Uses 35mm, $2\frac{1}{4} \times 2\frac{1}{4}$, 4×5 color transparencies.

Payment & Terms: Pays 50% commission on color transparencies and digital files and for b&w photos. Average price per image (to clients): $125 minimum for color and b&w. Works on exclusive contract basis only. Contracts renew automatically for 5 years. Statements issued quarterly. Payment made quarterly. Does not allow photographer to review account records; any deductions are itemized. Offers one-time rights. Model/property release preferred for people, private property. Captions required; location, species, genus name, Latin name, points of interest.

Making Contact: Query with résumé of credits. SASE. Expects minimum initial submission of 200 images with annual submission of 2,000. Reports in 3 months on completed submission; 1 week acknowledgement. Photo guidelines free with SASE. Catalog available. Want lists distributed to all active photographers monthly.

Tips: "We look for strong dramatic angles, beautiful light, sharpness. No gimmicks (prism, color, starburst filters, etc.). We like photos that express moods/feelings and show us a unique eye/style. We like work to be properly captioned. Caption labels should be typed or computer generated and they should contain all vital information regarding the photograph." Sees a trend "toward a journalistic style of stock photos. We are asked for natural settings, dramatic use of light and/or angles. Photographs should not be contrived and should express strong feelings toward the subject. We advise photographers to shoot a lot of film, photograph what they really love and follow our want lists."

⊕ ■ EDUARDO COMESAÑA-AGENCIA DE PRENSA, Casilla De Correo 178 (SUC.26), Buenos Aires Argentina 1426. Phone: (541)771-9418. Fax: (541)777-3719. E-mail: comesana@arnet.com.ar. Director: Eduardo Comesaña. Estab. 1977. Stock agency, news/feature syndicate. Has 600,000 photos in files. Clients include: advertising agencies, businesses, newspapers, postcard publishers, book publishers, calendar companies, magazine publishers.

Needs: Wants photos of babies, celebrities, children, couples, families, parents, teens, disasters, environmental, landscapes/scenics, wildlife, beauty, education, adventure, entertainment, events, health/fitness, humor, performing arts, travel, agriculture, buildings, business concepts, computers, industry, medicine, political, portraits, science, technology. Interested in documentary, fine art, historical/vintage.

Specs: Uses 8×10, glossy, color prints; 35mm, $2\frac{1}{4} \times 2\frac{1}{4}$ transparencies. Accepts images in digital format for Windows. Send via CD, floppy disk, e-mail.

Payment & Terms: Pays 50% commission for b&w photos; 50% for color photos. Average price per image (to clients): $80 minimum-$200 maximum for b&w photos; $100 minimum-$300 maximum for color photos. Offers volume discounts to customers; terms specified in photographers' contracts. Photographers can choose not to sell images on discount terms. Works with photographers with or without contract; negotiable. Offers limited regional exclusivity. Contracts renew automatically with additional submissions.

Statements issued quarterly. Payment made quarterly. Photographers allowed to review account records in cases of discrepancies only. Offers one-time rights. Model release preferred; property release required.
Making Contact: Send query letter with tearsheets, stock list. Provide self-promotion piece to be kept on file. Expects minimum initial submission of 200 images with monthly submissions of at least 200 images. Reports back only if interested, send non-returnable samples.

[N] CORBIS, 902 Broadway, New York NY 10010. (212)777-6200. Fax: (212)228-1835. E-mail: leorak@ corbis.com. Website: http://www.corbis.com. Managing Photo Editor: Leora Kahn. Estab. 1991. Stock agency, picture library, news/feature syndicate. Member of the Picture Agency Council of America (PACA). Corbis also has offices in London, San Diego, Seattle and Los Angeles. Clients include: advertising agencies, businesses, newspapers, postcard publishers, public relations firms, book publishers, calendar companies, audiovisual firms, magazine publishers, greeting card companies.
• Corbis recently acquired Digital Stock Corp. and Westlight.
Needs: Wants photos of babies, celebrities, children, couples, multicultural, families, parents, senior citizens, teens, education, adventure, automobiles, entertainment, events, health/fitness, hobbies, sports, medicine, science, technology. Interested in avant garde, digital, documentary, fine art, historical/vintage.
Payment & Terms: Pays on a commission basis. Discount sales terms not negotiable. Works with photographers on contract basis only. Offers exclusive contract only to image. Statements issued quarterly. Photographers allowed to review account records in cases of discrepancies only. Offers one-time rights, electronic media rights. Model release preferred. Photo captions required.
Making Contact: Send query letter or portfolios may be dropped of every Tuesday. Provide self-promotion piece to be kept on file. Reports back only if interested; send non-returnable samples. Photo guidelines sheet free with SASE.

[globe icon] SYLVIA CORDAIY LIBRARY LTD., 45 Rotherstone, Devizes, Wilshire SN10 2DD England. Phone: 01380728327. Fax: 01380728328. E-mail: 113023.2732@compuserve.com. Website: http://www.p hotosource.co.uk/photosource/sylvia_cordaiy.htm. Estab. 1990. Stock photo agency. Has 200,000 photos in files. Clients include: advertising agencies, public relations firms, audiovisual firms, businesses, book publishers, magazine publishers, newspapers, calendar companies, greeting card companies, postcard publishers.
Needs: Worldwide, travel, wildlife, environmental issues, architecture, the polar regions, ancient civilizations, natural history, flora and fauna, livestock, domestic pets, veterinary, equestrian and marine biology, specialist files include London and UK, transport railways, shipping, aircraft, aerial photography. Also interested in babies, children, couples, multicultural, families, parents, senior citizens, teens, cities/urban, education, gardening, religious, rural, adventure, food/drink, health/fitness, sports, agriculture, buildings, business concepts, computers, industry, military, product shots/still life, science, technology, documentary, historical/vintage, regional, seasonal. Handles the Paul Kaye archive of 20,000 b&w prints.
Specs: Uses 35mm, $2\frac{1}{4} \times 2\frac{1}{4}$, 4×5, 8×10 transparencies.
Payment/Terms: Pays 50% commission on b&w and color photos. Pay "varies widely according to publisher and usage." Offers volume discounts to customers. Works with photographers with or without a contract, negotiable. Offers exclusive contract only, limited regional exclusivity, nonexclusive contract. Charges for return postage. Statements issued monthly. Payments made monthly. Statements only issued with payments. Photographers allowed to review account records. Offers one-time rights, electronic media rights. Model release preferred. Photo captions required; include location and content of image.
Making Contact: Send query with samples, stock photo list. Provide résumé, business card, self-promotion piece or tearsheets to be kept on file for possible future assignments. Agency will contact photographer for portfolio review if interested. Portfolio should include transparencies. Keeps samples on file; include SASE for return of material. Expects minimum initial submission of 100 images. Reports in 2 weeks on queries; 2 weeks on samples. Photo guidelines sheet free with SASE.
Tips: "Send SASE, location of images list and brief résumé of previous experience."

[N] [icons] COREL PHOTO COLLECTION, Corel Corporation, 1600 Carling Ave., Ottawa, Ontario KCL 8R7 Canada. Phone: (613)728-0826. Fax: (613)761-8055. E-mail: photos@corel.ca Website: http:// www.corel.com/studio. Contact: Photographic Images Content Development. Estab. 1993. Stock agency.

MARKET CONDITIONS are constantly changing! If you're still using this book and it's 2001 or later, buy the newest edition of *Photographer's Market* at your favorite bookstore or order directly from Writer's Digest Books.

Has thousands of photos in files. Clients include: advertising agencies, public relations firms, businesses, book publishers, magazine publishers, newspapers, calendar companies, greeting card companies, postcard publishers, small businesses, travel agencies.

Needs: Wants photos of babies, children, couples, multicultural, families, parents, senior citizens, teens, beauty, cities/urban, education, adventure, entertainment, events, health/fitness, hobbies, humor, sports, travel, business concepts, computers, industry, medicine, portraits, product shots/still life, science, technology. Interested in alternative process, avant garde, digital, fashion/glamour, fine art, historical/vintage, regional, seasonal.

Specs: Uses 35mm, 2¼×2¼ , 4×5, 8×10 transparencies. Accepts images in digital format for Mac, Windows. Send via CD as TIFF files at 300 dpi.

Payment & Terms: Pays $25 minimum-$100 maximum for b&w photos or color photos. Average price per PCD image (to clients): $39.99. Offers volume discounts to customers. Discount sales terms not negotiable. Offers exclusive contract only for the images sold. Photographers can work with other agencies. Payments initiate 30 days after the execution of the contract. Royalty free usage. Model release is required; property release is required; minor release is required. Photo captions are required; include location.

Making Contact: Contact through rep. Does not keep samples on file; include SASE for return of material. Reports in 4-6 weeks on samples.

Tips: "We are looking for images of international people, lifestyles, business and concepts. We prefer submissions in medium and large formats. To obtain submission information, e-mail us or call."

⊕ SUE CUNNINGHAM PHOTOGRAPHIC, 56 Chatham Rd., Kingston Upon Thames, Surrey KT1 3AA England. Phone: (+44)20 8541 3024. Fax: (+44)20 8561 5388. E-mail: pictures@scphotographic.com. Website: scphotographic.com. Partner: Sue or Patrick Cunningham. Estab. 1989. Picture library. Member of BAPLA (British Association of Picture Libraries and Agencies). Has 120,000 photos in files. Clients include: advertising agencies, audiovisual firms, businesses, book publishers, magazine publishers, newspapers.

Needs: "Broad subject coverage on the areas listed. A submission should cover a range of subjects from one or more of these areas/subjects: local icons and typical views (must be excellent pictures); buildings, banks, political institutions, industry, tourism, landscapes, agriculture, couples, multicultural, families, teens, disasters, environmental, wildlife, cities/urban, education, rural, events, food/drink, travel, technology, documentary. Establishing shots which typify the location. Areas: Latin America, Spain, Portugal, Central and Eastern Europe. Other areas covered in depth will be considered if the submission represents a marketable body of work."

Specs: Uses 8×10 glossy b&w prints; 35mm, 2¼×2¼, 4×5 transparencies.

Payment/Terms: Pays 50% commission on b&w and color photos. Average price per image (to clients): $90-9,000 for b&w and color. Negotiates fees below stated minimums. "Clients using large numbers of images on a single project occasionally receive a discount which brings the individual cost per image below the minimum. Offers volume discounts to customers. Works with photographers on contract basis only. Offers nonexclusive contract. Statements issued quarterly; payment made quarterly. Offers one-time or electronic media rights. Informs photographer and allows them to negotiate when client requests all rights. "50% fee applicable to all sales arising out of a contact established by us." Photo captions required; include "location, date (can be approximate), any details directly related to subject (name of person, building etc., history, etc.)"

Making Contact: Send query letter with samples, brochure, stock photo list, tearsheets. Agency will contact photographer for portfolio review if interested. Expects minimum initial submission of 250 images with annual submission of at least 100 images. Reports in 2 weeks on queries; 1 month on samples.

Tips: "We are currently in the run-up to digital systems. They are essential to the future of the stock picture industry, and we will have a searchable website in the foreseeable future. Send only well-framed images which are technically good. Use only Fujichrome Velvia/Provia/Sensia, Kodachrome or new Ectachrome. Submit a good cross-section of work, bearing in mind the end users. Send non-returnable copies or enclose reply-paid addressed envelope."

■ CUSTOM MEDICAL STOCK PHOTO, Dept. PM, The Custom Medical Bldg., 3660 W. Irving Park Rd., Chicago IL 60618. (773)267-3100. Fax: (773)267-6071. E-mail: info@cmsp.com. Website: http://www.cmsp.com. Medical Archivists: Mike Fisher, Henry Schleichkorn. Member of Picture Agency Council of America (PACA), American Society of Picture Professionals (ASPP), Biological Photographic Association (BPA) and Association of Medical Illustrations (AMI). Clients include: advertising agencies, magazines, journals, textbook publishers, design firms, audiovisual firms, hospitals and Web designers—all commercial and editorial markets that express interest in medical and scientific subject area.

Needs: Biomedical, scientific, healthcare environmentals and general biology for advertising illustrations, textbook and journal articles, annual reports, editorial use and patient education.

Specs: Uses 35mm, $2\frac{1}{4} \times 2\frac{1}{4}$, 4×5, 6×7, 6×9 transparencies; negatives for electron microscopy; 4×5 copy transparencies of medical illustrations or flat art. Digital files accepted with Preview in Mac or Windows. Send via CD-ROM, online, floppy disk, SyQuest, Zip disk or JAZZ drive.

Payment & Terms: Pays per shot or commission. Per-shot rate depends on usage. Commission: 40-50% on domestic leases; 30% on foreign leases. Works on contract basis only. Offers guaranteed subject exclusivity contract. Contracts of 5-7 years automatically renew yearly. Administrative costs charged based on commission structure. Statements issued bimonthly. Payment made bimonthly. Credit line given if applicable, client discretion. Offers one-time, electronic media and agency promotion rights; other rights negotiable. Informs photographers but does not permit them to negotiate when a client requests all rights.

Making Contact: Query with list of stock photo subjects or check contributor website. Call for address and submission packet. "PC captioning disk available for database inclusion; please request. Do not send uncaptioned unsolicited photos by mail." SASE. Reports on average 1 month. Monthly want list available on Internet. Model and property release copies required.

Tips: "Our past want lists are a valuable guide to the types of images requested by our clients. Past want lists are available on the Web. Environmentals of researchers, hi-tech biomedicine, physicians, nurses and patients of all ages in situations from neonatal care to mature adults are requested frequently. Almost any image can qualify to be medical if it touches an area of life: breakfast, sports, etc. Trends also follow newsworthy events found on newswires. Photos should be good clean images that portray a single idea, whether it is biological, medical, scientific or conceptual. Photographers should possess the ability to recognize the newsworthiness of subjects. Put together a minimum of 20 images for submission. Call before shipping to receive computer disk, caption information and return information. Contributing to our agency can be very profitable if a solid commitment can exist."

N. CYR COLOR PHOTO AGENCY, Box 2148, Norwalk CT 06852. (203)838-8230. Contact: Judith A. Cyr. Has 125,000 transparencies. Clients include: advertising agencies, businesses, book publishers, magazine publishers, encyclopedia publishers, calendar companies, greeting card companies, poster companies and record companies.

Needs: "As a stock agency, we are looking for all types. There has been a recent interest in family shots (with parents and children) and people in day-to-day activities. Also modern offices with high-tech equipment and general business/professional settings. Mood shots, unusual activities, etc. are always popular—anything not completely 'standard' and common. Photos must be well-exposed and sharp, unless mood shots."

Specs: Uses 35mm to 8×10 transparencies.

Payment & Terms: Pays 50% commission. Works on contract basis only. Offers nonexclusive contract. Statements are never issued. Payment made upon payment from client. Photographers can inquire about their own accounts only. Offers one-time rights, all rights, first rights or outright purchase; price depends upon rights and usage. Informs photographers and allows them to negotiate when client requests all rights. Model release preferred. Captions required; include location and if it is a flower or animal, include species.

Making Contact: Send material by mail for consideration. SASE. "Include postage for manner of return desired." Reports in 1 month. Distributes tips sheet periodically to active contributors "usually when returning rejects."

Tips: Each submission should be accompanied by an identification sheet listing subject matter, location, etc., for each photo included in the submission. All photos should be in vinyl holders and properly numbered, with photographer's initials. "We have received more requests from clients to use 35mm in a slide presentation only (i.e., one time) and/or in a video presentation. Thus, there are more uses of a photo with limited copyright agreements."

DESIGN CONCEPTIONS, 112 Fourth Ave., New York NY 10003. (212)254-1688. Fax: (212)533-0760. Owner: Elaine Abrams. Picture Agent: Joel Gordon. Estab. 1970. Stock photo agency. Has 500,000 photos. Clients include: book/encyclopedia publishers, magazine publishers, advertising agencies.

Needs: "Real people." Also interested in children, couples, families, parents, senior citizens, teens, landscapes, events, health/fitness, buildings, medicine, science, technology, documentary, fine art.

Specs: Uses 8×10 RC b&w prints; 35mm transparencies.

Payment & Terms: Charges 50% commission on b&w and color photos. Average price per image (to clients): $200 minimum/b&w; $250 minimum/color. Enforces minimum prices. Offers volume discounts to customers; terms specified in photographer's contract. Works with or without contract. Offers limited regional exclusivity, nonexclusive. Statements issued monthly. Payment made monthly. Photographers allowed to review account records. Offers one-time rights. Offers electronic media and agency promotion rights. Informs photographer when client requests all rights. Model/property release preferred. Captions preferred.

Making Contact: Arrange personal interview to show portfolio. Query with samples.

Tips: Looks for "real people doing real, not set up, things."

🌐 **DIANA PHOTO PRESS**, Box 6266, S-102 34 Stockholm Sweden. Phone: (46)8 314428. Fax: (46)8 314401. Manager: Diana Schwarcz. Estab. 1973. Clients include: magazine publishers and newspapers.
Needs: Personalities and portraits of well-known people. Features on science, new discoveries, ecology and adventure are also of interest.
Specs: Uses 18×24 b&w prints; 35mm transparencies. "No CD-ROM; no computerising; no electronics."
Payment & Terms: Pays 30% commission on b&w and color photos. Average price per image (to clients): $150/b&w and color image. Enforces minimum prices. Works on contract basis only. Statements issued monthly. Payment made in 2 months. Offers one-time rights. Informs photographer and allows them to negotiate when client requests all rights. Captions required.
Making Contact: Query with samples. Samples kept on file. SASE. Does not report; "Wait for sales report."

DIGITAL STOCK CORP., 750 Second St., Encinitas CA 92024. This company was recently acquired by Corbis. See the Corbis listing in this section.

DIMENSIONS & DIRECTIONS LTD., 41 Old Rt. 6, RR 9, Brewster NY 10509. (914)279-7043. Fax: (914)279-0023. President: Helena Frost. Estab. 1972. Stock photo agency. Has 100,000 photos in files. Clients include: book publishers.
Payment/Terms: Offers volume discounts to customers. Photographers can choose not to sell images on discount terms. Works with photographers on contract basis only. Statesments issued annually. Photographers allowed to review account records. Offers one-time rights. Informs photographers and allows them to negotiate when a client requests all rights. Model release preferred. Photo captions preferred.
Making Contact: Send query letter with stock photo list. Agency will contact photographer for portfolio review if interested. Portfolio should include tearsheets. Works with freelancers on assignment only. Does not keep samples on file; include SASE for return of material.

🌐 **DINODIA PICTURE AGENCY**, 13 Vithoba Lane, 2nd Fl., Vithalwadi, Kalbadevi, Mumbai 400 002 India. Phone: (91)22-2014026. Fax: (91)22-2067675. E-mail: jagarwal@giasbm01.vsnl.net.in. Website: http://www.pickphoto.com/dinodia. Owner: Jagdish Agarwal. Estab. 1987. Stock photo agency. Has 500,000 photos. Clients include: advertising agencies, public relations firms, audiovisual firms, businesses, book/encyclopedia publishers, magazine publishers, newspapers, postcard companies, calendar companies and greeting card companies.
Needs: "We specialize in photos of India—people and places, fairs and festivals, scenic and sports, animals and agriculture." Other Indian subjects include: babies, celebrities, children, couples, families, parents, senior citizens, teens, disasters, environmental, landscapes, wildlife, architecture, beauty, education, gardening, interiors, pets, religious, rural, adventure, automobiles, entertainment, events, food/drink, health/fitness, hobbies, humor, performing arts, travel, buildings, business, computers, industry, medicine, military, policital, portraits, still life, science, technology, fashion/glamour, fine art, historical/vintage, seasonal.
Specs: Uses 35mm, 2¼×2¼ and 4×5 transparencies.
Payment & Terms: Pays 50% commission on b&w and color photos. General price range (to clients): US $100-600. Negotiates fees below stated minimum prices. Offers volume discounts to customers; inquire about specific terms. Discount sales terms not negotiable. Works on contract basis only. Offers limited regional exclusivity. "Prefers exclusive for India." Contracts renew automatically with additional submissions for 5 years. Statement issued monthly. Payment made monthly. Photographers permitted to review sales figures. Informs photographer and allows them to negotiate when client requests all rights. Offers one-time rights. Model release preferred. Captions required.
Making Contact: Query with résumé of credits, samples and list of stock photo subjects. SASE. Reports in 1 month. Photo guidelines free with SASE. DPA news distributed monthly to contracted photographers.
Tips: "We look for style, maybe in color, composition, mood, subject-matter, whatever, but the photos should have above-average appeal." Sees trend that "market is saturated with standard documentary-type photos. Buyers are looking more often for stock that appears to have been shot on assignment."

DRK PHOTO, 265 Verde Valley School Rd., Sedona AZ 86351. (520)284-9808. Fax: (520)284-9096. Website: http://www.drkphoto.com. President: Daniel R. Krasemann. "We handle only the personal best of a select few photographers—not hundreds. This allows us to do a better job aggressively marketing the work of these photographers." Member of Picture Agency Council of America (PACA) and A.S.P.P. Clients include: ad agencies; PR and AV firms; businesses; book, magazine, textbook and encyclopedia publishers;

newspapers; postcard, calendar and greeting card companies; branches of the government and nearly every facet of the publishing industry, both domestic and foreign.

Needs: "Especially need marine and underwater coverage." Also interested in S.E.M.'s, African, European and Far East wildlife, and good rainforest coverage.

Specs: Uses 35mm, 2¼×2¼ and 4×5 transparencies.

Payment & Terms: Pays 50% commission on color photos. General price range (to clients): $100 "into thousands." Works on contract basis only. Offers nonexclusive contracts. Contracts renew automatically. Statements issued quarterly. Payment made quarterly. Offers one-time rights; "other rights negotiable between agency/photographer and client." Model release preferred. Captions required.

Making Contact: "With the exception of established professional photographers shooting enough volume to support an agency relationship, we are not soliciting open submissions at this time. Those professionals wishing to contact us in regards to representation should query with a brief letter of introduction and tearsheets."

EARTH IMAGES, P.O. Box 10352, Bainbridge Island WA 98110. (206)842-7793. Managing Director: Terry Domico. Estab. 1977. Picture library specializing in worldwide outdoor and nature photography. Member of the Picture Agency Council of America (PACA). Has 150,000 photos; 2,000 feet of film. Has 2 branch offices; contact above address for locations. Clients include: ad agencies, public relations firms, audiovisual firms, businesses, book/encyclopedia publishers, magazine publishers, newspapers, calendar companies, greeting card companies, postcard publishers and overseas news agencies.

Needs: Natural history and outdoor photography (from micro to macro and worldwide to space); plant and animal life histories, natural phenomena, conservation projects and natural science.

Specs: Uses 35mm, 4×5 transparencies.

Payment & Terms: Pays 50% commission. Enforces minimum prices. Offers volume discounts to customers. Works on contract basis only. Offers nonexclusive contract. Contracts renew automatically with additional submissions. Buys one-time and electronic media rights. Model release preferred. Captions required; include species, place and pertinent data.

Making Contact: "Unpublished photographers need not apply." Query with resume of credits. "Do not call for first contact." Samples kept on file. SASE. Expects minimum initial submission of 100 images. "Captions must be on mount." Reports in 3-6 weeks. Photo guidelines free with SASE.

Tips: "Sending us 500 photos and sitting back for the money to roll in is poor strategy. Submissions must be continuing over years for agencies to be most effective. Specialties sell better than general photo work. Animal behavior sells better than portraits. Environmental (such as illustrating the effects of acid rain) sells better than pretty scenics. 'Nature' per se is not a specialty; macro and underwater photography are."

ECOSCENE, The Oasts, Headley Lane, Passfield, Liphook, Hampshire AU30 7RX United Kingdom. Phone: (44)1428 751056. Fax: (44)1428 751057. E-mail: ecoscene@photosource.co.uk. Website: http://www.photosource.co.uk/photosource/ecoscene.htm. Owner: Sally Morgan. Estab. 1988. Stock photo agency and picture library. Has 80,000 photos. Clients include: advertising agencies, book/encyclopedia publishers, magazine publishers, newspapers and multimedia.

Needs: Wants photos of disasters, environment, wildlife, energy, education, gardening, pets, rural, health/fitness, travel, tourism, agriculture, industry, medicine, science, technology.

Specs: Uses 35mm, 2¼×2¼ transparencies.

Payment & Terms: Pays 55% commission on color photos. Average price per image (to clients): $90 minimum/color photo. Negotiates fees below stated minimum prices, depending on quantity reproduced by a single client. Offers volume discounts to customers. Discount sales terms not negotiable. Works on contract basis only. Offers nonexclusive contract. Statements issued quarterly. Payment made quarterly. Offers one-time and electronic media rights. Informs photographers and allows them to negotiate when clients request all rights. Model/property release preferred. Captions required; include common and Latin names of wildlife and as much detail as possible.

Making Contact: Query with résumé of credits. Samples kept on file. SASE. Expects initial submission of at least 100 images with annual submissions of at least 200 images. Reports in 3 weeks. Photo guidelines free with SASE. Catalog available. Market tips sheet distributed quarterly to anybody who requests and to all contributors.

EMPICS LTD., 26 Musters Rd., West Bridgford, Nottingham NG2 7PL England. Phone: (44)(0)115 840 4444. Fax: (44)(0)115 840 4445. E-mail: info@empics.co.uk. Website: http://www.empics.co.uk. Picture library. Has more than 300,000 photos in files. Clients include: advertising agencies, businesses, newspapers, postcard publishers, public relations firms, book publishers, calendar companies, audiovisual firms, magazine publishers.

Needs: Wants photos of sports.

Specs: Uses glossy, matte, color, b&w prints; 35mm transparencies. Accepts images in digital format.
Payment & Terms: Negotiates fees below stated minimums. Offers volume discounts to customers. Works with photographers on contract basis only. Rights offered varies.
Making Contact: Send query letter or e-mail. Does not keep samples on file; cannot return material.

🌐 🎞 **ENVIRONMENTAL INVESTIGATION AGENCY**, 69-85 Old St., London EC1V 9HX England. Phone: (71)490-7040. Fax: (71)490-0436. E-mail: eiauk@gn.apc.org. Communications Manager: Matthew Snead. Estab. 1986. Conservation organization with picture and film library. Has 5,000 photos, 13,000 hours film. Clients include: book/encyclopedia publishers, magazine publishers and newspapers.
Needs: Photos about conservation of animals and the environment; trade in endangered species and endangered wildlife; and habitat destruction.
Specs: Uses 5×7 color prints; 35mm transparencies; 16mm film; BetaSP and HI-8 videotape.
Payment & Terms: Average price per image (to clients): $100/b&w photo; $200/color photo; $800/videotape. Negotiates fees below standard minimum prices. Offers volume discounts to customers; terms specified in photographer's contract. Offers one-time rights; will "negotiate on occasions in perpetuity or 5-year contract." Informs photographers and allows them to negotiate when client requests all rights. Captions required; include "full credit and detail of investigation/campaign where possible."
Making Contact: Query with samples. Query with stock photo list. Works with local freelancers only. Samples kept on file. SASE. Expects minimum initial submission of 10 images with periodic submission of additional images. Reports in 1-2 weeks.

ENVISION, 50 Pine St., New York NY 10005. (212)344-4000. Director: Sue Pashko. Estab. 1987. Stock photo agency. Member of the Picture Agency Council of America (PACA). Has 150,000 photos. Clients include: advertising agencies, public relations firms, businesses, book/encyclopedia publishers, magazine publishers, newspapers, calendar and greeting card companies and graphic design firms.
Needs: Professional quality photos of food, commercial food processing, fine dining, crops, Third World lifestyles, marine mammals, European landmarks, tourists in Europe and Europe in winter looking lovely with snow, and anything on Africa and African-Americans.
Specs: Uses 35mm, $2\frac{1}{4} \times 2\frac{1}{4}$, 4×5 or 8×10 transparencies. "We prefer large and medium formats."
Payment & Terms: Pays 50% commission on b&w and color photos. General price range (to clients): $200 and up. Works on contract basis only. Statements issued monthly. Payment made monthly. Offers one-time rights; "each sale individually negotiated—usually one-time rights." Model/property release required. Captions required.
Making Contact: Arrange personal interview to show portfolio. Query with résumé of credits "on company/professional stationery." Regular submissions are mandatory. SASE. Reports in 1 month.
Tips: "Clients expect the very best in professional quality material. Photos that are unique, taken with a very individual style. Demands for traditional subjects *but* with a different point of view; African- and Hispanic-American lifestyle photos are in great demand. We have a need for model-released, professional quality photos of people with food—eating, cooking, growing, processing, etc."

EWING GALLOWAY, 100 Merrick Rd., Rockville Centre NY 11570. (516)764-8620. Fax: (516)764-1196. Photo Editor: Janet McDermott. Estab. 1920. Stock photo agency. Member of Picture Agency Council of America (PACA), American Society of Media Photographers (ASMP). Has 3 million photos. Clients include: advertising agencies, public relations firms, audiovisual firms, businesses, book/encyclopedia publishers, magazine publishers, newspapers, postcard companies, calendar companies, greeting card companies and religious organizations.
Needs: General subject library. Does not carry personalities or news items. Lifestyle shots (model released) are most in demand.
Specs: Uses 8×10 glossy b&w prints; 35mm, $2\frac{1}{4} \times 2\frac{1}{4}$ and 4×5 transparencies.
Payment & Terms: Pays 30% commission on b&w photos; 50% on color photos. General price range: $400-450. Charges catalog insertion fee of $400/photo. Statements issued monthly. Payment made monthly. Offers one-time rights; also unlimited rights for specific media. Model/property release required. Photo captions required; include location, specific industry, etc.
Making Contact: Query with samples. Send unsolicited photos by mail for consideration; must include return postage. SASE. Reports in 3 weeks. Photo guidelines with SASE (55¢). Market tips sheet distributed monthly; SASE (55¢).
Tips: Wants to see "high quality—sharpness, subjects released, shot only on best days—bright sky and clouds. Medical and educational material is currently in demand. We see a trend toward photography related to health and fitness, high-tech industry and mixed race in business and leisure."

🌐 ▣ **FAMOUS PICTURES & FEATURES**, Studio 4, Limehouse Cut, 46 Morris Rd., London E14 6NQ United Kingdom. Phone: (+44)171 510 2500. Fax: (+44) 171 510 2510. E-mail: famous@compuser ve.com. Website: http://www.famous.uk.com. Contact: Lee Howard. Estab. 1985. Picture library, news/feature syndicate. Has more than 50,000 photos in file. Clients include: advertising agencies, book publishers, magazine publishers, newspapers, calendar companies, postcard publishers.

Needs: Wants live, studio and party events of music, film, TV and other celebrities.

Specs: Uses 35mm, 4×5 transparencies. Accepts images in digital format for Mac. Send via CD, floppy disk, e-mail as TIFF, PICT, JPEG files.

Payment/Terms: Pays 50% commission on color photos. Offers volume discounts to customers. Photographers can choose not to sell images on discount terms. Works with photographers with or without a contract. Offers limited regional exclusivity. Statements issued quarterly; payments made bimonthly. Photographers allowed to review account records. Offers one-time rights. Photo captions required.

Making Contact: Send query letter with samples. Provide résumé, business card, self promotion piece or tearsheets to be kept on file for future assignments. Agency will contact photographers for portfolio review if interested. Portfolio should include transparencies. Keeps samples on file. Will return material with SAE/IRC.

Tips: "We are increasingly marketing images via computer networks. When submitting work, caption pictures correctly."

🆖 🌐 **FARMERS WEEKLY PICTURE LIBRARY**, Reed Business Information Ltd., Quadrant House, The Quadrant, Sutton, Surrey SM2 5AS England. Phone: (01144)181 4914. Fax: (01144)181 4005. E-mail: farmers.pictures@rbi.co.uk Website: http://www.fwi.co.uk. Manager: Barry Dixon. Estab. 1934. Picture library. Has 250,000 photos in files. Clients include: advertising agencies, public relations firms, businesses, book publishers, magazine publishers, newspapers.

Needs: Wants photos of food/drink, agriculture, rural settings.

Specs: Uses 4×6 to 6×8, glossy, color prints; 35mm transparencies.

Payment & Terms: Buys photos outright. Payment varies. Average price per image (to clients) varies. Offers volume discounts to customers. Works with photographers with or without a contract; negotiable. Photographers allowed to review account records in cases of discrepancies only. Offers one-time rights. Photo captions required; include full agricultural and technical data.

Making Contact: Contact through rep. Keeps samples on file. Provide business card. "We do not keep non-copyright stock pictures."

Tips: "Call before submitting."

🆖 🌐 **FFOTOGRAFF**, 10 Kyveilog St., Cardiff, Wales United Kingdom CF1 9J1. Phone: (0044)1222 236879. Fax: (0044)1222 229326. E-mail: ffotograff@easynet.co.uk. Website: http://www.cf.ac.uk/ccin/main/buscomm/ffotogra/ffoto1.html. Owner: Patricia Aithie. Estab. 1988. Picture library. Has 150,000 photos in files. Clients include: businesses, book publishers, magazine publishers, newspapers.

Needs: Wants photos of Middle and Far East countries—art, architecture, culture, travel, landscapes.

Specs: Uses 35mm, 2¼×2¼ transparencies only.

Payment & Terms: Pays 50% commission for color photos. Average price per image (to clients): $60 minimum-$500 maximum for color photos (transparencies only). Negotiates fees around market rate. Offers volume discounts to customers. Photographers can choose not to sell images on discount terms. Works with photographers on contract basis only. Offers nonexclusive contract. Contracts renew automatically with additional submissions "as long as the slides are kept by us." Statements issued when a sale is made. Offers one-time rights. Photo captions required.

Making Contact: Send query letter with résumé, slides. Does not keep samples on file; include SAE/IRC for return of material. Reports in 2 weeks on samples.

Tips: "Send interesting, correctly focused, well exposed transparencies that suit the specialization of the library. We are interested in images concerning Middle East and Far East countries, Australia, China, general travel images, arts, architecture, culture, landscapes, people, cities and everyday activities."

🆖 ▣ **FINE PRESS SYNDICATE**, Box 22323, Ft. Lauderdale FL 33335. Vice President: R. Allen. Has 49,000 photos and more than 100 films. Clients include: ad agencies, public relations firms, businesses, audiovisual firms, book publishers, magazine publishers, postcard companies and calendar companies worldwide.

Needs: Wants nudes, figure work and erotic subjects (female only).

Specs: Uses glossy color prints; 35mm, 2¼×2¼ transparencies; 16mm film; videocasettes: VHS and Beta.

Payment & Terms: Pays 50% commission on color photos and film. Price range "varies according to use and quality." Enforces minimum prices. Works on contract basis only. Offers exclusivity only. State-

ments issued monthly. Payment made monthly. Offers one-time rights. Does not inform photographers or permit them to negotiate when client requests all rights. Model/property release preferred.

Making Contact: Send unsolicited material by mail for consideration or submit portfolio for review. SASE. Reports in 2 weeks.

Tips: Prefers to see a "good selection of explicit work. Currently have European and Japanese magazine publishers paying high prices for very explicit nudes. Clients prefer 'American-looking' female subjects. Send as many samples as possible. Foreign magazine publishers are buying more American work as the value of the dollar makes American photography a bargain. More explicit poses are requested."

N 🌐 ▣ FIREPIX INTERNATIONAL, 68 Arkles Lane, Liverpool, Merseyside L4 2SP United Kingdom. Phone/fax: 044 151-2600111. E-mail: info@firepix.com. Contact: Tony Myers. Estab. 1995. Picture library. Has 17,000 photos in files. Clients include: advertising agencies, businesses, newspapers, postcard publishers, public relations firms, book publishers, calendar companies, magazine publishers.

Needs: Wants photos of disasters, firefighting, fire salvage, work of firefighters. Interested in digital, documentary, historical/vintage.

Specs: Uses various size, glossy, color, b&w prints; 35mm transparencies. Accepts images in digital format for Windows. Send via CD, floppy disk, Zip, e-mail as TIFF, GIF, JPEG files at any dpi.

Payment & Terms: Buys photos, film or videotape outright. Payment rates vary. Commission percentages vary. Terms are specified in photographer's contracts. Works with photographers on contract basis only. Contracts renew automatically with additional submissions. Payment made within 2 weeks of receiving sale invoice. Photographers allowed to review account records. Offers one-time rights. Model release required. Photo captions required.

Making Contact: Send query letter with slides. Keeps samples on file. Expects minimum initial submission of 20 images. Reports in 2 weeks on samples.

Tips: "Submit better quality images than existing library stock."

FIRTH PHOTOBANK, 15612 Hwy. 7, Suite 77, Minnetonka MN 55345. (612)931-0847. Fax: (612)938-9362. E-mail: firthphotobank@juno.com. Owner: Bob Firth. Stock photo agency. Has more than 500,000 photos in files. Clients include: advertising agencies, businesses, book publishers, magazine publishers, calendar companies, greeting card companies, postcard publishers.

Specs: Uses some 35mm, 2¼×2¼, 4×5 transparencies.

Making Contact: Send query letter with brochure, stock photo list, tearsheets or call. SASE.

🍁 ▣ 🏞 FOTO EXPRESSION INTERNATIONAL (Toronto), Box 1268, Station "Q," Toronto, Ontario M4T 2P4 Canada. (416)299-4887. Fax: (416)299-6442. E-mail: operations@fotopressnews.com. Website: http://www.fotopressnews.com. Director: John Milan Kubik. Selective archive of photo, film and audiovisual materials. Clients include: ad agencies; public relations and audiovisual firms; TV stations and networks; film distributors; businesses; book, encyclopedia, trade and news magazine publishers; newspapers; postcard, calendar and greeting card companies.

Needs: Wants city views, aerial, travel, wildlife, nature/natural phenomena and disasters, underwater, aerospace, weapons, warfare, industry, research, computers, educational, religions, art, antique, abstract, models, sports, worldwide news and features, personalities and celebrities. Also interested in babies, children, couples, multicultural, families, parents, senior citizens, teens, architecture, beauty, gardening, interiors, pets, rural, adventure, automobiles, entertainment, events, food/drink, health/fitness, hobbies, humor, performing arts, agriculture, buildings, business, medicine, political, portraits, product shots/still life, science, technology, alternative process, avant garde, digital, documentary, erotic, fashion/glamour, historical/vintage, regional, seasonal.

Specs: Uses 8×10 b&w prints; 35mm and larger transparencies; 16mm, 35mm film; VHS, Beta and commercial videotapes (AV); motion picture, news film, film strip and homemade video. Accepts images in digital format for Windows. Send via compact disc, floppy disk or e-mail as TIFF, EPS, PICT, BMP, GIF, JPEG files.

FOR EXPLANATIONS OF THESE SYMBOLS, SEE THE INSIDE FRONT AND BACK COVERS OF THIS BOOK.

Payment & Terms: Pays 50% commission for b&w photos; 60% for color photos, film and videotape. Average price per image (to clients): $75-150 for b&w photos; $200-2,500 for color photos. Statements issued semi-annually. Payment made monthly. Offers one-time and electronic rights. Model release required for photos. Captions required.

Making Contact: Submit portfolio for review. The ideal portfolio for 8×10 b&w prints includes 10 prints; for transparencies include 60 selections in plastic slide pages. With portfolio you must send $4 US money order or $4.50 Canadian money order for postage—no personal checks, no postage stamps. Reports in 3 weeks. Photo guidelines free with SAE. Tips sheet distributed twice a year only "on approved portfolio."

Tips: "We require photos, slides, motion picture films, news film, homemade video and AV that can fulfill the demand of our clientele." Quality and content is essential. Photographers, cameramen, reporters, writers, correspondents and representatives are represented worldwide by FOTOPRESS, Independent News Service International, (416)299-4887, Fax: (416)299-6442.

FOTOCONCEPT INC., 18020 SW 66th St., Ft. Lauderdale FL 33331. (305)680-1771. Fax: (305)680-8996. Vice President: Aida Bertsch. Estab. 1985. Stock photo agency. Member of Picture Agency Council of America (PACA). Has 250,000 photos. Clients include: magazines, advertising agencies, newspapers and publishers.

Needs: Wants general worldwide travel, medical and industrial.

Specs: Uses 35mm, 2¼×2¼, 4×5 transparencies.

Payment & Terms: Pays 50% commission for color photos. Works on contract basis only. Offers nonexclusive contract. Contracts renew automatically with each submission for 1 year. Statements issued quarterly. Payment made quarterly. Photographers allowed to review account records to verify sales figures. Offers one-time rights. Informs photographer and allows them to negotiate when client requests all rights. Model release required. Captions required.

Making Contact: Query with list of stock photo subjects. SAE. Reports in 1 month. Tips sheet distributed annually to all photographers.

Tips: Wants to see "clear, bright colors and graphic style. Looking for photographs with people of all ages with good composition, lighting and color in any material for stock use."

FOTO-PRESS TIMMERMANN, Speckweg 34A, D-91096 Moehrendorf, Germany. Phone: 499131/42801. Fax: 499131/450528. E-mail: timmermann.foto@t-online.de. Contact: Wolfgang Timmermann. Stock photo agency. Has 750,000 slides. Clients include: ad agencies, audiovisual firms, businesses, book/encyclopedia publishers, magazine publishers, newspapers and calendar companies.

Needs: Wants all themes: landscapes, countries, travel, tourism, towns, people, business, nature, babies, children, couples, families, parents, senior citizens, teens, beauty, adventure, entertainment, health/fitness, hobbies, buildings, industry, medicine, portraits, technology. Interested in erotic, fine art, seasonal.

Specs: Uses 2¼×2¼, 4×5 and 8×10 transparencies (no prints). Accepts images in digital format for Windows. Send via CD, Zip as TIFF files.

Payment & Terms: Pays 50% commission for color photos. Works on nonexclusive contract basis (limited regional exclusivity). First period: 3 years; contract automatically renewed for 1 year. Photographers allowed to review account records. Statements issued quarterly. Payment made quarterly. Offers one-time rights. Informs photographers and permits them to negotiate when a client requests to buy all rights. Model/property release preferred. Captions required; include state, country, city, subject, etc.

Making Contact: Query with list of stock photo subjects. Send unsolicited photos by mail for consideration. SAE/IRC. Reports in 1 month.

FOTOS INTERNATIONAL, 10410 Palms Blvd., Suite 9, Los Angeles CA 90034-4812. (310)477-9800. Fax: (310)445-0028. E-mail: entertainment@earthlink.net or fotos@mail.org. Manager: Max B. Miller. Has 4 million photos. Clients include: advertising agencies, public relations firms, businesses, book publishers, magazine publishers, encyclopedia publishers, newspapers, calendar companies, TV and posters.

Needs: "We are the world's largest entertainment photo agency. We specialize exclusively in motion picture, TV and popular music subjects. We want color only! The subjects can include scenes from productions, candid photos, rock, popular or classical concerts, etc., and must be accompanied by full caption information."

Specs: Uses 35mm color transparencies only.

Payment & Terms: Buys photos outright; no commission offered. Pays $5-200/photo. Works with or without contract. Offers nonexclusive contract and guaranteed subject exclusivity (within files). Offers one-time, first, electronic media and agency promotion rights. Model release optional. Captions required.

Making Contact: "We prefer e-mails or faxes." Query with list of stock photo subjects. Reports

"promptly which could be one hour or two months, depending on importance and whatever emergency project we're on."

FPG INTERNATIONAL LLC, 32 Union Square E., New York NY 10003. (212)777-4210. Fax: (212)777-2301. Director of Photography: Rana Faure. Affiliations Manager: Claudia Micare. A full service agency with emphasis on images for the advertising, corporate, design and travel markets. Member of Picture Agency Council of America (PACA).

Needs: Wants high-tech industry, model-released lifestyles, foreign and domestic scenics in medium formats, still life, animals, architectural interiors/exteriors with property releases.

Specs: Minimum submission requirement per year—1,000 original color transparencies, exceptions for large format, 250 b&w full-frame 8×10 glossy prints.

Payment & Terms: Pays 50% commission upon licensing of reproduction rights. Works on contract basis only. Offers exclusive contract only. Contracts renew automatically upon contract date; 4-year contract. Charges catalog insertion fee; rate not specified. Statements issued monthly. Payment made monthly. Photographers allowed to review account records to verify sales figures. Licenses one-time rights. "We sell various rights as required by the client." When client requests all rights, "we will contact a photographer and obtain permission."

Making Contact: "Initial approach should be by mail. Tell us what kind of material you have, what your plans are for producing stock and what kind of commercial work you do. Enclose reprints of published work and/or your portfolio." Photo guidelines and tip sheets provided for affiliated photographers. Model/property releases required and must be indicated on photograph. Captions required.

Tips: "Submit regularly; we're interested in committed, high-caliber photographers only. Be selective and send only first-rate work. Our files are highly competitive."

FRONTLINE PHOTO PRESS AGENCY, P.O. Box 162, Kent Town, South Australia 5071 Australia. 18 Wall St., Norwood, South Australia 5067 Australia. Phone: 61-8-8333-2691. Fax: 61-8-8364-0604. E-mail: info@frontline.net.au. Website: http://www.frontline.net.au. Photo Editor: Carlo Irlitti. Sales & Marketing: Marco Irlitti. Estab. 1988. Stock photo agency, picture library and photographic press agency. Has 400,000 photos. Clients include: advertising agencies, marketing/public relations firms, book/encyclopedia publishers, magazine publishers, newspapers, postcard publishers, calendar companies, poster companies, multimedia/audiovisual firms, graphic designers, corporations, private and government institutions.

Needs: Wants people (all walks of life, at work and at leisure, babies, children, couples, families, parents, teens, senior citizens, multicultural, celebrities), lifestyles, sports, cities and landscapes, travel, industrial and agricultural, natural history, enviromental, social documentary, concepts, science, medicine, disasters, wildlife, architecture, beauty, education, adventure, entertainment, events, food/drink, health/fitness, performing arts, business concepts, computers, military, political, technology. Interested in alternative process, digital, documentary, historical/vintage.

Specs: Uses 8×12 glossy color and b&w prints; 35mm color and b&w negatives; 35mm, $2\frac{1}{4} \times 2\frac{1}{4}$, 4×5, 8×10 transparencies; CD-ROMs in ISO 9660 Format, Kodak Photo/Pro Photo CD Masters (Base $\times 16$ and Base $\times 64$). Accepts images in digital format for Mac and Windows. Send via CD, floppy disk, Zip, e-mail, FTP as TIFF files at 72 dpi (only for review. Much larger files and higher resolutions for archiving.)

Payment & Terms: Pays 60% commission for b&w and color photos. Assignment rates negotiable. Average price per stock image (to photographers): b&w $AUD125, color $AUD200; (to clients): $AUD80 minimum for b&w and color photos. Prices vary considerably depending on use, market and rights requested. Enforces minimum prices. Discounts only on bulk sales. Prefers to work on contract basis but can work without if necessary. Offers exclusive, nonexclusive and tailored contracts to suit the individual photographer. Contracts are for a minimum of 3 years and are automatically renewed 6 months before the expiration date (if not advised in writing) or renewed automatically with additional submissions. No charges for filing or duping. No charge on in-house produced low and high resolution CD-ROM catalog insertions but charges a once only 50% Photo CD insertion rate on Photo CD Base \times 64 high resolution scans. Statements issued monthly (quarterly outside Australia). Payment made monthly and within 15 days (quarterly and within 15 days outside Australia). Photographers allowed to review account records as stipulated in contract. Offers one-time and first-time rights, but also promotional, serial, exclusive and electronic media rights. Photographers informed and allowed to negotiate when client requests all rights. Agency will counsel, but if photographer is unable to negotiate agency will revert to broker on his/her behalf. Model/property release required. Accepts accompanying mss or extended captions with images submitted; commission on copy negotiable.

Making Contact: Interested in receiving work from competent amateur and professional photographers only. Query with samples or list of stock subjects. Send unsolicited photos (negatives with proofs, transparencies, CD-ROMs ISO 9660), Zip disks and images by e-mail for consideration. Works with local and foreign freelancers on assignment. Samples kept on file with permission. SASE (include insurance and

IRC). Expects minimum initial submission of 100-200 images with periodic submissions of 200-1,000 images/year. Reports in 1-3 weeks. Photo guidelines free with SAE and IRCs. Market tips sheet distributed to photographers on contract; free upon request.

Tips: "We look for creative photographers who are dedicated to their work, who can provide unique and technically sound images. We prefer our photographers to specialize in their subject coverage in fields they know best. All work submitted must be original, well-composed, well-lit (depending on the mood), sharp and meticulously edited with quality in mind. In the initial submission we prefer to see 100-200 of the photographer's best work. Send slides in plastic files and not in glass mounts or loose in boxes. All material must be captioned or attached to an information sheet; indicate if model/property released. Model and property releases are mostly requested for advertising and are essential for quick, hassle-free sales. Please package work appropriately; we do not accept responsibility for losses or damage. We would like all subjects covered equally but the ones most sought are: environmental issues, science and medicine, people (occupations, life-style and leisure), dramatic landscapes, general travel and conceptual images. We also need more pictures of sports (up-and-coming and established athletes who make the news worldwide), celebrities and entertainers, important people, social documentary (contemporary issues) including captioned photo-essays for our editorial clients. Feature articles on topical issues, celebrity gossip, sport, travel, lifestyle, fashion, beauty, women's interests, general interest etc., are welcomed and will help sell images in editorial markets, but inquire first before sending any copy. Write, call or fax for complete subject list. We also provide regular advice for our contributors and will direct freelancers to photograph specific, market-oriented subjects as well as help in coordinating their own private assignments to assure saleable subjects."

FUNDAMENTAL PHOTOGRAPHS, Dept. PM, 210 Forsyth St., New York NY 10002. (212)473-5770. Fax: (212)228-5059. E-mail: 70214.3663@compuserve.com. Website: http://www.fphoto.com. Partner: Kip Peticolas. Estab. 1979. Stock photo agency. Applied for membership into the Picture Agency Council of America (PACA). Has 100,000 photos. Clients include: advertising agencies, book/encyclopedia publishers.

Needs: Science-related topics.

Specs: Uses 35mm, 2¼×2¼, 4×5 and 8×10 transparencies.

Payment & Terms: Pays on commission basis; b&w 40%, color 50%. General price range (to clients): $100-500/b&w photo; $150-1,200/color photo, depends on rights needed. Enforces strict minimum prices. Offers volume discount to customers which requires photographer's approval but does not allow him to negotiate when client requests all rights. Works on contract basis only. Offers guaranteed subject exclusivity. Contracts renew automatically with additional submissions for 1 or 2 years. Charges 50% duping fees ($25/4×5 dupe). Statements issued quarterly. Payment made quarterly. Photographers allowed to review account records with written request submitted 2 months in advance. Offers one-time and electronic media rights. Informs photographer when client requests all rights; negotiation conducted by Fundamental (the agency). Model release required. Captions required; include date and location.

Making Contact: Arrange a personal interview to show portfolio. Submit portfolio for review. Query with résumé of credits, samples or list of stock photo subjects. Keeps samples on file. SASE. Expects minimum initial submission of 100 images. Reports in 1-2 weeks. Photo guidelines free with SASE. Tips sheet distributed.

Tips: "Our primary market is science textbooks. Photographers should research the type of illustration used and tailor submissions to show awareness of saleable material. We are looking for science subjects ranging from nature and rocks to industrials, medicine, chemistry and physics; macrophotography, stroboscopic; well-lit still life shots are desirable. The biggest trend that affects us is the increased need for images that relate to the sciences and ecology."

N ⊕ ▣ ⊠ GALAXY CONTACT, BP26 7 Rue Gustave Cuvelier, Calais France 62101. Phone (+33)321 352515. Fax: (33)321 35 1789. E-mail: galaxycontact@netinfo.fr. Website: http://www.spacepho tos.com. Manager: J.M. Hagmere. Estab. 1982. Stock agency, picture library. Has 20,000 photos in files. Has 350-400 hours of video footage. Clients include: advertising agencies, audiovisual firms, book publishers.

Needs: Wants photos of landscapes/scenics, military, science, technology. Interested in digital, documentary, historical/vintage.

Specs: Uses 35mm, 2¼×2¼, 4×5 transparencies; Beta. Accepts images in digital format for Windows. Send via CD, e-mail as TIFF, JPEG files at 300 dpi minimum.

Payment & Terms: Buys photos outright. Pays 50% commission for b&w photos; color photos; and videotape. Average price per image (to clients): $100 minimum-no maximum for color photos; $250 minimum- no maximum for videotape. Negotiates fees below standard minimum prices. Offers volume discounts to customers; terms specified in photographers' contracts. Photographers can choose not to sell images on discount terms. Works with photographers with or without a contract; negotiable. Offers

nonexclusive contract. Statements issued quarterly. Payment made quarterly. Photographers allowed to review account records. Informs photographers and allows them to negotiate when a client requests all rights.

Making Contact: Send query letter with résumé, slides, stock list. Provide self-promotion piece to be kept on file. Expects minimum initial submission of 50 images with triannual submissions of at least 20 images. Reports in 1 month. Catalog available.

N ⊕ ▣ GALAXY PICTURE LIBRARY, 1 Milverton Dr., Ickenham, Uxbridge United Kingdom UB10 8PP. Phone: (44)1895 637463. Fax: (44)1895 623277. E-mail: galaxypix@compuserve.com. Website: http://ourworld.compuserve.com/homepages/galaxypix. Estab. 1992. Picture library. Has 15,000 photos in files. Advertising agencies, public relations firms, book publishers, magazine publishers, newspapers.
Needs: Wants photos of astronomy, space, science.
Specs: Uses color prints; 35mm, 2¼×2¼ transparencies. Accepts images in digital format for Windows. Send via CD, floppy disk, Zip, e-mail as TIFF, BMP, GIF, JPEG.
Payment & Terms: Average price per image (to clients): $75 minimum-$1,500 maximum for color photos. Offers volume discounts to customers. Discount sales terms not negotiable. Works with photographers with or without contract; negotiable. Offers nonexclusive contract. Contracts renew automatically with additional submissions. Statements issued annually; payments made annually. Photographers allowed to review account records. Offers one-time rights. Photo captions preferred.
Making Contact: Send query letter. Does not keep samples on file; cannot return material. Reports back only if interested; send non-returnable samples. Photo guidelines available online.

⊕ ▣ GARDEN & WILDLIFE MATTERS, Marlham, Henley Down, Battle, Sussex TN33 9BN United Kingdom. Phone: (+44)(0)1424-830566. Fax: (+44)(0)1424-830224. E-mail: gardens@ftech.co. uk. Website: http://web.ftech.net/~gardens. Contact: John Feltwell. Estab. 1990. Stock photo agency. Member of B.A.P.L.A. Has 100,000 photos on files. Clients include: advertising agencies, public relations firms, businesses, book publishers, magazine publishers, newspapers, greeting card companies, postcard publishers.
Needs: Garden: plant profiles, gardening, houseplants, crops, rainforests, trees, herbs. Wildlife: whales, African wildlife, mammals, birds. Also needs architecture, rural, urban, hobbies, travel, agriculture, science.
Specs: Uses 35mm, 4×5 transparencies. Accepts images in digital format for Mac, Windows. Send via CD, floppy disk, Zip as TIFF, JPEG files.
Payment/Terms: Offers volume discounts to customers. Works with photographers on contract basis only. Offers nonexclusive contract. Contracts renew automatically with additional submissions. Statements issued quarterly; payment made quarterly. Photographers allowed to review account records. Offers one-time rights. Does not inform photographers and allow them to negotiate when a client requests all rights. Model/property release required. Photo captions required.
Making Contact: Send query letter or telephone. Agency will contact photographer for portfolio review if interested. Portfolio should include transparencies. Will return material with SAE. Expects minimum initial submission of 50 images. Reports in 2 weeks. Catalog available. Market tips sheet not available.
Tips: "We are marketing images via computer networks."

N ⟐ ▣ GARDENIMAGE, Garden Image Photo Collection Inc., 980 St. Catherine St. W., 4th Floor, Montreal, Quebec H3B 1E5 Canada. (514)398-0432. Fax: (514)398-0930. E-mail: info@gardenimage.com. Website: http://www.gardenimage.com. Estab. 1997. Stock agency. "We are a new agency and our files are growing rapidly." Clients include: advertising agencies, postcard publishers, book publishers, calendar companies, design studios, magazine publishers, greeting card companies.
Needs: Wants photos of landscapes/scenics, gardening, agriculture. Interested in alternative process, digital, regional, seasonal. Other specific photo needs: perennials, annuals, plant portraits, trees, shrubs, herbs, vegetables, fruit, people in the garden, garden views, garden structures, garden ornaments, flower arranging, studio work, digital work.
Specs: Uses 8×10, color and b&w prints (for initial review only); 35mm, 2¼× 2¼, 4×5, 8×10 transparencies. Accepts images in digital format for Windows. Send via CD, Zip as TIFF, EPS files at 350 dpi.
Payment & Terms: Pays 50% commission for b&w and for color images. Enforces minimum prices. Offers volume discounts to customers. Works with photographers on contract basis only. Offers image exclusivity. Contracts renew automatically every 3 years. Terms and fees discussed upon accepting to agency. Statements issued monthly. Payments made monthly. Photographers allowed to review account records by appointment only. Offers one-time rights, electronic media rights. Informs photographers and allows them to negotiate when client requests all rights. Model release required; property release required. Photo captions required; include Latin names (genus and species) for plants.
Making Contact: Contact Director of Photography. Send query letter requesting free submission guide-

lines with SAE/IRC. Does not keep samples on file; include SAE/IRC for return of material. Expects minimum initial submission of 50 images. Reports in 3-4 weeks on samples. Photo guidelines sheet free with SAE/IRC. Market tips sheet available quarterly to agency photographers.

Tips: "The initial submission and review process represents more than your opportunity to enter our stock file; it is Gardenimage's chance to find out what drives you creatively, see how you interpret nature, discover your ability to relay concepts and evaluate your technical strengths. Contact Gardenimage for guidelines before submitting work. We are looking for high quality, innovative, unique, well edited images of plants, gardens and related subjects. Try to show us what sets you apart from other garden and horticultural photographers. Gardenimage is also looking for photographers who can send new submissions on a regular basis."

N ⊕ ▣ GLOBAL PICTURES, Vanderstichelenstreet, 62-64, Brussels Belgium B-1080. Phone: (32.2)426 6903. Fax: (32.2)426.47.22. E-mail: global@isopress.be. Director: Bernadette Lepers. Estab. 1985. Stock agency. Has 1 million photos in files. Clients include: advertising agencies, public relations firms, businesses, book publishers, magazine publishers, newspapers, calendar companies, postcard publishers.

Needs: Wants photos of babies, children, couples, families, parents, senior citizens, teens, environmental, landscapes/scenics, wildlife, architecture, beauty, cities/urban, education, gardening, interiors/decorating, pets, religious, rural, food/drink, health/fitness, hobbies, humor, performing arts, sports, agriculture, buildings, business concepts, computers, industry, medicine, military, portraits, science, technology. Interested in avant garde, digital, documentary, fashion/glamour, fine art, historical/vintage, regional, seasonal.

Specs: Uses 35mm, 2¼ × 2¼ transparencies. Accepts images in digital format for Mac, Windows. Send via CD, Jaz, e-mail as TIFF, EPS, PICT, JPEG.

Payment & Terms: Pays 50-60% commission for b&w and for color photos. Enforces strict minimum prices. Offers volume discounts to customers. Discount sales terms not negotiable. Works with photographers on contract basis only. Offers limited regional exclusivity. Statements issued monthly. Payment made monthly. Photographers allowed to review account records in cases of discrepancies only. Model release preferred; property release preferred. Photo captions required.

Making Contact: Send query letter with résumé. Does not keep samples on file; include SAE/IRC for return of material. Expects minimum initial submission of 1,000 images every 4 months of at least 500 images.

JOEL GORDON PHOTOGRAPHY, 112 Fourth Ave., New York NY 10003. (212)254-1688. E-mail: joelgordon112@juno.com. Picture Agent: Joel Gordon. Stock photo agency. Clients include: ad agencies, designers and textbook/encyclopedia publishers.

Specs: Uses 8 × 10 b&w prints, 35mm transparencies, b&w contact sheets and b&w negatives.

Payment & Terms: Usually charges 50% commission on b&w and color photos. Offers volume discounts to customers; terms specified in contract. Photographers can choose not to sell images on discount terms. Works with or without a contract. Offers nonexclusive contract. Payment made after client's check clears. Photographers allowed to review account records to verify sales figures. Informs photographer and allows them to negotiate when client requests all rights. Offers one-time, electronic media and agency promotion rights. Model/property release preferred. Captions preferred.

N ⊕ ▣ ▨ GRANATA PRESS SERVICE, 94 Via Vallazze, Milan Italy 20131. Phone: (0039)02 26680702. Fax: (0039)02 26681126. E-mail: peggy.granata@granatapress.it. Manager: Peggy Granata. Estab. 1985. Stock agency, picture library. Member of the Picture Agency Council of America (PACA). Has 2 million photos in files. Clients include: advertising agencies, newspapers, book publishers, calendar companies, audiovisual firms and magazine publishers.

Needs: Wants photos of babies, celebrities, children, couples, families, parents, senior citizens, teens, disasters, environmental, landscapes/scenics, wildlife, pets, adventure, food/drink, health/fitness, sports, travel, agriculture, buildings, business concepts, computers, industry, medicine, political, product shots/still life, science, technology.

Specs: Uses 35mm, 2¼ × 2¼, 4 × 5 transparencies. Film: PAL. Video: PAL. Accepts images in digital format. Send via CD, Zip, e-mail.

Payment & Terms: Buys photos, film or videotape outright. Pays on commission basis. Negotiates fees below stated minimums in cases of volume deals. Offers volume discounts to customers. Photographers can choose not to sell images on discount terms. Works with photographers on contract basis only. Offers exclusive contract only. Contracts renew automatically with additional submissions for 1 year. Statements issued monthly. Photographers allowed to review account records in cases of discrepancies only. Offers one-time rights. Model release preferred; property release preferred. Photo captions required; include location, country, and any other relevant information.

Making Contact: Send query letter with slides, transparencies, stock list.

GEORGE HALL/CHECK SIX, 426 Greenwood Beach, Tiburon CA 94920. (415)381-6363. Fax: (415)383-4935. E-mail: george@check-6.com. Website: http://www.check-6.com. Owner: George Hall. Estab. 1980. Stock photo agency. Member of the Picture Agency Council of America (PACA). Has 50,000 photos. Clients include advertising agencies, public relations firms, businesses, magazine publishers, calendar companies.
Needs: All modern aviation and military.
Specs: Uses 35mm, 2¼×2¼, 4×5 transparencies.
Payment & Terms: Pays 50% commission on color photos. Average price per stock sale: $1,000. Has minimum price of $300 (some lower fees with large bulk sales, rare). Offers volume discounts to customers; terms specified in photographer's contract. Photographers can choose not to sell images on discount terms. Works on contract basis only. Offers nonexclusive contract. Payment made within 5 days of each sale. Photographers allowed to review account records. Offers one-time and electronic media rights. Does not inform photographer or allow him to negotiate when client requests all rights. Model release preferred. Captions preferred; include basic description.
Making Contact: Call or write. SASE. Reports in 3 days. Photo guidelines available.

GEORGE HALL/CODE RED, 426 Greenwood Beach, Tiburon CA 94920. (415)381-6363. Fax: (415)383-4935. E-mail: george@code-red.com. Website: http://www.code-Red.com. Owner: George Hall. Stock photo agency. Member of the Picture Agency Council of America (PACA). Has 5,000 photos (just starting). Clients include: advertising agencies, public relations firms, businesses, book/encyclopedia publishers, magazine publishers, calendar companies.
Needs: Interested in firefighting, emergencies, disasters, hostile weather: hurricanes, quakes, floods, etc.
Specs: Uses color prints; 35mm, 2¼×2¼, 4×5 transparencies.
Payment & Terms: Pays 50% commission. Average price (to clients) $1,000. Enforces strict minimum prices of $300. Offers volume discounts to customers; terms specified in photographer's contract. Photogra-

Photographer Tom Carter first sold this image of an upside down fire truck to the *Washington Times* for $75. He then submitted the slide, along with several others, to George Hall/Code Red after reading the listing in *Photographer's Market*. Carter was recently paid $400, 50% of an $800 sale the stock agency made to *Fire Engineering* magazine. "I have been taking photos, for several years, of fires and firemen and selling them to local newspapers," Carter says. Code Red is a new way for Carter to get his work out there.

phers can choose not to sell images on discount terms. Works on contract basis only. Offers nonexclusive contract. Payment made within 5 days of each sale. Photographers allowed to review account records. Offers one-time rights. Does not inform photographer or allow him to negotiate when client requests all rights. Model release preferred. Captions required.

Making Contact: Call or write with details. SASE. Reports in 3 days. Photo guidelines available.

N HAVELIN COMMUNICATIONS, INC., 6100 Pine Cone Lane, Austell GA 30168. (770)745-4170. E-mail: havelin@mindspring.com. Website: http://www.mindspring.com/~havelin. Contact: Michael F. Havelin. Has 30,000 b&w and color photos. Clients include: advertising agencies, public relation firms, audiovisual firms, businesses, book/encyclopedia publishers, magazine publishers, newspapers, postcard companies, calendar companies and greeting card companies.

Subject Needs: "We stock photos of pollution and its effects; animals, insects, spiders, reptiles and amphibians; solar power and alternative energy sources and guns, hunting and motorcycle roadracing."

Specs: Uses b&w prints; 35mm, 2¼×2¼, 8×10 and 4×5 transparencies.

Payment & Terms: Pays 50% commission for b&w photos. General price range: highly variable. Offers nonexclusive contract. Statements issued after sales. Payment made quarterly upon sales and receipt of client payment. Photographers allowed to review account records to verify sales figures upon request. Offers one-time rights. Informs photographer and allows them to negotiate when client requests all rights. Model release preferred for recognizable people. Photo captions required; include who, what, where, when, why and how.

Making Contact: Photo guidelines free with SASE. Tips sheet distributed intermittently; free with SASE.

Tips: "We are not seeking to represent more photographers. We stock well-exposed, informative images that have impact, as well as photo essays or images which tell a story on their own, and photo illustrated articles. People who work in visual media still need to write coherent business letters and intelligent, informative captions. Don't take rejection personally. It may not be the right time for the editor to use your material. Don't give up. Be flexible."

HOLT STUDIOS INTERNATIONAL, LTD., The Courtyard, 24 High St., Hungerford, Berkshire, RG17 0NF United Kingdom. Phone: +44 1488 683523. Fax: +44 1488 683511. E-mail: library@holt~studios.co.uk. Website: http://www.holt~studios.co.uk/library. Directors: Nigel D. Cattlin and Andy Morant. Picture library. Has 1000,000 photos. Clients include: advertising agencies, public relations firms, book publishers, magazines, newspapers, national and multinational industries and commercial customers.

Needs: Photographs of world agriculture, livestock, crops, crop production, horticulture and aquaculture and crop protection including named species of weeds, pests, diseases and examples of abiotic disorders, general farming, people and agricultural and biological research and innovation. Also needs photos of gardens, gardening, named varieties of ornamental plants, clearly identified natural history subjects and examples of environmental issues.

Specs: Uses all formats of transparencies from 35mm up.

Payment & Terms: Pays 50% commission. Average price per image (to clients): $70 minimum. Offers photographers nonexclusive contract. Contracts renew automatically with additional submissions for 3 years. Photographers allowed to review account records. Statements issued quarterly. Payment made quarterly. Offers one-time non-exclusive rights. Model release preferred. Captions required.

Making Contact: Write, call or e-mail outlining the type and number of photographs being offered. Photo guidelines free with SAE.

HORIZON INTERNATIONAL IMAGES LTD., P.O. Box 144, 3 St. Anne's Walk, Alderney, Guernsey GY9 3HF British Channel Islands (United Kingdom). Phone: (44)1481 822587. Fax: (44)1481 823880. E-mail: mail@hrzn.com. Website: http://www.hrzn.com. Estab. 1978. Stock photo agency. Has branch offices. UK London Office. Horizon Stock Images (UK) Ltd. 212 Piccadilly London W1V 9LD UK. Phone: 0171 917 2937. Fax: 0171 917 2938. Licensed representative in Australia is 1PL Pro-File Pty. Ltd. Also represented in North America, South America, Europe and Asia (including China and Japan). Horizon sells stock image use rights via catalogs, international agents and website.

Needs: Wants "digital imagery, all commercial formats of photography, illustration, and film and video so long as it is suitable for advertising use." Subjects include babies, children, couples, multicultural, families, parents, senior citizens, teens, disasters, environmental, landscapes, wildlife, beauty, cities/urban, pets, rural, adventure, entertainment, food/drink, health/fitness, humor, sports, travel, agriculture, business concepts, computers, industry, medicine, science, technology. Interested in alternative process, avant garde, digital.

Specs: Uses digital JPEG files, thumbnails (100K approximately) suitable for viewing in Windows. For accepted images need 4 meg plus 24 meg or larger. Prefer CD or consult website."

Payment/Terms: Buys photos/film outright; payment subject to individual negotiation. See terms and

conditions for commission. Prices (to clients): based on details of use and subject to individual negotiation with clients. Information sheet, terms and conditions available upon request.

Making Contact: Unsolicited submissions not accepted. Horizon purchases and commissions stock. "Horizon considers solicited stock images only after information and standard terms and conditions of representation have been received by interested party. Okay to submit after reading and agreeing with terms and conditions for image creators published on website."

Tips: "Photographers should address initial correspondence and all submissions to: Margaret Mapp at Horizon's UK Creative Centre situated at their British Channel Islands address. Check out website hrzn.c om. Then submit best images. Only Horizon's Terms & Conditions apply. Usually Horizon acts as sole stock agent world-wide for photographers or illustrators. Both exceptions can be made for prolific suppliers with other agents."

HORTICULTURAL PHOTOGRAPHY™, R.O. Marsh Enterprises, 337 Bedal Lane, Campbell CA 95008. (408)364-2015. Fax: (408)364-2016. E-mail: hortphoto@gardenscape.com. Website: http://www.gardenscape.com/hortphoto.html. Estab. 1956. Picture library. Has 200,000 photos in files. Clients include: advertising agencies, public relations firms, businesses, book publishers, magazine publishers, calendar companies, greeting card companies.

Needs: Wants photos of gardens, agriculture, plants.

Specs: Uses 35mm transparencies.

Payment & Terms: Pays 30-50% commission for color photos. Average price per image (to clients): $150 minimum-$500 maximum for color photos. Negotiates fees below stated minimums; depends on quantity. Offers volume discounts to customers. Discount sales terms not negotiable. Works with photographers with or without contract; negotiable. Offers nonexclusive contract. Photographers allowed to review account records in cases of discrepancies only. Offers one-time rights, electronic media rights. Photo captions required; include names of plants, date taken, location.

Making Contact: Contact through rep. Does not keep samples on file; include SASE for return of material.

HOT SHOTS STOCK SHOTS, INC., 341 Lesmill Rd., Toronto, Ontario M3B 2V1 Canada. (416)441-3281. Fax: (416)441-1468. Contact: Joanne Kolody. Clients include: advertising and design agencies, publishers, major printing houses, large corporations and manufacturers.

Needs: Wants people and human interest/lifestyles, business and industry, nature and wildlife.

Specs: Color transparencies only; any size.

Payment & Terms: Pays 50% commission, quarterly payments and statements upon collection. Price ranges (to clients): $200-7,500. Works on contract basis only. Contracts are individually negotiated upon acceptance. All rights are negotiated. Model/property release required. Photo captions required, include name, where, when, what, who.

Making Contact: Must send a minimum of 300 images. Unsolicited submissions must have return postage. Reports in 2 weeks. Photo guidelines free with business SAE/IRC.

Tips: "Submit colorful, creative, current, technically strong images with negative space. Transparencies should be of superior technical quality for scanning or duplication." Looks for people, lifestyles, variety, bold composition, style, flexibility and productivity. "People should be model released. Prefers medium format, tightly edited, good technical points (exposure, sharpness, etc.), professionally mounted and clearly captioned/labeled."

HUTCHISON PICTURE LIBRARY, 118B Holland Park Ave., London W11 4UA England. Phone: (071)229-2743. Fax: (0171)792-0259. E-mail: library@hutchisonpic.demon.co.uk. Director: Michael Lee. Stock photo agency, picture library. Has around 500,000 photos. Clients include: ad agencies, public relations firms, audiovisual firms, businesses, book/encyclopedia publishers, magazine publishers, newspapers, postcard companies, calendar companies, television and film companies.

Needs: "We are a general, documentary library (no news or personalities, no modeled 'set-up' shots). We file mainly by country and aim to have coverage of every country in the world. Within each country we cover such subjects as industry, agriculture, people, customs, urban, landscapes, etc. We have special files on many subjects such as medical (traditional, alternative, hospital etc.), energy, environmental issues, human relations (relationships, childbirth, young children, etc. but all *real people*, not models). Also interested in babies, couples, multicultural, families, parents, senior citizens, teens, disasters, architecture, education, gardening, interiors, religious, rural, health/fitness, travel, buildings, military, political, science, technology, documentary, seasonal. We are a color library."

Specs: Principally 35mm transparencies.

Payment & Terms: Pays 50% commission for color photos. Statements issued semiannually. Payment made semiannually. Sends statement with check in June and January. Offers one-time rights. Model release preferred. Captions required.

Making Contact: Only very occasionally accepts a new collection. Arrange a personal interview to show portfolio. Send letter with brief description of collection and photographic intentions. Reports in about 2 weeks, depends on backlog of material to be reviewed. "We have letters outlining working practices and lists of particular needs (they change)." Distributes tips sheets to photographers who already have a relationship with the library.

Tips: Looks for "collections of reasonable size (rarely less than 1,000 transparencies) and variety; well captioned (or at least well indicated picture subjects; captions can be added to mounts later); sharp pictures (an out of focus tree branch or whatever the photographer thinks adds mood is not acceptable; clients must not be relied on to cut out difficult areas of any picture), good color, composition and informative pictures. Prettiness is rarely enough. Our clients want information, whether it is about what a landscape looks like or how people live, etc." The general rule of thumb is that we would consider a collection which has a subject we do not already have coverage of or a detailed and thorough specialist collection. Please do no send *any* photographs without prior agreement."

⊕ **THE ICCE,** Burcott House, Wing, Leighton Buzzard LU7 0JW England. Phone/fax: (0044)(0)1296688245. E-mail: iccephd@aol.com.uk. Contact: Jacolyn Wakeford. Estab. 1984. Specialist environmental photo library founded by The International Centre for Conservation Education. Has 60,000 photos in files. Clients include: advertising agencies, businesses, newspapers, public relations firms, book publishers, calendar companies, audiovisual firms, magazine publishers, environmental organizations.

Needs: Wants high quality photos of wildlife, conservation, worldwide environment, bears, polar bears, pandas, tigers, arctic, underwater, American wildlife and scenics.

Specs: Uses 35mm, 2¼×2¼, 4.5×6 transparencies.

Payment/Terms: Pays 50% commission for color transparencies and b&w photos. Average price per image (to clients): £102 for color transparencies. Negotiates fees below stated minimums occasionally for low budget bona fide conservation organizations. Offers volume discounts to customers. Discount sales terms not negotiable. Works with photographers on contract basis only. Offers nonexclusive contract. Contracts renew automatically with additional submissions. Statements issued semiannually. Payments made semiannually. Photographers allowed to review account records. Offers one-time rights. Model/property release preferred. Photo caption required; include subject title, scientific names where appropriate, details of behavior, location, country and month/year as per our notes on captioning.

Making Contact: Send query letter and SAE. Agency will contact photographer for portfolio review if interested. Portfolio should include color slides, transparencies. Works with freelancers on assignment only. Will return material with SAE. Expects minimum initial submission of 100 images with ongoing submissions of appropriate images. Reports ASAP on queries. Photo guidelines sheet free. Lists of subjects/regions represented available free. Market tips sheet available.

Tips: "Send high quality, well edited, appropriate material captioned in accordance with our guidelines and presented with credits in individual photosleeves only after initial letter/phone call. All submissions must be accompanied by adequate return postage and recorded delivery."

N̄ IDEAL IMAGES, 2389 Main St., Suite 304, Dept. PM, Glastonbury CT 06033. (860)633-8600. Fax: (860)659-3235. President: Rich James. Affiliate of New England Stock Photo. Stock agency. Member of the Picture Agency Council of America. Clients include: advertising agencies, corporate direct, editorial, design firms.

Needs: Subject needs include lifestyle (great people shots such as multicultural, business, senior citizens, children, teenagers, couples and middle-aged adults); business (ideas, concepts, occupations in both business and industry); and unique, one-of-a-kind shots.

Specs: Uses 35mm, 2¼×2¼, 4×5 transparencies.

Payment & Terms: Pays 50% commission. Average price per image (to clients): $100-5,000. Works with photographers on contract basis only. Offers nonexclusive contract. Informs photographers when clients request exclusivity or all rights. Model/property release preferred. Captions required; include who, what, where.

Making Contact: "Accepts small submissions of high quality images with return postage for new catalogs on an ongoing basis."

Tips: "Ideal Images focuses on handling stock photography that is advertised through print, digital or on-line catalogs. Ideal Images serves photographers who desire increased image promotion without the hassle.

THE INTERNATIONAL MARKETS INDEX, located in the back of this book, lists markets located outside the U.S. by country.

Photographers who participate in our promotions don't have to handle the sales negotitations, the delivery and tracking of images or invoicing and collection of fees."

N ⊕ ▣ **IFOT**, P.O. Box 2704, Rosenvaengets alle 37, Copenhagen Denmark DK-2100. Phone: (0045) 35 38 61 11. Fax: (00 45)35 43 16 11. E-mail: ifot@ifot.com. Managing Director: Anette Schneider. Estab. 1936. Stock agency, news/feature syndicate. Has approx. 16 million photos in files. Clients include: advertising agencies, public relations firms, audiovisual firms, book publishers, magazine publishers, newspapers.

Needs: "We are only interested in photojournalism. We would like text and photos on special subjects including speed, action, drama, adventure, human interest, at home with stars or royals, actors, well known celebrities, animals, medicine and new technology."

Specs: Uses 35mm, 4×5 transparencies. Accepts images in digital format for Mac. Send via CD, ISDN or e-mail as JPEG files.

Payment & Terms: Pays 60/40 on all sales. Enforces strict minimum prices. Offers volume discounts to customers. Photographers can choose not to sell images on discount terms. Works with photographers with or without contract; negotiable. Offers limited regional exclusivity. Contracts renew automatically with additional submissions "until we agree to stop." Statements issued monthly. Payment made monthly. Photographers allowed to review account records in cases of discrepancies only. Offers one-time rights, electronic media rights. Photo captions required.

Making Contact: Send query letter.

Tips: "Photographers should write first and introduce themselves. They should specify what type of material they have, so that we can discuss whether we have a market for the material in Denmark and Norway."

N ❧ ▣ **IMAGE CONCEPT INC.**, 56 The Esplanade, Suite 509, Toronto, Ontario M5E 1A7 Canada. (416)365-0782. Fax: (416)365-3307. E-mail: image@imageconcept.com. Website: http://www.imageconce pt.com Creative Director: Ilya Narizhny. Estab. 1997. Stock agency. Has 5,000 photos in files. Clients include: advertising agencies, businesses, newspapers, postcard publishers, public relations firms, book publishers, calendar companies, audiovisual firms, magazine publishers, greeting card companies.

Needs: Wants photos of babies, children, couples, families, parents, senior citizens, teens, disaster, wildlife, education, pets, adventure, automobiles, entertainment, food/drink, health/fitness, hobbies, humor, sports, travel, agriculture, business concepts, computers, industry, medicine, military, product shots/still life, science, technology. Interested in alternative process, avant garde, digital.

Specs: Uses 8×10 glossy, matte, color, b&w prints; 35mm, 2¼×2¼, 4×5, 8×10 transparencies. Accepts images in digital format for Mac, Windows. Send via CD, SyQuest, floppy disk, Zip, e-mail as TIFF, EPS, JPEG files at 300 dpi.

Payment & Terms: Pays 50% commission for b&w and color photos. Average price per image (to clients): $200-1,000 for b&w photos; $200-3,000 for color photos. Negotiates fees below stated minimums. Offers volume discounts to customers. Photographers can choose not to sell images on discount terms. Works with photographers on contract basis only. Offers nonexclusive contract. Contracts renew automatically with additional submissions for the same period as previous one. Statements issued monthly. Payment made monthly. Photographers allowed to review account records. Offers one-time rights, electronic media rights, agency promotion rights. Informs photographers and allows them to negotiate when client requests all rights. Model release required; property release preferred. Photo captions preferred.

Making Contact: Send query letter with prints, photocopies. Provide résumé, business card. Expects minimum initial submission of 50 images with monthly submissions of at least 30 images. Reports in 2 weeks on samples; 1 month on portfolios. Reports back only if interested; send non-returnable samples. Catalog $12.

Tips: Suggests that photographers provide "subject titles, release forms and location" for all submissions.

THE IMAGE FINDERS, 2003 St. Clair Ave., Cleveland OH 44114. (216)781-7729. Fax: (216)443-1080. E-mail: ifinders@raex.com. Website: agpix.com/theimagefinders.shtml. Owner: Jim Baron. Estab. 1988. Stock photo agency. Has 150,000 photos. Clients include: advertising agencies, public relations firms, audiovisual firms, businesses, book/encyclopedia publishers, magazine publishers, calendar companies, greeting card companies.

Needs: General stock agency. Always interested in good Ohio images. Also needs children, couples, multicultural, families, senior citizens, disasters, landscapes, wildlife, architecture, cities/urban, gardening, automobiles, food/drink, sports, travel, agriculture, business concepts, industry, medicine, science, technology, fashion/glamour, historical/vintage, seasonal.

Specs: Uses 35mm, 2¼×2¼, 4×5, 4.5×6, 6×7,6×9 transparencies.

Payment & Terms: Pays 50% commission on b&w and color photos. Average price per image (to

clients): $40-2,000 for b&w photos; $40-2,000 for color photos. "This is a small agency and we will, on occasion, go below stated minimum prices." Offers volume discounts to customers; terms specified in photographer's contract. Works on contract basis only. Contracts renew automatically with additional submissions for 2 years. Statements issued monthly if requested. Payment made monthly. Photographers allowed to review account records. Offers one-time rights; negotiable depending on what the client needs and will pay for. Informs photographer and allows them to negotiate when client requests all rights. "This is rare for us. I would inform photographer of what client wants and work with photographer to strike best deal." Model release required. Property release preferred. Captions required; include location, city, state, country, type of plant or animal, etc.

Making Contact: Query with stock photo list. Call before you send anything. SASE. Expects minimum initial submission of 100 images with periodic submission of at least 100-500 images. Reports in 3 weeks. Photo guidelines free with SASE. Market tips sheet distributed 2-4 times/year to photographers under contract.

Tips: Photographers must be willing to build their file of images. "We need more people images, industry, lifestyles, medical, etc. Scenics and landscapes must be outstanding to be considered. Call first. Submit at least 100 good images. Must have ability to produce more than 100-200 images per year."

N ❖ ▦ IMAGE NETWORK INC., 16 E. Third Ave., Vancouver, British Columbia V5T 1C3 Canada. Phone (888)511-3939. Fax: (604)879-1290. E-mail: info@imagenetwork.com. Website: http://www.imagenetworkinc.com. President: Trudy Woodcock. Estab. 1994. Stock agency. Member of the Picture Agency Council of America (PACA). Has 250,000 photos in files. Has 350 hours of video footage. Clients include: advertising agencies, public relation firms, audiovisual firms, businesses, book publishers, magazine publishers, newspapers, calendar companies, postcard publishers, video production, graphic design studios.

Needs: Wants photos of babies, children, couples, multicultural, families, parents, senior citizens, teens, landscapes/scenics, wildlife, pets, adventure, food/drink, health/fitness, humor, sports, business concepts, computers, industry, medicine, portraits, product shots/still life, science, technology. Interested in alternative process, avant garde.

Specs: Uses 35mm, 2¼×2¼, 4×5, 8×10; BETASP.

Payment & Terms: Pays 50% commission for b&w photos; color photos; film and videotape. Average price per image (to clients): $200 for b&w photos, color photos, film, videotape. Negotiates fees below standard minimum prices. Offers volume discounts to customers; terms specified in photographers' contracts. Discount sales terms not negotiable. Works with photographers on contract basis only. Offers image exclusive rights. Contracts renew automatically with additional submissions. New submissions not required, renewal is automatic regardless. Statements issued quarterly. Payment made quarterly. Photographers allowed to review account records for their accounts only. Offers one-time rights. "We involve photographer on buyouts, we negotiate but discuss with photographer before any deal is made." Model and property release required. Photo captions are required; include subject, location, model or property release and number. Requires copies of all releases.

Making Contact: Contact through rep. Send query letter with résumé, transparencies. Portfolio may be dropped off Monday-Friday. Does not keep samples on file; include SAE/IRC for return of material. Expects minimum initial submission of 100 images. Submission schedule dependent upon what we and the photographer deem reasonable. Reports in 2 weeks on samples. Photo guidelines sheet free with SASE/IRC and via web page.

Tips: "Please do an extremely tight edit; only send us your very best material. Please only submit one or two images of a particular series or shoot rather than 50 images of the same shoot. See our web page for guidelines."

■ THE IMAGE WORKS, P.O. Box 443, Woodstock NY 12498. (914)679-8500. Fax: (914)679-0606. E-mail: info@theimageworks.com. Website: http://www.theimageworks.com. Co-Director: Alan Carey. Estab. 1983. Stock photo agency. Member of Picture Agency Council of America (PACA). Has 750,000 photos. Clients include: ad agencies, book/encyclopedia publishers, magazine publishers, newspapers, postcard publishers and greeting card companies.

Needs: "We are always looking for excellent documentary photography. Our prime subjects are people related subjects like family, education, health care, work place issues. In the past year we began building an extensive environmental issues file including nature, wildlife and pollution."

Specs: Uses 35mm and 2¼×2¼ transparencies. Accepts images in digital format for Mac and Windows.

Payment & Terms: Pays 50% commission on b&w and color photos. Works on contract basis only. Offers nonexclusive contract. Offers guaranteed subject exclusivity (within files). Charges $2/image duping fee. Charges catalog insertion fee of 50%. Statements issued monthly. Payment made monthly. Photographers allowed to review account records to verify sales figures by appointment. Offers one-time, agency

promotion and electronic media rights. Informs photographers and allows them to negotiate when clients request all rights. Model release preferred. Captions required.

Making Contact: Query with list of stock photo subjects and tearsheets. SASE. Reports in 1 month. Expects minimum initial submission of 200 images. Tips sheet distributed monthly to contributing photographers.

Tips: "The Image Works was one of the first agencies to market images digitally. We continue to do so over our website and CD-ROMs. Most of our digital efforts have been for private delivery to clients and sub-agents around the world. We also accept digital images from our photographers. This technology will greatly transform the stock photo industry and we intend to make it an essential part of the way we operate on many levels, not just for marketing. When making a new submission to us be sure to include a variety of images that show your range as a photographer. We also want to see some depth in specialized subject areas. Thorough captions are a must. We will not look at uncaptioned images."

IMAGES PICTURES CORP., Dept. PM, 89 Fifth Ave., New York NY 10003. (212)675-3707. Fax: (212)243-2308. Managers: Peter Gould and Barbara Rosen. Has 100,000 photos. Clients include: public relations firms, book publishers, magazine publishers and newspapers.

Needs: Current events, celebrities, feature stories, pop music, pin-ups and travel. Also wants babies, children, couples, multicultural, families, parents, senior citizens, teens, disasters, environmental, landscapes, wildlife, beauty, cities/urban, pets, adventure, automobiles, entertainment, food/drink, health/fitness, hobbies, humor, performing arts, sports, travel, agriculture, buildings, business concepts, computers, industry, medicine, military, political, portraits, product shots/still life, science, technology, alternative process, avant garde, digital, documentary, erotica, fashion/glamour, historical/vintage, regional, seasonal.

Specs: Uses b&w prints, 35mm transparencies, b&w contact sheets and b&w negatives.

Payment & Terms: Pays 50% commission for b&w and color photos. Average price per image (to clients) varies. Offers one-time rights or first rights. Captions required.

Making Contact: Query with résumé of credits or with list of stock photo subjects. Also send tearsheets or photocopies of "already published material, original story ideas, gallery shows, etc." SASE. Reports in 2 weeks.

Tips: Prefers to see "material of wide appeal with commercial value to publication market; original material similar to what is being published by magazines sold on newsstands. We are interested in ideas from freelancers that can be marketed and assignments arranged with our clients and sub-agents." Wants to see "features that might be of interest to the European or Japanese press, and that have already been published in local media. Send copy of publication and advise rights available." To break in, "be persistent and offer fresh perspective."

Ⓝ ⊕ ◼ IMS BILDBYRA AB, P.O. Box 45252, Stockholm Sweden. Phone: (+46)8-302500. Fax: (+46)8-33-8875. E-mail: barbro@imspix.com. Website: http://www.imspix.com. President: Barbro Kaufmann. Estab. 1946. Stock agency, picture library and news/feature syndicate. Has 15 million photos in files. Clients include: advertising agencies, public relations firms, businesses, book publishers, magazine publishers, newspapers, calendar companies, greeting card companies, postcard publishers.

Needs: Wants photos of babies, celebrities, children, couples, multicultural, families, parents, senior citizens, teens, disasters, environmental, landscapes/scenics, wildlife, beauty, cities/urban, education, gardening, interiors/decorating, pets, rural, adventure, entertainment, events, food/drink, health/fitness, hobbies, humor, performing arts, sports, travel, agriculture, buildings, business concepts, computers, industry, medicine, military, political, portraits, product shots/still life, science, technology. Interested in alternative process, avant garde, digital, documentary, fashion/glamour, fine art, historical/vintage, regional, seasonal.

Specs: Uses glossy, matte, color or b&w prints; 35mm, 2¼×2¼, 4×5, 8×10 transparencies. Accepts images in digital format for Windows. Send via CD, Zip as JPEG files at 300 dpi.

Payment & Terms: Pays 60% commission for b&w and color photos. Average price per image (to clients): $100-3,400 for b&w and color photos. Offers volume discounts to customers. Photographers can choose not to sell images on discount terms. Works with photographers on contract basis only. Offers limited regional exclusivity. Contracts renew automatically with additional submissions; for 1-3 years. Statements issued monthly. Payment made monthly. Our accountant reviews records. Offers one-time, electronic media and agency promotion rights. Informs photographers and allows them to negotiate when a client requests all rights. Model release and property release required. Photo captions required.

Making Contact: Send query letter with slides, prints, photocopies, tearsheets, transparencies. Expects minimum initial submission of 500 images with 1-3 submissions of at least 100 images. Reports in 1 month on samples. Photo guidelines and catalog free with SAE/IRC. Market tips sheet available.

Ⓝ ◼ IPOL, (formerly Rangefinder), Dept. PM, 275 Seventh Ave., 14th Floor, New York NY 10001. (212)807-0192. Fax: (807)627-8934. E-mail mariah@ipolinc.com. Contact: Mariah Agaier. Estab. 1950.

Stock photo agency. Has 2 million photos. Member of the Picture Agency Council of America (PACA). Clients include: advertising agencies, public relations firms, book/encyclopedia publishers, magazine publishers, newspapers, calendar companies, television and online magazines.

Needs: Celebrities, music, politics, news and photo stories such as human interest.

Specs: Uses up to 8 × 10 glossy color and b&w prints; 2¼ × 2¼ and 35mm transparencies. Accepts images in digital format. Send via floppy disk, SyQuest, Jaz, Zip.

Payment & Terms: Pays 50% commission on b&w and color photos. General price range (to clients): minimum $175/b&w; minimum $200/color; rate based on usage. Enforces minimum prices. Offers volume discounts. Photographers can choose not to sell images on discount terms. Works with or without contract; exclusive, negotiable. Contracts renew automatically with additional submissions. Statements issued monthly. Payment made monthly. Photographers are allowed to review account records to verify sales figures. Offers one-time and negotiated rights. Model release preferred. Captions required.

Making Contact: Arrange personal interview to show portfolio. Keeps samples on file. SASE. Expects minimum initial submission of 40 images. Reports in 3 weeks. Market tips sheet available on request.

N ⊕ ▣ THE IRISH PICTURE LIBRARY, Davison & Associates Ltd., 69b Heather Rd., Sandyford Industrial Estate, Dublin Ireland 18. Phone: (353)1295 0799. Fax: (353)1295 0705. Contact: David Davison. Estab. 1990. Picture library. Has 60,000 photos in files. Clients include: advertising agencies, businesses, book publishers, magazine publishers, newspapers, calendar companies.

Needs: Wants photos of historic Irish material. Interested in alternative process, fine art, historical/vintage.

Specs: Uses any prints. Accepts images in digital format for Mac, Windows. Send via CD, SyQuest, floppy disk, Zip as TIFF, EPS, JPEG files at 200 dpi.

Payment & Terms: Pays 50% commission for b&w and color photos. Average price per image (to clients): $100-800 for b&w and color photos. Enforces minimum prices. Offers volume discounts to customers. Photographers can choose not to sell images on discount terms. Works with photographers on contract basis only. Statements issued quarterly. Payment made quarterly. Photographers allowed to review account records. Offers one-time rights, electronic media rights. Property release and photo captions required.

Making Contact: Send query letter with photocopies. Does not keep samples on file; include SAE for return of material.

N ⊕ ▣ ISOPRESS SENEPART, Vanderstichelenstreet, 62-64, Brussels Belgium B1080. Phone: (32.2)420 30 50. Fax: (32.2)420.43.96. E-mail: isopress@isopress.be. Director: Bernadette Lepers. Estab. 1984. News/feature syndicate. Has 5 million photos in files. Clients include: advertising agencies, public relations firms, businesses, book publishers, magazine publishers, newspapers, calendar companies, postcard publishers.

Needs: Wants photos of babies, celebrities, children, couples, families, parents, senior citizens, teens, disasters, environmental, landscapes/scenics, wildlife, beauty, education, religious, events, food/drink, health/fitness, hobbies, humor, agriculture, buildings, business concepts, computers, industry, medicine, science, technology. Interested in alternative process, avant garde, digital, documentary, fashion/glamour, fine art, historical/vintage, regional, seasonal.

Specs: Uses glossy, matte, color prints; 35mm, 2¼ × 2¼ transparencies. Accepts images in digital format for Mac, Windows. Send via CD, Jaz, Zip, e-mail as TIFF, EPS, PICT, GIF, JPEG.

Payment & Terms: Pays 60-65% commission for b&w and color photos. Enforces strict minimum prices. Offers volume discounts to customers. Discount sales terms not negotiable. Works with photographers on contract basis with or without contract; negotiable. Offers limited regional exclusivity. Contracts renew automatically with additional submissions. Statements issued monthly. Payment made monthly. Photographers allowed to review account records in cases of discrepancies only. Model release and property release preferred. Photo captions required.

Making Contact: Contact through rep. Does not keep samples on file; include SAE/IRC for return of material. Expects minimum initial submission of 1,000 images with quarterly submissions of at least 500.

BRUCE IVERSON PHOTOMICROGRAPHY, 31 Boss Ave., Portsmouth NH 03801. Phone/fax: (603)433-8484. E-mail: baiverson@aol.com. Owner: Bruce Iverson. Estab. 1981. Stock photo agency. Has 10,000 photos. Clients include: advertising agencies, book/encyclopedia publishers.

Needs: Currently only interested in submission of scanning electron micrographs and transmission electron micrographs—all subjects.

Specs: Uses 8 × 10 glossy or matte color and b&w prints; 35mm, 2¼ × 2¼, 4 × 5 transparencies; 6 × 17 panoramic.

Payment & Terms: Pays 50% commission on b&w and color photos. Average price per image (to clients): $175 minimum for b&w and color photos. Terms specified in photographer's contract. Works on contract basis only. Offers nonexclusive contracts. Photographer paid within 1 month of agency's receipt

of payment. Offers one-time rights. Captions required; include magnification and subject matter.
Making Contact: "Give us a call first. Our subject matter is very specialized." SASE. Reports in 1-2 weeks.
Tips: "We are a specialist agency for science photos and technical images taken through the microscope."

JAYAWARDENE TRAVEL PHOTO LIBRARY, 7A Napier Rd., Wembley, Middlesex HA0 4UA United Kingdom. Phone: (0181)902-3588. Fax: (0181)902-7114. Contact: Rohith or Marion Jayawardene. Estab. 1992. Stock photo agency and picture library. Has 125,000 photos. Clients include: advertising agencies, businesses, book/encyclopedia publishers, magazine publishers, newspapers, greeting card companies, postcard publishers and tour operators/travel companies.
Needs: Travel and tourism-related images worldwide, particularly of the US, the Caribbean and South America; couples/families on vacation and local lifestyle. "Pictures, especially of city views, must not be out of date."
Specs: Uses 35mm, 2¼×2¼, 4½×6cm, 6×7 cm transparencies.
Payment & Terms : Pays 50% commission. Average price per image (to clients): $125-1,000. Enforces minimum prices of $100, "but negotiable on quantity purchases." Offers volume discounts to customers; inquire about specific terms. Discount sales terms not negotiable. Works on contract basis only. Offers limited regional exclusivity contract. Statements issued semiannually. Payment made semiannually, within 30 days of payment received from client. Offers one-time and exclusive rights for fixed periods. Does not inform photographer or allow him to negotiate when client requests all rights. Model/property release preferred. Captions required; include country, city/location, subject description.
Making Contact: Query letter with stock photo list. Expects a minimum initial submission of 300 images with periodic submission of at least 150 images on quarterly basis. Reports in 3 weeks. Photo guidelines and market tips sent. Include SAE/IRC with query letter and initial submission.

JAYDEE MEDIA, P.O. Box 149, Cochrane, Alberta T0L 0W0 Canada. Phone/fax: (403)932-9397. E-mail: images@jaydeemedia.com. Owner: J. David Corry. Stock photo agency. Has 80,000 photos; limited BetacamSp video. Clients include: advertising agencies, public relations firms and businesses.
Needs: Agricultural—crop, livestock and food production.
Specs: Uses 35mm, 2¼×2¼, panoramic, 4×5 transparencies; Betacam SP videotape.
Payment & Terms: Pays 50% commission on b&w, color photos; film; videotape. Average price per image (to clients): $50-500/b&w; $150 minimum/color; $1,000 minimum/film; $750 minimum/second, videotape. Negotiates fees below stated minimum for educational purposes or noncommercial uses. Offers volume discounts to customers; terms specified in photographer's contract. Discount sales terms not negotiable. Works on contract basis only. Statements issued quarterly. Payments made quarterly. Offers one-time rights. Informs photographer and allows them to negotiate when client requests all rights. Model/property release preferred for people, recognizable vehicles, equipment and buildings. Captions preferred.
Making Contact: Query with stock photo list. SAE. Expects minimum initial submission of 100-200 images with periodic submissions of 100-200 images. Reports in 1 month. Photo guidelines free with SAE/IRC. Market tips sheet distributed annually; free with SAE.
Tips: Looks for talent with solid agricultural background and photographic expertise. Photos must be agriculturally and technically correct. Documentaries should "tell a true story with artistic composition and lighting."

JEROBOAM, 120-D 27th St., San Francisco CA 94110. (415)824-8085. Call first before faxing. E-mail: jeroboam@inreach.com. Contact: Ellen Bunning. Estab. 1972. Has 150,000 b&w photos, 150,000 color slides. Clients include: text and trade books, magazine and encyclopedia publishers and editorial.
Needs: "We want people interacting, relating photos, artistic/documentary/photojournalistic images, especially ethnic and handicapped. Images must have excellent print quality—contextually interesting and exciting, and artistically stimulating." Needs shots of school, family, career and other living situations. Child development, growth and therapy, medical situations. No nature or studio shots.
Specs: Uses 8×10 double weight glossy b&w prints with a ¾″ border. Also uses 35mm transparencies.
Payment & Terms: Works on consignment only; pays 50% commission. Works without a signed contract. Statements issued monthly. Payment made monthly. Photographers allowed to review account records to verify sales figures. Offers one-time and electronic media rights. Informs photographer and allows them to negotiate when client requests all rights. Model/property release preferred for people in contexts of special education, sexuality, etc. Captions preferred; include "age of subject, location, etc."
Making Contact: Call if in the Bay area; if not, query with samples and list of stock photo subjects; send material by mail for consideration or submit portfolio for review. "Let us know how long you've been shooting." SASE. Reports in 2 weeks.
Tips: "The Jeroboam photographers have shot professionally a minimum of five years, have experienced

some success in marketing their talent and care about their craft excellence and their own creative vision. Jeroboam images are clear statements of single moments with graphic or emotional tension. We look for people interacting, well exposed and printed with a moment of interaction. New trends are toward more intimate, action shots; more ethnic images needed. Be honest in regards to subject matter (what he/she *likes* to shoot)."

N ⊕ ▢ KEYPHOTOS INTERNATIONAL, Keystone Press Agency Japan, Taiyo-Seimei Bldg., 2-17-2, Shibuya Shibuya-ku, Tokyo Japan 150-0002. Phone (81)03-3409-4394. Fax: (81)03-3407-0392. E-mail: keystone@eva.hi-ho.ne.jp. Director: Hidetoshi Miyagi. Estab. 1960. Stock agency. Has 1 million photos in files. Has offices in Ginza (Tokyo), Osaka, Nagoya, Fukuoka, Yamanashi. Contact main office in Tokyo. Clients include: advertising agencies, audiovisual firms, book publishers, magazine publishers, calendar companies, greeting card companies, postcard publishers.

Needs: Wants photos of babies, celebrities, children, couples, multicultural, families, parents, senior citizens, teens, disasters, environmental, landscapes/scenics, wildlife, architecture, beauty, cities/urban, education, gardening, interiors/decorating, pets, religious, rural, adventure, automobiles, entertainment events, food/drink, health/fitness, hobbies, humor, performing arts, sports, travel, agriculture, buildings, business concepts, computers, industry, medicine, military, political portraits, product shots/still life, science, technology. Interested in alternative process, avant garde, digital, computer graphics, documentary, erotic, fashion/glamour, fine art, historical/vintage, regional, seasonal.

Specs: Uses 35mm, 2¼×2¼, 4×5 transparencies. Accepts images in digital format for Mac. Send via CD, e-mail as JPEG files at 72 dpi.

Payment & Terms: Pays 50% commission for b&w and color photos. Average price per image (to clients): $185-750 for b&w photos; $220-1,100 for color photos. Negotiates fees below stated minimums. Offers volume discounts to customers; terms specified in photographers' contracts. Discount sales terms not negotiable. Works with photographers on contract basis only. Offers nonexclusive contract. Contracts renew automatically with additional submissions for first 3 years. Statements issued monthly. Payments made quarterly. Photographers allowed to review account records in cases of discrepancies only. Offers one-time rights. Informs photographers and allows them to negotiate when client requests all rights. Model release, property release and photo captions required.

Making Contact: Send query letter with résumé, transparencies. Does not keep samples on file; include SAE for return of material. Reports in 3 weeks on samples; 3 months on portfolios.

⊕ ▢ KEYSTONE PRESSEDIENST GMBH, Kleine Reichenstr. 1, 20457 Hamburg, 2 162 408 Germany. Phone: (040)33 66 9799. Fax: (040)32 40 36. E-mail: keystonede@aol.com. Website: http://www.key stone-press.de. President: Jan Leidicke. Stock photo agency, picture library and news/feature syndicate. Has 3.5 million color transparencies and b&w photos. Clients include: ad agencies, public relations firms, audiovisual firms, businesses, book/encyclopedia publishers, magazine publishers, newspapers, postcard companies, calendar companies, greeting card companies and TV stations.

Needs: Wants all subjects excluding sports events.

Specs: Uses b&w prints; 35mm, 2¼×2¼, 4×5 and 8×10 transparencies. Accepts images in digital format for Windows as TIFF or JPEG. Send via CD, Zip disk or online.

Payment & Terms: Charges 40-50% commission on b&w and color photos. General price range: $30-1,000. Works on contract basis only. Contracts renew automatically for one year. Does not charge duping, filing or catalog insertion fees. Payment made one month after photo is sold. Offers one-time and agency promotion rights. "We ask the photographer if client requests exclusive rights." Model release preferred. Captions required; include who, what, where, when and why.

Making Contact: Send unsolicited photos by mail for consideration. Contact us before first submission! Deals with local freelancers by assignment only. SAE. Reports in 2 weeks. Distributes a monthly tip sheet.

Tips: Prefers to see "American way of life—people, cities, general features—human and animal, current events—political, show business, scenics from the USA—travel, tourism, personalities—politics, TV. An advantage of working with KEYSTONE is our wide circle of clients and very close connections to all leading German photo users. We especially want to see skylines of all U.S. cities. Send only highest quality work."

N ⊕ ▢ ▨ KPA GmbH, Content Interest Group, Charlottenstrasse 95, Berlin Germany D-10969. Phone: (++)30 2590020. Fax: (++)30 2510828. E-mail: info@kpa.de. Website: http://www.kpa.de. Managing Director: Birgitta Blankenmeier. Estab. 1954. Picture library. Has 1 million photos in files. Has 40,000 hours of footage. Clients include: advertising agencies, public relations firms, audiovisual firms, book publishers, magazine publishers, newspapers, calendar companies.

Needs: Wants photos of babies, celebrities, children, couples, multicultural, families, parents, senior citizens, teens, disasters, environmental, landscapes/scenics, wildlife, architecture, cities/urban, education,

interiors/decorating, adventure, entertainment, events, food/drink, health/fitness, hobbies, humor, performing arts, sports, travel, agriculture, buildings, business concepts, computers, industry, medicine, political, portraits, science, technology. Interested in alternative process, avant garde, digital, documentary, fashion/glamour, fine art, historical/vintage, regional, seasonal.
Specs: Uses all size prints; $2\frac{1}{4} \times 2\frac{1}{4}$, 4×5 transparencies; 16mm, 35mm Beta SP video. Accepts images in digital format for Mac. Send via CD, SyQuest, Jaz, e-mail as TIFF, PICT, BMP, JPEG files at 300 dpi.
Payment & Terms: Buys photos, film or videotape. Pays 50% commission for b&w and color photos; film; and videotape. Offers volume discounts to customers; terms specified in photographers' contracts. Works with photographers on contract basis only. Offers limited regional exclusivity, nonexclusive contract. Statements issued quarterly. Payment made quarterly. Offers one-time, electronic media, agency promotion rights. Model and property release preferred. Photo captions required.
Making Contact: Send query letter with résumé, stock list. Catalog free with SAE.

JOAN KRAMER AND ASSOCIATES, INC., 10490 Wilshire Blvd., Suite 1701, Los Angeles CA 90024. (310)446-1866. Fax: (310)446-1856. President: Joan Kramer. Member of Picture Agency Council of America (PACA). Has 1 million b&w and color photos dealing with travel, cities, personalities, animals, flowers, lifestyles, underwater, scenics, sports and couples. Clients include: ad agencies, magazines, recording companies, photo researchers, book publishers, greeting card companies, promotional companies and AV producers.
Needs: "We use any and all subjects! Stock slides must be of professional quality."
Specs: Uses 8×10 glossy b&w prints; any size transparencies.
Payment & Terms: Pays 50% commission. Offers all rights. Model release required.
Making Contact: Query or call to arrange an appointment. Do not send photos before calling. SASE.

LAND OF THE BIBLE PHOTO ARCHIVE, 8 Wedgwood St., Jerusalem Israel 93108. Phone: (972)2 566 2167. Fax: (972)2 566 3451. E-mail: radovan@netvision.net.il. Contact: Zev Radovan. Estab. 1975. Picture library. Has 50,000 photos in files. Clients include: book publishers, magazine publishers, newspapers, calendar companies, postcard publishers.
Needs: Wants photos of museum objects, archaeological sites. Also multicultural, landscapes/scenics. Interested in fine art, historical/vintage.
Specs: Uses 35mm, $2\frac{1}{4} \times 2\frac{1}{4}$ transparencies.
Payment & Terms: Offers volume discounts to customers; terms specified in photographers' contracts.
Tips: "Our archives contain tens of thousands of color slides covering a wide range of subjects: historical and archaeological sites, aerial and close-up views, museum objects, mosaics, coins, inscriptions, the myriad ethnic and religious groups individually portrayed in their daily activities, colorful ceremonies, etc. Upon request, we accept assignments for in-field photography."

LIAISON AGENCY, 11 E. 26th St., New York NY 10010. (212)779-6303. Fax: (212)779-6334. Website: http://www.liaisonphoto.com. or http://www.hultongetty.com. Vice President/Director of Photography: Susan Carolonza. Has 23 million photographs. Extensive editorial and stock files include news (reportage), human interest stories, movie stills, personalities/celebrities, entertainment. Clients include: newspapers, magazines, all book publishers, advertising agencies, corporations and design firms.
• This agency has a second division, Liaison Assignment Photography which offers a complete assignment service with a worldwide network of outstanding photographers serving the needs of commercial and editorial clients.
Specs: Uses most formats.
Payment & Terms: Pays 50% commission. Works with or without contract. Offers exclusive contract and guaranteed subject exclusivity (within files). Contracts renew automatically for 5 years. Charges processing and shipping fee. Statements issued monthly. Payment made monthly. Photographers allowed to review account records. Offers one-time rights. Informs photographers and permits them to negotiate when a client requests to buy all rights. Leases one-time rights. Captions required.
Making Contact: Call or e-mail for submission guidelines.
Tips: Involves a "rigorous trial period for first six months of association with photographer. Prefers previous involvement in publishing industry."

LIGHT SOURCES STOCK, 23 Drydock Ave., Boston MA 02210. This company was recenty acquired by Index Stock, 23 W. 18th, 3rd Floor, New York NY 10011. Website: http://www.indexstock.com.

LIGHTWAVE, 170 Lowell St., Arlington MA 02174. Phone/fax: (781)646-1747. (800)628-6809 (outside 781 area code). E-mail: lightwav@tiac.net. Website: http://www.tiac.net/users/lightwav. Contact: Paul Light. Has 250,000 photos. Clients include: advertising agencies and textbook publishers.

• Paul Light offers photo workshops over the Internet. Check out his website for details.

Needs: Wants candid photos of people in school, work and leisure activities.

Specs: Uses 35mm color transparencies.

Payment & Terms: Pays $210/photo; 50% commission. Works on contract basis only. Offers nonexclusive contract. Contracts renew automatically each year. Statements issued annually. Payment made "after each usage." Offers one-time rights. Informs photographer and allows them to negotiate when client requests all rights. Model/property release preferred. Captions preferred.

Making Contact: Send SASE or e-mail for guidelines.

Tips: "Photographers should enjoy photographing people in everyday activities. Work should be carefully edited before submission. Shoot constantly and watch what is being published. We are looking for photographers who can photograph daily life with compassion and originality."

LINEAIR FOTOARCHIEF, B.V., van der Helllaan 6, Arnhem 6824 HT Netherlands. (00.31)26.4456713. Fax: (00.31)26.3511123. E-mail: lineair@worldonline.nl. Manager: Ron Giling. Estab. 1990. Stock photo agency. Has 200,000 photos. Clients include advertising agencies, public relations firms, book/encyclopedia publishers, magazine publishers. Library specializes in images from Asia, Africa, Latin America, Eastern Europe and nature in all forms on all continents.

• Due to international cooperation with nature photo agencies LINEAIR established a specialized nature section in May 1998.

Needs: Interested in everything that has to do with the development of countries in Asia, Africa and Latin America and from all over the world.

Specs: Uses 8×10 b&w prints; 35mm, $2\frac{1}{4} \times 2\frac{1}{4}$ transparencies.

Payments & Terms: Pays 50% commission on color and b&w prints. Average price per image (to clients): $75-125/b&w; $100-400/color. Enforces minimum prices. Offers volume discounts to customers; inquire about specific terms. Photographers can choose not to sell images on discount terms. Works with or without a signed contract; negotiable. Offers limited regional exclusivity. Charges 50% duping fees. Statements issued quarterly. Payment made quarterly. Photographers allowed to review account records. "They can review bills to clients involved." Offers one-time rights. Informs photographer and allows them

© Ron Giling/Lineair-Netherlands

Photographer Ron Giling was offered a standard 50 percent stock split by Lineair Fotoarchief for his image of a smiling plantation worker. "We like simple photos that give a lot of information so they can be used in many ways," says the Dutch stock agency. This image was chosen because it can be used to illustrate agriculture, Africa or a woman at work.

to negotiate when client requests all rights. Captions required; include country, city or region, description of the image.

Making Contact: Submit portfolio for review. SAE. There is no minimum for initial submissions. Reports in 3 weeks. Brochure free with SAE/IRC. Market tips sheet available upon request.

Tips: "We like to see high-quality pictures in all aspects of photography. So we'd rather see 50 good ones, than 500 for us to select the 50 out of."

MACH 2 STOCK EXCHANGE LTD., 204-1409 Edmonton Tr NE, Calgary, Alberta T2E 3K8 Canada. (403)230-9363. Fax: (403)230-9364. E-mail: pam@m2stock.com. Website: http://www.m2stock.-com. Manager: Pamela Varga. Estab. 1986. Stock photo agency. Member of Picture Agency Council of America (PACA). Clients include: advertising agencies, public relations firms, audiovisual firms and corporations.

Needs: Corporate, high-tech, lifestyle, industry. In all cases, prefer people-oriented images.

Specs: Uses 35mm, 2¼×2¼, 4×5, 8×10 transparencies.

Payment & Terms: Pays 50% commission on color photos. Average price per image (to clients): $300. Works on contract basis only. Offers limited regional exclusivity. Contracts renew automatically with additional submissions. Charges 50% duping and catalog insertion fees. Statements issued monthly. Payment made monthly. "All photographers' statements are itemized in detail. They may ask us anything concerning their account." Offers 1-time and 1-year exclusive rights; no electronic media rights for clip art type CD's. Informs photographer and allows them to negotiate when client requests all rights. "We generally do not sell buy-out." Model/property release required. Captions required.

Making Contact: Query with samples and list of stock photo subjects. SASE. Reports in 1 month. Market tips sheet distributed quarterly to contracted photographers.

Tips: "Please call first. We will then send a basic information package. If terms are agreeable between the two parties then original images can be submitted pre-paid." Sees trend toward more photo requests for families, women in business, the environment and waste management, active vibrant seniors, high-tech and computer-generated or manipulated images, conceptual, minorities (Asians mostly).

MAJOR LEAGUE BASEBALL PHOTOS, 245 Park Ave., 30th Floor, New York NY 10022. Fax: (212)949-5699. Manager: Rich Pilling. Estab. 1994. Stock photo agency. Has 500,000 photos. Clients include: advertising agencies, public relations firms, businesses, book/encyclopedia publishers, magazine publishers, newspapers, calendar companies, greeting card companies, postcard publishers and MLB licensees.

Needs: Wants photos of any subject for major league baseball—action, feature, fans, stadiums, umpires, still life.

Specs: Uses 8×10 glossy color prints; 35mm, 2¼×2¼ transparencies; CD-ROM digital format.

Payment & Terms: Pays 50% commission on photos. Enforces minimum prices. Offers volume discounts to customers; inquire about specific terms. Discount sales terms not negotiable. Works on contract basis only. Offers exclusive contract only. Statements issued monthly. Payment made monthly. Photographers allowed to review account records. Offers one-time rights. Informs photographer and allows them to negotiate when client requests all rights. Captions preferred.

Making Contact: Arrange personal interview to show portfolio. Works with local freelancers on assignment only. Samples kept on file. SASE. No minimum number of images expected with initial submission. Reports in 1-2 weeks. Photo guidlines available.

MASTERFILE, 175 Bloor St. E., South Tower, 2nd Floor, Toronto, Ontario M4W 3R8 Canada. (416)929-3000. Fax: (416)929-2104. E-mail: inquiries@masterfile.com. or portfolios@masterfile.com. Website: http://www.masterfile.com. Artist Liaison: Linda Crawford. Stock photo agency. Has 300,000 photos. Clients include: advertising agencies, public relations firms, audiovisual firms, book/encyclopedia publishers, magazine publishers, newspapers, postcard publishers, calendar companies, greeting card companies, all media.

Specs: Uses 35mm, 2¼×2¼, 4×5, 8×10 transparencies. Accepts images in digital format.

Payment & Terms: Pays 40-50% royalties. Enforces strict minimum prices. Offers volume discounts to customers; terms specified in photographer's contract. Discount sales terms not negotiable. Works on contract basis only. Offers worldwide exclusive contracts only. Contracts renew automatically after 5 years for 1 year terms. Charges duping and catalog insertion fees. Statements issued monthly. Payments made monthly. Photographers allowed to review account records. Offers one-time and electronic media rights and allows artist to negotiate when client requests total buyout. Model release required. Property release preferred. Captions required.

Making Contact: Ask for submission guidelines. SASE. Expects maximum initial submission of 200 images. Reports in 1-2 weeks on portfolios; same day on queries. Photo guidelines free. Market tips sheet

distributed to contract photographers only. "Masterfile also accepts submissions for a royalty free affiliate."

N ⬛ MICHELE MATTEI PRODUCTIONS, 1714 N. Wilton Place, Los Angeles CA 90028. (323)462-6342. Fax: (323)462-7572. E-mail: mattei786@aol.com. Director: Michele Mattei. Estab. 1974. Stock photo agency and news/feature syndicate. Has "several thousand" photos. Clients include: book/encyclopedia publishers, magazine publishers, television, film.

Needs: Wants television, film, studio, celebrity, paparazzi, feature stories (sports, national and international interest events, current news stories). Written information to accompany stories needed. "We do not wish to see fashion and greeting card-type scenics." Also wants environmental, architecture, cities/urban, health/fitness, computers, portraits, science, technology, glamour.

Specs: Uses 35mm, 2¼×2¼ transparencies.

Payment & Terms: Pays 50% commission for color and b&w photos. Average price per image (to clients): $35 minimum for color photos. Offers one-time rights. Model release preferred. Captions required.

Making Contact: Query with résumé of credits. Query with samples. Query with list of stock photo subjects. Works with local freelancers. Occasionally assigns work.

Tips: "Studio shots of celebrities, and home/family stories are frequently requested." In samples, looking for "marketability, high quality, recognizable personalities and current newsmaking material. Also, looks for paparazzi celebrities at local and national events. We deal mostly in Hollywood entertainment stories. We are interested mostly in celebrity photography and current events. Written material on personality or event helps us to distribute material faster and more efficiently."

N 🌐 MAURITIUS DIE BILDAGENTUR GMBH, Postfach 209, 82477 Mittenwald, Mühlenweg 18, 82481 Mittenwald Germany. Phone: (49)8823/42-0. Fax: (49)8823/8881. E-mail: info@mauritius-images.com. President: Hans-Jörg Zwez. CEO: Joachim Koutzky. Stock photo agency. Has 1.8 million photos. Has 5 branch offices in Germany and Austria. Clients include: advertising agencies, businesses, book/encyclopedia publishers, magazine publishers, postcard companies, calendar companies and greeting card companies.

Needs: All kinds of contemporary themes: geography, people, animals, plants, science, economy.

Specs: Uses 2¼×2¼, 4×5 and 8×10 transparencies and 35mm for people shots.

Payment & Terms: Pays 50% commission for color photos. Offers one-time rights. Model release required. Captions required.

Making Contact: Query with samples. Submit portfolio for review. SAE. Reports in 2 weeks. Tips sheet distributed once a year.

Tips: Prefers to see "people in all situations, from baby to grandparents, new technologies, transportation."

⬛ MEDICAL IMAGES INC., 40 Sharon Rd., P.O. Box 141, Lakeville CT 06039. (860)435-8878. Fax: (860)435-8890. E-mail: medimag@ntplx.net. President: Anne Darden. Estab. 1990. Stock photo agency. Has 50,000 photos. Clients include: advertising agencies, public relations firms, corporate accounts, book/encyclopedia publishers, magazine publishers and newspapers.

Needs: Wants medical and health-related material, including commercial-looking photography of generic doctor's office scenes, hospital scenarios and still life shots. Also, technical close-ups of surgical procedures, diseases, high-tech colorized diagnostic imaging, microphotography, nutrition, exercise and preventive medicine.

Specs: Uses 8×10 glossy b&w prints; 35mm, 2¼×2¼, 4×5 and 8×10 transparencies. Accepts images in digital format for Mac. Send via CD.

Payment & Terms: Pays 50% commission for b&w and color photos. Average price per image (to clients): $150 minimum. Enforces minimum prices. Works with or without contract. Offers nonexclusive contract. Contracts renew automatically. Statements and checks issued bimonthly. "If client pays within same period, photographer gets check right away; otherwise, in next payment period." Photographer's accountant may review records with prior appointment. Offers one-time and electronic media rights. Model/property release preferred. Captions required; include medical procedures, diagnosis when applicable, whether model released or not, etc.

Making Contact: Query with list of stock photo subjects or telephone with list of subject matter. SASE. Reports in 2 weeks. Photo guidelines available. Market tips sheet distributed quarterly to contracted photographers.

● **SPECIAL COMMENTS** within listings by the editor of *Photographer's Market* are set off by a bullet.

Tips: Looks for "quality of photograph—focus, exposure, composition, interesting angles; scientific value; and subject matter being right for our markets." Sees trend toward "more emphasis on editorial or realistic looking medical situations. Anything too 'canned' is much less marketable. Write and send some information about type (subject matter) of images and numbers available."

MEDICHROME, 232 Madison Ave., New York NY 10016. (212)679-8480. Fax: (212)532-1934. E-mail: medichrome@aol.com. Website: http://www.workbook.com. Manager: Ivan Kaminoff. Has 1 million photos. Clients include: advertising agencies, design houses, publishing houses, magazines, newspapers, in-house design departments, and pharmaceutical companies.
Needs: Wants everything that is considered medical or health-care related, from the very specific to the very general. "Our needs include doctor/patient relationships, surgery and diagnostics processes such as CAT scans and MRIs, physical therapy, home health care, micrography, diseases and disorders, organ transplants, counseling services, use of computers by medical personnel and everything in between."
Specs: "We accept b&w prints but prefer color, 35mm, 2¼×2¼, 4×5 and 8×10 transparencies."
Payment & Terms: Pays 50% commission on b&w and color photos. All brochures are based on size and print run. Ads are based on exposure and length of campaign. Offers one-time or first rights; all rights are rarely needed—very costly. Model release preferred. Captions required.
Making Contact: Query by "letter or phone call explaining how many photos you have and their subject matter." SASE. Reports in 2 weeks. Distributes tips sheet every 6 months to Medichrome photographers only.
Tips: Prefers to see "loose prints and slides in 20-up sheets. All printed samples welcome; no carousel, please. Lots of need for medical stock. Very specialized and unusual area of emphasis, very costly/difficult to shoot, therefore buyers are using more stock."

■ MEGAPRESS IMAGES, 5352 St. Laurent Blvd., Montreal, Quebec H2T 1S5 Canada. (514)279-9859. Fax: (514)279-1971. Estab. 1992. Stock photo agency. Half million photos. Has 2 branch offices. Clients include: book/encyclopedia publishers, magazine publishers, postcard publishers, calendar companies, greeting card companies.
Needs: Wants photos of people (couples, children, beauty, teenagers, people at work, medical); animals including puppies in studio; industries; celebrities and general stock.
Specs: Uses 35mm, 2¼×2¼, 4×5 transparencies.
Payment & Terms: Pays 50% commission on color photos. General price range (to client): $75-500/image. Enforces minimum prices. Will not negotiate below $60. Works with or without a signed contract. Offers limited regional exclusivity. Statements issued semiannually. Payments made semiannually. Offers one-time rights. Model release required for people and controversial news. Captions required. Each slide must have the name of the photographer and the subject.
Making Contact: Submit portfolio for review by registered mail or courier only. Samples not kept on file. SAE. Expects minimum initial submission of 250 images with periodic submission of at least 1,000 pictures per year. Make first contact by fax.
Tips: "Pictures must be very sharp. Work must be consistent. We also like photographers who are specialized in particular subjects."

MIDWESTOCK, 1925 Central, Suite 200, Kansas City MO 64108. (816)474-0229. Fax: (816)474-2229. E-mail: photogs@midwestock.com. Website: http://www.midwestock.com. Director: Susan L. Anderson. Estab. 1991. Stock photo agency. Has 200,000 photos. Clients include: advertising agencies, public relations firms, businesses, book/encyclopedia publishers, magazine publishers, newspapers, postcard publishers, calendar companies, greeting card companies.
Needs: "We need more quality people shots depicting ethnic diversity." Also general interest with distinct emphasis on "Heartland" and agricultural themes.
Specs: "Clean, stylized business and lifestyle themes are biggest sellers in 35mm and medium formats. In scenics, our clientele prefers medium and large formats." Uses 35mm, 4×5, 6×6, 6×7, 8×10 transparencies.
Payment & Terms: Pays 50% commission. Average price per image (to clients): $300/color. Enforces minimum prices of $195, except in cases of reuse or volume purchase. Offers volume discounts to customers; inquire about specific terms. Works on contract basis only. "We negotiate with photographers on an individual basis." Prefers exclusivity. Contracts renew automatically after 2 years and annually thereafter, unless notified in writing. Statements issued monthly. Payment made monthly. Model release required. Offers one-time and electronic media rights; negotiable. Property release preferred. Captions required.
Making Contact: Query with stock photo list. Request submittal information first. Expects minimum initial submission of 1,000 in 35mm format (less if larger formats). Reports in 3 weeks. Photo guidelines provided by e-mail. Market tips sheet distributed quarterly to photographers on contract.

Tips: "We prefer photographers who can offer a large selection of medium and large formats and who are full-time professional photographers who already understand the value of upholding stock prices and trends in marketing and shooting stock. If you don't have internet access with an e-mail address, you won't keep up here."

N 📷 MIRA, Copyright Clearance Center, 222 Rosewood Dr., 9th Floor, Danvers MA 01923. (978)750-8400, ext. 2663. Fax: (978)739-9025. E-mail: mdooley@mira.com. Website: http://www.mira.com. Rightsholder Coordinator: Mona Dooley. Estab. 1997. Stock agency. Clients include: advertising agencies, audiovisual firms, book publishers, magazine publishers, newspapers, calendar companies, greeting card companies, postcard publishers, corporate and business clients, graphic design firms, CD-ROM and web producers, travel companies.
Needs: Wants high-quality, carefully edited, images in all subject areas. Particularly interested in natural history, travel and location, people and lifestyles, current events and celebrities, health and medical, business and technology, fine arts, historical and conceptual images.
Specs: Uses 35mm transparencies. Prefers images in digital format. Send as TIFF, PCD files at 300 dpi or more; minimum of 18MB, prefer 25MD or more.
Payment & Terms: Photographers pay for scans of all images.
Making Contact: Do not send unsolicited images. Contact Mona Dooley for guidelines. All originals will be returned after review and/or scanning. "We have a very fast turnaround."
Tips: "We are looking for very high-quality, technically excellent, well-edited images with unusual subjects or the more usual subjects creatively presented. Images must be accurately and thoroughly captioned. Include the who, what, where, when (copyright date and date shot) and information about releases and restrictions. When submitting for review, put transparencies in protective covers and sheets; edit very selectively; group by subject; pack images well. Include accurate and detailed Delivery Memo. Provide SASE or FedEx Account number for return shipping."

MONKMEYER, 118 E. 28th St., New York NY 10016. (212)689-2242. Fax: (212)779-2549. E-mail: anita@monkmeyerphotos.com. Website: http://www.monkmeyerphotos.com. Owner: Anita Duncan. Estab. 1930s. Has 500,000-800,000 photos. Clients include: book/encyclopedia publishers.
Needs: General human interest and educational images with a realistic appearance.
Specs: Uses 8×10 matte b&w prints; 35mm transparencies.
Payment & Terms: Pays 50% commission on b&w and color photos. Average price per image (to clients): $140/b&w, $185/color. Offers volume discounts to customers. Model/property release preferred. Captions preferred.
Making Contact: Arrange personal interview to show portfolio. Expects minimum initial submission of 200 images.
Tips: "Watch your backgrounds and shadows."

MOTION PICTURE AND TV PHOTO ARCHIVE, 16735 Saticoy St., Van Nuys CA 91406. (818)997-8292. Fax: (818)997-3998. President: Ron Avery. Estab. 1988. Stock photo agency. Has over 1 million photos. Clients include: advertising agencies, book/encyclopedia publishers, magazine publishers, newspapers, postcard publishers, calendar companies, greeting card companies.
Needs: Color shots of current stars and old TV and movie stills.
Specs: Uses 8×10 b&w/color prints; 35mm, 2¼×2¼, 4×5 and 8×10 transparencies.
Payment & Terms: Buys photos/film outright. Pays 50% commission on b&w and color photos. Average price per image (to clients): $180-1,000/b&w image; $180-1,500/color image. Enforces strict minimum prices. Offers volume discounts to customers; terms specified in photographer's contract. Works on contract basis only. Offers exclusive contract. Contracts renew automatically with additional submissions. Statements issued monthly. Payment made monthly. Photographers allowed to review account records. Rights negotiable; "whatever fits the job."
Making Contact: Reports in 1-2 weeks.

MOUNTAIN STOCK PHOTO & FILM, P.O. Box 1910, Tahoe City CA 96145. (530)583-6646. Fax: (530)583-5935. Contact: Meg de Vine. Estab. 1986. Stock photo agency. Member of Picture Agency Council of America (PACA). Has 60,000 photos; minimal films/videos. Clients include: ad agencies, public relations firms, audiovisual firms, businesses, book/encyclopedia publishers, magazine publishers, newspapers, calendar companies, greeting card companies.
Needs: "We specialize in and always need action sports, scenic and lifestyle images."
Specs: Uses 35mm, 2¼×2¼, 4×5, transparencies.
Payment & Terms: Pays 50% commission on color photos. Enforces minimum prices. "We have a $100 minimum fee." Offers volume discounts to customers; inquire about specific terms. Discount sales terms

not negotiable. Works on contract basis only. Some contracts renew automatically. Charges 50% catalog insertion fee. Statements issued quarterly. Payment made quarterly. Photographers are allowed to review account records with due notice. Offers unlimited and limited exclusive rights. Informs photographer and allows them to negotiate when client requests all rights. Model/property release required. Captions required.
Making Contact: Query with résumé of credits. Query with samples. Query with stock photo list. Samples kept on file. SASE. Expects minimum initial submission of 500 images. Reports in 1 month. Photo guidelines free with SAE and 64¢ postage. Market tips sheet distributed quarterly to contracted photographers upon request.
Tips: "I see the need for images, whether action or just scenic, that evoke a feeling or emotion."

NATURAL SCIENCE PHOTOS, 33 Woodland Dr., Watford, Hertfordshire WD1 3BY England. Phone: 01923-245265. Fax: 01923-246067. Partners: Peter and Sondra Ward. Estab. 1969. Stock photo agency and picture library. Members of British Association of Picture Libraries and Agencies (BAPLA). Has 175,000 photos. Clients include: advertising agencies, public relations firms, audiovisual firms, businesses, book/encyclopedia publishers, magazine publishers, newspapers, postcard companies, calendar companies, greeting card companies and television.
Needs: Natural science of all types, including wildlife (terrestrial and aquatic), habitats (including destruction and reclamation), botany (including horticulture, agriculture, pests, diseases, treatments and effects), ecology, pollution, geology, primitive peoples, astronomy, scenics (mostly without artifacts), climate and effects (e.g., hurricane damage), creatures of economic importance (e.g., disease carriers and domestic animals and fowl). "We need all areas of natural history, habitat and environment from South and Central America, also high quality marine organisms."
Specs: Uses 35mm, 2¼×2¼ original color transparencies.
Payment & Terms: Pays 33-50% commission. General price range: $55-1,400. "We have minimum fees for small numbers, but negotiate bulk deals sometimes involving up to 200 photos at a time." Works on contract basis only. Offers nonexclusive contract. Statements issued semiannually. Payment made semiannually. "We are a private company; as such our books are for tax authorities only." Offers one-time and electronic media rights; exclusive rights on calendars. Informs photographers and permits them to negotiate when a client requests all rights. Copyright not sold without written permission. Captions required include English and scientific names, location and photographer's name.
Making Contact: Arrange a personal interview to show a portfolio. Submit portfolio for review. Query with samples. Send unsolicited photos by mail for consideration. "We require a sample of at least 20 transparencies together with an indication of how many are on offer, also likely size and frequency of subsequent submissions." Samples kept on file. SAE. Reports in 1-4 weeks, according to pressure on time.
Tips: "We look for all kinds of living organisms, accurately identified and documented, also habitats, environment, weather and effects, primitive peoples, horticulture, agriculture, pests, diseases, etc. Animals, birds, etc., showing action or behavior particularly welcome. We are not looking for 'arty' presentation, just straightforward graphic images, only exceptions being 'moody' scenics. There has been a marked increase in demand for really good images with good color and fine grain with good lighting. Pictures that would have sold a few years ago that were a little 'soft' or grainy are now rejected, particularly where advertising clients are concerned."

NATURAL SELECTION STOCK PHOTOGRAPHY INC., 183 St. Paul St., Rochester NY 14604. (716)232-1502. Fax: (716)232-6325. E-mail: nssp@netacc.net. Manager: David L. Brown. Estab. 1987. Stock photo agency. Member of the Picture Agency Council of America (PACA). Has over 750,000 photos. Clients include: advertising agencies, public relations firms, businesses, book/encyclopedia publishers, magazine publishers, newspapers, postcard publishers, calendar companies, greeting card companies.
Needs: Interested in photos of nature in all its diversity.
Specs: All formats.
Payment & Terms: Pays 50% commission on color photos. Works on contract basis only. Offers nonexclusive contracts with image exclusivity. Contracts renew automatically with additional submissions for 3 years. Payment made monthly on fees collected. Offers one-time rights. "Informs photographer when client requests all rights." Model/property release required. Captions required; include photographer's name, where image was taken and specific information as to what is in the picture.
Making Contact: Query with résumé of credits; include types of images on file, number of images, etc. SASE. Expects minimum initial submission of 200 images. Reports in 1 month. Market tips sheet distributed quarterly to all photographers under contract.
Tips: "All images must be completely captioned, properly sleeved, and of the utmost quality."

NAWROCKI STOCK PHOTO, P.O. Box 16565, Chicago IL 60616. (312)427-8625. Fax: (312)427-0178. Director: William S. Nawrocki. Stock photo agency, picture library. Member of Picture Agency

Council of America (PACA). Has over 300,000 photos and 500,000 historical photos. Clients include: advertising agencies, public relations firms, editorial, businesses, book/encyclopedia publishers, magazine publishers, newspapers, postcard companies, calendar companies and greeting card companies.

Needs: Model-released people, all age groups, all types of activities; families; couples; relationships; updated travel, domestic and international; food.

Specs: Uses 35mm, 2¼×2¼, 2¼×2¾, 4×5 and 8×10 transparencies. "We look for good composition, exposure, subject matter and color." Also, finds large format work "in great demand." Medium format and professional photographers preferred.

Payment & Terms: Buys only historical photos outright. Pays variable percentage on commission according to use/press run. Commission depends on agent—foreign or domestic 50%/40%/35%. Works on contract basis only. Contracts renew automatically with additional submissions for 5 years. Offers limited regional exclusivity and nonexclusivity. Charges duping and catalog insertion fees. Statements issued quarterly. Payment made quarterly. Offers one-time media and some electronic rights; other rights negotiable. Requests agency promotion rights. Informs photographer when client requests all rights. Model release required. Captions required. Mounted images required.

Making Contact: Arrange a personal interview to show portfolio. Query with résumé of credits, samples and list of stock photo subjects. Submit portfolio for review. Provide return Federal Express. SASE. Reports ASAP. Allow 2 weeks for review. Photo guidelines free with SASE. Tips sheet distributed "to our photographers." Suggest that you call first—discuss your photography with the agency, your goals, etc. "NSP prefers to help photographers develop their skills. We tend to give direction and offer advice to our photographers. We don't take photographers on just for their images. NSP prefers to treat photographers as individuals and likes to work with them." Label and caption images. Has network with domestic and international agencies.

Tips: "A stock agency uses just about everything. We are using more people images, all types—family, couples, relationships, leisure, the over-40 group. Looking for large format—variety and quality. More images are being custom shot for stock with model releases. Model releases are very, very important—a key to a photographer's success and income. Model releases are the most requested for ads/brochures."

NETWORK ASPEN, 319 Studio N, Aspen Business Center, Aspen CO 81611. (970)925-5574. Fax: (970)925-5680. E-mail: images@networkaspen.com. Website: http://www.networkaspen.com. Founder/Owner: Jeffrey Aaronson. Studio Manager: Becky Green. Photojournalism and stock photography agency. Has 250,000 photos. Clients include: advertising agencies, public relations, businesses, book/encyclopedia publishers, magazine publishers, newspapers, calendar companies.

Needs: Reportage, world events, travel, cultures, business, the environment, sports, people, industry.

Specs: Uses 35mm transparencies.

Payment & Terms: Pays 50% commission on color photos. Works on contract basis only. Offers nonexclusive and guaranteed subject exclusivity contracts. Statements issued quarterly. Payments made quarterly. Photographers allowed to review account records. Offers one-time and electronic media rights. Model/property release preferred. Captions required.

Making Contact: Query with résumé of credits. Query with samples. Query with stock photo list. Keeps samples on file. SASE. Expects minimum initial submission of 250 duplicates. Reports in 3 weeks.

Tips: "Our agency focuses on world events, travel and international cultures, but we would also be interested in reviewing other subjects as long as the quality is excellent."

NEW ENGLAND STOCK PHOTO, 2389 Main St., Dept. PM, Glastenbury CT 06033. (860)659-3737. Fax: (860)659-3235. President: Rich James. Estab. 1985. A full service agency with emphasis toward serving advertising, corporate, editorial and design companies. Member of the Picture Agency Council of America (PACA). Stock photo agency.

• New England Stock Photo participated in: Stock Workbook Print Catalogues (10, 11, 12, 13); Stock Workbook CD ROM's (5, 6, 7, 8 and specialty disks); Blackbook CD ROM's (3 & 4); and is producing catalogue 4 and CD ROM.

Needs: "We are a general interest agency with a growing variety of clients and subjects. Always looking for great people shots—(especially multicultural, business, children, teenagers, couples, families, middle age and senior citizens) engaged in every day life situations (business, home, travel, recreation, outdoor activities and depicting ethnicity). Other needs include sports and recreation, architecture (cities and towns), transportation, nature (animals and wildlife) birds, waterfowl, technology, energy and communications. We get many requests for particular historical sites, annual events and need more coverage of towns/cities, main streets and tourist spots.

Specs: Uses 35mm, 2¼×2¼, 4×5 transparencies.

Payment & Terms: Pays 50% commission; 75% to photographer on assignments obtained by agency. Average price per image (to client): $100-5,000. Works with photographers on contract basis only. Offers

nonexclusive contract. Charges catalog insertion fee. Offers one-time rights; postcard, calendar and greeting card rights. Informs photographer and allows them to negotiate when client requests all rights. Model/property release preferred (people and private property). Captions required; include who, what, where.
Making Contact: Interested in receiving work. Query with list of stock photo subjects or send unsolicited photos by mail for consideration with check or money order for $9.95. Reports as soon as possible. Distributes newsletter and tips sheet regularly. "We provide one of the most comprehensive photo guideline packages in the business. Please write for it, including $4.95 for shipping and handling."
Tips: "There is an increased use of stock. Submissions must be high quality, in sharpest focus, perfectly composed and with strongest composition. Whether you are a picture buyer or photographer, we will provide the personalized service you need to succeed."

NEWS FLASH INTERNATIONAL, INC., Division of Observer Newspapers, P.O. Box 407, Bellmore NY 11710. (516)679-9888. Fax: (516)731-0338. Editor: Jackson B. Pokress. Has 25,000 photos. Clients include: advertising agencies, public relations firms, businesses and newspapers.
Needs: "We handle news photos of all major league sports: football, baseball, basketball, boxing, wrestling, hockey. We are now handling women's sports in all phases, including women in boxing, basketball, softball, etc." Some college and junior college sports. Wants emphasis on individual players with dramatic impact. "We are now covering the Washington DC scene. There is currently an interest in political news photos."
Specs: Super 8 and 16mm documentary and educational film on sports, business and news; 8×10 glossy b&w prints or contact sheet; transparencies.
Payment & Terms: Pays 40-50% commission/photo and film. Pays $5 minimum/photo. Works with or without contract. Offers nonexclusive contracts. Informs photographer and allows them to negotiate when client requests all rights. Statements issued quarterly. Payment made monthly or quarterly. Photographers allowed to review account records. Offers one-time, agency promotion or first rights. Informs photographer and allows them to negotiate when client requests all rights. Model release required. Captions required.
Making Contact: Query with samples. Send material by mail for consideration or make a personal visit if in the area. SASE. Reports in 1 month. Free photo guidelines and tips sheet on request.
Tips: "Exert constant efforts to make good photos—what newspapers call grabbers. Make them different than other photos, look for new ideas. There is more use of color and large format chromes." Has special emphasis on major league sports. "We cover Mets, Yankees, Jets, Giants, Islanders on daily basis and Rangers and Knicks on weekly basis. We handle bios and profiles on athletes in all sports. There is an interest in women athletes in all sports."

NEWSMAKERS, Newsmakers LLC, 733 15th St. NW, Suite 517, Washington DC 20005. (202)347-2050. Fax: (202)347-2052. E-mail: info@newsmakers.net. Website: http://www.newsmakers.net. Director: Richard Ellis. Estab. 1997. News/feature syndicate. Has 20,000 photos in files. Clients include: magazine publishers, newspapers, online services.
Needs: Wants general news picture, celebrities, disasters, environmental, religious, entertainment, events, food/drink, sports, travel, agriculture, computers, industry, medicine, military, political, portraits, science, technology, documentary.
Specs: Accepts images only in digital format for Mac, Windows. Send via CD, floppy disk, Jaz, Zip, e-mail, FTP as JPEG files at 200 dpi $8 \times 10''$.
Payment & Terms: Pays 60% commission for b&w and color photos. Average price per image (to clients): $10-600 for b&w and color photos. Works with photographers with or without a contract; negotiable. Offers nonexclusive contract. Statements issued monthly. Payment made monthly. Photographers allowed to review account records. Offers one-time/electronic media rights. Informs photographers and allows them to negotiate when client requests all rights. Photo captions required; include who, what, when and where.
Making Contact: Send query letter with résumé, slides, prints, photocopies, tearsheets, transparencies. Portfolio may be submitted by e-mail. Provide business card and self-promotion piece to be kept on file. Expects minimum initial submission of 10 images with monthly submissions of at least 10 images. Reports in 2 weeks on samples; 2 weeks on portfolios. Photo guidelines sheet free with SASE.
Tips: "Have working professionals review you work first."

911 PICTURES, 60 Accabonac Rd., East Hampton NY 11937. (516)324-2061. Fax: (516)329-9264. E-mail: mheller@hamptons.com Website: http://www.911pictures.com. President: Michael Heller. Estab. 1996. Stock agency. Has 1,200 photos in files. Clients include: advertising agencies, public relations firms, audiovisual firms, businesses, book publishers, magazine publishers, calendar companies, insurance companies, public safety training facilities.
Needs: Wants photos of disaster services, public safety/emergency services, fire, police, EMS, rescue,

Haz-Mat. Interested in documentary.

Specs: Uses 4×6 to 8×10, glossy, matte, color and/or b&w prints; 35mm transparencies. Accepts images in digital format for Windows for review and thumbnail purposes only. Send via e-mail, CD, Jaz as BMP, GIF, JPEG files at 72 dpi.

Payment & Terms: Pays 50% commission for b&w and color photos; 75% for film and videotape. Enforces minimum prices. Offers volume discounts to customers. Works with photographers on contract basis only. Offers nonexclusive contract. Charges any print fee (from negative or slide) or dupe fee (from slide). Statements issued/sale. Payments made/sale. Photographers allowed to review account records in cases of discrepancies only. Offers one-time rights. Informs photographers and allows them to negotiate when client requests all rights. Model release preferred. Photo captions preferred; photographer's name, and a short caption as to what is occurring in photo.

Making Contact: Send query letter with résumé, slides, prints, photocopies, tearsheets. "Photographers can also send e-mail with thumbnail (low-resolution) attachments." Does not keep samples on file; include SASE for return of material. Reports back only if interested; send non-returnable samples. Photo guidelines sheet free with SASE. Catalog for $10.

Tips: "Keep in mind that there are hundreds of photographers shooting hundreds of fires, car accidents, rescues, etc. every day. Take the time to edit your own material, so that you are only sending in your best work. At this time 911 Pictures is only soliciting work from those photographers who shoot professionally or who shoot public-safety on a regular basis. We are not interested in occasional submissions of one or two images."

NONSTOCK INC. PHOTOGRAPHY & ILLUSTRATION ARCHIVES, 5 W. 19th St., 6th Floor, New York NY 10011. 1(800)673-6222. Fax: (212)741-3412. E-mail: service@nonstock.com. Website: http://www.nonstock.com. President: Jerry Tavin. Stock photography and illustration agency. Clients include: advertising agencies, public relations firms, audiovisual firms, businesses, book/encyclopedia publishers, magazine publishers, newspapers, postcard publishers, calendar companies, greeting card companies.

Needs: Interested in images that are commercially applicable.

Specs: Uses 35mm transparencies.

Payment & Terms: Pays 50% commission for b&w, color and film. All fees are negotiated, balancing the value of the image with the budget of the client. Offers volume discounts to customers; inquire about specific terms. Works on contract basis only. Statements issued quarterly. Payment made quarterly. Photographers allowed to review account records. Offers all rights, "but we negotiate." Model/property release required. Captions preferred; include industry standards.

Making Contact: Submit portfolio for review. Keeps samples on file. SASE. Expects minimum initial submission of 50 images. Reports in 1-2 weeks. Photo guidelines free with SASE. Catalog free with SASE.

Tips: "Send a formal, edited submission of your best, most appropriate work, and indicate if model released or not."

N **M** **▢** **NORTHWEST PHOTOWORKS**, P.O. Box 222, Chilliwack, British Columbia V2P 6J1 Canada. (1877)640-3322. Fax: (1604)796 0635. E-mail: photosubs@ncphoto.com. Website: http://www.northwestphotoworks.com. President: Nick Morley. Estab. 1994. Stock agency. Has 10,000 photos in files. Clients include: advertising agencies, businesses, postcard publishers, public relations firms, book publishers, audiovisual firms, magazine publishers, greeting card companies.

Needs: Wants photos of babies, celebrities, children, couples, multicultural, families, parents, senior citizens, teens, disasters, environmental, landscapes/scenics, wildlife, architecture, beauty, cities/urban, education, gardening, rural, adventure, automobiles, entertainment, food/drink, health/fitness, hobbies, sports, travel, agriculture, business concepts, computers, industry, medicine, product shots/still life, science, technology. Interested in digital, documentary, erotic, fine art, historical/vintage, seasonal.

Specs: Uses 35mm transparencies. Accepts images in digital format for Windows. Send via CD, Zip, FTP as TIFF, EPS, BMP, JPEG files at 300 dpi.

Payment & Terms: Pays 50% commission for b&w and color photos. Average price per image (to clients): $150 minimum for b&w and color photos. Enforces minimum prices. Offers volume discounts to customers. Terms specified in photographers' contracts. Works with photographers on contract basis only. Offers nonexclusive contract. Photographers allowed to review account records in cases of discrepancies only. Offers one-time/electronic media rights. Informs photographers and allows them to negotiate when client requests all rights. Model release required; property release preferred. Photo captions required.

Making Contact: Send query letter with résumé, slides, stock list. Keeps samples on file. Provide business card. Expects minimum initial submission of 50 images with yearly submissions of at least 100 images. Reports in 1 month on samples; 1 month on portfolios. Photo guidelines sheet free with SAE. Market tips sheet available quarterly to affiliated photographers.

Tips: "We are also interested in receiving submissions from new or lesser known photographers. We look for compelling, professional quality images. Industry, lifestyle, medical, science and technology images are always in demand. Accurate captions are required. We need more people images of all types—must be model released."

NOVASTOCK, 1306 Matthews Plantation Dr., Matthews NC 28105-2463. (704)847-6185. Fax: (704)841-8181. E-mail: novastock@aol.com. Submission Department: Anne Clark. Estab. 1993. Stock agency. Clients include: advertising agencies, businesses, postcard publishers, public relations firms, book publishers, calendar companies, magazine publishers, greeting card companies and large international network of subagents.
Needs: "We need all the usual stock subjects like lifestyles, fitness, business, science, medical, family, etc. However, we also are looking for the unique and unusual imagery. We have one photographer who burns, scratches and paints on his film. Hand colored or digitally manipulated images are fine." Wants photos of children, couples, multicultural, families, parents, senior citizens, teens, disasters, environmental, wildlife, cities/urban, pets, religious, rural, adventure, entertainment, health/fitness, hobbies, humor, performing arts, sports, travel, business concepts, computers, industry, medicine, science, technology. Interested in alternative process, avant garde, digital, fine art, seasonal.
Specs: If you manipulate prints (e.g. hand coloring) submit first-class copy transparencies. Uses 35mm, 2¼×2¼, 4×5 transparencies.
Payment & Terms: Buys photos outright. "We quote on the purchase of collections small and large (5-50,000) after viewing." Pays 50% commission for b&w and color photos. "We never charge for dupes, scanning or catalog insertion." Works with photographers on contract basis only. Offers nonexclusive contract; exclusive only for images and similars. Photographer is allowed to market work not represented by Novastock. Statements and payments are made in the month following receipt of income from sales. Photographers allowed to review account records in cases of discrepancies only. Offers one-time, electronic media and agency promotion rights. Informs photographers and allows them to negotiate when client requests all rights. Model/property release preferred. Photo captions required; include who, what and where. "It is not necessary to describe the obvious (girl on bike). Science and technology need detailed and accurate captions. All photos must be marked with name and model release. "
Making Contact: Send query letter with slides, tearsheets, transparencies, stock list. Does not keep samples on file; include SASE for return of material or check covering return costs. Expects minimum initial submission of 200 images with 3 yearly submissions of at least 100 images each. Fewer required for conceptual, digital or hand manipulated images. Reports in 1 week on submissions. Photo guidelines sheet free with SASE or $5.
Tips: "Photos must be submitted in the following form: 35mm slides in 20-up sheets; 2¼×2¼, 6×7 and 4×5 in individual acetate sleeves and then inserted in clear pages. All images must be labeled with caption (if necessary) and marked with model release information and your name and copyright. We market agency material through more than 50 agencies in our international subagency network. Due to the costs of catalog fees and our extensive duping program, we accept only the few images from each submission we think will do very well. The photographer is permitted to freely market non-similar work anyway he/she wishes. If you are unsure if your work meets the highest level of professionalism as used in current advertising, please do not contact."

OKAPIA K.G., Michael Grzimek & Co., D-60 385 Frankfurt/Main, Roderbergweg 168 Germany. Phone: 01149/69/449041. Fax: 01149/69/498449; or Constanze Presse-haus, Kurfürstenstr. 72 -74 D-10787 Berlin Germany. Phone: 01149/30/26400180. Fax: 01149/30/26400182; or Bilder Pur Kaiserplatz 8 D-80803 München Germany. Phone: 01149/89/339070. Fax: 01149/89/366435. E-mail: OKAPIA@t-online. de. Website: http://www.okapia.com. President: Grzimek. Stock photo agency and picture library. Has 700,000 photos. Clients include: ad agencies, book/encyclopedia publishers, magazine publishers, newspapers, postcard companies, calendar companies, greeting card companies and school book publishers.
Needs: Natural history, babies, children, couples, families, parents, senior citizens, teens, gardening, pets, adventure, health/fitness, travel, agriculture, industry, medical, science and technology, and general interest. Interested in digital.
Specs: Uses 35mm, 2¼×2¼ and 4×5 transparencies. Accepts digital images for Windows, Mac. Send via CD, floppy disk as JPEG files at 355 dpi.
Payment & Terms: Pays 50% commission on color photos. Average price per image (to clients): $60-120 for color photos. Enforces strict minimum prices. Offers volume discounts to customers; not negotiable. Works on contract basis only. Offers nonexclusive contract, limited regional exclusivity and guaranteed subject exclusivity (within files). Contracts renew automatically for 1 year with additional submissions. Charges catalog insertion fee. Statements issued quarterly, semiannually or annually, depending on money photographers earn. Payment made quarterly, semiannually or annually with statement. Photographers

allowed to review account records in the case of discrepancies only. Offers one-time, electronic media and agency promotion rights. Does not permit photographer to negotiate when client requests all rights. Model/property release preferred. Captions required.

Making Contact: Send query letter with slides. Does not keep samples on file; include SASE for return of material. Expects minimum initial submission of 300 slides. Photo guidelines free with SASE. Reports in 5 weeks. Distributes tips sheets on request semiannually to photographers with statements.

Tips: "We need every theme which can be photographed." For best results, "send pictures continuously." Work must be of "high standard quality."

N 🖼 OMEGA NEWS GROUP/USA, P.O. Box 309, Lehighton PA 18235-0309. (610)377-6420. Managing Editor: Tony Rubel. Stock photo agency and news/feature syndicate. Clients include: newspapers and magazines, book/encyclopedia publishers, audiovisual producers, paper product companies (calendars, postcards, greeting cards).

Needs: Wants news, sports, features, personalities/celebrities, human interest, conflicts/wars, material from Eastern Europe, primarily from Ukraine.

Specs: Prefers transparencies, however, all formats accepted. For film/tape, send VHS for review.

Payment & Terms: Pays 60% commission on color and 50% on b&w. General price range: $75 and up, depending on usage. Offers first North American serial rights; other rights can be procured on negotiated fees. Model release, if available, should be submitted with photos. Captions required.

Making Contact: "Submit material for consideration, preferably transparencies we can keep on file, by mail." Submissions should be made on a trial and error basis. Include return postage for material submitted if you want it returned. Provide résumé, business card, brochure, flier or tearsheet to be kept on file for possible future assignments. Photo guidelines not available. Tip sheets sometimes distributed to photographers on file.

Tips: Looking for quality and content, color saturation, clarity and good description. Comprehensive story material welcomed. "We will look at anything if the quality is good."

■ OMNI-PHOTO COMMUNICATIONS, 10 E. 23rd St., New York NY 10010. (212)995-0805. Fax: (212)995-0895. E-mail: omni_photo@earthlink.net. Website: http://www.omniphoto.com. President: Roberta Guerette. Director of Photo Services: David Parret. Estab. 1979. Stock photo agency. Has 100,000 photos. Clients include: advertising agencies, public relations firms, audiovisual firms, businesses, book/encyclopedia publishers, magazine publishers, postcard publishers, calendar companies, greeting card companies.

Needs: Photos of babies, children, couples, multicultural, famlies, parents, senior citizens, teens, disasters, environmental, landscapes/scenics, wildlife, architecture, cities/urban, religious, rural, entertainment, food/drink, health/fitness, sports, travel, agriculture, buildings, computers, industry, medicine. Interested in alternative process, fine art.

Specs: Uses 8×10 b&w prints; 35mm, $2\frac{1}{4} \times 2\frac{1}{4}$, 4×5, 8×10 transparencies. Accepts images in digital format for Mac. Send via Zip.

Payment & Terms: Pays 50% commission on b&w and color photos. Works on contract basis only. Offers limited regional exclusive contracts. Contracts renew automatically with additional submissions for 4 years. Charges catalog insertion fee. Statements issued with payment on a quarterly basis. Offers one-time rights. Informs photographer and allows them to negotiate when client requests all rights. Model/property release required. Captions required.

Making Contact: Query with résumé of credits. Query with samples. SASE. Send 100-200 transparencies in vinyl sheets; b&w, 25-50 8×10 prints. Photo guidelines free with SASE.

Tips: "We want spontaneous-looking, yet professional quality photos of people interacting with each other. Have carefully thought out backgrounds, props and composition, commanding use of color. Stock photographers must produce high quality work at an abundant rate. Self-assignment is very important, as is a willingness to obtain model releases; caption thoroughly and make submissions regularly."

🌐 ORION PRESS, 1-13 Kanda-Jimbocho, Chiyoda-ku, Tokyo Japan 101. Phone: (03)3295-1400. Fax: (03)3295-0227. E-mail: info@orionpress.co.jp. Website: http://www.orionpress.co.jp. Contact: Ms. Hisako Kawasaki. Estab. 1952. Stock photo agency. Member of PACA. Has 700,000 photos. Has 3 branch offices in Osaka, Nagoya and Tokyo. Clients include: advertising agencies, public relations firms, businesses,

THE GEOGRAPHIC INDEX, located in the back of this book, lists markets by the state in which they are located.

book/encyclopedia publishers, magazine publishers, newspapers, postcard publishers, calendar companies, greeting card companies.

Needs: Wants photos of babies, children, celebrities, couples, multicultural, families, parents, senior citizens, teens, disasters, environmental, landscapes/scenics, wildlife, architecture, beauty, cities/urban, religious, education, gardening, interiors/decorating, pets, rural, adventure, automobiles, entertainment, events, food/drink, health/fitness, hobbies, performing arts, sports, humor, travel, agriculture, buildings, business concepts, computers, military, political, industry, medicine, portraits, product shots/still life, science, technology. Interested in digital, documentary, erotic, fashion/glamour, fine art, historical/vintage, regional, seasonal.

Specs: Uses 35mm, 2¼×2¼ transparencies. Accepts images in digital format for Mac, Windows. Send via CD, disk, Zip, e-mail as TIFF, JPEG.

Payment & Terms: Pays 60% commission on b&w and color photos. Average price per image (to clients): $120-800/b&w photo; $200-800/color photo. Enforces strict minimum prices. Offers volume discounts to customers; inquire about specific terms. Discount sales terms not negotiable. Works on contract basis only. Offers exclusive contract only. Contracts renew automatically with additional submissions for 2 years. Statements issued monthy. Payment made monthly. Photographers allowed to review account records. Offers one-time and electronic media rights. Model/property release required. Captions required.

Making Contact: Query with transparencies. SAE. Expects minimum initial submission of 100 images with periodic submission of at least 200 images. Reports in 1 month. Photo guidelines and catalog free with SAE.

🌐 ⬛ 🖼 **OXFORD SCIENTIFIC FILMS**, Lower Road, Long Hanborough, Oxfordshire OX8 8LL England. Phone/Fax: +44 (993)881881. E-mail: photolibrary@osf.uk.com Website: http://www.osf.uk.com. Picture Editor: Gilbert Woolley. Estab: 1968. Stock agency. Film unit and stills and film libraries. Has 300,000 photos; over 2 million feet of stock footage on 16mm, and 40,000 feet on 35mm. Clients include: advertising agencies, design companies, audiovisual firms, book/encyclopedia publishers, magazine and newspaper publishers, merchandising companies, multimedia publishers, film production companies.

Needs: Wants natural history: animals, plants, behavior, close-ups, life-histories, histology, embryology, electron microscopy, scenics, geology, weather, conservation, country practices, ecological techniques, pollution, special-effects, high speed, time-lapse, landscapes, environmental, travel, pets, domestic animals, wildlife, disasters, gardening, rural, agriculture, industry, medicine, science, technology, digital, regional, seasonal.

Specs: Uses 35mm and larger transparencies; 16 and 35mm film and videotapes. Accepts images in digital format for Windows. Send via CD or e-mail as TIFF files.

Payment & Terms: Pays 50% commission on b&w and color photos, film and videotape. Negotiates fees below stated minimums on bulk deals. Average price per image (to clients) $210 minimum for b&w and color photos. Offers volume discounts to regular customers; inquire about specific terms. Discount sale terms not negotiable. Works on contract basis only; prefers exclusivity, but negotiable by territory. Offers exclusive contract, limited regional exclusivity, nonexclusive contract, guaranteed subject exclusivity. Contracts renew automatically with additional submissions. "All contracts reviewed after three years initially, either party may then terminate contract, giving three months notice in writing." Charges $99/image or 10% for catalog insertion. There is a charge for taking on handling footage. Statements issued quarterly. Payment made quarterly. Photographers permitted to review sales figures. Offers one-time, electronic media and agency promotion rights. Informs photographer and allows them to negotiate when client requests all rights. Model/property release preferred. Photo captions required, include common name, Latin name, behavior, location and country, magnification where appropriate, if captive, if digitally manipulated.

Making Contact: Send query letter with résumé, tearsheets and stocklist. Does not keep samples on file; include SASE for return of material. Expects minimum initial submission of 100 images with quarterly submissions of at least 100 images. Interested in receiving high quality, creative, inspiring work from both amateur and professional photographers. Reports in 1 month. Photo guidelines sheet and catalog free with SAE. Market tips sheet available for free with SAE, distributed quarterly to anyone.

Tips: Prefers to see "good focus, composition, exposure, rare or unusual natural history subjects and behavioral and action shots, inspiring photography, strong images as well as creative shots. Download photographer's pack from website (stills only) or e-mail/write to request a pack, giving brief outline of areas covered and specialties and size. Send fully labeled slides in slide sheets."

⬛ **OZARK STOCK**, 1926 S. Glenstone #325, Springfield MO 65804. Phone/fax: (417)890-5600. E-mail: info@ozstock.com. Website: http://www.ozstock.com. Director: John S. Stewart. Estab. 1991. Stock photo agency. Has 45,000 photos. Clients include: advertising agencies, public relations firms, businesses, book/encyclopedia publishers, magazine publishers, newspapers, postcard publishers, calendar companies.

Needs: "Photos of people at work, at play, in the workplace, interacting with other people young and old

and interacting with pets; children, toddlers through teens, interacting with others younger and older and racially mixed; agriculture and farm and related subjects; health care and people doing 'healthy' things like exercise and eating and shopping for healthy foods. Also, need images of the Ozarks showing the scenic beauty of this fast growing area, travel destinations of the area and the people who live there."
Specs: Uses 35mm, color negative or transparencies, b&w film. Accepts images in digital format for Mac. Send via CD, floppy disk, Zip as PICT, JPEG.
Payment & Terms: Pays 50% commission on all usage fees. "Photographer retains all original negatives and chromes and is free to sell elsewhere. The photographer's name is attached to each image in our file. Each photographer is assigned an account number. The computer keeps track of the sales activity for that account number and checks are written monthly. Statements issued and photographers paid monthly.
Making Contact: "See our website and follow current instructions."
Tips: "Include caption information. The more information, like where photo was taken, the better. Sales are sometimes lost because not enough specific information is known and there just is not time to call up the photographer."

PACIFIC STOCK, 758 Kapahulu Ave., Suite 250, Honolulu HI 96816. (808)735-5665. Fax: (808)735-7801. E-mail: pics@pacificstock.com. Website: http://pacificstock.com. Owner/President: Barbara Brundage. Estab. 1987. Stock photo agency. Member of Picture Agency Council of America (PACA). Has 150,000 photos. Clients include advertising agencies, public relations firms, audiovisual firms, businesses, book/encyclopedia publishers, magazine publishers, postcard companies, calendar companies and greeting card companies. Previous/current clients: American Airlines, *Life* magazine (cover), Eveready Battery (TV commercial).
Needs: "Pacific Stock is the *only* stock photo agency worldwide specializing exclusively in Pacific- and Asia-related photography." Locations include North American West Coast, Hawaii, Pacific Islands, Australia, New Zealand, Far East, etc. Subjects include: people (babies, children, couples, multicultural, families, parents, senior citizens, teens), travel, culture, sports, marine science, industrial, environmental, landscapes, wildlife, adventure, food/drink, health/fitness, sports, travel, agriculture, buildings, business concepts."
Specs: Uses 35mm, 2¼×2¼, 4×5 and 8×10 (all formats) transparencies.
Payment & Terms: Pays 50% commission on color photos. Average price per image (to clients): $250-550 for color photos. Works on contract basis only. Offers limited regional exclusivity. Charges catalog insertion rate of 50%/image. Statements issued monthly. Payment made monthly. Photographers allowed to review account records to verify sales figures. Offers one-time or first rights; additional rights with photographer's permission. Informs photographer and allows them to negotiate when client requests all rights. Model and property release required for all people and certain properties, i.e., homes and boats. Photo captions are required; include: "who, what, where."
Making Contact: Query with résumé of credits and list of stock photo subjects. SASE. Reports in 2 weeks. Photo guidelines free with SASE. Tips sheet distributed quarterly to represented photographers; free with SASE to interested photographers.
Tips: Looks for "highly edited shots preferably captioned in archival slide pages. Photographer must be able to supply minimum of 1,000 slides (must be model released) for initial entry and must make quarterly submissions of fresh material from Pacific and Asia area destinations and from areas outside Hawaii." Major trends to be aware of include: "increased requests for 'assignment style' photography so it will be resellable as stock. The two general areas (subjects) requested are: tourism usage and economic development. Looks for focus, composition and color. As the Asia/Pacific region expands, more people are choosing to travel to various Asia/Pacific destinations while greater development occurs, i.e., tourism, construction, banking, trade, etc. Be interested in working with our agency to supply what is on our want lists."

PAINET, 20 8th St. S., New Rockford ND 58356. (701)947-5932. Fax: (701)947-5933. E-mail: photog s@painetworks.com. Website: http://www.painetworks.com. Owner: Mark Goebel. Estab. 1985. Picture library. Has 120,000 digital photos. Clients include: advertising agencies and magazine publishers.
Needs: "Anything and everything."
Specs: Accepts images in digital format for Mac (JPEG only). Send via CD, floppy disk, Jaz disk or send as an attachment to an e-mail. Resolution requirement is 6×9 inches at 72dpi.
Payment & Terms: Pays 50% commission. Works with or without signed contract. Offers nonexclusive contract. Payment made immediately after sale is made. Offers one-time rights. Informs photographers and allows them to negotiate when client requests all rights.
Making Contact: "To receive bi-weekly photo requests from our clients, send an e-mail message to addphotog@painetworks.com."
Tips: "Selected photographers can have their images placed on our Website in the gallery section. Painet markets color and b&w images electronically by internet or by contact with the photographer. Because

images and image descriptions are entered into a database from which searches are made, we encourage our photographers to include lengthy descriptions which improve their chances of finding their images during a database search. Photographers who provide us their e-mail address will receive a bi-weekly list of current photo requests from buyers. Photographers can then send matching images in JPEG format via e-mail and we forward them to the buyer. When the buyer selects an image, we contact the photographer to upload a larger file (usually in TIFF format) to our FTP site. Instructions are provided on how to do this. The buyer then downloads the image file from our FTP site. Credit card payment is made in advance by the buyer. Photographer is paid immediately after sale is made."

N PANORAMIC IMAGES, 70 E. Lake St., Suite 415, Chicago IL 60601. (312)236-8545. Fax: (312)704-4077. E-mail: cmccarty@panoramicimages.com. Website: http://www.panoramicimages.com. Contact: Colleen McCarty. Estab. 1986. Stock photo agency. Member of PACA, ASPP and IAPP. Clients include advertising agencies, magazine publishers, newspapers, design firms, graphic designers, corporate art consultants, postcard and calendar companies.

Needs: Works only with *panoramic formats* (2:1 aspect ratio or greater). Subject include: cityscapes/skylines, landscape/scenics, international travel, nature, sports, industry, architecture, tabletop, backgrounds, conceptual, agriculture, still life, regional, seasonal. "No 35mm."

Specs: Uses 2¼×5, 2¼×7 and 2¼×10 (6×12cm, 6×17cm and 6×24cm). "2¼ formats (chromes only) preferred; will accept 70mm pans, 5×7, 4×10 and 8×10 horizontals and verticals."

Payment & Terms: Pays 50% commission for photos. Average price: $750. Statements issued quarterly; payments made quarterly. Offers one-time, electronic rights and limited exclusive usage. Model release preferred "and/or property release, if necessary." Captions required. Call for submission guidelines before submitting.

Making Contact: Arrange a personal interview to show portfolio. Query with list of stock photo subjects. Reports in 1 month; also sends "response postcard to all photo submissions." Newsletter distributed 3-4 times yearly to photographers. Specific want lists created for contributing photographers. Photographer's work is represented in catalogs with worldwide distribution.

Tips: Wants to see "well-exposed chromes. Panoramic views of well-known locations nationwide and worldwide. Also, generic beauty panoramics. PSI has grown in gross sales, staff and number of contributing photographers. Releases a new catalog yearly."

PANOS PICTURES, 1 Chapel Court, Borough High St., London SE1 1HH United Kingdom. Phone: (44)171-234-0010. Fax: (44)171-357-0094. E-mail: pics@panos.co.uk. Website: http://www.panos.co.uk. Contact: Adrian Evans. Estab. 1986. Picture library. Member of B.A.P.L.A. Has 250,000 photos in files. Clients include: book publishers, magazine publishers, newspapers.

Needs: "Documentary photography from developing world and Eastern Europe (i.e. everywhere except North America and Western Europe)."

Specs: Uses 8×10 b&w prints; 35mm transparencies.

Payment/Terms: Pays 50% commission for b&w and color photos. Average price per image (to clients): $100 minimum for b&w and color. Enforces strict minimum prices. Offers volume discounts to customers. Works with photographers with or without a contract. Offers nonexclusive contract. Contracts renew automatically with additional submissions. Statements issued quarterly. Photographers allowed to review account records in cases of discrepancies only. Offers one-time rights. Informs photographers and allows them to negotiate when a client requests all rights. Model release preferred. Photo captions required.

Making Contact: Send query letter with stock photo list, tearsheets. Expects minimum initial submission of 500 images.

Tips: "I will begin to market images via computer networks this year." When submitting work, photographers should have "good captions and edit their work tightly."

PHOTO AGORA, Hidden Meadow Farm, Keezletown VA 22832. Phone/fax: (540)269-8283. E-mail: photoagora@aol.com. Contact: Robert Maust. Estab. 1972. Stock photo agency. Has 50,000 photos. Clients include: businesses, book/encyclopedia and textbook publishers, magazine publishers and calendar companies.

Needs: Wants photos of families, children, students, Virginia, Africa and other third world areas, work situations, etc. Also needs babies, couples, multicultural, parents, senior citizens, teens, disasters, environmental, landscapes/scenics, wildlife, beauty, cities/urban, education, gardening, religious, rural, health/fitness, travel, agriculture, medicine, science. Also interested in documentary, regional, seasonal.

Specs: Uses 8×10 matte and glossy b&w prints; 35mm, 2¼×2¼, 4×5 transparencies.

Payment & Terms: Pays 50% commission on b&w and color photos. Average price per image (to clients): $40 minimum/b&w photo; $100 minimum/color photo. Negotiates fees below standard minimum prices. Offers volume discounts to customers; inquire about specific terms. Photographers can choose not

© 1999 David Kreider/Photo Agora

"This playful role reversal captures a doctor's caring bedside manner with her young patient. The child is listening to the doctor's heartbeat," says photographer David Kreider. The image was sold by stock agency Photo Agora for use in a medical pamphlet called *Children Now*. "We carry many photos of children, especially candids and adult/child relationships," says agency owner Robert Maust. Kreider and Maust both live in Virginia and their working relationship began as a personal acquaintanceship.

to sell images on discount terms. Works with or without a signed contract. Offers nonexclusive contract. Statements issued quarterly. Payment made quarterly. Photographer allowed to review account records. Offers one-time rights. Informs photographer and allows them to negotiate when client requests all rights. Model/property release preferred. Captions required; include location, important dates, names etc.

Making Contact: Call, write or e-mail. No minimum number of images required in initial submission. Reports in 3 weeks. Photo guidelines free with SASE.

■ PHOTO ASSOCIATES NEWS SERVICE, P.O. Box 2163, Reston VA 20195. (703)721-9524. Voice Pager: (800)915-6353. Bureau Manager: Peter Heimsath. Estab. 1970. News/feature syndicate. Has 25,000 photos. Clients include: public relations firms, book publishers, magazine publishers, newspapers, newsletters.

Needs: Wants photos for features and immediate news for worldwide distribution, also celebrities doing unusual things.

Specs: Uses 8×10 glossy or matte b&w or color prints; 35mm transparencies, CD-ROM. Accepts images in digital format for Windows. Send via e-mail as JPEG files at 300 dpi.

Payment & Terms: Pays $150-1,000/color photo; $75-150/b&w photo. Pays 50% commission on b&w and color photos. Average price per image (to clients): $150-1,000/b&w photo; $300-1,500/color photo. Negotiates fees at standard minimum prices depending on subject matter and need; reflects monies to be charged. Offers discounts to customers; terms specified in photographer's contract. Photographers can choose not to sell images on discount terms. Works on contract basis only. Offers nonexclusive contract. Statements issued monthly. Payment made "as we are paid. Photographers may review records to verify sales, but don't make a habit of it. Must be a written request." Offers one-time rights. Informs photographer and allows them to negotiate when client requests all rights. Photo Associates News Service will negotiate with client requests of all rights. Model/property release required. Captions required; include name of subject, when taken, where taken, competition and process instructions.

Making Contact: "First, send us e-mail with an attachment. Then mail more samples after we respond. Expects minimum initial submission of 20 images with periodic submission of at least 50 images every two months. Reports in 1 month. Photo guidelines free with SASE. Market tips sheet distributed to those who make serious inquiries with SASE.

Tips: "Put yourself on the opposite side of the camera, to grasp what the composition has to say. Are you satisfied with your material before you submit it? More and more companies seem to take the short route to achieve their visual goals. They don't want to spend real money to obtain a new approach to a possible old idea. Too many times, photographs lose their creativity because the process isn't thought out correctly."

🌐 **PHOTO INDEX**, 2 Prowse St., West Perth 6005 Western Australia. Phone: (08)948-10375. Fax: (08)948-16547. E-mail: photodex@wantree.com.au. Manager: Lyn Woldendorp. Estab. 1979. Stock photo agency. Has 100,000 photos. Clients include: advertising agencies, public relations firms, audiovisual firms, businesses, book/encyclopedia publishers, magazine publishers, postcard publishers, calendar companies.
Needs: Wants generic stock photos, especially lifestyle, sport and business with people. Also needs babies, children, couples, multicultural, families, parents, senior citizens, teens, disasters, environmental, pets, food/drink, agriculture, buildings, business concepts, computers, industry, medicine, portraits, product shots/still life, science, technology.
Specs: Uses 35mm, 2¼×2¼, 4×5 transparencies.
Payment & Terms: Pays 50% commission for color photos. Five-year contract renewed automatically. Statements issued quarterly. Payment made quarterly. Photographers permitted to review account records to verify sales figures or account for various deductions "within reason." Offers one-time rights. Informs photographer and allows them to negotiate when client requests all rights. Model/property release required. Captions required.
Making Contact: Query with samples. Expects minimum initial submission of 500 images with periodic submissions. Reports in 3-4 weeks. Photo guidelines free with SAE. Catalog available. Market tips sheet distributed quarterly to contributing photographers.
Tips: "A photographer working in the stock industry should treat it professionally. Observe what sells of his work in each agency, as one agency's market can be very different to another's. Take agencies' photo needs lists seriously. Treat it as a business."

🌐 **THE PHOTO LIBRARY** (Photographic Library of Australia, Ltd.), Level 1, No. 7 West St., North Sydney 2060 N.S.W. Australia. Phone: (02)9929-8511. Fax: (02)9923-2319. E-mail: nick@photolibrary. com. Editor: Nick Green. Estab. 1967. Stock agency. Has over 500,000 photos. Clients include: advertising agencies, book/magazine publishers, government departments and corporate clients.
Needs: Wants good-quality, strong images. Subjects include babies, children, couples, multicultural, families, senior citizens, teens, landscapes, wildlife, food/drink, health/fitness, sports, travel, agriculture, business, computers, industry, medicine, science, technology.
Specs: Uses 2¼×2¼ and 4×5 transparencies.
Payment & Terms: Pays 50% commission for photos. Enforces strict minimum prices. Offers volume discounts to customers. Discount sales terms not negotiable. Works on contract basis only. Offers exclusive 5 year contract and regional exclusivity in Australia and New Zealand. After 5 years contract continues until photographer wants to withdraw images. Statements issued quarterly. Payment made quarterly. Photographers allowed to verify sales figures in cases of discrepancies only. Offers one-time and electronic media rights. Informs photographers when clients request all rights; handles all negotiations. Requires model release (held by photographer), property release and photo captions.
Making Contact: Send query letter with stock list. Does not keep samples on file; include SAE for return of material. Expects minimum initial submission of 200 images with biannual submissions of at least 100 images. Reports in 1 month if interested; send nonreturnable samples.
Tips: Notes "35mm does not sell as well as the medium and large formats but will accept 35mm if other formats are included. Remember Australian clients' photo needs are different than North America's. Images that have strong global sales potential are the most sought."

🅽 🖳 **PHOTO NETWORK**, Dept. PM, 1415 Warner Ave., Suite B, Tustin CA 92780. (714)259-1244. Fax: (714)259-0645. E-mail: photonetwork@worldnet.att.net. Owner: Cathy Aron. Stock photo agency. Member of Picture Agency Council of America (PACA). Has 1 million photos. Clients include: ad agencies, AV producers, textbook companies, graphic artists, public relations firms, newspapers, corporations, magazines, calendar companies and greeting card companies.
Needs: Needs shots of personal sports and recreation, industrial/commercial, high-tech, families, couples, ethnics (all ages), animals, travel and lifestyles. Special subject needs include people over 55 enjoying life,

THE INTERNATIONAL MARKETS INDEX, located in the back of this book, lists markets located outside the U.S. by country.

medical shots (patients and professionals), children and domestic animals.

Specs: Uses 35mm, 2¼×2¼, 4×5 transparencies. Accepts images in digital format for Mac.

Payment & Terms: Pays 50% commission. Works on contract basis only. Offers limited regional exclusivity. Contracts automatically renew with each submission for 3 years. Statements issued monthly. Payment made monthly. Photographers allowed to review account records to verify sales figures. Offers one-time rights. Informs photographer and allows them to negotiate when client requests all rights. Model/property release preferred. Captions preferred; "include places—parks, cities, buildings, etc. No need to describe the obvious, i.e., mother with child."

Making Contact: Query with list of stock photo subjects. Send a sample of 200 images for review. SASE. Reports in 1 month.

Tips: Wants to see a portfolio "neat and well-organized and including a sampling of photographer's favorite photos." Looks for "clear, sharp focus, strong colors and good composition. We'd rather have many very good photos rather than one great piece of art. Would like to see photographers with a specialty or specialties and have it covered thoroughly. You need to supply new photos on a regular basis and be responsive to current trends in photo needs. Contract photographers are supplied with quarterly 'want' lists and information about current trends."

N PHOTO PHOENIX INTERNATIONAL, 33-29 58 St., Woodside NY 11377. (718)651-8145. Fax: (718)651-8145. E-mail: clockout29@worldnet.att.net. Senior Editor: John Lawrence. Estab. 1997. Picture library. Has offices in Florida and New York. Photographers should contact main office in Woodside, New York.

Needs: Wants photos of babies, multicultural, families, parents, senior citizens, environmental, landscapes/scenics, wildlife, beauty, interiors/decorating, pets, religious, rural, adventure, health/fitness, hobbies, performing arts, sports, travel, portraits. Interested in avant garde, documentary, erotic, fashion/glamour, fine art.

Specs: Uses 4×5, 8×10, glossy, color and/or b&w prints; 35mm, 2¼×2¼, 4×5, 8×10 transparencies.

Payment & Terms: Pays 75% commission for b&w and color photos. Photographers can choose not to sell images on discount terms. Works with photographers on contract basis only. Offers exclusive contract only. Free sample review and $50 portfolio review. Statements issued annually. Payment made monthly. Photographers allowed to review account records. Rights negotiable. Model/property release preferred. Photo captions preferred.

Making Contact: Send query letter with résumé, slides, prints, photocopies, tearsheets, transparencies. Expects minimum initial submission of 10 images. Reports in 1 month on samples; 1 month on portfolios. Photo guidelines sheet free with SASE.

Tips: "Organize your work in efficient manner which clearly reflects your style and the kind of projects you really want to handle. Be a professional. Be thorough. Present your work so that it expresses your love for photography."

PHOTO RESEARCHERS, INC., 60 E. 56th St., New York NY 10022. (212)758-3420. Fax: (212)355-0731. E-mail: info@photoresearchers.com. Website: http://www.photoresearchers.com. Stock photography agency representing over 1 million images specializing in science, wildlife, medicine, people and travel. Member of Picture Agency Council of American (PACA). Clients include: advertising agencies, graphic designers, publishers of textbooks, encyclopedias, trade books, magazines, newspapers, calendars, greeting cards and foreign markets.

Needs: All aspects of science, astronomy, medicine, people (especially contemporary shots of teens, couples and seniors). Particularly needs model-released people, European wildlife, up-to-date travel and scientific subjects.

Specs: Any size transparencies.

Payment & Terms: Rarely buys outright; works on 50% stock sales and 30% assignments. General price range (to clients): $150-7,500. Works on contract basis only. Offers limited regional exclusivity. Contracts renew automatically with additional submissions for 5 years initial term/1 year thereafter. Charges 50% foreign duping fee for subagents; 50% catalog insertion fee; placement cost when image sells (if no sales or sales less than 50% placement amount, 0-49%). Photographers allowed to review account records upon reasonable notice during normal business hours. Statements issued monthly, bimonthly or quarterly, depending on volume. Offers one-time, electronic media and one-year exclusive rights. Informs photographer and allows them to negotiate when a client requests to buy all rights, but does not allow direct negotiation with customer. Model/property release required for advertising; preferred for editorial. Captions required; include who, what, where, when. Indicate model release on photo.

Making Contact: Query with description of work, type of equipment used and subject matter available. Send to Bug Sutton, Creative Director. Submit portfolio for review when requested. SASE. Reports in 1 month maximum.

Tips: "When a photographer is accepted, we analyze his portfolio and have consultations to give the photographer direction and leads for making sales of reproduction rights. We seek the photographer who is highly imaginative or into a specialty and who is dedicated to technical accuracy. We are looking for serious photographers who have many hundreds of photographs to offer for a first submission and who are able to contribute often."

PHOTO RESOURCE HAWAII, 116 Hekili St., #204, Kailua HI 96734. (808)599-7773. Fax: (808)599-7754. E-mail: photohi@lava.net. Website: http://www.photoresourcehawaii.com. Owner: Tami Dawson. Estab. 1983. Stock photo agency. Has 150,000 photos. Clients include: ad agencies, audiovisual firms, businesses, book/encyclopedia publishers, magazine publishers, calendar companies, greeting card companies and postcard publishers.
Needs: Photos of Hawaii and the South Pacific.
Specs: Uses 35mm, 2¼×2¼, 4×5 transparencies.
Payment & Terms: Pays 50% commission. Enforces minimum prices. Offers volume discounts to customers. Discount sales terms not negotiable. Works on contract basis only. Offers exclusive contract. Contracts renew automatically with additional submissions. Statements issued bimonthly. Payment made bimonthly. Photographers allowed to review account records. Offers one-time and other negotiated rights. Model/property release preferred. Captions required.
Making Contact: Query with samples. SASE. Expects minimum initial submission of 100 images with periodic submissions at least 5 times a year. Reports in 3 weeks.

■ **PHOTO 20-20**, 435 Brannan St., Suite 203, San Francisco CA 94107. (415)543-8983. Fax: (415)543-2199. Principal Editor: Ted Streshinsky. Estab. 1990. Stock photo agency. Has 500,000 photos. Clients include: advertising agencies, public relations firms, book/encyclopedia publishers, magazine publishers, newspapers, calendar companies, greeting card companies, design firms.
● This agency also markets images via the Picture Network International.
Needs: Wants photos of model released people, international travel destinations. Also needs celebrities, couples, multicultural, parents, teens, disasters, environmental, wildlife, beauty, cities/urban, education, adventure, entertainment, food/drink, health/fitness, performing arts, sports, agriculture, business concepts, computers, industry, medicine, military, political, science, technology. Interested in avant garde, digital, documentary, fine art, historical/vintage, regional, seasonal.
Specs: Uses 35mm, 2¼×2¼, 4×5, 6×7, 8×10 transparencies. Accepts digital images for Mac.
Payment & Terms: Pays 50% commission on sales. Enforces minimum prices. Works on contract basis only. Offers nonexclusive contract. Contract renews automatically. "As payment for their work arrives checks are sent with statements." Leases one-time rights. Requests photographer's permission to negotiate when client requests buy out. Model/property release preferred. Detailed captions essential.
Making Contact: Query with stock photo list and non-returnable printed samples. Expects minimum initial submission of 300 images with periodic submission of at least 300 images every 3 months. Market tips sheet distributed every 2 months to contracted photographers.
Tips: "Our agency's philosophy is to try to avoid competition between photographers within the agency. Because of this we look for photographers who are specialists in certain subjects and have unique styles and approaches to their work. Photographers must be technically proficient, productive, and show interest and involvement in their work."

N ⊕ ■ PHOTOBANK YOKOHAMA, 7F RK Cube 6-85 Otamachi, Naka-ku Yokohama-shi, Kanagawa Japan 231-0011. Phone: (+81)45 212 3855. Fax: (+81)45 212 3839. E-mail: pbyjp@aol.com. Contact: Chie Tamura. Estab. 1981. Stock agency. Member of the Picture Agency Council of America (PACA). Has 400,000 photos in files. Clients include: advertising agencies, public relations firms, businesses, book publishers, magazine publishers, calendar companies, greeting card companies, postcard publishers, department store.
Needs: Wants photos of babies, celebrities, children, couples, families, teens, disasters, environmental, landscapes/scenics, wildlife, beauty, cities/urban, gardening, interiors/decorating, pets, adventure, entertainment, health/fitness, hobbies, humor, performing arts, sports, buildings, business concepts, computers, industry, medicine, political, portraits, product shots/still life, science, technology. Interested in avant garde, digital, fashion/glamour, fine art, seasonal.
Specs: Uses 35mm, 2¼×2¼, 4×5 transparencies. Accepts images in digital format for Mac. Send via CD, Zip, e-mail, MO as TIFF, PICT, JPEG files at 200-400 dpi.
Payment & Terms: Pays 60% commission for color photos. Enforces minimum prices. Works with photographers on contract basis only. Offers nonexclusive contract. Contracts renew automatically with additional submissions for 1 year. Statements issued monthly. Payment made monthly. Photographers

This futuristic cityscape is indicative of the kind of work PhotoBank Yokohama typically distributes. The Japanese stock agency describes this image as "innovative and attractive" and included it in their print catalog. Chie Tamura finds photographers for the agency by reviewing portfolios and transparencies.

allowed to review account records. Offers one-time rights. Model release required; property release preferred. Photo captions required.

Making Contact: Contact Chie Tamura through fax and e-mail only. Send transparencies. Portfolio may be dropped off Monday-Wednesday. Does not keep samples on file; include SAE for return of material. Expects minimum initial submission of 50 images. Catalog for $20 (includes cost and freight).

Tips: "First, please contact us by fax, airmail or e-mail, then send transparencies."

PHOTODAILY, Pine Lake Farm, Osceola WI 54020. (715)248-3800 ext. 24. Fax: (715)-248-7394. E-mail: eds@photosource.com. Website: http://www.photosource.com. Editor: Deb Koehler. Estab. 1976. Sales lead marketer. Members have 1,500,000 photos in files. Has one branch office. Clients include: advertising agencies, public relations firms, book publishers, magazine publishers, greeting card companies.

Needs: Wants editorial stock photography.

Specs: Uses 35mm transparencies. Accepts images in digital format.

Payment/Terms: Photographer receives 100% of sale. Average price per image (to client) $125 minimum for b&w and color photos. Terms specified in photographer's contracts. Works with photographers with or without a contract. Offers nonexclusive contract. Charges no fees. Offers one-time rights. Informs photographer and allows them to negotiate when client requests all rights. Model/property release preferred. Not needed for editorial use.

Making Contact: Send query letter with stock photo list, tearsheets. Provide résumé, business card, self-promotion piece or tearsheets to be kept on file. Cannot return material. Reports back only if interested. Photo guidelines sheet free with SASE. Market tips sheet available daily to subscribers for $48 monthly (fax) $27.50 e-mail or channel.

Tips: "We transmit via fax and e-mail, plus use Internet Explorer Channel (push) technology."

PHOTOEDIT, 110 W. Ocean Blvd., Suite 403, Long Beach CA 90802-4623. (562)435-2722. Fax: (562)435-7161. E-mail: photoedit@earthlink.net. President: Leslye Borden. Estab. 1987. Stock photo

agency. Member of Picture Agency Council of America (PACA). Has 500,000 photos. Clients include: advertising agencies, public relations firms, businesses, book/encyclopedia publishers, magazine publishers.

Needs: People—seniors, teens, children, families, minorities, handicapped.

Specs: Uses 35mm transparencies.

Payment & Terms: Pays 50% commission on color photos. Average price per image (to clients): $200/quarter page textbook only, other sales higher. Works on contract basis only. Offers nonexclusive contract. Charges catalog insertion fee of $400/image. Statements issued quarterly; monthly if earnings over $1,000/month. Payment made monthly or quarterly at time of statement. Photographers are allowed to review account records. Offers one-time rights; limited time use. Consults photographer when client requests all rights. Model release preferred.

Making Contact: Submit portfolio for review. Query with samples. Samples not kept on file. SASE. Expects minimum initial submission of 1,000 images with additional submission of 1,000 per year. Reports in 1 month. Photo guidelines free with SASE.

Tips: In samples looks for "drama, color, social relevance, inter-relationships, current (*not* dated material), tight editing. We want photographers who have easy access to models (not professional) and will shoot actively and on spec."

N ⊕ ▣ **PHOTOLIFE CORPORATION LTD.**, 1203A, Capitol Centre, 5-19 Jardine's Bazaar, Causeway Bay Hong Kong. (852)2808 0012. Fax: (852)2808 0072. E-mail: photo@photolife.com.hk. Website: http://www.photolife.com.hk. Photographer Liasion: Sarin Li. Estab. 1994. Stock agency. Has over 250,000 photos in files. Clients include: advertising agencies, businesses, newspapers, postcard publishers, public relations firms, book publishers, calendar companies, audiovisual firms, magazine publishers, greeting card companies.

Needs: Wants high quality and inspired great stock, imagery on all general subjects for Asian distribution.

Specs: Uses 35mm, medium format transparencies. Accepts images in digital format for Windows. Send via CD, floppy disk, e-mail as JPEG files.

Payment & Terms: Pays 50% commission for b&w and color photos. Average price per image (to clients): $105-1,550 for b&w photos; $105-10,000 for color photos. Offers volume discounts to customers; terms specified in photographers' contracts. Photographers can choose not to sell images on discount terms. Works with photographers on contract basis only. Offers limited regional exclusivity. Contracts renew automatically with additional submissions for 2 years. Charges 100% duping fee. Statements issued monthly. Photographers allowed to review account records in cases of discrepancies only. Offers one-time, electronic media and agency promotion rights. Informs photographers and allows them to negotiate when client requests all rights. Model release required; property release preferred. Photo captions required; include destination and country.

Making Contact: Send sample of transparencies and stocklist. SAE. Expects minimum initial submission of 50 images.

Tips: "We are interested in receiving work from newer, lesser-known photographers. We want to see all images; works that can keep up with current trends in advertising and print photography, especially Asian oriented subject matter. Since the stock photography industry has become increasingly more competitive, the image buyer is always willing to pay for a good understanding of subject and images that are unique and costly to shoot. Edit your work tightly. Topic areas include leisure activities, resorts, home and office interiors/exteriors, architecture, travel, wildlife and all Asian oriented subjects in general."

▣ **PHOTOPHILE**, 2400 Kettner Blvd., Studio 250, San Diego CA 92101. (619)595-7989. Fax: (619)595-0016. E-mail: stkphoto@photo-phile.com. Website: http://www.photo-phile.com/stkphoto. Owner: Nancy Likins-Masten. Clients include: advertising agencies, public relations firms, audiovisual firms, businesses, publishers, postcard and calendar producers, and greeting card companies.

Needs: Wants photos of lifestyle, vocations, sports, industry, entertainment, business, computer graphics, medical and travel.

Specs: Uses 35mm, 2¼×2¼, 4×5 and 6×7 original transparencies. Accepts images in digital format for Mac. Send via compact disc or Zip disk.

Payment & Terms: Pays 50% commission. Payment negotiable. Works on contract basis only. Offers limited regional exclusivity. Contracts renew automatically for 5 years. Statements issued quarterly. Payment made quarterly. Photographers are allowed to review account records. Offers one-time and electronic media rights; negotiable. Informs photographer and allows them to negotiate when client requests all rights. Model/property release required. Captions required; include location or description of obscure subjects; travel photos should be captioned with complete destination information.

Making Contact: Write with SASE for photographer's information. "Professionals only, please." Expects

a minimum submission of 500 saleable images and a photographer must be continuously shooting to add new images to files.

Tips: "Specialize, and shoot for the broadest possible sales potential. Get releases!" The greatest need is for model-released people subjects; sharp-focus and good composition are important. If photographer's work is saleable, "it will sell itself."

🔲 🖼 **PHOTRI INC. - MICROSTOCK,** 3701 S. George Mason Dr., Suite C2 North, Falls Church VA 22041. (703)931-8600. Fax: (703)998-8407. E-mail: photri@mail.erols.com. Website: http://www.micr ostock.com. Director: William Howe. Estab: 1980. Stock agency. Member of Picture Agency Council of America (PACA). Has 2 million b&w photos and color transparencies of all subjects. Clients include: book and encyclopedia publishers, advertising agencies, record companies, calendar companies, and "various media for AV presentations."

Needs: Military, computer graphics, space, science, technology, energy, romantic couples, people doing things, humor, picture stories, major sports events, babies, celebrities, children, families, parents, senior citizens, teens, architecture, cities/urban, education, pets, religious, rural, adventure, automobiles, entertainment, events, food/drink, travel, agriculture, buildings, business concepts, industry, medicine, portraits. Interested in alternative process, digital, documentary, fashion/glamour, fine art, historical/vintage, seasonal. Special needs include calendar and poster subjects. Needs ethnic mix in photos. Has sub-agents in 10 foreign countries interested in photos of USA in general.

Specs: Uses glossy color, b&w prints; 35mm, $2\frac{1}{4} \times 2\frac{1}{4}$, 4×5, 8×10 transparencies. Accepts images in digital format for Windows. Send via CD, e-mail, floppy or Zip disk as TIFF, JPEG.

Payment & Terms: Seldom buys outright; pays 50% commission for b&w/color photos; film; videotape. Average price per image (to clients): $50 minimum for b&w photos; $125 minimum for color photos; $500 minimum for film and videotape. Negotiates fees below standard minimums. Offers volume discounts to customers; terms specified in photographer's contract. Photographers can choose not to sell images on discount terms. Works with or without contract. Offers nonexclusive contract. Contracts renew automatically with additional submissions. Charges 15% catalog insertion fee. Statements issued quarterly. Payment made quarterly. Photographers allowed to review records in case of discrepancies only. Offers one-time, electronic media rights. Informs photographers and allows them to negotiate when client requests all rights. Model/property release preferred. Captions required.

Making Contact: Call to arrange an appointment or query with tearsheets, transparencies and stock list. SASE. Expects initial submission of 100 images. Reports in 1 month. Photo guidelines free with SASE. Catalog available for $5. Market tips sheet available.

Tips: "Respond to current needs with good quality photos. Send examples with SASE and 20 slides/dupes."

🌐 🖼 **PICTOR INTERNATIONAL, LTD.,** Lymehouse Studios, 30-31 Lyme St., London NW1 0EE England. Phone: (171)482-0478. Fax: (171)267-5759. E-mail: editing@london.pictor.co.uk. Creative Director: Adrian Peacock. Stock photo agency with 9 offices including London, Paris, Munich, Hamburg, Madrid, Vienna, New York, and Washington DC and 17 affiliated agencies worldwide. Clients include: advertising and design agencies, book publishers, magazine publishers, calendar companies, travel industry and new media/Internet.

Needs: "Creative images to supply our diverse client base which includes the advertising, design, publishing and travel industries."

Specs: Uses color/b&w transparencies. Accepts images in digital format. Send via CD or e-mail thumbnails.

Payment & Terms: Pays 50% commission.

Making Contact: Write to John Henry Rice, picture editor, Uniphoto, 3307 M St. NW, Suite 300, Washington DC 20007.

Tips: "We are keen to see material that reflects 'real' people/lifestyle situations, model released, fresh, innovative 'travel experience' pics and future concepts."

🖼 **THE PICTURE CUBE INC.,** Division of Index Stock Imagery, Dept. PM, 110 Broad St., Boston MA 02110. (617)443-1113. Fax: (617)443-1114. E-mail: sherib@indexstock.com. Website: http://www.ind exstock.com. Managing Director: Sheri Blaney. Member of Picture Agency Council of America (PACA). Has 600,000 photos. Clients include: advertising agencies, public relations firms, businesses, audiovisual firms, textbook publishers, magazine publishers, encyclopedia publishers, newspapers, postcard companies, calendar companies, greeting card companies and TV. Guidelines available with SASE.

Needs: Wants US and foreign coverage, contemporary images, agriculture, industry, energy, high technology, religion, family life, multicultural, animals, transportation, work, leisure, travel, ethnicity, communications, people of all ages, psychology and sociology subjects. "We need lifestyle, model-released images

of families, couples, technology and work situations. We emphasize New England/Boston subjects for our ad/design and corporate clients. We also have a growing vintage collection."
Specs: Uses 35mm, 2¼ × 2¼, 4 × 5 and larger slides. "Our clients use both color and b&w photography."
Payment & Terms: Pays 50% commission. Average price per image (to clients): $150-400/b&w; $195-500/color photo. "We negotiate special rates for nonprofit organizations." Offers volume discounts to customers; inquire about specific terms. Discount sales terms not negotiable. Works on contract basis only. Offers limited exclusivity contract. Contracts renew automatically for 5 years. Charges 50% catalog insertion fee. Payment made quarterly with statement. Photographers allowed to review account records to verify sales figures. Offers one-time rights. Model/property release preferred. Captions required; include event, location, description, if model-released.
Making Contact: Request guidelines before sending any materials. Arrange a personal interview to show portfolio. SASE. Reports in 1 month.
Tips: Serious freelance photographers "must supply a good amount (at least 1,000 images per year, sales-oriented subject matter) of material, in order to produce steady sales. All photography submitted must be high quality, with needle-sharp focus, strong composition, correctly exposed. All of our advertising clients require model releases on all photos of people and often on property (real estate)."

PICTURE LIBRARY ASSOCIATES, 4800 Hernandez Dr., Guadalupe CA 93434. (805)343-1844. Fax: (805)343-6766. E-mail: pla@pictlib.com. Website: http://www.pictlib.com. Director of Marketing: Robert A. Nelson. Director of Administration: Bess Nelson. Estab. 1991. Stock photo agency. Clients include: ad agencies, public relations firms, audiovisual firms, businesses, book/encyclopedia publishers, magazine publishers, newspapers, postcard publishers, calendar companies, greeting card companies, electronic publishing companies.
Needs: All subjects. "People doing their thing in everyday activities." All ages and races. Must be carefully pre-edited for good technical quality.
Specs: Uses 35mm transparencies (slides); videotape (contact agency for specifics).
Payment & Terms: Photographer specifies minimum amount to charge. Pays 60% commission. Original slides only are accepted. Photographer retains all slides after selected ones are digitized. Photographer pays shipping costs. This agency uses ASMP contract. Works on nonexclusive contract basis. Payment made within a few days of agency's receipt of payment. Model/property release required for recognizable persons and recognizable property.
Making Contact: Full information to clients and photographers is available online. FAQs answer most questions. Contact PLA if you have questions that are not answered. (All photographers doing business with PLA must have a computer or access to one. They must have an e-mail address or fax, preferably both.) No minimum submissions are required. Established photographers asked to consider PLA as an additional outlet for their images. Only low resolution digitized images are retained by PLA.
Tips: "Primarily look at technical quality for reproduction. Try to submit horizontal and verticals of each subject submitted. Increased need for ethnic people and subject matter. Need people doing things. Need senior citizen activity. Need health-related subject matter with people involved. Shoot for a theme when possible. Submit new stock regularly. Repeat: Don't submit recognizable people without model releases."

PICTURESQUE STOCK PHOTOS, 1520 Brookside Dr., 3, Raleigh NC 27604. (919)828-0023. Fax: (919)828-8635. E-mail: picturesque@picturesque.com. Website: http://www.picturesque.com. Manager: Syd Jeffrey. Estab. 1987. Stock photo agency. Has over 250,000 photos. Clients include: advertising agencies, design firms, corporations, book/encyclopedia publishers and magazine publishers.
Needs: Model-released people, lifestyle, business, industry, healthcare, concept, travel/scenic.
Specs: Uses 35mm, 2¼ × 2¼, 4 × 5 transparencies. Accepts images in digital format for Mac (TIFF). Send via compact disc or Zip disk.
Payment & Terms: Pays 50% commission. Works on contract basis only. Offers nonexclusive contract. Contracts renew automatically. Statements issued monthly. Payment made monthly. Photographers allowed to review account records. Offers one-time and various rights depending on client needs. Contacts photographer for authorization of sale when client requests all rights. Model/property release required. Captions required.
Making Contact: Contact by telephone or Website for submission guidelines. SASE.

PIX INTERNATIONAL, 88 W. Schiller St., 803, Chicago IL 60610-2032. (312)951-5891. E-mail: pixintl@aol.com. Website: http://www.pixintl.com. President: Linda Matlow. Estab. 1976. Stock agency, and news/feature syndicate. Has 200,000 photos in files. Clients include: advertising agencies, public relations firms, businesses, book publishers, magazine publishers, newspapers.
Needs: Wants photos of celebrities, entertainment, performing arts.
Specs: Uses 35mm transparencies. Accepts images in digital format for Mac. "Do not send any unsolicited

digital files. Make contact first to see if we're interested."

Payment & Terms: Pays 50% commission for sales. Average price per image (to clients): $35-500 for b&w photos; $75-3,000 for color photos. Enforces minimum prices. Offers volume discounts to customers; terms specified in photographers' contracts. Discount sales terms not negotiable. Works with photographers with or without contract; negotiable. Statements issued monthly. Payment made monthly. Photographers allowed to review account records in cases of discrepancies only. Offers one-time rights. Informs photographers and allows them to negotiate when client requests all rights. Model release not required for general editorial. Photo captions required; include who, what, when, where, why.

Making Contact: Send query letter with photocopies, tearsheets, stock list. Does not keep samples on file; include SASE for return of material. Reports in 2 weeks on samples. Reports back only if interested; send non-returnable samples. Photo guidelines sheet free with SASE.

Tips: "We are looking for razor sharp images that stand up on their own without needing a long caption."

PLANET EARTH PICTURES, The Innovation Centre, 225 Marsh Wall, London E14 9FX England. Phone: (171)293-2999. Fax: (171)293-2998. E-mail: planetearth@visualgroup.com. Website: http://www.planet-earth-pictures.com. Library Manager: Jennifer Jeffrey. Estab. 1970. Picture library. Has 500,000 photos. Clients include: advertising agencies, public relations and audiovisual firms, businesses, book/encyclopedia and magazine publishers, and postcard and calendar companies.

Needs: Natural history and natural environment pictures. Subjects include landscapes, wildlife, travel, science, seasonal.

Specs: Uses any size color transparencies. Accepts images in digital format for Mac, Windows. Send via CD as JPEG files.

Payment & Terms: Pays 50% commission on color photos. Average price per image (to clients): £80 to over £2,500 for advertising use. Prices negotiable according to use. Works on contract basis only. Offers exclusive and nonexclusive contracts. Statements issued quarterly. Payment made quarterly. Photographers allowed to review account records. Offers one-time and electronic media rights. Model release preferred. Captions required.

Making Contact: Send query letter with samples. SAE. Reports in 1 week on queries; 1 month on samples. Photo guidelines sheet available free.

Tips: "Fax or e-mail us with details. We like photographers to receive our photographer's booklet and current color brochure that gives details about photos and captions and additional information about the library. We would then like to see an initial submission of about 150-200 original transparenies to decide if they are suitable for inclusion. In reviewing a portfolio, we look for a range of photographs on any subject—important for the magazine market—and the quality. Trends change rapidly. There is a strong emphasis that photos taken in the wild are preferable to studio pictures. Advertising clients still like larger format photographs. Exciting and artistic photographs used even for wildlife photography and environmental protection."

N ⊕ PORPOISE PHOTOSTOCK, 45 Madhurima, M.G. Rd., Kandivli (W) Mumbai 400067 India. Phone: (00-91)22-8088267. Fax: 91-22-8063573. E-mail: porpoisephotos@hotmail.com. Website: http://www.porpoisephotos.com. Proprietor: Mr. Sunjoy Monga. Estab. 1991. Stock agency. Has 80,000 photos in files. Clients include: advertising agencies, businesses, newspapers, postcard publishers, public relations firms, book publishers, calendar companies, magazine publishers, greeting card companies..

Needs: Wants photos of babies, couples, families, disasters, environmental, landscapes/scenics, wildlife, architecture, interiors/decorating, adventure, automobiles, sports, travel, agriculture, industry, medicine, science, technology. Interested in fashion/glamour, seasonal.

Specs: Uses 35mm, 2¼×2¼, 4×5 transparencies.

Payment & Terms: Pays 50% commission for color photos. Average price per image (to clients): $25-200 for b&w photos; $40-350 for color photos. Negotiates fees below stated minimums. Offers volume discounts to customers. Works with photographers with or without a contract; negotiable. Offers limited regional exclusivity. Statements issued semiannually. Payment made quarterly, semiannually. Photographers allowed to review account records. Offers one-time rights. Informs photographers and allows them to negotiate when client requests all rights. Model release required; property release preferred. Photo captions preferred; include place and time of year.

Making Contact: Send query letter. Keeps samples on file. Expects minimum initial submission of 100 images. Reports back only if interested; send non-returnable samples.

Tips: "Have patience. Look for images beyond the usual in terms of lighting, angle, behavior."

POSITIVE IMAGES, 89 Main St., Andover MA 01810. (978)749-9901. Fax: (978)749-2747. E-mail: positiveimag@mdc.net. Manager: Pat Bruno. Stock photo agency. Member ASPP. Clients include advertis-

ing agencies, public relations firms, book/encyclopedia publishers, magazine publishers, greeting card companies, sales/promotion firms, design firms.

● This agency has images on *The Stock Workbook* CD-ROM.

Needs: Garden/horticulture, fruits and vegetables, insects, plant damage, health, nutrition, nature, human nature, babies, children, couples, multicultural, families, parents, senior citizens, teens, environmental, landscapes/scenics, wildlife, architecture, beauty, cities/urban, education, pets, rural, adventure, events, food/drink, health/fitness, travel, agriculture, buildings, business concepts—all suitable for advertising and editorial publication.

Payment & Terms: Pays 50% commission. Average price per image (to clients): $250 for b&w and color. Charges $350 for catalog insertion; CD-Rom insertion is $35 per image. Works on contract basis only. Offers limited regional exclusivity and guaranteed subject exclusivity (within files). Charges fee for CD insertion and national advertising. Statements issued annually. Payment issued monthly. Photographers allowed to review account records. Offers one-time and electronic media rights. "We never sell all rights."

Making Contact: Query letter. Call to schedule an appointment. Reports in 2 weeks.

Tips: "We take on only one or two new photographers per year. We respond to everyone who contacts us and have a yearly portfolio review. Positive Images accepts only fulltime working professionals who can contribute regular submissions. Our wildlife and scenic nature files are overstocked, but we are always interested in garden photography."

POWERSTOCK/ZEFA, Unit 910, 59 Chilton St., London E2 6EA United Kingdom. Phone: (0171)729-7473. Fax: (0171)729-7476. E-mail: zefa@powerstock.com. Website: http://www.powerstock.com. Creative Director: Ian Allenden. Estab. 1988. Stock photo agency. Member of BAPLA. Has 250,000 photos in files. Clients include: advertising agencies, businesses, newspapers, postcard publishers, public relations firms, book publishers, calendar companies, audiovisual firms, magazine publishers, greeting card companies.

Payment/Terms: Pays 50% commission on b&w and color photos. Average price per image (to clients): £96-175 for b&w. Enforces strict minimum prices. Offers volume discounts to customers. Discount sales terms not negotiable. Works with photographers on contract basis only. Offers guaranteed subject exclusivity (within files). Contracts renew automatically with additional submissions for 5 years. Statements issued monthly and quarterly. Payments made monthly and quarterly. Photographers allowed to review account records in cases of discrepancies only. Offers one-time and electronic media rights. Inform photographers and allows them to negotiate when a client requests all rights. Model release required; property release preferred. Photo captions required.

Making Contact: Send query letter with samples. Portfolio should include b&w, color prints, slides. Expects minimum initial submission of 200 images with bimonthly submissions of at least 200 images. Reports in 1 week on queries; 1 month on samples. Photo guidelines sheet free with SAE. Market tips sheet available every 6 months for contracted suppliers upon request.

Tips: "We consider online databases too large and download times too slow for the majority of clients to use constructively. We would rather use our expertise in understanding our clients picture needs to research suitable images and use the speed of new technologies such as e-mail to deliver material to them. When submitting work be original, include work which, through your own research, will be right for stock and right for our needs as an agency rather than things that they personally like."

RAINBOW, Dept. PM, P.O. Box 573, Housatonic MA 01236. (413)274-6211. Fax: (413)274-6689. E-mail: rainbow@bcn.net. Website: http://www.rainbowimages.com. Director: Coco McCoy. Library Manager: Kate Cook. Estab. 1976. Stock photo agency. Member of Picture Agency Council of America (PACA). Has 195,000 photos. Clients include: advertising agencies, public relations firms, design agencies, audiovisual firms, book/encyclopedia publishers, magazine publishers and calendar companies. 20% of sales come from overseas.

● Rainbow offers its own CD-ROM discs and has 7,000 images on-line at http://www.picturequest.com and over 200 at http://www.rainbowimages.com.

Needs: Although Rainbow is a general coverage agency, it specializes in high technology images and is continually looking for computer graphics, pharmaceutical and DNA research, photomicrography, communications, lasers and space. "We are also looking for graphically strong and colorful images in physics, biology and earth science concepts; also active children, teenagers and elderly people. Worldwide travel

 SPECIAL COMMENTS within listings by the editor of *Photographer's Market* are set off by a bullet.

locations are always in demand, showing people, culture and architecture. Our rain forest file is growing but is never big enough!"

Specs: Uses 35mm and larger transparencies. Accepts images in digital format for Mac.

Payment & Terms: Pays 50% commission. Works with or without contract; negotiable. Offers limited regional exclusivity contract. Contracts renew automatically with each submission; no time limit. Statements issued quarterly. Payment made quarterly. Photographers allowed to review account records to verify sales figures. Offers one-time rights. Informs photographer and allows them to negotiate when client requests all rights. Model release is required for advertising, book covers or calendar sales. Photo captions required for scientific photos or geographic locations, etc.; include simple description if not evident from photo, prefers both Latin and common names for plants and insects to make photos more valuable.

Making Contact: Interested in receiving work from published photographers. "Photographers may e-mail, write or call us for more information. We may ask for an initial submission of 150-300 chromes." Arrange a personal interview to show portfolio or query with samples. SASE. Reports in 2 weeks. Guidelines sheet for SASE. Distributes a tips sheet twice a year.

Tips: "The best advice we can give is to encourage photographers to carefully edit their photos before sending. No agency wants to look at grey rocks backlit on a cloudy day! With no caption!" Looks for luminous images with either a concept illustrated or a mood conveyed by beauty or light. "Clear captions help our researchers choose wisely and ultimately improve sales. As far as trends in subject matter go, health issues and strong, simple images conveying the American Spirit—families together, farming, scientific research, winning marathons, hikers reaching the top—are the winners. Females doing 'male' jobs, black scientists, Hispanic professionals, all races of children at play, etc. are also in demand. The importance of model releases for editorial covers, selected magazine usage and always for advertising/corporate clients cannot be stressed enough!"

◼ ◻ REFLEXION PHOTOTHEQUE, 1255 Square Phillips, Suite 307, Montreal, Quebec H3B 3G1 Canada. (514)876-1620. Fax: (514)876-3957. E-mail: reflexio@interlink.net. Website: http://www.reflexio n.com. President: Michel Gagne. Estab. 1981. Stock photo agency. Has 100,000 photos. Clients include: ad agencies, public relations firms, audiovisual firms, businesses, book/encyclopedia publishers, magazine publishers, newspapers, postcard companies, calendar companies and greeting card companies.

Needs: Wants photos of model-released people of all ages in various activities. Also need beautiful homes, recreational sports, North American wildlife, industries, US cities, antique cars, hunting and fishing scenes, food, and dogs and cats in studio setting.

Specs: Uses 35mm, 2¼×2¼, 4×5, 8×10 transparencies. Accepts images in digital format for Mac.

Payment & Terms: Pays 50% commission on color photos. Average price per image (to client): $150-500. Enforces minimum prices. Offers volume discounts to customers; inquire about specific terms. Discount sales terms not negotiable. Works on contract basis only. Offers limited regional exclusivity. Contracts renew automatically for 5 years. Charges 50% duping fee and 100% catalog insertion fee. Statements issued quarterly. Payment made quarterly. Offers one-time rights. Model/property release preferred. Photo captions required; include country, place, city, or activity.

Making Contact: Arrange a personal interview to show portfolio. Query with list of stock photo subjects. Submit portfolio for review. SASE. Reports in 1 month. Photo guidelines available.

Tips: "Limit your selection to 200 images. Images must be sharp and well exposed. Send only if you have high quality material on the listed subjects."

◼ ⊕ ◻ RESO EEIG, 223 Chausseé de Waterloo, 7060 Brussels, Belgium. Phone/fax:(33)3-20-138988. E-mail: reso@etnet.fr. Secretary: Jacques Camelet. Estab. 1989. Stock agency and picture library. Clients include advertising agencies, businesses, newspapers, postcard publishers, public relations firms, book publishers, calendar companies, audiovisual firms, magazine publishers, greeting card companies.

Needs: "All kinds of images, especially people." Subjects include babies, children, couples, multicultural, families, parents, senior citizens, teens, environmental, landscapes/scenics, wildlife, architecture, beauty, cities/urban, education, gardening, interiors/decorating, pets, rural, adventure, automobiles, entertainment, food/drink, health/fitness, hobbies, humor, sports, travel, agriculture, buildings, business concepts, computers, industry, medicine, portraits, science, technology, avant garde, digital, regional, seasonal.

Specs: Uses color prints; 35mm, 2¼×2¼ transparencies. Accepts images in digital format for Mac. Send via CD, SyQuest, floppy disk, Jaz, e-mail.

Pament/Terms: Pays on commission basis. Works with photographers with or without contract; negotiable. Charges no filing or catalog insertion fees "for the moment." Allows photographers to review account records in cases of discrepancies only. Model/property release required. Photo captions required; include location.

Making Contact: Send query letter with slides. Does not keep samples on file; include SASE or IRC for return of material.

Tips: "We are a group of two photo agencies in France and Belgium. We make and distribute worldwide generalist photo catalogs. We are searching for high-quality photographs."

⚡ REX USA LTD, 351 W. 54th St., New York NY 10019. (212)586-4432. Fax: (212)541-5724. Manager: Charles Musse. Estab. 1935. Stock photo agency, news/feature syndicate. Affiliated with Rex Features in London. Member of Picture Agency Council of America (PACA). Has 1.5 million photos. Clients include: advertising agencies, public relations firms, audiovisual firms, businesses, book/encyclopedia publishers, magazine publishers, newspapers, postcard companies, calendar companies, greeting card companies and TV, film and record companies.

Needs: Wants primarily editorial material: celebrities, personalities (studio portraits, candid, paparazzi), human interest, news features, movie stills, glamour, historical, geographic, general stock, sports and scientific.

Specs: Uses all sizes and finishes of b&w and color prints; 35mm, 2¼×2¼, 4×5, and 8×10 transparencies; b&w and color contact sheets; b&w and color negatives; VHS videotape.

Payment & Terms: Pays 50-65% commission; payment varies depending on quality of subject matter and exclusivity. "We obtain highest possible prices, starting at $100-100,000 for one-time sale." Pays 50% commission on b&w and color photos. Works with or without contract. Offers nonexclusive contracts. Statements issued monthly. Payment made monthly. Photographers allowed to review account records. Offers one-time, first and all rights. Informs photographers and allows them to negotiate when client requests all rights. Model release required. Captions required.

Making Contact: Arrange a personal interview to show portfolio. Query with samples. Query with list of stock photo subjects. If mailing photos, send no more than 40; include SASE. Reports in 1-2 weeks.

⚡ H. ARMSTRONG ROBERTS, Dept. PM, 4203 Locust St., Philadelphia PA 19104. (800)786-6300. Fax: (800)786-1920. President: Bob Roberts. Estab. 1920. Stock photo agency. Member of the Picture Agency Council of America (PACA). Has 2 million photos. Has 1 branch office. Clients include: advertising agencies, public relations firms, audiovisual firms, businesses, book/encyclopedia publishers, magazine publishers, newspapers, postcard publishers, calendar companies and greeting card companies.

Needs: Uses images on all subjects in depth except personalities and news.

Specs: Uses b&w negatives only; 35mm, 2¼×2¼, 4×5 and 8×10 transparencies.

Payment & Terms: Buys only b&w negatives outright. Payment negotiable. Pays 35% commission on b&w photos; 45-50% on color photos. Works with or without a signed contract, negotiable. Offers various contracts including exclusive, limited regional exclusivity, and nonexclusive. Guarantees subject exclusivity within files. Charges duping fee 5%/image. Charges .5%/image for catalog insertion. Statements issued monthly. Payment made monthly. Payment sent with statement. Photographers allowed to review account records to verify sales figures "upon advance notice." Offers one-time rights. Informs photographer and allows them to negotiate when client requests all rights. Model release and captions required.

Making Contact: Query with résumé of credits. Does not keep samples on file. SASE. Expects minimum initial submission of 250 images with quarterly submissions of 250 images. Reports in 1 month. Photo guidelines free with SASE.

▪ RO-MA STOCK, P.O. Box 50983, Pasadena CA 91115-0983. (626)799-7733. Fax: (626)799-6622. E-mail: romastock@aol.com. Website: http://www.eyecatchingimages.com. Owner: Robert Marién. Estab. 1989. Stock photo agency. Member of Picture Agency Council of America (PACA). Has more than 150,000 photos. Clients include: advertising agencies, multimedia firms, corporations, graphic design and film/video production companies. International affiliations in Malaysia, Germany, Spain, France, Italy, England, Poland, Brazil, Japan and Argentina.

Needs: Looking for fictional images of Earth and outerspace, microscopic and electromicrographic images of insects, micro-organisms, cells, etc.; general situations in sciences (botany, ecology, geology, astronomy, weather, natural history, medicine); extreme close-up shots of animal faces including baby animals; very interested in people (young adults, elderly, children and babies) involved with nature and/or with animals and outdoor action sports involving every age range; people depicting their occupations as technicians, workers, scientists, doctors, executives, etc. Most well-known landmarks and skylines around the world are needed. Also wants couples, parents, disasters, landscapes, architecture, cities/urban, gardening, pets, rural, adventure, events, food/drink, health/fitness, sports, travel, agriculture, buildings, industry, military, portraits, technology.

Specs: Primarily uses 35mm. "When submitting medium, large and digital formats, these images should have a matching 35mm slide for scanning purposes. This will speed up the process of including selected images in our marketing systems. All selected images are digitized and stored on Photo-CD." Accepts images in digital format for Mac. Send via CD, Zip.

Payment & Terms: Buys photos outright; pays $5-10 for b&w photos; $6-12 for color photos. Pays

50% commission on b&w and color photos; film; videotape. Average price per image (to clients): $50-10,000 for b&w and color photos, film and videotape. Offers volume discounts to customers; terms specified in photographer's contract. Guaranteed subject exclusivity (within files). Contract renews automatically with each submission (of 1,000 images) for 1 year. Charges 100% duping fees; 50% catalog insertion fee from commissions and $3.50/each image scanned for the CD-ROM catalog to cover half of digitizing cost. Statements issued with payment. Offers one-time and first rights. Informs photographer when client requests all rights for approval. Model/property release required for recognizable people and private places "and such photos should be marked with 'M.R.' or 'N.M.R.' respectively." Captions required for animals/plants; include common name, scientific name, habitat, photographer's name; for others include subject, location, photographer's name.

Making Contact: Query with résumé of credits, tearsheets and list of specialties. No unsolicited original work. Responds with tips sheet, agency profile and questionnaire for photographer with SASE. Photo guidelines and tips distributed periodically to contracted photographers.

Tips: Wants photographers with ability to produce excellent competitive photographs for the stock photography market on specialized subjects and be willing to learn, listen and improve agency's file contents. Looking for well-composed subjects, high sharpness and color saturation; emphasis in medical and laboratory situations; people involved with the environment, manufacturing and industrial. Also photographers with collections of patterns in nature, art, architecture and macro/micro imagery are welcome.

RSPCA PHOTOLIBRARY, RSPCA Royal Society for the Protection of Animals, Causeway, Horsham, West Sussex RH12 1HG England. (01403)223150. Fax: (01403)241048. E-mail: photolibrary@rspca.org.uk. Website: http://www.rspca.org.uk. Photolibrary Manager: Andrew Forsyth. Estab. 1992. Picture library. Has 43,000 photos in files. Clients include: advertising agencies, public relations firms, businesses, book publishers, magazine publishers, newspapers, marketing.

Needs: Transparencies of any format/color of environmental issues, wild animals, domestic animals, exotic animals, birds, scenics and plants, insects, marine and work of the RSPCA.

Specs: Uses 35mm, 2¼×2¼, 4×5, 8×10 transparencies. Accepts digital images.

Payment: Pays 50% commission; uses BAPLA price guidelines, though does negotiate special deals. Offers volume discounts to customers; terms specified in photographers' contracts. Works with photographers on contract basis only. Offers nonexclusive contract. "Must be unique images." Statements issued quarterly. Payments made quarterly. Photographers allowed to review account records. Offers one-time, electronic media and agency promotion rights. Informs photographers and allows them to negotiate when a client requests all rights. Model release required. Photo captions required; include Latin species name, country and origin.

Making Contact: Send query letter. Provide résumé, business card, self-promotion piece or tearsheets to be kept on file for possible future assignments. Works with local freelancers only. Works with freelancers on assignment only. Does not keep samples on file; include SASE for return of material. Expects minimum initial submission of 24 images with quarterly submissions of at least 24 images. Photo guidelines sheet and catalog free with SAE.

Tips: "CD-ROM images can be sent to us and then onto clients. All photos should be numbered and fully captioned and properly edited before submitting."

S.O.A. PHOTO AGENCY, 87 York St., London United Kingdom W1H 1DU. Phone: (+44)171-258.0202. Fax: (+44)171-258.0188. E-mail: soaphotos@btinternet.com. Website: http://www.btinternet.com/~sabine.soa. Contact: B. Bott. Estab. 1992. Picture library. Has 100,000 photos in files. Clients include: advertising agencies, book publishers, magazine publishers, newspapers, greeting card companies, postcard publishers, TV.

Needs: Wants photos of babies, children, couples, multicultural, families, parents, senior citizens, teens, environmental, landscapes/scenics, wildlife, architecture, beauty, cities/urban, gardening, pets, rural, food/drink, health/fitness, humor, sports, travel, agriculture, buildings, business concepts, computers, industry, medicine, product shots/still life, science, technology. Interested in alternative process, avant garde, digital, documentary, fine art, historical/vintage, seasonal.

Specs: Uses any size prints, transparencies. Accepts images in digital format for Windows. Send via CD as TIFF, JPEG files at 300 dpi minimum.

Payment & Terms: Pays 50% commission for b&w and color photos. Average price per image (to clients): $125 minimum for b&w and color photos. Enforces minimum prices. Offers volume discounts to customers. Discount sales terms not negotiable. Works with photographers on contract basis only. Offers guaranteed subject exclusivity (within files). Statements issued quarterly. Payment made quarterly. Photographers allowed to review account records via an accountant. Offers one-time/electronic media rights. Model release required; property release preferred. Photo captions required.

Making Contact: Send query letter with photocopies, stock list. Portfolio may be dropped off every

Monday. Keep samples on file; include business card, self-promotion piece. Expects minimum initial submission of 20 images with yearly submissions of at least 50 images. Reports in 6 weeks on samples; 2 weeks on portfolios. Photo guidelines sheet free with SAE. Catalog free with SAE.

Tips: "Only send us your best images in your specialized subject. Send a proper delivery note stating the number of pictures sent and a description. Pack properly (no floppy brown envelopes) in jiffy bags with strengtheners. Don't just turn up on our doorstep—make an appointment beforehand."

N **SCIENCE PHOTO LIBRARY, LTD.**, 112 Westbourne Grove, London W2 5RU England. Phone: (0171)727-4712. Fax: (0171)727-6041. Research Director: Rosemary Taylor. Stock photo agency. Has 100,000 photos. Clients include: advertising agencies, public relations firms, audiovisual firms, businesses, book/encyclopedia publishers, magazine publishers, newspapers, postcard companies, calendar companies and greeting card companies.

Needs: SPL specializes in all aspects of science, medicine and technology. "Our interpretation of these areas is broad. We include earth sciences, landscape and sky pictures and animals. We have a major and continuing need for high-quality photographs showing science, technology and medicine *at work*: laboratories, high-technology equipment, computers, lasers, robots, surgery, hospitals, etc. We are especially keen to sign up American freelance photographers who take a wide range of photographs in the fields of medicine and technology. We like to work closely with photographers, suggesting subject matter to them and developing photo features with them. We can only work with photographers who agree to our distributing their pictures throughout Europe, and preferably elsewhere. We duplicate selected pictures and syndicate them to our agents around the world."

Specs: Uses color prints and 35mm, $2\frac{1}{4} \times 2\frac{1}{4}$, 4×5, 6×7, 5×6 and 6×9 transparencies.

Payment & Terms: Pays 50% commission for b&w and color photos. Average price per image (to clients): $80-1,000; varies according to use. Only discounts below minimum for volume or education. Offers volume discounts to customers; inquire about specific terms. Discount sales terms not negotiable. Works on contract basis only. Offers exclusivity; exceptions are made; subject to negotiation. Agreement made for 4 years; general continuation is assured unless otherwise advised. Statements issued quarterly. Payment made quarterly. Photographers allowed to review account records to verify sales figures; fully computerized accounts/commission handling system. Offers one-time and electronic media rights. Model release required. Captions required.

Making Contact: Query with samples or query with list of stock photo subjects. Send unsolicited photos by mail for consideration. Returns material submitted for review. Reports in 1 month.

Tips: Prefers to see "a small (20-50) selection showing the range of subjects covered and the *quality*, style and approach of the photographer's work. Our bestselling areas in the last two years have been medicine and satellite imagery. We see a continuing trend in the European market towards very high-quality, carefully-lit photographs. This is combined with a trend towards increasing use of medium and large-format photographs and decreasing use of 35mm (we make medium-format duplicates of some of our best 35mm); impact of digital storage/manipulation; problems of copyright and unpaid usage. The emphasis is on an increasingly professional approach to photography."

SHARPSHOOTERS, INC., 5000 SW 75th Ave., 3rd Floor, Miami FL 33155. (305)666-1266. Fax: (305)666-5485. Manager, Photographer Relations: Edie Tobias. Estab. 1984. Stock photo agency. Member of Picture Agency Council of America (PACA). Has 500,000 photos. Clients include: advertising agencies.

Needs: Wants photos of model-released people for advertising use; well-designed, styled photographs that capture the essence of life: children; families; couples at home, at work and at play; also beautiful landscapes and wildlife geared toward advertising. Large format preferred for landscapes.

Specs: Uses transparencies only, all formats.

Payment & Terms: Pays 50% commission on color photos. Average price per image (to clients): $275-15,000. Works on contract basis only. Offers exclusive contract only. Statements issued monthly. Payments made monthly. Photographers allowed to review account records; "monthly statements are derived from computer records of all transactions and are highly detailed." Offers one-time and electronic media rights usually, "but if clients pay more, they get more usage rights. We never offer all rights on photos." Model/property release required. Photo captions preferred.

Making Contact: Query with nonreturnable printed promotion pieces. Cannot return unsolicited material. Reports in 1 week.

Tips: Wants to see "technical excellence, originality, creativity and design sense, excellent ability to cast and direct talent and commitment to shooting stock." Observes that "photographer should be in control of all elements of his/her production: casting, styling, props, location, etc., but be able to make a photograph that looks natural and spontaneous."

■ **SILVER IMAGE PHOTO AGENCY, INC.**, 4104 NW 70th Terrace, Gainesville FL 32606. (352)373-5771. Fax: (352)374-4074. E-mail: silverimag@aol.com. Website: http://www.silver-image.com. President/Owner: Carla Hotvedt. Estab. 1988. Stock photo agency. Assignments in Florida/S. Georgia. Has 35,000 color/b&w photos. Clients include: public relations firms, book/encyclopedia publishers, magazine publishers and newspapers.

Needs: Florida-based travel/tourism, Florida cityscapes and people, nationally oriented topics such as drugs, environment, disasters, landscapes, travel, recycling, pollution, humorous people, animal photos and movie/TV celebrities.

Specs: Uses 35mm transparencies and prints. Accepts images in digital format for Mac. Send via CD, floppy disk, Zip, e-mail as JPEG files.

Payment & Terms: Pays 50% commission on b&w/color photos. Average price per image (to clients): $150-600. Works on contract basis only. Offers nonexclusive contract. Statements issued twice monthly. Payment made twice monthly. Photographers allowed to review account records. Offers one-time rights. Informs photographer and allows them to be involved when client requests all rights. Model release preferred. Captions required; include name, year shot, city, state, etc.

Making Contact: Query via e-mail only. Do not submit material unless first requested.

Tips: "I will review a photographer's work if it rounds out our current inventory. Photographers should review our website to get a feel for our needs."

Ⓝ ■ SILVER VISIONS, P.O. Box 2679, Aspen CO 81612. (970)923-3137. E-mail: jjohnson@rof.net. Website: http://www.rof.net/yp/silvervisions. Owner: Joanne M. Johnson. Estab. 1987. Stock photo agency. Has 10,000 photos. Clients include: book/encyclopedia publishers, magazine publishers, postcard companies, calendar companies and greeting card companies.

Needs: Emphasizes lifestyles—people, families, children, couples involved in work, sports, family outings, pets, etc. Also scenics of mountains and deserts, horses, dogs, cats, cityscapes—Denver, L.A., Chicago, Baltimore, NYC, San Francisco, Salt Lake City, capitol cities of the USA.

Specs: Uses 8×10 or 5×7 glossy or semigloss b&w prints; 35mm, $2\frac{1}{4} \times 2\frac{1}{4}$ or 4×5 transparencies. Accepts images in digital format for Windows. Send via compact disc, online or floppy disk.

Payment & Terms: Pays 40-50% commission on b&w and color photos. General price range: $35-750. Offers nonexclusive contract. Charges $15/each for entries in CD-ROM catalog. Statements issued semiannually. Payment made semiannually. Offers one-time rights and English language rights. Informs photographer and allows them to negotiate when client requests all rights. Model/property release required for pets, people, upscale homes. Captions required; include identification of locations, species.

Making Contact: Query with samples. SASE. Reports in 2 weeks. Photo guidelines free with SASE.

Tips: Wants to see "emotional impact or design impact created by composition and lighting. Photos must evoke a universal human interest appeal. Sharpness and good exposures—needless to say." Sees growing demand for "minority groups, senior citizens, fitness."

⊕ **SKISHOOT-OFFSHOOT**, Hall Place, Upper Woodcott, Whitchurch, Hants RG28 7PY Britain. (44)1635 255527. Fax: (44)1635 255528. E-mail: skishoot@surfersparadise.net. Estab. 1986. Stock photo agency. Member of British Association of Picture Libraries and Agencies (BAPLA). Has 200,000 photos in files. Clients include: advertising agencies, book publishers, magazine publishers, newspapers, greeting card companies, postcard publishers.

Needs: Photos of skiing, snowboarding and other winter sports.

Specs: Uses 8×10 (approx.) glossy color prints; 35mm, $2\frac{1}{4} \times 2\frac{1}{4}$, 4×5, 8×10 transparencies.

Payment/Terms: Pays 50% commission for color photos. Average price per image (to clients): $100-5,000 for color. Enforces strict minimum prices. BAPLA recommended rates are used. Offers volume discounts to customers. Photographers can choose not to sell images on discount terms. Works with photographers with or without a contract; negotiable. Offers limited regional exclusivity. Contracts renew automatically with additional submissions within originally agreed time period. Charges 50% of cost of dollar transfer fees from £sterling. Statements issued quarterly. Payments made quarterly. Photographers allowed to review account records in cases of discrepancies only. Offers one-time rights. Does inform photographers when a client requests all rights. Model release preferred for ski and snowboarding action models. Photo captions required; include location details.

Making Contact: Send query letter with samples, stock photo list. Portfolio should include color. Works on assignment only. Include SAE for return of material. Expects minimum initial submission of 50 images. Reports in 1 month on queries.

Tips: "We are about to start digitalizing our work so that we can send images to clients by modem or isdn. Label each transparency clearly or provide clear list which relates to transparencies sent."

⊕ ▣ **SKYSCAN PHOTOLIBRARY**, Oak House, Toddington, Cheltenham, Glos. GL54 5BY United Kingdom. (+44)1242 621357. Fax: (+44)1242 621343. E-mail: info@skyscan.co.uk. Website: http://www.skyscan.co.uk. Library Manager: Brenda Marks. Estab. 1984. Picture library. Member of British Association of Picture Libraries and Agencies (BAPLA). Has 100,000. Clients include: advertising agencies, public relations firms, businesses, book publishers, magazine publishers, newspapers, calendar companies, postcard publishers.

Needs: Wants anything aerial! Air to ground; aviation; aerial sports. As well as holding images ourselves, we also wish to make contact with holders of other aerial collections worldwide to exchange information.

Specs: Uses color and b&w prints; 35mm, 2¼×2¼, 4×5, 8×10 transparencies. Accepts images in digital format—CD-ROM; e-mailed images also handled.

Payment/Terms: Buys photos/film outright. Pays 50% commission for b&w and color. Average price per image (to clients): $100 minimum. Enforces strict minimum prices. Offers volume discounts to customers. Photographers can choose not to sell images on discount terms. Works with photographers with or without a contract; negotiable. Offers guaranteed subject exclusivity (within files) negotiable to suit both parties. Statements issued quarterly; payments made quarterly. Photographers allowed to review account records in cases of discrepancies only. Offers one-time, electronic media and agency promotion rights. Informs photographers and allows them to negotiate when a client requests all rights. Will inform photographers and act with photographer's agreement. Model release preferred. Property release preferred for "air to ground of famous buildings (some now insist they have copyright to their building)." Photo captions required; include subject matter; date of photography; location; interesting features/notes.

Making Contact: Send query letter. Provide résumé, business card, self-promotion piece or tearsheets to be kept on file for possible future assignments. Agency will contact photographer for portfolio review if interested. Portfolio should include color slides and transparencies. Does not keep samples on file; include SAE for return of material. No minimum submissions. Reports back only if interested, send non-returnable samples. Photo guidelines sheet free with SAE. Catalog free with SAE. Market tips sheet free quarterly to contributors only.

Tips: "We see digital transfer of low resolution images for layout purposes as essential to stock libraries future and we are investing in suitable technology. Contact first by letter or e-mail with résumé of material held and subjects covered."

⊕ **THE SLIDE FILE**, 79 Merrion Square, Dublin 2 Ireland. Phone: (0001)6766850. Fax: (0001)66224476. E-mail: admin@slidefile.ie. Website: http://www.slidefile.ie/stock. Picture Editor: Ms. Carrie Fonseca. Stock photo agency and picture library. Has 130,000 photos. Clients include: advertising agencies, public relations firms, businesses, book/encyclopedia publishers, magazine publishers, newspapers and designers.

Needs: Overriding consideration is given to Irish or Irish-connected subjects. Has limited need for overseas locations, but is happy to accept material depicting other subjects, particularly people.

Specs: Uses 35mm, 2¼×2¼ and 4×5 transparencies.

Payment & Terms: Pays 50% commission on color photos. Average price per image (to client): £60-1,000 English currency ($90-1,500). Works on contract basis only. Offers exclusive contracts and limited regional exclusivity. Contracts renew automatically with additional submissions. Statements issued quarterly. Payment made quarterly. Photographers allowed to review account records. Offers one-time and electronic media rights. Informs photographer when client requests all rights, but "we take care of negotiations." Model releases required. Captions required.

Making Contact: Query with list of stock photo subjects. Works with local freelancers only. Does not return unsolicited material. Expects minimum initial submission of 250 transparencies; 1,000 images annually. "A return shipping fee is required: important that all similars are submitted together. We keep our contributor numbers down and the quantity and quality of submissions high. Send for information first." Reports in 1 month.

Tips: "Our affiliation with international picture agencies provides us with a lot of general material of people, overseas travel, etc. However, our continued sales of Irish-oriented pictures need to be kept supplied. Pictures of Irish-Americans in Irish bars, folk singing, Irish dancing, would prove to be useful. They would be required to be beautifully lit, carefully composed and good-looking, model-released people."

Ⓝ ▣ **SOUTH BEACH PHOTO AGENCY**, 1521 Alton Rd., 48, Miami Beach FL 33139. (305)535-1288. Fax: (305)535-6573. E-mail: sobephoto@aol.com. Managing Director: Carole Moore. Estab. 1996. Stock agency. Has 1 million photos in files. Clients include: public relations firms, book publishers, magazine publishers, newspapers. Member of ASPP.

Needs: Wants photos of celebrities, entertainment, events.

Specs: Uses color prints; 35mm transparencies. Accepts images in digital format for Mac. Send via ISDN as JPEG files at 300 dpi.

Payment & Terms: Buys photos outright. Pays 50% commission for b&w and color photos; film; videotape. Average price per image (to clients): $75 minimum for b&w photos; $150 minimum for color photos. Negotiages fees below stated minimums. "We always work with client's budget." Offers volume discounts to customers; terms specified in photographers' contracts. Photographers can choose not to sell images on discount terms. Works with photographers with or without contract; negotiable; depends on images. Statements issued monthly. Payment made monthly. Offers one-time rights. Informs photographers and allows them to negotiate when client requests all rights. Photo captions required; include who, what, when, where, how.

Making Contact: Contact through rep or send query letter with stock list. Does not keep samples on file; include SASE for return of material. Reports back only if interested; send non-returnable samples.

Tips: "Be sure to caption photos completely."

N ⊕ ▣ SPECTRUM PICTURES, Vtunich 11, Prague 2 Czech Republic 12072. Phone/fax: (4202)2494-2029. E-mail: spectrum@terminal.cz. Website: http://www.spectrum.cz. Director: Lee Malis. Estab. 1992. Stock agency and news/feature syndicate. Has 35,000 photos in files. Clients include: advertising agencies, audiovisual firms, businesses, book publishers, magazine publishers, newspapers, calendar companies.

Needs: "We work only with pictures from Central, Eastern Europe and Eurasia." Wants photos of celebrities, children, multicultural, families, parents, senior citizens, teens, disasters, environmental, landscapes/scenics, wildlife, architecture, beauty, cities/urban, education, religious, rural, adventure, entertainment, events, health/fitness, humor, performing arts, travel, agriculture, buildings, business concepts, computers, industry, medicine, military, political, science, technology. Interested in alternative process, avant garde, documentary, fashion/glamour, fine art, historical/vintage, regional, seasonal.

Specs: Uses 35mm, 2¼×2¼, 4×5 transparencies. Accepts images in digital format for Mac, Windows. Send via CD, floppy disk as JPEG files at about 10MB.

Payment & Terms: Pays 50% commission for b&w and color photos and film. Average price per image (to clients): $175-5,000 for b&w and color photos. Negotiates fees below standard minimum prices. Offers volume discounts to customers. Photographers can choose not to sell images on discount terms. Works with photographers with or without contract; negotiable. Offers nonexclusive contract. Contracts renew automatically with additional submissions. Payment made monthly. Photographers allowed to review account records in cases of discrepancies only. Offers one-time, electronic media and agency promotion rights. Informs photographers and allows them to negotiate when client requests all rights. Photo captions required.

Making Contact: Send query letter with résumé, business card, self-promotion piece to be kept on file. Expects minimum initial submission of 50 images. Reports in 2 weeks. Reports back only if interested; send non-returnable samples.

Tips: "Please e-mail before sending samples. We prefer that no one send original slides via mail. Send scanned low resolution images on CD-ROM or floppy disks. Remember that we specialize in Eastern Europe, Central Europe, and Eurasia (Russia, Georgia, former Soviet countries). We are primarily a photo journalist agency, but we work with other clients as well."

▪ ▣ SPECTRUM STOCK INC., (formerly Canada in Stock Inc.), 109 Vanderhoof Ave., Suite 214, Toronto, Ontario M4G 2H7 Canada. (416)425-8215. Fax: (416)425-6966. E-mail: canstock@istar.ca. Website: www.spectrumstock.com. Director: Ottmar Bierwagen. Estab. 1994. Stock photo agency. Member of the Picture Agency Council of America (PACA). Has 125,000 photos. Clients include: advertising agencies, public relations firms, businesses, book/encyclopedia publishers, magazine publishers, calendar companies, government and graphic designers.

Needs: "Our needs are model-released people, lifestyles and medical." Wants photos of Europe, Asia, babies, children, couples, multicultural, families, parents, senior citizens, teens, landscapes, wildlife, cities/urban, gardening, rural, adventure, food/drink, health/fitness, sports, travel, agriculture, business concepts, computers, industry, technology.

Specs: Uses 35mm, 2¼×2¼, 4×5, 8×10 transparencies. Accepts images in digital format for Windows. Send via Zip, e-mail as TIFF, JPEG files at 72 dpi.

Payment & Terms: Pays 40-50% commission on b&w and color photos. Average price per image (to clients): $200/b&w; $200-10,000 for color photo. Enforces minimum prices. Offers volume discounts to customers; inquire about specific terms. Photographers can choose not to sell images on discount terms. Works on contract basis only. Offers exclusive or limited regional exclusivity contracts. Contracts renew automatically with additional submissions. Charges 50% duping and catalog insertion fees. Statements issued quarterly. Payment made quarterly. Photographers allowed to review account records. Offers one-time rights and North American rights; exclusivity and/or buyouts negotiated. "We negotiate with client, but photographer is made aware of the process." Model release required; property release preferred. Captions

required; include location, detail, model release, copyright symbol and name (no date).

Making Contact: Query with samples and stock photo list. Works with local freelancers on assignment only. Samples kept on file. SAE. Expects minimum initial submission of 300-500 images with 300 more annually. Reports in 3 weeks. Photo guidelines free with SAE. Market tips sheet distributed monthly via fax to contracted photographers.

Tips: "Ask hard questions and expect hard answers. Examine a contract in detail. Accepting work is becoming more difficult with generalists; specialty niche photographers have a better chance."

SPORTSLIGHT PHOTO, 6 Berkshire Circle, Gt. Barrington MA 01230. (413)528-6524. Website: http://www.fotoshow.com/fotoshow/sportslight/. Director: Roderick Beebe. Stock photo agency. Has 500,000 photos. Clients include: advertising agencies, public relations firms, corporations, book publishers, magazine publishers, newspapers, postcard companies, calendar companies, greeting card companies and design firms.

Needs: "We specialize in every sport in the world. We deal primarily in the recreational sports such as skiing, golf, tennis, running, canoeing, etc., but are expanding into pro sports, and have needs for all pro sports, action and candid close-ups of top athletes. We also handle adventure-travel photos, e.g., rafting in Chile, trekking in Nepal, dogsledding in the Arctic, etc."

Specs: Uses 35mm transparencies.

Payment & Terms: Pays 50% commission. Average price per image (to clients): $100-6,000. Contract negotiable. Offers limited regional exclusivity. Contract is of indefinite length until either party (agency or photographer) seeks termination. Charges fees for catalog and CD-ROM promotions. Statements issued quarterly. Payment made quarterly. Photographers allowed to review account records to verify sales figures "when discrepancy occurs." Offers one-time rights, rights depend on client, sometimes exclusive rights for a period of time. Informs photographer and consults with them when client requests all rights. Model release required for corporate and advertising usage. (Obtain releases whenever possible.) Strong need for model-released "pro-type" sports. Captions required; include who, what, when, where, why.

Making Contact: Interested in receiving work from newer and known photographers. Query with list of stock photo subjects, "send samples *after* our response." SASE must be included. Cannot return unsolicited material. Reports in 2-4 weeks. Photo guideline sheet free with SASE.

Tips: In reviewing work looks for "range of sports subjects that shows photographer's grasp of the action, drama, color and intensity of sports, as well as capability of capturing great shots under all conditions in all sports. Want well edited, perfect exposure and sharpness, good composition and lighting in all photos. Seeking photographers with strong interests in particular sports. Shoot variety of action, singles and groups, youths, male/female—all combinations; plus leisure, relaxing after tennis, lunch on the ski slope, golf's 19th hole, etc. Clients are looking for all sports these days, all ages. Sports fashions change rapidly, so that is a factor. Art direction of photo shoots is important. Avoid brand names and minor flaws in the look of clothing. Attention to detail is very important. Shoot with concepts/ideas such as teamwork, determination, success, lifestyle, leisure, cooperation in mind. Clients look not only for individual sports but for photos to illustrate a mood or idea. There is a trend toward use of real-life action photos in advertising as opposed to the set-up slick ad look. More unusual shots are being used to express feelings, attitude, etc."

■ TOM STACK & ASSOCIATES, 103400 Overseas Hwy., Suite 238, Key Largo FL 33037. (305)453-4344. Fax: (305)453-3868. Contact: Therisa Stack. Has 1.5 million photos. Clients include: advertising agencies, public relations firms, businesses, audiovisual firms, book publishers, magazine publishers, encyclopedia publishers, postcard companies, calendar companies and greeting card companies.

Needs: Wants photos of wildlife, endangered species, marine-life, landscapes, foreign geography, people and customs, children, sports, abstract/art and mood shots, plants and flowers, photomicrography, scientific research, current events and political figures, Native Americans, etc. Especially needs women in "men's" occupations; whales; solar heating; up-to-date transparencies of foreign countries and people; smaller mammals such as weasels, moles, shrews, fisher, marten, etc.; extremely rare endangered wildlife; wildlife behavior photos; current sports; lightning and tornadoes; hurricane damage; sharp images, dramatic and unusual angles and approach to composition, creative and original photography with impact. Especially needs photos on life science, flora and fauna and photomicrography. No run-of-the-mill travel or vacation shots. Special needs include photos of energy-related topics—solar and wind generators, recycling, nuclear power and coal burning plants, waste disposal and landfills, oil and gas drilling, supertankers, electric cars, geo-thermal energy.

Specs: Uses 35mm transparencies. Accepts images in digital format for Mac. Send via CD or Zip disk as TIFF file.

Payment & Terms: Pays 50-60% commission. Average price per image (to clients): $150-200/color; as high as $7,000. Works on contract basis only. Contracts renew automatically with additional submissions for 3 years. Charges duping and catalog insertion fees. Statements issued quarterly. Payment made quarterly.

Offers one-time and electronic media rights. Informs photographer and allows them to negotiate when client requests all rights. Model release preferred. Captions preferred.

Making Contact: Query with list of stock photo subjects or send at least 800 transparencies for consideration. SASE or mailer for photos. Reports in 2 weeks. Photo guidelines with SASE.

Tips: "Strive to be original, creative and take an unusual approach to the commonplace; do it in a different and fresh way." Have "more action and behavioral requests for wildlife. We are large enough to market worldwide and yet small enough to be personable. Don't get lost in the 'New York' crunch—try us. Shoot quantity. We try harder to keep our photographers happy. We attempt to turn new submissions around within two weeks. We take on only the best so we can continue to give more effective service."

N STOCK BOSTON INC., 36 Gloucester St., Boston MA 02115-2509. (617)266-2300. Fax: (617)353-1262. E-mail: info@stockboston.com. Website: http://www.stockboston.com. Head of Research: Jean Howard. Estab. 1970. Stock agency. Has approximately 1 million photos in files. Clients include: advertising agencies, book publishers, magazine publishers, calendar companies, greeting card companies.

Needs: Wants photos of children, couples, multicultural, families, parents, senior citizens, teens, disasters, environmental, wildlife, cities/urban, education, adventure, food/drink, health/fitness, hobbies, sports, travel, business concepts, computers, industry, medicine, science, technology, documentary.

Specs: Uses 8×10, glossy, b&w prints; 35mm, $2\frac{1}{4} \times 2\frac{1}{4}$, 4×5 transparencies.

Payment & Terms: Pays 50% commission for b&w and color photos. Works with photographers on contract basis only. Payments made monthly. Model release preferred. Photo captions required.

Making Contact: Call or e-mail for submission guidelines and contract. Expects minimum initial submission of 200 images. Reports in 1-2 weeks. Photo guidelines sheet available.

Tips: "Read our guidelines carefully."

■ THE STOCK BROKER, Dept. PM, 757 Santa Fe Dr., Denver CO 80204. (303)260-7540. Fax: (303)260-7543. E-mail: quality@tsbroker.com. Website: http://www.tsbroker.com. Contact: Dawn Fink. Estab. 1981. Stock photo agency. Member of Picture Agency Council of America (PACA). Has 500,000 photos. Clients include: advertising agencies, public relations firms, audiovisual firms, businesses, book/encyclopedia publishers, magazine publishers, graphic designers, travel agencies and calendar companies.

Needs: Wants photos of recreational and adventure sports, travel, business/industry, people and lifestyles.

Specs: Uses 8×10 glossy b&w prints; 35mm, $2\frac{1}{4} \times 2\frac{1}{4}$, 4×5 or 8×10 transparencies. Accepts images in digital format for Mac.

Payment & Terms: Pays 50% commission. Offers volume discounts to customers; discount sales terms not negotible. Works on contract basis only. Offers nonexclusive contract. Statements issued quarterly. Payment made monthly. Photographers allowed to review account records in case of discrepancies only. Offers one-time rights. Informs photographers and allows them to negotiate when client requests all rights. Model release required. Photo captions preferred.

Making Contact: Query with samples. Keeps samples on file; provide résumé, business card and self-promotion piece to be kept on file. Expects minimum initial submission of 60 images. SASE. Reports in 1 month. Photo guidelines free with SASE. Market tips sheet distributed to contract photographers.

■ STOCK CONNECTION, INC., 110 Frederick Ave., Suite A, Rockville MD 20850. (301)251-0720. Fax: (301)309-0941. E-mail: cheryl@chd.com. Website: http://www.pickphoto.com. President: Cheryl Pickerell. Stock photo agency. Member of PACA. Has 10,000 photos in files. Clients include advertising agencies, graphic design firms, businesses, postcard publishers, public relations firms, book publishers, calendar companies, audiovisual firms, magazine publishers, greeting card companies.

Needs: "We handle many subject categories including people, lifestyles, sports, business, concepts, landscapes, scenics, wildlife. We will help photographers place their images into catalogs."

Specs: Uses color and b&w prints, 35mm, $2\frac{1}{4} \times 2\frac{1}{4}$, 4×5, 8×10 transparencies. Accepts images in digital format (PICT files no larger than 4MB for submission).

Payment & Terms: Pays 65% commission. Average price per image (to client): $650. Enforces strict minimum prices. "We will only go below our minimum of $250 for certain editorial uses. We will turn away sales if a client is not willing to pay reasonable rates." Works with photographers on contract basis only. Offers nonexclusive contract. Contracts renew automatically with additional submissions for life of catalog. Photographers may cancel contract with 60 days written notice. Charges $10-60/image for catalog insertion. Statements issued monthly. Photographers allowed to review account records. Offers one-time rights. Informs photographers when a client requests all rights. Model and property release preferred. Photo captions required, include locations, non-obvious elements.

Making Contact: Send query letter with samples, stock photo list, tearsheets. Reports back only if interested, send non-returnable samples. Provide resume, business card, self-promotion piece or tearsheets

to be kept on file. Agency will contact photographer for portfolio review if interested. Expects minimum initial submission of 100 images. Market tips sheet available for $3.

Tips: "We market very heavily through CD-ROM and Internet technology. Based on the results we have gotten over the past five years, we are convinced this is where the market is going. The cost to advertise images in this medium is so much less than in print catalogs. The return on investment is much greater for photographers."

N ⊕ **THE STOCK HOUSE LTD.**, 178 Johnston Rd., 1101 Chinachem Johnston Plaza, Wanchai Hong Kong. E-mail: stockhse@netvigator.com. Contact: Bob Davis. Estab. 1980. Stock agency. Has 500,000 photos in files. Clients include: advertising agencies, public relations firms, audiovisual firms, businesses, book publishers, magazine publishers, newspapers, calendar companies, greeting card companies, postcard publishers.

Needs: Wants photos of babies, celebrities, children, couples, multicultural, families, wildlife, beauty, interiors/decorating, automobiles, food/drink, health/fitness, sports, travel, business concepts, industry, product shots/still life, science, technology. Interested in avant garde, fashion/glamour.

Specs: Uses 35mm transparencies.

Payment & Terms: Pays 50% commission for color photos. Average price per image (to clients): $100 minimum for color photos. Offers volume discounts to customers. Works with photographers on contract basis only. Offers exclusive contract (Hong Kong only). Statements issued quarterly. Payment made quarterly. Photographers allowed to review account records in cases of discrepancies only. Offers one-time rights. Model/property release required. Photo captions required.

Making Contact: Send query letter with résumé, slides, transparencies. Expects minimum initial submission of 200 images with quarterly submissions of at least 200 images. Reports back only if interested; send non-returnable samples.

THE STOCK MARKET, 360 Park Ave. S., New York NY 10010. (212)684-7878. Fax: (212)532-6750. Contact: Gerry Thies or Keith Goldstein. Estab. 1981. Stock photo agency. Member of Picture Agency Council of America (PACA). Has 3 million images. Clients include: ad agencies, public relations firms, corporate design firms, book/encyclopedia publishers, magazine publishers, newspapers, postcard companies, calendar companies and greeting card companies.

Needs: Topics include lifestyle, corporate, industry, nature, travel and digital concepts.

Specs: Uses color and b&w, all formats. Houses transparencies only.

Payment & Terms: Pays 50% gross sale on color photos. Works on exclusive contract basis only. Charges catalog insertion fee of 50%/image for US edition only. Statements issued monthly. Payment made monthly. Photographers allowed to review account records to verify sales figures. Offers one-time rights. When client requests to buy all rights, "we ask permission of photographer, then we negotiate." Model/property release required for all people, private homes, boats, cars, property. Captions are required; include "what and where."

Making Contact: Send SASE for portfolio guideline information..

Tips: "The Stock Market represents work by some of the world's best photographers. Producing work of the highest caliber, we are always interested in reviewing work by dedicated professional photographers who feel they can make a contribution to the world of stock."

STOCK OPTIONS®, Dept. PM, 4602 East Side Ave., Dallas TX 75226. (214)823-6262. Fax: (214)826-6263. Owner: Karen Hughes. Estab. 1985. Stock photo agency. Member of Picture Agency Council of America (PACA). Has 200,000 photos. Clients include: advertising agencies, public relations firms, audiovisual firms, corporations, book/encyclopedia and magazine publishers, newspapers, postcard companies, calendar and greeting card companies.

Needs: Emphasizes the southern US. Files include Gulf Coast scenics, wildlife, fishing, festivals, food, industry, business, people, etc. Also western folklore and the Southwest.

Specs: Uses 35mm, 2¼×2¼ and 4×5 transparencies.

Payment & Terms: Pays 50% commission on color photos. Average price per image (to client): $300-3,000. Works on contract basis only. Offers nonexclusive contract. Contract automatically renews with each submission to 5 years from expiration date. When contract ends photographer must renew within 60

THE SUBJECT INDEX, located at the back of this book, lists publications, book publishers, galleries, greeting card companies, stock agencies, advertising agencies and graphic design firms according to the subject areas they seek.

days. Charges catalog insertion fee of $300/image and marketing fee of $6/hour. Statements issued upon receipt of payment from client. Payment made immediately. Photographers allowed to review account records to verify sales figures. Offers one-time and electronic media rights. "We will inform photographers for their consent only when a client requests all rights, but we will handle all negotiations." Model/property release preferred for people, some properties, all models. Captions required; include subject and location.
Making Contact: Interested in receiving work from full-time commercial photographers. Arrange a personal interview to show portfolio. Query with list of stock photo subjects. Contact by "phone and submit 200 sample photos." Tips sheet distributed annually to all photographers.
Tips: Wants to see "clean, in focus, relevant and current materials." Current stock requests include: industry, environmental subjects, people in up-beat situations, minorities, food, cityscapes and rural scenics.

THE STOCK SHOP, 232 Madison Ave., New York NY 10016. (212)679-8480. Fax: (212)532-1934. E-mail: stockshop@aol.com. Website: http://www.workbook.com. President: Barbara Gottlieb. Estab. 1975. Member of Picture Agency Council of America (PACA). Has over 2 million photos. Clients include: advertising agencies, public relations firms, businesses, book/encyclopedia publishers, magazine publishers, postcard companies, calendar companies and greeting card companies.
Needs: Wants photos of travel, industry and medicine. Also interested in model-released lifestyle including old age, couples, babies, men, women, families.
Specs: Uses 35mm, 2¼×2¼, 4×5 and 8×10 transparencies.
Payment & Terms: Pays 50% commission on color photos. General price range: $250 and up. Works on exclusive contract basis only. Contracts renew automatically with each submission for length of original contract. Charges catalog insertion fee of 7½%/image. Statements issued monthly. Payment made monthly. Offers one-time rights. Does inform photographer of client's request for all rights. Model release required. Captions required.
Making Contact: Arrange a personal interview to show portfolio. Submit portfolio for review. SASE. Tips sheet distributed as needed to contract photographers only.
Tips: Wants to see "a cross section of the style and subjects the photographer has in his/her library. 200-300 samples should tell the story. Photographers should have at least 1,000 in their library. Photographers should not photograph people *before* getting a model release. The day of the 'grab shot' is over."

STOCK SHOT, 27 Hartington Place, Edinburgh EH1O 4LF United Kingdom. Phone: (0131)228-9368. Fax: (0131)228-9464. E-mail: info@stockshot.co.uk. Website: http://www.stockshot.co.uk. Estab. 1988. Picture library. Has 50,000 photos in file. Clients include: advertising agencies, public relations firms, businesses, book publishers, magazine publishers, newspapers, calendar companies, tour operators.
Needs: Wants extreme adventure sports and adventure travel—skiing, mountaineering, snowboarding, kayaking, windsurfing. Also wants landscapes/scenics, health/fitness. For full list call office.
Specs: Uses 35mm transparencies. Accepts images in digital format for Mac. Send via CD, SyQuest, Jaz, e-mail, ISDN as TIFF, BMP, JPEg files.
Payment/Terms: Pays 50% commission for color photos. Average price per image (to clients): $100-500 for color. Negotiates fees below stated minimums "depending on circumstances e.g. discount for quality usage." Offers volume discounts to customers. Photographers can choose not to sell images on discount terms. Works with photographers on contract basis only. Offers nonexclusive contract. Photographers allowed to review account records. Offers one-time rights. Model release required. Photo captions required.
Making Contact: Send query letter with stock photo list. Agency will contact photographer for portfolio review if interested. Portfolio should include slides. Will return material with SAE/IRC. Photo guidelines sheet free with SAE/IRC. Catalog free with SAE/IRC.
Tips: "Take on board the fact that we are an adventure sports and travel library. Scenic shots which reflect this may be accepted."

STOCKFILE, 5 High St., Sunningdale, Berkshire SL5 0LX England. Phone: (+44)1344 872249. Fax: (+44)1344 872263. E-mail: sbehr@cix.co.uk. Library Manager: Jill Behr. Estab. 1989. Stock photo agency. Member of British Association of Picture Libraries and Agencies (BAPLA). Has 50,000 photos in files. Clients include: advertising agencies, public relations firms, businesses, book publishers, magazine publishers, newspapers and calendar companies.
Needs: Images of cycling, skiing, mountain biking and snowboarding; need shots in USA, Canada and worldwide ski resorts.
Specs: Uses 35mm transparencies.
Payment/Terms: Pays 50% commission for color photos. Average price per image (to clients): $40-1,000 for color. Offers volume discounts to customers. Discount sales terms not negotiable. Works with photographers with or without a contract, negotiable. Offers nonexclusive contract. Charges for marketing

and administrative costs are "negotiable—no charges made without consultation." Statements issued semi-annually; payments made semiannually. Photographers allowed to review account records in cases of discrepancies only. Offers one-time rights. Informs photographer and allows them to negotiate when client requests all rights. Model release preferred. Photo captions required; include location.

Making Contact: Send query letter with stock photo list. Expects minimum initial submission of 50 images with annual submissions of at least 50 images. Reports back only if interested; send non-returnable samples. Photo guidelines sheet free with SAE. Market tips sheet not available.

Tips: "Edit out unsharp or badly exposed pictures, and caption properly."

THE STOCKHOUSE, INC., 3301 W. Alabama, Houston TX 77098. (713)942-8400. Fax: (713)526-4634. E-mail: stockhouse@mcnee.com. Website: http://www.stockhouse-houston.com. Director, Sales & Marketing: Celia Jumonville. Estab. 1980. Stock photo agency. Has 500,000 photos on file. Clients include: advertising agencies, public relations firms, audiovisual firms, businesses, book publishers, magazine publishers, newpapers, calendar companies, greeting card companies, postcard publishers, anyone who needs photos.

Needs: Wants all subjects, especially industry, lifestyles, travel, medical.

Specs: Uses color prints; 35mm, 2¼×2¼, 4×5 transparencies.

Payment/Terms: Pays 50% commission for color and b&w prints. Average price per image (to clients): $250 minimum. "Prices are based on usage only. Minimum is $250 printed and negotiable for exclusive or layouts." Offers volume discounts to customers. Works with photographers on contract basis only. Offers limited regional exclusivity. Contracts are valid until canceled. Photographers allowed to review account records by appointment. Offers one-time rights. Inform photographers and allows them to negotiate when a client requests all rights. Model/property release preferred. Photo captions required; include location and specific type of industry shown.

Making Contact: Send query letter. Portfolios may be dropped off Monday-Friday. Agency will contact photographer for portfolio review if interested. Portfolio should include color slides, transparencies. Expects minimum initial submission of 200-300 images with quarterly submissions of at least 200 images. Photo guidelines sheet free with SASE. Market tips sheet available quarterly to photographers, free with SASE.

N ▦ ▢ **TONY STONE IMAGES, INC.,** 6762 Lexington Ave., Los Angeles CA 90038. (323)769-9300. Fax: (323)769-9301. (Offices in 25 locations worldwide). Director of Photography: Charlie Holland. Estab. in US 1988, worldwide 1968. Stock photo agency. Member of Picture Agency Council of America (PACA). For branch offices, contact: Patrick Donohue (Seattle) (206)622-6262; Susan Cardanza (New York) (212)779-6300. Clients include: advertising agencies; public relations firms; audiovisual firms; businesses; book/encyclopedia publishers; magazine publishers; newspapers; calendar, greeting card and travel companies.

Needs: Very high quality, technically and creatively excellent stock imagery on all general subjects for worldwide and US distribution.

Specs: Uses 8×10 glossy, matte, color, b&w prints; 35mm, 2¼×2¼, 4×5, 8×10 transparencies. "Large and medium format transparencies are always put into our custom mounts, so you do not have to mount them. We do, however, want them submitted (with acetate sleeves) in appropriately-sized viewing sheets." Accepts images in digital format for Mac. Send via CD, SyQuest, floppy disk, Jaz, Zip, e-mail as TIFF, EPS, PICT, BMP, GIF, JPEG files.

Making Contact: "Please do not send unsolicited images. Call our Creative Department for free submission guidelines." Expects minimum initial submission of 50 images.

Tips: Wants to see "technical ability, creativity, commitment to high standards." Sees increased demand for high quality. "If you can't shoot better imagery than that already available, don't bother at all."

SUPERSTOCK INC., 7660 Centurion Pkwy, Jacksonville FL 32256. (904)565-0066. E-mail: photoeditor @superstockimages.com. Website: www.superstockimages.com. Photographer Development Talent Liaison: Renee Hawkins. Photo Editor: Vincent Hobbs. International stock photo agency represented in 38 countries. Extensive contemporary, vintage and fine art collections available for use by clients. Clients include: advertising agencies, public relations firms, audiovisual firms, businesses, book/encyclopedia publishers, magazine publishers, newspapers, postcard companies, calendar companies, greeting card companies and major corporations.

Needs: "We are a general stock agency involved in all markets. Our files are comprised of all subject matter."

Specs: Uses small and large format transparencies and prints

Payment & Terms: "We work on a contract basis." Statements issued monthly. Photographers allowed to review account records to verify sales figures. Rights offered "vary, depending on client's request." Informs photographer when client requests all rights. Model releases and captions required.

Making Contact: Query with samples. "When requested, we ask that you submit a portfolio of a maximum of 100 original transparencies, duplicate transparencies or prints as your sample. If we need to see additional images, we will contact you." Reports in approximately 3 weeks. Photo guidelines free if requested via mail, e-mail or phone. Newsletter distributed quarterly to contributing photographers.

Tips: "We are interested in seeing fresh, creative images that are on the cutting edge of photography. We are particularly interested in lifestyles, people, sports, still life, digital concepts, business and industry, as well as other images that show the range of your photography."

SWANSTOCK AGENCY INC., 100 N. Stone, Suite 1105, Tucson AZ 85701. (520)622-7133. Fax: (520)622-7180. Contact: Submissions. Estab. 1991. Stock photo agency. Has 100,000 photos. Clients include: advertising agencies, public relations firms, book publishers, magazine publishers, newspapers, design firms, record companies and inhouse agencies.

Needs: Swanstock's image files are artist-priority, not subject-driven. Needs range from photo-illustration to realistic family life in the '90s. (Must be able to provide releases upon submission.)

Specs: Uses 8×10 or smaller color and b&w prints; 35mm, $2\frac{1}{4} \times 2\frac{1}{4}$, 4×5, 8×10 transparencies. Send dupes only.

Payment & Terms: All sales of Swanstock imagery is conducted through The Image Bank affiliate offices (worldwide). Average price per image (to clients): $500. Works on contract basis only; artists must provide complete captions and releases if relevant. Photographers provide multiple duplicates to Tucson library; if imagery is selected for worldwide duping program, photographer contributes toward expenses.

Making Contact: Interested in seeing personal fine art photography, not commercial or "stock" photography. Send SASE in advance to receive complete submission information. Reviews quarterly. Reporting time may be 6 weeks.

Tips: "We look for bodies of work that reflect the photographer's consistent vision and sense of craft—whether their subject be the landscape, still lifes, family, or more interpretive illustration. Alternative processes are encouraged (i.e., Polaroid transfer, hand-coloring, infrared films, photo montage, pinhole and Diana camera work, etc.). Long-term personal photojournalistic projects are of interest as well. We want to see the work that you feel strongest about, regardless of the quantity. Artists are not required to submit new work on any specific calendar, but rather are asked to send new bodies of work upon completion. We do not house traditional commercial stock photography, but rather work that was created by fine art photographers for personal reasons or for the gallery/museum arena. The majority of requests we receive require images to illustrate an emotion, a gesture, a season rather than a specific place geographically or a particular product. Our goal with each submission to clients is to send as many different photographers' interpretations of their need, in as many photographic processes as possible. "Swanstock became a division of The Image Bank, Inc., in the summer of 1997; a year later 'First Edition,' Swanstock's first catalogue was published. The book is unique within the stock industry as it is more of a fine art book (hardbound, dustjacket) than a traditional stock photography catalogue. The book underscores the differences between Swanstock and other stock photography agencies. We are confident that this 'niche' market is continuing to grow and encourage artists who previously felt there was no market for their personal work to write for submission guidelines."

TAKE STOCK INC., 307, 319 Tenth Ave. SW, Calgary, Alberta T2R 0A5 Canada. (403)261-5815. Fax: (403)261-5723. Estab. 1987. Stock photo agency. Clients include: advertising agencies, public relations firms, audiovisual firms, corporate, book/encyclopedia publishers, magazine publishers, newspapers, postcard, calendar and greeting card companies.

Needs: Wants model-released people, lifestyle images (all ages), Asian people, Canadian images, arts/recreation, industry/occupation, business, high-tech, beach scenics with and without model released people.

Specs: Uses 35mm, medium to large format transparencies.

Payment & Terms: Pays 50% commission on transparencies. General price range (to clients): $300-700. Works on contract basis only. Offers limited regional exclusivity. Contracts renew automatically with additional submissions for 3 year terms. Charges 100% duping and catalog insertion fees. Statements issued monthly. Payment made monthly. Photographers allowed to review account records to verify sales figures, "with written notice and at their expense." Offers one-time, exclusive and some multi-use rights; some buy-outs with photographer's permission. Model/property release required. Captions required.

Making Contact: Query with list of stock photo subjects. SAE/IRC. Reports in 3 weeks. Photo guidelines free with SAE/IRC. Tips sheet distributed every 2 months to photographers on file.

TELLURIDE STOCK PHOTOGRAPHY, Telluride Production Group, P.O. Box 1215, 619 W. Columbia Ave., E-149, Telluride CO 81435. (970)728-6503. Fax: (970)728-0581. E-mail: tellfoto@rni.net. Photo Editor: Doug Berry. Estab. 1984. Stock agency. Has 10,000 photos in files. Has 30-40 hours of film/video footage. Clients include: advertising agencies, public relations firms, audiovisual firms,

businesses, book publishers, magazine publishers, newspapers, calendar companies, multimedia.

Needs: Wants photos of couples, families, white glove service, landscapes/scenics, wildlife, adventure, food/drink, health/fitness, sports, travel. "We would like to see more unstyled, realistic, lifestyle images."

Specs: Uses 35mm, 2¼×2¼, 4×5 transparencies, Beta SP transfers from film, Beta SP video.

Payment & Terms: Buys photos outright; negotiable. Pays 50% commission for color photos and video-tape. Enforces minimum prices. Offers volume discounts to customers; terms specified in photographers' contracts. Works with photographers with or without contract; negotiable. Offers nonexclusive contract. Statements issued annually. Payment made monthly. Offers one-time rights. Informs photographers and allows them to negotiate when client requests all rights. Model release/property release required. Photo captions required.

Making Contact: Send query letter with résumé, slides, stock list, demo reel on Beta SP. Does not keep samples on file; include SASE for return of material. Expects minimum initial submission of 200 images with biannual submissions of at least 200 images. Reports in 2 weeks on samples. Photo guidelines sheet free with SASE.

Tips: "Before submitting, know the type of images we want. Call us and tell us what you have currently and what you are working on. Unlike a lot of agencies, we like direct phone dialogue with shooters and are looking for new experienced stock photographers. We would like to see a lot of film and video sports action only on Beta S.P."

[N] [■] TOP STOCK, 33855 LaPlata Lane, Pine CO 80470. (303)838-2203. (800)333-5961. Fax: (303)838-7398. E-mail: wa@denver.net. Website: http://www.worldangler.com/topstock. Owner: Tony Oswald. Estab. 1985. Stock agency. Has 36,000 photos in files. Clients include: advertising agencies, public relations firms, book publishers, magazine publishers, calendar companies.

Needs: Wants photos of environmental, landscapes/scenics, wildlife, adventure, sports, travel.

Specs: Uses color prints; 35mm, 2¼×2¼, 4×5, 8×10. Accepts images in digital format for Windows. Send via CD as TIFF files.

Payment & Terms: Pays on commission basis. Average price per image (to clients): $100 minimum for b&w photos or color photos. Enforces minimum prices. Offers volume discounts to customers; terms specified in photographers' contracts. Photographers can choose not to sell images on discount terms. Works with photographers with or without contract; negotiable. Contracts renew automatically with additional submissions for 2 years. Charges 50% filing fee. Statements issued quarterly. Payment made quarterly. Photographers allowed to review account records in cases of discrepancies only. Offers one-time rights. Informs photographers and allows them to negotiate when client requests all rights. Model release required; property release preferred. Photo captions required; include names of people, places.

Making Contact: Send query letter with tearsheets. Does not keep samples on file; include SASE for return of material. Expects minimum initial submission of 100 images with monthly submissions of at least 25 images. Reports in 1 month. Photo guidelines sheet free with SASE.

[⊕] TROPIX PHOTOGRAPHIC LIBRARY, 156 Meols Parade, Meols, Merseyside L47 6AN England. Phone/fax: 151-632-1698. E-mail: tropixphoto@postmaster.co.uk. Website: http://www.merseyworld.com/Tropix. Proprietor: Veronica Birley. Picture library specialist. Has 50,000 transparencies. Clients include: advertising agencies, book/encyclopedia publishers, magazine publishers, newspapers, government departments, public relations firms, businesses, calendar/card companies and travel agents.

Needs: "All aspects of the developing world and the natural environment. Detailed and accurate captioning according to Tropix guidelines is essential. Tropix documents the developing world from its economy and environment to its society and culture: education, medicine, agriculture, industry, technology and other developing world topics. Particularly need to show positive, modern aspects and the full range of environmental topics worldwide; only very recent stock except for historical prints." Also wants disasters, wildlife, religious, travel.

Specs: 35mm transparencies preferred; some medium and large format.

Payment & Terms: Pays 50% commission for b&w/color photos. Average price per image (to clients): £45-1,800 (English currency) for b&w and color photos. Offers guaranteed subject exclusivity. Charges cost of returning photographs by insured/registered post, if required and 50% duping fee. Statements made quarterly with payment. Photographers allowed to have qualified auditor review account records to verify sales figures in the event of a dispute but not as routine procedure. Offers one-time, electronic media and agency promotion rights. Informs photographer when a client requests all rights but agency handles negotiation. Model release preferred, for commercial use and for medical images. Full photo captions required; accurate, detailed data, to be supplied on disk. It is essential to follow guidelines available from agency.

Making Contact: Query with list of stock photo subjects and destinations, plus SAE/IRC (Stamped

International Reply Paid Coupon to value of £3) or download details from the website. "*No* unsolicited photographs, please." Reports in 1 month, sooner if material is topical. "On receipt of our leaflets, a very detailed reply should be made by letter. Transparencies are requested only after receipt of this letter, if the collection appears suitable. When submitting transparencies, always screen out those which are technically imperfect."

Tips: Looks for "special interest topics, accurate and informative captioning, sharp focus always, correct exposure, strong images and an understanding of and involvement with specific subject matters. Travel scenes, views and impressions, however artistic, are not required except as part of a much more informed, detailed collection. Not less than 100 saleable transparencies per country photographed should be available." Digital images supplied to clients by email or CD-ROM, but transparencies are still preferred.

N ⊕ ▣ ULLSTEIN BILDERDIENST, Ullstein GmbH, 65 Axel-Springer-Str., Berlin Germany 10888. Phone: (0049)30-2591-3608. Fax: (0049)30-2591-3896. E-mail: ubluebue@asv.de. Estab. 1950. Stock agency, picture library and news/feature syndicate. Has approximately 10 million photos in files. Clients include: advertising agencies, public relations firms, audiovisual firms, businesses, book publishers, magazine publishers, newspapers, calendar companies, greeting card companies, postcard publishers, TV companies.

Needs: Wants photos of celebrities, environmental, landscapes/scenics, wildlife, architecture, cities/urban, education, pets, religious, rural, automobiles, entertainment, events, health/fitness, hobbies, sports, travel, agriculture, buildings, computers, industry, medicine, military, political, portraits, science, technology. Interested in digital, documentary, fashion/glamour, historical/vintage, regional, seasonal.

Specs: Uses 180mm × 240mm color prints; 35mmm 2¼ × 2¼, 4 × 5 transparencies. Accepts images in digital format for Mac, Windows. Send via CD, e-mail, easy-transfer, LEONARDO as JPEG files at minimum 15mb decompressed.

Payment & Terms: Pays on commission basis. Works with photographers on contract basis only. Offers nonexclusive contract for 5 years minimum. Statements issued monthly, quarterly, annually. Payment made monthly, quarterly, annually. Photographers allowed to review account records in cases of discrepancies only. Offers one-time rights. Photo captions required; include date, names, events, place.

Making Contact: Send query letter with slides, prints, transparencies, stock list. Portfolio may be dropped off anytime. Expects minimum initial submission of 100 images with quarterly submissions of at least 50 images. Reports in 2 weeks.

ULTRASTOCK, INC., 6460 N. 77th Way, Scottsdale AZ 85250. (602)596-0099. Fax: (602)530-3686. E-mail: sherilyn1@ultrastock.com. President: Sherilyn McLain. Estab. 1997. Stock photo agency. Has 20,000 photos in files. Clients include: advertising agencies, public relations firms, businesses, book publishers, magazine publishers, newspapers, calendar companies, greeting card companies, postcard publishers.

Needs: Photos of babies, children, couples, families, parents, senior citizens, teens, wildlife, adventure, health/fitness, humor, buildings, computers, industry, technology, business, food, lifestyle, medical, people, sports, transportation, travel/scenic, and ethnic people—all ages. Interested in fashion/glamour, historical/vintage, regional, seasonal.

Specs: Uses color prints; 35mm, 2¼ × 2¼ transparencies.

Payment/Terms: Pays 50% commission on b&w and color photos. Average price per image (to clients): $200 minimum for b&w and color. Enforces strict minimum prices. Works with photographers on contract basis only. Offers nonexclusive contract, guaranteed subject exclusivity. Statements issued when paid—comes with check. "When we get paid, photographer gets paid." Photographers allowed to review account records "for their own account only." Model release required; property release is required; include recognizable people and places (privately owned). Photo captions required; include who, what, when, where and © with name.

Making Contact: Send query letter with sample, stock photo list, e-mail address. "We do not keep duplicates, but if you are submitting dupes for reference, please mark clearly with a 'D.'" Agency will contact photographer for portfolio review if interested. Keeps samples on file. Will return material with SASE. Expects minimum initial submission of 50 images. Reports in 1 month. Photo guidelines free with SASE. Market tips sheet free monthly to photographers signed with us.

Tips: "Call or e-mail. We are happy to talk about stock."

UNICORN STOCK PHOTOS L.L.C., 6501 Yankee Hill Rd., Lincoln NE 68516. (402)423-4747. Fax: (402)423-4742. E-mail: info@unicorn-photos.com. Website: http://www.unicorn-photos.com. President/Owner: Carol Prange. Has over 350,000 color slides. Clients include: advertising agencies, corporate accounts, textbooks, magazines, calendars and religious publishers.

Needs: Wants ordinary people of all ages and races doing everyday things at home, school, work and

play. Current skylines of all major cities, tourist attractions, historical, wildlife, seasonal/holiday, and religious subjects. "We particularly need images showing two or more races represented in one photo and family scenes with BOTH parents. There is a critical need for more minority shots including Hispanics, Asians and African-Americans. We also need ecology illustrations such as recycling, pollution and people cleaning up the earth." Also wants babies, children, couples, senior citizens, teens, disasters, landscapes, gardening, pets, rural, adventure, food/drink, health/fitness, hobbies, sports, travel, agriculture, buildings, regional.

Specs: Uses 35mm color slides.

Payment & Terms: Works on contract basis only. Offers nonexclusive contract. Contracts renew automatically with additional submissions for 4 years. Charges duping fee of $5. Statement issued quarterly. Payment made quarterly. Offers one-time, electronic media and agency promotion rights. Informs photographer and allows them to negotiate when client requests all rights. Model release preferred; increases sales potential considerably. Photo captions required; include: location, ages of people, dates on skylines.

Making Contact: Write first for guidelines. "We are looking for professionals who understand this business and will provide a steady supply of top-quality images. At least 500 images are generally required to open a file. Contact us by letter including $10 for our 'Information for Photographers' package."

Tips: "We keep in close, personal contact with all our photographers. Our monthly newsletter is a very popular medium for doing this. Our biggest need is for minorities and interracial shots. Because UNICORN is in the Midwest, we have many requests for farming/gardening/agriculture/winter and general scenics of the Midwest."

UNIPHOTO PICTURE AGENCY, a Pictor Group company, 3307 M St. NW, Suite 300, Washington DC 20007. (202)333-0500. Fax: (202)338-5578. East Coast Editor: John Henry Rice. West Coast Recruiter: Elizabeth Carr. Estab. 1977. Stock photo agency. Has more than 3.5 million images. Has 22 other branch offices worldwide. US photographers contact Washington DC. European photographers please see Pictor International in this section. Clients include: advertising agencies, public relations firms, designers, corporations, book/encyclopedia publishers, magazine publishers, display companies, calendar companies, greeting card companies and travel agencies.

Needs: Uniphoto is a general library and requires all stock subjects.

Specs: Uses 35mm, 2¼×2¼, 4×5 transparencies.

Payment & Terms: Buys photos outright occasionally. Payment "depends on the pictures." Pays 50% commission. Average fee per image (to clients): $250-30,000. Enforces strict minimum prices. Works on contract basis only. Contract terms may be negotiated. Contracts renew automatically with additional submissions for 5 years. Charges various rates for catalog insertion fees. Statements issued monthly. Payment made monthly within 3½ months. Offers one-time and all other commercial rights. "When client requests all rights, we negotiate with photographer's permission." Model/property release required. Captions required.

Making Contact: Query with résumé of credits and non-returnable samples. Keeps samples on file. SASE. Reports in 4 months on queries; up to 2 weeks on portfolio submissions. Portfolio submission guidelines free with SASE. Market tips sheet distributed to Uniphoto photographers only.

Tips: "Portfolios should demonstrate the photographer's creative and technical range. We seek professional photographers and accomplished fine artists with commercial potential as well as experienced stock photographers."

THE VIESTI COLLECTION, INC., P.O. Box 4449, Durango CO 81302. (970)382-2600. Fax: (970)382-2700. E-mail: photos@theviesticollection.com. President: Joe Viesti. Estab. 1987. Stock photo agency. Has 30 affiliated foreign sub-agents. Clients include: advertising agencies, businesses, book/encyclopedia publishers, magazine publishers, calendar companies, greeting card companies, design firms.

Needs: "We are a full service agency."

Specs: Uses 35mm, 2¼×2¼, 4×5, 6×7, 8×10 transparencies; both color and b&w transparencies.

Payment & Terms: Charges 50% commission. "We negotiate fees above our competitors on a regular basis." Works on contract basis only. "Catalog photos are exclusive." Contract renews automatically for 5 years. Charges duping fees "at cost. Many clients now require submission of dupes only." Statements issued quarterly. "Payment is made quarterly after payment is received. Rights vary. Informs photographer and allows them to negotiate when client requests all rights. Model/property release preferred. Captions required.

Making Contact: Query with samples. Send no originals. Send dupes or tearsheets only with bio info and size of available stock; include return postage if return desired. Samples kept on file. Expects minimum submissions of 500 edited images; 100 edited images per month is average. Submissions edited and returned usually within one week. Catalog available for fee, depending upon availability.

Tips: There is an "increasing need for large quantities of images for interactive, multimedia clients and

traditional clients. There is no need to sell work for lower prices to compete with low ball competitors. Our clients regularly pay higher prices if they value the work."

[N] VIEWFINDERS, C. Bruce Forster Photography, 1325 NW Flanders, Portland OR 97209. (503)417-1545. Fax: (503)274-7995. E-mail: studio@europa.com. Website: http://www.viewfindersnw.com. Director: JoAnn Calfee. Estab. 1996. Stock agency. Member of the Picture Agency Council of America (PACA). Has 70,000 photos in files. Clients include: advertising agencies, public relations firms, businesses, book publishers, magazine publishers.
Needs: All images should come from the Pacific Northwest-Oregon, Washington, Northern California, British Columbia and/or Idaho. Wants photos of babies, celebrities, children, couples, multicultural, families, parents, senior citizens, teens, cities/urban, education, gardening, rural, adventure, events, health/fitness, sports, travel, business concepts, computers, industry, science, technology. Interested in alternative process, avant garde, regional.
Specs: Uses 35mm, 2¼×2¼, 4×5, 8×10 in original format.
Payment & Terms: Pays 50% commission for b&w and color photos. Works with photographers on contract basis only. Offers limited regional exclusivity. Statements issued monthly. Payment made monthly. Photographers allowed to review account records. Model/property release preferred. Photo captions required.
Making Contact: Send query letter with résumé, slides, stock list. Keeps samples on file; include self-promotion piece to be kept on file. Expects minimum initial submission of 200 images. Reports in 1-2 months. Photo guidelines sheet free with SASE.
Tips: "Know as much as possible about the agency. Viewfinders is a regional niche agency specializing in the Pacific Northwest; therefore I can't use images of zebras! Be prepared to make regular submissions. ◊Be professional. Edit, Edit, Edit. Please call or e-mail before submitting material."

[■] VINTAGE IMAGES, P.O. Box 4699, Silver Spring MD 20914. (301)879-6522. Fax: (301)879-6524. E-mail: vimages@erols.com. Website: http://www.vintageimages.com. President: Brian Smolens. Estab. 1987. Has 50,000 photos in files. Advertising agencies, businesses, book publishers, greeting card companies, postcard publishers.
Needs: Wants photos of babies, children, couples, families, parents, architecture, beauty, pets, religious, adventure, entertainment, events, food/drink, health/fitness, hobbies, humor, sports, travel, agriculture, buildings, business concepts, computers, industry, medicine, military, political, portraits, product shots/still life, science, technology. Interested in documentary, erotic/nudes, historical/vintage.
Specs: Uses 8×10 b&w prints; 35mm transparencies. Accepts images in digital format for Mac, Windows. Send via CD, Zip as TIFF files at 300 dpi.
Payment & Terms: Buys photos outright; pays $10-150 for b&w and color photos. Pays 10% commission for b&w and color photos. Average price per image (to clients): $250-1,500 for b&w and color photos. Negotiates fees below stated minimums for bulk usage. Offers volume discounts to customers; terms specified in photographers' contracts. Discount sales terms not negotiable. Works with photographers on contract basis only. Offers nonexclusive contract; guaranteed subject exclusivity. Statements issued quarterly. Payments made quarterly. Photographers allowed to review account records. Offers one-time, electronic media and agency promotion rights. Model release required. Photo captions preferred.
Making Contact: Send query letter with photocopies. Provide self-promotion piece to be kept on file. Expects minimum initial submission of 125 images. Reports in 2 months on samples. Reports back only if interested; send non-returnable samples. Photo guidelines free with SASE. Catalog available for $3.
Tips: "We are developing a series of CD-ROM semi-royalty free disks (not royalty-free for commercial usage); 125 images at average price of $125. Photographers need 125 images on each theme: computers, industrial, medical, etc. We will consider all periods. Formats and themes will be considered. Do not submit anything requiring return. If we can't keep it on file—no value."

VIREO (Visual Resources for Ornithology), The Academy of Natural Sciences, 1900 Benjamin Franklin Pkwy, Philadelphia PA 19103-1195. (215)299-1069. Fax: (215)299-1182. E-mail: vireo@acnatsci.org. Website: http://www.acnatsci.org/vireo. Director: Doug Wechsler. Estab. 1979. Picture library. "We specialize in birds only." Has 90,000 photos in files. Clients include: advertising agencies, businesses, book publishers, magazine publishers, newspapers, calendar companies, CD-ROM publishers.
Needs: "Wants high-quality photographs of birds from around the world with special emphasis on behavior. All photos must be related to birds or ornithology."
Specs: Uses 35mm, 2¼×2¼ transparencies.
Payment/Terms: Pays 50% commission for b&w and color photos. Average price per image (to clients): $125. Negotiates fees below stated minimums; "we deal with many small nonprofits as well as commercial clients." Offers volume discounts to customers. Discount sales terms not negotiable. Works with photogra-

phers on contract basis only. Offers nonexclusive contract. Statements issued semiannually; payments made semiannually. Offers one-time rights. Model release preferred when people are involved. Photo captions preferred; include date, location.

Making Contact: Send query letter. To show portfolio, photographer should follow-up with a call. Reports in 1 month on queries. Catalog not available.

Tips: "Write describing the types of bird photographs you have, the type of equipment you use, and where you do most of your bird photography. We are currently sending scanned images to clients over the Internet. We expect to expand electronic offerings dramatically in the future. Edit work carefully."

■ **VISIONQUEST**, P.O. Box 8005, Charlotte NC 28203. (704)525-4800; (800)801-6717. Fax: (704)525-7030. E-mail: atvisionquest@mindspring.com. Website: http://www.atvisionquest.com. Owner: Pamela Brackett. Estab. 1994. Has 200,000 photos. Clients include: advertising agencies, businesses, newspapers, postcard publishers, public relations firms, book/encyclopedia publishers, calendar companies, audiovisual firms, magazine publishers and greeting card companies.

Needs: Wants photos of babies, children, couples, multicultural, families, parents, senior citizens, teens, cities/urban, pets, religious, rural, adventure, events, health/fitness, humor, performing arts, sports, travel, agriculture, buildings, business concepts, computers, industry, medicine, military, political, portraits, product shots/still life, science, technology.

Specs: Uses transparencies. Accepts images in digital format for Windows. Send via CD, Zip as JPEG files at 300 dpi.

Payment & Terms: Pays 50% commission on b&w and color photos. Average price per image (to clients): $400 for b&w and color photos. Offers volume discounts to customers; terms specified in photographer's contract. Works on contract basis only. Offers limited regional exclusivity contracts. Contracts renew automatically with additional submissions after 5 years. Statements issued annually. Payment made semiannually. Offers one-time rights. "If client pays more they can get more usage rights. But, this is not recommended. We will negotiate with client if approved by photographer." Model release required. Property release preferred. Captions required.

Making Contact: Query with résumé of credits, samples, stock photo list. Keeps samples on file. SASE. Expects minimum intial submission of 200 images. Reports in 1-2 weeks. Photo guidelines free with SASE. Catalog available. VisionQuest offers seminars and lectures to organizations and clients.

Tips: Looking for "professional photographers with excellence, creativity and personal style who are committed to shooting stock."

■ **VISUAL CONTACT**, 2100 Bloor St. W., Suite 6-146, Toronto, Ontario M6S 5A5 Canada. (416)532-8131. Fax: (416)532-3792. E-mail: viscon@interlog.com. Website: http://www.interlog.com/~viscon. President: Thomas Freda. Library Administrator: Jacqueline Brunshaw. Estab. 1990. Stock photo agency. Has applied to become PACA member. Has 30,000 photos. Clients include: advertising agencies, public relations firms, businesses, book/encyclopedia publishers, magazine publishers, calendar and greeting card companies.

Needs: Interested in photos of people/lifestyle, people/corporate, industry, nature, travel, science and technology, medical, food.

Specs: Uses transparencies.

Payment & Terms: Pays 50% commission on color photos. Offers volume discounts to customers; inquire about specific terms. Works with or without signed contract, negotiable. Offers exclusive only, limited regional, nonexclusive, or guaranteed subject exclusivity contracts. Contracts renew automatically with additional submissions for 1 year (after first 5 years). Charges 100% duping fee, 100% mounting, 100% CD/online service. Statements issued quarterly. Payment made quarterly. Photographers allowed to review account records in cases of discrepancies only. Offers one-time rights. Informs photographer and allows them to negotiate when client requests all rights. Model/property release required. Captions required; include location, specific names, i.e. plants, animals.

Making Contact: Arrange personal interview to show portfolio. Query with résumé of credits, samples and/or stock photo list. Keeps samples on file. SAE/IRC. Expects minimum initial submission of 100-200 images. Reports in 4-6 weeks. Photo guidelines free with SAE/IRC. Market tips sheet distributed free with SAE/IRC; also available, along with periodic newsletter, at website.

■ **VISUAL HELLAS**, Yoel Miller & Co., Ltd., 26 Akadimias St, 3rd Floor, Athens Greece 10671. Phone: (+301) 3611064. Fax: (+301) 3628886. E-mail: visual@compulink.glz. Managing Director: Nikos Arouch. Estab. 1994. Stock agency. Has 1 million photos in files. Has 1,000 hours film or video footage. Clients include: advertising agencies, public relations firms, audiovisual firms, businesses, book publishers, magazine publishers, calendar companies, internet providers.

Needs: "We prefer images of Greek, Italian and European people." Wants photos of babies, celebrities,

children, couples, families, parents, senior citizens, teens, environment, landscapes/scenics, wildlife, architecture, beauty, cities/urban, education, interiors/decorating, rural, adventure, entertainment, food/drink, health/fitness, hobbies, humor, sports, travel, agriculture, buildings, business concepts, computers, industry, medicine, portraits, product shots/still life, science, technology. Interested in alternatiave process, avant garde, digital, erotic, fashion/glamour, seasonal.

Specs: Uses 20×30, glossy, color and/or b&w prints; 35mm, 2¼×2¼, 4×5 transparencies. Preview VHS/PAL or U-matic/PAL. Accepts images in digital format for Windows. Send via CD, e-mail as TIFF, JPEG files at 72 dpi.

Payment & Terms: Pays 50% commission for b&w and color photos; film; videotape. Average price per image (to clients): $50-250 for b&w photos; $60-280 for color photos; $70-1,000 for film; $250-1,500 for videotape. Enforces strict minimum prices. Offers volume discounts to customers. Photographers can choose not to sell iamges on discount terms. Works with photographers on contract basis only. Offers limited regional exclusivity. Contracts renew automatically with additional submissions; negotiable. Charges $3 per image. Statements issued monthly. Payment made quarterly. Photographers allowed to review account records. Offers one-time rights. Model/property release preferred. Photo captions required.

Making Contact: Send query letter with résumé, photocopies, stock list. Provide résumé, self-promotion piece to kept on file. Expects minimum initial submission of 100 images with monthly submissions of at least 20 images. Reports in 2 weeks on samples; 3 weeks on portfolios. Reports back only if interested; send non-returnable samples.

Tips: "Work should be original."

Ⓝ ⊕ ▣ ▨ VISUAL PHOTO LIBRARY, 5 Hashla, Tel Aviv Israel 62283. Phone: (972).3.544-5583. Fax: (972).3.544-5653. E-mail: visual@visual.co.il. Website: http://www.visual.co.il. Sales Manager: Tammy Miller. Estab. 1989. Stock agency. Member of the Picture Agency Council of America (PACA). Has 500,000 photos in files. Has 2 branch offices in Athens Greece and Istanbul Turkey. Clients include: advertising agencies, audiovisual firms, book publishers, magazine publishers, newspapers, calendar companies.

Needs: Wants photos of babies, children, families, teens, beauty, religious, food/drink, health/fitness, sports, business concepts, computers, medicine.

Specs: Uses 35mm, 2¼×2¼ transparencies; VHS PAL. Accepts images in digital format for Mac, Windows. Send via CD, floppy disk, e-mail as JPEG files.

Payment & Terms: Pays 50% commission for b&w and color photos; film; videotape. Average price per image (to clients): $100-10,000 for color photos. Offers volume discounts to customers. Discount sales terms not negotiable. Works with photographers with or without a contract; negotiable. Offers limited regional exclusivity. Contracts renew automatically with additional submissions. Statements issued monthly. Payment made monthly. Photographers allowed to review account records. Offers one-time, electronic media and agency promotion rights. Informs photographers and allows them to negotiate when client requests all rights. Model release required; property release preferred. Photo captions required.

Making Contact: Send query letter with stock list.

▨ VISUALS UNLIMITED, Dept. PM, P.O. Box 10246, Swanzey NH 03446-0246. (603)352-6436. Fax: (603)357-7931. E-mail: visualsunlimited@monad.net. President: Dr. John D. Cunningham. Stock photo agency and photo research service. Has over 600,000 photos. Clients include: advertising agencies, public relations firms, audiovisual firms, businesses, book/encyclopedia publishers, magazine publishers, CD-ROM producers, television and motion picture, postcard, calendar and greeting card companies.

Needs: Wants all fields: biology, environmental, medical, natural history, geography, history, scenics, chemistry, geology, physics, industrial, astronomy and general (including babies, children, couples, multicultural, families, parents, senior citizens, teens, architecture, beauty, cities/urban, education, gardening, interiors/decorating, pets, religious, rural, adventure, automobiles, entertainment, food/drink, heatlh/fitness, hobbies, humor, sports, travel, agriculture, buildings, business concepts).

Specs: Uses 5×7 or larger b&w prints; 35mm, 2¼×2¼, 4×5 and 8×10 transparencies.

Payment & Terms: Pays 50% commission for b&w and color photos; film; videotape. Negotiates fees based on use, type of publication, user (e.g., nonprofit group vs. publisher). Average price per image (to clients): $30-90/b&w photo; $50-190/color photo. Offers volume discounts to customers; terms specified in contract. Photographers can choose not to sell images on discount terms. Works on contract basis only. Offers nonexclusive contract. Contracts renew automatically for an indefinite time unless return of photos is requested. Statements issued monthly. Payment made monthly. Photographers not allowed to review account records to verify sales figures; "All payments are exactly 50% of fees generated." Offers one-time rights. Informs photographer and allows them to negotiate when client requests all rights. Model release preferred. Captions required.

Making Contact: Query with samples or send unsolicited photos for consideration. Submit portfolio for

review. SASE. Reports in 3 weeks. Photo guidelines free with SASE. Distributes a tips sheet several times/ year as deadlines allow, to all people with files.

Tips: Looks for "focus, composition and contrast, of course. Instructional potential (e.g., behavior, anatomical detail, habitat, example of problem, living conditions, human interest). Increasing need for exact identification, behavior, and methodology in scientific photos; some return to b&w as color costs rise. Edit carefully for focus and distracting details; submit anything and everything from everywhere that is geographical, biological, geological, environmental and people oriented."

N **VISUM/+49**, Lange Reihe 29, 20099 Hamburg Germany. Phone: +49(0) 40.280 13 83. Fax: +49(0) 40.280 18 52. E-mail: visum@aol.com. Website: http://www.plus49.com or http://www.visum-photo.com. Managing Directors: Lars Bauernschmitt, Alfred Buellesbach. Estab. 1975. Stock agency. Has 1 million photos in files. Clients include: advertising agencies, public relations firms, businesses, book publishers, magazine publishers, newspapers.

Needs: Wants journalistic features, photos of disasters, environmental, landscape/scenics, cities/urban, adventure, health/fitness, travel, industry, medicine, political, science, technology.

Specs: Uses size 35mm, $2\frac{1}{4} \times 2\frac{1}{4}$ transparencies.

Payment & Terms: Pays 50% commission for color photos. "We use the fee recommendations of German Association of Photo-agencies (BVPA). Prices depend on type of market." Works with photographers on contract basis only. Offers limited regional exclusivity. Statements issued monthly. Payment made monthly. "A third party (lawyer, auditor . . .) who is required to maintain confidentiality by reason of his profession and who is instructed by the photographer may inspect the books and documents to check the statements of account." Offers one-time rights. Informs photographers and allows them to negotiate when client requests all rights. Photo captions required.

Making Contact: Send query letter with stock list. Keeps samples on file only after agreement.

Tips: "Before submitting work, contact our editor; he will explain our demands. We want to avoid submissions which do not fit in our market."

WESTLIGHT, 2223 S. Carmelina Ave., Los Angeles CA 90064. This agency was recently acquired by Corbis. See the Corbis listing in this section.

THE WILDLIFE COLLECTION, Division of Cranberry Press Inc., 166 W. Park Ave., 2nd Floor, Long Beach NY 11561. (516)432-8000. Fax: (516)889-6665. E-mail: office@wildlifephoto.com. Website: http://www.wildlifephoto.com. Director: Sharon A. Cohen-Powers. Estab. 1987. Stock photo agency. Has 250,000 photos. Clients include: advertising agencies, public relations firms, businesses, book/encyclopedia publishers, magazine publishers, newspapers, postcard, calendar and greeting card companies, zoos and aquariums.

Needs: "We handle anything to do with nature—animals, scenics, vegetation, underwater. We are in particular need of coverage from India, the Caribbean, Europe, Western Africa, South and Central America and the Middle East, as well as endangered animals, in particular bonobos and other primates and California Condors. We also need pets and farm animals, environmental and disasters."

Specs: Uses 35mm, $2\frac{1}{4} \times 2\frac{1}{4}$, 4×5, $4\frac{1}{2} \times 6$ transparencies.

Payment & Terms: Pays 50% commission on color photos. Average price per image (to clients): $200-6,000 or higher. Works on contract basis only. Minimum US exclusivity but prefers world exclusivity. Contracts renew automatically for 1 year. There are no charges to be included in catalogs or other promotional materials. Statements issued quarterly. Payment made quarterly. Photographers allowed to review sales figures. Offers one-time rights. Informs photographers when client requests all rights, "but they can only negotiate through us—not directly." Model release "not necessary with nature subjects." Photo captions required; include common, scientific name and location where taken.

Making Contact: Interested in receiving work from newer, lesser-known photographers, as well as more established photographers. Query with samples. SASE. Expects minimum initial submission of 200 images. "We would like 2,000 images/year; this will vary." Reports in 2 weeks. Photo guidelines and free catalog with $6\frac{1}{2} \times 9\frac{1}{2}$ SAE and 77¢ postage. Market tips sheet distributed quarterly to signed photographers only.

Tips: In samples, wants to see "great lighting, extreme sharpness, *non-stressed* animals, large range of subjects, excellent captioning, general presentation. Care of work makes a large impression. The effect of humans on the environment is being requested more often as are unusual and endangered animals. Write or e-mail us for guidelines. Make sure you have at least 2,000 images that are stock worthy before asking for guidelines."

WILDLIGHT PHOTO AGENCY, 87 Gloucester St., The Rocks, NSW 2000 Australia. Phone: 61-2-9251-5852. Fax: 61-2-9251-5334. E-mail: wild@geko.com.au Website: http://www.wildlight.com.au Contact: Manager. Estab. 1985. Photo agency and picture library. Has 300,000 photos. Clients include:

advertising agencies, public relations firms, audiovisual firms, businesses, book/encyclopedia publishers, magazine publishers, newspapers, postcard publishers, calendar and greeting card companies.
Specs: Uses 35mm, 4×5, 6×12, 6×17 transparencies.
Payment & Terms: Pays 50% commission on color photos. Works on exclusive contract basis only. Statements issued quarterly. Payment made quarterly. Offers one-time rights. Model/property release required. Captions required.
Making Contact: Arrange personal interview to show portfolio. Expects minimum initial submission of 1,000 images with periodic submission of at least 250/quarterly. Reports in 1-2 weeks. Photo guidelines available.

N: ⊕ WINDRUSH PHOTOS, 99 Noah's Ark, Kemsing, Sevenoaks, Kent TN15 6PD United Kingdom. Phone: (01732) 763486. Fax: (01732) 763285. Owner: David Tipling. Estab. 1990. Stock agency. Has 120,000 photos in files. Clients include: advertising agencies, public relations firms, audiovisual firms, book publishers, magazine publishers, newspapers, calendar companies, greeting card companies, postcard publishers. "Member of British Association of Picture Libraries & Agencies."
Needs: Specializes in birds. Wants photos of environment, panoramic landscapes/scenics, wildlife.
Specs: Uses 35mm, 2¼×2¼, 4×5, 8×10, 6×17 transparencies.
Payment & Terms: Pays 50% commission for b&w and color photos. Average price per image (to clients): $70 minimum for color photos. Negotiates fees below standard minimums for bulk sales (100+ pictures sold to single client for specific project). Offers volume discounts to customers. Discount sales terms not negotiable. Works with photographers with or without contract; negotiable. Offers nonexclusive contract. Statements issues semiannually. Payment made semiannually. Offers one-time rights. Model release required. Photo captions required.
Making Contact: Send query letter with résumé, tearsheets, stock list. Does not keep samples on file. Expects minimum initial submission of 200 images. Reports back only if interested; send non-returnable samples. Photo guidelines sheet free with SAE/IRC.
Tips: "Write outlining work offered—ideally including nonreturnable tearsheets. All transparencies should be presented in clear plastic filing wallets for ease of editing and should have typewritten labels. Due to the competitive market in the UK, we are only interested in seeing photographers' very best work."

⊕ WORLD PICTURES, 85A Great Portland St., London W1N 5RA England. Phone: (0171)437 2121. Fax: (0171)439 1307. Director: Carlo Irek. Stock photo agency. Has 750,000 photos in files. Clients include advertising agencies, businesses, book publishers, magazine publishers, newspapers, calendar companies, postcard publishers, tour operators.
Specs: Uses 2¼×2¼ and 4×5 transparencies.
Payment/Terms: Pays 50% commission. Discounts offered to valued clients making volume use of stock images. Discount sales terms not negotiable. Works with photographers with or without a contract, negotiable. Offers limited regional exclusivity. Contracts renew automatically with additional submissions. Statements issued quarterly. Payments made quarterly. Offers one-time rights. Model release required; property release preferred. Photo captions required.
Making Contact: Send query letter with samples. To show portfolio, photographer should follow-up with call. Portfolio should include transparencies. Reports in 2 weeks. Catalog not available.
Tips: "We are planning to market images via computer networks and CD-ROMs in the future."

WORLDWIDE IMAGES, P.O. Box 150547, San Rafael CA 94915. (415)383-7299. Owner: Norman Buller. Estab. 1988. Stock photo agency. Has 8,000 photos. Clients include: publishers, magazine publishers, postcard, calendar and greeting card companies and men's magazines, foreign and domestic.
Needs: Nude layouts for men's magazines, foreign and domestic; celebrities, rock stars, all professional sports teams, glamour, swimsuit—"anything in this field!" Subjects include disasters, wildlife, automobiles, entertainment, events, humor, performing arts, fashion/glamour.
Specs: Uses medium format and 4×5 transparencies.
Payment & Terms: Pays 50% commission on all sales. Works with or without a signed contract, negotiable. Average price per image (to client): $25 minimum for b&w and color photos. Offers nonexclusive contract. Statements issued upon request. Payment made immediately upon payment from client. Photographers allowed to review account records to verify sales figures. Offers one-time or first rights and all rights. Informs photographer and allows them to negotiate when client requests all rights but handles all negotiation. Model release required. Captions required.
Making Contact: Query with samples and list of stock photo subjects. Send unsolicited photos by mail for consideration. Reports immediately.
Tips: "Work must be good. Don't edit too tightly; let me see 90% of your material on hand and critique it from there. We're getting new clients from around the world every week and have more clients than

photos! We need new and varied photographers ASAP! We are the best agency for new photographers trying to break into this field. We work very hard for each and every photographer we have."

N ⊕ ▣ **ZEFA VISUAL MEDIA**, A.J. Ernstraat 665A, Amsterdam Netherlands 1082-LG. Phone: (31)20-6613866. Fax: (31)20-6613734. E-mail: info@zefa.nl. Website: http://www.zefa.nl. Director: Ton Mascini. Estab. 1991. Stock agency. Member of the Picture Agency Council of America (PACA). Has 150,000 photos in files. Has 100 hours of film/video footage. Clients include: advertising agencies, businesses, book publishers, magazine publishers, calendar companies, greeting card companies, postcard publishers.

Needs: Wants photos of babies, children, couples, families, parents, senior citizens, teens, disasters, environmental, landscapes/scenics, wildlife, architecture, beauty, cities/urban, education, gardening, interiors/decorating, pets, adventure, food/drink, health/fitness, hobbies, humor, performing arts, sports, travel, agriculture, buildings, business concepts, computers, industry, medicine, portraits, product shots/still life, science, technology. Interested in alternative process, digital, fashion/glamour, historical/vintage, seasonal.

Specs: Uses 35mm, 2¼×2¼, 4×5 transparencies; ¾ PAL.

Payments & Terms: Pays 50% commission for b&w photos; film; videotape. Average price per image (to clients): $110 minimum for b&w and color photos; $130 minimum for film; $130 minimum for videotape. Enforces minimum prices. Offers volume discounts to customers. Discount sales terms not negotiable. Works with photographers on contract basis only. Offers limited regional exclusivity. Contracts renew automatically with additional submissions. Statements issued monthly. Payment made monthly. Photographers allowed to review account records in cases of discrepancies only. Offers one-time, electronic media rights. Model release required; property release preferred. Photo captions required.

Making Contact: Send query letter with transparencies, stock list. Reports in 2 months on samples.

Tips: "We do not market material worldwide. But we guarantee 50% of our gross sales in the Netherlands and Belgium without any tax deduction or bank costs in our countries."

▣ **ZEPHYR IMAGES**, 339 N. Highway 101, Solana Beach CA 92075-1130. (619)755-1200. Fax: (619)755-3723. Owner: Leo Gradinger and R. Robinson. Estab. 1982. Stock photo agency. Member of Picture Agency Council of America (PACA). Also commercial photo studio. Has 400,000 photos. Clients include: advertising agencies, public relations firms, audiovisual firms, businesses, book/encyclopedia publishers, magazine publishers, newspapers, postcard and calendar companies, developers, corporate, finance, education, design studios and TV stations.

Needs: "Our image library is very diverse, but our specialty is model released people, buisness and lifestyle imagery."

Specs: Uses 35mm, 2¼×2¼, 4×5, 8×10, 6×7 transparencies. Accepts images in digital format for Windows. Send via compact, floppy or Zip disk as JPEG or TIFF.

Payment & Terms: Pays 50% commission for b&w and color photos. Average price per image (to client): $868. Enforces strict minimum prices. Sub-agency agreement 50% domestic, 40% to photographer on foreign sales. Offers volume discounts to customers; inquire about specific terms. Discount sales terms not negotiable. Works on contract basis only. Offers limited regional exclusivity. Contracts renew automatically for three years, auto-renewal each year thereafter. Statements issued monthly. Payment made monthly. Photographers allowed to review account records to verify sales figures. Offers one-time, electronic and agency promotion rights. Model/property release required. Captions required.

Making Contact: "We are always interested in reviewing the work of photographers who understand the demands and requirements needed to be successful in stock photography. Call first for our submission guideline package."

Tips: "We are looking for photographers who specialize in model released lifestyle imagery. Licensing fees will remain high for this type of photography and it is little influenced by the royalty-free market. We are known for the very best people, business and lifestyle photography since 1981. Catalog participation encouraged."

THE GEOGRAPHIC INDEX, located in the back of this book, lists markets by the state in which they are located.

Advertising, Design
& Related Markets

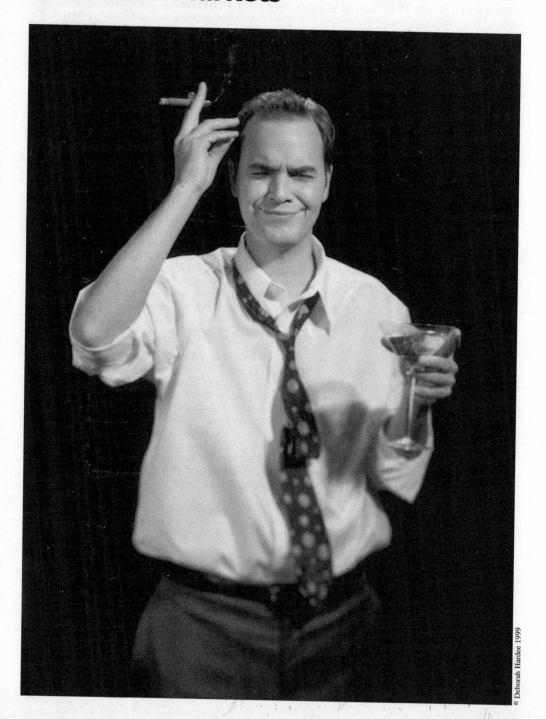

COMMERCIAL PHOTOGRAPHY

Advertising photography is always "commercial" in the sense that it is used to sell a product or service. However, assignments from ad agencies and graphic design firms can be some of the most creative and exciting that you'll ever receive.

Breaking into this lucrative market is challenging at best. You'll need to target your promotions specifically and show prospective clients only your best work. You may even want to shoot a mock assignment for one of an agency's large clients to show how much you'd like to work for them.

When you're beginning your career in advertising photography, it is usually easier to start close to home. That way, you can make appointments to show your portfolio to art directors. Meeting the photo buyers in person can show them that you are not only a great photographer but that you'll be easy to work with as well. This section is organized by region to make it easy to find agencies close to home.

When you're just starting out you should also look closely at the agency descriptions at the top of each listing. Agencies with smaller annual billings and fewer employees are more likely to work with newcomers. On the flip side, if you have a sizable list of ad and design credits, larger firms may be more receptive to your work and be able to pay what you're worth.

Trade magazines such as *HOW*, *Print*, *Communication Arts* and *Graphis* are good places to start when learning about design firms. These magazines not only provide information about how designers operate, but they also explain how creatives use photography. For ad agencies, try *Adweek* and *Advertising Age*. These magazines are more business oriented, but they reveal facts about the top agencies and about specific successful campaigns. (See Helpful Resources for Photographers on page 565 for ordering information.)

Regions

- **Northeast & Midatlantic**: Connecticut, Delaware, Maine, Maryland, Massachusetts, New Hampshire, New Jersey, New York, Pennsylvania, Rhode Island, Vermont, Washington DC.
- **Midsouth & Southeast**: Alabama, Arkansas, Florida, Georgia, Louisiana, Mississippi, North Carolina, South Carolina, Tennessee, Virginia, West Virginia.
- **Midwest & North Central**: Illinois, Indiana, Iowa, Kentucky, Michigan, Minnesota, Nebraska, North Dakota, Ohio, South Dakota, Wisconsin.
- **South Central & West**: Arizona, California, Colorado, Hawaii, Kansas, Missouri, Nevada, New Mexico, Oklahoma, Texas, Utah.
- **Northwest & Canada**: Alaska, Canada, Idaho, Montana, Oregon, Washington, Wyoming.
- **International**

◀ Computer giant IBM hired Deborah Hardee to create several images that would caricature the IBM sales force for a brochure introducing a new product line to them. This image of a "swinging GenXer" is in an outtake from the shoot that Hardee is particularly fond of. (Deborah Hardee explains how she uses a personal touch to promote her photography business to national clients on page 404.)

Handmade success: Deborah Hardee cracks the advertising market with a personal touch

Deborah Hardee

There is an infectious calm that flows through photographer Deborah Hardee. It hovers in her deep, melodic voice and wide smile. It settles lovingly on the personal images she creates as promotion pieces for her busy commercial studio. The individually printed, often hand-painted images she sends to potential clients have landed her advertising assignments for such corporate giants as IBM, Hewlett Packard, Nabisco and John Paul Mitchell Systems. Perhaps it is the whisper in her work that makes it stand out from the barrage of louder images that land on art directors' desks.

Hardee transfers the individual attention she pays to her images to each contact she cultivates for her business. "For me, it's a slow growing process," she says. "I hand pick them or sometimes names will come to me via photography friends or people who call. For example, PC Computing called in my portfolio, and I didn't get selected for the job, but the editor loved my work and wants me to keep in touch. So I continue to market to that person."

Hardee began the slow process of growing her business in 1989 when she opened her studio in Boise, Idaho. "In 1986, I decided I wanted to open a studio, but it took me three years to figure out how that was going to happen. I actually opened it with another photographer and three months after we opened, he decided he really did not want to do photography anymore."

Personal work gave Hardee a way to generate free press for her fledgling studio in the form of gallery shows. "I did fine art exhibitions and it was always covered in the paper with a photo. I got known from my exhibits. When I started to promote the studio, a lot of people knew me already before I contacted them directly, which was good because I was much more shy then than I am now."

Hardee relied on local photo buyers when she first started her business. To tackle larger clients, she turned to tightly targeted direct mail campaigns, researching potential clients by reading trade magazines like *Graphis, Communication Arts, Print* and *HOW*. This year, she decided to expand her marketing efforts by hiring a part-time marketing assistant.

"Because I spend so much time shooting and doing more personal follow-up with clients, I needed someone to do the day-to-day marketing tasks," Hardee explains. "I'm getting more and more aggressive with my marketing. It just became obvious that I needed help because I should be behind the camera or talking and getting to know people who will lead me to jobs."

And Hardee has found plenty of jobs from advertisers across the U.S. While many big-time ad shooters struggle to keep expensive studios on the coasts, Hardee finds life in Boise idyllic. "The quality of life is very sweet. It's great. Idaho has some of the best white-water rafting in the world, the most gorgeous wilderness mountains," she says. "I grew up in Los Angeles and lived in San Francisco and Phoenix. I'd probably be in a much bigger city if my family wasn't here."

But Hardee says many commercial photographers are finding ways to work from wherever they choose to live. "I think more and more you see people like Lori Adamski-Peek who lives in Park City, Utah, or Andy Anderson who lives in Mountain Home, Idaho, and there are a lot of big shooters in Sun Valley," she says.

And while finding top-notch clients requires a stringent marketing program, Hardee has been in business long enough that clients also seek her out. "I think some clients have found me through the ASMP Membership Directory," she says.

Networking through organizations like ASMP has been very important for her busi-

"I always show personal work to corporate buyers," says Deborah Hardee. The image on the left of Greg Red Elk, a Sioux Indian, is part of an ongoing personal project. Hardee advises all commercial photographers to show the kind of work they want to do more of. A fine art exhibition led to an assignment for Hewlett Packard. The image on the right is from an HP brochure promoting scanners.

ness. Hardee was able to use her four years as a Chapter President to bring in photography consultants from around the country to speak to the group. "I've consulted with both Elyse Weissberg and Selina Oppenheim and I think they're both great," she says.

Hardee also took full advantage of the networking opportunities at the PhotoPlus Expo in New York last Fall. "PhotoPlus was so extraordinary for me," she says. "I can't wait to go back again. I think it's really important to be open all the time. It's the six degrees of separation."

To reach out one more degree, Hardee plans to build a website for her business this year. "I want a way of communicating what I do quickly to people I'm already in contact with. For example, if *Inc.* magazine calls to see my work, I can send a portfolio but also offer the website where they can look at additional photographs."

Even with a website, Hardee still plans to send customized portfolios to potential clients. "What I select to put in my portfolio when I send it out is based upon the feedback I'm getting from the art director," she explains. This synergy of listening and communicating is part of what helps Hardee sell her very personal style of image-making, which leads to powerful commercial work.

"A lot of times what I show in my portfolios is personal work. My fine art work dramatically influences my commercial work. The Hewlett Packard piece I did is beautiful and it was a spin-off from a fine art exhibition. First I was a fine artist, then I became a commercial artist and I love the connection between the two of them. I think they are so interconnected and intermingled."

—*Megan Lane*

REGIONAL REPORT: NORTHEAST & MIDATLANTIC

This region encompasses states from Maine to Maryland including the advertising mecca of New York city. The main industries in this region vary from medical products to aircraft engines to publishing to clothing and textiles. Here you'll find heavy hitters like Saatchi & Saatchi and Ogilvy & Mather creating advertising campaigns for Procter & Gamble and Pepsi.

Leading national advertisers

American Express, New York NY
American Home Products, New York NY
AT&T, New York NY
Bell Atlantic Corp., New York NY
Bristol-Myers Squibb, New York NY
Campbell Soup Co., Camden NJ
Colgate-Palmolive, New York NY
Eastman Kodak Corp., Rochester NY

Estee Lauder, New York NY
General Electric Co., Fairfield CT
Gillette Co., Boston MA
Hershey Foods Corp., Hershey PA
IBM Corp., Armonk NY
Johnson & Johnson, New Brunswick NJ
Merck & Co., Whitehouse Station NJ
PepsiCo, Purchase NY

Pfizer Inc., New York NY
Philip Morris Cos., New York NY
RJR Nabisco, New York NY
Schering-Plough Corp., Madison NJ
Time Warner, New York NY
U.S. Government, Washington DC
Viacom, New York NY
Warner-Lambert, Morris Plains NJ

Notable ad agencies in the region

Adworks, 2401 Pennsylvania Ave. NW, Suite 200, Washington DC 20037. (202)342-5585. Major accounts: Baltimore Opera Company, Friends of the National Zoo, HQ, Library of Congress, Rowe ShowPlace.

Doner Direct, 400 E. Pratt St., Baltimore MD 21202. (410)347-1600. Major accounts: AARP, Ikon, Teligent.

Gillespie, 3450 Princeton Pike, Lawrenceville NJ 08648. (609)895-0200. Major accounts: American Chemical Society, Bank of New York, GE Capital, Modern Baking, Wall Street Journal.

Grey Advertising, 777 Third Ave., New York NY 10017. (212)546-2000. Major accounts: American Egg Board, Butterball Turkey Co., Ethan Allen, M&M/Mars, Slim-Fast Foods.

Hill, Holliday, Connors, Cosmopulos, John Hancock Tower, 200 Clarendon St., Boston MA 02116. (617)437-1600. Major accounts: American Express, Dunkin' Donuts, Rolling Rock Beer, Sony Corp., Top-Flite Golf Balls.

KSV Communications, 212 Batter St., Burlington VT 05401-4724. (802)862-8261. Website: http://www.ksvc.com. Major accounts: Cellular One, Evergreen Bank, Kids First, Nordica Kastle, Vermont National Bank.

MARC Advertising, 4 Station Square, Pittsburgh PA 15219. (412)562-2000. Website: http://www.marcadv.com. Major accounts: Carnegie Museum, Lucite Paint, Radio Shack, Rite Aid.

Mintz & Hoke, 40 Tower Lane, Avon CT 06001. (860)678-0473. Website: http://www.mintzhoke.com. Major accounts: Aetna Retirement Services, Art Institute of Boston, Lego Mindstorms, Resorts Casino Hotel, Vision Corner.

OGBE McGee, 1000 Elm St., 20th Floor, Manchester NH 03101-1730. (603)625-5713. Website: http://www.ogbe.com. Major accounts: Bellevance Beverages, Citizen's Bank, New Hampshire Lottery, Optima Healthcare, WMUR TV-9.

RDW Group, 89 Ship St., Providence RI 02903. (401)521-2700. Website: http://www.rdwgroup.com. Major accounts: Amica Mutual Insurance, Bose Corp., Lifespan, Providence Gas Co., Rhode Island Public Transit Authority.

■ **A.T. ASSOCIATES**, 63 Old Rutherford Ave., Charlestown MA 02129. (617)242-8595. Fax: (617)242-0697. Contact: Dan Kovacevic. Estab. 1980. Member of IDSA. Design firm. Approximate annual billing: $200,000. Number of employees: 3. Specializes in publication design, display design, packaging, signage and product. Types of clients: industrial, financial and retail. Examples of recent projects: real estate brochures (city scapes); and sales brochure (bikes/bikers).
Needs: Works with 1 freelancer/month. Uses photos for catalogs, packaging and signage. Reviews stock photos as needed. Model/property release preferred. Captions preferred.
Specs: Uses 35mm, 4×5 transparencies; and film (specs vary). Accepts images in digital format for Windows.
Making Contact & Terms: Provide résumé, business card, brochure, flier or tearsheets to be kept on file for possible future assignments. Works with local freelancers only. Keeps samples on file. Cannot return material. Reports only if interested. Payment negotiable. **Pays on receipt of invoice.** Credit line sometimes given. Buys all rights; negotiable.

■ ▨ ○ **ADVERTEL, INC.**, P.O. Box 18053, Pittsburgh PA 15236-0053. (412)886-1400, ext. 107. Fax: (412)886-1411. President: Paul Beran. Estab. 1994. Member of MMTA (Multimedia Telecommunications Association). Specialized production house. Approximate annual billing: $500,000-1 million. Types of clients: all, including airlines, utility companies, manufacturers, distributors and retailers.
Needs: Uses photos for direct mail, P-O-P displays, catalogs, signage and audiovisual. Subjects include: communications, telecommunications and business. Reviews stock photos. Model release preferred. Property release required.
Audiovisual Needs: Uses slides and printing and computer files.
Specs: Uses 4×5 matte color and b&w prints; 4×5 transparencies; VHS videotape; PCX, TIFF digital format.
Making Contact & Terms: Query with stock photo list or with samples. Provide résumé, business card, brochure, flier or tearsheets to be kept on file for possible future assignment. Works with local freelancers only. Keeps samples on file. Cannot return material. Reporting time varies; "I travel a lot." Payment negotiable. **Pays on receipt of invoice,** net 30 days. Rights negotiable.
Tips: Looks for ability to mix media—video, print, color, b&w.

ELIE ALIMAN DESIGN, INC., 134 Spring St., New York, NY 10012. (212)925-9621. Fax: (212)941-9138. Creative Director: Elie Aliman. Estab. 1981. Design firm. Specializes in annual reports, publication design, display design, packaging, direct mail. Types of clients: industrial, financial, publishers, nonprofit.
Needs: Works with 4 freelancers/month. Uses photos for annual reports, consumer and trade magazines,

direct mail, posters. Model release required. Property release preferred. Photo captions preferred.
Specs: Uses 35mm, 2¼×2¼, 4×5, 8×10 color transparencies.
Making Contact & Terms: Query with résumé of credits. Provide résumé, business card, brochure, flier or tearsheets to be kept on file for possible future assignments. Keeps samples on file. Cannot return material. Payment negotiable. **Pays on receipt of invoice.** Credit line sometimes given. Buys first rights, one-time rights and all rights; negotiable.
Tips: Looking for "creative, new ways of visualization and conceptualization."

$ $ AMERICA HOUSE COMMUNICATIONS, 2 Marlborough St., Newport RI 02840. (401)849-9600. Fax: (401)846-1379. E-mail: nmilici@americahouse.com. Associate Creative Director: Nicole C. Milici. Estab. 1992. Design, advertising, marketing and PR firm. Specializes in publication design, display design, packaging, direct mail, signage and advertising. Types of clients: tourism, industrial, financial, retail, publishers and health care. Examples of recent projects: *1999 Rhode Island State Guide.*
Needs: Works with 1 freelancer/month. Uses photos for direct mail, P-O-P displays, catalogs and destination guides. Reviews stock photos of New England scenics, people and medical/health care. Model/property release preferred. Captions preferred.
Specs: Uses 8×10 prints; 35mm, 2¼×2¼, 4×5 transparencies.
Making Contact & Terms: Submit portfolio for review. Provide résumé, business card, brochure, flier or tearsheets to be kept on file for possible future assignments. Keeps samples on file. Cannot return material. Reporting time varies depending on project. Pays $800-1,100/day. Pays on receipt of invoice, net 30 days. Credit line given depending on usage. Buys one-time rights unless client photo shoot.
Tips: Looks for composition and impact.

[A] [■] AMMIRATI PURIS LINTAS, 1 Dag Hammarskjold Plaza, New York NY 10017. (212)605-8000. Art Buyers: Jean Wolff, Julie Rosenoff, Betsy Thompson, Stephanie Perrott. Member of AAAA. Ad agency. Approximate annual billing: $500 million. Number of employees: 750. Types of clients: financial, food, consumer goods. Examples of recent projects: Four Seasons Hotels, RCA, Burger King, Johnson & Johnson, Bacardi, LaBatts, UPS.
Needs: Works with more than 50 freelancers/month. Uses photos for billboards, trade magazines, direct mail, P-O-P displays, catalogs, posters, newspapers. Reviews stock photos. Model/property release required for all subjects.
Specs: Accepts images in digital format for Mac. Send via online, floppy disk, SyQuest or Zip disk.
Making Contact & Terms: Interested in receiving work from newer, lesser-known photographers. Contact through rep. Arrange personal interview to show portfolio. Submit portfolio for review. Provide résumé, business card, brochure, flier or tearsheets to be kept on file for possible future assignments. Works on assignment only. Keeps samples on file. SASE. Reports in 1-2 weeks. Payment negotiable. Pays extra for electronic usage of images. **Pays on receipt of invoice.** Credit line not given. Buys all rights.

$ $[A] [▨] AM/PM ADVERTISING, INC., 196 Clinton Ave., Newark NJ 07108. (201)824-8600. Fax: (201)824-6631. President: Robert A. Saks. Estab. 1962. Member of Art Directors Club, Illustrators Club, National Association of Advertising Agencies and Type Directors Club. Ad agency. Approximate annual billing: $250 million. Number of employees: 1,100. Types of clients: food, pharmaceuticals, health and beauty aids and entertainment industry. Examples of recent projects: AT&T (TV commercials); Nabisco (print ads for Oreo cookies); and Revlon (prints ads for lipstick colors).
Needs: Works with 6 freelance photographers/month. Uses photos for consumer and trade magazines, direct mail, P-O-P displays, catalogs, posters, newspapers and audiovisual. Subjects include: fashion, still life and commercials. Reviews stock photos of food and beauty products. Model release required. Captions preferred.
Audiovisual Needs: "We use multimedia slide shows and multimedia video shows."
Specs: Uses 8×10 color and/or b&w prints; 35mm, 2¼×2¼, 4×5, 8×10 transparencies; 8×10 film; broadcast videotape.

FOR EXPLANATIONS OF THESE SYMBOLS,
SEE THE INSIDE FRONT AND BACK COVERS OF THIS BOOK.

Making Contact & Terms: Arrange personal interview to show portfolio. Send unsolicited photos by mail for consideration. Provide résumé, business card, brochure, flier or tearsheets to be kept on file for possible future assignments. Works on assignment only. Keeps samples on file. Reports in 1-2 weeks. Pays $50-250/hour; $500-2,000/day; $2,000-5,000/job; $50-500/color or b&w photo. **Pays on receipt of invoice.** Credit line sometimes given, depending upon client and use. Buys one-time, exclusive product, electronic and all rights; negotiable.

Tips: In portfolio or samples, wants to see originality. Sees trend toward more use of special lighting.

$ 🖼 A-I FILM AND VIDEO WORLD WIDE DUPLICATION, 2670 Dewey Ave., Rochester NY 14616. (716)663-1400. Fax: (716)663-0246. President: Michael Gross Ordway. Estab. 1976. AV firm. Approximate annual billing: $1 million. Number of employees: 7. Types of clients: industrial and retail.

Needs: Works with 4 freelance photographers, 1 filmmaker and 4 videographers/month. Uses photos for trade magazines, direct mail, catalogs, Internet and audiovisual uses. Reviews stock photos or video. Model release required.

Audiovisual Needs: Uses slides, film and video.

Specs: Uses color prints; 35mm transparencies; 16mm film and all types of videotape.

Making Contact & Terms: Fax or write only. Works with local freelancers only. Pays $12/hour; $96/day. **Pays on receipt of invoice.** Credit line not given. Buys all rights.

$ 🄰 BOB BARRY ASSOCIATES, 4109 Goshen Rd., Newtown Square PA 19073. Phone: (610)353-7333. Fax: (610)356-5759. Contact: Bob Barry. Estab. 1964. Design firm. Approximate annual billing: $300,000. Number of employees: 5. Specializes in annual reports, publication design, displays, packaging, exhibitions, museums, interiors and audiovisual productions. Types of clients: industrial, financial, commercial and government. Examples of recent projects: corporate profile brochures, corporate marketing prorams, exhibits and displays.

Needs: Works with 2-3 freelancers per month. Uses photos for annual reports, consumer and trade magazines, direct mail, P-O-P displays, catalogs, posters, packaging and signage. Subjects include: products, on-site installations, people working. Reviews stock images of related subjects. Model release preferred for individual subjects.

Specs: Uses matte b&w and color prints, "very small to cyclorama (mural) size;" 35mm, 2¼×2¼, 4×5, 8×10 transparencies.

Making Contact & Terms: Provide résumé, business card, brochure, flier or tearsheets to be kept on file for possible future assignments. Works on assignment only. Keeps samples on file. SASE. Reports as needed; can be "days to months." Pays $50-150/hour; $600-1,200/day; other payment negotiable. Pays on variable basis, according to project. Credit lines sometimes given, depending upon "end use and client guidelines." Buys all rights; negotiable.

Tips: Wants to see "creative use of subjects, color and lighting. Also, simplicity and clarity. Style should not be too arty." Points out that the objective of a photo should be readily identifiable. Sees trend toward more use of photos within the firm and in the design field in general. To break in, photographers should "understand the objective" they're trying to achieve. "Be creative within personal boundaries. Be my eyes and ears and help me to see things I've missed. Be available and prompt."

$ $ $🖼 🄾 BODZIOCH DESIGN, 30 Robbins Farm Rd., Dunstable MA 01827. (978)649-2949. Fax: (978)649-2969. Art Director: Leon Bodzioch. Estab. 1986. Design firm. Specializes in annual reports, publication design and direct mail. Types of clients: industrial. Examples of recent projects: direct mail, Analog Devices (electronic circuit photography); product brochure/fact sheet, Simplex Time Recorder Co. (product and people photography); Centra Software (product photography); and direct mail, Nebs, Inc. (background textures).

Needs: Uses 4 freelancers/month. Uses photos for annual reports and direct mail. Subjects include: high tech issues. Reviews stock photos. Model/property release preferred. Captions required; identify whether straight or computer-manipulated photography.

Specs: Uses 35mm, 2¼×2¼, 4×5 transparencies and Photoshop files.

Making Contact & Terms: Query with stock photo list and samples. Send unsolicited photos by mail for consideration. Keeps samples on file. SASE. Reports when need arises. Pays based on project quote or range of $1,200-2,200/day. Pays net 30 days. Credit line sometimes given depending upon agreement. Buys one-time and all rights; negotiable.

Tips: Looks for "strong artistic composition and unique photographic point-of-view without being trend driven imagery. Photographer's ability to provide digital images on disk is also a benefit."

$ [A] ANITA HELEN BROOKS ASSOCIATES, 155 E. 55th St., New York NY 10022. (212)755-4498. Contact: Anita Helen Brooks. PR firm. Types of clients: beauty, entertainment, fashion, food, publishing, travel, society, art, politics, exhibits and charity events.
Needs: Photos used in PR releases, AV presentations and consumer and trade magazines. Buys "several hundred" photos/year. Most interested in fashion shots, society, entertainment and literary celebrity/personality shots. Model release preferred.
Specs: Uses 8×10 glossy b&w or color prints; contact sheet OK.
Making Contact & Terms: Provide résumé and brochure to be kept on file for possible future assignments. Query with résumé of credits. No unsolicited material; cannot return unsolicited material. Works on assignment only. Pays $50 minimum/job; negotiates payment based on client's budget. Credit line given.

[N] $ $ [▪] [▫] [▪] [◑] [◎] BYNUMS ADVERTISING SERVICE, 401 Wood St., Suite 900, Pittsburgh PA 15222. (412)471-4332. Fax: (412)471-1383. Website: http://www.bynums.com. President: Russell Bynum. Estab. 1985. Ad agency. Number of employees: 8. Firm specializes in annual reports, collateral, direct mail, magazine ads, packaging, publication design, signage. Types of clients: financial, healthcare, consumer goods, nonprofit.
Needs: Works with 1 photographer/month. Uses photos for billboards, brochures, direct mail, newspapers, posters. Subjects include: babies, children, couples, multicultural, families, parents, senior citizens, teens, environmental, wildlife, cities/urban, education, religious, adventure, automobiles, events, food/drink, health/fitness, performing arts, sports, computers, medicine, portraits, product shots/still life, science. Interested in digital, fine art, regional, seasonal. Model/property release required. Photo captions preferred.
Audiovisual Needs: Works with 1 videographer and 1 filmmaker/year. Uses slides, film, videotape.
Specs: Uses 8×10, glossy, matte, color, b&w prints; 35mm, 4×5 transparencies. Accepts images in digital format for Mac. Send via Zip, e-mail as TIFF files.
Making Contact and Terms: Send query letter with résumé, prints, tearsheets, stock list. Provide business card, self-promotion piece to be kept on file. Reports back only if interested, send non-returnable samples. Pays $150-300 for b&w and color photos. "Payment may depend on quote and assignment requirements." Buys electronic rights.

$ $ $ [A] [◑] CAMBRIDGE PREPRESS, 215 First St., Cambridge MA 02142. (617)354-1991. Fax: (617)494-6575. E-mail: cindydavis@aol.com. Creative Director: Cynthia Davis. Estab. 1968. Design firm. Approximate annual billing: $3.5 million. Number of employees: 50. Specializes in publication design. Types of clients: financial and publishers. Examples of past projects: "Fidelity Focus," Fidelity Investments (editorial); Goldhirsh Group (editorial); and "Dragon Dictate" Dragon Systems (packaging).
Needs: Works with 5-10 freelancers/month. Uses photos for consumer magazines, trade magazines, catalogs and packaging. Subjects include: people. Reviews stock photos. Model release preferred.
Specs: Uses 35mm, 2¼×2¼ transparencies; film appropriate for project.
Making Contact & Terms: Query with samples. Works on assignment only. Keeps samples on file. Do not submit originals. Payment negotiable. Pays 30 days net. Credit line given. Rights purchased depend on project; negotiable.

$ CHARITABLE CHOICES, 1804 "S" St. NW, Washington DC 20009. (202)483-2906. Fax: (202)328-0627. E-mail: info@charitablechoices.org. Managing Partner: Robert Minnich. Estab. 1984. PR firm. Approximate annual billing: $300,000. Number of employees: 10. Types of clients: industrial, financial, charities, nonprofit groups and government.
Needs: Uses photos for catalogs and newspapers. Subjects include environment, international, children, civil and human rights and social services. Reviews stock photos.
Specs: Uses b&w prints.
Making Contact & Terms: Submit portfolio for review. Query with stock photo list. Send unsolicited photos by mail for consideration. SASE. Reports in 3 months. Pays $75-125/b&w photo. **Pays on acceptance.** Buys one-time rights.

[A] [▪] COX ADVERTISING, 379 W. Broadway, New York NY 10012. (212)334-9141. Fax: (212)334-9179. Ad agency. Associate Creative Director: Marc Rubin. Types of clients: industrial, retail, fashion and travel.
Needs: Works with 2 freelance photographers or videographers/month. Uses photographers for billboards, consumer magazines, trade magazines, direct mail, P-O-P displays, catalogs, posters, newspapers, signage and audiovisual. Reviews stock photos or video.
Audiovisual Needs: Uses photos for slide shows; also uses videotape.
Specs: Uses 16×20 b&w prints; 35mm, 2¼×2¼, 4×5 and 8×10 transparencies.
Making Contact & Terms: Arrange personal interview to show portfolio. Works on assignment only.

Cannot return material. Reports in 1-2 weeks. Pay depends on assignment. Pays within 30-60 days of receipt of invoice. Buys all rights when possible. Model release required. Credit line sometimes given.

N $ $ $ 🖥 ⬭ DAVID CURRY DESIGN, 275 Central Park W., 9E, New York NY 10024-3046. (212)579-7560. Fax: (212)579-7563. E-mail: dcd@davidcurrydesign.com. Website: http://www.davidcurry design.com Director of Marketing: Marjorie Carmelia. Estab. 1983. Member of ICPNY. Design firm. Number of employees: 6. Firm specializes in collateral, direct mail, magazine ads, publication design, web design and multimedia. Types of clients: arts and entertainment. Examples of recent clients: Calvin Klein, Club Med.
Needs: Works with 1 photographer/month. Uses photos for brochures, catalogs, consumer magazines, direct mail, posters, trade magazines, web design and multimedia. Subjects include: babies, celebrities, children, couples, multicultural, families, parents, senior citizens, teens, architecture, beauty, adventure, entertainment, sports, travel, computers, portraits, product shots/still life, science, technology. Interested in alternative process, avant garde, digital, documentary, erotic, fashion/glamour, fine art. Model release required; property release preferred. Photo captions required.
Specs: Uses 35mm transparencies. Accepts images in digital format for Windows. Send via CD as JPEG files.
Making Contact and Terms: Send query letter with résumé, slides, photocopies. Provide résumé, business card, self-promotion piece to be kept on file. Include SASE for return of material if return requested by sender. Reports back only if interested; send non-returnable samples. Payment depends on client, project, frequency, reach and usage. Pays on receipt of invoice (30 days). Credit line not given. Buys all rights.
Tips: "Photographers should be aware of the growing trend of multi-ethnicity in images. Images should convey an awareness of history."

$ $ 🖼 ⬭ DCP COMMUNICATIONS GROUP, LTD., 301 Wall St., Princeton NJ 08540-1515. (609)921-3700. Fax: (609)921-3283. Picture Editor: Logan Connors. Estab. 1979. Specializes in multimedia production, video production.
Needs: Buys 20 photos/year; offers 10 assignments/year. Uses freelancers for lifestyle, editorial, public relation shots. Examples of recent uses: video montages for manufacturers. Model/property release required. Captions required.
Audiovisual Needs: Uses videotape for multimedia purposes (corporate marketing). Subjects include: lifestyles.
Specs: Uses 8×10 glossy color and b&w prints; 35mm, 2¼×2¼, 4×5 transparencies; Betacam SP videotape.
Making Contact & Terms: Query with résumé of credits, samples and stock photo list. Provide résumé, business card, self-promotion piece or tearsheets to be kept on file for possible future assignments. Keeps samples on file. SASE. Reports in 1 month. Pays $100-150/hour; $500-1,500/day. **Pays on acceptance.** Credit line given. Buys first, one-time and all rights; negotiable.

$ 🅐 DESIGN CONCEPTS-CARLA SCHROEDER BURCHETT, 104 Main St., Box 5A, Unadilla NY 13849-9701. (607)369-4709. Owner: Carla Schroeder. Estab. 1972. Number of employees: 2. Specializes in direct mail. Types of clients: industrial, manufacturers. Examples of projects: "Used Footlets" (marketing firm).
Needs: Uses photos for catalogs. Subjects include: wild nature to still life and houses. Model release preferred. Captions required.
Specs: Uses prints; 35mm transparencies.
Making Contact & Terms: Send nonreturnable samples by mail for consideration. SASE for reply. Payment negotiable. **Pays on acceptance.** Credit line given. Buys first rights; negotiable.

$ $ ⬭ DESIGNATION, 53 Spring St., 5th Floor, New York NY 10012. (212)226-6024. Fax: (212)219-0331. President/Creative Director: Mike Quon. Design firm. Specializes in packaging, direct mail, signage, illustration. Types of clients: industrial, financial, retail, publishers, nonprofit.
 • Mike Quon says he is using more stock photography and less assignment work.
Needs: Works with 1-3 freelancers/year. Uses photos for direct mail, P-O-P displays, packaging, signage. Model/property release preferred. Captions required; include company name.
Specs: Uses color, b&w prints; 2¼×2¼, 4×5 transparencies.
Making Contact & Terms: Submit portfolio for review by mail only. Send unsolicited photos by mail for consideration. "Please, do not call office. Contact through mail only." Keeps samples on file. Cannot return material. Reports only when interested. Pays net 30 days. Credit line given when possible. Buys first rights, one-time rights; negotiable.

N A DIEGNAN & ASSOCIATES, 3 Martens, Lebanon NJ 08833. President: N. Diegnan. Ad agency/PR firm. Types of clients: industrial, consumer.
Needs: Commissions 15 photographers/year; buys 20 photos/year from each. Uses photos for billboards, trade magazines and newspapers. Model release preferred.
Specs: Uses b&w contact sheet or glossy 8 × 10 prints. For color, uses 5 × 7 or 8 × 10 prints; also 2¼ × 2¼ transparencies.
Making Contact & Terms: Arrange a personal interview to show portfolio. Local freelancers preferred. SASE. Reports in 1 week. Payment negotiable. Negotiates payment based on client's budget and amount of creativity required from photographer. Pays by the job. Buys all rights.

$ $ A ▣ ◑ DIRECT SOURCE ADVERTISING, 4403 Wickford Rd., Baltimore MD 21210-2809. (410)366-5429. Fax: (410)366-6123. Owner: Cynthia Serfas. Estab. 1988. Design firm. Approximate annual billing: $150,000. Number of employees: 3. Specializes in publication design and direct mail. Types of clients: financial, publishers and insurance.
Needs: Uses photos for direct mail. Subjects include: families, health, real estate, senior market and credit card usage. Model/property release required.
Specs: Uses 8 × 10 glossy b&w prints; 35mm, 2¼ × 2¼, 4 × 5 transparencies, high-res digital files (Mac format).
Making Contact & Terms: Arrange personal interview to show portfolio. Send unsolicited photos by mail for consideration. Provide résumé, business card, brochure, flier or tearsheets to be kept on file for possible future assignments. Works on assignment only. Keeps samples on file. SASE. Responds if an appropriate assignment is available. Pays $300-900/shot depending on usage. Pays 30 days from receipt of invoice. Credit line not given. Buys one-time rights.
Tips: "I like everyday-type people in the shots with a good cross-market representation."

$ $ ▣ ◑ DONAHUE ADVERTISING, LLC, 227 Lawrence St., Hartford CT 06106. (860)728-0000. Fax: (860)247-9247. Ad agency and PR firm. President: Jim Donahue. Estab. 1980. Types of clients: industrial, high-tech, food/beverage, corporate and finance.
Needs: Works with 2-3 photographers/month. Uses photos for trade magazines, catalogs and posters. Subjects include: products.
Specs: Uses 8 × 10 matte and glossy color or b&w prints; 4 × 5 transparencies. Accepts images in digital format for Mac. Send via CD, Zip as EPS files at 300 dpi.
Making Contact & Terms: Send samples by mail for consideration. Provide résumé, business card, brochure, flier or tearsheets to be kept on file for possible future assignments. Keeps samples on file. Cannot return material. Reports in 1-2 weeks. Pays $1,200-1,500/day. Buys all rights. Model/property release required. Credit line not given.

$ DOWNEY COMMUNICATIONS, INC., 4800 Montgomery Lane, Suite 710, Bethesda MD 20814. (301)718-7600. Fax: (301)718-7604. Art Director: Craig Borucki. Estab. 1969. Member of Art Directors Club of Washington DC and AIGA. Specializes in publication design.
Needs: Works with 1-2 freelancers/month. Uses photos for trade magazines. Subjects include: people and interiors. Model release preferred. Captions required; include name, title, occupation of subject.
Specs: Uses 35mm, 2¼ × 2¼ transparencies.
Making Contact & Terms: Send unsolicited photos by mail for consideration. Keeps samples on file. SASE. Pays $450-500/day. Pays on publication. Credit line given. Buys one-time rights.
Tips: Looks for composition, style and uniqueness of traditional people shots.

N A ▣ ▨ EATON & NOBLE STRATEGIC COMMUNICATIONS, (formerly Guilford Marketing), 6 Paddock Lane, Suite 201, Guilford CT 06437-2809. E-mail: guilmark@aol.com or eaton.noble@cshore.com. Owner/Creative Director: R.S. Eaton. Estab. 1990. Ad/PR agency and public affairs. Number of employees: 1 full-time, 1 part-time. Types of clients: industrial, real estate, fast food, professions and financial. Examples of recent projects: new store launch for Dunkin' Donuts; internal communications for U.S. Postal Service and launch for renovated corporate office building owned by Geometry Realty, Inc., New York NY.
Needs: Works with 1-2 freelancers/month. Connecticut/New York area photographers only. Uses photos for billboards, consumer magazines, direct mail, P-O-P displays, posters, newspapers, signage, brochures and other collateral, TV. Subjects include: people, scenes, products (heavy real estate). Reviews stock photos. Model release required. Property release preferred. Caption preferred; include location, subject, date, file code/source/photographer credit.
Audiovisual Needs: Uses slides and video for meetings, sales promotion and TV. Subjects include: real estate products, low-cost PR shots, some head and shoulder portraits, some situational.

Specs: Uses color and b&w prints; 35mm, 2¼ × 2¼, 4 × 5 transparencies. Accepts images in digital format for Mac. Send via compact disc, online or floppy disk (minimum 600 dpi for b&w).
Making Contact & Terms: Query with stock photo list. Query with samples. Works on assignment only. Keeps samples on file. SASE. Will contact if future work is anticipated or if need is immediate. Otherwise, will not contact. Payment negotiable. Pays within 30 days of invoice. Credit line "sometimes given depending on job, client and, sometimes, available space or other design criteria." Buys first, one-time and all rights; negotiable.
Tips: "No kinky, off-beat material. Generally, sharp focus, good depth of field, good use of light. In real estate, must have swing back camera to correct distortions. Retouch capability is a plus. For PR, need extremely fast turn-around and low pricing schedule."

$ Ⓐ ▣ EPSTEIN & WALKER ASSOCIATES, #5A, 65 W. 55th St., New York NY 10019. Phone/fax: (212)246-0565. President/Creative Director: Lee Epstein. Member of Art Directors Club of New York. Ad agency. Approximate annual billing: $1.5 million. Number of employees: 3. Types of clients: retail, publication, consumer.
Needs: Works with 1-2 freelance photographers/year. Uses photos for consumer and trade magazines, direct mail and newspapers. Subjects include still life, people, etc.; "depends on concept of ads." Model release required.
Specs: Any size or format b&w prints; also 35mm, 2¼ × 2¼ transparencies.
Making Contact & Terms: Arrange personal interview to show portfolio. Provide résumé, business card, brochure, flier or tearsheets to be kept on file for possible future assignments. Works with local freelancers on assignment only. Cannot return material. Reports "as needed." Pays minimum of $250/b&w photo or negotiates day rate for multiple images. Pays 30-60 days after receipt of invoice. Credit line not given. Usually buys rights for "1 year usage across the board."
Tips: Trend within agency is "to solve problems with illustration, and more recently with type/copy only, more because of budget restraints regarding models and location expenses." Is receptive to working with new talent. To break in, show "intelligent conceptual photography with exciting ideas and great composition."

▣ ▤ FINE ART PRODUCTIONS, RICHIE SURACI PICTURES, MULTI MEDIA, INTER-ACTIVE, 67 Maple St., Newburgh NY 12550-4034. Phone/fax: (914)561-5866. E-mail: rs7.fap@mhv.net. Websites: http://www.woodstock69.com; http://www.broadcast.com/books; http://www.audiohighway.com; http://indyjones.simplenet.com/kunda.htm; http://www.mhv.net/~rs7.fap/netWORKEROTICA.html. Director: Richie Suraci. Estab. 1989. Ad agency, PR firm and AV firm. Types of clients: industrial, financial, fashion, retail, food—all industries. Examples of previous projects: "Great Hudson River Revival," Clearwater, Inc. (folk concert, brochure); feature articles, Hudson Valley News (newspaper); "Wheel and Rock to Woodstock," MS Society (brochure); and Network Erotica (Website).
Needs: Uses photos for billboards, consumer and trade magazines, direct mail, P-O-P displays, catalogs, posters, Web Pages, brochures, newspapers, signage and audiovisual. Especially needs erotic art, adult erotica, science fiction, fantasy, sunrises, waterfalls, beautiful nude women and men, futuristic concepts. Reviews stock photos. Model/property release required. Captions required; include basic information.
Audiovisual Needs: Uses slides, film (all formats) and videotape.
Specs: Uses color and b&w prints, any size or finish; 35mm, 2¼ × 2¼, 4 × 5, 8 × 10 transparencies; film, all formats; ½″, ¾″ or 1″ Beta videotape. Accepts images in digital format for Mac (2HD). Send via online or floppy disk (highest resolution).
Making Contact & Terms: Submit portfolio for review. Query with résumé of credits, list of stock photo subjects or samples. Provide résumé, business card, brochure, flier or tearsheets to be kept on file for possible future assignments. SASE. Reports in 1 month or longer. "All payments negotiable relative to subject matter." Pays on acceptance, publication or on receipt of invoice; "varies relative to project." Credit line sometimes given, "depending on project or if negotiated." Buys first, one-time and all rights; negotiable.
Tips: "We are also requesting any fantasy, avant-garde, sensuous or classy photos, video clips, PR data, short stories, adult erotic scripts, résumé, fan club information, PR schedules, etc. for use on our Website. Nothing will be posted unless accompanied by a release form. We will post this free of charge on the Website and give you free advertising for the use of your submissions We will make a separate agreement for usage for any materials besides ones used on the Website and/or any photos or filming sessions we create together in the future. If you would like to make public appearances in our network and area, send a return reply and include PR information for our files."

▣ FORDESIGN GROUP LTD., 87 Dayton Rd., Redding CT 06896. (203)938-0008. Fax: (203)938-0805. E-mail: fordsign@webquill.com. Website: http://www.Fordesign.com. Creative Director: Steven

Ford. Estab. 1990. Member of AIGA, P.D.C. Design firm. Specializes in packaging. Types of clients: industrial, retail. Examples of recent projects: Talk Xpress for AT&T Wireless (location, people); Packaging for SONY (product); and KAME Chinese Food for Liberty Richter (food).

Needs: Works with 2 freelancers/month. Uses photos for packaging. Subjects include: food. Reviews stock photos. Model release required.

Specs: Uses 4×5 transparencies. Accepts images in digital format for Mac (EPS, Photoshop, TIFF). Send via CD, e-mail, floppy disk, SyQuest or Zip.

Making Contact & Terms: Submit portfolio for review. Query with samples. Send unsolicited photos by mail for consideration. Keeps samples on file. SASE. Reports in 1-2 weeks. Pays "typical" day rate. **Pays on receipt of invoice.** Credit line given. Rights negotiable.

[A] [■] [▣] DAVID FOX, PHOTOGRAPHER, 59 Fountain St., Framingham MA 01702. (508)820-1130. Fax: (508)820-0558. E-mail: dfphoto@cwix.com. Website: http://www.portfoliocentral.com/davidfo xphotographer. President: David Fox. Estab. 1983. Member of Professional Photographers of America, Professional Photographers of Massachusetts. Video production/post production photography company. Approximate annual billing: $150,000. Number of employees: 2.5. Types of clients: consumer, industrial and corporate. Examples of recent projects: Wayside Community Projects (brochures, newsletter); Harlem Rockers National Basketball Team photos, American Heart Association, Kraft Foods.

Needs: Works with 2-4 freelance photographers/videographers/year. Subjects include: executive portraiture, fine art, stock, children, families. Reviews area footage. Model/property release required. Captions preferred.

Audiovisual Needs: Uses videotape; photos, all media related materials. "We are primarily producers of photographic and video images."

Specs: Uses 35mm, 2¼×2¼ and 4×5 transparencies, and ½″, SVHS, Hi 8mm and 8mm formats of videotape. Accepts images in digital format for Mac and Windows. Send as PICT, TIFF, EPS files via floppy disk, e-mail, CD, Zip, Jaz.

Making Contact & Terms: Arrange personal interview to show portfolio. Provide résumé, business card, brochure, flier or tearsheets to be kept on file for possible future assignments. Portfolio and references required. Works on assignment only. Looking for wedding photographers and freelancers. Works closely with freelancers. Buys all rights; negotiable.

Tips: Looks for style, abilities, quality and commitment similar to ours. "We have expanded our commercial photography. We tend to have more need in springtime and fall, than other times of the year. We're very diversified in our services—projects come along and we use people on an as-need basis. We are scanning and delivering images on disk to our clients. Manipulation of images enables us to create new images for stock use."

[N] [$] [□] [▣] AMY FRITH CREATIVE RESOURCING, 131 G St. 3, Boston MA 02127. (617)268-2506. Fax: (617)464-1304. Contact: Amy Frith. Estab. 1990. Art buying and creative resourcing for ad agencies, design firms and corporate direct. Firm specializes in the sourcing and hiring of assignment photographers for consumer ads, collateral, direct mail, outdoor and internet uses. Types of clients: financial, retail, corporate direct, ad agencies and design firms. Examples of recent clients: "CTW," Smash Advertising brand campaign; "Reebok," Heater Advertising (brand campaign); "TDK" (direct).

Needs: Uses photos for billboards, brochures, catalogs, consumer magazines, direct mail, newspapers, P-O-P displays, posters, signage, trade magazines and website. Styles include: alternative process, digital, documentary, fashion/glamour, historical/vintage, regional, seasonal. Model/property release required.

Audiovisual Needs: Uses slides, film, videotape for broadcast and print ads.

Specs: "Submissions can be in any format—preferably one that is lightweight. The work is what counts." Accepts images in digital format for Mac. Send via CD, floppy disk, Zip.

Making Contact & Terms: Send query letter with résumé, slides, prints, tearsheets, transparencies. Provide self-promotion piece to be kept on file. Reports back only if interested; send non-returnable samples. Pays extra for electronic usage of photos. Pays on receipt of invoice. Credit line sometimes given depending upon the project. Buys all rights; negotiable.

Tips: "Send only your best images. Weed out the rejects; one weak photo will bring down the integrity of the entire book."

FUESSLER GROUP INC., 288 Shawmut Ave., Boston MA 02118. (617)451-9383. Fax: (617)451-5950. E-mail: fuessler@fuessler.com. Website: http://www.fuessler.com. President: Rolf Fuessler. Estab. 1984. Member of Society for Marketing Professional Services, Public Relations Society of America. Marketing communications firm. Types of clients: industrial, professional services.

Needs: Works with 2 freelancers/month; rarely works with videographers. Uses photos for trade magazines, collateral advertising and direct mail pieces. Subjects include: industrial and environmental. Reviews

stock photos. Model/property release required, especially with hazardous waste photos. Captions preferred.
Specs: Uses 35mm, 4×5 transparencies.
Making Contact & Terms: Query with résumé of credits. Query with samples. Works with local freelancers on assignment only. Keeps samples on file. SASE. Reports in 3 weeks. Payment negotiable. Pays on receipt of invoice. Credit line given. Buys first, one-time and all rights and has purchased unlimited usage rights for one client; negotiable.

N $ $ ◫ ⊠ ⊘ GIARNELLA DESIGN, 259 Main St., East Berlin CT 06023. (860)828-8410. Fax: (860)829-1270. President: Andrew Giarnella. Estab. 1978. Member of Connecticut Art Directors Club. Approximate annual billing: 1 million. Number of employees: 2. Firm specializes in annual reports, collateral, direct mail, magazine ads, packaging, signage. Types of clients: industrial, publishing, business to business—other agencies. Examples of recent clients: Konica (direct mail); Hartford Steam Boiler (direct mail).
Needs: Works with 2 photographers/month. Uses photos for brochures, catalogs, consumer magazines, direct mail, trade magazines. Subjects include: babies, children, couples, multicultural, families, parents, senior citizens, teens, environmental, landscapes/scenics, architecture, beauty, cities/urban, education, automobiles, humor, computers, medicine, science, technology. Interested in alternative process, avant garde, digital, documentary, erotic, fashion/glamour, fine art, seasonal. Model and property release required. Photo captions preferred.
Audiovisual Needs: Works with 1 videographer. Uses slides. Subjects include: people, computers, finance, science.
Specs: Uses 8×10 matte, color and b&w prints; 35mm transparencies. Accepts images in digital format for Mac. Send via CD, Zip as EPS files at 600 dpi.
Making Contact and Terms: Send query letter with résumé, prints, business card, self-promotion piece to be kept on file. Reports back only if interested; send non-returnable samples. Pays $150-500 for b&w photos; $300-1,500 for color photos. Pays on publication or within 30 days. Credit line sometimes given if editorial. Rights purchased depend on client.
Tips:

A ⊘ GRAPHIC COMMUNICATIONS, 3 Juniper Lane, Dover MA 02030-2146. (508)785-1301. Fax: (508)785-2072. Owner: Richard Bertucci. Estab. 1970. Member of Art Directors Club, Graphic Artists Guild. Ad agency. Approximate annual billing: $1 million. Number of employees: 5. Types of clients: industrial, consumer, finance. Examples of recent projects: campaigns for Avant Incorporated; Bird Incorporated; and Ernst Asset Management.
Needs: Works with 3 freelancers/month. Uses photos for consumer magazines, trade magazines, catalogs, direct response and annual reports. Subjects include: products, models. Reviews stock photos. Model/property release required. Captions preferred.
Specs: Uses 8×10 glossy color and b&w prints; 2¼×2¼, 4×5 transparencies.
Making Contact & Terms: Query with stock photo list. Provide résumé, business card, brochure, flier or tearsheets to be kept on file for possible future assignments. Works with local freelancers on assignment only. Keeps samples on file. Cannot return material. Reports as needed. Payment negotiable. Pays on receipt of invoice. Credit line not given. Buys all rights.

$ A HAMMOND DESIGN ASSOCIATES, 79 Amherst St., Milford NH 03055. (603)673-5253. Fax: (603)673-4297. President: Duane Hammond. Estab. 1969. Design firm. Specializes in annual reports, publication design, display design, packaging, direct mail, signage. Types of clients: industrial, financial, publishers and nonprofit. Examples of projects: Resonetics Capabilities brochure, Micro Lasering (product photos, cover and inside); golf courses yardage guides; Granite Bank (advertising literature); and Cornerstone Software (collateral material).
Needs: Works with 1 freelancer/month. Uses photos for annual reports, trade magazines, direct mail, catalogs and posters. Subject matter varies. Reviews stock photos. Model release required. Property release preferred. Captions preferred.
Specs: Uses 8×10 and 4×5 matte or glossy, color and b&w prints; 35mm, 2¼×2¼, 4×5 transparencies.
Making Contact & Terms: Send unsolicited photos by mail for consideration. Provide résumé, business card, brochure, flier or tearsheets to be kept on file for possible future assignments. Works with freelancers on assignment only. Cannot return unsolicited material. Pays $25-100/hour; $450-1,000/day; $25-2,000/

job; $50-100/color photo; $25-75/b&w photo. Pays on receipt of invoice net 30 days. Credit line sometimes given. Buys one-time, exclusive product and all rights; negotiable.

Tips: Wants to see creative and atmosphere shots, "turning the mundane into something exciting."

$ $ 🄰 ▣ 🖼 ◑ ◎ HARRINGTON ASSOCIATES INC., 57 Fairmont Ave., Kingston NY 12401-5221. (914)331-7136. Fax: (914)331-7168. E-mail: gharring@aol.com. President: Gerard Harrington. Estab. 1988. Member of Hudson Valley Area Marketing Association, Hudson Valley Direct Marketing Association. PR firm. Specializes in collateral. Types of clients: industrial, high technology, retail, fashion, finance, transportation, architectural, artistic and publishing. Examples of recent clients include: Ulster Performing Arts Center (PR, brochures, advertising); Salomon Smith Barney, Inc. (community relations, investment product/service brochures); MICR Data Systems, Inc. (corporate ID campaign, product/service brochure, advertising campaign, Website enhancement).

- This company has received the Gold Eclat Award, Hudson Valley Area Marketing Association, for best PR effort.

Needs: Number of photographers used on a monthly basis varies. Uses photos for consumer and trade magazines, P-O-P displays, catalogs and newspapers. Subjects include: general publicity including head shots and candids. Also still lifes. Model release required.

Specs: Uses b&w prints, any size and format. Also uses 4×5 color transparencies. Accepts images in digital format for Mac, Windows. Send via SyQuest, Zip, e-mail as TIFF, EPS, PICT, BMP, GIF, JPEG files.

Audiovisual Needs: Betacam SP Videotape.

Making Contact & Terms: Provide résumé, business card, brochure, flier or tearsheets to be kept on file for possible future assignments. Works with freelancers on assignment only. Cannot return material. Reports only when interested. Payment negotiable. Pays on receipt of invoice. Credit line given whenever possible, depending on use. Buys all rights; negotiable.

$ $ ◑ ICONS, 76 Elm St., Suite 313, Boston MA 02130. Phone: (617)522-0165. Fax: (617)524-5378. Contact: Glenn Johnson. Estab. 1984. Design firm. Approximate annual billing: $250,000. Number of employees: 2. Specializes in annual reports, publication design, packaging, direct mail and signage. Types of clients: high-tech. Examples of clients: SQA Inc., Leaf Systems, Picturetel.

Needs: Works with 2 freelancers/month. Uses photos for annual reports, trade magazines, packaging, direct mail and posters. Subjects include: portraits, photo montage and products. Reviews unusual abstract, non-conventional stock photos. Model/property release preferred for product photography. Captions preferred; include film and exposure information and technique details.

Specs: Uses 4×5 transparencies.

Making Contact & Terms: Query with samples. Works with local freelancers only. Keeps samples on file. SASE. Reports in 3 weeks. Pays $1,200-1,800/day; $750-5,000/job. **Pays on receipt of invoice.** Credit line given. Buys first rights.

$ $ $ 🄰 ▣ 🖼 IMAGE ZONE, INC., 101 Fifth Ave., New York NY 10003. (212)924-8804. Fax: (212)924-5585. Managing Director: Doug Ehrlich. Estab. 1986. AV firm. Approximate annual billing: $5 million. Number of employees: 15. Types of clients: industrial, financial, fashion, pharmaceutical. Examples of recent projects: Incentive meeting for Entex (a/v show); awards presentation for Lebar Friedman; exhibit presentation for Pfizer; J&J, Ortho (launch meeting).

Needs: Works with 1 freelance photographer, 2 filmmakers and 3 videographers/month. Uses photos for audiovisual projects. Subjects vary. Reviews stock photos. Model/property release preferred. Captions preferred.

Audiovisual Needs: Uses slides, film and videotape. Subjects include: "original material."

Specs: Uses 35mm transparencies; ¾" or ½" videotape. Accepts images in digital format for Mac (various formats).

Making Contact & Terms: Query with résumé of credits. Provide résumé, business card, brochure, flier or tearsheets to be kept on file for possible future assignments. Works with local freelancers on assignment only. Keeps samples on file. Cannot return material. Reports when needed. Pays $500-1,500/job; also depends on size, scope and budget of project. Pays within 30 days of receipt of invoice. Credit line not given. Buys one-time rights; negotiable.

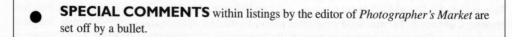

● **SPECIAL COMMENTS** within listings by the editor of *Photographer's Market* are set off by a bullet.

$ $ $ [A] [icon] [icon] INDUSTRIAL F/X, INC., (formerly Sandy Connor Art Direction), 90 Ship St., Providence RI 02903. (401)831-5796. Fax: (401)831-5797. E-mail: sandy@industrialfx.com. Owner: Sandy Connor. Estab. 1992. Member of Providence Chamber of Commerce and Providence Creative Communication Club. Design firm, advertising/design. Approximate annual billing $100,000. Number of employees: 1. Specializes in annual reports, collateral, direct mail, magazine ads, publication design. Types of clients: industrial, financial, nonprofit. Examples of recent projects: Washington Trust Bancorp (annual report); TTI Testron (catalog).

Needs: Works with 1 freelancer/month. Uses photos for annual reports, trade magazines, direct mail, P-O-P displays, catalogs. Subjects include: landscapes/scenics, wildlife, babies, children, couples, multicultural, families, parents, senior citizens, education, business concepts, computers, teens, architecture, cities/urban, gardening, interiors/decorating, rural, adventure, hobbies, performing arts, travel, buildings, industry, portraits, products shots/still life, science, technology, industrial, location. Interested in alternative process, avant garde, digital, documentary, fine art, historical/vintage, regional, seasonal. Reviews stock photos. Model release required.

Specs: Uses b&w prints; 35mm, 2¼×2¼, 4×5, 8×10 transparencies. Accepts images in digital format for Mac. Send via CD, Zip as TIFF, EPS high resolution files.

Making Contact & Terms: Submit portfolio for review. Query with samples. Send unsolicited photos by mail for consideration. Provide résumé, business card, brochure, flier or tearsheets to be kept on file for possible future assignments. Works on assignment only. Keeps samples on file. Reports as need for work arises. Pays $50-200/hour; $1,000-2,000/day. Pays on acceptance; 30 days from receipt of invoice. Buys first, one-time and all rights; negotiable.

$ [icon] INSIGHT ASSOCIATES, 14 Rita Lane, Oak Ridge NJ 07438. (973)697-0880. Fax: (973)697-6904. E-mail: insightnj1@aol.com. President: Raymond Valente. Types of clients: major industrial companies, public utilities. Examples of projects: "Savety on the Job" for Ecolab, Inc.; "Handling Gases" for Matheson Gas; and "Training Drivers" for Suburban Propane (all inserts to videos).

Needs: Works with 4 freelancers/month. Uses freelancers for slide sets, multimedia productions, videotapes and print material—catalogs. Subjects include: industrial productions. Examples of clients: Matheson (safety); Witco Corp. (corporate image); Volvo (sales training); P.S.E.&G.; Ecolab Inc. Interested in stock photos/footage. Model release preferred.

Specs: Uses 35mm, 2¼×2¼ and 4×5 transparencies.

Making Contact & Terms: Arrange a personal interview to show portfolio. SASE. Reports in 1 week. Pays $450-750/day. **Pays on acceptance.** Credit line given. Buys all rights.

Tips: "Freelance photographers should have knowledge of business needs and video formats. Also, versatility with video or location work. In reviewing a freelancer's portfolio or samples we look for content appropriate to our clients' objectives. Still photographers interested in making the transition into film and video photography should learn the importance of understanding a script."

$ [A] [icon] JEF FILMS INC, 143 Hickory Hill Circle, Osterville MA 02655-1322. (508)428-7198. Fax: (508)428-7198. President: Jeffrey H. Aikman. Estab. 1973. AV firm. Member of American Film Marketing Association, National Association of Television Programmers and Executives. Types of clients: retail. Examples of projects: "Yesterday Today & Tomorrow," JEF Films (video box); "M," Aikman Archive (video box).

Needs: Works with 5 freelance photographers, 5-6 filmmakers and 5-6 videographers/month. Uses photos for billboards, consumer magazines, trade magazines, direct mail, P-O-P displays, catalogs, posters, newspapers and audiovisual. Subjects include glamour photography. Reviews stock photos of all types. Model release preferred. Property release required. Captions preferred.

Audiovisual Needs: Uses slides, films and/or video for videocassette distribution at retail level.

Specs: Uses 35mm transparencies.

Making Contact & Terms: Submit portfolio for review. Works on assignment only. Keeps samples on file. Cannot return material. Reports in 1 month. Pays $25-300/job. Pays on publication. Credit line is not given. Buys all rights.

KEENAN-NAGLE ADVERTISING, 1301 S. 12th St., Allentown PA 18103-3814. (610)797-7100. Fax: (610)797-8212. Ad agency. Contact: Art Director. Types of clients: industrial, retail, finance, health care and high-tech.

Needs: Works with 7-8 freelance photographers/month. Uses photos for billboards, consumer magazines, trade magazines, direct mail, posters, signage and newspapers. Model release required.

Specs: Uses b&w and color prints; 35mm, 2¼×2¼, 4×5 and 8×10 transparencies.

Making Contact & Terms: Query with samples. Provide résumé, business card, brochure, flier or tear-

sheets to be kept on file for possible future assignments. Does not return unsolicited material. Payment negotiable. Pays on receipt of invoice. Credit line sometimes given.

$ 🅰 ▣ 🖼 KJD TELEPRODUCTIONS, INC., 30 Whyte Dr., Voorhees NJ 08043. (609)751-3500. Fax: (609)751-7729. E-mail: mactoday@ios.com. President: Larry Scott. Estab. 1989. Member of National Association of Television Programming Executives. AV firm. Approximate annual billing: $600,000. Number of employees: 6. Types of clients: industrial, fashion, retail, professional, service and food. Examples of projects: Marco Island Florida Convention, ICI Americas (new magazine show); "More Than Just a Game" (TV sports talk show); and PA Horticulture Society, Gardeners Studio (TV promo).
Needs: Works with 2 photographers, filmmakers and/or videographers/month. Uses photos for trade magazines and audiovisual. Model/property release required.
Audiovisual Needs: Primarily videotape; also slides and film.
Specs: Uses ½″, ¾″, Betacam/SP 1″ videotape, DVC Pro Video format. Accepts images in digital format for Mac (any medium). Send via CD, e-mail, floppy disk, SyQuest or Zip.
Making Contact & Terms: Send unsolicited photos by mail for consideration. Works on assignment only. Keeps samples on file. Reports in 1 month. Pays $50-300/day. **Pays on acceptance.** Credit lines sometimes given. Buys one-time, exclusive product, all and electronic rights; negotiable.
Tips: "We are seeing more use of freelancers, less staff. Be visible!"

$ $ 🅰 ▣ 🖼 ◎ KOLLINS COMMUNICATIONS, INC., 425 Meadowlands Pkwy., Secaucus NJ 07094. (201)617-5555. Fax: (201)319-8760. Manager: R.J. Martin. Estab. 1992. Firm specializes in collateral, display design, publication design. Types of clients: industrial, consumer electronics, manufacturers. Examples of projects: Sony (brochures); Toshiba (training manuals).
Needs: Works with 1-2 freelance photographers/quarter. Uses photos for product shots, multimedia productions and videotapes. Subjects include: children, couples, families, parents, teens, disasters, landscapes/scenics, architecture, beauty, adventure, automobiles, entertainment, events, health/fitness, hobbies, sports, travel, business concepts, computers. Interested in digital. Model release required.
Audiovisual Needs: Uses Hi 8, ½″ Betacam, SP, S-VHS.
Specs: Uses 35mm, 2¼×2¼, 4×5 transparencies; accepts images in digital format for Mac. Submit via compact disc, floppy disk or Zip disk.
Making Contact & Terms: Submit portfolio by mail. Provide résumé, business card, self-promotion piece or tearsheets to be kept on file for possible future assignments. Works on assignment only. Cannot return material. Reports in 2 weeks. Payment negotiable. Pays per day or per job. Pays by purchase order 30 days after work completed. Credit line given "when applicable." Buys all rights.
Tips: "Be specific about your best work (what areas), be flexible to budget on project—represent our company when on business."

$ $ 🅰 ▣ ◐ LIEBER BREWSTER DESIGN INC., (formerly Lieber Brewster Corporate Design), 19 W. 34th St., Suite 618, New York NY 10001. (212)279-9029. Contact: Anna Lieber. Estab. 1988. Design firm. Number of employees: 4. Specializes in corporate communications and marketing promotion. Types of clients: health care, financial, publishers, nonprofit, industrial.
Needs: Works with freelancers on a per project basis. Uses photos for direct mail, catalogs, brochures, annual reports and ads. Subjects include: locations, babies, children, couples, multicultural, families, parents, senior citizens, teens, food/drink, health/fitness, sports, business concepts, computers, industry, medicine, portraits, product shots/still life, technology.
Specs: Uses 8×10 b&w prints; 35mm, 2¼×2¼, 4×5, 8×10 transparencies. Accepts images in digital format for Mac as TIFF, EPS files.
Making Contact & Terms: Provide résumé, business card, brochure, flier or tearsheets to be kept on file for possible future assignments. Works with freelancers on assignment only. Keeps samples on file. SASE. Reports only on solicited work. Pays $75-150/hour; $250-700/day; $500-2,000/job. **Pays on acceptance or receipt of invoice.** Credit line given. Rights negotiable.
Tips: Wants to see an "extremely professional presentation, well-defined style and versatility. Send professional mailers with actual work for clients, as well as creative personal work."

🅰 🖼 ◐ ◎ LIPPSERVICE, 305 W. 52nd St., New York NY 10019. Phone/fax: (212)956-0572. President: Ros Lipps. Estab. 1985. Celebrity consulting firm. Types of clients: industrial, financial, fashion, retail, food; "any company which requires use of celebrities." Examples of past projects: Projects for United Way of Tri-State, CARE, AIDS benefits, Child Find of America, League of American Theatres & Producers, *Celebrate Broadway*, United Jewish Appeal (UJA).
Needs: Works with freelance photographers and/or videographers. Uses photos for billboards, trade magazines, P-O-P displays, posters, audiovisual. Subjects include: celebrities, senior citizens, pets, entertainment,

events, performing arts. Interested in fine art. Model/property release required.

Audiovisual Needs: Uses videotape.

Making Contact & Terms: Provide résumé, business card, brochure, flier or tearsheets to be kept on file for possible future assignments. Works on assignment only. Keeps samples on file. Cannot return material. Reports in 3 weeks. Payment negotiable. Credit line given. Rights purchased depend on job; negotiable.

Tips: Looks for "experience in photographing celebrities. *Contact us by mail only.*"

$ [A] [■] [⊘] MASEL ENTERPRISES, 2701 Bartram Rd., Bristol PA 19007. (215)785-1600. Fax: (215)785-1680. E-mail: richard-goldberg@masel.net. Marketing Manager: Richard Goldberg. Estab. 1906. Catalog producer. Photos used in posters, magazines, press releases, catalogs and trade shows.

Needs: Buys over 250 photos/year; offers 15-20 assignments/year. Examples of recent uses: Internet Dictionary of Orthodontic Terms (website); "Gold Denture Teeth" (postcard); assorted product work for mail order catalogs. Reviews stock photos. Needs children and adults with braces on their teeth. Model release required.

Specs: Uses 4×5 glossy b&w prints; 35mm, 2¼×2¼, 4×5 transparencies. Accepts images in digital format for Mac. Send via CD, e-mail, floppy disk, SyQuest or Zip disk.

Making Contact & Terms: Provide résumé, business card, self promotion piece or tearsheets to be kept on file for possible future assignments. Works with local freelancers on assignment only. Keeps samples on file. SASE. Reports in 2 weeks if interested. Pays $100/color or b&w inside; $250-500/cover shot; $800 maximum/day. Volume work is negotiated. **Pays on acceptance**. Credit line depends on terms and negotiation. Buys all rights.

Tips: "We're an interesting company with great layouts. We are always looking for new ideas. We invite input from our photographers and expect them to get involved."

$ [📷] [⊘] MCANDREW ADVERTISING CO., 210 Shields Rd., Red Hook NY 12571. Phone/fax: (914)756-2276. Contact: Robert McAndrew. Estab. 1961. Ad agency, PR firm. Approximate annual billing: $250,000. Number of employees: 2. Firm specializes in catalogs. Types of clients: industrial and technical. Examples of recent projects: "UPI 60," Electronic Devices, Inc. (publicity release); "Industrial Catalog," Gula Corporation (catalog).

Needs: Works with 1 freelance photographer/month. Uses photos for trade magazines, direct mail, brochures, catalogs, newspapers, audiovisual. Subjects include: technical products, business concepts, computers, industry, medicine, portraits, product shots/still life, science, technology. Model release required for recognizable people. Property release required.

Audiovisual Needs: Uses slides and videotape.

Specs: Uses 8×10 glossy b&w or color prints; 35mm, 4×5 transparencies.

Making Contact & Terms: Interested in working with local photographers. Query with résumé of credits, business card, brochure, flier, tearsheets or non-returnable samples to be kept on file for possible future assignments. Reports when appropriate. Pays $50-100/b&w photo; $100-200/color photo; $700/day. "Prices dropping because business is bad." Pays 30 days after receipt of invoice. Credit line sometimes given. Buys all rights; negotiable.

Tips: Photographers should "let us know how close they are and what their prices are. We look for photographers who have experience in industrial photography." In samples, wants to see "sharp, well-lighted" work.

$ MEDIA LOGIC, INC., 1520 Central Ave., Albany NY 12205. (518)456-3015. Fax: (518)456-4279. E-mail: jhoe@mlinc.com. Production Manager: Jennifer Hoehn. Estab. 1984. Ad agency. Number of employees: 45. Types of clients: industrial, financial, fashion and retail.

Needs: Works with 2 freelancers/month. Uses photos for billboards, consumer magazines, trade magazines, direct mail, P-O-P displays, catalogs, posters, newspapers and signage. Subject matter varies. Reviews stock photos. Model release required. Property release preferred.

Specs: Uses transparencies.

Making Contact & Terms: Send unsolicited photos by mail for consideration. Provide résumé, business card, brochure, flier or tearsheets to be kept on file for possible future assignments. Keeps samples on file. SASE. Reports in 1-2 weeks. Pays $800/day. **Pays on receipt of invoice.** Credit line not given. Buys all rights; negotiable.

$ [A] [📷] MIRACLE OF ALOE, 521 Riverside Ave., Westport CT 06880. (203)454-1919. Fax: (203)226-7333. Vice President: Jess F. Clarke, Jr. Estab. 1980. Manufacturers of aloe products for mail order buyers of healthcare products. Photos used in newsletters, catalogs, direct mail, consumer magazines, TV spots and infomercials.

Needs: Works with 2 freelancers per month. Uses testimonial photos and aloe vera plants. Model release preferred.

Making Contact & Terms: Provide résumé, business card, self-promotion piece or tearsheets to be kept on file for possible future assignments. Works on assignment only. Uses 4×5 b&w or color prints and 35mm transparencies. SASE. Reports in 1 month. Pays $30-45/photo. **Pays on receipt of invoice.** Credit line given. Buys one-time rights.

Tips: In freelancer's samples, looks for "older folks, head shots and nice white-haired ladies. Also show aloe vera plants in fields or pots; shoot scenes of southern Texas aloe farms. We need video photographers to do testimonials of aloe users all around the country for pending 30-minute infomercial."

$ $ ▣ ◎ MITCHELL STUDIOS DESIGN CONSULTANTS, 1111 Fordham Lane, Woodmere NY 11598. (516)374-5620. Fax: (516)374-6915. E-mail: msdcdesign@aol.com. Principal: Steven E. Mitchell. Estab. 1922. Design firm. Number of employees: 6. Firm specializes in packaging. Types of clients: industrial and retail. Examples of projects: Lipton Cup-A-Soup, Thomas J. Lipton, Inc.; Colgate Toothpaste, Colgate Palmolive Co.; and Chef Boy-Ar-Dee, American Home Foods—all three involved package design.

Needs: Works with variable number of freelancers/month. Uses photographs for direct mail, P-O-P displays, catalogs, posters, signage and package design. Subjects include: still life/product. Reviews stock photos of still life/people. Model release required. Property release preferred. Captions preferred.

Specs: Uses all sizes and finishes of color and b&w prints; 35mm, 2¼×2¼, 4×5, 8×10 transparencies. Accepts images in digital format for Mac. Send via CD, SyQuest, floppy disk, Jaz, Zip, e-mail as EPS files.

Making Contact & Terms: Submit portfolio for review. Provide résumé, business card, brochure, flier or tearsheets to be kept on file for possible future assignments. Cannot return material. Reports as needed. Pays $35-75/hour; $350-1,500/day; $500 and up/job. **Pays on receipt of invoice.** Credit line sometimes given depending on client approval. Buys all rights.

Tips: In portfolio, looks for "ability to complete assignment." Sees a trend toward "tighter budgets." To break in with this firm, keep in touch regularly.

$ $ ▣ MIZEREK ADVERTISING INC., 318 Lexington Ave., New York NY 10016. (212)689-4885. E-mail: mizerek@aol.com. President: Leonard Mizerek. Estab. 1974. Types of clients: fashion, jewelry and industrial.

Needs: Works with 2 freelance photographers/month. Uses photographs for trade magazines. Subjects include: still life and jewelry. Reviews stock photos of creative images showing fashion/style. Model release required. Property release preferred.

Specs: Uses 8×10 glossy b&w prints; 4×5 and 8×10 transparencies. Accepts images in digital format for Mac. Send via Zip disk or online.

Making Contact & Terms: Submit portfolio for review. Provide résumé, business card, brochure, flier or tearsheets to be kept on file for possible future assignments. SASE. Reports in 2 weeks. Pays $500-1,500/job; $1,500-2,500/day; $600/color photo; $400/b&w photo. **Pays on acceptance.** Credit line sometimes given.

Tips: Looks for "clear product visualization. Must show detail and have good color balance." Sees trend toward "more use of photography and expanded creativity." Likes a "thinking" photographer.

$ $ $ ▣ ▣ ▣ MONTGOMERY & PARTNERS, INC., 2345 Bernville Rd., Reading PA 19605-9604. (610)372-5106. Fax: (610)376-7636. E-mail: montgomery@montyads.com. Website: http://www.montyads.com. President: Beverly Montgomery. Estab. 1986. Member of AAAA (American Association of Advertising Agencies). Ad agency. Approximate annual billing: $2 million. Number of employees: 15. Firm specializes in magazine ads, collateral, Internet. Types of clients: industrial, financial, retail, nonprofit.

Needs: Works with 4 freelancers/month. Uses photos for brochures, catalogs, consumer magazines, newspapers, P-O-P displays, trade magazines. Reviews stock photos. Model release required; property release required.

Audiovisual Needs: Uses slides and/or powerpoint presentations.

Specs: Uses 35mm transparencies. Accepts images in digital format.

Making Contact & Terms: Provide résumé, business card, self-promotion piece or tearsheets to be kept on file for possible future assignments. Art director will contact photographer for portfolio review if interested. Portfolio should include b&w, color, tearsheets, slides, transparencies. Works with freelancers on assignment only. Keeps samples on file. **Pays on receipt of invoice.** Credit line sometimes given depending upon usage. Buys one-time rights and negotiated rights based on length of time of usage.

$ $ [A] [image] [image] RUTH MORRISON ASSOCIATES, 246 Brattle St., Cambridge MA 02138. (617)354-4536. Fax: (617)354-6943. Account Executive: Rebecca Fields. Estab. 1972. PR firm. Types of clients: food, home furnishings, travel and general business.
Needs: Works with 1-2 freelance photographers/month. Uses photos for newspapers, consumer and trade magazines, posters and brochures.
Specs: Specifications vary according to clients' needs. Typically uses b&w prints and transparencies.
Making Contact & Terms: Send résumé, business card, brochure, flier or tearsheets to be kept on file for possible future assignments. Works with freelancers on assignment only. Reports "as needed." Pays $200-1,000 depending upon client's budget. Credit line sometimes given, depending on use. Rights negotiable.

$ $ [image] NASSAR DESIGN, 560 Harrison Ave., Boston MA 02146. (617)482-1464. Fax: (617)426-3604. President: Nélida Nassar. Estab. 1980. Member of American Institute of Graphic Arts, Art Guild, Boston Spanish Association. Design firm. Approximate annual billing: $1.5 million. Number of employees: 4. Firm specializes in collateral, display design, direct mail, publication design, signage. Types of clients: publishers, nonprofit and industrial. Examples of recent projects: The Chinese Porcelain Company (photography of all objects); Metropolitan Museum of Art (photography of all sculptures); Harvard University (photography of the campus and the architecture); and Howard University (book on Singapore).
Needs: Works with 1-2 freelancers/month. Uses photos for catalogs, posters, signage. Subjects include art objects, architectural sites, products, babies, multicultural, families, parents, environmental, landscapes/scenics, interiors/decorating, entertainment, travel, buildings, computers,medicine, science, technology. Interested in avant garde, fashion/glamour, fine art. Reviews stock photos. Model release required; property release preferred. Captions required.
Specs: Uses 8×10 glossy color and b&w prints; 4×5 transparencies. Accepts images in digital format for Mac. Send via CD, SyQuest, floppy disk, Jaz, Zip, e-mail as TIFF, EPS, JPEG files at 360 dpi.
Making Contact & Terms: Submit portfolio for review. Query with samples. Keeps samples on file. SASE. Reports in 1-2 weeks. Pays $1,200-1,500/day; $150-300 for b&w photos; $400-600 for color photos; $150-175/hour; $3,000-6,000/job. **Pays on receipt of invoice.** Credit line given. Buys all rights.
Tips: "We always look for the mood created in a photograph that will make it interesting and unique."

$ NATIONAL BLACK CHILD DEVELOPMENT INSTITUTE, 1023 15th St. NW, Suite 600, Washington DC 20005. (202)387-1281. Fax: (202)234-1738. Vice President: Vicki D. Pinkston. Estab. 1970. Photos used in brochures, newsletters, annual reports and annual calendar.
Needs: Candid action photos of black children and youth. Reviews stock photos. Model release required.
Specs: Uses 5×7 or 8×10 color and glossy b&w prints and color slides or b&w contact sheets.
Making Contact & Terms: Query with samples. Send unsolicited photos by mail for consideration. SASE. Reports in 1 month. Pays $70/cover photo and $20/inside photo. Credit line given. Buys one-time rights.
Tips: "Candid action photographs of one black child or youth or a small group of children or youths. Color photos selected are used in annual calendar and are placed beside an appropriate poem selected by organization. Therefore, photograph should communicate a message in an indirect way. Black & white photographs are used in quarterly newsletter and reports. Obtain sample of publications published by organization to see the type of photographs selected."

$ NATIONAL TEACHING AIDS, INC., 401 Hickory St., Fort Collins CO 80524. (800)446-8767. Fax: (970)484-1198. National Sales Manager: Candace Coffman. Estab. 1960. AV firm. Types of clients: schools. Produces filmstrips and CD-ROMs.
Needs: Buys 20-100 photos/year. Subjects include: science; needs photomicrographs and space photography.
Specs: Uses 35mm transparencies.
Making Contact & Terms: Cannot return material. Pays $50 minimum. Buys one-time rights; negotiable.

$ $ [A] [image] THE NEIMAN GROUP, 415 Market St., Suite 201, Harrisburg PA 17101. (717)232-5554. Fax: (717)232-7998. E-mail: neimangrp@aol.com. Website: http://www.neimangrp.com. Contact: Art Director. Estab. 1980. Ad agency, PR firm. Firm specializes in annual reports, magazine ads, packaging, direct mail, signage, collateral. Types of clients: financial, retail, nonprofit, agricultural, food, medical, industrial.
Needs: Uses photos for brochures, consumer magazines, direct mail, newspapers, trade magazines. Model release required.
Making Contact & Terms: Send query letter with samples, tearsheets. Art director will contact photographer for portfolio review if interested. Works with local freelancers on assignment only. Keeps samples

on file. Pays by the project. **Pays on receipt of invoice.** Buys one-time rights, all rights.

$ $ ⬛🖼 ◐ ◎ LOUIS NELSON ASSOCIATES INC., 80 University Place, New York NY 10003. (212)620-9191. Fax: (212)620-9194. Design firm. Estab. 1980. Types of clients: corporate, retail, not-for-profit and government agencies.
Needs: Works with 3-4 freelance photographers/year. Uses photographs for consumer and trade magazines, catalogs and posters. Reviews stock photos only with a specific project in mind.
Audiovisual Needs: Occasionally needs visuals for interactive displays as part of exhibits.
Making Contact & Terms: Submit portfolio for review. Provide résumé, business card, brochure, flier or tearsheets to be kept on file for possible future assignments. Cannot return material. Does not report; call for response. Payment negotiable. **Pays on receipt of invoice.** Credit line sometimes given depending upon client needs.
Tips: In portfolio, wants to see "the usual . . . skill, sense of aesthetics that doesn't take over and ability to work with art director's concept." One trend is that "interactive videos are always being requested."

$ NOSTRADAMUS ADVERTISING, #1128A, 250 W. 57th, New York NY 10107. (212)581-1362. Fax: (212)581-1369. President: Barry Sher. Estab. 1974. Ad agency. Types of clients: politicians, nonprofit organizations and small businesses.
Needs: Uses freelancers occasionally. Uses photos for consumer and trade magazines, direct mail, catalogs and posters. Subjects include: people and products. Model release required.
Specs: Uses 8×10 glossy b&w and color prints; transparencies, slides.
Making Contact & Terms: Provide résumé, business card, brochure. Works with local freelancers only. Cannot return material. Pays $50-100/hour. Pays 30 days from invoice. Credit line sometimes given. Buys all rights (work-for-hire).

$ $ A ◨ 🖼 ◯ NOVUS VISUAL COMMUNICATIONS, INC., 18 W. 27th St., New York NY 10001-6904. (212)689-2424. Fax: (212)696-9676. E-mail: novuscom@aol.com. Owner/President: Robert Antonik. Estab. 1988. Creative marketing and communications firm. Specializes in advertising, annual reports, publication design, display design, multi-media, packaging, direct mail, signage and website and Internet and DVD development. Types of clients: industrial, financial, retail, health care, telecommunications, entertainment and nonprofit. Examples of recent clients: "Annual Report," IPRO; "Native American Calendar," Heidelberg.
Needs: Works with 1 freelancer/month. Uses photos for annual reports, billboards, consumer and trade magazines, direct mail, P-O-P displays, catalogs, posters, packaging and signage. Subjects include: babies, children, couples, multicultural, families, parents, senior citizens, teens, environmental, landscapes/scenics, wildlife, architecture, beauty, cities/urban, education, gardening, interiors/decorating, pets, religious, rural, adventure, automobiles, entertainment, events, food/drink, health/fitness, hobbies, humor, performing arts, sports, travel, agriculture, buildings, business concepts, computers, industry, medicine, military, political, portraits, product shots/still life, science, technology. Interested in alternative process, avant garde, digital, documentary, fashion/glamour, fine art, historical/vintage, regional, seasonal. Reviews stock photos. Model/property release required. Captions preferred.
Audiovisual Needs: Uses film and videotape.
Specs: Uses color and b&w prints; 35mm, 2¼×2¼, 4×5, 8×10 transparencies. Accepts images in digital format for Mac. Send via Zip disk, CD-ROM, as TIFF files.
Making Contact & Terms: Arrange personal interview to show portfolio. Works on assignment only. Keeps samples on file. Material cannot be returned. Reports in 1-2 weeks. Pays $75-150 for b&w photos; $150-250 for color photos; $300-750 for film; $150-300 for videotape. Pays upon client's payment. Credit line given. Rights negotiable.
Tips: "The marriage of photos with illustrations or opposite usage continues to be trendy, but more illustrators and photographers are adding stock usage as part of their business, alone or with stock shops. Send sample on a post card; follow up with phone call."

$ $ $ 🖼 PARAGON ADVERTISING, 43 Court St., Suite 1111, Buffalo NY 14202. (716)854-7161. Fax: (716)854-7163. Senior Art Director: Leo Abbott. Estab. 1988. Ad agency. Types of clients: industrial, retail, food.

THE SUBJECT INDEX, located at the back of this book, lists publications, book publishers, galleries, greeting card companies, advertising agencies, design firms and stock agencies according to the subject areas they seek.

Needs: Works with 0-5 photographers, 0-1 filmmakers and 0-1 videographers/month. Uses photos for billboards, consumer and trade magazines, P-O-P displays, catalogs, posters, newspapers, signage and audiovisual. Subjects include: location. Reviews stock photos. Model release required. Property release preferred.
Audiovisual Needs: Uses film and videotape for on-air.
Specs: Uses 8×10 prints; 2¼×2¼ or 4×5 transparencies; 16mm film; and ¾", 1" Betacam videotape.
Making Contact and Terms: Submit portfolio for review. Query with stock photo list. Send unsolicited photos by mail for consideration. Keeps samples on file. SASE. Reports in 1-2 weeks. Pays $500-2,000 day; $100-5,000 job. Pays on receipt of invoice. Credit line sometimes given. Buys all rights; negotiable.

$ $ $ [A] [□] [▨] PERCEPTIVE MARKETERS AGENCY, LTD., 1100 E. Hector St., Suite 301, Conshohocken PA 19428. (610)825-8710. Fax: (610)825-9186. E-mail: perceptmkt@aol.com. Contact: Jason Solovitz. Estab. 1972. Member of Advertising Agency Network International, Philadelphia Ad Club, Philadelphia Direct Marketing Association. Ad agency. Number of employees: 8. Types of clients: health care, business, industrial, financial, fashion, retail and food. Examples of recent projects: 900 Services Quarterly Newsletter, AT&T; Technology Campaign, Johnson Matthey; Transit Program, Young Windows; Model 51 Launch, OPEX Corporation.
Needs: Works with 3 freelance photographers, 1 filmmaker and 1 videographer/month. Uses photos for consumer magazines, trade magazines, direct mail, P-O-P displays, catalogs, posters, newspapers, signage and audiovisual. Reviews stock photos. Model release required; property release preferred. Captions preferred.
Audiovisual Needs: Uses slides and film or video.
Specs Uses 8×12 and 11×14 glossy color and b&w prints; 2¼×2¼, 4×5 transparencies. Accepts images in digital format for Mac. Send via CD, SyQuest, floppy or Zip disk or Online.
Making Contact & Terms: Query with stock photo list. Provide résumé, business card, brochure, flier or tearsheets to be kept on file for possible future assignments. Works on assignment only. Keeps samples on file. Pays minimum $75/hour; $800/day. **Pays on receipt of invoice.** Credit line not given. Buys all rights; negotiable.

[A] [□] [▨] THE PHILIPSON AGENCY, 241 Perkins St., Suite B201, Boston MA 02130. (617)566-3334. Owner/Creative Director: Joe Philipson. Estab. 1977. Ad Agency. Number of employees: 4. Types of clients: financial, consumer product manufacturers, food service, computer products.
Needs: Works with 1 photographer/month. Uses photos for trade magazine ads, direct mail, P-O-P displays, catalogs, packaging, brochures and posters. Subjects include: product shots. Reviews stock photos. Model/property release preferred.
Audiovisual Needs: Uses slides for sales presentations.
Specs: Uses all sizes and finishes color and b&w prints; 35mm, 2¼×2¼, 4×5, 8×10 transparencies; film; and digital format. Accepts Mac compatible Tiff, EPS and JPEG files on CD, floppy, Zip, SyQuest or Online.
Making Contact & Terms: Query with samples. Provide résumé, business card, brochure, flier or tearsheets to be kept on file for possible future assignments. Works on assignment only. Keeps samples on file. Cannot return material. Calls photographer when work needed. Payment negotiable. **Pays on receipt of invoice.** Credit line sometimes given depending on client. Buys all rights.

$ [A] [□] [◪] [◎] POSEY SCHOOL OF DANCE, INC., Box 254, Northport NY 11768. (516)757-2700. E-mail: 74534.1660@compuserve.com. President: Elsa Posey. Estab. 1953. Sponsors a school of dance and a regional dance company. Photos used in brochures, news releases and newspapers.
Needs: Buys 10-12 photos/year; offers 4 assignments/year. Special subject needs include children dancing, ballet, modern dance, jazz/tap (theater dance) and classes including women and men. Reviews stock photos. Model release required.
Specs: Uses 8×10 glossy b&w prints. Send via CD as GIF files.
Making Contact & Terms: "Call us." Works on assignment only. SASE. Reports in 1 week. Pays $25-150/b&w; $35-160/color photo. Credit line given if requested. Buys one-time rights; negotiable.
Tips: "We are small but interested in quality (professional) work. Capture the joy of dance in a photo of children or adults. We prefer informal action photos not 'posed pictures.' We need photos of REAL dancers doing dance. Call first. Be prepared to send photos on request."

$ $ $ [▨] [◪] SUSAN M. RAFAJ MARKETING ASSOCIATES, 135 E. 55th St., New York NY 10022. (212)759-1991. Fax: (212)755-4841. Website: http://www.rafaj.com. Executive Vice President: John Collier. Estab. 1978. Member of American Association of Advertising Agencies. Ad agency and

design firm. Firm specializes in display design, magazine ads, packaging, collateral. Types of clients: industrial.

Needs: Uses photos for P-O-P displays. Subjects include: beauty and lifestyle. Reviews stock photos. Model release required.

Audiovisual Needs: Uses slides and/or videotape.

Making Contact & Terms: Send query letter with stock photo list. Art director will contact photographer for portfolio review if interested. Keeps samples on file; include SASE for return of material. Reports back only if interested, send non-returnable samples. Pays on receipt of invoice. Credit line not given. Rights negotiable.

[N] $ [A] [■] [◑] [◎] RAINCASTLE COMMUNICATIONS INC., 288 Walnut St., Newton MA 02460. Website: http://www.raincastle.com. Creative Director: Jennifer McPhilimy. Estab. 1994. Member of AIGA. Print and interactive design firm. Approximate annual billing: 2 million. Number of employees: 15. Specializes in corporate identity, branding, annual reports, packaging, collateral, websites. Examples of recent projects: See portfolio at www.raincastle.com.

Needs: Uses photos for annual reports, packaging, collateral and websites. Subjects include: architecture, computers, high-tech, elegant, conceptual. Reviews stock photos.

Specs: Uses 35mm transparencies. Accepts images in digital format for Mac.

Making Contact & Terms: Provide résumé, business card, brochure, flier or tearsheets to be kept on file for possible future assignments. Works with local freelancers on assignment only. Keeps samples on file. Payment negotiable. Pays net 30 days. Credit line sometimes given. Rights purchased depending upon project.

Tips: "Send tearsheets. We mainly use local photographers for original images or stock from anywhere."

$ ROSEN-COREN AGENCY, 2381 Philmont Ave., Suite 117, Huntingdon PA 19006. (215)938-1017. Fax: (215)938-7634. Office Administrator: Ellen R. Coren. PR firm. Types of clients: industrial, retail, fashion, finance, entertainment, health care.

Needs: Works with 4 freelance photographers/month. Uses photos for PR shots.

Specs: Uses b&w prints.

Making Contact & Terms: "Follow up with phone call." Works with local freelancers only. Reports when in need of service. Pays $75-85/hour for b&w and color photos. Pays when "assignment completed and invoice sent—45 days."

PETER ROTHHOLZ ASSOCIATES, INC., 355 Lexington Ave., 17th Floor, New York NY 10017. (212)687-6565. Contact: Peter Rothholz. PR firm. Types of clients: pharmaceuticals (health and beauty), government, travel.

Needs: Works with 2 freelance photographers/year, each with approximately 8 assignments. Uses photos for brochures, newsletters, PR releases, AV presentations and sales literature. Model release required.

Specs: Uses 8×10 glossy b&w prints; contact sheet OK.

Making Contact & Terms: Provide letter of inquiry to be kept on file for possible future assignments. Query with résumé of credits or list of stock photo subjects. Local freelancers preferred. SASE. Reports in 2 weeks. Payment negotiable based on client's budget. Credit line given on request. Buys one-time rights.

Tips: "We use mostly standard publicity shots and have some 'regulars' we deal with. If one of those is unavailable we might begin with someone new—and he/she will then become a regular."

$ $ $ [■] [◑] RPDGROUP, Richard Puder Design, 2 W. Blackwell St., P.O. Box 1520, Dover NJ 07801. (973)361-1310. Fax: (973)361-1663. E-mail: talentbank@strongtype.com. Website: http://www.s-trongtype.com. Owner: Richard Puder. Estab. 1985. Member of Type Directors Club. Design firm. Approximate annual billing: $300,000. Number of employees: 3. Specializes in annual reports, publication design, packaging and direct mail. Types of clients: publishers, corporate and communication companies.

Needs: Works with 1 freelancer/month. Uses photos for annual reports, trade magazines, direct mail, posters and packaging. Subjects include: corporate situations and executive portraits. Reviews stock photos. Model/property release preferred.

Specs: Accepts images in digital format in TIF, JPEG and PDF files. Send via CD, online, Zip.

Making Contact & Terms: Provide résumé, business card, brochure, flier or tearsheets to be kept on file for possible future assignments. Keeps samples on file. Cannot return material. "We reply on an as needed basis." Pays $500-1,200/day. Pays in 30 days upon receipt of invoice. Credit line sometimes given depending upon client needs and space availability. Buys one-time rights; negotiable.

A ▣ **RSVP MARKETING, INC.**, 450 Plain St., Marshfield MA 02050. (617)837-2804. Fax: (617)837-5389. E-mail: rsvpmktg@aol.com. President: Edward G. Hicks. Estab. 1981. Member of NEDMA, DMA, AMA. Ad agency and AV firm. Types of clients: industrial, financial, fashion, retail and construction. Examples of recent projects: "Landfill Reclamation," RETECH (trade shows); "Traffic," Taylor (print media); and "Fund Raising," CHF (newsletter).
Needs: Works with 1-2 freelance photographers and 1-2 videographers/month. Uses photos for trade magazines, direct mail, catalogs, newspapers and audiovisual. Subjects include: environment and people. Model release required.
Audiovisual Needs: Uses slides and videotape for advertising and trade shows.
Specs: Uses 5×7 color and b&w prints; 35mm, 2¼×2¼, 4×5, 8×10 transparencies.
Making Contact & Terms: Query with stock photo list or samples. Works with freelancers on assignment only. Keeps samples on file. Reports in 1 month. Payment negotiable. Pays net 30 days. Buys all rights.

$ $ $ $ ▣ **ARNOLD SAKS ASSOCIATES**, 350 E. 81st St., New York NY 10028. (212)861-4300. Fax: (212)535-2590. Photo Librarian: Patricia Chan. Estab. 1968. Member of AIGA. Graphic design firm. Number of employees: 15. Types of clients: industrial, financial, legal, pharmaceutical and utilities. Clients include: 3M, American Home Products, Alcoa, Olin and UBS.
Needs: Works with approximately 15 photographers during busy season. Uses photos for annual reports and corporate brochures. Subjects include corporate situations and portraits. Reviews stock photos; subjects vary according to the nature of the annual report. Model release required. Captions preferred.
Specs: Uses b&w prints; 35mm, 2¼×2¼, 4×5, 8×10 transparencies.
Making Contact & Terms: "Appointments are set up during the spring for summer review on a first-come only basis. We have a limit of approximately 30 portfolios each season." Call to arrange an appointment. Reports as needed. Payment negotiable, "based on project budgets. Generally we pay $1,250-2,250/day." Pays on receipt of invoice and payment by client; advances provided. Credit line sometimes given depending upon client specifications. Buys one-time and all rights; negotiable.
Tips: "Ideally a photographer should show a corporate book indicating his success with difficult working conditions and establishing an attractive and vital final product. Our company is well known in the design community for doing classic graphic design. We look for solid, conservative, straightforward corporate photography that will enhance these ideals."

A **JACK SCHECTERSON ASSOCIATES**, 5316 251 Place, Little Neck NY 11362. (718)225-3536. Fax: (718)423-3478. Principal: Jack Schecterson. Estab. 1962. Design firm. Specializes in product, packaging and graphic design. Types of clients: industrial, consumer product manufacturers.
Needs: "Depends on work in-house." Uses photos for P-O-P displays and packaging. Reviews stock photos. Model/property release required. Captions preferred.
Specs: Variety of size color/b&w prints; 35mm, 2¼×2¼, 4×5 and 8×10 transparencies.
Making Contact & Terms: Works with local freelancers on assignment only. Cannot return material. Reports in 3 weeks. Payment negotiable, "depends upon job." Credit line sometimes given. Buys all rights.
Tips: Wants to see creative and unique images.

N **$ $ $ $** ▣ ▢ **TONI SCHOWALTER DESIGN**, 1133 Broadway, Suite 1610, New York NY 10010. (212)727-0072. Fax: (212)727-0071. E-mail: toni@schowalter.com. Website: http://www.scho walter.com. Estab. 1987. Member of AIGA, SMPS. Design firm. Approximate annual billing: $500,000. Number of employees: 4. Firm specializes in collateral. Types of clients: industrial. Examples of recent clients: "Stanworth Furniture," CFI (brochure); "Interiors," Tobin Parrier (brochure).
Needs: Works with 1-2 photographers/month. Uses photos for brochures. Subjects include: buildings, busines concepts, product shots/still life, technology.
Specs: Uses 8×10, glossy, matte, color and b&w prints; 4×5 transparencies. Accepts images in digital format for Mac. Send via Zip files.
Making Contact and Terms: Send query letter with tearsheets. Provide self-promotion piece to be kept on file. Pays by the project, $500 minimum. Pays on receipt of invoice. Buys one-time rights.

▣ ▢ **SELBERT PERKINS DESIGN**, 2067 Massachusetts Ave., Cambridge MA 02140. (617)497-6605. Fax: (617)661-5772. E-mail: spdeast@aol.com. Website: http://www.selbertperkins.com. Second location: 1916 Main St., Santa Monica CA 90405. (310)664-9100. Fax: (310)452-7180. Estab. 1982. Member of AIGA, SEGD. Design firm. Number of employees: 50. Specializes in strategic brand identity design, environmental communications design, product and packaging design, landscape architecture, urban design, public art and multimedia design. Types of clients: architecture, institutional, entertainment, consumer products, sports, high tech and financial. Examples of current clients: State Street Research, Hasbro, University of Southern California, Care Group, Fidelity Investments.

Needs: Number of photos bought each month varies. Uses photos for annual reports, billboards, consumer and trade magazines, direct mail, P-O-P displays, catalogs, posters, packaging and signage. Subjects include: children, couples, parents, senior citizens, environmental, landscapes/scenics, architecture, cities/urban, education, rural, adventure, health/fitness, performing arts, sports, travel, business concepts, computers, industry, technology. Interested in alternative process, avant garde, digital, fashion/glamour, historical/vintage, regional, seasonal. Reviews stock photos.

Specs: Accepts images in digital format for Mac. Send via CD, Zip as TIFF files.

Making Contact & Terms: Submit portfolio for review. Provide résumé, business card, brochure, flier or tearsheets to be kept on file for possible future assignments. "We have a drop off policy." Keeps samples on file. SASE. Payment negotiable. Credit line given.

N $ $ $ ▣ ▦ SIMON DESIGN, 146 Banck St., 3A, New York NY 10014. (212)255-3038. Fax: (212)924-7725. E-mail: ksimon@interport.net. Website: http://www.simondoes.com. Estab. 1993. Member of AIGA, GAG. Design firm. Firm specializes in annual reports, collateral, publication design. Types of clients: industrial, financial, nonprofit, entertainment. Examples of recent clients: Public School Reform Initiative, The Ford Foundation; "Girls Program Brochure," the MS Foundation for Women.

Needs: Works with 1 photographer every other month. Uses photos for billboards, brochures, direct mail, newspapers, P-O-P displays, posters, signage. Subjects include: children, couples, multicultural, senior citizens, education, events, humor, sports, business concepts, computers, medicine. Interested in alternative process, avant garde, seasonal. Model and property release required.

Audiovisual Needs: Uses any format for video and film.

Specs: Uses any size prints. Accepts images in digital format for Mac. Send via Jaz, Zip, e-mail as TIFF, EPS files at 300 dpi.

Making Contact and Terms: Send query letter with tearsheets. Provide self-promotion piece to be kept on file. Reports back only if interested; send non-returnable samples. Pays extra for electronic usage. Pays on publication. Credit line sometimes given depending upon client. Rights negotiable.

$ $ ▣ ▦ ◉ SORIN PRODUCTIONS, INC., 919 Hwy. 33, Suite 46, Freehold NJ 07728. (732)462-1785. Fax: (732)462-8411. E-mail: info@sorinproductions.com. Website: http://www.sorinproductions.com. President: David Sorin. Type of client: corporate.

Needs: Works with 2 freelance photographers/month. Uses photographers for slide sets, multimedia productions, films and videotapes. Subjects include people and products.

Specs: Uses b&w and color prints; 35mm and 2¼×2¼ transparencies. Accepts images in digital format for Mac. Send via Zip or e-mail (72 dpi).

Making Contact & Terms: Query with stock photo list. Provide résumé, business card, self-promotion piece or tearsheets to be kept on file for possible future assignments. Does not return unsolicited material. Reports in 2 weeks. Payment negotiable. Pays per piece or per job. **Pays on acceptance.** Buys all rights. Captions and model releases preferred. Credit line given by project.

▦ SPENCER PRODUCTIONS, INC., 736 West End Ave., New York NY 10025. General Manager: Bruce Spencer. Estab. 1961. PR firm. Types of clients: business, industry. Produces motion pictures and videotape.

Audiovisual Needs: Works with 1-2 freelance videographers/month on assignment only. Buys 2-6 films/year. Satirical approach to business and industry problems. Length: "Films vary—from a 1-minute commercial to a 90-minute feature." Freelance photos used on special projects. Model/property release required. Captions required.

Making Contact & Terms: Provide résumé and letter of inquiry to be kept on file for possible future assignments. Query with samples and résumé of credits. "Be brief and pertinent!" SASE. Reports in 3 weeks. Pays $50-150/color and b&w photos (purchase of prints only; does not include photo session); $15/hour; $500-5,000/job. Payment negotiable based on client's budget. Pays a royalty of 5-10%. **Pays on acceptance.** Buys one-time and all rights; negotiable.

Tips: "Almost all of our talent was unknown in the field when hired by us. For a sample of our satirical philosophy, see paperback edition of *Don't Get Mad . . . Get Even* (W.W. Norton), by Alan Abel which we promoted, or *How to Thrive on Rejection* (Dembner Books, Inc.) or rent the home video *Is There Sex After Death?*, an R-rated comedy featuring Buck Henry."

$ Ⓐ ▦ STEWART DIGITAL VIDEO, 525 Mildred Ave., Primos PA 19018. (610)626-6500. Fax: (610)626-2638. Studio and video facility. Director of Sales/New Media: Mark von Zeck. Estab. 1970. Types of clients: corporate, commercial, industrial, retail.

Audiovisual Needs: Uses 15-25 freelancers/month for film and videotape productions.

Specs: Reviews film or video of industrial and commercial subjects. Film and videotape (specs vary).

Making Contact & Terms: Provide résumé, business card, brochure to be kept on file for possible future assignments. Works with freelancers on assignment basis only. Reports as needed. Pays $250-800/day; also pays "per job as market allows and per client specs." Photo captions preferred.

Tips: "The industry is really exploding with all types of new applications for film/video production." In freelancer's demos, looks for "a broad background with particular attention paid to strong lighting and technical ability." To break in with this firm, "be patient. We work with a lot of freelancers and have to establish a rapport with any new ones that we might be interested in before we will hire them." Also, "get involved on smaller productions as a 'grip' or assistant, learn the basics and meet the players."

A 🖼 ⊘ TALCO PRODUCTIONS, 279 E. 44th St., New York NY 10017. (212)697-4015. Fax: (212)697-4827. E-mail: alaw@enet.com. President: Alan Lawrence. Vice President: Marty Holberton. Estab. 1968. Public relations agency and TV, film, radio and audiovisual production firm. Number of employees: 5. Types of clients: industrial, legal, political and nonprofit organizations. Produces motion pictures, videotape and radio programs.

Needs: Works with 1-2 freelancers/month. Model/property release required.

Audiovisual Needs: Uses 16mm and 35mm film, Beta videotape. Filmmaker might be assigned "second unit or pick-up shots."

Making Contact & Terms: Query with résumé of credits. Provide résumé, flier or brochure to be kept on file for possible future assignments. Prefers to see general work or "sample applicable to a specific project we are working on." Works on assignment only. SASE. Reports in 3 weeks. Payment negotiable according to client's budget and where the work will appear. **Pays on receipt of invoice.** Buys all rights.

Tips: Filmmaker "must be experienced—union member is preferred. We do not frequently use freelancers except outside the New York City area when it is less expensive than sending a crew. Query with résumé of credits only—don't send samples. We will ask for specifics when an assignment calls for particular experience or talent."

N $ $ 🖼 🖼 ⊘ TELE-PRESS ASSOCIATES, INC., 321 E. 53rd., New York NY 10022. (212)688-5580. Fax: (212)688-5857. President: Alan Macnow. Project Director: Devin Macnow. PR firm. Number of employees: 10. Firm specializes in direct mail, magazine ads, publication design. Uses brochures, annual reports, press releases, AV presentations, consumer and trade magazines. Serves beauty, fashion, jewelry, food, finance, industrial and government clients. Example of recent client: Cultured Pearl Information Center (ads, press releases, brochures).

Needs: Works with 3 freelance photographers/month on assignment only. Subjects include: wildlife. Interested in fashion/glamour.

Audiovisual Needs: Works with freelance filmmakers in production of 16mm documentary, industrial and educational films.

Specs: Uses 8×10 glossy b&w prints; 35mm, 2¼×2¼, 4×5 or 8×10 transparencies. Accepts images in digital format for Windows. Send via CD, floppy disk, Zip, e-mail as TIFF, JPEG files.

Making Contact & Terms: Provide résumé, business card and brochure to be kept on file for possible future assignments. Query with résumé of credits or list of stock photo subjects. SASE. Reports in 2 weeks. Pays $100-200/b&w and color photo; $800-1,500/day; negotiates payment based on client's budget. Buys all rights. Model release and captions required.

Tips: In portfolio or samples, wants to see still life, and fashion and beauty, shown in dramatic lighting. "Send intro letter, do either fashion and beauty or food and jewelry still life."

$ $ $ 🖼 🖼 MARTIN THOMAS, INC., Advertising & Public Relations, 334 County Road, Barrington RI 02806. (401)245-8500. Fax: (401)245-1242. E-mail: mpottle@martinthomas.com. President: Martin K. Pottle. Estab. 1987. Ad agency, PR firm. Approximate annual billing: $6 million. Number of employees: 6. Types of clients: industrial and business-to-business. Examples of ad campaigns: "Bausch & Lomb," for GLS Corporation (magazine cover); "Soft Bottles," for McKechnie (booth graphics); and "Perfectly Clear," for ICI Acrylics (brochure).

Needs: Works with 3-5 freelance photographers/month. Uses photos for trade magazines. Subjects include: location shots of equipment in plants and some studio. Model release required.

Audiovisual Needs: Uses videotape for 5-7 minute capabilities or instructional videos.

Specs: Uses 8×10 color and b&w prints; 35mm and 4×5 transparencies. Accepts images in digital format for Windows (call first). Send via compact disc, on line or floppy disk.

Making Contact & Terms: Send stock photo list. Provide résumé, business card, brochure, flier or tearsheets to be kept on file for possible future assignments. Send materials on pricing, experience. "No unsolicited portfolios will be accepted or reviewed." Works with local freelancers on assignment only. Cannot return material. Pays $1,000-1,500/day; $300-900/b&w photo; $400-1,000/color photo. Pays 30 days following receipt of invoice. Buys exclusive product rights; negotiable.

Tips: To break in, demonstrate you "can be aggressive, innovative, realistic and can work within our clients' parameters and budgets. Be responsive; be flexible."

$ $ [A] [▣] [▨] TOBOL GROUP, INC., 14 Vanderventer Ave., Port Washington NY 11050. (516)767-8182. Fax: (516)767-8185. E-mail: mt@tobolgroup.com. Website: http://www.tobolgroup.com. Ad agency/design studio. President: Mitch Tobol. Estab. 1981. Types of clients: high-tech, industrial, business-to-business and consumer. Examples of ad campaigns: Weight Watchers (in-store promotion); Eutectic & Castolin; Mainco (trade ad); and Light Alarms.

Needs: Works with up to 4 photographers/videographers/month. Uses photos for billboards, consumer and trade magazines, direct mail, P-O-P displays, catalogs, posters, newspapers and audiovisual. Subjects are varied; mostly still-life photography. Reviews business-to-business and commercial video footage. Model release required.

Audiovisual Needs: Uses videotape.

Specs: Uses 4×5, 8×10, 11×14 b&w prints; 35mm, 2¼×2¼ and 4×5 transparencies; and ½″ videotape. Accepts images in digital format for Mac. Send via Zip, floppy, CD, SyQuest, optical or e-mail.

Making Contact & Terms: Send unsolicited photos by mail for consideration. Query with samples. Provide résumé, business card, brochure, flier or tearsheets to be kept on file for possible future assignments: follow-up with phone call. Works on assignment only. SASE. Reports in 3 weeks. Pays $100-10,000/job. Pays net 30 days. Credit line sometimes given, depending on client and price. Rights purchased depend on client.

Tips: In freelancer's samples or demos, wants to see "the best—any style or subject as long as it is done well. Trend is photos or videos to be multi-functional. Show me your *best* and what you enjoy shooting. Get experience with existing company to make the transition from still photography to audiovisual."

$ $ $ [A] [▨] TR PRODUCTIONS, 1031 Commonwealth Ave., Boston MA 02215. (617)783-0200. Executive Vice President: Ross P. Benjamin. Types of clients: industrial, commercial and educational.

Needs: Works with 1-2 freelance photographers/month. Uses photographers for slide sets and multimedia productions. Subjects include: people shots, manufacturing/sales and facilities.

Specs: Uses 35mm transparencies.

Making Contact & Terms: Provide résumé, business card, self-promotion piece or tearsheets to be kept on file for possible future assignments. Works with local freelancers on assignment only; interested in stock photos/footage. Cannot return unsolicited material. Reports "when needed." Pays $600-1,500/day. Pays "14 days after acceptance." Buys all AV rights.

[A] [▨] VISUAL HORIZONS, 180 Metro Park, Rochester NY 14623. (716)424-5300 or (800)424-1011. Fax: (716)424-5313 or (800)424-5411. E-mail: info@visualhorizons.com. Website: http://www.visualhoriz ons.com. President: Stanley Feingold. AV firm. Types of clients: industrial.

Audiovisual Needs: Works with 1 freelance photographer/month. Uses photos for AV presentations. Also works with freelance filmmakers to produce training films. Model release required. Captions required.

Specs: Uses 35mm transparencies and videotape.

Making Contact & Terms: Provide résumé, business card, brochure, flier or tearsheets to be kept on file for possible future assignments. Works on assignment only. Reports as needed. Payment negotiable. Pays on publication. Buys all rights.

[N] WAVE DESIGN WORKS, 560 Harrison Ave., Boston MA 02118. (617)482-4470. Fax: (617)482-2356. Office Manager: Lori Salzman. Estab. 1986. Member of AIGA. Design firm. Approximate annual billing: $650,000-800,000. Number of employees: 3. Specializes in display design, packaging and identity/collateral/product brochures. Types of clients: biotech, medical instrumentation and software manufacturing. Examples of recent projects: brochure, Siemens Medical (to illustrate benefits of medical technology); annual report, United South End Settlements (to illustrate services, clientele); and 1996 catalog, New England Biolabs (environmental awareness).

Needs: Works with 2 freelancers/year. Uses photos for annual reports, trade magazines, catalogs, signage and product brochures. Subjects include product shots. Reviews stock photos, depending upon project. Model/property release preferred. Captions preferred.

Specs: Uses 2¼×2¼, 4×5 transparencies.

CONTACT THE EDITOR of *Photographer's Market* by e-mail at photomarket@fwpubs.com with your questions and comments.

Making Contact & Terms: Provide résumé, business card, brochure, flier or tearsheets to be kept on file for possible future assignments. Works with local freelancers only. SASE. Reports on unsolicited material only if asked; 1-2 weeks for requested submissions. Payment negotiable. Pays on receipt of payment of client. Credit line sometimes given depending on client and photographer. Rights negotiable depending on client's project.

Tips: "Since we use product shots almost exclusively, we look for detail, lighting and innovation in presentation."

N $ A ◑ **WEYMOUTH DESIGN INC.**, 332 Congress St., Boston MA 02210. (617)542-2647. Fax: (617)451-6233. Office Manager: Judith Benfari. Estab. 1973. Design firm. Specializes in annual reports, new media, publication design, packaging and signage. Types of clients: industrial, financial, retail and nonprofit.

Needs: Uses photos for annual reports and catalogs. Subjects include executive portraits, people pictures or location shots. Subject matter varies. Model/property release required. "Photo captions are written by our corporate clients."

Specs: Uses 35mm, 2¼×2¼, 4×5 transparencies.

Making Contact & Terms: Submit portfolio for review. Portfolio reviews May-August only; otherwise send/drop off portfolio for review. Works with freelancers on assignment only. "Mike Weymouth shoots most of the photographs for our clients." Keeps samples on file. SASE. Pays $125-200/hr.; $1,250-2,500/day. "We give our clients 10-hour days on our day-rate quotes." **Pays on receipt of invoice**. Buys one-time rights; negotiable.

▲ WOLFF/SMG, 96 College Ave., Rochester NY 14607. (716)461-8300. Fax: (716)461-0835. E-mail: wolff@eznet.net. Creative Services Manager: Adele Simmons. Promotional communications agency. Types of clients: industrial, fashion, consumer, packaged goods.

Needs: Works with 3-4 freelance photographers/month. Uses photos for database, consumer magazines, direct mail, P-O-P displays, brochures, catalogs, posters, newspapers, AV presentations. Also works with freelance filmmakers to produce TV commercials.

Making Contact & Terms: Provide résumé, business card, brochure, flier or tearsheets to be kept on file for possible future assignments. Does not return unsolicited material. Terms vary by project.

N ◯ **WORCESTER POLYTECHNIC INSTITUTE**, 100 Institute Rd., Worcester MA 01609. (508)831-5609. Fax: (508)831-5820. Director of Communications: Michael Dorsey. Estab. 1865. Publishes periodicals and promotional, recruiting and fund-raising printed materials. Photos used in brochures, newsletters, posters, audiovisual presentations, annual reports, catalogs, magazines and press releases.

Needs: On-campus, comprehensive and specific views of all elements of the WPI experience. Relations with industry, alumni. Reviews stock photos. Captions preferred.

Specs: Uses 5×7 (minimum) glossy b&w prints; 35mm, 2¼×2¼, 4×5 transparencies; b&w contact sheets.

Making Contact & Terms: Arrange a personal interview to show portfolio or query with stock photo list. Provide résumé, business card, brochure, flier or tearsheets to be kept on file for possible future assignments. "No phone calls." SASE. Reports in 2 weeks. Payment negotiable. Credit line given in some publications. Buys one-time or all rights; negotiable.

N $ $ ◑ **YASVIN DESIGNERS**, P.O. Box 116, Hancock NH 03449. Estab. 1989. Member of N.H. Creative Club. Design firm. Number of employees: 3. Specializes in advertising, publication design and packaging. Types of clients: industrial, financial and nonprofit. Recent projects include work on annual reports, college view books and display graphics for trade shows.

Needs: Works with 2-5 freelancers/month. Uses photos for advertising in consumer magazines, trade magazines, P-O-P displays, catalogs, posters and packaging. Subject matter varies. Reviews stock photos. Model release required.

Specs: Image specifications vary.

Making Contact & Terms: Query with résumé of credits and samples, business card, brochure, flier or tearsheets to be kept on file for possible future assignments. Keeps samples on file. SASE. Reporting time varies. Payment negotiable. Buys first and all rights; negotiable.

■ SPENCER ZAHN & ASSOCIATES, 2015 Sansom St., Philadelphia PA 19103. (215)564-5979. Fax: (215)564-6285. President: Spencer Zahn. Estab. 1970. Member of GPCC. Marketing, advertising and design firm. Approximate annual billing: $5 million. Number of employees: 10. Specializes in direct mail and print ads. Types of clients: financial and retail. Examples of projects: Whiter Shade of Pale for Procol

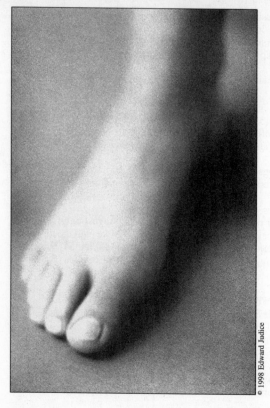

"This image recalls the early photographic style of Pictorialism, a style that I have embraced my whole career," says photographer Edward Judice. Michael Havey of Yasvin Designers hired Judice for his unique style after reviewing his portfolio. This image was shot as an assignment for a Theresia Shoes brochure. "The old-fashioned, classic feel of the photograph furthered this classic line of shoes," Havey says. Judice was paid $500 for one-time rights to the image.

© 1998 Edward Judice

Harum (portrait); Stored Value Cards for First Union National Bank (portraits and action sports); and direct mail piece for National City Card Services (sky/sunset).

Needs: Works with 1-3 freelancers/month. Uses photos for billboards, consumer magazines, trade magazines, direct mail, P-O-P displays, posters and signage. Subjects include: people, still life. Reviews stock photos. Model/property release required.

Specs: Uses b&w and color prints; 4×5 transparencies. Accepts digital images on Zip, CD, etc.

Making Contact & Terms: Submit portfolio for review. Query with résumé of credits, stock photo list, samples. Provide résumé, business card, brochure, flier or tearsheets to be kept on file for possible future assignments. Keeps samples on file. SASE. Reports in 1 month. **Pays on publication.** Credit line sometimes given. Buys one time and/or all rights; negotiable.

ZMIEJKO & COMPANIES, INC., P.O. Box 126, Freeland PA 18224-0126. (570)636-2304. Fax: (570)636-9878. President: Thomas B.J. Zmiejko. Estab. 1971. Member of ASMP, PPANM, PPA, IPSW, Albuquerque Guild of Professional Photographers. Design firm. Number of employees: 5. Specializes in annual reports, publication design, display design, packaging, direct mail, signage, murals and billboards. Types of clients: industrial, financial, retail, publishers and nonprofit. Examples of recent projects: Pizza Hut House Organ; prep school newsletter; and Public Service New Mexico (murals).

Needs: Model/property release required. Captions required.

Specs: Uses 8×10 flat color and b&w prints; 35mm, 2¼×2¼, 4×5, 8×10 transparencies; Betacam videotape.

Making Contact & Terms: Arrange personal interview to show portfolio. Query with stock photo list. Provide résumé, business card, brochure, flier or tearsheets to be kept on file for possible future assignments. Works with freelancers on assignment only. Keeps samples on file. SASE. Reports in 3 weeks. Payment negotiable. Pays on publication. Credit line given. Buys one-time rights.

REGIONAL REPORT: MIDSOUTH & SOUTHEAST

This region stretches southeast from Tennessee to Florida encompassing the states that make up the South. Atlanta is the advertising center of a region whose major industries include food

processing, tobacco, wood and paper products and chemical production. Major advertisers like Coca-Cola, Wal-Mart and America Online are based here.

Leading national advertisers

BellSouth Corp., Atlanta GA
Chattem, Chattanooga TN
Circuit City Stores, Richmond VA
Coca-Cola, Atlanta GA
Darden Restaurants, Orlando FL
Delta Air Lines, Atlanta GA
Dillard's, Little Rock AK

Federal Express, Memphis TN
First Union Corp., Charlotte NC
Flagstar, Spartanburg SC
Home Depot, Atlanta GA
Mars Inc., McLean VA
MCI WorldCom, Jackson MS
Michelin Group, Greenville SC

Office Depot, Delray Beach FL
Republic Industries, Ft. Lauderdale FL
State of Florida, Tallahassee FL
Triarc Cos., Miami Beach FL
Wal-Mart Stores, Bentonville AK

Notable ad agencies in the region

Arnold Communications, 8300 Greensboro Dr., Suite 1700, McLean VA 22102. (703)760-2800. Major accounts: American Red Cross, DeWalt Power Tools, Mobil Oil, Sallie Mae, Volkswagon of America, Southeast Region.

The Buntin Group, 1001 Hawkins St., Nashville TN 37203. (615)244-5720. Major accounts: Blue Cross & Blue Shield of Tennessee, Dollar General Corp., The Kroger Co., Red Lobster, Vanity Fair Factory Outlet.

Chernoff/Silver and Associates, 801 Gervais St., Columbia SC 29201. (803)765-1323. Website: http://www.chernoffsilver.com. Major accounts: Coburg Dairy, Dayton Power & Light, Nickelodeon, Shell Oil Products, Sprint Communications.

Cranford Johnson Robinson Woods, Capitol Center, 303 W. Capitol Ave., Little Rock AR 72201-3593. (501)975-6251. Website: http://www.cjrw.com. Major accounts: Alltell Corp., Arkansas Dept. of Parks and Tourism, Excelsior Hotel, First Commercial Corp., Greater Little Rock Chamber of Commerce.

Long Haymes Carr, 140 Charlois Blvd., Winston-Salem NC 27103. (336)765-3630. Major accounts: Auto Nation, Camel Cigarettes, Hanes, Nabisco Foods Group, Remington Arms.

Martin Advertising, 2801 University Blvd., Suite 200, Birmingham AL 35233. (205)930-9200. Major account: Pontiac Dealers Association.

The Martin Agency, 1 Shockoe Plaza, Richmond VA 23219-4132. (804)-698-8000. Website: http://www.martingagency.com. Major accounts: Banc One Corp., Coca-Cola, Kindercare, National Geographic Society, Wrangler Corp.

Peter A. Mayer, 324 Camp St., New Orleans LA 70130. (504)581-7191. Website: http://www.peteramayer.com. Major accounts: Audubon Zoo, Bell South Entertainment, Hilton Hotels & Resorts, Popeye's, Times-Picayune Newspaper.

WestWayne, 1100 Peachtree St. NE, Suite 1800, Atlanta GA 30309. (404)347-8700. Major accounts: Bassett Furniture, Bell South Corp., R.J. Reynolds Tobacco, Royal Caribbean, Sun Trust Banks.

Zimmerman & Partners, 2200 W. Commercial Blvd., Suite 300, Ft. Lauderdale FL 33309. (954)731-2900. Major accounts: Budget Car Sales, First Choice Auto, Neighborhood Mitsubishi Dealers Assoc., Plaza Auto Mall, Pools by Andrews.

A **AD CONSULTANT GROUP INC.**, 3111 University Dr., 408, Coral Springs FL 33065. (954)340-0883. President: B. Weisblum. Estab. 1994. Ad agency. Approximate annual billing: $3 million. Number of employees: 3. Types of clients: fashion, medical, retail and food.
Needs: Works with 1 freelancer and 1 videographer/month. Uses photos for consumer magazines, trade magazines, direct mail, catalogs and newspapers. Reviews stock photos. Model/property release required.
Audiovisual Needs: Uses videotape.
Making Contact & Terms: Query with stock photo list. Send unsolicited photos by mail for consideration. Provide résumé, business card, brochure, flier or tearsheets to be kept on file for possible future assignments. Works with freelancers on assignment only. Cannot return material. Reports in 3 weeks. Payment negotiable. **Pays on acceptance.** Credit line sometimes given. Buys all rights; negotiable.

$ $⒜▣⊠ AMERICAN AUDIO VIDEO, 2862 Hartland Rd., Falls Church VA 22043. (703)573-6910. Fax: (703)573-3539. E-mail: sales@aav.com. President: John Eltzroth. Estab. 1972. Member of ICIA and MPI. AV/Presentation Technology firm. Types of clients: industrial, financial, retail, nonprofit.

Needs: Works with 1 freelance photographer and 2 videographers/month. Uses photos for catalogs and audiovisual uses. Subjects include: product shots/still life, technology; "inhouse photos for our catalogs and video shoots for clients." Reviews stock photos.

Audiovisual Needs: Uses slides and videotape.

Specs: Uses 35mm transparencies; Beta videotape. Accepts images in digital format for Windows.

Making Contact & Terms: Arrange personal interview to show portfolio. Send unsolicited photos by mail for consideration. Provide résumé, business card, brochure, flier or tearsheets to be kept on file for possible future assignments. SASE. Reports in 1 month. Payment negotiable. **Pays on acceptance and receipt of invoice.** Credit line not given. Buys all rights; negotiable.

Ⓝ $ $⊠◯ ARREGUI INTERNATIONAL ADVERTISING, 814 Ponce De Leon Blvd., Suite 204, Coral Gables FL 33134. (305)448-5317. Fax: (305)448-2069. Estab. 1961. Ad agency. Approximate annual billing: $2.5 million. Number of employees: 10. Types of clients: industrial, financial, retail.

Needs: Works with 2 photographers/month. Uses photos for billboards, brochures, catalogs, newspapers. Subjects include: babies, children, couples, multicultural, families, parents, senior citizens, teens, environmental, landscapes/scenics, gardening, automobiles, food/drink, health/fitness, travel, buildings, medicine. Interested in avant garde, documentary, fashion/glamour, regional. Model and property release preferred. Photo captions preferred.

Audiovisual Needs: Works with 2 videographers and 2 filmmakers/year. Uses videotape.

Making Contact and Terms: Send query letter with résumé, slides, stock list. Provide self-promotion piece to be kept on file. Reports back only if interested; send non-returnable samples. Pays on receipt of invoice. Rights negotiable.

Tips: Freelance photographers should be aware of need for "Hispanic images for Hispanic market."

Ⓝ B-MAN DESIGN, INC., 768 Marietta St., NW, Loft 102, Marietta GA 30318. (404)523-5990. Fax: (404)523-5992. E-mail: b-man@mindspring.com. Website: http://b-man.home.mindspring.com. President: Barry Brager. Estab. 1994. Design firm. Number of employees: 4. Firm specializes in annual reports, collateral, display design, publication design, signage. Types of clients: industrial, financial, retail, publishing, nonprofit.

Needs: Uses photos for brochures, catalogs, posters, signage, trade magazine.

Making Contact and Terms: Send query letter or portfolio may be dropped off Monday-Friday. Rights negotiable.

$▣◎ BOB BOEBERITZ DESIGN, 247 Charlotte St., Asheville NC 28801. (828)258-0316. E-mail: bobb@main.nc.us. Website: http://www.main.nc.us/bbd. Owner: Bob Boeberitz. Estab. 1984. Member of American Advertising Federation, Asheville Area Chamber of Commerce, Laurens County Chamber of Commerce, Asheville Freelance Network, National Academy of Recording Arts & Sciences. Graphic design studio. Number of employees: 1. Firms specializes in collateral, direct mail, packaging. Types of clients: management consultants, retail, recording artists, mail-order firms, industrial, nonprofit, restaurants, hotels and book publishers. Example of recent client: "Catalog," Cross Canvas Co. (to show product).

● Awards include: 1997-1998 Asheville Area Chamber of Commerce Volunteer of the Year Award; 1995 Arts Alliance/Asheville Chamber Business Support of the Arts Award; Citation of Excellence in Sales Promotion/Packaging; 1995 3rd District AAF ADDY Competition; 1 Addy and 3 Citations of Excellence in the 1995 Greenville Addy Awards.

Needs: Works with 1 freelance photographer every 2 or 3 months. Uses photos for consumer and trade magazines, direct mail, brochures, catalogs and posters. Subjects include: business concepts, computers, portraits, studio product shots, some location, some stock photos. Model/property release required.

Specs: Uses 8×10 b&w glossy prints; 35mm or 4×5 transparencies. Accepts images in digital format for Windows. Send via CD, Zip disk or online as TIFF, BMP, JPEG files at 300 dpi.

Making Contact & Terms: Provide résumé, business card, brochure, flier or tearsheets to be kept on file for possible future assignments. Cannot return unsolicited material. Reports "when there is a need." Pays $50-200/b&w photo; $100-500/color photo; $50-100/hour; $350-1,000/day. Pays on per-job basis. Buys all rights; negotiable.

Tips: "I usually look for a specific specialty. No photographer is good at everything. I also consider studio space and equipment. Show me something different, unusual, something that sets you apart from any average local photographer. If I'm going out of town for something, it has to be for something I can't get done locally."

BROWER, LOWE & HALL ADVERTISING, INC., 8805 S. Pleasantburg Dr., P.O. Box 16179, Greenville SC 29606. (864)242-5350. Fax: (864)233-0893. President: Ed Brower. Estab. 1945. Ad agency. Uses photos for billboards, consumer and trade magazines, direct mail, newspapers, P-O-P displays, radio and TV. Types of clients: consumer and business-to-business.
Needs: Commissions 6 freelancers/year; buys 50 photos/year. Model release required.
Audiovisual Needs: Uses videotape.
Specs: Uses 8 × 10 b&w and color semigloss prints; also videotape.
Making Contact & Terms: Arrange personal interview to show portfolio or query with list of stock photo subjects; will review unsolicited material. SASE. Reports in 2 weeks. Payment negotiable. Buys all rights; negotiable.

$ $ **CAMBRIDGE CAREER PRODUCTS**, 90 MacCorkle Ave., SW, South Charleston WV 25303. (800)468-4227. Fax: (304)744-9351. President: E.T. Gardner, Ph.D. Managing Editor: Amy Pauley. Estab. 1981.
Needs: Works with 2 still photographers and 3 videographers/month. Uses photos for multimedia productions, videotapes and catalog still photography. "We buy b&w prints and color transparencies for use in our 11 catalogs." Reviews stock photos/footage on sports, hi-tech, young people, parenting, general interest topics and other. Model release required.
Audiovisual Nees: Uses videotape.
Specs: Uses 5 × 7 or 8 × 10 b&w prints; 35mm, 2¼ × 2¼, 4 × 5, and 8 × 10 transparencies and videotape.
Making Contact & Terms: Video producers arrange a personal interview to show portfolio. Still photographers submit portfolio by mail. SASE. Reports in 2 weeks. Pays $20-80/b&w photo, $250-850/color photo and $8,000-45,000 per video production. Credit line given. "Color transparencies used for catalog covers and video production but not for b&w catalog shots." Buys one-time and all rights (work-for-hire); negotiable.
Tips: "Still photographers should call our customer service department and get a copy of *all* our educational catalogs. Review the covers and inside shots, then arrange a meeting to show work. Video production firms should visit our headquarters with examples of work. For still color photographs we look for high-quality, colorful, eye-catching transparencies. Black & white photographs should be on sports, home economics (cooking, sewing, child rearing, parenting, food, etc.), and guidance (dating, sex, drugs, alcohol, careers, etc.). We have stopped producing educational filmstrips and now produce only full-motion video. Always need good b&w or color still photography for catalogs."

STEVEN COHEN MOTION PICTURE PRODUCTION, 1182 Coral Club Dr., Coral Springs FL 33071. (954)346-7370. Contact: Steven Cohen. Examples of productions: TV commercials, documentaries, 2nd unit feature films and 2nd unit TV series. Examples of recent clients: "Survivors of the Shoam," Visual History Foundation; "March of the Living," Southern Region 1998.
Needs: Subjects include: celebrities, couples, families, parents, senior citizens, teens, performing arts, sports, portraits, product shots/still life. Interested in documentary, historical/vintage. Model release required.
Audiovisual Needs: Uses videotape.
Specs: Uses 16mm, 35mm film; ½" VHS, Beta videotape, S/VHS videotape.
Making Contact & Terms: Query with résumé. Provide business card, self-promotion piece or tearsheets to be kept on file for possible future assignments. Works on assignment only. Cannot return material. Reports in 1 week. Payment negotiable. **Pays on acceptance** or publication. Credit line given. Buys all rights (work-for-hire).

DEADY ADVERTISING, 17 E. Cary St., Richmond VA 23219. (804)643-4011. Fax: (804)643-4043. Website: http://www.deady.com. President: Jim Deady. Member of Chesterfield Business Council, Richmond Public Relations Association, Marketing Communications Agency Network. Approximate annual billing: $2 million. Number of employees 5. Types of clients: industrial, web technology and food. Examples of past projects: "Reynolds Food Service," Reynolds Metals (brochures, trade journal ads); Mad Duck Technologies and Educational Technologies.
Needs: Works with 3-5 freelancers/month. Uses photos for billboards, consumer magazines, trade magazines, direct mail, catalogs, posters, newspapers and multimedia presentations, websites and exhibit signage. Subjects include: equipment, products and people. Reviews stock photos. Model/property release preferred.
Specs: Uses color and b&w prints; 35mm, 4 × 5 transparencies.
Making Contact & Terms: Arrange personal interview to show portfolio. Query with stock photo list. Works on assignment only. Keeps samples on file. Cannot return material. Reports in 1-2 weeks. Payment negotiable. **Pays on receipt of invoice.** Credit line sometimes given. Buys all rights.

N̄. ⯐ EPLEY ASSOCIATES, 6302 Fairview Rd., Suite 200, Charlotte NC 28210. (704)442-9100. Fax: (704)442-9903. E-mail: epley-pr.com. Vice President: Ron Vinson. Estab. 1968. Number of employees: 36. Types of clients: industrial and others.
Needs: Works with 1-2 freelance photographers and/or videographers/month. Subjects include: photojournalism. Model/property release required.
Audiovisual Needs: Uses slides and videotape.
Specs: "Specifications depend on situation."
Making Contact & Terms: Works on assignment only. Payment negotiable. **Pays on receipt of invoice.** Buys various rights. Credit line sometimes given, "depends on client circumstance."

$ $ A ▣ ⯐ ◎ FRASER ADVERTISING, 1201 George C. Wilson Dr., #B, Augusta GA 30909. (706)855-0343. Fax: (706)855-0256. E-mail: jfraser653. President: Jerry Fraser. Estab. 1980. Ad agency. Approximate annual billing: $1.6 million. Number of employees: 5. Types of clients: automotive, business-to-business, industrial, manufacturing, medical, residential.
Needs: Works with "possibly one freelance photographer every two or three months." Uses photos for consumer and trade magazines, catalogs, posters and AV presentations. Subject matter: product and location shots. Model release required. Property release preferred.
Audiovisual Needs: Uses videotape, film. Also works with freelance filmmakers to produce TV commercials on videotape.
Specs: Uses glossy b&w and color prints; 35mm, 2¼×2¼ and 4×5 transparencies. "Specifications vary according to the job." Accepts images in digital format for Mac. Send via CD, floppy disk, Jaz, Zip or e-mail as TIFF, EPS, PICT, JPEG.
Making Contact & Terms: Provide résumé, business card, brochure, flier or tearsheets to be kept on file for possible future assignments. Works with freelance photographers on assignment only. Cannot return unsolicited material. Reports in 1 month. Payment negotiable according to job. Pays on publication. Buys exclusive/product, electronic, one-time and all rights; negotiable.
Tips: Prefers to see "samples of finished work—the actual ad, for example, not the photography alone. Send us materials to keep on file and quote favorably when rate is requested."

▣ ⯐ GOLD & ASSOCIATES, INC., 6000-C Sawgrass Village Circle, Ponte Verde Beach FL 32082. (904)285-5669. Fax: (904)285-1579. Creative Director: Keith Gold. Estab. 1988. Marketing/design/advertising firm. Approximate annual billing: $21 million in capitalized billings. Number of employees: 19. Specializes in music, publishing, tourism and entertainment industries. Examples of recent projects: Time-Warner (videos, video packaging and music packaging); Harcourt General (book and collateral designs); and Ripley's Entertainment (advertising).
Needs: Works with 1-4 freelance photographers and 1-2 filmmakers/month. Uses photos for video, television spots, films and CD packaging. Subjects vary. Reviews stock photos and reels. Tries to buy out images.
Audiovisual Needs: Uses videotape and film.
Specs: Uses transparencies and disks.
Making Contact & Terms: Contact through rep. Provide flier or tearsheets to be kept on file for possible future assignments. Works with freelancers from across the US. Cannot return material. Only reports to "photographers being used." Payment negotiable. **Pays on receipt of invoice.** Credit line given only for original work where the photograph is the primary design element; never for spot or stock photos. Buys all rights.

$ $ HACKMEISTER ADVERTISING & PUBLIC RELATIONS COMPANY., 2631 E. Oakland, Suite 204, Ft. Lauderdale FL 33306. (954)568-2511. President: Dick Hackmeister. Estab. 1979. Ad agency and PR firm. Serves industrial, electronics manufacturers who sell to other businesses.
Needs: Works with 1 freelance photographer/month. Uses photos for trade magazines, direct mail, catalogs. Subjects include: electronic products. Model release and captions required.
Specs: Uses 8×10 glossy b&w and color prints and 4×5 transparencies.
Making Contact & Terms: "Call on telephone first." Does not return unsolicited material. Pays by the day and $200-2,000/job. Buys all rights.
Tips: Looks for "good lighting on highly technical electronic products—creativity."

$ $ ⯐ ◎ HODGES ASSOCIATES, INC., P.O. Box 53805, 912 Hay St., Fayetteville NC 28305. (910)483-8489. Fax: (910)483-7197. Art Director: Jeri Allison. Estab. 1974. Ad agency. Types of clients: industrial, financial, retail, food. Examples of projects: House of Raeford Farms (numerous food packaging/publication ads); The Esab Group, welding equipment (publication ads/collateral material).
Needs: Works with 1-2 freelancers/month. Uses photos for consumer magazines, trade magazines, direct mail, P-O-P displays, catalogs, posters, newspapers, signage, audiovisual uses. Subjects include: food,

welding equipment, welding usage, financial, health care, industrial fabric usage, agribusiness products, medical tubing. Reviews stock photos. Model/property release required.

Audiovisual Needs: Uses slides and video. Subjects include: slide shows, charts, videos for every need.

Specs: Uses 4×5, 11×14, 48×96 color and b&w prints; 35mm, 2¼×2¼, 4×5, 8×10 transparencies.

Making Contact & Terms: Submit portfolio for review. Keeps samples on file. SASE. Reports in 1-2 weeks. Pays $200/hour; $1,600/day. **Pays on receipt of invoice.** Credit line given depending upon usage PSAs, etc. but not for industrial or consumer ads/collateral. Buys all rights; negotiable.

Tips: Looking for "all subjects and styles." Also, the "ability to shoot on location in adverse conditions (small cramped spaces). For food photography a kitchen is a must, as well as access to food stylist. Usually shoot both color and b&w on assignment. For people shots . . . photographer who works well with talent/models." Seeing "less concern about getting the 'exact' look, as photo can be 'retouched' so easily in Photoshop or on system at printer. Electronic retouching has enabled art director to 'paint' the image he wants. But by no means does this mean he will accept mediocre photographs."

$ $ $ $ [A] [◑] HOWARD, MERRELL & PARTNERS ADVERTISING, INC., 8521 Six Forks Rd., Raleigh NC 27615. (919)848-2400. Fax: (919)845-9845. Art Buyer/Broadcast Business Supervisor: Jennifer McFarland. Estab. 1976. Member of Affiliated Advertising Agencies International, American Association of Advertising Agencies, American Advertising Federation. Ad agency. Approximate annual billing: $86 million. Number of employees: 83.

Needs: Works with 10-20 freelancers/month. Uses photos for consumer and trade magazines, direct mail, catalogs and newspapers. Reviews stock photos. Model/property release required.

Specs: Uses 8×10 glossy b&w prints; 35mm, 2¼×2¼, 4×5, 8×10 transparencies.

Making Contact & Terms: Provide tearsheets to be kept on file for possible future assignments. Works on assignment only. Keeps samples on file. SASE. Reports in 3 weeks. Payment individually negotiated. **Pays on receipt of invoice.** Buys one-time and all rights (1-year or 2-year unlimited use); negotiable.

$ $ [A] [▭] [◑] [◎] PETER JAMES DESIGN STUDIO, 700 E. Atlantic Blvd., Studio 307, Pompano Beach FL 33060. (954)784-8440. Fax: (954)784-8429. President/Creative Director: Jim Spangler. Estab. 1980. Design firm. Number of employees: 4. Firm specializes in collateral, display design, direct mail, magazine ads, packaging. Types of clients: industrial, retail, nonprofit. Example of recent project: VSI International (packaging/print), Siemens Telecom Networks (product branding).

Needs: Works with 1-2 freelancers/month. Uses photos for consumer and trade magazines, direct mail, P-O-P displays, catalogs, posters and packaging. Subjects include: babies, children, couples, multicultural, families, parents, senior citizens, teens, architecture, beauty, cities/urban, gardening, interiors/decorating, religious, rural, adventure, entertainment, events, food/drink, health/fitness, humor, performing arts, sports, travel, agriculture, business concepts, computers, industry, medicine, portraits, science, technology, lifestyle shots and products. Interested in alternative process, avant garde, digital, documentary, fashion/glamour, regional, seasonal. Reviews stock photos. Model release required. Captions preferred.

Specs: Uses 8×10, glossy, color prints; 35mm, 2¼×2¼, 4×5 transparencies. Accepts images in digital format for Mac. Send via Zip, e-mail as TIFF, EPS, JPEG files.

Making Contact & Terms: Arrange personal interview to show portfolio. Query with résumé of credits. Query with samples. Provide résumé, business card, brochure, flier or tearsheets to be kept on file for possible future assignments. Works with freelancers on assignment only. Keeps samples on file. SASE. Reports as needed. Pays $150 minimum/hour; $1,200 minimum/day. Pays net 30 days. Credit line sometimes given depending upon usage.

Tips: Wants to see "specific style, knowledge of the craft, innovation."

LORENC DESIGN, 724 Longleaf Dr., Atlanta GA 30342. (404)266-2711. Fax: (404)233-5619. Manager: Jennifer Cauchon. Estab. 1978. Member of SEGD, AIGA, AIA. Design firm. Approximate annual billing: $750,000. Number of employees: 7. Specializes in display design and signage. Types of clients: industrial, financial and retail. Examples of recent projects: "Holiday Inn Worldwide Headquarters," Holiday Inn (exhibit); and "Georgia Pacific Sales Center," Georgia-Pacific (exhibit).

Needs: Works with 1 freelancer/month. Uses photos for P-O-P displays, posters, signage and exhibits. Subjects include: architectural photography, scenery and people. Reviews stock photos.

Specs: Uses 8×10 glossy color and b&w prints; 35mm, 4×5 transparencies.

THE GEOGRAPHIC INDEX, located in the back of this book, lists markets by the state in which they are located.

Making Contact & Terms: Contact through rep. Submit portfolio for review. Keeps samples on file. SASE. Reports in 1-2 weeks. **Pays on receipt of invoice.** Credit line given. Buys all rights; negotiable.

$ $ A ☆ THE MEDIA MARKET, INC., 285 College St., P.O. Box 2692, Batesville AR 72503-2692. (870)793-6902. Fax: (870)793-7603. Art Director: Barth Boyd. Estab. 1980. Ad agency. Approximate annual billing: $500,000. Number of employees: 4. Types of clients: industrial, financial, retail, health care and tourism. Examples of recent projects: "See the Ozark Gateway," Ozark Gateway Tourist Council (television promotion); "Appreciation," Union Planters Bank (newspaper); and "People-Hometown Choice," Citizens Bank of Batesville (varied media).
Needs: Works with 1-3 freelance photographers, 1-3 filmmakers and 1-3 videographers/month. Uses photos for billboards, consumer magazines, trade magazines, direct mail, P-O-P displays, catalogs, posters, newspapers, signage and audiovisual. Subjects include: tourism and financial. Reviews stock photos. Model/property release required. Captions preferred.
Audiovisual Needs: Uses slides, film and videotape for business-to-business and business-to-consumer.
Specs: Uses all sizes glossy color and b&w prints; 35mm, 2¼×2¼, 4×5 transparencies; ¾″ film; VHS videotape.
Making Contact & Terms: Provide résumé, business card, brochure, flier or tearsheets to be kept on file for possible future assignments. Works on assignment only. Keeps samples on file. SASE. Reports in 1-2 weeks. Pays $25-50/hour; $200-400/day; $50-400/job; $25-200/color or b&w photo. Pays on publication. Credit line sometimes given depending upon terms. Buys all rights; negotiable.

MYRIAD PRODUCTIONS, P.O. Box 888886, Atlanta GA 30356. (770)698-8600. President: Ed Harris. Estab. 1965. Primarily involved with sports productions and events. Works with freelance photographers on assignment only basis.
Needs: Uses photos for portraits, live-action and studio shots, special effects, advertising, illustrations, brochures, TV and film graphics, theatrical and production stills. Model/property release required. Captions preferred; include name(s), location, date, description.
Specs: Uses 8×10 b&w glossy prints, 8×10 color prints; and 2¼×2¼ transparancies.
Making Contact & Terms: Provide brochure, résumé and samples to be kept on file for possible future assignments. Send material by mail for consideration. Cannot return material. Reporting time "depends on urgency of job or production." Payment negotiable. Credit line sometimes given. Buys all rights.
Tips: "We look for an imaginative photographer; one who captures all the subtle nuances. Working with us depends almost entirely on the photographer's skill and creative sensitivity with the subject. All materials submitted will be placed on file and not returned, pending future assignments. Photographers should not send us their only prints, transparencies, etc., for this reason."

N A ☆ ○ NORTHERN VIRGINIA YOUTH SYMPHONY ASSOCIATION, 4026 Hummer Rd., Annandale VA 22003. (703)642-8051, ext. 21. Fax: (703)642-8054. Director of Public Relations: Paco Martinez. Estab. 1964. Nonprofit organization that promotes and sponsors 4 youth orchestras. Photos used in newsletters, posters, audiovisual uses and other forms of promotion.
Needs: Photographers usually donate their talents. Offers 8 assignments annually. Photos taken of orchestras, conductors and soloists. Captions preferred.
Audiovisual Needs: Uses slides and videotape.
Specs: Uses 5×7 glossy color and b&w prints.
Making Contact & Terms: Arrange a personal interview to show portfolio. Works with local freelancers on assignment only. Keeps samples on file. SASE. Payment negotiable. "We're a résumé-builder, a nonprofit that can cover expenses but not service fees." **Pays on acceptance.** Credit line given. Rights negotiable.

$ $ $ $ A ☆ ⊘ STEVE POSTAL PRODUCTIONS, P.O. Box 428, 108 Carraway St., Bostwick FL 32007. (904)325-9356. Website: http://www.caisa.com/worstfilms. Director: Steve Postal. Estab. 1957. Member of SMPTE. AV firm. Approximate annual billing: $1 million plus. Number of employees: 11-50. Firm specializes in magazine ads, packaging, publication design, production stills for feature films. Types of clients: industrial, financial, publishing, nonprofit. Examples of recent projects: "World of People," Church of the Good Within, Inc.; "Amtrack Goes!" AMTRAK; and many feature films on video for release (distributed to many countries).
Needs: Works with 2-3 freelance photographers, 2-3 filmmakers and 3-4 videographers/month. Uses photos for billboards, consumer magazines, trade magazines, direct mail and audiovisual. Subjects include: babies, families, teens, landscapes/scenics, architecture, beauty, pets, religious, rural, automobiles, hobbies, performing arts, travel, agriculture, buildings, political, portraits, product shots/still life, science. Interested in avant garde, erotic, fine art, regional, feature film publicity. Also reviews stock photos of travel, food,

glamour modeling and industrial processes. Model/property release preferred for glamour modeling. Captions required; include name, address, telephone number, date taken and equipment used.
Audiovisual Needs: Uses slides and/or film or video.
Specs: Uses 4×5, 8×10 glossy color and/or b&w prints; 35mm, 2¼×2¼ transparencies; 16mm film; VHS (NTSC signal) videotape.
Making Contact & Terms: Query with samples. Provide résumé, business card, brochure, flier or tearsheets to be kept on file for possible future assignments. Works with freelancers on assignment only. Keeps samples on file. Photographers should call in 3 weeks for report. Pays $1,500 maximum for b&w and color photos; film and videotape, negotiable. **Pays on acceptance.** Credit line given. Buys all rights.
Tips: Looks for "sharpness of image, trueness of color, dramatic lighting or very nice full lighting."

PRODUCTION INK, 2826 NE 19 Dr., Gainesville FL 32609-3391. (352)377-8973. Fax: (352)373-1175. President: Terry Van Nortwick. Ad agency, PR, marketing and graphic design firm. Types of clients: hospital, industrial, computer.
Needs: Works with 1 freelance photographer/month. Uses photos for ads, billboards, trade magazines, catalogs and newspapers. Reviews stock photos. Model release required.
Specs: Uses b&w prints and 35mm, 2¼×2¼ and 4×5 transparencies.
Making Contact & Terms: Arrange personal interview to show portfolio. Submit portfolio for review. Provide résumé, business card, brochure, flier or tearsheets to be kept on file for possible future assignments. Keeps samples on file. Payment negotiable. **Pays on receipt of invoice.** Credit line sometimes given; negotiable. Buys all rights only.

$ $ $ ◎ SIDES AND ASSOCIATES, 404 Eraste Landry Rd., Lafayette LA 70506. (318)233-6473. Fax: (318)233-6485. E-mail: sides@1stnet.com. Account Executive: Eric Wirtheim. Estab. 1976. Member of AAAA, PRSA, Chamber of Commerce, Better Business Bureau. Ad agency. Number of employees: 13. Firm specializes in publication design, display design, signage, video and radio production. Types of clients: industrial, financial, retail, nonprofit. Examples of recent clients: name change for Iberia Bank (revised all brochures and new newspaper); annual report, for Franciscan Missionaries of Our Lady Health System; celebrity campaign for Louisiana Dairy Industry Promotion Board (posters).
Needs: Works with 2 freelance photographers, 2 filmmakers, 2 videographers/month. Uses photos for billboards, brochures, newspapers, P-O-P displays, posters, signage. Subjects include: setup shots of people. Reviews stock photos of everything. Model release required; property release required.
Audiovisual Needs: Uses slides and/or film or video for broadcast, TV, newspaper.
Specs: Uses 35mm, 2¼×2¼, 4×5; 35 film.
Making Contact & Terms: Provide résumé, business card, self-promotion piece or tearsheets to be kept on file for possible future assignments. Works with local freelancers only. Keeps samples on file. Reports back only if interested, send non-returnable samples. Payment determined by client and usage. Pays "when paid by our client." Rights negotiable.
Tips: "Freelance photographers should keep size standard—8½×11. We need fast workers with quick turnaround."

$ $ ▣ ◐ SMITH ADVERTISING & ASSOCIATES, P.O. Drawer 2187, Fayetteville NC 28302. (910)323-0920. Fax: (910)323-3328. Contact: Creative Director. Estab. 1974. Ad agency, PR firm. Types of clients: industrial, medical, financial, retail, tourism, resort, real estate.
Needs: Works with 0-10 photographers, 0-3 filmmakers, 0-3 videographers/month. Uses photos for billboards, consumer and trade magazines, direct mail, P-O-P displays, catalogs, posters, newspapers, signage, audiovisual. Subjects include: area, specific city, specific landmark. Model release preferred for identifiable people in photos for national publications. Property release preferred. Photo captions preferred.
Audiovisual Needs: Uses slides, film, videotape for slide shows, TVC. Subjects include: archive, early years.
Specs: Uses 2¼×2¼, 4×5 transparencies; 16 and 35mm film; Beta SP tape.
Making Contact & Terms: Provide résumé, business card, brochure, flier or tearsheets to be kept on file for possible future assignments. Samples are kept on file "for limited time." SASE. Reports in 1-2 weeks. Payment negotiable according to client's budget. Pays on publication. Credit lines sometimes given depending on subject and job. Buys all rights; negotiable.

▣ TOWNSEND, BARNEY & PATRICK, 5909 Airport Blvd., Mobile AL 36608. (334)343-0640. Ad agency. Vice President/Creative Services: George Yurcisin. Types of clients: industrial, financial, medical, retail, fashion, fast food, tourism, packaging, supermarkets and food services.
Needs: Works with 1-3 freelance photographers/month. Uses photos for consumer magazines, trade magazines, direct mail, brochures, P-O-P displays, audiovisuals, posters and newspapers. Model release required.

Audiovisual Needs: Works with freelance filmmakers to produce audiovisuals.
Specs: Uses 8×10 and 11×17 glossy b&w prints; 35mm, 2¼×2¼, 4×5 and 8×10 transparencies; 16mm, 35mm film and videotape.
Making Contact & Terms: Arrange a personal interview to show portfolio. Query with samples and list of stock photo subjects. Provide résumé, business card, brochure, flier or tearsheets to be kept on file for possible future assignments. Does not return unsolicited material. Reports as needed. Payment "varies according to budget." Pays net 30. Buys all rights.

$ A ■ WILLIAMS/CRAWFORD & ASSOCIATES, INC., P.O. Box 789, Ft. Smith AR 72901. (501)782-5230. Fax: (501)782-6970. Creative Director: Branden Sharp. Estab. 1983. Types of clients: financial, health care, manufacturing, tourism. Examples of ad campaigns: Touche-Ross, 401K and employee benefits (videos); Cummins Diesel Engines (print campaigns); and Freightliner Trucks (sales promotion and training videos).
Needs: Works with 2-3 freelance photographers, filmmakers or videographers/month. Uses photos for consumer magazines, trade magazines, direct mail, P-O-P displays, catalogs, posters, newspapers and audiovisual uses. Subjects include: people, products and architecture. Reviews stock photos, film or video of health care and financial.
Audiovisual Needs: Uses photos/film/video for 30-second video and film TV spots; 5-10-minute video sales, training and educational.
Specs: Uses 5×7, 8×10 b&w prints; 35mm, 2¼×2¼ and 4×5 transparencies.
Making Contact & Terms: Query with samples, provide résumé, business card, brochure, flier or tearsheets to be kept on file for possible future assignments. Works with freelancers on assignment basis only. Cannot return material. Reports in 1-2 weeks. Pays $500-1,200/day. Pays on receipt of invoice and client approval. Buys all rights (work-for-hire). Model release required; captions preferred. Credit line given sometimes, depending on client's attitude (payment arrangement with photographer).
Tips: In freelancer's samples, wants to see "quality and unique approaches to common problems." There is "a demand for fresh graphics and design solutions." Freelancers should "expect to be pushed to their creative limits, to work hard and be able to input ideas into the process, not just be directed."

YEAR ONE INC., 4820 Hammermill Rd., Tucker GA 30084. (770)493-6568. Fax: (770)723-3498. Graphics Manager: Phil Brewer. Estab. 1981. Mail order catalog company for automotive restoration parts. Photos used in catalogs.
Needs: Buys 75 photos/year. Subjects include historic photos of car-related themes (1955-1975) or photos with muscle-car theme. "We are mainly looking for historic photos from Muscle Car Era 60s and 70s. The photos can be b&w or color. The photos will represent the era by showing normal daily occurances that highlight or accent the American muscle car. These photos can be of racing themes, gas stations, drive-ins, traffic scenes, street scenes, car dealerships, factory assembly lines, or other related photos."
Specs: Uses 5×7, 8×10 b&w or color prints; 35mm, 2¼×2¼, 4×5, 8×10 transparencies.
Making Contact & Terms: Query with samples. Query with stock photo list. Provide résumé, business card, self-promotion piece or tearsheets to be kept on file for possible future assignments. Keeps samples on file. SASE. Reports in 1 month. **Pays on acceptance**; net 30 days of invoice. Buys first, one-time, electronic and all rights. Rights negotiable.

REGIONAL REPORT: MIDWEST & NORTH CENTRAL

This region cuts a square from the middle of America, North Dakota to Ohio. The industries here lean heavily toward agriculture and automobiles. Plastic and rubber products are also important. Chicago, the big advertising city in this region, is home to Leo Burnett, Foote Cone & Belding and J. Walter Thompson, among other important agencies.

Leading national advertisers

Abbott Laboratories, Abbott Park IL
Best Buy Co., EdenPrairie MN
Chrysler Corp., Highland Park MI
ConAgra, Omaha NE
Dayton Hudson Corp., Minneapolis MN
Federated Department Stores, Cincinnati OH
Gateway, North Sioux City SD
General Mills, Minneapolis MN

General Motors Corp., Detroit MI
Goodyear Tire & Rubber, Akron OH
Hormel & Co., Austin MN
Kellogg Co., Battle Creek MI
Kmart Corp., Troy MI
Kroger Co., Cincinnati OH
McDonald's Corp., Oak Brook IL
Montgomery Ward, Chicago IL
Procter & Gamble, Cincinnati OH
Quaker Oats, Chicago IL

S.C. Johnson, Racine WI
Sara Lee Corp., Chicago IL
Sears, Roebuck & Co., Chicago IL
Sherwin-Williams, Cleveland OH
Tricon Global Restaurants, Louisville KY
U.S. Dairy Producers, Processors, Rosemont IL
Wendy's International, Dublin OH

Notable ad agencies in the region

Bozell, 1000 Town Center, Suite 1500, Southfield MI 48075-1241. (248)354-5400. Website: http://www.bozell.com. Major accounts: AirTouch Cellular, Chrysler Corp., Hush Puppies, The Rocketts, Second City.

Leo Burnett, 35 W. Wacker Dr., Chicago IL 60601. (312)220-5959. Major Accounts: Allstate Insurance, Benson & Hedges Cigarettes, Cheer, Disneyland, Hallmark, Nintendo Game Boy.

Campbell Mithun Esty, 222 S. Ninth St., Minneapolis MN 55402. (612)347-1000. Major accounts: Armour, Bugle Corn Snacks, Dow Bathroom Cleaner, Honeywell Corp., Kmart Stores.

Cramer-Krasselt, 733 N. Van Buren, Milwaukee WI 53202. (414)227-3500. Major accounts: Appleton Papers, Birds Eye Frozen Vegetables, Dremel Tools, Master Lock, Snap-On Tools.

DDB Needham, 200 E. Randolph Dr., Chicago IL 60601-6414. (312)552-6000. Website: http://www.ddbn.com. Major accounts: Anheuser-Busch Cos., Bisquick, L'eggs Hosiery, Playtex Apparel, Westin Hotels & Resorts.

Fallon McElligott, 901 Marquette Ave., Suite 3200, Minneapolis MN 55402. (612)321-2345. Website: http://www.fallon.com. Major accounts: BMW Cars, Fit & Trim, Lee Jeans, Nordstrom, Timex Watches.

HMS Partners, 250 Civic Center Dr., Suite 500, Columbus OH 43215. (614)221-7667. Major accounts: American Automobile Association, Carnival Cruise Lines, Ohio Travel & Tourism, Target Stores, U.S. Air Force Reserves.

Kragie/Newell, 2633 Fleur Dr., Des Moines IA 50321. (515)288-7910. Website: http://www.knewell.com. Major accounts: Caterpillar, Chevrolet, NAPA, Pella, Tabasco.

Laughlin/Constable, 207 E. Michigan Ave., Milwaukee WI 53202. (414)272-2400. Major accounts: Firstar Bank, Lawn-Boy, Miller Brewery Tours, Osh Kosh B'Gosh, Wisconsin Tourism.

J. Walter Thompson, 500 Woodward Ave., Detroit MI 48226-3428. (313)964-3800. Website: http://www.jwtdet.com. Major accounts: Bosch Automotive Equipment, City of Detroit, Ford Cars & Trucks, Sherwin-Williams, White Castle.

■ ▨ ⬡ **AGA COMMUNICATIONS**, 2557C N. Terrace Ave., Milwaukee WI 53211-3822. (414)962-9810. E-mail: greink@juno.com. CEO: Arthur Greinke. Estab. 1984. Member of Public Relations Society of America, International Association of Business Communicators, Society of Professional Journalists. Number of employees: 9. Ad agency, PR firm and marketing firm. Firm specializes in annual reports, collateral, display design, direct mail, magazine ads, packaging, publication design, signage. Types of clients: entertainment, special events, music business, adult entertainment, professional sports, olympic sports, industrial, financial, retail, publishing, nonprofit.
Needs: Works with 6-12 freelance photographers, 2 filmmakers, 4-8 videographers/year. Uses photos for billboards, direct mail, P-O-P displays, posters, newspapers, signage, audiovisual. Most photos come from special events. Reviews stock photos of anything related to entertainment/music industry, model photography. Model/property release preferred. Captions preferred; include who, what, where, why, how.
Audiovisual Needs: Uses slides, film, videotape. Subjects include: special events and model work.
Specs: Uses 5×7 or 8×10 color and b&w prints; 2¼×2¼, 4×5 transparencies; 16mm and 35mm film; ½″ and ¾″ videotape. Accepts images in digital format for Windows. Send via CD, floppy disk or Zip as TIFF, EPS, PICT, BMP, GIF or JPEG files.
Making Contact & Terms: Query with résumé of credits. Query with stock photo list or samples. Provide résumé, business card, brochure, flier or tearsheets to be kept on file for possible future assignments. Cannot return material. "We respond when we need a photographer or a job becomes available for their special skills." Payment negotiable. **Pays on acceptance**. Credit line sometimes given depending on client. Buys all rights; negotiable.
Tips: "Search for a specific style or look, and make good use of light and shade."

$ $ Ⓐ ▣ ◎ ART ETC., 316 W. 4th St., Cincinnati OH 45202. (513)621-6225. Fax: (513)621-6316. Art Director: Doug Carpenter. Estab. 1971. Art Studio. Approximate annual billing: $200 million. Number of employees: 4. Specializes in collateral, direct mail, magazine ads. Types of clients: industrial, financial, nonprofit.
Needs: Works with 1-2 freelance photographers/6 months. Uses photos for consumer and trade magazines,

direct mail, P-O-P displays, catalogs and posters. Subjects include: musical instruments, OTC drugs, pet food, people, children, families, senior citizens, teens, environmental, landscapes/scenics, architecture, cities/urban, education, entertainment, events, food/drink, performing arts, buildings, business concepts, computers, industry, portraits, product shots/still life, technology and skin products. Interested in alternative process, avant garde, digital. Reviews stock photos. Model/property release required.

Specs: Uses 4×5, 8×10 color and b&w prints; 35mm, 2¼×2¼, 4×5, 8×10 transparencies. Accepts images in digital format for Mac, Windows. Send via CD, floppy disk, Jaz, Zip, e-mail as TIFF, EPS files at 400 dpi.

Making Contact & Terms: Contact through rep. Arrange personal interview to show portfolio. Query with list of stock photo subjects. Provide résumé, business card, brochure, flier or tearsheets to be kept on file for possible future assignments. Works with local freelancers on assignment only. Keeps samples on file. SASE. Reports in 1-2 weeks. Pays $40-250/hour; $600-2,000/day; $150-3,500/job; $150-1,500/color photo and b&w photo. Pays in 30 days. Buys all rights; negotiable. Credit line sometimes given depending upon marketing target.

A **📷** **BARON ADVERTISING, INC.**, 1422 Euclid Ave., Suite 645, Cleveland OH 44115-1901. (216)621-6800. President: Selma Baron. Incorporated 1973. Ad agency. Types of clients: food, industrial, electronics, telecommunications, building products, architectural. In particular, serves various manufacturers of tabletop and food service equipment.

Needs: Uses 20-25 freelance photographers/month. Uses photos for direct mail, catalogs, newspapers, consumer magazines, P-O-P displays, posters, trade magazines, brochures and signage. Subject matter varies. Model/property release required.

Audiovisual Needs: Works with freelance filmmakers for AV presentations.

Making Contact & Terms: Arrange a personal interview to show portfolio. Query with list of stock photo subjects. Provide résumé, business card, brochure, flier or tearsheets to be kept on file for possible future assignments. Works with freelancers on assignment only. Cannot return material. Payment negotiable. Payment "depends on the photographer." Pays on completion. Buys all rights.

Tips: Prefers to see "food and equipment" photos in the photographer's samples. "Samples not to be returned."

$ **A** **BRAGAW PUBLIC RELATIONS SERVICES**, 800 E. Northwest Hwy., Suite 1040, Palatine IL 60067. (847)934-5580. Fax: (847)934-5596. Contact: Richard S. Bragaw. Estab. 1981. Member of Public Relations Society of America, Publicity Club of Chicago. PR firm. Number of employees: 3. Types of clients: professional service firms, high-tech entrepreneurs.

Needs: Works with 1 freelance photographer/month. Uses photos for trade magazines, direct mail, brochures, newspapers, newsletters/news releases. Subjects include: "products and people." Model release preferred. Captions preferred.

Specs: Uses 3×5, 5×7 and 8×10 glossy prints.

Making Contact & Terms: Provide résumé, business card, brochure, flier or tearsheets to be kept on file for possible future assignments. Works with freelance photographers on assignment basis only. SASE. Pays $25-100/b&w photo; $50-200/color photo; $35-100/hour; $200-500/day; $100-1,000/job. **Pays on receipt of invoice.** Credit line "possible." Buys all rights; negotiable.

Tips: "Execute an assignment well, at reasonable costs, with speedy delivery."

A **📷** **BRIGHT LIGHT PRODUCTIONS**, 602 Main St., Suite 810, Cincinnati OH 45202. (513)721-2574. Fax: (513)721-3329. President: Linda Spalazzi. Film and videotape firm. Types of clients: national, regional and local companies in the governmental, educational, industrial and commercial categories. Examples of productions: Health Power (image piece); Procter & Gamble (quarterly video); and Martiny & Co. (corporate image piece). Produces 16mm and 35mm films and videotape, including Betacam.

Needs: Model/property release required. Captions preferred.

Audiovisual Needs: 16mm and 35mm documentary, industrial, educational and commercial films.

Making Contact & Terms: Provide résumé, flier and brochure to be kept on file for possible future assignments. Call to arrange appointment or query with résumé of credits. Works on assignment only. Pays $100 minimum/day for grip; payment negotiable based on photographer's previous experience/reputation and day rate (10 hours). Pays within 30 days of completion of job. Buys all rights.

Tips: Sample assignments include camera assistant, gaffer or grip. Wants to see sample reels or samples of still work. Looking for sensitivity to subject matter and lighting. "Show a willingness to work hard. Every client wants us to work smarter and provide quality at a good value."

BVK/MCDONALD, INC, 250 W. Coventry Court, Milwaukee WI 53217. (414)228-1990. Ad agency. Art Directors: Lisa Kunzelmann, Brent Goral, Mike Lyons. Estab. 1984. Types of clients: travel, health care,

financial, industrial and fashion clients such as Funjet Vacations, Flyjet Vacations, Covenant HealthCare, Waukesha Memorial Hospital, United Vacations, Budgetel, Tenet Health Systems, Airadigm Communications.

Needs: Uses 5 freelance photographers/month. Uses photos for billboards, consumer magazines, trade magazines, direct mail, catalogs, posters and newspapers. Subjects include travel and health care. Interested in reviewing stock photos of travel scenes in Carribean, California, Nevada, Mexico and Florida. Model release required.

Specs: Uses 35mm, 2¼×2¼, 4×5, 8×10 transparencies.

Making Contact & Terms: Arrange a personal interview to show portfolio or query with résumé of credits or list of stock photo subjects. Provide résumé, business card, brochure, flier or tearsheets to be kept on file for possible future assignments. Cannot return material. Payment negotiable. Buys all rights.

Tips: Looks for "primarily cover shots for travel brochures; ads selling Florida, the Caribbean, Mexico, California and Nevada destinations."

[N] [A] [■] CARMICHAEL-LYNCH, INC., 800 Hennepin Ave., Minneapolis MN 55403. (612)334-6000. Fax: (612)334-6085. E-mail: kdalager@clynch.com. Member of American Association of Advertising Agencies. Ad agency. Executive Creative Director: Kerry Casey. Send print information to Manager of Art Buying: Pam Schmidt. Art Buyer: Jill Kahn. Art Buyer: Bonnie Butler. Assistant Art Buyer: Sandy Boss-Febbo. Broadcast information to Jack Steinmann. Types of clients: finance, healthcare, sports and recreation, beverage, outdoor recreational. Examples of recent projects: Harley-Davidson (ads, motor clothes and literature); OMC (ads and collateral); Brown/Forman (print and TV ads); Solomon; American Standard.

Needs: Uses many freelance photographers/month. Uses photos for billboards, consumer and trade magazines, direct mail, P-O-P displays, brochures, posters, newspapers and other media as needs arise. Also works with freelance filmmakers to produce TV commercials.

Audiovisual Needs: Uses 16mm and 35mm film and videotape for broadcast.

Specs: Uses all formats for print.

Making Contact & Terms: Provide résumé, business card, brochure, flier or tearsheets to be kept on file for possible future assignments. Submit portfolio for review. To show portfolio, call Sandy Boss-Febbo. Works with freelance photographers on assignment basis only. Payment negotiable. Pay depends on contract. Buys all, one-time or exclusive product rights, "depending on agreement." Model/property release required for all visually recognizable subjects.

Tips: "No 'babes on bikes'! In a portfolio, we prefer to see the photographer's most creative work—not necessarily ads. Show only your most technically, artistically satisfying work."

$ $ [■] COMMUNICATIONS ELECTRONICS JOURNAL, P.O. Box 1045-PM, Ann Arbor MI 48106. (734)996-8888. Fax: (734)663-8888. CEO: Ken Ascher. Estab. 1969. Ad agency. Approximate annual billing: $7 million. Number of employees: 38. Types of clients: industrial, financial, retail. Examples of recent projects: Super Disk (computer ad); Eaton Medical (medical ad); Ocean Tech Group (scuba diving ad); and Weather Bureau (weather poster ad).

Needs: Works with 45 freelance photographers, 4 filmmakers and 5 videographers/month. Uses photos for consumer magazines, trade magazines, direct mail, P-O-P displays, catalogs, posters and newspapers. Subjects include: merchandise. Reviews stock photos of electronics, hi-tech, scuba diving, disasters, weather. Model/property release required. Captions required; include location.

Audiovisual Needs: Uses videotape for commercials.

Specs: Uses various size glossy color prints; 35mm, 2¼×2¼, 4×5 transparencies.

Making Contact & Terms: Query with résumé of credits. Provide résumé, business card, brochure, flier or tearsheets to be kept on file for possible future assignments. Cannot return material. Reports in 1 month. Pays $100-2,000/job; $15-1,000/color photo. Pays on publication. Credit line sometimes given depending on client. Buys one-time rights.

$ JOHN CROWE ADVERTISING AGENCY, 2319½ N. 15th St., Springfield IL 62702-1226. (217)528-1076. President: Bryan J. Crowe. Ad agency. Serves clients in industry, commerce, aviation, banking, state and federal government, retail stores, publishing and institutes.

Needs: Works with 1 freelance photographer/month on assignment only. Uses photos for billboards, consumer and trade magazines, direct mail, newspapers and TV. Model release required.

Specs: Uses 8×10 glossy color and b&w prints; and 2¼×2¼ transparencies.

Making Contact & Terms: Send material by mail for consideration. Provide letter of inquiry, flier, brochure and tearsheet to be kept on file for future assignments. SASE. Reports in 2 weeks. Pays $50 minimum/job or $18 minimum/hour. Payment negotiable based on client's budget. Buys all rights.

$ $ A ⚏ DEFRANCESCO/GOODFRIEND, 444 N. Michigan Ave., Suite 1000, Chicago IL 60611. (312)644-4409. Fax: (312)644-7651. E-mail: garygo@dgpr.com. Partner: John DeFrancesco. Estab. 1985. PR firm. Approximate annual billing: $1 million. Number of employees: 11. Types of clients: industrial, consumer products. Examples of recent projects: publicity campaigns for Promotional Products Association International and S-B Power Tool Company, and a newsletter for Teraco Inc.
Needs: Works with 1-2 freelancers/month. Uses photos for consumer magazines, trade magazines, direct mail, newspapers, audiovisual. Subjects include: people, equipment. Model/property release required. Captions preferred.
Audiovisual Needs: Uses slides and video for publicity, presentation and training.
Specs: Uses 5×7, 8×10, glossy color and b&w prints; 35mm transparencies; ½″ VHS videotape.
Making Contact & Terms: Query with résumé of credits. Provide résumé, business card, brochure, flier or tearsheets to be kept on file for possible future assignments. Works with freelancers on assignment only. Keeps samples on file. SASE. Reports in 1-2 weeks. Pays $25-200/hour; $500-2,500/day; $250-2,500/job; payment negotiable. Pays in 30 days..
Tips: "Because most photography is used in publicity, the photo must tell the story. We're not interested in high-style, high-fashion techniques."

$ $ ⬤ DESIGN & MORE, 1222 Cavell, Highland Park IL 60035. (847)831-4437. Fax: (847)831-4462. Principal Creative Director: Burt Bentkover. Estab. 1989. Design and marketing firm. Approximate annual billing: $300 million. Number of employees: 2. Firm specializes in annual reports, collateral, display design, magazine ads, publication design, signage. Types of clients: foodservice and business-to-business, industrial, retail.
Needs: Works with 1 freelancer/month. Uses photos for annual reports, consumer and trade magazines and sales brochures. Subjects include abstracts and food. Reviews stock photos of concepts and food. Property release required.
Specs: Uses 35mm and 2¼×2¼ transparencies.
Making Contact & Terms: Provide résumé, business card, brochure, flier or tearsheets to be kept on file for possible future assignments. Never send originals. Cannot return material. Reports in 1-2 weeks. Pays $500-1,000/day. Pays in 45 days. Cannot offer photo credit. Buys negotiable rights.
Tips: Submit nonreturnable photos."

A ⚏ EGD & ASSOCIATES, INC., 4300 Lincoln Ave., Suite K, Rolling Meadows IL 60008. (847)991-1270. Fax: (847)991-1519. Vice President: Kathleen Williams. Estab. 1970. Ad agency. Types of clients: industrial, retail, finance, food. Examples of ad campaigns: national ads for Toshiba and Sellstrom; packaging for Barna.
Needs: Works with 3-4 freelance photographers and videographers/month. Uses photos for billboards, consumer and trade magazines, direct mail, P-O-P displays, catalogs and audiovisual. Subjects include: industrial products and facilities. Reviews stock photos/video footage of "creative firsts." Model release required. Captions preferred.
Audiovisual Needs: Uses photos/video for slide shows and videotape.
Specs: Uses 5×7 b&w/color prints; 35mm, 2¼×2¼, 4×5, 8×10 transparencies.
Making Contact & Terms: Arrange personal interview to show portfolio. Provide résumé, business card, brochure, flier or tearsheets to be kept on file for possible future assignments. Works on assignment basis only. Cannot return material. Reports in 3 weeks. Pays according to "client's budget" within 30 days of invoice. Credit line sometimes given; credit line offered in lieu of payment. Buys all rights.
Tips: Sees trend toward "larger budget for exclusive rights and creative firsts. Contact us every six months."

$ $ $ ⬛ ⚏ ⬤ FLINT COMMUNICATIONS, 101 10th St. N., Fargo ND 58102. (701)237-4850. Fax: (701)234-9680. Website: http://www.flintcom.com. Art Director: Gerri Lien. Estab. 1946. Ad agency. Approximate annual billing: $9 million. Number of employees: 30. Firm specializes in display design, direct mail, magazine ads, publication design, signage. Types of clients: industrial, financial, agriculture and health care.
Needs: Works with 2-3 freelance photographers, 1-2 filmmakers and 1-2 videographers/month. Uses photos for direct mail, P-O-P displays, posters and audiovisual. Subjects include: couples, families, parents, senior citizens, environmental, gardening, rural, automobiles, sports, travel, computers, industry, medicine, product shots/still life, technology, manufacturing, finance, agriculture, health care and business. Interested in alternative process, avant garde, digital, regional, seasonal. Reviews stock photos. Model release preferred.
Audiovisual Needs: Uses slides and film.
Specs: Uses 35mm, 2¼×2¼, 4×5 transparencies. Accepts images in digital format for Mac. Send via

CD, Zip as TIFF, EPS, JPEG files.
Making Contact & Terms: Submit portfolio for review. Query with stock photo list. Provide résumé, business card, brochure, flier or tearsheets to be kept on file for possible future assignments. Keeps samples on file. Reports in 1-2 weeks. Pays $50-150 for b&w photos; $50-1,500 for color photos; $50-100/hour; $400-800/day; $100-1,000/job. **Pays on receipt of invoice.** Buys one-time rights.

$ $ [A] ◍ FRANZ DESIGN GROUP, 115 5th Ave. S., Suite 401, LaCrosse WI 54601. (608)791-1020. Fax: (608)791-1021. Design firm. Creative Director: Alan Franz. Estab. 1990. Specializes in publication design, corporate identity and packaging. Types of clients: industrial, retail.
Needs: Works with 2 freelance photographers/month. Uses photos for trade magazines, P-O-P displays, catalogs and packaging. Subjects include: models, products and food. Reviews stock photos of studio-food and location-models. Model/property release preferred; usually needs model shots. Captions preferred.
Specs: Uses 2¼×2¼, 4×5 transparencies.
Making Contact & Terms: Provide tearsheets to be kept on file for possible future assignments. Works with freelancers on assignment only. Keeps samples on file. SASE. Reports in 1-2 weeks. Pays $100-3,500/job. **Pays on receipt of invoice.** Credit lines sometimes given depending on the project; "yes, if we can make the decision." Buys all rights; negotiable.
Tips: Interested in "general quality of portfolio and specifically the design and styling of each photo. We like to work with photographers who can suggest solutions to lighting and styling problems."

[A] H. GREENE & COMPANY, 230 W. Huron, Chicago IL 60610. (312)642-0088. Fax: (312)642-0028. President: Howard Greene. Estab. 1985. Member of AIGA. Design firm. Approximate annual billing: $5 million. Number of employees: 11. Specializes in annual reports, publication design, direct mail, signage and technology. Types of clients: industrial, financial and nonprofit. Examples of recent clients: Rand McNally, Motorola, Nalco and Comdisco.
Needs: Works with 1 freelancer/month. Uses photos for direct mail, catalogs and posters. Subjects include: people and locations. Reviews stock photos. Model/property release required.
Specs: Uses 35mm, 2¼×2¼, 4×5 transparencies.
Making Contact & Terms: Provide résumé, business card, brochure, flier or tearsheets to be kept on file for possible future assignments. Works on assignment only. Keeps samples on file. Cannot return material. Payment negotiable. **Pays on receipt of invoice.** Credit line given. Buys one-time and electronic rights; negotiable.

$ HEART GRAPHIC DESIGN, 501 George St., Midland MI 48640. (517)832-9710. Owner: Clark Most. Estab. 1982. Design studio. Approximate annual billing: $250,000. Number of employees: 3. Types of clients: industrial.
Needs: Works with 4 freelancers/year. Uses photos for consumer magazines, catalogs and posters. Subjects include: product shots. Reviews stock photos. Model/property release preferred. Captions preferred.
Specs: Uses 8×10, 11×14 color and b&w prints; 2¼×2¼, 4×5 and 8×10 transparencies.
Making Contact & Terms: Send unsolicited photos by mail for consideration. Provide résumé, business card, brochure, flier or tearsheets to be kept on file for possible future assignments. Works with local freelancers only. Keeps samples on file. SASE. Reports in 1-2 weeks. Pays $200-2,500/job. **Pays on receipt of invoice.** Credit line not given. Rights negotiated depending on job.
Tips: "Display an innovative eye, ability to creatively compose shots and have interesting techniques."

$ $ ▣ ◿ HUTCHINSON ASSOCIATES, INC., 1147 W. Ohio St., Suite 305, Chicago IL 60622-5874. (312)455-9191. Fax: (312)455-9190. E-mail: hutch@hutchinson.com. Website: http://www.hutchinson.com. Design firm. Contact: Jerry Hutchinson. Estab. 1988. Member of American Center for Design, American Institute of Graphic Arts. Number of employees: 3. Firm specializes in annual reports, marketing

brochures, design, signage. Types of clients: industrial, financial, real estate, retail, and medical. Examples of recent projects: annual reports and capabilities brochures, multimedia and website design.

Needs: Works with 1 freelance photographer/month. Uses photographs for annual reports, brochures, consumer and trade magazines, direct mail, catalogs and posters. Reviews stock photos. Subjects include: still life, real estate.

Specs: Uses 35mm, 2¼×2¼, 4×5, color and b&w prints; 35mm, 4×5 transparencies. Accepts images in digital format for Mac. Send via CD, Zip, e-mail as TIFF, EPS, PICT, BMP, GIF, JPEG files at 300 dpi.

Making Contact & Terms: Query with samples. Keeps samples on file. SASE. Reports "when the right project comes along." Payment rates depend on the client. Pays within 30 days. Buys one-time, exclusive product and all rights; negotiable. Credit line sometimes given.

Tips: In samples "quality and composition count."

$ 🅰 🖼 IDEA BANK MARKETING, 701 W. Second St., P.O. Box 2117, Hastings NE 68902. (402)463-0588. Fax: (402)463-2187. E-mail: mail@ideabankmarketing.com. Vice President/Creative Director: Sherma Jones. Estab. 1982. Member of Lincoln Ad Federation. Ad agency. Approximate annual billing: $1.2 million. Number of employees: 9. Types of clients: industrial, financial, tourism and retail.

Needs: Works with 1-2 freelance photographers and 1 videographer/month. Uses photos for direct mail, catalogs, posters and newspapers. Subjects include people and product. Reviews stock photos. Model release required. Property release preferred.

Audiovisual Needs: Uses slides and videotape for presentations.

Specs: Uses 5×7 glossy color and b&w prints.

Making Contact & Terms: Provide résumé, business card, brochure, flier or tearsheets to be kept on file for possible future assignments. Works with freelancers on assignment only. Keeps samples on file. SASE. Reports in 1-2 weeks. Pays $75-125/hour; $650-1,000/day. **Pays on acceptance** with receipt of invoice. Credit line sometimes given depending on client and project. Buys all rights; negotiable.

$ $ 🖼 KAUFMAN RYAN STRAL INC., 650 North Dearborn, Suite 700, Chicago IL 60610. (312)467-9494. Fax: (312)467-0298. E-mail: big@bworld.com. Website: http://www.bworld.com. President: Robert Ryan. Estab. 1993. Member of BMA, BPA, AICE. Ad agency, web developer. Approximate annual billing: $4.5 million. Number of employees: 5. Types of clients: industrial and trade shows.

Needs: Works with 1 photographer and 1 videographer/month. Uses photos for trade magazines, direct mail, catalogs, posters, newspapers, signage and audiovisual. Model/property release preferred.

Audiovisual Needs: Uses slides and videotape.

Making Contact & Terms: Query with résumé of credits. Provide résumé, business card, brochure, flier or tearsheets to be kept on file for possible future assignments. Keeps samples on file. SASE. Reports in 3 weeks. Pays $900-1,500/day. Pays on receipt of invoice. Credit line sometimes given depending upon project. Buys all rights.

🄽 ▢ 🖼 ⊘ KINETIC CORPORATION, 200 Distillery Commons, Suite 400, Louisville KY 40206. (502)719-9500. Fax: (502)719-9509. E-mail: dave@kinetic.distillery.com. Studio Manager: David Howard. Estab. 1968. Types of clients: industrial, financial, fashion, retail and food.

Needs: Works with freelance photographers and/or videographers as needed. Uses photos for audiovisual and print. Subjects include: location photography. Model and/or property release required.

Audiovisual Needs: Uses photos for slides and videotape.

Specs: Uses varied sizes and finishes color and b&w prints; 35mm, 2¼×2¼, 4×5, 8×10 transparencies; and ½″ Beta SP videotape. Accepts images in digital format for Mac, Windows. Send via CD, Jaz, Zip as TIFF files.

Making Contact & Terms: Provide résumé, business card, brochure, flier or tearsheets to be kept on file for possible future assignments. Works with local freelancers only. Keeps samples on file. SASE. Reports only when interested. Payment negotiable. Pays within 30 days. Buys all rights.

$ $ ⊘ LERNER ET AL, INC., 670 Lakeview Plaza Blvd., Suite N, Worthington OH 43085. (614)840-1756. Fax: (614)840-1769. President: Frank Lerner. Estab. 1987. Ad agency and design firm with inhouse photography. Approximate annual billing: $1.5 million. Number of employees: 10. Firm specializes in annual reports, collateral, direct mail, magazine ads, publication design. Types of clients: industrial, financial, publishing and manufacturers. Examples of recent clients: "Text Books," McGraw Hill (advertising); "Trade Advertising," Seradyn (direct mail).

Needs: Works with 1-2 freelancers/month. Uses photos for consumer magazines, trade magazines, direct mail, P-O-P displays, catalogs, posters, annual reports and packaging. Subjects include: couples, multicultural, families, teens, landscapes/scenics, health/fitness, travel, business concepts, computers, industry,

medicine, science, technology, commercial products. Interested in regional, seasonal. Model release required. Property release preferred. Captions preferred.

Spec: Uses all sizes of color and b&w prints; 35mm, 2¼×2¼, 4×5 transparencies. Accepts images in digital format for Mac. Send via CD.

Making Contact & Terms: Arrange personal interview to show portfolio. Submit portfolio for review. Send unsolicited photos by mail for consideration. Query with samples. Provide résumé, business card, brochure, flier or tearsheets to be kept on file for possible future assignments. Keeps samples on file. SASE. Reports depending on the job. Pays $150-350/day (in-studio). Pays net 30 days. Credit line not given. Buys all rights.

Tips: Looks for skill with lifestyles (people), studio ability, layout/design ability, propping/setup speed and excellent lighting techniques.

LIGGETT STASHOWER ADVERTISING, INC., 1228 Euclid Ave., Cleveland OH 44115. (216)348-8500. Fax: (216)736-8113. Contact: Alyssa Deai (print, web) or Maura Mooney (video). Estab. 1932. Ad agency. Types of clients: full service agency. Examples of recent projects: Forest City Management, Cleveland Cavaliers, BF Goodrich and Cedar Point.

Needs: Works with 10 freelance photographers, filmmakers and/or videographers/month. Uses photos for billboards, websites, consumer and trade magazines, direct mail, P-O-P displays, catalogs, posters, newspapers, signage and audiovisual. Interested in reviewing stock photos/film or video footage. Model/property release required.

Audiovisual Needs: Uses film and videotape for commercials.

Specs: Uses b&w/color prints (size and finish varies); 35mm, 2¼×2¼, 4×5, 8×10, 16mm film; ¼-¾″ videotape.

Making Contact & Terms: Send unsolicited photos by mail for consideration. Query with samples. Provide résumé, business card, brochure, flier or tearsheets to be kept on file for possible future assignments. SASE. Reports only if interested. Pays according to project. Buys one-time, exclusive product, all rights; negotiable.

$ $ LOHRE & ASSOCIATES INC., 2330 Victory Pkwy., Suite 701, Cincinnati OH 45206. (513)961-1174. President: Charles R. Lohre. Ad agency. Types of clients: industrial.

Needs: Works with 1 photographer/month. Uses photographers for trade magazines, direct mail, catalogs and prints. Subjects include: machine-industrial themes and various eye-catchers.

Specs: Uses 8×10 glossy b&w and color prints; 4×5 transparencies.

Making Contact & Terms: Query with résumé of credits, business card, brochure, flier or tearsheets to be kept on file for possible future assignments. Works with local freelancers only. SASE. Reports in 1 week. Pays $60/b&w photo; $250/color photo; $60/hour; $275/day. Pays on publication. Buys all rights.

Tips: Prefers to see eye-catching and thought-provoking images/non-human. Need someone to take 35mm photos on short notice in Cincinnati plants.

$ $ MAUCK & ASSOCIATES, 516 Third St., Suite 200, Des Moines IA 50309. (515)243-6010. Fax: (515)243-6011. President: Kent Mauck. Estab. 1986. Design firm. Specializes in annual reports and publication design. Types of clients: industrial, financial, retail, publishers and nonprofit. Examples of recent projects: Iowa Health System annual report; Iowa State University publications; Wellmark Blue Cross Publications.

Needs: Works with 3 freelancers/month. Uses photos for annual reports, billboards, consumer and trade magazines and posters. Subject matter varies. Reviews stock photos. Model release required.

Specs: Uses 35mm, 2¼×2¼, 4×5 transparencies.

Making Contact & Terms: Arrange personal interview to show portfolio. Query with stock photo list or samples. Provide résumé, business card, brochure, flier or tearsheets to be kept on file for possible future assignments. Keeps samples on file. SASE. Reports only when interested. Pays $700-1,000/day. **Pays on receipt of invoice.** Credit line given. Rights negotiable.

N $ A McGUIRE ASSOCIATES, 1234 Sherman Ave., Evanston IL 60202. (847)328-4433. Fax: (847)328-4425. Owner: James McGuire. Estab. 1979. Design firm. Specializes in annual reports, publication design, direct mail, corporate materials. Types of clients: industrial, retail, nonprofit.

Needs: Uses photos for annual reports, consumer magazines, trade magazines, direct mail, catalogs, brochures. Reviews stock photos. Model release required.

Specs: Uses color, b&w prints; 35mm, 2¼×2¼, 4×5, 8×10 transparencies.

Making Contact & Terms: Provide résumé, business card, brochure, flier or tearsheets to be kept on file for possible future assignments. Works on assignment only. Keeps samples on file. Cannot return

material. Pays $600-1,800/day. Pays on receipt of invoice. Credit line sometimes given depending upon client or project. Buys all rights; negotiable.

[A] [icon] ART MERIMS COMMUNICATIONS, 600 Superior Ave., Suite 1300, Cleveland OH 44114. (216)522-1909. Fax: (216)479-6801. E-mail: amerims@hqcom.com. President: Art Merims. Estab. 1981. Member of Public Relations Society of America. Ad agency and PR firm. Approximate annual billing: $700,000. Number of employees: 4. Types of clients: industrial, financial, fashion, retail and food.
Needs: Works with 1 freelancer/month. Uses photo for consumer magazines, trade magazines and newspapers. Model/property release preferred. Captions preferred.
Audiovisual Needs: Uses videotape for advertising.
Specs: Uses prints.
Making Contact & Terms: Query with résumé of credits. Works with local freelancers on assignment only. Cannot return material. Payment negotiable. **Pays on receipt of invoice.** Credit line sometimes given. Rights negotiable.

$[icon] MESSAGE MAKERS, 1217 Turner St., Lansing MI 48906. (517)482-3333. Fax: (517)482-9933. Executive Director: Terry Terry. Estab. 1977. Member of LRCC, NSPI, AIVF, ITVA. AV firm. Number of employees: 9. Types of clients: broadcast, industrial and retail.
Needs: Works with 2 freelance photographers, 1 filmmaker and 2 videographers/month. Uses photos for direct mail, posters and newspapers. Subjects include: people or products. Model release preferred. Property release required. Captions preferred.
Audiovisual Needs: Uses slides, film, video and CD.
Specs: Uses 4×5 color and b&w prints; 35mm, 2¼×2¼ transparencies; Beta SP videotape.
Making Contact & Terms: Provide résumé, business card, brochure, flier or tearsheets to be kept on file for possible future assignments. Keeps samples on file. Cannot return material. Reports only if interested. Payment negotiable. **Pays on receipt of invoice.** Credit line sometimes given depending upon client. Buys all rights; negotiable.

[A] MG DESIGN ASSOCIATES CORP., 824 W. Superior St., Chicago IL 60622. (312)243-3661. Fax: (312)243-5268. E-mail: solutions@mgdesign.com. Contact: Graphics Designer. Estab. 1959. Member of TSEA, EDPA, HCEA. Design firm. Number of employees: 30. Specializes in display design and signage. Types of clients: corporate.
Needs: Subjects include: corporate images and industrial. Model release required. Captions preferred.
Specs: Uses 35mm, 4×5, 8×10 transparencies.
Making Contact & Terms: Query with résumé of credits. Works on assignment only. Does not keep samples on file. Reports in 1 month. Payment negotiable. **Pays on receipt of invoice.** Credit line not given.

$ $[A][icon][icon] MSR ADVERTISING, INC., P.O. Box 10214, Chicago IL 60610-0214. (312)573-0001. Fax: (312)573-1907. E-mail: marc@msradv.com. Website: http://www.msradv.com. President: Marc S. Rosenbaum. Vice President: Barry Waterman. Creative Director: Indiana Wilkins. Estab. 1983. Ad agency. Number of employees: 7. Types of clients: industrial, fashion, financial, retail, food, aerospace, hospital, legal and medical. Examples of recent projects: "Back to Basics," MPC Products; "Throw Mother Nature a Curve," New Dimensions Center for Cosmetic Surgery; and "Innovative Strategies Practical Solutions," Becker & Pouakoff (full identity).
Needs: Works with 4-6 freelance photographers and 1-2 videographers/month. Uses photos for billboards, consumer and trade magazines, direct mail, P-O-P displays, catalogs, posters and signage. Subject matter varies. Reviews stock photos. Model/property release required.
Audiovisual Needs: Uses slides and videotape for business-to-business seminars, consumer focus groups, etc. Subject matter varies.
Specs: Uses 35mm, 2¼×2¼, 4×5 and 8×10 transparencies. Accepts images in digital format for Mac. Send via CD, SyQuest or Zip disk (low and high resolution).
Making Contact & Terms: Submit portfolio for review. Query with samples. Provide résumé, business card, brochure, flier or tearsheets to be kept on file for possible future assignments. Works on assignment only. Keeps samples on file. SASE. Reports in 1-2 weeks. Pays $750-1,500/day. Payment terms stated on invoice. Credit line sometimes given. Buys all rights; negotiable.

[N] $[icon][icon] NELSON PRODUCTIONS, INC., 1533 N. Jackson St., Milwaukee WI 53202. (414)271-5211. Fax: (414)271-5235. E-mail: dnell555@aol.com. President: David Nelson. Estab. 1968. Produces videotapes and motion pictures. Types of clients: heavy industry, business to business and ad agencies.
Needs: Industrial, graphic art and agriculture.

Audiovisual Needs: Video stock, slides, computer graphics.
Specs: Uses transparencies, computer originals.
Making Contact & Terms: Query with résumé of credits before sending material for consideration. "We're looking for high quality photos with an interesting viewpoint." Pays $250-1,200/day. Buys one-time rights. Model release required. Captions preferred.
Tips: "Send only top quality images."

[A] [■] **OMNI PRODUCTIONS**, 12955 Old Meridian St., P.O. Box 302, Carmel IN 46032-0302. (317) 844-6664. Fax: (317)573-8189. President: Winston Long. AV firm. Types of clients: industrial, corporate, educational, government and medical.
Needs: Works with 6-12 freelance photographers/month. Uses photographers for AV presentations. Subject matter varies. Also works with freelance filmmakers to produce training films and commercials.
Specs: Uses b&w and color prints; 35mm transparencies; 16mm and 35mm film and videotape.
Making Contact & Terms: Provide résumé, business card, brochure, flier or tearsheets to be kept on file for possible future assignments. Works with freelance photographers on assignment basis only. Cannot return unsolicited material. Payment negotiable. **Pays on acceptance.** Buys all rights "on most work; will purchase one-time use on some projects." Model release required. Credit line given "sometimes, as specified in production agreement with client."

$ $ [A] [■] **PHOENIX MARKETING AND COMMUNICATIONS**, W. Delta Park, Hwy. 18 W., Clear Lake IA 50428. (515)357-9999. Fax: (515)357-5364. Contact: James Clark. Ad agency. Estab. 1986. Types of clients: industrial, financial and consumer. Examples of projects: "Western Tough," Bridon (print/outdoor/collateral); "Blockbuster," Video News Network (direct mail, print); and "Blue Jeans," Clear Lake Bank & Trust (TV/print/newspaper).
Needs: Works with 2-3 photographers or videographers/month. Uses photos for billboards, consumer and trade magazines, direct mail, P-O-P displays, catalogs, posters, newspapers, signage, audiovisual uses. Subjects include: people/products. Reviews stock photos and/or video.
Audiovisual Needs: Uses slides and videotape.
Specs: Uses 8×10 color and b&w prints; 35mm, 2¼×2¼, 4×5, 8×10 transparencies; ½″ or ¾″ videotape.
Making Contact & Terms: Contact through rep or submit portfolio for review. Provide résumé, business card, brochure, flier or tearsheets to be kept on file for possible future assignments. Works on assignment only. Keeps samples on file. SASE. Reports in 3 weeks. Pays $1,000-10,000/day. **Pays on receipt of invoice.** Buys first rights, one-time rights, all rights and others; negotiable. Model/property release required. Credit line sometimes given; no conditions specified.

[N] [A] [■] [O] **PIHERA ADVERTISING ASSOCIATES, INC.**, P.O. Box 676, Lebanon OH 45036. (513)932-5649. President: Larry Pihera. Estab. 1970. Ad agency. Number of employees: 4. Types of clients: industrial, fashion and retail. Examples of recent projects: Arkay Industries (20-page brochure); The Elliott Company (series of brochures); Remodeling Designs for Elegance in Remodeling (newspaper/TV campaign).
Needs: Works with 3 freelance photographers and filmmakers or videographers/month. Uses photos for consumer magazines, trade magazines, direct mail, catalogs and newspapers. Subjects include: people and industrial/retail scenes with glamour. Reviews stock photos. Model/property release required.
Audiovisual Needs: Uses slides and film or video for corporate films (employee orientation/training). Subjects include: all types.
Specs: Uses 8×10 color and b&w prints; 35mm, 2¼×2¼, 4×5 transparencies.
Making Contact & Terms: Query with stock photo. Works with freelancers on assignment only. Cannot return material. Reports in 1-2 weeks. Payment negotiable. Pays on receipt of invoice. Credit line given. Buys all rights.

[N] **$ $** [■] **PROMOTIVISION, INC.**, 5929 Baker Rd., Suite 460, Minnetonka MN 55345. (612)933-6445. Fax: (612)933-7491. President: Michael M. Greene. Estab. 1984. Photos used in TV commercials, sports, corporate image and industrial.
Audiovisual Needs: Uses film and video. Subjects include legal, medical, industrial and sports.
Specs: Uses 8×10 glossy b&w prints.
Making Contact & Terms: Interested in receiving work from professional photographers. Provide résumé, business card, self-promotion piece or tearsheets to be kept on file for possible future assignments. Works with freelancers on occasion. Uses 16mm color neg; Betacam SP videotape. Keeps samples on file. SASE. Pays $500-1,000/day. **We pay immediately.** Weekly shows we roll credits." Buys all rights; negotiable.

Tips: "We are only interested in quality work. At times, in markets other than ours, we solicit help and send a producer/director to work with local photo crew. Film is disappearing and video continues to progress. We are only 15 years old and started as an all film company. Now film comprises less than 5% of our business."

[A] **QUALLY & COMPANY, INC.**, Suite 3, 2238 Central St., Evanston IL 60201-1457. (847)864-6316. Creative Director: Robert Qually. Ad agency and graphic design firm. Types of clients: finance, package goods and business-to-business.

Needs: Works with 4-5 freelance photographers/month. Uses photos for billboards, consumer and trade magazines, direct mail, P-O-P displays, posters and newspapers. "Subject matter varies, but is always a 'quality image' regardless of what it portrays." Model release required.

Specs: Uses b&w and color prints; 35mm, 2¼×2¼, 4×5 and 8×10 transparencies.

Making Contact & Terms: Query with samples or submit portfolio for review. Provide résumé, business card, brochure, flier or tearsheets to be kept on file for possible future assignments. Works with local freelance photographers on assignment only. Cannot return material. Reports in 2 weeks. Payment negotiable. **Pays on acceptance** or net 45 days. Credit line sometimes given, depending on client's cooperation. Rights purchased depend on circumstances.

[A] [■] [©] **PATRICK REDMOND DESIGN**, P.O. Box 75430-PM, St. Paul MN 55175-0430. (651)646-4254. Designer/Owner/President: Patrick Michael Redmond, M.A. Estab. 1966. Design firm. Specializes in publication design, book covers, books, packaging, direct mail, posters, logos, trademarks, annual reports. Number of employees: 1. Firm specializes in collateral, direct mail, publication design, book cover design, general graphic design, corporate identity. Types of clients: publishers, financial, retail, advertising, marketing, education, nonprofit, industrial, arts. Examples of recent projects: "At the Bottom of the Sky," Poems by Donald Morrill, Mid-List Press (book cover); Hauser Artists World Music & Dance Promotional Material, Hauser Artists (promotional material).

 ● Books designed by Redmond won awards from Midwest Independent Publishers Association, Midwest Book Achievement Awards, Publishers Marketing Association Benjamin Franklin Awards.

Needs: Uses photos for books and book covers, direct mail, P-O-P displays, catalogs, posters, packaging, annual reports. Subject varies with client—may be editorial, product, how-to, etc. May need custom b&w photos of authors (for books/covers designed by PRD). "Poetry book covers provide unique opportunities for unusual images (but typically have miniscule budgets)." Reviews stock photos; subject matter varies with need—like to be aware of resources. Model/property release required; varies with assignment/project. Captions required; include correct spelling and identification of all factual matters regarding images; i.e., names, locations, etc.—to be used optionally—if needed.

Specs: Uses 5×7, 8×10 glossy prints; 35mm, 2¼×2¼, 4×5 transparencies. Accepts images in digital format for Mac; type varies with need, production requirements, budgets. "Do not send digital formats unless requested."

Making Contact & Terms: Contact through rep. Arrange personal interview to show portfolio. Query with résumé of credits. Query with stock photo list. Provide résumé, business card, brochure, flier, or tearsheets to be kept on file for possible future assignments. "Patrick Redmond Design will not reply unless specific photographer may be needed for respective project." Works with local freelancers on assignment only. Keeps samples on file. Cannot return material. Payment negotiable. "Client typically pays photographer directly even though PRD may be involved in photo/photographer selection and photo direction." Payment depends on client. Credit line sometimes given depending upon publication style/individual projects. Rights purchased vary with project; negotiable. "Clients typically involved with negotiation of rights directly with photographer."

Tips: Needs are "open—vary with project . . . location work; studio; table-top; product; portraits; travel; etc." Seeing "use of existing stock images when image/price are right for project and use of b&w photos in low-to-mid budget/price books. Provide URLs (website addresses) and e-mail addresses. Freelance photographers need web presence in today's market—in addition to exposure via direct mail, catalogs, brochures, etc. See examples of book covers designed by Patrick Redmond at www.http.//che.tc.umn.edu/Redmond/ (Patrick Redmond also teaches design at the University of Minnesota)."

[A] [■] **SANDRA SANOSKI COMPANY, INC.**, 166 E. Superior St., Chicago IL 60611. (312)664-7795. President: Sandra Sanoski. Estab. 1974. Marketing communications and design firm specializing in display and promotion design, packaging and web/internet design. Types of clients: retail and consumer goods.

Needs: Works with 3-4 freelancers/month. Uses photos for catalogs and packaging. Subject matter varies. Reviews stock photos. Model/property release required.

Specs: Uses 35mm, 2¼×2¼, 4×5, 8×10 transparencies. Accepts digital images.

At the Bottom
of the Sky

Poems by
Donald Morrill

FIRST SERIES: POETRY

One-time rights for this photo by Woody Walters were secured by Mid-List Press for the cover of a book of poetry called *At the Bottom of the Sky*. Mid-List then enlisted the services of designer Patrick Redmond to create a book cover incorporating the moody image titled "Evening Storm, Lido Beach, Sarasota."

Making Contact & Terms: Query with list of stock photo images. Arrange personal interview to show portfolio. Works on assignment only. Keeps samples on file. SASE. Payment negotiable. Pays net 30 days. Credit line not given. Buys all rights.

$ $ $ [A] [□] [▨] SWANSON RUSSELL AND ASSOCIATES, 9140 W. Dodge Rd., Suite 402, Omaha NE 68114. (402)393-4940. Fax: (402)393-6926. E-mail: paul_b@oma.sramarketing.com. Associate Art Director: Paul Berger. Estab. 1963. Member of NAMA, PRSA, DMA, Ad Club, AIGA, 4-As. Ad agency. Approximate annual billing: $40 million. Number of employees: 80. Examples of past projects: "Nuflor Product Launch"; "Orbax Product Launch," Schering-Plough Animal Health (print, direct mail); and "Branding Campaign," Alegant Health System (print and TV).
Needs: Works with 2 photographers/month; 3-4 filmmakers/year and 1 videographer/year. Uses photos for billboards, trade magazines, direct mail, P-O-P displays, newspapers and audiovisual. Subjects include human health, animal health, pharmaceuticals and agriculture (cattle, hogs, crops, rural life). Model/property release preferred. Captions preferred.
Audiovisual Needs: Uses slides, film and video for training videos, etc.
Making Contact & Terms: Submit portfolio for review. Query with samples. Provide résumé, business card, brochure, flier or tearsheets to be kept on file for possible future assignments. Work with local freelancers on assignment only. Keeps samples on file. SASE. Reports in 1-2 weeks. Pays $100-150/hour; $800-1,500/day; $400-1,000/color photo. **Pays on receipt of invoice.** Credit line sometimes given. Buys first, one-time, electronic and all rights; negotiable.
Tips: "We have begun to use photographers who also have the skills and tools to digitally manipulate their images."

[A] [▨] TAKE 1 PRODUCTIONS, 5325 W. 74th St., Minneapolis MN 55439. (612)831-7757. Fax: (612)831-2193. E-mail: take1@take1productions.com. Producer: Bob Hewitt. Estab. 1985. Member of ITVA, IICS. AV firm. Approximate annual billing: $1 million. Number of employees: 10. Types of clients: industrial. Examples of recent projects: USWest; Kraft (industrial); Paramount (broadcast).
Needs: Works with 2 photographers and 4 videographers/month. Uses photos for direct mail and audiovisual. Subjects include: industrial. Reviews stock photos. Model/property release required. Captions preferred.
Audiovisual Needs: Uses slides and/or video.
Specs: Uses 35mm transparencies; Betacam videotape.
Making Contact & Terms: Provide résumé, business card, brochure, flier or tearsheets to be kept on file for possible future assignments. Works with freelancers on assignment only. Keeps samples on file. Cannot return material. Reports in 1 month. Payment negotiable. **Pays on receipt of invoice**, net 30 days. Credit line not given. Buys all rights.

[N] $ $ [A] [◪] TORQUE, 309 N. Justine, Chicago IL 60607. (312)421-7858. Fax: (312)421-7866. Contact: Roxanne Hubbard. Estab. 1989. Design firm. Approximate annual billing: $2 million. Number of employees: 25. Specializes in new venture launches, identity development, brand building and marketing campaigns. Types of clients: technology, industrial, retail and publishers. Recent clients include: Border's Books and Music, National Geographic, PriceWaterhouseCoopers.
Needs: Works with 1-2 freelancers/month. Uses photos for posters, corporate collateral, direct mail. Reviews stock photos. Model/property release preferred. Captions preferred.
Specs: Uses 4×5 and 8×10 transparencies.
Making Contact & Terms: Query with samples. Provide résumé, business card, brochure, flier or tearsheets to be kept on file for possible future assignments. Works on assignment only. Keeps samples on file. Cannot return material. Reports generally in 1 month. Pays $1,000-1,800/day. Pays within 30 days. Credit line sometimes given. Buys one-time rights; negotiable.
Tips: Wants to see conceptual content in the photographer's work. "Style can be just about anything. We're looking for a mind behind the lens."

$ [◪] UNION INSTITUTE, 440 E. McMillan St., Cincinnati OH 45206. (513)861-6400. Fax: (513)861-9960. Website: http://www.tvi.edu. Publications Manager: Carolyn Krause. Provides alternative

MARKET CONDITIONS are constantly changing! If you're still using this book and it's 2001 or later, buy the newest edition of *Photographer's Market* at your favorite bookstore or order directly from Writer's Digest Books.

higher education, baccalaureate and doctoral programs. Photos used in brochures, newsletters, magazines, posters, audiovisual presentations, annual reports, catalogs and news releases.
Specs: Uses 5×7 glossy b&w and color prints; b&w and color contact sheets.
Needs: Uses photos of the Union Institute community involved in their activities. Subjects include: multicultural, senior citizens, architecture, education, business concepts, military, portraits, science, technology. Also, photos that portray themes. Model release required.
Making Contact & Terms: Arrange a personal interview to show portfolio. SASE. Reports in 3 weeks. Pays $50 for color photos. Credit line given.
Tips: Prefers "good closeups and action shots of alums/faculty, etc. Our alumni magazines reach an international audience concerned with major issues. Illustrating stories with quality photos involving our people is our constant challenge. We welcome your involvement."

$ $ A ▣ ◪ VARON & ASSOCIATES, INC., 31255 Southfield Rd., Beverly Hills MI 48025. (248)645-9730. Fax: (248)642-4166. President: Shaaron Varon. Estab. 1963. Ad agency. Approximate annual billing: $1 million. Number of employees: 6. Types of clients: industrial and retail.
Needs: Uses photos for trade magazines, catalogs and audiovisual. Subjects include: industrial. Reviews stock photos. Model/property release required. Captions preferred.
Audiovisual Needs: Uses slides and videotape for sales and training. Subjects include: industrial.
Specs: Uses 8×10 color prints; 4×5 transparencies. Accepts images in digital format for Mac and Windows.
Making Contact & Terms: Arrange personal interview to show portfolio. Works with freelancers on assignment only. Keeps samples on file. Cannot return material. Reports in 1-2 weeks. Pays $1,000/day. **Pays on acceptance.** Credit line sometimes given. Buys all rights.

$ $ A ▣ ◪ VIDEO I-D, INC., 105 Muller Rd., Washington IL 61571. (309)444-4323. Fax: (309)444-4333. E-mail: videoid@videoid.com. Website: http://www.videoid.com. President: Sam B. Wagner. Number of employees: 6. Types of clients: health, education, industry, service, cable and broadcast.
Needs: Works with 5 freelance photographers/month to shoot slide sets, multimedia productions, films and videotapes. Subjects "vary from commercial to industrial—always high quality." "Somewhat" interested in stock photos/footage. Model release required.
Audiovisual Needs: Uses film and videotape.
Specs: Uses 35mm transparencies; 16mm film; U-matic ¾" and 1" videotape, Beta SP. Accepts images in digital format for Windows ("inquire for file types"). Send via CD, Online, floppy, Zip disk or Jaz disc.
Making Contact & Terms: Provide résumé, business card, self-promotion piece or tearsheets to be kept on file for possible future assignments; "also send video sample reel." Works with freelancers on assignment only. SASE. Reports in 3 weeks. Pays $10-65/hour; $160-650/day. Usually pays by the job; negotiable. **Pays on acceptance.** Credit line sometimes given. Buys all rights; negotiable.
Tips: Sample reel—indicate goal for specific pieces. "Show good lighting and visualization skills. Show me you can communicate what I need to see—and have a willingness to put out effort to get top quality."

WILLIAM K. WALTHERS, INC., 5601 W. Florist Ave., Milwaukee WI 53218. (414)527-0770. Fax: (414)527-4423. Publications Manager: Kim Benson. Estab. 1932. Importer/wholesaler of hobby products. Photos used in catalogs, text illustration and promotional materials.
Needs: Buys 50-100 photos/year; offers 20 assignments/year. Interested in any photos relating to historic or model railroading. Reviews stock photos. Model/property release required. Captions preferred; include brief overview of action, location, any unusual spellings, names of photographer and model builder.
Specs: Uses 4×5, 8½×11 color and b&w prints; 35mm, 2¼×2¼ transparencies.
Making Contact & Terms: Send unsolicited photos by mail for consideration. Keeps samples on file. SASE. Reports in 1-2 weeks. Payment negotiated based on usage. Pays on publication or **receipt of invoice.** Credit line given. Buys all rights.
Tips: "Knowledge of railroading is essential since customers consider themselves experts on the subject. With model railroad shots, it should be difficult to see that the subject is a miniature."

A ◪ WATT, ROOP ADVERTISING LTD., (formerly Olson and Gibbons, Inc.), 1100 Superior Ave., Cleveland OH 44114-2543. (216)566-7019. Fax: (216)566-0857. E-mail: bolson@wattroop.com. Executive Vice-President/Creative Director: Barry Olson. Estab. 1998. Ad agency, PR/marketing firm. Types of clients: industrial, financial, medical, automotive, retail and food. Examples of recent projects: regional Transit Authority, (newspaper, outdoor, cinema, TV, radio, direct mail); Lake View Cemetery (newspaper, direct mail, outdoor); Ansell Edmont (ads, literature, direct mail); STERIS (corporate ads); OM Group (financial ads).
Needs: Works with 10 freelancers/month. Uses photos for billboards, trade magazines, consumer news-

papers and magazines, direct mail and P-O-P displays. Model/property release required.

Audiovisual Needs: Uses film and videotape.

Specs: Uses color and/or b&w prints; 35mm, 2¼×2¼, 4×5, 8×10 transparencies; 16mm, 35mm film.

Making Contact & Terms: Arrange personal interview to show portfolio. Provide résumé, business card, brochure, flier or tearsheets to be kept on file for possible future assignments. Works with local freelancers on assignment only. Keeps samples on file. SASE. Reports in 1-2 weeks. Payment negotiable. **Pays on receipt of invoice,** payment by client. Credit line not given. Buys one-time or all rights; negotiable.

REGIONAL REPORT: SOUTH CENTRAL & WEST

This region, stretching from California to Texas, includes several major advertising cities—Dallas, Houston, Los Angeles, San Francisco. The industries here lean heavily toward tourism and computer hardware manufacturing, but also include mining and food products. Major advertisers in this region include Walt Disney, Anheuser-Busch, Levi Strauss and Apple Computer.

Leading national advertisers

Airtouch Communications, San Francisco CA
AMR Corp., Dallas TX
Anheuser-Busch, St. Louis MO
Boston Chicken, Golden CO
Charles Schwab, San Francisco CA
Clorox, Oakland CA
Compaq Computer, Houston TX
CompUSA, Dallas TX
The Gap, San Francisco CA

Hallmark Cards, Kansas City MO
Hewlett-Packard, Palo Alto CA
Intel Corp., Santa Clara CA
J.C. Penney, Plano TX
Kimberley-Clark, Irving TX
Levi Strauss, San Francisco CA
May Department Stores, St. Louis MO
Ralston Purina, St. Louis MO
Roll International, Los Angeles CA

SBC Communications, San Antonio TX
Sprint Corp., Shawnee Mission KS
Sun Microsystems, Palo Alto CA
Tandy Corp., Fort Worth TX
U.S. West, Englewood CO
Visa International, San Francisco CA
Walt Disney, Burbank CA

Notable ad agencies in the region

Ackerman McQueen, 1601 NW Highway, 100 Bank IV Tower, Oklahoma City OK 73118. (405)843-7777. Major accounts: Bank of Oklahoma, Dallas Cowboys, National Rifle Association, Oklahoma Tourism, Six Flags.

Bernstein-Rein Advertising, 4600 Madison Ave., Suite 1500, Kansas City MO 64122. (816)756-0640. Website: http://www.bradv.com. Major accounts: Bayer, Blockbuster, McDonald's, Wal-Mart.

D'Arcy Masius Benton & Bowles, 1 Memorial Dr., St. Louis MO 63102. (314)342-8600. Major accounts: Coca-Cola, Mars Almond Bars, Skittles, Southwestern Bell, Trans World Airlines.

EURO RSCG/DSW Partners, 4 Triad Center, Suite 400, Salt Lake City UT 84180. (801)364-0919. Website: http://www.dsw.com. Major accounts: Adaptec, Cybermedia, Intel Microprocessors, Minolta Peripheral Products, Trilogy.

Foote, Cone & Belding, 733 Front St., San Francisco CA 94111-1909. (415)820-8000. Website: http://www.fcbsf.com. Major accounts: AT&T Wireless, Amazon.com, Coors, Disney Interactive, MTV.

Rick Johnson & Company, 1120 Pennsylvania NE, Albuquerque NM 87110. (505)266-1100. Major accounts: McDonald's, New Mexico Tourism, Sun Healthcare Corp., University of New Mexico, Angel Fire Resort.

Jordan Associates, 1000 W. Wilshire, Suite 428, Oklahoma City OK 73116. (405)840-3201. Website: http://www.jordanet.com. Major accounts: American Dental Association, Deaconess Hospital, Hardee's, Kraft Foods, Oklahoma Department of Commerce.

The Richards Group, 8750 N. Central Expressway, #1200, Dallas TX 75231-6437. (214)891-5700. Major accounts: AlphaGraphics, Chick-Fil-A, Florida Citrus Products, Motel 6, 7-Eleven.

TBWA/Chiat/Day, 5353 Gosvenor Blvd., Los Angeles CA 90066-6319. (310)305-5000.

Website: http://www.tbwachiat.com. Major accounts: ABC Television, Apple Computer, Energizer, Infiniti, Kinko's.

Temerlin McClain, 201 E. Carpenter Freeway, Irving TX 75062. (972)556-1100. Major accounts: American Airlines, GTE Corp., Just My Size Pantyhose, Nations Bank, Subaru Cars.

THE AD AGENCY, P.O. Box 470572, San Francisco CA 94147. President: Michael Carden. Estab. 1970. Member of NCAAA, San Francisco Ad Club. Ad agency. Number of employees: 14. Types of clients: industrial, financial, retail and food.
Needs: Number of photographers, filmmakers and videographers used on a monthly basis varies. Uses photos for billboards, consumer magazines, trade magazines, direct mail, catalogs, posters and newspapers. Subject matter varies. Reviews stock photos. Model/property release preferred. Captions preferred.
Audiovisual Needs: Uses film and videotape for commercials.
Making Contact & Terms: Submit portfolio for review. Query with samples. Keeps samples on file. SASE. Reports in 1 month. Payment negotiable. Rights negotiable.

$ $ ⊞ ▨ THE ADVERTISING CONSORTIUM, 10536 Culver Blvd., Suite D., Culver City, CA 90232. (310)287-2222. Fax: (310)287-2227. E-mail: theadco97@earthlink.net. President: Kim Miyade. Estab. 1985. Full-service ad agency. Firm specializes in magazine ads. Types of clients: industrial, retail. Current clients include Bernini, Royal-Pedic Mattress, Davante, Maison D'Optique, Westime, Modular Communication Systems.
Needs: Number of photographers used on a monthly basis varies. Uses photos for billboards, consumer magazines, trade magazines, direct mail, posters, newspapers and signage. Subjects include: children, couples, families, parents, landscapes/scenics, wildlife, beauty, health/fitness, sports, computers, technology, product shots and model and stock photographs. Interested in avant garde, digital, fashion/glamour, regional, seasonal. Reviews stock photos. Model release required. Property release preferred.
Audiovisual Needs: Uses slides and film.
Specs: Uses color and b&w prints. Accepts images in digital format for Mac.
Making Contact & Terms: Send unsolicited photos by mail for consideration. Provide résumé, business card, brochure, flier or tearsheets to be kept on file for possible future assignments. Works with local freelancers only. Keeps samples on file. Notification dependent upon opportunity. Payment negotiable. **Pays half on invoice, half upfront.** Credit line sometimes given. Buys all rights.

▨A▨ ▨ ▨ ⊘ ANGEL FILMS NATIONAL ADVERTISING, 967 Highway 40, New Franklin MO 65274-9778. Phone/fax: (314)698-3900. E-mail: angelfilm@aol.com. Vice President Marketing & Advertising: Linda G. Grotzinger. Estab. 1980. Ad agency, AV firm. Approximate annual billing: $9.5 million. Number of employees: 30. Types of clients: fashion, retail, film, TV and records. Examples of recent projects: Teddies Album, Angel One Records (album cover/posters); MESN Swimwear, MESN (print-TV); The Christmas Teddie Mouse, Angel Films (print-TV ads/posters/record cover).
Needs: Works with 4 freelance photographers, 1 filmmaker and 1 videographer/month. Uses photos for billboards, consumer and trade magazines, direct mail, catalogs, posters, newspapers and audiovisual. Subjects include: attractive women in swimwear and lingerie. Glamour type shots of both Asian and non-Asian women needed. Reviews stock photos of attractive women and athletic men with attractive women. Model release required.
Audiovisual Needs: Uses slides and video for fill material in commercial spots.
Specs: Uses all sizes color and b&w prints; 35mm transparencies; 16mm film; ½″ videotape. Accepts images in digital format for Windows. Send via CD, e-mail or floppy disk as JPEG, TIFF files at 300 dpi or better.
Making Contact & Terms: Provide résumé, business card, brochure, flier or tearsheets to be kept on file for possible future assignments. Works on assignment only. Keeps samples on file. SASE. Reports in 1 month. Payment negotiable based upon budget of project. Pays within 30 days of receipt of invoice. Credit line sometimes given depending upon the project. Buys all rights.
Tips: "Our company does business both here and in Asia. We do about six record covers a year and accompanying posters using mostly glamour photography. All we want to see is examples of work, then we will go from there."

N̄ $A▨ ARIZONA CINE EQUIPMENT INC., 2125 E. 20th St., Tucson AZ 85719. (520)623-8268. Contact: Linda Oliver. Estab. 1972. AV firm. Types of clients: industrial and retail.
Needs: Works with 6 photographers, filmmakers and/or videographers/month. Uses photos for audiovisual. Model/property release required. Captions preferred.
Audiovisual Needs: Uses slides, film and videotape.

Specs: Uses color prints; 35mm, 4×5 transparencies.
Making Contact & Terms: Query with résumé of credits, list of stock photo subjects and samples. Works with freelancers on assignment only. Keeps samples on file. SASE. Reports in 3 weeks. Pays $15-30/hour; $250-500/day; or per job. **Pays on receipt of invoice.** Buys all rights; negotiable. Credit line sometimes given.

$ $ [A] [□] [▨] [◒] BELL & ROBERTS, INC., 1275 N. Manassero St., Anaheim Hills CA 92807. (714)777-8600. Fax: (714)777-9571. President/Creative Director: Thomas Bell. Estab. 1980. Ad agency. Number of employees: 6. Types of clients: retail, food, motor sports companies. Examples of recent projects: annual campaigns for Van-K Engineering, Total Food Management and Cornell Computers.
Needs: Works with 1 freelancer and 1 videographer/month. Uses photos for consumer magazines, trade magazines, direct mail, P-O-P displays, catalogs and newspapers. Subjects include various product shots. Reviews stock images. Model release required. Property release preferred.
Audiovisual Needs: Uses ½″ videotape for internal reviewing.
Specs: Uses 8×10 or larger b&w prints; 2¼×2¼, 4×5 transparencies. Accepts images in digital format for Windows. Send via compact disc or Online.
Making Contact & Terms: Provide résumé, business card, brochure, flier or tearsheets to be kept on file for possible future assignments. Do not submit photos. Works with freelancers on assignment only. Keeps samples on file. Cannot return material. Payment negotiable. Pays on receipt of invoice. Credit line not given. Rights purchased depend on usage.

[A] [□] BERSON, DEAN, STEVENS, 210 High Meadow St., Wood Ranch CA 93065. (805)582-0898. Owner: Lori Berson. Estab. 1981. Design firm. Specializes in annual reports, display design, packaging and direct mail. Types of clients: industrial, financial and retail.
Needs: Works with 1 freelancer/month. Uses photos for billboards, trade magazines, direct mail, P-O-P displays, catalogs, posters, packaging and signage. Subjects include: product shots and food. Reviews stock photos. Model/property release required.
Specs: Uses 8×10 b&w prints; 35mm, 2¼×2¼, 4×5, 8×10 transparencies. Accepts images in digital format for Mac (Photoshop).
Making Contact & Terms: Provide résumé, business card, brochure, flier or tearsheets to be kept on file for possible future assignments. Works on assignment only. Keeps samples on file. SASE. Reports in 1-2 weeks. Payment negotiable. Pays within 30 days after receipt of invoice. Credit line not given. Rights negotiable.

$ [A] [▨] BETHUNE THEATREDANSE, 8033 Sunset Blvd., Suite 221, Los Angeles CA 90046. (323)874-0481. Fax: (323)851-2078. E-mail: zbethune@aol.com. Administrative Director: Marcy Hanigan. Estab. 1979. Dance company. Photos used in posters, newspapers, magazines.
Needs: Number of photos bought annually varies; offers 2-4 freelance assignments annually. Photographers used to take shots of dance productions, dance outreach classes (disabled children's program) and performances, and graphics and scenic. Examples of uses: promotional pieces for the dance production "Cradle of Fire" and for a circus fundraiser performance (all shots in 35mm format). Reviews stock photos if they show an ability to capture a moment. Captions preferred; include company or name of subject, date, and equipment shown in photo.
Audiovisual Needs: Uses slides and videotape. "We are a multimedia company and use videos and slides within our productions. We also use video for archival purposes." Subject matter varies.
Specs: Uses 8×10 color or b&w prints; 35mm transparencies and videotape.
Making Contact & Terms: Provide résumé, business card, self-promotion piece or tearsheets to be kept on file for possible future assignments. Keeps samples on file. Cannot return material. Reports only when in need of work. Payment for each job is negotiated differently. Buys all rights; negotiable. Credit line sometimes given depending on usage. "We are not always in control of newspapers or magazines that may use photos for articles."
Tips: "We need to see an ability to see and understand the aesthetics of dance—its lines and depth of field. We also look for innovative approaches and a personal signature to each individual's work. Our productions work very much on a collaborative basis and a videographer's talents and uniqueness are very important to each production. It is our preference to establish ongoing relationships with photographers and videographers."

BOB BOND & OTHERS, The Bond Group, 5025 Araphaho Rd., #300, Dallas TX 75248. (972)991-0077. Fax: (972)991-8982. E-mail: abby@bbando.com. Website: http://www.bbando.com. Traffic Coordinator: Angela Bond. Estab. 1975. Ad agency. Approximate annual billing: 8 million. Number of employees: 13. Firm specializes in annual reports, publication design, display design, magazine ads, direct mail, collateral.

Types of clients: industrial, financial, nonprofit. Examples of recent clients: "Flagship Brochure" for Source Services (business setting); ad for Sterling Commerce (police line up); presentation for Virtual Impact (hospital).

Needs: Works with 2 freelancers/month. Uses photos for billboards, brochures, catalogs, consumer magazines, direct mail, newspapers, P-O-P diaplays, posters, signage, trade magazines. Model/property release required.

Making Contact & Terms: Provide résumé, business card, self-promotion piece or tearsheets to be kept on file for possible future assignments. Art director will contact photographer for portfolio review if interested. Portfolio should include b&w prints, slides, thumbnails, tearsheets. Keeps samples on file; cannot return material. Reports back only if interested, send non-returnable samples. **Pays on receipt of invoice.** Credit line sometimes given. Buys all rights; negotiable.

$ $ [A] [☉] BRAINWORKS DESIGN GROUP, 2 Harris Court, Suite A-7, Monterey CA 93940. (831)657-0650. Fax: (831)657-0750. E-mail: brainwks@mbay.net. Website: http://www.brainwks.com. President: Al Kahn. Estab. 1986. Design firm. Approximate annual billing: $1-2 million. Number of employees: 8. Specializes in publication design and collateral. Types of clients: nonprofit.

Needs: Works with 4 freelancers/month. Uses photographs for direct mail, catalogs and posters. Wants conceptual images. Model release required.

Specs: Uses 35mm, 4×5 transparencies.

Making Contact & Terms: Arrange personal interview to show portfolio. Send unsolicited photos by mail for consideration. Works with freelancers on assignment only. Keeps samples on file. Cannot return material. Reports in 1 month. Pays $200-400/b&w photo; $400-600/color photo; $100-150/hour; $750-1,200/day; $2,500-4,000/job. **Pays on receipt of invoice.** Credit line sometimes given, depending on client. Buys first, one-time and all rights; negotiable.

$ $ [S] [▣] [☉] BROWNING, One Browning Place, Morgan UT 84050. (801)876-2711. Fax: (801)876-3331. Art Directors: Jodi VanOrman and John Gibby. Estab. 1878. Photos used in posters, magazines, catalogs. Uses photos to promote sporting good products, for Browning and Winchester product lines.

Needs: Works with 2 freelancers/month. Outdoor, wildlife, hunting, shooting sports and archery. Reviews stock photos. Model/property release required. Captions preferred; include location, types of props used, especially brand names (such as Winchester and Browning).

Specs: Uses 35mm, 2¼×2¼, 4×5, 8×10 transparencies. Accepts images in digital format for Mac. Send via CD at 300 dpi.

Making Contact & Terms: Interested in receiving work from outdoor and wildlife photographers. Query with samples. Provide résumé, business card, self-promotion piece or tearsheets to be kept on file for possible future assignments. Keeps samples on file. Reports in 1 month. Payment within 30 days of invoice. Buys one-time rights, all rights; negotiable.

Tips: "We look for dramatic lighting, exceptional settings and believable interactions."

$ $ [A] [☉] CALIFORNIA REDWOOD ASSOCIATION, 405 Enfrente Dr., Suite 200, Novato CA 94949. (415)382-0662. Fax: (415)382-8531. E-mail: allsebrook@world.net.att.net. Website: http://www.calredwood.org. Publicity Manager: Pamela Allsebrook. Estab. 1916. "We publish a variety of literature, a small black and white periodical, run color advertisements and constantly use photos for magazine and newspaper publicity. We use new, well-designed redwood applications—residential, commercial, exteriors, interiors and especially good remodels and outdoor decks, fences, shelters."

Needs: Gives 40 assignments/year. Prefers photographers with architectural specialization. Model release required.

Specs: Uses b&w prints. For color, uses 2¼×2¼ and 4×5 transparencies.

Making Contact & Terms: Send query material by mail for consideration for assignment or send finished speculation shots for possible purchase. Reports in 1 month. Simultaneous submissions and previously published work OK if other uses are made very clear. Payment based on previous use and other factors. Usually buys all but national advertising rights. Credit line given whenever possible.

Tips: "We like to see any new redwood projects showing outstanding design and use of redwood. We don't have a staff photographer and work only with freelancers. We generally look for justified lines, true color quality, projects with style and architectural design, and tasteful props. Find and take 'scout' shots or finished pictures of good redwood projects and send them to us."

$ $ $ [A] [◕] CLIFF AND ASSOCIATES, 715 Fremont Ave., South Pasadena CA 91030. (626)799-5906. Fax: (626)799-9809. Owner: Greg Cliff. Estab. 1984. Design firm. Specializes in annual

reports, display design, direct mail, signage. Types of clients: industrial, financial, corporate. Examples of recent projects: international brochure for ARCO.

Needs: Works with 1-2 freelancers/month. Uses photos for annual reports, direct mail, P-O-P displays, catalogs. Subjects include: babies, celebrities, children, couples, multicultural, families, parents, senior citizens, teens, architecture, beauty, cities/urban, education, interiors/decorating, pets, religious, rural, adventure, automobiles, entertainment, events, health/fitness, hobbies, humor, performing arts, sports, travel, disasters, environmental, landscapes/scenics, wildlife, agriculture, buildings, business concepts, computers, industry, medicine, military, political, portraits, product shots/still life, science, technology and food. Interested in alternative process, avant garde, digital, documentary, erotic, fashion/glamour, historical/vintage, regional, seasonal. Reviews stock photos. Model/property release preferred. Captions preferred.

Specs: Uses all glossy color prints.

Making Contact & Terms: Provide résumé, business card, brochure, flier or tearsheets to be kept on file for future assignments. Works with local freelancers on assignment only. Keeps samples on file. SASE. Reports in 1-2 weeks. Pays $600-3,500/day. **Pays net 30 on receipt of invoice.** Credit line sometimes given. Rights negotiable.

[N] [picture] COAKLEY HEAGERTY, 1155 N. First St., San Jose CA 95112. (408)275-9400. Fax: (408)995-0600. Art Director: Ray Bauer. Estab. 1960. Member of MAAN. Ad agency. Approximate annual billing: $25 million. Number of employees: 25. Types of clients: industrial, financial, retail, food and real estate. Examples of recent projects: Seniority (senior care); Florsheim Homes (real estate); and ABHOW (senior care).

Needs: Works with 2-3 freelance photographers, 1 filmmaker and 1 videographer/month. Uses photos for consumer magazines, trade magazines, direct mail and newspapers. Subjects vary. Model release required.

Specs: Uses b&w prints; 35mm, 2¼×2¼, 4×5, 8×10, transparencies; 16 mm, 35mm film; and Beta SP D-2 videotape.

Making Contact & Terms: Send unsolicited photos by mail for consideration. Keeps samples on file. Cannot return material. Reports as needed. Pays on receipt of invoice; 60 days net. Credit line not given. Buys all rights; negotiable.

[A] [picture] [picture] DYKEMAN ASSOCIATES INC., 4115 Rawlins, Dallas TX 75219. (214)528-2991. Fax: (214)528-0241. E-mail: adykeman@airmail.net. Website: http://www.dykemanassoc.com. Contact: Alice Dykeman. Estab. 1974. Member of Public Relations Society of America. PR and AV firm. Firm specializes in collateral, direct mail, magazine ads, publication design. Types of clients: industrial, financial, sports, nonprofit.

Needs: Works with 4-5 photographers and/or videographers. Uses photos for publicity, billboards, consumer and trade magazines, direct mail, P-O-P displays, catalogs, posters, newspapers, signage, and audiovisual uses. "We handle model and/or property releases."

Audiovisual Needs: "We produce and direct video. Just need crew with good equipment and people and ability to do their part."

Specs: Uses 8½×11 and glossy b&w transparencies or color prints; ¾" or Beta videotape. Accepts images in digital format for Mac, Windows. Send via floppy disk, SyQuest or on Zip disk, at 300 dpi.

Making Contact & Terms: Arrange personal interview to show portfolio. Provide résumé, business card, brochure, flier or tearsheets to be kept on file for possible future assignments. Works on assignment only. Cannot return material. Pays $800-1,200/day; $250-400/1-2 days. "Currently we work only with photographers who are willing to be part of our trade dollar network. Call if you don't understand this term." Pays 30 days after receipt of invoice.

Tips: Reviews portfolios with current needs in mind. "If video, we would want to see examples. If for news story, we would need to see photojournalism capabilities. Show portfolio, state pricing; remember that either we or our clients will keep negatives or slide originals."

[picture] [picture] [picture] EDUCATIONAL VIDEO NETWORK, 1401 19th St., Huntsville TX 77340. (409)291-9995. Fax: (409)295-0020. E-mail: evn@edvidnet.com. Website: http://www.edvidnet.com. Chief Executive Officer: George H. Russell. Estab. 1953. AV firm. Number of employees: 70. Types of clients: "We produce for ourselves in the education market." Examples of recent projects: catalogs to illustrate EVN video titles.

Needs: Works with 2-3 videographers/month. Subjects include: multicultural, teens, environmental, landscapes/scenics, education, religious, rural, entertainment, food/drink, health/fitness, hobbies, performing arts, sports, travel, agriculture, buildings, business concepts, computers, industry, medicine, science, technology. Interested in fine art.

Audiovisual Needs: Uses videotape for all projects; slides.

Specs: Uses ½" videotape. Accepts images in digital format for Mac. Send via online, Zip disk or Jaz

disk or e-mail as TIFF, PICT, JPEG files at 300 dpi.

Making Contact & Terms: Query with program proposal. SASE. Reports in 3 weeks. Payment negotiable. Pays in royalties or flat fee based on length, amount of post-production work and marketability; royalties paid quarterly. Credit line given. Buys all rights; negotiable.

Tips: In freelancer's demos, looks for "literate, visually accurate, curriculum-oriented video programs that could serve as a class lesson in junior high, high school or college classroom. The switch from slides and filmstrips to video is complete. The schools need good educational material. E-mail letter of introduction with at least three thumbnail samples attached."

\$ \$ [A] [■] [▨] [⊘] FARNAM COMPANIES, INC., Dept. PM, 301 W. Osborn, Phoenix AZ 85013-3928. (602)664-1264. Fax: (602)207-2147. E-mail: shall@mail.farnam.com. Website: http://www.farnam.com. Creative Director: Trish Spencer. Firm specializes in display design, magazine ads, packaging. Types of clients: retail.

• This company has an in-house ad agency called Charles Duff Advertising.

Needs: Works with 2 freelance photographers/month. Uses photos for direct mail, catalogs, consumer magazines, P-O-P displays, posters, AV presentations, trade magazines and brochures. Subject matter includes horses, dogs, cats, birds, farm scenes, ranch scenes, cowboys, cattle, horse shows, landscapes/scenics, gardening.

Audiovisual Needs: Uses film and videotape. Occasionally works with freelance filmmakers to produce educational horse health films and demonstrations of product use.

Specs: Uses 35mm, 2¼×2¼ and 4×5 transparencies; 16mm and 35mm film and videotape. Accepts images in digital format for Mac. Send via CD, Zip.

Making Contact & Terms: Query with samples. Provide résumé, business card, brochure, flier or tearsheets to be kept on file for possible future assignments. Works with freelance photographers on assignment basis only. SASE. Pays $50-350/color photo. Pays on publication. Buys one-time rights. Model release required. Credit line given whenever possible.

Tips: "Send me a number of good, reasonably priced for one-time use photos of dogs, horses or farm scenes. Better yet, send me good quality dupes I can keep on file for *rush* use. When the dupes are in the file and I see them regularly, the ones I like stick in my mind and I find myself planning ways to use them. We are looking for original, dramatic work. We especially like to see horses, dogs, cats and cattle captured in artistic scenes or poses. All shots should show off quality animals with good conformation. We rarely use shots if people are shown and prefer animals in natural settings or in barns/stalls."

[N] \$ [■] [▨] FOCUS ADVERTISING, INC., 292 Placitas NW, Albuquerque NM 89107. (505)345-8480. Fax: (505)341-2608. President: Al Costanzo. Member of Nikon Professional Services, New Mexico Professional Photographer's Association. Ad agency. Approximate annual billing: $350,000. Number of employees: 3-5. Types of clients: industry, electronics, software, government, law. Produces overhead transparencies, slide sets, motion pictures, sound-slide sets, videotape, print ads, trade show displays and brochures. Examples of recent projects: "S.O.P.," for Xynatech, Inc.; and "Night Sights," for Innovative Weaponry (brochures/ads/trade show displays).

Needs: Works with 1-2 freelance photographers/month on assignment only basis. Buys 70 photos and 5-8 films/year. Subjects include: health, business, environment and products. No animals or flowers. Length requirements: 80 slides or 8-12 minutes.

Specs: Produces ½" and ¾" video for broadcasts; also b&w photos or color prints and 35mm transparencies, "and a lot of 2¼×2¼ transparencies and some 4×5 transparencies." Accepts images in digital format for Windows. Send via Jazz or CD-ROM.

Making Contact & Terms: Arrange personal interview or query with résumé, flier and brochure to be kept on file for possible future assignments. Prefers to see a variety of subject matter and styles in portfolio. Does not return unsolicited material. Pays minimum $75/b&w or color photo; $40-75/hour; $350-750/day; $100-1,000/job. Negotiates payment based on client's budget and photographer's previous experience/reputation. Pays on job completion. Buys all rights. Model release required.

\$ [▨] [⊘] FRIEDENTAG PHOTOGRAPHICS, 356 Grape St., Denver CO 80220. (303)333-7096. Manager: Harvey Friedentag. Estab. 1957. AV firm. Approximate annual billing: $100,000. Number of employees: 3. Firm specializes in annual reports, display design, direct mail, magazine ads, publication design. Serves clients in business, industry, finance, retail, publishing, nonprofit, government, trade and union organizations. Produces slide sets, motion pictures and videotape.

Needs: Works with 5-10 freelancers/month on assignment only. Buys 1,000 photos and 25 films/year. Reviews stock photos of business, training, public relations and industrial plants showing people and equipment or products in use. Other subjects include: medicine, military, political. Interested in avant garde, documentary, erotic. Model release required.

Audiovisual Needs: Uses freelance photos in color slide sets and motion pictures. No posed looks. Also produces mostly 16mm Ektachrome and some 16mm b&w; ¾″ and VHS videotape. Length requirement: 3-30 minutes. Interested in stock footage on business, industry, education and unusual information. "No scenics please!"

Specs: Uses 8×10 glossy b&w and color prints; 35mm, 2¼×2¼ or 4×5 color transparencies.

Making Contact & Terms: Send material by mail for consideration. Provide flier, business card and brochure and nonreturnable samples to show clients. SASE. Reports in 3 weeks. Pays $400/day for still; $600/day for motion picture plus expenses; $100 maximum for b&w photos; $200 maximum for color photo; $700 maximum for film; $700 maximum for videotape. **Pays on acceptance.** Buys rights as required by clients.

Tips: "More imagination needed—be different, no scenics, pets or portraits and above all, technical quality is a must. There are more opportunities now than ever, especially for new people. We are looking to strengthen our file of talent across the nation."

$ $ GEILE/REXFORD CREATIVE ASSOCIATES, 7777 Bonhomme, St. Louis MO 63105. (314)727-5850. Fax: (314)727-5819. Creative Director: David Geile. Estab. 1989. Member of American Marketing Association, BPAA. Ad agency. Approximate annual billing: $4 million. Number of employees: 15. Types of clients: industrial and financial. Recent clients include: Texas Boot Company; First Bank; and Monsanto.

Needs: Works with 2-3 freelance photographers/month, 3 filmmakers and 5 videographers/year. Uses photos for billboards, consumer and trade magazines, direct mail, P-O-P displays, catalogs, posters and newspapers. Subjects include: product shots. Model/property release preferred.

Audiovisual Needs: Computer generated and projected graphics for sales meetings.

Specs: Uses color and b&w prints; 35mm, 2¼×2¼, 4×5 transparencies; 16mm film; 1″ videotape.

Making Contact & Terms: Provide résumé, business card, brochure, flier or tearsheets to be kept on file for possible future assignments. Keeps samples on file. Cannot return material. Reports when approval is given from client. Pays $800-1,200/day; $300-500/b&w photo; also accepts bids for jobs. Pays net 30-45 days. Buys one-time and all rights.

A GORDON GELFOND ASSOCIATES, INC., Suite 350, 11500 Olympic Blvd., Los Angeles CA 90064. (310)478-3600. Fax: (310)477-4825. Ad agency. Art Director: Barry Brenner. Types of clients: retail, financial, hospitals and consumer eletronics.

Needs: Works with 1-2 photographers/month. Uses freelance photographers for billboards, consumer magazines, trade magazines, direct mail and newspapers. Subject matter varies.

Specs: Uses b&w and color prints; 35mm, 2¼×2¼ and 4×5 transparencies.

Making Contact & Terms: Reps only to show portfolio, otherwise drop off portfolio on Thursdays only. Provide résumé, business card, brochure, flier or tearsheets to be kept on file for possible future assignments. Works with local freelance photographers on assignment basis only. Reports ASAP. Payment negotiable/job. "Works within a budget." Payment is made 30 days after receipt of invoice. Buys all rights. Model release required. Credit line sometimes given.

A GK&A ADVERTISING, INC., 1120 Empire Central Place, Suite 300, Dallas TX 75247. (214)634-9486. Fax: (214)634-9490 or (214)638-4984. Production Manager: Tracy Rotter. Estab. 1982. Member of AAAA. Ad agency, PR firm. Approximate annual billing: $3 million. Number of employees: 4. Types of clients: financial, service, retail.

● This agency is using computer manipulation and stock photos on CD.

Needs: Works with 1 freelance photographer, 2 filmmakers and 2 videographers/month. Uses photos for billboards, direct mail, P-O-P displays, posters, newspapers, audiovisual uses. Reviews stock photos. Model/property release required. Captions preferred.

Audiovisual Needs: Uses slides, film and video.

Specs: Uses 35mm transparencies; ½″ VHS videotape.

Making Contact & Terms: Submit portfolio for review. Works on assignment only. Keeps samples on file. Cannot return material. Reports in 3 weeks. Payment negotiable. Pays net 30 days. Credit line not given. Buys one-time rights.

$ $ GRAFICA, 7053 Owensmouth Ave., Canoga Park CA 91303. (818)712-0071. (818)712-0071. Fax: (818)348-7582. E-mail: graficaeps@aol.com. Website: http://www.graficaeps.com. Owner: Larry Girardi. Estab. 1974. Member of Apple Developer Group, Adobe Authorized Imaging Center, Quark Service Alliance, Corel Approved Service Bureau. Design Studio and Service Bureau. Approximate annual billing: $250,000. Number of employees: 5. Specializes in reports, magazine ads, direct mail, publication design, collateral design and video graphics-titling. Types of clients: industrial, retail, publishers and enter-

tainment. Examples of recent clients: "Irvine's Law," Irvine Optical Co. (trade show exhibit, lapel pins); "Nutraskin ADV," Silvercloud (consumer ad, 4-color brochure).

Needs: Works with 1-2 freelancers/month. Uses photos for annual reports, billboards, consumer magazines, trade magazines, P-O-P displays, catalogs, posters and packaging. Reviews stock photos. Subjects include: babies, celebrities, children, couples, multicultural, families, parents, senior citizens, teens, disasters, environmental, landscapes, scenics, wildlife, architecure, beauty, cities/urban, education, gardening, interiors/decorating, pets, religious, rural, adventure, automobiles, entertainment, events, food/drink, health/fitness, hobbies, humor, performing arts, sports, travel, agriculture, buildings, business concepts, computers, industry, medicine, military, political, portraits, product shots/still life, science, technology. Interested in alternative process, avant garde, digital, documentary, erotic, fashion/glamour, fine art, historical/vintage, regional, seasonal. Model release required. Property release preferred.

Specs: Uses 35mm, 2¼×2¼, 4×5 transparencies. Accepts images in digital format for Mac. Send via CD, SyQuest, floppy disk, Jaz, Zip, e-mail as TIFF files.

Making Contact & Terms: Query with samples. Provide résumé, business card, brochure, flier or tearsheets to be kept on file for possible future assignments. Keeps samples on file. SASE. Reports in 1-2 weeks. Pays $100-1,000 for b&w and color photos. Credit line sometimes given. Buys first, one-time, electronic and all rights; negotiable.

Tips: "Send samples sheets (non-returnable) for our files. We will contact when appropriate project arises."

$ $ [A] [⊡] [▨] [⊘] GRAPHIC DESIGN CONCEPTS, 4123 Wade St., Suite 2, Los Angeles CA 90066. (310)306-8143. President: C. Weinstein. Estab. 1980. Design firm. Number of employees: 10. Specializes in annual reports, collateral, publication design, display design, packaging, direct mail and signage. Types of clients: industrial, financial, retail, publishers and nonprofit. Examples of recent clients: "Travel Brochure," 4th Dimension Travel (brochures); "Financial Marketing," Trust Financial (marketing materials).

Needs: Works with 10 freelancers/month. Uses photos for annual reports, billboards, consumer and trade magazines, direct mail, P-O-P displays, catalogs, posters, packaging and signage. Subjects include: celebrities, children, couples, multicultural, families, parents, teens, environmental, wildlife, architecture, beauty, cities/urban, gardening, interiors/decorating, pets, rural, adventure, automobiles, entertainment, events, food/drink, health/fitness, hobbies, humor, performing arts, travel, agriculture, buildings, business concepts, computers, industry, medicine, military, political, portraits, product shots/still life, science, technology, pictorial, scenic. Interested in alternative process, avant garde, digital, documentary, fashion/glamour, fine art, historical/vintage, regional, seasonal. Model/property release required for people, places, art. Captions required; include who, what, when, where.

Audiovisual Needs: Uses film and videotape.

Specs: Uses 8×10 glossy, color and b&w prints; 35mm, 2¼×2¼, 4×5, 8×10 transparencies. Accepts images in digital format for Windows. Send via CD, floppy disk as TIFF files.

Making Contact & Terms: Provide résumé, business card, brochure, flier or tearsheets to be kept on file for possible future assignments. Works with freelancers on assignment only. Keeps samples on file. SASE. Reports as needed. Pays $15 minimum/hour; $100 minimum/day; $100 minimum/job; $50 minimum/color photo; $25 minimum/b&w photo. Pays $200 minimum for film; $200 minimum for videotape. **Pays on receipt of invoice.** Credit line sometimes given depending upon usage. Buys rights according to usage.

Tips: In samples, looks for "composition, lighting and styling." Sees trend toward "photos being digitized and manipulated by computer."

[▨] HALLOWES PRODUCTIONS & ADVERTISING, 11260 Regent St., Los Angeles CA 90066-3414. (310)390-4767. Fax: (310)397-2977. Creative Director/Producer-Director: Jim Hallowes. Estab. 1984. Produces TV commercials, corporate films and print advertising.

Needs: Buys 8-10 photos annually. Uses photos for magazines, posters, newspapers and brochures. Reviews stock photos; subjects vary.

Audiovisual Needs: Uses film and video for TV commercials and corporate films.

Specs: Uses 35mm, 4×5 transparencies; 35mm/16mm film; Beta SP videotape.

Making Contact & Terms: Query with résumé of credits. Do not fax unless requested. Keeps samples on file. SASE. Reports if interested. Payment negotiable. Pays on usage. Credit line sometimes given, depending upon usage, usually not. Buys first and all rights; rights vary depending on client.

[▨] HAYES ORLIE CUNDALL INC., 46 Varda Landing, Sausalito CA 94965. (415)332-7414. Fax: (415)332-5924. Art Director: Ted Davis. Estab. 1991. Ad agency. Uses all media except foreign. Types of clients: industrial, retail, fashion, finance, computer and hi-tech, travel, healthcare, insurance.

Needs: Works with 1 freelance photographer/month on assignment only. Model release required. Captions

preferred.

Making Contact & Terms: Provide résumé, business card and brochure to be kept on file for future assignments. "Don't send anything unless it's a brochure of your work or company. We keep a file of talent—we then contact photographers as jobs come up." Payment negotiable. Pays on a per-photo basis; negotiates payment based on client's budget, amount of creativity required and where work will appear. "We abide by local photographer's rates and prefer total buyouts to limited use agreements."

Tips: "We look for creative and technical excellence, then how close to our offices; cheap versus costly; personal rapport; references from friends in agencies who've used him/her. Call first. Send samples and résumé if we're not able to meet with you personally due to work pressure. Keep in touch with new samples." Produces occasional audiovisual, CDs and videos.

$ [A] [photo] [o] HEPWORTH ADVERTISING CO., 3403 McKinney Ave., Dallas TX 75204. (214)220-2415. Fax: (214)220-2416. President: S.W. Hepworth. Estab. 1952. Ad agency. Uses all media except P-O-P displays. Types of clients: industrial and financial. Examples of recent projects: Houston General Insurance, Holman Boiler, Hillcrest State Bank.

Needs: Uses photos for trade magazines, direct mail, newspapers and audiovisual. Subjects include: wildlife, computers, documentary. Model/property release required. Captions required.

Specs: Uses 8×10 glossy color prints, 35mm transparencies.

Making Contact & Terms: Submit portfolio by mail. Works on assignment only. Reports in 1-2 weeks. Pays $350 minimum/job; negotiates payment based on client's budget and photographer's previous experience/reputation. **Pays on acceptance.** Credit line sometimes given. Buys all rights.

Tips: "For best relations with the supplier, we prefer to seek out a photographer in the area of the job location." Sees trend toward machinery shots. "Contact us by letter or phone."

[A] [] THE HITCHINS COMPANY, 22756 Hartland St., Canoga Park CA 91307. Phone/fax: (818)715-0510. E-mail: hitchins@soca.com. President: W.E. Hitchins. Estab. 1985. Ad agency. Approximate annual billing: $300,000. Number of employees: 2. Types of clients: industrial, retail (food) and auctioneers. Examples of recent projects: Electronic Expediters (brochure showing products); Allan-Davis Enterprises (magazine ads).

Needs: Uses photos for trade and consumer magazines, direct mail and newspapers. Model release required.

Specs: Uses b&w and color prints. "Copy should be flexible for scanning." Accepts images in digital format for Mac (TIFF or EPS). Send via CD, floppy disk, Zip, SyQuest or e-mail.

Making Contact & Terms: Provide résumé, business card, brochure, flier or tearsheets to be kept on file for possible future assignments. Works on assignment only. Cannot return material. Payment negotiable depending on job. **Pays on receipt of invoice** (30 days). Rights purchased negotiable; "varies as to project."

Tips: Wants to see shots of people and products in samples.

[N] [A] [o] HOWRY DESIGN ASSOCIATES, 354 Pine St., Suite 600, San Francisco CA 94104. (415)433-2035. Fax: (415)433-0816. Website: http://www.howry.com. Office Manager: Marie Duran. Estab. 1987. Design firm. Number of employees: 12. Specializes in annual reports. Types of clients: industrial, financial and publishers. Also moving into multimedia. Examples of recent projects: Xoma Corp. (annual report); McKesson Corp. (annual report); Ascend (annual report).

Needs: Works with 2-4 freelancers/month. Uses photos for annual reports. Subjects vary. Reviews stock photos. Model/property release preferred. Captions preferred.

Specs: Uses 35mm, 2¼×2¼, 4×5, 8×10 transparencies.

Making Contact & Terms: Query with samples. Provide résumé, business card, brochure, flier or tearsheets to be kept on file for possible future assignments. Works on assignment only. Keeps samples on file. Reports in 1-2 weeks. Payment negotiable. **Pays on receipt of invoice.** Buys one-time rights.

[A] [] [photo] HUMPHREY ASSOCIATES, 233 S. Detroit, Suite 201, Tulsa OK 74120. (918)584-4774. Fax: (918)584-4773. E-mail: humpass@earthlink.net. Art Director: Larry Hamblin. Estab. 1986. Ad agency. Approximate annual billing: $2 million. Types of clients: industrial, financial, retail. Examples of recent projects: Ramsey Winch (consumer ad campaign); Flare/Duct Burner campaign, Callidus Technologies (direct mail and trade magazines).

Needs: Works with 3-6 freelance photographers, 1 filmmaker and 1 videographer/month. Uses photos for billboards, consumer magazines, trade magazines, direct mail, P-O-P displays, catalogs, posters, newspapers, signage. Subjects include vehicles in rugged setting with Ramsey Winch. Reviews stock photos. Model release required.

Audiovisual Needs: Uses slides and video.

Specs: Uses 8×10 color and b&w prints; 35mm, 2¼×2¼, 4×5 transparencies; digital format (any Mac

format).

Making Contact & Terms: Query with stock photo list or samples. Provide résumé, business card, brochure, flier or tearsheets to be kept on file for possible future assignments. Works with local freelancers on assignment only. Keeps samples on file. SASE. Reports depending upon projects. Payment negotiable. Credit line sometimes given. Buys first, one-time, electronic and all rights; negotiable.

A ▣ ◪ IMAGE INTEGRATION, 2418 Stuart St., Berkeley CA 94705. (510)841-8524. Fax: (510)704-1868. E-mail: vince@bmre.berkeley.edu. Owner: Vince Casalaina. Estab. 1971. Specializes in material for TV productions and Internet sites. Approximate annual billing: $100,000. Examples of projects: "Ultimate Subscription" for *Sailing World* (30 second spot); "Road to America's Cup" for ESPN (stock footage); and "Sail with the Best" for US Sailing (promotional video).

Needs: Works with 1 freelance photographer and 1 videographer/month. Reviews stock photos of sailing. Property release preferred. Captions required; include regatta name, regatta location, date.

Audiovisual Needs: Uses videotape. Subjects include: sailing.

Specs: Uses 4×5 or larger matte color or b&w prints; 35mm transparencies; 16mm film and Betacam videotape. Accepts mages in digital format for Mac. Send via Zip or Jazz disk.

Making Contact & Terms: Send unsolicited photos by mail for consideration. Works on assignment only. Keeps samples on file. SASE. Reports in 1-2 weeks. Payment depends on distribution. Pays on publication. Credit line sometimes given, depending upon whether any credits included. Buys nonexclusive rights; negotiable.

N A ▣ INNOVATIVE DESIGN AND ADVERTISING, 1424 Fourth St., #702, Santa Monica CA 90401. (310)395-4332. Fax: (310)394-9633. E-mail: design@i-d-a.com. Design firm. Partners: Susan Nickey and Kim Crossett. Estab. 1991. Specializes in annual reports, publication design, corporate identity. Types of clients: industrial, financial, retail, nonprofit and corporate. Examples of recent projects: Children's Hospital, Fifth Floor Production Music.

Needs: Works with less than 1 freelance photographer/month. Uses photographs for trade magazines, direct mail and brochures. Subjects include: people and studio. Reviews stock photos on a per-assignment basis. Model/property release required for models, any famous works.

Specs: Uses 35mm, 2¼×2¼, 4×5 transparencies. Accepts images in digital format for Mac. Send via compact disc, online, floppy disk, SyQuest or jaz disk.

Making Contact & Terms: Provide résumé, business card, brochure, flier or tearsheets to be kept on file for possible future assignments. Works with freelancers on assignment only. Keeps samples on file. SASE. Reports in 1 month. "When we receive a job in-house we request photographers." Payment "on a per-job basis as budget allows." Pays within 30 days. Credit lines sometimes given depending on client. "We like to give credit where credit is due!" Payment negotiable. "No calls."

Tips: "Be punctual and willing to work within our client's budget."

N BRENT A. JONES DESIGN, 328 Hayes St., San Francisco CA 94102. (415)626-8337. Fax: (415)626-8337. Contact: Brent A. Jones. Estab. 1983. Design firm. Specializes in annual reports and publication design. Types of clients: industrial, financial, retail, publishers and nonprofit.

Needs: Works with 1 freelancer/month. Uses photos for annual reports, consumer magazines, catalogs and posters. Reviews stock photos as needed. Model/property release required. Captions preferred.

Specs: Uses color and b&w prints; no format preference. Also uses 35mm, 4×5, 8×10 transparencies.

Making Contact & Terms: Query with résumé of credits. Query with samples. Provide résumé, business card, brochure, flier or tearsheets to be kept on file for possible future assignments. Works with local freelancers only. Keeps samples on file. Cannot return material. Reports in 1 month. Pays on per hour basis. **Pays on receipt of invoice**. Credit line sometimes given. Buys one-time rights; negotiable.

◪ PAUL S. KARR PRODUCTIONS, 2925 W. Indian School Rd., Phoenix AZ 85017. (602)266-4198. Contact: Kelly Karr. Film and tape firm. Types of clients: industrial, business and education. Works with freelancers on assignment only.

Needs: Uses filmmakers for motion pictures. "You must be an experienced filmmaker with your own location equipment and understand editing and negative cutting to be considered for any assignment." Primarily produces industrial films for training, marketing, public relations and government contracts. Does high-speed photo instrumentation. Also produces business promotional tapes, recruiting tapes and instructional and entertainment tapes for VCR and cable. "We are also interested in funded co-production ventures with other video and film producers."

Specs: Uses 16mm films and videotapes. Provides production services, including sound transfers, scoring and mixing and video production, post production, and film-to-tape services.

Making Contact & Terms: Query with résumé of credits and advise if sample reel is available. Payment

negotiable. Pays/job; negotiates payment based on client's budget and photographer's ability to handle the work. Pays on production. Buys all rights. Model release required.

Tips: Branch office in Utah: Karr Productions, 1045 N. 300 East, Orem UT 84057. (801)226-8209. Contact: Mike Karr.

PAUL S. KARR PRODUCTIONS, UTAH DIVISION, 1024 N. 250 East, Orem UT 84057. (801)226-8209. Vice President & Manager: Michael Karr. Types of clients: education, business, industry, TV-spot and theatrical spot advertising. Provides inhouse production services of sound recording, looping, printing and processing, high-speed photo instrumentation as well as production capabilities in 35mm and 16mm.

Needs: Same as Arizona office but additionally interested in motivational human interest material—film stories that would lead people to a better way of life, build better character, improve situations, strengthen families.

Making Contact & Terms: Query with résumé of credits and advise if sample reel is available. Payment negotiable. Pays per job, negotiates payment based on client's budget and ability to handle the work. Pays on production. Buys all rights. Model release required.

KOCHAN & COMPANY, 800 Geyer Ave., St Louis MO 63104. (314)621-4455. Fax: (314)621-1777. Creative Director/Vice President: Tracy Tucker. Estab. 1987. Member of AAAA. Ad agency. Number of employees: 9. Firm specializes in display design, magazine ads, packaging, direct mail, signage. Types of clients: industrial, retail, nonprofit. Example of recent projects: Alton Bell Casino (billboards/duratrans); Pasta House Co. (menu inserts); Jake's Steaks (postcard).

Needs: Uses photos for billboards, brochures, catalogs, direct mail, newspapers, posters, signage. Reviews stock photos. Model release required; property release required. Photo caption required.

Making Contact & Terms: Send query letter with samples, brochure, stock photo list, tearsheets. To show portfolio, photographer should follow-up with call and/or letter after initial query. Portfolio should include b&w, color, prints, tearsheets, slides, transparencies. Works with freelancers on assignment only. Keeps samples on file. Reports back only if interested, send non-returnable samples. **Pays on receipt of invoice.** Credit line given. Buys all rights.

LEVINSON ASSOCIATES, 1440 Veteran Ave., Suite 650, Los Angeles CA 90024. (323)663-6940. Fax: (323)663-2820. E-mail: leviinc@aol.com. Assistant to President: Jed Leland, Jr. Estab. 1969. PR firm. Types of clients: industrial, financial, entertainment. Examples of recent projects: Beyond Shelter; Temple Hospital; Health Care Industries, Inc. (sales brochure); *CAL Focus Magazine*; U4EA!; and "Hello, Jerry," for Hollywood Press Club (national promotion), Moulin D'Or Recordings; Council On Natural Nutrition, Avenue Records.

Needs: Works with varying number of freelancers/month. Uses photos for trade magazines and newspapers. Subjects vary. Model release required. Property release preferred. Captions preferred.

Making Contact & Terms: Works with local freelancers only. Keeps samples on file. Cannot return material. Payment negotiable. Buys all rights; negotiable.

$ $ 🅰 ⯐ LINEAR CYCLE PRODUCTIONS, Box 2608, Sepulveda CA 91393-2608. Production Manager: R. Borowy. Estab. 1980. Member of Internation United Photographer Publishers, Inc. Ad agency, PR firm. Approximate annual billing: $5 million. Number of employees: 10. Types of clients: industrial, commercial, advertising. Examples of recent projects: "The Sam Twee," Bob's Bob-O-Bob (ad); "Milk the Milk," Dolan's (ad); "Faster . . . not better," Groxnic, O'Fopp & Pippernatz (ad).

Needs: Works with 7-10 freelance photographers, 8-12 filmmakers, 8-12 videographers/month. Uses photos for billboards, consumer magazines, direct mail, P-O-P displays, posters, newspapers, audiovisual uses. Subjects include: candid photographs. Reviews stock photos, archival. Model/property release required. Captions required; include description of subject matter.

Audiovisual Needs: Uses slides and/or film or video for television/motion pictures. Subjects include: archival-humor material.

Specs: Uses 8×10 color and b&w prints; 35mm, 8×10 transparencies; 16mm-35mm film; ½″, ¾″, 1″ videotape.

Making Contact & Terms: Submit portfolio for review. Query with résumé of credits. Query with stock photo list. Provide résumé, business card, brochure, flier or tearsheets to be kept on file for possible future assignments. Works with local freelancers on assignment only. Keeps samples on file. Reports in 1 month. Pays $100-500/b&w photo; $150-750/color photo; $100-1,000/job. Prices paid depend on position. Pays on publication. Credit line given. Buys one-time rights; negotiable.

Tips: "Send a good portfolio with color pix shot in color (not b&w of color). No sloppy pictures or portfolios! The better the portfolio is set up, the better the chances that we would consider it . . . let alone

look at it!" Seeing a trend toward "more archival/vintage and a lot of humor pieces!"

$ $ $ $ [A] ▨ **MARKEN COMMUNICATIONS**, 3375 Scott Blvd., Suite 108, Santa Clara CA 95054-3111. (408)986-0100. Fax: (408)986-0162. E-mail: marken@cerfnet.com. President: Andy Marken. Production Manager: Leslie Posada. Estab. 1977. Ad agency and PR firm. Approximate annual billing: $4.5 million. Number of employees: 8. Types of clients: furnishings, electronics and computers. Examples of recent ad campaigns include: Burke Industries (resilient flooring, carpet); Sigma Designs (mpeg2); InfoValu (streaming media); AT&T Surfnet (ISP).

Needs: Works with 3-4 freelance photographers/month. Uses photos for trade magazines, direct mail, publicity and catalogs. Subjects include: product/applications. Model release required.

Audiovisual Needs: Slide presentations and sales/demo videos.

Specs: Uses color and b&w prints; 35mm, 2¼ × 2¼ and 4 × 5 transparencies.

Making Contact & Terms: Arrange a personal interview to show portfolio. Query with samples. Submit portfolio for review. Works with freelancers on assignment basis only. SASE. Reports in 1 month. Pays $50-1,000/b&w photo; $100-1,800/color photo; $50-100/hour; $500-1,000/day; $200-2,500/job. Pays 30 days after receipt of invoice. Credit line sometimes given. Buys one-time rights.

$ $ MARKETAIDE, INC., Dept. PM, 1300 E. Iron, P.O. Box 500, Salina KS 67402-0500. (800)204-2433. (913)825-7161. Fax: (913)825-4697. Copy Chief: Ted Hale. Marketing Manager: Kathleen Atkinson. Ad agency. Uses all media. Serves industrial, retail, financial, nonprofit organizations, political, agribusiness and manufacturing clients.

Needs: Needs industrial photography (studio and on site), agricultural photography and photos of banks, people and places.

Making Contact & Terms: Call to arrange an appointment. Provide résumé and tearsheets to be kept on file for possible future assignments. Reports in 3 weeks. SASE. Buys all rights. "We generally work on a day rate ranging from $200-1,000/day." Pays within 30 days of invoice.

Tips: Photographers should have "a good range of equipment and lighting, good light equipment portability, high quality darkroom work for b&w, a wide range of subjects in portfolio with examples of processing capabilities." Prefers to see "set-up shots, lighting, people, heavy equipment, interiors, industrial and manufacturing" in a portfolio. Prefers to see "8 × 10 minimum size on prints, or 35mm transparencies, preferably unretouched" as samples.

$ $ [A] ▣ ▨ ◯ **MEDIA CONSULTANTS INC.**, P.O. Box 130, 201 N. Stoddard, Sikeston MO 63801-0130. (573)472-1116. Fax: (573)472-3299. E-mail: media@ldd.net. President: Rich Wrather. Estab. 1980. Ad agency, AV firm. Number of employees: 10. Firm specializes in annual reports, collateral, display design, direct mail, magazine ads, packaging, signage. Types of clients: industrial, financial, fashion, retail and food.

Needs: Works with 2-4 photographers and 1-2 videographers/month. Uses photos for billboards, consumer magazines, trade magazines, direct mail, P-O-P displays, catalogs, posters, newspapers, signage and audiovisual. Subjects include: babies, children, couples, multicultural, families, parents, senior citizens, teens, landscapes/scenics, architecture, beauty, cities/urban, gardening, interiors/decorating, rural, automobiles, entertainment,events, health/fitness, agriculture, buildings, business concepts, industry, medicine, political. Interested in digital, erotic, regional, seasonal. Reviews stock photos. Model/property release required. Photo captions preferred.

Audiovisual Needs: Uses film and videotape for audiovisual presentations and commercials. Subjects include stock.

Specs: Uses color and b&w prints; 35mm, 2¼ × 2¼ transparencies; ¾"-½" film. Accepts images in digital format for Mac. Send via CD, Zip as TIFF, EPS, PICT, JPEG files.

Making Contact & Terms: Send unsolicited photos by mail for consideration. Query with samples. Provide résumé, business card, brochure, flier or tearsheets to be kept on file for possible future assignments. Works on assignment only. Keeps samples on file. Cannot return material. Reports only if interested. Payment negotiable. Pays on publication. Credit line not given. Buys first and all rights; negotiable.

Tips: "Mail samples and rates."

[N] **$ $ $ $** ◎ **THE MILLER GROUP**, 2719 Wilshire, 250, Santa Monica CA 90403. (310)264-5494. Fax: (310)264-5498. E-mail: millergrup@aol.com. Website: http://www.millergroup.net. Estab. 1990. Member of WSAAA. Approximate annual billing: $3.5 million. Number of employees: 3. Firm specializes in magazine ads. Types of clients: consumer.

Needs: Uses photos for billboards, brochures, consumer magazines, direct mail, newspapers. Model release required.

Making Contact and Terms: Contact through rep or send query letter with photocopies. Provide self-

promotion piece to be kept on file. Buys all rights; negotiable.
Tips: "Please no calls!"

$ ⊠ ON-Q PRODUCTIONS INC., 618 E. Gutierrez St., Santa Barbara CA 93103. (805)963-1331. President: Vincent Quaranta. Estab. 1984. Producers of multi-projector slide presentations and computer graphics. Types of clients: industrial, fashion and finance.
Needs: Buys 100 freelance photos/year; offers 50 assignments/year. Uses photos for brochures, posters, audiovisual presentations, annual reports, catalogs and magazines. Subjects include: scenic, people and general stock. Model release required. Captions required.
Specs: Uses 35mm, 2¼×2¼ and 4×5 transparencies.
Making Contact & Terms: Provide stock list, business card, brochure, flier or tearsheets to be kept on file for possible future assignments. Pays $100 minimum/job. Buys rights according to client's needs.
Tips: Looks for stock slides for AV uses.

$ $ Ⓐ ◎ ORIGIN DESIGN, INC., (formerly Zierhut Design Studios), 2014 Platinum, Garland TX 75042. Phone: (972)276-1722. Fax: (972)272-5570. Executive Vice President: Kathleen Zierhut. President: Jerry Nichols. Estab. 1956. Design firm. Specializes in displays, packaging and product design. Types of clients: industrial.
Needs: Uses photos for direct mail, catalogs and packaging. Subjects usually are "prototype models." Model/property release required.
Specs: Uses 8×10 color prints, matte finish; 35mm transparencies.
Making Contact & Terms: Provide résumé, business card, brochure, flier or tearsheets to be kept on file for possible future assignments. Works with local freelancers only. Keeps samples on file. Cannot return material. Reports in 1-2 weeks. Payment negotiable on bid basis. **Pays on receipt of invoice.** Credit line sometimes given depending upon client. Buys all rights.
Tips: Wants to see product photos showing "color, depth and detail."

Ⓝ $ $ ◐ ▣ PENN-JUDE PARTNERS, 1911 W. Alabama St., Suite C, Houston TX 77098-2705. (713)520-6682. Fax: (713)520-6692. E-mail: pennjude@earthlink.net. Art Director: Judith Dollar. Estab. 1994. Member of Houston Art Directors Club, American Advertising Federation. Approximate annual billing: $230,000. Number of employees: 2. Firm specializes in collateral, direct mail, packaging. Types of clients: industrial, high tech, medical, pet food, service. Examples of recent projects: safety equipment catalog; communications brochure.
Needs: Works with 1 freelance photographer/month. Uses photos for brochures, catalogs, direct mail, trade magazines, trade show graphics. Needs photos of families, senior citizens, education, pets, business concepts, computers, industry, portraits, product shots/still life, technology. Interested in digital, historical/vintage images. Model release required. Property release preferred. Photo captions preferred.
Specs: Uses 5×7, 8×10 glossy prints; 35mm, 2¼×2¼, 4×5 transparencies. Accepts images in digital format for Mac. Send via CD, Zip as TIFF, EPS, JPEG files at 350 dpi.
Making Contact & Terms: Send query letter with prints, photocopies, tearsheets. Provide business card, self-promotion piece to be kept on file. Reports back only if interested; send nonreturnable samples. Pays by the project, $75 and up. Pays on receipt of invoice.

$ $ Ⓐ ▣ POINT BLANK, 307 Orchard City Dr., Campbell CA 95008-2948. Fax: (408)341-0928. Ad agency. Art Director: Nate Digre. Serves travel, high technology and consumer technology clients. Examples of recent projects: Avansys (ad campaign and website).
Needs: Works with 3 photographers/month. Uses work for trade show graphics, websites, consumer magazines, trade magazines, direct mail, P-O-P displays, newspapers. Subject matter of photography purchased includes: conceptual shots of people and table top (tight shots of electronics products).
Specs: Uses 8×10 matte b&w and color prints; 35mm, 2¼×2¼, 4×5 or 8×10 transparencies. Accepts images in ditigal format for Mac. Send via compact disc, online, floppy disk, or Zip disk.
Making Contact & Terms: Arrange a personal interview to show portfolio. Send unsolicited photos by mail for consideration. Provide résumé, business card, brochure, flier or tearsheets to be kept on file for possible future assignments. Works on assignment basis only. Does not return unsolicited material. Reports in 3 weeks. Pays $100-5,000/b&w photo; $100-8,000/color photo; maximum $5,000/day; $200-2,000 for electronic usage (Web banners, etc.), depending on budget. **Pays on receipt of invoice.** Buys one-time, exclusive product, electronic and all rights (work-for-hire); negotiable. Model release required, captions preferred.
Tips: Prefers to see "originality, creativity, uniqueness, technical expertise" in work submitted. There is more use of "photo composites, dramatic lighting and more attention to detail" in photography.

$ $ [A] PURDOM PUBLIC RELATIONS, 2330 Marinship Way, Sausalito CA 94965. (415)339-2890. Fax: (415)339-2989. E-mail: purdom@purdompr.com. President: Paul Purdom. Estab. 1965. Member of IPREX, Public Relations Society of America. PR firm. Approximate annual billing: $1.75 million. Number of employees: 17. Types of clients: computer manufacturers, software, industrial, general high-technology products. Examples of recent PR campaigns: Sun Microsystems, Autodesk, Vanian Assoc., Acuron Corporation (all application articles in trade publications).
Needs: Works with 4-6 freelance photographers/month. Uses photos for trade magazines, direct mail and newspapers. Subjects include: high technology and scientific topics. Model release preferred.
Specs: Uses 35mm and 2¼ × 2¼ transparencies.
Making Contact & Terms: Query with résumé of credits and list of stock photo subjects. Provide résumé, business card, brochure, flier or tearsheets to be kept on file for possible future assignments. Works on assignment only. Cannot return material. Reports as needed. Pays $50-150/hour, $400-1,500/day. Pays on receipt of invoice. Buys all rights; negotiable.

[N] [icon] RED HOTS ENTERTAINMENT, 634 N. Glenoaks Blvd., Suite 374, Burbank CA 91502-2024. (818)954-0092. President/Creative Director: Chip Miller. Estab. 1987. Motion picture, music video, commercial and promotional trailer film production company. Types of clients: industrial, fashion, entertainment, motion picture, TV and music.
Needs: Works with 2-6 freelance photographers/month. Uses freelancers for TV, music video, motion picture stills and production. Model release required. Property release preferred. Captions preferred.
Audiovisual Needs: Uses film and video.
Making Contact & Terms: Provide business card, résumé, references, samples or tearsheets to be kept on file for possible future assignments. Payment negotiable "based on project's budget." Rights negotiable.
Tips: Wants to see a minimum of 2 pieces expressing range of studio, location, style and model-oriented work. Include samples of work published or commissioned for production.

$ $ TED ROGGEN ADVERTISING AND PUBLIC RELATIONS, 5858 Westheimer, Suite 630, Houston TX 77057. (713)789-0999. Fax: (713)465-0625. Contact: Ted Roggen. Estab. 1945. Ad agency and PR firm. Types of clients: construction, entertainment, food, finance, publishing and travel.
Needs: Buys 25-50 photos/year; offers 50-75 assignments/year. Uses photos for billboards, direct mail, radio, TV, P-O-P displays, brochures, annual reports, PR releases, sales literature and trade magazines. Model release required. Captions required.
Specs: Uses 5 × 7 glossy or matte b&w prints; 4 × 5 transparencies; 5 × 7 color prints. Contact sheet OK.
Making Contact & Terms: Provide résumé to be kept on file for possible future assignments. Pays $75-250/b&w photo; $125-300/color photo; $150/hour. **Pays on acceptance.** Rights negotiable.

$ [A] [icon] [icon] SAN FRANCISCO CONSERVATORY OF MUSIC, 1201 Ortega St., San Francisco CA 94122. (415)564-8086. Fax: (415)759-3499. E-mail: cin@sfcm.edu. Website: http://www.sfcm.edu. Publications Coordinator: Cindy Dove. Estab. 1917. Firm specializes in annual reports, collateral, magazine ads, publication design. Provides publications about Conservatory programs, concerts and musicians. Photos used in brochures, posters, newspapers, annual reports, catalogs, magazines and newsletters.
Needs: Offers 10-15 assignments/year. Subjects include cities/urban, entertainment, performances, head shots, rehearsals, classrooms, candid student life, some environmental, instruments, operas, orchestras, ensembles, special events. Interested in fine art. Does not use stock photos.
Audiovisual Needs: Uses film.
Specs: Uses 5 × 7 b&w prints and color slides.
Making Contact & Terms: "Contact us only if you are experienced in photographing performing musicians." Knowledge of classical music helpful. Works with local freelancers only. Payment varies by photographer. Pays $10-20/b&w photo; $15-25 for color photos; $10-25 for film; $100-300/job. Prefers to pay hourly. Credit line given "most of the time." Buys one-time and all rights; negotiable.
Tips: "Send self-promo piece. We will call if interested."

$ $ [icon] [icon] SANDERS, WINGO, GALVIN & MORTON ADVERTISING, 4050 Rio Bravo, Suite 230, El Paso TX 79902. (915)533-9583. E-mail: swgm@swgm.com. Creative Director: Kerry Jackson. Member of American Association of Advertising Agencies. Ad agency. Approximate annual billing: $14 million. Number of employees: 30. Uses photos for billboards, consumer and trade magazines, direct mail, foreign media, newspapers, P-O-P displays, radio and TV. Types of clients: finance, retail and apparel industries. Examples of recent projects: "Marketbook," Farah USA, Inc. (ads, posters, outdoor); "Write Your Own Ticket," Sears (ads, posters).
Needs: Works with 5 photographers/year. Model release required.
Audiovisual Needs: Works with freelance filmmakers in production of slide presentations and TV com-

mercials.

Specs: Uses b&w photos and color transparencies. Accepts images in digital format for Mac (all file types). Send via compact disc, online, floppy disk, SyQuest or Zip disk.

Making Contact & Terms: Query with samples, list of stock photo subjects. Send material by mail for consideration. Submit portfolio for review. SASE. Reports in 1 week. Pays $65-500/hour, $600-3,500/day, negotiates pay on photos. Buys all rights.

$ $ [A] [■] [◑] SANGRE DE CRISTO CHORALE, P.O. Box 4462, Santa Fe NM 87502. (505)662-9717. Fax: (505)665-4433. Business Manager: Hastings Smith. Estab. 1978. Producers of chorale concerts. Photos used in brochures, posters, newspapers, press releases, programs and advertising.

Needs: Buys one set of photos every two years; offers 1 freelance assignment every two years. Photographers used to take group shots of performers. Examples of recent uses: newspaper feature (5×7, b&w); concert posters (5×7, b&w); and group pictures in a program book (5×7, b&w).

Specs: Uses 8×10, 5×7 glossy b&w prints, slides and digital.

Making Contact & Terms: Provide résumé, business card, self-promotion piece or tearsheets to be kept on file for possible future assignments. Works with local freelancers only. Keeps samples on file. SASE. Reports in 1 month, or sooner. Payment negotiable. **Pays on acceptance**. Credit line given. Buys all rights; negotiable.

Tips: "We are a small group—35 singers with a $45,000/year budget. We need promotional material updated about every two years. We prefer photo sessions during rehearsal, to which we can come dressed. We find that the ability to provide usable action photos of the group makes promotional pieces more acceptable."

$ $ $ STEVEN SESSIONS, INC., 5177 Richmond Ave, Suite 500, Houston TX 77056. Phone: (713)850-8450. Fax: (713)850-9324. President: Steven Sessions. Estab. 1982. Design firm. Specializes in annual reports, packaging and publication design. Types of clients: industrial, financial, women's fashion, cosmetics, retail, publishers and nonprofit.

Needs: Always works with freelancers. Uses photos for annual reports, consumer and trade magazines, P-O-P displays, catalogs and packaging. Subject matter varies according to need. Reviews stock photos. Model/property release preferred.

Specs: Uses b&w and color prints; no preference for format or finish. Prefers 35mm, 2¼×2¼, 4×5, 8×10 transparencies.

Making Contact & Terms: Submit portfolio for review. Send unsolicited photos by mail for consideration. Provide résumé, business card, brochure, flier or tearsheets to be kept on file for possible future assignments. Keeps samples on file. SASE. Reports in 1-2 weeks. Pays $1,800-5,000/day. **Pays on receipt of invoice**. Credit line given. Sometimes buys all rights; negotiable.

SIGNATURE DESIGN, 2101 Locust St., St. Louis MO 63103. (314)621-6333. Fax: (314)621-0179. Contact: Therese McKee. Estab. 1988. Design firm. Specializes in print graphics and exhibit design and signage. Types of clients: corporations, museums, botanical gardens and government agencies. Examples of projects: Center for Biospheric Education and Research exhibits, Huntsville Botanical Garden; walking map of St. Louis, AIA, St. Louis Chapter; Flood of '93 exhibit, U.S. Army Corps of Engineers; brochure, U.S. Postal Service; Center for Home Gardening exhibits, Missouri Botanical Garden; Hawaii exhibits, S.S. Independence; Delta Queen Steamboat Development Co.

Needs: Works with 1 freelancer/month. Uses photos for posters, copy shots, brochures and exhibits. Reviews stock photos.

Specs: Uses prints and 35mm, 2¼×2¼ and 4×5 transparencies.

Making Contact & Terms: Arrange personal interview to show portfolio. Send unsolicited photos by mail for consideration. Provide résumé, business card, brochure, flier or tearsheets to be kept on file for possible future assignments. Keeps samples on file. Reports in 1-2 weeks. Payment negotiable. Pays 30 days from receipt of invoice. Credit line sometimes given. Buys all rights; negotiable.

[A] [▨] [◑] SOTER ASSOCIATES INC., 209 N. 400 West, Provo UT 84601. (801)375-6200. Fax: (801)375-6280. Ad agency. President: N. Gregory Soter. Types of clients: industrial, financial, hardware/

THE SUBJECT INDEX, located at the back of this book, lists publications, book publishers, galleries, greeting card companies, advertising agencies, design firms and stock agencies according to the subject areas they seek.

software and other. Examples of projects: national campaigns for vertical-market software manufacturers, boating publications ad campaign for major boat manufacturer; consumer brochures for residential/commercial mortgage loan company; private school brochure; software ads for magazine use; various direct mail campaigns.

Needs: Uses photos for consumer and trade magazines, direct mail and newspapers. Subjects include product, editorial or stock. Reviews stock photos/videotape. Model/property release required.

Audiovisual Needs: Uses photos for slides and videotape.

Specs: Uses 8×10 b&w prints; 2¼×2¼, 4×5 transparencies; videotape.

Making Contact & Terms: Arrange personal interview to show portfolio. Query with samples. Provide résumé, business card, brochure, flier or tearsheets to be kept on file for possible future assignments. Works on assignment only. Keeps samples on file. SASE. Reports in 1-2 weeks. Payment negotiable. **Pays on receipt of invoice**. Credit line not given. Buys all rights; negotiable.

$ ▤ ▨ ◯ SOUNDLIGHT, 1565 Markawao Ave., Makawao HI 96768-9509. (808)573-5574. Fax: (808)573-8189. E-mail: keth@earthling.net. Website: http://www.maui.net/~kethluke/awaken. Contact: Keth Luke. Estab. 1972. Approximate annual billing: $150,000. Number of employees: 3. Firm specializes in direct mail, magazine ads, publication design. Types of clients: corporations, industrial, businesses, training institutions, astrological and spiritual workshops, books, calendars, fashion, magazines, nonprofit, web pages. Examples of recent clients "Astrology Promo," by Jan Carter (brochure, business cards, mailing); "Retreat Promo," Aloha Ranch (advertising, brochure, signs, posters).

Needs: Works with 1 freelance photographer/3 months. Subjects include: celebrities, couples, multicultural, teens, people in activities, scenics/landscapes, disasters, environmental, animals, beauty, religious, adventure, health/fitness, hobbies, humor, performing arts, agriculture, medicine, portraits, science, technology, travel sites and activities, dance and models (glamour and nude). Interested in alternative process, digital, erotic, fine art, seasonal. Reviews stock photos, slides, computer images. Model release preferred for models and advertising people. Captions preferred; include "who, what, where."

Audiovisual Needs: Uses freelance photographers for slide sets, multimedia productions, videotapes, websites.

Specs: Uses 4×6 to 8×10 glossy color prints, 35mm color slides. Accepts images in digital format for Windows. Send via CD, SyQuest, floppy disk, e-mail as TIFF, GIF, JPEG files at 640×480, or higher dpi.

Making Contact & Terms: Query with résumé. Send stock photo list. Provide prints, slides, business card, computer disk, CD, contact sheets, self-promotion piece or tearsheets to be kept on file for possible future assignments. Works on assignment; sometimes buys stock model photos. May not return unsolicited material. Reports in 3 weeks. Pays $100 maximum b&w and color photo; $10-1,800 for videotape; $10-100/hour; $50-750/day; $2,000 maximum/job; sometimes also pays in "trades." Pays on publication. Credit line sometimes given. Buys one-time, all rights; various negotiable rights depends on use.

Tips: In portfolios or demos, looks for "unique lighting, style, emotional involvement, beautiful, artistic, sensual viewpoint." Sees trend toward "manipulated computer images. Send query about what you have to show, to see what we can use at that time."

$ $▢ STUDIO WILKS, 2148-A Federal Ave., Los Angeles CA 90025. Fax: (310)478-0013. E-mail: teri@graphic.com. Owners: Teri and Richard Wilks. Estab. 1991. Member of American Institute of Graphic Arts. Design firm. Number of employees: 3. Specializes in annual reports, publication design, packaging, signage. Types of clients: corporate, retail.

Needs: Works with 1-2 freelancers/month. Uses photos for annual reports, trade magazines, catalogs, packaging, signage. Reviews stock photos.

Specs: Uses 8×10 prints.

Making Contact & Terms: Provide résumé, business card, brochure, flier or tearsheets to be kept on file for possible future assignments. Works with local freelancers only. Keeps samples on file. SASE. Reports in 3 weeks. Pays $300-750/day. **Pays on receipt of invoice.** Credit line given. Buys one-time, exclusive and all rights; negotiable.

Tips: Looking for "interesting, conceptual, experimental."

$ $ $▤ ▨ ◎ RON TANSKY ADVERTISING CO., Suite 111, 14852 Ventura Blvd., Sherman Oaks CA 91403. (818)990-9370. Fax: (818)990-0456. Consulting Art Director: Norm Galston. Estab. 1976. Ad agency and PR firm. Serves all types of clients.

Needs: Uses photos for billboards, consumer and trade magazines, direct mail, P-O-P displays, brochures, catalogs, signage, newspapers and AV presentations. Subjects include: "mostly product—but some without product as well," industrial electronics, nutrition products and over-the-counter drugs. Model release required.

Audiovisual Needs: Works with freelance filmmakers to produce TV commercials.

Specs: Uses b&w or color prints; 2¼×2¼, 4×5 transparencies; 16mm film and videotape. Accepts images in digital format for Mac "if that is the only way it can be delivered." Send via online, floppy disk or on SyQuest.

Making Contact & Terms: Query with résumé of credits. Provide résumé, business card, brochure, flier or tearsheets to be kept on file for possible future assignments. SASE. Payment "depends on subject and client's budget." Pays $50-250/b&w photo; $100-1,500/color photo; $500-1,500/day; $100-1,500/complete job. Pays in 30 days. Buys all rights.

Tips: Prefers to see "product photos, originality of position and lighting in a portfolio. We look for creativity and general competence, i.e., focus and lighting as well as ability to work with models." Photographers should provide "rate structure and ideas of how they would handle product shots." Also, "don't use fax unless we make request."

$ $▣ ▨ ▢ ◎ THINK TWICE, INC., (formerly Impact Media Group), 230 California St., Suite 301, San Francisco CA 94111. Fax: (415)834-2005. E-mail: garner@thinktwiceinc.com. Website: http://www.thinktwiceinc.com. Creative Director: Garner Moss. Estab. 1996. Member of American Advertising Association, Art Directors of America, Robot Warrior Association-IRWA. Digital design firm. Number of employees: 20. Firm specializes in annual reports, publication design, display design, packaging, direct mail, signage, litigation, exhibits and PREIPO clients, website design/corporate identities and logos. Types of clients: industrial, financial, retail, publishers, nonprofit, political, high-tech, virtual reality and Internet/intranet. Examples of recent projects: Hitachi CD-ROM (package and CD design); Samantec (four color ads); Silicon Graphics (ads and POP displays); Bank of America (website).

Needs: Works with 10 freelancers/month. Uses photos for annual reports, billboards, consumer magazines, direct mail, P-O-P displays, packaging, signage, website and political mail. Subjects include: babies, celebrities, children, couples, multicultural, families, parents, senior citizens, teens, disasters, environmental, landscapes/scenics, wildlife, architecture, beauty, cities/urban, education, gardening, interiors/decorating, pets, religious, rural, adventure, automobiles, entertainment, events, food/drink, health/fitness, hobbies, humor, performing arts, sports, travel, agriculture, buildings, business concepts, computers, industry, medicine, military, political, portraits, product shots/still life, science, technology and portraits. Interested in digital, documentary, erotic, fashion/glamour, fine art. Reviews stock photos. Model/property release preferred. Captions preferred.

Audiovisual Needs: Uses film and videotape.

Specs: Uses 5×7, 8×10 prints; 35mm transparencies; videotape. Accepts images in digital format Mac. Send via CD.

Making Contact & Terms: Arrange personal interview to show portfolio. Send unsolicited photos by mail or e-mail for consideration. Provide résumé, business card, brochure, flier or tearsheets to be kept on file for possible future assignments. Send disk with samples on it. Keeps samples on file. SASE. Reports in 3 weeks. Pays $20-750 for b&w and color photos; $40-750 for film and videotape; $20-100/hour; $100-1,000/day. **Pays on receipt of invoice.** Credit line sometimes given depending upon publication or website. Rights negotiable.

$ $▢ TRIBOTTI DESIGNS, 22907 Bluebird Dr., Calabasas CA 91302. (818)591-7720. Fax: (818)591-7910. E-mail: bob4149@aol.com. Contact: Bob Tribotti. Estab. 1970. Design firm. Approximate annual billing: $200,000. Number of employees: 2. Specializes in annual reports, publication design, display design, packaging, direct mail and signage. Types of clients: educational, industrial, financial, retail, government, publishers and nonprofit. Examples of projects: school catalog, SouthWestern University School of Law; magazine design, *Knitking*; signage, city of Calabasas.

Needs: Uses photos for annual reports, consumer and trade magazines, direct mail, catalogs and posters. Subjects vary. Reviews stock photos. Model/property release required. Captions preferred.

Specs: Uses 8×10, glossy, color and b&w prints; 35mm, 2¼×2¼, 4×5, 8×10 transparencies.

Making Contact & Terms: Contact through rep. Query with résumé of credits. Provide résumé, business card, brochure, flier or tearsheets to be kept on file for possible future assignments. Works with local freelancers only. Keeps samples on file. Cannot return material. Reports in 3 weeks. Pays $500-1,000/day; $75-1,000/job; $50 minimum/b&w photo; $50 minimum/color photo; $50 minimum/hour. **Pays on receipt of invoice.** Credit line sometimes given. Buys one-time, electronic and all rights; negotiable.

▨ UNELL & BALLOU, INC., 6740 Antioch, Suite 155, Merriam KS 66204. (913)722-1090. Fax: (913)722-1767. Art Director: Cindy Himmelberg. Creative Director: Russell McCorkle. Estab. 1984. Member of Kansas City Ad Club, Missouri-Kansas NAMA, Council of Growing Companies. Ad agency and marketing communications firm. Number of employees: 15. Types of clients: industrial, financial, retail and agriculture. Recent clients include: Golden Harvest Seeds, Inc.; Interconnect Devices, Inc.; and Copaken, White & Blitt.

Needs: Works with 5 freelance photographers and 1 videographer/month. Uses photos for trade magazines, direct mail, catalogs, posters and signage. Subjects include: agriculture (on location); studio (technology). Reviews stock photos. Model release required. Property release preferred. Photo captions preferred.
Audiovisual Needs: Uses slides and videotape.
Specs: Uses color prints; 35mm, 2¼×2¼, 4×5 transparencies.
Making Contact & Terms: Query with résumé of credits or samples. Provide résumé, business card, brochure, flier or tearsheets to be kept on file for possible future assignments. Keeps samples on file. SASE. Reports in 1 month. Payment negotiable. **Pays on receipt of invoice.** Credit line given. Rights negotiable.

VISUAL AID MARKETING/ASSOCIATION, Box 4502, Inglewood CA 90309-4502. (310)399-0696. Manager: Lee Clapp. Estab. 1965. Ad agency. Number of employees: 3. Types of clients: industrial, fashion, retail, food, travel hospitality. Examples of projects: "Robot Show, Tokyo" (magazine story) and "American Hawaii Cruise" (articles).
Needs: Works with 1-2 freelance photographers, 1-2 filmmakers and 1-2 videographers/month. Uses photos for billboards, consumer magazines, trade magazines, direct mail, P-O-P displays, catalogs, posters, newspapers, signage. Model/property release required for models and copyrighted printed matter. Captions required; include how, what, where, when, identity.
Audiovisual Needs: Uses film and videotape and slides for travel presentations.
Specs: Uses 8×10, glossy color and b&w prints; 35mm, 2¼×2¼, 4×5, 8×10 transparencies; Ektachrome film; Beta/Cam videotape.
Making Contact & Terms: Query with résumé of credits or stock photo list. Provide résumé, business card, brochure, flier or tearsheets. Works with local freelancers on assignment only. Reports in 1-2 weeks. Payment negotiable upon submission. **Pays on acceptance,** publication or **receipt of invoice.** Credit line given depending upon client's wishes. Buys first and one-time rights; negotiable.

WALKER AGENCY, #160, 15855 N. Greenway Hayden Loop, Scottsdale AZ 85260-1726. (602)483-0185. Fax: (602)948-3113. E-mail: mike@walkeragency.com. Website: http://www.walkeragency.com. President: Mike Walker. Estab. 1982. Member Outdoor Writers Association of America, Public Relations Society of America. Marketing communications firm. Number of employees: 8. Types of clients: marine industry, shooting sports and outdoor recreation products.
Needs: Uses photos for consumer and trade magazines, posters, newspapers and multimedia presentation systems. Subjects include outdoor recreation scenes: fishing, camping, etc. "We also publish a newspaper supplement, 'Escape to the Outdoors,' which goes to 11,000 papers." Model/property release required.
Specs: Uses 8×10 glossy b&w prints with borders; 35mm, 2¼×2¼, 4×5 transparencies. Accepts images in digital format (high-res).
Making Contact & Terms: Query with résumé of credits. Query with list of stock photo subjects. Provide résumé, business card, brochure, flier or tearsheets to be kept on file for possible future assignments. Reports in 1 week. Pays $25/b&w or color photo; $150-500/day; also pays per job. Pays on receipt of invoice. Buys North American serial rights; other rights negotiable.
Tips: In portfolio/samples, prefers to see a completely propped scene. "There is more opportunity for photographers within the advertising/PR industry."

WATKINS ADVERTISING DESIGN, 621 W. 58th Terrace, Kansas City MO 64113-1157. (816)333-6600. Fax: (816)333-6610. E-mail: wadcorp@unicom.net. Creative Director: Phil Watkins III. Estab. 1991. Member of Kansas City Advertising Club. Design firm. Number of employees: 1. Specializes in publication design, packaging, direct mail, collateral. Types of clients: industrial, retail, nonprofit, business-to-business. Examples of past projects: "Italian Feast," Mr Goodcents (posters, in-store promotion). California Health Vitamins, products brochure (shots of product line); Sprint, 1999 International Invitation (invitation/golf shots); Met Life, agricultural investments brochure (direct mail/people shots).
Needs: Works with 1 freelancer/month. Uses photos for trade magazines, direct mail, P-O-P displays, catalogs, packaging, newspaper, newsletter. Subjects include: location photographs, people. Reviews stock photos. Model release preferred for locations, people shots for retail.
Specs: Uses 8×10 matte b&w prints; 35mm, 2¼×2¼ transparencies.
Making Contact & Terms: Arrange personal interview to show portfolio. Works with freelancers on assignment only. Keeps samples on file. SASE. Reports in 1-2 weeks. Pays $1,000-1,500/day. Pays on publication. Credit line sometimes given. Buys one-time or all rights "if usage to span one or more years."

DANA WHITE PRODUCTIONS, INC., 2623 29th St., Santa Monica CA 90405. (310)450-9101. Full-service audiovisual, multi-image, photography and design, video/film production studio. President: Dana White. Estab. 1977. Types of clients: corporate, government and educational. Examples

of productions: Southern California Gas Company/South Coast AQMD (Clean Air Environmental Film Trailers in 300 LA-based motion picture theaters); Glencoe/Macmillan/McGraw-Hill (textbook photography and illustrations, slide shows); Pepperdine University (awards banquets presentations, fundraising, biographical tribute programs); US Forest Service (slide shows and training programs); Venice Family Clinic (newsletter photography); Johnson & Higgins (brochure photography).

Needs: Works with 2-3 freelance photographers/month. Uses photos for catalogs, audiovisual and books. Subjects include: people, products, still life and architecture. Interested in reviewing 35mm stock photos by appointment. Signed model release required for people and companies.

Audiovisual Needs: Uses all AV formats including slides for multi-image presentations using 1-9 projectors.

Specs: Uses color and b&w prints; 35mm, 2¼×2¼ transparencies.

Making Contact & Terms: Arrange a personal interview to show portfolio and samples. Works with freelancers on assignment only. Will assign certain work on spec. Do not submit unsolicited material. Cannot return material. **Pays when images are shot to White's satisfaction**—never delays until acceptance by client. Pays according to job: $25-100/hour, up to $500/day; $20-50/shot; or fixed fee based upon job complexity and priority of exposure. Hires according to work-for-hire and will share photo credit when possible.

Tips: In freelancer's portfolio or demo, Mr. White wants to see "quality of composition, lighting, saturation, degree of difficulty and importance of assignment. The trend seems to be toward more video, less AV. Clients are paying less and expecting more. To break in, freelancers should "diversify, negotiate, be flexible, go the distance to get and keep the job. Don't get stuck in thinking things can be done just one way. Support your co-workers."

$ $ $ A ⊡ **EVANS WYATT ADVERTISING & PUBLIC RELATIONS**, 346 Mediterranean Dr., Corpus Christi TX 78418. (512)939-7200. Owner: E. Wyatt. Estab. 1975. Ad agency, PR firm. Types of clients: industrial, technical, distribution and retail. Examples of recent projects: H&S Construction Co. (calendars); L.E.P.C. Industrial (calendars and business advertising); The Home Group (newspaper advertising).

Needs: Works with 3-5 freelance photographers and/or videographers/month. Uses photos for consumer and trade magazines, direct mail, catalogs, posters and newspapers. Subjects include: people and industrial. Reviews stock photos/video footage of any subject matter. Model release required. Captions preferred.

Audiovisual Needs: Uses slide shows and videos.

Specs: Uses 5×7 glossy b&w and color prints; 35mm, 2¼×2¼ transparencies; ½" videotape (for demo or review), VHS format.

Making Contact & Terms: Query with résumé of credits, list of stock photo subjects and samples. Submit portfolio for review. Provide résumé, business card, brochure, flier or tearsheets to be kept on file for possible future assignments. Works on assignment only. Reports in 1 month. Pays $500-1,000/day; $100-700/job; negotiated in advance of assignment. Pays on receipt of invoice. Credit line sometimes given, depending on client's wishes. Buys all rights.

Tips: "Resolution and contrast are expected." Especially interested in industrial photography. Wants to see "sharpness, clarity and reproduction possibilities." Also, creative imagery (mood, aspect, view and lighting). Advises freelancers to "do professional work with an eye to marketability. Pure art is used only rarely."

N A ⊡ **YAMAGUMA & ASSOC./DESIGN 2 MARKET**, 255 N. Market St., #120, San Jose CA 95110. (408)279-0500. Fax: (408)293-7819. E-mail: sayd2m@aol.com. Operations Manager: Donna Shin. Design firm. Approximate annual billing: $750,000. Number of employees: 3. Specializes in publication design, display design, packaging, direct mail and advertising. Types of clients: industrial, retail, nonprofit and technology. Examples of recent projects: Compro & Ads poster for ACS; calendar-race cars for ORBIT Semiconductor; and ad, poster for Chem USA/5D.

Needs: Works with 6 freelancers/month. Uses photos for trade magazines, direct mail, P-O-P displays, catalogs, posters, packaging and advertising. Subjects include: people, computers, equipment. Reviews stock photos. Model/property release required.

Specs: Uses 35mm, 2¼×2¼, 4×5 transparencies; Mac formats. Accepts images in digital format for Mac.

Making Contact & Terms: Send unsolicited photos by mail for consideration. Provide résumé, business card, brochure, flier or tearsheets to be kept on file for possible future assignments. Works on assignment only. Keeps samples on file. SASE. Payment negotiable. Credit line sometimes given. Buys all rights.

REGIONAL REPORT: NORTHWEST & CANADA

Although this region includes only a few U.S. states and the entire country of Canada, its

main industries are the same—fishing, mining, forest products and oil and petroleum products. Computer software manufacturing is also big here, but concentrated in Washington. The major advertising cities in this region include Seattle and Toronto.

Leading national advertisers

Allied Domecq, Windsor, Ontario
 CAN
Microsoft Corp, Redmond WA
Nike, Beaverton OR
Seagram Co., Montreal, Quebec CAN

Notable ad agencies in the region

BBDO Canada, 2 Bloor St. W., 32nd Floor, Toronto Ontario M4W 3R6 Canada. (416)972-5731. Major accounts: Campbell Soup Company, Chrysler Canada, FedEx Canada, Hostess Frito-Lay Canada, Molson Breweries, PepsiCo.

Cossette Communication, 437 Grande Allee E., Quebec PQ G1R 2J5 Canada. (418)647-2727. Major accounts: Canadian Petroleum Products Institute, General Motors, McDonald's Restaurants of Canada, SAAB, Isuzu.

Elgin DDB, 1008 Western Ave., Suite 601, Seattle WA 98104. (206)442-9900. Website: http://www.ddbn.com. Major accounts: Holland America Line, NARAL, Nordstrom, Seagate Software, Seattle Post-Intelligencer.

Karakas, Van Sickle, Ouellette, Inc., 200 SW Market St., Suite 1400, Portland OR 97201-5741. (503)221-1551. Website: http://www.kvo.com. Major accounts: Gemstone, Hitachi, Mentor Graphics, Standard Insurance, Wall Data.

MacLaren McCann Canada, 10 Bay St., 13th Floor, Toronto Ontario M5J 2S3 Canada. (416)594-6221. Major accounts: Bacardi-Martini Canada Inc., Black & Decker Canada Inc., General Motors of Canada, Johnson & Johnson Inc., Molson Breweries, Motorola Information Systems.

McCann-Erickson, 1011 Western Ave., Suite 600, Seattle WA 98104. (206)971-4200. Website: http://www.mccann.com/cor/mew.shtml. Major accounts: Continental Mills, IKEA, Power-Ade, Seattletimes.com, Washington Apple Commission.

The Nerland Agency, 808 E St., Anchorage AK 99501. (907)274-9553. Website: http://www.nerland.com. Major accounts: Alaska Seafood Marketing Institute, MAPCO Alaska Petroleum, McDonald's, Cook-Inlet Co-op, University of Alaska, Valley Hospital.

Palmer Jarvis DDB, 777 Hornby St., Suite 1600, Vancouver British Columbia V6Z 2T3 Canada. (604)687-7911. Major accounts: Clorox, Colombian Coffee Growers, Michelin, Mohawk Oil, SmithKline Beecham.

Wieden & Kennedy, 320 SW Washington, Portland OR 97204. (503)228-4381. Major accounts: Barq's Rootbeer, ESPN, Microsoft Computer Software, Nike, Oregon Department of Tourism.

The Young & Rubicam Group of Companies, 60 Bloor St. W., 9th Floor, Toronto Ontario M4W 1J2 Canada. (416)324-2064. Major accounts: AT&T Long Distance Services, Book-of-the-Month Club, Campbell Soup Company Ltd., Ford Motor Company of Canada Ltd., Kraft Canada Inc., RadioShack.

N **$ $ $** **A** **□** **∅** **AUGUSTUS BARNETT ADVERTISING/DESIGN**, (formerly Augustus Barnett Design & Creative Services), 632 St. Helens Ave. S., Tacoma WA 98402. (253)627-8508. President: Charlie Barnett. Estab. 1981. Ad agency, design firm. Approximate annual billing: $1.1 million. Number of employees: 3. Firm specializes in magazine ads, collateral, direct mail, business to business, retail, food, package design and identities. Types of Clients: industrial, financial, retail, nonprofit. Examples of recent clients: "U of W, Tacoma Brochure," University of Washington (brochures); "Alaska Seafood Express," Alaska Seafood (retail promo, trade advertisement).
Needs: Works with 1-2 freelance photographers/month. Uses photos for consumer and trade magazines,

direct mail, P-O-P displays, newspapers. Subjects include: industrial, food-related product photography. Model release required. Property release preferred for fine art, vintage cars, boats and documents. Captions preferred.

Specs: Uses 5×7, 8×10, color and b&w glossy prints; 35mm, 2¼×2¼, 4×5 transparencies. Accepts images in digital format for Mac. Send via CD, Jaz, Zip as TIFF, EPS, JPEG files, hi resolution only.

Making Contact & Terms: Call for interview or drop off portfolio. Works on assignment only. Keeps samples on file. SASE. Reports in 1-2 weeks. Pays $90-150/hour; $600-1,500/day; negotiable. **Pays on receipt of invoice**. Credit line sometimes given "if the photography is partially donated for a nonprofit organization." Buys one-time and exclusive product rights; negotiable.

Tips: To break in "make appointment to leave portfolio and references/résumé and to meet face-to-face."

$ ▦ ◎ BRIDGER PRODUCTIONS, INC., P.O. Box 8131, Jackson Hole WY 83002. (307)733-7871. Fax: (307)734-1947. President: Mike Emmer. Estab. 1990. Operates as a freelancer for ESPN, Prime Network. AV firm. Number of employees: 3. Types of clients: industrial, financial, fashion, retail, food and sports. Examples of recent projects: national TV ads for Michelin, ESPN and Dark Light Pictures; Hi-Def TV or such clients as Microsoft, Zenith, Phillips.

Needs: Works with 1-2 freelance photographers, 1-2 filmmakers and 1-2 videographers/month. Uses photos for billboards, trade magazines, P-O-P displays, catalogs, posters, video covers and publicity. Subjects include: sports. Model/property release required for sports. Captions required; "include name of our films/programs we are releasing."

Audiovisual Needs: Uses slides, film, videotape and digital mediums for promotion of national broadcasts. Subjects include: sports.

Specs: Uses 8×10 glossy color prints; 16 or 35mm film; Beta or Digital (IFF-24) videotape.

Making Contact & Terms: Query with résumé of credits. Query with stock photo list. Works with local freelancers only. SASE. Reporting time "depends on our schedule and how busy we are." Pays for assignments. **Pays on acceptance**. Credit line given. Buys one-time and electronic rights; negotiable.

$ ▧ Ⓐ ▤ THE CABER PRODUCTION COMPANY, 266 Rutherford Rd. S., #22, Brampton, Ontario L6W 3N3 Canada. (905)454-5141. Fax: (905)454-5936. E-mail: caber@trigger.net. Producers: Chuck Scott and Christine Rath. Estab. 1988. Film and video producer with a focus in the television market. Recent projects include the second season of "A Day In The Country" for Life Network, and the new series "Home Additions", airing on HGTV. Upcoming projects include series, one-off dramas and documentaries. Caber still maintains their corporate client base.

Needs: Works with 2-3 freelance photographers and 3-5 videographers/month. Uses photos for posters, newsletters, brochures. Model/property release required.

Audiovisual Needs: Uses film or video. "We mainly shoot our own material for our projects."

Specs: 35mm, 2¼×2¼, 4×5 transparencies; videotape (Betacam SP quality or better).

Making Contact & Terms: Contact through rep. Query with résumé of credits. Provide résumé, business card, brochure, flier or tearsheets to be kept on file for possible future assignments. Works with local freelancers on assignment only. Keeps samples on file. SASE. Reports in 1-2 weeks. Pays $250/3-hour day. **Pays on receipt of invoice**. Rights negotiable.

▧ Ⓐ ▤ CHISHOLM ARCHIVES INC., 99 Atlantic Ave., #50, Toronto, Ontario M6K 3J8 Canada. (416)588-5200. Fax: (416)588-5324. E-mail: chisholm@istar.ca. Website: http://www.chisholmarchives.com. President: Mary Di Tursi. Estab. 1956. Stock, film and video library. Member of International Television and Video Association, The Federation of Commercial Audio Visual Libraries, Canadian Film and Television Producers Association, Toronto Women in Film and Television, International Quorum of Film Producers, Association of Moving Image Archivists, International Federation of Television Archives. Types of clients: finance, industrial, government, TV networks and educational TV/multimedia, corporate producers.

Needs: Supplies stock film and video footage.

Making Contact & Terms: Works with freelancers on an assignment basis only. Rights negotiable.

$ $ CIPRA AD AGENCY, 314 E. Curling Dr., Boise ID 83702. (208)344-7770. Fax: (208)344-7794. President: Ed Gellert. Estab. 1979. Ad agency. Types of clients: agriculture (regional basis), transmission repair, health information.

Needs: Works with 1 freelance photographer/month. Uses photos for trade magazines. Subjects include: electronic, agriculture and garden. Reviews general stock photos. Model release required.

Specs: Uses 4×5, 8×10, 11×14 glossy or matte, color and b&w prints; 35mm, 4×5 transparencies.

Making Contact & Terms: Provide résumé, business card, brochure, flier or tearsheets to be kept on file for possible future assignments. Usually works with local freelancers only. Keeps samples on file.

Cannot return material. Reports as needed. Pays $75/hour. Pays on publication. Buys all rights.

$ $ ▣ ◐ CREATIVE COMPANY, 3276 Commercial St. SE, Salem OR 97302. (503)363-4433. Fax: (503)363-6817. E-mail: brains@creativeco.com. Website: http://www.creativeco.com. President: Jennifer L. Morrow. Creative Director: Steven Johnsen. Estab. 1978. Member of American Institute of Graphic Artists, Portland Ad Federation. Marketing communications firm. Approximate annual billing: $1 million. Number of employees: 13. Firm specializes in collateral, direct mail, magazine ads, packaging, publication design. Types of clients: service, industrial, financial, manufacturing, non-profit, business-to-business. Examples of recent projects: Church Extension Plan sales inquiry materials (brochures, postcards, mailers); Norpac Foods (Just Add brand packaging); Tec Lab's Oak'n Ivy Brand; and Tec Labs (collateral, direct mail).

Needs: Works with 1-2 freelancers/month. Uses photos for direct mail, P-O-P displays, catalogs, posters, audiovisual and sales promotion packages. Subjects include: children, multicultural, families, senior citizens, landscapes/scenics, gardening, religious, rural, food/drink, health/fitness, humor, agriculture, business concepts, computers, industry, product shots/still life, technology. Interested in alternative process, avant garde, digital, fine art, historical/vintage, regional, seasonal. Model release preferred.

Specs: Uses 5×7 and larger glossy color or b&w prints; 2¼×2¼, 4×5 transparencies. Accepts images in digital format for Mac. Send via CD, online, floppy disk, Zip disk as TIFF.

Making Contact & Terms: Arrange personal interview to show portfolio. Provide résumé, business card, brochure, flier or tearsheets to be kept on file for possible future assignments. Works with local freelancers only. SASE. Reports "when needed." Pays $75-300/b&w photo; $200-1,000/color photo; $20-75/hour; $700-2,000/day, $200-15,000/job. Credit line not given. Buys one-time, one-year and all rights; negotiable.

Tips: In freelancer's portfolio, looks for "product shots, lighting, creative approach, understanding of sales message and reproduction." Sees trend toward "more special effect photography and manipulation of photos in computers." To break in with this firm, "do good work, be responsive and understand what color separations and printing will do to photos."

▣ ▨ AL DOYLE ADVERTISING DIRECTION, 4775 Blakely Heights Dr., Bainbridge Island WA 98110. (206)718-2121. Fax: (206)842-1618. E-mail: aldoyle@aol.com. Creative Director: Al Doyle. Estab. 1981. Ad agency. Number of employees: 1-10. Types of clients: industrial, financial, retail, food. Examples of recent projects; Sky Island Ranch Planned Community (billboard, collateral print); Daniel's Ranch Planned Community (collateral, print); Shoreside Townhomes (collateral, print).

Needs: Works with 3-5 freelance photographers, varying numbers of filmmakers and videographers/month. Uses photos for billboards trade magazines and signage. Subjects include: lifestyle, people and families, active recreation and home life. Reviews stock photos. Model release required.

Audiovisual Needs: Uses slides and video for video presentations and brochures.

Specs: Uses color prints; 35mm, 2¼×2¼ transparencies; digital format.

Making Contact & Terms: Does not keep samples on file. SASE. Reports in 1-2 weeks. Payment negotiable. Rights negotiable.

Tips: "We use over 50% digital images from stock sources."

$ $ ▨ ▣ ◐ DUCK SOUP GRAPHICS, INC., 257 Grandmeadow Crescent, Edmonton, Alberta T6L 1W9 Canada. (403)462-4760. Fax: (403)463-0924. Creative Director: William Doucette. Estab. 1980. Design firm. Approximate annual billing: $2.5 million. Number of employees: 7. Firm specializes in annual reports, collateral, magazine ads, publication design, corporate literature/identity, packaging and direct mail. Types of clients: industrial, government, institutional, financial and retail.

Needs: Works with 2-4 freelancers/month. Uses photos for annual reports, billboards, consumer and trade magazines, direct mail, posters and packaging. Subjects includes celebrities, couples, multicultural, families, environmental, landscapes/scenics, wildlife, architecture, cities/urban, rural, adventure, automobiles, entertainment, events, health/fitness, performing arts, sports, travel, agriculture, buildings, business concepts, industry, medicine, product shots/still life, science, technology. Interested in alternative process, avant garde, digital, documentary, erotic, fashion/glamour, fine art, historical/vintage. Reviews stock photos. Model release preferred.

Specs: Uses color and b&w prints; 35mm, 4×5, 8×10 transparencies. Accepts images in digital format for Mac. Send via CD, Jaz, Zip as EPS files.

Making Contact & Terms: Interested in seeing new, digital work. Provide résumé, business card, brochure, flier or tearsheets to be kept on file for possible future assignments. Works on assignment only. Keeps samples on file. SAE and IRC. Reports in 1-2 weeks. Pays $100-200/hour; $1,000-2,000/day; $1,000-15,000/job. **Pays on receipt of invoice**. Credit line given depending on number of photos in publication. Buys first rights; negotiable.

Tips: "Call for an appointment or send samples by mail."

$ ▣ ◎ MATTHEWS ASSOC. INC., 603 Stewart St., Suite 1018, Seattle WA 98101. (206)340-0680. Fax: (206)626-0988. E-mail: matthewsassociates@msn.com. Ad agency. President: Dean Matthews. Types of clients: industrial.

Needs: Works with 0-3 freelance photographers/month. Uses photographers for trade magazines, direct mail, P-O-P displays, catalogs and public relations. Frequently uses architectural photography; other subjects include building products.

Specs: Uses 8×10 b&w and color prints; 35mm, 2¼×2¼ and 4×5 transparencies. Accepts images in digital format for Windows. Send via CD.

Making Contact & Terms: Arrange a personal interview to show portfolio if local. If not, provide résumé, business card, brochure, flier or tearsheets to be kept on file for possible future assignments. SASE. Payment negotiable. Pays per hour, day or job. **Pays on receipt of invoice.** Buys all rights. Model release preferred.

Tips: Samples preferred depends on client or job needs. "Be good at industrial photography."

$ $ THE NERLAND AGENCY, 808 E St., Anchorage AK 99501. (907)274-9553. Ad agency. Contact: Graham Biddle. Types of clients: retail, hotel, restaurant, fitness, health care. Client list free with SASE.

Needs: Works with 3 freelance photographers/month. Uses photos for consumer magazines, trade magazines, newspaper ads, direct mail and brochures and collateral pieces. Subjects include people and still lifes.

Specs: Uses 11×14 matte b&w prints; 35mm, 2¼×2¼ and 4×5 transparencies.

Making Contact & Terms: Query with samples. Provide résumé, business card, brochure, flier or tearsheets to be kept on file for possible future assignments. Does not return unsolicited material. Pays $500-800/day or minimum $100/job (depends on job). **Pays on receipt of invoice.** Buys all rights or one-time rights. Model release and captions preferred.

Tips: Prefers to see "high technical quality (sharpness, lighting, etc). All photos should capture a mood—good people, expression on camera. Simplicity of subject matter. Keep sending updated samples of work you are doing (monthly). We are demanding higher technical quality and looking for more 'feeling' photos than still life of product."

$ ⬚ Ⓐ ⬚ SUN.ERGOS, A Company of Theatre and Dance, 130 Sunset Way, Priddis, Alberta T0L 1W0 Canada. (403)931-1527. Fax: (403)931-1534. E-mail: waltermoke.sunergos.com. Website: http://www.sunergos.com. Artistic and Managing Director: Robert Greenwood. Estab. 1977. Company established in theater and dance, performing arts, international touring. Photos used in brochures, newsletters, posters, newspapers, annual reports, magazines, press releases, audiovisual uses and catalogs.

Needs: Buys 10-30 photos/year; offers 3-5 assignments/year. Performances. Examples of recent uses: "Birds of Stones" (8×10 b&w slides); "A Christmas Gift" (8×10 b&w slides); "Pearl Rain/Deep Thunder" (8×10 b&w slides). Reviews theater and dance stock photos. Property release required for performance photos for media use. Captions required; include subject, date, city, performance title.

Audiovisual Needs: Uses slides, film and videotape for media usage, showcases and international conferences. Subjects include performance pieces/showcase materials.

Specs: Uses 8×10, 8½×11 color and b&w prints; 35mm, 2¼×2¼ transparencies; 16mm film; NTSC/PAL/SECAM videotape.

Making Contact & Terms: Arrange a personal interview to show portfolio. Query with résumé of credits. Provide résumé, business card, self-promotion piece or tearsheets to be kept on file for possible future assignments. Works on assignment only. Keeps samples on file. SASE. Reporting time depends on project. Pays $100-150/day; $150-300/job; $2.50-10/color photo; $2.50-10/b&w photo. Pays on usage. Credit line given. Buys all rights.

Tips: "You must have experience shooting dance and *live* theater performances."

Ⓝ Ⓐ THOMAS PRINTING, INC., 38 Sixth Ave. W., Kalispell MT 59901. (406)755-5447. Fax: (406)755-5449. E-mail: tpi@digisys.net. CEO: Frank Thomas. Estab. 1962. Member of NAPL. Commercial printer, graphic design firm, prepress house. Approximate annual billing: $3 million. Number of em-

CONTACT THE EDITOR of *Photographer's Market* by e-mail at photomarket@fwpubs.com with your questions and comments.

ployees: 21. Types of clients: industrial and financial. Examples of recent projects: "Downhill Skiing," Mt. Baker Ski Area; "Outdoor & Wildlife," *Mountain Living Magazine*; "Golf," *Flathead Golf* magazine; "Products," manufactures individual products. Graphics and commercial printing—state of the art printing factory.

Needs: Works with 1-5 freelancers/month. Uses photos for direct mail, P-O-P displays, catalogs and posters. Subjects include: mostly product photo and outdoor shots. Reviews stock photos. Model/property release required.

Specs: Uses 8×10 color prints; 35mm, $2\frac{1}{4} \times 2\frac{1}{4}$, 4×5, 8×10 transparencies.

Making Contact & Terms: Provide résumé, business card, brochure, flier or tearsheets to be kept for possible future assignments. Works on assignment only. Keeps samples on file. SASE. Reports depending on project. Payment negotiable. **Pays on acceptance.** Credit line sometimes given depending upon project. Rights negotiable.

WARNE MARKETING & COMMUNICATIONS, 111 Avenue Rd., Suite 810, Toronto, Ontario M5R 3J8 Canada. (416)927-0881. Fax: (416)927-1676. President: Keith Warne. Estab. 1979. Ad agency. Types of clients: business-to-business.

Needs: Works with 5 photographers/month. Uses photos for trade magazines, direct mail, P-O-P displays, catalogs and posters. Subjects include: in-plant photography, studio set-ups and product shots. Special subject needs include in-plant shots for background use. Model release required.

Audiovisual Needs: Uses both videotape and slides for product promotion.

Specs: Uses 8×10 glossy b&w prints; 4×5 transparencies and color prints.

Making Contact & Terms: Send letter citing related experience plus 2 or 3 samples. Works on assignment only. Cannot return material. Reports in 2 weeks. Pays $1,000-1,500/day. Pays within 30 days. Buys all rights.

Tips: In portfolio/samples, prefers to see industrial subjects and creative styles. "We look for lighting knowledge, composition and imagination."

International

$ $ AWY ASSOCIATES, Peten 91, Col. Narvarte, D.F. 03020 Mexico. Phone: (525)530-3439. Fax: (525)530-3479. E-mail: ideas@enter.net.mx. Website: http://www.webstatione.com. Creative Director: Isaac Ajzen. Estab. 1982. Member of DTP International Club, Asociacion Mexicana de Fotografia. Ad agency and PR firm. Number of employees: 15. Types of clients: industrial, financial, fashion, retail, food, computers, services. Examples of recent projects: "Mazal Bedspread," Grupo Textil Mazal (product, catalog, poster); "Ecomagico," Quimild Biodegradable (product, posters); "Enterprise Partners," Enterprise (catalogs, mailings, fliers).

Needs: Works with 2-3 photographers and 1 videographer/month. Uses photos for comsumer magazines, direct mail, catalogs, posters. Subjects include: fashion, food, science and technology. Reviews stock photos. Model/property release preferred. Captions preferred.

Audiovisual Needs: Uses videotape.

Specs: Uses prints; 35mm, 4×5 transparencies; VHS videotape. Accepts images in digital format for Windows. Send via online, floppy disk or Zip disk as TIFF, CDR, BMP files at 600 dpi.

Making Contact & Terms: Submit portfolio for review. Send unsolicited photos by mail for consideration. Provide resume, business card, brochure, flier or tearsheets to be kept on file for possible future assignments. Works on assignment only. Keeps samples on file. SASE. Reports in 3 weeks. Pays $120-400 for b&w and color photos; $1,200-10,000/job. Pays for electronic usage of photos (depending on the work). Pays 2 weeks after photo session. Credit line sometimes given, depending on client and kind of work. Buys one-time rights; negotiable.

Tips: Looks for "creativity, new things, good focus on the subject and good quality."

$ $ EH6 DESIGN CONSULTANTS, The Silvermills Groups, 19 Silvermills Court, Henderson Place Lane, Edinburgh, Scotland EH3 5DG UK. Phone: (0044)131 558 3383. Fax: (0044)131 556 1154. E-mail: k.greenan@silvermills.co.uk. Design Co-ordinator: Karen Greenan. Estab. 1992. Design firm. Number of employees: 10. Firm specializes in annual reports, display design, direct mail, packaging, signage, corporate identities. Types of clients: industrial, financial, retail. Examples of recent clients: "Scotland on Location," Scottish Screen (landscape/interior shots); "Corporate Brochure," Scottish Screen (various/vague representations of brochure subject matter).

Needs: Half of projects use freelance photographers. Uses photos for brochures. Subjects include babies, celebrities, children, couples, multicultural, families, parents, senior citizens, teens, disasters, environmental, landscapes/scenics, wildlife, architecture, beauty, cities/urban, education, gardening, interiors/decorat-

ing, pets, religious, rural, adventure, automobiles, entertainment, events, food/drink, health/fitness, hobbies, humor, performing arts, sports, travel, agriculture, buildings, business concepts, computers, industry, medicine, military, political, portraits, product shots/still life, science, technology. Interested in alternative process, avant garde, digital, documentary, erotic, fashion/glamour, fine art, historical/vintage, regional, seasonal.

Specs: Uses color prints; 4×5 transparencies.

Making Contact & Terms: Provide résumé, business card, self-promotion piece or tearsheets to be kept on file for possible future assignments. Art director will contact photographer for portfolio review if interested. Portfolio should include b&w and color. Works with local freelancers only. Keeps samples on file. Reports back only if interested; send non-returnable samples. Payment depends on usage/project. Pays on publication.

Tips: "Prefer to use local freelancers, as it is often easier to get hold of them for quick turnarounds, and briefing. When submitting work, you should enclose samples to keep on our files, as we cannot use everyone we see—and it is good to have a comprehensive list and samples of people who have been in. Send as many samples as possible, and also send in up-to-date samples at regular periods. Our designers do look at the work when it comes in and will get in touch with you if they like what they see!"

N ⊕ GROUP GCI MEXICO S.A. DE C.V., Jaime Balmes 8-103, Col. Los Morales Polanco, D.F. 11510 Mexico. Phone: (525)280-9077. President: Guillermo Grimm. PR firm. Types of clients: industrial, fashion, financial. Client list free with SAE and IRC.

Needs: Works with 4 freelance photographers/month. Uses photos for consumer and trade magazines, P-O-P displays, catalogs, posters, signage and newspapers. Subjects include: client events or projects, portraits, models. Model release preferred. Captions preferred.

Specs: Uses 5×7 glossy color prints; 35 mm or 4×5 transparencies.

Making Contact & Terms: Send unsolicited photos by mail for consideration. Works with freelance photographers on an assignment basis only. SAE and IRCs. Reports in 2 weeks. Payment depends on client budget. Payment made 15 days after receipt of invoice. Credit line sometimes given. Buys all rights.

Tips: Prefers to see portraits, product shots, landscapes, people. "Freelance photographers should provide recommendations, complete portfolio, good prices. Trends include journalism-type photography, audiovisuals."

Galleries

A MARKET FOR FINE PHOTOGRAPHY

The popularity of photography as a collectible art form has improved the market for fine art photographs over the last decade. Viewers now recognize the investment value of prints by Ansel Adams, Irving Penn and Henri Cartier-Bresson, and therefore frequently turn to galleries for stirring photographs to place in their private collections.

The gallery/fine art market is one that can make money for many photographers. However, unlike commercial and editorial markets, galleries seldom generate quick income for artists. Galleries should be considered venues for important, thought-provoking imagery, rather than markets through which you can make a substantial living.

More than any other market, this area is filled with photographers who are interested in delivering a message. Whole shows often focus on one overriding theme by a single artist. Group shows also are popular for galleries that see promise in the styles of several up-and-coming photographers.

It might be easiest to think of the gallery market as you would book publishing. The two are similar in that dozens of pictures are needed to thoroughly tell a story or explore a specific topic. Publishers and gallery directors are interested in the overall interpretation of the final message. And they want artists who can excite viewers, make them think about important subjects and be willing to pay for photographs that stir their emotions.

As with picture buyers and art directors, gallery directors love to see strong, well-organized portfolios. Limit your portfolio to 20 top-notch images. When putting together your portfolio focus on one overriding theme. A director wants to be certain you have enough quality work to carry an entire show. After the portfolio review, if the director likes your style, then you might discuss future projects or past work that you've done.

Directors who see promise in your work, but don't think you're ready for a solo exhibition, may place your material in a group exhibition. In group shows, numerous artists display work at the same time. You might even see different mediums, such as painting, illustration or abstract sculptures, on display. The emphasis of a group show is to explore an overriding theme from various perspectives. Such shows may be juried, which means participants have been accepted by a review committee, or non-juried.

HOW GALLERIES OPERATE

In exchange for brokering images a gallery often receives a commission of 40-50 percent. They usually exhibit work for a month, sometimes longer, and hold openings to kick off new shows. And they frequently provide pre-exhibition publicity. Something to be aware of is that some smaller galleries require exhibiting photographers to help with opening night reception expenses. Galleries also may require photographers to appear during the show or opening. Be certain that such policies are put in writing before you allow them to show your work.

Gallery directors who foresee a bright future for you might want exclusive rights to represent your work. This type of arrangement forces buyers to get your images directly from the gallery that represents you. Such contracts are quite common, usually limiting the exclusive rights to

◄ "Orit Raff works in a minimalist style, often depicting home and familiar themes in simple, elegant ways," says Gen Art's Adam Walden. Her work has appeared in several Gen Art group shows, including their New Vision '98 show, "Under Construction," and "Summertime Views," Gen Art's '98 summer benefit. (Walden discusses Gen Art's role in bringing fine art to a new generation on page 481.)

specified distances. For example, a gallery in Tulsa, Oklahoma, may have exclusive rights to distribute your work within a 200-mile radius of the gallery. This would allow you to sign similar contracts with galleries outside the 200-mile range.

FIND THE RIGHT FIT

As you search for the perfect gallery, it's important to understand the different types of exhibition spaces and how they operate. The route you choose depends on your needs, the type of work you do, your long term goals, and the audience you're trying to reach. (The following descriptions were provided by the editor of *Artist's & Graphic Designer's Market*.)

- **Retail or commercial galleries.** The goal of the retail gallery is to sell and promote artists while turning a profit. Retail galleries take a commission of 40 to 50 percent of all sales.
- **Co-op galleries.** Co-ops exist to sell and promote artists' work, but they are run by artists. Members exhibit their own work in exchange for a fee, which covers the gallery's overhead. Some co-ops also take a commission of 20-30 percent to cover expenses. Members share the responsibilities of gallery-sitting, sales, housekeeping and maintenance.
- **Rental galleries.** The gallery makes its profit primarily through renting space to artists and consequently may not take a commission on sales (or will take only a very small commission). Some rental spaces provide publicity for artists, while others do not. Showing in this type of gallery is risky. Rental galleries are sometimes thought of as "vanity galleries" and, consequently they do not have the credibility other galleries enjoy.
- **Nonprofit galleries.** Nonprofit spaces will provide you with an opportunity to sell work and gain publicity, but will not market your work agressively, because their goals are not necessarily sales-oriented. Nonprofits normally take a commission of 20-30 percent.
- **Museums.** Don't approach museums unless you have already exhibited in galleries. The work in museums is by established artists and is usually donated by collectors or purchased through art dealers.
- **Art consultancies.** Generally, art consultants act as liasions between fine artists and buyers. Most take a commission on sales (as would a gallery). Some maintain small gallery spaces and show work to clients by appointment.

If you've never exhibited your work in a traditional gallery space before, you may want to start with a less traditional kind of show. Alternative spaces are becoming a viable way to help the public see your work. Try bookstores (even large chains), restaurants, coffee shops, upscale home furnishings stores and boutiques. The art will help give their business a more pleasant, interesting environment at no cost to them an you may generate a few fans or even a few sales.

Think carefully about what you take pictures of and what kinds of businesses might benefit from displaying them. If you shoot flowers and other plant life perhaps you could approach a nursery about hanging your work in their sales office. If you shoot landscapes of exotic locations maybe a travel agent would like to take you on. Think creatively and don't be afraid to approach a business person with a proposal. Just make sure the final agreement is spelled out in writing so there will be no misunderstandings, especially about who gets what money from sales.

Whether you're a newcomer to the gallery scene or a seasoned professional, read the listings carefully to determine which galleries will suit you best. Some provide guidelines or promotional information about recent exhibits for a self-addressed, stamped envelope. Galleries are also included in our Subject Index on page 588. Check this index to help you narrow your search for galleries interested in your type of work. Whenever possible, visit galleries that interest you to get a real feel for their particular needs, philosophy and exhibition capabilities. Do not, however, try to show a portfolio without first making an appointment.

Artist's Statement

When you approach a gallery about a solo exhibition, they will usually expect your body of work to be organized around a theme. To present your work and its theme to the public, the gallery will expect you to write an artist's statement, a brief essay about how and why you make photographic images. There are several things to keep in mind when writing your statement:

1. Be brief. Most statements should be 100 to 300 words long. You shouldn't try to tell your life's story leading up to this moment.

2. Write as you speak. There is no reason to make up complicated motivations for your work if there aren't any. Just be honest about why you shoot the way you do.

3. Stay focused. Limit your thoughts to those that deal directly with the specific exhibit for which you're preparing.

Before you start writing your statement, consider your answers to the following questions:

1. Why do you make photographs (as opposed to using some other medium)?
2. What are your photographs about?
3. What are the subjects in your photographs?
4. What are you trying to communicate through your work?

The following artist's statements were written by Ohio photographer Dennis Savage (see an example of his work on page 489). The first is from a solo exhibition at the Ascherman Gallery in Cleveland. The second is from a group show at ROY G BIV Gallery in Columbus.

Photography has become an integral part of my life and routine over the years. It is a tool that allows me to express things that I simply couldn't say any other way. Most of my work is about the people and region where I live in southeastern Ohio. These portraits are of family members, friends and students from the school where I teach. After many years of working, I am still drawn to the camera's ability to capture some of the mysterious and enigmatic qualities of being human. The Guardian series images are my attempt to comment on our primal and vital connection to the earth, and to articulate the delicate balance that exists between our species and the planet.

The Artifact series is one of several bodies of work inspired by the area where I live in southeastern Ohio. Much of the landscape in the Hocking Hills region is alive with spirits and energy from the past. From unique geological formations to traces of earlier cultures, it is an exciting environment. When I am alone in the landscape, I'm often aware of what Walt Whitman described as "a vital unseen presence." The Artifact series is an attempt to give physical manifestation to these personal observations and experiences, and also to express the mystery and power of the artifact.

Artsomething: nontraditional gallery brings fine art to a new generation

For twenty- or thirtysomethings interested in buying photography or art, a traditional gallery can seem intimidating, stodgy, even exclusionary. For photographers and artists of the same generation, breaking into the art world and having their work shown can be a battle. In 1993, two brothers named Ian and Stefan Gerard and their friend Melissa Neumann (all twentysomething) decided to do something about both of these issues and at the same time bring the two groups—emerging artists and young collectors—together. They created Gen Art.

Adam Walden

"The concept was to create alternatively formatted art environments where these two groups could meet," says Adam Walden, managing director of Gen Art's visual arts program. Originally focusing solely on the fine arts, Gen Art now also offers programs involving film and fashion.

The staff of Gen Art is "very passionate about art; we love art; but we're not artists. We come from very different backgrounds where we're very sensitive and very passionate about the arts but have very strong business skills and disciplines," Walden says. "We're sort of outside the art world, and as such, we really look at opportunities and new ways to give people exposure, to get their names out there, to get their art sold and to get their art collected by young collectors.

"We try to walk that fine line between what art is—there's a lot of history to art—and what art should be and how it should be displayed. There's always that history that we are definitely embracing, but at the same time, we look at it as 'hey— the more people who see this the better.' " For that reason, Gen Art seldom offers a show featuring only one artist or photographer. "We usually do group shows, because our goal is to get as many people's work out there as we can."

Gen Art works from a different model than nonprofit galleries. They don't have any government or public funding. "All of our money comes from the private sector, corporations and private donations. Our biggest source of revenue is corporate sponsors. Often interesting ideas come out of trying to work with corporate sponsors. We don't let them hang up banners and do nasty stuff. We really try to be creative

about it. We work with really cool people—Absolut Vodka, Armani, Banana Republic and Guinness & Bass Ale. When we start pitching them, we think of creative ideas to integrate them into the whole program, so their presence actually adds value, it doesn't detract. We never go to the philanthropy side and say, 'Oh help support the arts; we're hungry artists.' We have a business sale to them, that says work with us and you'll have access to our audience, which is very desirable."

The visual arts branch of Gen Art strives to offer exhibits in nontraditional formats such as their successful "The Art Market" exhibition which attracted 800 guests. "We really wanted to redefine what art is, or a least examine what it is, making it a commodity," says Walden. Gen Art transformed a huge warehouse into a market, bringing in big freezers and refrigerators, and things that would be found in a grocery store, and displayed art in this setting, "almost going with the concept of 'art by the pound.' We had blue light specials and shopping carts. There were 36 artists. People could go from stand to stand. They could look at the art in different environments and put it in their carts, then walk out with it at checkout. We tried to make the process as comfortable and easy as possible."

Walden feels that art and photography offered in interesting, nontraditional spaces is easier to digest for the viewer—and more fun. "We always try to make an exhibit an enjoyable and fun experience. It's always somewhat social. Generally we have an open bar and music. We try to break down the barriers and not have it be so intimidating."

This untitled image by Abby Gennett is from a group of self-portraits offering "a quirky peek into the life of today's 20-something woman. Each photographer created scenarios exemplifying or exaggerating different women's issues, including domesticity, femininity and self-perception." Gennett's work was exhibited in Gen Art's Art Market show as well as their 1998 summer benefit, "Summertime Views."

© Abby Gennett 1995

To find artists and photographers for their shows, Gen Art has an open submission policy throughout the year—anyone can submit slides for their files, which now include the work of nearly a thousand artists. "Every time we have an exhibition coming up, we'll bring a curator in and go through the files, looking for work that matches the tone or theme of the show. They'll find a big selection they like and narrow it down, doing actual studio visits."

Gen Art has regional offices in New York, San Francisco and Los Angeles, and they focus on artists and photographers in those three areas but residing in these areas is not essential. "We do take submissions from other locations, and we have shown artists in other locations—it's just more difficult in the sense that we like to do studio visits and we like to incorporate the artists and photographers into the shows."

The curators and staff are not looking for a certain kind of photography or art. "We don't have a specific niche that we follow in any area," says Walden. "We're looking for talented emerging artists. Besides that, any medium, any subject matter, black and white or color—it doesn't matter."

The Internet is an important tool for Gen Art in terms or finding artists and reaching their intended audience. They launched a website in 1995 (www.genart.org) and now have a large e-mail list. "The Web has been very good for us," says Walden. "We sell tickets to our events over the Web. We display select work over the Web. Artists have sold work and have definitely made contacts. It's been great." They also have a mailing list with 10,000 names in the New York area alone. In 1999 Gen Art's annual New Vision exhibition (held during fashion week and curated by Alexandra Rowley) featured the title "Some Girls" and showcased the work of emerging female photographers. "Gen Art focuses not only on art, but also on film and fashion. Photography is sort of the glue that brings those two areas together. Fashion and fashion photography are always intrinsically linked—without photography, fashion would die. Same with film. Photography is an element of it, not only in production stills. An art director or cinematographer is always composing a work, very similar to a photographer looking through a lens. It's a very similar artistic eye."

New Vision '99 was Gen Art's first photography-only event. They are open to doing more in the future. "We try to do different things all the time. We try not to show the same people too many times. We try to keep doing new things constantly," Walden says. "The idea of Gen Art is to bring in talented artists who are having trouble getting to the next level, who haven't been accepted by the traditional art world, and give them a boost."

—*Alice Pope*

A.R.C. GALLERY, 1040 W. Huron, 2nd Floor, Chicago IL 60622. (312)733-2787. President: Aviva Kramer. Estab. 1973. Examples of exhibitions: "Presence of Mind," by Jane Stevens (infrared photographs, b&w); "Take Away the Pictures . . . ," by Barbara Thomas (C-prints); "Watershed Investigations . . . ," by Mark Abrahamson (cibachrome prints). Presents 5-8 shows/year. Shows last 1 month. General price range of work: $100-1,200.

Exhibits: Must send slides, résumé and statement to gallery for review. All styles considered. Contemporary fine art photography, documentary and journalism.

Making Contact & Term: Charges no commission. Reviews transparencies. Interested in seeing slides for review. No size limits or other restrictions. Send material by mail for consideration. SASE. Reports in 1 month.

Tips: Photographers "should have a consistent body of work. Show emerging and experimental work."

ANSEL ADAMS CENTER FOR PHOTOGRAPHY, 250 Fourth St., San Francisco CA 94103. (415)495-7000. Fax: (415)495-8517. E-mail: staff@friendsofphotography.org. Website: www.friendsofpho tography.org. Associate Curator: Nora Kabat. Nonprofit museum. The Center was established in 1989. The Friends of Photography, the parent organization which runs the center, was founded in 1967. Approached by 500 artists a year; exhibits 50 artists. Sponsors 10-15 exhibits per year. Average display time 2-3 months. Examples of recent exhibitions: "Picasso and Villers: The Diurnes Portfolio" by Pablo Picasso and Andre Villers; "The Wilderness Idea: Ansel Adams and the Sierra Club" and "Summer of Love: Evolution and Revolution," photography which examines 1960s subculture in the Bay area. Gallery open daily 11:00 to 5:00. Closed New Years, Thanksgiving and Christmas.

Exhibits: "Photographers and curators are welcome to submit exhibition proposals through our portfolio review system. This entails sending 15-20 slides, a brief exhibition statement and fact sheet, a checklist, a résumé and a SASE for return of submission. Exhibits photos of landscapes/scenics and multicultural. Interested in alternative process, avant garde, fine art and historical/vintage.

Making Contact & Terms: Payment negotiable. Interested in unframed, mounted or unmounted, matted or unmatted work. Write to arrange a personal interview to show portfolio of slides. Mail portfolio for review. Send query letter with artist's statement, bio, slides, résumé, business card, reviews and SASE. Send SASE for guidelines for portfolio reviews. Reports back on portfolio reviews in 2 weeks; submitted work in 1 month. Find artists through word of mouth.

Tips: "We are a museum, not a gallery. We don't represent artists and usually *exhibit* only established artists (local or national). We are, however, very open to seeing/reviewing new work and welcome portfolios as long as artists follow the guidelines."

ADIRONDACK LAKES CENTER FOR THE ARTS, Rt. 28, P.O. Box 205, Blue Mt. Lake NY 12812. (518)352-7715. Fax: (518)352-7333. E-mail: alca@telnet.net. Program Coordinator: Daisy Kelley. Estab. 1967. Examples of recent exhibits: "The Passage of Time," by Edgar Praus; "Intimate Landscapes," by Nancy Rotenberg; "Nature—A Simple Perspective," by Karen Siemsen; "Meditation on Small Things," by Lisa Goodlin; "Adirondack Vistas," by Daniel Way. Presents 15-20 exhibits/year. General price range $100-500. Shows last 1 month. General price range of work: $100-500. Most work sold at $250.

Exhibits: Exhibits photos of babies, celebrities, children, couples, multicultural, families, parents, senior citizens, teens, disasters, environmental, landscapes/scenics, wildlife, architecture, beauty, education, gardening, interiors/decorating, pets, religious, rural, adventure, automobiles, entertainment, events, food/drink, health/fitness, hobbies, humor, performing arts, sports, travel. Send résumé, artist's statement, slides or photos. Interested in contemporary Adirondack, nature photography, alternative process, avant garde, digital, documentary, fashion/glamour, fine art, historical/vintage, regional, seasonal.

Making Contact & Terms: Charges 30% commission. "Pricing is determined by photographer. Payment made to photographer at end of exhibit." Reviews transparencies. Interested in framed and matted work. Send material by mail for consideration. SASE. Material reviewed annually in February.

Tips: "Our gallery is open during all events taking place at the Arts Center, including concerts, films, workshops and theater productions. Guests for these events are often customers seeking images from our gallery for their own collections or their places of business. Customers are often vacationers who have come to enjoy the natural beauty of the Adirondacks. For this reason, landscape and nature photographs sell well here."

AKRON ART MUSEUM, 70 E. Market St., Akron OH 44308. (330)376-9185. Website: http://www.akro nartmuseum.org. Chief Curator: Barbara Tannenbaum. Example of recent exhibitions: "A History of Women Photographers"; "Hiroshi Sugimoto." Presents 8 exhibits/year. Shows last 3 months.

 ● This gallery annually awards the Knight Purchase Award to a living artist working with photo-graphic media.

Exhibits: To exhibit, photographers must possess "a notable record of exhibitions, inclusion in publica-

tions, and/or a role in the historical development of photography. We also feature area photographers (northeast Ohio)." Interested in innovative works by contemporary photographers; any subject matter.
Making Contact & Terms: Payment negotiable. Buys photography outright. Will review transparencies. Send material by mail for consideration. SASE. Reports in 1-2 months, "depending on our workload."
Tips: "Prepare a professional-looking packet of materials including high-quality slides, and always send a SASE. Never send original prints."

ALBER GALLERIES, 3300 Darby Rd., 5111, Haverford PA 19041-1072. (610)896-9297. Director: Howard Alber. Estab. 1977. Has shown work by Michael Hogan, Harry Auspitz (deceased), Barry Slavin, Joan E. Rosenstein, Ken Roberts (computer-restoration), and Joan Z. Rough. "Cooperative show space only. We do not have our own gallery space." General price range of work: $75-1,000.
• This is a private gallery with a very limited operation.
Exhibits: Professional presentation, well priced for sales, consistent quality and willingness to deliver promptly. Interested in Philadelphia subjects, land conservation, wetlands, artful treatments of creative presentation.
Making Contact & Terms: Charges 40% commission. Reviews transparencies; only as requested by us. Not interested in new presentations. Slides only on first presentation.
Tips: "Give us copies of all reproduced photos, calendars, etc., only if we can retain them permanently."

THE ALBUQUERQUE MUSEUM, 2000 Mountain Rd. NW, Albuquerque NM 87104. (505)243-7255. Fax: (505)764-6546. Curator of Art: Ellen Landis. Estab. 1967. Examples of previous exhibitions: "Gus Foster," by Gus Foster (panoramic photographs); "Santiago," by Joan Myers (b&w 16×20); and "Frida Kahlo," by Lola Alvaraz Bravo (b&w, various sizes). Presents 3-6 shows/year. Shows last 2-3 months.
Exhibits: Interested in all subjects.
Making Contact & Terms: Buys photos outright. Reviews transparencies. Interested in framed or unframed work, mounted or unmounted work, matted or unmatted work. Arrange a personal interview to show portfolio. Submit portfolio for review. Send material by mail for consideration. "Sometimes we return material; sometimes we keep works on file." Reports in 1 month.

AMERICAN SOCIETY OF ARTISTS, INC., Box 1326, Palatine IL 60078. (847)991-4748 or (312)751-2500. Membership Chairman: Helen Del Valle.
Exhibits: Members and nonmembers may exhibit. "Our members range from internationally known artists to unknown artists—quality of work is the important factor. We have about 25 shows throughout the year which accept photographic art."
Making Contact & Terms: Interested in framed, mounted or matted work only. Send SASE and 5 slides/ photos representative of your work and request membership information and application. Reports in 2 weeks. Accepted members may participate in lecture and demonstration service. Member publication: *ASA Artisan*.

ARIZONA STATE UNIVERSITY ART MUSEUM, Nelson Fine Arts Center, Tempe AZ 85287-2911. (602)965-2787. Fax: (602)965-5254. E-mail: artmuse@asuvm.inre.asu.edu. Website: http://www.asuam.fa. asu.edu. Director: Marilyn Zeitlin. Curator: Heather Lineberry. Estab. 1950. Examples of recent exhibits: "Big Sister/Little Sister," by Annie Lopez (photography and installation); "The Curtain Falls: Russian American Stories," by Tamarra Kaida (photography and installation); "Art on the Edge of Fashion," photographs by Elaine Reichek, Nich Vaughn and Beverly Semmes. Shows last 2-3 months. The ASU Art Museum has two facilities and approximately eight galleries of 2,500 square feet each; mounts over 20 exhibitions per year.
Exhibits: Work must be approved by curatorial staff as meeting museum criteria.
Making Contact & Terms: Sometimes buys photography outright for collection. Reviews transparencies. Interested in framed, mounted, matted work. Query with samples. Send material by mail for consideration. SASE. Reports "depending on when we can review work."

**FOR EXPLANATIONS OF THESE SYMBOLS,
SEE THE INSIDE FRONT AND BACK COVERS OF THIS BOOK.**

ART CENTER AT FULLER LODGE, 2132 Central Ave., Los Alamos NM 87544. (505)662-9331. Director: Gloria Gilmore-House. Non-profit visual arts organization. Estab. 1977. Examples of recent exhibits: "Through the Looking Glass 1998," regional show devoted exclusively to photography, initiated in 1993; "Contemporary Art 1999," a regional juried exhibition (all media); and "Traditional Fine Arts 1999," a regional juried competition (all media). Regional competitions open to residents of AZ, CO, NM, OK, TX and UT. Cash and sponsored awards presented after viewing actual works. Shows juried from 35mm slides. Presents 9-10 art shows/year, 3 of which are juried. Shows last 5-6 weeks. Interested in all styles and genres. General price range of work: $50-1,000. Most work sold at $100-200.
Exhibits: For more information and prospectus send SASE.
Making Contact & Terms: Charges 30% commission. Interested in framed or unframed, mounted or unmounted work. "Sales opportunity in the Gallery Shop for members: matted and framed photos under $200. Entry by jury committee. 30% commission." Query with résumé of credits. SASE. Reports in 3 weeks.
Tips: "Be aware that we never do one-person shows—artists must apply to scheduled shows. Work should show impeccable craftsmanship. We rely on a variety of expert jurors, so preferences vary show to show, but all subjects, styles are considered. Work must have been completed in last two years for consideration. Follow instructions on show entry forms. We do not do portfolio reviews."

N ART CONCEPTS BY DESIGN, P.O. Box 25173, Arlington VA 22202-9073. (703)965-3855. Director: Ja-Ney Sears. Art consultancy, for profit gallery. Estab. 1987. Approached by 20 artists a year; represents or exhibits 10 artists. Sponsors 2 photography exhibits per year. Average display time 3 months. Gallery open Monday through Friday from 10 to 5. Features lobby exhibitions for public and commercial retail spaces. Overall price range $1,000-5,000. Most work sold at $1,000.
Exhibits: Exhibits photos of celebrities, multicultural, environmental, landscapes/scenice, architecture, cities/urban, interiors/decorating, adventure, performing arts, travel, buildings, computers, industry, portraits, science, technology. Interested in alternative process, avant garde, digital, fashion/glamour, fine art, historical/vintage.
Making Contact & Terms: Artwork is accepted on consignment and there is a 15% commission. Artwork bought outright for 50% of retail price; net 15 days. Gallery provides contract. Accepted work should be mounted. Accepts only artists from USA and Europe. Perfers only photography. Mail portfolio for review. Send query letter with artist's statement, bio, photographs, résumé, reviews, SASE or slides. Returns material with SASE. Replies only if interested within 1 month. Finds artists through submissions, portfolio reviews, Internet.
Tips: "Submit professional looking portfolios with slide package. Use the latest graphics software for any layout (if available). Provide a complete bio."

N THE ART DIRECTORS CLUB, 250 Park Ave., S., New York NY 10003. (212)674-0500. Fax: (212)460-8506. E-mail: adcny@interport.net. Website: http://www.adcny.org. Associate Director: Olga Grisaitis. Estab. 1920. Examples of recent exhibits: "Young Guns NYC II"; Duffy Design, "Creative Oxygen," by Bartle, Bogle, Hagarty (BBH). Presents 8-10 shows/year. Shows last 1 month.
Exhibits: Exhibits photos of babies, celebrities, children, couples, multicultural, families, parents, senior citizens, teens, disasters, environmental, landscapes/scenics, wildlife, architecture, beauty, cities/urban, education, gardening, interiors/decorating, pets, religious, rural, adventure, automobiles, entertainment, events, food/drink, health/fitness, hobbies, humor, performing arts, sports, travel, agriculture, buildings, business concepts, computers, industry, medicine, military, political, portraits, product shots/still life, science, technology. Also interested in alternative process, avant garde, digital, documentary, erotic, fashion, glamour, fine art, historical/vintage, regional, seasonal. Must be a group show with theme and sponsorship. Interested in work for advertising, publication design, graphic design, new media.
Making Contact & Terms: Query with samples. Cannot return material. Reports depending on review committee's schedule.

N ART IN GENERAL, 79 Walker St., New York NY 10013. (212)219-0473. Fax: (212)219-0511. E-mail: info@artingeneral.org. Website: http://www.artingeneral.org. Assistant Director: Catherine Ruello. Alternative space, nonprofit gallery. Estab. 1981. Approached by hundreds of artists a year; represents or exhibits 50 artists. Sponsors variable number of photography exhibits per year. Average display time 6-8 weeks. Gallery open Tuesday through Saturday from 12 to 6. Closed Thanksgiving weekend, Christmas and New Year's Day. Located in downtown Manhattan. Arts in General offers 3,500 sq. ft. of exhibition space, divided into 2 gallery spaces, a street-level window exhibition and an audio piece in the elevator.
Exhibits: Exhibits photos of multicultural, performing arts. Interested in alternative process, avant garde, fine art.
Making Contact & Terms: Send query letter with SASE. Finds artists through open call.

Tips: "Label all work with the name of artist, date, media, photo credit (if necessary) and dimensions. Send complete application—follow guidelines exactly. For application guidelines send query letter and SASE."

▣ ART INDEPENDENT GALLERY, 623 Main, Lake Geneva WI 53147. (414)248-3612. Fax: (414)248-2227. Owner: Betty Sterling. Estab. 1968. Examples of recent exhibitions: Ray Hartl (landscapes, architectural details); Gail Jung-Kuffel (floral, fantasy); and David Roth (b&w landscapes). Presents 2-4 shows/year. Shows last several weeks. "Photography is always part of the mix." Sponsors openings; sends out invitations, provides entertainment and refreshments, hangs and sets up the show. General price range of work: $145-950.
Exhibits: Should be "beautiful—nothing overtly sexual or political. Contemporary styles are best." Interested in landscapes, florals and architectural details.
Making Contact & Terms: Charges 50% commission. Reviews transparencies. Interested in framed or unframed work. Requires exclusive representation in 10 mile radius. Works are limited to those that are not "outrageously large—4' × 5' is not acceptable." Arrange a personal interview to show portfolio. Query with résumé of credits. Send slides for review. SASE. Shows artists from Midwestern states only.

▣ ART INSTITUTE OF PHILADELPHIA, 1622 Chestnut St., Philadelphia PA 19103. (215)567-7080. Fax: (215)246-3339. Gallery Director: Kathryn Phelps. Estab. 1973. Examples of recent exhibits: George Krause (fine art, b&w); Lisa Goodman (commercial, b&w/color); Enrique Bostelmann (documentary, b&w/color). Presents 1 exhibit/year. Shows last 30 days. General price range of work: $150-2,000.
Exhibits: All work must be ready to hang under glass or Plexiglas; no clip frames. Interested in fine and documentary art.
Making Contacts & Terms: Interested in receiving work from established photographers. Sold in gallery. Reviews transparencies. Interested in matted or unmatted work. Query with samples. Include 10-20 slides and a résumé. SASE. Reports in 1 month.

▣ ▣ ART SOURCE L.A., INC., 11901 Santa Monica Blvd., Suite 555, Los Angeles CA 90025. (310)479-6649. Fax: (310)479-3400. E-mail: ellmanart@aol.com. Website: http://www.artsourcela.com. President: Francine Ellman. In Maryland: 182 Kendrick Place, Suite 32, North Potomac MD 20878. (301)208-9201. Fax: (301)208-8855. E-mail: bkogodart@aol.com. Director: Bonnie Kogod. Estab. 1980. Exhibitions vary. General price range of work: $300-15,000. Represents photographers Linda Adelstein, Sara Einstein, Robert Glenn Ketchum, Jill Enfield, Fae Horowitz, Lou Roberts.
Exhibits: "We do projects worldwide, putting together fine art for public spaces, hotels, restaurants, corporations, government, private collections." Interested in all types of quality work. "We use a lot of photography."
Making Contact & Terms: Interested in receiving work from emerging and established photographers. Charges 50% commission. Reviews transparencies. Interested in unframed work, mounted or matted OK. Submit portfolio for review. Include for consideration visuals, résumé, SASE. Reports in 1-2 months.
Tips: "We review actuals, video, CD ROM, photo disk transparencies, photographs, laser color and/or black and white, as well as pieces created through digital imagery or other high-tech means. Show a consistent body of work, well-marked and presented so it may be viewed to see its merits."

▣ ARTBEAT GALLERY, 3266 21st St., San Francisco CA 94110-2423. Phone/fax: (415)643-8721. Business Manager: Ana Montano. Estab. 1997. Examples of recent exhibits: Jeffrey Smith (b&w); René Peña (b&w); and Sa 'Longo Lee (b&w). Presents 1-3 shows/year. Shows last 5-8 weeks. Sponsors openings; provides publicity and hosts a reception with the artist. General price range of work: $75-500.
Exhibits: Complete and professional presentation—résumé; bio, samples of work; slides are fine. Interested in b&w, all subject matter.
Making Contact & Terms: Charges 40% commission. Reviews transparencies. Interested in framed or unframed work. Works are limited to no larger than 36 × 42. Query with samples. SASE. Reports in 1 month.

ARTISTS' COOPERATIVE GALLERY, 405 S. 11th St., Omaha NE 68102. (402)342-9617. President: Dale Skenefelt. Estab. 1974. Examples of exhibitions: works by Sue Lawler (all types of prints); Pam King (polaroid transfers); Dale Shenefelt (Dianatypes and Silver prints); Nancy Gould-Ratliff (Rolaroid image and emulsion prints); Alessandra Petersen (C-prints, large format prints); and Margie Schimenti (Cibachrome prints). Presents 14 shows/year. Shows last one month. Gallery sponsors 1 all-member exhibit and outreach exhibits, individual artists sponsor their own small group exhibits throughout the year. General price range of work: $100-300.
Exhibits: Fine art photography only. "Artist must be willing to work 13 days per year at the gallery or

pay another member to do so. We are a member-owned and-operated cooperative. Artist must also serve on one committee." Interested in all types, styles and subject matter.

Making Contact & Terms: Charges no commission. Reviews transparencies. Interested in framed work only. Query with résumé of credits. SASE. Reports in 2 months.

Tips: "Write for membership application. Membership committee screens applicants August 1-15 each year. Reports back by September 1. New membership year begins October 1. Members must pay annual fee of $300. Will consider well-known artists of regional or national importance for one of our community outreach exhibits. Membership is not required for outreach program and A gallery will host a one-month exhibit with opening reception."

ARTWORKS GALLERY, 233 Pearl St., Hartford CT 06103. (860)247-3522. Fax: (860)548-0779. Website: artworksgallery@erols.com. Executive Director: Judith Green. Estab. 1976. Examples of recent exhibits: Maria Reid Morsted, Roger Crossgrove and John Bryan. Shows last 1 month. General price range of work: $100-5,000. Most work sold at $500-800.

Exhibits: Exhibits photos of disasters, environmental, landscapes/scenics, wildlife, multicultural. "We have juried shows; members must be voted in after interview." Interested in contemporary work, alternative process, avant garde, digital, documentary, erotic, fine art.

Making Contact & Terms: There is a Co-op membership fee plus a donation of time. There is a 30% commission. Reviews transparencies. Send for membership application. SASE. Reports in 1 month.

Tips: "Have a close relationship with the gallery director. Be involved; go to events. Work!"

ASCHERMAN GALLERY/CLEVELAND PHOTOGRAPHIC WORKSHOP, 23500 Mercantile Rd., Suite D, Beachwood OH 44122. (216)464-4944. Fax: (216)464-3188. E-mail: herbasch@apk.net. Director: Herbert Ascherman, Jr. Estab. 1977. Sponsored by Cleveland Photographic Workshop. Presents 5 shows/year. Shows last about 10 weeks. Openings are held for some shows. Photographers are expected to contribute toward expenses of publicity. Overall price range $250-900. Most work sold at $300.

Exhibits: "All forms of photographic art and production." Subjects include celebrities, children, couples, environmental, landscapes/scenics, architecture, beauty, rural, performing arts, portraits. Interested in alternative process, avant garde, documentary, erotic, fashion/glamour, fine art, historical/vintage. "Membership is not necessary. A prospective photographer must show a portfolio of 40-60 slides or prints for consideration. We prefer to see distinctive work—a signature in the print, work that could only be done by one person, not repetitive or replicative of others."

Making Contact & Terms: Charges 25% commission, depending on the artist. Sometimes buys photography outright. Will review transparencies. Matted work only for show.

Tips: "Photographers should show a sincere interest in photography as fine art. Be as professional in your presentation as possible; identify slides with name, title, etc.; matte, mount, box prints. We are a Midwest gallery and we are always looking for innovative work that best represents the artist (all subject matter). We enjoy a variety of images and subject matters. Know our gallery; call first; find out something about us, about our background or interests. Never come in cold."

BARRON ARTS CENTER, 582 Rahway Ave., Woodbridge NJ 07095. (908)634-0413. Director: Stephen J. Kager. Estab. 1975. Examples of recent exhibitions: New Jersey Print Making Council. General price range of work: $150-400.

Making Contact & Terms: Photography sold in gallery. Charges 20% commission. Reviews transparencies but prefers portfolio. Submit portfolio for review. SASE. Reports "depending upon date of review but in general within a month of receiving materials."

Tips: "Make a professional presentation of work with all pieces matted or treated in a like manner. In terms of the market, we tend to hear that there are not enough galleries existing that will exhibit photography."

N: BELIAN ART CENTER, 5980 Rochester Rd., Troy MI 48098. (810)828-1001. Fax: (810)828-1905. Director: Zabel Belian. Estab. 1985. Examples of exhibits: "Ommagio," by Robert Vigilatti (people in motion); "Parian," by Levon Parian (reproduced on brass); and "Santin," by Lisa Santin (architectural). Presents 1-2 shows/year. Shows last 3 weeks. Sponsors openings. General price range of work: $200-2,000.

Exhibits: Originality, capturing the intended mood, perfect copy, limited edition. Subjects include landscapes, cities, rural, events, agriculture, buildings, still life.

Making Contact & Terms: Charges 40-50% commission. Buys photos outright. Reviews transparencies. Interested in framed or unframed, matted or unmatted work. Requires exclusive representation locally. No size limit. Arrange a personal interview to show portfolio. Query with résumé of credits. SASE. Reports in 1-2 weeks.

© Dennis Savage

"We are always on the lookout for new talent for exhibitions in our gallery," says Ascherman Gallery owner Herbert Ascherman, Jr. "Dennis Savage approached us with a comprehensive portfolio that emphasized his vision as a photographer and his craftsmanship as a printer." Savage discovered the Ascherman Gallery through their listing in *Photographer's Market*. "Most of my work is related to the natural environment where we live in southeastern Ohio. Even in this portrait of my daughter Katy, 'Katy as Medusa,' the snake skins are from our barn and the clay that covers her face and torso is from a nearby stream bed," Savage says.

BENHAM STUDIO GALLERY, 1216 First Ave., Seattle WA 98101. (206)622-2480. Fax: (206)622-6383. E-mail: benham@halcyon.com. Website: http://www.halcyon.com/benham. Owner: Marita Holdaway. Estab. 1987. Examples of recent exhibitions: works by Michael Gesinger-toned nudes; Phil Borges-selectively toned portraits from Africa & Indonesia; landscapes by David Fokes. Presents 9 shows/year. Shows last 6 weeks. Overall price range $250-9,750. Most work sold at $500.
Exhibits: Photos of architecture, multicultural, environmental, landscapes/scenics, humor, travel. Interested in alternative process, avant garde, digital, documentary, erotic, fine art, historical/vintage.
Making Contact & Terms: Call in December for review criteria. Charges 50% commission.
Tips: "Present 15-20 pieces of cohesive work in an easy to handle portfolio."

[N] BONNI BENRUBI GALLERY, 52 E. 76th St., New York NY 10021. (212)517-3766. Fax: (212)288-7815. Director: Karen Marks. Estab. 1987. Examples of recent exhibits: "Early Work: 1930's," by Andreas Feninger (vintage prints); "Quiet Grace," by Tom Baril (contemporary); and "Paris/NY," by Louis Steltner (modern). This gallery represents numerous photographers, including Merry Alpern, Dick Arentz, Andreas Feininger, Rena Bass Forman, Joel Meyerowitz, Tom Baril and Abelardo Morell. Presents 7-8 shows/year. Shows last 6 weeks. General price range of work: $500-50,000.
Exhibits: Portfolio review is the first Thursday of every month. Out-of-towners can send slides with SASE and work will be returned. Interested in 19th and 20th century photography, mainly contemporary.
Making Contact & Terms: Charges commission. Buys photos outright. Reviews transparencies. Accepted work should be matted. Requires exclusive representation locally. No manipulated work. Submit portfolio for review. SASE. Reports in 1-2 weeks.

[■] MONA BERMAN FINE ARTS, 78 Lyon St., New Haven CT 06511. E-mail: mbfineart@snet.com. Director: Mona Berman. Estab. 1979. Examples of previous exhibits: "From the Occident to the Orient: Part 2," featuring photographs of Angkor Wat by Tom Hricko. Presents 0-1 exhibits/year. Shows last 1 month. General price range of work: $300-1,200. Most work sold at $700.
 • "We are primarily art consultants serving corporations, architects and designers. We also have private clients. We hold very few exhibits; we mainly show work to our clients for consideration and sell a lot of photographs."
Exhibits: "Photographers must have been represented by us for over two years. Interested in all except figurative, although we do use some portrait work."
Making Contact & Terms: Charges 50% commission. "Payment to artist 30 days after receipt of payment from client." Reviews 35mm transparencies only. Interested in seeing unframed, unmounted, unmatted work only. Accepts images in digital format for Windows. Send via online or Zip disk. Inquire about file format first. Submit portfolio for review (35mm slides only). Query with résumé of credits. Send material by mail for consideration (35mm slides with RETAIL prices and SASE). Reports in 1 month.
Tips: "Looking for new perspectives, new images, new ideas, excellent print quality, ability to print in large sizes, consistency of vision."

JESSE BESSER MUSEUM, 491 Johnson St., Alpena MI 49707. (517)356-2202. Chief of Resources: Robert Haltiner. Estab. 1965. Examples of exhibits: "Ophthalmic Images," extreme color close-ups of the eye and its problems by Csaba L. Martonyi; "One-Percent—To The Right," by Scott J. Simpson (color photography); "Fall-En Leaves: Primal Maps Home," by David Ochsner (Ilfochrome photography). Presents 1-2 shows/year. Shows last 6-8 weeks. Price range: $50-500. Most work sold at $150-200.
Exhibits: Interested in a variety of photos suitable for showing in general museum.
Making Contact & Terms: Charges 20% sales commission. "However, being a museum, emphasis is not placed on sales, per se." Reviews transparencies. Submit samples to Chief of Resources, Robert Haltiner. Framed work only. SASE for return of slides. Reports in 2 weeks. "All work for exhibit must be framed and ready for hanging. Send *good* slides of work with résumé and perhaps artist's statement. Trend is toward manipulative work to achieve the desired effect."
Tips: Most recently, northern Michigan scenes sell best.

[N] BLACKFISH GALLERY, 420 NW Ninth Ave., Portland OR 97209. (503)224-2634. Director: Stephanie Schlicting. Estab. 1979. Examples of recent exhibits: Tina Dworakowski (photos); and Nancy Helmsworth (photos, collage). Shows last 1 month. Sponsors openings; "Members greet guests so artist is free to talk with people." General price range of work: $300.
Exhibits: "Applicant must be willing to join the gallery. BlackFish is a cooperative gallery. Invitation fee is $150; monthly dues are $70, and member must be able to sit at the gallery 12-5 p.m. once per month." Interested in all types, subject to approval by membership.
Making Contact & Terms: Charges 40% commission. Interested in framed or unframed, mounted or

Paul Bridgewater of the Bridgewater/Lustberg Gallery in New York discovered the work of photographer Sheryl Rubinstein through a studio visit. This self-portrait was part of a recent solo exhibition at the gallery. "This image was created by the Cliché-verre technique, which was first developed in the 19th century. It is a self-portrait and I've updated the technique using 20th century laser technology," Rubinstein says. "I've had many responses from buyers, dealers and art consultants, all of whom have liked my work very much."

© Sheryl Rubinstein

unmounted, matted or unmatted work. Submit portfolio for review. Send material by mail for consideration. Include résumé of credits and galleries. SASE.

Tips: "Make sure the body of work submitted represents your most recent work."

BOOK BEAT GALLERY, 26010 Greenfield, Oak Park MI 48237. (248)968-1190. Fax: (248)968-3102. E-mail: bookbeat@aol.com. Director: Cary Loren. Estab. 1982. Examples of recent exhibitions: "Male Nudes," by Bruce of Los Angeles; "Stills from Andy Warhol," by Billy Name (films); "Mr. Lotus Smiles," by Jeffrey Silverthorne (still life). Presents 6-8 shows/year. Shows last 1-2 months. General price range of work: $200-5,000.

Making Contact & Terms: Charges 50% commission. Buys photos outright. Reviews transparencies. Interested in framed or unframed, mounted or unmounted, matted or unmatted work. Arrange a personal interview to show portfolio. Query with samples. Submit résumé, artist's statement, slide sheets and SASE for return of slides. Reports in 1-2 months.

Tips: "We have just published our first catalog and are marketing some of our photographers internationally. Photographers should display a solid portfolio with work that is figurative, documentary, surrealistic, off-beat, mythological or theatrical."

N ▣ **BRIDGEWATER/LUSTBERG GALLERY**, 560 Broadway, New York NY 10012. (212)941-6355. Fax: (212)941-7712. E-mail: bridgelust@aol. President: Paul Bridgewater. For profit gallery. Estab. 1974. Sponsors 2-3 photography exhibits per year. Average display time 5 weeks. Gallery open Tuesday through Saturday from 12 to 6. Closed August. Located in one of Soho's premier gallery buildings at Broadway and Prince. Overall price range $300-20,000. Most work sold at $2,000.

Exhibits: Exhibits photos of architecture, cities/urban, landscapes/scenics, wildlife, travel, buildings, still life. Interested in alternative process, digital, fine art.

Making Contact & Terms: Artwork is accepted on consignment and there is a 50% commission. Gallery provides insurance, promotion. Accepted work should be framed. Requires exclusive representation locally. Call/write to arrange personal interview to show portfolio of slides. Send query letter with bio, brochure, reviews, SASE, slides. Replies in 1 month. Finds artists through word of mouth, submissions, referrals by other artists.

Tips: "All submitted slides should have sizes, titles and technique."

N **J.J. BROOKINGS GALLERY**, 669 Mission St., San Francisco CA 94105. (415)546-1000. Director: Timothy C. Duran. Examples of exhibitions: James Crable, Lisa Gray, Ansel Adams, Eberhard Grames, Misha Grodin, Irving Penn, Edward S. Curtis, Nicholas Pavlov, Ben Schonzeit, Sandy Skoglund, Robert

Glenn Ketchum and Todd Watts. Presents rotating group shows. Sponsors openings. General price range of work: $500-15,000.

Exhibits: Professional presentation, realistic pricing, numerous quality images. Interested in photography created with a painterly eye.

Making Contact & Terms: Charges 50% commission. Reviews transparencies. Send material by mail for consideration. Reports in 3-5 weeks; "if not acceptable, reports immediately."

Tips: Interested in "whatever the artist thinks will impress us the most. 'Painterly' work is best. No documentary or politically-oriented work."

THE CAMERA OBSCURA GALLERY, 1309 Bannock St., Denver CO 80204. (303)623-4059. E-mail: hgould@iws.net. Website: http://www.thor.he.net/~methney. Owner/Director: Hal Gould. Estab. 1980. Approached by 350 artists a year; represents or exhibits 20 artists. Examples of recent exhibitions: "Still in the Dark" by Jerry Uelsmann; "Two Generations" by Paul Caponigro and John Paul Caponigro; and "Retrospective" by Willy Ronnis (France). Sponsors 8 photography exhibits/year. Open Tuesday through Saturday from 10 to 6; Sunday from 1 to 5, all year. Overall price range $350-20,000. Most work sold at $500.

Making Contact & Terms: Artwork is accepted on consignment. Write to arrange a personal interview to show portfolio of photographs. Send bio, brochure, résumé, reviews. Replies in 1 month. Finds artists by word of mouth, submissions, portfolio reviews, art exhibits, art fairs, referrals by other artists, reputation.

Tips: "To make a professional gallery submission, provide a good representation of your finished work that is of exhibition quality. Slowly but certainly we are experiencing a more sophisticated audience. The last few years have shown a tremendous increase in media reporting on photography-related events and personalities, exhibitions, artist profiles and market news."

N WILLIAM CAMPBELL CONTEMPORARY ART, Dept. PM, 4935 Byers Ave., Ft. Worth TX 76107. (817)737-9566. Owner/Director: William Campbell. Estab. 1974. Examples of previous exhibitions: A group show, "The Figure In Photography: An Alternative Approach," by Patrick Faulhaber, Francis Merritt-Thompson, Steven Sellars, Dottie Allen and Glenys Quick. Presents 8-10 shows/year. Shows last 5 weeks. Sponsors openings; provides announcements, press releases, installation of work, insurance, cost of exhibition.

Exhibits: "Primarily interested in photography which has been altered or manipulated in some form."

Making Contact & Terms: Charges 50% commission. General price range of work: $300-1,500. Reviews transparencies. Interested in framed or unframed work; mounted work only. Requires exclusive representation within metropolitan area. Send slides and résumé by mail. SASE. Reports in 1 month.

CAPITOL COMPLEX EXHIBITIONS, Florida Division of Cultural Affairs, Department of State, The Capitol, Tallahassee FL 32399-0250. (850)487-2980. Fax: (850)922-5259. E-mail: sshaughnessy@mail.do s.state.fl.us. Website: www.dos.state.fl.us. Arts Administrator: Sandy Shaughnessy. Examples of recent exhibits: J.D. Hayward (b&w); Mark Alan Francis (b&w); and Janet Finnegan (color). Shows last 3 months.

Exhibits: Exhibits photos of babies, celebrities, children, couples, multicultural, families, parents, senior citizens, teens, landscapes/scenics, wildlife, architecture, beauty, cities/urban, gardening, pets, adventure, buildings, military, portraits, still life. Interested in fine art, historical/vintage, regional, seasonal. "The Capitol Complex Exhibitions Program is designed to showcase Florida artists and art organizations. Exhibition spaces include the Capitol Gallery (22nd floor), the Cabinet Meeting Room, the Old Capitol Gallery, the Secretary of State's Reception Room and the Florida Supreme Court. Exhibitions are selected based on quality, diversity of medium, and regional representation."

Making Contact & Terms: Does not charge commission. Interested in framed work only. Request an application. SASE. Reports in 3 weeks. Only interested in Florida artists or arts organizations.

N CLAUDIA CARR GALLERY, 478 W. Broadway, New York NY 10012. (212)673-5518. Fax: (212)673-0123. E-mail: claudiacarr@erols.com. Owner: Claudia Carr. Gallery. Estab. 1995. Approached by 120 artists/year. Sponsors 1-2 photography exhibits/year. Shows last 4-6 weeks. Open Wednesday-Saturday from 11 a.m. to 5:30 p.m. Closed from Christmas to New Year's and mid-July to August. Small, intimate SoHo Gallery. Overall price range of work: $300-6,000.

MARKET CONDITIONS are constantly changing! If you're still using this book and it's 2001 or later, buy the newest edition of *Photographer's Market* at your favorite bookstore or order directly from Writer's Digest Books.

Exhibits: Architectural and historical/vintage photographs.

Making Contact & Terms: Artwork is accepted on consignment and there is a 50% commission. Gallery provides insurance, promotion. Accepted work should be framed, mounted, matted. Requires exclusive representation locally.

Submissions: Write to arrange personal interview to show portfolio of photographs, transparencies, slides. Send query letter with bio, photocopies, photographs, résumé, slides, SASE. Replies in 2 months. Finds artists through word of mouth, referrals by other artists.

Tips: "Write cover letter, include biographical information. Make certain to include SASE. Be professional."

SANDY CARSON GALLERY, 125 W. 12th Ave., Denver CO 80202. (303)573-8585. Fax: (303)573-8587. E-mail: scarson@ecentral.com. Director: Beth McBride. Estab. 1975. Examples of recent exhibits: "We the People," by Rimma & Valeriy Gerlovin (color); "Recent Exposures," by Peter de Lory and others (b&w and color); photography by Thomas Harris, Carolyn Krieg, David Teplica, Rimma & Valeriy Gerlovin, Gary Isaacs; Teresa Camozzi (photo college). Shows last 6 weeks.

Exhibits: Professional, committed, body of work and continually producing new work. Interests vary.

Making Contact & Terms: Charges 50% commission. Reviews transparencies. Interested in framed or unframed, matted or unmatted work. Requires exclusive representation locally. Send material by mail for consideration. SASE. Reports in 6-8 weeks.

Tips: "We like an original point of view and properly developed prints. We are seeing more photography being included in gallery shows."

KATHARINE T. CARTER & ASSOCIATES, P.O. Box 2449, St. Leo FL 33574. (352)523-1948. Fax: (352)523-1949. New York: 7 W. 87th St., 2C New York NY 10024. (212)533-9530. Fax: (212)874-7843. Website: http://www.ktcassoc.com. E-mail: ktc@ktcassoc.com. Executive Director: Katharine T. Carter. Estab. 1985. Examples of recent exhibitions: Joan Rough (Cibachrome); Sally Crooks-Holst (Polaroid); Danny Conant (Polaroid Transfer); Marian Bingham (Mixed-media). Schedules one-person and group museum exhibitions and secures gallery placements for artist/clients. The company is a marketing and public relations firm for professional artists working in all media.

Exhibits: One-person and thematic group exhibitions are scheduled in mid-size museums and art centers as well as alternative, corporate and better college and university galleries.

Making Contact & Terms: Services are fee based. Reviews transparencies. Send résumé and slides. SASE to Marty Menane, Director of Artist Services at the St. Leo address.

Tips: "Katherine T. Carter & Associates is committed to the development of the careers of its artist clients. Gallery space in St. Leo, Florida is primarily used to exhibit only the work of artist/clients with whom long standing relationships have been built over many years and for whom museum exhibitions have been scheduled. For professionals working with highly innovative and alternative forms of photography, they may contact Michael von Üchtrup, the Associate Director of the New York office, who is an independent curator; he will accept slides and résumés in the following areas of experimental, contemporary photography: cameraless or lenseless photography, holography, x-ray, ultraviolet and infrared, lenticular, and techniques from the arts and sciences."

N CENTER FOR CREATIVE PHOTOGRAPHY, The University of Arizona, P.O. Box 210103, Tucson AZ 85721. (520)621-7968. Fax: (520)621-9444. E-mail: oncenter@ccp.arizona.edu. Website: http://www.creativephotography.org. Curatorial Assistant: Pat Evans. Museum, museum retail shop. Estab. 1975. Sponsors 6-7 photography exhibits per year. Average display time 6-7 weeks. Gallery open Monday through Friday from 9 to 5; weekends from 12 to 5. Closed Christmas, Thanksgiving, most holidays. 5,500 sq. ft.

Making Contact & Terms: Portfolios are only reviewed 2-3 times/year. Send query letter with artist's statement, bio, business card, photographs, résumé, reviews, slides.

N ■ CENTER FOR EXPLORATORY AND PERCEPTUAL ART, 617 Main St., Suite 201, Buffalo NY 14203. (716)856-2717. Fax: (716)856-2720. E-mail: cepa@aol.com. Website: http://cepa.buffnet.net. Curator: Robert Hirsch. Estab. 1974. "CEPA is an artist-run space dedicated to presenting photographically based work that is under-represented in traditional cultural institutions." The total gallery space is approximately 6,500 square feet. Examples of recent exhibitions: 25th Anniversary Members show and 4th Annual Emerging Artists Exhibition. Presents 5-6 shows/year. Shows last 6 weeks. Sponsors openings; reception with lecture. General price range of work: $200-3,500.

• CEPA conducts an annual Emerging Artist Exhibition for its members. You must join the gallery in order to participate.

Exhibits: Interested in political, culturally diverse, contemporary and conceptual works.

Making Contact & Terms: Extremely interested in exhibiting work of newer, lesser-known photographers. Reviews 10-20 transparencies. Interested in framed or unframed, mounted or unmounted, matted or unmatted work. Query with résumé of credits. Send artist's statement and material by mail for consideration. Accepts images in digital format for Mac (PICT or TIFF). Send via compact disc, floppy disk, or Zip disk. SASE. Reports in 3 months.

Tips: "We review CD-ROM portfolios and encourage digital imagery. We will be showcasing work on our website."

CENTER FOR PHOTOGRAPHIC ART, P.O. Box 1100, Suite 1, San Carlos & Ninth Ave., Carmel CA 93921. (831)625-5181. Fax: (831)625-5199. Estab. 1988. Examples of recent exhibits: "Immediate Family," by Sally Mann (b&w large format); Michael Kenna (b&w medium format); "Oil on Silver," by Holly Roberts (b&w, overpainted oils on large-scale prints). Presents 7-8 shows/year. Shows last 5-7 weeks.

Exhibits: Interested in fine art photography.

Making Contact & Terms: Reviews transparencies. Interested in slides. Send slides, résumé and artists statement with cover letter. SASE. Reports in 1 month.

Tips: "Submit for exhibition consideration: slides or transparencies accompanied by a concise bio and artist statement. We are a nonprofit."

CENTER FOR PHOTOGRAPHY AT WOODSTOCK, 59 Tinker St., Woodstock NY 12498. (914)679-9957. Fax: (914)679-6337. E-mail: cpwphoto@aol.com. Website: http://users.aol.com/cpwphoto. Associate Director: Kathleen Kenyon. Alternative space, nonprofit gallery. Approached by over 100 artists a year. Estab. 1977. Examples of previous exhibits: "Home is Where the Heart Is"; "Mirror-Mirror"; and "High Anxiety" (all were group shows). Sponsors 10 photography exhibits per year. Shows last 6 weeks. Sponsors openings. Open Wednesday through Sunday from 12:00-5:00. Closed January. Overall price range $500-1,000.

Exhibits: Interested in all creative photography, including photos of babies, celebrities, children, couples, multicultural, families, parents, senior citizens, teens, disasters, environmental, landscapes/scenics, wildlife, architecture, beauty, cities/urban, education, gardening, interiors/decorating, pets, religious, rural, adventure, automobiles, entertainment, events, food/drink, health/fitness, hobbies, humor, performing arts, sports, travel, agriculture, buildings, business concepts, computers, industry, medicine, military, political, portraits, still life, science, technology. Interested in alternative process, avant garde, digital, documentary, erotic, fashion/glamour, fine art, historical/vintage, regional, seasonal.

Making Contact & Terms: Charges 25% sales commission. Gallery provides insurance, promotion and contract. Accepted work should be framed. Primarily represents art photography. Send 20 slides plus cover letter, résumé and artist's statement by mail for consideration. SASE. Reports in 4 months. Finds artists through word of mouth, art exhibits, portfolio reviews and referrals by other artists.

Tips: "We are closed Mondays and Tuesdays. Interested in innovative, contemporary work. Emerging and minority photographers encouraged."

THE CENTRAL BANK GALLERY, Box 1360, Lexington KY 40590. In U.S. only (800)637-6884. In Kentucky (800)432-0721. Fax: (606)253-6244. Curator: John G. Irvin. Estab. 1987. Examples of recent exhibits: "Travels," by Herb Abendt; "Alaska Today" by David Massey; and "Stealing Home" by Doug Flynn. Presents 2-3 photography shows/year. Shows last 3 weeks. "We pay for everything, invitations, receptions and hanging. We give the photographer 100 percent of the proceeds." General price range of work: $75-1,500.

Exhibits: No nudes and only Kentucky photographers. Interested in all types of photos.

Making Contact & Terms: Charges no commission. Query with telephone call. Reports back probably same day.

Tips: "We enjoy encouraging artists."

CENTRAL CALIFORNIA ART LEAGUE GALLERY, 1402 "I" St., Modesto CA 95354. (209)529-3369. Fax: (209)529-9002. E-mail: ccal@a.com. Estab. 1951.

Exhibits: "League members judge artwork the first and third Wednesday of the month. Interested in landmarks, landscapes and personalities of Central California.

Making Contact & Terms: Charges 30% commission. Interested in framed or unframed, mounted, matted or unmatted work. Cannot return material.

CHAPMAN ART CENTER GALLERY, Cazenovia College, Cazenovia NY 13035. (315)655-7162. Fax: (315)655-2190. E-mail: jaistars@cazcollege.edu. Director: John Aistars. Estab. 1978. Examples of recent exhibits: "Bridge of Transparent Hours," by Leslie Yudelson (b&w surrealistic photos); Jeri Robinson (Cibachrome prints); "Masterworks of 20th Century Photography" (collection of Donald Baxter).

Presents 1-2 shows/year. Shows last 3-4 weeks. "The Cazenovia College Public Relations Office will publicize the exhibition to the news media and the Cazenovia College community, but if the artist wishes to schedule an opening or have printed invitations, it will have to be done by the artist at his/her own expense. College food service will provide a reception for a fee." General price range of work: $150-300.
Exhibits: Submit work by March 1. Interested in "a diverse range of stylistic approaches."
Making Contact & Terms: Charges no commission. Reviews transparencies. Interested in framed or unframed, mounted or unmounted, matted or unmatted work. Send material by mail for consideration. SASE. Reports approximately 3 weeks after Exhibitions Committee meeting.
Tips: "The criteria in the selection process is to schedule a variety of exhibitions every year to represent different media and different stylistic approaches; other than that, our primary concern is quality."

CATHARINE CLARK GALLERY, 49 Geary St., 2nd Floor, San Francisco CA 94108. (415)399-1439. Fax: (415)399-0675. E-mail: morphos@cclarkgallery.com. Website: http://www.cclarkgallery.com. Director: Catharine Clark (via slide submission only). For profit gallery. Estab. 1991. Approached by 500 artists a year; represents or exhibits 13 artists. Sponsors 1-3 photography exhibits per year. Average display time 4-6 weeks. Gallery open Tuesday through Friday from 10:30 to 5:30; Saturday from 11 to 5:30. Closed August. Located in downtown San Francisco in major gallery building (with 13 other galleries) with 2,000 sq. ft. of exhibition space. Overall price range $200-150,000. Most work sold at $2,500.
Exhibits: Exhibits photos of environmental, landscapes/scenics, gardening, adventure. Interested in alternative process, avant garde, digital. Other specific subjects/processes: The work shown tends to be vanguard both with respect to medium concept and process.
Making Contact & Terms: Artwork is accepted on consignment and there is a 50% commission. Gallery provides insurance, promotion. Accepted work should be framed, mounted, matted. Requires exclusive representation locally. General emphasis is on West Coast artists.
Submissions: "Do not call. Submit slides or 4×5 transparencies. Send query letter with artist's statement, bio, résumé, reviews, SASE. Returns material with SASE. Slides are reviewed in August and December. Finds artists through word of mouth, submissions, portfolio reviews, art exhibits, art fairs, referrals by other artists.
Tips:

CLEVELAND STATE UNIVERSITY ART GALLERY, 2307 Chester Ave., Cleveland OH 44114. (216)687-2103. Fax: (216)687-9340. E-mail: r.thurmer@popmail.csuohio.edu. Website: http://www.csuohio.edu/artgallery. Director: Robert Thurmer. Estab. 1973. Examples of recent exhibits: "Re-Photo Construct," with Lorna Simpson; "El Salvador," by Steve Cagan; "In Search of the Media Monster," with Jenny Holzer; and "Body of Evidence: The Figure in Contemporary Photography," by Dieter Appelt, Cindy Sherman, Joel Peter Witkin and others, curated by Robert Thurmer (1995). Presents 0-1 show/year. Shows last 1 month. General price range of work: $100-1,000. Most work sold at $300.
Exhibits: Photographs must be of superior quality. Interested in all subjects and styles. Looks for professionalism, creativity, uniqueness.
Making Contact & Terms: Artwork is accepted for exhibition—sales are incidental—gallery gets 25% commission. Reviews transparencies. Interested in framed or unframed, mounted or unmounted, matted or unmatted work. Send material by mail for consideration. SASE. Reports within 3 months.
Tips: "Write us! Do not submit oversized materials. This gallery is interested in new, challenging work—we are not interested in sales (sales are a service to artists and public)."

COASTAL CENTER FOR THE ARTS, INC., 2012 Demere Rd., St. Simons Island GA 31522. Phone/fax: (912)634-0404. E-mail: coastalart@thebest.net. Director: Mittie B. Hendrix. Estab. 1946. Examples of recent exhibits: "Nature & Wildlife," by Micki Sandford (nature studies); "Photo National/99"; and "Photoworks." Presents 2 shows/year. Shows last 3 weeks. Art center includes six galleries and four classrooms for a total of 12,000 sq. ft. General price range of work: $1,000-3,000.
Exhibits: Exhibits photos of babies, children, couples, multicultural, families, senior citizens, teens, landscapes/scenics, wildlife, architecture, beauty, cities/urban, education, gardening, interiors/decorating, pets, religious, rural, performing arts, portraits. Interested in alternative process, avant garde, digital, documentary, fine art, historical/vintage, regional, seasonal. Unframed work must be shrink-wrapped for bin; framed work must be ready for hanging. Looking for "photo art rather than 'vacation' photos."
Making Contact & Terms: Charges 30% commission to members; 40% to nonmembers. Reviews transparencies. Interested in framed or unframed work. "We have six galleries and can show photos of all sizes." Send slides and résumé of credits. SASE. Reports in 3-4 weeks.
Tips: "In past years national jurors selected computer art to be hung in our annual Artists' National, considered the year's premiere exhibit for the region. If framed, use a simple frame. Know what the gallery mission is—more fine art (as we are) or walk-in tourists (as others in the area). Use a good printer. Do not

substitute other work for work selected by the gallery. Don't 'overframe' (a common error). Use simple frame."

STEPHEN COHEN GALLERY, 7358 Beverly Blvd., Los Angeles CA 90036. (323)937-5525. Fax: (323)937-5523. E-mail: sc@stephencohengallery.com. Website: http://www.stephencohengallery.com. Photography and photo-based art gallery. Estab. 1992. Approximately 10 shows per year; represents 40 artists. Exhibited artists include Lynn Geesaman, Bill Witt, Luis Gonzales Palma, Lauren Greenfield, John Dugdale. Examples of recent exhibits: "In Primary Light," by Frederic Weber (cibachrome soft-focus portraits); "Portraits in Life and Death," by Peter Hujar; "New Work," by Luis Gonzalez Palma (mixed media compositions). Average display time 1 month. Gallery open Tuesday through Saturday from 11 to 5; all year. "We are a large, spacious, clean gallery and are flexible in terms of types of shows we can mount." Overall price range $400-20,000. Most work sold at $2,000.
Exhibits: All styles of photography and photo-based art.
Making Contact & Terms: Artwork is accepted on consignment and there is a 50% commission. Gallery provides insurance, promotion, contract. Requires exclusive representation locally. Mail portfolio for review. Send query letter with artist's statement, bio, brochure, business card, photographs, résumé, reviews, SASE. Replies only if interested within 3 months. Finds artists through word of mouth, published work.
Tips: "Photography is still the best bargain in 20th century art. There are more people collecting photography now, increasingly sophisticated and knowledgeable people aware of the beauty and variety of the medium."

N: THE COLLECTIVE GALLERY, 3121 Huntoon, Topeka KS 66604-1662. (785)234-4254. E-mail: thecolgal@aol.com. Website: http://members.aol.com/thecolgal/thecollective.html. President: Phil Jones. Cooperative gallery. Estab. 1988. Approached by 25 artists/year; exhibits 30 artists/year. Sponsors 1-2 photography exhibits/year. Shows last 1 month. Open Wednesday-Saturday from 12 p.m. to 4 p.m.; weekends from 10 a.m. to 5 p.m. The exhibition space is long and narrow, white walls, 2 levels, lots of street exposure. Overall price range of work: $25-2,000. Most work sold at $400.
Exhibits: Interested in alternative process, avant garde, digital and fine art photography.
Making Contact & Terms: Artwork is accepted on consignment basis and there is a 40% commission. If the artist is a member of the Co-op, there is a Co-op membership fee plus a donation of time and a 30% commission. Gallery provides insurance, promotion, contract. Accepted work should be framed, matted, mounted.
Submissions: Call or write to arrange a personal interview to show portfolio of photographs, slides. Send query letter with artist's statement, photographs, résumé, SASE. Returns material with SASE. Replies only if interested within 2 months. Finds artists through submissions, word of mouth, art fairs, art exhibits, portfolio reviews, referrals by other artists.
Tips: "Please send typed résumé, artist's statement and a couple of slides or photographs that best represent your work. We will contact artist for additional information if the work fits into our gallery."

■ COLLECTOR'S CHOICE GALLERY, 20352 Laguna Canyon Rd., Laguna Beach CA 92651-1164. Phone/fax: (714)494-8215. E-mail: canyonco@aol.com. Director: Beverly Inskeep. Estab. 1979. Examples of recent exhibits: "Deceptions," by Jennifer Griffiths (photo magic); "Portraits," by Glenn Aaron and D. Richardson (faces around world). General price range of work: $25-3,000 and "models." Most work sold at $800.
Exhibits: Exhibits photos of celebrities, multicultural, environmental, landscapes/scenics, architecture, performing arts, travel, portraits. Interested in vintage styles, surrealism, computer-enhanced works, documentary, erotic, fine art, historical/vintage, digital.
Making Contact & Terms: Charges 40% commission. Buys photos outright. Interested in unframed, unmounted and unmatted work only. Accepts images in digital format for Windows. Send via compact disc or Online (150 dpi). Works are limited to unmounted, 13′×16′ largest. No minimum restrictions. Send material by mail for consideration. SASE. Reports in 3 weeks.
Tips: "When we review a freelancer's portfolio we look for a large body of work . . . sustainable inventory skills and a unique eye on the subject."

N: COMMENCEMENT ART GALLERY, 902 Commerce, Tacoma WA 98402-4407. (253)591-5341. Fax: (253)591-5232. E-mail: balvez@ci.tacoma.wa.us. Website: http://www.ci.tacoma.wa.us. Gallery Coordinator: Benjamin Meeker. Estab. 1993. Presents 48 shows/year. Shows last 1 month. Sponsors openings; sends full-color postcard to mailing list of 1,500; food and beverages catered. General price range of work: $300-1,000. Most work sold at $450.
Exhibits: "We are open to all photographic media art as it relates to contemporary art practice. Photographs may be 'stand alone' or integrated into a larger work of art." Must be Washington resident. Interested in

all subjects including alternative process, avant garde, digital, documentary, fine art.
Making Contact & Terms: Does not charge commission. Potential buyers are referred directly to artists. The gallery does no sales itself. Work limited to those ready to hang. Send résumé, 10 slides and slide list for entry into juried competition held in June of every year. No fee. Reports upon completion of jury process.
Tips: "We are interested in receiving challenging photographic work from Washington State artists that 'posters' at the boundaries of the media."

CONCEPT ART GALLERY, 1031 S. Braddock, Pittsburgh PA 15218. (412)242-9200. Fax: (412)242-7443. Director: Sam Berkovitz. Estab. 1972. Examples of exhibits: "Home Earth Sky," by Seth Dickerman and "Idyllic Pittsburgh," 20th century photographs by Orlando Ramig, Selden Davis, Luke Swank, Mark Perrot, Pam Bryan, Charles Biddle and others.
Exhibits: Desires "interesting, mature work," work that stretches the bounds of what is perceived as typical photography.
Making Contact & Terms: Payment negotiable. Reviews transparencies. Interested in unmounted work only. Requires exclusive representation within metropolitan area. Send material by mail for consideration. SASE.
Tips: "Mail portfolio with SASE for best results. Will arrange appointment with artist if interested."

N THE CONTEMPORARY ARTS CENTER, Dept. PR, 115 E. Fifth St., Cincinnati OH 45202. (513)345-8400. Fax: (513)721-7418. Contact: Curator. Nonprofit arts center. Examples of recent exhibits: "Jim Dine Photographs." Presents 5 installations/year with 1-3 shows per installation. Shows last 6-12 weeks. Sponsors openings; provides printed invitations, music, refreshments, cash bar. General price range of work: $200-500.
Exhibits: Photographer must be selected by the curator and approved by the board. Interested in avant garde, innovative photography.
Making Contact & Terms: Photography sometimes sold in gallery. Charges 15% commission. Reviews transparencies. Send query with résumé and slides of work. SASE. Reports in 2 months.

N CONTEMPORARY ARTS COLLECTIVE, 103 E. Charleston Blvd., Las Vegas NV 89104. (702)382-3886. Website: http://www.contemporary.artscollective.org. Director: Diane Bush. Nonprofit gallery. Estab. 1989. Sponsors 9 total exhibits per year. Average display time 5 weeks. Gallery open Tuesday through Saturday from 12 to 5; weekends from 12 to 5. Closed Christmas, Thanksgiving, New Year's Day. 710 sq. ft. Overall price range $200-2,000. Most work sold at $400.
Exhibits: Interested in alternative process, avant garde, digital, documentary, fine art.
Making Contact & Terms: Artwork is accepted through annual call for proposals of self-curated group shows, and there is a 20% commission. Gallery provides insurance, promotion, contract. Call/write to arrange personal interview to show portfolio of photographs or transparencies or send query letter with SASE. Finds artists through annual call for proposals, word of mouth, submissions, portfolio reviews, art exhibits, art fairs, referrals by other artists and walk-ins.
Tips: Submitted slides should be "well labeled and properly exposed with correct color balance."

THE COPLEY SOCIETY OF BOSTON, 158 Newbury St., Boston MA 02116. (617)536-5049. Fax: (617)267-9396. Gallery Manager: Karen Pfefferle. Estab. 1879. A nonprofit institution. Examples of exhibits: portraiture by Al Fisher (b&w, platinum prints); landscape/exotic works by Eugene Epstein (b&w, limited edition prints); and landscapes by Jack Wilkerson (b&w). Presents 15-20 shows/year. Shows last 3-4 weeks. General price range of work: $100-10,000.
Exhibits: Must apply and be accepted as an artist member. Once accepted, artists are eligible to compete in juried competitions. Guaranteed showing in annual Small Works Show. There is a possibility of group or individual show, on an invitational basis, if merit exists. Interested in all styles. Workshops offered.
Making Contact & Terms: Charges 40% commission. Reviews slides only with application. Request membership application. Quarterly review deadlines.
Tips: Wants to see "professional, concise and informative completion of application. The weight of the judgment for admission is based on quality of slides. Only the strongest work is accepted. We are in the process of strengthening our membership, especially as regards photographers. We look for quality work in any genre, medium or discipline."

CREATIONS INTERNATIONAL FINE ARTS GALLERY, P.O. Box 492, New Smyrna Beach FL 32170-0492. Phone/fax: (904)673-8778. E-mail: creationsintl@prodigy.net. Owner: Benton Ledbetter. Director: William Hastings. Assistant Director: Sean Ledbetter. Estab. 1984. Recent exhibits: Sara Catlette,

Michelle Starry, Crystal Ledbetter, Thoran Beatty. Presents 12 shows/year. Shows last 1 month. General price range of work: $50 and up.

Exhibits: "There are no limits in the world of art, but we do keep it clean here due to the large numbers of children and families that visit Creations International each year."

Making Contact & Terms: Charges 25% commission. Reviews transparencies. Interested in framed or unframed, mounted or unmounted, matted or unmatted work. Accepts images in digital format. Send via CD, e-mail, floppy disk or Zip. Submit bio indicating past shows, awards, collectors, education, and any other information that will help present the artist and the work. SASE. Reports in 1 month in most cases.

Tips: "We currently have several Web pages and are up to date with the new computer trends. We represent work by slide registry and disk registry and train other businesses to use computers for their market needs. Be faithful to your work as an artist and keep working at it no matter what."

N: CROSSMAN GALLERY, University of Wisconsin-Whitewater, 950 W. Main St., Whitewater WI 53190. (414)472-5708. Director: Michael Flanagan. Estab. 1971. Examples of recent exhibits: "Color Photography Invitational," by Regina Flanagan, Leigh Kane and Janica Yoder. Presents 1 show biannually. Shows last 3-4 weeks. Sponsors openings; provides food, beverage, show announcement, mailing, shipping (partial) and possible visiting artist lecture/demo. General price range of work: $250-2,800.

Exhibits: "We primarily exhibit artists from the Midwest." Interested in all types, of innovative approaches to photography. Photographic works are regularly included in exhibition schedule.

Making Contact & Terms: Submit 10-20 slides, artist's statement and résumé for consideration for inclusion in exhibitions. SASE.

Tips: "The Crossman Gallery operates within a university environment. The focus is on exhibits that have the potential to educate viewers about processes and techniques and have interesting thematic content."

DALLAS VISUAL ART CENTER, 2917 Swiss Ave., Dallas TX 75204. (214)821-2522. Fax: (214)821-9103. Executive Director: Katherine Wagner. Estab. 1981. Examples of recent exhibits: Will Taylor (solo show of South African wildlife); Mosaics series by Pablo Esparza (b&w/airbrushed). Presents variable number of photo shows (2-3)/year. Shows last 3-6 weeks.

Exhibits: Photographer must be from Texas. Interested in all types.

Making Contact & Terms: Charges no commission (nonprofit organization). Reviews slides. Send material by mail for consideration. SASE. Reports Oct. 15 annually.

Tips: "We have funding from Exxon Corporation to underwrite exhibits for artists who have incorporated their ethnic heritage in their work; they should make a note that they are applying for the Mosaics series. (We have a Collector series for which we underwrite expenses. All submissions are reviewed by committee.) Other gallery space is available for artists upon slide review. We have a resource newsletter that is published bimonthly and contains artist opportunities (galleries, call for entries, commissions) available to members (membership starts at $35)."

N: TIBOR DE NAGY GALLERY, 724 Fifth Ave., New York NY 10019. (212)262-5050. Fax: (212)262-1841. Directors: Eric Brown and Andrew Arnot. Estab. 1950. Examples of recent exhibits: "Photographs," by Allen Ginsberg and "A Photo Retrospective," by Rudy Burckhardt. Presents 2 shows/year. Shows last 1 month. Sponsors openings for gallery artists only. General price range of work: $1,200-5,000.

Exhibits: Interested in figures, nature, collages.

Making Contact & Terms: Charges 50% commission. Not currently reviewing photographs. Requires exclusive representation locally. SASE.

N: DREXEL UNIVERSITY DESIGN ARTS GALLERY, Nesbitt College of Design Arts, 33rd and Markets Sts., Philadelphia PA 19104. (215)895-4944. Fax: (215)895-4917. E-mail: gallery@drexel.edu. Website: http://www.coda.drexel.edu/gallery/gallery.htm. Director: Lydia Hunn. Nonprofit gallery. Estab. 1986. Sponsors 8 total exhibits per year. 1 or 2 photography exhibits per year. Average display time 1 month. Gallery open Monday through Friday from 11 to 5. Closed summer. Clients include local community.

Making Contact & Terms: Artwork bought outright. Gallery takes 20% commission. Gallery provides insurance, promotion. Accepted work should be framed, mounted, matted. "We will not pay transport fees." Write to arrange personal interview to show portfolio. Send query letter with artist's statement, bio,

THE SUBJECT INDEX, located at the back of this book, lists publications, book publishers, galleries, greeting card companies, stock agencies, advertising agencies and graphic design firms according to the subject areas they seek.

résumé, SASE. Returns material with SASE. Replies only if interested by February. Finds artists through referrals by other artists, academic instructors.

N EASTERN SHORE ART CENTER, 401 Oak St., Fairhope AL 36532. (334)928-2228. Fax: (334)928-5118. E-mail: esac@mindspring.com. Director: B.G. Hinds. Estab. 1961. General price range of work: $10-2,000. Most work sold between $100-300.

Exhibits: Exhibits photos of babies, celebrities, children, couples, multicultural, families, parents, senior citizens, teens, disasters, environmental, landscapes/scenics, wildlife, architecture, beauty, cities/urban, education, gardening, interiors/decorating, pets, religious, rural, adventure, automobiles, entertainment, events, food/drink, health/fitness, hobbies, humor, performing arts, sports, travel, agriculture, buildings, political, portraits, still life, science. Interested in alternative process, avant garde, digital, documentary, fine art, historical/vintage, regional.

Making Contact & Terms: Artwork is accepted on consignment and there is a 25% commission. Reviews prints or transparencies. Interested in framed work only Works are limited to 7'5" height, no width restriction. Send material by mail for consideration. SASE. Reports in 1 month.

Tips: "Be willing to schedule far in advance. If interested in sales, keep prices below $200 (good market for art, but photos don't sell terribly well here.) Make sure submissions are either high-quality slides or prints. Mark each submission with the person's name. Keep in mind the Eastern Shore Art Center is part of a small, relatively conservative community when submitting work for consideration."

CATHERINE EDELMAN GALLERY, Lower Level, 300 W. Superior, Chicago IL 60610. (312)266-2350. Fax: (312)266-1967. Director: Catherine Edelman. Estab. 1987. Presents 9 exhibits/year. Shows last 4-5 weeks. General price range of work: $600-5,000.

Exhibits: "We exhibit works ranging from traditional photography to mixed media photo-based work."

Making Contact & Terms: Charges 50% commission. Reviews transparencies. Accepted work should be matted. Requires exclusive representation within metropolitan area. Send material by mail for consideration. SASE. Reports in 2 weeks.

Tips: Looks for "consistency, dedication and honesty. Try to not be overly eager and realize that the process of arranging an exhibition takes a long time. The relationship between gallery and photographer is a partnership."

PAUL EDELSTEIN GALLERY, 519 N. Highland, Memphis TN 38122-4521. (901)454-7105. Fax: (901)458-2169. E-mail: pedelst414@aol.com. Website: www.pauledelsteingallery.com. Director/Owner: Paul R. Edelstein. Estab. 1985. Examples of exhibits: vintage b&w and color prints by William Eggleston; "Mind Visions," by Vincent de Gerlando (figurative); "Eudora Welty Portfolio," by Eudora Welty (figurative); and "Still Lives," by Lucia Burch Dogrell. Features new artist Ann Robinson Smithwick. Shows are presented continually throughout the year. Overall price range: $275-25,000. Most work sold between $300-400.

Exhibits: Exhibits photos of babies, celebrities, children, couples, multicultural, families, parents, senior citizens, environmental, landscapes/scenics, architecture, beauty, cities/urban, rural, automobiles, entertainment, food/drink, buildings, military. Interested in avant garde, fine art and 20th century photography "that intrigues the viewer"—figurative still life, landscape, abstract—by upcoming and established photographers.

Making Contact & Terms: Artwork is accepted on consignment and there is a 40% commission. Buys photos outright. Reviews transparencies. Interested in framed or unframed, mounted or unmounted, matted or unmatted work. There are no size limitations. Submit portfolio for review. Query with samples. Cannot return material. Reports in 3 months.

Tips: "Looking for figurative and abstract figurative work."

EGEE ART CONSULTANCY, 9 Chelsea Manor Studios Flood St., London SW 3 5SR United Kingdom. Phone: (44+)171 3516818. Fax: (44+)171376. E-mail: egee.art@btinternet.com. Website: http://www.egeeart.co.uk. Director: Dale Egee. Art Consultant: Kate Brown. Art consultancy. Estab. 1978. Approached by 50 artists a year; represents or exhibits 30-40 artists. Examples of recent exhibits: "Art of the Alhambra" (mixed show); "Contemporary Art of the Arab World" (mixed). "We are consultants therefore there are not many exhibitions." Average display time 1 month. Open Monday through Friday from 8:30 to 5:30; weekends by appointment, all year. "Located in a Victorian artists studio just off the King's Road in Chelsea. Egee Art Consultancy is based in a light and airy gallery space." Overall price range $100-80,000. Most work sold at $1,500.

Exhibits: Exhibits photos of landscapes/scenics, architecture, cities/urban, religious, buildings, only. "Middle East subjects, particularly architecture/dhows/souks."

Making Contact & Terms: Artwork is accepted on consignment. Retail price set by gallery. "Normally

we reframe." Exclusive representation locally preferred. Accepts only artists whose work is influenced by the Middle East. Call/write to arrange personal interview to show portfolio. Mail for review. Send query letter with bio, photographs, résumé. Replies in 1 week. Finds artists by word of mouth, submissions, portfolio reviews, art exhibits, art fairs, referrals by other artists, trade directories, internet.

Tips: It is "worthwhile typing c.v./résumé, cover letter making it clear they want us to represent them, not just any gallery; show good clear photos/transparencies; any reviews/articles."

ELEVEN EAST ASHLAND (Independent Art Space), 11 E. Ashland, Phoenix AZ 85004. (602)257-8543. Director: David Cook. Estab. 1986. Examples of recent exhibits: works by Jack Stuler (b&w photo); Allen A. Dutton (b&w photo); Jean Vallette (b&w photo French West Indies); Steve Hoover (b&w photo); Jim Kearns (b&w photo); and one juried show in fall of each year "for adults only." (Call for information—$25 fee, 3 slides, SASE, deadline 10/15). Presents 10 shows/year. Shows last 3 weeks. General price range of work: $100-500. Most work sold at $100-200.

Exhibits: Exhibits photos of couples, environmental, architecture, cities/urban, automobiles, entertainment, events, performing arts, buildings. Contemporary only (portrait, landscape, genre, mixed media in b&w, color, non-silver, etc.); photographers must represent themselves, complete exhibition proposal form and be responsible for own announcements. Interested in "all subjects in the contemporary vein—manipulated, straight and non-silver processes." Interested in alternative process, avant garde, digital, documentary, erotic, fine art.

Making Contact & Terms: Artwork is accepted on consignment and there is a 25% commission. There is a rental fee for space. The rental fee covers 1 month. Reviews transparencies. Interested in framed or unframed, mounted or unmounted, matted or unmatted work. Shows are limited to material able to fit through the front door and in the 4'×8' space. Query with résumé of credits. Query with samples. SASE. Reports in 2 weeks.

Tips: "Sincerely look for a venue for your art and follow through. Search for traditional and non-traditional spaces."

[N] FAHEY/KLEIN GALLERY, 148 N. La Brea Ave., Los Angeles CA 90036. (323)934-2250. Fax: (323)934-4243. Co-Director: David Fahey. Estab. 1986. Examples of exhibits: works by Irving Penn, Henri Cartier-Bresson and McDermott & McGough. Presents 10 shows/year. Shows last 5 weeks. Sponsors openings; provides announcements and beverages served at reception. General price range of work: $600-200,000.

Exhibits: Must be established for a minimum of 5 years; preferably published. Interested in established work. Fashion/documentary/nudes/portraiture/fabricated to be photographed work.

Making Contact & Terms: Charges 50% commission. Buys photos outright. Interested in unframed, unmounted and unmatted work only. Requires exclusive representation within metropolitan area. Send material by mail for consideration. SASE. Reports in 2 months. Interested in seeing mature work with resolved photographic ideas and viewing complete portfolios addressing one idea.

Tips: "Have a comprehensive sample of innovative work."

FIELD ART STUDIO, 24242 Woodward Ave., Pleasant Ridge MI 48069-1144. (248)399-1320. Fax: (248)399-7018. Owner: Jerome S. Feig. Estab. 1950. Presents 6-8 shows/year. Shows last 1 month.

Making Contact & Terms: Charges 40% commission. Reviews transparencies. Interested in framed or unframed work. Requires exclusive representation locally. Works are limited to maximum 30×40. Query with samples. SASE. Reports in 1-2 weeks.

[N] FLETCHER/PRIEST GALLERY, 5 Pratt St., Worcester MA 01609. (508)791-5929. Fax: (508)791-5929. E-mail: priest@ma.ultranet.com. Website: http://www.ultranet.com/~priest. Director: Terri Priest. For profit gallery. Estab. 1990. Approached by 15 artists a year. Sponsors 2 photography exhibits per year. Average display time 3 weeks. Gallery open Wednesday through Thursday from 12 to 6; weekends by appointment. Closed June through August. Located off Park Avenue. Features 12 to 15 pieces depending on size of work. Overall price range $400-10,000. Most work sold at $1,200.

Exhibits: Exhibits photos of environmental, landscapes/scenics, architecture, cities/urban. Interested in avant garde, documentary, fine art.

Making Contact & Terms: Artwork is accepted on consignment and there is a 50% commission. Gallery provides insurance, promotion. Requires exclusive representation locally. Call to show portfolio of photographs. Send query letter with artist's statement, bio, reviews, SASE, slides. Replies in 3 months. Finds artists through word of mouth, portfolio reviews, art exhibits, referrals by other artists.

Tips: "Send a consistent body of at least 15 images done in the last 1-2 years."

FOCAL POINT GALLERY, 321 City Island Ave., New York NY 10464. (718)885-1403. Fax: (718)885-1403 ext. 51. Photographer/Director: Ron Terner. Estab. 1974. Examples of recent exhibits: Charles Brackman (warm toned prints); Mark Woods (personal portfolio b&w); and Laine Whitcomb (nudes, gum prints and Kodalith combined). General price range of work: $100-700. Most work sold at $175.

Exhibits: Open to all subjects, styles and capabilities. "I'm looking for the artist to show me a way of seeing I haven't seen before." Nudes and landscapes sell best. Interested in alternative process, avant garde, digital, documentary, erotic, fashion/glamour, fine art.

Making Contact & Terms: Artwork is accepted on consignment and there is a 30% commission. Artist should call for information about exhibition policies.

Tips: Sees trend toward more use of alternative processes. "The gallery is geared toward exposure—letting the public know what contemporary artists are doing—and is not concerned with whether it will sell. If the photographer is only interested in selling, this is not the gallery for him/her, but if the artist is concerned with people seeing the work and gaining feedback, this is the place. Most of the work shown at Focal Point Gallery is of lesser-known artists. Don't be discouraged if not accepted the first time. But continue to come back with new work when ready. Have high-quality slides of work since this is what we see first. If we are the interested, we will look at the actual work."

GALERIA MESA, P.O. Box 1466, 155 N. Center, Mesa AZ 85211-1466. (602)644-2056. Fax: (602)644-2901. E-mail: robert_schultz@ci.mesa.az.us. Website: http://www.artresources.com. Contact: Curator. Estab. 1980. Presents 7-9 national juried exhibits/year. Shows last 4-6 weeks. General price range of work: $500-2,000. Most work sold at $600. Upcoming national exhibitions: "99 Cups" juried by Heather Lineberry; "Insight: Contemporary Self-Portraits"; Environments 2000" juried by Lisa Sette; "Arizona Art Educators." Please write or call for 1999/2000 prospectus.

Exhibits: Exhibits photos of babies, celebrities, children, couples, multicultural, families, parents, senior citizens, teens, disasters, environmental, landscapes/scenics, wildlife, architecture, beauty, cities/urban, education, gardening, interiors/decorating, pets, religious, rural, adventure, automobiles, entertainment, events, hobbies, humor, performing arts, travel, buildings, industry, political, portraits, science, technology. Interested in alternative process, avant garde, digital, documentary, fashion/glamour, fine art, historcial/vintage, regional, seasonal and contemporary photography as part of its national juried exhibitions in any and all media.

Making Contact & Terms: Charges 25% commission. Interested in seeing slides of all styles and aesthetics. Slides are reviewed by changing professional jurors. Must fit through a standard size door and be ready for hanging. Enter national juried shows; awards total $2,000. SASE. Reports in 1 month.

Tips: "We do invitational or national juried exhibits only. Submit professional quality slides."

N GALERIA SAN FRONTERAS, 1701 Guadalupe, Austin TX 78701. Phone/fax: (512)478-9448. Website: http://www.i0.com/ngsf. Director: Gilbert Cardenas. Estab. 1986. Examples of recent exhibits: "Holiday Extravaganza," by Alan Pogue (b&w documentary); "Hasta la Victoria," by Byron Brauchli (b&w photos of deforestation in Mexico). Presents 1 show/year. Shows last 10 weeks. Sponsors openings; provides b&w invitations, food and drink. General price range of work: $100-1,000.

Exhibits: Interested in photojournalism, especially work that documents Mexicans, Mexican-Americans, migrant workers, etc.

Making Contact & Terms: Charges 50% commission. Reviews transparencies. Requires exclusive representation locally. Query with samples. "Make an appointment. Don't expect to walk in and get an interview." Reports in 1 month.

Tips: The gallery deals in contemporary Mexican/Latino art."

GALLERY 825/LA ART ASSOCIATION, 825 N. La Cienega Blvd., Los Angeles CA 90069. (310)652-8272. Fax: (310)652-9251. Website: www.laaa.flashnet.com. Director: LeRad Nilles. Assistant Director: Cynthia Peters. Estab. 1924. Examples of recent exhibits: "Nature (re)Contained," by Bob Sanov (b&w nature); "Objects/Images/Ideas," by Nick Capito (sepia toned b&w urban landscape); and Gary Rosenblum (color poloroid abstracts). Presents 6-11 shows/year. Shows last 3-5 weeks. Sponsors openings; provides wine/cheese. General price range of work: $200-5,000. Most work sold at $600.

Exhibits: Exhibits photos of entertainment, performing arts. Must "go through membership screening conducted twice a year; contact the gallery for dates. Shows are group shows." Interested in Southern Californian artists—all media and avant garde, alternative process, fine art

Making Contact & Terms: Charges 33% commission. Reviews transparencies on screening dates. Interested in framed or unframed, mounted or unmounted, matted or unmatted work. Works are limited to 100 lbs. Submit 3 pieces during screening date. Reports immediately following screening. Call for screening dates and prospectus shows.

Tips: "Apply for membership. Work is juried by boardmembers; all shows are juried."

GALLERY ET. AL., 29205 Greening Blvd., Farmington Hills MI 48334-2945. (248)932-0090. Fax: (248)932-8763. E-mail: jsapub@aol.com. Director: Joe Ajlouny. Retail gallery and exhibition space.
Exhibits: "Interested in b&w nudes or partial nudes only. Variations on this theme are acceptable, even in color."
Making Contact & Terms: Send query letter with photographs, contact sheets. Replies in 1 month.

[N] GALLERY LUISOTTI, Bergamot Station A-2, 2525 Michigan Ave., Santa Monica CA 90404. (310)453-0043. E-mail: rampub@gte.net. Owner: Theresa Luisotti. For profit gallery. Estab. 1993. Approached by 80-100 artists a year; represents or exhibits 15 artists. Sponsors 6 photography exhibits per year. Average display time 2 months. Gallery open Tuesday through Saturday from 10:30 to 5:30; weekends from 10:30 to 5:30. Closed December 20-January 1 and last 2 weeks in August. Located in Bergamot Station Art Center in Santa Monica. Clients include local community. Overall price range $500-100,000. Most work sold at $3,000.
Exhibits: Exhibits photos of celebrities, children, couples, environmental, beauty, cities/urban, rural, automobiles, entertainment, portraits, science, technology. Interested in alternative process, avant garde, digital, documentary, erotic, fashion/glamour, fine art, historical/vintage, regional. Other specific subject/processes: Topographic artists from 1970s. Also represents artists who work both in photo and also film, painting and sculpture. Considers installation, mixed media, oil, paper, pen & ink.
Making Contact & Terms: Artwork is accepted on consignment and there is a 50% commission. Gallery provides insurance, promotion, contract. Requires exclusive representation locally. Write to arrange personal interview to show portfolio of transparencies. Returns material with SASE. Gallery is not accepting new artists at this time.

[N] GALLERY NAGA, 67 Newbury St., Boston MA 02116. (617)267-9060. Fax: (617)267-9040. E-mail: mail@gallerynaga.com. Website: http://www.gallerynaga.com. Director: Arthur Dion. For profit gallery. Estab. 1976. Approached by 150 artists a year; represents or exhibits 40 artists. Sponsors 11 photography exhibits per year. Average display time 1 month. Gallery open Tuesday through Saturday from 10 to 5:30. Overall price range $850-35,000. Most work sold at $2,000-3,000.
Exhibits: Exhibits photos of architecture, cities/urban, gardening.
Making Contact & Terms: Artwork is accepted on consignment and there is a 25% commission. Gallery provides insurance. Accepted work should be framed. Requires exclusive representation locally. Accept only artists from New England/Boston. Send query letter with artist's statement, photocopies, SASE, bio, slides, résumé. Returns material with SASE. Replies in 1 month. Finds artists through submissions, portfolio reviews, art exhibits.

[N] GALLERY OF ART, UNIVERSITY OF NORTHERN IOWA, Cedar Falls IA 50614-0362. (319)273-6134. Estab. 1976. Interested in all styles of high-quality contemporary art and photojournalistic works. Example of recent exhibits: Magic Silver Show (juried national show). Presents an average of 4 shows/year. Shows last 1 month. Open to the public.
Making Contact & Terms: Work presented in lobby cases. "We do not often sell work; no commission is charged." Will review transparencies. Interested in framed or unframed work, mounted and matted work. May arrange a personal interview to show portfolio, résumé and samples. Send material by mail for consideration or submit portfolio for review. SASE. Reporting time varies.

[N] GALLERY TARANTO, 39 W. 14th St., 5th Floor, New York NY 10011. (212)691-8040. Fax: (212)366-6829. Website: http://www.TaranTolabs.com. Director: Lorena La Grassa. Nonprofit gallery. Estab. 1984. Approached by 150 artists a year; represents or exhibits 25 artists. Average display time 1 month. Gallery open Monday through Friday from 9:30 to 7; weekends from 11 to 5. Overall price range $350-800. Most work sold at $350.
Exhibits: Exhibits photos of children, couples, multicultural, disasters, environmental, landscapes/scenics, wildlife, architecture, cities/urban, religious, rural, adventure, humor, performing arts, travel, agriculture, buildings, business concepts, computers, industry, portraits, product shots/still life, science, technology. Interested in alternative process, avant garde, digital, documentary, erotic, fashion/glamour, fine art, historical/vintage.
Making Contact & Terms: Artwork is accepted on consignment and ther is a 35% commission. Gallery provides insurance, promotion, contract. Accepted work should be matted. Prefers only: photography. Call of write to arrange personal interview to show portfolio of photographs, transparencies, slides, contact sheets. Send query letter with artist's statement, bio, brochure, business card, photocopies, photographs, résumé, reviews, SASE, slides. Returns material with SASE. Replies in 1 month.
Tips: "The most important thing is the work. Artists must do what they think is good for their work."

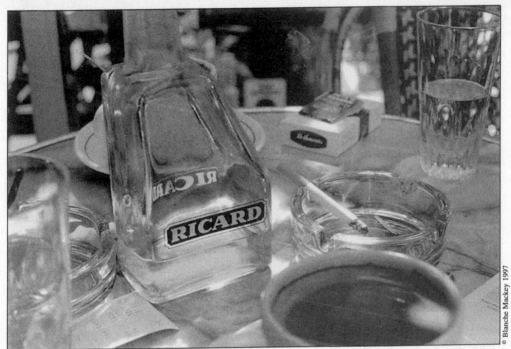

"'Time's Promise' was a very successful exhibition that sold ten pieces and attracted the attention of many people," says Lorena La Grassa, director of Gallery Taranto. "Paris, 1997" was part of this solo exhibition by photographer Blanche Mackey. Mackey submitted her work to the gallery and La Grassa decided to give her a solo show because the work was so strong. "This picture symbolizes the feeling and the meaning of Blanche's photography. Of course, this is also a beautiful picture with a good sense of lighting, composition and contrast," La Grassa says. The images in the show were taken during Mackey's travels through Europe, primarily in Paris and Prague.

GALLERY 218/WALKER'S POINT ARTISTS, 218 S. 2nd St., Milwaukee WI 53204. (414)270-1043. E-mail: jhha@exec.pc.com. President: Judith Hooks. Estab. 1990. Examples of recent exhibits: Fred Stein (hand-colored photographs); Mike Sohns (color digital photography); Philo (b&w photography); Camille Elias (large color photography). Presents 12 show/year. Show lasts 1 month. Sponsors openings. "If a group show, we make arrangements and all artists contribute. If a solo show, artist provides everything." General price range of work: $100-1,000. Most work sold at $350.
Exhibits: Exhibits photos of architecture, cities/urban, rural, multicultural, environmental, landscapes/scenics, buildings, political, portraits. Interested in alternative process, avant garde, digital, documentary, erotic, fine art. Must be a member for 1 month before exhibiting. Membership dues: $45/year. Artists help run the gallery. Group and solo shows available. Interested in avante-garde and other type photos except commercial shots. Photography is shown alongside fine arts painting, printmaking, sculpture, etc.
Making Contact & Terms: Charges 25% commission. There is an entry fee for each show. Fee covers the rent for 1 month. Files submissions in slide registry. Reviews transparencies. Interested in framed work only. Send SASE for an application."
Tips: "Get involved in the process if the gallery will let you. We require artists to help promote their show so that they learn what and why certain things are required. Have inventory ready."

GALMAN LEPOW ASSOCIATES, INC., Unit 12, 1879 Old Cuthbert Rd., Cherry Hill NJ 08034. (609)354-0771. Fax: (609)428-7559. Principals: Elaine Galman and Judith Lepow. Estab. 1979.
Making Contact & Terms: Reviews transparencies. Interested in seeing matted or unmatted work. No size limit. Query with résumé of credits. Visual imagery of work is helpful. SASE. Reports in 3 weeks.
Tips: "We are corporate art consultants and use photography for our clients."

GEN ART, 145 W. 28th St., Suite 11C, New York NY 10001. (212)290-0312. Also has offices at 8522 National Blvd., Suite 100, Culver City CA 90232 and P.O. Box 460819, San Francisco CA 94146. E-mail: info@genart.org. Website: http://www.genart.org. Alternative space. Estab. 1993.

Exhibits: "Gen Art has an open submission policy for all visual artists 35 years old and younger."
Submissions: "Please submit up to 20 35mm slides or prints which are clearly marked with your name. Each slide or print should be numbered and correspond to a list that includes each image's title, date, dimension and medium. Please enclose a résumé if available and a SASE."

FAY GOLD GALLERY, 247 Buckhead Ave., Atlanta GA 30305. (404)233-3843. Fax: (404)365-8633. Owner/Director: Fay Gold. Estab. 1981.
Exhibits: Contemporary fine art photography by established artists. Holds monthly photography exhibitions. In addition, the gallery maintains a major inventory of vintage and recent prints for beginning and advanced collectors, museums and institutions.
Making Contact & Terms: Send slides, résumé and artist's statement with SASE for weekly review. Terms discussed on an individual basis.
Tips: "Please do not send original material for review."

WELLINGTON B. GRAY GALLERY, East Carolina University, Greenville NC 27858. (252)328-6336. Fax: (252)328-6441. Director: Gilbert Leebrick. Estab. 1978. Examples of exhibits: "A Question of Gender," by Angela Borodimos (color C-prints) and "Photographs from America," by Marsha Burns (gelatin silver prints). Presents 1 show/year. Shows last 1-2 months. General price range of work: $200-1,000.
Exhibits: For exhibit review, submit 20 slides, résumé, catalogs, etc., by November 15th annually. Exhibits are booked the next academic year. Work accepted must be framed or ready to hang. Interested in fine art photography.
Making Contact & Terms: Charges 20% commission. Reviews transparencies. Interested in framed work for exhibitions; send slides for exhibit committee's review. Send material by mail for consideration. SASE. Reports 1 month after slide deadline (November 15th).

HALLWALLS CONTEMPORARY ARTS CENTER, 2495 Main St., Suite 425, Buffalo NY 14214. (716)835-7362. Fax: (716)835-7364. E-mail: hallwall@pce.net. Website: www.ple.net/hallwall. Visual Arts Director: Sara Kellner. Estab. 1974. Examples of recent exhibits: "Feed," by Heidi Kumao (zoetrope, mixed media); "Amendments," including Ricardo Zulueta (b&w performance stills); and "Altered Egos," including Janieta Eyre (Polaroid portraits). Presents 10 shows/year. Shows last 6 weeks.
Exhibits: Hallwalls is a nonprofit multimedia organization. "While we do not focus on the presentation of photography alone, we present innovative work by contemporary photographers in the context of contemporary art as a whole. Sales are not our focus. If a work does sell, we suggest a donation of 15% of the purchse price." Interested in work which expands the boundaries of traditional photography. No limitations on type, style or subject matter.
Making Contact & Terms: Photography sold in gallery. Reviews transparencies. Send material by mail for consideration. Do not send work. Work may be kept on file for additional review for 6 months.
Tips: "We're looking for photographers with innovative work; work that challenges the boundaries of the medium."

LEE HANSLEY GALLERY, 16 W. Martin St., 201, Raleigh NC 27601. (919)828-7557. Website: http://www.citysearch.com/rdu/hansleygallery. Gallery Director: Lee Hansley. Estab. 1993. Examples of recent exhibitions: "Nudes in Nature," by Ruth Pinnell (b&w photos); "Portrait of America," by Marsha Burns (large framed silver prints); "Landscapes," by Nona Short (b&w prints); Karl Koga (color prints); "The City" by Diana Bloomfield (platinum/paladium prints). Presents 3 shows/year. Shows last 4-6 weeks. General price range of work: $200-800.
Exhibits: Interested in new images using the camera as a tool of manipulation; also wants minimalist works. Looks for top-quality work and a unique vision.
Making Contact & Terms: Charges 50% commission. Payment within one month of sale. Reviews transparencies. Interested in framed or unframed work. No mural-size works. Send material by mail for consideration. SASE. Reports in 2 months.
Tips: Looks for "originality and creativity—someone who sees with the camera and uses the parameters of the format to extract slices of life, architecture and nature."

HAYDON GALLERY, 335 N. Eighth St., Suite A, Lincoln NE 68508. (402)475-5421. Fax: (402)475-5422. E-mail: haydongallery@navix.net. Director: Anne Pagel. Estab. 1987 (part of Sheldon Art & Gift Shop for 20 years prior). Example of recent exhibit: "The Art of Jazz Photography," 10 internationally known artists. Presents 1 or 2 (of 9 solo exhibitions) plus group exhibitions/year. Shows last 1 month. Hors d'oeuvres provided by host couple, cost of beverages split between gallery and artist. (Exhibitions booked through 2002.) Artist presents gallery talk 1 week after the opening. General price range of work: $350-1,500.

Exhibits: Must do fine-quality, professional level art. "Interested in any photography medium or content, so long as the work is of high quality."

Making Contact & Terms: Charges 45% commission. Reviews transparencies. Interested in seeing framed or unframed, mounted or unmounted, matted or unmatted work. "Photos in inventory must be framed or boxed." Requires exclusive representation locally. Arrange a personal interview to show portfolio. Submit portfolio for review. SASE. Reports in 1 month.

Tips: "Submit a professional portfolio, including résumé, statement of purpose and a representative sampling from a cohesive body of work." Opportunities for photographers through galleries is becoming more competitive. My observation has been that although people express a preference for b&w photography, they purchase color."

[N] HERA EDUCATIONAL FOUNDATION AND ART GALLERY, P.O. Box 336, Wakefield RI 02880. (401)789-1488. Director: Betty Sekator. Estab. 1974. The number of photo exhibits varies each year. Shows last 3-4 weeks. Sponsors openings; provides refreshments and entertainment or lectures, demonstrations and symposia for some exhibits. Call for information on exhibitions.

Exhibits: Must show a portfolio before attaining membership in this co-operative gallery. Interested in all types of innovative contemporary art which explores social and artistic issues.

Making Contact & Terms: Charges 25% commission. Prices set by artist. Reviews transparencies. Works must fit inside a 6′ 6″ × 2′6″ door. Reports in 2-3 weeks. Inquire about membership and shows. Membership guidelines mailed on request.

Tip: "Hera exhibits a culturally diverse range of visual artists and emerging artists."

HUGHES FINE ARTS CENTER, Dept. of Visual Arts, Box 7099, Grand Forks ND 58202-7099. (701)777-2906. Fax: (701)777-3395. Website: http://www.und.edu/dept/fac/visual-home.html. Director: Brian Paulsen. Estab. 1979. Examples of exhibits: works by James Falkofske and Alexis Schaefer. Presents 11-14 shows/year. Shows last 2-3 weeks. Gallery has 99 feet of wall space. "We pay shipping costs."

Exhibits: Interested in any subject; mixed media photos, unique technique, unusual subjects.

Making Contact & Terms: Does not charge commission; sales are between artist and buyer. Reviews transparencies. "Works should be framed and matted." No size limits or restrictions. Send 10-20 transparencies with résumé. SASE. Reports in 2 weeks.

Tips: "Send slides of work . . . we will dupe originals and return ASAP and contact you later." Needs "fewer photos imitating other art movements. Photographers should show their own inherent qualities. No Ansel Adams. No airport lobby landscapes. Have a personal vision or statement."

HUNTSVILLE MUSEUM OF ART, 300 Church St. South, Huntsville AL 35801. (205)535-4350. Fax: (205)532-1743. Chief Curator: Peter J. Baldaia. Estab. 1970. Examples of recent exhibits: "Still Time," by Sally Mann (b&w/color); "Salvation on Sand Mountain," by Melissa Springer/Jim Neel (b&w documentary); and "Encounters," by John Reese (b&w Alabama subjects). Presents 1-2 shows/year. Shows last 6-8 weeks.

Exhibits: Must have professional track record and résumé, slides, critical reviews in package (for curatorial review). Regional connection preferred. No specific stylistic or thematic criteria.

Making Contact & Terms: Buys photos outright. Reviews transparencies. Interested in framed or unframed, mounted or unmounted, matted or unmatted work. Send material by mail for consideration. SASE. Reports in 1-3 months.

ICEBOX QUALITY FRAMING & GALLERY, 2401 Central Ave. NE, Minneapolis MN 55418. Phone/fax: (612)788-1790. E-mail: icebox@bitstream.net. Contact: Howard Christopherson. Exhibition, promotion and sales gallery. Estab. 1988. Examples of recent exhibits: "The Nude, Form & Spirit," by Doug Beasley; "South of the Border," by 13 Minnesota photographers (photographs of South and Central America); "Ecosystem Continuum," by Vance Gellert; "People Places & Dreams," by H.M. Christopherson; and "Greetings From New York City," by Flo Fox. Represents photographers and fine artists in all media. Specializes in "thought-provoking artwork and photography, predominantly Minnesota artists."

CONTACT THE EDITOR of *Photographer's Market* by e-mail at photomarket@fwpubs.com with your questions and comments.

© 1997 Vance Gellert

"I've known Howard Christopherson [owner of the Icebox Gallery] for years. He approached me about doing a show about a year ago," says photographer Vance Gellert. "This image is from the series 'Ecosystem Continuum,' consisting of 50 photographs. It is probably the most popular and promoted the exhibition well. It also sells well." Christopherson was also pleased with the success of the exhibit. "This was a good example of the artist and gallery working together for mutual reward," he says. This exhibit was featured on 2 Minneapolis TV stations, in 2 major city papers, in 34 local newspapers; the artist was awarded a grant.

Markets include: corporate collections; interior decorators; museums; private collections. Overall price range: $200-1,000. Most work sold at $500.

Exhibits: Exhibits photos of landscapes/scenics, rural and fine art photographs of "artists with serious, thought-provoking work who find it hard to fit in with the more commercial art gallery scene." Interested in alternative process, avant garde, documentary, erotic, fashion/glamour, regional. A for-profit alternative gallery, Icebox sponsors installations and exhibits in the gallery's black-walled space.

Making Contact & Terms: Charges ⅓ commission. Send letter of interest telling why you would like to exhibit at Icebox. Include slides and other appropriate materials for review. "At first, send materials that can be kept at the gallery and updated as needed."

Tips: "We are also experienced with the out-of-town artist's needs."

N **ILLINOIS ART GALLERY**, 100 W. Randolph, Suite 2-100, Chicago IL 60601. (312)814-5322. Fax: (312)814-3471. Website: http://www.museum.state.il.us. Director: Kent Smith. Assistant Administrator:

Jane Stevens. Estab. 1985. Examples of exhibits: "Poetic Vision," by Joseph Jachna (landscape, large-format); "New Bauhaus Photographs 1937-1940," by James Hamilton Brown, Nathan Lerner, Gyorgy Kepes, Laszlo Moholy-Nagy and Arthur Siegel (photograms). Presents 2-3 shows/year. Shows last 2 months. Sponsors openings; provides refreshments at reception and sends out announcement cards for exhibitions.

Exhibits: Must be an Illinois photographer. Interested in contemporary and historical photography, alterntive process, avant garde, digital, documentary, fine art, regional.

Making Contact & Terms: Reviews transparencies. Interested in mounted or unmounted work. Send résumé, artist's statement and 10 slides. SASE. Reports in 1 month.

INDIANAPOLIS ART CENTER, 820 E. 67th St., Indianapolis IN 46220. (317)255-2464. Fax: (317)254-0486. E-mail: inartctr@inetdirect.net. Website: http://www.indplsartcenter.org. Exhibitions Curator: Julia Moore. Estab. 1934. Examples of exhibitions: "Rough Basement," by Deborah Brackenburg, Aimee Bott and Mark Sawrie (photo-based installations); "Memories," by Mary Pencheff and Keith Holmes (infrared photography; photo installation); Iris prints by Graham Nash; and (Untitled) by Richard Jurus, Amanda Warner Fruits and Kellie Murphy Klein (unusual processes). Presents 1-2 photography shows/year out of 13-20 shows in a season. Shows last 4-6 weeks. General price range of work: $100-2,000. Most work sold at $250-500.

Exhibits: Preferably live within 250 miles of Indianapolis. Interested in avant garde, digital, documentary, fine art and very contemporary work, preferably unusual processes.

Making Contact & Terms: Charges 35% commission. One-person show: $300 honorarium; two-person show: $200 honorarium; three-person show $100 honorarium; plus $0.28/mile travel stipend. Reviews transparencies. Interested in framed (or other finished-presentation formatted) work only for final exhibition. Send material by mail for consideration. Send minimum 20 slides with résumé, reviews, artist's statement by December 31. No wildlife or landscape photography. Interesting color work is appreciated. SASE.

Tips: "We like photography with a very contemporary look that incorporates unusual processes and/or photography with mixed media."

N ☐ INDIVIDUAL ARTISTS OF OKLAHOMA, P.O. Box 60824, Oklahoma OK 73146. (405)232-6060. Fax: (405)232-6060. Director: Shirley Blaschke. Alternative space. Estab. 1979. Approached by 60 artists a year; represents or exhibits 30 artists. Sponsors 10 photography exhibits per year. Average display time 3-4 weeks. Gallery open Tuesday through Friday from 11 to 4; weekends from 1 to 4. Closed August. Gallery is located in downtown art district, 2,300 sq. ft. with 10' ceilings and track lighting. Overall price range $100-1,000. Most work sold at $300.

Exhibits: Exhibits photos of agriculture, buildings, industry, medicine, political, science, technology. Interested in alternative process, avant garde, digital, documentary, erotic, fine art, regional. Other specific subjects/processes: contemporary approach to variety of subjects.

Making Contact & Terms: Artwork is accepted on consignment and there is a 20% commission. Gallery provides insurance, promotion, contract. Accepted work must be framed. Prefers Oklahoma artists. Mail portfolio for review with artist's statement, bio, photocopies or slides, résumé, SASE. Replies in 3 months. Finds artists through word of mouth, art exhibits, referrals by other artists.

INTERNATIONAL CENTER OF PHOTOGRAPHY, 1130 Fifth Ave., New York NY 10128. (212)860-1777. Fax: (212)360-6490. Contact: Department of Exhibitions. Estab. 1974.

Making Contact & Terms: Portfolio reviews are held the first Monday of each month. Submit portfolio to the receptionist by noon and pick up the following afternoon. Include cover letter, résumé of exhibitions and publications, artist's statement and, if necessary, a project description. "Once reviewed by the Exhibitions Department Curatorial Committee, the portfolio can be picked up on the following day any time after noon. We would prefer that you submit only one portfolio and that it not exceed 20×24 inches. The exterior of the portfolio must be labeled clearly with your name, address, and telephone number." Work may also be submitted by mail. "We do not recommend sending prints through the mail due to the possibility of loss or damage. We suggest sending 20-40 slides, along with the supporting materials listed above. All slides should be labeled or accompanied by a slide list. Please allow 6-8 weeks for response. Video work should be submitted in ½-¾ inch format. Return postage must be included to ensure return of materials."

ISLIP ART MUSEUM, 50 Irish Lane, Islip NY 11730. (516)224-5402. Director: M.L. Cohalan. Estab. 1973. Has exhibited work by Robert Flynt, Skeet McAuley and James Fraschetti. Shows last 6-8 weeks. General price range of work: $200-3,000.

Exhibits: Interested in contemporary or avant-garde works.

Making Contact & Terms: Charges 30% commission. Reviews transparencies. Send slides and résumé;

no original work. Reports in 1 month.

Tips: "Our museum exhibits theme shows. We seldom exhibit work of individual artists. Themes reflect ideas and issues facing current avant-garde art world. We are a museum. Our prime function is to exhibit, not promote or sell work."

Ⓝ JACKSON FINE ART, 3115 E. Shadowlawn Ave., Atlanta GA 30305. (404)233-3739. Fax: (404)233-1205. E-mail: jacksonfineart@mindspring.com. Website: http://www.photogal.com. President: Jane Jackson. Estab. 1990. Exhibition schedule includes mix of classic vintage work and new contemporary work. General price range of work: $600-150,000. Most work sold at $1,500.

Exhibits: Exhibits photos of celebrities, children, couples, architecture,cities/urban, gardening, interiors/decorating, rural. "Photographers must be established, preferably published in books or national art publications. They must also have a strong biography, preferably museum exhibitions, either one-person or group." Interested in innovative photography, avant garde, documentary, erotic (nudes), fine art.

Making Contact & Terms: Only buys vintage photos outright. Reviews transparencies. Requires exclusive representation locally. Send material by mail for consideration. "Send slides first. We will not accept unsolicited original work, and we are not responsible for slides. We also review portfolios on CD-ROM and sell work through CD-ROM." SASE. Reports in 2-3 months.

Tips: "Be organized. Galleries are always looking for exciting fresh work. The work should be based on a single idea or theme."

JADITE GALLERIES, 413 W. 50th St., New York NY 10019. (212)315-2740. Fax: (212)315-2793. E-mail: jaditeart@aol.com. Website: artscape2000.com. Director: Roland Sainz. Estab. 1985. Examples of recent exhibits: "Old World/New World," by Juliet Stelsman (b&w photographs); Rayographs Photography by David Pollack; and "ErOs," by Luis Mayo (mixed media photographs). Presents 1-2 shows/year. Shows last 1 month. General price range of work: $200-1,000. Most work sold at $2,000.

Exhibits: Exhibits photos of architecture, cities/urban, landscapes/scenics, travel, buildings, portraits. Interested in avant garde, digital, documentary and b&w, color and mixed media.

Making Contact & Terms: Artwork is bought outright for 50% of retail price; net 30 days. There is a rental fee for space. The rental fee covers 1 month plus consignment. Reviews transparencies. Interested in unframed work only. Arrange a personal interview to show portfolio. Submit portfolio for review. SASE. Reports in 2-5 weeks.

KEARON-HEMPENSTALL GALLERY, 536 Bergen Ave., Jersey City NJ 07304. (201)333-8855. Fax: (201)333-8488. E-mail: khgallery@usa.net Director: Suzann McKiernan. Estab. 1980. Example of recent exhibits: "Guitars," by Emanuel Pontoriero (16×20 Cibachrome/guitars and the female form). Presents 1 show/year. Shows last 1 month. General price range of work: $150-400.

Exhibits: Interested in color and b&w prints.

Making Contact & Terms: Charges 50% commission. Reviews transparencies. Interested in mounted, matted work only. Requires exclusive representation locally. Send material by mail for consideration. Include resume, exhibition listing, artist's statement and price of sold work. SASE. Reports in 1 month.

Tips: "Be professional: have a full portfolio; be energetic and willing to assist with sales of your work."

KENT STATE UNIVERSITY SCHOOL OF ART GALLERY, Dept. PM, KSU, 201 Art Building, Kent OH 44242. (330)672-7853. Fax: (330)672-9570 Director: Fred T. Smith. Examples of recent exhibits: "Settings by Eight: New Work by Northern Ohio Women Photographers," Mary Adler, Linda Bourassa, Linda Butler, Judith McMillian, Rene Psiakas, Penny Rakoff, Mary Jo Toles, Garie Waltzer. Presents 1 show/year. Exhibits last 3 weeks.

Exhibits: Interested in all types, styles and subject matter of photography. Photographer must present quality work.

Making Contact & Terms: Photography can be sold in gallery. Charges 20% commission. Buys photography outright. Will review transparencies. Write a proposal and send with slides. Send material by mail for consideration. SASE. Reports usually in 4 months, but it depends on time submitted.

ROBERT KLEIN GALLERY, 38 Newbury St., Boston MA 02116. (617)267-7997. Fax: (617)267-5567. President: Robert L. Klein. Estab. 1978. Examples of recent exhibits: work by William Wegman, Tom Baril and Atget. Presents 10 exhibits/year. Shows last 5 weeks. General price range of work: $600-200,000.

Exhibits: Must be established a minimum of 5 years; preferably published. Interested in fashion, documentary, nudes, portraiture, and work that has been fabricated to be photographs.

Making Contact & Terms: Charges 50% commission. Buys photos outright. Reviews transparencies. Interested in unframed, unmmatted, unmounted work only. Requires exclusive representation locally. Send material by mail for consideration. SASE. Reports in 2 months.

PAUL KOPEIKIN GALLERY, 138 N. La Brea Ave., Los Angeles CA 90036. (213)937-0765. Fax: (213)937-5974. Estab. 1990. Examples of recent exhibitions: Lee Friedlander (b&w 35mm); Karen Halverson (color landscapes); Elliott Erwitt; Helen Levitt. Presents 7-9 shows/year. Shows last 4-6 weeks.
Exhibits: Must be highly professional. Quality and unique point of view also important. No restriction on type, style or subject.
Making Contact & Terms: Charges 50% commission. Reviews transparencies. Requires exclusive West Coast representation. Submit slides and support material. SASE. Reports in 1-2 weeks.
Tips: "Don't waste people's time by showing work before you're ready to do so."

KUFA GALLERY, 26 Westbourne Grove, London W 2 5RH United Kingdom. Phone: (0171)229-1928. Fax: (0171)243-8513. E-mail: kufa@dikon.co.uk. Manager: Walid Atiyeh. Nonprofit gallery. Estab. 1986. Approached by 50 artists a year; represents or exhibits 12 artists. Sponsors 12 photography exhibits/year. Average display time 2-4 weeks. Open 10 through 6 from Tuesday to Saturday.
Exhibits: Photographic work on the Middle East, mainly architecture and historical places.
Making Contact & Terms: Retail price set by the artist. Accepted work should be framed, mounted, matted. Requires exclusive representation locally. Call/write to arrange a personal interview to show portfolio of photographs, slides, transparencies, other. Send query letter. Finds artists through submissions.
Tips: "Send work or call but must have good slides or photographs."

KUNTSWERK GALERIE, 1800 W. Cornelia, Chicago IL 60657. (773)935-1854. Fax: (773)478-2395. Website: http://www.fota.com. Co-director: Thomas Frerk. Estab. 1995. Examples of recent exhibits: "Legume du Jour," by Scott Mayer (b&w city photography); "Manhood," by Gina Dawden (layered b&w male figurative); and "Art Crawl," by Terry Gaskins (Chicago personalities). Presents 4-8 shows/year. Shows last 2-6 weeks. General price range of work: $50-500.
Exhibits: Photographer "must be interested in showing work in a more avant garde setting." Interested in female/male figurative; landscapes (b&w preferably); experimental (i.e., layered images, polaroid transfers, photography painting, etc.).
Making Contact & Terms: Charges maximum 25% commission; varies by artist. Reviews transparencies. Interested in framed or unframed, matted or unmatted work. Send material by mail for consideration. SASE. Reports in 1 month.
Tips: "We encourage emerging artists. Go out and beat the bushes. Beginners should be wary of overpricing their work. To avoid this, don't bother framing or use simple framing to keep costs down. Also, find outlets to get your work published, i.e., bands who need album covers and free newspapers in search of artistic photos. We can arrange for an artist to put their portfolio on our website."

LA MAMA LA GALLERIA, 6 E. First Street, New York NY 10003. (212)505-2476. Director/Curator: Merry Geng. Assistant Director: Cesar Llamas. Estab. 1982. La Galleria is located in the downtown East Village section of Manhattan. Close to various transportation. Street level access. Also doubles as a poetry/play reading center during weekends. Open Thursday through Sunday 1-6.
Exhibits: Exhibits photos of architecture, landscapes/scenics, wildlife, performing arts, science. Interested in all fine art. Looking for "focused creativity."
Making Contact & Terms: Charges 20% commission. Prices set by agreement between director/curator and photographer. Reviews transparencies. Interested in framed or mounted work. Arrange a personal interview to show portfolio. Send material by mail for consideration. SASE. Reports in 1 month.
Tips: "Be patient; we are continuously booked 18 months-2 years ahead. I look for something that catches my interest by way of beauty, creativity. Also looking for unusual combinations of photography/art work."

J. LAWRENCE GALLERY, 1435 Highland Ave., Melbourne FL 32935. (407)259-1492. Fax: (407)259-1494. E-mail: joemar@mindspring.com. Owner: Joseph L. Conneen, Jr. Estab. 1984. Examples of exhibits: works by Lloyd Behrendt (hand-tinted b&w); Steve Vaughn (hand-tinted b&w and panoramic photos); Chuck Harris (Cibachrome), and Clyde & Nikki Butcher (b&w and hand-tinted b&w). Most shows are group exhibits. Shows last 6 weeks. General price range of work: $300-2,000. Most work sold at $700.
Exhibits: Exhibits photos of babies, celebrities, children, couples, multicultural, families, parents, senior citizens, teens, environmental, landscapes/scenics, wildlife, architecture, beauty, cities/urban, education, gardening, interiors/decorating, pets, religious, rural, adventure, automobiles, entertainment, events, food/drink, health/fitness, hobbies, humor, performing arts, sports, travel, agriculture, buildings, business concepts, industry, medicine, military, political, portraits, still life, science, technology. Must be original works done by the photographer. Interested in alternative process, avant garde, digital, documentary, erotic, fashion/glamour, fine art, historical/vintage, regional, seasonal; Cibachrome; hand-tinted b&w.
Making Contact & Terms: Charges 40-50% commission. Reviews transparencies. Interested in framed or unframed, mounted or unmounted, matted or unmatted work. Requires exclusive representation locally.

Arrange a personal interview to show portfolio. Submit portfolio for review. Query with résumé of credits. Query with samples. Send material by mail for consideration. SASE. Reports in 1-2 weeks.
Tips: "The market for fine art photography is growing stronger."

LE PETIT MUSÉE, P.O. Box 556, Housatonic MA 01236. (416)274-9913. E-mail: indearts@aol.com. Director: Sherry Steiner. Estab. 1992. General price range of work: $50-500.
Exhibits: Exhibits photos of celebrities, architecture, cities/urban, interiors/decorating, rural, food/drink, performing arts, travel, buildings, portraits. Interested in alternative process, avant garde, documentary, fine art, historical/vintage, regional, seasonal.
Making Contact & Terms: Charges 50% commission. Exhibition at various locations. Reviews transparencies. Interested in framed work. Works are limited to no larger than 12×16 framed. Send material by mail for consideration. SASE. Reports in 1-2 weeks.

Ｎ LEHIGH UNIVERSITY ART GALLERIES, 420 E. Packer Ave., Bethlehem PA 18015. (610)758-3615. Fax: (610)758-4580. Director/Curator: Ricardo Viera. Presents 5-8 shows/year. Shows last 6-8 weeks.
Exhibits: Interested in all types of works. The photographer should "preferably be an established professional." Sponsors openings.
Making Contact & Terms: Payment negotiable. Reviews transparencies. Arrange a personal interview to show portfolio. SASE. Reports in 1 month.
Tips: Don't send more than 10 (top) slides.

LEWIS LEHR INC., Box 1008, Gracie Station, New York NY 10028. (212)288-6765. Director: Lewis Lehr. Estab. 1984. Private dealer. Buys vintage photos. Examples of recent exhibits: "American West" and "Farm Security Administration," both by various photographers; "Camera Work," by Stieglitz. General price range of work: $50-5,000 plus.
Exhibits: Interested in alternative process, avant garde, historical/vintage.
Making Contact & Terms: Charges 50% commission. Buys photography outright. Do not submit transparencies or photographs. Requires exclusive representation within metropolitan area. Query with résumé of credits. SASE. Member AIPAD.
Tips: Vintage American sells best. Sees trend toward "more color and larger" print sizes. To break in, "knock on doors." Do not send work or slides.

THE LIGHT FACTORY, P.O. Box 32815, Charlotte NC 28232. (704)333-9755. Fax: (704)333-5910. E-mail: info@lightfactory.org. Website: http://www.lightfactory.org. Executive Director: Bruce Lineker. Nonprofit. Estab. 1975. Museum. Sponsors 20 photography exhibits per year. Shows last 2 months. Open Wednesday through Friday from 10:00-6:00; Thursday 10:00-8:00; weekends from 12:00-6:00. Located in the warehouse disrict of downtown Charlotte, the museum offers a 6,000 sq.ft. facility of exhibition space, including a darkroom and digital lab. General price range of work: $500-15,000.
Exhibits: Photographer must have a professional exhibition record. Interested in light-generated media (photography, video, film, the Internet). Exhibitions often push the limits of photography as an art form and addresses political, social or cultural issues.
Making Contact & Terms: Artwork sold in the gallery. "Artists price their work." Charges 33% commission. Gallery provides insurance. "We do not represent artists, but present changing exhibitions." No permanent collection. Reviews transparencies. Query with résumé of credits and slides. Artist's statement requested. SASE. Reports in 2 months.

LIZARDI/HARP GALLERY, P.O. Box 91895, Pasadena CA 91109. (626)791-8123. Fax: (626)791-8887. E-mail: lizardiharp@earthlink.net. Director: Grady Harp. Estab. 1981. Examples of exhibits: "E.F. Kitchen," by E.F. Kitchen (nudes, still lifes); "Ghosting," by Erik Olson (male nudes); and "Vatican Series," by Christopher James ("inside" view of nuns). Presents 3-4 shows/year. Shows last 4-6 weeks. General price range of work: $500-4,000. Most work sold at $1,500.
Exhibits: Exhibits photos of celebrities, children, couples, multicultural, senior citizens, teens, disasters, rural, portraits. Must have more than one portfolio of subject, unique slant and professional manner. Interested in alternative process, avant garde, erotic, fine art, figurative, nudes, "maybe" manipulated work, documentary and mood landscapes, both b&w and color.
Making Contact & Terms: Charges 50% commission. Reviews transparencies. Interested in unframed, unmounted and matted or unmatted work. Submit portfolio for review. Query with résumé of credits. Query with samples. Send material by mail for consideration. SASE. Reports in 1 month.
Tips: Include 20 labeled slides, résumé and artist statement with submission.

LONGVIEW MUSEUM OF FINE ARTS, P.O. Box 3484, 215 E. Tyler St., Longview TX 75606. (903)753-8103. Fax: (903)753-8217. Director: Carolyn Fox-Hearne. Nonprofit museum. Estab. 1958. Approached by 50 artists a year; represents or exhibits 90 artists. Sponsors 1 photography exhibit per year. Average display time 6 weeks. Museum open Tuesday through Friday from 10 to 4; Saturday from 12 to 4. Large open gallery, originally a furniture store with old hardwood floors, large doors, 15,000 sq. ft. Overall price range $125-4,000. Most work sold at $300.
Exhibits: Exhibits photos of architecture, beauty, landscapes/scenics, nudes.
Making Contact & Terms: Gallery provides insurance. Accepted work should be framed. Call/write to arrange personal interview to show portfolio of slides. Mail portfolio for review. "Mail slides and please state whether they may be kept for files if desired." Send query letter with bio, SASE, slides. Return material with SASE. Replies only if interested within 2 months. Finds artists through word of mouth, submissions, portfolio reviews, art exhibits, referrals by other artists.

M.C. GALLERY, 400 First Ave. N., Suite 100, Minneapolis MN 55401. (612)339-1480. Fax: (612)513-9551. E-mail: mcgallery1@aol.com. Director: M.C. Anderson. Fine art gallery. Estab. 1984. Examples of recent exhibits: works by Gloria Dephilips Brush, Ann Hofkin and Catherine Koemptgen. Shows last 6 weeks. General price range of work: $250-1,200. Most work sold at $400.
Exhibits: Exhibits photos of children, couples, multicultural, families, parents, senior citizens, disasters, environmental, landscapes, scenics, architecture, beauty, cities/urban, gardening, entertainment, events. Interested in avant garde and fine art.
Making Contact & Terms: Charges 50% commission. Reviews transparencies. Interested in framed or unframed work. Requires exclusive representation within metropolitan area. Submit portfolio for review. Query with résumé of credits. Send material by mail for consideration. Material will be returned 2-3 times/year. SASE. Reports in 1-2 weeks if strongly interested. Finds artists through word of mouth, portfolio reviews and referrals by other artists.
Tips: "Photographers should present quality slides which are clearly labeled. No form letters or mass mailings."

MACALESTER GALLERY, Janet Wallace Fine Arts Center, Macalester College, 1600 Grand Ave., St. Paul MN 55105. (651)696-6416. Fax: (651)696-6266. E-mail: gallery@macalester.edu. Gallery Curator: Devin A. Colman. Nonprofit gallery. Estab. 1964. Approached by 15 artists a year; represents or exhibits 3 artists. Sponsors 1 photography exhibit per year. Average display time 6-8 weeks. Gallery open Monday through Friday 9 to 8; weekends from 11 to 6. Closed major holidays, summer and school holidays. Located in the core of the Janet Wallace Fine Arts Center on the campus of Macalester College. Gallery is approx. 1,100 sq. ft. and newly renovated.
Exhibits: Exhibits photos of celebrities, multicultural, environmental, landscapes/scenics, architecure, rural, adventure, portraits. Interested in avant garde, documentary, fine art, historical/vintage, regional.
Making Contact & Terms: Gallery provides insurance. Accepted work should be framed, mounted, matted. Send query letter with artist's statement, bio, brochure, business card, photocopies, photographs, résumé, reviews, SASE, slides. Replies in 3 weeks. Finds artists through word of mouth, portfolio reviews, referrals by other artists.
Tips: "Photographers should present quality slides which are clearly labeled. Include a concise artist's statement. Always include a SASE. No form letters or mass mailings."

MAINE COAST ARTISTS, 162 Russell Ave., Rockport ME 04856. (207)236-2875. Fax: (207)236-2490. E-mail: mca@midcoast.com. Website: http://www.midcoast.com/~mca. Curator: Bruce Brown. Estab. 1952. Examples of 1999 exhibits: Maine Photographic Workshop Faculty Exhibition; "The Seven Deadly Sins," by Tad Beck; "Still," by Jocelyn Lee; "Rakin' the Blues," by David Stess; "Time & Light, A Record of Things Seen," by Dirk McDonnell. Number of shows varies. Shows last 1 month. General price range of work: $200-2,000.
● This gallery has received a National Endowment for the Arts grant.
Exhibits: Photographer must live and work part of the year in Maine; work should be recent and not previously exhibited in the area.
Making Contact & Terms: Charges 40% commission. Reviews transparencies. Accepts images in digital format for Mac. Send via compact disc or Online. Query with résumé of credits. Query with samples. Send material by mail for consideration. SASE. Reports in 2 months.
Tips: "A photographer can request receipt of application for our annual juried exhibition, as well as apply for solo or group exhibitions."

MARBLE HOUSE GALLERY, 44 Exchange Place, Salt Lake City UT 84111. (801)532-7332. Fax: (801)532-7338, "call first." Owner: Dolores Kohler. Estab. 1988. Examples of recent exhibits: "Unique

Panoramas," by Kendall Davenport; "Color and Softness," by Dolores Kohler; and "Photos," by John Stevens. Presents 2 shows/year. Shows last 1 month. Past member of the Salt Lake Gallery Association. Also provides public relations, etc. General price range of work: $50-1,000.

Exhibits: Exhibits photos of children, couples, families, parents, senior citizens, teens, landscapes/scenics, wildlife, architecture, beauty, cities/urban, education, gardening, pets, religious, rural, adventure, hobbies, performing arts, travel, buildings, computers, still life. Interested in painterly, abstract, digital, documentary, fine art, historical/vintage, regional, seasonal, landscapes. No documentary or politically-oriented work. No nudes.

Making Contact & Terms: Charges 50% commission. Buys photos outright. Reviews transparencies. Interested in framed or unframed, mounted or unmounted, matted or unmatted work. Requires exclusive representation within metropolitan area. No size limits. Arrange a personal interview to show a portfolio. Submit portfolio for review. Query with résumé of credits. Query with samples. Send material by mail for consideration. SASE. Reports in 1 month.

Tips: To make gallery submissions professional have "balanced composition, subtle or vibrant color, clear, minute detail and finish the photo in harmony with the intended image."

MARLBORO GALLERY, Prince George's Community College, 301 Largo Road, Largo MD 20772-2199. (301)322-0967. Fax: (301)808-0418. Gallery Curator: Tom Bedault. Estab. 1976. Example of recent exhibition: "Through The Mind's Eye," five contemporary photographers. Shows last 1 month. General price range of work: $50-2,000. Most work sold between $75-350.

Exhibits: Exhibits photos of celebrities, landscapes/scenics, wildlife, adventure, entertainment, events, travel portraits. Interested in alternative process, avant garde, digital, fine art. Not interested in commercial work. "We are looking for fine art photos; we need between 10 to 20 to make assessment. Reviews are done every six months. We prefer submissions February-April."

Making Contact & Terms: Reviews transparencies. Interested in framed work only. Query with samples. Send material by mail for consideration. SASE. Reports in 3-4 weeks.

Tips: "Send examples of what you wish to display and explanations if photos do not meet normal standards (i.e., in focus, experimental subject matter)."

MARSH ART GALLERY, University of Richmond, Richmond VA 23173. (804)289-8276. Fax: (804)287-6006. E-mail: rwaller@richmond.edu. Website: http://www.richmond.edu/. Director: Richard Waller. Estab. 1968. Example of recent exhibition: "Personal Visions: 101 Photographs by 101 Photographers." Presents 8-10 shows/year. Shows last 1 month.

Exhibits: Interested in all subjects.

Making Contact & Terms: Charges 10% commission. Reviews transparencies. Interested in framed or unframed, mounted or unmounted, matted or unmatted work. Work must be framed for exhibition. Query with résumé of credits. Query with samples. Send material by mail for consideration. Reports in 1 month.

Tips: If possible, submit material which can be left on file and fits standard letter file. "We are a nonprofit university museum interested in presenting contemporary art."

MORTON J. MAY FOUNDATION GALLERY—MARYVILLE UNIVERSITY, 13550 Conway Rd., St. Louis MO 63141. (314)529-9415. Fax: (314)529-9940. Gallery Director and Art Professor: Nancy N. Rice. Examples of recent exhibits: "Recent Work," by Stacey C. Morse (b&w landscapes). Presents 1-3 shows/year. Shows last 1 month. General price range of work: $75-600. Most work sold at $200.

Exhibits: Must transcend student work, must have a consistent aesthetic point of view or consistent theme and must be technically excellent.

Making Contact & Terms: Photographer is responsible for all shipping costs to and from gallery. Gallery takes no commission; photographer responsible for collecting fees. Interested in framed or unframed, mounted or unmounted, matted or unmatted work (when exhibited, work must be framed or suitably presented.) Send material by mail for consideration. SASE. Reports in 3-4 months.

THE MAYANS GALLERY LTD., 601 Canyon Rd., Santa Fe NM 87501. (505)983-8068. Fax: (505)982-1999. E-mail: arte2@aol.com. Website: http://www.arnet.com./mayans/html. Director: Ernesto Mayans. Associate: Ava M. Hu. Estab. 1977. Examples of exhibits: "Cholos/East L.A.," by Graciela Iturbide (b&w); "Ranchos de Taos Portfolio," by Doug Keats (Fresson), "A Diary of Light," by André Kertész (b&w), "Floralia" by Willis Lee (photo gravures prints). Publishes books, catalogs and portfolios. General price range of work: $200-5,000.

Making Contact & Terms: Charges 50% commission. Consigns; also buys photos outright. Interested in framed or unframed, mounted or unmounted work. Requires exclusive representation within area. Size limited to 11×20 maximum. Arrange a personal interview to show portfolio. Send inquiry by mail for consideration. SASE. Reports in 1-2 weeks.

Tips: "Please call before submitting."

R. MICHELSON GALLERIES, 132 Main St., Northampton MA 01060. (413)586-3964. Fax: (413)587-9811. E-mail: rm@rmichelson.com. Website: rmichelson.com. Owner and President: Richard Michelson. Estab. 1976. Examples of exhibits: Works by Michael Jacobson-Hardy (landscape); Jim Wallace (landscape); and Robin Logan (still life/floral). Presents 1 show/year. Show lasts 6 weeks. Sponsors openings. General price range of work: $100-1,000.
Exhibits: Interested in contemporary, landscape and/or figure, environmental, generally realistic work.
Making Contact & Terms: Sometimes buys photos outright. Reviews transparencies. Interested in framed or unframed, mounted or unmounted, matted or unmatted work. Requires exclusive representation locally. Not taking on new photographers.

PETER MILLER GALLERY, 740 N. Franklin, Chicago IL 60610. (312)951-1700. Fax: (312)951-0252. E-mail: pmgallery@aol.com. Directors: Peter Miller and Natalie R. Domchenko. Estab. 1979. Gallery is 2,000 sq. ft. with 12 foot ceilings. Overall price range $2,000-24,000. Most work sold at $5,000.
Exhibits: "We are interested in adding photography to the work currently exhibited here." Interested in alternatiave process, avant garde and digital work.
Making Contact & Terms: Artwork is accepted on consignment and there is a 50% commission. Reviews transparencies. Interested in framed or unframed, mounted or unmounted, matted or unmatted work. Requires exclusive representation locally. Send 20 slides of the most recent work with SASE. Reports in 1-2 weeks.
Tips: "We look for work we haven't seen before, i.e. new images and new approaches to the medium."

MOBILE MUSEUM OF ART, P.O. Box 8426, Mobile AL 36689 or 4850 Museum Dr., Mobile AL 36608. (334)343-2667. Fax: (334)343-2680. Executive Director: Joe Schenk. Estab. 1964. Examples of recent exhibits: "Generations in Black and White: Photography by Carl Van Vechten," from the James Weldon Johnson Memorial Collection; and "From the Heart, The Power of Photography: A Collector's Choice," the Sondra Gilman Collection. Presents 1-2 shows/year. Shows last about 6 weeks. Sponsors openings; provides light hors d'oeuvres and wine.
Exhibits: Open to all types and styles.
Making Contact & Terms: Photography sold in gallery. Charges 20% commission. Occasionally buys photos outright. Reviews transparencies. Interested in framed work only. Arrange a personal interview to show portfolio; send material by mail for consideration. Returns material when SASE is provided "unless photographer specifically points out that it's not required."
Tips: "We look for personal point of view beyond technical mystery."

MONTEREY MUSEUM OF ART, 559 Pacific St., Monterey CA 93940. (831)372-5477. Fax: (831)372-5680. Website: http://www.montereyart.org. Director: Richard W. Gadd. Estab. 1969. Examples of recent exhibits: "The Edge of Shadow," photographs from the Page Collection; photographs by Dody Weston Thomson. Presents 4-6 shows/year. Shows last approximately 6-12 weeks.
Exhibits: Interested in all subjects.
Making Contact & Terms: Reviews transparencies. Work must be framed to be displayed; review can be by slides, transparencies. Send material by mail for consideration. SASE. Reports in 1 month.
Tips: "Send 20 slides and résumé at any time to the attention of the museum director."

MONTPELIER CULTURAL ARTS CENTER, 12826 Laurel-Bowie Rd., Laurel MD 20708. (301)953-1993. Fax: (301)206-9682. Director: Richard Zandler. Estab. 1979. Examples of exhibits: "Photographs by Jason Horowitz," (panoramic b&w); "In The Shadow of Crough Patrick," photos by Joan Rough (color landscapes of Ireland); photos by Robert Houston (b&ws of urban life); "Images in Time," by Andrew Davidhazy. Shows last 1-2 months.
Exhibits: Open to all photography.
Making Contact & Terms: "We do not sell much." Charges 25% commission. Reviews transparencies. Interested in framed work only. "Send 20 slides, résumé and exhibit proposal for consideration. Include SASE for return of slides. Work must be framed and ready for hanging if accepted." Reports "after scheduled committee meeting; depends on time of year."

MORGAN GALLERY, 412 Delaware, Suite A, Kansas City MO 64105. (816)842-8755. Fax: (816)842-3376. Director: Dennis Morgan. Estab. 1969. Examples of recent exhibitions: photos by Holly Roberts; Dick Arentz (platinum); Linda Conner (b&w) and William Christenberry. Presents 1-2 shows/year. Shows last 4-6 weeks. General price range of work: $250-5,000.
Making Contact & Terms: Reviews transparencies. Submit portfolio for review. Send material by mail

for consideration. SASE. Reports in 3 months.

THE MUSEUM OF CONTEMPORARY PHOTOGRAPHY, COLUMBIA COLLEGE CHICAGO, 600 S. Michigan Ave., Chicago IL 60605-1996. (312)663-5554. Fax: (312)344-8067. E-mail: mocp@aol.com. Website: http://www.mocp.org. Director: Denise Miller. Assistant Director: Nancy Fewkes. Estab. 1984. Examples of exhibits: "Photography's Multiple Roles: Art, Document, Market, Science," (overview of contemporary American and US-Resident photography); "Some Southern Stories" (photographers and writers living in the Southern United States). "We present a range of exhibitions exploring photography's many roles: as a medium of artistic expression, as a documenter of life and the environment, as a commercial industry and as a powerful tool in the service of science and technology." Presents 5 main shows and 8-10 smaller shows/year. Shows last 8 weeks.
Exhibits: Interested in fine art, documentary, photojournalism, commercial, technical/scientific. "All high quality work considered."
Making Contact & Terms: Buys photos outright. Reviews transparencies. Interested in reviewing unframed work only, matted or unmatted. Submit portfolio for review. SASE. Reports in 2 weeks. No critical review offered.
Tips: "Professional standards apply; only very high quality work considered."

MUSEUM OF PHOTOGRAPHIC ARTS, 1649 El Prado, Balboa Park, San Diego CA 92101. (619)238-7559. Fax: (619)238-8777. E-mail: info@mopa.org. Website: http://www.mopa.org. Director: Arthur Ollman. Curator: Diana Gaston. Estab. 1983. Examples of recent exhibits featuring contemporary photographers from the U.S. and abroad include: "Points of Entry: A Nation of Strangers," "Under the Dark Cloth: The View Camera in Contemporary Photography," "Kenro Izu: Light Over Ancient Anqkor," and "Abelardo Morell and the Camera Eye." Presents 6-8 exhibitions annually from 19th century to contemporary. Each exhibition lasts approximately 2 months. Exhibition schedules planned 2-3 years in advance. Holds a private Members' Opening Reception for each exhibition.
Exhibits: "The criteria is simply that the photography be the finest and most interesting in the world, relative to other fine art activity. MoPA is a museum and therefore does not sell works in exhibitions. There are no fees involved."
Making Contact & Terms: "For space, time and curatorial reasons, there are few opportunities to present the work of newer, lesser-known photographers." Send an artist's statement and a résumé of credits with a portfolio (unframed photographs) or slides. Portfolios may be submitted for review with advance notification and picked up in 2-3 days. Files are kept on contemporary artists for future reference. Send return address and postage. Reports in 2 months.
Tips: "Exhibitions presented by the museum represent the full range of artistic and journalistic photographic works." There are no specific requirements. "The executive director and curator make all decisions on works that will be included in exhibitions. There is an enormous stylistic diversity in the photographic arts. The museum does not place an emphasis on one style or technique over another."

N MUSEUM OF THE PLAINS INDIAN & CRAFTS CENTER, Junction of Highways 2 and 89, Browning MT 59417. (406)338-2230. Fax: (406)338-7404. Curator: Loretta Pepion. Estab. 1941. Shows last 6 weeks. Sponsors openings. Provides refreshments and a weekend opening plus a brochure. Admission charged June 1 to September 30.
Exhibits: Must be a Native American of any tribe within the 50 states, proof required.
Making Contact & Terms: Charges 25% commission. Reviews transparencies. Interested in framed and matted work. Query with samples. Send material by mail for consideration.

N NEVADA MUSEUM OF ART, 160 W. Liberty St., Reno NV 89501. (775)329-3333. Fax: (775)329-1541). E-mail: art@nma.reno.nv.us. Website: http://www.nevadaart.org. Estab. 1931. Presents 10-12 exhibits/year in various media. Exhibitions run 3-4 months. Examples of recent exhibitions include *Through Their Own Eyes: Edward Weston and Ansel Adams and the War Trilogy;* photographs by Avi Holtzman. Upcoming exhibitions inclue *The Altered Landscape: A Focus Collection of the Nevada Museum of Art* that concerns the interactive aspects of man with the modern landscape.
Making Contact & Terms: Portfolios with slides should be sent to Diane Deming, curator.
Tips: "The Nevada Museum of Art is a private, nonprofit institution dedicated to providing a forum for the presentation of creative ideas through its collections, education programs, exhibitions and community outreach."

N NEW ORLEANS MUSEUM OF ART, Box 19123, City Park, New Orleans LA 70179. (504)488-2631. Fax: (504)484-6662. Website: http://www.noma.org. Curator of Photography: Steven Maklansky. Collection estab. 1973. Examples of exhibits: "Cameraderie," by 64 photographers and "Double Expo-

sure," by 50 photographers. Presents shows continuously. Shows last 1-3 months.
Exhibits: "Send thought-out images with originality and expertise. Do not send commercial-looking images." Interested in all types of photography.
Making Contact & Terms: Buys photography outright; payment negotiable. Present budget for purchasing contemporary photography is very small. Sometimes accepts donations from established artists, collectors or dealers. Query with color photocopies (preferred) or slides and résumé of credits. SASE. Reports in 1-3 months.

N: NICOLAYSEN ART MUSEUM & DISCOVERY CENTER, 400 E. Collins, Casper WY 82601. (307)235-5247. Fax: (307)235-0923. Director: Joe Ellis. Estab. 1967. Presents 2 shows/year. Shows last 2 months. Sponsors openings. General price range of work: $250-1,500.
Exhibits: Artistic excellence and work must be appropriate to gallery's schedule. Interested in all subjects and media.
Making Contact & Terms: Charges 40% commission. Reviews transparencies. Interested in framed or unframed work. Send material by mail for consideration (slides, vita, proposal). SASE. Reports in 1 month.
Tips: "We have a large children/youth audience and gear some of what we do to them."

NORTHLIGHT GALLERY, School of Art, Arizona State University, Tempe AZ 85287-1505. Website: http://www.northlight.fa.asu.edu. Contact: Advisory Committee. Estab. 1972. Examples of recent exhibits: "Family Matters," by Sally Mann, Vince Leo, Melissa Shook, Phillip Lorca DiCorcia, Richard Bolton, Jay Wolke, Paul DaMato, Beaumont Newhall. Presents 6 shows/year. Shows last 1 month.
Exhibits: Interested in alternative process, avant garde, digital, documentary, fine art, historical/vintage.
Making Contact & Terms: Northlight advisory committee reviews transparencies for academic year scheduling. SASE. Reports in 1 month.

NORTHWEST ART CENTER, 500 University Ave. W., Minot ND 58707. (701)858-3264. Fax: (701)839-6933. Director: Linda Olson. Estab. 1976. Presents 24 shows/year. Shows last 1 month. Northwest Art Center consists of 2 galleries: Hartnet Hall Gallery and the Library Gallery. General price range of work: $50-300. Examples of recent exhibitions: "Abandon in Place," by Zoe Spooner (b&w photos).
Making Contact & Terms: Charges 30% commission. Reviews transparencies. Interested in framed work only, mounted or unmounted, matted or unmatted. Send material by mail for consideration. SASE. Reports in 1 month.

THE NOYES MUSEUM OF ART, Lily Lake Rd., Oceanville NJ 08231. (609)652-8848. Fax: (609)652-6166. E-mail: noyesnews@jerseycape.com. Website: http://www.users.jerseycape.com/thenoyes. Curator: Stacy Smith. Estab. 1983. Examples of recent exhibitions: "American Amusements," by David Ricci (silver dye-bleach); photographs by Dwight Hiscano (Cibachrome); "Friends and Families," photographs by Rita Bernstein (b&w and gelatin silver prints); "Dust-shaped Hearts: Photographic Portraits," by Don Camp (casein and earth pigment monoprints). Presents 2-3 shows/year. Shows last 6-12 weeks. General price range of work: $150-1,000.
Exhibits: Exhibits photos of children, multicultural, families, environmental, landscapes/scenics, wildlife, architecture, cities/urban, rural. Interested in alternative process, documentary, fine art. Works must be ready for hanging, framed preferable.
Making Contact & Terms: Charges 10% commission. Infrequently buys photos for permanent collection. Reviews transparencies. Any format OK for initial review. Send material by mail for consideration; include résumé and slide samples. Reports in 1 month.
Tips: "Send challenging, cohesive body of work. May include photography and mixed media."

O.K. HARRIS WORKS OF ART, 383 W. Broadway, New York NY 10012. (212)431-3600. Director: Ivan C. Karp. Estab. 1969. Examples of exhibits: "Mama's Boy," by Peter Monroe (color photographs of men who live with their mothers); "New York-Sacred Ground," by Mike Nogami (photographs of desolate New York City landscapes); John Stockdale (color photographs of close-ups of metal shutters and boarded buildings in New York City). Presents 3-6 shows/year. Shows last 4 weeks. Gallery closed the month of August. General price range of work: $350-1,200.
Exhibits: Exhibits photos of families, multicultural, rural, buildings. "The images should be startling or profoundly evocative. No rocks, dunes, weeds or nudes reclining on any of the above or seascapes." Interested in urban and industrial subjects, cogent photojournalism, digital, fine art.
Making Contact & Terms: Charges 50% commission. Interested in matted framed work. Appear in person, no appointment: Tuesday-Friday 10-6. SASE. Reports back immediately.
Tips: "Do not provide a descriptive text."

⊕ **THE 198 GALLERY**, 194-198, Railton Rd., London SE24 0JT United Kingdom. Phone: (0171)978-8309. Fax: (0171)652-1418. E-mail: 198gallery@globalnet.co.uk. Website: http://www.globalnet.co.uk/~198gallery. Director: Zoë Linsley-Thomas. Nonprofit gallery, craft shop, artists studios. Estab. 1989. Approached by 40-50 artists a year; represents or exhibits 10 artists. Examples of recent exhibits: "Family Histories," by Rita Keegan (photographic portraits). Sponsors 1 photography exhibit/year. Average display time 4-5 weeks. Open Tuesday through Saturday from 1-6, all year; Tuesday through Friday from 9-1 for education/schools. "Located at Herne Hill near Brixton with two small galleries, exclusive craft shop, education workshop and exhibition space."
Exhibits: Cultural issue based art.
Making Contact & Terms: Artwork is accepted on consignment and there is a 33% commission. Retail price set by the artist. Accepted work should be framed. Accepts artists from culturally diverse backgrounds. Write to arrange a personal interview to show portfolio of photographs, transparencies. Send query letter with artist's statement, bio, photographs, reviews. Replies in 2 months. Finds artists through submissions, degree shows.

ORGANIZATION OF INDEPENDENT ARTISTS, 19 Hudson St., 402, New York NY 10013. (212)219-9213. Fax: (212)219-9216. Website: http://www.arts-online.com/oia.htm. Program Director: Nadini Richardson. Estab. 1976. Presents several shows a year. Shows last 4-6 weeks.
 ● OIA is a non-profit organization that helps sponsor group exhibitions at the OIA office and in public spaces throughout New York City.
Making Contact & Terms: Membership $40 per year. Submit slides with proposal. Send material by mail for consideration according to guidelines only. Write for information on membership. SASE. "We review twice a year (April and October)."
Tips: "It is not required to be a member to submit a proposal, but interested photographers may want to become OIA members to be included in OIA's active slide file that is used regularly by curators and artists. You must be a member to have your slides in the registry and to be considered for exhibits at the OIA gallery, Gallery 402."

ORLANDO GALLERY, Dept. PM, 14553 Ventura Blvd., Sherman Oaks CA 91403. Phone/fax: (818)789-6012. Website: http://artsceneal.com.gotoorlando. Directors: Robert Gino, Don Grant. Estab. 1958. Examples of recent exhibits: landscapes by Steve Wallace; personal images by Fred Kurestski; figures by Pat Whiteside Phillips; and collage photos/landscapes by Lynn Bassler. Shows last 1 month. Price range of work: $600-3,000.
Exhibits: Interested in photography demonstrating "inventiveness" on any subject.
Making Contact & Terms: Charges 50% commission. Query with résumé of credits. Send material by mail for consideration. SASE. Accepts images in digital format. Framed work only. Reports in 1 month. Requires exclusive representation in area.
Tips: Make a good presentation. "Make sure that personality is reflected in images. We're not interested in what sells the best—just good photos."

PACEWILDENSTEINMACGILL, 32 E. 57th St., 9th Floor, New York NY 10022. (212)759-7999. Contact: Laura Santaniello. Estab. 1983. Presents 18 shows/year. Shows last 6-8 weeks. General price range of work: $1,000-300,000.
 ● PaceWildensteinMacGill has a second location in Los Angeles: 9540 Wilshire Blvd., Beverly Hills CA 90212. (310)205-5522. Contact: Chelsea Hadley.
Exhibits: "We like to show original work that changes the direction of the medium."
Making Contact & Terms: Photography sold in gallery. Commission varies. On occasion, buys photos outright.
Tips: "Review our exhibitions and ask, 'Does my work make a similar contribution to photography?' If so, seek third party to recommend your work."

N PENTIMENTI GALLERY, 133 N. Third St., Philadelphia PA 19106. (215)625-9990. Fax: (215)625-8488. E-mail: pentimen@pond.com. Website: http://www.pentimenti.com. Art consultancy, commercial gallery. Estab. 1992. Average display time 1 month. Gallery open Monday through Tuesday by appointment; Wednesday through Friday 12-6; weekends from 12 to 5. Closed Christmas and New Years day. Located

● **SPECIAL COMMENTS** within listings by the editor of *Photographer's Market* are set off by a bullet.

in the heart of Old City Cultural District in Philadelphia. Overall price range $500-8,000. Most work sold at $2,800.

Exhibits: Exhibits photos of multicultural, families, environmental, landscapes/scenics, wildlife, architecture, beauty, cities/urban, gardening, entertainment, events. Interested in avant garde, documentary, fashion/glamour, fine art, historical/vintage, regional.

Making Contact & Terms: Artwork is accepted on consignment and there is a 50% commission. Gallery provides insurance, promotion, contract. Accepted work should be framed, mounted, matted. Call to arrange personal interview to show portfolio of photographs, slides, transparencies. Send query letter with artist's statement, bio, brochure, photocopies, photographs, résumé, reviews, SASE, slides. Returns material with SASE. Replies in 3 months. Finds artists through word of mouth, portfolio reviews, art fairs, referrals by other artists.

[N] THE PEORIA ART GUILD, 1831 N. Knoxville Ave., Peoria IL 61603-3095. (309)685-7522. Fax: (309)685-7446. Director: Tyson Joye. Estab. 1969. Examples of recent exhibits: "Digital Photography '98"; a Fine Art Fair and a Fine Art Show & Sale with photography included. Presents 1-2 shows/year. Shows last 1 month. Sponsors openings; provides food and drink, occasionally live music. General price range of work: $75-500.
• The Guild has a successful annual Digital Photo Competition. Write for details.

Making Contact & Terms: Charges 40% commission. Reviews transparencies. Interested in framed or unframed work. Submit portfolio for review. Query with résumé of credits. Send material by mail for consideration. SASE. Reports in 1 month.

[N] PEPPER GALLERY, 38 Newbury St., Boston MA 02116. (617)236-4497. Fax: (617)266-4492. Director: Audrey Pepper. For profit gallery. Estab. 1993. Represents or exhibits 18 artists. Sponsors 1-2 photography exhibits per year. Average display time 5 weeks. Gallery open Tuesday through Saturday from 10 to 5:30. Closed August 15-Labor Day, Christmas-January 2. Approximately 800 sq. ft. Overall price range $700-24,000. Most work sold at $1,000-7,000.

Exhibits: Interested in alternative process, fine art.

Making Contact & Terms: Artwork is accepted on consignment and there is a 50% commission. Gallery provides insurance, promotion. Accepted work should be framed, mounted, matted. Requires exclusive representation locally. Mail portfolio for review or send query letter with artist's statement, bio, résumé, reviews, SASE, slides. Returns material with SASE. Replies in 2 months. Finds artists through word of mouth, art exhibits, referrals by other artists.

PHOENIX GALLERY, 568 Broadway, Suite 607, New York NY 10012. (212)226-8711. Fax: (212)343-7303. Website: http://www.gallery-guide.com/gallery/phoenix. Director: Linda Handler. Estab. 1958. Presents 10-12 shows/year. Shows last 1 month. General price range of work: $100-10,000. Most work sold at $2,500.
• The gallery is celebrating its 40th anniversary and seeking new members.

Exhibits: "The gallery is an artist-co-operative and an artist has to be a member in order to exhibit in the gallery." Exhibits photos of disasters, environmental, multicultural. Interested in all media, alternative process, avant garde, documentary, fine art.

Making Contact & Terms: Charges 25% commission. Reviews transparencies and slides. Accepted work must be framed. Ask for membership application. SASE. Reports in 1 month.

Tips: "The Gallery has a small works PROJECT ROOM where nonmembers can exhibit their work. If an artist is interested he/she may send a proposal with art to the gallery. The space is free. The artist also shares in the cost of the reception with the other artists showing at that time."

[N] THE PHOTO GALLERY, Truckee Meadows Community College, 7000 Dandini Blvd., Reno NV 89512. (775)674-7698. Website: http://www.tmcc.edu/library/art. Gallery Director: Roger Kinnaman. Estab. 1990. Number of photography exhibits presented each year depends on jury. Shows last 1 month.

Exhibits: Interested in all styles, subject matter, techniques—traditional, innovative and/or cutting edge.

Making Contact & Terms: Reviews transparencies. Interested in exhibiting matted work only. Send 15 slides, résumé and SASE for consideration (35mm glassless dupes). Work is reviewed once a year; write for deadline in Spring.

Tips: "Slides submitted should be sharp, accurate color and clearly labeled with name, title, dimensions, medium—the clearer the vitae the better. Statements optional."

PHOTOGRAPHIC IMAGE GALLERY, 240 SW First St., Portland OR 97204. (503)224-3543. Fax: (503)224-3607. E-mail: photogal@teleport.com. Director: Guy Swanson. Estab. 1984. Examples of recent exhibits: "The Enduring Spirit," by Phil Borges; Cibachrome landscapes by Christopher Burkett; and

Fotofest artists. Presents 12 shows/year. Shows last 1 month. General price range of work: $300-1,500.

Exhibits: Interested in primarily mid-career to contemporary Master-Traditional Landscape in color and b&w.

Making Contact & Terms: Charges 50% commission. Reviews transparencies. Requires exclusive representation within metropolitan area. Query with résumé of credits. SASE. Reports in 1 month.

Tips: Current opportunities through this gallery are fair. Sees trend toward "more specializing in imagery rather than trying to cover all areas."

⊠ PHOTOGRAPHIC RESOURCE CENTER, 602 Commonwealth Ave., Boston MA 02215. (617)353-0700. Fax: (617)353-1662. E-mail: prc@bu.edu. Website: http://web.bn.edu/PRC. Director of Exhibitions: Sara Rosenfeld Dassel. "The PRC is a nonprofit arts organization founded in 1976 to facilitate the study and dissemination of information relating to photography." Examples of previous exhibitions: "Facing Death: Portaits from Cambodia's Killing Fields"; "Extended Play: Between Rock & An Art Space"; "Recollecting a culture: photography and the Evolution of a Socialist Aesthetic in East Germany"; and The Leopold Godowsky, Jr. Color Photography Awards (focusing on Asian artists for 1998). Presents 5-6 group thematic exhibitions in the David and Sandra Bakalar Gallery and 5-6 one- and two-person shows in the Natalie G. Klebenov Gallery/year. Shows last 6-8 weeks. Open Tuesday through Sunday from 12:00-5:00; Thursday 12:00-8:00, closed major holidays. Located in the heart of Boston University. Gallery brings in nationally recognized artists to lecture to large audiences and host workshops on photography.

Exhibits: Interested in contemporary and historical photography and mixed-media work incorporating photography. "The photographer must meet our high quality requirements."

Making Contact & Terms: Send query letter with artist's statement, bio, slides, résumé, reviews and SASE. Send material by mail for consideration. Replies in 2-3 months "depending upon frequency of programming committee meetings. We are continuing to consider new work, but because the PRC's exhibitions are currently scheduled into 2001, we are not offering exhibition dates." Finds artists through word of mouth, art exhibits and portfolio reviews.

Tips: "Present a cohesive body of work."

PHOTO-SPACE AT ROCKLAND CENTER FOR THE ARTS, 27 S. Greenbush Rd., West Nyack NY 10994. (914)358-0877. Fax: (914)358-0971. Executive Director: Julianne Ramos. Estab. 1947. Examples of recent exhibits: "Panoramic Photography," by Sally Spivak; "Tomorrow," new works by young photographers; and "Digital Photography." Presents 4-5 shows/year. Shows last 2 months. General price range of work: $250-2,500.

Exhibits: Geographic Limits: Rockland, Westchester and Orange counties in New York and Bergen County in New Jersey. Interested in all types of photos.

Making Contact & Terms: Charges 33% commission. Reviews transparencies. Interested in matted or unmatted work. Shows are limited to 32 × 40. Query with samples. Send material by mail for consideration. SASE. Reports in 3 months.

Ⓝ PLATTSBURGH STATE ART MUSEUM, State University of New York, 101 Broad St., Plattsburgh NY 12901. (518)564-2813 or (518)564-2474. Director: Edward Brohel. Estab. 1969. Presents "about 7 shows per year." Shows last 7 weeks. Sponsors openings. "Generally 4 gallery spaces have openings on the same day. One general reception or tea is held. It varies as to which gallery hosts." General price range of work: $25-200.

Exhibits: "Professional work only."

Making Contact & Terms: Reviews transparencies. Interested in framed work only. Requires exclusive representation to a degree within metropolitan area. Send material by mail for consideration or submit portfolio for review. Returns material "if requested—some are kept on file." Reporting time "varies with gallery pressures."

Tips: "Be serious, be yourself and think."

PRAKAPAS GALLERY, 1 Northgate 6B, Bronxville NY 10708. (914)961-5091. Fax: (914)961-5192. Director: Eugene J. Prakapas.

Making Contact & Terms: Commission "depends on the particular situation." General price range of work: $500-100,000.

Tips: "We are concentrating primarily on vintage work, especially from between the World Wars, but some as late as the 70s. We are not currently doing exhibitions."

Ⓝ THE PRINT CENTER, 1614 Latimer St., Philadelphia PA 19103. (215)735-6090. Fax: (215)735-5511. E-mail: print@libertynet.org. Website: http://www.libertynet.org/~print. Gallery Store Manager: Marguerite Levy. Nonprofit gallery. Estab. 1915. Approached by hundreds of artists a year; represents over

100 in gallery store. Sponsors 5 photography exhibits per year. Average display time 5 weeks. Gallery open Tuesday through Saturday from 11 to 5:30. Closed Christmas through January 2. Three galleries. Overall price range $45-21,000. Most work sold at $500.

Exhibits: Interested in alternative process, digital, documentary, fine art.

Making Contact & Terms: Artwork is accepted on consignment and there is a 50% commission. Gallery provides insurance, promotion, contract. Accepted work should be matted. Artists must be printmakers or photographers. Call to arrange personal interview to show portfolio. Send query letter with artist's statement, letter of intent, bio, résumé. Returns material with SASE. Replies in 1 month. Finds artists through word of mouth, submissions, portfolio reviews, art exhibits, art fairs and referrals by other artists (slides are submitted by our artist members for review by Program Committee).

⬛ PUCKER GALLERY, 171 Newbury St., Boston MA 02116. (617)267-9473. Fax: (617)424-9759. E-mail: puckergall@com. For profit gallery. Estab. 1967. Approached by 50 artists a year; represents or exhibits 40 artists. Sponsors 1 photography exhibit per year. Average display time 1 month. Gallery open Monday through Saturday from 10 to 5:30; Sunday from 1 to 5. 4 floors of exhibition space. Overall price range $500-100,000.

Exhibits: Exhibits photos of celebrities, children, multicultural, families, parents, senior citizens, environmental, landscapes/scenics, architecture, beauty, cities/urban, interiors/decorating, religious, rural. Interested in fashion/glamour, fine art, regional, seasonal. Other specific subjects/processes: hand-colored photographs, iris prints.

Making Contact & Terms: Gallery provides insurance, promotion. Write to arrange personal interview to show portfolio or mail portfolio for review. Send query letter with artist's statement, bio, SASE, slides. Finds artists through submissions, referrals by other artists.

QUEENS COLLEGE ART CENTER, Benjamin S. Rosenthal Library, Queens College, Flushing NY 11367-1597. (718)997-3770. Fax: (718)997-3753. E-mail: sbsqc@cunyvm.cuny.edu. Website: http://www. qc.edu/Library/art/center/html. Director: Suzanna Simor. Curator: Alexandra de Luise. Estab. 1952. Examples of recent exhibits: Francesc Catalá-Roca; Antigua Guatemala. Shows last approximately 1 month. Sponsors openings. Photographer is responsible for providing/arranging, refreshments and cleanup. General price range of work: $100-500.

Exhibits: Open to all types, styles, subject matter; decisive factor is quality.

Making Contact & Terms: Charges 40% commission. Interested in framed or unframed, mounted or unmounted, matted or unmatted work. Query with résumé of credits and samples. Send material by mail for consideration. SASE. Reports in 3-4 weeks.

◼ MARCIA RAFELMAN FINE ARTS, 10 Clarendon Ave., Toronto, Ontario M4V 1H9 Canada. (416)920-4468 Fax: (416)968-6715. E-mail: mrfa@ican.net. President: Marcia Rafelman. Semi-private gallery. Estab. 1984. Examples of recent exhibits: "insideout," group show (photography); "Curator's Choice," group show (photographs, paintings and graphics). Average display time 1 month. Gallery is centrally located in Toronto, 2,000 sq. ft. on 2 floors. Overall price range $500-30,000. Most work sold at $1,500.

Exhibits: Exhibits photos of fashion/glamour, fine art, historical/vintage, photo journalism, landscape, photo documentary, b&w.

Making Contact & Terms: Artwork is accepted on consignment and there is a 50% commission. Gallery provides insurance, promotion, contract. Requires exclusive representation locally. Mail portfolio for review, include bio, photographs, reviews. Replies only if interested within 1-2 weeks. Finds artists through word of mouth, submissions, art fairs, referrals by other artists.

Tips: "We only accept work that is archival."

⬛ RED VENUS GALLERY, P.O. Box 927113, San Diego CA 92192. (619)452-2599. E-mail: redvenusg allery@hotmail.com. Owner/Director: Kimberly Dotseth. Alternative space, art consultancy, for profit gallery. Estab. 1994. Approached by 12-15 artists a year; represents or exhibits 20 artists. Sponsors 6 photography exhibits per year. Average display time 2 months. Gallery open Monday through Sunday by appointment. Private, 1,200 sq. ft. home—all redesigned for art exhibitions. Overall price range $200-900. Most work sold at $500.

Exhibits: Exhibits photos of landscapes/scenics, alternative process, avant garde, historical/vintage, regional. Other specific subjects/processes: platinum; color.

Making Contact & Terms: Artwork is accepted on consignment and there is a 50% commission. Gallery provides promotion, contract. Accepted work should be framed, matted or in a nice portfolio/box. Requires exclusive representation locally only during exhibition times. Represents photography only—no nudes and no shock value. Call/write to arrange personal interview to show portfolio of photographs, transparencies,

slides or mail portfolio for review with bio, business card, photographs, résumé, slides. Returns material only with SASE. Replies in 1 month. Finds artists through word of mouth, submissions, portfolio reviews, art exhibits, art fairs, referrals by other artists.

Tips: "Type your cover letter, include an SASE and keep the number of images/slides to under 20."

ANNE REED GALLERY, P.O. Box 597, 620 Sun Valley Rd., Ketchum ID 83340. (208)726-3036. Fax: (208)726-9630. E-mail: annereed@micron.net. Website: http://www.AnneReedGallery.com. Director: Joy Kasputys. Estab. 1980. Example of recent exhibits: "The Selective Eye," works by Tom Baril, Keith Carter, Lynn Geesaman, Kenro Izu, Michael Kenna, Sarah, Moon, Robert Parke Harrison, Masao Yamamoto. Presents 1-2 photography shows/year. Shows last 1 month. General price range of work: $400-7,000. Most work sold at $2,500-3,000.

Exhibits: Work must be of exceptional quality. Interested in platinum, palladium prints, landscapes, still lifes, alternative process, fine art and regional material (West).

Making Contact & Terms: Artwork is accepted on consignment and there is a 50% commission. Interested in framed or unframed, mounted or unmounted, matted or unmatted work. Requires exclusive representation locally. Send query letter with résumé, slides or other visuals, bio and SASE. Replies in 2 months.

Tips: "We're interested only in fine art photography. Work should be sensitive, social issues are difficult to sell. We want work of substance, quality in execution and uniqueness. Please send only slides or other visuals of current work accompanied by updated résumé. Check gallery representation prior to sending visuals. Always include SASE. Exhibitions are planned one year in advance. Photography is still a difficult medium to sell; however there is always a market for exceptional work!"

ROBINSON GALLERIES, 2800 Kipling, Houston TX 77098. (713)521-2215. Fax: (713)526-0763. E-mail: robin@wt.net. Website: http://web.wt.net/~robin. Director: Thomas V. Robinson. Estab. 1969. Examples of recent exhibits: works by Pablo Corral (Cibachrome); Ron English (b&w and hand-colored silver gelatin prints); Blair Pittman (audiovisual with 35mm slides in addition to Cibachrome and b&w framed photographs); and Fotofest '98 exhibition of b&w 35mm and Holga prints of Terry Vine. Presents 1 show every other year. (Photographs included in all media exhibitions 1 or 2 times per year.) Shows last 4-6 weeks. Sponsors openings; provides invitations, reception and traditional promotion. General price range $100-1,000.

● Robinson Galleries, through Art Travel Studies, has developed various travel programs whereby individual photographers provide their leadership and expertise to travel groups of other photographers, artists, museum personnel, collectors, ecologists and travelers in general. Ecuador and Mexico are the featured countries, however, the services are not limited to any one destination. Artists/photographers are requested to submit biographies and proposals for projects that would be of interest to them and possibly to others that would pay the expenses and an honorarium to the photographer leader.

Exhibits: Archivally framed and ready for presentation. Limited editions only. Work must be professional. Not interested in pure abstractions.

Making Contact & Terms: Charges 50% commission. Reviews transparencies. Interested in framed or unframed, matted or unmatted work. Requires exclusive representation within metropolitan or state area. Arrange a personal interview to show portfolio. Submit portfolio for review. Query with résumé of credits. SASE. Reports in 1-2 weeks.

Tips: "Robinson Galleries is a fine arts gallery first, the medium is secondary."

THE ROLAND GALLERY, 601 Sun Valley Rd., P.O. Box 221, Ketchum ID 83340. (208)726-2333. Fax: (208)726-6266. E-mail: rolandart1@aol.com. Contact: Roger Roland. Estab. 1990. Example of recent exhibition: works by Al Wertheimer (1956 original Elvis Presley prints). Presents 5 shows/year. Shows last 1 month. General price range of work: $100-1,000. Most work sold at $300.

Exhibits: Exhibits photos of babies, celebrities, multicultural, senior citizens, architecture, adventure, entertainment, sports, travel. Interested in alternative process, avant garde, digital, erotic, fashion/glamour, fine art, historical/vintage, regional, seasonal.

Making Contact & Terms: Reviews transparencies. Interested in matted or unmatted work. Submit portfolio for review. SASE. Reports in 1 month.

THE ROSSI GALLERY, 2821 McKinney Ave., Dallas TX 75204. (214)871-0777. Fax: (214)871-1343. Owner: Hank Rossi. Estab. 1987. Examples of recent exhibits: "Visions of the West," by Skeeter Hagler (b&w); photography by Natalie Caudill (mixed media photographs); "Spirit," by David Chasey (b&w). Presents 2 shows/year. Shows last 1 month. General price range of work: $400-1,500.

Exhibits: Pays shipping both ways. Interested in b&w film noir. Challenging work and conceptual are preferred.

Making Contact & Terms: Charges 40% commission. Reviews transparencies. Interested in mounted, matted, or unmatted work only. Query with samples. SASE. Reports in 1 month.
Tips: "Be responsible and prompt. Figurative work is very strong."

THE ROTUNDA GALLERY, 33 Clinton St., Brooklyn NY 11201. (718)875-4047. Fax: (718)488-0609. Director: Janet Riker. Examples of previous exhibits: "All That Jazz," by Cheung Ching Ming (jazz musicians); "Undiscovered New York," by Stanley Greenberg (hidden New York scenes); "To Have and to Hold," by Lauren Piperno (ballroom dancing). Presents 4-5 show/year. Shows last 6-7 weeks.
Exhibits: Must live in, work in or have a studio in Brooklyn. Interested in contemporary works.
Making Contact & Terms: Charges 20% commission. Reviews transparencies. Interested in framed or unframed, mounted or unmounted, matted or unmatted work. Shows are limited by walls that are 22 feet high. Send material by mail for consideration. Join artists slide registry and call for form. SASE.

SANGRE DE CRISTO ARTS CENTER, 210 N. Santa Fe Ave., Pueblo CO 81003. (719)543-0130. Fax: (719)543-0134. Curator of Visual Arts: Jennifer Cook. Estab. 1972. Examples of exhibits: Yousef Karsh (b&w, large format); Laura Gilpin (photos of the Southwest); James Balog ("Survivors" series) and "Material World," international photographic project. Presents 3 shows/year. Shows last 3 months. General price range of work: $200-800.
Exhibits: Work must be artistically and technically superior; all displayed works must be framed. It is preferred that emerging and mid-career artists be regional.
Making Contact & Terms: Charges 30% commission. Reviews transparencies. Interested in framed work. Submit portfolio for review. Query with résumé of credits. Query with samples. Send material by mail for consideration. Reports in 2 months.

N SANTA BARBARA CONTEMPORARY ARTS FORUM, 653 Paseo Nuevo, Santa Barbara CA 93101. (805)966-5373. Fax: (805)962-1421. E-mail: sbcaf@silcom.com. Contact: Exhibition Committee. Nonprofit gallery. Estab. 1976. Approached by 150 artists a year; represents or exhibits 40 artists. Average display time 8-10 weeks. Gallery open Tuesday through Saturday from 11 to 5; Sunday from 12 to 5. Closed between exhibitions. "CAF's facilities include 2,800 sq. ft. of exhibition space and access to a state-of-the-art 'black box' theater."
Making Contact & Terms: Gallery provides insurance, promotion. Accepted work should be framed, mounted, matted. Mail portfolio for review. Finds artists through word of mouth, submissions, portfolio reviews, art exhibits, referrals by other artists. "Please submit up to 20 slides (35mm), background material, résumé, and a SASE for return of materials. Materials are generally reviewed and returned within 60-90 days."

N ◼ SCHMIDT/DEAN SPRUCE, 1721 Spruce St., Philadelphia PA 19146 and 1636 Walnut St., Philadelphia PA 19103. (215)546-9577. Fax: (215)546-7212. E-mail: lonnnnn.msn.com. Director: Carol Larson. For profit gallery. Estab. 1988. Sponsors 4 photography exhibits per year. Average display time 6 weeks. Gallery open Tuesday through Saturday from 10:30 to 6. Closed August. The space at Walnut is commercial and the one at Spruce is a townhouse. Overall price range $500-12,000.
Exhibits: Interested in alternative process, digital, documentary, fine art.
Making Contact & Terms: Artwork is accepted on consignment and there is a 50% commission. Gallery provides insurance, promotion. Accepted work should be framed, mounted, matted. Requires exclusive representation locally. Call/write to arrange personal interview to show portfolio of slides. Send query letter with SASE. "Send 10 to 15 slides, a résumé, which gives a sense of your working history. Include a SASE."

SECOND STREET GALLERY, 201 Second St. NW, Charlottesville VA 22902. (804)977-7284. Fax: (804)979-9793. E-mail: fsg@cstone.net. Director: Sarah Sargent. Estab. 1973. Examples of recent exhibitions: works by Bill Emory, Nick Havholm, Jeanette Montgomery Baron and Elijah Gowin. Presents 1-2 shows/year. Shows last 1 month. General price range of work: $250-2,000.
Making Contact & Terms: Charges 25% commission. Reviews transparencies in fall. Submit 10 slides for review. SASE. Reports in 6-8 weeks.
Tips: Looks for work that is "cutting edge, innovative, original."

SELECT ART, 10315 Gooding Dr., Dallas TX 75229. (214)353-0011. Fax: (214)350-0027. Owner: Paul Adelson. Estab. 1986. General price range of work: $250-600.
• This market deals fine art photography to corporations and sells to collectors.
Exhibits: Interested in architectural pieces and landscapes.
Making Contact & Terms: Charges 50% commission. General price range of work: $100-1,000. Reviews

transparencies. Interested in unframed and matted work only. Send material by mail for consideration. SASE. Reports in 1 month.

Tips: Make sure the work you submit is fine art photography, not documentary/photojournalistic or commercial photography. No nudes.

N SHAPIRO GALLERY, 250 Sutter St., 3rd Floor, San Francisco CA 94108. (415)398-6655. Fax: (415)398-0667. E-mail: shapirophoto@earthlink.net. Owner: Michael Shapiro. Estab. 1980. Examples of exhibits: Aaron Siskind (b&w); Andre Kertesz (b&w); and Vernon Miller (platinum). Shows last 2 months. Sponsors openings. General price range of work: $500-50,000.
Exhibits: Interested in "all subjects and styles (particularly fine art). Superior printing and presentation will catch our attention."
Making Contact & Terms: Artwork is accepted on consignment. Weekly portfolio drop off for viewing on Wednesdays. No personal interview or review is given. "No slides please." SASE.
Tips: "Classic, traditional" work sells best.

N B. J. SPOKE GALLERY, 299 Main Street, Huntington NY 11743. (516)549-5106. Coordinators: Marilyn Lavi, Debbie La Mantia. Examples of recent exhibits: "Reflections on China"; "Photography '98, Invitational," by 8 photographers (varied subjects); "Photography '99 Invitational," by 20 photographers (varied subjects). Shows last 1 month. Sponsors openings. General price range of work: $200-800.
Exhibits: Annual national/international juried show. Deadline December 13, 1999. Send for prospectus. Interested in "all styles and genres, photography as essay, as well as 'beyond' photography."
Making Contact & Terms: Charges 25% commission. Photographer sets price. Reviews transparencies. Interested in framed or unframed, matted or unmatted work. Arrange a personal interview to show portfolio. Query with résumé of credits. Send material by mail for consideration. SASE. Reports back in 2 months.
Tips: Offers photography invitational every year. Curatorial fee: $75.

THE STATE MUSEUM OF PENNSYLVANIA, P.O. Box 1026, Third & North Streets, Harrisburg PA 17108-1026. (717)783-9904. Fax: (717)783-4558. Website: http://www.state.pa.us. Senior Curator, Art Collections: N. Lee Stevens. Museum established in 1905; Current Fine Arts Gallery opened in 1993. Examples of exhibits: "Art of the State: PA '94," by Bruce Fry (manipulated, sepia-toned, b&w photo) and works by Norinne Betjemann (gelatin silver print with paint) and David Lebe (painted photogram). Number of exhibits varies. Shows last 2 months. General price range of work: $50-3,000.
Exhibits: Photography must be created by native or resident of Pennsylvania or contain subject matter relevant to Pennsylvania. Fine art photography is a new area of endeavor for The State Museum, both collecting and exhibiting. Interested in works produced with experimental techniques.
Making Contact & Terms: Work is sold in gallery, but not actively. Connects artists with interested buyers. No commission. Reviews transparencies. Interested in framed work. Send material by mail for consideration. SASE. Reports in 1 month.

N STUDIO ZE GALLERY, 598 Broadway, 2nd Floor, New York NY 10012. (212)219-3304. Website: http://www.sudioz.com. Contact: Sandra Sing. Alternative space. Estab. 1990. Exhibits 20 artists. Sponsors 3 photography shows/year. Most work sold at $3,000.
Exhibits: Interested in alternative process and avant garde photography.
Making Contact & Terms: Artwork is accepted on consignment basis and there is a 50% commission. Gallery provides promotion, contract. Accepted work should be mounted. Call to show portfolio. Finds artists through art exhibits, referrals by other artists.

N LILLIAN & COLEMAN TAUBE MUSEUM OF ART, (formerly Minot Art Gallery) P.O. Box 325, Minot ND 58702. (701)838-4445. Executive Director: Jeanne Rodgers. Estab. 1970. Presents 3 photography shows/year. Shows last about 1 month. Sponsors openings. "Museum is located at 2 North Main in a newly renovated historic landmark building with room to show two shows at once." General price range of work: $15-225. Most work sold at $40. Example of exhibits: "Wayne Jansen: Photographs," by Wayne Jansen (buildings and landscapes).
Exhibits: Exhibits photos of babies, children, couples, multicultural, families, parents, senior citizens, teens, disasters, landscapes/scenics, wildlife, beauty, rural, travel, agriculture, buildings, military, portraits. Interested in avant garde, fine art.

THE INTERNATIONAL MARKETS INDEX, located in the back of this book, lists markets located outside the U.S. by country.

Making Contact & Terms: Artwork is accepted on consignment and there is a 30% commission/member; 40%/nonmember. Submit portfolio or at least 6 examples of work for review. Prefers transparencies. SASE. Reports in 6 months.

Tips: "Wildlife, landscapes and floral pieces seem to be the trend in North Dakota. The new director likes the human figure and looks for high quality in photos. We get many slides to review for our three photography shows a year. Do something unusual, creative, artistic. Do not send postcard photos."

N: THREAD WAXING SPACE, 476 Broadway, 2nd floor, New York NY 10013. (212)966-9520. Fax: (212)274-0792. Executive Director: Ellen Salpeter. Estab. 1991. Examples of recent exhibits: "The Family of Men," by Barbara Pollack; "Imitation of Life," by Luther Price; and video retrospective of Cecelia Dougherty. Shows last 6 weeks. Sponsors openings.

Exhibits: "We are a nonprofit exhibition and performance space and do not sell or represent work. We have no set parameters but, generally, we exhibit emerging artists' work or work that is not ordinarily accessible to the public."

Making Contact & Terms: Reviews transparencies. Send slides with SASE.

N: THROCKMORTON FINE ART, 153 E. 61st St., New York NY 10021. (212)223-1059. Fax: (212)223-1937. E-mail: throckmorton@earthlink.net. Website: http://www.artnet.com/throckmorton.h. Director: Malin Barth. For profit gallery. Estab. 1993. Approached by 50 artists a year; represents or exhibits 20 artists. Sponsors 7 photography exhibits per year. Average display time 6 weeks. Overall price range $1,000-10,000.

Exhibits: Interested in Latin American photography.

Making Contact & Terms: Artwork is accepted on consignment from artists and there is a 50% commission. Gallery provides insurance, promotion. Accepts only artists from Latin America. Write to arrange personal interview to show portfolio of photographs, slides or send query letter with artist's statement, bio, photocopies, SASE, slides. Replies in 3 weeks. Finds artists through word of mouth, portfolio reviews.

Tips: "Present your work nice and clean."

■ UCR/CALIFORNIA MUSEUM OF PHOTOGRAPHY, University of California, Riverside CA 92521. (909)787-4787. Fax: (909)787-4797. Website: http://www.cmp.ucr.edu. Director: Jonathan Green. Examples of recent exhibitions: "Ocean View: The Depiction of Southern California Coastal Lifestyle"; "Chance Encounters: The LA Project," by Dough McCulloh; "Independent Visions: Women Photographers," UCR/CMP's Collection; "Continuous Replay: The Photographs of Arnie Zane." Presents 12-18 shows/year. Shows last 6-8 weeks.

Exhibits: The photographer must have the "highest quality work."

Making Contact & Terms: Curatorial committee reviews transparencies and/or matted or unmatted work. Query with résumé of credits. Accepts images in digital format for Mac. Send via compact disc, or Zip disk. SASE. Reports in 90 days.

Tips: "This museum attempts to balance exhibitions among historical, technology, contemporary, etc. We do not sell photos but provide photographers with exposure. The museum is always interested in newer, lesser-known photographers who are producing interesting work. We're especially interested in work relevant to underserved communities. We can show only a small percent of what we see in a year. The UCR/CMP has moved into a renovated 23,000 sq. ft. building. It is the largest exhibition space devoted to photography in the West."

UNIVERSITY ART GALLERY, NEW MEXICO STATE UNIVERSITY, Dept. 3572, P.O. Box 30001, Las Cruces NM 88003. (505)646-2545. Fax: (505)646-8036. Director: Charles M. Lovell. Estab. 1973. Examples of recent exhibitions: "Indo-Hispano Spirituality," by Miguel Gandert (documentary photographs of New Mexico religious traditions); "Celia Munoz," by Celia Munoz (conceptual); and "Nino Fidencio, A Heart Thrown Open," by Dore Gardner (documentary photographs of followers of a Mexican faith healer). Presents 1 show/year. Shows last 2 months. General price range of work: $300-2,500.

Making Contact & Terms: Buys photos outright. Interested in framed or unframed work. Arrange a personal interview to show portfolio. Submit portfolio for review. Query with samples. Send material by mail for consideration by end of October. SASE. Reports in 3 months.

Tips: Looks for "quality fine art photography. The gallery does mostly curated, thematic exhibitions. Very few one-person exhibitions."

N: VERED GALLERY, 68 Park Place, East Hampton NY 11937. (516)324-3303. Fax: (516)324-3303. Vice President: Janet Lehr. Estab. 1977. Examples of recent exhibitions: works by Edouard Baldus, Rober Fenton, Lewis Hine, Harold Edgerton. Shows last 3 weeks. Sponsors openings. General price range $3,000.

Exhibits: Interested in avant-garde work.

Making Contact & Terms: Charges 50% commission. Reviews transparencies. Interested in slides or transparencies, then exhibition prints. Requires exclusive representation within metropolitan area. Query with résumé of credits. SASE. Reports in 3 weeks.

VIRIDIAN ARTISTS, INC., 24 W. 57 St., New York NY 10019. Phone/fax: (212)245-2882. E-mail: ncognith@earthfire.org. Director: Vernita Nemec. Estab. 1968. Examples of recent exhibits: works by Susan Hockaday and Robert Smith. Presents 12-15 shows/year. Shows last 3 weeks. General price range of work: $300-3,000. Most work sold at $600.
Exhibits: Interested in eclectic work in all fine art media including photography, installation, painting, mixed media and sculpture. Subjects include environmental, landscapes/scenics. Interested in alternative process, avant garde, fine art. Member of Cooperative Gallery.
Making Contact & Terms: Charges 30% commission. Will review transparencies only if submitted as membership application. Interested in framed or unframed, mounted, and matted or unmatted work. Request membership application details. Send materials by mail for consideration. SASE. Reports in 3 weeks.
Tips: Opportunities for photographers in galleries are "improving." Sees trend toward "a broad range of styles" being shown in galleries. "Photography is getting a large audience that is seemingly appreciative of technical and aesthetic abilities of the individual artists. Present a portfolio (regardless of format) that expresses a clear artistic and aesthetic focus that is unique, individual and technically outstanding."

WACH GALLERY, 31860 Walker Rd., Avon Lake OH 44012. (440)933-2780. Fax: (440)933-2781. Owner: Peter M. Wach. Private dealer. Estab. 1979. Approached by 10 artists/year; represents or exhibits 100 artists. Examples of recent exhibits: Brett Weston retrospective; Ansel Adams; Carl Hyatt, nude studies in platinum. Open all year by appointment. Overall price range: $400-50,000. Most work sold at $2,500.
Exhibits: Exhibits photos of celebrities, couples, multicultural, families, disasters, environmental, landscapes/scenics, architecture, cities/urban, gardening, interiors/decorating, rural, automobiles, events, performing arts, travel, buildings, industry, portraits, science. Interested in alternative process, avant garde, digital, documentary, erotic, fashion/glamour, fine art, historical/vintage. Considers all styles and genres of photography, including conceptualism, post modernism, expressionism. "Must be archival process."
Making Contact & Terms: Artwork is accepted on consignment and there is a 50% commission. Gallery provides insurance. Accepted work should be mounted. Call or write to show portfolio of slides and transparencies. When submitting include artist bio, education, exhibit, representation (past and current). Replies in 1 week to queries. Finds artists by word of mouth, submissions, art exhibits and art fairs.
Tips: "Do not explain images. Let the image speak for itself. Before the artist frames and mats the work, consult with the gallery about the various techniques and styles. Framing must be archival with UV filtering plastic. I personally like images unmounted. The photography market is affected by the economy. Usually a ten year cycle determines the prices. When a recession occurs, lower priced images (contemporaries) sell over the higher priced masters."

THE WAILOA CENTER GALLERY, P.O. Box 936, Hilo HI 96720. (808)933-0416. Fax: (808)933-0417. Director: Mrs. Pudding Lassiter. Estab. 1967. Examples of recent exhibits: Gustavo Arriagada (photography of Hawaii and Chile); Franz Ucko (computer digital images, microlithography); Jean Vallente (photographs); Jacqui Marlin (a photographic journey). Presents 3 shows/year. Shows last 30 days.
Exhibits: Pictures must be submitted to Director for approval.
Making Contact & Terms: Gallery receives 10% "donation" on works sold. Reviews transparencies. Interested in framed work only. "Pictures must also be fully fitted for hanging. Expenses involved in shipping, insurance, etc. are the responsibility of the exhibitor." Submit portfolio for review. Query with resume of credits. Query with samples. SASE. Reports in 3 weeks.
Tips: "The Wailoa Center Gallery is operated by the State of Hawaii, Department of Land and Natural Resources. We are unique in that there are no costs to the artist to exhibit here as far as rental or commissions are concerned. We welcome artists from anywhere in the world who would like to show their works in Hawaii. The gallery is also a visitor information center with thousands of people from all over the world visiting."

SANDE WEBSTER GALLERY, 2018 Locust St., Philadelphia PA 19103. (215)732-8850. Fax: (215)732-7850. E-mail: swgart@erols.com. Contact: Jason Brooks. Examples of exhibits: "Dust Shaped Hearts," by Don Camp (photo sensitized portraits); works by Norrine Betjemann (hand-tinted); Kevin Reilly (documentary landscape and automotive images). Also carries works by emerging talents Ron Tarver, Elena Bouvier, Ray Holman, Leonard Morris, Andrea Baldeck and Steve Leibowitz. Presents 10 shows/year. Shows last 1 month. General price range of work: $200-5,000.
 • The gallery will review the work of emerging artists, but due to a crowded exhibition schedule, may defer in handling their work.

Exhibits: Interested in avant garde and contemporary, fine art photography in limited editions. "We encourage the use of non-traditional materials in the pursuit of expression, but favor quality as the criterion for inclusion in exhibits."

Making Contact & Terms: Charges 50% commission. Reviews transparencies. Interested in framed or unframed work. Send material by mail for consideration. Include résumé, price list and any additional support material. SASE. Reports in 1 month.

[N] WESTCHESTER GALLERY, 196 Central Ave., County Center, White Plains NY 10606. (914)684-0094. Fax: (914)684-0608. Gallery Coordinator: Abre Chen. Example of recent exhibition: works by Tim Keating and Alan Rokach. Presents 2 photo shows/year (usually). Shows last 1 month. Sponsors openings; gallery covers cost of space, light, insurance, mailers (printing and small mailing list) and modest refreshments. General price range $150-3,750. Most sales are at low end, $150.

Making Contact & Terms: Charges 33⅓% commission. Reviews transparencies. Interested in any presentable format ready to hang. Arrange a personal interview to show portfolio. Submit portfolio for review. Query with résumé of credits. Send material by mail for consideration. SASE. Reports in 1 month.

Tips: "Gallery space is flexible and artists are encouraged to do their own installation."

[N] WHITE GALLERY-PORTLAND STATE UNIVERSITY, Box 751/SD Portland OR 97207. (503)725-5656 or (800)547-8887. Fax: (503)725-4882. Associate Director: Jessica Bobillot. Estab. 1969. Presents 12 shows/year. Exhibits last 1 month. Sponsors openings. General price range of work: $175-400. Examples of recent exhibitions: "I Dream in Infrared," by Dirk Kenyon; "Computer Painting," by Emily Young; "The New Religion," by Eric Blau.

Making Contact & Terms: Charges 30% commission. Interested in unframed, mounted, matted work. "We prefer matted work that is 16×20." Send material by mail for consideration. SASE. Reports in 1 month.

Tips: "Best time to submit is September-October of the year prior to the year show will be held. We only go by what we see, not the name. We see it all and refrain from the trendy. Send slides. Do something different . . . view life upside down."

WYCKOFF GALLERY, 648 Wyckoff Ave., Wyckoff NJ 07481. (201)891-7436. Director: Sherry Cosloy. Estab. 1978. Example of exhibits: works by Jorge Hernandez (landscapes). Presents 1 exhibit/year. Shows last 1 month. General price range of work: $200-2,000.

Exhibits: Prior exhibition schedule, mid-career level. Interested in all styles except depressing subject matter (e.g. AIDS, homelessness).

Making Contact & Terms: Reviews transparencies. Interested in framed or unframed, mounted or unmounted, matted or unmatted work. Requires exclusive presentation locally. Query with résumé of credits. Query with samples. SASE. Reports in 1-2 weeks.

Tips: "I am predominantly a fine arts (paintings and sculptures) gallery so photography is not the prime focus. People like photography that is hand-colored and/or artistic in composition and clarity."

YESHIVA UNIVERSITY MUSEUM, 2520 Amsterdam Ave., New York NY 10033. (212)960-5390. Fax: (212)960-5406. Website: http://www.yu.edu/museum. Director: Sylvia A. Herskowitz. Estab. 1973. The museum has several gallery spaces separated by steps; the fourth floor gallery is accessible by elevator from lobby of building. Examples of recent exhibits: "Silenced Sacred Spaces: Selected Photographs of Syrian Synagogues," by Robert Lyons; "Keeping the Light: A photographic diary of South India," by Suzon Fuks; "The Mekubalim of Jerusalem: Photographs of Prayer and Religious Celebration," by Joshua Haruni. Presents 3-4 shows/year. Shows last 4-6 months.

• Beginning January 2000, the Yeshiva University main galleries will be relocated to 16 W. 16th St., at the Center for Jewish History. A YUM branch gallery will remain on the main campus of the university. The new location will include four galleries and several exhibition arcades. All galleries will be handicapped accessible.

Exhibits: Seeks work focusing on Jewish themes and interest, framed work essential.

Making Contact & Terms: Photography on exhibit available for sale through museum, 30% commission. Send color slide portfolio of 10-12 slides or photos, exhibition proposal, résumé with SASE for consideration. Reviews take place three times/year.

Tips: "We exhibit contemporary art and photography based on a Jewish theme. We look for excellent quality; individuality; and especially look for unknown artists who have not widely exhibited either in the New York area or at all."

Resources
Art/Photo Representatives

As your photographic business grows you may find yourself inundated with office work, such as creating self promotions, billing clients, attending portfolio reviews and filing images. All of this takes time away from shooting, and most photographers would rather practice their craft. However, there are ways to remove the marketing burden that's been placed upon you. One of the best ways is to hire a photo rep.

When you sign with a photo rep you basically hire someone to tote your portfolio around town to art directors, make cold calls in search of new clients, and develop promotional ideas to market your talents. The main goal is to find assignment work for you with corporations, advertising firms, or design studios. And, unlike stock agencies or galleries, a photo rep is interested in marketing your talents rather than your images.

For their time most reps charge 20-30 percent commission. They handle several photographers at one time, usually making certain that each shooter specializes in a different area. For example, a rep may have contracts to promote three different photographers, one who handles product shots, another who shoots interiors and a third who photographs food.

HOW TO DECIDE IF YOU NEED A REP
You need a rep if you:
- are too busy with work to make the personal contacts necessary to find new clients and keep the ones you have.
- have enough "bread-and-butter" work in a stable client base that allows you to spend money on the additional promotional material reps require.
- have a strong style or specialty that a rep can target clients for.
- have enough knowledge about how to sell yourself but want someone else to do it.
- consider yourself first as a business than as a photographer. Reps work best with people who appreciate the "profit-making" nature of their work. Anyone can say they want to be successful, but that means you must have the business education to be in charge of setting your goals and direction. A rep is there to realize your goals, not set them for you.
- are willing to spend the time to assist the rep in selling your work. You won't spend less time on marketing. You just won't do the same things. For example, instead of showing the portfolio, you will be creating new portfolio pieces for the rep to show.
- are looking for ways to promote your business and need a rep's time and expertise.
- practice good business management methods and have a professional attitude toward promotion. Established and efficient project management procedures and policies are important criteria of professionalism required by reps.
- have a head start on a portfolio of the kind of work you want to do. With commission sales, no portfolio means "down" time a rep can't afford.
- have the marketing plan and budget for your promotion pieces and plans to support the direction you give the rep.

(These tips are excerpted from Marketing & Promoting Your Work *©1995 by Maria Piscopo. Published by North Light Books. Reprinted by permission of North Light Books.)*

As you search for a rep there are numerous points to consider. First, how established is the rep you plan to approach? Established reps have an edge over newcomers in that they know the territory. They've built up contacts in ad agencies, magazines and elsewhere. This is essential since most art directors and picture editors do not stay in their positions for long periods of time. Therefore, established reps will have an easier time helping you penetrate new markets.

If you decide to go with a new rep, consider paying an advance against commission in order to help the rep financially during an equitable trial period. Usually it takes a year to see returns on portfolio reviews and other marketing efforts, and a rep who is relying on income from sales might go hungry if he doesn't have a base income from which to live.

And whatever you agree upon, always have a written agreement. Handshake deals won't cut it. You must know the tasks that each of you is required to complete and having your roles discussed in a contract will guarantee there are no misunderstandings. For example, spell out in your contract what happens with clients that you had before hiring the rep. Most photographers refuse to pay commissions for these "house" accounts, unless the rep handles them completely and continues to bring in new clients.

Also, it's likely that some costs, such as promotional fees, will be shared. For example, freelancers often pay 75 percent of any advertising fees (such as sourcebook ads and direct mail pieces).

If you want to know more about a specific rep, or how reps operate, contact the Society of Photographers and Artists Representatives, 60 E. 42nd St., Suite 1166, New York NY 10165, (212)779-7464. SPAR sponsors educational programs and maintains a code of ethics to which all members must adhere.

ARTIST DEVELOPMENT GROUP, 21 Emmett St., Suite 2, Providence RI 02903-4503. (401)521-5774. Fax: (401)521-5776. Contact: Rita Campbell. Represents photography, fine art, graphic design, as well as performing talent. Estab. 1982. Member of Rhode Island Women's Advertising Club. Markets include: advertising agencies; corporations/clients direct.
Handles: Illustration, photography.
Terms: Rep receives 20-25% commission. Advertising costs are split: 50% paid by talent; 50% paid by representative. For promotional purposes, talent must provide direct mail promotional piece; samples in book for sales meetings.
How to Contact: For first contact, send résumé, bio, direct mail flier/brochure. Reports in 3 weeks. After initial contact, drop off or mail in appropriate materials for review. Portfolios should include tearsheets, photographs.

ROBERT BACALL REPRESENTATIVE, 350 Seventh Ave., 20th Floor, Suite 2004, New York NY 10011-5013. (212)695-1729. Fax: (212)695-1739. E-mail: rob@bacall.com. Website: http://www.bacall.com. Contact: Robert Bacall. Commercial photography representative. Estab. 1988. Represents 6 photographers. Specializes in food, still life, fashion, beauty, kids, corporate, environmental, portrait, lifestyle, location, landscape. Markets include: advertising agencies; corporations/clients direct; design firms; editorial/magazines; publishing/books; sales/promotion firms.
Terms: Rep receives 30% commission. Exclusive area representation required. For promotional purposes, talent must provide portfolios, cases, tearsheets, prints, etc. Advertises in *Creative Black Book*, *NY Gold*, *Workbook*, *Single Image*.
How to Contact: For first contact, send query letter, direct mail flier/brochure. Reports only if interested. After initial contact, drop off or mail materials for review.
Tips: "Seek representation when you feel your portfolio is unique and can bring in new business."

CECI BARTELS ASSOCIATES, 3284 Ivanhoe, St. Louis MO 63139. (314)781-7377. Fax: (314)781-8017. Contact: Ceci Bartels. Commercial illustration, photography and graphic design representative. Estab. 1980. Member of SPAR, Graphic Artists Guild, ASMP. Represents 30 illustrators, 4 photographers and 1 designer. Markets include advertising agencies; corporations/client direct; design firms; publishing/books; sales/promotion firms.
Handles: Illustration, photography, and new media. "Photographers who can project human positive emotions with strength interest us. We also want NYC talent and photographers to do liquids, splashes and pours."
Terms: Rep receives 30% commission. Advertising costs are 100% paid by talent. "We need direct mail

support and advertising to work on the national level. We welcome 6 portfolios/artist. Artist is advised not to produce multiple portfolios or promotional materials until brought on." Advertises in *American Showcase, The Workbook*.

How to Contact: For first contact, send query letter, direct mail flier/brochure, tearsheets, slides, SASE, portfolio with SASE or promotional materials. Reports if SASE enclosed. Rep will contact photographer for portfolio review if interested. Portfolio should include "the best work the artist has, displayed to its best advantage." Obtains new talent through recommendations from others, solicitations and artists submitting work."

Tips: "We like to look at new work but can't always market the styles sent. Your work may be outstanding but we need to be able to market it within our niche. Usually we need to see it to make that determination."

BEATE WORKS, 2400 S. Shenandoah St., Los Angeles CA 90034-2026. (310)558-1100. Fax: (310)842-8889. Website: www.i-netmall.com/shops/beateworks. Contact: Beate Chelette. Commercial photography representative. Estab. 1992. Represents 3 photographers. Staff includes Larry Bartholomew (fashion and lifestyle); Nic Scala (fashion and celebrities); and Grey Crawford (architecture and interior). A full service agency that covers preproduction to final product. Markets include advertising agencies, corporations/clients direct, design firms, publishing/books and editorial/magazines.

Handles: Photography. Only interested in established photographers. "Must have a client base."

Terms: Rep receives 25% commission. Charges all messenger fees postage (bulk mailings only); FedEx is charged back. Exclusive area representation required. Advertising costs are split: 75% paid by talent; 25% paid by representative. For promotional purposes, talent must provide at least 3 portfolios and plenty of promo cards.

How to Contact: For first contact, send photos. Reports in a week if interested. Rep will contact for portfolio review if interested. Portfolios should include b&w and color tearsheets and prints.

BENJAMIN PHOTOGRAPHERS NY, 149 Fifth Ave., Suite 803, New York NY 10010. (212)253-8688. Fax: (212)253-8689. E-mail: benjamin@portfolioview.com. Website: http://www.portfolioview.com. Contact: Benjamin. Commercial photography representative. Estab. 1992. Represents 4 photographers. Staff includes Skip Caplan (still-life), Dennis Gottlieb (food/still-life), Zan (still-life) and Rafael Fuchs (people/portrait). Agency specializes in advertising. Markets include: advertising agencies; corporations/clients direct; design firms; editorial/magazines; paper products/greeting cards; publishing/books; sales/promotion firms.

Will Handle: Photography.

Terms: Exclusive area representation required. Advertises in *Creative Black Book* and *The Workbook*.

How to Contact: Send tearsheets. If no reply, photographer should call. Rep will contact photographer for portfolio review if interested. Portfolio should include color tearsheets, transparencies.

BERENDSEN & ASSOCIATES, INC., 2233 Kemper Lane, Cincinnati OH 45206. (513)861-1400. Fax: (513)861-6420. E-mail: bob@photographersrep.com. Website: photographersrep.com. Contact: Bob Berendsen. Commercial illustration, photography, graphic design representative. Estab. 1986. Represents 25 illustrators, 5 photographers, 25 Mac designers/illustrators in the MacWindows Group Division. Specializes in "high-visibility consumer accounts." Markets include: advertising agencies; corporations/clients direct; design firms; editorial/magazines; paper products/greeting cards; publishing/books; sales/promotion firms.

Handles: Illustration, photography.

Terms: Rep receives 25% commission. Charges "mostly for postage but figures not available." No geographic restrictions. Advertising costs are split: 75% paid by talent; 25% paid by representative. For promotional purposes, "artist must co-op in our direct mail promotions, and sourcebooks are recommended. Portfolios are updated regularly." Advertises in *RSVP*, *Creative Illustration Book*, *The Ohio Source Book* and *American Showcase*.

How to Contact: For first contact, send query letter, résumé, non-returnable tearsheets, slides, photo-

**FOR EXPLANATIONS OF THESE SYMBOLS,
SEE THE INSIDE FRONT AND BACK COVERS OF THIS BOOK.**

graphs and photocopies. After initial contact, drop off or mail in appropriate materials for review. Portfolios should include tearsheets, slides, photographs, photostats, photocopies and SASE if materials need to be returned.

Tips: Obtains new talent "through recommendations from other professionals. Contact Bob Berendsen, president of Berendsen and Associates, Inc. for first meeting."

BERNSTEIN & ANDRIULLI INC., 60 E. 42nd St., New York NY 10165. (212)682-1490. Fax: (212)286-1890. Contact: Howard Bernstein. Photography representative. Estab. 1975. Member of SPAR. Represents 16 photographers. Markets include: advertising agencies; corporations/clients direct; design firms; editorial/magazines.
Handles: Photography.
Terms: Rep receives a commission. Exclusive career representation is required. No geographic restrictions. Advertises in *Creative Black Book*, *The Workbook*, *CA Magazine*, *Archive Magazine* and *Klik*.
How to Contact: For first contact, send query letter, direct mail flier/brochure, tearsheets, slides, photographs, photocopies. Reports in 1 week. After initial contact, drop off or mail in appropriate materials for review. Portfolio should include tearsheets and personal photos.

☒ BLACK INC. CREATIVE REPRESENTATIVES, 2512 E. Thomas, Suite 2, Phoenix AZ 85016. (602)381-1332. Fax: (602)381-1406. E-mail: blackmail@blackinc.com. Website: http://www.blackinc.c om. President: Pamela Black. Commercial photography representative. Commercial illustration representative. Estab. 1987. Member of SPAR, Graphic Artists Guild, AIGA Board of Directors, Arizona Chapter. Represents: 7 photographers, 11 illustrators. Staff includes Stephanie Burton: account management, sales and marketing; Pauline Bowie: accountant; Erin Bearby: office assistant. Agency specializes in photography and illustration. Markets include advertising agencies, corporate/client direct, design firms.
Handles: Illustration, photography. Looking for established artists only. Particularly interested in golf photography/stock. Always looking for unique styles in both illustration and photography.
Terms: Rep receives 25% commission. Exclusive area representation required. Advertising costs are paid by talent. For promotional purposes, talent must provide 1 show portfolio, 2 traveling portfolios with updated leave behinds and 2-4 new promo pieces per year. Advertises in *American Showcase*, *Creative Black Book*.
How to Contact: Send query letter, bio, brochure, tearsheets, SASE. Replies only if interested within 3 weeks. Rep will contact photographer for portfolio review if interested.

BRAUN ART INTERNATIONAL, INC., (formerly Braun Art), 2925 Griffith St., San Francisco CA 94124. (415)467-9676. Fax: (415)467-5252. E-mail: braunart@dnai.com. Contact: Star Jilek. Commercial photography buyer, fine art and commercial illustration buyer; illustration and photography broker; graphic design buyer. Estab. 1980. Staff includes Kathy Braun and Star Jilek. Markets include: advertising agencies; corporations/clients direct; design firms; editorial/magazines; publishing/books; sales/promotion firms; packaging.
Handles: Illustration, photography, fine art, design.
Terms: Advertises in *American Showcase*, *The Workbook*.
How to Contact: For first contact, send tearsheets. Photographer should "send 8½ × 11 samples we can keep on file." Buyer will contact photographer for portfolio review if interested.

MARIANNE CAMPBELL ASSOCIATES, Pier 9 Embarcadero, San Francisco CA 94111. (415)433-0353. Fax: (415)433-0351. Contact: Marianne Campbell or Quinci Payne. Commercial photography representative. Estab. 1989. Member of APA, SPAR, Western Art Directors Club. Represents 8 photographers. Markets include: advertising agencies; corporations/clients direct; design firms; editorial/magazines.
Handles: Photography.
Terms: Negotiated individually with each photographer.
How to Contact: For first contact, send printed samples of work. Reports in 2 weeks, only if interested. After initial contact, call for appointment to show portfolio of tearsheets, slides, photographs.
Tips: Obtains new talent through recommendations from art directors and designers and outstanding promotional materials.

CORPORATE ART PLANNING, 27 Union Square West, Suite 407, New York NY 10003. (212)645-3490. Fax: (212)242-9198. Contact: Maureen McGovern. Fine art consultant and corporate curator. Estab. 1983. Specializes in corporate art programs. Markets include corporations/clients direct, architects, corporate collections, museums and developers.
Handles: Photography, fine art only.

Terms: Rep receives 15% commission. Advertising costs are split: 30% paid by talent; 70% paid by the representative. Advertises in *Art in America*, *Creative Black Book*, *American Showcase* and *The Workbook*.
How to Contact: For first contact, send query letter, résumé, bio, direct mail flier/brochure, tearsheets, SASE, e-mail address and color photocopies. Reports in 10 days. Rep will contact photographer for portfolio review only if interested. Portfolios should include tearsheets, thumbnails, slides, photographs and photocopies.
Tips: Obtains new talent through gallery recommendations.

BROOKE DAVIS & COMPANY, 4323 Bluffview Blvd., Dallas TX 75209. (214)352-9192. Fax: (214)350-2101. Contact: Brooke Davis. Commercial illustration and photography representative. Estab. 1988. Member of Graphic Artists Guild. Represents 6 illustrators, 4 photographers. "Owner has 18 years experience in sales and marketing in the advertising and design fields." Markets include: advertising agencies, corporations/clients direct; design firms, editorial/magazines; sales/promotion firms.
Will Handle: Illustration and photography.
Terms: Rep receives 25% commission. Advertising costs are split: 75% paid by talent; 25% paid by representative. For promotional purposes, talent must provide a "solid portfolio and arresting and informational 'leave behinds.'" Advertises in *Creative Black Book* and *The Workbook*.
How to Contact: For first contact, send bio, direct mail flier/brochure, and a "sample we can keep on file if possible." SASE. Reports in 3 weeks. If no reply, photographer should follow-up. Portfolio should include b&w and color tearsheets, transparencies and whatever photographer feels is the best representation of work as well as reproduced samples."
Tips: Obtains new talent through referral or by an interest in a specific style. "Only show your best work. Develop an individual style. Show the type of work that you enjoy doing and want to do more often. We

Corporate Art Planning is a curatorial and exhibition firm that selects artwork for their clients from a stable of artists but does not keep the artists under exclusive contracts. Photographer Don Laurino contacted the company through the mail by sending slides and a description of his work. "We have been pleased to recommend Mr. Laurino's work to our clients," says Maureen McGovern, corporate curator. "It feels good to find others sharing my vision," Laurino says.

must have a sample to leave with potential clients. Keep current, advertise and constantly test and update portfolio."

LINDA DE MORETA REPRESENTS, 1839 Ninth St., Alameda CA 94501. (510)769-1421. Fax: (510)521-1674. E-mail: ldmreps@earthlink.net. Contacts: Linda de Moreta and Ron Lewis. Commercial photography and illustration representative; also portfolio and career consultant. Estab. 1988. Member of Western Art Directors Club and Graphic Artists' Guild. Represents 4 photographers, 1 photodigital imager, 11 illustrators and 2 lettering artists. Markets include: advertising agencies; design firms; corporations/client direct; editorial/magazines; paper products/greeting cards; publishing/books; sales/promotion firms.
Handles: Photography, digital imaging, illustration, calligraphy.
Terms: Exclusive representation requirements and commission arrangements vary. Advertising costs are handled by individual agreement. Materials for promotional purposes vary with each artist. Advertises in *The Workbook*, *American Showcase*, *The Black Book*, *Alternative Pick*.
How to Contact: For first contact, send direct mail flier/brochure, tearsheets, slides, photocopies, photostats and SASE. "Please do *not* send original art. SASE for any items you wish returned." Responds to any inquiry in which there is an interest. Portfolios are individually developed for each artist and may include prints, transparencies.
Tips: Obtains new talent primarily through client and artist referrals, some solicitation. "I look for a personal vision and style of photography or illustration and exceptional creativity, combined with professionalism, maturity and commitment to career advancement."

FRANCOISE DUBOIS/DENNIS REPRESENTS, 305 Newbury Lane, Newbury Park CA 91320. (805)376-9738. Fax: (805)376-9729. E-mail: fdubois@primenet.com. Owner: Francoise Dubois. Commercial photography representative and creative and marketing consultant. Represents 5 photographers. Staff includes Andrew Bernstein (sports and sports celebrities), Ron Derhacopian (still-life/fashion), Eric Sander (people with a twist), Stephen Lee (fashion/entertainment) and Michael Baciu (photo impressionism). Agency specializes in commercial photography for advertising and editorial and creative and marketing consulting for freelance photographers. Markets include: advertising agencies; corporations/clients direct; design firms; editorial/magazines; paper products/greeting cards; publishing/books; sales/promotion firms.
Handles: Photography.
Terms: Rep receives 25% commission. Charges FedEx charges (if not paid by advertising agency or other potential client). Exclusive area representation required. Advertising costs are 100% paid by talent. For promotional purposes, talent must provide "3 portfolios, advertising in national sourcebook, 3 or 4 direct mail pieces a year. All must carry my name and number." Advertises in *Creative Black Book*, *The Workbook*, *The Alternative Pick* and *Klik*.
How to Contact: Send tearsheets, bio and interesting direct mail promos. Replies only if interested within 6-8 weeks. Rep will contact photographer for portfolio review if interested. Portfolio should include "whatever format as long as it is consistent."
Tips: "Do not look for a rep if your target market is too small a niche. Do not look for a rep if you're not somewhat established. Hire a consultant to help you design a consistent and unique portfolio, a marketing strategy and to make sure your strengths are made evident and you remain focused."

RHONI EPSTEIN ARTISTS' MANAGEMENT, (formerly Rhoni Epstein), 11977 Kiowa Ave., Los Angeles CA 90049-6119. (310)207-5937. E-mail: gr8rep@earthlink.net. Contact: Rhoni Epstein. Photography representative and expert portfolio and marketing consultants. Estab. 1983. Member of APA and on faculty of Art Center College of Design, Pasadena CA. Represents 8 photographers. Specializes in advertising/entertainment photography.
Handles: Photography.
Terms: Rep receives 30% commission. Exclusive representation required in specific geographic area. Advertising costs are paid by talent. For promotional purposes, talent must have a strong direct mail campaign and/or double-page spread in national advertising book and a portfolio to meet requirements of agent. Advertises in *The Workbook*, *Blackbook* and *Alternative Pick*.
How to Contact: For first contact, send direct mail samples. Reports in 1 week, only if interested. After initial contact, call for appointment to drop off or mail in appropriate materials for review. Portfolio should demonstrate own personal style.
Tips: Obtains new talent through recommendations. "Research the rep and her/his agency the way you would research an advertising agency before soliciting work! Remain enthusiastic. There is always a market for creative and talented people."

FORTUNI, 2508 E. Belleview Place, Milwaukee WI 53211. (414)964-8088. Fax: (414)332-9629. E-mail: marian@fortuni.com. Contact: Marian Deegan. Commercial photography and illustration representative.

Estab. 1989. Member of ASMP. Represents 2 photographers and 6 illustrators. Fortuni handles artists with unique, distinctive styles appropriate for commercial markets. Markets include advertising agencies, corporations, design firms, editorial/magazines, publishing/books.

Handles: Illustration and photography. "I am interested in artists with a thorough professional approach to their work."

Terms: Rep receives 30% commission. Fees include postage and direct mail promotion production. Exclusive representation required. Advertising costs are split: 70% paid by the talent; 30% paid by the representative. For promotional purposes, talent must provide 4 duplicate transparency portfolios, leave behinds and 4-6 promo pieces per year. "All artist materials must be formatted to my promotional specifications." Advertises in *Workbook*, *Single Image* and *Chicago Source Book*.

How To Contact: For first contact, send query letter, direct mail flier/brochure, tearsheets, photocopies and SASE. Reports in 2 weeks only if interested.

Tips: "I obtain new artists through referrals. Identify the markets appropriate for your style, organize your work in a way that clearly reflects your style, and be professional and thorough in your initial contact and follow-through."

JEAN GARDNER & ASSOCIATES, 444 N. Larchmont Blvd., Suite 207, Los Angeles CA 90004. (213)464-2492. Fax: (213)465-7013. Contact: Jean Gardner. Commercial photography representative. Estab. 1985. Member of APA. Represents 6 photographers. Specializes in photography. Markets include: advertising agencies; design firms.

Handles: Photography.

Terms: Rep receives 25% commission. Exclusive representation is required. No geographic restrictions. Advertising costs are paid by talent. For promotional purposes, talent must provide promos, *Workbook* advertising and a quality portfolio. Advertises in *The Workbook*.

How to Contact: For first contact, send direct mail flier/brochure.

GIANNINI & TALENT, 5612 Heming Ave., Springfield VA 22151-2706. (703)534-8316. Fax: (703)451-8704. E-mail: gt@giannini~t.com. Website: http://www.giannini~t.com. Contact: Judi Giannini. Stock photography and commercial photography representative. Estab. 1987. Member of ADCMW. Represents 6 photographers. Specializes in talent working in fine art and commercial arenas, or "who have singular personal styles that stand out in the market place." Markets include: advertising agencies; corporations/client direct; design firms; editorial/magazines; publishing/books; art consultants. Clients include private collections.

Handles: Photography, select DC images, panoramic images, digital and video animation.

Terms: Rep receives 25% commission. Charges for out-of-town travel, messenger and FedEx services, newsletter. Exclusive East Coast and Southern representation is required. Advertising costs are split: 75% paid by the talent; 25% paid by the representative. For promotional purposes, talent must provide leave-behinds and "at least have a direct mail campaign planned, as well as advertising in local and national sourcebooks. Portfolio must be professional." Advertises in *American Showcase*, *Creative Black Book*, *The Workbook* and *Creative Sourcebook*.

How to Contact: For first contact, talent should send query letter, direct mail flier/brochure. Reports in 3 weeks, only if interested. Call for appointment to show portfolio of slides, photographs.

Tips: "Learn to be your own best rep while you are getting established. Then consider forming a co-op with other artists of non-competitive styles who can pay someone for six months to help them get started. Candidates for good reps have an art and sales background."

BARBARA GORDON ASSOCIATES LTD., 165 E. 32nd St., New York NY 10016. (212)686-3514. Fax: (212)532-4302. Contact: Barbara Gordon. Commercial illustration and photography representative. Estab. 1969. Member of SPAR, Society of Illustrators, Graphic Artists Guild. Represents 9 illustrators, 1 photographer. "I represent only a small select group of people and therefore give a great deal of personal time and attention to the people I represent."

Terms: Rep receives 25% commission. No geographic restrictions in continental US.

How to Contact: For first contact, send direct mail flier/brochure. Replies in 2 weeks. After initial contact, drop off or mail in appropriate materials for review. Portfolio should include tearsheets, slides, photographs; "if the talent wants materials or promotion piece returned, include SASE."

Tips: Obtains new talent through recommendations from others, solicitation, at conferences, etc. "I have obtained talent from all of the above. I do not care if an artist or photographer has been published or is experienced. I am essentially interested in people with a good, commercial style. Don't send résumés and don't call to give me a verbal description of your work. Send promotion pieces. *Never* send original art. If you want something back, include a SASE. Always label your slides in case they get separated from your cover letter. And always include a phone number where you can be reached."

CAROL GUENZI AGENTS, INC., 865 Delaware, Denver CO 80204-4533. (303)820-2599. Fax: (303)820-2598. E-mail: artagent@artagent.com. Website: http://www.artagent.com. Contact: Carol Guenzi. Commercial illustration, film and animation representative. Estab. 1984. Member of Denver Advertising Federation, Art Directors Club of Denver, SPAR and ASMP. Represents 25 illustrators, 5 photographers, 3 computer designers. Specializes in a "wide selection of talent in all areas of visual communications." Markets include: advertising agencies; corporations/clients direct; design firms; editorial/magazine; paper products/greeting cards; sales/promotions firms.

Handles: Illustration, photography. Looking for "unique style application" and digital imaging.

Terms: Rep receives 25-30% commission. Exclusive area representation is required. Advertising costs are split: 70-75% paid by talent; 25-30% paid by the representation. For promotional purposes, talent must provide "promotional material after six months, some restrictions on portfolios." Advertises in *American Showcase*, *Creative Black Book*, *The Workbook*, *Creative Options*, *Rocky Mountain Sourcebook*.

How to Contact: For first contact, send direct mail flier/brochure, tearsheets, slides, photocopies. Replies only if interested within 2-3 weeks. After initial contact, call or write for appointment to drop off or mail in appropriate materials for review, depending on artist's location. Portfolio should include tearsheets, slides, photographs.

Tips: Obtains new talent through solicitation, art directors' referrals, and active pursuit by individual. "Show your strongest style and have at least 12 samples of that style before introducing all your capabilities. Be prepared to add additional work to your portfolio to help round out your style. We do a large percentage of computer manipulation and accessing on network. All our portfolios are on disk or CD-ROM."

PAT HACKETT/ARTIST REPRESENTATIVE, 1809 Seventh Ave., Suite 1710, Seattle WA 98101-1320. (206)447-1600. Fax: (206)447-0739. E-mail: pathackett@aol.com. Website: http://www.pathackett.com. Contact: Pat Hackett. Commercial illustration and photography representative. Estab. 1979. Member of Graphic Artists Guild. Represents 30 illustrators, 3 photographers. Markets include: advertising agencies; corporations/client direct; design firms; editorial/magazines.

Handles: Illustration and photography.

Terms: Rep receives 25-33% commission. Exclusive area representation is required. No geographic restrictions, but sells mostly in Washington, Oregon, Idaho, Montana, Alaska and Hawaii. Advertising costs are split: 75% paid by talent; 25% paid by representative. For promotional purposes, talent must provide "standardized portfolio, i.e., all pieces within the book are the same format. Reprints are nice, but not absolutely required." Advertises in *American Showcase*, *The Workbook*, *New Media Showcase*.

How to Contact: For first contact, send direct mail flier/brochure. Replies only if interested within 3 weeks. After initial contact, drop off or mail in appropriate materials: tearsheets, slides, photographs, photostats, photocopies.

Tips: Obtains new talent through "recommendations and calls/letters from artists moving to the area. We represent talent based both nationally and locally."

INDUSTRY ARTS, P.O. Box 1737, Beverly Hills CA 90213-1737. (310)302-0088. Fax: (310)305-7364. E-mail: jacreative@industryarts.com. Website: http://www.industryarts.com. Agent/Broker: Marc Tocker. Commercial photography, illustration, digital art and graphic design representative. Photography and digital art broker. Estab. 1997. Member of California Lawyers for the Arts. Represents 1 photographer, 1 illustrator, 1 designer. Agency specializes in "cutting edge design based upon a philosophy that challenges dominant cultural paradigms." Markets include advertising agencies, corporations/clients direct, design firms.

Handles: Illustration, photography, digital art and graphic design. "We are looking for design mindful people who create cutting edge work."

Terms: Rep receives 15-25% commission. Exclusive area representation required. Advertising costs are paid by talent. Portfolio must be adopted to digital format for internet website presentation. Advertises in The Workbook.

How to Contact: Send query letter, bio, brochure, tearsheets, photos, SASE. Replies in 2 weeks. To show portfolio, photographer should follow-up with call. Portfolio should include b&w and/or color prints, tearsheets or transparencies.

Tips: New talent obtained by recommendations, solicitations. "Distinguish yourself in the new hyper-competitive international art market through innovative structure, meaning and humor."

INFINITY FEATURES, 313 Heathcote Rd., Scarsdale NY 10583-7154. (914)472-9459. Fax: (914)472-7496. E-mail: infinityf@aol.com. President: Leslie Wigon. Illustration and photography broker, photo editor. Estab. 1982. Member of ASPP. Agency specializes in "finding overseas buyers for images already produced for domestic (editorial and commercial) clients. We market both photo features and stock and are most successful with spectacular images of unique people, places and things, geography (world-wide) and animals (domestic and wild)." Markets include advertising agencies, editorial/magazines, sales/promo-

tion firms, corporations/clients direct, paper products/greeting cards, publishing/books.
Will Handle: Photography and photo/text packages. "We only work with well established, professional photographers whose work is published on a regular basis."
Terms: Commission varies from nothing to 50%. "We take nothing when dealing with certain magazines."
How to Contact: Send tearsheets, list of magazine credits and detailed descriptions of available images. Replies only if interested within 2 weeks.
Tips: "A lot of the photos and photo stories we circulate to overseas clients are found in domestic magazines and newspapers. We also find new and interesting photos to market via the many photo catalogs available."

INTERPRESS WORLDWIDE, P.O. Box 8374, Universal City CA 91618-8374. (323)876-7675. Contact: Ellen Bow. Representative for commercial and fashion photography, illustration, fine art, graphic design, models, actors/musicians, make-up artists and hairstylists; also illustration and photography broker. Estab. 1989. Represents 10 photographers, 6 make-up artists, 4 hairstylists, 20 models, 15 musicians, 4 actors, 2 illustrators, 2 designers and 5 fine artists, 2 video directors, 1 cinematographer. Specializes in subsidiaries worldwide: Vienna, Austria; Milan, Italy; London, England; and Madrid, Spain. Markets include: advertising agencies; corporations/clients direct; editorial/magazines; publishing/books; movie industry; art publishers; galleries; private collections; music industry; commercial and documentary productions.
Handles: Illustration, photography, fine art, design, graphic art.
Terms: Rep receives 30% commission. Charges initial rep fee and postage. Exclusive representation negotiable. Advertising costs are split: 80% paid by the talent; 20% paid by representative. For promotional purposes, talent must provide 2 show portfolios, 6 traveling portfolios. Advertises in *Creative Black Book*, *The Workbook*, *Production-Creation*, *The Red Book*.
How to Contact: For first contact, send query letter, résumé, bio, direct mail flier/brochure, tearsheets, photos, photostats, e-folio, VHS, audio portfolio, CD, tape. Replies in 45-60 days. After initial contact, call or write for appointment or drop off or mail materials for review. Portfolios should include thumbnails, roughs, original art, tearsheets, slides, photographs, photostats, e-folio (Mac disk), CD-ROM (Mac), reels (VHS), audio tape, CD, MD.
Tips: Obtains new talent through recommendations from others and the extraordinary work, personality and talent of the artist. "Try as hard as you can and don't take our 'no' as a 'no' to your talent."

[N] KLIMT REPRESENTS, 15 W. 72 St. 7-U, New York NY 10023. (212)799-2241. Fax: (212)799-2362. Commercial photography and fine art representative. Estab. 1980. Member of Society of Illustrators. Represents 1 photographer and 10 illustrators. Staff includes David Blattel (photo/computer), Wayne Alfano, Frank Morris, and Vince Natale (photo realistic illustration). Agency specializes in young adult book art. Markets include advertising agencies, corporate/client direct, interior decorators, private collectors.
Terms: Rep receives 25% commission. Advertising costs are split: 75% paid by talent; 25% paid by representative. For promotional purposes, talent must provide all materials.
How to Contact: Send query letter, tearsheets. Replies in 2 weeks. To show portfolio, photographer should call. Rep will contact photographer for portfolio review if interested.

KORMAN & COMPANY, 360 W. 34th St., Suite 4E, New York NY 10011. (212)402-2455. Fax: (212)727-1443. Second office: 325 S. Berkeley, Pasadena CA 91107. (626)583-1442. Fax: (626)796-3313. Contact: Alison Korman or Patricia Muzikar. Commercial photography representative. Estab. 1984. Markets include: advertising agencies; corporations/clients direct; editorial/magazines; publishing/books.
Handles: Photographers internationally.
Terms: Rep receives 25-30% commission. Exclusive area representation is required. Advertizes in trade directories and via direct mail.
How to Contact: For first contact, send promo. Reports in 1 month if interested. After initial contact, write for appointment or drop off or mail in portfolio of tearsheets, photographs.
Tips: Obtains new talent through "recommendations, seeing somebody's work out in the market and liking it. Be prepared to discuss your short term and long term goals and how you think a rep can help you achieve them."

ELAINE KORN ASSOCIATES, LTD., 2E, 372 Fifth Ave., New York NY 10018. (212)760-0057. Fax: (212)465-8093. Commercial photography representative. Estab. 1983. Member of SPAR. Represents 6 photographers. Specializes in advertising photography, still life, fashion, kids/babies. Markets include: advertising agencies; editorial/magazines; sales/promotion firms; corporations/clients direct; paper products/greeting cards; design firms; publishing/books.
Handles: Photography.

How to Contact: For first contact, send promotional pieces, brochure, résumé, photostats, tearsheets and query letter. After initial contact, call or write for appointment to show portfolio.
Tips: While looking for a rep, "don't give up and don't be a pain."

JOAN KRAMER AND ASSOCIATES, INC., 10490 Wilshire Blvd., 1701, Los Angeles CA 90024. (310)446-1866. Fax: (310)446-1856. Contact: Joan Kramer. Commercial photography representative and stock photo agency. Estab. 1971. Member of SPAR, ASMP, PACA. Represents 45 photographers. Specializes in model-released lifestyle. Markets include: advertising agencies; design firms; publishing/books; sales/promotion firms; producers of TV commercials.
Handles: Photography.
Terms: Rep receives 50% commission. Advertising costs split: 50% paid by talent; 50% paid by representative. Advertises in *Creative Black Book*, *The Workbook*.
How to Contact: Call to schedule an appointment or send a query letter. Portfolio should include slides. Replies only if interested.
Tips: Obtains new talent through recommendations from others.

CAROYL LABARGE REPRESENTING, 161 E. 89th St., 4B, New York NY 10128. Fax: (212)831-6050. E-mail: lyorac@earthlinknet.com. Commercial photography representative. Contact by fax: Caroyl LaBarge. Commercial photography representative. Estab. 1991. Represents 5 photographers. Agency specializes in still life. Markets include: advertising agencies; corporations/clients direct; design firms; editorial/magazines; publishing/books; sales/promotion firms.
Handles: Photography.
Terms: Rep receives 25% commission. Charges 25% of all expenses incurred. Exclusive area representation required. Advertising costs are split: 75% paid by talent; 25% paid by representative. For promotional purposes, talent must provide promo pieces.
How to Contact: Send query letter, tearsheets and fax materials or contact through e-mail. Replies only if interested within 1 week. Rep will contact photographer for portfolio review if interested. Portfolio should include b&w and color prints, slides and tearsheets.
Tips: Obtains new talent through references and magazines. "Contact me by e-mail or direct mail only."

N LEE + LOU PRODUCTIONS INC., 8522 National Blvd., #108, Culver City CA 90232. (310)287-1542. Fax: (310)287-1814. E-mail: leelou@earthlink. Commercial illustration and photography representative, digital and traditional photo retouching. Estab. 1981. Represents 10 illustrators, 5 photographers. Specializes in automotive. Markets include: advertising agencies.
Handles: Photography.
Terms: Rep receives 25% commission. Charges for shipping, entertainment. Exclusive area representation required. Advertising costs are paid by talent. For promotional purposes, talent must provide direct mail advertising material. Advertises in *Creative Black Book*, *The Workbook* and *Single Image*.
How to Contact: For first contact, send direct mail flier/brochure, tearsheets. Replies in 1 week. After initial contact, call for appointment to show portfolio of photographs.
Tips: Obtains new talent through recommendations from others, some solicitation.

LEVIN•DORR, 1123 Broadway, Suite 1005, New York NY 10010. (212)627-9871. Fax: (212)243-4036. E-mail: therepboys@aol.com. President: Bruce Levin. Commercial photography representative. Estab. 1983. Member of SPAR and ASMP. Represents 10 photographers. Agency specializes in advertising, editorial and catalogue; heavy emphasis on fashion, lifestyle and computer graphics.
Handles: Photography. Looking for photographers who are "young and college-educated."
Terms: Rep receives 25% commission. Exclusive area representation is required. Advertising costs are split: 75% paid by talent; 25% paid by representative. Advertises in *The Workbook* and other sourcebooks.
How to Contact: For first contact, send brochure, photos; call. Portfolios may be dropped off every Monday and Friday.
Tips: Obtains new talent through recommendations, research, word-of-mouth, solicitation.

MARKET CONDITIONS are constantly changing! If you're still using this book and it's 2001 or later, buy the newest edition of *Photographer's Market* at your favorite bookstore or order directly from Writer's Digest Books.

LORRAINE & ASSOCIATES, 2311 Farrington, Dallas TX 75207. (214)688-1540. Fax: (214)688-1608. E-mail: lorainel@airmail.net. Contact: Lorraine Haugen. Commercial photography, illustration and digital imaging representative. Estab. 1992. Member of DSVC. Represents 3 photographers, 2 illustrators, 1 fine artist, 1 digital retoucher. "We have over eight years experience marketing and selling digital retouching and point-of-purchase advertising in a photographic lab." Markets include: advertising agencies; corporations/clients direct; design firms; interior decorators; high-end interior showrooms and retail.
Handles: Illustration, photography, digital illustrators and co-animators. Looking for unique established photographers and illustrators, CD digital animators and interactive CD-ROM animators.
Terms: Rep receives 25-30% commission, plus monthly retainer fee per talent. Advertising costs are split: 90% paid by talent; 10% paid by representative. For promotional purposes, talent must provide 2 show portfolios, 1 traveling portfolio, leave-behinds and at least 5 new promo pieces per year. Must advertise in national publications and participate in pro bono projects. Advertises in *American Showcase*, *Black Book*.
How to Contact: For first contact, send bio, direct mail flier/brochure, tearsheets. Reports in 2-3 weeks if interested. After initial contact, call to schedule an appointment. Portfolios should include photographs.
Tips: Obtains new talent through referrals and personal working relationships. "Talents' portfolios are also reviewed by talent represented for approval and complement of styles to the group represented. Photographer should be willing to participate in group projects and be very professional in following instructions, organization and presentation."

MCCONNELL & MCNAMARA, 182 Broad St., Wethersfield CT 06109. (860)563-6154. Fax: (860)563-6159. E-mail: jack_mcconnell@msn.com. Contact: Paula McNamara. Commercial photography and fine art representative. Estab. 1975. Member of SPAR, ASMP, ASPP. Represents 1 illustrator, 1 photographer, 1 fine artist and 1 designer. Staff includes Paula McNamara (photography, illustration and fine art). Specializes in advertising and annual report photography. Markets include: advertising agencies; corporations/client direct; design firms; editorial/magazines; paper products/greeting cards; publishing/books; sales/promotion firms; stock photography/travel; corporate collections; galleries.
Handles: Photography. "Looking for photographers specializing in stock photography of New England and 'concept' photography."
Terms: Rep receives 25-30% commission. Exclusive area representation is required. Advertising costs are split: 75% paid by talent; 25% paid by representative. For promotional purposes, talent must provide "professional portfolio and tearsheets already available and ready for improving; direct mail piece needed within 3 months after collaborating."
How to Contact: For first contact, send query letter, bio, résumé, direct mail flier/brochure, tearsheets, SASE. Replies only if interested within 1 month. "Unfortunately we don't have staff to evaluate and investigate new talent or offer counsel." After initial contact, write for appointment to show portfolio of tearsheets, slides, photographs.
Tips: Obtains new talent through "recommendations by other professionals, sourcebooks and industry magazines. We prefer to follow our own leads rather than receive unsolicited promotions and inquiries. It's best to have represented yourself for several years to know your strengths and be realistic about your marketplace. The same is true of having experience with direct mail pieces, developing client lists, and having a system of follow up. We want our talent to have experience with all this so they can properly value our contribution to their growth and success—otherwise that 25% becomes a burden and point of resentment."

COLLEEN MCKAY PHOTOGRAPHY, 229 E. Fifth St., #2, New York NY 10003. (212)598-0469. Fax: (212)598-4059. E-mail: mckayphoto@aol.com. Contact: Colleen McKay. Commercial photography and fine art representative. Estab. 1985. Member of SPAR. Represents 1 photographer. "Our photographers cover a wide range of work from location, still life, fine art, fashion and beauty." Markets include: advertising agencies; design firms; editorial/magazines; retail.
Handles: Commercial and fine art photography.
Terms: Rep receives 25% commission. Exclusive area representation is required. Advertising costs are split: 75% paid by talent; 25% paid by representative. "Promotional pieces are very necessary. They must be current. The portfolio should be established." Advertises in *Creative Black Book*, *Select*, *New York Gold*.
How to Contact: For first contact, send query letter, résumé, bio, direct mail flier/brochure, tearsheets, slides, photographs. Replies within 2-3 weeks. "I like to respond to everyone, but if we're really swamped I may only get a chance to respond to those we're most interested in." Portfolio should include tearsheets, slides, photographs, transparencies (usually for still life).
Tips: Obtains talent through recommendations of other people and solicitations. "I recommend that you look in current resource books and call the representatives who are handling the kind of work that you

admire or is similar to your own. Ask these reps for an initial consultation and additional references. Do not be intimidated to approach anyone. Even if they do not take you on, a meeting with a good rep can prove to be very fruitful! Never give up! A clear, positive attitude is very important."

MASLOV AGENT INTERNATIONAL, 608 York St., San Francisco CA 94110. (415)641-4376. Contact: Norman Maslov. Commercial photography and illustration representative. Estab. 1986. Member of APA. Represents 5 photographers, 13 illustrators. Markets include: advertising agencies; corporations/clients direct; design firms; editorial/magazines; paper products/greeting cards; publishing/books; private collections.
Handles: Photography. Looking for "original work not derivative of other artists. Artist must have developed style."
Terms: Rep receives 25% commission. Exclusive US national representation required. Advertising costs split varies. For promotional purposes, talent must provide 3-4 direct mail pieces a year. Advertises in *Single-Image*, *Archive*, *Workbook*, *Alternative Pick*.
How to Contact: For first contact, send query letter, direct mail flier/brochure, tearsheets. DO NOT send original work. Reports in 2-3 weeks only if interested. After initial contact, call to schedule an appointment or drop off or mail materials for review. Portfolio should include photographs.
Tips: Obtains new talent through suggestions from art buyers and recommendations from designers, art directors and other agents. "Enter your best work into competitions such as *Communication Arts* and *Graphis* photo annuals. Create a distinctive promotion mailer if your concepts and executions are strong."

MEO REPRESENTS, 60 Spring St., Suite 314, New York NY 10012. (212)965-9346. Fax: (212)965-9397. Contact: Frank Meo. Commercial photography representative. Estab. 1985. Member of SPAR. Represents 4 photographers. Markets include: advertising agencies.
Handles: Photography.
Terms: Rep receives 25% commission. Exclusive representation required. Advertising costs are split: 25% paid by talent; 75% paid by representative. Advertises in *Creative Black Book*, *The Workbook*.
How to Contact: For first contact, send query letter, tearsheets. Rep will contact photographer for portfolio review if interested.
Tips: Obtains new talent through submissions.

N MONACO REPS, 389 Bleecker St., New York NY 10014. (212)647-0336. E-mail: monacoreps@aol.com. Contact: Claudia Monaco. Commercial photography representative. Estab. 1987. Member of SPAR. Represents 11 photographers. Agency specializes in management and growth of careers; multilevel planning, including direction on competitive portfolios and creative growth. Markets include advertising agencies, corporate/client direct, design firms, editorial/magazines, direct mail firms.
Will Handle: Photography.
Terms: Rep receives 25% commission. Exclusive area representation required. For promotional purposes, talent must provide 3 or more complete portfolios and must have resources to produce at least 6 high-quality mailers. Advertise in our own sourcebooks.
How to Contact: Send bio, brochure, photocopies. Replies only if interested within 2 weeks. Portfolios may be dropped off every Tuesday, Wednesday, Thursday. To show portfolio, photographer should follow up with a call.
Tips: Finds new talent through submissions and recommendations from other artists. "Your presentation must be well established and polished. Good reproduction and simple presentation are musts."

MUNRO GOODMAN ARTISTS REPRESENTATIVES, 4 E. Ohio St., Studio B, Chicago IL 60611. (312)321-1336. Fax: (312)321-1350. Contact: Steve Munro. Commercial photography and illustration representative. Estab. 1987. Member of SPAR, CAR (Chicago Artist Representatives). Represents 2 photographers, 22 illustrators. Markets include: advertising agencies; corporations/clients direct; design firms; publishing/books.
Handles: Illustration, photography.
Terms: Rep receives 25-30% commission. Exclusive area representation required. Advertising costs are split: 75% paid by talent; 25% paid by representative. For promotional purposes, talent must provide 2 portfolios, leave-behinds, several promos. Advertises in *American Showcase*, *Creative Black Book*, *The Workbook*, other sourcebooks.
How to Contact: For first contact, send query letter, bio, tearsheets and SASE. Replies within 2 weeks, only if interested. After initial contact, write to schedule an appointment.
Tips: Obtains new talent through recommendations, periodicals. "Do a little homework and target appropriate rep."

THE NEIS GROUP, 11440 Oak Dr., P.O. Box 174, Shelbyville MI 49344. (616)672-5756. Fax: (616)672-5757. Website: http://www.neisgroup.com. Contact: Judy Neis. Commercial illustration and photography representative. Estab. 1982. Represents 30 illustrators, 12 photographers. Markets include: advertising agencies; design firms; editorial/magazines; publishing/books.
Handles: Illustration, photography.
Terms: Rep receives 25% commission. Advertising costs are split: 75% paid by talent; 25% paid by representative. Advertises in *The American Showcase*, *Black Book*, *Picture Book* and *Workbook*.
How to Contact: For first contact, send direct mail flier/brochure, tearsheets, photographs. Reports in 5 days. After initial contact, drop off or mail in appropriate materials for review. Portfolio should include non-returnable tearsheets, photographs.
Tips: "I am mostly sought out by the talent. If I pursue, I call and request a portfolio review."

N. PHOTOKUNST, 2461 San Diego Ave., 205, San Diego CA 92110-2879. (619)294-3489. Fax: (619)699-6591. E-mail: photokunst@aol.com. Owners: Barbara Cox and Lynne Walker. Fine Art photography representative. Estab. 1998. Represents 4-10 artists; approached by 30 artists a year. Exhibited artists include Phil Borges, Kari Koenig, Chris Rainer. "We are photographers' agents and work placing exhibits in galleries nationally and internationally." Overall price range $1,000-5,000. Most work sold at $1,500.
Handles: Multicultural, landscapes/scenics. Interested in alternative process, avant garde, documentary and fine art.
How to Contact: Write to arrange a personal interview to show portfolio of photographs, transparencies, slides. Send query letter, bio, slides, photocopies, SASE, business card, reviews. Replies in 3-4 weeks.
Tips: Finds new talent through submissions, recommendations from other artists, word of mouth, art exhibits, art fairs, portfolio reviews.

MARIA PISCOPO, 2973 Harbor Blvd., 229, Costa Mesa CA 92626-3912. (714)556-8133. Fax: (714)556-8133. E-mail: mpiscopo@aol.com. Website: http://e-folio.com/piscopo. Contact: Maria Piscopo. Commercial photography representative. Estab. 1978. Member of SPAR, Women in Photography, Society of Illustrative Photographers. Markets include: advertising agencies; design firms; corporations.
Handles: Photography. Looking for "unique, unusual styles; handles only established photographers."
Terms: Rep receives 25-30% commission. Exclusive area representation is required. No geographic restrictions. Advertising costs are split: 50% paid by talent; 50% paid by representative. For promotional purposes, talent must provide 1 show portfolio, 3 traveling portfolios, leave-behinds and at least 6 new promo pieces per year. Plans advertising and direct mail campaigns.
How to Contact: For first contact, send query letter, bio, direct mail flier/brochure and SASE. Replies only if interested within 2 weeks.
Tips: Obtains new talent through personal referral and photo magazine articles. "Be very business-like, organized, professional and follow the above instructions!"

ALYSSA PIZER, 13121 Garden Land Rd., Los Angeles CA 90049. (310)440-3930. Fax: (310)440-3830. Contact: Alyssa Pizer. Commercial photography representative. Estab. 1990. Member of APCA. Represents 5 photographers. Specializes in entertainment (movie posters, TV Gallery, record/album); fashion (catalog, image campaign, department store). Markets include: advertising agencies, corporations/clients direct, design firms, editorial/magazines, record companies; movie studios, TV networks, publicists.
Handles: Photography. Established photographers only.
Terms: Rep receives 25% commission. Photographer pays for Federal Express and messenger charges. Talent pays 100% of advertising costs. For promotional purposes, talent must provide 1 show portfolio, 4-7 traveling portfolios, leave-behinds and quarterly promotional pieces.
How to Contact: For first contact, send query letter or direct mail flier/brochure or call. Reports in a couple of days. After initial contact, call to schedule an appointment or drop off or mail materials for review.
Tips: Obtains new talent through recommendations from clients.

REDMOND REPRESENTS, 4 Cormer Court, Apt. 304, Timonium MD 21093. (410)560-0833. E-mail: sony@erols.com. Contact: Sharon Redmond. Commercial illustration and photography representative. Estab. 1987. Represents photographers and illustrators. Markets include: advertising agencies; corporations/client direct; design firms.
Handles: Illustration, photography.
Terms: Rep receives 30% commission. Exclusive area representation is required. No geographic restrictions. Advertising costs and expenses are split: 50% paid by talent; 50% paid by representative. For promotional purposes, talent must provide a small portfolio (easy to Federal Express) and at least 6 direct mail pieces (with fax number). Advertises in *American Showcase*, *Creative Black Book*.

How to Contact: For first contact, send mailouts. Replies only if interested within 2 weeks.
Tips: "Even if I'm not taking in new talent, I do want samples sent of new work. I never know when an ad agency will require a different style of illustration/photography, and it's always nice to refer to my files."

KERRY REILLY: REPS, 1826 Asheville Place, Charlotte NC 28203. Phone/fax: (704)372-6007. Contact: Kerry Reilly. Commercial illustration and photography representative. Estab. 1990. Represents 16 illustrators, 3 photographers. Markets include: advertising agencies; corporations/clients direct; design firms; editorial/magazines.
Handles: Illustration, photography.
Terms: Rep receives 25% commission. Exclusive area representation is desired. No geographic restrictions. Advertising costs are split: 75% paid by talent; 25% paid by representative. For promotional purposes, talent must provide at least 2 pages printed leave-behind samples. Preferred format is 9×12 pages, portfolio work on 4×5 transparencies. Advertises in *American Showcase, Workbook.*
How to Contact: For first contact, send direct mail flier/brochure or samples of work. Reports in 2 weeks. After initial contact, call for appointment to show portfolio or drop off or mail tearsheets, slides, 4×5 transparencies.
Tips: Obtains new talent through recommendations from others. "It's essential to have printed samples."

JULIAN RICHARDS, 594 Broadway, 908, New York NY 10012. (212)219-1269. Fax: (212)219-1877. Contact: Jesse Wennik. Commercial photography representative. Estab. 1992. Represents 5 photographers. Specializes in portraits, travel. Markets include: advertising agencies; design firms; editorial/magazines; publishing/books.
Terms: Rep receives 25% commission. Exclusive area representation required. Advertising costs are split: 80% paid by talent; 25% paid by representative.
How to Contact: For first contact, send direct mail flier/brochure.
Tips: Obtains new talent by working closely with potential representees over a period of months. "Be reasonable in your approach—let your work do the selling."

THE ROLAND GROUP INC., 4948 St. Elmo Ave., 201, Bethesda MD 20814. (301)718-7955. Fax: (301)718-7958. E-mail: info@therolandgroup.com. Website: www.therolandgroup.com. Contact: Rochel Roland. Commercial photography and illustration representatives as well as illustration and photography brokers. Estab. 1988. Member of SPAR, ASMP, Art Directors Club and Ad Club. Represents 300 photographers, 10 illustrators. Markets include advertising agencies; corporations/clients direct; design firms and sales/promotion firms.
Handles: Illustration, photography.
Terms: Agent receives 35% commission. For promotional purposes, talent must provide transparencies, slides, tearsheets or a digital portfolio. Advertises in *Print Magazine, American Showcase, The Workbook, Creative Sourcebook, KLIK, International Creative Handbook, Black Book, AR 100.*
How to Contact: For first contact, send résumé, tearsheets or photocopies and any other nonreturnable samples. Replies only if interested. After initial contact, portfolio materials may be called in for review. Portfolios should include tearsheets, slides, photographs, photocopies.
Tips: "The Roland Group provides the National Photography Network Worldwide Service in which over 300 photographers are assigned to specific geographic territories around the world to handle projects for all types of clients."

SHARPE + ASSOCIATES INC., 7536 Ogelsby Ave., Los Angeles, CA 90045. (310)641-8556. Fax: (310)641-8534. E-mail: sharpela@eastlink.net. Contact: John Sharpe (LA), Colleen Hedleston (NY: (212)595-1125). Commercial illustration and photography representative. Estab. 1987. Member of APA. Represents 5 illustrators, 5 photographers. Not currently seeking new talent but "always willing to look at work." Staff includes: John Sharpe, Irene Sharpe, Colleen Hedleston and Eva Burnett (general commercial—advertising and design), "all have ad agency marketing backgrounds. We tend to show more nonmainstream work." Markets include: advertising agencies; corporations/clients direct; design firms; editorial/magazines; music/publishing; sales/promotion firms.
Handles: Illustration, photography.
Terms: Agent recieves 25% commission. Exclusive area representation is required, Advertising costs are paid by talent. For promotional purposes, "promotion and advertising materials are the talent's responsibility. The portfolios are 100% the talent's responsiblity, and we like to have at least three complete books per market." Advertises in major sourcebooks and through direct mail.
How to Contact: For first contact, call, then follow up with printed samples. Reports in 2 weeks. After initial contact, call for appointment to show portfolio.

Tips: "Once they have a professional portfolio together and at least one representative promotional piece, photographers should target reps along with potential buyers of their work as if the two groups are one and the same. They need to market themselves to reps as if the reps are potential clients."

SOODAK REPRESENTS, 11135 Korman Dr., Potomac MD 20854. (301)983-2343. Fax: (301)983-3040. Contact: Arlene Soodak. Commercial photography representative and broker. Estab. 1985. Member of ASMP, AIGA. Represents 3 photographers. Specializes in national capabilities—photography, food, location, still life. Markets include: advertising agencies; design firms, corporations.
Handles: Photography. Looking for "unique, young photographers; a few years out of school."
Terms: Rep receives 25% commission. Exclusive area representation is required. Payment of advertising costs "depends on length of time artist is with me." For promotional purposes, talent must provide "intact portfolio of excellent quality work and promo package and direct mail campaign which I will market." Advertises in *The Workbook* and featured on cover of *CA Magazine*, January 1996.
How to Contact: For first contact, send direct mail flier/brochure, tearsheets, photocopies. Replies in 10 days. After initial contact, drop off or mail in portfolio for review.

TM ENTERPRISES, 270 N. Canon Dr., Suite 2020, Beverly Hills CA 90210. (310)274-2664. Fax: (310)274-4678. E-mail: tmarques@idt.net. Contact: Tony Marques. Commercial photography representative and photography broker. Estab. 1985. Member of Beverly Hills Chamber of Commerce. Represents 50 photographers. Specializes in photography of women only: high fashion, swimsuit, lingerie, glamour and fine (good taste) *Playboy*-style pictures. Markets include: advertising agencies; corporations/clients direct; editorial/magazines; paper products/greeting cards; publishing/books; sales/promotion firms; medical magazines.
Handles: Photography.
Terms: Rep receives 50% commission. Advertising costs are paid by representative. "We promote the standard material the photographer has available, unless our clients request something else." Advertises in Europe, South and Central America and magazines not known in the US.
How to Contact: For first contact, send everything available. Replies in 2 days. After initial contact, drop off or mail in appropriate materials for review. Portfolio should include slides, photographs, transparencies, printed work.
Tips: Obtains new talent through worldwide famous fashion shows in Paris, Rome, London and Tokyo; by participating in well-known international beauty contests; recommendations from others. "Send your material clean and organized (neat). Do not borrow other photographers' work in order to get representation. Protect—always—yourself by copyrighting your material. Get releases from everybody who is in the picture (or who owns something in the picture)."

JONI TUKE INC., 325 W. Huron St., 512, Chicago IL 60610. (312)787-6826. Fax: (312)787-9459. E-mail: tukester@aol.com. Representative: Joni Tuke. Commercial photography and illustration representative. Estab. 1975. Represents 3 photographers and 15 illustrators. Markets include advertising agencies, corporate/client direct, design firms, editorial/magazines, direct mail firms.
Terms: Rep receives 25% commission. Advertising costs are split: 75% paid by talent; 25% paid by representative. For promotional purposes, talent must provide all materials. Advertises in *The Workbook*.
How to Contact: Send query letter, bio, tearsheets. Replies in 2-4 weeks. Rep will contact photographer for portfolio review if interested.
Tips: "Be professional and have a well planned portfolio."

TY REPS, 920¼ N. Formosa Ave., Los Angeles CA 90046. (323)850-7957. Fax: (323)850-0245. Contact: Ty Methfessel. Commercial photography and illustration representative. Specializes in automotive photography, portfolio reviews and marketing advice. Markets include advertising agencies; corporations/clients direct; design firms.
Handles: Illustration and photography.
Terms: Rep receives 25-30% commission. Exclusive area representation required. Advertising costs paid by talent. For promotional purposes, talent must provide a minimum of 3 portfolios, 4 new promos per year and a double-page ad in a national directory. Advertises in *American Showcase*, *Creative Black Book* and *The Workbook*.
How to Contact: For first contact, send query letter, direct mail flier/brochure and tearsheets. Reports in 2 weeks only if interested.

ELYSE WEISSBERG, 225 Broadway, Suite 700, New York NY 10007. (212)227-7272. Fax: (212)385-0349. E-mail: elyserep@aol.com. Website: http://www.elyserep.com. Contact: Elyse Weissberg. Commercial photography representative, photography creative consultant. Estab. 1982. Member of SPAR. Markets

include: advertising agencies; corporations/clients direct; design firms; editorial/magazines; publishing/books; sales/promotion firms.

Handles: Commercial photography. "I'm not looking for talent at this time."

Terms: "Each talent contract is negotiated separately." No geographic restrictions. No specific promotional requirements. "My only requirement is ambition." Advertises in *N.Y. Gold*, *Creative Black Book*, *The Workbook*.

How to Contact: Send mailers.

Tips: Elyse Weissberg is available on a consultation basis. She reviews photography portfolios and gives direction in marketing and promotion.

THE WILEY GROUP, (formerly David Wiley Represented), 94 Natoma St., Suite 200, San Francisco CA 94105. (415)442-1822. Fax: (415)442-1823. E-mail: dww@wco.com. Website: http://www.thewileygroup.com. Contact: David Wiley. Commercial illustration and photography representative. Estab. 1984. Member of AIP (Artists in Print), Society of Illustrators, Bay Area Lawyers for the Arts and Graphic Artists Guild (GAG). Represents 12 illustrators, 3 photographers. Specializes in "creative solutions."

Terms: Rep receives 25% commission. No geographical restriction. Artist is responsible for 100% of portfolio costs. Creative directory costs are paid 100% by artist. Annual tearsheet mailing is paid 100% by rep, as well as each artist's website. Quarterly postcard mailings are paid by the artist. Each year the artists are promoted in *American Showcase*, *Black Book* and *Workbook*, *Directory of Illustration*, through direct mail (bimonthly mailings, quarterly postcard mailings).

How to Contact: For first contact, send query letter, tearsheets ("very important"), slides, photographs and SASE . Will call back if requested within 48 hours. After initial contact, call for appointment or drop off appropriate materials. "To find out what's appropriate, just ask! Portfolio should include self promotion and commissioned work."

Tips: "Generate new clients through creative directories, direct mail and a rep relationship. To create new images that will hopefully sell, consult an artist rep or someone qualified to suggest ideas keeping in alignment with your goals. Remember to give yourself permission to make mistakes—it's just another way of doing something."

WINSTON WEST, LTD., 204 S. Beverly Dr., Suite 109, Beverly Hills CA 90212. (310)275-2858. Fax: (310)275-2858. Website: www.winstonwest.com. Contact: Bonnie Winston. Commercial photography representative (fashion/entertainment). Estab. 1986. Represents 8 photographers. Specializes in "editorial fashion and commercial advertising (with an edge)." Markets include: advertising agencies; client direct; editorial/magazines.

Handles: Photography.

Terms: Rep receives 25% commission. Charges 100% for courier services. Exclusive area representation is required. No geographic restrictions. Advertising costs are paid by talent 100%. Advertises by direct mail and industry publications.

How to Contact: For first contact, send direct mail flier/brochure, photographs, photocopies, photostats. Replies only if interested within days. After initial contact, call for appointment to show portfolio of tearsheets.

Tips: Obtains new talent through "recommendations from the modeling agencies. If you are a new fashion photographer or a photographer who has relocated recently, develop relationships with the modeling agencies in town. They are invaluable sources for client leads and know all the reps."

WORLWIDE IMAGES, P.O. Box 150547, San Rafael CA 94915. (415)383-7299. Owner: Norm Buller. Commercial photography representative and broker. Estab. 1978. Represents 36 photographers. Specializes in all professional sports, men's magazine, bands and musicians, nudes, glamour. Markets include paper products/greeting cards, publishing/books.

Handles: Photography, only (5 lines, transparencies, prints).

Terms: Rep receives 50% commission. For promotional purposes, talent must provide slides, transparencies, prints on video tapes. Advertises in sourcebooks.

How to Contact: Send prints, slides or transparencies. Replies in 1 week.

Tips: Finds new talent through submissions and recommendations from other artists. "Send photos so we can see how many clients you can service for us."

JIM ZACCARO & ASSOC., 315 E. 68th St., New York NY 10021. (212)744-4000. E-mail: jimzacc@earthlink.net. Website: http://www.home.earthlink.net/~jimzacc. Contact: Jim Zaccaro. Commercial photography, illustration and fine art representative. Estab. 1962. Member of DGA. Represents 4 photographers.

How to Contact: For first contact, send query letter, direct mail flier/brochure. Reports in 10 days. After initial contact, call for appointment to show portfolio.

Workshops

Photography is headed in a new direction, one filled with computer manipulation, compact discs and online images. Technological advances are no longer the wave of the future—they're here.

Even if you haven't invested a lot of time and money into electronic cameras, computers or software, you should understand what you're up against if you plan to succeed as a professional photographer. Outdoor and nature photography are still popular with instructors, but technological advances are examined closely in a number of the workshops listed in this section.

As you peruse these pages take a good look at the quality of workshops and the level of photographers the sponsors want to attract. It is important to know if a workshop is for beginners, advanced amateurs or professionals, and information from a workshop organizer can help you make that determination.

These workshop listings contain only the basic information needed to make contact with sponsors and a brief description of the styles or media covered in the programs. We also include information on workshop costs. Write for complete information.

The workshop experience can be whatever the photographer wishes—a holiday from the normal working routine, or an exciting introduction to new skills and perspectives on the craft. Whatever you desire, you'll probably find a workshop that fulfills your expectations on these pages.

AERIAL AND CREATIVE PHOTOGRAPHY WORKSHOPS, Hangar 23 Box 470455, San Francisco CA 94147. (415)771-2555. Fax: (415)771-5077. Director: Herb Lingl. Offers Polaroid sponsored seminars covering creative uses of Polaroid films and aerial photography workshops in unique locations from helicopters, light planes and balloons.

[N] AFRICAN PHOTO SAFARIS, H.C.R. 60 Box 239, Porthill ID 83853. (208)267-5586. Fax: (208)267-5585. Contact: Brent Rosengrant. "Intense 21-day workshops and Photo Safaris limited to only four photographers in a safari equipped Land Rover. Regions explored include Etosha National Park, Namib Desert, the Skeleton Coast, Okovango Delta and Victoria Falls."

ALASKA ADVENTURES, P.O. Box 111309, Anchorage AK 99511. (907)345-4597. Contact: Chuck Miknich. Offers photo opportunities of Alaska wildlife and scenery on remote fishing/float trips and remote fish camp. Trips are conducted throughout the remotest parts of the state. "All trips offer a variety of wildlife viewing opportunities besides great fishing. You don't have to be a fisherman to enjoy these trips. The varying locations and timings of our trips offer a wide range of photo opportunities, so any particular interests should be directed to our attention."

ALASKA PHOTO TOURS, Box 141, Talkeetna AK 99676. (800)799-3051. E-mail: photoak@alaska.net. Website: http://www.alaska.net/~photoak. Guide: Steve Gilroy. Cost: $2,000-4,000; includes lodging, transportation and most meals. Workshop for beginner to advanced photographers covering landscape, macro and wildlife work. Custom trips last from 6 to 12 days, featuring private marine life boat excursions, bear viewing camps and other exclusive services.

ALASKA'S SEAWOLF ADVENTURES, P.O. Box 97, Gustavus AK 99826. (907)697-2416. Contact: Trip Coordinator. Cost: $1,500/5 days. "Photograph glaciers, whales, bears, wolves, incredible scenics etc., while using the Seawolf, a 65 foot yacht, as your basecamp in the Glacier Bay area."

ALDERMAN'S SLICKROCK ADVENTURES, 19 W. Center St., Kanab UT 84741. (435)644-5981. E-mail: fotomd@xpressweb.com. Website: http://www.onpages.com/fotomd. Contact: Terry Alderman. Cost: $75/day; 2 person minimum. Covers landscape photography of ghost towns, arches, petroglyphs and narrow canyons in the back country of Utah and Arizona.

ALLAMAN'S MONTANA PHOTOGRAPHIC ADVENTURES, Box 77, Virginia City MT 59755-0077. (406)843-5550. Contact: Ken Allaman. Cost: $695/week. Five-day workshop and photo opportunities for beginning to advanced photographers covering landscape and wildlife photography in Montana.

AMERICAN SOUTHWEST PHOTOGRAPHY WORKSHOPS, 11C Founders, El Paso TX 79906. (915)757-2800. Director: Geo. B. Drennan. Offers intense field and darkroom workshops for the serious b&w photographer. Technical darkroom workshops limited to 5 days, 2 participants only.

AMPRO PHOTO WORKSHOPS, 636 E. Broadway, Vancouver BC V5T 1X6 Canada. (604)876-5501. Fax: (604)876-5502. Website: http://www.ampro-photo.com. Course tuition ranges from under $100 for part-time to $7,900 (Canadian) for full-time. Approved trade school. Offers part-time and full-time career courses in commercial photography and photofinishing. "Offers many different courses in camera, darkroom and studio lighting—from basic to advanced levels. Special seminars with top professional photographers. Career courses in photofinishing, photojournalism, electronic imaging and commercial photography and new digital courses in Photoshop." Fall week-long field photography shoots.

ANDERSON RANCH ARTS CENTER, P.O. Box 5598, Snowmass Village CO 81615. (970)923-3181. Fax: (970)923-3871. Weekend to 3-week workshops run June to September in photography, digital imaging and creative studies. "Instructors are top artists from around the world. Classes are small and the facilities have the highest quality equipment." Program highlights include portrait and landscape photography; technical themes include photojournalism and advanced techniques. Offers field expeditions to the American Southwest and other locations around the globe.

APER TOUR PHOTOGRAPHY WORKSHOP, Calle Tonala #27, San Cristobal, Chiapas Mexico. Phone: (52)967-85727 or (800)303-4983. E-mail: apertour@sancristobal.podernet.com.mx. Website: http://www.mexonline.com/aper1.htm. Contact: Cisco Craig Dietz. Cost: $1,200, includes lodging, transportation at school and most meals. Nine-day photography tour of Chiapas, Mexico. Emphasizes people, landscape work, finding a new outlook and darkroom technique.

ARROWMONT SCHOOL OF ARTS AND CRAFTS, P.O. Box 567, Gatlinburg TN 37738. (423)436-5860. Tuition is $280 per week. Room and board packages start at $185. Offers 1- and 2-week spring and summer workshops in various techniques.

ART NEW ENGLAND SUMMER WORKSHOPS, 425 Washington St., Brighton MA 02135. (617)232-1604. Cost: $885, including lodging and meals. Week-long workshop for intermediate to advanced students covering fine art photography. Classes include alternative photography, portrait, hand coloring and cliché verre.

ASSIGNMENT PHOTOGRAPHER WORKSHOP, 7622 Katella Ave., 386, Stanton CA 90680. (714)379-5604. Instructor: Stan Zimmerman. "The workshop provides the instruction necessary in taking professional quality photographs, marketing these skills, and earning money in the process."

NOELLA BALLENGER & ASSOCIATES PHOTO WORKSHOPS, P.O. Box 457, La Canada CA 91012. (818)954-0933. Fax: (818)954-0910. E-mail: noella1b@aol.com. Website: http://www.noellaballenger.com. Contact: Noella Ballenger. Travel and nature workshop/tours, west coast locations. Individual instruction in small groups emphasizes visual awareness, composition and problem solving in the field. All formats and levels of expertise welcome. Call or write for information.

FRANK BALTHIS PHOTOGRAPHY WORKSHOPS, P.O. Box 255, Davenport CA 95017. (831)426-8205. Photographer/Owner: Frank S. Balthis. Cost depends on the length of program and travel costs. "Workshops emphasize natural history, wildlife and travel photography. World-wide locations range from Baja, California to Alaska. Frank Balthis runs a stock photo business and is the publisher of the Nature's Design line of cards and other publications. Workshops often provide opportunities to photograph marine mammals."

THE INTERNATIONAL MARKETS INDEX, located in the back of this book, lists markets located outside the U.S. by country.

BIRDS AS ART/INSTRUCTIONAL PHOTO-TOURS, 1455 Whitewood Dr., Deltona FL 32725. (407)860-2013. E-mail: birdsasart@worldnet.att.net. Website: http://www.birdsasart.com. Instructor: Arthur Morris. Cost varies by length of tour. Approximately $150/day. The tours, which visit the top bird photography hot spots in North America, feature evening in-classroom lectures, in-the-field instruction, 6 or more hours of photography and post-workshop written critique service.

HOWARD BOND WORKSHOPS, 1095 Harold Circle, Ann Arbor MI 48103. (734)665-6597. Owner: Howard Bond. Offers 1-day workshop: View Camera Techniques; and 2-day workshops: Zone System for All Formats, Refinements in B&W Printing, and Unsharp Masking for Better Prints.

NANCY BROWN HANDS-ON WORKSHOPS, 6 W. 20 St., New York NY 10011. (212)924-9105. Fax: (212)633-0911. Website: www.nancybrown.com. Contact: Michelle Hendryx. Cost: $1,500 for 3-day workshop, breakfast and lunch included in her New York studio. Workshops held in September. "Nancy also offers one-on-one intensive workshops of shooting with Nancy and with models. Hair and makeup artist and assistants are at your convenience throughout the year." Tuition $1,500/person. Call, fax, e-mail, or see web site for more information.

CALIFORNIA PHOTOGRAPHIC WORKSHOPS, 2500 N. Texas St., Fairfield CA 94533. (888)422-6606. E-mail: calif_school@juno.com. Director: James Inks. Five-day seminar covering many aspects of professional commercial and portrait photography. May 14-19, 2000.

⚊N⚊ THE CALUMET INSTITUTE'S MASTER PHOTOGRAPHIC WORKSHOPS, 890 Supreme Dr., Bensenville IL 60106. Call (888)280-3686 to register or register online at http://www.calumetphoto.com. Workshops are held on the campus of Salisbury State University in Salisbury, Maryland. Tuition: $1,199, includes room and board for the week-long workshop; plus a $75 lab fee. Workshops held the first 2 weeks in June. "The Calumet Institute's Master Photographic Workshops are structured to provide an intensive, extended workshop experience that provides participants with personalized, one-on-one instruction and immediate feedback to work created during the session. Each session features field trips, hands-on teaching, technical lectures and discussions, access to studio and darkroom facilities and the most current tools."

JOHN C. CAMPBELL FOLK SCHOOL, One Folk School Rd., Brasstown NC 28902. (828)837-2775 or (800)365-5724. Website: http://www.folkschool.com. Cost: $142-258 tuition; room and board available for additional fee. The Folk School offers weekend and week-long courses in photography year-round (b&w, color, wildlife and plants, image transfer, darkroom set-up, abstract landscapes). Please call for free catalog.

◼ CANADIAN ROCKIES NATURE PHOTOGRAPHY WORKSHOP, 132 Eagle Terrace Rd., Canmore, Alberta T1W 2Y5 Canada. (403)609-3850. E-mail: jemphoto@net/jem_photography. Website: http://www.canadianrockies.net/JemPhotogrpahy. Owner: John Marriott. Cost: $960 CDN, includes lodging, breakfast and lunch and ground transportation. Four-day landscape and wildlife workshop led by a professional nature photographer.

CAPE COD NATURE PHOTOGRAPHY FIELD SCHOOL, P.O. Box 236, S. Wellfleet MA 02663. (508)349-2615. Program Coordinator: Melissa Lowe. Cost: $400 per week. Week long field course on Cape Cod focusing on nature photography in a coastal setting. Whale watch, saltmarsh cruise, sunrise, sunset, stars, wildflowers, shore birds featured. Taught by John Green. Sponsored by Massachusetts Audubon Society.

CAPE COD PHOTO WORKSHOPS, 135 Oak Leaf Rd., P.O. Box 1619, N. Eastham MA 02651. (508)255-6808. E-mail: ccpw@capecod.net. Director: Linda E. McCausland. Cost: 1 day/$95, weekend/$195, week-long/$295-325. 20-25 weekend or weeklong photography workshops for beginner to advanced students. Workshops run June-September.

VERONICA CASS ACADEMY OF PHOTOGRAPHIC ARTS, 7506 New Jersey Ave., Hudson FL 34667. (727)863-2738. E-mail: veronicacassinc@worldnet.att.net. Office Manager: Allison Fiedler. Price per week: $410. Offers 8 one-week workshops in photo retouching techniques.

CENTER FOR PHOTOGRAPHY, 59 Tinker St., Woodstock NY 12498. (914)679-9957. Fax: (914)679-9957. E-mail: cpwphoto@aol.com. Website: http://www.users.aol.com/photo. Contact: Director. Offers monthly exhibitions, a summer and fall workshop series, annual call for entry shows, library, darkroom,

fellowships, memberships, and photography magazine, classes, lectures. Has interns in workshops and arts administration. Free workshop catalog available in March.

CLOSE-UP EXPEDITIONS, 858 56th St., Oakland CA 94608. (510)654-1548 or (800)457-9553. E-mail: close-up@earthlink.net. Guide and Outfitter: Donald Lyon. Worldwide, year-round travel and nature photography expeditions, 7-25 days. "Professional photographic guides put you in the right place at the right time to create unique marketable images."

COASTAL CENTER FOR THE ARTS, 2012 Demere Rd., St. Simons Island GA 31522. Director: Mittie B. Hendrix. Write for details.

COMMUNITY DARKROOM, 713 Monroe Ave., Rochester NY 14607. (716)271-5920. Director: Sharon Turner. Associate Director: Marianne Pojman. Costs $35-160, depending on type and length of class. "We offer over 20 different photography classes for all ages on a quarterly basis. Classes include basic and intermediate camera and darkroom techniques; studio lighting; matting and framing; hand-coloring; alternative processes; night, sports and nature photography and much much more! Call for a free brochure."

CONROE PHOTOGRAPHY CENTER, 201 Enterprise Row #3, Conroe TX 77301. (409)756-5933. Owners: Karl and Lorane Hoke. Cost: $400 for 3-week workshop. Teaches basics of camera functions, darkroom techniques, color printing, studio photography, flash fill, filters and open areas of students' interests.

CORY NATURE PHOTOGRAPHY WORKSHOPS, P.O. Box 42, Signal Mountain TN 37377. (423)886-1004 or (800)495-6190. E-mail: tompatcory@aol.com. Website: http://members.aol.com/tompatc ory/index.html Contact: Tom or Pat Cory. Small workshops/field trips with some formal instruction but mostly one-on-one instruction tailored to each individual's needs. "We spend the majority of our time in the field. Cost and length vary by workshop. Many of our workshop fees include single occupancy lodging and some also include home-cooked meals and snacks. We offer special prices for two people sharing the same room and, in some cases, special non-participant prices. Workshops include spring and fall workshops in Smoky Mountain National Park and Chattanooga, Tennessee. Other workshops vary from year to year but include locations such as the High Sierra of California, Olympic National Park, Arches National Park, Acadia National Park, the Upper Peninsula of Michigan, Mt. Rainier National Park, Bryce Canyon/Zion National Park, Death Valley National Park and Glacier National Park." Write, call or e-mail for a brochure or more information or visit our website.

CREALDE SCHOOL OF ART, 600 St. Andrews Blvd., Winter Park FL 32792. (407)671-1886. Website: http://www.crealde.org. Executive Director: Peter Schreyer. Director of Photography: Rick Lang. Cost: Membership fee begins at $35/individual. Offers classes covering b&w and color photography; dark room techniques; and landscape, portrait, travel, wildlife and abstract photography.

CREATIVE ARTS WORKSHOP, 80 Audubon St., New Haven CT 06511. (203)562-4927. Photography Department Head: Harold Shapiro. Offers advanced workshops and exciting courses for beginning and serious photographers.

🌐 **CREATIVE PHOTOGRAPHY WORKSHOPS**, W. Dean, Chichester, W. Sussex PO18 OQZ United Kingdom. Phone: (+44)1243 811301. Fax: (+44)1243 811343. E-mail: westdean@pavilion.co.uk. Website: http://www.westdean.org.uk/. Press & Public Relations Co-ordinator: Heather Way. Cost: £388 to 477. "West Dean College runs week long summer courses in photography including master class garden and plant photography; full creative control of your SLR camera, black and white photography; creative printing techniques; hand coloring for black and white photographs and getting the best from your camera."

🔳 **CYPRESS HILLS PHOTOGRAPHIC WORKSHOP**, 73 Read Ave., Regina, Saskatchewan S4T 6R1 Canada. (306)543-8546. Fax: (306)569-3516. E-mail: winverar@sk.sympatico.ca. Contact: Wayne Inverarity. Cost: $495 CDN before set date and $545 CDN after; partial workshop $295; CDN for full workshop which includes lodging, meals and ground transportation onsite and film and processing for critique sessions. Five-day, annual workshop held in summer. Covers areas of participant interest and can include portrait, landscape, animal, macro and commercial.

DAUPHIN ISLAND ART CENTER, 1406 Cadillac Ave., P.O. Box 699, Dauphin Island AL 36528. (800)861-5701. Director: Nick Colquitt. Offers workshops, seminars and safaris to amateur and professional photographers. "The Center serves as a wholesaler of its student's work. Items sold include greeting cards,

loose and matted prints and wall decor, all sizes." Free photography course catalog upon request.

■ ■ ■ **DAWSON COLLEGE CENTRE FOR IMAGING ARTS AND TECHNOLOGIES**, 4001 de Maisonneuve Blvd. W., Suite 2G.1, Montreal, Quebec H3Z 3G4 Canada. (514)933-0047. Fax: (514)937-3832. Director: Donald Walker. Cost: ranges from $160-400. Workshop subjects include imaging arts and technologies, animation, photography, computer imaging, desktop publishing, multimedia and web publishing.

DISCOVER THE SOUTHWEST, (formerly Pecos River Workshop), Santa Fe Workshop, Box 9916, Santa Fe NM 87504. (505)983-1400. E-mail: sfworkshop@aol.com. Website: http://www.pecosrivercabins. com. Contact: Bruce Dale. Cost: $730. 7-day documentary and travel photography workshop at a private retreat on the Pecos River. "Small class size provides ample feedback and opportunity for one-on-one critiques." Open to photographers of all levels.

DJERASSI RESIDENT ARTISTS PROGRAM, 2325 Bear Gulch Rd., Woodside CA 94062-4405. (650)747-1250. Residency Coordinator: Judy Freeland. Cost: $25 application fee. 4-week residencies April-November, in country setting, open to international artists in dance, music, visual arts, literature, media arts/new genres. Application deadline is February 15, each year, for the following year.

DORLAND MOUNTAIN ARTS COLONY, P.O. Box 6, Temecula CA 92593. (909)302-3837. E-mail: dorland@ez2.net. Website: http://www.ez2.net/dorland. Contact: Admissions Committee. Cost: $50 non-refundable scheduling fee; $300/month. Tranquil environment providing uninterrupted time to artists for serious concentrated work in their respective field. Residents housed in individual rustic cottages with private baths and kitchens but no electricity. Encourages multi-cultural and multi-discipline applications. Deadlines are March 1 and September 1.

■ **EAST COAST SCHOOL PHOTOGRAPHIC WORKSHOPS**, 705 Randolph St., E, Thomsville NC 27360. (336)476-4938. E-mail: clatruell@aol.com. Website: http://www.ppofnc.com. Director: Rex C. Truell. Annual seminar for advanced photographers covering commercial and fine art work, including digital imaging.

ROHN ENGH'S HOW TO PRODUCE MARKETABLE PHOTOS/HOW TO SELL YOUR MARKETABLE PHOTOS, Pine Lake Farm, 1910 35th Rd., Osceola WI 54020. (800)624-0266, ext. 21. E-mail: info@photosource.com. Website: http://www.photosource.com. Cost: $595 early registration; $695 after May 15th. "A three-day 'hands-on' workshop in July 2000 on how to take marketable photos and how to sell and resell your photos. Workshop geared to anyone with a collection of 500 or more photos who wants to see their work published." Taught by Rohn Engh, a veteran editorial stock photographer. Workshop is held at Pine Lake Farm, Osceola WI 54020. For details: http//www.photosource.com/seminar.

JOE ENGLANDER PHOTOGRAPHY WORKSHOPS & TOURS, P.O. Box 1261, Manchaca TX 78652. (512)295-3348. Website: http://www.englander-workshops.com. Contact: Joe Englander. Cost: $275-5,000. "Photographic instruction in beautiful locations throughout the world, all formats, color and b&w, darkroom instruction." Locations covered include Europe, Asia as well as USA. Brochures available by calling (800)474-9707 and through website.

EXPOSURES PHOTO WORKSHOPS, 2076 Constitution Blvd., Sarasota FL 34231. (941)927-2003. E-mail: photolearn@aol.com. Website: http://www.wimall.com/fotoworkshop. or http://www.apogeephoto. com. Director: John Hynal. Cost: $30-100. "One- to four-day workshop covering professional commercial photography (advertising, boudoir, landscape, wedding, wildlife, etc.)."

F/8 AND BEING THERE, Bob Grytten and Associates, P.O. Box 3195, Holiday FL 34690. (727)934-1222; (800)990-1988. E-mail: f8news@aol.com. Director: Bob Grytten. Offers weekend tours and workshops in 35mm nature photography emphasizing Florida flora and fauna. Also offers programs on marketing.

CONTACT THE EDITOR of *Photographer's Market* by e-mail at photomarket@fwpubs.com with your questions and comments.

California dreaming: seclusion of art colony breeds creativity

Dorland Mountain Arts Colony is not for those who wish to be catered to, nor those uncomfortable in the absence of technology. It is certainly not a place to mingle, let alone network. But for the most dedicated of photographers, these qualities are what make Dorland so attractive, and successful. As one of the most widely known and respected artist colonies in the U.S., Dorland offers relief from the sometimes harried environment of a workshop or conference. Karen Parrott, director of operations, describes it as "a respite from the glitz and noise of the day-to-day world, a quiet, natural environment conducive to contemplation and the flow of creative energy."

Established in 1930, Dorland Mountain Arts Colony was the brainchild of Ellen Babcock Dorland, a concert pianist and highly regarded music instructor. Dorland was enamored with the East Coast artist colonies she had attended and hoped to establish a similar community on the West Coast. She envisioned a safe space for artists to work undisturbed, to absorb and utilize nature as a muse, and to convene for opportunities to collaborate. With help from friend (and noted environmentalist) Barbara Horton, Dorland's vision became a reality. The colony, which at first was a gathering place for Dorland's friends, became a hermitage where photographers, visual artists, writers and composers could experience what Parrott calls a "Walden-like existence." Set amidst 300 acres of unspoiled wilderness, the colony provides residents seclusion and inspiration that would have made Thoreau green with envy.

Dorland Mountain Arts Colony could easily be called rustic—its six cottages are heated by woodstoves, lit by kerosene lamps, sans television and telephone—and privacy is clearly a priority. Residents are asked to contact each other by placing notes in on-site mailboxes and are never contacted in their cottages except in an emergency. This "natural atmosphere of solitude," Parrott says, "seems to foster an introspection that often results in the artist finding a surprising new direction for his or her work." However, those with cabin fever can venture into the local town of Temecula or make the 60-mile trip to Los Angeles or the 100-mile trip to San Diego.

Parrott stresses that although the Dorland staff "imposes no structured socializing or collaboration," there are studio sessions which provide artists-in-residence a chance to join forces, an opportunity for photographers to provide images for poets' or writers' work, or authors to "narrate" a photographer's visuals. In addition, there is a monthly "Works-in-Progress" evening staged at a local gallery where artists can "share and explain their work to each other as well as to the local community."

Dorland lacks facilities usually found at photography workshops, but because the

colony is situated on a nature preserve, there is boundless subject matter to capture on film. "That we do not have darkroom facilities seems not to have been an obstacle for previous residents," Parrot says, and adds that those tiring of the flora and fauna surrounding the colony can seek subjects elsewhere. "We are within a one-hour drive of the California desert and beach areas." Parrott admits that the colony has, in the past, accommodated fewer photographers in relation to the number of visual artists, composers, and writers. Because of this, she encourages more photographers, both beginners and those with established careers, to apply. "Dorland has always encouraged emerging artists," she says. "Our review board makes selections based not only on credentials but also their promise and commitment to their art." Photographers, no matter how experienced, can expect to have a similar experience, however. "Living in what is most likely a very different environment, the majority of Dorland residents experience fresh, unexpected concepts and directions."

Although shorter residencies are available, Parrott recommends photographers plan at least a two-week stay at Dorland and suggests that the average stay of one month proves the most beneficial. This longer time frame allows the resident a necessary period of adjustment to what is, for some, a very foreign environment.

There are no restrictions on what kinds of work photographers can submit for admission, but they are required to send three sets of six slides in plastic sheets, three copies of a brief description of their work in progress, and reasons for wanting to visit Dorland. The submission package should also include three copies of the photographer's résumé of educational experience and any other information the applicant feels would be helpful in the selection process. Applications are considered twice a year by a diverse panel of artists and others, and once accepted, photographers are given additional information about scheduling, transportation, and what to bring. Parrott encourages those interested to request application material by mail (include a SASE), or obtain it via the Dorland Mountain Arts Colony website (http://www.ez2.net/dorland), which also provides details about past residents and their work.

Upon admission, the colony requires a $50 scheduling fee to confirm the residency and monthly "cabin donations" of $300 (half of which is due 6 months prior to the artist's stay). Parrott believes the Dorland experience is well worth this modest price. "Nature has been the inspiration for many of the greatest works of art in all disciplines," Parrott says, "and the images of nature certainly seem to delight and inspire every photographer who has had a previous residency at Dorland."

—*Amanda Heele*

FINDING & KEEPING CLIENTS, 2973 Harbor Blvd., 229, Costa Mesa CA 92626-3912. Phone/fax: (714)556-8133. Website: http://e-folio.com/piscopo. Instructor: Maria Piscopo. "How to find new photo assignment clients and get paid what you're worth! Call for schedule and leave address or fax number or send query to 'seminars,' mpiscopo@aol.com."

FIRST LIGHT PHOTOGRAPHIC WORKSHOPS AND SAFARIS, P.O. Box 240, East Moriches NY 11940. (516)874-0500. E-mail: photours@aol.com. President: Bill Rudock. Photo workshops and photo safaris for all skill levels. Workshops are held on Long Island, all national parks, Africa and Australia.

FIRST LIGHT PHOTOGRAPHY TOURS, P.O. Box 11066, Englewood CO 80151. (303)762-8191. E-mail: zshort@aol.com. Owner: Andy Long. Cost: $500-1,500. Offers 4- to 7-day small group trips focusing on wildlife and nature at locations throughout North America.

FLORENCE PHOTOGRAPHY WORKSHOP, Washington University, St. Louis MO 63130. (314)935-6597. E-mail: sjstremb@art.wustl.edu. Professor: Stan Strembicki. "Four week intensive photographic study of urban and rural landscape, June 2000. Black and white darkroom, field trips, housing available."

FLORIDA SCHOOL OF PROFESSIONAL PHOTOGRAPHY, 13424 White Cypress Rd., Astatula FL 34705. (800)330-0532. Director: Robin Phillips. Annual seminar held in May. Covers professional commercial photography topics for beginning and advanced photographers. Includes traditional and digital imaging.

FOCUS ADVENTURES, P.O. Box 771640, Steamboat Springs CO 80477. Phone/fax: (970)879-2244. Owner: Karen Schulman. Workshops in the Art of Seeing, Self-discovery through Photography and Hand Coloring Photographs. Field trips to working ranches and wilderness areas. Offers an annual photo workshop in Cozumel Mexico each February and a scuba-dive underwater photo trip. Customized private and small group lessons available year round. Workshops in Steamboat Springs are summer and fall.

FORT SCOTT COMMUNITY COLLEGE PHOTO WORKSHOPS, 2108 S. Horton, Fort Scott KS 66701. (316)223-2700. E-mail: johnbl@fsccax.ftscott.cc.ks.us. Website: http://www.ftscott.cc.ks.us. Photography Instructor: John W. Beal. Cost: $80-180. Weekend workshops in Zone System, color printing, b&w fine printing and nature photography.

FRIENDS OF ARIZONA HIGHWAYS PHOTO WORKSHOPS, P.O. Box 6106, Phoenix AZ 85005-6106. (602)271-5904. Offers photo adventures to Arizona's spectacular locations with top professional photographers whose work routinely appears in *Arizona Highways*.

FRIENDS OF PHOTOGRAPHY, 250 Fourth St., San Francisco CA 94103. (415)495-7000, ext. 319. Director of Education: Julia Brashares. "One-day seminars are conducted by a faculty of well-known photographers and provide artistic stimulation and technical skills in a relaxed, focused environment."

GALAPAGOS TRAVEL, 783 Rio Del Mar Blvd., Suite 47, Aptos CA 95003. (800)969-9014. E-mail: galapagostravel@compuserve.com. Website: http://www.galapagostravel.com. Cost: $3,050/two weeks, includes lodging and most meals. Landscape and wildlife photography tour of the islands with an emphasis on natural history.

N **ANDRÉ GALLANT/FREEMAN PATTERSON PHOTO WORKSHOPS**, 3487 Rte 845, Long Reach NB E5S 1X4 Canada. (506)763-2189. Cost: $700 (Canadian) for 6-day course plus accommodations and meals. All workshops are for anybody interested in photography and visual design from the complete novice to the experienced amateur or professional. "Our experience has consistently been that a mixed group functions best and learns the most."

GERLACH NATURE PHOTOGRAPHY WORKSHOPS & TOURS, P.O. Box 259, Chatham MI 49816. (906)439-5991. Fax: (906)439-5144. Office Manager: Bill Jasko. Cost: $450 tuition; tours vary. Professional nature photographers John and Barbara Gerlach conduct intensive seminars and field workshops in the beautiful Upper Penninsula of Michigan. They also lead wildlife photo expeditions to exotic locations. Write for their informative color catalog.

GETTING & HAVING A SUCCESSFUL EXHIBITION, 163 Amsterdam Ave., 201, New York NY 10023. (212)838-8640. Speaker: Bob Persky. Cost: 1999/2000 tuition, $125 for 1-day seminar; course manual alone $28.95 postpaid.

THE GLACIER INSTITUTE PHOTOGRAPHY WORKSHOPS, P.O. Box 7457. Kalispell MT 59904. (406)755-1211. Executive Director: Kris Bruninga. Cost: $130-175. Workshops sponsored in the following areas: nature photography, advanced photography, wildlife photography and photographic ethics. "All courses take place in beautiful Glacier National Park."

GLENGARRY PHOTOGRAPHIC WORKSHOP, 812 Pitt, Unit 29, Cornwall, Ontario K6J 5R3 Canada. (613)936-9456. E-mail: photobiz@cnwl.igs.net. Website: http://www.ventureseast.com/shadows.

Contact: Aubrey Johnson. Cost: $60. Weekend workshops for beginner to advanced photographers. Topics include landscape, macro, fine art, portraiture and wildlife.

GLOBAL PRESERVATION PROJECTS, P.O. Box 30866, Santa Barbara CA 93130. (805)682-3398. Fax: (805)563-1234. Director: Thomas I. Morse. Offers workshops promoting the preservation of environmental and historic treasures. Produces international photographic exhibitions and publications.

GOLDEN GATE SCHOOL OF PROFESSIONAL PHOTOGRAPHY, 1251 Fifth Ave., Redwood City CA 94063-4019. (650)548-0889. Website: http://www.goldengateschool.com. Contact: Julie Olson. Offers short courses in photography in the San Francisco Bay Area.

HALLMARK INSTITUTE OF PHOTOGRAPHY, P.O. Box 308, Turners Falls MA 01376. (413)863-2478. E-mail: hallmark@tiac.net Website: http://www.hallmark-institute.com. President: George J. Rosa III. Director of Admissions: Tammy Murphy. Tuition: $15,950. Offers an intensive 10-month resident program teaching the technical, artistic and business aspects of professional photography for the career-minded individual.

JOHN HART PORTRAIT SEMINARS, 344 W. 72nd St., New York NY 10023. (212)873-6585. One-on-one advanced portraiture seminars covering lighting and other techniques. John Hart is a New York University faculty member and author of *50 Portrait Lighting Techniques*.

HAWAII PHOTO SEMINARS, Changing Image Workshops, P.O. Box 99, Kualapu, Molokai HI 96757. (808)567-6430. Contact: Rik Cooke. Cost: $1,550, includes lodging, meals and ground transportation. 7-day landscape photography workshop for beginners to advanced. Workshops taught by 2 *National Geographic* photographers and a multimedia producer.

HEART OF NATURE PHOTOGRAPHY WORKSHOPS, 14618 Tyler Foote Rd., Nevada City CA 95959. (916)478-7778. Contact: Robert Frutos. Cost: $265/weekend workshop. "Will greatly increase your ability to capture dynamic images and convey the wonder, beauty and power of your experience in nature."

🌐 **DAVID HEMMINGS SEMINARS**, 9 Booker Ave., Bradwell Common, Milton Keynes MK 13 8AY England. Phone: (44)1908-240460. Cost: £125-275, includes accomodation and meals. "One, two and three day hands-on seminars and photo holidays for photographers (all abilities welcome) to help them improve their picture taking skills by learning the techniques and artistry of photographing recreationally."

HORIZONS: THE NEW ENGLAND CRAFT PROGRAM, 108 N. Main St.-L, Sunderland MA 01375. (413)665-0300. Fax: (413)665-4141. E-mail: horizons@horizons-art.org. Website: http://www.horizons-art.org. Director: Jane Sinauer. Cross Cultural Art and Travel Programs: week-long workshops in Italy, the American Southwest, France, Ireland and Spain. Horizons intensives in Massachusetts: long weekend workshops (spring, summer, fall) and 2 3-week summer sessions for high school students in b&w (July, August).

HORSES! HORSES! THE "ART" OF EQUINE PHOTOGRAPHY, 1984 Rt. 109, Acton ME 04001. (207)636-1304. E-mail: ladyhawkimages@worldnet.att.net. Contact: Dusty L. Perin. Cost: $35 half day; $95 full day. "Learn to capture the beauty and fire of horses on film. The live shoot segments feature free running purebred Arabian horses. The full day course is limited to 14 participants. The half day course is classroom only. Familiarity around horses is helpful."

ILLINOIS WORKSHOPS, 229 E. State St., Box 318, Jacksonville IL 62650. (217)245-5418. Director: Steve Humphrey. Registration Trustee: Bret Wade. Annual 5-day seminar covering professional commercial photography topics. Open to advanced photographers.

IMAGES INTERNATIONAL ADVENTURE TOURS, 37381 S. Desert Star Dr., Tucson AZ 85739. (520)825-9355. E-mail: imageint@concentric.net. Contact: Erwin "Bud" Nielsen. Cost: $600-3,600, de-

pending on location. Landscape/wildlife photography tours. Programs offered year-round.

IN FOCUS WITH MICHELE BURGESS, 20741 Catamaran Lane, Huntington Beach CA 92646. (714)536-6104. Fax: (714)536-6578. E-mail: micheleburgess@hotmail.com. Website: http://www.infocustravel.com. President: Michele Burgess. Tour prices range from $4,000 to $6,000 from US. Offers overseas tours to photogenic areas with expert photography consultation at a leisurely pace and in small groups (maximum group size 20).

INTERNATIONAL CENTER OF PHOTOGRAPHY, 1130 Fifth Ave., New York NY 10128. (212)860-1776. Education Associate: Donna Ruskin. "The cost of our weekend workshops range from $255 to $325 plus registration and lab fees. Our five- and ten-week courses range from $220 to $430 plus registration and lab fees." ICP offers photography courses, lectures and workshops for all levels of experience—from intensive beginner classes to rigorous professional workshops.

N ⧉ INTERNATIONAL WILDLIFE FILM FESTIVAL, 27 Ft. Missoula Rd., Suite 2, Missoula MT 59804-7200. (406)728-9380. Fax: (406)728-2881. E-mail: iwff@wildlifefilms.org. Website: http://www.wildlifefilms.org. Executive Director: Amy Hetzler. Cost: $30 for entry to all public screenings; $275 for festival pass that includes admission to all special events, seminars, panel discussions, screenings, receptions, the awards ceremony and banquet dinner. Matinees $4; evening shows, and general admission $7; child/senior $5. Held every April. Festival events include juried film competition, public screenings of the year's best natural history and wildlife films, seminars, six-day course on wildlife film making, receptions, Wildwalk Parade and Wildlife and Nature Photography Contest. See website for more information.

IRISH PHOTOGRAPHIC & CULTURAL EXCURSIONS, Voyagers, P.O. Box 915, Ithaca NY 14851. (607)273-4321. Offers 2-week trips in County Mayo in the west of Ireland from May-October.

KANSAS PROFESSIONAL PHOTOGRAPHERS SCHOOL, 4105 SW 29th St., Topeka KS 66614. (785)271-5355. E-mail: info.kpps.com. Website: http://www.kpps.com. Director: Ron Clevenger. Week-long workshop covering wedding and portrait photography for intermediate to advanced photographers.

ART KETCHUM HANDS-ON WORKSHOPS, 2818 W. Barry Ave., Chicago IL 60618. (773)478-9217. E-mail: ketch22@ix.netcom.com. Website: http://www.artketchum.com. Owner: Art Ketchum. Cost: 1-day workshops in Chicago studio $85; 2-day workshops in various cities across US, $289. Hands-on photo workshops with live models. Emphasizes learning the latest lighting techniques and building a great portfolio.

GEORGE LEPP WORKSHOP, P.O. Box 6240, Los Osos CA 93412. (805)528-7385. Website: leppphoto.com. Coordinator: Arlie Lepp. "We are always stressing knowing one's equipment; maximizing gear and seeing differently. Offers small groups."

⧉ THE LIGHT FACTORY, P.O. Box 32815, Charlotte NC 28232. (704)333-9755. Executive Director: Bruce Lineker. Since 1972. The Light Factory is an art museum presenting the latest in light-generated media (photography, video, film, the Internet). Year-round education programs, community outreach and special events complement its changing exhibitions.

LIGHT WORK ARTIST-IN-RESIDENCE PROGRAM, 316 Waverly Ave., Syracuse NY 13244. (315)443-1300. E-mail: mlhodgen@syr.edu. Website: http://sumweb.syr.edu/com_dark/lw.html. Administraive Assistant: Mary Lee Hodgens. Artist-in-Residence Program for Photographers. Artists are awarded a $1,200 stipend, an apartment for one month and 24-hour a day access to darkrooms. Their work is then published in Contact Sheet.

C.C. LOCKWOOD WILDLIFE PHOTOGRAPHY WORKSHOP, 821 Rodney Dr., Baton Rouge LA 70808. (225)769-4766. Fax: (225)767-3726. E-mail: cactusclyd@aol.com. Photographer: C.C. Lockwood. Cost: Atchafalaya Swamp, $125; Yellowstone, $1,895; Grand Canyon, $1,795. Each October and April C.C. conducts a 2-day Atchafalaya Basin Swamp Wildlife Workshop. It includes lecture, canoe trip into the swamp and critique session. Every other year C.C. does a 7-day winter wildlife workshop in Yellowstone National Park. C.C. leads an 8-day Grand Canyon raft trip photo workshop, May 13 and July 29.

LONG ISLAND PHOTO WORKSHOP, 216 Lakeville Rd., Great Neck NY 11020. (516)487-1313. Registrar: Ronald J. Krowne. Annual 5-day seminar covering professional wedding and portrait photography. Open to advanced photographers.

HELEN LONGEST-SLAUGHTER SACCONE AND MARTY SACCONE, P.O. Box 690518, Quincy MA 02269-0518. (617)847-0091. Fax: (617)847-0952. E-mail: mjsquincy@pipeline.com. or helen_marty@yahoo.com Photo workshops offered in North Carolina Outer Banks, Costa Rica, Florida and New England. 1-day seminars in various cities in the US covering how-to be creative and marketing. "Spirit Place"—multi-projector slide presentation about living in harmony with the Earth presented in various cities.

THE MacDOWELL COLONY, 100 High St., Peterborough NH 03458. (603)924-3886. Website: http://www.macdowellcolony.org. Founded in 1907 to provide creative artists with uninterrupted time and seclusion to work and enjoy the experience of living in a community of gifted artists. Residencies of up to 2 months for writers, composers, film/video makers, visual artists, architects and interdisciplinary artists. Artists in residence receive room, board and exclusive use of a studio. Average length of residency is 6 weeks. Ability to pay for residency is not a factor. Application deadlines: January 15: summer (May-August); April 15: fall/winter (September-December); September 15: winter/spring (January-April). Please write or call for application and guidelines.

MACRO TOURS PHOTO WORKSHOPS, P.O. Box 460041, San Francisco CA 94146. (800)369-7430. Director: Bert Banks. Fees range from $55-2,995 for 1- to 10-day workshops. Offers workshops on digital darkroom, color slide printing, stock photography and beginner classes. Offers weekend and week-long tours to various USA destinations. Brochure available; call or write.

MANSCAPES NUDE FIGURE PHOTOGRAPHY WORKSHOPS, 5666 La Jolla Blvd., Suite 111, La Jolla CA 92037. (800)684-2872. Website: http://manscapes.com. Director: Bob Stickel. Cost: $100-295/day. Ten Management offers a range of studio and location (mountain, beach, desert, etc.) workshops on the subject of photographing the male nude figure.

JOE & MARY ANN McDONALD WILDLIFE PHOTOGRAPHY WORKSHOPS AND TOURS, 73 Loht Rd., McClure PA 17841-9340. (717)543-6423. Owner: Joe McDonald. Offers small groups, quality instruction with emphasis on wildlife. Workshops and tours range from $400-2,000.

McNUTT FARM II/OUTDOOR WORKSHOP, 6120 Cutler Lake Rd., Blue Rock OH 43720. (740)674-4555. Director: Patty L. McNutt. 1994 Fees: $160/day/person, lodging included. Minimum of 2 days. Outdoor shooting of livestock, pets, wildlife and scenes in all types of weather.

MENDOCINO COAST PHOTOGRAPHY SEMINARS, P.O. Box 1614, Mendocino CA 95460. (707)961-0883. Program Director: Deirdre Lamb. Offers a variety of workshops.

MEXICO PHOTOGRAPHY WORKSHOPS, Otter Creek Photography, Hendricks WV 26271. (304)478-3586. Instructor: John Warner. Cost: $1,300. Intensive week-long, hands-on workshops held throughout the year in the most visually rich regions of Mexico. Photograph snow-capped volcanos, thundering waterfalls, pre-Columbian ruins, botanical gardens, fascinating people, markets and colonial churches in jungle, mountain, desert and alpine environments.

MID-AMERICA INSTITUTE OF PROFESSIONAL PHOTOGRAPHY, 626 Franklin, Pella IA 50219. (515)683-7824. Website: http://www.netins.net/showcase/maipp. Director: Al DeWild. Annual 5-day seminar covering professional commercial photography. Open to beginning and advanced photographers.

MIDWEST PHOTOGRAPHIC WORKSHOPS, 28830 W. Eight Mile Rd., Farmington Hills MI 48336. (248)471-7299. E-mail: mpw@mpw.com. Website: http://www.mpw.com. Co-Director: Alan Lowy. Cost varies as to workshop. "One-day weekend and week-long photo workshops, small group sizes and hands-on shooting seminars by professional photographers-instructors."

MISSOURI PHOTOJOURNALISM WORKSHOP, 109 Lee Hills Hall, Columbia MO 65211. (573)882-5737. Coordinator: Catherine Mohesky. Workshop for photojournalists. Participants learn the fundamentals of documentary photo research, shooting, editing and layout.

MONO LAKE PHOTOGRAPHY WORKSHOPS, P.O. Box 29, Lee Vining CA 93541. (760)647-6595. Website: http://www.monolake.org. Contact: Education Director. Cost: $100-250. "The Mono Lake Committee offers a variety of photography workshops in the surreal and majestic Mono Basin." Workshop leaders include local photographers Moose Peterson, Don Jackson and Richard Knepp. 2- to 3-day workshops take place March, July and October. Cost: $150-$195. Call or write for free brochure.

MOUNTAIN WORKSHOP, Western Kentucky University, Garrett Center 215, Bowling Green KY 42101. (502)745-6292. E-mail: mike.morse@wku.edu. Photojournalism Program Coordinator: Mike Morse. Cost: $500 plus expenses. Annual week-long documentary photojournalism workshop for intermediate to advanced shooters.

NATURAL HABITAT ADVENTURES, 2945 Center Green Court, Boulder CO 80301. (800)543-8917. E-mail: nathab@worldnet.att.net. Website: http://www.nathab.com. Cost: $2,500-12,000, includes lodging, meals and ground transportation. Guided photo tours for wildlife photographers. Tours last from 5 to 27 days. Destinations include Mexico, Canada, Australia, Costa Rica, Southern Africa and others.

N NATURAL TAPESTRIES, 1208 St. Rt. 18, Aliquippa PA 15001. (724)495-7493. Fax: (724)495-7370. E-mail: tapestry@ccia.com. Website: http://www.ccia.com/~tapestry. Owners: Nancy Rotenberg, Michael Lustbader. Cost: varies by workshop; $350 for weekend workshops in PA. Workshop held in summer. "We offer small groups with quality instruction with an emphasis on nature. Garden and Macro workshops are held on our farm in Pennsylvania, and others are held in various locations in North America." Open to all skill levels. Photographs should call or e-mail.

NATURE PHOTOGRAPHY WORKSHOPS, GREAT SMOKY MOUNTAIN INSTITUTE AT TREMONT, Great Smoky Mountains National Park, 9275 Tremont Rd., Townsend TN 37882. (423)448-6709. Instructors: Bill Lea, David Duhl and others. Offers programs which emphasize the use of natural light in creating quality scenic, wildflower and wildlife images.

NATURE'S IMAGES OF LIFE, P.O. Box 690518, Quincy MA 02269. (617)847-0091. E-mail: mjsquincy@pipeline.com. Directors: Helen Longest-Slaughter Saccone and Marty Saccone. Cost: $265-2,100. Travel, landscape and wildlife photography workshops for all skill levels. 2- to 8-day trips along the east coast of America, Alaska or Costa Rica.

NATURE'S LIGHT PHOTOGRAPHY, 7805 Lake Ave., Cincinnati OH 45236. (513)793-2346. E-mail: natureslight@fuse.net. Director: William Manning. Cost: Workshops $325; Tours vary $1,000-3,000. Offers small group tours and workshops. Fifteen programs worldwide, with emphasis on landscapes and wildlife.

NEVER SINK PHOTO WORKSHOP, P.O. Box 641, Woodbourne NY 12788. (212)929-0008; (914)434-0575. E-mail: lou@loujawitz.com. Owner: Louis Jawitz. Offers weekend workshops in scenic, travel, location and stock photography from late July through early September in Catskill Mountains.

■ NEW ENGLAND INSTITUTE OF PROFESSIONAL PHOTOGRAPHY, 659 Sandy Lane, Warwick RI 02886. (401)738-3778. Registrar: Serafino Genuario. Annual 6-day seminar for professional photographers. Topics include marketing, portrait, wedding and digital photography.

NEW ENGLAND SCHOOL OF PHOTOGRAPHY, 537 Commonwealth Ave., Boston MA 02215. (617)437-1868. Academic Director: Martha Hassell. Instruction in professional and creative photography.

NEW MEDIA PHOTO EDITING WORKSHOP, Western Kentucky University, Garrett Center 215, Bowling Green KY 42101. (502)745-6292. E-mail: mike.morse@wku.edu. Director: Mike Morse. Cost: $500. Week-long photojournalism workshop. Participants will edit and produce a photo book using only digital technologies.

NEW VISIONS SEMINAR, 10 E. 13th St., Atlantic IA 50022. Director: Jane Murray. Offers workshops in developing personal vision for beginning and intermediate photographers.

THE INTERNATIONAL MARKETS INDEX, located in the back of this book, lists markets located outside the U.S. by country.

NIKON SCHOOL OF PHOTOGRAPHY, 1300 Walt Whitman Rd., Melville NY 11747. (516)547-8666. Fax: (516)547-0309. Website: http://www.nikonusa.com. Cost: $99. Weekend seminars for amateur to advanced amateur photographers covering SLR photo techniques. Traveling seminar visits 21 major cities in the US.

NORTH AMERICAN NATURE PHOTOGRAPHY ASSOCIATION-ANNUAL SUMMIT, 10200 W. 44th, 304, Wheat Ridge CO 80033. (303)422-8527. E-mail: nanpa@resourcenter.com. Summit includes workshops, portfolio reviews and special programs for young photographers; emphasizes wildlife and landscape photography.

NORTHEAST PHOTO ADVENTURE SERIES WORKSHOPS, 55 Bobwhite Dr., Glemont NY 12077. (518)432-9913. E-mail: images@peterfinger.com. Website: http://www.peterfinger.com/photo-workshops.html. President: Peter Finger. Price ranges from $95 for a weekend to $695 for a week-long workshop. Offers over 20 weekend and week-long photo workshops, held in various locations. 1998 workshops include: the coast of Maine, Acadia National Park, Great Smokey Mountains, Southern Vermont, White Mountains of New Hampshire, South Florida and the Islands of Georgia. "Small group instruction from dawn till dusk." Write for additional information.

NORTHLIGHT PHOTO EXPEDITIONS & WORKSHOPS, 96 Gordon Rd., Middletown NY 10941. (800)714-1375. Director: Brent McCullough. Cost: $625 (approx.). 6- to 8-day workshops in the field. Emphasizes outdoor photography. Locations include Yellowstone, Great Smoky Mountains, Acadia and Death Valley National Parks.

■ **NYU TISCH SCHOOL OF THE ARTS**, Dept. of Photography, 721 Broadway, 8th Floor, New York NY 10003. (212)998-1930. E-mail: photo.tsoa@nyu.edu. Website: http://www.nyu.edu/tisch/photo. Contact: Department of Photography. Summer classes offered for credit and noncredit covering photography topics, including digital imaging, basic photography and darkroom techniques. Courses offered for all skill levels. Also summer photography program in Florence Italy.

OLIVE-HARVEY COLLEGE, 10001 S. Woodlawn Ave., Chicago IL 60628. (773)291-6292. Cost: $35. 6-week Saturday workshop for beginners. Covers basic darkroom techniques.

OSPREY PHOTO WORKSHOPS & TOURS, 2719 Berwick Ave., Baltimore MD 21234-7616. (410)426-5071. Workshop Operator: Irene Hinke-Sacilotto. Cost: varies. Programs for 1999/2000 include: Mexico & South Texas; Acadia Maine; Lilpons, MD; Canaan Valley/Blackwater Falls, WV; South Dakota's Badlands and Black Hills; Outer Banks, NC; South Florida; Chincoteague, VA; Southeast Alaska; New Jersey Coast; and South West Virginia. Classes are small with personal attention and practical tips.

OUTBACK RANCH OUTFITTERS, P.O Box 384, Joseph OR 97846. (503)426-4037. Owner: Ken Wick. Offers photography trips by horseback or river raft into Oregon wilderness areas.

■ **PACIFIC NORTHWEST SCHOOL OF PROFESSIONAL PHOTOGRAPHY**, 6203 97th Ave. Ct. West, Tacoma WA 98467. (253)565-1711. Director: Russell Rodgers. Offers 2-5 day seminars for advanced photographers covering professional topics including digital imaging.

PETERS VALLEY CRAFT CENTER, 19 Kuhn Rd., Layton NJ 07851. (973)948-5200. Fax: (973)948-0011. Offers workshops May, June, July, August and September; 3-6 days long. Offers instruction by talented photographers as well as gifted teachers in a wide range of photographic disciplines as well as classes in blacksmithing/metals, ceramics, fibers, fine metals and woodworking. Located in northwest New Jersey in the Delaware Water Gap National Recreation Area, 1½ hours west of New York City. Write, call or fax for catalog.

PHOTO ADVENTURE TOURS, 2035 Park St., Atlantic Beach NY 11509-1236. (516)371-0067. Fax: (516)371-1352. Manager: Richard Libbey. Offers photographic tours to Iceland, India, Nepal, China, Scandinavia and domestic locations such as New Mexico, Navajo Indian regions, Hawaiian Islands, Albuquerque Balloon Festival and New York.

N: PHOTO ADVENTURES, P.O. Box 591291, San Francisco CA 94159. (415)221-3171. Instructor: Jo-Ann Ordano. Offers practical workshops covering creative and documentary photo technique in California nature subjects and night photography in San Francisco.

PHOTO DIARY, 625 Commerce St., 500, Tacoma WA 98402. (253)428-8258. E-mail: sbourne@f64.com. Website: http://www.photodiary.com. President: Scott Bourne. One day seminars July-September. $300 per person. Landscape techniques, field trips, hands-on teaching and evaluation for all skill levels.

PHOTO EXPLORER TOURS, 2506 Country Village, Ann Arbor MI 48103-6500. (800)315-4462 and (734)996-1440. Director: Dennis Cox. Specialist since 1981 in annual photo tours to China's most scenic areas and major cities with guidance to special photo opportunities by top Chinese photographers. Program now includes tours to various other countries including Turkey, India, South Africa, and Myanmar (Burma) with emphasis on travel photography and photojournalism.

PHOTO FOCUS/COUPEVILLE ARTS CENTER, P.O. Box 171 MP, Coupeville WA 98239. (360)678-3396. E-mail: cac@whidbey.net. Website: http://www.coupevillearts.org. Director: Judy Lynn. Cost: $235-330. Locations: Whidbey Island, and various locations throughout the Pacific Northwest. Held April through October. "Workshops in b&w, photojournalism, stock photography, portraiture, human figure, nature photography and more with internationally acclaimed faculty. PhotoFocus 2000 includes workshops on Whidbey Island and on location in the Puget Sound area in nature, portraiture, photojournalism, photo design and photo history."

PHOTOCENTRAL, 1099 E St., Hayward CA 94541. (510)881-6721. Fax: (510)881-6763. E-mail: photcentrl@aol.com. Coordinators: Geir and Kate Jordahl. Cost: $50-300/workshop. PhotoCentral offers workshops for all photographers with an emphasis on small group learning, development of vision and balance of the technical and artistic approaches to photography. Special workshops include panoramic photography, infrared photography and handcoloring. Workshops run 1-4 days and are offered year round.

PHOTOGRAPHIC ARTS CENTER, 24-20 Jackson Ave., Long Island City NY 11101-4332. (718)482-9816. President: Gilbert Pizano. Cost varies. Offer workshops on basics to advanced, b&w and color; Mac computers, Photoshop and Digital photography. Rents studios and labs and offers advice to photographers. Gives English and Spanish lessons.

N: PHOTOGRAPHIC ARTS WORKSHOPS, P.O. Box 1791, Granite Falls WA 98252. (360)691-4105. Director: Bruce Barnbaum. Offers a wide range of workshops across US, Mexico, Europe and Canada. Workshops feature instruction in composition, exposure, development, printing, photographic goals and philosophy. Includes critiques of student portfolios. Sessions are intense, held in field, darkroom and classroom with various instructors. Ratio of students to instructor is always 8:1 or fewer, with detailed attention to problems students want solved.

PHOTOGRAPHIC CENTER NORTHWEST, 900 12th Ave., Seattle WA 98121. (206)720-7222. E-mail: ponw@photocenternw.org. Website: http://www.photocenternw.org. Director of Education: Jenifer Schramm. Day and evening classes and workshops in fine art photography for photographers of all skill levels; accredited certificate program.

PHOTOGRAPHS II, P.O. Box 4376, Carmel CA 93921. (831)624-6870. E-mail: rfremier@redshift.com. Website: http://www.starrsites.com/photos2/. Contact: Roger Fremier and Henry Gilpin. Cost range: $150-255 for domestic skill and field studies and $1,050 to $3,500 for international. Offers 6-8 programs/year.

PHOTOGRAPHY AT THE SUMMIT: JACKSON HOLE, Denver Place Plaza Tower, 1099 18th St., Suite 1840, Denver CO 80202. (303)295-7770 or (800)745-3211. Administrator: Jennifer Logan. A week-long workshop and weekend conferences with top journalistic, fine art and illustrative photographers and editors.

PHOTOGRAPHY INSTITUTES, % Pocono Environmental Education Center, RR2, Box 1010, Dingmans Ferry PA 18328. (717)828-2319. Attention: Steve Van Mater. Offers weekend and week-long institutes throughout the year focusing on subjects in the natural world.

THE PHOTOGRAPHY SCHOOLHOUSE, 2330 E. McDowell Rd., Phoenix AZ 85006-2440. (602)267-7038. E-mail: nick@photographyschool.com. Website: http://www.photographyschool.com.

Owner: George "Nick" Nichols. Cost: $125-1,000. Teaches basic photo and darkroom workshops and advanced classes in lighting, wedding and advanced photography.

PHOTONATURALIST, P.O. Box 621454, Littleton CO 80162. (303)933-0732. E-mail: magicscene@aol.com. Website: http://www.photonaturalist.com. Program Director: Charles Campbell. Cost: $333-$450. Workshop covering Chroma-Zone exposure system and nature photography for all skill levels. Program lasts 3-4 days. Call for catalog.

PHOTOWORKS, 7300 MacArthur Blvd., Glen Echo MD 20812. (301)229-7930. Director: Karen Keating. Photoworks is an artist residency in b&w photography located at Glen Echo Park and managed by The National Park Service. Offers courses and an open darkroom to the public year round.

PT. REYES FIELD SEMINARS, Pt. Reyes National Seashore, Pt. Reyes CA 94956. (415)663-1200. Director: Margaret Pearson Pinkham. Fees range from $50-350. Offers 1-5 day photography seminars taught by recognized professionals. Classes taught in the field at Pt. Reyes National Seashore.

PORT TOWNSEND PHOTOGRAPHY IMMERSION WORKSHOP, 269-2023 E. Sims Way, Port Townsend WA 98368. (604)469-1651. Instructor: Ron Long. Cost: $470. Six-day workshops include lectures, critiques, overnight processing, individual instruction, field trips and lots of shooting. All levels welcome.

PROFESSIONAL PHOTOGRAPHER'S SOCIETY OF NEW YORK PHOTO WORKSHOPS, 121 Genesee St., Avon NY 14414. (716)226-8351. Director: Lois Miller. Cost is $475. Offers week-long, specialized, hands-on workshops for professional photographers in August.

PUBLISHING YOUR PHOTOS AS CARDS, POSTERS, & CALENDARS, 163 Amsterdam Ave., #201, New York NY 10023. (212)362-6637. Lecturer: Harold Davis. 1999/2000 cost: $150 including course manual. Course manual alone $23.95, postpaid. This is a one-day workshop.

BRANSON REYNOLDS' PHOTOGRAPHIC WORKSHOPS, P.O. Box 3471, Durango CO 81302. (970)247-5274. Fax: (970)247-1441. E-mail: branson@simwell.com. Website: http://www.simwell.com/reynolds and http://www.desertdolphin.com/reynolds. Owner: Branson Reynolds. Cost: $755-1,350. Offers a variety of workshops including, Southwestern landscapes, Native Americans, and "Figure-in-the-Landscape." Workshops are based out of Durango, Colorado.

JEFFREY RICH PHOTOGRAPHY TOURS, P.O. Box 66, Millville CA 96062. (530)547-3480. Fax: (530)547-5542. E-mail: jrich@shastalink.klz.ca.us. Owner: Jeff Rich. Leading wildlife photo tours in Alaska and western USA since 1990; bald eagles, whales, birds, Montana predators and more. Call or fax for brochure.

ROCHESTER INSTITUTE OF TECHNOLOGY ADOBE PHOTOSHOP IMAGE RESTORATION AND RETOUCHING, 66 Lomb Memorial Dr., Rochester NY 14623. (800)724-2536. Cost: $895. This learn-by-doing workshop demystifies the process for digitally restoring and retouching images in Photoshop. This intensive 3-day hands-on workshop is designed for imaging professionals who have a solid working knowledge of Photoshop and want to improve their digital imaging skills for image restoration and retouching.

ROCHESTER INSTITUTE OF TECHNOLOGY DIGITAL PHOTOGRAPHY, 66 Lomb Memorial Dr., Rochester NY 14623. (800)724-2536. Cost: $895. A 3-day, hands-on exploration of this new technology. Through lectures, practice, evaluation and discussion, learn how to use digital photography. Create and produce images in the "electronic darkroom."

**FOR EXPLANATIONS OF THESE SYMBOLS,
SEE THE INSIDE FRONT AND BACK COVERS OF THIS BOOK.**

N̄ ROCHESTER INSTITUTE OF TECHNOLOGY DIGITAL PHOTOGRAPHY TO PRE-PRESS, 66 Lomb Memorial Dr., Rochester NY 14623. (800)724-2536. Cost: $1,095. "Photographers today need to go beyond the camera to ensure the highest quality printed reproduction of their digital photos. This program pulls together the entire photography-to-prepress process so that you can learn to maintain the quality of your images all the way to print." Send SASE for more information.

N̄ ROCHESTER INSTITUTE OF TECHNOLOGY KODAK DCS PHOTOGRAPHY WORK-SHOP, 66 Lomb Memorial Dr., Rochester NY 14623. (800)724-2536. Cost: $795. "This hands-on workshop gives you a thorough overview of the Kodak Digital Camera Systems, including the AP NC2000, 400 series, EOS series and latest 315 and 520c models." Send SASE for more information.

N̄ ROCKY MOUNTAIN PHOTO WORKSHOPS, % Latigo Ranch, Box 237, Kremmling CO 80459. (800)227-9655. Director: Jim Yost. Cost (1999): $1,495 (wildflower workshop), $1,495 (round-up workshop); price includes meals, lodging, taxes, gratuities and instructions. Offers workshops in photography featuring western cattle round-ups and wildflowers.

ROCKY MOUNTAIN SCHOOL OF PHOTOGRAPHY, 210 N. Higgins, Suite 101, Missoula MT 59802. (406)543-0171 or (800)394-7677. Co-director: Jeanne Chaput de Saintonge. Cost: $200-4,500. "RMSP offers professional career training in an 11-week 'Summer Intensive' program held each year in Missoula, Montana. Program courses include: basic and advanced color and b&w, studio and natural lighting, portraiture, marketing, stock, landscape, portfolio and others. Offers 10-day advanced training programs in nature, commercial, weddings, stock, and documentary photography. We also offer over 25 workshops year-round with Galen Rowell, Bruce Barnbaum, John Shaw, Alison Shaw, David Middleton and others with locations all across U.S. and abroad."

ROCKY MOUNTAIN SEMINARS, Rocky Mountain National Park, Estes Park CO 80517. (970)586-0108. Seminar Coordinator: Nancy Wilson. Cost: $125, weekend seminars covering photographic techniques of wildlife and scenics in Rocky Mountain National Park. Professional instructors include David Halpern, Perry Conway, Wendy Shattil, Bob Rozinski and James Frank.

■ SANTA FE PHOTOGRAPHIC & DIGITAL WORKSHOPS, P.O. Box 9916, Santa Fe NM 87504-5916. (505)983-1400. E-mail: sfworkshop@aol.com. Website: http://www.sfworkshop.com. Registrar: Roberta Koska. Cost: $645-1,095 for tuition; lab fees, housing and meals added. Over 120 week-long workshops encompassing all levels of photography and 40 five-day digital workshops annually. Led by top professional photographers, the workshops are located on a campus not far from the center of Santa Fe. Call for free brochure.

PETER SCHREYER PHOTOGRAPHIC TOURS, (Associated with Crealdé School of Art), P.O. Box 533, Winter Park FL 32790. (407)671-1886. Tour Director: Peter Schreyer. Specialty photographic tours to the American West, Europe and the backroads of Florida. Travel in small groups of 10-15 participants.

"SELL & RESELL YOUR PHOTOS" SEMINAR, by Rohn Engh, Pine Lake Farm, Osceola WI 54020. (715)248-3800. Fax: (715)248-7394. E-mail: info@photosource.com. Website: http://www.photosource.com. Seminar Coordinator: Sue Bailey. Offers half-day workshops in major cities. 1999 cities included: Philadelphia, Washington DC, Detroit, Minneapolis, San Francisco, Atlanta, Charlotte, Orlando, St. Louis, Las Vegas, Honolulu and Houston. Workshops cover principles based on methods outlined in author's best-selling book of the same name. Marketing critique of attendee's slides follows seminar.

BARNEY SELLERS OZARK PHOTOGRAPHY WORKSHOP FIELDTRIP, 40 Kyle St., Batesville AR 72501. (870)793-4552. Conductor: Barney Sellers. Retired photojournalist after 36 years with *The Commercial Appeal*, Memphis. Cost for 2-day trip: $100. Participants furnish own food, lodging, transportation and carpool. Limited to 12 people. No slides shown. Fast moving to improve alertness to light and outdoor subjects. Sellers also shoots.

SELLING YOUR PHOTOGRAPHY, 2973 Harbor Blvd., #229, Costa Mesa CA 92626-3912. (714)556-8133. E-mail: mpiscopo@aol.com. Website: http://www.e-folio.com/piscopo. Contact: Maria Piscopo. Cost: $25-100. One-day workshops cover techniques for marketing photography for photographers of all skill levels.

JOHN SEXTON PHOTOGRAPHY WORKSHOPS, 291 Los Agrinemsors, Carmel Valley CA 93924. (831)659-3130. Website: http://www.apogeephoto.com/johnsexton.html. Director: John Sexton.

Cost: $150 deposit; workshops range from $650-750. Offers a selection of intensive workshops with master photographers in scenic locations throughout the US and abroad. All workshops offer a combination of instruction in the aesthetic and technical considerations involved in making expressive prints.

BOB SHELL PHOTO WORKSHOPS, P.O. Box 808, Radford VA 24141. (540)639-4393. E-mail: bob@bobshell.com. Website: http://www.bobshell.com. Owner: Bob Shell. Cost: $450-500. "Glamour and nude photography workshops in exciting locations with top models. Taught by Bob Shell, one of the world's top glamour/nude photographers and editor of *Shutterbug* magazine. Full details on website."

SHENANDOAH PHOTOGRAPHIC WORKSHOPS, P.O. Box 54, Sperryville VA 22740. (703)937-5555. Director: Frederick Figall. Three days to 1-week photo workshops in the Virginia Blue Ridge foothills, held in summer and fall. Weekend workshop held year round in Washington DC area.

BOB SISSON'S "THE ART OF CLOSE UP AND NATURE PHOTOGRAPHY," P.O. Box 1649, Englewood FL 34295. (941)475-0757. Contact: Bob Sisson (Former Chief Natural Sciences Division, *National Geographic Magazine*.) Cost: $260/day. Special one-on-one course; "you will be encouraged to take a closer look at nature through the lens, to learn the techniques of using nature's light correctly and to think before exposing film."

SOUTHAMPTON MASTER PHOTOGRAPHY WORKSHOP, % Long Island University-Southampton College, Southampton NY 11968-9822. (516)287-8349. E-mail: summer@southampton.liunet.edu. Contact: Carla Caglioti, Summer Director. Offers a diverse series of 1-week and weekend photo workshops during July and August.

N SOUTHWEST PHOTOGRAPHY TOURS, P.O. Box 35461, Houston TX 77235. (888)325-3715. Fax: (713)729-7905. E-mail: swestphoto@aol.com. Website: http://hometown.aol.com/swestphoto/bizcard/index.htm. Contact: Sharon Blackwell, owner. Cost: Varies, depending on location, $200-$600 (meals and lodging are not included). Workshop held annually. Offers: "Workshops and tours in nature, wildlife and landscape photography during summer, fall and winter. 'Wildflowers in the Hill Country of Texas' in Big Bend Texas. Emphasis will be on composition, lighting and special techniques. Other workshops include landscapes of arches, Bryce, Zion, Slot Canyon in Utah; North Arizona and Monument Valley; South Arizona deserts and wildflowers; fall foliage in the Appalachian Mountains; Yellow Stone and Grand Tetons." Custom courses can be arranged. Workshops and tours are very small; around 6 people." Open to all skill levels. Call or e-mail for more information.

SPECIAL EFFECTS BACKGROUNDS, P.O. Box 767, San Marcos TX 78667. (800)467-4935 or (512)396-7251. Fax: (512)396-8767. E-mail: jwilson@px/magic.com. Director of Photography: Jim Wilson. Offers 3-day programs in background projection techniques. Open to all levels of photographic education; participants are limited to 11 workshop. Workshops are scheduled every month except December.

SPORTS PHOTOGRAPHY WORKSHOP: COLORADO SPRINGS, Rich Clarkson & Associates LLC, 1099 18th St., Suite 1840, Denver CO 80202. (303)295-7770. (800)745-3211. Administrator: Jennifer Logan. A week-long workshop in sports photography at the U.S. Olympic Training Center with *Sports Illustrated* photographers and editors.

■ SUMMER WEEKEND OF PHOTOGRAPHY, P.O. Box 1333, Holland MI 49422-1333. (616)925-8238. E-mail: swmccc.novagate.com. Website: http://www.swmccc.org. Registrar: Randy Kleinhelcsel. Program Coordinator: Sylvia Schlender. Cost: $300 for room and board and tuition—a small optional fee for field trips. Classes for novice and intermediate. Workshops designed to be hands-on. Subjects include nature, portraiture, blacklight, travel, digital, etc.

SUMMIT PHOTOGRAPHIC WORKSHOPS, P.O. Box 889, Groveland CA 95321. (209)962-4321. E-mail: shtgstar@sonnet.com. Website: http://www.summitphotographic.com. Owner: Barbara Brundege. Cost: $59-500. Photo tours available.

SUPERIOR/GUNFLINT PHOTOGRAPHY WORKSHOPS, P.O. Box 19286, Minneapolis MN 55419. Director: Layne Kennedy. Prices range from $585-895. Write for details on session dates. Fee

includes all meals/lodging and workshop. Offers wilderness adventure photo workshops twice yearly. Winter session includes driving your own dogsled team in northeastern Minnesota. Summer session includes kayak trips into border waters of Canada-Minnesota and Apostle Islands in Lake Superior. All trips professionally guided. Workshop stresses how to shoot effective and marketable magazine photos.

SYNERGISTIC VISIONS WORKSHOPS, P.O. Box 2585, Grand Junction CO 81502. Phone/fax: (970)245-6700. E-mail: synvis@gj.net. Website: http://www.synvis.com. Director: Steve Traudt, NANPA. Costs vary. Offers a variety of classes, workshops and photo trips including Galapagos, Slot Canyons, Colorado Wildflowers and more. All skill levels welcome. Author of *Heliotrope-The Book* and creator of *Hyperfocal Card*, "Traudt's trademark is enthusiasm and his classes promise a true synergy of art, craft and self." Call or write for brochures.

TAOS INSTITUTE OF ARTS, 108 Civic Plaza Dr., Taos NM 87571. (505)758-2793. Director: Thomas A. Decker. Cost: $355. "In the magnificent light of northern New Mexico improve your skills with some of the best photographers in the country."

TEXAS SCHOOL OF PROFESSIONAL PHOTOGRAPHY, 1501 W. Fifth, Plainview TX 79072. (806)296-2276. E-mail: ddickson@lonestarbbs.com. Director: Don Dickson. Cost: $360-420. Seventeen different classes offered including Portrait, Wedding, Marketing, Background Painting and Video.

TOUCH OF SUCCESS PHOTO SEMINARS, P.O. Box 194, Lowell FL 32663. (352)867-0463. Director: Bill Thomas. Costs vary from $250-895 (US) to $5,000 for safaris. Offers workshops on nature scenics, plants, wildlife, stalking, building rapport and communication, composition, subject selection, lighting, marketing and business management. Workshops held at various locations in US. Photo safaris led into upper Amazon, Andes, Arctic, Alaska, Africa and Australia. Also offers sailboat whale safaris in Washington's San Juan Islands and Canada's Inland Passage. Writer's workshops for photographers who wish to learn to write are available.

TRAVEL IMAGES, 1809 Regal St., Boise ID 83704. (800)325-8320. E-mail: jaybee@cyberhighway.net. Website: http://www.travelimages.com. Owners: John and Anne Baker. Small workshops in the field. Locations include Alaska, Canada, India, Thailand, Japan, Germany, Wales, Yellowstone, Africa, Scotland, Ireland and New Zealand.

TRIANGLE INSTITUTE OF PROFESSIONAL PHOTOGRAPHY, 441 State St., Baden PA 15005. (724)869-5455. E-mail: tpa@timesnet.net. Website: http://www.trianglephotographers.org. Director: Sam Pelaia. "Founded in 1967, The Triangle Institute of Professional Photography is held the third week of January in the Pittsburgh, PA area. Affiliated with Professional Photographers of America, Triangle is admired for its innovative and progressive ideas in photographic education as well as providing a quality learning environment for the beginner or the advanced photographer."

N **UNIVERSITY OF CALIFORNIA SANTA CRUZ EXTENSION PHOTOGRAPHY WORKSHOPS**, 740 Front St., Suite 155, Santa Cruz CA 95060. (831)427-6620. Contact: Photography Program. Ongoing program of workshops in photography throughout California and international study tours in photography. Call or write for details.

UNIVERSITY OF WISCONSIN SCHOOL OF THE ARTS AT RHINELANDER, 726 Lowell Center, 610 Langdon St., Madison WI 53703. (608)263-3494. Fax: (608)265-2475. E-mail: kathy.berigan@ ccmail.adp.wisc.edu. Website: http://www.dcs.wisc.edu/art/soa.htm. Coordinator: Kathy Berigan. One-week multi-disciplinary arts program held during July in northern Wisconsin.

UTAH CANYONS WORKSHOPS, P.O. Box 296, Springdale UT 84767. (435)772-0117. Director: Michael Plyler. Cost: $250 Northern Nevada Railway Museum, Ely Nevada; $350 Burr Trail; $495 Zion Canyon. "Utah Canyons Workshops starts its fourth year by adding the new Northern Nevada Railway Museum/Ely Nevada workshop. Because enrollment in all workshops is limited to 12 participants, our 6:1 student to teacher ratio ensures a quality workshop experience."

THE GEOGRAPHIC INDEX, located in the back of this book, lists markets by the state in which they are located.

JOSEPH VAN OS PHOTO SAFARIS, INC., P.O. Box 655, Vashon Island WA 98070. (206)463-5383. Fax: (206)463-5484. E-mail: info@photosafaris.com. Website: http://www.photosafaris.com. Director: Joseph Van Os. Offers over 50 different photo tours and workshops worldwide.

VENICE CARNIVAL PHOTO TOUR, Great Travels, 5506 Connecticut Ave. NW, Suite 28, Washington DC 20015. (202)237-5220. E-mail: gtravels@erols.com. President: Patricia Absher. Cost: $2,895, includes lodging and some meals. Small 6-day photo tour of Venice during Carnival (February 28-March 7, 2000). Offers hands-on instruction in people and architecture photography. Small groups.

VENTURE WEST, P.O. Box 7543, Missoula MT 59807. (406)825-6200. Owner: Cathy Ream. Offers various photographic opportunities, including wilderness pack and raft trips, ranches, housekeeping cabins, fishing and hunting.

VILLA MONTALVO ARTIST RESIDENCY PROGRAM, P.O. Box 158, Saratoga CA 95071-0158. (408)961-5818. E-mail: kfunk@villamontalvo.org. Website: http://www.villamontalvo.org. Artist Residency Program Director: Kathryn Funk. Free 1-3 month residencies—$20 application processing fee. "Villa Montalvo, a nonprofit arts center located on a 175 acre historic estate, offers free one- to three-month residencies to writers, musicians and visual artists. Artists must provide their own food, supplies and living expenses." Application deadlines are March 1 and September 1.

N VISITING ARTISTS WORKSHOPS, % Southwest School of Art & Craft, 300 Augusta, San Antonio TX 78205. (210)224-1848. Workshops range from $150-200. Approximately four photography workshops are offered during the spring and fall sessions.

MARK WARNER NATURE PHOTO WORKSHOPS, P.O. Box 398, Hollis Center ME 04042. (207)727-4375. Twenty year plus experience teaching personalized nature photography workshops for National Audubon, Sierra Club and other environmental organizations. Author of "Best Places to Photograph North American Wildlife" and "On The Button—Practical Advice for the Nature Photographer." Widely published in leading national magazines. 1-6 day workshops. Write for brochure.

AL WEBER WORKSHOPS, 145 Boyd Way, Carmel CA 93923. (408)624-5535. Contact: Al Weber. Cost: $100/day. Workshops for advanced photographers emphasizing fine art, landscape and craft photography. Have offered workshops since 1963.

WEST CRETE PHOTO WORKSHOPS, Galatas, Chania 73100 Crete Greece. Phone/fax: (011)30-821-32201. E-mail: mail@steveoutram.com. Website: http://www.steveoutram.com. Workshop Photographer: Steve Outram. Cost: $1,750 per person, including lodging. 7-day workshops in May and October in Chania Town, the most picturesque harbour in Greece. "Capture on film, the landscape, the people, the light and the graphic image." Workshops are a maximum of 8 people.

WILD EYES PHOTO ADVENTURES, 894 Lake Dr., Columbia Falls MT 59912. (406)387-5391. E-mail: wildeyes@bigsky.net. Website: http://kalispell.bigsky.net/wildeyes. Owner: Robin Allen. Cost $1,025. Three-day photo tours limited to 6. Tuition includes meals, lodging and 2 photo sessions per day.

WILDERNESS ALASKA, Box 113063, Anchorage AK 99511. (907)345-3567. Fax: (907)345-3967. E-mail: macgill@alaska.net. Website: http://www.wildernessalaska.com. Contact: MacGill Adams. Offers custom photography trips featuring natural history and wildlife to small groups.

N WILDERNESS PHOTOGRAPHIC WORKSHOPS, 1017 Margaret Court, Novato CA 94957. (415)382-6604. President: Brenda Tharp. Offers multiday photography workshops and tours throughout the US, Alaska, and some foreign destinations. Specializes in outdoor and travel photography with an emphasis on creativity. Offers personalized, one-on-one instruction with small group sizes. Brenda Tharp, with 15 years experience as an international instructor, leads all workshops/tours, occasionally using co-leaders. Destinations for 2000 include Alaska, Arizona, California, Hawaii, Italy, Maine, New Mexico, Utah, Washington.

WILDERNESS PHOTOGRAPHY EXPEDITIONS, 402 S. Fifth, Livingston MT 59047. (406)222-2302. President: Tom Murphy. Offers programs in wildlife and landscape photography in Yellowstone National Park and special destinations.

WILDLIFE PHOTOGRAPHY SEMINAR, Leonard Rue Enterprises, 138 Millbrook Rd., Blairstown NJ 07825. (908)362-6616. E-mail: rue@rue.com. Website: www.rue.com. Program Support: Barbara. This is an indepth day-long seminar covering all major aspects of wildlife photography based on a slide presentation format with question and answer periods. Taught by Lee Rue III and/or Len Rue Jr.

WINSLOW PHOTO TOURS, INC., P.O. Box 334, Durango CO 81302-0334. (970)259-4143. Fax: (970)259-7748. President: Robert Winslow. Cost: varies from workshop to workshop and photo tour to photo tour. "We conduct wildlife model workshops in totally natural settings."

WOMEN'S PHOTOGRAPHY WORKSHOP, P.O. Box 3998, Hayward CA 94540. (510)278-7705. E-mail: kpjordahl@aol.com. Coordinator: Kate Jordahl. Cost: $160/intensive 3-day workshop. Workshops dedicated to inspiring women toward growth in their image making.

WOMEN'S STUDIO WORKSHOP, SUMMER ARTS INSTITUTE, P.O. Box 489, Rosendale NY 12472. (914)658-9133. E-mail: wsu@ulster.net. Website: http://www.wsworkshop.org. Program Director: Amy Ciullo. Cost: 2-day workshop, $215/$200 for members; 5-day workshop, $430/$410 for members. WSW offers weekend and week-long classes in our comprehensive fully-equipped studios throughout the summer. Photographers may also spend 2-4 weeks here November-May as part of our fellowship program.

THE HELENE WURLITZER FOUNDATION, P.O. Box 545, Taos NM 87571. (505)758-2413. Fax: (505)758-2559. Acting Executive Director: Michael A. Knight. Offers residencies to creative, *not* interpretive, artists in all media for varying periods of time, usually 3 months, from April 1 through September 30, annually, and on a limited basis from October 1 through March 31. No deadlines on applications. However, all residences are assigned into 2002. Send SASE or fax request for application.

YELLOWSTONE INSTITUTE, P.O. Box 117, Yellowstone National Park WY 82190. (307)344-2294. Registrar: Diane Kline. Offers workshops in nature and wildlife photography during the summer, fall and winter. Custom courses can be arranged.

YOSEMITE FIELD SEMINARS, P.O. Box 230, El Portal CA 95318. (209)379-2321. Seminar Coordinator: Penny Otwell. Costs: $80-250. Offers small (8-15 people) workshops in outdoor field photography and natural history throughout the year. Write or call for free brochure. "We're a nonprofit organization."

N **YOUR WORLD IN COLOR**, % Stone Cellar Darkroom, 51 Hickory Flat Rd., Buckhannon WV 26201. (304)472-1111. Director: Jim Stansbury. Offers workshops in color processing, printing and related techniques. Also arranges scenic field trips. "Reasonable fees, write for info on variety of workshops."

AIVARS ZAKIS PHOTOGRAPHER, Rt. 1, Box 236, Mason WI 54856. (715)765-4427. Photographer/Owner: Aivars Zakis. Cost: $450. Basic photographic knowledge is required for a 3-day intense course in nature close-up photography with 35mm, medium or large format cameras. Some of the subjects covered include lenses, exposure determination, lighting including flash, films, accessories and problem solving.

ZEGRAHM EXPEDITIONS, 1414 Dexter Ave. N., #327, Seattle WA 98109. (206)285-4000. E-mail: zoe@zeco.com. Website: http://www.zeco.com. President: Werner Zehnder. 10-day to 1-month photo expeditions for all skill levels. Locations include Antarctica, Indonesia, South America, Africa and Australia.

THE INTERNATIONAL MARKETS INDEX, located in the back of this book, lists markets located outside the U.S. by country.

Schools

ASSOCIATE DEGREE AND CERTIFICATE PROGRAMS

Antonelli College, 124 E. Seventh St., Cincinnati OH 45202. (513)241-4338. E-mail: mdms@mindspring.com. Website: http://www.antonellic.com.

The Creative Circus, 1935 Cliff Valley Way, Atlanta GA 30329. (800)728-1590. E-mail: admissions@creativecircus.com. Website: http://www.creativecircus.com.

Fashion Institute of Technology, 227 W. 27th St., New York NY 10001. (212)760-7999. E-mail: fitinfo@sfitva.cc.fitsuny.edu. Website: http://www.fitnyc.suny.edu.

Hallmark Institute of Photography, The Airport, Turner Falls MA 01376. (413)863-2478. Website: http://www.hallmark-institute.com.

Ohio Institute of Photography and Technology, 2029 Edgefield Rd., Dayton OH 45439. (800)932-9698. E-mail: ohiophoto@hotmail.com. Website: http://www.oipt.com.

Portfolio Center, 125 Bennett St., Atlanta GA 30309. (800)255-3169 or (404)351-5055. E-mail: admis@portfoliocenter.com. Website: http://www.portfoliocenter.com.

Rockport College, 2 Central St., P.O. Box 200, Rockport ME 04856. (207)236-8581. E-mail: info@meworkshops.com. Website: http://www.MEworkshops.com.

Visual Studies Workshop, 31 Prince St., Rochester NY 14607. (716)442-8676. Website: http://www.vsw.org.

BACHELOR DEGREE AND ADVANCED PROGRAMS

Art Center College of Design, 1700 Lida St., Pasadena CA 91103. (626)396-2373. Website: http://www.artcenter.edu.

Brooks Institute of Photography, 801 Alston Rd., Santa Barbara CA 93108. (805)966-3888. E-mail: brooks@brooks.edu. Website: http://www.brooks.edu.

California Institute of the Arts, 24700 McBean Pkwy., Valencia CA 91350. (800)545-2787 (outside CA). E-mail: admissions@calarts.edu. Website: http://www.calarts.edu.

International Center of Photography, 1130 Fifth Ave., New York NY 10128. (212)860-1776, ext. 156. E-mail: education@icp.org. Website: http://www.icp.org.

Rochester Institute of Technology, School of Photographic Arts & Sciences, One Lomb Memorial Dr., Rochester NY 14623-5604. (716)475-6631. Website: http://www.rit.edu.

San Francisco Art Institute, 800 Chestnut St., San Francisco CA 94133. (415)749-4500 or (800)345-7324. E-mail: admissions@cdmweb.sfai.edu. Website: http://www.sfai.edu.

School of Visual Arts, Photography Dept., 209 E. 23rd St., New York NY 10010. (212)592-2100. E-mail: admissions@adm.schoolofvisualarts.edu. Website: http://www.schoolofvisualarts.edu.

University of Missouri School of Journalism, P.O. Box 838, Columbia MO 65205. (800)225-6075. E-mail: mu4u@missouri.edu. Website: http://www.jour.missouri.edu.

Professional Organizations

The organizations in the following list can be valuable to photographers who are seeking to broaden their knowledge and contacts within the photo industry. Typically, such organizations have regional or local chapters and offer regular activities and/or publications for their members. To learn more about a particular organization and what it can offer you, call or write for more information.

ADVERTISING PHOTOGRAPHERS OF NEW YORK (APNY), 27 W. 20th St., Suite 601, New York NY 10011. (212)807-0399. Website: http://www.apny.com.

AMERICAN SOCIETY OF MEDIA PHOTOGRAPHERS (ASMP), 14 Washington Rd., Suite 502, Princeton Junction NJ 08550-1033. (609)799-8300. Website: http://www.asmp.org.

AMERICAN SOCIETY OF PICTURE PROFESSIONALS (ASPP), ASPP Membership, 409 S. Washington St., Alexandria VA 22314. (703)299-0219. Website: http://www.aspp.com.

THE ASSOCIATION OF PHOTOGRAPHERS UK, 81 Leonard St., London EC2A 4QS England. Phone: 44 171 739-6669. Fax: 44 171 739-8707. Website: http://www.aophoto.co.uk.

BRITISH ASSOCIATION OF PICTURE LIBRARIES AND AGENCIES, 18 Vine Hill, London EC1R 5DX England. Phone: 44 171 713-1780. Fax: 44 171 713-1211. Website: http://www.bapla.org.uk.

BRITISH INSTITUTE OF PROFESSIONAL PHOTOGRAPHY (BIPP), Fox Talbot House, 2 Amwell End, Ware, Hertsfordshire SG12 9HN England. Phone: 44 1920 464011. Fax: 44 1920 487056. Website: http://www.bipp.com

CANADIAN ASSOCIATION OF JOURNALISTS, St. Patrick's Building, Carleton University, 1125 Colonel By Dr., Ottawa, Ontario K1S 5B6 Canada. (613)526-8061 Website: http://www.eagle.ca/caj.

CANADIAN ASSOCIATION OF PHOTOGRAPHERS & ILLUSTRATORS IN COMMUNICATIONS, 100 Broadview Ave., Suite 322, Toronto, Ontario M4M 3H3 Canada. (416)462-3700. Fax: (416)462-3678. Website: http://www.capic.org.

CANADIAN ASSOCIATION FOR PHOTOGRAPHIC ART, 31858 Hopedale Ave., Clearbrook, British Columbia V2T 2G7 Canada (604)855-4848. Website: http://www.capa-acap.ca.

THE CENTER FOR PHOTOGRAPHY AT WOODSTOCK (CPW), 59 Tinker St., Woodstock NY 12498. (914)679-9957. Website: http://www.cpw.org.

EVIDENCE PHOTOGRAPHERS INTERNATIONAL COUNCIL (EPIC), 600 Main St., Honesdale PA 18431. (717)253-5450. Website: http://www.epic-photo.org.

THE FRIENDS OF PHOTOGRAPHY, 250 Fourth St., San Francisco CA 94103. (415)495-7000. Website: http://www.photoarts.com/fop.

INTERNATIONAL ASSOCIATION OF PANORAMIC PHOTOGRAPHERS, P.O. Box 2816, Boca Raton FL 33427. (407)276-0886. Website: http://www.panphoto.com.

INTERNATIONAL CENTER OF PHOTOGRAPHY (ICP), 1130 Fifth Ave., New York NY 10128. (212)860-1781. Website: http://www.icp.org.

THE LIGHT FACTORY (TLF) PHOTOGRAPHIC ARTS CENTER, 809 W. Hill St., Charlotte NC 28208. Mailing Address: P.O. Box 32815, Charlotte NC 28232. (704)333-9755. Website: http://www.lightfactory.org.

NATIONAL ASSOCIATION OF FREELANCE PHOTOGRAPHERS, 1501 Broadway, Room 708, New York NY 10036. (718)965-2790. Website: http://www.thenafp.org.

NATIONAL PRESS PHOTOGRAPHERS ASSOCIATION (NPPA), 3200 Croasdaile Dr., Suite 306, Durham NC 27705. (800)289-6772. Website: http://www.metalab.unc.edu/nppa.

NORTH AMERICAN NATURE PHOTOGRAPHY ASSOCIATION (NANPA), 10200 W. 44th Ave., Suite 304, Wheat Ridge CO 80033-2840. (303)422-8527. Website: http://www.nanpa.org.

PHOTO MARKETING ASSOCIATION INTERNATIONAL, 3000 Picture Place, Jackson MI 49201. (517)788-8100. Website: http://www.pmai.org.

PHOTOGRAPHIC SOCIETY OF AMERICA (PSA), 3000 United Founders Blvd., Suite 103, Oklahoma City OK 73112. (405)843-1437. Website: http://www.psa-photo.org.

PICTURE AGENCY COUNCIL OF AMERICA (PACA), P.O. Box 308, Northfield MN 55057-0308. (800)457-7222. Website: http://www.indexstock.com/pages/paca.htm.

PROFESSIONAL PHOTOGRAPHERS OF AMERICA (PPA), 229 Peachtree St. NE, Suite 2200, Atlanta GA 30303. (404)522-8600. Website: http://www.ppa-world.org.

PROFESSIONAL PHOTOGRAPHERS OF CANADA (PPOC), P.O. Box 337, Gatineau, Quebec J8P GJ3 Canada. Website: http://www.ppoc.ca.

THE ROYAL PHOTOGRAPHIC SOCIETY, The Octagon, Milsom St., Bath BA1 1DN England. Phone: (44) 1225 462841. Fax: (44) 1225 448688. Website: http://www.rps.org.

SOCIETY FOR PHOTOGRAPHIC EDUCATION, P.O. Box 222116, Dallas TX 75222. Website: http://www.spenational.org.

SOCIETY OF PHOTOGRAPHERS AND ARTISTS REPRESENTATIVES, INC. (SPAR), 60 E. 42nd St., Suite 1166, New York NY 10165. (212)779-7464.

VOLUNTEER LAWYERS FOR THE ARTS, 1 E. 53rd St., 6th Floor, New York NY 10022. (212)319-2910.

WEDDING & PORTRAIT PHOTOGRAPHERS INTERNATIONAL (WPPI), P.O. Box 2003, 1312 Lincoln Blvd., Santa Monica CA 90406. (310)451-0090. Website: http://www.wppi-online.com.

WHITE HOUSE NEWS PHOTOGRAPHERS' ASSOCIATION, INC. (WHNPA), 7119 Ben Franklin Station, Washington DC 20044-7119. (202)785-5230. Website: http://www.whnpa.org.

Helpful Resources for Photographers

Photographer's Market recommends the following additional material to stay informed about market trends as well as to find additional names and addresses of photo buyers. Most are available either in a library or bookstore or from the publisher.

PERIODICALS

ADVERTISING AGE, 220 E. 42nd St., New York NY 10017-5846. (212)210-0100. Website: http://www.adage.com. Weekly magazine covering marketing, media and advertising.

ADWEEK, 1515 Broadway, 12th Floor, New York NY 10036. (212)536-1423. Website: http://www.adweek.com. Weekly magazine covering advertising agencies.

AMERICAN PHOTO, 1633 Broadway, 43rd Floor, New York NY 10019. (212)767-6273. Monthly magazine emphasizing the craft and philosophy of photography.

ART CALENDAR, P.O. Box 199, Upper Fairmont MD 21867-0199. (410)651-9150. Monthly magazine listing galleries reviewing portfolios, juried shows, percent-for-art programs, scholarships and art colonies.

ASMP BULLETIN, 14 Washington Rd., Suite 502, Princeton Junction NJ 08550-1033. (609)799-8300. Monthly newsletter of the American Society of Media Photographers. Subscription with membership.

COMMUNICATION ARTS, 410 Sherman Ave., Box 10300, Palo Alto CA 94303. (650)326-6040. Website: http://www.commarts.com. Magazine covering design, illustration and photography.

EDITOR & PUBLISHER, The Editor & Publisher Co., Inc., 11 W. 19th St., New York NY 10011-4234. (212)675-4380. Website: http://www.mediainfo.com. Weekly magazine covering latest developments in journalism and newspaper production. Publishes an annual directory issue listing syndicates and another directory listing newspapers.

FOLIO, 11 Riverbend Dr. S., P.O. Box 4272, Stamford CT 06907-0272. (203)358-9900. Monthly magazine featuring trends in magazine circulation, production and editorial.

GRAPHIS, 141 Lexington Ave., New York NY 10016-8193. (212)532-9387. Fax: (212)213-3229. Website: http://www.pathfinder.com. Magazine for the visual arts.

GUILFOYLE REPORT, AG Editions, 41 Union Square W., #523, New York NY 10003. (212)929-0959. Website: http://www.agpix.com. Market tips newsletter for nature and stock photographers.

HOW, F&W Publications, 1507 Dana Ave., Cincinnati OH 45207. (800)289-0963. Website: http://www.howdesign.com. Bimonthly magazine for the design industry.

NEWS PHOTOGRAPHER, 1446 Conneaut Ave., Bowling Green OH 43402. (419)352-8175. Monthly news tabloid published by the National Press Photographers Association.

OUTDOOR PHOTOGRAPHER, 12121 Wilshire Blvd., Suite 1200, Los Angeles CA 90025. (310)820-1500. Monthly magazine emphasizing equipment and techniques for shooting in outdoor conditions.

PETERSEN'S PHOTOGRAPHIC MAGAZINE, 6420 Wilshire Blvd., Los Angeles CA 90048-5515. (323)782-2200. Monthly magazine for beginning and semi-professional photographers.

PHOTO DISTRICT NEWS, 1515 Broadway, New York NY 10036. (212)536-5222. Website: http//www.pdn-pix.com. Monthly trade magazine for the photography industry.

PHOTOSOURCE INTERNATIONAL, Pine Lake Farm, 1910 35th Rd., Osceola WI 54020. (715)248-3800. This company publishes several helpful newsletters, including *PhotoLetter, PhotoMarket, Photo-Bulletin* and *PhotoStockNotes*.

POPULAR PHOTOGRAPHY, 1633 Broadway, New York NY 10019. (212)767-6578. Monthly magazine specializing in technical information for photography.

PRINT, RC Publications Inc., 104 Fifth Ave., 19th Floor, New York NY 10011. (212)463-0600. Fax: (212)989-9891. Bimonthly magazine focusing on creative trends and technological advances in illustration, design, photography and printing.

PROFESSIONAL PHOTOGRAPHER, Professional Photographers of America (PPA), 229 Peachtree St. NE, Suite 2200, Atlanta GA 30303. (404)522-8600. Website: http://www.ppa-world.org. Monthly magazine emphasizing technique and equipment for working photographers.

PUBLISHERS WEEKLY, Bowker Magazine Group, Cahners Publishing Co., 245 W. 17th St., New York NY 10011. (212)463-6758. Website: http://www.bookwire.com/pw. Weekly magazine covering industry trends and news in book publishing, book reviews and interviews.

THE RANGEFINDER, 1312 Lincoln Blvd., Santa Monica CA 90401. (310)451-8506. Monthly magazine on photography technique, products and business practices.

SHUTTERBUG, Patch Communications, 5211 S. Washington Ave., Titusville FL 32780. (407)268-5010. Monthly magazine of photography news and equipment reviews.

STUDIO PHOTOGRAPHY AND DESIGN, Cygnus Publishing, 445 Broad Hollow Rd., Melville NY 11747. (516)845-2700.

TAKING STOCK, published by Jim Pickerell, Pickerell Services, 110 Frederick Ave., Suite A, Rockville MD 20850. (301)251-0720. Website: http://www.pickphoto.com. Newsletter for stock photographers; includes coverage of trends in business practices such as pricing and contract terms.

BOOKS & DIRECTORIES

ADWEEK AGENCY DIRECTORY, Adweek Publications, 1515 Broadway, New York NY 10036. (212)536-5336. Website: http://www.adweek.com. Annual directory of advertising agencies in the U.S.

ADWEEK CLIENT (BRAND) DIRECTORY, Adweek Publications, 1515 Broadway, New York NY 10036. (212)536-5336. Directory listing top 2,000 brands, ranked by media spending.

ASMP COPYRIGHT GUIDE FOR PHOTOGRAPHERS, 14 Washington Rd., Suite 502, Princeton Junction NJ 08550. (609)799-8300.

ASMP PROFESSIONAL BUSINESS PRACTICES IN PHOTOGRAPHY, 5th Edition, published by Allworth Press, distributed by Writer's Digest Books, 1507 Dana Ave., Cincinnati OH 45207. (800)289-0963. Handbook covering all aspects of running a photography business.

BACON'S DIRECTORY, 332 S. Michigan Ave., Suite 900, Chicago IL 60604. (312)922-2400. Directory of magazines.

BLUE BOOK, AG Editions, 41 Union Square W., #523, New York NY 10003. (212)929-0959. Website: http://www.agpix.com. Biannual directory of geographic, travel and destination stock photographers for use by photo editors and researchers.

BUSINESS AND LEGAL FORMS FOR PHOTOGRAPHERS, by Tad Crawford, Allworth Press, 10 E. 23rd St., New York NY 10010. (212)777-8395. Negotiation book with 24 forms for photographers.

THE BUSINESS OF COMMERCIAL PHOTOGRAPHY, by Ira Wexler, Amphoto Books, 1515 Broadway, New York NY 10036. Comprehensive career guide including interviews with 30 leading commercial photographers.

THE BUSINESS OF STUDIO PHOTOGRAPHY, by Edward R. Lilley, Allworth Press, 10 E. 23rd St., New York NY 10010. (212)777-8395. A complete guide to starting and running a successful photography studio.

CHILDREN'S WRITERS & ILLUSTRATOR'S MARKET, Writer's Digest Books, 1507 Dana Ave., Cincinnati OH 45207. (800)289-0963. Annual directory including photo needs of book publishers, magazines and multimedia producers in the children's publishing industry.

CREATIVE BLACK BOOK, 10 Astor Place, 6th Floor, New York NY 10003. (800)841-1246. Sourcebook used by photo buyers to find photographers.

DIRECT STOCK, 10 E. 21st St., 14th Floor, New York NY 10010. (212)979-6560. Website: http://www.directstock.com. Sourcebook used by photo buyers to find photographers.

FRESH IDEAS IN PROMOTION (2), by Betsy Newberry, North Light Books, 1507 Dana Ave., Cincinnati OH 45207. (800)289-0963. Idea book of self-promotions.

GREEN BOOK, AG Editions, 41 Union Square W., #523, New York NY 10003. (212)929-0959. Website: http://www.agpix.com. Biannual directory of nature and general stock photographers for use by photo editors and researchers.

HOW TO SHOOT STOCK PHOTOS THAT SELL, by Michal Heron, published by Allworth Press, distributed by Writer's Digest Books, 1507 Dana Ave., Cincinnati OH 45207. (513)531-2222.

HOW YOU CAN MAKE $25,000 A YEAR WITH YOUR CAMERA, by Larry Cribb, published by Writer's Digest Books, 1507 Dana Ave., Cincinnati OH 45207. (800)289-0963. Newly revised edition of the popular book on finding photo opportunities in your own hometown.

KLIK, American Showcase, 915 Broadway, 14th Floor, New York NY 10010. (212)673-6600. Sourcebook used by photo buyers to find photographers.

LA 411, 7083 Hollywood Blvd., Suite 501, Los Angeles CA 90028. (323)460-6304. Website: http://www.la411.com. Music industry guide, including record labels.

LEGAL GUIDE FOR THE VISUAL ARTIST, 4th Ed., by Tad Crawford, Allworth Press, 10 E. 23rd St., Suite 210, New York NY 10010. (212)777-8395. The author, an attorney, offers legal advice for artists and includes forms dealing with copyright, sales, taxes, etc.

LITERARY MARKET PLACE, R.R. Bowker Company, 121 Chanlon Rd., New Providence NJ 07974. (908)464-6800. Directory that lists book publishers and other book industry contacts.

NEGOTIATING STOCK PHOTO PRICES, by Jim Pickerell, 110 Fredereck Ave., Suite A, Rockville MD 20850. (800)868-6376. Website: http://www.pickphoto.com. Hardbound book which offers pricing guidelines for selling photos through stock photo agencies.

NEWSLETTERS IN PRINT, Gale Research Inc., 27500 Drake Rd., Farmington Hills MI 48331. (313)961-6083. Annual directory listing newsletters.

O'DWYER DIRECTORY OF PUBLIC RELATIONS FIRMS, J.R. O'Dwyer Company, Inc., 271 Madison Ave., New York NY 10016. (212)679-2471. Annual directory listing public relations firms, indexed by specialties.

PHOTOGRAPHER'S GUIDE TO MARKETING & SELF-PROMOTION, by Maria Piscopo, Allworth Press, 10 E. 23rd St., New York NY 10010. (212)777-8395. Marketing guide for photographers.

THE PHOTOGRAPHER'S INTERNET HANDBOOK, by Joe Farace, Allworth Press, 10 E. 23rd St., New York NY 10010. (212)777-8395. Covers the many ways photographers can use the Internet as a marketing and informational resource.

THE PHOTOGRAPHER'S MARKET GUIDE TO PHOTO SUBMISSION & PORTFOLIO FORMATS, by Michael Willins, Writer's Digest Books, 1507 Dana Ave., Cincinnati OH 45207. (800)289-0963. A detailed, visual guide to making submissions and selling yourself as a photographer.

PHOTOGRAPHER'S RESOURCE, The Watson-Guptill Guide to Workshops, Conferences, Artists' Colonies and Academic Programs, by Stuart Cohen, Watson-Guptill, 1515 Broadway, New York NY 10036.

PRICING PHOTOGRAPHY: THE COMPLETE GUIDE TO ASSIGNMENT & STOCK PRICES, 2nd Edition, by Michal Heron and David MacTavish, published by Allworth Press, 10 E. 23rd St., New York NY 10010. (212)777-8395.

PROFESSIONAL PHOTOGRAPHER'S GUIDE TO SHOOTING & SELLING NATURE & WILDLIFE PHOTOS, by Jim Zuckerman, Writer's Digest Books, 1507 Dana Ave., Cincinnati OH 45207. (800)289-0963. A well-known nature photographer explains how to take great nature shots and how to reach the right markets for them.

SELL & RESELL YOUR PHOTOS, 4th Ed., by Rohn Engh, Writer's Digest Books, 1507 Dana Ave., Cincinnati OH 45207. (800)289-0963. Revised edition of the classic volume on marketing your own stock.

SONGWRITER'S MARKET, Writer's Digest Books, 1507 Dana Ave., Cincinnati OH 45207. (800)289-0963. Annual directory listing record labels.

STANDARD DIRECTORY OF ADVERTISERS, Reed Reference Publishing Co., 121 Chanlon Rd., New Providence NJ 07974. (908)464-6800. Annual directory listing advertising agencies.

STANDARD RATE AND DATA SERVICE (SRDS), 1700 Higgins Rd., Des Plains IL 60018-5605. (847)375-5000. Website: http://www.srds.com. Directory listing magazines, plus their advertising rates.

STOCK PHOTOGRAPHY: THE COMPLETE GUIDE, by Ann and Carl Purcell, published by Writer's Digest Books, 1507 Dana Ave., Cincinnati OH 45207. (800)289-0963. Everything a stock photographer needs to know from what to shoot to organizing an inventory of photos.

THE STOCK WORKBOOK, Scott & Daughters Publishing, Inc., 940 N. Highland Ave., Suite A, Los Angeles CA 90038. (323)856-0008. Annual directory of stock photo agencies.

WRITER'S MARKET, Writer's Digest Books, 1507 Dana Ave., Cincinnati OH 45207. (800)289-0963. Annual directory listing markets for freelance writers. Many listings also list photo needs and payment rates.

WEBSITES

Photography business

The Alternative Pick http://www.AltPick.com

Black Book http://www.blackbook.com

The Copyright Website http://www.benedict.com

Photo News Network http://www.photonews.com

Small Business Administration http://www.sba.gov

Magazine and book publishing

AcqWeb http://www.library.vanderbilt.edu/law/acqs/acqs.html

American Journalism Review's **News Links** http://www.newslink.org

Bookwire http://www.bookwire.com

Electronic Newsstand http://www.enews.com

Stock photography

Global Photographers Search http://www.photographers.com/default.asp

PhotoSource International http://www.photosource.com

Stock Photo Price Calculator http://photographersindex.com/stockprice.htm

Most major stock agencies have their own websites. You should always gather as much information about an agency as possible before sending your work—the following sites are fast and easy information gathering tools.

Black Star http://www.blackstar.com

Comstock http://www.comstock.com

Corbis http://www.corbisimages.com

FPG Stock http://www.fpg.com

Image Bank http://www.imagebank.com

Liaison International http://www.liaisonintl.com

Photo Disc http://www.photodisc.com

Sharpshooters http://www.sharpshooters.com

Tony Stone Images http://www.tonystone.com

Advertising photography

Advertising Age http://www.adage.com

Adweek, Mediaweek and *Brandweek* http://www.adweek.com

Communication Arts Magazine http://www.commarts.com/index.html

Fine art photography

Art Support http://www.gonesouth.com/artsupport/

Art DEADLINES List http://www.xensei.com/adl/

Fine Art Nudes http://www.ethoseros.com/cnpn.html

Photography in New York International http://www.photography-guide.com/index.html

Photojournalism

The Digital Journalist http://digitaljournalist.org

National Press Photographers Association Online http://metalab.unc.edu/nppa

foto8 http://www.foto8.com

Photo magazines

Blind Spot Photography http://www.blindspot.com

Focus Online http://www.focus-online.com

PEI Magazine http://www.peimag.com

Photo District News http://www.pdn-pix.com

Photo Resource Magazine http://www.photoresource.com

Technical

Hyperzine http://www.hyperzine.com

Image Perfected http://home.earthlink.net/~lwaldron

Photo.net http://photo.net/photo/

The Pixel Foundry http://www.pixelfoundry.com

Links

There are thousands of sites useful to photographers on the Internet, and it would be impossible to list them all, so here are some great links pages that will connect you to an endless source of photographic inspiration and resources.

All-Photography.com http://www.all-photography.com/indx_1.html

Bengt's Photo Page http://www.algonet.se/~bengtha/photo

Charles Daney's Photography Pages http://www.mbay.net/~cgd/photo/pholinks.htm

Focus on Photography http://www.goldcanyon.com/photography/index.html

The Photo Page http://www.generation.net/~gjones

Photography Lists http://www.rit.edu/~andpph/photolists.html

Photography Consultants

If you're ready to move your work in a new direction, want to target clients who are different from the ones you usually work with, or just need to add a little "umph" to your marketing program, consider working with a photography consultant. Consultants provide services to creative professionals, from designing promotional materials to creating a new portfolio to completely rethinking and planning for your photography career. Before you choose a consultant to work with, be sure you understand the costs involved and ask for references from past clients.

Deanne Delbridge Creative Focus, 499 Marina Blvd., #206, San Francisco CA 94123. (415)346-3621. Fax: (415)346-1193. Creative consultant. Specializes in portfolio, promotion design and development and stock photography.

Suzanne T. Donaldson, 433 Third St., #2, Brooklyn NY 11215. Fax: (718)788-4216. E-mail: sdphoto1@aol.com. Website: http://www.artandphoto.com. Photography and art consultant. Helps art directors at magazines and ad agencies locate talent for their projects. "Send promotional material only."

Milano Marketing, 652 Carroll St., Brooklyn NY 11215. (718)788-1173. E-mail: milanocarol@ earthlink.net. Contact: Carol Milano. "We create promotional materials: brochures, newsletters, postcards, sales literature."

Maria Piscopo, 2973 Harbor Blvd., #229, Costa Mesa CA 92626-3912. (714)556-8133, ext. 3. E-mail: mpiscopo@aol.com. Website: http://e-folio.com/piscopo. Offers consulations in pricing techniques, steps to selling, portfolios and writing a marketing plan.

Port Authority, 368 Congress St., Boston MA 02210. (617)350-0116. Fax: (617)350-0310. E-mail: info@1portauthority.com. Website: http://www.1portauthority.com. Contact: Selina Oppenheim. Offers "portfolio reviews, portfolio builds, national portfolio delivery program, 12-month advertising program creation."

Bernadette Rogus, P.O. Box 12963, Prescott AZ 86301. (520)541-0962. Fax: (520)541-0957. E-mail: bbr@cybertrails.com. Photographic and visual arts consultant. "I evaluate photographers' imagery and advise on markets best suited to work/style of the photographer. I also advise on stock agency selection."

Brian Seed & Associates, 7432 Lamon Ave., Skokie IL 60077. (847)677-7887. E-mail: bseed@ wwa.com. Specializes in stock photography consultancy. "This includes a critical review of images' technical quality, subject matter and marketability. Also offers the quick movement of images into the marketplace via appropriate and carefully selected stock agencies."

Elaine Sorel, 640 West End Ave., New York NY 10024. (212)873-4417. Fax: (212)874-0831. Career analyst. Serves individuals and corporate clients seeking creative business strategies.

Elyse Weissberg, 225 Broadway, Suite 700, New York NY 10007. (212)227-7272. Fax: (212)385-0349. E-mail: elyserep@aol.com. Website: http://www.ElyseRep.com. "Photographer's rep will review your portfolio, give you direction in marketing and promotion and show you how to find valuable clients."

Glossary

Absolute-released images. Any images for which signed model or property releases are on file and immediately available. For working with stock photo agencies that deal with advertising agencies, corporations and other commercial clients, such images are absolutely necessary to sell usage of images. Also see model release, property release.

Acceptance (payment on). The buyer pays for certain rights to publish a picture at the time it is accepted, prior to its publication.

Agency promotion rights. Stock agencies request these rights in order to reproduce a photographer's images in promotional materials such as catalogs, brochures and advertising.

Agent. A person who calls on potential buyers to present and sell existing work or obtain assignments for a client. A commission is usually charged. Such a person may also be called a *photographer's rep*.

All rights. A form of rights often confused with work for hire. Identical to a buyout, this typically applies when the client buys all rights or claim to ownership of copyright, usually for a lump sum payment. This entitles the client to unlimited, exclusive usage and usually with no further compensation to the creator. Unlike work for hire, the transfer of copyright is not permanent. A time limit can be negotiated, or the copyright ownership can run to the maximum of 35 years.

Alternative Processes. Printing processes that do not depend on the sensitivity of silver to form an image. These processes include cyanotype and platinum printing.

Archival. The storage and display of photographic negatives and prints in materials that are harmless to them and prevent fading and deterioration. Archival products include storage boxes, slide pages, mats and other mounting agents.

Artist's statement. A short essay, no more than a paragraph or two, describing a photographer's mission and creative process. Most galleries require photographers to provide an artist's statement.

Assign (designated recipient). A third-party person or business to which a client assigns or designates ownership of copyrights that the client purchased originally from a creator, such as a photographer. This term commonly appears on model and property releases.

Assignment. A definite OK to take photos for a specific client with mutual understanding as to the provisions and terms involved.

Assignment of copyright, rights. The photographer transfers claim to ownership of copyright over to another party in a written contract signed by both parties. Terms are almost always exclusive, but can be negotiated for a limited time period or as a permanent transfer.

Audiovisual (AV). Materials such as filmstrips, motion pictures and overhead transparencies which use audio backup for visual material.

Automatic renewal clause. In contracts with stock photo agencies, this clause works on the concept that every time the photographer delivers an image, the contract is automatically renewed for a specified number of years. The drawback is that a photographer can be bound by the contract terms beyond the contract's termination and be blocked from marketing the same images to other clients for an extended period of time.

Avant garde. Photography that is innovative in form, style or subject matter. Avant-garde works often are considered difficult and challenging.

Bio. A sentence or brief paragraph about a photographer's life and work, sometimes published along with photos.

Bimonthly. Occurring once every two months.

Biweekly. Occurring once every two weeks.

Blurb. Written material appearing on a magazine's cover describing its contents.

Buyout. A form of work for hire where the client buys all rights or claim to ownership of copyright, usually for a lump sum payment. Also see All rights, Work for hire.

Caption. The words printed with a photo (usually directly beneath it) describing the scene or action. Synonymous with *cutline*.

CCD. Charged Coupled Device. A type of light detection device, made up of pixels, that generates an electrical signal in direct relation to how much light struck the sensor.

CD-ROM. Compact disc read-only memory; non-erasable electronic medium used for digitized image and document storage and retrieval on computers.

Chrome. A color transparency, usually called a slide.

Cibachrome. A photo printing process that produces fade-resistant color prints directly from color slides.

Clip art. Collections of copyright-free, ready-made illustrations available in b&w and color, both line and tone, in book form or in digital form.

Clips. See Tearsheets.

CMYK. Cyan, magenta, yellow and black—refers to four-color process printing.

Color Correction. Adjusting an image to compensate for digital input and output characteristics.

Commission. The fee (usually a percentage of the total price received for a picture) charged by a photo agency, agent or gallery for finding a buyer and attending to the details of billing, collecting, etc.

Composition. The visual arrangement of all elements in a photograph.

Compression. The process of reducing the size of a digital file, usually through software. This speeds processing, transmission times and reduces storage requirements.

Consumer publications. Magazines sold on newsstands and by subscription that cover information of general interest to the public, as opposed to a trade magazine, which cover information specific only to a specialized field.

Contact Sheet. A sheet of negative-size images made by placing negatives in direct contact with the printing paper during exposure. They are used to view an entire roll of film on one piece of paper.

Contributor's copies. Copies of the issue of a magazine sent to photographers in which their work appears.

Copyright. The exclusive legal right to reproduce, publish and sell the matter and form of an artistic work.

C-print. Any enlargement printed from a negative.

Cover letter. A brief business letter introducing a photographer to a potential buyer. A cover letter may be used to sell stock images or solicit a portfolio review. Do not confuse cover letter with query letter.

Credit line. The byline of a photographer or organization that appears below or beside a published photo.

Cutline. See Caption.

Day rate. A minimum fee which many photographers charge for a day's work, whether a full day is spent on a shoot or not. Some photographers offer a half-day rate for projects involving up to a half-day of work.

Demo(s). A sample reel of film or sample videocassette that includes excerpts of a filmmaker's or videographer's production work for clients.

Density. The blackness of an image area on a negative or print. On a negative, the denser the black, the less light that can pass through.

Digital Camera. A filmless camera system that converts an image into a digital signal or file.

DPI. Dots per inch. The unit of measure used to describe the resolution of image files, scanners and output devices. How many pixels a device can produce in one inch.

Electronic Submission. A submission made by modem or on computer disk, CD-ROM or other removable media.

Emulsion. The light sensitive layer of film or paper.

Enlargement. An image that is larger than its negative, made by projecting the image of the negative onto sensitized paper.

Exclusive property rights. A type of exclusive rights in which the client owns the physical image, such as a print, slide, film reel or videotape. A good example is when a portrait is shot for a person to keep, while the photographer retains the copyright.

Exclusive rights. A type of rights in which the client purchases exclusive usage of the image for a negotiated time period, such as one, three or five years. May also be permanent. Also see All rights, Work for hire.

Fee-plus basis. An arrangement whereby a photographer is given a certain fee for an assignment—plus reimbursement for travel costs, model fees, props and other related expenses incurred in completing the assignment.

File Format. The particular way digital information is recorded. Common formats are TIFF and JPEG.

First rights. The photographer gives the purchaser the right to reproduce the work for the first time. The photographer agrees not to permit any publication of the work for a specified amount of time.

Format. The size or shape of a negative or print.

Four-color printing, four-color process. A printing process in which four primary printing inks are run in four separate passes on the press to create the visual effect of a full-color photo, as in magazines, posters and various other print media. Four separate negatives of the color photo—shot through filters—

are placed identically (stripped) and exposed onto printing plates, and the images are printed from the plates in four ink colors.

GIF Graphics Interchange Format. A graphics file format common to the Internet.

Glossy. Printing paper with a great deal of surface sheen. The opposite of matte.

Hard Copy. Any kind of printed output, as opposed to display on a monitor.

Honorarium. Token payment—small amount of money and/or a credit line and copies of the publication.

Image Resolution. An indication of the amount of detail an image holds. Usually expressed as the dimension of the image in pixels and the color depth each pixel has. Example: 640×480, 24 bit image has higher resolution than a 640×480, 16 bit image.

IRC. Abbreviation for International Reply Coupon. IRCs are used with self-addressed envelopes instead of stamps when submitting material to buyers located outside a photographer's home country.

JPEG Joint Photographic Experts Group. One of the more common digital compression methods that reduces file size without a great loss of detail.

Leasing. A term used in reference to the repeated selling of one-time rights to a photo.

Matte. Printing paper with a dull, nonreflective surface. The opposite of glossy.

Model release. Written permission to use a person's photo in publications or for commercial use.

Ms, mss. Manuscript and manuscripts, respectively.

Multi-image. A type of slide show which uses more than one projector to create greater visual impact with the subject. In more sophisticated multi-image shows, the projectors can be programmed to run by computer for split-second timing and animated effects.

Multimedia. A generic term used by advertising, public relations and audiovisual firms to describe productions using more than one medium together—such as slides and full-motion, color video—to create a variety of visual effects.

News release. See Press release.

No right of reversion. A term in business contracts that specifies once a photographer sells the copyright to an image, a claim of ownership is surrendered. This may be unenforceable, though, in light of the 1989 Supreme Court decision on copyright law. Also see All rights, Work for hire.

One-time rights. The photographer sells the right to use a photo one time only in any medium. The rights transfer back to the photographer on request after the photo's use.

On spec. Abbreviation for "on speculation." Also see Speculation.

Page rate. An arrangement in which a photographer is paid at a standard rate per page in a publication.

Photo CD. A trademarked Eastman Kodak designed digital storage system for photographic images on a CD.

PICT. The saving format for bit-mapped and object-oriented images.

Picture Library. See Stock photo agency.

Pixels. The individual light sensitive elements that make up a CCD array. Pixels respond in a linear fashion. Doubling the light intensity doubles the electrical output of the pixel.

Point-of-purchase, point-of-sale (P-O-P, P-O-S). A term used in the advertising industry to describe in-store marketing displays that promote a product. Typically, these highly-illustrated displays are placed near check out lanes or counters, and offer tear-off discount coupons or trial samples of the product.

Portfolio. A group of photographs assembled to demonstrate a photographer's talent and abilities, often presented to buyers.

PPI Pixels per inch. Often used interchangeably with DPI, PPI refers to the number of pixels per inch in an image. See DPI.

Press release. A form of publicity announcement that public relations agencies and corporate communications staff people send out to newspapers and TV stations to generate news coverage. Usually this is sent with accompanying photos or videotape materials. Also see Video news release.

Property release. Written permission to use a photo of private property or public or government facilities in publications or for commercial use.

Public domain. A photograph whose copyright term has expired is considered to be "in the public domain" and can be used for any purpose without payment.

Publication (payment on). The buyer does not pay for rights to publish a photo until it is actually published, as opposed to payment on acceptance.

Query. A letter of inquiry to a potential buyer soliciting interest in a possible photo assignment.

Rep. Trade jargon for sales representative. Also see Agent.

Resolution. The particular pixel density of an image, or the number of dots per inch a device is capable of recognizing or reproducing.

Résumé. A short written account of one's career, qualifications and accomplishments.

Royalty. A percentage payment made to a photographer/filmmaker for each copy of work sold.

R-print. Any enlargement made from a transparency.

SAE. Self-addressed envelope.

SASE. Self-addressed stamped envelope. (Most buyers require a SASE if a photographer wishes unused photos returned to him, especially unsolicited materials.)

Self-assignment. Any project photographers shoot to show their abilities to prospective clients. This can be used by beginning photographers who want to build a portfolio or by photographers wanting to make a transition into a new market.

Self-promotion piece. A printed piece photographers use for advertising and promoting their businesses. These pieces usually use one or more examples of the photographer's best work, and are professionally designed and printed to make the best impression.

Semigloss. A paper surface with a texture between glossy and matte, but closer to glossy.

Semimonthly. Occurring twice a month.

Serial rights. The photographer sells the right to use a photo in a periodical. Rights usually transfer back to the photographer on request after the photo's use.

Simultaneous submissions. Submission of the same photo or group of photos to more than one potential buyer at the same time.

Speculation. The photographer takes photos with no assurance that the buyer will either purchase them or reimburse expenses in any way, as opposed to taking photos on assignment.

Stock photo agency. A business that maintains a large collection of photos it makes available to a variety of clients such as advertising agencies, calendar firms and periodicals. Agencies usually retain 40-60 percent of the sales price they collect, and remit the balance to the photographers whose photo rights they've sold.

Stock photography. Primarily the selling of reprint rights to existing photographs rather than shooting on assignment for a client. Some stock photos are sold outright, but most are rented for a limited time period. Individuals can market and sell stock images to individual clients from their personal inventory, or stock photo agencies can market photographers' work for them. Many stock agencies hire photographers to shoot new work on assignment, which then becomes the inventory of the stock agency.

Subsidiary agent. In stock photography, this is a stock photo agency that handles marketing of stock images for a primary stock agency in certain US or foreign markets. These are usually affiliated with the primary agency by a contractual agreement rather than by direct ownership, as in the case of an agency that has its own branch offices.

SVHS. Abbreviation for Super VHS. Videotape that is a step above regular VHS tape. The number of lines of resolution in a SVHS picture is greater, thereby producing a sharper picture.

Tabloid. A newspaper about half the page size of an ordinary newspaper, which contains many photos and news in condensed form.

Tearsheet. An actual sample of a published work from a publication.

TIFF Tagged Image File Format. A common bitmap image format developed by Aldus. TIFFs can be b&w or color.

Trade journal. A publication devoted strictly to the interests of readers involved in a specific trade or profession, such as beekeepers, pilots or manicurists and generally available only by subscription.

Transparency. Color film with a positive image, also referred to as a slide.

Unlimited use. A type of rights in which the client has total control over both how and how many times an image will be used. Also see All rights, Exclusive rights, Work for hire.

Unsolicited submission. A photograph of photographs sent through the mail that a buyer did not specifically ask to see.

Work for hire, Work made for hire. Any work that is assigned by an employer and the employer becomes the owner of the copyright. Copyright law clearly defines the types of photography which come under the work-for-hire definition. An employer can claim ownership to the copyright only in cases in which the photographer is a fulltime staff person for the employer or in special cases in which the photographer negotiates and assigns ownership of the copyright in writing to the employer for a limited time period. Stock images cannot be purchased under work-for-hire terms.

World rights. A type of rights in which the client buys usage of an image in the international marketplace. Also see All rights.

Worldwide exclusive rights. A form of world rights in which the client buys exclusive usage of an image in the international marketplace. Also see All rights.

Geographic Index

This index lists photo markets by the state in which they are located. It is often easier to begin marketing your work to companies close to home. You can also determine with which companies you can make appointments to show your portfolio, near home or when traveling.

International Index

This index lists photo markets located outside the United States. Twenty-one countries are included here, however, most of the markets are located in Canada and the United Kingdom. To work with markets located outside your home country, you will have to be especially professional and patient.

Subject Index

This index can help you find buyers who are searching for the kinds of images you are producing. Consisting of markets from the Publications, Book Publishers, Greeting Cards, Gifts & Products, Stock Photo Agencies, Advertising, Design & Related Markets and Galleries sections, this index is broken down into 52 different subjects. If for example, you shoot outdoor scenes and want to find out which markets purchase this material, turn to the categories Landscapes/Scenics and Environmental.

Adventure: Accent Alaska/Ken Graham 314; Ace Photo Agency 314; Adirondack Lakes Center for the Arts 484; Adventure Photo & Film 315; Aflo Foto Agency 315; After Five 59; Alaska Stock Images 317; Allpix Photo Agency 318; Amelia 61; American Fitness 62; American Forests 62; American Photo Library 318; Argus Photoland, Ltd. 320; A+E 320; AppaLight 320; Arnold Publishing Ltd. 248; Art Concepts by Design 486; Art Directors & Trip Photo Library 322; Art Directors Club 486; Art Resource International/Bon Art 288; Artwerks Stock Photography 323; Asia Pacific Photographic Library 323; Aurora & Quanta Productions 324; Austral-International 325; Barnett Advertising/Design, Augustus 471; Bavaria Bildagentur 325; Benelux Press 326; Bowhunter 74; Bynums Advertising Service 410; Cape Cod Life 80; Capitol Complex Exhibitions 492; CardMakers 290; Cascade Geographic Society 291; Cedco Publishing 291; Center for Photography at Woodstock 494; Chatham Press 252; Clark Gallery, Catharine 495; Cliff and Assoc. 455; Coleman Photo Library, Bruce 331; Comesaña-Agencia De Prensa, Eduardo 331; Compass American Guides 253; Corbis 332; Cordaiy Photo Library, Sylvia 332; Corel Photo Collection 332; Countryman Press 255; Creative Company 255; Crossing Press 256; Crumb Elbow Publishing 257; Current 293; Curry Design, David 411; Daloia Design 293; Diana Photo Press 335; Dinodia Picture Agency 335; Diversion 93; Duck Soup Graphics 473; Dynamic Graphics 294; Eastern Shore Art Center 499; EH6 Design Consultants 475; Elegant Greeting 294; Foto Expression 339; Foto-Press Timmerman 340; France Today 103; Frontline Photo Press Agency 341; Galeria Mesa 501; Gallery Taranto 502; Grafica 458; Granata Press Service 344; Graphic Design Concepts 459; Holiday Inn Express Navigator 112; Horizon International Images Ltd. 346; Horizons 112; IFOT 349; Image Concept Inc. 349; Images Pictures 351; Ims Bildbyra 351; Industrial F/X 417; Inspiration Art & Scripture 296; James Design Studio, Peter 435; JII Sales Promotion Associates 297; Keyphotos Int. 354; Kollins Communications Inc. 418; KBA 354; Kramer and Associates, Joan 355; Latina 122; Lawrence Gallery, J. 509; Lonely Planet Publications 268; Lynx Images Inc. 269; Macalester Gallery 511; Marble House Gallery 511; Marlboro Gallery 512; Mayfair 126; Nature Conservancy 131; Nonstock Inc. 364; Northwest Photoworks 364; Novastock 365; Novus Visual Communications 422; Okapia K.G. 365; Oklahoma Today 136; Orion Press 366; Our State 137; Outpost 140; OWL 140; Pacific Stock 368; Pacific Yachting 141; Peak 142; Persimmon Hill 143; Petersen's Photographic 144; Photo Phoenix International 372; Photo Technique 144; Photo Techniques 223; Photo 20-20 373; PhotoBank Yokohama 373; PhotoResource 145; Photri Inc.—Microstock 376; Popular Science 148; PORPOISE PhotoStock 378; Portfolio Graphics 300; Positive Images 378; Ranger Rick and Your Big Backyard 151; Redmond Design, Patrick 448; Reidmore Books Inc. 276; RESO EEIG 380; Rock & Ice 153; Roland Gallery 520; Ro-Ma Stock 381; Selbert Perkins Design 425; Smart Apple Media 278; Soundlight 467; Specialty Travel Index 233; Spectrum Pictures 386; Spectrum Stock Inc. 386; Spirit 163; Sport 164; Sportslight Photo 387; Stock Boston Inc. 388; Stock Broker 388; Stock Shot 390; Stockfile 390; Stockhouse 391; Surface 167; Telluride Stock Photography 392; Think Twice 468; Tide-Mark Press 304; Top Stock 393; Ultrastock 394; Unicorn Stock Photos 394; Viewfinders 396; Vintage Images 396; VisionQuest 397; Visual Hellas 397; Visuals Unlimited 398; Visum/+49 399; Warm Greetings 305; Weigl Educational Publishers 283; YOU! 182; Zefa Visual Media 401

Agriculture: Accent Alaska/Ken Graham 314; Aflo Foto Agency 315; Agencee d'Illustration Photographique Edimedia 316; Agritech Publishing Group Inc. 245; AGStock USA 316; Alabama Living 59; Allpix Photo Agency 318; American Agriculturist 196; American Forests 62; American Photo Library 318; American Planning Assoc. 246; Argus Photoland, Ltd. 320; AppaLight 320; Arnold Publishing Ltd. 248; Art Directors & Trip Photo Library 322; Artwerks Stock Photography 323; ASAP Israel Stock Photo Agency 323; Asia Pacific Photographic Library 323; Assoc. of Brewers 248; Aurora & Quanta Productions 324; Austral-International 325; Barnett Advertising/Design, Augustus 471; Bavaria Bildagentur 325; Belian Art Center 488; Benelux Press 326; Birds & Blooms 73; Bryant Stock Photography, D. Donne 327; Capitol Complex Exhibitions 492; Cascade Geographic Society 291; Center for Photography at Woodstock 494; Charlton Photos 330; Cliff and Assoc. 455; Coleman Photo Library, Bruce 331; Comesaña-Agencia De Prensa, Eduardo 331; Cordaiy Photo Library, Sylvia 332; Country 89; Creative Company 473; Creative Company 255; Crumb Elbow Publishing 257;

graphic Library 323; Atlanta Homes & Lifestyles 68; Austral-International 325; Automated Builder 200; Bach Production, Eric 325; Back Home in Kentucky 69; Barnett Advertising/Design, Augustus 471; Bavaria Bildagentur 325; Benham Studio Gallery 490; Bridgewater/Lustberg Gallery 491; Buildings 201; California Redwood Assoc. 455; Cape Cod Life 80; Capitol Complex Exhibitions 492; Carr Gallery, Claudia 492; Cascade Geographic Society 291; Center for Photography at Woodstock 494; Charlotte Magazine & Charlotte Home Design 83; Chatham Press 252; Cicada 85; Cipra Ad Agency 472; Classic CD 86; Cleveland 87; Cliff and Assoc. 455; Coastal Center for the Arts 495; Coffee House Press 253; Coleman Photo Library, Bruce 331; Collector's Choice Gallery 496; Compass American Guides 253; Construction Equipment Guide 204; Cordaiy Photo Library, Sylvia 332; Creative Company 255; Crossing Press 256; Crumb Elbow Publishing 257; Curry Design, David 411; Daloia Design 293; Dinodia Picture Agency 335; Diversion 93; Dodge City Journal 93; Duck Soup Graphics 473; Eastern Shore Art Center 499; Edelstein Gallery, Paul 499; Egee Art Consultancy 499; EH6 Design Consultants 475; Elegant Greeting 294; Eleven East Ashland 500; Ffotograff 338; Fletcher/Priest Gallery 500; Foto Expression 339; FPG International LLC 341; Frontline Photo Press Agency 341; Galeria Mesa 501; Gallery Naga 502; Gallery Taranto 502; Gallery 218 503; Garden & Wildlife Matters 343; German Life 105; Giarnella Design 415; Global Pictures 344; Grafica 458; Graphic Arts Center Publishing Company 261; Graphic Design Concepts 459; Guest Informant 108; Guideposts 109; Harvard Design Magazine 211; Historic Traveler 111; Holiday Inn Express Navigator 112; Hutchison Picture Library 347; I.G. Publications Ltd. 265; Image Finders 349; Industrial F/X 417; Iowan 117; Jackson Fine Art 508; Jadite Galleries 508; James Design Studio, Peter 435; Keyphotos Int. 354; Kitchen & Bath Business 215; Kollins Communications Inc. 418; KBA 354; Kramer and Associates, Joan 355; Kufa Gallery 509; La Mama La Galleria 509; Latina 122; Lawrence Gallery, J. 509; Le Petit Musée 510; Levy Fine Art Publishing, Leslie 299; Longview Museum of Fine Arts 511; Lorenc Design 435; M.C. Gallery 511; Macalester Gallery 511; Magazine Antiques 125; Marble House Gallery 511; Mattei Productions, Michele 358; Matthews Assoc. Inc. 474; McGaw Graphics, Bruce 299; Media Consultants Inc. 463; MGI Publications 217; Mountain Living 128; Nassar Design 421; New England Stock Photo 362; New Mexico 133; New York Graphic Society 299; Nonstock Inc. 364; Northwest Photoworks 364; Novus Visual Communications 422; Noyes Museum of Art 515; Omni-Photo 366; Orion Press 366; Outpost 140; Panoramic Images 369; Peak 142; Pentimenti Gallery 516; Petersen's Photographic 144; Photo Techniques 223; PhotoResource 145; Photri Inc.—Microstock 376; PORPOISE PhotoStock 378; Portfolio Graphics 300; Positive Images 378; Postal Productions, Steve 436; Press Chapeau 301; Pucker Gallery 519; Rag Mag 151; Rainbow 379; RainCastle Communications Inc. 424; Redmond Design, Patrick 448; Reflexion Phototheque 380; RESO EEIG 380; Roland Gallery 520; Ro-Ma Stock 381; S.O.A. Photo Agency 382; Sacramento 155; Selbert Perkins Design 425; Select Art 521; Smart Apple Media 278; Sparrow & Jacobs 303; Spectrum Pictures 386; Stained Glass 233; Stockhouse 391; Surface 167; Think Twice 468; Tide-Mark Press 304; Ullstein Bilderdienst 394; Union Institute 450; US Airways Attaché 174; Vermont 175; Vintage Images 396; Visual Hellas 397; Visuals Unlimited 398; Voyageur Press 282; Wach Gallery 524; Weigl Educational Publishers 283; Wiesner Inc. 180; Williams/Crawford & Associates 438; Wisconsin Architect 237; Zefa Visual Media 401

Automobiles: AAA Midwest Traveler 57; Accent Alaska/Ken Graham 314; Ace Photo Agency 314; Adirondack Lakes Center for the Arts 484; Aflo Foto Agency 315; After Five 59; Aftermarket Business 195; Agencee d'Illustration Photographique Edimedia 316; All American Chevys 60; Allpix Photo Agency 318; American Fitness 62; American Photo Library 318; Argus Photoland, Ltd. 320; Arregui International Advertising 432; Art Directors & Trip Photo Library 322; Art Directors Club 486; Asia Pacific Photographic Library 323; Austral-International 325; Auto Restorer 69; Auto Trim & Restyling News 199; Bavaria Bildagentur 325; Bentley Automotive Publishers 249; Bracket Racing USA 75; Bynums Advertising Service 410; California Views 328; Car Craft 81; CardMakers 290; Cascade Geographic Society 291; Center for Photography at Woodstock 494; Chatham Press 252; Classic Motorcycle 86; Classics 86; Cliff and Assoc. 455; Corbis 332; Crumb Elbow Publishing 257; Daloia Design 293; Dinodia Picture Agency 335; Diversion 93; Driving 95; Duck Soup Graphics 473; Eastern Shore Art Center 499; Edelstein Gallery, Paul 499; EH6 Design Consultants 475; Elegant Greeting 294; Eleven East Ashland 500; Flint Communications 442; Foto Expression 339; Fraser Advertising 434; Galeria Mesa 501; Gallery Luisotti 502; Giarnella Design 415; Grafica 458; Graphic Design Concepts 459; Greenberg Art Publishing, Raymond L. 295; Holiday Inn Express Navigator 112; Howell Press 265; Humphrey Associates 460; Image Concept Inc. 349; Image Finders 349; Images Pictures 351; Inside Automotives 214; ITechnology Journal 118; Keyphotos Int. 354; Kollins Communications Inc. 418; Kramer and Associates, Joan 355; Law & Order 216; Lawrence Gallery, J. 509; Mayfair 126; Media Consultants Inc. 463; Mopar Muscle 127; Motorbooks International 270; Nonstock Inc. 364; Northwest Photoworks 364; Novus Visual Communications 422; Orion Press 366; Owen Publishers, Richard C. 273; Peak 142; PhotoResource 145; Photri Inc.—Microstock 376; Popular Science 148; PORPOISE PhotoStock 378; Portfolio Graphics 300; Postal Productions, Steve 436; Redmond Design, Patrick 448; Reflexion Phototheque 380; RESO EEIG 380; Smart Apple Media 278; Sole Source 303; Southern Motoracing 192; Stock Car Racing 165; Stock House Ltd. 389; Stockhouse 391; Super Ford 167; Surface 167; Teldon Calendars 304; Think Twice 468; Traffic Safety 235; Triumph World 171; Ullstein Bilderdienst 394; US Airways Attaché 174; Utility and Telephone Fleets 236; Viper 175; Visuals Unlimited 398; Voyageur Press 282; Wach Gallery 524; Worldwide Images 400; Year One Inc. 438

Beauty: Adirondack Lakes Center for the Arts 484; Advertising Consortium 453; Aflo Foto Agency 315; Allpix Photo Agency 318; American Fitness 62; American Forests 62; American HomeStyle & Gardening 63; American Photo Library 318; AM/PM Advertising 408; Argus Photoland, Ltd. 320; Art Directors & Trip Photo Library 322; Art Directors Club 486; Ascherman Gallery 488; Asia Pacific Photographic Library 323; Austral-International 325; Bavaria Bildagentur 325; Beauty Handbook 71; Benelux Press 326; Big Pictures UK 327; Bride Again 76; Capitol Complex Exhibitions 492; Center for Photography at Woodstock 494; Chatham Press 252; Cicada 85; Cleveland 87; Cliff and Assoc. 455; Coastal Center for the Arts 495; Comesaña-Agencia De Prensa, Eduardo 331; Complete Woman 88; Corel Photo Collection 332; Crossing Press 256; Crumb Elbow Publishing 257; Curry Design, David 411; Daloia Design 293; Designer Greetings 293; Dinodia Picture Agency 335; Eastern Shore Art Center 499; Edelstein Gallery, Paul 499; EH6 Design Consultants 475; Elegant Greeting 294; Elliott, Kristin 294; Foto Expression 339; Foto-Press Timmerman 340; Frontline Photo Press Agency 341; Galeria Mesa 501; Gallery Luisotti 502; Giarnella Design 415; Global Pictures 344; Grafica 458; Graphic Design Concepts 459; Grit 107; Health & Beauty 111; Hiller Publishing 263; Holiday Inn Express Navigator 112; Horizon International Images Ltd. 346; Images Pictures 351; Ims Bildbyra 351; Isopress Senepart 352; James Design Studio, Peter 435; Keyphotos Int. 354; Kollins Communications Inc. 418; Kramer and Associates, Joan 355; La Mama La Galleria 509; Latina 122; Lawrence Gallery, J. 509; Longview Museum of Fine Arts 511; M.C. Gallery 511; Marble House Gallery 511; Media Consultants Inc. 463; Megapress Images 359; National News Bureau 190; Nonstock Inc. 364; Northwest Photoworks 364; Nova Media Inc. 300; Novus Visual Communications 422; Orion Press 366; Peak 142; Pentimenti Gallery 516; Photo Agora 369; Photo Phoenix International 372; Photo Techniques 223; Photo 20-20 373; PhotoBank Yokohama 373; PhotoResource 145; Portfolio Graphics 300; Positive Images 378; Postal Productions, Steve 436; Prevention 148; Pucker Gallery 519; Rafaj Marketing, Susan M. 423; Recycled Paper Greetings 301; Redmond Design, Patrick 448; RESO EEIG 380; S.O.A. Photo Agency 382; Show Biz News 191; Soundlight 467; Spectrum Pictures 386; Stock House Ltd. 389; Stockhouse 391; Surface 167; Taube Museum of Art 522; Tele-Press Associates 427; Think Twice 468; Today's Model 169; Toronto Sun Publishing 193; Truth Consciousness/Desert Ashram 280; Vermont Life 174; Vintage Images 396; Visual Hellas 397; Visual Photo Library 398; Visuals Unlimited 398; Zefa Visual Media 401

Buildings: Accent Alaska/Ken Graham 314; Aflo Foto Agency 315; Allpix Photo Agency 318; Amelia 61; American Banker 196; American Photo Library 318; American Planning Assoc. 246; Anvil Press 247; Arcaid 321; Archipress 321; Arregui International Advertising 432; Art Concepts by Design 486; Art Directors & Trip Photo Library 322; Art Directors Club 486; Art Etc. 439; Artwerks Stock Photography 323; ASAP Israel Stock Photo Agency 323; Asia Pacific Photographic Library 323; Austral-International 325; Bavaria Bildagentur 325; Belian Art Center 488; Bridgewater/Lustberg Gallery 491; California Redwood Assoc. 455; Calliope 77; Cape Cod Life 80; Capitol Complex Exhibitions 492; Cascade Geographic Society 291; Center for Photography at Woodstock 494; Chatham Press 252; Cleveland 87; Cliff and Assoc. 455; Coleman Photo Library, Bruce 331; Comesaña-Agencia De Prensa, Eduardo 331; Commercial Building 203; Construction Equipment Guide 204; Cordaiy Photo Library, Sylvia 332; Covenant Companion 89; Creative Company 255; Crossing Press 256; Crumb Elbow Publishing 257; Cunningham Photographic, Sue 333; Daloia Design 293; Dealmakers 205; Design Conceptions 334; Dinodia Picture Agency 335; Duck Soup Graphics 473; Eastern Shore Art Center 499; Edelstein Gallery, Paul 499; Educational Video Network 456; Egee Art Consultancy 499; EH6 Design Consultants 475; Eleven East Ashland 500; Foto Expression 339; Foto-Press Timmerman 340; Fraser Advertising 434; Friedentag Photographics 457; Galeria Mesa 501; Gallery Taranto 502; Gallery 218 503; Global Pictures 344; Grafica 458; Granata Press Service 344; Graphic Design Concepts 459; Guernica Editions 262; Harvard Design Magazine 211; Home Planners 264; Hutchison Picture Library 347; Images Pictures 351; Ims Bildbyra 351; Individual Artists of Oklahoma 507; Industrial F/X 417; Isopress Senepart 352; Jackson Fine Art 508; Jadite Galleries 508; Journal of Property Management 215; Judicature 215; Keyphotos Int. 354; KBA 354; Kramer and Associates, Joan 355; Lawrence Gallery, J. 509; Le Petit Musée 510; Log Home Living 123; Lohre & Associates Inc. 445; Marble House Gallery 511; Mattei Productions, Michele 358; Matthews Assoc. Inc. 474; Media Consultants Inc. 463; MGI Publications 217; Nails 218; Nassar Design 421; Nonstock Inc. 364; Novus Visual Communications 422; O.K. Harris Works of Art 515; Oliver Press 272; Omni-Photo 366; Orion Press 366; Pacific Builder & Engineer 221; Pacific Stock 368; Peak 142; People Management 222; Pet Product News 223; Photo Index 371; PhotoBank Yokohama 373; PhotoResource 145; Photri Inc.—Microstock 376; Popular Science 148; Portfolio Graphics 300; Positive Images 378; Postal Productions, Steve 436; Press Chapeau 301; Quick Frozen Foods International 228; Redmond Design, Patrick 448; RESO EEIG 380; Ro-Ma Stock 381; S.O.A. Photo Agency 382; Schowalter Design, Tony 425; Smart Apple Media 278; Spectrum Pictures 386; Surface 167; Taube Museum of Art 522; Think Twice 468; Travel Productions 428; Ullstein Bilderdienst 394; Ultrastock 394; Unicorn Stock Photos 394; Vintage Images 396; VisionQuest 397; Visual Hellas 397; Visuals Unlimited 398; Voyageur Press 282; Wach Gallery 524; Weigl Educational Publishers 283; Yale Robbins 239; Zefa Visual Media 401

Business Concepts: AAA Image Makers 314; ABA Banking Journal 194; Accent Alaska/Ken Graham 314; Accounting Today 195; Ace Photo Agency 314; Across the Board 58; Aflo Foto Agency 315; Allpix Photo Agency 318; Allyn and Bacon Publishers 245; Alphastock 318; America West Airlines 61; American Photo Library 318; American Planning Assoc. 246; Argus Photoland, Ltd. 320; Art Directors & Trip Photo Library 322; Art Directors Club 486; Art Etc. 439; Artwerks Stock Photography 323; ASBO International 185; Asia Pacific Photographic Library 323; Asian Enterprise 199; Atlantic Publication Group Inc. 199; Aurora & Quanta

Productions 324; Austral-International 325; Avionics 200; Barry Associates, Bob 409; Benelux Press 326; Boeberitz Design, Bob 432; Bryant Stock Photography, D. Donne 327; Business 99 76; Business NH 201; Career Focus 81; Center for Photography at Woodstock 494; Cleveland 87; Cliff and Assoc. 455; Coleman Photo Library, Bruce 331; College Preview 88; Comesaña-Agencia De Prensa, Eduardo 331; Commercial Building 203; Complete Woman 88; Computer Currents 88; Concord Litho Group 292; Construction Bulletin 203; Cordaiy Photo Library, Sylvia 332; Corel Photo Collection 332; Creative Company 473; Crossing Press 256; Crumb Elbow Publishing 257; CYR Color Photo Agency 334; Daloia Design 293; Dance Teacher 205; DECA Dimensions 205; Design & More 442; Dinodia Picture Agency 335; Duck Soup Graphics 473; Dynamic Graphics 294; Educational Video Network 456; EH6 Design Consultants 475; Electric Perspectives 206; Electrical Apparatus 206; Entrepreneur 96; Environment 97; Europe 207; Flint Communications 442; Florida Underwriter 209; Focus Advertising 457; Fortune 102; Foto Expression 339; Friedentag Photographics 457; Frontline Photo Press Agency 341; Gallery Taranto 502; Global Pictures 344; Grafica 458; Granata Press Service 344; Grand Rapids Business Journal 187; Graphic Design Concepts 459; Guideposts 109; Horizon International Images Ltd. 346; Hot Shots Stock Shots 347; Ideal Images 348; IEEE Spectrum 213; Image Concept Inc. 349; Image Finders 349; Image Works 350; Images Pictures 351; Ims Bildbyra 351; Independent Business 213; Independent Business 115; Industrial F/X 417; Isopress Senepart 352; James Design Studio, Peter 435; Keyphotos Int. 354; Kiplinger's Personal Finance 120; Kiwanis 120; Kollins Communications Inc. 418; KBA 354; Kramer and Associates, Joan 355; Lawrence Gallery, J. 509; Lerner Et Al 444; Lieber Brewster Design Inc. 418; Lohre & Associates Inc. 445; Mach 2 Stock Exchange Ltd. 357; McAndrew Advertising Co. 419; Media Consultants Inc. 463; Mekler & Deahl, Publisher 269; MGI Publications 217; MIRA 360; Modern Baking 217; Mortgage Originator 217; Multinational Monitor 128; Nation's Business 219; Network Aspen 362; New Choices Living Even Better After 50 132; New England Stock Photo 362; New Impact Journal 220; Nonstock Inc. 364; Northeast Export 220; Northwest Photoworks 364; Novastock 365; Novus Visual Communications 422; Orion Press 366; Pacific Stock 368; Peak 142; Penn-Jude Partners 464; Pet Business 223; Photo Index 371; Photo Library 371; Photo 20-20 373; PhotoBank Yokohama 373; Photophile 375; PhotoResource 145; Photri Inc.—Microstock 376; Picturesque Stock Photos 377; Portfolio Graphics 300; Positive Images 378; Progressive Rentals 226; Purchasing 227; Quick Frozen Foods International 228; Redmond Design, Patrick 448; Registered Representative 229; RESO EEIG 380; Rotarian 154; RPD Group, Richard Puder Design 424; S.O.A. Photo Agency 382; Saks Associates, Arnold 425; Schowalter Design, Tony 425; Scrap 231; Selbert Perkins Design 425; Simon Design 426; Spare Time 163; Spectrum Pictures 386; Spectrum Stock Inc. 386; Star Publishing Company 279; Stock Boston Inc. 388; Stock Broker 388; Stock Connection 388; Stock House Ltd. 389; Stock Market 389; Stock Options® 389; Stockhouse 391; Successful Meetings 234; Superstock Inc. 391; Take Stock Inc. 392; Think Twice 468; Ultrastock 394; Union Institute 450; Viewfinders 396; Vintage Images 396; VisionQuest 397; Visual Contact 397; Visual Hellas 397; Visual Photo Library 398; Visuals Unlimited 398; Warm Greetings 305; Wholesaler 236; Wireless Review 237; Zefa Visual Media 401; Zephyr Images 401

Celebrities: Adirondack Lakes Center for the Arts 484; Advanced Graphics 288; Aflo Foto Agency 315; Agencee d'Illustration Photographique Edimedia 316; Allpix Photo Agency 318; American Fitness 62; American Forests 62; American Motorcyclist 63; American Photo Library 318; Americas Cutter 65; Art Concepts by Design 486; Art Directors Club 486; Ascherman Gallery 488; Aurora & Quanta Productions 324; Australian Picture Library 324; Austral-International 325; Bavaria Bildagentur 325; Big Pictures UK 327; Briarpatch 75; Brooks Associates, Anita Helen 410; Bynums Advertising Service 410; Camera Press Ltd. 328; Camerique Inc. Int. 329; Cape Cod Life 80; Capital Pictures 329; Capitol Complex Exhibitions 492; Cascade Geographic Society 291; Center for Photography at Woodstock 494; Central California Art League Gallery 494; Chess Life 83; Christian Herald 186; Classic CD 86; Classics 86; Cleveland 87; Cliff and Assoc. 455; Cohen, Steven 433; Coleman Photo Library, Bruce 331; Collector's Choice Gallery 496; Compix Photo Agency 186; Complete Woman 88; Corbis 332; Creative Company 255; Creative Editions 256; Crumb Elbow Publishing 257; Curry Design, David 411; Daloia Design 293; Dealmakers 205; Diana Photo Press 335; Dinodia Picture Agency 335; Duck Soup Graphics 473; Eastern Shore Art Center 499; ECW Press 259; Edelstein Gallery, Paul 499; EH6 Design Consultants 475; Famous Pictures & Features 338; Foto Expression 339; Fotos International 340; France Today 103; Frontline Photo Press Agency 341; Galeria Mesa 501; Gallery Luisotti 502; Genre 104; Girlfriends 105; Globe 187; Golf Traveler 107; Grafica 458; Granata Press Service 344; Graphic Design Concepts 459; Guest Informant 108; Holiday Inn Express Navigator 112; IFOT 349; Image Connection America 296; Images Pictures 351; Ims Bildbyra 351; Inspiration Art & Scripture 296; Ipol 351; Isopress Senepart 352; Jackson Fine Art 508; JazzTimes 118; Keyphotos Int. 354; Keystone Pressedienst GmbH 354; KBA 354; Kramer and Associates, Joan 355; Ladies Home Journal 121; Latina 122; Lawrence Gallery, J. 509; Le Petit Musée 510; Leader 188; Lerner Publications 267; Levy Fine Art Publishing, Leslie 299; Lippservice 418; Lizardi/Harp Gallery 510; Lucent Books 269; Macalester Gallery 511; Marlboro Gallery 512; Mattei Productions, Michele 358; Mayfair 126; McGaw Graphics, Bruce 299; Megapress Images 359; MIRA 360; Mode 127; Model News 189; Modern Drummer 127; Motion Picture and TV Photo Archive 360; Musclemag Int. 128; Nails 218; National News Bureau 190; Native Peoples 130; Natural Living Today 131; New York Graphic Society 299; New York Times Magazine 190; Newsmakers 363; Noch & Associates, Andrew 299; Northwest Photoworks 364; Nova Media Inc. 300; Omega News Group 366; Orion Press 366; Outburn 138; Oxford American 140; Peak 142; Persimmon Hill 143; Photo Associates News Service 370; Photo Technique 144; Photo 20-20 373; PhotoBank Yokohama 373; PhotoResource 145; Photri Inc.—Microstock 376; Pix Interna-

tional 377; Play The Odds 190; Playboy 145; Portfolio Graphics 300; Pucker Gallery 519; Ranger Rick and Your Big Backyard 151; Real People 152; Redmond Design, Patrick 448; Rex USA Ltd. 381; Rockford Review 154; Roland Gallery 520; Rolling Stone 154; Rosen Publishing Group 277; Rutledge Hill Press 278; Score, Canada's Golf 158; Show Biz News 191; Silver Image Photo Agency 384; Singer Media Corp. 191; Slo-Pitch News 191; Soundlight 467; South Beach Photo Agency 385; Spectrum Pictures 386; SPFX 163; Spirit 163; Sport 164; Star 165; Stock Car Racing 165; Stock House Ltd. 389; Stockhouse 391; Sun 192; Surface 167; Tennis Week 168; Think Twice 468; Tiger Beat 169; Today's Model 169; Toronto Sun Publishing 193; Truth Consciousness/Desert Ashram 280; Ullstein Bilderdienst 394; US Airways Attaché 174; Vanity Fair 174; Viewfinders 396; Vista 176; Visual Hellas 397; Wach Gallery 524; Washingtonian 177; Weigl Educational Publishers 283; Where 179; Worldwide Images 400; Wrestling World 181; YOU! 182; Your Health 182

Children: AAP News 194; Accent Alaska/Ken Graham 314; Ace Photo Agency 314; Adirondack Lakes Center for the Arts 484; Advanced Graphics 288; Advertising Consortium 453; Aflo Foto Agency 315; Agencee d'Illustration Photographique Edimedia 316; Alive Now 60; Allpix Photo Agency 318; Alphastock 318; Amelia 61; American Fitness 62; American Forests 62; American Photo Library 318; American Planning Assoc. 246; American School Health Assoc. 247; Argus Photoland, Ltd. 320; AppaLight 320; Arregui International Advertising 432; Art Directors & Trip Photo Library 322; Art Directors Club 486; Art Etc. 439; Ascherman Gallery 488; Ashton-Drake Galleries 289; Asia Pacific Photographic Library 323; At-Home Mother 68; Atlanta Parent 68; Aurora & Quanta Productions 324; Austral-International 325; Avanti Press Inc. 289; Bavaria Bildagentur 325; Behrman House Inc. 249; Benelux Press 326; Bible Advocate 72; Big Apple Parent 185; Blackbird Press 250; Brazzil 75; Bride Again 76; Bureau for At-Risk Youth 251; Burgoyne Inc. 290; Bynums Advertising Service 410; Capitol Complex Exhibitions 492; Cascade Geographic Society 291; Center for Photography at Woodstock 494; Charitable Choices 410; Charlesbridge Publishing 252; Children's Digest 84; Christian Century 84; Christian Herald 186; Christian Home & School 84; Cicada 85; Clavier 202; Cliff and Assoc. 455; Coastal Center for the Arts 495; Coleman Photo Library, Bruce 331; Comesaña-Agencia De Prensa, Eduardo 331; Concord Litho Group 292; Corbis 332; Cordaiy Photo Library, Sylvia 332; Corel Photo Collection 332; Crabtree Publishing Company 255; Creative Company 473; Crossing Press 256; Crumb Elbow Publishing 257; Current 293; Curry Design, David 411; CYR Color Photo Agency 334; Daloia Design 293; Design Conceptions 334; Designer Greetings 293; Dial Books for Young Readers 257; Dinodia Picture Agency 335; Dynamic Graphics 294; Eastern Shore Art Center 499; Edelstein Gallery, Paul 499; Educational Leadership 206; EH6 Design Consultants 475; Elegant Greeting 294; Family Publishing Group 98; Flashcards 294; Foto Expression 339; Foto-Press Timmerman 340; Fox, Photographer, David 414; Fraser Advertising 434; Frontline Photo Press Agency 341; Galeria Mesa 501; Gallery Luisotti 502; Gallery Taranto 502; General Learning Communications 104; Giarnella Design 415; Global Pictures 344; Gospel Herald 107; Grafica 458; Granata Press Service 344; Graphic Design Concepts 459; Greenberg Art Publishing, Raymond L. 295; Grit 107; Gryphon House 262; Guideposts 109; Hadassah Magazine 109; Highlights for Children 111; Hiller Publishing 263; Home Education 112; Horizon International Images Ltd. 346; Hutchison Picture Library 347; Ideal Images 348; Image Concept Inc. 349; Image Connection America 296; Image Finders 349; Images Pictures 351; Ims Bildbyra 351; Industrial F/X 417; Inner Traditions Int. 265; Inspiration Art & Scripture 296; Isopress Senepart 352; Jackson Fine Art 508; James Design Studio, Peter 435; Jeroboam 353; Jossey-Bass Publishers 265; Junior Scholastic 119; Kashrus 119; Keene Kards Inc. 298; Keyphotos Int. 354; Kiwanis 120; Kollins Communications Inc. 418; KBA 354; Kramer and Associates, Joan 355; Ladies Home Journal 121; Latina 122; Lawrence Gallery, J. 509; Leader 188; Lerner Publications 267; Levy Fine Art Publishing, Leslie 299; Lieber Brewster Design Inc. 418; Lizardi/Harp Gallery 510; Lonely Planet Publications 268; Lutheran 124; M.C. Gallery 511; Marble House Gallery 511; Media Consultants Inc. 463; Megapress Images 359; Mennonite Publishing House 126; Na'amat Woman 129; National Black Child Development Institute 421; Native Peoples 130; Nature Conservancy 131; New England Stock Photo 362; New Moon® 133; Nonstock Inc. 364; Northwest Photoworks 364; Novastock 365; Novus Visual Communications 422; Noyes Museum of Art 515; Okapia K.G. 365; Olson & Co., C. 273; Omni-Photo 366; Orion Press 366; Our Family 137; Owen Publishers, Richard C. 273; OWL 140; Ozark Stock 367; Pacific Stock 368; Pediatric Annals 222; Petersen's Photographic 144; Photo Index 371; Photo Library 371; Photo Network 371; PhotoBank Yokohama 373; PhotoEdit 374; PhotoResource 145; Photri Inc.—Microstock 376; Porterfield's Fine Art in Limited Editions 300; Portfolio Graphics 300; Posey School of Dance 423; Positive Images 378; Principal 225; Pucker Gallery 519; Rainbow 379; Ranger Rick and Your Big Backyard 151; Recycled Paper Greetings 301; Redmond Design, Patrick 448; Reflexion Phototheque 380; Reidmore Books Inc. 276; RESO EEIG 380; Ro-Ma Stock 381; Rosen Publishing Group 277; S.O.A. Photo Agency 382; Sanghaui Enterprises Ltd. 303; School Mates 158; Science and Children 230; Selbert Perkins Design 425; Sharpshooters 383; Silver Moon Press 278; Silver Visions 384; Simon Design 426; Skipping Stones 161; Skylight Training and Publishing Inc. 278; Slo-Pitch News 191; Specialty Travel Index 233; Spectrum Pictures 386; Spectrum Stock Inc. 386; Stack & Associates, Tom 387; Stock Boston Inc. 388; Stock House Ltd. 389; Stockhouse 391; Sunrise Publications 304; Taube Museum of Art 522; Think Twice 468; Truth Consciousness/Desert Ashram 280; Ultrastock 394; Unicorn Stock Photos 394; Victory Productions 282; Viewfinders 396; Vintage Images 396; VisionQuest 397; Visual Hellas 397; Visual Photo Library 398; Visuals Unlimited 398; Warm Greetings 305; Weigl Educational Publishers 283; Whiskey Island 179; Young Romantic 182; Your Health 182; Zefa Visual Media 401; Zolan Fine Arts, LLC 306

229; S.O.A. Photo Agency 382; Science Photo Library, Ltd. 383; Selbert Perkins Design 425; Simon Design 426; Smart Apple Media 278; Spectrum Pictures 386; Spectrum Stock Inc. 386; Stock Boston Inc. 388; Stockhouse 391; Surface 167; Think Twice 468; Ullstein Bilderdienst 394; Ultrastock 394; Viewfinders 396; Vintage Images 396; VisionQuest 397; Visual Hellas 397; Visual Photo Library 398; Zefa Visual Media 401

Couples: Accent Alaska/Ken Graham 314; Ace Photo Agency 314; Adirondack Lakes Center for the Arts 484; Advanced Graphics 288; Advertising Consortium 453; Aflo Foto Agency 315; Agencee d'Illustration Photographique Edimedia 316; Alive Now 60; Allpix Photo Agency 318; Alphastock 318; Amelia 61; American Forests 62; American Photo Library 318; American Planning Assoc. 246; Argus Photoland, Ltd. 320; AppaLight 320; Arregui International Advertising 432; Art Directors & Trip Photo Library 322; Art Directors Club 486; Ascherman Gallery 488; Asia Pacific Photographic Library 323; Aurora & Quanta Productions 324; Austral-International 325; Avanti Press Inc. 289; Bavaria Bildagentur 325; Benelux Press 326; Bible Advocate 72; Bride Again 76; Bride's 76; Bynums Advertising Service 410; Capitol Complex Exhibitions 492; Cascade Geographic Society 291; Center for Photography at Woodstock 494; Christian Herald 186; Cicada 85; Cleveland 87; Cliff and Assoc. 455; Coastal Center for the Arts 495; Cohen, Steven 433; Coleman Photo Library, Bruce 331; Comesaña-Agencia De Prensa, Eduardo 331; Complete Woman 88; Corbis 332; Cordaiy Photo Library, Sylvia 332; Corel Photo Collection 332; CRC Product Services 89; Crossing Press 256; Crumb Elbow Publishing 257; Cunningham Photographic, Sue 333; Curry Design, David 411; Daloia Design 293; Design Conceptions 334; Dinodia Picture Agency 335; Duck Soup Graphics 473; Dynamic Graphics 294; Eastern Shore Art Center 499; Edelstein Gallery, Paul 499; EH6 Design Consultants 475; Elegant Greeting 294; Eleven East Ashland 500; Family Motor Coaching 98; Flint Communications 442; Foto Expression 339; Foto-Press Timmerman 340; Fraser Advertising 434; Frontline Photo Press Agency 341; Galeria Mesa 501; Gallery Luisotti 502; Gallery Taranto 502; Giarnella Design 415; Global Pictures 344; Grafica 458; Granata Press Service 344; Graphic Design Concepts 459; Greenberg Art Publishing, Raymond L. 295; Grit 107; Guest Informant 108; Highways 111; Horizon International Images Ltd. 346; Hutchison Picture Library 347; Ideal Images 348; Image Concept Inc. 349; Image Finders 349; Images Pictures 351; Ims Bildbyra 351; Industrial F/X 417; Inspiration Art & Scripture 296; Isopress Senepart 352; Jackson Fine Art 508; James Design Studio, Peter 435; Jaywardene Travel Photo Library 353; Keyphotos Int. 354; Kollins Communications Inc. 418; KBA 354; Kramer and Associates, Joan 355; Latina 122; Lawrence Gallery, J. 509; Leader 188; Lerner Et Al 444; Lieber Brewster Design Inc. 418; Lizardi/Harp Gallery 510; Llewellyn Publications 268; Lonely Planet Publications 268; Lutheran 124; M.C. Gallery 511; Marble House Gallery 511; Mayfair 126; Media Consultants Inc. 463; Megapress Images 359; Mountain Living 128; Native Peoples 130; Nature Conservancy 131; Nawrocki Stock Photo 361; New England Stock Photo 362; Nonstock Inc. 364; Northwest Photoworks 364; Novastock 365; Novus Visual Communications 422; Nugget 135; Okapia K.G. 365; Omni-Photo 366; Orion Press 366; Our Family 137; Pacific Stock 368; Pacific Union Recorder 141; Petersen's Photographic 144; Photo Agora 369; Photo Index 371; Photo Library 371; Photo Network 371; Photo Researchers 372; Photo 20-20 373; PhotoBank Yokohama 373; PhotoResource 145; Photri Inc.—Microstock 376; PORPOISE PhotoStock 378; Portfolio Graphics 300; Positive Images 378; Redmond Design, Patrick 448; RESO EEIG 380; Ro-Ma Stock 381; Rosen Publishing Group 277; S.O.A. Photo Agency 382; Selbert Perkins Design 425; Sharpshooters 383; Silver Visions 384; Simon Design 426; Soundlight 467; Specialty Travel Index 233; Spectrum Stock Inc. 386; Stock Boston Inc. 388; Stock House Ltd. 389; Stock Shop 390; Stockhouse 391; Taube Museum of Art 522; Telluride Stock Photography 392; Think Twice 468; Truth Consciousness/Desert Ashram 280; Ultrastock 394; Unicorn Stock Photos 394; Viewfinders 396; Vintage Images 396; VisionQuest 397; Visual Hellas 397; Visual Photo Library 398; Visuals Unlimited 398; Wach Gallery 524; Warner Books 283; Weigl Educational Publishers 283; Whap! 179; YOU! 182; Young Romantic 182; Your Health 182; Zefa Visual Media 401

Disasters: Adirondack Lakes Center for the Arts 484; Agencee d'Illustration Photographique Edimedia 316; Allpix Photo Agency 318; American Fire Journal 197; American Forests 62; American Photo Library 318; American Planning Assoc. 246; American Survival Guide 64; Argus Photoland, Ltd. 320; Arnold Publishing Ltd. 248; Art Directors & Trip Photo Library 322; Art Directors Club 486; Artworks Gallery 488; Asia Pacific Photographic Library 323; Austral-International 325; Bavaria Bildagentur 325; Benelux Press 326; Big Pictures UK 327; California Views 328; Cascade Geographic Society 291; Center for Photography at Woodstock 494; Cliff and Assoc. 455; Coleman Photo Library, Bruce 331; Comesaña-Agencia De Prensa, Eduardo 331; Communications Electronics Journal 441; Creative Company 255; Crumb Elbow Publishing 257; Cunningham Photographic, Sue 333; Daloia Design 293; Dinodia Picture Agency 335; Eastern Shore Art Center 499; Ecoscene 336; EH6 Design Consultants 475; Environment 97; Fellowship 99; Fire Chief 208; Fire Engineering 208; Firehouse 209; Firepix Int. 339; Foto Expression 339; Frontline Photo Press Agency 341; Galeria Mesa 501; Gallery Taranto 502; Grafica 458; Granata Press Service 344; Guideposts 109; Hall/Code Red, George 345; Horizon International Images Ltd. 346; Hutchison Picture Library 347; Image Concept Inc. 349; Image Finders 349; Images Pictures 351; Ims Bildbyra 351; Isopress Senepart 352; Keyphotos Int. 354; Kollins Communications Inc. 418; KBA 354; Kramer and Associates, Joan 355; Leader 188; Lerner Publications 267; Lizardi/Harp Gallery 510; Lucent Books 269; Lutheran 124; Lynx Images Inc. 269; M.C. Gallery 511; Mayfair 126; Natural Science Photos 361; Newsmakers 363; 911 Pictures 363; 911 Magazine 220; Nonstock Inc. 364; Northwest Photoworks 364; Novastock 365; Omni-Photo 366; Oxford Scientific Films 367; Phoenix Gallery 517; Photo Agora 369; Photo

490; Bible Advocate 72; Bird Watching 72; Bowhunter 74; Briarpatch 75; Bristol Gift Co. Inc. 290; Bynums Advertising Service 410; California Journal 77; California Wild 77; Calypso Log 78; Cape Cod Life 80; Cascade Geographic Society 291; Center for Photography at Woodstock 494; Centric Corp. 291; Charitable Choices 410; Charlesbridge Publishing 252; Chickadee 83; Children's Digest 84; Cicada 85; Clark Gallery, Catharine 495; Cleveland 87; Cliff and Assoc. 455; Climate Business 203; Coleman Photo Library, Bruce 331; Collector's Choice Gallery 496; Comesaña-Agencia De Prensa, Eduardo 331; Community Darkroom 546; Cordaiy Photo Library, Sylvia 332; Countryman Press 255; Covenant Companion 89; Creative Company 255; Crossing Press 256; Crumb Elbow Publishing 257; Cunningham Photographic, Sue 333; Daloia Design 293; Designer Greetings 293; Diana Photo Press 335; Dinodia Picture Agency 335; Duck Soup Graphics 473; E Magazine 95; Earth Images 336; Eastern Shore Art Center 499; Ecoscene 336; Edelstein Gallery, Paul 499; Educational Video Network 456; EH6 Design Consultants 475; Eleven East Ashland 500; Elliott, Kristin 294; Environment 97; Environmental Investigation Agency 337; Farmers Weekly 208; Fellowship 99; Fine Art Productions, InterActive 413; Firehouse 209; Fletcher/Priest Gallery 500; Flint Communications 442; Focus Advertising 457; Forest Landowner 210; Foto Expression International 339; Frontline Photo Press Agency 341; Fuessler Group Inc. 414; Galeria Mesa 501; Gallery Luisotti 502; Gallery Taranto 502; Gallery 218 503; Game & Fish Publications 103; Giarnella Design 415; Global Pictures 344; Grafica 458; Granata Press Service 344; Graphic Arts Center Publishing Company 261; Graphic Design Concepts 459; Grit 107; Growing Edge 211; Havelin Communications 346; Homestead Publishing 264; Horizon International Images Ltd. 346; Horse Illustrated 113; Hutchison Picture Library 347; ICCE 348; IEEE Spectrum 213; Image Concept Inc. 349; Image Works 350; Images Pictures 351; Ims Bildbyra 351; International Wildlife 116; Iowan 117; Isopress Senepart 352; Kali Press 266; Kashrus 119; Keyphotos Int. 354; Kite Lines 120; KBA 354; Kramer and Associates, Joan 355; Lawrence Gallery, J. 509; Lerner Publications 267; Lonely Planet Publications 268; Lucent Books 269; Lynx Images Inc. 269; M.C. Gallery 511; Macalester Gallery 511; Mach 2 Stock Exchange Ltd. 357; Mattei Productions, Michele 358; Mauritius Die Bildagentur GmbH 358; Mayfair 126; McGaw Graphics, Bruce 299; Michelson Galleries, R. 513; Milkweed Editions 270; Mother Earth News 128; Nassar Design 421; National Parks 130; National Wildlife 130; Natural Science Photos 361; Natural Selection Stock Photography Inc. 361; Nature Photographer 132; Network Aspen 362; New York State Conservationist 133; Newsmakers 363; Nonstock Inc. 364; Northeast Export 220; Northwest Photoworks 364; Novastock 365; Novus Visual Communications 422; Noyes Museum of Art 515; Oliver Press 272; Olson & Co., C. 273; Omni-Photo 366; Onboard Media 136; Outdoor America 138; Outpost 140; Owen Publishers, Richard C. 273; OWL 140; Oxford American 140; Oxford Scientific Films 367; Pacific Stock 368; Panoramic Images 369; Paper Age 222; Pennsylvanian 142; Pentimenti Gallery 516; Phoenix Gallery 517; Photo Agora 369; Photo Index 371; Photo Phoenix International 372; Photo 20-20 373; PhotoBank Yokohama 373; PhotoResource 145; Photri Inc.—Microstock 376; Planet Earth Pictures 378; Popular Science 148; PORPOISE PhotoStock 378; Portfolio Graphics 300; Positive Images 378; Professional Photographer/Storytellers 226; Progressive 150; Psychology Today 150; Pucker Gallery 519; Ranger Rick and Your Big Backyard 151; Redmond Design, Patrick 448; Reidmore Books Inc. 276; Resource Recycling 229; Ro-Ma Stock 381; Rosen Publishing Group 277; RSPCA Photolibrary 382; RSVP Marketing 425; S.O.A. Photo Agency 382; San Francisco Conservatory of Music 465; Selbert Perkins Design 425; Silver Image Photo Agency 384; Smart Apple Media 278; Soundlight 467; Spectrum Pictures 386; Stack & Associates, Tom 387; Star Publishing Company 279; Stock Boston Inc. 388; Stock Market 389; Stockhouse 391; Straight 166; Sunrise Publications 304; Surface 167; Syracuse Cultural Workers 304; Think Twice 468; Top Stock 393; Tree Care Industry 235; Tropix Photographic Library 393; Trout 172; Ullstein Bilderdienst 394; Unicorn Stock Photos 394; US Airways Attaché 174; Vermont Life 174; Virginia Wildlife 176; Viridian Artists 524; Visual Hellas 397; Visum/+49 399; Voyageur Press 282; Wach Gallery 524; Waveland Press 283; Weigl Educational Publishers 283; Whiskey Island 179; Wildlife Collection 399; Windrush Photos 400; Yankee 181; Zefa Visual Media 401

Erotic: Agencee d'Illustration Photographique Edimedia 316; Akehurst Bureau Ltd. 317; Alfresco Publications 288; Amelia 61; American Photo Library 318; Anvil Press 247; Art Directors Club 486; Artworks Gallery 488; Ascherman Gallery 488; Austral-International 325; BabyFace 69; Bavaria Bildagentur 325; Benham Studio Gallery 490; Big Pictures UK 327; Center for Photography at Woodstock 494; Center Press 251; Chatham Press 252; Cliff and Assoc. 455; Collector's Choice Gallery 496; Comstock Cards 292; Crumb Elbow Publishing 257; Curry Design, David 411; Daloia Design 293; Duck Soup Graphics 473; EH6 Design Consultants 475; Eleven East Ashland 500; Fahey/Klein Gallery 500; Fine Art Productions, InterActive 413; Fine Press Syndicate 338; First Hand Ltd. 101; Focal Point Gallery 501; Foto Expression 339; Foto-Press Timmerman 340; Friedentag Photographics 457; Galaxy Publications 103; Gallery et. al. 502; Gallery Luisotti 502; Gallery Taranto 502; Gallery 218 503; Gent 105; Giarnella Design 415; Grafica 458; Greenberg Art Publishing, Raymond L. 295; Icebox Quality Framing & Gallery 505; Image Connection America 296; Images Pictures 351; Individual Artists of Oklahoma 507; Jackson Fine Art 508; Keene Kards Inc. 298; Keyphotos Int. 354; Klein Gallery, Robert 508; Kramer and Associates, Joan 355; Lawrence Gallery, J. 509; Leg Sex 122; LIBIDO 123; Lizardi/Harp Gallery 510; Llewellyn Publications 268; Mayfair 126; Media Consultants Inc. 463; Naked 129; National News Bureau 190; Naturist Life International 132; Naughty Neighbors 132; Nonstock Inc. 364; Northwest Photoworks 364; Nova Media Inc. 300; Nugget 135; Orion Press 366; Outburn 138; Photo Phoenix International 372; PhotoResource 145; Playboy 145; Playboy's Newsstand Specials 146; Portfolio Graphics 300; Postal Productions, Steve 436; Recreational Hair News 152; Redmond Design, Patrick 448; Rockshots 302; Roland Gallery 520; Sanghaui

Enterprises Ltd. 303; Score 158; Surface 167; Swank 167; Think Twice 468; Toronto Sun Publishing 193; Vintage Images 396; Wach Gallery 524; Whap! 179; Worldwide Images 400

Events: AAIMS Publishers 245; Accent Alaska/Ken Graham 314; Adirondack Lakes Center for the Arts 484; Aflo Foto Agency 315; After Five 59; Agencee d'Illustration Photographique Edimedia 316; Allpix Photo Agency 318; Amelia 61; American Fitness 62; American Forests 62; American Photo Library 318; Anvil Press 247; Argus Photoland, Ltd. 320; Art Directors & Trip Photo Library 322; Art Directors Club 486; Art Etc. 439; Artwerks Stock Photography 323; ASAP Israel Stock Photo Agency 323; Asia Pacific Photographic Library 323; Austral-International 325; Bavaria Bildagentur 325; Belian Art Center 488; Big Pictures UK 327; Bryant Stock Photography, D. Donne 327; Bynums Advertising Service 410; Camera Press Ltd. 328; Cape Cod Life 80; Capper's 185; Cascade Geographic Society 291; Catholic News Service 329; Center for Photography at Woodstock 494; Charlotte Magazine & Charlotte Home Design 83; Chatham Press 252; Chess Life 83; Cicada 85; Classic CD 86; Cleveland 87; Cliff and Assoc. 455; Comesaña-Agencia De Prensa, Eduardo 331; Compass American Guides 253; Corbis 332; Corel Photo Collection 332; Crabtree Publishing Company 255; Creative Company 255; Crumb Elbow Publishing 257; Cunningham Photographic, Sue 333; Daloia Design 293; Design Conceptions 334; Dinodia Picture Agency 335; Diversion 93; Duck Soup Graphics 473; Dynamic Graphics 294; Eastern Shore Art Center 499; EH6 Design Consultants 475; Eleven East Ashland 500; Famous Pictures & Features 338; Foto Expression 339; Fraser Advertising 434; Frontline Photo Press Agency 341; Galeria Mesa 501; Go Boating 106; Grafica 458; Graphic Design Concepts 459; Guernica Editions 262; Guest Informant 108; Guideposts 109; Holiday Inn Express Navigator 112; Horizons 112; I.G. Publications Ltd. 265; Images Pictures 351; Ims Bildbyra 351; Inspiration Art & Scripture 296; Iowan 117; Isopress Senepart 352; James Design Studio, Peter 435; Junior Scholastic 119; Keyphotos Int. 354; Kite Lines 120; Kollins Communications Inc. 418; KBA 354; Kramer and Associates, Joan 355; Lawrence Gallery, J. 509; Leader 188; Lerner Publications 267; Lippservice 418; M.C. Gallery 511; Marlboro Gallery 512; Mayfair 126; Media Consultants Inc. 463; Model News 189; New England Stock Photo 362; New Mexico 133; Newsmakers 363; Nonstock Inc. 364; Novus Visual Communications 422; Orion Press 366; Our State 137; Outburn 138; Outpost 140; Peak 142; Pentimenti Gallery 516; Persimmon Hill 143; Pet Product News 223; PhotoResource 145; Photri Inc.—Microstock 376; Play The Odds 190; Polo Players Edition 147; Portfolio Graphics 300; Positive Images 378; Powerline 225; Redmond Design, Patrick 448; Reidmore Books Inc. 276; Ro-Ma Stock 381; San Francisco Conservatory of Music 465; Simon Design 426; Skipping Stones 161; Smart Apple Media 278; South Beach Photo Agency 385; Spectrum Pictures 386; Speech Bin Inc. 279; Sport 164; Stock Options® 389; Stockhouse 391; Surface 167; Think Twice 468; Ullstein Bilderdienst 394; US Airways Attaché 174; Viewfinders 396; Vintage Images 396; VisionQuest 397; Vista 176; Wach Gallery 524; Warm Greetings 305; Weigl Educational Publishers 283; Where 179; Wisconsin Trails Books 284

Families: AAA Image Makers 314; AAP News 194; Accent Alaska/Ken Graham 314; Ace Photo Agency 314; Adirondack Lakes Center for the Arts 484; Advanced Graphics 288; Advertising Consortium 453; Aflo Foto Agency 315; Agencee d'Illustration Photographique Edimedia 316; Alive Now 60; Allpix Photo Agency 318; Alphastock 318; Amelia 61; American Bar Assoc. Press 245; American Fitness 62; American Forests 62; American HomeStyle & Gardening 63; American Photo Library 318; American Planning Assoc. 246; Argus Photoland, Ltd. 320; AppaLight 320; Arregui International Advertising 432; Art Directors & Trip Photo Library 322; Art Directors Club 486; Art Etc. 439; Asia Pacific Photographic Library 323; At-Home Mother 68; Austral-International 325; Bavaria Bildagentur 325; Benelux Press 326; Bible Advocate 72; Big Apple Parent 185; Bride Again 76; Bureau for At-Risk Youth 251; Bynums Advertising Service 410; Cape Cod Life 80; Capitol Complex Exhibitions 492; Cascade Geographic Society 291; Catholic News Service 329; Center for Photography at Woodstock 494; Christian Herald 186; Christian Home & School 84; Cleveland 87; Cliff and Assoc. 455; Coastal Center for the Arts 495; Cohen, Steven 433; Coleman Photo Library, Bruce 331; Comesaña-Agencia De Prensa, Eduardo 331; Concord Litho Group 292; Corbis 332; Cordaiy Photo Library, Sylvia 332; Corel Photo Collection 332; CRC Product Services 89; Creative Company 473; Crossing Press 256; Cunningham Photographic, Sue 333; Curry Design, David 411; CYR Color Photo Agency 334; Daloia Design 293; Design Conceptions 334; Dinodia Picture Agency 335; Direct Source Advertising 412; Doyle Advertising Direction, Al 473; Duck Soup Graphics 473; Dynamic Graphics 294; Eastern Shore Art Center 499; Edelstein Gallery, Paul 499; EH6 Design Consultants 475; Family Motor Coaching 98; Family Publishing Group 98; Flint Communications 442; Foto Expression 339; Foto-Press Timmerman 340; Fox, Photographer, David 414; Fraser Advertising 434; Frontline Photo Press Agency 341; Galeria Mesa 501; Giarnella Design 415; Global Pictures 344; Go Boating 106; Gospel Herald 107; Grafica 458; Granata Press Service 344; Graphic Design Concepts 459; Great Quotations Publishing Co. 261; Grit 107; Guest Informant 108; Guideposts 109; Hadassah 109; Hiller Publishing 263; Home Education 112; Horizon International Images Ltd. 346; Hutchison Picture Library 347; Image Concept Inc. 349; Image Connection America 296; Image Finders 349; Image Works 350; Images Pictures 351; Ims Bildbyra 351; Industrial F/X 417; Inspiration Art & Scripture 296; Isopress Senepart 352; James Design Studio, Peter 435; Jaywardene Travel Photo Library 353; Jeroboam 353; Keyphotos Int. 354; Kiwanis 120; Kollins Communications Inc. 418; KBA 354; Kramer and Associates, Joan 355; Latina 122; Lawrence Gallery, J. 509; Leader 188; Lerner Et Al 444; Lieber Brewster Design Inc. 418; Lonely Planet Publications 268; Lutheran 124; M.C. Gallery 511; Mach 2 Stock Exchange Ltd. 357; Marble House Gallery 511; Media Consultants Inc. 463; Mennonite Publishing House 126; Na'amat Woman 129; Nassar Design 421; Native Peoples 130; Nature Conservancy 131; Naturist

Editions 256; Crossing Press 256; Crumb Elbow Publishing 257; Curio 90; Current 293; Curry Design, David 411; Custom & Limited Editions 257; Daloia Design 293; Design Conceptions 334; Designer Greetings 293; Dinodia Picture Agency 335; Duck Soup Graphics 473; Eastern Shore Art Center 499; Edelstein Gallery, Paul 499; Educational Video Network 456; EH6 Design Consultants 475; Elegant Greeting 294; Eleven East Ashland 500; Elliott, Kristin 294; Event 97; Fellowship 99; Field 99; Fletcher/Priest Gallery 500; Focal Point Gallery 501; Foto Expression 339; Foto-Press Timmerman 340; Fox, Photographer, David 414; Galeria Mesa 501; Gallery 825 501; Gallery Luisotti 502; Gallery Taranto 502; Gallery 218 503; Genre 104; German Life 105; Giarnella Design 415; Global Pictures 344; Grafica 458; Graphic Design Concepts 459; Gray Gallery, Wellington B. 504; Greenberg Art Publishing, Raymond L. 295; Guest Informant 108; Guideposts 109; Harper's 110; Harvard Design Magazine 211; Hiller Publishing 263; Holiday Inn Express Navigator 112; Holt, Rinehart and Winston 264; Horizon International Images Ltd. 346; Icebox Quality Framing & Gallery 505; Illinois Art Gallery 506; Image Connection America 296; Images Pictures 351; Ims Bildbyra 351; Indianapolis Art Center 507; Individual Artists of Oklahoma 507; Industrial F/X 417; Inner Traditions Int. 265; Inspiration Art & Scripture 296; Irish Picture Library 352; Isopress Senepart 352; Jackson Fine Art 508; Judicature 215; Kalliope, A Journal of Women's Literature & Art 119; Keyphotos Int. 354; Kiwanis 120; Kramer and Associates, Joan 355; La Mama La Galleria 509; Land of the Bible Photo Archive 355; Lawrence Gallery, J. 509; Le Petit Musée 510; Lerner Publications 267; Lippservice 418; Liturgy Training Publications 267; Lizardi/Harp Gallery 510; Llewellyn Publications 268; Lutheran 124; M.C. Gallery 511; Macalester Gallery 511; Marble House Gallery 511; Marlboro Gallery 512; McGaw Graphics, Bruce 299; Mediphors 126; MIRA 360; Modern Art 299; Museum of Contemporary Photography, Columbia College Chicago 514; Nassar Design 421; Nevada Museum of Art 514; New York Graphic Society 299; Nonstock Inc. 364; Northlight Gallery 515; Northwest Photoworks 364; Nova Media Inc. 300; Novastock 365; Novus Visual Communications 422; Noyes Museum of Art 515; O.K. Harris Works of Art 515; Omni-Photo 366; 198 Gallery 516; Orion Press 366; Outburn 138; Oxford American 140; Peak 142; Pentimenti Gallery 516; Pepper Gallery 517; Persimmon Hill 143; Petersen's Photographic 144; Phoenix Gallery 517; Photo Phoenix International 372; Photo Techniques 223; Photo 20-20 373; PhotoBank Yokohama 373; Photographic Arts Center 275; Photographic Resource Center 518; PhotoResource 145; Photri Inc.—Microstock 376; Pittsburgh City Paper 190; Portfolio Graphics 300; Postal Productions, Steve 436; Poster Porters 301; Press Chapeau 301; Print Center 518; Pucker Gallery 519; Rafelman Fine Arts, Marcia 519; Rag Mag 151; Recreational Hair News 152; Recycled Paper Greetings 301; Redmond Design, Patrick 448; Reed Gallery, Anne 520; Rockford Review 154; Rodale Press 277; Roland Gallery 520; S.O.A. Photo Agency 382; San Francisco Conservatory of Music 465; Santa Barbara Contemporary Arts Forum 521; Schmidt/Dean Spruce 521; Sentimental Sojourn 160; Shapiro Gallery 522; Smart Apple Media 278; Soaring Spirit 162; Soundlight 467; Spectrum Pictures 386; Spinsters Ink 279; SportsSM&H 165; Stack & Associates, Tom 387; State Museum of Pennsylvania 522; Sub-Terrain 166; Sun 166; Surface 167; Tampa Review 168; Taube Museum of Art 522; Think Twice 468; Truth Consciousness/Desert Ashram 280; University Art Gallery, New Mexico State University 523; Uno Mas 173; US Airways Attaché 174; Vanity Fair 174; Vermont 175; Viridian Artists 524; Voyageur Press 282; Wach Gallery 524; Warm Greetings 305; Waveland Press 283; Webster Gallery, Sande 524; Weigl Educational Publishers 283; Westart 193; Whap! 179; Where 179; Whiskey Island 179; Wiesner Inc. 180; Wyckoff Gallery 525; Young Romantic 182

Food/Drink: Ace Photo Agency 314; Adirondack Lakes Center for the Arts 484; Aflo Foto Agency 315; Agencee d'Illustration Photographique Edimedia 316; Alabama Living 59; Allpix Photo Agency 318; American Brewer Magazine 197; American Fitness 62; American HomeStyle & Gardening 63; American Photo Library 318; Ammirati Puris Lintas 408; AM/PM Advertising 408; Argus Photoland, Ltd. 320; Arregui International Advertising 432; Art Directors & Trip Photo Library 322; Art Directors Club 486; Art Etc. 439; Artwerks Stock Photography 323; Asia Pacific Photographic Library 323; Assoc. of Brewers 248; Austral-International Photographic Library 325; AWY Associates 475; Bach Production, Eric 325; Barnett Advertising/Design, Augustus 471; Bartender 200; Bavaria Bildagentur 325; Benelux Press 326; Berson, Dean, Stevens 454; Beverage & Food Dynamics 200; Big Pictures UK 327; Bynums Advertising Service 410; Camera Press Ltd. 328; Caribbean Travel and Life 81; Center for Photography at Woodstock 494; Cephas Picture Library 330; Charlotte Magazine & Charlotte Home Design 83; Chatham Press 252; Chef 201; City Merchandise Inc. 292; Cleveland 87; Cliff and Assoc. 455; Compass American Guides 253; Cordaiy Photo Library, Sylvia 332; Creative Company 473; Crossing Press 256; Crumb Elbow Publishing 257; Cunningham Photographic, Sue 333; Daloia Design 293; Design & More 442; Dinodia Picture Agency 335; Diversion 93; Dockery House Publishing Inc. 257; Eastern Shore Art Center 499; Edelstein Gallery, Paul 499; Educational Video Network 456; EH6 Design Consultants 475; Energy Times 96; Envision 337; Farmers Weekly Picture Library 338; Food & Wine 102; Food Distribution 210; Fordesign Group LTD 413; Foto Expression 339; Franz Design Group 443; Frontline Photo Press Agency 341; Funworld 210; Global Pictures 344; Golden West Publishers 261; Grafica 458; Granata Press Service 344; Graphic Design Concepts 459; Guest Informant 108; Health & Beauty 111; Health Products Business 212; Hippocrene Books Inc. 263; Hodges Associates 434; Holiday Inn Express Navigator 112; Horizon International Images Ltd. 346; Image Concept Inc. 349; Image Finders 349; Images Pictures 351; Ims Bildbyra 351; Inner Traditions Int. 265; Inspiration Art & Scripture 296; Isopress Senepart 352; James Design Studio, Peter 435; Kashrus 119; Kat Kards 298; Keyphotos Int. 354; Kinetic Corporation 444; KBA 354; Kramer and Associates, Joan 355; Latina 122; Lawrence Gallery, J. 509; Le Petit Musée 510; Lerner Publications 267; Lieber Brewster Design Inc. 418; Marketing & Technology Group 217; Mayfair 126; Merims Communications, Art 446; Mississippi Publishers 189; Modern Baking 217; National Gardening 129; Nawrocki Stock Photo 361; New York

Get America's #1 Writing Resource Delivered to Your Door—and Save!

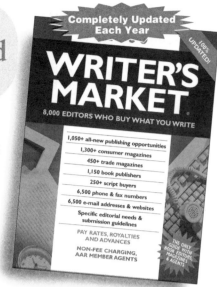

Completely Updated Each Year

WRITER'S MARKET

8,000 EDITORS WHO BUY WHAT YOU WRITE

- 1,050+ all-new publishing opportunities
- 1,300+ consumer magazines
- 450+ trade magazines
- 1,150 book publishers
- 250+ script buyers
- 6,500 phone & fax numbers
- 6,500 e-mail addresses & websites
- Specific editorial needs & submission guidelines
- PAY RATES, ROYALTIES AND ADVANCES
- NON-FEE CHARGING, AAR MEMBER AGENTS

THE ONLY GUIDE WITH BOOK EDITORS, MAGAZINES & AGENTS

Finding the right markets for your work is crucial to your success. With constant changes in the publishing industry, staying informed as to who, where and why is a challenge. That's why every year the most savvy writers turn to the new edition of *Writer's Market* for the most up-to-date information on the people and places that will get their work published and sold (over 8,000 editors and contact information is included). This definitive resource also features insider tips from successful industry professionals which will further increase publishing opportunities.

2001 Writer's Market will be published and ready for shipment in August 2000.

Through this special offer, you can get the *2001 Writer's Market* at the 2000 price—just $27.99!

> Order these essential resources at your local bookstore, or use the handy order card on the reverse.

NOW AVAILABLE! Writer's Market on CD-ROM!
The fastest, easiest way to locate your most promising markets!

Now you can get the vital *Writer's Market* information in a compact, searchable, electronic CD-ROM format. It's easier than ever to locate the information you need...fast! The electronic edition also includes these additional features:

2000
WRITER'S MARKET
THE ELECTRONIC EDITION

Book/ CD Combo

- **Customized search capabilities**—set any parameters (by pay rates, subject, state, or any other criteria).
- **Submission Tracker**—create and call up submission records to see which publishers are past due answering your queries, or late in paying.
- **Writer's Guidelines**—more listings now include all the data you need to submit your work. No more writing for guidelines.
- **Writer's Encyclopedia, Third Edition**—this handy reference tool is also included—at no additional cost!

Writer's Market can make the difference between a sale and a rejection. So order today!

More Great Books to Help You Sell Your Work!

Latest Edition! 2000 Novel & Short Story Writer's Market
edited by Barbara Kuroff
Discover buyers hungry for your work! You'll find the names, addresses, pay rates and editorial needs of thousands of fiction publishers. Plus, loads of helpful articles and informative interviews with professionals who know what it takes to get published! #10625/$24.99/675 pages/paperback/available January 2000

Totally Updated! 2000 Guide to Literary Agents
edited by Donya Dickerson
Enhance your chances of publishing success by teaming up with an agent! You'll find more than 500 listings of literary and script agents, plus valuable information about how to choose the right agent to represent your work. #10627/$21.99/335 pages/paperback/available January 2000

The Insider's Guide to Getting an Agent
by Lori Perkins
In today's fast-paced publishing industry, getting an agent is crucial—but where do you begin to find one that's right for you? Lori Perkins takes the mystery out of finding an agent by providing an industry overview, explaining the role and responsibilities of an agent, then guiding you through researching and contacting an agent. #10630/$16.99/240 pages paperback

Formatting & Submitting Your Manuscript
This easy-to-use guide offers dozens of charts, lists, models and sidebars to show you exactly what it takes to successfully submit your work. You'll find information on creating effective query letters, proposals, outlines, synopses and follow-up correspondence. #10618/$18.99/208 pgs/paperback

Graphic Society 299; Newsmakers 363; Nonstock Inc. 364; Northwest Photoworks 364; Novus Visual Communications 422; Ohio Tavern News 221; Omni-Photo 366; Orion Press 366; Outpost 140; Over the Back Fence 140; Pacific Stock 368; Peak 142; Pelican Publishing Co. 274; Photo Index 371; Photo Library 371; Photo 20-20 373; PhotoResource 145; Photri Inc.—Microstock 376; Play The Odds 190; Playboy 145; Portfolio Graphics 300; Positive Images 378; Postal Productions, Steve 436; QSR 227; Redmond Design, Patrick 448; Reflexion Phototheque 380; Reidmore Books Inc. 276; RESO EEIG 380; Restaurant Hospitality 229; Ristorante 230; Ro-Ma Stock 381; Rutledge Hill Press 278; S.O.A. Photo Agency 382; Smart Apple Media 278; Spectrum Stock Inc. 386; Spirit 163; Stock Boston Inc. 388; Stock House Ltd. 389; Stock Options® 389; Stockhouse 391; Surface 167; Telluride Stock Photography 392; Think Twice 468; Tide-Mark Press 304; Tuttle Publishing 281; Ultrastock 394; Unicorn Stock Photos 394; US Airways Attaché 174; Vintage Images 396; Visual Contact 397; Visual Hellas 397; Visual Photo Library 398; Visuals Unlimited 398; Warner Books 283; Washingtonian 177; Weigl Educational Publishers 283; Where 179; Wine & Spirits 180; Woman's Day Special Interest Publications 181; Yankee 181; Your Health 182; Zefa Visual Media 401

Gardening: Accent Alaska/Ken Graham 314; Adirondack Lakes Center for the Arts 484; Aflo Foto Agency 315; Agencee d'Illustration Photographique Edimedia 316; Agritech Publishing Group Inc. 245; Alabama Living 59; Alive Now 60; Allpix Photo Agency 318; American Forests 62; American Gardener 62; American HomeStyle & Gardening 63; American Photo Library 318; Argus Photoland, Ltd. 320; AppaLight 320; Archipress 321; Arregui International Advertising 432; Art Directors Club 486; Art Independent Gallery 487; Art Resource International/Bon Art 288; Asia Pacific Photographic Library 323; Atlanta Homes & Lifestyles 68; Aurora & Quanta Productions 324; Austral-International 325; Back Home in Kentucky 69; Bavaria Bildagentur 325; Benelux Press 326; Bird Watcher's Digest 72; Bird Watching 72; Birds & Blooms 73; Cape Cod Life 80; Capitol Complex Exhibitions 492; Cascade Geographic Society 291; Center for Photography at Woodstock 494; Charlotte Magazine & Charlotte Home Design 83; Chatham Press 252; Cicada 85; Cipra Ad Agency 472; Clark Gallery, Catharine 495; Cleveland 87; Coastal Center for the Arts 495; Coffee House Press 253; Concord Litho Group 292; Cordaiy Photo Library, Sylvia 332; Country 89; Countryman Press 255; Creative Company 473; Creative Company 255; Crumb Elbow Publishing 257; Current 293; Daloia Design 293; Dinodia Picture Agency 335; Diversion 93; Dummies Trade Press/IDG Books 259; Dynamic Graphics 294; Eastern Shore Art Center 499; Ecoscene 336; EH6 Design Consultants 475; Elegant Greeting 294; Farm & Ranch Living 99; Farnam Companies 457; Field 99; Flint Communications 442; Flower & Garden 101; Foto Expression 339; Galeria Mesa 501; Gallery Naga 502; Garden & Wildlife Matters 343; Gardenimage 343; German Life 105; Global Pictures 344; Grafica 458; Graphic Design Concepts 459; Greenberg Art Publishing, Raymond L. 295; Grit 107; Growing Edge 211; Hearth and Home 212; Hiller Publishing 263; Holiday Inn Express Navigator 112; Horticultural Photography™ 347; Horticulture 113; Howell Press 265; Hutchison Picture Library 347; Image Finders 349; Ims Bildbyra 351; Industrial F/X 417; Inspiration Art & Scripture 296; Jackson Fine Art 508; James Design Studio, Peter 435; Keyphotos Int. 354; KBA 354; Kramer and Associates, Joan 355; Lawrence Gallery, J. 509; Layla Production Inc. 266; Llewellyn Publications 268; M.C. Gallery 511; Marble House Gallery 511; Media Consultants Inc. 463; Miracle of Aloe 419; Modern Art 299; Mother Earth News 128; Mountain Living 128; National Gardening 129; New York Graphic Society 299; Nonstock Inc. 364; Northwest Photoworks 364; Novus Visual Communications 422; Okapia K.G. 365; Orion Press 366; Our State 137; Oxford Scientific Films 367; Pentimenti Gallery 516; Peter Pauper Press 274; Photo Agora 369; PhotoBank Yokohama 373; PhotoResource 145; Portfolio Graphics 300; Positive Images 378; Redmond Design, Patrick 448; Reiman Publications, L.P. 277, 301; Reminisce 153; RESO EEIG 380; Rodale Press 277; Ro-Ma Stock 381; S.O.A. Photo Agency 382; Sanghaui Enterprises Ltd. 303; Sparrow & Jacobs 303; Spectrum Stock Inc. 386; Stockhouse 391; Surface 167; Syracuse Cultural Workers 304; Think Twice 468; Tide-Mark Press 304; Tree Care Industry 235; Truth Consciousness/Desert Ashram 280; Unicorn Stock Photos 394; Vermont Life 174; Viewfinders 396; Visuals Unlimited 398; Wach Gallery 524; Washingtonian 177; Weigl Educational Publishers 283; Woman's Day Special Interest Publications 181; Zefa Visual Media 401

Health/Fitness: AAA Image Makers 314; AAP News 194; Accent Alaska/Ken Graham 314; Accent on Living 57; Ace Photo Agency 314; Adirondack Lakes Center for the Arts 484; Advertising Consortium 453; Aflo Foto Agency 315; After Five 59; Agencee d'Illustration Photographique Edimedia 316; Allpix Photo Agency 318; Allyn and Bacon Publishers 245; Alphastock 318; Amelia 61; American Fitness 62; American Forests 62; American Photo Library 318; Argus Photoland, Ltd. 320; Arregui International Advertising 432; Art Directors & Trip Photo Library 322; Art Directors Club 486; Art Resource International/Bon Art 288; Artwerks Stock Photography 323; Asia Pacific Photographic Library 323; Austral-International 325; Barnett Advertising/Design, Augustus 471; Bavaria Bildagentur 325; Beauty Handbook 71; Benelux Press 326; Big Pictures UK 327; BVK/McDonald Inc. 440; Bynums Advertising Service 410; CardMakers 290; Cascade Geographic Society 291; Catholic Health World 186; Center for Photography at Woodstock 494; Chatham Press 252; Children's Digest 84; Christian Herald 186; Cleveland 87; Cliff and Assoc. 455; College Preview 88; Comesaña-Agencia De Prensa, Eduardo 331; Complete Woman 88; Corbis 332; Cordaiy Photo Library, Sylvia 332; Corel Photo Collection 332; Creative Company 473; Creative Company 255; Crossing Press 256; Crumb Elbow Publishing 257; Curio 90; Custom Medical Stock Photo 333; Daloia Design 293; Dance Teacher 205; Design Conceptions 334; Dinodia Picture Agency 335; Duck Soup Graphics 473; Dynamic Graphics 294; Eastern Shore Art Center 499; Ecoscene 336; Educational Video Network 456; EH6 Design Consultants 475; Energy Times 96; Focus Advertising 457;

Foto Expression 339; Foto-Press Timmerman 340; Fraser Advertising 434; Frontline Photo Press Agency 341; Global Pictures 344; Golf Tips 106; Grafica 458; Granata Press Service 344; Graphic Design Concepts 459; Grit 107; Guest Informant 108; Health & Beauty 111; Health Products Business 212; Holiday Inn Express Navigator 112; Holt, Rinehart and Winston 264; Horizon International Images Ltd. 346; Hutchison Picture Library 347; Image Concept Inc. 349; Image Works 350; Images Pictures 351; Ims Bildbyra 351; Inspiration Art & Scripture 296; Isopress Senepart 352; James Design Studio, Peter 435; Journal of Psychoactive Drugs 215; Kali Press 266; Keyphotos Int. 354; Kollins Communications Inc. 418; KBA 354; Kramer and Associates, Joan 355; Latina 122; Lawrence Gallery, J. 509; Lerner Et Al 444; Lerner Publications 267; Lieber Brewster Design Inc. 418; Llewellyn Publications 268; Mattei Productions, Michele 358; Mayfair 126; Media Consultants Inc. 463; Medical Images Inc. 358; Medichrome 359; Mediphors 126; MIRA 360; Musclemag Int. 128; Nailpro 218; New Choices Living Even Better After 50 132; Nonstock Inc. 364; Northwest Photoworks 364; Nova Media Inc. 300; Novastock 365; Novus Visual Communications 422; Okapia K.G. 365; Omni-Photo 366; Orion Press 366; Oxygen 141; Ozark Stock 367; Pacific Stock 368; Peak 142; Photo Agora 369; Photo Library 371; Photo Phoenix International 372; Photo 20-20 373; PhotoResource 145; Picturesque Stock Photos 377; PN/Paraplegia News 146; Portfolio Graphics 300; Positive Images 378; Prevention 148; Prime Time Sports & Fitness 149; Redmond Design, Patrick 448; RESO EEIG 380; Retired Officer 230; Rodale Press 277; Ro-Ma Stock 381; Rosen Publishing Group 277; S.O.A. Photo Agency 382; Secure Retirement 159; Selbert Perkins Design 425; Smart Apple Media 278; Soundlight 467; Specialty Travel Index 233; Spectrum Pictures 386; Spectrum Stock Inc. 386; Sport 164; Stock Boston Inc. 388; Stock House Ltd. 389; Stock Shot 390; Stockhouse 391; Sun 192; Swanson Russell and Associates 450; Telluride Stock Photography 392; Think Twice 468; Ullstein Bilderdienst 394; Ultrastock 394; Ulysses Press 281; Unicorn Stock Photos 394; Viewfinders 396; Vintage Images 396; VisionQuest 397; Visual Hellas 397; Visual Photo Library 398; Visuals Unlimited 398; Visum/+49 399; Woman's Day Special Interest Publications 181; Woodmen 181; Yoga Journal 182; Your Health 182; Zefa Visual Media 401

Historical/Vintage: AAA Midwest Traveler 57; Adirondack Lakes Center for the Arts 484; Agencee d'Illustration Photographique Edimedia 316; Alaska Stock Images 317; Allen Photo Library, J. Catling 318; Amelia 61; American Forests 62; American Photo Library 318; American Planning Assoc. 246; American Power Boat Assoc. 198; Ancient Art & Architecture Collection 319; AppaLight 320; Archipress 321; Archive Photos 322; Art Concepts by Design 486; Art Directors Club 486; Artwerks Stock Photography 323; Ascherman Gallery/Cleveland Photographic Workshop 488; Austral-International 325; Barnett Advertising/Design, Augustus 471; Bavaria Bildagentur 325; Bedford/St. Martin's 249; Benelux Press 326; Benham Studio Gallery 490; Bennett Studios, Bruce 326; California Views 328; Calliope 77; Cape Cod Life 80; Capitol Complex Exhibitions 492; CardMakers 290; Carr Gallery, Claudia 492; Cascade Geographic Society 291; Chatham Press 252; Chinastock 330; Classic CD 86; Classics 86; Cliff and Assoc. 455; Coastal Center for the Arts 495; Cobblestone: American History for Kids 87; Coffee House Press 253; Cohen, Steven 433; Collector's Choice Gallery 496; Comesaña-Agencia De Prensa, Eduardo 331; Compass American Guides 253; Concord Litho Group 292; Corbis 332; Cordaiy Photo Library, Sylvia 332; Corel Photo Collection 332; Country 89; Countryman Press 255; Creative Company 473; Creative Company 255; Creative Editions 256; Crumb Elbow Publishing 257; Daloia Design 293; Designer Greetings 293; Dinodia Picture Agency 335; Duck Soup Graphics 473; Eastern Press 259; Eastern Shore Art Center 499; EH6 Design Consultants 475; Elegant Greeting 294; Farm & Ranch Living 99; Fifth House Publishers 260; Firepix Int. 339; Foto Expression 339; Fraser Advertising 434; Frith Creative Resourcing 414; Frontline Photo Press Agency 341; Galaxy Contact 342; Galeria Mesa 501; Gallery Luisotti 502; Gallery Taranto 502; German Life 105; Global Pictures 344; Grafica 458; Graphic Design Concepts 459; Grit 107; Guest Informant 108; Guideposts 109; Harper's 110; Harvard Design Magazine 211; Hiller Publishing 263; Historic Traveler 111; Holiday Inn Express Navigator 112; Horizon International Images Ltd. 346; Horizons 112; Howell Press 265; Illinois Art Gallery 506; Image Connection America 296; Image Finders 349; Images Pictures 351; Ims Bildbyra 351; Industrial F/X 417; Inner Traditions Int. 265; Inspiration Art & Scripture 296; Iowan 117; Irish Picture Library 352; Isopress Senepart 352; Italian America 117; ITechnology Journal 118; Judicature 215; Keyphotos Int. 354; Kramer and Associates, Joan 355; Kufa Gallery 509; Land of the Bible Photo Archive 355; Lawrence Gallery, J. 509; Le Petit Musée 510; Lerner Publications 267; Lewis Lehr 510; Llewellyn Publications 268; Lonely Planet Publications 268; Lucent Books 269; Lynx Images Inc. 269; Macalester Gallery 511; Marble House Gallery 511; McGaw Graphics, Bruce 299; MIRA 360; Muzzle Blasts 129; Nails 218; Naval History 219; New England Stock Photo 362; New York State Conservationist 133; Nonstock Inc. 364; Northlight Gallery 515; Northwest Photoworks 364; Nova Media Inc. 300; Novus Visual Communications 422; Orion Press 366; Our State 137; Oxford American 140; Pacific Yachting 141; Peak 142; Penn-Jude Partners 464; Pentimenti Gallery 516; Persimmon Hill 143; Photo Techniques 223; Photo 20-20 373; PhotoResource 145; Photri Inc.—Microstock 376; Portfolio Graphics 300; Poster Porters 301; Press Chapeau 301; Rafelman Fine Arts, Marcia 519; Recreational Hair News 152; Recycled Paper Greetings 301; Red Venus Gallery 519; Redmond Design, Patrick 448; Reidmore Books Inc. 276; Reiman Publications, L.P. 277; Reminisce 153; Rex USA Ltd. 381; Rodale Press 277; Roland Gallery 520; Rosen Publishing Group 277; S.O.A. Photo Agency 382; Selbert Perkins Design 425; Silver Moon Press 278; Smart Apple Media 278; Spectrum Pictures 386; Sport 164; State 165; Syracuse Cultural Workers 304; Tropix Photographic Library 393; Ullstein Bilderdienst 394; US Airways Attaché 174; Vintage Images 396; Voyageur Press 282; Wach Gallery 524; Waveland Press 283; Weigl Educational Publishers 283; Whap! 179; Wisconsin Trails Books 284; Year One Inc. 438; Young Romantic 182; Zefa Visual Media 401

Hobbies: Accent Alaska/Ken Graham 314; Ace Photo Agency 314; Adirondack Lakes Center for the Arts 484; Aflo Foto Agency 315; After Five 59; Allpix Photo Agency 318; Amelia 61; American Bee Journal 196; American Fitness 62; American Forests 62; American Photo Library 318; American Power Boat Association 198; Argus Photoland, Ltd. 320; Art Directors & Trip Photo Library 322; Art Directors Club 486; Artwerks Stock Photography 323; Asia Pacific Photographic Library 323; Assoc. of Brewers 248; Aurora & Quanta Productions 324; Austral-International 325; Bavaria Bildagentur 325; Benelux Press 326; Big Pictures UK 327; Bird Watching 72; CardMakers 290; Cascade Geographic Society 291; Center for Photography at Woodstock 494; Classics 86; Cliff and Assoc. 455; Coleman Photo Library, Bruce 331; Corbis 332; Corel Photo Collection 332; Creative Company 255; Crumb Elbow Publishing 257; Daloia Design 293; Dinodia Picture Agency 335; Diversion 93; Eastern Shore Art Center 499; Educational Video Network 456; EH6 Design Consultants 475; Family Motor Coaching 98; Figurines & Collectibles 99; Finescale Modeler 100; Foto Expression 339; Foto-Press Timmerman 340; Front Striker Bulletin 187; Galeria Mesa 501; Games 104; Garden & Wildlife Matters 343; Global Pictures 344; Grafica 458; Graphic Design Concepts 459; Grit 107; Hiller Publishing 263; Holiday Inn Express Navigator 112; Horizons 112; Howell Press 265; Image Concept Inc. 349; Images Pictures 351; Ims Bildbyra 351; Industrial F/X 417; Inspiration Art & Scripture 296; Isopress Senepart 352; Keyphotos Int. 354; Kite Lines 120; Kollins Communications Inc. 418; KBA 354; Kramer and Associates, Joan 355; Lawrence Gallery, J. 509; Marble House Gallery 511; Mature Outlook 125; Mayfair 126; Mennonite Publishing House 126; Muzzle Blasts 129; Naturally Nude Recreation & Travel 131; New Moon® 133; Nonstock Inc. 364; Northwest Photoworks 364; Novastock 365; Novus Visual Communications 422; Orion Press 366; OWL 140; Peak 142; Pet Reptile 143; Photo Phoenix International 372; PhotoBank Yokohama 373; PhotoResource 145; Popular Science 148; Portfolio Graphics 300; Postal Productions, Steve 436; Redmond Design, Patrick 448; Reidmore Books Inc. 276; RESO EEIG 380; Smart Apple Media 278; Soaring 162; Soundlight 467; SPFX 163; Stock Boston Inc. 388; Stockhouse 391; Think Twice 468; Tide-Mark Press 304; Ullstein Bilderdienst 394; Unicorn Stock Photos 394; US Airways Attaché 174; Vintage Images 396; Visual Hellas 397; Visuals Unlimited 398; Weigl Educational Publishers 283; With 180; Zefa Visual Media 401

Humor: AAA Midwest Traveler 57; Accent Alaska/Ken Graham 314; Accent on Living 57; Ace Photo Agency 314; Adirondack Lakes Center for the Arts 484; Aflo Foto Agency 315; After Five 59; Allpix Photo Agency 318; Amelia 61; American Motorcyclist 63; American Photo Library 318; Anvil Press 247; Argus Photoland, Ltd. 320; AppaLight 320; Art Directors & Trip Photo Library 322; Art Directors Club 486; Asia Pacific Photographic Library 323; Austral-International 325; Avanti Press Inc. 289; Bavaria Bildagentur 325; Benelux Press 326; Benham Studio Gallery 490; BePuzzled 289; Big Pictures UK 327; Birds & Blooms 73; Camera Press Ltd. 328; Campus Life 78; CardMakers 290; Cascade Geographic Society 291; Catholic News Service 329; Center for Photography at Woodstock 494; Centric Corp. 291; Cicada 85; Cleveland 87; Cliff and Assoc. 455; Comesaña-Agencia De Prensa, Eduardo 331; Comstock Cards 292; Corel Photo Collection 332; Creative Company 473; Crumb Elbow Publishing 257; Current 293; Daloia Design 293; Design Design 293; Designer Greetings 293; Dinodia Picture Agency 335; Driving 95; Eastern Shore Art Center 499; EH6 Design Consultants 475; Elegant Greeting 294; Fellowship 99; Flashcards 294; Foto Expression 339; Fotofolio 295; Galeria Mesa 501; Gallery Taranto 502; Giarnella Design 415; Global Pictures 344; Grafica 458; Graphic Design Concepts 459; Great Quotations Publishing Co. 261; Greenberg Art Publishing, Raymond L. 295; Grit 107; Holiday Inn Express Navigator 112; Horizon International Images Ltd. 346; Image Concept Inc. 349; Image Connection America 296; Images Pictures 351; Ims Bildbyra 351; Inspiration Art & Scripture 296; Isopress Senepart 352; James Design Studio, Peter 435; Kashrus 119; Keene Kards Inc. 298; Keyphotos Int. 354; Kogle Cards 298; KBA 354; Kramer and Associates, Joan 355; Latina 122; Lawrence Gallery, J. 509; Marketers Forum 217; Mayfair Magazine 126; Musclemag Int. 128; Noch & Associates, Andrew 299; Nonstock Inc. 364; Novastock 365; Novus Visual Communications 422; Oklahoma Today 136; Orion Press 366; Our Family 137; Over the Back Fence 140; OWL 140; Peak 142; Photo Technique 144; PhotoBank Yokohama 373; PhotoResource Magazine 145; Photri Inc.—Microstock 376; Police 224; Psychology Today 150; Ranger Rick and Your Big Backyard 151; Recycled Paper Greetings 301; Redmond Design, Patrick 448; RESO EEIG 380; Rockshots 302; Rural Heritage 155; S.O.A. Photo Agency 382; Shooter's Rag—The Practical Photographic Gazette 232; Silver Image Photo Agency 384; Simon Design 426; Soundlight 467; Sparrow & Jacobs 303; Spectrum Pictures 386; Stockhouse 391; Sun 192; Surface 167; Think Twice 468; Tide-Mark Press 304; Trailer Boats 170; Ultrastock 394; Unique Greetings 305; US Airways Attaché 174; Vermont Life 174; Vintage Images 396; VisionQuest 397; Visual Hellas 397; Visuals Unlimited 398; With 180; Woodmen 181; Worldwide Images 400; Zefa Visual Media 401

Industry: AAA Image Makers 314; Accent Alaska/Ken Graham 314; Ace Photo Agency 314; Across the Board 58; Advanced Manufacturing 195; Aflo Foto Agency 315; Agencee d'Illustration Photographique Edimedia 316; Allpix Photo Agency 318; Alphastock 318; American Metal Market 184; American Photo Library 318; American Planning Assoc. 246; Anvil Press 247; Argus Photoland, Ltd. 320; Art Concepts by Design 486; Art Directors Club 486; Art Etc. 439; Artwerks Stock Photography 323; ASAP Israel Stock Photo Agency 323; Asia Pacific Photographic Library 323; Asian Enterprise 199; Assoc. of Brewers 248; Atlantic Publication Group Inc. 199; Aurora & Quanta Productions 324; Australian Picture Library 324; Austral-International 325; Avionics 200; Barry Associates, Bob 409; Bavaria Bildagentur 325; Benelux Press 326; Bryant Stock Photography, D. Donne 327; Business NH 201; Cascade Geographic Society 291; Center for Photography at Woodstock 494; Cleveland 87; Cliff and Assoc. 455; Coleman Photo Library, Bruce 331; Comesaña-Agencia De Prensa, Eduardo 331;

Community Darkroom 546; Cordaiy Photo Library, Sylvia 332; Corel Photo Collection 332; Covenant Companion 89; Cranberries 204; Creative Company 473; Creative Company 255; Crumb Elbow Publishing 257; Cunningham Photographic, Sue 333; Daloia Design 293; Dinodia Picture Agency 335; Duck Soup Graphics 473; Ecoscene 336; Educational Video Network 456; EGD & Associates 442; EH6 Design Consultants 475; Electrical Apparatus 206; Farnam Companies 457; Flint Communications 442; Foto Expression 339; Fotoconcept Inc. 340; Foto-Press Timmerman 340; Fraser Advertising 434; Friedentag Photographics 457; Frontline Photo Press Agency 341; Fuessler Group Inc. 414; Galeria Mesa 501; Gallery Taranto 502; Global Pictures 344; Grafica 458; Granata Press Service 344; Grand Rapids Business Journal 187; Graphic Design Concepts 459; Heating, Plumbing & Air Conditioning 212; Hodges Associates 434; Horizon International Images Ltd. 346; Horizons 112; Hot Shots Stock Shots 347; Hutchison Picture Library 347; Ideal Images 348; IEEE Spectrum 213; Image Concept Inc. 349; Image Finders 349; Images Pictures 351; Ims Bildbyra 351; Individual Artists of Oklahoma 507; Indoor Comfort News 213; Industrial F/X 417; Insight Associates 417; International Publishing Management Assoc. 187; Isopress Senepart 352; ITechnology Journal 118; James Design Studio, Peter 435; Keyphotos Int. 354; Kinetic Corporation 444; KBA 354; Kramer and Associates, Joan 355; Lawrence Gallery, J. 509; Lerner Et Al 444; Lerner Publications 267; Lieber Brewster Design Inc. 418; Lohre & Associates Inc. 445; Mach 2 Stock Exchange Ltd. 357; Marketaide 463; Marketing & Technology Group 217; McAndrew Advertising Co. 419; Media Consultants Inc. 463; Megapress Images 359; MG Design Associates 446; Multinational Monitor 128; Nelson Productions 446; Network Aspen 362; Newsmakers 363; Nonstock Inc. 364; Northeast Export 220; Northwest Photoworks 364; Novastock 365; Novus Visual Communications 422; Okapia K.G. 365; Oliver Press 272; Omni-Photo 366; Orion Press 366; Oxford Scientific Films 367; Pacific Stock 368; Panoramic Images 369; Paper Age 222; Penn-Jude Partners 464; People Management 222; Pet Product News 223; Photo Index 371; Photo Library 371; Photo Network 371; Photo 20-20 373; PhotoBank Yokohama 373; Photophile 375; PhotoResource 145; Photri Inc.—Microstock 376; Picture Cube Inc. 376; Picturesque Stock Photos 377; Pihera Advertising Associates 447; Plastics News 224; Popular Science 148; PORPOISE PhotoStock 378; Portfolio Graphics 300; Postal Productions, Steve 436; Professional Photographer/Storytellers 226; Promotivision 447; Public Works 227; QSR 227; Quick Frozen Foods International 228; Redmond Design, Patrick 448; Reflexion Phototheque 380; Reidmore Books Inc. 276; RESO EEIG 380; Resource Recycling 229; Ro-Ma Stock 381; S.O.A. Photo Agency 382; Scrap 231; Selbert Perkins Design 425; Smart Apple Media 278; Southern Lumberman 233; Spectrum Pictures 386; Spectrum Stock Inc. 386; Stock Boston Inc. 388; Stock Broker 388; Stock House Ltd. 389; Stock Market 389; Stock Options® 389; Stock Shop 390; Stockhouse 391; Superstock Inc. 391; Take 1 Productions 450; Take Stock Inc. 392; Tansky Advertising Co., Ron 467; Think Twice 468; Thomas, Martin 427; Travel Productions 428; Tropix Photographic Library 393; Truck Accessory News 235; Ullstein Bilderdienst 394; Ultrastock 394; Varon & Associates 451; Video I-D 451; Viewfinders 396; Vintage Images 396; VisionQuest 397; Visual Contact 397; Visual Hellas 397; Visum/+49 399; Wach Gallery 524; Warne Marketing & Communications 475; Weigl Educational Publishers 283; Wholesaler 236; Wines & Vines 236; Worcester Polytechnic Institute 429; World Fence News 237; World Fishing 237; Zefa Visual Media 401

Interiors/Decorating: Allpix Photo Agency 318; Alphastock 318; Argus Photoland, Ltd. 320; Arcaid 321; Art Concepts by Design 486; Art Directors & Trip Photo Library 322; Art Directors Club 486; Art Resource International/Bon Art 288; Asia Pacific Photographic Library 323; Austral-International 325; Bavaria Bildagentur 325; Benelux Press 326; Bride's 76; Cape Cod Life 80; Caribbean Travel and Life 81; Charlotte Magazine & Charlotte Home Design 83; Cicada 85; Cleveland 87; Cliff and Assoc. 455; Coastal Center for the Arts 495; Commercial Building 203; Crumb Elbow Publishing 257; Daloia Design 293; Decorative Artist's Workbook 91; Dinodia Picture Agency 335; Downey Communications 412; Eastern Shore Art Center 499; EH6 Design Consultants 475; Elliott, Kristin 294; Foto Expression 339; FPG International LLC 341; Fraser Advertising 434; German Life 105; Global Pictures 344; Grafica 458; Graphic Design Concepts 459; Holiday Inn Express Navigator 112; Home Lighting & Accessories 212; Hutchison Picture Library 347; Ims Bildbyra 351; Industrial F/X 417; Jackson Fine Art 508; James Design Studio, Peter 435; Kashrus 119; Keyphotos Int. 354; KBA 354; Kramer and Associates, Joan 355; Lawrence Gallery, J. 509; Le Petit Musée 510; Log Home Living 123; Magazine Antiques 125; Media Consultants Inc. 463; MGI Publications 217; Mountain Living 128; Nailpro 218; Nassar Design 421; Nonstock Inc. 364; Novus Visual Communications 422; Orion Press 366; Photo Phoenix International 372; PhotoBank Yokohama 373; PORPOISE PhotoStock 378; Portfolio Graphics 300; Press Chapeau 301; Pucker Gallery 519; Redmond Design, Patrick 448; RESO EEIG 380; Stock House Ltd. 389; Stockhouse 391; Surface 167; Think Twice 468; US Airways Attaché 174; Visual Hellas 397; Visuals Unlimited 398; Where 179; Woman's Day Special Interest Publications 181; Zefa Visual Media 401

Landscapes/Scenics: AAA Michigan Living 57; Ace Photo Agency 314; Adirondack Lakes Center for the Arts 484; Adventure Photo & Film 315; Advertising Consortium 453; After Five 59; Akehurst Bureau Ltd. 317; Alabama Living 59; Alaska Stock Images 317; Alfred Publishing Co. 245; Alive Now 60; Allpix Photo Agency 318; Amelia 61; America House Communications 408; America West Airlines 61; American Agriculturist 196; American Bible Society 246; American Forests 62; American Gardener 62; American Photo Library 318; Argus Photoland, Ltd. 320; A + E 320; Appalachian Trailway News 66; AppaLight 320; Archipress 321; Arnold Publishing Ltd. 248; Arregui International Advertising 432; Art Concepts by Design 486; Art Directors & Trip Photo Library 322; Art Directors Club 486; Art Etc. 439; Art Independent Gallery 487; Art Resource International/Bon Art 288; Artwerks Stock Photography 323; Artworks Gallery 488; ASAP Israel Stock Photo Agency 323; Ascher-

Multicultural: AAA Image Makers 314; Accent Alaska/Ken Graham 314; Ace Photo Agency 314; Adirondack Lakes Center for the Arts 484; Advanced Graphics 288; Aflo Foto Agency 315; Agencee d'Illustration Photographique Edimedia 316; AIM 59; Alive Now 60; Allpix Photo Agency 318; Allyn and Bacon Publishers 245; Amelia 61; American Bible Society 246; American Fitness 62; American Forests 62; American Photo Library 318; American Planning Assoc. 246; Anvil Press 247; Argus Photoland, Ltd. 320; AppaLight 320; Arnold Publishing Ltd. 248; Arregui International Advertising 432; Art Concepts by Design 486; Art Directors & Trip Photo Library 322; Art Directors Club 486; Art in General 486; Artworks Gallery 488; Asia Pacific Photographic Library 323; Asian Enterprise 199; Aurora & Quanta Productions 324; Austral-International 325; Bavaria Bildagentur 325; Beacon Press 249; Bedford/St. Martin's 249; Benelux Press 326; Benham Studio Gallery 490; Bible Advocate 72; Brazzil 75; Bryant Stock Photography, D. Donne 327; Bureau for At-Risk Youth 251; Bynums Advertising Service 410; Campus Life 78; Capitol Complex Exhibitions 492; Career Focus 81; Cascade Geographic Society 291; Center for Photography at Woodstock 494; Charlesbridge Publishing 252; Christian Century 84; Christian Home & School 84; Christian Ministry 201; Cleveland 87; Cliff and Assoc. 455; Coastal Center for the Arts 495; Coffee House Press 253; Coleman Photo Library, Bruce 331; Collector's Choice Gallery 496; Compass American Guides 253; Concord Litho Group 292; Corbis 332; Cordaiy Photo Library, Sylvia 332; Corel Photo Collection 332; Crabtree Publishing Company 255; Creative Company 473; Crossing Press 256; Crumb Elbow Publishing 257; Cunningham Photographic, Sue 333; Curry Design, David 411; Daloia Design 293; DECA Dimensions 205; Dinodia Picture Agency 335; Duck Soup Graphics 473; Dynamic Graphics 294; Eastern Shore Art Center 499; Edelstein Gallery, Paul 499; Educational Video Network 456; EH6 Design Consultants 475; Envision 337; Fellowship 99; Foto Expression 339; Frontline Photo Press Agency 341; Galeria Mesa 501; Gallery Taranto 502; Gallery 218 503; General Learning Communications 104; Giarnella Design 415; Girlfriends 105; Grafica 458; Graphic Design Concepts 459; Greenberg Art Publishing, Raymond L. 295; Grit 107; Guest Informant 108; Guideposts 109; Hadassah 109; Horizon International Images Ltd. 346; Hues 114; Hutchison Picture Library 347; Ideal Images 348; Image Finders 349; Images Pictures 351; Ims Bildbyra 351; Industrial F/X 417; Inner Traditions Int. 265; Inspiration Art & Scripture 296; Italian America 117; James Design Studio, Peter 435; Jeroboam 353; Keyphotos International 354; Kiwanis 120; KBA 354; Kramer and Associates, Joan 355; Land of the Bible Photo Archive 355; Latina 122; Lawrence Gallery, J. 509; Leader 188; Lerner Et Al 444; Lerner Publications 267; Lieber Brewster Design Inc. 418; Liturgy Training Publications 267; Lizardi/Harp Gallery 510; Llewellyn Publications 268; Lonely Planet Publications 268; Lutheran 124; M.C. Gallery 511; Macalester Gallery 511; Media Consultants Inc. 463; MIDWESTOCK 359; Nassar Design 421; NASW Press 271; National Black Child Development Institute 421; Native Peoples 130; Nature Conservancy 131; New England Stock Photo 362; New Impact Journal 220; New Moon® 133; Nonstock Inc. 364; Northwest Photoworks 364; Nova Media Inc. 300; Novastock 365; Novus Visual Communications 422; Noyes Museum of Art 515; NTC/Contemporary Publishing Group 272; O.K. Harris Works of Art 515; Omni-Photo 366; 198 Gallery 516; Orion Press 366; Outpost 140; Owen Publishers, Richard C. 273; Pacific Stock 368; Pacific Union Recorder 141; Peak 142; Pelican Publishing Co. 274; Pentimenti Gallery 516; Persimmon Hill 143; Phoenix Gallery 517; Photo Agora 369; Photo Index 371; Photo Library 371; Photo Network 371; Photo Phoenix International 372; Photo Techniques 223; Photo 20-20 373; PhotoEdit 374; PhotoResource 145; Picture Cube Inc. 376; Portfolio Graphics 300; Positive Images 378; Pucker Gallery 519; Quarasan Group 276; Rag Mag 151; Rainbow 379; Ranger Rick and Your Big Backyard 151; Redmond Design, Patrick 448; Reidmore Books Inc. 276; RESO EEIG 380; Roland Gallery 520; Rosen Publishing Group 277; S.O.A. Photo Agency 382; Simon Design 426; Skipping Stones 161; Slo-Pitch News 191; Soundlight 467; Specialty Travel Index 233; Spectrum Pictures 386; Spectrum Stock Inc. 386; Spinsters Ink 279; Stock Boston Inc. 388; Stock House Ltd. 389; Stockhouse 391; Straight 166; Syracuse Cultural Workers 304; Taube Museum of Art 522; Think Twice 468; Touch 170; Tropix Photographic Library 393; Truth Consciousness/Desert Ashram 280; Ultrastock 394; Unicorn Stock Photos 394; Union Institute 450; Vibe 175; Viewfinders 396; VisionQuest 397; Vista 176; Visuals Unlimited 398; Wach Gallery 524; Waveland Press 283; Weigl Educational Publishers 283; Whiskey Island 179; YOU! 182; Young Romantic 182; Your Health 182; Zolan Fine Arts, LLC 306

Parents: Accent Alaska/Ken Graham 314; Ace Photo Agency 314; Adirondack Lakes Center for the Arts 484; Advanced Graphics 288; Advertising Consortium 453; Aflo Foto Agency 315; Agencee d'Illustration Photographique Edimedia 316; Alive Now 60; Allpix Photo Agency 318; American Fitness 62; American Forests 62; American Photo Library 318; American Planning Assoc. 246; Argus Photoland, Ltd. 320; AppaLight 320; Arregui International Advertising 432; Art Directors & Trip Photo Library 322; Art Directors Club 486; Asia Pacific Photographic Library 323; At-Home Mother 68; Atlanta Parent 68; Austral-International 325; Avanti Press Inc. 289; Bavaria Bildagentur 325; Benelux Press 326; Bible Advocate 72; Bureau for At-Risk Youth 251; Bynums Advertising Service 410; Cambridge Career Products 433; Capitol Complex Exhibitions 492; Cascade Geographic Society 291; Center for Photography at Woodstock 494; Christian Herald 186; Christian Home & School 84; Cleveland 87; Cliff and Assoc. 455; Cohen, Steven 433; Coleman Photo Library, Bruce 331; Comesaña-Agencia De Prensa, Eduardo 331; Concord Litho Group 292; Corbis 332; Cordaiy Photo Library, Sylvia 332; Corel Photo Collection 332; Crossing Press 256; Crumb Elbow Publishing 257; Curry Design, David 411; Daloia Design 293; Design Conceptions 334; Dinodia Picture Agency 335; Dynamic Graphics 294; Eastern Shore Art Center 499; Edelstein Gallery, Paul 499; EH6 Design Consultants 475; Flint Communications 442; Foto Expression 339; Foto-Press Timmerman 340; Frontline Photo Press Agency 341; Galeria Mesa 501; Giarnella Design 415; Global Pictures 344; Gospel Herald 107; Grafica 458; Granata Press Service 344; Graphic Design Concepts 459;

Grit 107; Guideposts 109; Hiller Publishing 263; Home Education 112; Horizon International Images Ltd. 346; Hutchison Picture Library 347; Image Concept Inc. 349; Images Pictures 351; Ims Bildbyra 351; Industrial F/X 417; Inspiration Art & Scripture 296; Isopress Senepart 352; James Design Studio, Peter 435; Keyphotos Int. 354; Kiwanis 120; Kollins Communications Inc. 418; KBA 354; Kramer and Associates, Joan 355; Latina 122; Lawrence Gallery, J. 509; Leader 188; Lieber Brewster Design Inc. 418; Lonely Planet Publications 268; Lutheran 124; M.C. Gallery 511; Marble House Gallery 511; Media Consultants Inc. 463; Nassar Design 421; Native Peoples 130; Nature Conservancy 131; New England Stock Photo 362; Nonstock Inc. 364; Northwest Photoworks 364; Novastock 365; Novus Visual Communications 422; Okapia K.G. 365; Omni-Photo 366; Orion Press 366; Our Family 137; OWL 140; Pacific Stock 368; Pacific Union Recorder 141; Petersen's Photographic 144; Photo Agora 369; Photo Index 371; Photo Phoenix International 372; Photo 20-20 373; PhotoResource 145; Photri Inc.—Microstock 376; Portfolio Graphics 300; Positive Images 378; Pucker Gallery 519; Redmond Design, Patrick 448; Reflexion Phototheque 380; RESO EEIG 380; Ro-Ma Stock 381; Rosen Publishing Group 277; S.O.A. Photo Agency 382; Sea 159; Selbert Perkins Design 425; Skylight Training and Publishing Inc. 278; Slo-Pitch News 191; Spectrum Pictures 386; Spectrum Stock Inc. 386; Stock Boston Inc. 388; Stockhouse 391; Taube Museum of Art 522; Think Twice 468; Truth Consciousness/Desert Ashram 280; Ultrastock 394; Unicorn Stock Photos 394; Viewfinders 396; Vintage Images 396; VisionQuest 397; Visual Hellas 397; Visuals Unlimited 398; Weigl Educational Publishers 283; Your Health 182; Zefa Visual Media 401

Performing Arts: Accent Alaska/Ken Graham 314; Adirondack Lakes Center for the Arts 484; Aflo Foto Agency 315; After Five 59; Allpix Photo Agency 318; Amelia 61; American Fitness 62; American Photo Library 318; Anvil Press 247; Argus Photoland, Ltd. 320; Art Concepts by Design 486; Art Directors & Trip Photo Library 322; Art Directors Club 486; Art Etc. 439; Art in General 486; ASAP Israel Stock Photo Agency 323; Ascherman Gallery 488; Asia Pacific Photographic Library 323; Austral-International 325; Barnett Advertising/Design, Augustus 471; Bavaria Bildagentur 325; Bedford/St. Martin's 249; Bethune TheatreDanse 454; Big Pictures UK 327; Bynums Advertising Service 410; Capitol Complex Exhibitions 492; Cascade Geographic Society 291; Center for Photography at Woodstock 494; Chatham Press 252; Christianity and The Arts 84; Cicada 85; Classic CD 86; Classical Singer 202; Cleveland 87; Cliff and Assoc. 455; Coastal Center for the Arts 495; Cohen, Steven 433; Collector's Choice Gallery 496; Comesaña-Agencia De Prensa, Eduardo 331; Cornerstone Productions Inc. 254; Creative Company 255; Crumb Elbow Publishing 257; Daloia Design 293; Dinodia Picture Agency 335; Diversion 93; Duck Soup Graphics 473; Eastern Shore Art Center 499; Educational Video Network 456; EH6 Design Consultants 475; Eleven East Ashland 500; Elliott, Kristin 294; Foto Expression 339; Fraser Advertising 434; Frontline Photo Press Agency 341; Galeria Mesa 501; Gallery 825 501; Gallery Taranto 502; Gig 105; Global Pictures 344; Grafica 458; Graphic Design Concepts 459; Guest Informant 108; Guideposts 109; Holiday Inn Express Navigator 112; Horizons 112; Images Pictures 351; Ims Bildbyra 351; Industrial F/X 417; Inspiration Art & Scripture 296; Iowan 117; James Design Studio, Peter 435; Keyphotos Int. 354; KBA 354; Kramer and Associates, Joan 355; La Mama La Galleria 509; Latina 122; Lawrence Gallery, J. 509; Le Petit Musée 510; Leader 188; Lerner Publications 267; Lippservice 418; Lutheran 124; Marble House Gallery 511; Mayfair 126; National News Bureau 190; New York Graphic Society 299; Nonstock Inc. 364; Northern Virginia Youth Symphony Assoc. 436; Novastock 365; Novus Visual Communications 422; Oklahoma Today 136; Orion Press 366; Oxford American 140; Photo Phoenix International 372; Photo 20-20 373; PhotoBank Yokohama 373; PhotoResource 145; Pittsburgh City Paper 190; Pix International 377; Players Press Inc. 275; Portfolio Graphics 300; Posey School of Dance 423; Postal Productions, Steve 436; Redmond Design, Patrick 448; Reidmore Books Inc. 276; San Francisco Conservatory of Music 465; Sangre De Cristo Chorale 466; Selbert Perkins Design 425; Smart Apple Media 278; Songwriter's Monthly 232; Soundlight 467; Spectrum Pictures 386; Spirit 163; Stockhouse 391; Strain 166; Sun.Ergos 474; Surface 167; Syracuse Cultural Workers 304; Think Twice 468; Tide-Mark Press 304; Today's Model 169; VisionQuest 397; Wach Gallery 524; Weigl Educational Publishers 283; Worldwide Images 400; Zefa Visual Media 401

Pets: Accent Alaska/Ken Graham 314; Ace Photo Agency 314; Adirondack Lakes Center for the Arts 484; Aflo Foto Agency 315; Agencee d'Illustration Photographique Edimedia 316; Agritech Publishing Group Inc. 245; Allpix Photo Agency 318; Amelia 61; American Fitness 62; American Photo Library 318; American Society for the Prevention of Cruelty to Animals 64; Animal Action/Animal Life 65; Animal Sheltering 198; Animals 65; Argus Photoland, Ltd. 320; A+E 320; AppaLight 320; Art Directors & Trip Photo Library 322; Art Directors Club 486; Asia Pacific Photographic Library 323; Atlantic City 68; Austral-International 325; Avanti Press Inc. 289; Back Home in Kentucky 69; Barton-Cotton Inc. 289; Bavaria Bildagentur 325; Benelux Press 326; Benelux Press 326; Bird Times 72; Buildings 201; Bynums Advertising Service 410; Capitol Complex Exhibitions 492; Cascade Geographic Society 291; Cats & Kittens 82; Center for Photography at Woodstock 494; Charlton Photos 330; Cicada 85; Cliff and Assoc. 455; Coastal Center for the Arts 495; Coleman Photo Library, Bruce 331; Concord Litho Group 292; Cordaiy Photo Library, Sylvia 332; Creative Company 255; Crossing Press 256; Crumb Elbow Publishing 257; Daloia Design 293; Designer Greetings 293; Dinodia Picture Agency 335; Dog & Kennel 93; Dog Fancy 94; Dummies Trade Press/IDG Books 259; Eastern Shore Art Center 499; Ecoscene 336; EH6 Design Consultants 475; Elegant Greeting 294; Elliott, Kristin 294; Farnam Companies 457; Foto Expression 339; Galeria Mesa 501; Global Pictures 344; Grafica 458; Granata Press Service 344; Graphic Design Concepts 459; Greyhound Review 211; Grit 107; Horizon International Images Ltd. 346; I Love Cats 114; Image Concept Inc. 349; Image Connection America 296; Images Pictures 351; Ims Bildbyra 351; Inner Traditions Int.

Kaplan Co., Arthur A. 298; Kashrus 119; Keyphotos International 354; Keystone Pressedienst GmbH 354; Kitchen & Bath Business 215; Kramer and Associates, Joan 355; Latina 122; Lawrence Gallery, J. 509; Lieber Brewster Design Inc. 418; Marble House Gallery 511; Marken Communications 463; Marketers Forum 217; Marketing & Technology Group 217; Masel Enterprises 419; McAndrew Advertising Co. 419; Message Makers 446; Mitchell Studios Design Consultants 420; Mizerek Advertising Inc. 420; Mode Magazine 127; Modern Art 299; Modern Drummer 127; Myriad Productions 436; Nassar Design 421; Nerland Agency 474; New Methods 220; Nonstock Inc. 364; Northwest Photoworks 364; Nostradamus Advertising 422; Novus Visual Communications 422; Ohio Tavern News 221; Origin Design 464; Orion Press 366; Oxford American 140; Panoramic Images 369; Peak 142; Penn-Jude Partners 464; Pet Product News 223; Philipson Agency 423; Photo Index 371; Photo Technique 144; PhotoBank Yokohama 373; PhotoResource 145; Popular Science 148; Portfolio Graphics 300; Postal Productions, Steve 436; Press Chapeau 301; QSR 227; Quick Frozen Foods International 228; Redmond Design, Patrick 448; Reidmore Books Inc. 276; S.O.A. Photo Agency 382; Sacramento 155; Schowalter Design, Tony 425; Sorin Productions 426; Stock Car Racing 165; Stock House Ltd. 389; Stockhouse 391; Superstock Inc. 391; Surface 167; Tansky Advertising Co., Ron 467; Tele-Press Associates 427; Think Twice 468; Thomas Printing 474; Tobol Group 428; Travel & Leisure 171; US Airways Attaché 174; Vermont 175; Vintage Images 396; VisionQuest 397; Visual Hellas 397; Warne Marketing & Communications 475; Warner Books 283; Wave Design Works 428; White Productions, Dana 469; Williams/Crawford & Associates 438; Yankee 181; Zahn & Associates, Spencer 429; Zefa Visual Media 401

Religious: Accent Alaska/Ken Graham 314; Adirondack Lakes Center for the Arts 484; Aflo Foto Agency 315; Agencee d'Illustration Photographique Edimedia 316; Alive Now 60; Allen Photo Library, J. Catling 318; Allpix Photo Agency 318; American Bible Society 246; American Photo Library 318; Ancient Art & Architecture Collection 319; Andes Press Agency 319; AppaLight 320; Arnold Publishing Ltd. 248; Art Directors & Trip Photo Library 322; Art Directors Club 486; ASAP Israel Stock Photo Agency 323; Augsburg Fortress, Publishers 248; Austral-International 325; Barton-Cotton Inc. 289; Bavaria Bildagentur 325; Behrman House Inc. 249; Benelux Press 326; Benelux Press 326; Bible Advocate 72; B'Nai B'Rith International Jewish Monthly 74; Bristol Gift Co. Inc. 290; Bryant Stock Photography, D. Donne 327; Bynums Advertising Service 410; Canada Lutheran 79; Catholic Near East 82; Catholic News Service 329; Center for Photography at Woodstock 494; Charisma 83; Christian Century 84; Christian Herald 186; Christian Ministry 201; Christianity and The Arts 84; Classic CD 86; Cliff and Assoc. 455; Coastal Center for the Arts 495; Company 88; Concord Litho Group 292; Cordaiy Photo Library, Sylvia 332; Covenant Companion 89; Creative Company 473; Crumb Elbow Publishing 257; Daloia Design 293; Das Fenster 91; Dinodia Picture Agency 335; Dynamic Graphics 294; Eastern Press 259; Eastern Shore Art Center 499; Educational Video Network 456; Egee Art Consultancy 499; EH6 Design Consultants 475; Fellowship 99; Foto Expression 339; Galeria Mesa 501; Gallery Taranto 502; Global Pictures 344; Gospel Herald 107; Grafica 458; Greenberg Art Publishing, Raymond L. 295; Grit 107; Guide 108; Hiller Publishing 263; Hutchison Picture Library 347; Inner Traditions Int. 265; Insight 116; Inspiration Art & Scripture 296; Isopress Senepart 352; James Design Studio, Peter 435; Jewish Action 118; Kashrus 119; Keyphotos Int. 354; Kramer and Associates, Joan 355; Lake Superior 121; Latina 122; Lawrence Gallery, J. 509; Leader 188; Liturgy Training Publications 267; Living Church 123; Llewellyn Publications 268; Lutheran Forum 124; Lutheran 124; Marble House Gallery 511; Mennonite Publishing House 126; New Leaf Press 271; News Flash International 363; Newsmakers 363; Nonstock Inc. 364; Nova Media Inc. 300; Novastock 365; Novus Visual Communications 422; Omni-Photo 366; Orion Press 366; Our Family 137; Our Sunday Visitor 273; Oxford American 140; Pentecostal Evangel 143; Photo Agora 369; Photo Phoenix International 372; PhotoResource 145; Photri Inc.—Microstock 376; Picture Cube Inc. 376; Portfolio Graphics 300; Postal Productions, Steve 436; Preacher's Magazine 225; Presbyterian Record 148; Pucker Gallery 519; Redmond Design, Patrick 448; Reform Judaism 153; Rodale Press 277; Rosen Publishing Group 277; Sacramento 155; Seek 160; Soundlight 467; Spectrum Pictures 386; Stockhouse 391; Straight 166; Think Twice 468; Touch 170; Tropix Photographic Library 393; Truth Consciousness/Desert Ashram 280; Tuttle Publishing 281; Ullstein Bilderdienst 394; Unicorn Stock Photos 394; Vintage Images 396; VisionQuest 397; Visual Photo Library 398; Visuals Unlimited 398; Waveland Press 283; Weigl Educational Publishers 283; Weiser Inc., Samuel 283; Whiskey Island 179; With 180; YOU! 182

Rural: Accent Alaska/Ken Graham 314; Adirondack Lakes Center for the Arts 484; Aflo Foto Agency 315; After Five 59; Agencee d'Illustration Photographique Edimedia 316; Alabama Living 59; Alive Now 60; Allen Photo Library, J. Catling 318; Amelia 61; American Agriculturist 196; American Fitness 62; American Forests 62; American Photo Library 318; American Planning Assoc. 246; Anvil Press 247; AppaLight 320; Art Directors & Trip Photo Library 322; Art Directors Club 486; Art Resource International/Bon Art 288; Ascherman Gallery 488; Asia Pacific Photographic Library 323; Aurora & Quanta Productions 324; Austral-International 325; Back Home in Kentucky 69; Barnett Advertising/Design, Augustus 471; Bavaria Bildagentur 325; Bedford/St. Martin's 249; Belian Art Center 488; Benelux Press 326; Bible Advocate 72; Birds & Blooms 73; Canadian Rodeo News 79; Cape Cod Life 80; Cascade Geographic Society 291; Center for Photography at Woodstock 494; Chatham Press 252; Cicada 85; Cliff and Assoc. 455; Coastal Center for the Arts 495; Coleman Photo Library, Bruce 331; Compass American Guides 253; Concord Litho Group 292; Country 89; Countryman Press 255; Creative Company 473; Creative Company 255; Crossing Press 256; Crumb Elbow Publishing 257; Cunningham Photographic, Sue 333; Current 293; Daloia Design 293; Dinodia Picture Agency 335; Duck Soup Graphics 473; Eastern

Seasonal: Accent Alaska/Ken Graham 314; Ace Photo Agency 314; Adirondack Lakes Center for the Arts 484; Advanced Graphics 288; Advertising Consortium 453; Alaska Stock Images 317; Alphastock 318; American Fitness 62; American Forests 62; American HomeStyle & Gardening 63; American Photo Library 318; Argus Photoland, Ltd. 320; AppaLight 320; Arcaid 321; Art Directors & Trip Photo Library 322; Art Directors Club 486; Artwerks Stock Photography 323; Aurora & Quanta Productions 324; Austral-International 325; Back Home in Kentucky 69; Barton-Cotton Inc. 289; Bavaria Bildagentur 325; Benelux Press 326; BePuzzled 289; Bible Advocate 72; Birds & Blooms 73; Blue Sky Publishing 290; Burgoyne Inc. 290; Bynums Advertising Service 410; Cape Cod Life 80; Capitol Complex Exhibitions 492; Capper's 185; CardMakers 290; Cascade Geographic Society 291; Catholic News Service 329; Center for Photography at Woodstock 494; Centric Corp. 291; Cliff and Assoc. 455; Coastal Center for the Arts 495; Coffee House Press 253; Comstock Cards 292; Concord Litho Group 292; Cordaiy Photo Library, Sylvia 332; Corel Photo Collection 332; Country 89; Countryman Press 255; CRC Product Services 89; Creative Company 473; Creative Company 255; Crumb Elbow Publishing 257; Current 293; Daloia Design 293; Design Design 293; Designer Greetings 293; Dinodia Picture Agency 335; Dodo Graphics Inc. 293; Dynamic Graphics 294; EH6 Design Consultants 475; Elegant Greeting 294; Elliott, Kristin 294; Farm & Ranch Living 99; Field 99; Flashcards 294; Flint Communications 442; Foto Expression 339; Fotofolio 295; Foto-Press Timmerman 340; Fraser Advertising 434; Frith Creative Resourcing 414; Galeria Mesa 501; Gallant Greetings Corp. 295; Gardenimage 343; German Life 105; Giarnella Design 415; Global Pictures 344; Gospel Herald 107; Grafica 458; Graphic Design Concepts 459; Greenberg Art Publishing, Raymond L. 295; Guest Informant 108; Guideposts 109; High Range Graphics 295; Hiller Publishing 263; Horizons 112; Hutchison Picture Library 347; Image Finders 349; Images Pictures 351; Impact 296; Ims Bildbyra 351; Industrial F/X 417; Inspiration Art & Scripture 296; Intercontinental Greetings 297; Iowan 117; Isopress Senepart 352; James Design Studio, Peter 435; Jillson & Roberts Gift Wrappings 298; Kansas 119; Kashrus 119; Keene Kards Inc. 298; Keyphotos Int. 354; Kogle Cards 298; Kramer and Associates, Joan 355; Lawrence Gallery, J. 509; Le Petit Musée 510; Leader 188; Lerner Et Al 444; Lonely Planet Publications 268; Lutheran 124; Marble House Gallery 511; Media Consultants Inc. 463; Michigan Out-of-Doors 127; Mushing 218; New York State Conservationist 133; Nonstock Inc. 364; Nors Graphics 300; Northwest Photoworks 364; Nova Media Inc. 300; Novastock 365; Novus Visual Communications 422; Orion Press 366; Our State 137; Outpost 140; OWL 140; Oxford Scientific Films 367; Pacific Yachting 141; Panoramic Images 351; Peak 142; Pentecostal Evangel 143; Persimmon Hill 143; Pet Product News 223; Petersen's Photographic 144; Photo Agora 369; Photo Technique 144; Photo 20-20 373; PhotoBank Yokohama 373; PhotoResource 145; Photri Inc.—Microstock 376; Planet Earth Pictures 378; PORPOISE PhotoStock 378; Portfolio Graphics 300; Pucker Gallery 519; Recycled Paper Greetings 301; Redmond Design, Patrick 448; Reiman Publications, L.P. 277, 301; Reminisce 153; Renaissance Greeting Cards, 302; RESO EEIG 380; Resource Recycling 229; Rights International Group 302; Rockshots 302; Roland Gallery 520; S.O.A. Photo Agency 382; Sanghaui Enterprises Ltd. 303; Selbert Perkins Design 425; Simon Design 426; Soundlight 467; Sparrow & Jacobs 303; Spectrum Pictures 386; Speech Bin Inc. 279; Surface 167; Teldon Calendars 304; Tide-Mark Press 304; Ullstein Bilderdienst 394; Ultrastock 394; Unicorn Stock Photos 394; Vagabond Creations 305; Voyageur Press 282; Warm Greetings 305; Weigl Educational Publishers 283; Where 179; Whiskey Island 179; Wisconsin Trails 305; Young Romantic 182; Zefa Visual Media 401

Senior Citizens: AAA Image Makers 314; Accent Alaska/Ken Graham 314; Ace Photo Agency 314; Adirondack Lakes Center for the Arts 484; Advanced Graphics 288; Aflo Foto Agency 315; Agencee d'Illustration Photographique Edimedia 316; Alive Now 60; Allpix Photo Agency 318; Alphastock 318; Amelia 61; American Fitness 62; American Forests 62; American Photo Library 318; AppaLight 320; Arregui International Advertising 432; Art Directors & Trip Photo Library 322; Art Directors Club 486; Art Etc. 439; Asia Pacific Photographic Library 323; Aurora & Quanta Productions 324; Austral-Internation 325; Bavaria Bildagentur 325; Benelux Press 326; Birds & Blooms 73; Brazzil 75; Bynums Advertising Service 410; Capitol Complex Exhibitions 492; Cascade Geographic Society 291; Catholic News Service 329; Center for Photography at Woodstock 494; Christian Herald 186; Cicada 85; Cleveland 87; Cliff and Assoc. 455; Coastal Center for the Arts 495; Cohen, Steven 433; Coleman Photo Library, Bruce 331; Concord Litho Group 292; Corbis 332; Cordaiy Photo Library, Sylvia 332; Corel Photo Collection 332; Country 89; Creative Company 473; Crossing Press 256; Crumb Elbow Publishing 257; Curry Design, David 411; Daloia Design 293; Design Conceptions 334; Dinodia Picture Agency 335; Direct Source Advertising 412; Dynamic Graphics 294; Eastern Shore Art Center 499; Edelstein Gallery, Paul 499; EH6 Design Consultants 475; Family Motor Coaching 98; Farm & Ranch Living 99; Flint Communications 442; Foto Expression 339; Foto-Press Timmerman 340; Fraser Advertising 434; Frontline Photo Press Agency 341; Galeria Mesa 501; Giarnella Design 415; Global Pictures 344; Grafica 458; Granata Press Service 344; Grit 107; Guideposts 109; Highways 111; Horizon International Images Ltd. 346; Hutchison Picture Library 347; Ideal Images 348; Image Concept Inc. 349; Image Finders 349; Images Pictures 351; Ims Bildbyra 351; Industrial F/X 417; Inspiration Art & Scripture 296; Isopress Senepart 352; James Design Studio, Peter 435; Keyphotos Int. 354; Kiwanis 120; KBA 354; Kramer and Associates, Joan 355; Latina 122; Lawrence Gallery, J. 509; Leader 188; Lieber Brewster Design Inc. 418; Lippservice 418; Lizardi/Harp Gallery 510; Lonely Planet Publications 268; Lutheran 124; M.C. Gallery 511; Mach 2 Stock Exchange Ltd. 357; Marble House Gallery 511; Mature Outlook 125; Media Consultants Inc. 463; Modern Maturity 127; Native Peoples 130; Nature Conservancy 131; New England Stock Photo 362; Nonstock Inc. 364; Northwest Photoworks 364; Novastock 365; Novus Visual Communications 422; Okapia K.G. 365; Omni-Photo 366; Orion Press 366; Our Family 137; Ozark Stock 367; Pacific Stock 368; Pacific Union Recorder 141; Penn-Jude Partners 464; Persimmon Hill 143; Photo Agora 369;

friends 105; Go Boating 106; Golf Tips 106; Grafica 458; Granata Press Service 344; Graphic Arts Center Publishing Company 261; Graphic Design Concepts 459; Grit 107; Guest Informant 108; Guideposts 109; Hadassah 109; Highways 111; Hippocrene Books Inc. 263; Historic Traveler 111; Holiday Inn Express Navigator 112; Hollow Earth Publishing 263; Horizon International Images Ltd. 346; Horizons 112; Howell Press 265; Hutchison Picture Library 347; Image Concept Inc. 349; Image Finders 349; Images Pictures 351; Impact 296; Ims Bildbyra 351; Industrial F/X 417; Iowan Magazine 117; Islands and AQUA 117; Italian America 117; ITechnology Journal 118; Jadite Galleries 508; James Design Studio, Peter 435; Jaywardene Travel Photo Library 353; Jewish Action 118; Kashrus Magazine 119; Keyphotos Int. 354; Keystone Pressedienst GmbH 354; Kollins Communications Inc. 418; KBA 354; Kramer and Associates, Joan 355; Lake Superior 121; Langenscheidt Publishers 266; Latina 122; Lawrence Gallery, J. 509; Le Petit Musée 510; Leisure World 122; Lerner Et Al 444; Lineair Fotoarchief B.V. 356; Lonely Planet Publications 268; Lutheran 124; Lynx Images Inc. 269; Marble House Gallery 511; Marlboro Gallery 512; Mayfair 126; Michigan Natural Resources 126; MIRA 360; Moon Publications 270; Muir Publications, John 270; Nassar Design 421; Naturally Nude Recreation & Travel 131; Naturist Life International 132; Nawrocki Stock Photo 361; New Choices Living Even Better After 50 132; New England Stock Photo 362; New York State Conservationist 133; Newsmakers 363; Nonstock Inc. 364; Northwest Photoworks 364; Nor'westing 134; Novastock 365; Novus Visual Communications 422; NTC/Contemporary Publishing Group 272; Ohio 136; Okapia K.G. 365; Oklahoma Today 136; Omni-Photo 366; Orion Press 366; Outpost 140; Oxford Scientific Films 367; Ozark Stock 367; Pacific Stock 368; Panoramic Images 369; Peak 142; Pelican Publishing Co. 274; Persimmon Hill 143; Petersen's Photographic 144; Photo Agora 369; Photo Library 371; Photo Life 144; Photo Network 371; Photo Phoenix International 372; Photo Researchers 372; Photo Technique 144; Photo Techniques 223; Photo 20-20 373; Photophile 375; PhotoResource 145; Photri Inc.—Microstock 376; Picturesque Stock Photos 377; Planet Earth Pictures 378; Play The Odds 190; Playboy 145; Polo Players Edition 147; Pontoon & Deck Boat 147; Popular Science 148; PORPOISE PhotoStock 378; Portfolio Graphics 300; Positive Images 378; Postal Productions, Steve 436; Prime Times 149; Q San Francisco 150; Rainbow 379; Recommend Worldwide 228; Recreational Ice Skating 152; Redmond Design, Patrick 448; Reiman Publications, L.P. 277, 301; Reminisce 153; RESO EEIG 380; Retired Officer 230; Roanoker 153; Roland Gallery 520; Ro-Ma Stock 381; Rutledge Hill Press 278; S.O.A. Photo Agency 382; St. Maarten Nights 156; Score, Canada's Golf 158; Sea 159; Selbert Perkins Design 425; Showboats Int. 160; Silver Image Photo Agency 384; Ski Canada 161; Smart Apple Media 278; Soaring 162; Soundlight 467; Specialty Travel Index 233; Spectrum Pictures 386; Spectrum Stock Inc. 386; Speech Bin Inc. 279; Spirit 163; Sport 164; Sportslight Photo 387; State 165; Stock Boston Inc. 388; Stock Broker 388; Stock House Ltd. 389; Stock Market 389; Stock Shop 390; Stock Shot 390; Stockhouse 391; Surfing 167; Taube Museum of Art 522; Teldon Calendars 304; Telluride Stock Photography 392; Think Twice 468; Tide-Mark Press 304; Top Stock 393; Trailer Boats 170; Transitions Abroad 171; Travel & Leisure 171; Traveller 171; Tropix Photographic Library 393; Ullstein Bilderdienst 394; Ultrastock 394; Ulysses Press 281; Unicorn Stock Photos 394; US Airways Attaché 174; Vermont Life 174; Vermont 175; Viewfinders 396; Vintage Images 396; VisionQuest 397; Visual Contact 397; Visual Hellas 397; Visuals Unlimited 398; Visum/+49 399; Voyageur Press 282; Wach Gallery 524; Washingtonian 177; Watercraft World 178; Weigl Educational Publishers 283; Where 179; Wiesner Inc. 180; Windsurfing 180; Wine & Spirits 180; Woodmen 181; Yankee 181; Yoga Journal 182; Your Health 182; Zefa Visual Media 401

Wildlife: Ace Photo Agency 314; Adirondack Lakes Center for the Arts 484; Advanced Graphics 288; Adventure Photo & Film 315; Advertising Consortium 453; After Five 59; Agencee d'Illustration Photographique Edimedia 316; AGStock USA 316; Alabama Living 59; Alaska Stock Images 317; Allpix Photo Agency 318; Amelia 61; America West Airlines 61; American Agriculturist 196; American Angler 61; American Forests 62; American Hunter 63; American Photo Library 318; American Society for the Prevention of Cruelty to Animals 64; Animal Action/Animal Life 65; Animals 65; Argus Photoland, Ltd. 320; A+E 320; Appalachian Trailway News 69; AppaLight 320; Arnold Publishing Ltd. 248; Art Directors & Trip Photo Library 322; Art Directors Club 486; Art Resource International/Bon Art 288; Artwerks Stock Photography 323; Artworks Gallery 488; ASAP Israel Stock Photo Agency 323; Asia Pacific Photographic Library 323; Audubon 69; Austral-International 325; Avanti Press Inc. 289; Bach Production, Eric 325; Back Home in Kentucky 69; Backpacker 70; Barton-Cotton Inc. 289; Bavaria Bildagentur 325; BC Outdoors 71; Bears 71; Benelux Press 326; Big Pictures UK 327; Bird Times 72; Bird Watcher's Digest 72; Bird Watching 72; Blackbird Press 250; Blue Ridge Country 74; Blue Sky Publishing 290; Bowhunter 74; Bridgewater/Lustberg Gallery 491; Browning 455; Bugle 76; Bynums Advertising Service 410; California Wild 77; Calypso Log 78; Cape Cod Life 80; Capitol Complex Exhibitions 492; Caribbean Travel and Life 81; Cascade Geographic Society 291; Cedco Publishing 291; Center for Photography at Woodstock 494; Charlesbridge Publishing 252; Chickadee 83; Children's Digest 84; Cicada 85; Cliff and Assoc. 455; Coastal Center for the Arts 495; Coleman Photo Library, Bruce 331; Comesaña-Agencia De Prensa, Eduardo 331; Community Darkroom 546; Compass American Guides 253; Concord Litho Group 292; Cordaiy Photo Library, Sylvia 332; Countryman Press 255; Crabtree Publishing Company 255; Creative Company 255; Creative Editions 256; Crossing Press 256; Crumb Elbow Publishing 257; Current 293; Daloia Design 293; Das Fenster 91; Deer and Deer Hunting 91; Defenders 92; Design Concepts-Carla Schroeder Burchett 411; Designer Greetings 293; Dinodia Picture Agency 335; Diversion 93; Dolphin Log 94; DRK Photo 335; Duck Soup Graphics 473; Ducks Unlimited 95; Dynamic Graphics 294; E Magazine 95; Earth Images 336; Eastern Shore Art Center 499; Ecoscene 336; EH6 Design Consultants 475; Elliott, Kristin 294; Environment 97; Environmental Investigation Agency 337; Fellowship 99; Field 99; Fly Rod & Reel 102; Forest Landowner 210; Foto Expression 339;

General Index

This index lists every market appearing in the book; use it to find specific companies you wish to approach. The index also lists companies that appeared in the 1999 edition of *Photographer's Market*, but do not appear this year. Instead of page numbers, beside these markets you'll find two-letter codes in parentheses that explain why they were excluded. The codes are: **(ED)**—Editorial Decision **(NS)**—Not Accepting Submissions, **(NR)**—No or Late Response to Listing Request, **(OB)**—Out of Business, **(RP)**—Business Restructured or Sold, **(RR)**—Removed by Market's Request, **(UC)**–Unable to Contact.